# INTERNATIONAL HANDBOOK OF RESEARCH IN ARTS EDUCATION

# Springer International Handbook of Research in Arts Education

## VOLUME 16

*A list of titles in this series can be found at the end of this volume.*

# International Handbook of Research in Arts Education

## Part One

Editor: Liora Bresler
*University of Illinois at Urbana-Champaign, U.S.A.*

 Springer

A C.I.P. Catalogue record for this book is available from the Library of Congress.

ISBN-10 1-4020-4857-2 (PB)
ISBN-13 978-1-4020-4857-9 (PB)
ISBN-10 1-4020-2998-5 (HB)
ISBN-13 978-1-4020-2998-1 (HB)
ISBN-10 1-4020-3052-5 (e-book)
ISBN-13 978-1-4020-3052-9 (e-book)

Published by Springer,
P.O. Box 17, 3300 AA Dordrecht, The Netherlands

*www.springer.com*

*Printed on acid-free paper*

# TABLE OF CONTENTS

# INTRODUCTION

## Liora Bresler

Over the past 40 years, a quiet development has been taking place – a positioning of the individual arts and the respective disciplines of arts education within a larger umbrella of "The Arts." At the institutional tertiary level, the disciplines of music, visual art, dance, and drama and the various disciplines of arts education are often housed within one college. This location has intellectual and political ramifications. The umbrella of "arts education," for example, proved to be a powerful tool in forming the arts component in the National and State Standards in the United States. In working on Goals 2000, the arts education organizations – National Art Education Association, Music Education National Conference, the American Alliance for Theater and Education, and the National Dance Association came together to forge a common vision and coordinate shared goals. At the artistic level, we are increasingly witnessing the generation of innovative artwork with mixed forms of representation, where the visual, auditory, and kinesthetic combine to create new types of art.

This development has not transformed the arts disciplines. The individual disciplines have maintained their distinctive identities, organizations, traditions, and areas of practice and scholarship. What this reframing and its institutional, curricular, and artistic structures generate is a productive tension between the individual arts disciplines and the larger arena that is referred to as "arts" and "arts education." This productive tension creates interest in learning about existing practice and research in the various arts education communities to explore ways that they can cross-fertilize each other.

Intensified cross-fertilization is part of a larger characteristic of the twenty-first century, manifested in both artistic and intellectual spheres: the *softening of boundaries* (Detels, 1999) between what used to be solid concepts and domains. Softer boundaries allow *border crossing* (Giroux, 1992). Within the individual arts disciplines, crossing borders is manifested in the juxtaposition of artistic genres and styles. For example, performance centers traditionally dedicated to classical music now host what used to be "music untouchables" (Nettl, 1995) – music typically played in night clubs. Similarly, leading classical musicians such as Yo Yo Ma, Nigel Kennedy, and

L. Bresler (Ed.), International Handbook of Research in Arts Education, xvii–xxiv.
© 2007 Springer.

Daniel Barenboim cross musical genres to perform folk and indigenous musics of various cultures, as well as popular music and rock.

Crossing boundaries is evident in our conceptualization of knowledge and its reorganizations into new disciplines. I regard the concept of discipline as an open-ended one, much like the concept of art (Weitz, 1956). In order to exist, it needs boundaries. At the same time, to maintain its vibrancy and cutting-edge quality, it needs to be able to extend these boundaries, to venture into new territories. Cross-fertilization is manifested at the university level with the emergence of hybrid disciplines, such as biophysics, molecular biology, computational neuroscience, social psychology, and psychological economics. What does this mean for the interaction of the disciplines of arts education with other disciplines?

Crossing borders is not a new phenomenon for arts education. In the past, arts educators reached out to other scholarly disciplines, initially to legitimize and strengthen their position in the school curriculum. A familiar example from the United States was in the "post-Sputnik" era of the late 1950s and 1960s, when the heightened attention to science and mathematics prompted all school disciplines to articulate rationales in order to justify their existence. Music and art educators realized that they, too, needed an explicit, solid basis for their subject to secure its place in public schooling. In this endeavor, the discipline of philosophy provided arguments articulating a broad educational role for the arts, highlighting cognitive aspects and connecting them intimately to what has traditionally been regarded as the essence of art: affect (e.g., Broudy, 1958, 1972; Langer, 1957). In establishing cognition as fundamental for the arts, psychology, too, provided useful support (e.g., Arnheim, 1966, 1974; Meyer, 1956; for more recent empirical psychological research on the cognitive merits of the arts, see Rauscher, Shaw, & Ky, 1993; Rauscher et al., 1997). If the flow of ideas and findings from philosophy and psychology was generated by policy and a need for advocacy, it ended up affecting the conceptualization and practice of arts education. For example, the philosophical area of aesthetics shaped the curriculum movement of Discipline Based Arts Education, as did the discipline of art history (Dobbs, 1998; Greer, 1984; MacGregor, 1997).

The change of research climate as part of the post-modern paradigm has also affected research in arts education. In the 1980s and 1990s, we note a framing of the arts within broad sociocultural ideas and contexts (e.g., Lave & Wenger, 1991; Vygotsky, 1986; Wenger, 1998) in ways that further expanded the theory and practice of the arts. Anthropological and sociological perspectives view the arts as reflecting a society and what it values (e.g., Geertz, 1976; Small, 1998), serving as social and political tools; such lenses draw attention to the communal and spiritual roles in diverse cultures (e.g., Ajayi, 1996; Blacking, 1995; Nzewi, 1978/9; Yanagi, 1989). Examinations of other cultures serve to "make the strange familiar," and at the same time, can "make the familiar strange," helping us discern implicit value systems in our own cultures.

The handbook is based on this dialectic of familiar and strange, autonomous disciplines and soft boundaries. It is grounded in the distinct traditions and areas of scholarship within a specific arts discipline, but with a view to outlining connections and common principles, where individual chapters are placed within a larger perspective. The handbook does not propose to blur the distinctions among the various disciplines of arts education. Rather, it aims to cultivate an awareness among the various arts

education communities about compelling, relevant literatures in their "sister" disciplines, and to foster communication and dialogue among these communities in order to enrich knowledge and informed practice. To this end, most individual chapters focus on one subject (e.g., music education, dance education), while seeking to draw connections and communicate with readers *across* the various arts education disciplines. These connections are highlighted by the organization of chapters within sections.

To summarize, this handbook aims at two related functions. On one level, the handbook is expected to be a distillation of knowledge in the respective disciplines of dance, drama, literature, music, and visual arts education, with inclusion, when relevant, of media. It is meant to be a standard volume that synthesizes an existing scholarship, helping define and shape the past and present, and point to the future of that discipline. In that respect, its purpose is to address, interpret and organize a field of research within arts education, mapping theoretical and practical directions, and providing conceptual definition to an area of inquiry. More than an object, the power of this handbook is in the *processes* it sets in motion, its generative momentum, its ability to frame significant themes, juxtapose interpretations, launch new directions, and propel people to pursue innovative directions. Its second function is based on the assumption that communication among the arts disciplines will advance each of them individually and facilitate cross-fertilization.

Accordingly, in searching for topics and scholars, I aimed at a balance among the arts disciplines. I was cautious about overreliance on the perspectives of the two arts disciplines with longer traditions and wider practice – music and visual arts education, and underrepresentation of dance and drama. I found the inclusion of poetry and literature to be generative in that it provides additional important lenses to conceptualize the arts disciplines. Literature and poetry, though often not included in the institutional and political "Arts" umbrella, share with the arts a deep aesthetic tradition and rich scholarship, as well as aesthetic goals, contents, and pedagogies.

In addition to the individual arts education frameworks, the chapters are informed by diverse theoretical frameworks. These include aesthetics, anthropology, cultural psychology, cultural studies, critical theory, sociology, and curriculum theories, among others, illustrating the interdisciplinary nature of contemporary educational thinking and research.

Another principle that shaped the contents and structure of the handbook is its commitment to international perspectives. Indeed, the scholarship outside the mainstreams of academia in North America, England and Australia is significant and compelling. International literature is reported by some 50 International Advisory Board members from six continents and 35 countries. Serving as windows or appetizers (depending on one's view and relationship to scholarship) to diverse cultural contexts, these commentaries, placed at the end of the chapters, include summaries of research and scholarship in some 20 languages.

Existing as an underlying assumption, more understated but not least important is the commitment to the living presence of art. All of us, in the various disciplines of arts education, have come to be where we are out of love of the arts. While research can at times seem distant from the experience of art, this handbook aspires, through loosely structured interludes, to maintain connection with artistic experiences.

In terms of organization, the handbook is organized into 13 sections, each centering on a key area in arts education research. Preludes, written by the Section Editors, introduce the theme of the section, providing context and conceptual frameworks. The individual chapters typically address cross-cultural research related to the central theme of the section from the perspectives of the particular art discipline (i.e., music, visual art, dance, drama, literature, and on occasion, media). Interludes provide reflective, often expressive and poetic meditations on the theme.

In the spirit of soft boundaries, issues and themes could belong to more than one section. For example, informal learning, while it exists as a section of its own, is clearly ever-present, in the strictest of formal setting as well as in the more laissez-faire settings of cultural centers. Creativity underlies all human endeavors, as do the body, social issues, and technology in its broadest sense. And each of these themes has a history, often a rich one. Specific themes, such as metaphor, for example, were identified in various sections (in this case, in composition, appreciation, informal learning, and the body). These recurrent themes operate much like a sonata with its separate movements but shared motifs.

The "planned handbook" provided a solid model for the "operational handbook." But in the process of becoming the organic body that it is, as all processes do, it assumed a life of its own. Part of the work of this editor involved facilitating exchange of drafts between authors, both within as well as across sections; this helped authors stay aware of what others were doing. In that sense, the handbook is a huge mosaic with striking themes and emerging patterns. It is, of course people who construct themes, play with boundaries, and do the unexpected. Bob Stake, for example, who initially opted to write for the evaluation section, became caught up by Maxine Greene's interlude on Appreciation and wrote his own interlude as a response to hers, crossing from one section to another. Another example of the handbook's emergent process occurred after two authors in two independent sections who did not know each other read each other's preliminary drafts; Julian Sefton-Green and Lissa Soep then chose to merge their chapters. Initial chapters by Monica Prendergast and Carl Leggo's, as well as Rishma Dunlop's, assumed the form and style of poetic interludes.

As important as what is in a handbook is what is not included, the *null*. One early decision was to leave out explicit discussion of research methodologies and methodological issues, too vast and complex to be treated with the dignity and the thoroughness they deserve. Other key areas that are not included are teacher education and policy.

Every project is embedded within a concrete set of circumstances. This book started as an invitation over breakfast during a conference of the American Education Research Association, following my editorship of a book series on arts education. That invitation, from what was then Kluwer Publishing (now Springer) resonated with my interest in having the various communities of arts education gather around a set of issues and a joint mission. My own history involved crossing intellectual as well as geographical borders. In my earlier role as a musician, my thesis in musicology observed how history and ideology shaped artistic styles: while focusing on music, I also noted similar patterns in the visual arts, literature, dance and drama (Bresler, 1982, 1985). Crossing geographical borders when moving to the United States was equally formative in alerting me to the power of multiple cultural perspectives in facilitating perceptions and

interpretations (Bresler, 2002). The excitement of creating this space for the various communities of arts education was directly related to my own crossings which I found to be immensely enriching journeys.

## Acknowledgments

Handbooks are, by nature, collaborative work. This particular handbook involved many hundreds of people. It was, to draw on the common adage, raised by a whole village, one that, in its scope, felt as big as a city, but (miraculously) was able to maintain the closeness and caring of a smaller community.

The role of section editors – Gordon Cox, Sue Stinson, Regina Murphy, Magne Espeland, Sarah McCarthey, Margaret Barrett, Beau Vallance, Minette Mans, Tina Thompson, Doug Risner, Tracie Costantino, Pam Burnard, Kim Powell, Peter Webster, and Rita Irwin, cannot be overly emphasized. This project would not be possible without them. Grounded within various arts disciplines – music, visual art, literature, and dance – and different countries, including the United States, Canada, England, Australia, Namibia, Ireland, and Norway, they were deeply wise, thoughtful, and hard working. Generous beyond the call of duty, they showed an impressive ability to care about larger ideas as well as great attention to detail (and there were lots of both!). I could not have imagined better, kinder and wiser companions along this fascinating road.

This book, a collage of more than 100 pieces, was created by 116 authors, leading scholars in the disciplines of arts education. Mostly North Americans, British, and Australians, this group too encompassed diverse countries, from the Netherlands, Finland, Sweden and Denmark, to Nigeria, Cyprus, Israel and Japan. Clearly, this handbook is based on their knowledge, wisdom, and commitment to the field and to this project. Another crucial yet invisible group is the reviewers. Each chapter was reviewed by at least four (including section editor and editor) people, often more. These reviewers, listed at the front of the handbook, undertook the important task of providing informed, thorough feedback.

A handbook of Arts Education cannot be complete without art. I am deeply indebted to Jana Mason, an acknowledged and inspiring visual artist with a deep commitment to education. Previously a prominent scholar in educational psychology, Jana has worked diligently and artistically to create images for the sections.

Tracie Costantino and Su-Jeong Wee did an outstanding job of helping with central aspects of editorial and management work. Gabriel Rusinek, provided a generous, highly skilled proof reading and invaluable feedback at the very last stage. Their dedication and great attention to detail, as well as sound advice and wisdom in various aspects of this project is greatly appreciated.

I could not wish for better teammates at the publishing house – initially Michel Lokhorst, then Harmen van Paradijs. Harmen's work through the various stages of the manuscript was exemplary – prompt, judicious, ever attentive, always insightful, combining attention to detail with deep understanding of the bigger picture. In her position as Editorial Director of Social Issues, Myriam Poort was gracious as she was wise, helping in difficult moments to negotiate between the ideals of scholarship and the aim

of wide accessibility and commercial interests. Bernadette Deelen provided the needed technical support. Marianna Pascale manifested extraordinary skills and dedication to this project, proving to be thorough, thoughtful, and gracious even at situations that would have been overwhelming for any other person. John Normansell, from the production end, worked tirelessly and with impressive commitment, late nights and weekends, to create the final version of this work.

Finally, I would like to dedicate this handbook to all those that inspired me in the various domains of life, artistically and intellectually. These include my teachers, friends, colleagues, students, children, and foremost, my husband – Yoram.

# References

Ajayi, O. S. (1996). In contest: The dynamics of African religious dances. In K. Welsh-Asante (Ed.), *African dance: An artistic, historical and philosophical inquiry* (pp. 183–202). Trenton, NJ: Africa World Press.

Arnheim, R. (1966). *Towards a psychology of art*. Berkeley, CA: University of California Press.

Arnheim, R. (1974). *Art and visual perception*. Berkeley, CA: University of California Press.

Blacking, J. (1995). *Music, culture, and experience*. Chicago, IL: University of Chicago Press.

Bresler, L. (1982). *The Mediterranean style in Israeli music*. [in Hebrew] Master's thesis in Musicology, Tel Aviv University, Israel.

Bresler, L. (1985, December). The Mediterranean manifests in the musical style in Israel. [in Hebrew] *Cathedra, 38*, 137–160.

Bresler, L. (2002). The interpretive zone in international qualitative research. In L. Bresler & A. Ardichvili (Eds.), *International research in education: Experience, theory and practice* (pp. 39–81). New York: Peter Lang.

Broudy, H. (1958). A realist philosophy of music education. In N. Henry (Ed.), *Basic concepts in music education* (Part I, pp. 62–87). Chicago: University of Illinois.

Broudy, H. (1972). *Enlightened cherishing: An essay on aesthetic education*. Urbana, IL: University of Illinois Press.

Detels, C. (1999). *Soft boundaries: Re-visioning the arts and aesthetics in American education*. Westport, CT: Bergin & Garvey.

Dobbs, S. (1998). *Learning in and through art: A guide to discipline based art education*. Los Angeles, CA: Getty Education Institute for the Arts.

Geertz, C. (1976). Art as a cultural system. *MLN, 91*, 1473–1499.

Giroux, H. (1992). *Border crossings*. New York: Perigee Books.

Greer, D. (1984). Discipline-based art education: Approaching art as a subject of study. *Studies in Art Education, 25*(4), 212–218.

Langer, S. K. (1957). *Problems of art*. New York: Charles Scribner's Sons.

Lave, J., & Wenger, E. (1991). *Situated learning: Legitimate peripheral participation*. New York: Cambridge University Press.

MacGregor, R. N. (1997). Editorial: The evolution of discipline-based art education. *Visual Arts Research, 23*(2), 1–3.

Meyer, L. B. (1956). *Emotion and meaning in music*. Chicago, IL: University of Chicago Press.

Nettl, B. (1995). *Heartland excursions*. Urbana, IL: University of Illinois Press.

Nzewi, M. (1978/9). Folk music in Nigeria: A communion. *African Music, 6*(1), 6–21.

Rauscher, F., Shaw, G., & Ky, K. (1993). Music and spatial task performance. *Nature, 365*(6447), 611.

Rauscher, F., Shaw, G., Levine, L. J., Wright, E. L., Dennis, W. R., & Newcomb, R. L. (1997). Music training causes long-term enhancement of preschool children's spatial – temporal reasoning. *Neurological Research, 19*(1), 1–8.

Small, C. (1998). *Musicking*. Hanover: Wesleyan University Press.

Vygotsky, L. (1986). *Thought and language* (A. Kozulin, Trans. & Ed.). Cambridge, MA: Cambridge University.

Weitz, M. (1956). The role of theory in aesthetics. *Journal of Aesthetics and Art Criticism, 15*(1), 27–35.

Wenger, E. (1998). *Communities of practice: Learning, meaning, and identity.* New York: Cambridge University Press.

Yanagi, S. (1989). *The unknown craftsman.* Tokyo: Kodansha International.

# LIST OF REVIEWERS

Abbs, Peter
Apol, Laura
Aróstegui, José Luis
Bai, Heesoon
Barone, Tom
Barrett, Margaret
Barrett, Terry
Blandy, Doug
Boey, Kim Cheng
Bond, Karen
Bowman, Wayne
Bruce, Bertram
Bumgarner Gee, Constance
Burn, Andrew
Carspecken, Phil
Chalmers, Graeme
Chappell, Kerry
Cope, Peter
Costantino, Tracie
Custodero, Lori
Dahl, Karin
Day, Christopher
Delacruz, Elizabeth
Denton, Diana
Desai, Dipti
Dhillon, Pradeep
Dimitriadis, Greg
Doddington, Chris
Doll, Mary Aswell
Donelan, Kate
Dressman, Mark
Duncum, Paul
Dzansi-McPalm, Mary
Elliott, David

Ellis, Viv
Farrell, Lindsay
Feck, Candace
Fels, Lynn
Flood, Adele
Forrest, David
Glover, Jo
Gruhn, Wilfried
Hagood, Tom
Hall, James
Hannah, Judith Lynne
Harwood, Eve
Hawisher, Gail
Hebert, David
Hennessy, Sarah
Henry, Carole
Hermans, Peter
Hickey, Maude
Hilton, Mary
Hohr, Hansjörg
Holgersen, Sven-Erik
Hopmann, Stefan
Humphreys, Jere
James, Jodie
Kan, Koon-Hwee
Karpati, Andrea
Keifer-Boyd, Karen
Kemp, Tony
Kerr-Berry, Julie
Kindler, Anna
Kolcio, Katja
Lavender, Larry
Leong, Sam
Leshnoff, Susan

L. Bresler, (Ed.), *International Handbook of Research in Arts Education*, xxv–xxvi.
© 2007 *Springer.*

Leung, Chi Cheung
Lindström, Lars
Lubeck, Loren
Machee, Diane
Mackey, Sally
Mans, Minette
Marques, Isabel
Marsh, Jackie
Marsh, Kathryn
Matsunobu, Koji
McCammon, Laura
McPherson, Gary
Miller, Carole
Mockabee, Valarie
Montgomery, Janet
Morrison, Morag
Murphy, Regina
Neall, Leslie
Neelands, Jonathan
Nixon, Helen
O'Farrell, Larry
Olsen, Eiliv
Olsson, Bengt
O'Neill, Cecily
O'Sullivan, Carmel
Pariser, David
Parsons, Michael
Perpener, John
Prentki, Tim
Press, Carol
Prior, Paul
Reese, Sam
Rolfe, Linda
Saldana, Johnny
Samson, Adrienne
Saxton, Juliana

Schonmann, Shifra
Shaban, Mohammad
Shapiro, Sherry
Shiel, Gerry
Shurkin, David
Sims, Wendy
Slattery, Patrick
Smith, Mary Lynn
Smith-Shank, Debbie
Soren, Barbara
Soter, Anna
Stauffer, Sandra
Stinson, Susan
Stokrocki, Mary
Sweeney, Robert
Stubley, Eleanor
Szatkowski, Janek
Taylor, Pamela
Thompson, Christine
Thompson, Dan
Thunder-McGuire, Steve
Tonfoni, Graziela
Trakarnrung, Somchai
Upitis, Rena
van de Water, Manon
Veblen, Kari
Vogt, Jürgen
Warburton, Ted
Warner, Christine
Weber, Sarah
Welch, Graham
White, John Howell
Whyte, Alyson
Williams, Patterson
Wing, Lizabeth

# Section 1

# HISTORY

**Section Editor: Gordon Cox**

# PRELUDE

# 1

# SOME CROSSING POINTS IN CURRICULUM HISTORY, HISTORY OF EDUCATION AND ARTS EDUCATION

**Gordon Cox**
*University of Reading, U.K.*

The opening of this Handbook deals with historical research in arts education, which is appropriate as all the arts have their roots in a variety of historical antecedents. Although historical studies of the arts in education have been sparse, the two related research fields of the history of curriculum, and the history of education offer a discourse to which arts education researchers can make a distinctive contribution.

According to the curriculum historian, Herbert M. Kliebard (1992), the curriculum can be seen as an invaluable relic in an archeological sense, of the forms of knowledge, social values, and beliefs that have achieved a special status in a given time or place. But competing doctrines have been, and still are, in a constant struggle for dominance: "curriculum historians play a particularly valuable role in unearthing and rendering visible the longstanding contested terrain of the curriculum" (Franklin, 1999, p. 476).

In his historical perspective of the arts in the curriculum, George Geahigan (1992) explores some of these competing doctrines. He argues that the drive toward universal mass education in the nineteenth century challenged arts educators, who offered a variety of rationales for the introduction of these subjects into the curriculum. There were appeals to tradition, to the contribution of the arts to the development of mental faculties, to practicality closely allied to vocational skills, and to the arts as a means of fostering ideals and promoting morality. But this variety of rationales, according to Geahigan, was symptomatic of a deep-seated ambivalence about the educational significance and value of the arts (apart from literature because of its ties to the language arts).

In a recent paper, Ellen Condliffe Lagemann (2005) takes up the seeming fragility of the humanities and the arts in the curriculum when she asks the question, "Does History Matter in Education Research?" She argues that history has the power to capture the imagination particularly when it connects with enduring dilemmas or current puzzles, so that we can see the present in more depth. One such enduring problem lies in understanding why the arts in education appear to be constantly under siege. Historical research might help us in this regard: "understanding must be a first step toward corrective action" (p. 21). In that sense presentist concerns "encourage one to

*L. Bresler (Ed.), International Handbook of Research in Arts Education, 3–6.*
© 2007 *Springer.*

understand the past on its own terms, as different from the present, and in drawing such a contrast help to illuminate both past and present" (p. 17).

While curriculum history for the most part focuses on formal educational settings, the history of education as a discipline has long since moved away from a concentration on "the great educators," the history of institutions and administration (acts and facts), and a celebration of state-sponsored education since the nineteenth century. From the late 1960s it has achieved much in its embrace of a whole raft of approaches that Cohen (1999) has detailed, including social control and social conflict, urban history, family history, history of women, history of people of color, history of religious minorities, and history "from the bottom up." However, even this is not an exhaustive list. Other significant influences have included functionalism, Marxism, and poststructuralism. Historians of education are increasingly drawing upon aspects of sociology, cultural studies, and anthropology in their research.

Each chapter in this section takes up some of these ideas from curriculum history and the history of education. Mary Ann Stankiewicz describes herself as a map-maker, mapping visual art education history in terms of the formation and transmission of capital, drawing on the work of Pierre Bourdieu. This leads her to ideas from postcolonialism to make sense of the dissemination of British, European, and North American modes of art education through cultural imperialism and economic globalization. Essentially she concludes that the motivating force for the development of art education has often been the need for a dominant culture to retain or export symbolic capital. Stankiewicz's use of the geographical metaphor of mapping, with Bourdieu's theory as the projection of the map, and a further set of concepts from his work as coordinates, provides us with a space within which connections can be made and historical understanding located (also see McCarthy, 2003).

It was the intention of Gordon Cox, in his chapter on music, to explore the different but related settings of family, church and school in relation to the teaching and the learning of music. Behind this lay a concern to understand the power of informal musical learning, the influence of "music education for religious conversion," and the way in which music teaching was adapted to meeting the needs of mass schooling. In such ways his chapter offers suggestions for expanding the scope of historical research in music education by including a close reading of context, attention to accounts and experiences of teaching and learning music, and encompassing a broad range of musical genres.

Gavin Bolton in his history of drama education presents images of the mosaic of activities that have occurred in schools as "drama education." He concentrates on trying to untangle the confused strands of classroom drama. Although Bolton's starting point is Great Britain he manages to convey the burgeoning influence of drama education internationally. Of particular interest are the conflicts among the different ideologies represented by "playway," "creative dramatics," "process drama," "children's theatre," "child drama," "creative drama," "living through" drama, and "applied theatre." The more recent notion of using theater to engage with the oppressed, and addressing a range of problematic issues including child abuse and AIDS challenge drama educators to apply meticulous judgment in developing such work effectively. Bolton's historical perspective should serve to help arts educators think about the need to discern substance from shadow.

In her historical treatment of dance education, Ann Dils focuses chiefly on American colleges and universities. Interestingly she points out that teaching dance in the early twentieth century offered, to women in particular, opportunities for a new profession. But at the root of her discussion is the "schizophrenia of dance in academia," and the question, "Where does it belong?" On the one hand dance had a close relationship with physical education, but on the other there was a trend to establishing it within departments of fine arts. Dils's listing of future research possibilities includes the development of a combination of social history and biography relating to how dance operates within an educational context. This reminds us of Barbara Finkelstein's resonant phrase about the use of biography in relation to the study of educational history "biography is to history what the telescope is to the stars" (Finkelstein, 1998, p. 45).

Finally, Alyson Whyte in her chapter on English Language Arts, contrasts teaching as replication, with an approach that emphasizes the experience of poetic language, itself particularly influenced by rational humanism and the Progressivist curriculum ideology. She then charts the rise of multi-literacies and new literacies in which students use multiple forms of representation. The 1990s witnessed the influence of the technical environment which has emphasized measuring and comparing schools' outcomes across and within countries. Whyte's hope is that support will be forthcoming for the view that the subject matter cannot be reduced productively to atomistic, routine tasks, but rather should be taught with the intention of fostering teachers' and students' mutual experience of poetic language.

Readers will become aware that each author takes a distinct historical perspective, and some are broader and wider than others. Nevertheless certain themes recur:

- Conflicting views amongst philosophers, politicians, and religious authorities about "the right place" of the arts in education, leading to their often problematic status particularly in formal educational settings.
- The dissemination of Western approaches to arts education in non-Western societies through colonialism and imperialism.
- The powerful influence of educational progressivism on the teaching of the arts, which also highlights the conflict between subject-centered and student-centered approaches to learning.
- The pressures of adapting effective arts education programs to utilitarian educational philosophies.
- Aspects of gender related to providing equal access to, and participation in the arts in education.
- The crucial and distinctive role historical research can play in relating the past to the present and the present to the past.

These chapters represent a beginning effort to bring together the separate but connected histories of the arts in education, with the intention of seeing the past on its own terms in order to see the present in more depth. Consequently arts educators may not only be able to imagine the past, but might also play a more powerful role in the crucial debate about the present and the future of the arts in education.

# References

Cohen, S. (1999). *Challenging orthodoxies: Toward a new cultural history of education*. New York: Peter Lang.

Finkelstein, B. (1998). Revealing human agency: The uses of biography in the study of educational history. In C. Kridel (Ed.), *Writing educational biography: Explorations in qualitative research* (pp. 45–49). New York: Garland.

Franklin, B. (1999). Review essay: The state of curriculum history. *History of Education, 28*(4), 459–476.

Geahigan, G. (1992). The arts in education: A historical perspective. In B. Reimer & R. A. Smith (Eds.), *The arts, education, and aesthetic knowing* (pp. 1–19). Chicago: National Society for the Study of Education.

Kliebard, H. M. (1992). Constructing a history of the American curriculum. In P. W. Jackson (Ed.), *Handbook of research on curriculum: A project of the American educational research association* (pp. 157–84). New York: MacMillan.

Lagemann, E. C. (2005). Does history matter in education research? A brief for the humanities in an age of science, *Harvard Educational Review, 75*(1), 9–23.

McCarthy, M. (2003). The past in the present: revitalising history in music education. *British Journal of Music Education, 20*(3), 121–134.

# 2

# CAPITALIZING ART EDUCATION: MAPPING INTERNATIONAL HISTORIES

**Mary Ann Stankiewicz**

*Pennsylvania State University, U.S.A.*

Histories of visual arts education may be framed in various ways. Historical periods, geopolitical entities, nationalism, networks of international influences, topics, or themes each might provide a framework or be combined to shape international history. Following Pearse's (1997) speculation about the history of Canadian art education, one might use a geographical, political scheme (examining art teaching and learning in turn in European, North and South American, Asian, Australia and Pacific Island, and African countries) or structure a story into historical periods. Such periods might include: (1) a prehistory of informal means of art education up to the Renaissance in European-dominated nations, roughly ca. 100 BCE-ca. 1600, later in the Pacific Rim or tricontinental sites (Young, 2001, 2003)[1]; (2) artist education and liberal art education for elite amateurs in the context of national formation, ca. 1600–1800; (3) emerging capitalism and middle-class aspirations, ca. 1800–1850 and later; (4) industrial drawing systems, dominated by South Kensington in English-speaking countries and colonies, ca. 1850–1910; (5) ideology of the self-expressive child artist, ca. 1910–1960; (6) turn toward intellectual rigor, ca. 1960 to the present. A third way of framing an international history of art education might be in relation to forming or maintaining national identity, a theme found in a number of written histories (Araño, 1992; Boschloo, 1989; Kraus, 1968; Masuda, 2003; Petrovich-Mwaniki, 1992). A fourth approach might be to map the complex web of influences from Western to the Pacific Rim and tricontinental countries, and, in some cases, back again (Barbosa, 1992; Boughton, 1989; Chalmers, 1985, 1992b; Foster, 1992; Okazaki, 1987, 1991, 1992; Rogers, 1992; van Rheeden, 1992). Freedman and Hernandez identify several waves of European influence on international art education, and, like Efland, position art education as a school subject, making history of art education a subset of curriculum history (Efland, 1990; Freedman & Hernandez, 1998).

*L. Bresler (Ed.), International Handbook of Research in Arts Education, 7–30.*
© 2007 *Springer.*

# Projection and Coordinates for One Historical Map

This chapter will treat the development of art education as an international professional field in contexts of cultural change and social factors that include technological and institutional development. Drawing on theoretical work by the French sociologist Pierre Bourdieu, I will map visual art education history in terms of the formation and transmission of capital – human capital, cultural capital, social capital, and economic capital (Bourdieu, 1983, 1984, 1996; Bourdieu & Darbel, 1990; Fauconnier, 1997; Storr, 1994).[2] Given that this framework privileges Western, developed nations, I will draw on postcolonialism as a way to give art learners a stronger voice while reminding myself and readers that art education can be found outside formal, state-supported schools, meeting individual desires as well as social needs.

Bourdieu (1983) defines capital as a force or power inscribed in the objectivity of things. In its primary usage, capital refers to an objectified or embodied potential capacity to produce financial profits, but Bourdieu uses it metaphorically, as in references to social capital or educational capital, both of which may be allied with possession of economic capital and enhanced life chances. Bourdieu asserts that "it is in fact impossible to account for the structure and functioning of the social world unless one reintroduces capital in all its forms and not solely in the one form recognized by economic theory" (1983, p. 242). He analyzes dynamics of four types of capital: economic, cultural, social, and symbolic. Works of visual art become economic capital when they are created, sold to collectors, then re-sold to other collectors or donated to a museum. Art objects can be converted to money (economic capital) and institutionalized in the form of property rights or ownership.

As cultural capital, visual arts contribute to the class status of those who not only own art objects, but, more importantly, respond to art works and consume works of visual culture. From Bourdieu and Darbel's (1990) sociological perspective, reception of art works depends on the complexity and sophistication of artistic codes in relation to an individual's mastery of social codes. Cultural capital signified economic capital, for example, when a young woman who received an ornamental education in the arts married a man of higher socioeconomic status. Educational qualifications, which can also be described as educational capital (and considered a subset of cultural capital), include the amount of formal schooling and number of diplomas or degrees one has. Thus, someone with greater expertise in the arts has higher cultural capital. Formal schooling institutionalizes cultural capital. Art education builds cultural capital whether it is part of formal or informal education. However, cultural capital can also be inherited and transmitted through families which engage with the arts, in such a way that it becomes a taken-for-granted part of one's identity.

Social capital refers to a network of friends or acquaintances; it can be converted into economic capital if a friend makes a loan and may be institutionalized through nobility or hierarchical social ranking. Participation in professional associations builds social capital in a specific field. Symbolic capital is, from Bourdieu's (1996) perspective, a kind of capital that denies its potential economic value, instead asserting its power as art for art's sake. Although an artist might earn a living producing art, some works have value beyond their material costs. Within a broad context of twentieth-century

visual culture, Duchamp's *The Large Glass* has high symbolic capital, but popular magazine illustrations are generally regarded as more closely tied to economic capital than to symbolic capital. Child art has functioned as symbolic capital signifying humanistic values of free self-expression in the educational systems of modern capitalist societies.

A fifth type of capital discussed in histories of education is human capital (Spring, 2004). This term refers to the functions of education, often exercised through formal schooling, that select people for particular occupations but also transmit skills to make individuals more productive in their work. Leaders of capitalist nations in the nineteenth and twentieth centuries argued that development of human capital is a major function of state-supported schooling. While one view of human capital, a sometimes dehumanized perspective, is top-down, individuals themselves seek skills and credentials that will enable them to get a job or find a better one. Thus, potential workers are interested in developing themselves as human capital. Art education functions to develop human capital and transmit cultural capital, purposes that sometimes seem to be at odds with each other, but that also touch on other forms of capital.

One more set of concepts from Bourdieu's work will serve as coordinates[3] for this chapter, four concepts to be considered in examining the development of an intellectual or artistic field: autonomy, heteronomy, dualism, and temporality. Artistic/intellectual fields exercise both autonomy and heteronomy. Autonomy refers to claims that the field exists independently of social forces and is staffed by disinterested practitioners, that is, people who create art for the sake of creating art, not for personal power or celebrity or wealth. Bourdieu (1996) argues that attaining autonomy is a necessary step in the emergence of an intellectual field such as nineteenth-century French literature. At the same time, the field faces pressure toward heteronomy, demands that the field be sensitive to external demands. The visual arts, like literature, experienced both autonomy and heteronomy in the nineteenth century. Artworks were created specifically to be displayed in the museums which developed during this era, but artists also contributed to beautifying cities, decorating structures that housed art collections, planning parks to surround cultural destinations, and designing posters to tell visitors what they might see. Bourdieu (1996) argues that most artistic fields have a dualistic structure, encompassing both high forms that appeal to elite tastes and popular forms more likely to be enjoyed by a mass market. As we will see, art education has been dualistic in other ways as well. Finally, temporality refers to changes in position over time. Painters, for example, who constitute one generation's avant-garde become traditionalists to their grandchildren. Expressionism and Fauvism were wild and shocking in the first years of the twentieth century; by the 1960s, variations on colorful, expressive paintings were the expected art-school style.

## Artist and Artisan Education: Pre-History of Art Education

As Efland wrote in his social history of art education: "as long as the arts have existed, artists, performers, and audience members have been educated for their roles" (1990, p. 1). In small-scale societies visual arts might play varied roles in culture. Objects

could be created in ways that enhanced both beauty and function. Images might inspire and symbolize spiritual beliefs, guide actions, or recall past people or events. Ownership of artfully made objects might denote political power. Art learning in such societies was typically informal. Art-making abilities could be equated with spiritual power and taught to selected students by a religious leader. Parents might teach their own children, or young people with interests in particular skills could be apprenticed to an experienced worker, typically of the same gender, whose abilities might have led to special status (Teaero, 2002). Media came from the natural environment. Traditional Nigerian art forms included carving, mostly with wood; modeling vessels or sculpting figures with clay; body painting and wall decoration; calabash decoration; all types of weaving; and work in metals such as brass or bronze (Onuchukwu, 1994). In Oceania, groups who lived on islands able to sustain trees carved dugout canoes; those on coral atolls made vessels by lashing planks together (Teaero, 2002). While intra-Oceanic exchange of art forms or visual languages might influence tattooing or pottery, conformity and continuity characterized indigenous arts and other aspects of culture until contact with colonizers. Although capitalist interpretations of small-scale cultures are anachronistic, such societies typically ascribed high cultural, social, and symbolic power to practitioners of valued arts.

Europeans and North Americans of European heritage have traced their artistic lineage to ancient Greece and Rome, looking to classical forms of art, discussions of aesthetic values, and models of education as precedents for visual art (Bennett, 1926; Efland, 1990; Macdonald, 2004). Dual attitudes toward the visual arts appear in the Greek separation of craft or manual arts from liberal arts, those suited to a free man or member of the ruling class. In Plato's republic, music and poetry enjoyed higher status than visual art. The philosopher argued that, because physical objects were imitations of ideal forms, a painter who imitated in two dimensions the bed a carpenter created in three-dimensional form offered an imitation of an imitation that might show sensuous form but could never give reliable knowledge. The arts were expected to contribute to morality, as they did in small-scale societies, but their emotional appeal was, like their status as knowledge, suspect for its irrationality. Thus, art making was typically reserved for slaves and lower classes. Discussions about artistic and aesthetic qualities were the province of elite males, while women of all classes likely participated in textile arts, although documentary evidence for such work only exists from the European Middle Ages.

In China two classes of painters existed: professional painters who were court artists or artisans, and literati or scholar-officials.[4] According to Chinese sources, the first imperial art academy was established by the Song emperor, Huizong Zhao Jie in 1104 (Pan, 2002). In imperial art academies, as in later European art academies, copying from models was a primary method for teaching and learning; development of skills and technical competence were emphasized. The literati, on the other hand, were amateur painters who learned from peers or through self-study in their leisure time, simultaneously pursuing the Three Perfections – poetry, calligraphy, and painting. Original self-expression was more important for early literati painters than rendering a likeness. Proper attitude or Tao was more valued than skill; once the painter attained Tao, artistic creation would proceed unconsciously (Bush, 1971). However, by the late Ming dynasty (late fifteenth-early sixteenth century), the literati style had become more

formalized and literati painters learned by faithful tracing or free-hand copying, as court artists did.

Like the literati, many seventeenth-century British aristocrats were amateur artists who found drawing an enjoyable and useful way to document their travels or estates, plan gardens or buildings, record scientific experiments or objects collected. As virtuosi, a label borrowed from Italian, they were expected to collect objects of *vertu*, demonstrating connoisseurship and innate artistic taste but not the technical proficiency professional artists acquired through hard work (Sloan, 2000). Early evidence that European children drew comes from the Sixth Day of Boccaccio's *Decameron*, written about 1350 (Brown University Department of Art, 1984). A storyteller compares the face typical of one particularly old family to "faces that little children make when they first learn how to draw" (p. 11). In medieval England, during the thirteenth and fourteenth centuries, architecture, sculpture, painting and artistic crafts were not taught in schools but through guilds which provided training for boy apprentices (Sutton, 1967). Similar patterns can be found on the Continent as well. In France, the Church controlled training for artists who, seeking to exercise more self-control over their work, gradually formed guilds which eventually would be replaced by a state-sponsored academic system (Boime, 1971).

Grammar schools, often staffed by male clergy, were exclusively male institutions, while nunnery schools taught weaving and sewing to female boarders from good families as well as to their own novices. Schools organized by religious orders typically served elite young people, although many had private tutors and education was not systematized. Writing, for example, was taught in schools for young boys as well as by traveling writing masters. In the late fifteenth century, Erasmus recommended that writing, because it was initially a form of drawing, be taught later than reading (Sutton, 1967). In 1531, Sir Thomas Elyot published *The Boke named the Governour*, the first English-language printed book on education. Focusing on education for noble children (those who might grow up to be governors of public welfare), Elyot recommended that children with a natural interest in drawing, painting or carving be allowed to develop it, not to become artisans, but to learn a skill useful in military campaigns, for illustrating math and science or history. Having developed this skill, the noble child would have better critical judgment and be able to adapt what was learned in art to support other subjects. Castaglione, whose book of dialogues on the proper education of courtiers was translated from Italian into English in 1536, recommended that a gentleman's children learn painting as an initial step into the liberal arts, a means to follow the hand of the First Artist, and a study that required knowledge of many things. By the mid-sixteenth century, then, European and English societies were continuing the duality of skilled but menial artisans and elite amateurs found in Greece and China.

## Formalizing Artist Education

About 1488, Lorenzo de Medici opened his gardens for a school of painting and sculpture, laying a foundation for the first Italian academy of art. Florence's Accademia del Disigno was established in 1563 as both a religious confraternity and an association

for teaching painting, sculpture, and architecture (Boschloo et al., 1989). During its first half-century, the Accademia developed a curriculum, taught by master artists and invited scholars, which included five main components: (1) mathematics, the theoretical foundation for perspective and symmetry and a means to train eye and hand in drafting geometric forms; (2) anatomy and life drawing, supported by an annual dissection, usually in winter, so history painters would understand how the body made thoughts and passions visible; (3) natural philosophy, part of the curriculum by 1590, encompassed the theory of humors and physiognomy so that artists might better understand human motivations; (4) study of inanimate forms, that is, how to draw drapery; and (5) architectural principles. In apprenticeship, technique preceded theory, but the Accademia reversed this pattern, in part to raise the status of the artist. The Florentine Accademia was formally incorporated as a guild controlling all matters related to the production of the arts in 1584, when it was already serving as a model for artist academies in other Italian city-states.

By the mid-seventeenth century, Louis XIV stopped importing Italian-trained artists, establishing a French royal academy to create an authoritative symbolic visual culture. Desires for national styles led artists in Britain, Mexico, the United States, and elsewhere to establish art academies as schools for professional and amateur artists during the eighteenth century. The central principle of the French academy, "Control instruction and you will control style," continued well into the nineteenth century (Boime, 1971, p. 4). Following the French Revolution and rise of the bourgeoisie, royal patrons would be replaced by wealthy collectors from the upper middle class. Responding to the rise of Romanticism with its spontaneous, sketch-like execution and privileging of originality, leading French artists after about 1830 adopted a middle-of-the-road style that balanced painterly aspects of Romanticism with more linear academic classicism.

Varied forms of art education existed in many parts of Europe and European colonies by late eighteenth century. Artist education had been formalized from apprenticeship to academic study, contributing to a rise in prestige for master artists. Formal and informal education for elite boys and girls typically included drawing as part of a liberal education, both enhancing and signifying their cultural capital. Male and female amateurs, again usually elites with both leisure and wealth, engaged in producing and consuming visual arts. The ability to talk critically about aesthetic qualities and issues was one mark that a gentleman possessed cultural capital; ladies, on the other hand, demonstrated their genteel femininity by drawing, painting in watercolors, or needlework. Lower class men and women might contribute to the production of artworks as skilled or semiskilled artisans, but were neither expected to appreciate the fine arts nor to possess cultural capital.

## Emerging Capitalism and Middle-Class Aspirations

In late eighteenth- and early nineteenth-century England, but with parallels in other nations struggling with industrialization, urbanization, and development of capitalist economies, definitions of what it meant to be an artist were changing (Bermingham, 2000).[5] Professional artists earned a living through painting, sculpture or another form

of fine art; they had been educated in theory and practice through academic methods; their work met cultural expectations for originality. Workers in lower art forms, such as engraving or other craft practices, did not merit the label artist. Amateur artists tended to come from upper or middle classes, drawing or painting during their leisure time (Sloan, 2000). Although they might be taught by or exhibit with professional artists, they did not support themselves by making art, but, nonetheless, tended to have more cultural capital than professional artists did. By the latter part of the nineteenth century, however, amateur artists were stereotyped as female. Earlier male amateurs joined professional artists to establish local art societies for discussions, exhibitions, and education – something between a men's club and a fraternal association that built members' social capital. In these groups, self-interest dominated and instruction was for members, unlike the mechanic's associations which opened lectures and discussions to working-class men as well as gentlemen.

Many professional artists depended on the interests of amateurs for their livelihood, notably drawing masters whose primary source of income came from teaching. Drawing masters often began as itinerant artist-teachers, traveling about to take on commissions and offer lessons. Some of these itinerant drawing masters settled in towns large enough to support them, establishing drawing schools of their own or offering services to families or private schools. Many taught by making drawings or paintings for students to copy. Some drawing masters published collections of drawings, with or without instructional text, extending their reputations and pedagogy beyond immediate reach (Marzio, 1976). Beginning about 1800, British drawing masters developed progressive drawing books with sequenced drawings from simple to complex or demonstrations of stages from line drawing to finished watercolor. Beautifully engraved drawing books were aimed at leisure classes; other books, published by manufacturers, encouraged users to buy art materials. These drawing books reflected new, sequential printmaking processes as well as educational ideas from the Swiss theorists Rousseau and Pestalozzi. The drawing masters who wrote them were ancestors of professional art educators whose consciousness of their hybrid status would emerge late in the nineteenth century.

In *Emile*, Rousseau suggested that an adult and a single, privileged child draw together, so that the child would improve from working with the more sophisticated adult. Rousseau also asserted that nature should be the primary teacher, eschewing drawing masters and their paper copies, in favor of drawing from observation to build a mental store of images (Sutton, 1967, p. 26). Rousseau's ideas supported belief in natural talent and innate good taste, obscuring dynamics of cultural capitalization beneath a Romantic veil. Pestalozzi, on the other hand, developed instructional methods that could be used by relatively untrained teachers, including mothers and other women, who worked with large masses of children displaced by war, economic depression, or effects of the industrial revolution (Ashwin, 1980). Pestalozzi's methods were based on his analysis of drawing as simply lines, angles, and curves. He believed that just as these elements could be combined to write letters and words, so also they could be used to convert weak sense impressions into clear ideas. Thus children would begin by imitating a teacher's straight line, gradually building line segments into outline drawings of common objects printed in the drawing book. Pestalozzi argued that

drawing was a necessary part of general education, crucial to harmonious development of the whole child.

Rousseau and Pestalozzi, influenced by growing romanticism in art and ideas, emphasized the importance of educating the eye, training children to see clearly and accurately. In London, then competing with Paris as an international cultural capital, residents and visitors encountered "a visual culture full of diversions" (Bermingham, 2000, p. 134). Eighteenth-century ideals of civic humanism were giving way to a utilitarian philosophy that defined happiness in terms of wealth rather than political self-determination, favoring material progress over moral improvement. The visual arts continued to be used for civic improvement, but more and more politicians and policies encouraged national pride in manufactures and individual pleasure in consumption of goods. Cultural and economic capitals were intertwined. When faced with civil disturbances, upper-class political leaders renewed older notions that exposure to art encouraged morality, thus *goods* ambiguously connoted material and moral benefits. When discussed in relation to working classes, consumption of fine art became a tool for civic reform.

Although the ideology of early nineteenth-century Britain created a supportive climate for professional work in art and design, Bermingham's (2000) analysis emphasizes the social and material conditions for growing amateur interest in art. Galleries and shops in London displayed paintings, sculptures, ceramic wares and beautifully designed furnishings. Middle-class men and women in outlying areas read books and especially illustrated magazines that disseminated urban chic and taught good taste, encouraging desires for new fads and fashions. Not only did these publications create a market for British manufacturers, but they illustrated a new role for middle-class women as virtuous consumers. In Bourdieu's (1996) terms, male professional artists exemplified autonomy of art expertise while female amateurs and consumers, for whom art education was a means to display patriotic responsibility as well as a fashionable pastime, illustrate heteronomy, the social dependence of art. Cycles of styles in painting and sculpture, architecture, and decorative arts demonstrate temporality, the fashionable style of one year becoming outdated and then revived. A number of dualities contributed to this art educational climate: producing art vs. consuming art; expert male professionals or dedicated connoisseurs vs. female amateurs and dilettantes; upper classes vs. lower, working classes.

One of the most subtle dualities was the ability of participation in the arts to both affirm social expectations for feminine behavior and to subvert femininity. On the one hand, the arts were expected elements of female education and domestic life. Embroidery disciplined female bodies, focusing the senses and emotions (Parker, 1984). Responding to art offered intellectual stimulation and moral inspiration. Simultaneously, making art offered apparent self-determination and freedom, a chance for personal expression, while responding to art might expand the narrow female world. Women's involvement with visual arts fell between professionalism and capitalism, the two major male discourses of the eighteenth and nineteenth centuries, according to Bermingham (2000, p. 180). Art works created by women were not commercialized; they entered a gift economy which was, nonetheless, embedded in the dominant culture of capitalism. Women's art was supposed to be created out of affection for family and home. Female fancy work relied on decorative techniques that had vanished from manufacturing.

The rhetoric of fancy work emphasized that it could be done in a short time, in brief moments snatched from other tasks; required minimal effort but gave rapid results; was imaginative rather than intellectual. Many forms of fancy work, like schoolgirl embroidery, depended on copying from prints, marking the woman amateur as a copyist, not an originator, and defining self-expression in terms of consumption. As more women became primary school teachers, these assumptions about femininity and art molded mass art education.

Another duality pitted romantic ideals of the autonomous artistic genius against arguments that framed government support of art in terms of competition with manufacturers of other nations and dissemination of useful knowledge. Beginning about 1823, the British history painter Benjamin Robert Haydon petitioned Parliament for government support of visual arts, specifically historical paintings for public buildings (Bermingham, 2000; Macdonald, 2004). Haydon's arguments grew out of his belief in male artistic genius (including his own) as well as his disdain for what he saw as commercialism and excessive self-interest in the Royal Academy of Art. He sought disinterested support of serious art, state encouragement of originality and autonomous genius, as opposed to economic self-interest. Ironically, eventual government authorization of government-funded art education was framed as supporting industrial competition and mass education.

## Industrial Drawing Systems

England approved establishment of a government-funded School of Design in 1835, providing a foundation for establishment of the Department of Science and Art in 1853 under the direction of Henry Cole. Most industrialized nations followed a similar pattern in disseminating drawing instruction through schools, developing state-supported schools to supplement or replace mixtures of church-supported and privately funded schools. Governments readily supported development of human capital to produce art goods and manufactures that could expand both economic and symbolic capital for nation-states. In Hungary, the 1777 legal code, the first to systematically describe the structure and content of education, included drawing as a compulsory subject at all levels of schooling (Karpati & Gaul, 1997). The second Austro-Hungarian educational code in 1806, however, abolished drawing from secondary grammar schools. Such schools, serving more elite students, offered art history, often taught by history or religion teachers, for knowledge and good taste, that is, cultural capital. Drawing schools were established from 1778 for visual rendering, but in state schools drawing was limited to the primary level only. Major motives in forming state systems of education were the need to educate poor children, to train workers for industry, and to control urban masses. Middle-class parents, acting out of self-interest, often supported the new public, common, or state schools as a way to maximize access to educational capital for their own children while stretching family economic resources.

Elementary schools typically served the most children, often, as in the United States, under a rhetorical umbrella of equalizing opportunity for all. Secondary schools were more likely to serve middle-class needs for advanced schooling in preparation for

business or higher education and as a source of cultural capital. An articulated school system trained docile, literate workers for industry as well as educating managers for business and home. Most nations, like England, Japan, European and South American countries, centralized control of education. In North America and Australia, most of the responsibility was exercised by provincial or state governments (Chalmers, 1993; Dimmack, 1955; Efland, 1990). As various nations established school systems, governments often sent a representative to other countries to compare school organization and curriculum., Uno Cygnaeus, Finland's father of elementary schooling, traveled to Switzerland, Germany, Holland, Austria and Sweden to prepare an 1859 report (Laukka et al., 1992). His 1861 report brought ideas from Pestalozzi and Froebel to Finnish schools along with his arguments that drawing could teach planning and that handicrafts could educate the whole person through a work school (Pohjakallio, 1992). Drawing was listed among required subjects in the first Finnish elementary education act in 1866.

Incorporating linear or industrial drawing in state schools was often part of a rationalization of education, an attempt to provide technical literacy that would meet the needs of industrial capitalism (Stevens, 1995). Better designed manufactured goods with more pleasing decorations were expected to improve a nation's ability to compete on world markets. Mixed motives of national pride and economic competition were displayed in the series of international exhibitions of arts and industries, or world's fairs, which began with the 1851 Crystal Palace Exhibition in London. The 1876 Centennial Exposition in Philadelphia provided Walter Smith, the first state drawing supervisor in the United States, with the opportunity to display students' drawings and also to advise Americans on the best examples of household taste (Chalmers, 2000; Korzenik, 1985; Stankiewicz, 2001). The 1893 Chicago World's Fair was the site not only for international displays on education in various nations but also of an International Congress of Art Instruction, the first in a series of international conferences that would enable art educators to share ideas and methods, building professional social capital (Steers, 2001).

After making international comparisons, either through travel and observation by one or more educational advocates or by seeing displays at a world's fair, most nations found a champion for drawing in schools, one person, often an artist or elite amateur, or a small group of influential business or political leaders. In Ontario, Canada, Egerton Ryerson was a prominent advocate for art education, while Samuel Passmore May supplied the organizational genius necessary for developing and implementing systematic industrial drawing (Chalmers, 1993). In the United States, a group of Boston manufacturers and merchants petitioned the state legislature for a law requiring drawing in state schools (Stankiewicz et al., 2004). Walter Smith was brought from England to implement his adaptation of the South Kensington system, also adopted in many parts of Canada (Chalmers, 1992b, 1993; Stirling, 1997). As each nation created its system of art education, these champions had to answer two big questions: what should be taught and who would teach. In Japan, the art curriculum was almost identical with government-authorized and issued textbooks (Masuda, 1992, 2003; Okazaki, 1991; Yamada, 1992). Smith entered a partnership with the American publisher Louis Prang to provide textbooks used across North America (Chalmers, 2000; Korzenik, 1985; Stankiewicz, 2001; Stirling, 1997), while other art teachers developed their own

texts which were sometimes officially adopted (Chalmers, 1985; Rogers, 1992; Soucy & Stankiewicz, 1990). Female teachers typically taught art to younger children; secondary art specialists were expected to have more specialized artistic training.

How teachers of art were prepared, whether art specialists or generalists who also taught drawing, depended on goals for art education. In Finland, art education was divided by political factions that emerged during the 1870s, after Finnish timber had become a valuable commodity. Fennomans, members of the nationalistic political movement to make Finnish the official language, with the clergy and peasants valued nationalism and agriculture. They followed German idealism, seeking art for art's sake within a context of tradition. Liberals included nobility and bourgeoisie who supported stronger international relations, commerce and industry. They asserted the importance of industry to produce refined goods that could compete with those from other countries, citing British models for art education. A craft or Sloyd school was established in 1871 and the Society for Industrial Arts in 1875. The Liberal approach, tied to a desire for social change, dominated into the 1880s; art teacher training was connected to design education in Finland and remains so even today. During the 1890s, however, when the Fennomans led intellectual life and sought a national identity, artists created rural landscapes, waterfalls, and scenes of idyllic nature (Pohjakallio, 1992).

Many countries experienced similar dualities (Kraus, 1968; Masuda, 2003; Onuchukwu, 1994; Thistlewood, 1992; Toren, 2004). Spanish guilds retained control of artist education longer than guilds in other nations, thus that nation did not develop as strongly unified an academic tradition as other countries (Boschloo, 1989). The first legal regulation of art teaching, the Royal Decree of 24 September 1844, defined painting, sculpture, and architecture as fine art subjects and described a system of competitions and prizes which rewarded artistic technique (Araño, 1992). Official art education tended to be conservative, serving the needs of church and state for art workers with reproductive skills (Freedman & Hernandez, 1998). On the other hand, a range of reform movements attempted to position expressive approaches to art teaching within visions of new human beings.

In England, drawing instruction for secondary students was considered a higher discipline than elementary art education which connoted play and little learning. Men in the National Society of Art Masters (NSAM), founded as the Society of Art Masters in 1888, encouraged high levels of technical accomplishment (Thistlewood, 1988, 1993); the predominantly female Art Teachers' Guild (ATG), on the other hand, sought to encourage creativity in children who might not pursue careers in visual arts as adults, following the beliefs of Ebenezer Cooke and others that art was an aspect of human development. To NSAM members, who held what Thistlewood refers to as a "classic thesis" of art education (1993, p. 149), the work of the ATG was peripheral and preparatory to the major tasks of teaching drawing and design. Drawing education addressed needs of industry for human capital and served national well-being. The ATG served individual needs with Marion Richardson as the heroine who discovered innate, unstructured creativity in adolescents, linking it to avant-garde art. Thistlewood refers to this as the "romantic antithesis" of twentieth-century art education (1993, p. 150).

Although political affiliations might differ from country to country, dual approaches to art teaching emerged in many nations during the last decade of the nineteenth century

and the early years of the twentieth. Some version of the classical thesis continued as the official form of art education, while seeds were planted for a romantic antithesis. Specialist art teachers identified themselves as artists or artist-teachers, not simply as teachers. Their personal experiences with the contemporary art of the day reflected more extensive studio education as well as opportunities for continuing professional development through artist-led summer school, university, or art school courses (Stankiewicz, 2001). The art specialist encouraged children to draw from memory, imagination, or observation of real objects, not simply to copy from flat examples. Nature study in part reflected nostalgia for a rural past, but also the popularity of impressionist landscapes and scientific study of the natural world. Some drawings from nature could be adapted for ornamental decoration; however, *design* no longer meant only ornament. The term could refer to theories about elements and principles of pictorial composition. The Prang texts, used in North America and influential as far away as Japan, discussed three functions of visual art: constructive, representational, and decorative work (Foster, 1992; Masuda, 2003; Pearse, 1997; Stankiewicz, 2001). No longer restricted to chalk or pencil, children were encouraged to use more fluid media as well as clay, cut paper, and other materials derived from Froebel's gifts and Victorian fancywork. Color interested art educators and students from North America to Egypt and Japan (El-Bassiouny, 1964; Masuda, 2003), as more and more art teachers recognized the charm of paintings produced by children outside the rigid bounds of the classical thesis of art education.

The classical thesis continued to be strong, particularly in colonial societies (Fennessy, 2005; Seibert, 1996; Stokrocki, 1997; van Rheeden, 1990, 1992). Students in British colonies followed the South Kensington system and into the twentieth century were subjected to drawing exams originally developed for admission to English universities (Calhoun, 1993; Carline, 1968). The classical thesis, the South Kensington system and its descendents, tended to be associated with art education for social control, art instruction that served the economic needs of the dominant culture and treated learners in state schools as future workers, human capital that needed to be civilized through acquiring a patina of cultural capital. Thus, art education contributed to cultural imperialism by teaching young people in colonial societies or indigenous groups that their traditional arts were not as highly ranked in an aesthetic hierarchy as European arts, nor their artistic taste as finely cultivated as that of European experts (Kosasa, 1998; Smith, 2003). Art educators transmitted racist beliefs through their assumptions that true art was solely a product of Greco-Roman traditions and that white males from northern nations possessed the best aesthetic taste and most genuine artistic genius (Chalmers, 1992a), devaluing the art forms and informal art education methods of pre-colonial societies.

## Self-expression and Child Art

What Thistlewood described as the romantic antithesis of art education spread internationally during the years following the World War I. This romanticism differed from earlier romantic idealist influences on art education in several respects (Efland, 1990; Stankiewicz, 1984). In the context of nineteenth-century romanticism, art was generally

heteronymous and integrated with morality. In modern romanticisms, artists staked strong claims for the autonomy of art even as art was used to symbolize nationalism and modernity. This tension and paradox would increase during the years between the two world wars.

The nineteenth-century romanticism of John Ruskin and his disciples in England, North America, and elsewhere contributed to an anti-modern critique of industrial societies (Lears, 1981). Although Ruskin and William Morris argued for art as a means to social change, their message was dissipated and distorted by the increasing separation of fine art from daily life. Ironically, Arts and Crafts designs were transformed into a preferred middle-class style for mass-marketed consumer goods. Morris's socialist politics were submerged into workforce education through manual training, which evolved into general enculturation intended to make workers satisfied with their lot in life (Soucy & Stankiewicz, 1990). As Lears explains, anti-modernism "was not simply escapism; it was ambivalent, often coexisting with enthusiasm for material progress" (1981, p. xiii). As a reaction against perceptions that modern life was overcivilized, alienating, and inauthentic, the upper-middle-class men who dominated this intellectual and artistic movement sought intense experiences, embracing premodern symbolism, spiritual and martial ideals, therapeutic self-fulfillment, and sensuous irrationality. The anti-modern symbolic culture they claimed offered a refuge from a complex, threatening world where wars, technocratic rationality, and capitalism threatened individual freedom even as these phenomena offered progress and the expanded opportunities of modernism.

Macdonald (2004) has identified three factors that contributed to the construction of child art: psychological studies; interest in art from small-scale societies; and appreciation of modern art. Anti-modernism created an intellectual climate where these elements could flower. The feminization of education and culture through ideals of women as social housekeepers contributed willing workers to nurture the child artist (Dalton, 2001). The rise of psychology led not only to research on child development but also to Freud's and Jung's psychoanalytic theories that uncovered the unconscious and revealed apparently universal archetypes. Tensions between unique individualism and universal forces contributed to new views of the child; each child was a unique personality, but also passed through universal stages of development. Children were no longer blank slates where adults could write the lines, angles, and curves of accepted artistic conventions. Like flowering plants, children unfolded with creativity at the heart of every blossom. Child art came from inside the budding infant, not from copying external models (Wilson, 2004).

If psychology contributed one-third to the child art equation, the art world contributed the balance. The child was equated with adults in preindustrial cultures, such as those colonized by European and American imperialism.[6] Both were regarded as potentially capable of creating expressive art spontaneously without the intellectualization characteristic of trained adult artists. Words such as natural, expressive, fresh, spontaneous, colorful, or organic characterized the discourse surrounding child art, so-called primitive art, and modern art. Spontaneity, natural development, and fluid self-expression were privileged over the slow mastery of conventions found in the classical thesis of art education. A number of modern artists collected examples of child art (Fineberg, 1997). Laslo Nagy organized the first exhibition of child art in Hungary in 1907 (Karpati &

Gaul, 1997). Ten years later in England, Marion Richardson met Roger Fry who included works by her students from Dudley Girls' High School in an exhibition at the Omega Workshops (Holdsworth, 1988). Fry was a leader among sophisticated critics, like Alfred Stieglitz in the United States, who displayed child art in galleries that also pioneered exhibitions of avant-garde painting and African sculpture.

Nagy, Richardson, Artus Perrelet in Brazil (Barbosa, 1992), and Kanae Yamamoto, who introduced the Free Drawing Movement in Japan (Okazaki, 1991), were among the professional heroes and heroines who emerged in the early twentieth century. Arthur Lismer, who immigrated to Canada in 1910, learned to teach on the job, forming the goal of teaching appreciation to everyone (Grigor, 2002; Pearse, 1992). Lismer believed that an artist is "a child who has never lost the gift of looking at life with curiosity and wonder" (Pearse, 1992, p. 88). Perhaps the most important professional hero of the early twentieth century was Franz Cizek of Austria, internationally recognized as "the father of child art" (Wilson, 2004, p. 308). A product of the Academy of Fine Arts in Vienna, Cizek reportedly observed that images created by children drawing on a fence near his lodgings followed what his disciple Viola termed "eternal laws of form" (Sutton, 1967, p. 263). In 1897 Cizek began offering private art classes for children with the goal of allowing them simply to grow, develop, and mature. Observers visiting these classes recorded his conversations with the children, marveling at how freely he encouraged children to draw what they felt. More critical interpretations, however, argue that what appeared to free the child was really adult intervention that mediated the child's experience, in effect colonizing the child's imagination to suit adult goals and aesthetic preferences. By limiting the materials available and using language to shape the child's mental images, Cizek generated what he saw as "pure style" that reflected the child's personality (Sutton, 1967). The child art style, symbolic capital for charismatic artist-teachers with idiosyncratic methods, became institutionalized as a "school art style" that humanized factory-like schoolrooms and hallways (Efland, 1976). Child art made school more enjoyable by offering art-like activities that could be completed in brief moments sandwiched between the real work of schools; required minimal effort but gave rapid, colorful results; and was imaginative rather than intellectual. Both the child and the indigenous artist, like nineteenth-century amateur women artists, were dominated by adult experts who directed them to make art that fit a desired look (Stokrocki, 1997).

Art educators around the globe embraced child art as a positive way to heal a world racked by war and economic depression (White, 2004). Child art celebrated individuality as well as universally shared human qualities. Child art was symbolic capital representing peace, access to education, freedom, and democracy. During the years preceding World War II, however, German and Japanese educators used art in schools to cultivate nationalism, ideals of patriotism and martial character (Petrovich-Mwaniki, 1987, 1992; Tatsutomi, 1997; Yamada, 1992). In the United States, art education helped create the image of a modern homeland, teaching good taste in selection of home décor and furnishings, instilling ideals of civic beauty, while also selling art materials and professional services (White, 2004). Following World War II, the Austrian immigrant, Viktor Lowenfeld, found a receptive audience for his particular approach to child art as indicator of creative and mental growth. During the Cold War of the 1950s, allied occupation

of Japan, and to a lesser extent Germany, brought American perspectives on art education to other nations, consolidating trends toward a global ideology of child art in art education.

Art education in countries under Soviet control, such as Hungary from 1950 to 1961, was mostly practical, geared to the success of communism, with realistic representation as the accepted style. The approved canon was disseminated from Moscow and Leningrad throughout Eastern and Central Europe. Future workers were taught to read plans, make signs and posters. Displaced as a form of cultural capital, art "*lost its traditional popularity as transmitter of high culture* that middle class families considered traditionally as an important quality of the erudite person" (Karpati & Gaul, 1997, p. 298, italics in original). During the 1960s, when communist dictatorship relaxed in Hungary, modern art experienced a rebirth with exhibitions by previously censored artists and publication of critical writings on the visual arts. Although the USSR looked to the west for approaches to art teaching, Soviet art educators criticized western permissiveness, emphasis on art as psychological therapy, and casual attitude toward teaching techniques and skills. In the Soviet Union, diverse institutions provided opportunities for art education, including special art schools for the gifted (Beelke, 1961a, 1961b; Morton, 1972; Pirogov, 1960a, 1960b).

## Turn toward Intellectual Rigor

During the later part of the twentieth century, many nations enlarged school systems to provide greater access to education. Art education was once again advocated as a way to develop human capital. Art educators gained status when more extensive educational credentials were required for teaching. Tricontinental nations, such as Morocco, Nigeria, and Pakistan, saw art education as a means toward economic development, but also a way to reclaim pre-colonial cultural identities (Davis, 1969; Freedman & Hernandez, 1998; Kauppinen & Diket, 1995; Peshkin, 1964, *Prospects of art education*, 1999). National educational goals led to emphasis on art for career education in Germany, where preparation for industrial work was a strong focus (Kraus, 1968), and in the United Kingdom which balanced expressive art with design. England instituted educational reforms intended to improve the status of art education, quality of instruction and accountability. Upgrading what had been diplomas to the status of degrees was one of several results of the 1960 Coldstream report (Ashwin, 1992; Thistlewood, 1992). Both England and Spain connected what had been independent schools of fine art to universities (Araño, 1992, 1997; Freedman & Hernandez, 1998), increasing the professional educational capital of art educators.

Curriculum content and art media expanded to include film, video, and, by the end of the century, digital arts. Finland was a leader in environmental art education (Laukka et al., 1992). In England Postmodern art emerged from the work of Richard Hamilton (Yeomans, 1988, 1992) and other artists who critiqued Abstract Expressionism and consumer society. When conceptual and performance art entered the art world during the 1960s, art became dematerialized, often resisting definition by necessary and sufficient conditions. Conceptual art engaged makers and viewers with intellectual speculation

about relationships between art and life. Even though some artists and critics expected performance and idea art to escape the commercialized world of galleries, documentations of such art quickly became commodified. On the other hand, romantic notions of innate creativity persisted among art educators.

## Australia in the 1960s

Australian art educators continued to follow the South Kensington classical thesis longer than their colleagues in most other nations (Boughton, 1989). Separate state educational authorities, a vast geographic area with widely dispersed population, dual school systems (denominational schools plus state-controlled and financed schools), and lack of contact among art educators across state boundaries contributed to disparities in art curricula (Dimmack, 1955). International influences and cross-fertilization among Australian art educators were encouraged by two UNESCO seminars, the first in Melbourne in June 1954 and the second in Canberra in May 1963 (Burke, 1964). At the Canberra seminar, a film portraying how art was taught in rural and urban schools in New South Wales generated controversy, revealing that apparent overlap between the classical and the romantic theses of art education masked a deep ideological division.

Planned to address the purpose of art teaching – how to preserve and train the child's creativity in an age when technology promoted passive reception of visual culture – the film included a segment where the narrator's method of teaching memory drawing was intended to guide students' aesthetic compositions while giving them freedom to express their own ideas (Peers, 2002). "Anti-methodists" saw even the slightest teacher intervention as cramping innate creativity, arguing that a good art educator refrained from any interference with natural self-expression (Peers, 2001). They asserted that the filmed teacher was likely to foster "parrot-like imitation" (Burke, 1964, p. 6), confounding modernist guidance with the restricted sequence of instruction derived from South Kensington and still used in many Australian art classes. "Methodists" pointed out that notions of free expression could be as dogmatic and stereotyped as teaching methods focused on accuracy and correctness. From the perspective of leading art educators, such as John Dabron, creative freedom for students, art education that taught tolerance for diversity, and art teachers who held definite goals for their students were not incompatible (Peers, 2002). This controversy highlights the dualism between laissez-faire art education and emerging use of more didactic methods, while revealing how much the romantic ideology had obscured dynamics of art education as acquisition of cultural capital.

## Quebec in the 1960s

In North America, reforms generated by Quebec's Quiet Revolution of the 1960s modernized and secularized art education, giving greater professional autonomy to art educators, within a social context of political liberation, secularization, urban industrial and economic growth, educational reform, development of a counter-culture, and art world expansion (Lemerise, 1992; Lemerise & Couture, 1990). Conservative ideologies were

defeated in favor of ideas advocated by artistic and intellectual groups; political power was claimed by liberal bourgeoisie, and the state intervened in areas of culture, social affairs, and education previously controlled by the Catholic Church. Early in the decade the provincial government created a contemporary art museum and ministry of cultural affairs, institutionalizing cultural capital. New galleries exhibited contemporary art; artists formed professional associations, asking the state to support creativity and a democratic culture.

Between 1963 and 1966, the five-volume Parent Commission report recommended educational reforms for democratization, cultural sensitivity and active pedagogy in preparing flexible future-oriented Québécois. A technocratic ideology, based on the needs of a market economy, contributed a capitalist subtext to these reforms. The commissioners declared that the arts were often neglected in the context of modern knowledge, endorsing the point of view of artist-teachers who, since 1940, had been trying to redefine art teaching based on child-development and modernism. The commissioners rejected instruction in technical skills that might impede development of creativity, advocating film as expressive language and a synthesis of the arts. In 1965, Quebec established a ministry of education; Sir George Williams University (now Concordia) established a fine arts faculty, offering a master's degree in art education which attracted some Francophone teachers thereby spanning the two cultures.

Following 1966 strikes by art students, the Rioux Commission was formed. The commission's 1969 report proposed "a unified vision of society in which art and art education are active participants" (Lemerise, 1992, p. 80), but was better received in the art world than by government authorities or school people. Although debate stimulated by this report supported efforts of art educators and avant-garde artists to bring arts and culture to a wider public, thereby increasing heteronomy, many art teachers developed autonomous school programs geared toward school culture with its focus on disciplinary knowledge and "objective evaluation of learning" (Lemerise & Couture, 1990, p. 233). This period of restructuring corresponded with growing professional autonomy for art educators, including a specialized diploma for public school artist-teachers, a new credential recognizing their hybrid status and amplifying their educational capital.

By the end of the decade, elementary art education in Quebec centered on expressive and creative capacities of children. Secondary programs offered two options, visual arts or visual arts and mass communication, each of which encompassed two- or three-dimensional ideas and techniques as well as themes or periods from art history. The goal of the visual-arts-only track was overall personal development; the second track sought to insert art and artists into mainstream society by defining mass media as arts. Although some artists "attacked the concept of autonomous art" and "criticized the marginalization of art, the myth of the solitary artist, and the artist's separation from industrial or technological culture" (Lemerise & Couture, 1990, p. 230), few art teachers brought contemporary art practices into their curricula or connected art with social reforms. Most viewed art education as compensation for excessive rationality in school learning. Some exhibited their own art, entered art-world dialogues of the period, and perceived a golden age where art educators were innovators in a context of modernist aesthetics focusing on abstraction. Their goal was to involve students "in *an artistic experience* and not in a knowledge of art" (Lemrise & Couture, 1990, p. 230,

italics in original). The notion of a work of art was replaced by emphasis on experiencing art; viewers became participants at happenings and multimedia environments directed to a broad audience. Critics were divided between those who saw avant-garde boundary-blurring as a threat to art, and those who perceived renewal for art through games, imagination, and creativity, concepts borrowed from Progressive Education. As Lemerise and Couture conclude:

> The depth of the relation between society, the schools, and art in Quebec society of the 1960s puts it [art education] at the heart of debates and problems that are emblematic of Western culture, whether it be an industrial society hesitating between participatory democracy and liberalism, an artistic tradition oscillating between consolidation of modernism and its destabilization by the avant-garde, or a school system that is ideologically humanistic and democratic, but technocentric and selective in its functioning. (1990, p. 233)

## Authority and Creativity

Trends toward systematic, sequential national curricula and more attention to assessments for accountability have been interpreted as reversions to the nineteenth century, classical thesis for art education (Boughton, 1995; Steers, 1995; Swift, 1995). The movement to encompass not only newer media and contemporary art, but also criticism, history and questions of aesthetic values, was termed Critical Studies in the United Kingdom and Discipline-based Art Education (DBAE) in the United States, where the J. Paul Getty Trust contributed to its dissemination. DBAE's greater breadth of art content (drawn from four art disciplines), desires for more academic rigor and higher status for art education, and focus on art as component of general education resonated with other nations, so that DBAE was adapted for use in Taiwan, Hong Kong, and elsewhere.

This continuation of the classical thesis of art education as cultural capital crossed with streams of romantic antithesis that emphasized art education as critical pedagogy (Efland, 1990). Subject-centered approaches to art education were criticized by child-centered art educators and by those who argued that art education should function as a means to social reconstruction through greater attention to diversity and pluralism. Although art education became more intellectual in western nations, development of technical skill through careful teacher guidance dominated art curricula in many Asian countries, for example, in China where adult control and learned self-discipline were stressed in child-rearing (Pan, 2002; Tatsutomi, 1997; Winner, 1989). The many reforms experienced by Korean art educators, on the other hand, illustrate effects of political instability on art education as well as on education in general (Kim, 1997).

Toren has described how this duality plays out in early childhood art education in Israel:

> The authoritative approach includes characteristics that are suited to working class laborers of the middle to lower classes. The creative approach befits the

future researcher, manager and designer of the middle to higher classes. In this manner, kindergarten may prepare the children under its care towards their future anticipated lifelong profession, relying on the social class to which they belong. (2004, p. 214)

Referring to Bourdieu's argument that "schools valorize upper class cultural capital and actively depreciate that of the lower classes" (p. 215), Toren explains that European artists and artworks are the focus of instruction in Ministry of Education and Culture materials; no Arab or Sephardic-style art is shown. Recognized Israeli artists are of European ancestry. The cultural capital of the middle and upper classes is reinforced, while school omission of cultural capital from lower classes teaches lower class and ethnically diverse young people that they have no worthwhile culture. When art education is pursued without critical analysis and reflection, it may contribute to continuing inequalities.

## Conclusion

Although histories of art education can be framed in various ways, this essay has mapped coordinates of the professional field in relation to national development and the desires of both nations and individuals to build human and cultural capital. As a mapmaker, I have selected and abstracted features that another writer might have depicted in landscape view. The motivating force for development of art education has often been the need of a dominant culture to retain or expand symbolic capital, sometimes subordinating the agency of the learner. British, European, and North American modes of art education developed with the rise of capitalism and emergence of a middle class; they have been disseminated through cultural imperialism and economic globalization. My interpretation asserts that Bourdieu's theories of cultural capital resonate with the existing discourse of art education's histories. Writing in the early 1960s, the Curator of the Museum of the History of Education in Paris explained how clear, logical displays of artworks gave "the child the opportunity of reaping maximum profit from his visit to a museum" (Rabec-Mailliard, 1964, p. 63). Learning to respond to works of art and images from visual culture, both forms of symbolic capital, transmits cultural capital valued by individuals and nation-states. Learning socially valued aesthetic attitudes and art-making techniques develops human capital necessary to global economies and national identities. Art educators may possess more cultural capital than economic or political capital, but gain social capital when they work together in national or international professional associations (MacGregor, 1979; Michael, 1997; Steers, 2001). Across national boundaries, art education has developed in tension between a classical thesis found in England's South Kensington system and a romantic antithesis celebrating individual expression and creativity (Thistlewood, 1993). Although peoples around the globe have had indigenous artistic traditions, developments in capitalist nations have influenced art education elsewhere. Theories or practices that have worked for the West should be fully examined in the context of other nations before being implemented (Hyeri Ahn, personal communication, 19 June 2005).

# Notes

1. Young (2001, 2003) uses "tricontinental" to refer to the postcolonial world, that is, what was left over after the division of the first and second worlds of capitalism and socialism.
2. My use of the geographical metaphor of mapping is intended to work on two levels; first, as a projective mapping of geography on international history of art education, and second, as a cognitive tool for constructing a meaningful account of a complex topic (Fauconnier, 1997). As a map, my account combines representation and abstraction (Storr, 1994, p. 13). Bourdieu's theory of cultural capital serves as the projection for this map, privileging certain features or continents in the way a Mercator projection distorts the northern hemisphere at the expense of the southern. This projection has been used to organize the mainly secondary sources used in this account.
3. Storr (1994, p. 9) explains the coordinates of a map as reference points defining earth's position in space. These four concepts define a field's relationship to the larger universe of social forces over time.
4. This information on Chinese art education and the literati tradition was provided by Yujie Li, whom I thank for assistance with this research and for translating Pan (2002) for my use.
5. Much of this section is based on Chapter 4 in Ann Bermingham's (2000) analysis of drawing in England, a study informed by theories from Bourdieu and critical social theory.
6. The word *primitive*, which was used by MacDonald (1970), tends to rub postmodern readers the wrong way, but indicates the cultural hierarchies of the era and the ties between colonialism and cultural imperialism. Note that equating children with indigenous adults was less a means to frame the child's work as sophisticated and more a reflection of racist constructions of exotic infantilized others.

# References

Araño, J. C. (1992). Art education in Spain: 150 years of cultural ideology. In P. M. Amburgy, D. Soucy, M. A. Stankiewicz, B. Wilson & M. Wilson (Eds.), *The history of art education: Proceedings from the second Penn State conference, 1989* (pp. 42–46). Reston, VA: National Art Education Association.

Araño, J. C. (1997). Ideology in art education and culture. In A. A. Anderson, Jr. & P. E. Bolin (Eds.), *History of art education: Proceedings of the third Penn State international symposium* (pp. 3–15). University Park, PA: Art Education Program, School of Visual Arts and the College of Arts and Architecture of the Pennsylvania State University.

Ashwin, C. (1980). *The teaching of drawing in general education in German-speaking Europe 1800–1900.* London: University of London.

Ashwin, C. (1992). The British colleges of art and design: The end of an experiment? In B. Wilson & H. Hoffa (Eds.), *The history of art education: Proceedings from the Penn State conference* (pp. 76–79). Reston, VA: National Art Education Association.

Barbosa, A. M. (1992). Artus Perrelet in Brazil: A cross-cultural influence. In P. M. Amburgy, D. Soucy, M. A. Stankiewicz, B. Wilson & M. Wilson (Eds.), *The history of art education: Proceedings from the second Penn State conference, 1989* (pp. 47–50). Reston, VA: National Art Education Association.

Beelke, R. G. (1961a). Art education in the U.S.S.R. Part I: The general school program. *Art Education, 14*(4), 7–9, 18–19, 21–22, 24.

Beelke, R. G. (1961b). Art education in the U.S.S.R. Part II: The special art schools. *Art Education, 14*(5), 4–7, 18, 20–21, 28.

Bennett, C. A. (1926). *History of manual and industrial education up to 1870.* Peoria, IL: The Manual Arts Press.

Bermingham, A. (2000). *Learning to draw: Studies in the cultural history of a polite and useful art.* New Haven: Yale University Press.

Boime, A. (1971). *The academy and French painting in the nineteenth century.* London: Phaidon.

Boschloo, A. W. A., Hendrikse, E. J., Smit, L. C., & van der Sman, G. J. (Ed.). (1989). *Academies of art between renaissance and romanticism* (Leids Kunsthistorisch jaarboek, Vol. V–VI [1986–1987]). [The Hague] SDU Uitgeverij.

Boughton, D. (1989). The changing face of Australian art education: New horizons or sub-colonial politics? *Studies in Art Education, 30*(4), 197–211.

Boughton, D. (1995). Six myths of national curriculum reforms in art education. *Journal of Art & Design Education, 14*(2), 139–151.

Bourdieu, P. (1983). The forms of capital. Retrieved May 11, 2005, from http://www.viet-studies.org/ Bourdieu_capital.htm

Bourdieu, P. (1984). *Distinction: A social critique of the judgment of taste* (R. Nice, Trans.). Cambridge, MA: Harvard University Press.

Bourdieu, P. (1996). *The rules of art* (S. Emanuel, Trans.). Stanford, CA: Stanford University Press.

Bourdieu, P., & Darbel, A. (1990). *The love of art* (C. B. N. Merriman, Trans.). Stanford, CA: Stanford University Press.

Brown University Department of Art. (1984). *Children of Mercury: The education of artists in the sixteenth and seventeenth centuries*. Providence, RI: Brown University.

Burke, J. (1964). Some aspects of the debate on art education in Australia. *Studies in Art Education, 5*(2), 5–11.

Bush, S. (1971). *The Chinese literati on painting*. Cambridge, MA: Harvard University Press.

Calhoun, A. (1993). A trade for their daughters: Women in the fine and applied arts in New Zealand from 1870 to 1900. *Bulletin of New Zealand Art History, 14*, 15–28.

Carline, R. (1968). *Draw they must: A history of the teaching and examining of art*. London: Edward Arnold.

Chalmers, F. G. (1985). South Kensington and the colonies: David Blair of New Zealand and Canada. *Studies in Art Education, 26*(2), 69–74.

Chalmers, F. G. (1992a). The origins of racism in the public school art curriculum. *Studies in Art Education, 33*(3), 134–143.

Chalmers, F. G. (1992b). South Kensington and the colonies II: The influence of Walter Smith in Canada. In B. Wilson, & Hoffa, H. (Ed.), *The history of art education: Proceedings from the Penn State conference* (pp. 108–112). Reston, VA: National Art Education Association.

Chalmers, F. G. (1993). Who is to do this great work for Canada? South Kensington in Ontario. *Journal of Art & Design Education, 12*(2), 161–178.

Chalmers, F. G. (2000). *A 19th century government drawing master: The Walter Smith reader*. Reston, VA: National Art Education Association.

Dalton, P. (2001). *The gendering of art education: Modernism, identity and critical feminism*. Buckingham, England; Philadelphia: Open University Press.

Davis, B. J. (Ed.). (1969). *Education through art: Humanism in a technological age*. Washington, DC: National Art Education Association.

Dimmack, M. C. (1955). Art education in Australia. *Art Education, 8*(4), 3–6, 18, 19.

Efland, A. (1976). The school art style: A functional analysis. *Studies in Art Education, 17*(2), 37–44.

Efland, A. (1990). *A history of art education: Intellectual and social currents in teaching the visual arts*. New York: Teachers College Press.

El-Bassiouny, M. Y. (1964). Art education in the United Arab Republic (Egypt). *Studies in Art Education, 5*(2), 21–27.

Fauconnier, G. (1997). *Mappings in thought and language*. Cambridge: Cambridge University Press.

Fennessy, K. M. (2005). "Industrial instruction" for the "industrious classes": Founding the Industrial and Technological Museum, Melbourne. *Historical Records of Australian Science, 16*(1), 45–64.

Fineberg, J. (1997). *The innocent eye: Children's art and the modern artist*. Princeton, NJ: Princeton University Press.

Foster, M. S. (1992). Exchanges between American and Japanese art educators: What did they learn from each other? In P. M. Amburgy, D. Soucy, M. A. Stankiewicz, B. Wilson & M. Wilson (Eds.), *The history of art education: Proceedings from the second Penn State conference, 1989* (pp. 104–108). Reston, VA: National Art Education Association.

Freedman, K., & Hernandez, F. (Eds.). (1998). *Curriculum, culture, and art education: Comparative perspectives*. Albany, NY: State University of New York Press.

Grigor, A. N. (2002). *Arthur Lismer: Visionary art educator*. Montreal & Kingston, Canada: McGill-Queen's University Press.

Holdsworth, B. (1988). Marion Richardson (1892–1946). *Journal of Art & Design Education, 7*(2), 137–154.

Karpati, A., & Gaul, E. (1997). Episodes from the social history of Hungarian art education from an international perspective. In A. A. Anderson, Jr. & P. E. Bolin (Eds.), *History of art education: Proceedings of the*

*third Penn State international symposium* (pp. 292–301). University Park, PA: Art Education Program, School of Visual Arts and the College of Arts and Architecture of the Pennsylvania State University.

Kauppinen, H., & Diket, R. (Eds.). (1995). *Trends in art education from diverse cultures.* Reston, VA: National Art Education Association.

Kim, J.-K. (1997). History of art education in Korea: From 1945 to the present. In A. A. Anderson, Jr. & P. E. Bolin (Eds.), *History of art education: Proceedings of the third Penn State international symposium* (pp. 454–459). University Park, PA: Art Education Program, School of Visual Arts and the College of Arts and Architecture of the Pennsylvania State University.

Korzenik, D. (1985). *Drawn to art: A nineteenth-century American dream.* Hanover, NH: University Press of New England.

Kosasa, K. K. (1998). Pedagogical sights/sites: Producing colonialism and practicing art in the Pacific. *Art Journal, 57*(3), 47–54.

Kraus, B. A. (1968). *History of German art education and contemporary trends.* Unpublished doctoral dissertation, The Pennsylvania State University, University Park, PA.

Laukka, M., Lahteenaho, M., & Pohjakallio, P. (Eds.). (1992). *Images in time: Essays on art education in Finland.* Helsinki: The Faculty of Art Education, University of Industrial Arts.

Lears, T. J. J. (1981). *No place of grace: Antimodernism and the transformation of American culture 1880–1920.* New York: Pantheon.

Lemerise, S. (1992). Study of the relationships of the art field and the social context to art education, applied to Québec in the 1960s. In P. M. Amburgy, D. Soucy, M. A. Stankiewicz, B. Wilson, & M. Wilson (Eds.), *The history of art education: Proceedings from the second Penn State conference, 1989* (pp. 79–84). Reston, VA: National Art Education Association.

Lemerise, S., & Couture, F. (1990). A social history of art and public art education in Québec: The 1960s. *Studies in Art Education, 31*(4), 226–233.

Macdonald, S. (2004). *The history and philosophy of art education* (reprint ed.). Cambridge, England: The Lutterworth Press.

MacGregor, R. N. (1979). *A history of the Canadian Society for Education through Art (1951–1975).* Lexington, MA: Ginn Custom Publishing.

Marzio, P. C. (1976). *The art crusade: An analysis of American drawing manuals.* Washington, DC: Smithsonian Institution Press.

Masuda, K. (1992). The transition of teaching methods in Japanese art textbooks. In P. M. Amburgy, D. Soucy, M. A. Stankiewicz, B. Wilson & M. Wilson (Eds.), *The history of art education: Proceedings from the second Penn State conference, 1989.* (pp. 98–103). Reston, VA: National Art Education Association.

Masuda, K. (2003). A historical overview of art education in Japan. *The Journal of Aesthetic Education, 37*(4), 3–11.

Michael, J. (Ed.). (1997). *The National Art Education Association: Our history – celebrating 50 years, 1947–1997.* Reston, VA: National Art Education Association.

Morton, M. (1972). *The arts and the Soviet child: The esthetic education of children in the USSR.* New York: The Free Press.

Okazaki, A. (1987). American influence on the history of Japanese art education: The case of Akira Shirahama. In B. Wilson & H. Hoffa (Eds.), *The history of art education: Proceedings from the Penn State conference* (pp. 59–66). Reston, VA: National Art Education Association.

Okazaki, A. (1991). European modernist art into Japanese school art: The free drawing movement in the 1920s. *Journal of Art & Design Education, 10*(2), 189–198.

Okazaki, A. (1992). American influence on the history of Japanese art education: The case of Seishi Shimoda. In P. M. Amburgy, D. Soucy, M. A. Stankiewicz, B. Wilson & M. Wilson (Eds.), *The history of art education: Proceedings from the second Penn State conference, 1989* (pp. 109–117). Reston, VA: National Art Education Association.

Onuchukwu, C. (1994). Art education in Nigeria. *Art Education, 47*(1), 54–60.

Pan, Y. (2002). *A history of modern art education in China.* Hangzhou: National Academy of Fine Art Press.

Parker, R. (1984). *The subversive stitch: Embroidery and the making of the feminine.* New York: Routledge.

Pearse, H. (1992). Arthur Lismer: Art educator with a social conscience. In P. M. Amburgy, D. Soucy, M. A. Stankiewicz, B. Wilson & M. Wilson (Eds.), *The history of art education: Proceedings from the second Penn State conference, 1989* (pp. 85–88). Reston, VA: National Art Education Association.

Pearse, H. (1997). Imagining a history of Canadian art education. In A. A. Anderson, Jr. & P. E. Bolin (Eds.), *History of art education: Proceedings of the third Penn State international symposium* (pp. 16–25). University Park, PA: Art Education Program, School of Visual Arts and the College of Arts and Architecture of the Pennsylvania State University.

Peers, C. (2001). A "methodist" intervention in the history of art education, http://www.aare.edu.au/01pap/pee01238.htm.

Peers, C. (2002). Tracing an approach to art teaching: A historical study of an art education documentary film. *Studies in Art Education, 43*(3), 264–277.

Peshkin, A. (1964). The changing function of art education in Pakistan. *Studies in Art Education, 5*(2), 12–20.

Petrovich-Mwaniki, L. (1987). The influence of National Socialism on German art education during the third Reich and on post war art education trends. In A. A. Anderson, Jr. & P. E. Bolin (Eds.), *History of art education: Proceedings of the third Penn State international symposium* (pp. 445–453). University Park, PA: Art Education Program, School of Visual Arts and the College of Arts and Architecture of the Pennsylvania State University.

Petrovich-Mwaniki, L. (1992). Musische education: Its origins, influence, and survival in West German art education. In P. M. Amburgy, D. Soucy, M. A. Stankiewicz, B. Wilson & M. Wilson (Eds.), *The history of art education: Proceedings from the second Penn State conference, 1989* (pp. 126–132). Reston, VA: National Art Education Association.

Pirogov, V. (1960a). Art education in the USSR. *Art Education, 13*(1), 4–6.

Pirogov, V. (1960b). Art in the general schools of the U.S.S.R. *Art Education, 13*(9), 6–8, 20.

Pohjakallio, P. (1992). The early stages of Finnish art education. In P. M. Amburgy, D. Soucy, M. A. Stankiewicz, B. Wilson & M. Wilson (Eds.), *The history of art education: Proceedings from the second Penn State conference, 1989* (pp. 89–92). Reston, VA: National Art Education Association.

*Prospects of art education in the 21st century: An international symposium in art education.* (1999). Taiwan Museum of Art, Taichung, Taiwan, ROC: Taiwan Art Education Association.

Rabec-Mailiard, M.-M. (1964). Art education in France. *Studies in Art Education, 5*(2), 57–66.

Rogers, T. (1992). British art education in the schools, 1895–1910 and its influence on the schools of British Columbia. In B. Wilson & H. Hoffa (Eds.), *The history of art education: Proceedings from the Penn State conference* (pp. 87–93). Reston, VA: National Art Education Association.

Seibert, A. (1996). The Queensland College of Art, Griffith University 1881–1996: Past, present and future. *Australian Art Education, 19*(2), 17–24.

Sloan, K. (2000). *"A noble art": Amateur artists and drawing masters c. 1600–1800.* London: British Museum Press.

Smith, J. (2003). The dilemmas of bicultural education policy in art education practice in Aotearoa New Zealand (n.p.).

Soucy, D., & Stankiewicz, M. A. (Eds.). (1990). *Framing the past: Essays on art education.* Reston, VA: National Art Education Association.

Spring, J. (2004). *The American school, 1642–2004* (6th ed.). Boston: McGraw-Hill Higher Education.

Stankiewicz, M. A. (1984). "The eye is a nobler organ": Ruskin and American art education. *Journal of Aesthetic Education, 18*(2), 51–64.

Stankiewicz, M. A. (2001). *Roots of art education practice.* Worcester, MA: Davis Publications.

Stankiewicz, M. A., Amburgy, P. M., & Bolin, P. E. (2004). Questioning the past: Contexts, functions and stakeholders in 19th century art education. In E. W. Eisner & M. D. Day (Eds.), *Handbook of research and policy in art education* (pp. 33–53). Mahwah, NJ: Lawrence Erlbaum Associates.

Steers, J. (1995). The national curriculum: Reformation or preservation of the status quo. *Journal of Art & Design Education, 14*(2), 129–137.

Steers, J. (2001). InSEA: A brief history and a vision of its future role. *Journal of Art & Design Education, 20*(2), 215–229.

Stevens, E. W., Jr. (1995). *The grammar of the machine.* New Haven: Yale University Press.

Stirling, J. C. (1997). The politics of drawing: Theory into practice: Walter Smith's influence on post-secondary Quebecindustrial art schools, 1876–1891. In A. A. Anderson, Jr. & P. E. Bolin (Eds.), *History of art education: Proceedings of the third Penn State international symposium* (pp. 355–366). University Park, PA: Art Education Program, School of Visual Arts and the College of Arts and Architecture of the Pennsylvania State University.

Stokrocki, M. (1997). Towards an ethnohistory of Amerindian art education: Navaho cultural preservation vs. assimilation. In A. A. Anderson, Jr. & P. E. Bolin (Eds.), *History of art education: Proceedings of the third Penn State international symposium* (pp. 71–80). University Park, PA: Art Education Program, School of Visual Arts and the College of Arts and Architecture of the Pennsylvania State University.

Storr, R. (1994). *Mapping*. New York: The Museum of Modern Art.

Sutton, G. (1967). *Artisan or artist? A history of the teaching of arts and crafts in English schools*. Oxford, UK: Pergamon Press.

Swift, J. (1995). Controlling the masses: The reinvention of a "national" curriculum. *Journal of Art & Design Education, 14*(2), 115–127.

Tatsutomi, Y. (1997). Changes in teacher's consciousness from 1872 to the present in Japan: From coercion to laissez-faire, inducement to freedom. In A. A. Anderson, Jr. & P. E. Bolin (Eds.), *History of art education: Proceedings of the third Penn State international symposium* (pp. 285–291). University Park, PA: Art Education Program, School of Visual Arts and the College of Arts and Architecture of the Pennsylvania State University.

Teaero, T. (2002). The role of indigenous art, culture and knowledge in the art education curricula at the primary school level, *United Nations Educational, Scientific, and Cultural Organisation Regional Conference on arts education in the Pacific*. Nadi, Fiji.

Thistlewood, D. (1988). The early history of the NSEAD: The Society of Art Masters (1888–1909) and the National Society of Art Masters (1909–1944). *Journal of Art & Design Education, 7*(1), 37–64.

Thistlewood, D. (1992). National systems and standards in art and design higher education in Britain. In B. Wilson & H. Hoffa (Eds.), *The history of art education: Proceedings from the Penn State conference* (pp. 80–86). Reston, VA: National Art Education Association.

Thistlewood, D. (1993). Herbert Read: A critical appreciation at the centenary of his birth. *Journal of Art & Design Education, 12*(2), 143–160.

Toren, Z. (2004). Art curriculum, learning materials, and cultural capital in the Israeli kindergarten. *Studies in Art Education, 45*(3), 206–220.

van Rheeden, H. (1990). Art education in the former Dutch East Indies in the 1930s: Questions of different cultures. *Journal of Art & Design Education, 9*(2), 171–195.

van Rheeden, H. (1992). The Indonesian art academies of Yogyakarta and Bandung: The Dutch contribution to Indonesian higher art education. In P. M. Amburgy, D. Soucy, M. A. Stankiewicz, B. Wilson & M. Wilson (Eds.), *The history of art education: Proceedings from the second Penn State conference, 1989* (pp. 54–61). Reston, VA: National Art Education Association.

White, J. H. (2004). 20th-century art education: A historical perspective. In E. W. Eisner & M. D. Day (Eds.), *Handbook of research and policy in art education* (pp. 55–84). Mahwah, NJ: Lawrence Erlbaum Associates.

Wilson, B. (2004). Child art after modernism: Visual culture and new narratives. In E. W. Eisner & M. D. Day (Eds.), *Handbook of research and policy in art education* (pp. 299–328). Mahwah, NJ: Lawrence Erlbaum Associates.

Winner, E. (1989). How can Chinese children draw so well? *Journal of Aesthetic Education, 23*(1), 41–63.

Yamada, K. (1992). The development of art courses of study in Japan. In P. M. Amburgy, D. Soucy, M. A. Stankiewicz, B. Wilson & M. Wilson (Eds.), *The history of art education: Proceedings from the second Penn State conference, 1989* (pp. 118–125). Reston, VA: National Art Education Association.

Yeomans, R. (1988). Basic design and the pedagogy of Richard Hamilton. *Journal of Art & Design Education, 7*(2), 155–173.

Yeomans, R. (1992). The pedagogy of Victor Pasmore and Richard Hamilton. In P. M. Amburgy, D. Soucy, M. A. Stankiewicz, B. Wilson & M. Wilson (Eds.), *The history of art education: Proceedings from the second Penn State conference, 1989* (pp. 72–78). Reston, VA: National Art Education Association.

Young, R. J. C. (2001). *Postcolonialism: An historic introduction*. Oxford: Blackwell.

Young, R. J. C. (2003). *Postcolonialism: A very short introduction*. Oxford: Oxford University Press.

# INTERNATIONAL COMMENTARY

# 2.1

# France

**Bernard Darras**
*University of Paris 1 Panthéon-Sorbonne, France*

By choosing a theoretical framework influenced by the thoughts of Pierre Bourdieu on one hand and Cultural Studies, on the other, Mary Ann Stankiewicz manages to establish a rich and audacious version of the social history of an educative field in the process of being structured. This contribution attempts to augment this history in adopting a cultural perspective (Ory, 2004).

## Division, Specialization, Autonomy and Elitisms in Europe

The European situation is interesting to study because of the conflicts that take place here and because of its international influence.

The Latin world divided human activities (and humans) into two categories which have durably structured Western society, on one hand the category of *artes liberales*, dedicated to the culture of the spirit of free men, and on the other hand, the *artes illiberales, sordidae,* or *mechanichae* which concerned manual activities reserved for slaves and employees. Music, associated with mathematics was a liberal art while painting and sculpture were mechanical arts. The values of Christian education were based on the liberal arts. This distinction between liberal and mechanical arts was cultivated throughout the Middle Ages.

It is in this context that were created the corporations and guilds, notably that of "imagers, painters and three-dimensional image makers" which gathered together a number of professions more or less related to image (the one in Paris was created in 1121). These image artisans were in charge of selling their products and had the right to have servants and apprentices who learned skills by copying their master and then making a Masterpiece to become an artisan too (Heinich, 1993).

The prestige that surrounded image was also progressively attributed to its producers. The elite members of corporations aspired to climbing the social scale and rejecting the corporate constraints. The practices and production became consequently

31

*L. Bresler (Ed.), International Handbook of Research in Arts Education, 31–34.*
© 2007 *Springer.*

hierarchized and some painters wished to leave the depreciated world of the mechanical arts to access the status granted by the liberal arts and the freedom they authorized. Their practice changed and became intellectualized accordingly. This is how, in the sixteenth and seventeenth centuries, academies of painting and sculpture appeared in Italy, then in France.

The activity of the Academy members did not consist only in the production of works of art, they also had to teach, organize and direct festivities, processions and triumphal marches.

The focus on the elite and on the first steps of the triumphal march of art and artists (these terms did not exist then in their current meaning), must not make one forget that the majority of imagers (92%) were organized in corporations of artisans who continued to produce, ply their trade and train apprentices. (In France, the corporations were dissolved in 1791).

The arrival of painters and sculptors in the liberal arts was therefore the result of a long disputed power struggle, but that managed to impose itself only because of a change of practice and the weakening of the distinction between mechanical and liberal arts. (Heinich, 1996). To deserve their new "intellectual" position, the academies promoted a teaching method divided into two parts "one regarding reason or theory, the other regarding the hand and practice" (Batteux 1747, in Heinich, 1993, p.93). The echoes of these divisions still resonate in the twenty first century in European education systems where the legitimacy of a manual, technical and practical education is still contested by the "legitimate" inheritors of the liberal arts. To make themselves accepted, the influential players in this domain did not cease to work at raising theoretical approaches (historical, aesthetic, critical, etc.) and valorizing the activities of the spirit (imagination, expression, creation), to the detriment of technical education. As for so-called applied arts, they have been devalued because of their manual activity, their technicality and their usefulness, and have even been confined to technical education with low cultural value.

The nineteenth century invented a new social type which emphasized the values of the liberal arts: the artist by vocation, a genius, singular, exceptional and innovative who despises commissions, honors and the market, and who opposes everything that represents the industrious bourgeois and the alienated worker. For these artists, the concepts of emancipation, independence and freedom developed with a backdrop of political deception and aristocratic nostalgia (in France). In reaction to the economic, political and social order that was then being established, they were going to build a new relationship with success as well as an economy shifting the material values towards spiritual values (Bourdieu, 1992). The absence of success in the present becomes a pledge of success for posterity and economic misery a sign of symbolic wealth. This invention of a new social type, precursor to many attitudes of the twentieth century, finds its roots in the liberal breeding ground of individualization and innovation, but also in an ideological context of disinterest, self-sacrifice and of art for art's sake. For the radical autonomists, all the forms and marks of interdependence (heteronomy) are assimilated to dependence (allonomy) which leads them to develop sectarian strategies and hermetic productions confined to the small world they fabricate for themselves.

The autonomy of the art of this time and that which followed is therefore relative. But the impact of these ideas on certain educators has been considerable. A gap then

appears between the defenders of an education oriented by the values of art and the advocates of a more utilitarian, scientific, technical and aesthetic education.

## From Opposition to Hegemony

For two centuries, four large educational projects have opposed each other and attempted to impose their contents and their vision of education.

- The functionalists extolled a teaching of scientific and communication drawing as a language for industry and contemporary life.
- The patrimonials defended the great artistic tradition.
- The pedagogues, supported by the psychologists, pleaded for drawing as a tool for individual and social development.
- The avant-garde modernists wanted to promote the works and the values of modern art … then postmodern. They were supported by the promoters of the democratization of art and of the democratization by artists who practice the paradox of the democratization of elite culture.

In France, the functionalists and patrimonials opposed each other for more than 50 years until the 1920s. The contents of the official educational curricula for teachers reflected the progression and regression of one and the other. The patrimonials finally won. They obtained the support of the pedagogues and the psychologists rather than from the modernists whose ideas were established from 1969 through the creation of a visual art[1] training in the universities, then in 1977 with the publication of new school curricula. In France, education in "The Arts" progressively imposed itself and became a monopoly.

Today, art is hardly taught in primary school, it is mandatory for all levels in junior high school and optional at high school level where, in total, artistic disciplines are practiced by 7.5% of students. However, the success of this method of artistic education is mixed, the changes of orientation and the paradoxical injunctions have fazed a number of teachers and students. The gap is increasing between the values of the art world and the values of a socially and ethnically diversified education system that has a responsibility to teach all children, not only the elite.

The curricula published in France in 2005 (Ministry of National Education, 2005) put an end to artistic hegemony and proposed an important rebalancing between culture and art. Drawing which had been banished from education under the pressure of modernists makes a strong return as a tool of thought and means of communication. Previously it had been replaced by painting whose relationship with art is less ambiguous (Darras, 1996, 1998). The knowledge and the practice of image and media are placed in a central position in the primary school curriculum and are distributed across various disciplines. The hegemony of art is relativized by the cultural approaches. "The access for all to culture seems to win over artistic education for all" (Panier, 2001). It is in a way the return of imagers, of drawing and of a visual culture open to all these facets and everyone's world. This new discipline is called "Artistic and cultural education".

# Rule and Practice

One must not forget that a teacher's career lasts about forty years and that they are not all pioneers or volunteers or resistant to change. Between the history of ambitious curricula and that of players in the field, there are large gaps that history does not record, but they nevertheless constitute the daily history of teachers, pedagogic teams, students and their families.

With the advent of modernism in art, the distance between the art of the present and the public has become wider. But in primary and high schools, the very academic, patrimonial and technical education has not perpetuated this break. On the other hand, as soon as the influence of the modernist pedagogues favored the introduction of issues related to modern art (then contemporary), this readjustment provoked considerable shocks. The majority of the teachers trained in academic methods were not ready to integrate the new content and the new teaching methods into their pedagogic practice. In the same way, the majority of students and families were not willing to accept the attitudes and artistic values developed in artistic microcosms, often elitist and hermetic. As for new teachers, trained in the practice of modern and postmodern art, they were not prepared to face an education system ignorant or hostile to issues and objects fashionable in artistic circles. The history of this resistance, these gaps, these daily inventions and "quick-fixes" remains to be written.

# Note

1. *Arts plastiques*: In Latin Europe and in France, the notion of "plastic arts" has been preferred to the terms of "Fine Arts" and "Visual Arts". "Fine Arts" was too influenced by its pre modernist origin, and "Visual Arts" also covered the areas of design and applied arts. In a period influenced by abstraction, it was also a way of highlighting what refers to artwork and its forms to the detriment of what refers to the perceptive and iconic experience.

# References

Bourdieu, P. (1992). *Les règles de l'art*. Paris, Seuil.

Darras, B. (1996). Policy and practice in French Art education: An analysis of change. *Art Education Policy Review, 97*(4), 12–17.

Darras, B. (1998). Pensée figurative, pensée visuelle et éducation artistique. Bilan de la modernité. In M. Richard et S. Lemerise (Dirs.), *Les arts plastiques à l'école* (pp. 53–81). Montréal: Editions logiques.

Heinich, N. (1993). *Du peintre à l'artiste. Artisans et académiciens à l'âge classique*. Paris: Les Editions de minuit. p. 244.

Heinich, N. (1996). *Etre Artiste*. Paris: Kincksieck.

Ministère de l'Education Nationale (2005). Qu'apprend-on à l'école, élémentaire. 2005–2006 les programmes. CNDP/XO éditions.

Ory, P. (2004). *L'histoire culturelle*. Paris: Presses Universitaires de France.

Panier, E. (2001). Art et enseignement, histoires particulières. In *L'art à l'école*. Paris, Beaux Arts magazine. p. 8.

# INTERNATIONAL COMMENTARY

# 2.2

# Africa

**Winston Jumba Akala**
*Catholic University of Eastern Africa, Kenya*

One of the areas given marginal analysis in Stankiewicz's analysis of art from a capitalized perspective are the early forms of art that preceded the Western art culture she clarifies. For instance, the hand axes found at the Olorgesaillie and Kariandusi historic sites in Kenya, the cave drawings and paintings in Olduvai Gorge in Tanzania, the great Pyramids of Egypt, and great Zimbabwe ruins represent Africa's oldest and most famous art traditions.

Currently, these sites experience a high profile for educational and tourist purposes and turn in immense profits for the various countries. The educational pursuit to understand the antiquities and their purpose is ever current, and the curiosity to encounter these great pieces of art burns within individuals who visit these sites. This underscores the emphasis on the beauty of art as explicated by Abiodun (2001/2).

Art in Africa has thus metamorphosed greatly from a leisure and utilitarian activity to an educational, historic, and political treasure – thereby taking on a highly capitalized function. Today, artists from the African continent produce more sophisticated art, which also bears a multicultural representation in order to appeal to a wide market. Thus the skill level has advanced while the cultural value has multiplied, albeit diluting the ethnic orientation assumed in precolonial times. Presently, reasonable success has been achieved – at every level of education in many African countries – in incorporating sculpture, woodwork, stone carving, ceramics (including pottery), moulding, fine art, dance, music and theater, and embroidery, among others in the curriculum as a strategy to develop the requisite human resources.

More specifically, the promotion of technical drawing in schools and the provision of government scholarships for innovative ideas, waiver of duty on electronic appliances such as computers and their accessories, are among the strategies the government of Kenya has employed in promoting industrial drawing and other forms of art. In Kenya, a special institution – the Kenya Technical Teachers College – in Nairobi is another

*L. Bresler (Ed.), International Handbook of Research in Arts Education*, 35–36.
© 2007 *Springer.*

initiative to ensure a continuous supply of qualified art teachers who can enhance culture-sensitive but internationally captivating art. As indicated by Flolu (2000) similar effort has been made in Ghana to revamp interest in art education.

# References

Abiodun, R. (2001/2). African aesthetics, *Journal of Aesthetic Education, 35*(40), 15–24.
Flolu, E. J. (2000). Rethinking arts education in Ghana, *Arts Education Policy Review, 101*(5), 25–25.

# INTERNATIONAL COMMENTARY

# 2.3

# Sweden

**Gunnar Åsén**
*Stockholm Institute of Education, Sweden*

In the first Swedish Public School Act of 1842 *Geometry and line drawing* was referred to as one of the subjects which the school should provide "some instruction in." At the end of the 1870s drawing became a separate subject in elementary school in Sweden and for the sake of continuity it was advised that the same teaching method should be used in all schools. The method recommended was devised by Adolf Stuhlmann and was in wide use in Germany at the same time. It was an elaboration of the methodological tradition established by Pestalozzi and his followers in which drawing instruction was based on geometric forms. The teaching methods were designed for mass instruction – that is, all the pupils were to carry out the same tasks at the same time and at a pace set by the teacher (Pettersson & Åsén, 1989; Åsén, 1997).

Toward the end of the nineteenth century, in Sweden and many other European countries, there was a notable increase in the publication of books on teaching methods. One factor in this upswing was the low salaries paid to art teachers. To publish and perhaps receive widespread acceptance of a textbook was one way teachers hoped to augment their income. Thus drawing became the first school subject to generate a textbook industry of its own (Åsén, 1999; cf. Ashwin, 1981).

The 1950s saw the breakthrough of creative self-expression in Swedish art education. In this connection modern art became an important model for art instruction. Reference was often made to Herbert Read who had written that "just as modernism freed the artist, it should also be able to free the schoolchild." It is paradoxical that when children's pictures and the importance of pictorial self-expression were mentioned in school texts it was with reference first and foremost to art. Earlier children's art had served as a model for artists – now almost 50 years later, it can be said, if with some exaggeration, that children are required to imitate artists, who earlier had imitated children (Åsén, 1997).

Political changes in the 1960s transformed Swedish art education. Cultural experimentation, popular culture and environmental concerns were first included in the national art curriculum in 1969 after art education scholars voiced opposition to the old traditions in art education. The field of art education was expanded to contain pictorial

*L. Bresler (Ed.), International Handbook of Research in Arts Education*, 37–38.

analysis and criticism as well as visual communication. For the past thirty years, Swedish art education has continued to embrace social and environmental concerns. Today, one major theme in Swedish art education curricula is the study of semiotics and visual culture (Karlsson, 1998, Lövgren & Karlsson, 1998).

# References

Åsén, G. (1997). From lines to images. In K. Hasselberg, U. Lind, & B.-M., Kühlhorn (Eds.), *Shifting images. 150 years of teaching art in school*. Stockholm: School of Art Education, University College of Arts, Crafts and Design.

Ashwin, C. (1981). *Drawing and education in German-Speaking Europe 1800–1900*. Ann Arbor, MI: UMI Research Press.

Karlsson, K. (1998). The pictorial language program: A critical review. In I. L. Lindström (Ed.), *Nordic visual arts research*. The Stockholm Library of Curriculum Studies, vol 2, 1998. Stockholm: HLS Förlag.

Lövgren, S., & Karlsson, S. (1998). From art making to visual communication: Swedish art education in the 20th century. In K. Freedman & F. Hernandez (Eds.), *Curriculum, culture and art education: Comparative practices*. New York: State University of New York.

Pettersson, S., & Åsén, G. (1989). *Bildundervisningen och det pedagogiska rummet. Traditioner, föreställ-ningar och undervisningsprocess inom skolämnet teckning/bild i grundskolan*. (Art Education and the ped-agogical room. On the traditions, suppositions and processes of teaching drawing/art in the compulsory school.) Stockholm: HLS Förlag.

# INTERLUDE

# 3

# ARTS EDUCATION, THE AESTHETIC AND CULTURAL STUDIES

**Arthur D. Efland**

*Ohio State University, U.S.A.*

In an essay called "Reclaiming the Aesthetic" George Levine described a radical transformation that had taken place in the field of literary study in colleges and universities in the 1970s and 1980s. These changes registered as a shift from questions about what texts mean to questions about the social systems that contain them. A second was a resistance to the idea of literary value, particularly to the idea of literary greatness. A third was an increasing emphasis on the necessity for interdisciplinary study where, in effect, literary study was an adjunct to anthropology and other social sciences. A fourth was contempt for formalism or the use of formal analysis to study the structure of art works, while yet another was the determination that all works of art are political. Collectively, these changes were characterized as a "reductive assimilation of literature to ideology" (1994, pp. 1–2).

With some slight adjustment in terminology, Levine's depiction of the changes within literary study could easily fit the present trend in teaching the visual arts and music as well. In the visual arts the shift became known as the study of visual culture. At the present moment the idea of a category of objects, having a special or unique character identified by such terms as "fine art" or classical music is all too often demeaned as a mode of upper class domination or eliteness, while aesthetic experience is equated with mystified ideology. Levine's project was to rescue literary study from its potential disappearance into culture and politics, and the question I raise is whether this objective should cover all the arts?

## The Problem with the Arts

Shall we defend the fine arts and serious music as significant cultural achievements worthy of study in their own right? Obviously yes, but how does one do this? Is the present shift toward cultural studies in the arts a difficulty brought on by a nasty bunch of Marxists who would have us shift instructional emphasis from the fine arts in all their

*L. Bresler (Ed.), International Handbook of Research in Arts Education*, 39–44.
© 2007 *Springer.*

pristine purity to studies of culture and politics? I think not. Rather, I see the problem with the arts as originating within the arts themselves.

In *Beyond the Brillo Box*, the philosopher and critic, Arthur Danto, (1992) described the cultural landscape as a map bounded by various zones. His map lays out zones like the art world, the mass media and the popular culture. But the boundaries that once kept these zones apart have either disappeared or are in the process of erasure. For example, the lines that separated the fine arts from popular culture either have become imperceptible or are marked as disputed territories.

Danto described the situation in the visual arts as getting its start in the 1960s. Pop art eliminated the boundary between high art and low art; minimalism erased the distinction between fine art and industrial process. The border separating mass-produced things from the images of fine art housed in museums has disappeared from the landscape. Another is the distinction between objects appreciated as exemplars of cultivated taste and the objects of the ordinary person's life-world including comic strips, soup cans, and cheeseburgers. No longer does art have to be beautiful or to resemble nature; indeed there is no longer any difference between works of art and what Danto calls "mere real things." (pp. 4–5) Danto also notes that, "you cannot tell when something is a work of art just by looking at it, for there is no particular way that art has to look. The upshot was that you could not teach the meaning of art by examples." (p. 5) If so, what does one teach?

Once our purpose was defined by a dedication to particular objects having a special or unique character identified by such terms as "fine art" or "classical music," objects created by the conscious use of the imagination to produce aesthetic objects, objects housed in museums or performed in concert halls – objects set apart from the concerns of daily living, but now, the differences that once isolated these from other things has dropped from view. Without a discernible difference between ordinary things and works of art, there is no rational basis for deciding what to teach.

## Visual and Cultural Studies

The waning of modernism. Throughout the modernist era which began roughly at the end of the nineteenth century, the modernist avant-garde established a hierarchy of values which placed the fine arts above such forms of popular culture as the folk traditions of art making, industrial, interior, package and graphic design, photography, commercial illustration, and the like. In championing a striving for purity in art, critics such as Clement Greenberg advocated the view that modern artists and critics should be disdainful of the imagery of popular culture and commerce. Indeed, Laura Kipnis once defined modernism "as the ideological necessity of erecting and maintaining exclusive standards of the literary and artistic against the constant threat of incursion and contamination" (1986, p. 21). Referring to popular visual culture as "kitsch," Greenberg dismissed it as an unfit subject for serious study in favor of the high art of the avant-garde. When artists such as Warhol and Lichtenstein began to appropriate imagery from popular culture and commerce, Greenberg and many others within the art world had difficulty accepting this as art (see Wallis, 1984, p. 2).

Greenberg's modernism was invested in maintaining the separation between the fine arts and the entertainment media including cinema, television, and their electronic extensions. The presence of these potent sources of visual imagery has changed the American landscape and culture affecting the lives of children growing up in the midst of these influences. As long as we defined instructional practice in terms of the fine arts, we may have known what we were supposed to teach but increasingly it became clear that the impact of imagery from the popular culture should receive educational attention.

If the fine arts and serious music comprise a small fraction of the totality covered by cultural studies, should they continue to remain the central focus of instruction as in the modernist past? Do the fine arts continue to have a role in education and what might that be? The proponents of visual culture don't say no to the fine arts though they advocate that more time and resources should be expended to study the arts of everyday life (Duncum, 2002). Freedman and Stuhr, though recognizing the importance of fine art as a carrier of historical and contemporary culture, nevertheless conclude, "fine art objects and 'good taste' can no longer be seen as the only visual cultural capital to serve elementary, secondary, or college level students" (2004, p. 817).

Though acknowledging the existence of fine art as a practice, they also describe it as a product from a bygone era (modernism) and are generally unconcerned with the task of teaching it as fine art in all its separateness and remoteness. Rather, the task they pursue is to help students become critically attentive to the cultural meanings that images convey for the purpose of understanding society and culture, including how these images help create the shared meanings we call culture. Critical citizenship rather than the appreciation of the finer things of life has become the aim (Tavin, 2001, p. 133).

If fine art as a cultural practice is acknowledged at all, it is grudgingly. It is often misequated with upper-class domination. Social critics like Pierre Bourdieu regard the high arts as no more than sign systems designating social status (in Johnson 2003, p. 5). Likewise, Tony Bennett, a British Marxist describes fine art as "sheltering the world of privilege ... from unwelcome political distractions" (see Harpham, 1994, p. 128). Thus numerous academic types, who once might have been counted on to champion fine art, literature, and classical music, stand less ready to support such offerings.

Since the study of works of art has as its purpose the critical understanding of the cultures or societies wherein such works originated, it is quite possible that students could be led to interpret their culture through a critical reading of images from the mass media, without ever considering works from the genre of the fine arts of the sort traditionally encountered in museums. This is an unfortunate possibility but life is serious and critical citizenship is an important goal to pursue.

## Fine Arts and Everyday Visual Culture

There is a more compelling reason why the fine arts and serious music have educational value and it is based on the contrast between the experiences we have with objects in the everyday world and objects traditionally categorized as fine art. I found

Paul Duncum's (2002) essay to be especially helpful in sorting out this problem. He draws a sharp distinction between "everyday aesthetic sites" as opposed to those art objects "which belong to the refined and the special" (p. 5). He writes

> Everyday cultural sites, then, are set apart from experiences of art insofar as their appeal is to popular sentiment … Their references are familiar and together they help form the common culture. They directly address the present moment. Unlike the art of the art-world, they are neither a collection of sites that derive from the past, nor an attempt to articulate the future. (Duncum, 2002, p. 5)

Duncum argues compellingly that the aesthetics of everyday encounters are offered by such sites as shopping malls, television, theme parks and fast-food restaurants and should not be overlooked by contemporary art educators as legitimate sources of content in contradistinction to the experiences provided by the arts of the museum. These latter are more likely to emphasize the one-of-a-kind, unique aspects of aesthetic experience. "Everyday life" in his view "involves the mundane world" which he characterizes as being unrelated to the major events of history. "It involves the reproduction and maintenance of life, not the production of new ways of thinking and acting" (Duncum 2002, p. 4).

When Duncum turns his attention to fine art, he describes it as a genre that "focuses exclusively on certain privileged forms of the visual. Its focus is on works that are considered spiritually elevating. Art is said to take us out of ourselves. Aesthetic appreciation is thus an especially heightened, even consummatory experience" (Duncum, 2002, pp. 6–7). "Creating calm reflective sites, separate from the overt, dynamic of a materialistic society was for this tradition the point of both fine art and the aesthetic" (p. 7). By contrast everyday aesthetics emphasizes "the present moment, an immersion in the immediacy of current experiences and activities" (Duncum, 2002, p. 4).

The musicologist Julian Johnson takes an opposing view. His little book *Who Needs Classical Music?* in large part can be read like a reply to Duncum though, of course, this was not its purpose. He writes:

> But sometimes art is not obviously concerned with the everyday. It is concerned with the extraordinary, the outer limits of our experience … it is the source of art's unique value as a means of articulating areas of experience beyond everyday linguistic discourse, and at the same time, it is a means of becoming fantasy, more or less unrelated to the concerns of the everyday (Johnson, 2002, p. 49).

And he continues:

> Art's apparent refusal of the everyday is not a refusal of the "human" as such: it is a refusal of the idea that the sum of what it is to be human is found in the everyday (Johnson, 2002, p. 49).

So, if we adopt Duncum's orientation we would emphasize the aesthetic encounters of everyday life. If we take Johnson's view we would look to the fine arts for a realm of experience that extends beyond the everyday, to enter perhaps, that spiritual world

alluded to earlier. Duncum has a point in asking students to become critically attentive to the aesthetic dimensions of everyday life. However, it is equally the case that on some occasions we should look beyond the everyday! But, in addition, goals such as critical citizenship, mentioned earlier, do not require that we must choose one genre over another.

This is where I differ with Duncum who in in some ways asks us to make a choice of one or the other. Moreover, his assumption that the fine arts only provide "calm, reflective sites," or that they are politically neutral is just plain wrong. The Ninth Symphony of Beethoven is an intensely political document, having a history of nearly 200 years, (see Buch, 2003) but knowing its role as an expression of freedom, as well as the subversion of its message during the Nazi era in Germany, is not the same as having a direct encounter with its musical presence.

## The Freedom of Cultural Life

Works of fine art, by virtue of the fact that they often have come from other times and places, help keep alive cultural memories. In turn they give people some basis for understanding their lives in the present. Moreover, this notion of a remembered past is not limited to the interpretation of past works of art. Memory works in new works as well. For example, the African American artist Aminah Robinson actually describes her works as "memory maps". She studied the history of her neighborhood community going back eleven generations at a time when it was called the "blackberry patch," a neighborhood that later became the site of Poindexter Village in the early 1940s, a public housing project in Columbus, Ohio. Her art consists of enormous quilts showing the shops and the streets of her old neighborhood. Some of her works took more than eighteen years to complete. They portrayed the families that lived there, the life of a thriving neighborhood that has largely disappeared. Though trained as a professional artist, her art embodies these memories in a folk-art medium namely quilt-making, one accessible to the community that she celebrates (Columbus Museum of Art, 2002).

Moreover, cultural memory is more likely to be experienced in the fine arts whereas objects in the popular culture often tend to focus on the present moment or the seasonal. Without a fine arts legacy one becomes a prisoner of the present, afflicted by a spiritual Altzheimer's syndrome in which the individual is trapped passively in the momentary sensations of the popular.

Now it is possible to say what role the fine arts and classical music are to serve in the context of a cultural studies curriculum. The aim of such a curriculum should be to make all the arts accessible, and this access is not only to enable future citizens to come to terms with their social world as it is represented in these various perspectives (popular and serious, or high and low) but to expand opportunities to enhance the freedom of cultural life, that is, the freedom to explore multiple forms of artistic expression unfettered by educational, ideological, ethnic, or social constraints about what can be art and what is legitimate to undertake in the study of art. The freedom of cultural life need not rule out formal considerations, nor need it exclude beauty as a purpose for particular works of art.

Under the modernist aesthetic that was dominant in the last century the study of the various forms of popular culture were pushed to the sidelines. Similarly, the postmodern critique of modernism allows the various forms of popular culture to be studied seriously but it has sometimes called into question the fine arts as valid content on the charge of elitism. The freedom of cultural life is not likely to develop if particular genres are singled out for exclusion, nor can it develop in a curriculum where one or the other are only grudgingly represented.

# References

Buch, E. (2003). *Beethoven's ninth: A political history*. (R. Miller, Trans.). Chicago: University of Chicago Press.

Columbus Museum of Art. (2002). *Symphonic poem: The art of Aminah Robinson*. Collumbus OH: Columbus Museum of Art in association with Abrams Inc.

Danto, A. (1992). *Beyond the Brillo box: The visual arts in post-historical perspective*. New York: Noonday Press.

Duncum, P. (2002). Clarifying visual culture art education. *Art Education, 55*(3), 6–11.

Freedman, K., & Stuhr, P. (2004). Curriculum change for the 21st century: Visual culture in art education. In E. Eisner & M. Day (Eds.), *Handbook of research and policy in art education*. Reston, VA: National Art Education Association.

Harpham, G. G. (1994). Aesthetics and the fundamentals of modernity. In G. Levine (Ed.), *Aesthetics and ideology*. New Brunswick, NJ: Rutgers University Press.

Johnson, J. (2002). *Who needs classical music? Cultural choice and musical value*. New York: Oxford University Press.

Kipnis, L. (1986) "Refunctioning" reconsidered: Towards a left popular culture. In C. MacCabe (Ed.), *High theory/ low culture* (p. 21). New York: St. Martin's Press.

Levine, G. (1994). Reclaiming the aesthetic. In G. Levine (Ed.), *Aesthetics and ideology*. New Brunswick, NJ: Rutgers University Press.

Tavin, K. (2001) Swimming up-stream in the jean pool: Developing a pedagogy towards critical citizenship in visual culture. *Journal of social theory in art education, 21*, 129–158.

Wallis, B. (1984) *Art after modernism: Rethinking representation*. New York: New Museum of Contemporary Art.

# 4

# A HISTORY OF DRAMA EDUCATION:
# A SEARCH FOR SUBSTANCE

**Gavin Bolton**
*University of Durham, U.K.*

## Introduction

In an introduction to *How Theatre Educates* (2003) Kathleen Gallagher of OISE at the University of Toronto rightly concludes: "… there is no correct pedagogical model on offer for drama education." By summarizing the input of a few selected teachers in the field, the aim of this chapter is to present images of the mosaic of activities that have occurred in schools under that umbrella term "drama education". A brief background explanation is also provided where the choice of *genre* has been in part determined by the political, religious or cultural climate of the time. For instance, in the Palestinian town of Ramallah in 2001 Wasim Kurdi conducted a series of workshops with 14 to 18-year olds on the siege of Akko by Napoleon, 200 years earlier. Such improvised drama is only meaningful if it is seen as a deliberately chosen distancing ploy, for Kurdi did not want his young people to use drama for venting their anger about their own political crisis, but as a chance to reflect on the broader strands of oppression (see Davis, 2003). Thus to understand a teacher's choice of drama it is often necessary to know something of the context.

Regretfully, there is not room in this chapter to include any detailed accounts of drama research, theories of drama education, the school play, the formation of national and international drama associations, traditional children's theater or the teaching of drama at university level, although these aspects are referred to occasionally. Rather it concentrates on trying to untangle the confused strands of classroom drama.

## Pre-Twentieth-Century Drama in Schools

Plato's opposition on moral grounds to any form of representation, including dramatic recitation celebrating Dionysus, gave authoritative support to opponents of school drama throughout its history: "… prolonged indulgence" he warned his contemporaries, "in

45

*L. Bresler (Ed.), International Handbook of Research in Arts Education*, 45–62.
© 2007 *Springer.*

any form of literature leaves its mark on the moral nature of man ..." (Plato, *The Republic*, trans.1955, Book 3, p. 395) He cannot have foreseen however when he also wrote, merely intending a pleasurable approach to learning, "... let your children's lessons take the form of play", (Ibid., Book 7, p. 537) that by the mid-twentieth century his words would be reinterpreted to mean freely expressed *dramatic* behavior in many classrooms round the Western world.

For many centuries following classical times drama was excluded from education. Plato's philosophical objection to theater turned into positive detestation in the early centuries of Christianity, partly because of the pagan subject matter, partly because of a general unease about breaking the Second Commandment relating to "graven image," partly because of the mixed emotions it aroused, enjoyment overriding compassion, and finally because of the degradation thought to be brought about by actors and indeed by theaters themselves, "sinks of uncleanliness" (Coggin, 1956, p. 38) as Augustine unambiguously put it. The Roman Catholic Church, however, through its Monastery schools, notably St. Gall of Switzerland, introduced in the tenth century the beginnings of drama by inviting the boys to use improvised words to liturgical chants. Gradually, actions were added to illustrate Bible stories, *Quem Queritis* being among the first recorded manuscripts.

The late mediaeval/early renaissance periods saw contrasted modes of theater:

1. Miracle plays entertaining the illiterate;
2. a Platonic "playful" approach to education resulting in the setting up of "La Casa Giocosa" in 1428 in Mantua, a "joyful house" of schooling;
3. a revival of Roman scripts in humanistic schools throughout northern Europe as a means of studying Latin;
4. in England, the performance of Shakespearean texts as models of rhetoric.

Dominating education during this period, however, were the Jesuit Schools, whose Catholic philosophy adopted the Aristotelian love of theater. Suitably pious plays performed in Latin became a regular feature of religious education on the continent, eventually extending to Poland and Russia. In some places, Vienna, for example, the Jesuit school was the only place where theatrical performances could be seen. By the seventeenth century the Jesuit influence on drama spread to Catholic royalty. King Louis X1V even encouraged performances by the convent *girls* in the House of Saint-Cyr.

However, the growth of enthusiasm for drama in Jesuit schools had not necessarily the approval of the Catholic Church outside the Jesuit boundaries. Father P. Lami, a French Catholic priest protested:

Apart from the fact that the plays are usually pitiful, that they waste a lot of time, that they distract the mind, that they wreak havoc with studies, over-excite the brain, and go to the head, they are, moreover, contrary to the gospel and to our statutes. (Coggin, 1956, p. 96)

Although written in 1685, the antipathy it expresses towards school drama and the reasons given for that hostility have never entirely disappeared even to present day. By 1764 the Austrian Empire, which included Bohemia and Moravia where school

drama had been popular, set about banning drama in schools (see Gaffen, 1999), while Puritanism, the extreme form that the Reformation took in England, ensured that the extinction of any kind of dramatic art in schools was sustained virtually until the end of the nineteenth century.

## Drama Education from 1900s to Present Day: Both Shadow and Substance

*Reintroducing Drama into the Classroom as Speech-Training*

If teachers were to revive an interest in drama education, then the logical step in the first half of the century was to link it with the teaching of English literature and language. A 1921 British Government publication firmly placed drama in the classroom as something to be written, read or acted – "in little scenes or pieces" and read out either from the pupils' desks or from the front of the class by teacher's chair (see Board of Education, 1921). In that year, however, such dramatic enactment was felt to be a brave step, building on the 20 years of pioneering work by Elsie Fogerty (1923) who in 1906 founded the Central School of Speech and Drama, an institution still having considerable influence on London drama teaching today. Thus began an enthusiastic, albeit narrow, approach to the study and practice of texts. "Elocution", as it was called, became very popular with the middle classes through private lessons from private teachers, along with graded examinations marking achievement levels. Paradoxically, this most socially interactive of the arts became an individualized exercise in speech practice, creating a genre of drama education unique to the United Kingdom and some of its colonies including Australia, New Zealand, India and South Africa. Clive Sansom, for instance, immigrated to Tasmania in 1951, where his influence on speech training spread throughout Australia. Even today Speech and Drama Colleges in London organize examinations in these countries.

*The Early Attempts to Liberalize Classroom Dramatic Activity*

Some schools, however, were aligning themselves with the new credo of "Progressive Education". With its roots in the European philosophies of Plato, Rousseau, Goethe and Schiller, "education as experience" rather than book learning became the new way of thinking about how children should be taught. Experiments in education following the principles of teachers such as Froebel, Pestalozzi, and Montessori emphasized the importance of the individual child. "Freedom," "self expression," and "activity," became the shibboleths of progressivism. Whereas some schools across Europe allowed young children to enjoy free "Wendy House" play, others adopted a more purposeful exploitation of dramatics. Esther Boman in Stockholm, for example, Principal of a progressive education Girls' School (1909–1936) used drama to focus on aspects of the curriculum and on personal problems connected with the girls' lives. Her ideas, however, were not published until 1932 (see Hagglund, 2001). In Prague, too, experiments in a more liberal use of drama were tried but without subsequent publication (see Slavik, 1996). The only

full accounts of this kind of experimental teaching published earlier, came from two British teachers.

From her appointment in 1897, a village school head teacher, Harriet Finlay-Johnson[1] (1911), experimented by using drama to teach the subjects of the curriculum. The pupils in her class, aged roughly 10 to 13, wrote, produced and rehearsed their own plays, performing them for each other in the classroom, each play demonstrating aspects of the curriculum they were currently studying. In keeping with the "democratic" conception of education promoted by John Dewey (1916) in America, the children saw themselves and their teacher as "fellow workers" with a shared responsibility for turning selected subject-matter into dramatic form.

This collective approach to self-learning through drama was matched in an entirely different kind of school. Appointed in 1911 as English master to a prestigious boys' independent school in Cambridge, Henry Caldwell Cook (1917), adopted the Platonic term "play-way" and used drama as the central methodology for teaching English. Pupils successfully transformed prose, poetry and Shakespearean texts into dramatic action based on what was known of the Elizabethan stage.

The word "successfully" is deliberately introduced into the last sentence because interested contemporaries reading Finlay-Johnson's or Caldwell Cook's publications or actually visiting the Perse School where Cook taught could very well have put these dramatic achievements down to the teacher's "genius" or "charisma". This raises a problem with respect to any pioneer whose outstanding skills appear to be unmatchable. In a 1922 unpublished report to the Board of Education the Inspector affirms:

> … it would be very dangerous for teachers to be encouraged to visit the School with the idea that they will find there something that they might and should imitate. That being so, it seems clear that if an application is ever made for an Art 39 grant for this experimental work, it would be well for the Board not to entertain it.

Using this approach indeed remained isolated, many teachers experiencing failure. One teacher, a distinguished classroom practitioner, was made painfully aware when he tried this "playway" approach to teaching history. In achieving little more than "undisguised amusement" from his students, he dismissively summarized this new method with: "In grasping at the substance, you have even lost the shadow" (Tomkinson, 1921, p. 46).

## Classroom "Acting"

In the United Kingdom during the period before World War II there were no teacher-training institutions offering their students advice on how to apply this "playway" approach to Drama. In Evanston, Illinois, however, from 1924 "Dramatics" was introduced into local schools as an elective, guidance being given from the staff, led by Winifred Ward, of Northwestern University's School of Speech. "Creative Dramatics", as it became called, was thus introduced as a school subject in its own right. That drama was "taught" rather than "used", gave the classes freedom to invent their own plays with all that implied of acting skills and "… a feeling for their theatre" (Ward, 1930, p. 27). Thus America's greatest pioneer in the history of drama education, along

with her contemporary, Isabel Burger and others who followed in her path, such as Geraldine Siks and Nellie McCaslin (1984), found a pathway in schools that paralleled professional theater. Nellie McCaslin[2] of New York became a world authority on drama education, particularly in training teachers how to use stories, including students' personal histories, to create their own dramatic form for presentation, a *genre* that continues to spread worldwide today (see Kelin, 2005). These American pioneers attracted visitors from all over Europe, especially Scandinavia. For instance, in 1942 Elsa Olenius of Sweden modeled her teaching on Burger's "creative playmaking", setting up Var Teater in Stockholm, the first children's theater in Europe to receive municipal support. Indeed Scandinavia[3] throughout the century became a pivotal laboratory for drama teaching, reflecting, researching, and revising the approaches of all the world's leaders. Most have been welcomed as visitors, culminating in the 1000 delegates arriving for the IDEA – International Drama in Education Association – World Congress held in Bergen in 2001.

## *Every Child Has His Own Drama Within Him: A New Kind of Substance? – Or Shadow?*

Peter Slade (1954, 1968, 1977) in the United Kingdom was at first part of a new movement, popular in many European[4] and American countries, introducing "Children's Theatre" into schools. Professional actors came into the school to entertain pupils with a play written and directed by Slade and specifically directed at a particular age group. He was the first director to insist that such performances be "in-the-round." By the 1940s, however, he was beginning to train teachers in his unique *classroom* methodology. In claiming that every child has his own "child drama" within him, he built on psychological theories of play that had been published since the beginning of the century[5] (see Isaacs, 1932; Lee, 1915; Sully, 1896). Typically, Slade required children to spread out in the school hall, each sitting cross-legged in a space of his or her own, whilst he, from the front, wove a story from their ideas. He would then proceed gently, invitingly, to narrate that story while all the class stood and simultaneously created the dictated actions. Sometimes the class would gradually merge into small groups and play out their own fantasies loosely connected with the story. Alternatively, he would put on a "78 rpm" gramophone record and the children would, separately and spontaneously, dance to the music. At the climax of their free expression in either action or dance he looked for what he called "golden moments." For the children, these trustful, exhilarating experiences were meant to be an expression of an unconscious dream, a spiritual journey.

Thus drama was seen to have a therapeutic aspect. Indeed Slade gave much of his professional time to working with "under-achieving and unhappy children."[6] For some followers of Slade this seemed a bye-product of the work in psychiatry founded in Vienna by Moreno (1946) in 1918 and continued in New York. For others this work blended in with the new philosophy of "educating the whole person." It was the architectural setting, however, that fixed the nature of Peter Slade's approach in the minds of most teachers. He recommended the use of the school hall, because "Child Drama" needed freedom of space. These spaces were normally allocated only for a school's morning assembly and physical education lessons, a daily routine of teacher instructions to pupils evenly spaced

throughout the hall. Thus the new drama activity in England was slipped into schools under the guise of physical education; "stripping for drama" became part of the pupils' routine.

Drama as fundamentally linked with physical training was being reaffirmed, from an entirely different source, coinciding uneasily with Slade's use of free dance. From the beginning of the century the practice of Jaques-Dalcroze (1921) in the field of *Eurhythmics* as a basis for all art education, had had a minor effect in Great Britain on progressive thinking about school drama, but a new pioneer of considerably more influence arrived from Germany in the 1930s. This was Rudolf Laban (1948) whose classification and planned procedures for basic human movement were rapidly taken up by the British teaching profession (the *female* teaching profession, that is, for the men were called up for military service) as a new approach to girls' Physical Education in Secondary schools.

But Laban was a man of the theater; he used his training in movement as a way of preparing actors, so that teachers in schools following a Laban program had no difficulty in seeing a kinship with professional theater. And yet it also paralleled what Slade was promoting in the primary schools. The government-led conclusion seemed to be that Laban/Slade methodologies, all requiring the school hall or gymnasium, were indeed providing a basic training for all the arts, including acting. Thus developed a curious ambiguity towards the subject. Visitors to a primary or secondary school in Yorkshire to observe drama lessons, could find themselves witnessing a series of carefully sequenced Laban movement exercises that had no make-believe element whatsoever. On departing they would be assured that such an approach was a "preparation" for future drama work. Thus drama without fiction – a new kind of shadow or a deeper, dance form of dramatic expression?

Confusion grew in England over whether appointees to the Drama Advisory Service or to teacher-training institutions should be seen as experts in traditional theater, speech-training, Laban movement or Sladian Child Drama. The latter, Child Drama, overtook the others, Peter Slade becoming for many years the virtual spokesman for the Government. Teachers of theater, in particular, found themselves pushed aside. The school stage became virtually redundant, except for the annual school play or the Christmas Nativity. Also ignored were the few remaining teachers who thought that drama was a classroom activity for exploring the subjects of the curriculum, for in Sladian Drama content was less important than freedom of expression. That children once wrote their own plays in the classroom became long forgotten.

Any teachers who felt uneasy about the freedom that Child Drama offered felt more secure when Brian Way (1967), a friend of Slade's and a pioneer in Children's Theatre with audience participation, came on the scene. He used the same structure as Slade – a physical education format – but he replaced the fantasy journey of the teacher's narration with short exercises in mimetic actions of everyday life and aimed at developing each child's intuition and concentration capacities. The personal development of the individual became the new objective for this "creative drama," a term quickly picked up in other countries, notably in Canada where the British academic, Richard Courtney (1968), contributed massively to providing a theoretical basis for the work. Even a non-Western country such as Turkey wrestled with the distinction between "theatre in

schools" and "creative drama" (see San, 1998). However, Way's anti-theater position paradoxically encouraged the introduction into schools of fashionable actor-training devices, so that a teacher's lessons plans began to include "warm-ups," games, relaxation, and sensitivity exercises. Indeed, from one point of view it could be argued that Slade and Way's innovatory classroom practice was but an extension of experimental work already taking place in theater schools in Moscow, St. Petersburg, Paris, New York, Chicago, and Bristol.

*Improvisation in Actor-Training – The Substance Lies in the "Releasing"*

Improvised entertainment began, long before Classical Greek times, with the Shaman and the Clown. The Shaman offered his or her audiences a glimpse of the "other" world or the dark side of the unconscious, while the Clown offered childish, scatological fantasies, or outrageous, satirical commentary. They both stand for a virtual reality, the very essence of the imagined. Absorbed into drama they appear in the Dorian *Mime* of Megara, the Sanskrit drama of India, the *Commedia dell'arte* of Italy, the little devils who ran amok through the spectators at the Mystery plays and the "masqueraders" of the Trinidadian carnivals today.

Thus begins the notion of improvised entertainment, a concept that was taken up seriously in the twentieth century with actor-trainers such as Vsevelod Meyerhold in Russia in 1910, and Jacques Copeau in the 1920s, in France. Both set up institutions with a view to reviving *Commedia dell'arte*. But their contribution extended beyond the revival of a particular *genre*: they became absorbed in improvisation as a valid training exercise. Meyerhold introduced what became known as "Biomechanics," a training of the body in kinaesthetic, spatial, and relational awareness; Copeau included games, mime, and mask work, alongside gymnastics. These routines as preparation for dramatic performance became the norm of progressive actor-training, so perhaps those visitors to Yorkshire schools should not have been disappointed, for physical training was indeed to be the new "substance".

There is, however, a parallel story to the European scene: in Chicago a city with a long-established tradition of theater, The Chicago Little Theater was opened in 1912 by Maurice Brown and his wife Ellen Van Volkenberg, beginning what became known as the "little theatre" movement in America. Living nearby was an astonishing figure in American Education, Neva L. Boyd, who in 1911 had already set up the Chicago Training School for Playground Workers. By 1914 she was appointed as Director of the Department of Recreation in the Chicago School of Civics and Philanthropy. Boyd was both a practitioner and an academic sociologist promoting the use of Play in teaching children and adults. Her classroom spaces hummed with physical games, story-telling, folk dancing and dramatics. It is not surprising that her philosophy has been linked with Caldwell Cook's "playway" approach to education. Her student, Viola Spolin, became the leading authority on the use of Theater Games and extended that philosophy and practice in further directions, for example, training community workers to use drama in their work and introducing the idea of improvising from audience-suggested material. Thus began the link with Chicago Little Theater and long before Spolin's 1963 publication, *Improvisation for Theater*, the "Chicago style" genre of theater performance

entered the school system. From Spolin's position as Director of the Young Actor's Company in California in 1946 the practice in improvisation became, as she defined it, "playing the game". This was perhaps a misleading construction, for in some schools the word "improvisation" was reduced to "skit" with all that can imply: having fun, being slick and, inevitably perhaps, "playing for laughs."

But in another part of America, New York, a very different meaning was being given to "improvisation". In 1924 profound interest in Stanislavski led to the establishment of the American Laboratory Theater. In addition to the physical aspect of training, improvisation was used to take actors on a private, inward journey. The object of this exercise, under the guidance of Maria Ouspenskaya, was to put the actor in touch with the life of the character. Later however, under Lee Strasbourg, the activity was directed towards helping actors to meet their own selves and to break down personal blockages. Thus professional theater seemed to overlap with therapy. Supported by the psychodramatic theory and practice of Moreno and later, by the personal growth literature of such thinkers as Carl Rogers (1961) and Abraham Maslow (1954), improvisation became associated in the minds of both theater directors and some drama teachers in schools with "finding the authentic self". In many schools throughout the western world, drama workshops acquired this therapeutic flavor.

There was still yet another use of improvisation, aimed at helping actors but also adopted in some classrooms. Its instigator, Keith Johnstone, following the experimental work of Jacques Copeau, Michel St. Denis, Jacques Lecoq and Dario Fo, was himself a London teacher before he turned to work with the Royal Court Theater actors. What started in the 1960s as "hysterically funny" (Johnstone, 1979, p. 27) improvised explorations setting out to free the imaginations of the actors, gradually developed into public demonstrations in various London colleges and then, with a group of actors. Taking on the title "The Theatre Machine", it grew into performances round many countries of Europe. Some London secondary schools, learning of this new lively approach on their doorstep, set about freeing the imaginations of their Drama classes with this "hysterically funny" way of working. Johnstone moved on to Canada, eventually settling for the rest of his career at the University of Calgary from whence his "International Theatresports Institute" became established on every continent, a model of comedy combined with competitiveness and slickness that many schools found irresistible.

## *A New Kind of Substance – "Change in Understanding"*

Dorothy Heathcote was appointed to Newcastle-upon-Tyne University, Institute of Education in 1950. Local teachers were excited by her "A Man in a Mess"[7] drama work, but it took the rest of the world and, in particular, American Professors Betty Jane Wagner (1976) and Anne Thurman, and in Canada, leading practitioners such as Norah Morgan[8] and Juliana Saxton (1991) to give full recognition to this innovative approach breaking with all previous traditions. In the UK Heathcote's efforts aroused suspicion, so that when her University applied to run the country's first full-time Advance Diploma course in Drama for experienced teachers, the Government gave its approval – providing Peter Slade taught part of the course. There was much respect but little meeting point in either philosophy or practice between these two pioneers.

Both these remarkable people, like Winifred Ward before them, based their practice on honoring what children had to offer. One point of practical similarity was that they both tended to use a large space, such as a hall or gymnasium so that a whole class could be actively engaged. For Heathcote, however, drama is a collective enterprise, "collective" in more than one sense. The class as a whole, often huddled in a tight group on the floor or sitting in a cluster of chairs in front of a blackboard, is invited to make skeletal decisions about the choice of topic for the drama. Whereas the well-established drama lesson advocated by Nellie McCaslin, for instance, might start with: "What do we understand about this character?" for Heathcote the question is likely to be: "How shall *we* set about solving this problem?"

It is the teacher's function of "teacher-in-role" (see Ackroyd, 2004) that brings extra complications to what became known as "living through" drama.[9] The teacher, playing a carefully chosen role, maneuvers the drama toward credibility and thoughtfulness. The teacher operates as a playwright/director and as teacher/artist, planting a seed, selecting the setting and just the right fictional moment in time that will gradually focus the children's choice of topic and resonate into deeper layers of meaning. Thus Heathcote replaces Slade's narrative of instructions with her own here-and-now in-role input to the drama. The group faced a problem, a mystery, a journey, a search, or a crisis of mankind – "a man in a mess" – or, alternatively, the class took on the responsibility of an investigator's role into precision. This was a new genre of theater that brought substance back to the drama lesson, culminating at its best in a moment of awe that belongs to all forms of theater. As Mike Fleming put it: "Any significant understanding of what being 'good at drama' entails, must include reference to content" (Fleming, 1994, p. 53). In my own practice at Durham University I tried to bring theater form to a combination of Heathcote/Way approaches, arguing that dramatic play and theater should be seen as a continuum.

So have we arrived at true educational "substance" here? Not in the view of Brian Way's faithful promoters such as Margaret Faulkes-Jendyk of Alberta and, later, more traditional teachers such as David Hornbrook (1991) in the United Kingdom, both of whom felt somewhat disenfranchised by the growing popularity round the English-speaking world of Heathcote's approach. Faulkes-Jendyk (1974, 1975) argued that Heathcote's teaching lacked "drama, creativity and education". Even supporters of an improvisational approach recognized potential flaws. Helen Nicholson (1995), a leading British academic and practitioner, pointed out that classroom drama can be dominated by cultural dispositions such as gender stereotyping. Likewise, Johnny Saldaña (1997) of Arizona State University drew attention to the potential cultural mistrust that can occur when teacher and class are of different ethnic groups. It is also true that drama can become a platform for a teacher's ideology – humanist, religious or political. David Davis' (1983) tongue-in-cheek choice of title for an article on the training of young employees, "Drama for Deference or Drama for Defiance?", nicely captures the urge felt among many radical teachers to harness drama for political ends and Sharon Grady's (2000) more recent polemic, casting drama as a tool for confronting our own prejudices, warns against assuming that drama can do nothing but good. And there can be government imposition. For instance, in the late 1940s in Poland, performance competitions between schools were set up with a view to "glorifying the new structures of the state and the role of the Soviet Union in the world" (see Lewiki,

1995). Tor-Helge Allern (1999) of Norway gives us a bald warning: "Drama can … be part of a destructive movement …" (p. 202).

## Actor-Teachers

Heathcote's work spread into the developed version of children's theater, newly entitled *Theatre in Education* (TIE). Brian Way (1923–2006), in the 1950s and 1960s had successfully created his London-based professional touring companies that experimented in conducting "in-the-round" performances while school audiences at fixed moments in the play gave active support to the actors – providing background sounds or answering a character's questions. The format of *Theatre in Education*, however, extended the performance into a half-day or full-day workshop. Tony Jackson (1980) of the University of Manchester, draws attention to the new structure and objectives:

> The T.I.E. programme is not a performance in schools of a self-contained play, a "one-off" event that is here today and gone tomorrow, but a co-ordinated and carefully structured programme of work, usually devised and researched by the company, around a topic of relevance both to the school curriculum and to the children's own lives, presented in school by the company and involving the children directly in an *experience* of the situations and problems that the topic throws up. (p. ix)

This new approach required a huge organizational shift from national children's theater touring companies to a theatre-in-education company attached to a local city theater, Coventry's "Belgrade Theatre" being the first. Often the selection of the theme for the drama was made in consultation with a local school. The term "actor-teacher" was coined, explicitly linking TIE [theatre-in-education (see O'Toole, 1976)] with DIE [drama in education]. How very different was the UK "Children's Theatre" and its subsequent "Theatre in Education" from the American and other countries' versions of "Children's Theatre," a tradition of plays written especially for children by skilled playwrights and performed in auditoria for children's audiences.[10] Edward Bond (see Davis, 2005) is perhaps the only playwright of world distinction who has devoted many years to writing for and working alongside a TIE company (The Big Brum Company in Birmingham, UK).

There is not room in this chapter to outline in detail the "sea changes" that Heathcote brought about in her own approaches. She developed, for example, a way of working in drama with severely challenged adults and children; she introduced with her "Mantle of the Expert" (1995)[11] approach to curriculum teaching what will surely become central to any vision of the future in teaching the young. Her present practice, helping young people to study texts, involves an extension of "Chamber Theatre" (see Heathcote, 2005, pp.7–17) begun by Robert Breen (1986) at Northwestern University, USA.

## Extending Heathcote's Approach

Whilst a deadening hand, political as well as philosophical, lay temporarily[12] on the development of drama in UK schools for the final decade of the twentieth century

elsewhere in the world the picture was more positive. In Poland, for example, Halina Machulska[13] set up a center for drama education [often referred to as "British" drama, meaning the "Heathcotian methodology"] in Warsaw's "Ochota Theatre". At this time too, at the Ohio State University, Cecily O'Neill (1995) sought a way of explicitly combining basic theater structures with Heathcote's communal, "living through" drama. Using "Process Drama", as it came to be called as a way of distinguishing it from the "performance drama" of many American Schools, O'Neill would select a pre-text that provided a class with an impetus for action within a tight, coherent dramatic framework, releasing students into unknown improvisational territory. [More recently, John Carroll (2004) at CSU, Bathurst, has extended O'Neill's concept of "pre-text" by introducing the immersive stimuli offered by digital technology, including email and the Internet].

In Toronto, David Booth (1994), a charismatic figure in world drama, has been creating his own version of communal, "living through" drama, a *genre* linking drama with stories, not the direct enactment of a story as in Winifred Ward's approach, but, rather, with the class's response to the themes or issues emanating from the story-line. Both "Process Drama" and "Storydrama" often rely on the use of "teacher-in-role" and the ambiguous seduction of a guide "leading the way while walking backwards" as O'Neill (1995, p. 67) nicely describes it. Consistently, the purpose of their work was growth in understanding.

## Beginnings of a World Picture

If the focus for innovation in classroom practice has tended to center on British and North American pioneers, from 1990 onwards Australia became a leading location for experimental practice and academic research. A sense of enterprise had uniquely brought its geographically distanced universities, under the leadership of Paul Roebuck,[14] John O'Toole (Griffiths & Melbourne Universities), John Deverall and Kate Donelan (University of Melbourne, where the first teacher-training course in drama was set up by Ron Danielson), Robin Pascoe (Western Australia), Brad Haseman (Queensland University of Technology), John Hughes and Jenny Simons, University of Sydney, Kathleen Warren (Macquarrie University) and others, into a cooperative thrust toward an expansion of educational drama, well-coordinated through the energetic National Association for Drama in Education, now "Drama Australia." In their search for a wider, multicultural, South-East Asian perspective, they distanced themselves from any particular philosophy or methodology. They further raised the standard of refereed journals, initially under the editorship of Philip Taylor of Griffith University, and began a program of research into drama teaching, "new paradigms" (see for example Taylor, 1995) becoming the *in vogue* expression. United States was the only other country to formalize research programs, mostly emerging from Arizona State University under the inspiration of Lin Wright who devoted her long career to classroom drama.

It was also during the 1990s that Augusto Boal's name featured on international drama conference programs. Mostly working with adults his approach nevertheless became a model for secondary classroom practice. His experimental theater work had started much earlier, in the early 1960s, in his homeland, Brazil where he developed the idea that an audience could stop a performance and suggest alternative behaviors

for the characters. He extended this eventually to inviting audience members onto the stage to take over from the actors, the plays always having the immediacy of current social or political issues in which the audience members had a vested interest. Indeed audiences saw themselves as victims of the very regime being openly exposed on stage. He called these newly empowered members of the public: "spect-actors."

In 1971, during the military coup, Boal was imprisoned as a cultural activist and subsequently was exiled to Argentina. From there he chose to live in Paris where he was able to resume his theater activities – with a difference. He now had to work at one remove, no longer engaging in grass-roots activism, but in demonstrating to France and other nearby countries his innovative use of theater with the oppressed. Such was his success that by the time he was able to return to Rio de Janeiro in 1986, Centers for the Theater of the Oppressed had been established worldwide, for example, the MS-Nepal and Aarohan Theater Group [combining Danish and Nepalese theater groups], the Blossom Trust of Tamil Nadu in India, and the People's Popular Theatre of Kenya (see Boal, 1985). Drama teachers flocked to his demonstrations at conferences; "forum theater" had become the new cult, the exposure of and opposition to "oppression" becoming the new substance.

As Boal, no longer working with "political victims," was obliged to target alternative issues (see Saldaňa, 2005) he came closer to Heathcote's approach, both pioneers having been influenced by the philosophy of Paulo Freire (1972) and the practice of Bertolt Brecht. A combination of the approaches of both Heathcote and Boal can be found, for example, in the work today of Beatriz Cabral (see Cabral, 1998) in Brazil and in the worldwide publicly demonstrated techniques of Jonathan Neelands of Warwick University whose expert teaching practices have become a model for lively discussion at most international drama education conferences.

A recent move in developing countries, promoted in part by charities,[15] such as the South and Central Asia Region of Save the Children and UNICEF, organizes workshops in Bangladesh and Malawi, respectively, (see Prentki, 2003; Keyworth & Pugh, 2003) has adopted the title of *Theatre for Development* (TFD) the original intention of which was the creation through workshops of a community's indigenous story-based project to be shared with a local audience.

Although the similarities between TIE, TFD, Boal's, and Heathcote's practice seem barely to have been acknowledged,[16] these and other parallel strands have been drawn together under the broader label of "Applied Theatre".[17] Experiments in this use of theater have been tried in different parts of the world for many years. For instance, in 1987 Carole Miller took a program dealing with child sexual abuse round Victoria, B.C. schools where professional consultants were present with whom members of the audience could have personal consultations immediately after the performance. Attempts have been made in some African countries [for instance, the Themba Interactive Theatre Company of Johannesburg] and in Thailand [Sang Fan Wan Mai, an amateur Group] to use theater to combat AIDS. Among the most well-established examples of "Applied theater," although retaining the more traditional "Theatre-in-Education" title, is *Arts-in-Action*, in Trinidad and Tobago under the directorship of Dani Lyndersay of the University of the West Indies. Since 1994 Lyndersay has been seeking to explore a range of problematic subjects "from social issues such as incest, child abuse, domestic violence,

gang warfare and drug and alcohol addiction, to the green revolution and corporate managerial relationships"[18] (see Lyndersay, 2005). "Sowing the seeds of a peaceful future" is the aim of teachers and university professors working together in Bosnia and Herzegovina under the project management of Roger Chamberlain (see McEntagart, 1998). Official recognition of the concept of "Applied Theatre" was confirmed in the mid-1990s by the Universities of Manchester and Griffiths where postgraduate courses were set up by James Thompson (see Thompson, 2001) and John O'Toole respectively. Philip Taylor of NYU, the first to edit the electronic *Applied Theatre Journal*, is among those who are trying to provide a theoretical basis for this kind of work, seeking, for instance, to draw a line between *Applied Theatre* and *Drama Therapy*, an area of healing developed and researched by his distinguished colleague, Robert Landy (1986) since the 1970s. Finding that line is critical, for the actors must not see themselves as therapists, confusing shadow and substance. Taylor's headings given in the introduction to *Applied Theatre* (2003) summarize the aims of this approach: "Raising awareness"; "Posing alternatives"; "Healing psychological wounds or barriers"; "Challenging contemporary discourses"; "Voicing the views of the silent or the marginal."

## Conclusion

Many teachers of drama and theater will feel comfortable with the above list of multi-purpose aims but for those whose concern is to concentrate on textual study or theater practice, as do the *partenariat* of France where teacher and actor cooperate in the classroom, such a list will seem inappropriate. Likewise the organization set up by Leah Gaffen in 1993, of "Class Acts" in Prague, with the purpose of training teachers of the English language, or the "Stopaids" street theater in Ghana, coordinated by Joseph Arthur, or the Jagran Theatre, a clown mime company working in the villages of India will each have its own well-defined, single-minded objective. Since the setting up in 1992 in Oporto of an International Drama in Education Association (IDEA), drama teachers all over the world have been communicating and celebrating together a wide range of aims and practices, but sensing, too, a shared, deeper purpose. Saldaña confirms that "The recent movements of theatre for social change and community-based theatre have influenced and affected many American drama practitioners' ways of working."[19] In 2002 Larry O'Farrell of Toronto, IDEA's President, expressed something of the underlying faith that a diverse group of teachers share in drama education. Referring to the many conflicts recently occurring in parts of the world he writes:

> Numerous testimonies have been given by teachers, artists, social workers, therapists and psychologists, working in refugee camps, bomb shelters, hospitals and improvised schools, on their use of drama and theatre to help children and young people to express their feelings of pain, loss, sorrow and anger and to declare their will to live and their hope for the future.' (O'Farrell, 2002)

Such an expression of confidence in drama is encouraging but idealistic. Experienced practitioners in the art know that its application requires meticulous judgment in: choice

of subtext, choice of point of entry, choice of dramatic form, choice of conventions, choice of texts, degree of persistence, pace of working, degree of student responsibility, extent and style of leader's input, timing, and modes of reflection. Shifra Schonmann of Haifa University, who has devoted much of her career to working with Jewish and Arab children for an understanding of peace, concludes that "Doing things wrongly is worse than doing nothing" (Schonmann, 2001). Real life, Schonmann reminds us, can sometimes burn through any dramatisation causing its framework to collapse. One can in this truth glimpse the grounds for Plato's disapproval. But dramatic art does have its own means of protection. We call it "distancing," a concept finely illustrated by Brian Edmiston of the University of Ohio in his account of attempting to ease sociocultural conflict within a school in Northern Ireland (Edmiston, 2002). Thus if we add "selection of the right degree of distancing" to the above list, then perhaps it can be claimed that we are on our way to true "substance."

# Notes

1.  A doctoral dissertation by Virginia Page Tennyson (1999) records a British contemporary of Harriet Finlay-Johnson by the name of Percival Chubb experimenting in drama teaching in a school in New York.
2.  Nellie McCaslin died in February 2005 at the age of 90.
3.  Leaders include Nils Braanaas of Oslo, Stig A. Eriksson of Bergen, Björn Rasmussen of Trondheim, Anita Grünbaum of Västerberg, and Janek Szatkowski of Aarhus.
4.  In the 1950s when Slade was reaching a peak in his career, puppetry became popular in countries on the Continent. For example, in Italy, Maria Signorelli introduced puppetry to teach children's literature.
5.  The first publication introducing the concept of *L'instinct dramatique* in young children came from the French psychologist Bernard Perez (1886).
6.  This is quote from his Obituary written by Harry Dodds and published in *The Guardian* Friday, August 20, 2004, following his death in June, at the age of 92.
7.  Heathcote took this label from Kenneth Tynan's "Theatre and Living" in *Declaration* (1957) by Tom Maschler.
8.  Norah Morgan of Brock University, Ontario, died in November 2004.
9.  Heathcote gives the source of the expression "living through" as a translation of the Greek meaning of "drama" in "Drama as Challenge" by D. Heathcote in *Uses of Drama* by J. Hodgson.(1972, p. 157).
10.  A leading authority on this traditional form of children's theatre was Lowell Swortzell of N.Y.U. who died in August 2004. One of his many publications was: *Theatre for Young Audiences: Around the World in 21 Plays* (1997).
11.  Research on the use in schools in South-Eastern England of "Mantle of the Expert" in the Primary Curriculum is currently being jointly conducted by Luke Abbott of Essex, Tim Taylor of Norwich and Brian Edmiston of the University of Ohio. Also see Warner (2004) and her notion of "framed expertise"
12.  Leading figures in British Universities, such as Judith Ackroyd, Mike Fleming, Andy Kempe, Jonathan Neelands, Helen Nicholson and Joe Winston have raised the standards of drama teaching once more, their courses attracting world interest.
13.  Machulska, Halina (1993) "Drama prowadzona przez Dorothy Heathcote" in *Drama: Poadnik dla nauczycieli I wychowawacow* 6 [12–14] It is interesting to note that the British use of the word "Drama" in this educational context could not be translated into a Polish equivalent.
14.  Roebuck set up (in Terrigal New South Wales in 1974) the first of many influential Australian conferences.
15.  It could be said that source of *funding* is now to some extent dictating the selection of issues.
16.  A contemporary view of the common ground between Heathcotean drama, TIE, and Edward Bond's conception of theater can be found in *Edward Bond and the Dramatic Child* (2005) edited by David Davis.

17. Barbara May McIntyre a pioneer of drama education in America and Canada, who died at the age of 88 in June 2005, bequeathed a fund for a Graduate Scholarship, specifically directed toward "Applied Theatre," to the University of Victoria where she had been founder of the Theater Department.
18. As I write this chapter (March 2005) Dani Lyndersay is consulting in Sri Lanka on how the arts can help in the rehabilitation process following Tsunami.
19. Private letter by Johnny Saldaña, April 2005.

# References

Ackroyd, J. (2004). *Role reconsidered: A re-evaluation of the relationship between teacher-in-role and acting*. Stoke-on-Trent & Sterling, USA: Trentham Books.

Allern, T.-H. (1999). Drama and aesthetic knowing in (late) modernity. In C. Miller & J. Saxton (Eds.), *International conversations*. Toronto: The International Drama in Education Research Instiute.

Boal, A. (1985). *Theatre of the oppressed*, New York: Theatre Communications Group.

Board of Education (1921). *The teaching of English in England*. London: HMSO.

Booth, D. (1994). *Drama and the making of meanings*. Newcastle upon Tyne UK: National Drama Publications.

Breen, S. (1986). *Chamber theatre*. Evanston, IL: William Caxton.

Cabral, B. (1998). Shells: Awareness of the environment through drama, Selected IDEIRI Papers. *N.A.D.I.E Journal, 22*(1), 27–31.

Caldwell-Cook, H. (1917). *The Playway*. London: Heinemann.

Carroll, J. (2004). Digital pre-text: Process drama and everyday technology. In C. Hatton & M. Anderson (Eds.), *The State of our Art* (pp. 66–76). Sydney: Current Press (chapt. 6).

Coggin, A. (1956). *Drama and education*. London: Thames and Hudson.

Courtney, R. (1968). *Play, drama and thought*. London: Cassel.

Davis, D. (1983) Drama for deference or drama for defiance. *2D Journal, 3*, 29.

Davis, D. (2003). Keynote address at the 3rd international conference of drama teachers in Athens. *NATD Journal, 19*(2), 39.

Davis, D. (Ed.). (2005). *Edward bond and the dramatic child*. Stoke-on-Trent UK & Sterling USA: Trentham Books.

Dewey, J. (1916). *Democracy and education*. New York: The MacMillan Company.

Edmiston, B. (2002). Playing in the dark with flickering lights: Using drama to explore sociocultural conflict. In B. Rasmussen & A.-L. Ostern (Eds.), *Playing betwixt and between* (pp. 178–187). *The IDEA Dialogues* 2001.

Faulkes-Jendyk, M. (1975). Creative dramatics learners face objective examination. *Children's Theater Review USA XXII,* Number 2, 3.

Finlay-Johnson, H. (1911). *The dramatic method of teaching*. London: Blackie.

Fleming, M. (1994). *Starting drama teaching*. London: David Fulton Publications.

Fogerty, E. (1923). *The speaking of english verse*. London & New York: J. M. Dent.

Freire, P. (1972). *Pedagogy of the oppressed* (M. B. Ramos, Trans.). Harmondsworth: Penguin.

Gaffen, L. (1999). Following Comenius: Drama education in the Czech Republic. *Perspectives Journal British Council, 9*, 34–37.

Gallagher, K., & Booth, D. (2003). *How theatre educates: Convergences and counterpoints*. Toronto: University of Toronto.

Grady, S. (2000). *Drama and diversity: A pluralistic perspective for educational drama*. Portsmouth, NH: Heinemann.

Hagglund, K. (2001). *Ester Boman, Tyringe, Helpension och teatern 1909–1936*, Ph.D. thesis, University of Stockholm.

Heathcote, D. (1972). Drama as challenge. In J. Hodgson (Ed.), *Uses of drama* (pp. 156–165). London: Eyre Methuen.

Heathcote, D. (2005). Chamber theatre: A bridge worth the forging. *The Journal for Drama in Education, 21*(2), 7–17.

Heathcote, D., & Bolton, G. (1995). *Drama for learning: Dorothy heathcote's mantle of the expert approach to education*. Portsmouth, NH: Heinemann.

Hornbrook, D. (1991). *Education as dramatic art*. Oxford: Blackwell.

Isaacs, S. (1932). *Children we teach: Seven to eleven years*. London: University of London Press.

Jackson, T. (Ed.), (1980). *Learning through theatre: Essays and casebooks on theatre in education*. Manchester, NH: Manchester University Press.

Jaques-Dalcroze, E. (1921). *Rhythm, music and education* (H. F. Rubenstein, Trans.). London: Chatto & Windus.

Johnstone, K. (1979). *Impro: Improvisation and the theatre*. London: Methuen.

Kelin, A. (2005). *To feel as our ancestors did: Collecting and performing oral histories*. Portsmouth, NH: Heinemann.

Keyworth, L., & Pugh, K. (2003). Theatre for development in Malawi. *Research in Drama Education, 8*(1), 82–87.

Laban, R. (1948). *Modern educational dance*. London: Macdonald & Evans.

Landy, R. (1986). *Drama therapy*. Springfield ILL: Charles C. Thomas.

Lee, J. (1915). *Play in education*. New York: MacMillan.

Lewiki, T. (1995). *Theatre/Drama in the United Kingdom, Italy and Poland*. Unpublished doctoral thesis, University of Durham, UK, vol. 1, 257.

Lyndersay, D. (2005). From stage to street: Fourth world theatre in the Caribbean, *IDEA'S Electronic Journal*.

Machulska, H. (1993). Drama prowadzona przez Dorothy Heathcote. *Drama: Poadnik dla nauczycieli I wychowawacow, 6*, 12–14.

Maschler, T. (Ed.), (1957). *Declaration*. London: MacGibbon and Kee.

Maslow, H. (1954). *Motivation and personality*. New York: Harper.

McCaslin, N. (1984). *Creative Drama in the Classroom*. London: Longmans.

Miller, C., & Saxton, J. (Eds.). (1999) *International conversations*. Toronto: International Drama in Education Research Institute.

Morgan, N., & Saxton, J. (1991). *Teaching, questioning and learning*. London: Routledge & Kegan Paul.

Moreno, L. (1946). *Psychodrama*. New York: Beacon House.

Nicholson, H. (1995). Genre, gender and play: Feminist theory and drama education. *New Paradigms in Drama Education N.A.D.I.E. Journal, 19*(2), 15–24.

O'Farrell, L. (2002). A greeting from the President, *International Drama/Theatre Associaion Newsletter1*, 1–2.

O'Neill, C. (1995). *Drama worlds: A framework for process drama*. Portsmouth, NH: Heinemann.

O'Toole, J. (1976). *Theatre in education*. London: Hodder and Stoughton.

Perez, B. (1886). *Les Trois Premières Anneés* (F. Alcan, Ed.) (3rd ed.). Paris: Ancien Libraire Germer-Bailliere et Co., pp. 325–328.

Prentki, T. (2003). Save the children – Change the world. *Research in Drama Education, 8*(1), 39–53.

Rogers, C. (1961). *On becoming a person*. New York: Constable.

Saldaňa, J. (1995). *Drama of color: Improvisation with multiethnic folklore*. Portsmouth, NH: Heinemann.

Saldaňa, J. (1997). Survival: A white teacher's conception of drama with inner-city hispanic youth. *Youth Theatre Journal, 11*, 25–46.

Saldaňa, J. (2005). Theatre of the oppressed with children: A field experiment. *Youth Theatre Journal, 19*, 117–133.

San, I. (1998). The development of drama education in Turkey. *Research in Drama Education, 3*(1), 96–99.

Schonmann, S. (2001). Quest for peace: Some reservations on peace education via drama. *Drama Australia Journal: Selected Papers IDEA 2001, 2*, 15–26.

Slade, P. (1954). *Child drama*. London: University of London Press.

Slade, P. (1968). *Experience of spontaneity*. London: Longman.

Slade, P. (1977). *Natural dance*. London: Hodder & Stoughton.

Slavik, M. (1996). *Cesta k Divadeinimi tvaru s detskym kolektivem*. Prague: Artama.

Spolin, V. (1963). *Improvisation for the theatre*. Evanston, IL: Northwestern University Press.

Sully, J. (1896). *Studies of childhood*. London: Longman.

Swortzel, L. (1997). *Theatre for young audiences: Around the world in 21 plays*. New York and London: Applause.

Taylor, P. (Ed.). (1995). New paradigms in drama education. *National Association for Drama Education Journal (Australia,) 19*, 2.

Taylor, P. (2003). *Applied theatre*. Portsmouth, NH: Heinemann.

Tennyson, V. P. (1999). Drama activities at the Ethical Culture School 1878–1930. Unpublished Ph.D. thesis, Arizona State University, U.S.A.

Thompson, J. (2001). Making a break for it: Discourse and theatre in prisons. *Applied Theatre Research, 2*(5).

Tomkinson, W. S. (1921). *The teaching of English*. London: Oxford University Press.

Wagner, B. J. (1976). *Dorothy Heathcote: Drama as a learning medium*. Washington: National Education Association.

Ward, W. (1930). *Creative dramatics*. New York & London: D. Appleton & Co.

Warner, C. (2004). On beyond word problems. *Education international, 1*, 49–57.

Way, B. (1967). *Development through drama*. London: Longman.

# INTERNATIONAL COMMENTARY

# 4.1

# Namibia

**Minette Mans**
*Windhoek, Namibia*

Africa has a rich and colorful heritage of dramatic rituals, with action, dance, costume and masks, but drama in formal education has been neglected. Anthropologists have collected much information on the educational use of stories and chantefables to act out the values, conflicts, histories and origins of the people. Meaningful gestures which show respect, for example, became formalized and symbolic in dance and art. Masks, pantomime and puppets served as metaphors for the dramatic moments in life. *Griots* (*jaliya*) enacted and sang the epics. By contrast, schools in southern African countries generally base their drama education on Western models (see main chapter), emulating the approaches of Slade, Heathcote and Bolton. Educational surveys show that drama teachers are generally educated in the same approaches, but for purposes of community theater also study and practise Boal's "Theatre of the Oppressed", while others demonstrate the influence of Marx, Brecht and Fanon.

While the "real" world of theater has been occupied by theater of resistance and protest – consider playwrights Ngugi wa Thi'ongo, Wole Soyinka, Zakes Mda, Athol Fugard who acted as the conscience of their societies – these plays were often only performed outside their original protest site. Considering their main purpose being to raise social and political awareness, questions have to be raised concerning their efficacy as theater of resistance in foreign locations (Graver 1999). To date, few studies have investigated the pedagogical implications of the thriving postcolonial African theater of resistance. The integrated arts approaches of formal education in Namibia and South Africa neglect in-depth drama education, and pay little attention to the philosophies and values embedded in traditional practices. Currently theater for development predominates, and CESO's (Centre for the Study of Education) study of the use of theater for social change in Africa, Asia, and Latin America (Epskamp 1992) described promising use of traditional practices in Zambia and Namibia. Ever-growing numbers of community theater groups perform to raise awareness of a wide range of social issues such as AIDS, violence against women and children, and ecological degradation. Traditions of African drama remain neglected, and although Zeeman and

*L. Bresler (Ed.), International Handbook of Research in Arts Education, 63–64.*

King (2002) compiled a manual for teachers using African examples, they retained the philosophical framework of the West.

Recent drama research, for example, in a South African AIDS awareness research project, used a popular television drama series *Tsha Tsha* to develop quantitative and qualitative research methods to measure processes of identification with characters. The findings were used in the development of a subsequent educational series that encourages problem-solving, development of solutions, and becoming "active agents in crafting the circumstances of their lives" (Parker, Ntlabati, & Hajiyiannis 2005, p. 1). A randomized community intervention trial investigated AIDS awareness drama-in-education programs in South Africa (Harvey, Stuart, & Swan, 2000), and a similar study on a radio soap in Zambia (Yoder, Hornik, & Chirwa, 1996), show that the use of drama proved more effective in changing attitudes and knowledge than programs without drama. Recent developments of the Southern African Theatre Initiative (Zeeman, 2005) have for the first time proposed an action plan for theaters, community theater, universities and schools to be implemented in the South African Development Community (SADC) region. This promises to delve into indigenous forms of knowledge to inform drama education.

# References

Epskamp, K. (1992). *Learning by performing arts: From indigenous to endogenous cultural development.* CESO Paperback no. 16. The Hague: Centre for the Study of Education in Developing Countries.

Graver, D. (Ed.).(1999). *Drama for a new South Africa: Seven plays.* Bloomington, IN: Indiana University Press.

Harvey, B., Stuart, J., & Swan, T. (2000). Evaluation of a drama-in-education programme to increase AIDS awareness in South African high schools. *International Journal of STD and AIDS.* Retrieved 20/08/05 from http://www.ncbi.nlm.gov/

Parker, W., Ntlabati, P., & Hajiyiannis, H. (2005). Television drama and audience identification: Experiences from *Tsha Tsha.* Centre for AIDS Development Research and Evaluation. Retrieved 08/08/05 from www.cadre.org.za/tshatsha.htm

Yoder, Hornik., & Chirwa (1996). Retrieved 22/08/05 from http://www.unicef.org/evaldatabase/ZAM_96.800.pdf

Zeeman, T., & King, J. (2002). *Action! An introductory drama manual.* Windhoek: New Namibia Books.

Zeeman, T. (2005). *Finding feet conference: Theatre education and training in the SADC Region.* A report on the Southern African Theatre Initiative Conference, Windhoek 11–15 May, 2003. Windhoek: New Namibia Books.

# INTERNATIONAL COMMENTARY

## 4.2

# Reflections from an Israeli Point of View

**Shifra Schonmann**
*University of Haifa, Israel*

While reading Gavin Bolton's chapter, *A History of Drama Education – a Search for Substance*, I realized once again how writing such an historical account is a problematic task. This is not only because of all the obstacles that Bolton mentioned but even when concentrating on trying to untangle the confused strands of *classroom drama* that he presents, there still remains an inherent problem in writing the history.

Two historically important parallel processes have occurred in Israel in recent years: mass immigration both from the former Soviet Union and from Ethiopia as well as an unending *war* for *peace* with the Palestinians. The tense political situation over the last decade has contributed to the notion that education, politics and ethics are all issues which cannot be separated from each other (Schonmann, 2004; Urian, 1990). The challenges confronting the Israeli educational system are intense and need imagination and powerful ideas. *Forum Theatre; Applied Theatre; Process Drama* are all powerful perceptions of theatrical work in use. Experiments in drama education as described in Bolton's historical account have been tried in different parts of the world; and they include Israel in which these ideas have been found extremely useful to a society living on the edge (Schonmann & Hardoff, 2000).

Drama education, as a field of knowledge, develops very slowly a culture in which practitioners and scholars want to discover its origins, its people and their ideas. It is worth mentioning that Judaism rejected the theater for 4,000 years. The first encounter between Judaism and the theater took place in the Greek and Roman period and Judaism developed a feeling of deep revulsion for this form of art. The "religious elders" (Ha'zal) connected theater to paganism and clowns. It was conceptualized as an expression of debauchery: the antithesis to religious education. In the eighteenth century with the diminishing power of religion, Jewish theater began to develop – but only on a very small scale. The original lack of theater in Judaism placed the teaching of theater in the Israeli education system in a special light. Literature, music, and even painting were adopted by Judaism, but the theater was without tradition and therefore when the Israeli education system opened its gates to teaching theater it was necessary to borrow from world culture and experience.

*L. Bresler (Ed.), International Handbook of Research in Arts Education, 65–66.*
© 2007 *Springer.*

The history of educational drama is inextricably bound up with the Progressive Educational Movement. While the development of drama/theater in education in Israel is, in essence, part of the above trend, the major difference is to be found in the short history of the State of Israel. Israel was established as a state only in 1948 and, due to economic hardships and lack of awareness in the first decades, very little was done in the area of drama education. Only in the 1970s did institutional interest in teaching drama/theater begin. Academic institutions, such as universities and colleges, began to open theater teacher training departments but, in those days, almost no research took place and there was very little academic writing on that subject. Then, in the 1980s, a considerable growth of theater teaching occurred due to an awakening in the arts and in education, and the first research projects began to appear.

Today, drama education is discussed with great interest, and reflects how much the theater as an area of both teaching and learning is needed although much of its substance is still unclear. In the Jewish schools, more and more attention is being paid to drama education (Feingold, 1996).

We need to remind ourselves that although drama education is now being viewed as a multilevel discourse, the true appeal and beauty of drama – theater in education lies in its power to create an alluring magic of theater and drama as artistic and aesthetic ways of expressing the human mind and spirit. From this point of view, historical developments can be examined in telling the stories of our professional practice. Involved in historical research, each drama/theater scholar needs to listen to the stories that are told. Only then, can he or she continue by narrating a substantive drama/theater story. A *search for substance* should include therefore more research into drama education history. Meanings that can be extracted from history can serve as important elements to open the horizons of the field.

# References

Feingold, B.-A. (1996). *Why Study Drama? Theatre and Education.* Tel Aviv: Eitav Publishing (in Hebrew).
Schonmann, S. (2004). Ethical tensions in drama teachers' behavior. *Applied Theatre Research Journal,* 5, 11–21.
Schonmann, S., & Hardoff, D. (2000). Exploring new possibilities and the limits of theatre education: A role-play project with adolescent actors to improve physicians' communication skills. *Arts & Learning Research Journal, 16*(1), 134–151.
Urian, D. (1990). *The Arab in Israeli Theatre.* Tel Aviv: Or Am (in Hebrew).

5

# THE TEACHING AND LEARNING OF MUSIC IN THE SETTINGS OF FAMILY, CHURCH, AND SCHOOL: SOME HISTORICAL PERSPECTIVES

**Gordon Cox**

*University of Reading, U.K.*

Historians have long recognized that "education" is not to be simply equated with "schooling," if by that is meant what is transacted in the formal institution called "school" (Charlton, 1988). Two other social institutions in particular challenge modern mass schooling in terms of their significance for an understanding of the history of education: the church and the family (McCulloch, 2005). Both long predate the school in Western society. The relative influence of these three educational agencies (family, church, and school) on the teaching and learning of music is the subject of this chapter. My purpose is to provide an annotated commentary which assembles a range of research undertaken by music educators,[1] ethnographers, folklorists, and historians of education. In order to keep the study within the bounds of possibility I have drawn my examples for the most part from the western hemisphere.

Underpinning this account are three central concerns I have about historical research in music education (see Cox, 2002b): Research should be responsive to the social, historical, ideological, and cultural contexts in which the learning and the teaching of music take place; due attention should be paid to the actual teaching and learning of music; and music education should be viewed as an essentially broad area of activity, encompassing both formal and informal settings. I shall relate my commentary to these concerns in the conclusion to the chapter.

## Music in the Family

The family is the most permanent and immediate educational unit (Aldrich, 1982). For centuries in this context children have learned the first essential social, economic and cultural skills, including music. I have selected examples from a range of settings in order to illustrate the family's pervasive influence, for good or ill, on the transfer of musical culture from one generation to the next. I present these examples chronologically.

\* \* \*

67

*L. Bresler (Ed.), International Handbook of Research in Arts Education, 67–80.*
© 2007 *Springer.*

Through the work of the English historian, Nicholas Orme (2003), we learn something of music and medieval family life in England, in particular related to royalty and the aristocracy as many of their records survive. Music was a courtly activity par excellence, and played a major part in English aristocratic life. Boys and girls of wealthy families were taught to play instruments as part of their education. Small boys might have drums, like Thomas and Edmund, the youngest sons of Edward 1 in 1306 when they were aged about four and five. Harp-strings were bought for Henry V in 1397 when he was ten, and all the surviving children of Henry VII appear to have learnt the lute.

The arrangements for the education of Edward V in 1473 demonstrate music's importance for this privileged group. Mass was said every day in his household "by note with children," in other words with polyphonic accompaniment. The noble boys who were with him were ordered to be specifically trained in music along with other "exercises of humanity" (Orme, 1984).

Rainbow (1989) points out that with the dissolution of the monasteries and song schools associated with protestant reform in England, between 1536 and 1542, the formal teaching of music in schools was eclipsed and the concept of the domestic music lesson gained favor. He notes that John Day's metrical psalter (1562) was an early attempt to provide "self-instruction," and in the following year Day's *Whole Psalmes in Foure Parts* (1563) contains a woodcut illustration of a staid father teaching his assembled family the Guidonian Hand (a visual aid to assist in memorising the sequence of note names called the Gamut).

By the eighteenth century, most courtesy and conduct writers in England favored the musical education of well-born girls who had a lot of time on their hands, which it was the duty of their parents to fill. In the innovative work of Richard Leppert (1988) on the teaching of music to upper-class amateurs in eighteenth-century Britain, based on the evidence of the portraiture of the time, it appears that music was routinely viewed by parents as an asset to their daughters' matrimonial stock. But their daughters' music making had to be passive and within the private confines of family and friends. The music lessons took place within the home, to which the music master came. Apparently, however, women generally abandoned music on marriage: "In some instances women rebelled against music in the recognition that its function in their lives was the re-enactment of oppression" (p. 45).

Continuing with the theme of musical oppression but in radically contrasting social circumstances, John Zucchi (1999) documented the case in the nineteenth century of "the little slaves of the harp" in which child musicians, uprooted from their villages in central and southern Italy, were taken as virtual slaves to Paris, London, and New York to perform as barrel-organists, harpists, violinists, fifers, pipers, and animal exhibitors. The children were part of the family economy back in Italy, and in times of severe economic fluctuation they contributed to the family's goal of preserving its position, with the father signing a contract with the padrone entrusting the child to the latter person for three years, in which time the child would be taught the harp, have an instrument provided, as well as being clothed, fed, and cared for. However, in practice the children were virtual slaves enduring appalling living conditions and cruelty. Their welfare gave rise to much controversy in their new urban settings.

The Italian case was not typical however of the musical socialization of young people within small-scale rural communities in the early twentieth century in England and the United States. As far as the transmission of traditional songs from one generation to another in rural New England was concerned, in the study by Jennifer Post (2004) based on a sampling of recordings made between 1924 and 1960, the most important sources for the songs were family members including parents, grandparents, and siblings, particularly brothers. Song repertoires represented "the web of contacts that bind family traditions together" (Post, 2004, p. 150).

We can observe some of these features of music transmission in family settings within the traditional song communities that Gillian Dunn (1980) investigated in East Suffolk, England. The majority of her informants had been born around the turn of the nineteenth and twentieth centuries. Most of them believed in the principle of "song ownership": that certain songs belonged to certain singers. Frequently song inheritance operated within the family structure. A singing family had its own collective repertoire. At home, song ownership was suspended in order to allow the transmission of song inheritance. Once children knew the songs, ownership was endowed by their place in that singing family (for recorded examples of such a singing family in the English tradition see the CD, *The Copper Family of Rottingdean* (2001)).

Teaching in small-scale rural communities was rarely formal, it was mostly through imitation, as in this reminiscence, recorded by the folklorist, Gerald Thomas (1993), of the French Newfoundland fiddler and storyteller, Emile Benoit (b. 1913–1992) whose uncle had reconstructed a primitive fiddle for his nephew:

> I didn't know where to put de fingers for to bring in … so I said "You show me how you" … "Now …" I said "I wants de fast, fast reel". Now he could play dis one "De Devil amongst de Tailors". So he passed de fiddle, I played it too … So I start. Well I played- all dat afternoon. Played all night didn't go to bed at all … I played till part of a next day. Nothing to eat, oh I was starved … And after that I had it made (Thomas, 1993, pp. 105–106).

In the contrasting urban environment of an English town in the 1980s, the musical influence of the family was clearly apparent to the anthropologist Ruth Finnegan (1989) who undertook an ethnography of music making in Milton Keynes. She found the family crucial in socializing children into a culture. Although musical socialization in this context might well involve electronic media and prerecorded music rather than learning songs at the mother's knee, Finnegan pointed out that the process was still initiated at home.

With the rise of single parent families, unwed parents, gay parents, and remarried parents there is a new complexity which will inevitably affect childhoods, and maybe musical childhoods. Something of this diversity of family structure is evident in Patricia Shehan Campbell's (1998) close study of the musical lives and influences of fifteen American children, six of whom were in families of divorced or separated parents, several being in households with absent fathers, but sometimes with live-in grandparents. Nevertheless she confirmed that the great musical unifier of this disparate group

was still their families, of whatever pattern. They exerted a pervasive influence on their children's musical thoughts and choices.

\* \* \*

In these accounts it is clear that the family has had a key role to play in providing a space for music practice, supplying the necessary resources, and informally transmitting a musical tradition. However, we should beware of an unduly rosy picture of family life and heed Mintz's (2004) observation that throughout American history family stability has been the exception rather than the norm. Whether the musical role of the family is confining or liberating depends no doubt on the prevailing social mores (attitudes toward women and musical accomplishment, for example), power structures (the "little slaves of the harp"), and the strength of the family's traditions.

## The Church

Christianity has always been an educational system with Christ as the divine master who commanded his disciples to go forth and teach all nations (Cremin, 1970). Historians have paid particular attention to the influence of the church, whether protestant or catholic, on the teaching and learning of music (see especially Barbier, 2003, on Vivaldi and the Counter-Reformation, and Butt, 1994, on Lutheranism and music education).

In this section I shall focus on three settings in order to convey some of the potential richness of this area of research for music education historians: medieval song schools in the west of England, the missionary work of the Catholic Church with native peoples from Latin America, and the American Singing Schools.

\* \* \*

The Judaeo-Christian tradition of psalm and hymn singing always provided an important medium for worship, and the founding of the Schola Cantorum in Rome in the fourth century ensured firm and lasting connections between music, the liturgy and education. The song schools subsequently set up throughout Europe for the purpose of disseminating Roman church music were to have a permanent effect on the general development of music teaching in educational institutions. Until the Reformation such schools were necessities for all monasteries and cathedrals (Mark & Gary, 1999; Plummeridge, 2001; Rainbow, 1989).

But what was life like for choristers in these song schools? I focus upon the work of Nicholas Orme (1976 and 1978), particularly from his detailed study of Education in the West of England 1066–1548. By 1236 Exeter Cathedral maintained and educated fourteen boy choristers. Their duties were twofold: they joined the canons and vicars in the choral services proper, and they also took part in singing antiphons in the worship of the Virgin [there was poignant symbolism in this connection between the idea of the boy as innocent and pure, and the litany of the Blessed Virgin (see Cooper, 1994)]. Their lessons must have centered upon the study of song, and also probably grammar.

We get more information about what these pupils were actually taught by looking at the contracts of the pre-Reformation instructors (Orme, 1976). At Salisbury Cathedral, Thomas Knight was appointed organist and master of the choristers with the duty of teaching them plainsong, pricksong (or notated music), faburden, and descant.

Days were long for the choristers of Wells Cathedral. Some had to rise in the night to sing mattins. The rest after rising had to cross themselves and repeat certain prayers while they dressed. The day began with studying plainsong and polyphony before breakfast. Some then went off to choir. In the afternoon the boys had more lessons, returning to the choir for evensong. After evensong came supper, and after supper those who had to sing the next morning's mattins were heard by the master until they were perfect. It was "a long and heavy day" (Orme, 1976, p. 81).

By the mid-sixteenth century the training of choristers was in decline, with the general trend toward the simplification of the liturgy: "choristers ... were perhaps never ... to enjoy such a full part in the Christian liturgy again" (Cooper, 1994, p. 274).

This link between music and the liturgy was used throughout the sixteenth century as a valuable tool in the cultural encounters and explorations of the Americas. With the Hispanic conquest of America came missionary schools, legitimizing the conquest, and the Spanish found similarities between their own musical practices and those of the indigenous peoples (Mark & Gary, 1999). Aguilar, Ramsey, and Lumsden (2002) point out that the hierarchy of indigenous musicians corresponded exactly with that found in Spanish cathedrals. Gradually the indigenous came to know their chants from memory, and the friars taught them to draw lines on paper, and write music notation. The friars created libraries of religious music copying books, and the most privileged indigenous promoted the European musical culture, and even small isolated communities established polyphonic choirs, and began to compose their own music in the European style (also see: de Couve, Pino, & Frega, 1997; 2004; for a reconstruction of the repertoire see the CD, *Bolivian Baroque*, 2004).

The following report makes clear the extent to which music became a central plank in the christianizing process of the Indians:

> The natural inclination to harmony that those people have is incredible ... They also have admirable skill for the music of the voices, and of musical instruments ... Therefore the wise missionaries are in the habit of choosing those boys who, from an early age, show the best voice timbre and through education make them into musical experts who understand notes and tempo to the point where their sacred music pleases and delights no less than European music. (Muratori, 1743, in Nawrot, 2004, p. 14)

Such work we might characterize as "music education for religious conversion" (Mark, 2002, p. 30).

My final example of the influence of the church on music education is the singing school tradition in America. Buechner (2003) has provided the definitive history of Yankee Singing Schools 1760–1800, and he emphasizes that the development has to be seen in the context of the first great wave of religious revivalism in the 1740s known in America as the Great Awakening, associated with which was a great deal of singing.

In time as interest in revivalism waned, the singing school came to be recognized as the proper means for improving church congregational music.

The influence of the singing school persisted into the twentieth century particularly in the South where the development of shape notes (which altered the shapes of notes to conform to the syllables involved) formed the basis for a vigorous singing tradition. The following reminiscence from the bluegrass musician, Charlie Monroe relates to his experience of participating in singing schools in the early years of the twentieth century growing up in Kentucky, and provides us with a vivid oral account of teaching method:

> Well, they'd have this singing school teacher to come in there and everybody that wanted to learn about shape notes, the timing of music and the rudiments of music, would come and take part. And that singing school teacher he would put the notes up on a board for you, shape notes they called them, and then he'd teach you the names of one of these notes and the sounds of them … and he would teach the singing school, say in Rosine, then he would lead that singing class at the singing convention, then his job was over. (Transcribed by Gordon Cox from the CD *Bill Monroe and the Bluegrass Boys*, 1993)

One religious denomination in particular, the Church of God, employed the singing schools with considerable effect in its work with thousands of poor whites in Alabama (see Martin, 1999). The singing schools were held nightly for a one- or two-week period during times when farming activities were minimal. The final service (which was an informal graduation) often featured a choir of the best students, sight-singing songs they did not know prior to their lessons.

The singing school movement consitituted the first formal system of mass education in the American colonies (Mark & Gary, 1999).

<div align="center">*    *    *</div>

Uncovering the mosaic of beliefs concerning the relationships among music, religion, and education prompts numerous questions concerning possible connections with the histories of Christianity, childhood, pedagogy, colonialism, and religious conversion. A more fundamental, and difficult task for historians, is to discern the links for musical learners and musical participants between religious and musical experience, both involving a combination of intellectual and emotional engagement, hard to translate into words. This might lead to a greater historical understanding of "musical participation as a source of spiritual fulfilment and pleasure" (Pitts, 2005, p. 144), and thus present some way forward in interpreting the significance of the relationship between the two modes of experience in the lives of musical learners.

## Compulsory Mass Schooling

In the eighteenth century, mass schooling emerged in the northern American colonies, Norway, some Swiss cantons, most provinces of the Netherlands, and various German

states (Ramirez & Boli, 1994). Family-directed socialization was rejected in favor of more systematic education in a differentiated social institution. There was also a gradual transfer of educational power from the church to the state, although this was a more complex process than simply the changing of the guard (see Miller & Davey, 2005). Finally, in the nineteenth century, compulsory mass schooling was introduced. The link between the state and compulsory schooling became apparent, as it was the state that had the authority to make schooling compulsory.

My examples have been chosen to illustrate what was actually going on musically in schools and classrooms based on the evidence of four observers: an American music educator visiting European schools in 1847, a British schools inspector reporting on individual institutions between 1922 and 1929, and an American ethnographer and a British anthropologist presenting accounts of music in late twentieth-century schools. To complete the picture, I shall discuss some studies dealing with the links between the state and music in schools.

\* \* \*

William Batchelor Bradbury (1816–1868) was one of a number of American travelers intent on observing what went on in the music classrooms of nineteenth-century Europe (Karpf, 2000). He was a significant contributor to the groundswell of interest in music education in the United States during the nineteenth century. In July 1847 he sailed for Europe and spent several weeks in Switzerland, and 18 months in Germany. He wrote up his observations in a series of 23 articles published in the *New York Evangelist*.

They provide us with vivid accounts of good practice. Bradbury was particularly impressed by his visit to the state supported Burger Schulen in Leipzig where vocal music was an integral part of the curriculum in all grades. The youngest students (aged 6 to 8) retained the same teacher for all subjects, but music specialists taught older children. Bradbury observed that the youngest students "sing entirely by ear. These [students] … have their [own] little music books, and some of the musical characters are generally explained to them during the lesson. No children are allowed to study the elementary principles of music until they can sing well by ear and readily distinguish musical intervals" (Karpf, 2002, p. 15).

With a class of 11 year-olds each child was provided with a little "Choral[e] Book" containing upwards of a hundred chorales. The teacher gave out the number of the chorale to be studied, and questioned the pupils about the key, the scale and its letters and the chord of the key. They then proceeded to sing the scale, and the chorale, first from letters, then with the words. After that children then turned to the "Juvenile Singing Book" to sing social, moral and patriotic songs. What impressed Bradbury was that there was equal emphasis upon the cultivation of the musical ear and on the understanding of the voice.

In Berne, Bradbury encountered at the Young Ladies Institution a noteworthy teacher, Herr Frolich, who had a strict analytical method of teaching the pupils of his highest class which bore considerable fruit:

A new piece of music … is usually taken as the basis of the instruction that follows … In fact, so interested do the young ladies become in their study that they

commence at once composing music suited to the spirit of the words … the pupils seek for a knowledge of the laws of harmony and thorough-base (sic). (p. 26)

In the first quarter of the twentieth century in England and Wales Arthur Somervell (1863–1937) was the music specialist in His Majesty's Inspectorate of Schools (HMI), and it was part of his job to inspect the teaching of music (see Cox, 2003). In that sense his reports could not merely focus upon good practice, and so they provide useful evidence for what was going on in classrooms. Such reports, we should bear in mind, were symptomatic of the state's desire to gather information, and to exercise control (Miller & Davey, 2005).

I shall focus on Somervell's music inspections of twenty-four secondary schools which he visited between 1922 and 1929 (see Cox, 1993). His reports deal with the traditional concerns of ear training, sight singing and singing, the rise of music appreciation, and of "extra-curricular" work and of time table allocation. No matter how excellent the singing, there would be a firm reprimand if ear training was not developed. Intelligent use of tonic sol-fa was the key. Moreover, competence in tonic sol-fa led to more effective sight reading and consequently to a more extensive repertory of songs. In the allocation of time for the teaching of music there was considerable disparity. Some schools took the subject all the way through, others used the boy's "breaking voice" as an excuse to phase out music. More encouragingly Somervell found a burgeoning interest in "extra-curricular" activities: a fairly unique example was at Christ's Hospital School where there were 54 in the orchestra, and in total 213 boys learnt a musical instrument.

Over 50 years later this "extra-curricular" aspect of music teaching had become firmly established, as Ruth Finnegan (1989) demonstrated in her report on music in schools in Milton Keynes. In the 46 schools responding to her survey in 1982 she counted 72 recorder groups, 33 choirs, 19 orchestral and similar groups, 14 guitar groups, 5 wind bands, 3 jazz groups, together with 1 each of a barber shop group, brass band, rock shop, dance band, Gilbert and Sullivan group, and folk group – 158 in all. She found around 10 to 15 percent of participation in voluntary self-chosen extra-curricular musical activity.

Finnegan's conclusions were that schools were more than just channels to lay the proper foundations of musical participation: they are *themselves* organized centers of music – a real part of local musical practice.

Whereas it was Somervell's task to reach some qualitative judgment about the schools he was inspecting, 60 years later, between 1987 and 1990 it was the task of a group of educational researchers in the United States to portray "the ordinary problems" of teachers teaching the arts in selected elementary schools: it was Liora Bresler (1991) who reported on music teaching in two elementary schools in Danville, Illinois. She observed that the balance of general musical skills, appreciation, and history varied widely from one teacher to another. Intriguingly she found that teacher practices and beliefs were reminiscent of the practice of the beginning of music in the United States in the first half of the nineteenth century, with music seen as the product of the people, the common man, rather than the product of a cultural elite. The central aim was still to read music and to sing acceptably. Worryingly what Bresler identified as

the heart of the curriculum (playing an instrument or singing) was not formally assessed. Instead assessment was applied to the secondary activities of history and appreciation. Music was a victim of pressure from "academic" subjects, partly because it did not contribute to measured achievement. As to "the people high above" music was regarded as the lowest priority on their list.

\* \* \*

Through this selective account of specific schools it is clear that singing became part of compulsory education in most countries in Europe. There was an age-related plan leading from singing by ear to singing at sight, often in different parts. From the twentieth century, whilst there is evidence of some new ideas, there is a reliance (for good or ill) on the traditional aims in music teaching, targeted upon "the common man." It is salutary to note that composing in the classroom (thought of as a fairly contemporary innovation) was a feature of the music curriculum in a school in Berne in the 1840s. Other observations from these accounts contain many themes familiar to music educators in their day-to-day work, including the question of music for the majority vs. music for the few, inappropriate assessment and a somewhat lowly status for the subject. More optimistically there appeared to be a growing demand for extra-curricular musical activities focusing upon musical performance.

\* \* \*

Mass schooling by its very nature was inclusive, and it developed a standardized curriculum. The power to influence the curriculum, to select text books, and to inaugurate innovative programs depends ultimately on political strength. Wai-Chung Ho's paper (2000) on the political influences on curriculum content and musical meaning in Hong Kong secondary music education 1949–1997 is an intriguing case study. Over the course of three decades (1950–1980) a particular political construction framed the development of music education in Hong Kong: an explicitly apolitical Western style of musical knowledge, but with an implicitly political purpose of controlling the content of musical knowledge. Prior to the 1980s depoliticization and de-Sinification characterized music education in Hong Kong. It perpetuated the social and cultural hegemony of traditional Western art music. But while ostensibly promoting diverse political cultures in the two "systems" scheme, Hong Kong music education remained ideologically in the European camp, and this conflicted with Chinese traditional cultures, and the socio-political values of the Peoples' Republic. Thus music educators found themselves attempting to achieve a precarious balance.

Such interactions with historical and contemporary policy have the potential to create a dialogue between research and practice. Other examples include Gammon's (1999) paper on the cultural politics of the English National Music Curriculum between 1991 and 1992, and Hargreaves and North's book *Musical Development and Learning* (2001) on international perspectives of music education, including some historical information on government policy which impacts upon the teaching of music in schools.

# Conclusion

I will conclude by considering my three central concerns outlined in the introduction:

- *That research should be responsive to the social, historical, ideological, and cultural contexts in which the teaching and learning of music take place.*

Each of the three educational settings I have explored has contained its own complexities and linkages. The changing nature of the family has been mirrored in the musical upbringing of members of the medieval English royal family, the musical education of upper-class females in eighteenth-century Britain, the musical exploitation of Italian child musicians in the nineteenth century, and the musical socialization of children within rural and urban settings in twentieth-century England and North America. The church has been the site of bitterly fought ideological conflicts, particularly with the Reformation which in England threatened the central musical role of children in the liturgy. Tensions were inevitably present in the Spanish missionaries' use of music education for the religious conversion of indigenous peoples in Bolivia, involving notions of what constituted being "civilized" and "uncivilized". Finally, the introduction of mass schooling in the nineteenth century by the state, taking over some of the educational functions of the family and the church, carried with it dangers for music, either for being used as a tool of government cultural policy (as in Hong Kong) or of being marginalized as a curriculum subject, low down in government priorities.

- *That due attention should be paid to the actual teaching and learning of music*

Within the medieval church it was boys who were privileged under the guidance of an instructor to uncover the mysteries of musical notation in relation to their singing of plainsong and polyphony. These same mysteries became available for a wider spectrum of the population through the Spanish missionaries' work with native peoples, and through the singing schools of America whose use of the shape note system particularly in the South became a valuable teaching aid. The music curriculum in nineteenth-century schools in Europe was also driven by the priority given to learning to sing by sight, using a variety of methods including tonic sol-fa (though the early use of classroom composition in Berne needs to be remembered). Gradually the curriculum increased in scope, although we should not fall into the trap of regarding this pedagogical history as a narrative of continuous progress. Whilst the mastery of notation played a large part in the teaching of music in churches and schools, we should remember that musical socialization within the families in rural Anglo-American communities focused upon an oral tradition, teaching through imitation and example, so that some children grew up inheriting song repertoires of considerable diversity.

- *That music education should be regarded as an essentially broad area of activity*

I have adopted a broad definition of music education as the basis of this chapter: It comprises all deliberate efforts to pass music from one generation to another (Lee, 1991). I have investigated both formal and informal instruction, state-sponsored education, and music education outside the aegis of the state, the learning and teaching of music by ordinary people in unstructured settings, as well as that undertaken by

specialists in structured settings. Musical breadth has also mirrored contextual breadth, encompassing a variety of musical genres from plainsong and medieval polyphony to American Country Music.

Finally it is my contention that such an expansive historical approach can enable researchers to more fully comprehend music's unique space within cultures, illuminating for us the process of cultural transmission, whether referring to young people, immigrants, women, or the "invisible realities" of families, and the formal settings of churches and schools. In such ways we can encounter the past in the present, and thus deepen our own understanding of the educative power of music.

## Acknowledgments

I am indebted to my colleagues Nicholas Bannan, Kevin Brehony, and Stephanie Pitts for commenting critically upon previous drafts of this chapter.

## Note

1. Research in the history of music education has its roots in a substantial body of classic histories published during the twentieth century in the United Kingdom (see Rainbow, 1967, 1989, 1990; Scholes, 1947; Simpson, 1967), and in the United States (see Birge, 1928; Britton, 1950, 1989; Keene, 1982; Mark, 1978; Mark & Gary, 1999; Sunderman, 1971; Tellstrom 1971). Outside the United States, moreover a significant number of books have been published since 1990 that have sought to uncover and reconstruct the history of music education and learning in different countries, including Canada (Green & Vogan, 1991), Germany (Gruhn, 2003), Great Britain (Cox, 1993, 2002a; Pitts, 2000; Rainbow with Cox, 2006), and Ireland (McCarthy, 1999a). Most recently McCarthy (2004) has published her history of the International Society of Music Education. Moreover for over 20 years, researchers have been nurtured by the pioneering efforts of the late George Heller, the founding editor of *The Bulletin of Historical Research in Music Education* (see McCarthy, 1999b). In 2000 the *Bulletin* was renamed the *Journal of Historical Research in Music Education* and it was edited by Jere Humpheys from 1999 to 2003, and since then by Mark Fonder. In the United Kingdom the publication of *Classic Texts in Music Education* initiated and edited by the late Bernarr Rainbow has been another invaluable resource.

## References

Aguilar, B., Ramsey, D., & B. Lumsden. (2002). The aztec empire and the Spanish missions: Early music education in North America. *Journal of Historical Research in Music Education, 24*(1), 62–82.

Aldrich, R. (1982). *An introduction to the history of education.* London: Hodder and Stoughton.

Barbier, P. (2003). *Vivaldi's Venice.* London: Souvenir Press.

Birge, E. B. (1928). *A history of public school music in the United States.* Philadelphia, PA: Oliver Ditson. (reprinted 1966 Reston, VA: MENC)

Bresler, L. (1991). Washington and Prairie Schools, Danville, Illinois. In R. E. Stake, L. Bresler, & L. Mabry (Eds.), *Custom and cherishing: The arts in elementary schools* (pp. 55–93). Urbana, IL: University of Illinois.

Britton, A. (1950). *Theoretical introductions in American tune-books to 1800.* Unpublished doctoral dissertation University of Michigan, Ann Arbor.

Britton, A. (1989). The how and why of teaching singing schools in eighteenth-century America. *Bulletin of the Council of Research in Music Education, 99*, 23–41.

Buechner, A. C. (2003). *Yankee singing schools and the golden age of choral music in New England, 1760–1800.* Boston, MA: Boston University for The Dublin Seminar for New England Folklife.

Butt J. (1994). *Music education and the art of performance in the German baroque.* Cambridge, MA: Cambridge University Press.

Campbell, P. S. (1998). *Songs in their heads: Music and its meaning in children's lives.* New York: Oxford University Press.

Charlton, K. (1988). "Not publike onely but also private and domestical": Mothers and familial education in pre-industrial England. *History of Education, 17*(1), 1–20.

Cooper, T. N. (1994). Children, the liturgy, and the reformation: The evidence of the Lichfield cathedral choristers. In D. Wood (Ed.), *The Church and Childhood* (pp. 261–274). Oxford: Blackwell.

Cox, G. (1993). *A history of music education in England 1872–1928.* Aldershot: Scolar Press.

Cox, G. (2002a). *Living music in schools 1923–1999: Studies in the history of music education in England.* Aldershot: Ashgate.

Cox, G. (2002b). Tansforming research in music education history. In R. Colwell & C. Richardson (Eds.), *The new handbook of research on music teaching and learning* (pp. 696–706). New York: Oxford University Press.

Cox, G. (Ed.). (2003). *Sir Arthur Somervell on music education: His writings, speeches and letters.* Woodbridge: Boydell Press. *Classic Texts in Music Education*, No. 26.

Cremin, L. (1970). *American education: The Colonial experience 1607–1783.* New York: Harper.

De Couve, A. C., Del Pino, C., & Frega, A. L. (1997). An approach to the history of music education in Latin America. *Bulletin of Historical Research in Music Education, XIX*, 10–39.

De Couve, A. C., Del Pino, C., & Frega, A. L. (2004). An approach to the history of music education in Latin America. Part II: Music education 16th–18th centuries. *Journal of Historical Research in Music Education, 26*(2), 79–95.

Dunn, J. (1980). *The fellowship of song: Popular singing traditions in East Suffolk.* London: Croom Helm.

Finnegan, R. (1989). *The hidden musicians: Music-making in an English town.* Cambridge: Cambridge University Press.

Gammon, V. (1999). Cultural Politics of the English National Curriculum for Music, 1991–1992. *Journal of Educational Administration and History, 31*(2), 130–147.

Green, J. P., & Vogan, N. (1991). *Music education in Canada: A historical* Account. Toronto: University of Toronto.

Gruhn, W. (2003). *Geschicte der Musikerziehung.* Hofheim: Wolke Verlag. Second edition.

Hargreaves, D., & North, A. C. (Eds.). (2001). *Musical development and learning: The international perspective.* London: Continuum.

Ho, W.-C. (2000). Political influences on curriculum content and musical meaning: Hong Kong secondary music education 1949–1997. *Journal of Historical Research in Music Education, 22*(1), 5–24.

Karpf, J. (2002). "Would that it were so in America": William Bradbury's observations of European music educators, 1847–49, *Journal of Historical Research in Music Education, 24*(1), 5–38.

Keene, J. A. (1982). *A history of music education in the United States.* Hanover, NH: University Press of New England.

Lee, W. (1991). Toward the morphological dimensions of research in the history of music education. In M. McCarthy & B. D. Wlson (Eds.), *Music in American Schools 1838–1988* (pp. 114–117). College Park: University of Maryland.

Leppert, R. (1988). *Music and image: Domesticity, ideology and socio-cultural formation in Eighteenth Century England.* Cambridge, MA: Cambridge University Press.

Mark, M. L. (1978). *Contemporary music education.* New York: Schirmer.

Mark, M. L. (Ed.). (2002). *Music education: Source readings from ancient Greece to today* (2nd ed.). New York: Routledge.

Mark, M. L., & Gary, C. L. (1999). *A history of American music education* (2nd ed.). Reston, VA: Music Educators National Conference.

Martin, B.L. (1999). The influence and function of shape notes and singing schools in the twentieth century: An historical study of the Church of God. *Journal of Historical Research in Music Education, 21*(1), 62–83.

McCarthy, M. (1999a). *Passing it on: The transmission of music in Irish culture.* Cork: University of Cork.

McCarthy, M. (1999b). The bulletin of historical research in music education: A content analysis of articles in the first twenty volumes. *The Bulletin of Historical Research in Music Education, 20*(3), 181–202.

McCarthy, M. (2004). *Toward a global community: The International Society for Music Education 1953–2003.* Nedlands, WA: ISME.

McCulloch, G. (2005). Introduction: history of education. In G. McCulloch (Ed.), *The RoutledgeFalmer reader in history of education* (pp. 1–12). London: Routledge.

Miller, P., & Davey, I. (2005). Family formation, schooling and the patriarchical state. In G. McCulloch(Ed.) *The Routledge Falmer reader in the history of eduction* (pp. 83–99). London: Routledge.

Mintz, S. (2004). *Huck's raft: A history of American childhood.* Cambridge, MA: The Belknap Press.

Nawrot, P. (2004). Baroque music in the Jesuit *Reducciones* (Settlements), liner notes for Florilegium, *Bolivian Baroque: Baroque music from the missions of Chiquitos and Moxos Indians.* Channel Classics CCS SA 22105.

Orme, N. (1976). *Education in the West of England 1066–1548.* Exeter: University of Exeter.

Orme, N. (1978). The early musicians of Exeter Cathedral, *Music and Letters, LIX*, 395–410.

Orme, N. (1984). *From Childhood to Chivalry: The education of the English kings and aristocracy 1066–1530.* London: Methuen.

Orme, N. (2003). *Medieval children.* New Haven, CT: Yale University Press.

Pitts, S. E. (2000). *A century of change in music education: Historical perspectives on contemporary practice in British secondary school music.* Aldershot: Ashgate.

Pitts, S. E. (2005). *Valuing musical participation.* Aldershot: Ashgate.

Plummeridge, C. (2001). Music in schools. In S. Sadie & J. Tyrrell (Eds.), *The new Grove dictionary of music and musicians* (2nd ed.). London: MacMillan.

Post, J. C. (2004). *Music in rural New England: Family and community life, 1870–1940.* Hanover: University Press of New England.

Rainbow, B. (1967). *The land without music: Musical education in England 1800–1860 and its continental antecedents.* London: Novello.

Rainbow, B. (1989). *Music in educational thought and practice: A Survey from 800 BC.* Aberystwyth: Boethius.

Rainbow, B. (1990). *Music and the English public school.* Aberystwyth, Wales: Boethius Press.

Rainbow, B., & Cox, G. (2006). *Music in educational thought and practice: A survey from 800 BC* (2nd ed.). Woodbridge: The Boydell Press.

Ramirez, F. O., & Boli, J. (1994). The political institutionalization of compulsory education: The rise of schooling in the Western cultural context. In J. A. Mangan (Ed.), *A significant social revolution: Cross-Cultural aspects of the evolution of compulsory education* (pp. 1–20). London: The Woburn Press.

Scholes, P. (1947). *The mirror of music 1844–1944: A century of musical life in Britain as reflected in the pages of the* Musical Times. London: Novello and Oxford University Press.

Simpson, K. (1967). *Some great music educators: A collection of essays.* London: Novello.

Sunderman, L. F. (1971). *Historical foundations of music education in the United States.* Metuchen, NJ: The Scarecrow Press.

Tellstrom, A. T. (1971). *Music in American education, past and present.* New York: Holt, Rhinehart & Winston.

Thomas, G. (1993). *The two traditions: The art of storytelling amongst French Newfoundlanders.* St. John's, Newfoundland: Breakwater Press.

Zucchi, J. E. (1999). *The little slaves of the harp: Italian child street musicians in nineteenth-century Paris, London, and New York.* Liverpool: University of Liverpool.

# Discography

*Bill Monroe and the Bluegrass Boys: Live Recordings 1959–1969. Off the Record. Vol. 1.* Washington: Smithsonian Folkways 9307-40063-2, 1993.

*Bolivian Baroque: Baroque music from the missions of Chiquitos and Moxos Indians.* Channel Classics CCS SA 22105, 2004.

*The Copper Family of Rottingdean: Come Write Me Down.* London: Topic Records, TSCD534, 2001.

# INTERNATIONAL COMMENTARY

# 5.1

# Germany

**Wilfried Gruhn**
*University of Freiburg, Germany*

From the centuries B.C. up to the end of the Middle Ages music in almost all European countries fulfilled either a clear public (political) purpose for ceremonies, parades, battles, etc. or a religious function in church services and rituals. Instrumental skills of court and military musicians were not taught formally but as a craft by practice. That is because music in ancient times was always seen as *usus* (practical use), not as *ars* (art form). Apart from church music, very little is known about the musical practices of the medieval *joglars* (lat.: *joculatores*, = itinerant musicians and jugglers) and their training, as well as fiddlers and minstrels. Although Plato had highlighted the ethical function of the Greek modes to strengthen the spirit of the youth, in medieval education music was not seen as essential. Formal musical training was mainly concerned with vocal practice including some theoretical knowledge about modes and rhythmic structures which took place in monastic singing schools to preserve and unify the many dialects of the Gregorian Chant.

We also know next to nothing about the musical praxis in families – if it existed at that time at all. We must be aware that the history of music education is mostly presented from a top down view, that is, from the perspective of church regulations (*Kirchenordnungen*), state edicts (*Erlasse*), and formal decrees, not from the bottom up view of teachers and learners. Only since the Enlightenment did music appear more visibly in social life and became documented in more detail including its educational application. However, we have always to keep in mind that what we know represents only a small selection of the music that was actually taught, learned, and performed in real life.

In the nineteenth century, when music became a domain of the bourgeoisie, it served as a means of emotional expression and artistic behavior and was used for spiritual education (*Gemütsbildung*). Progressive pedagogues such as Pestalozzi and Froebel discovered singing as a school subject that should be taught systematically and methodically. Countless "Singing Instructions" (*Gesangsbildungslehren*) were published between 1810 and 1850. One of them – Kübler's *Anleitung* (1826) – turned into Lowell Mason's

L. Bresler (Ed.), *International Handbook of Research in Arts Education*, 81–84.
© 2007 *Springer.*

*Manual of the Boston Academy of Music* (1834) and influenced American music education. In Germany, the most influential singing method book was that of Pfeiffer and Nägeli (1810) who claimed it to be based on Pestalozzian principles, which were then applied to singing lessons by many other educators. Interestingly, German speaking countries underwent a special development separated from other European countries. Whereas England and all Roman countries used solfège syllables as a teaching aid (which until now replaced the letter names for notes), German music teachers debated about the right method for singing instruction which focused on numerals instead of syllables. The most influential method with numerals in opposition to Pfeiffer and Naegeli was developed by Natorp (1813). Glover's Tonic-Solfa system first appeared in Germany in the outgoing nineteenth century and was introduced by Agnes Hundoegger (Tonika-Do, 1897/1925) and later as a means of the Kodály method.

Surprisingly a remarkable discrepancy appeared in Germany between the recognition of musical culture in society regarding the artistic quality of performances on the one hand, which is reflected by the activities of *Gesangvereine* and *Musikfeste* (music festivals) under the auspices of Zelter, Mendelssohn, or Schumann among others, and the desolate situation of music in public schools on the other hand, which has been reported by John Hullah (1880) and John Spencer Curwen (1901).

In Germany and other European countries, a progressive movement of education started at the beginning of the twentieth century with a new discovery of the child and its long neglected potential (Ellen Key, 1900; Maria Montessori, 1909/1969). Along with the philosophical innovations in arts education (*Kunsterziehungsbewegung*), in the arts (*Jugendstil*), as well as in many other domains of daily life the new philosophy of progressive education (*Reformpädagogik*) arose. Embedded in the embracing movement of *Jugendbewegung* (youth movement), the *Jugendmusikbewegung* (youth music movement) (see *Die Deutsche Jugendmusikbewegung* (1980)) and its charismatic leaders Fritz Jöde and Walther Hensel opened a new perspective for music education based on singing the "true" ancient folk-songs and early madrigals (*Singbewegung*) and active music-making opposed to passive listening to virtuous performances of professional musicians. The term *Musikant* characterized this new ideal of a musically active and creative dilettante. For these musicians a vocal and instrumental repertoire from the Renaissance up to the Baroque was newly edited and instruments of early music like the recorder, lute, fiddle, viola da gamba, etc. were re-introduced into musical practice because these instruments were seen as applicable to the technical skills of amateurs.

At the same time, a profound reform of the structure of music education in schools at all levels was initiated and installed in Prussia by Leo Kestenberg (see Gruhn, 2003). His reforms (*Kestenberg-Reform*) laid the ground for the basic principles of music education in Germany in the twentieth century (see Kestenberg, 1921). During the first decades of the twentieth century a very unique model of music education had been established, the so-called *Musische Erziehung*, which was based on integrated art activities (quadrivium of the Muses), but later transformed into *Nationalsozialistische Erziehung* (Krieck, 1935) which dominated the entire educational ideology in the Third Reich (Günther, 1992). The political implications of *Musische Bildung* during that period fostered the preference for the more neutral term of artistic or aesthetic education (*künstlerische Bildung*) and its anchoring in the school curriculum.

# References

Curwen, J. S. (1901). *School music abroad*. London: J. Curwen. Reprinted in J. Hullah and J. S. Curwen, *School music abroad 1879–1901*. Kilkenny: Boethius, 1984.

*Die Deutsche Jugendmusikbewegung* (1980). Archiv der Jugendmusikbewegung e.V. (Ed.), Wolfenbüttel: Möseler.

Gruhn, W. (2003). *Geschichte der Musikerziehung*. 2. erweiterte Auflage. Hofheim: Wolke.

Günther, U. (1992). *Die Schulmusikerziehung von der Kestenbergreform bis zum Ende des Drittes Reiches*, 2. Auflage. Augsburg: Wißner.

Hullah, J. (1880). *Report on musical instruction in elementary schools on the continent*. London: HMSO. Reprinted J. Hullah and J. S. Curwen, *School Music Abroad 1879–1901*. Kilkenny: Boethius, 1984.

Hundoegger, A. (1925). *Leitfaden der Tonika-Do-Lehre*. Hannover: Verlag der methodischen Schriften des Tonika-Do-Bundes. First edition 1897.

Kestenberg, L. (1921). *Musikerziehung und Musikpflege*. Leipzig: Quelle & Meyer.

Key, E. (1909). *The century of the child* [Barnets århundrade, 1900]. New York, London: Putnam's Sons.

Krieck, E. (1935). *Musische Erziehung*. Leipzig: Armanen Verlag.

Kübler, G. F. (1826). *Anleitung zum Gesang: Unterrichter in Schulen*. Stuttgart: Metzler'sche Buchhandlug.

Mason, L. (1834). *Manual of the boston academy of music for instruction in the elements of vocal music on the system of Pestalozzi*. Boston: J. H. Wilkins & R. B. Carter.

Montessori, M. (1969). *Die Entdeckung des Kindes* (*La scoperta del Bambino*, 1909). Freiburg: Herder.

Natorp, B. L. (1813). *Anleitung zur Unterweisung im Singen für Lehrer in Volksschulen*. Essen: Bädeker.

Pfeiffer, M. T., & Nägeli, H. G. (1810). *Gesangbildungslehre nach Pestalozzischen Grundsätzen*. Zürich: Nägeli.

# INTERNATIONAL COMMENTARY

# 5.2

# China

**Wai-Chung Ho**
*Hong Kong Baptist University, Hong Kong*

My commentary[1] on Gordon Cox's chapter will use China's music education as an illustration of (1) how traditional music education used music as moral discipline for encouraging people to conform to a virtuous life and (2) how modern Chinese music education has attempted to keep abreast with global sociopolitical changes. I will focus on how formal and informal music education has been shaped by social changes in the Chinese state.

Imperial China played a significant role in understanding musical knowledge as a sociopolitical discipline. Chinese emperors' adoption of the Confucian system to rationalize the hierarchical Chinese society[2] relied greatly on the discipline of moral education. The traditional social categories of Chinese music were categorized into three main kinds: "refined music" (*yayue* or "cultivated music," which was the formal or official music of the court and indigenous to the Han civilization[3]); "popular music" (*suyue* or "uncultivated music"); and "foreign music" (*huyue* or "barbarian music"). Because the Confucian social value of music stressed the bonds of kinship and social stability, "refined music," which implied the refinement of individuals, families, and society, was highly valued in the Imperial Chinese music education system. Music was regarded as a symbol of a good emperor and stable government. Confucius said, "If one should desire to know whether a kingdom is well governed, if its morals are good or bad, the quality of its music will furnish the answer" (Tame, 1986, p. 345). Thus, Confucians incorporated Chinese "refined" music (Yayue) into moral education. Music, together with ritual, was thought to provide a route to the achievement of an ideal life and an ideal state of mind (DeWoskin, 1982; Wang, 2004). Music and rites were viewed as pathways to human perfection, bringing human beings together with cosmic harmonies.

During the later nineteenth century, owing to military defeats by the West and Japan, China began to take an interest in Western music, and Chinese musicians were sent to Japan, America, and France. However, after China's military defeat by Western countries and Japan, protest songs were composed and promoted as antiforeign propaganda. In 1929, Mao Zedong, founder of the People's Republic of China (PRC), called

*L. Bresler (Ed.), International Handbook of Research in Arts Education*, 85–88.
© 2007 *Springer.*

for the formal inclusion of revolutionary songs in training programs for cadres and sol-
diers, and a committee was established to "produce appropriate songs" (Wong, 1984,
pp. 121–122). These protest songs, with Chinese texts, were mostly copied from
Russian tunes. The growth of nationalism in music education in Mainland China was
further reinforced by military invasions by foreign countries in World War II. During
the eight-year war against Japan (1937–1945) and the 4-year Civil War (1945–1949),
antiwar and patriotic songs were encouraged and used as teaching materials. From the
early 1960s, the PRC government also encouraged amateurs, such as factory workers,
peasants, soldiers, and students to compose their own songs in accordance with Mao's
"mass-line" theory. The musical fanfare which opened the Cultural Revolution
(1966–1976) – "The East is Red" – was a traditional Chinese folk tune with new lyrics
extolling Mao Zedong and the Communist regime. This song, which became the
movement's anthem (Kraus, 1989), "deified" Chairman Mao as the sun in heaven.
Because of its associations with the Cultural Revolution, the song has been rarely
heard after Deng Xiaoping's Open-door policy of the late 1970s, and has largely been
replaced by the "March of the Volunteers," which mentions neither the Communist
Party or Mao Zedong.

The sociopolitical transformation of China and its shift toward market economics in the
1980s set the tone for a new era that contrasts astonishingly with the past. However, the
Chinese state still promotes traditional Confucian respect for school songs, and grounds
education on traditional Chinese values and cultures to fill the moral "ideological vac-
uum" created by the promotion of *laissez-faire* market forces (Ho & Law, 2004; Law,
1998). Recently the Shanghai Municipal Education Commission compiled a list of 100
patriotic songs for middle school students, including Andy Lau's (a Hong Kong popular
artist) "The Chinaman," and Jay Chow's (a Taiwanese popular artist) "Snails." This list has
inflamed a heated debate about how patriotic education should be conducted. In particu-
lar, the song "Snails" has sparked controversy about whether it encourages individualism
rather than dedication to society. Since the Chinese state's policy of opening up to the out-
side world, marked particularly by its entry into the World Trade Organisation (WTO) and
successful bid for the 2008 Olympics, multiculturalism has been introduced into the
school music curriculum (Ministry of Education, 2001). Now, besides learning traditional
Chinese music, students are encouraged to have a broader sense of aesthetics and a greater
respect for other countries through learning about the rich diversity of the musical cultures
of the world (Ministry of Education, 2001).

Research into the history of music education acknowledges that teaching and learn-
ing music is politically and socially constructed. However, compared with the western
hemisphere, the power of the Chinese state is comparatively dominant over the other
three educational agencies of family, church, and school. This chapter tells us pointedly
that research into music education is needed that links national cultural contexts and cit-
izens' and pupils' developing identities (social and learning) so as to better understand
educational change in relation to the political, social, economic, and cultural challenges
of the twenty first century. Further research in the history of music education should
strike a balance between academic work and its practical application. We are looking for
not only an account of the changes in music education in different parts of the globe, but
also for a stimulating analysis and interpretation of these changes.

# Notes

1. My notes are drawn from my previous publications (see Ho, 2003, 2004; Ho & Law, 2004) and structured on Dr. Cox's chapter on the dynamics of the sociopolitical and historical development of music education with particular reference to China.
2. The distribution of power among people in Imperial China was reflected in five pairs of human relationships: between sovereign and subject, father and son, elder and younger, husband and wife, and between friends. The first-pair relation was dynastic; the last was social; whilst the other three were familial. The only nonhierarchical interaction was between all citizens that Confucius called "friends."
3. The Chinese often called themselves *Han* Ren (or "Men of the Han"), after a famous dynasty of that name, that is, Han Dynasty (206 B.C.–A.D. 200). The Han Chinese comprise 92 percent of the population of China. Over a period of 2000 years, Confucianism has held a place at the center of the traditional Han family. Han civilization developed in the eastern side of China: mostly located at the lower Yellow River, lower Yangzi River, and the coastal regions of the southern part of the country.

# References

DeWoskin, K. J. (1982). *A song for one or two: Music and the concept of art in early China*. Ann Arbor: Center for Chinese Studies, The University of Michigan.

Ho, W. C. (2003). Westernization and social transformations in Chinese music education, 1895–1949. *History of Education, 32*(3), 289–301.

Ho, W. C. (2004). A comparative study of music education in Shanghai and Taipei: westernisation and nationalization. *Compare, 34*(2), 231–249.

Ho, W. C., & Law, W. W. (2004). Values, music and education in China. *Music Education Research, 6*(2), 149–167.

Kraus, R. C. (1989). *Pianos and politics in China: Middle-class ambitions and the struggle over western music*. New York: Oxford University Press.

Law, W. W. (1998). Education in the People's Republic of China since 1978: Emergency of new actors and intensification of conflicts. In J. Y. S. Cheng (Ed.), *China in the post-Deng era* (pp. 559–588). Hong Kong: The Chinese University Press.

Ministry of Education, the People's Republic of China (2001). *Yinyue Kecheung Biaozhun* (Standard of Music Curriculum). Beijing: Normal University Publishing Company.

Tame, D. (1986). *The secret power of music: The transformation of self and society through musical energy*. New York: Destiny Books.

Wang, Y. W. (2004). The ethical power of music: Ancient Greek and Chinese thoughts. *Journal of Aesthetic Education, 38*(1), 89–104.

Wong, I. K. F. (1984) Geming Gequ: Songs for the education of the masses. In B. S. McDougall (Ed.), *Popular Chinese literature and performing* (pp. 112–143). London: University of California.

# INTERNATIONAL COMMENTARY

# 5.3

# Japan

**Koji Matsunobu**
*University of Illinois at Urbana-Champaign, U.S.A.*

In Japan music education traditionally involves life-long learning and practice in homes, temples, and shrines, as well as in master-apprentice settings, for religious, moral, cultural, and social functions. Although musical transmission of values in each of these settings is significant and needs further investigation, studies have exclusively dealt with music teaching and learning as part of formal school education.

Since its inception in the late nineteenth century, Japanese school music education has chiefly focused on disseminating Western musical values while excluding Japanese traditional music and its indigenous values (Imada, 2000; Ogawa, 2000). Until recently, many Japanese music educators have exclusively taught Western music and Western-style Japanese songs, a phenomenon that is often observed in colonized countries. In a sense, this Westernization of and through music, with its emphasis on the moral cultivation of students, has been viewed as a means for the Meiji Restoration Government to strengthen the nation's wealth and its military against the great world powers of the time (Yamazumi, 1967). Indeed, school music education played an important role in unifying the nation and establishing the Japanese nationalistic identity (Nishijima, 1994). Outside of Japan, however, school music was used by the Japanese government during the period of Japanese occupation as a means for controlling the Asian colonies by supplanting their indigenous values with Japanese values (see Liou, 2005, for a Taiwanese case; Park, 1994, for a Korean case).

The Westernization of and through music is also interpreted in part as a result of Christian missionary efforts to spread Christianity through the newly created Japanese songs in the hymn style, called *shoka*, intended solely for use in school music education. Although this religious conversion was largely unsuccessful, a series of the shoka has, with the support of the Japanese government, formed the main repertoire of the nation's school music. What was unique about this hybrid music was its continued popularity throughout Japan (Yasuda, 1993), although its acceptance and assimilation into Japanese schools was the consequence of a gradual negotiation between indigenous Japanese epistemology and Western values, which often conflicted with each

89

*L. Bresler (Ed.), International Handbook of Research in Arts Education, 89–90.*
© 2007 *Springer.*

other (Hashimoto, 2003; Imada, 2003). The end product of this form of musical colonization was a fertile ground for new seeds of talent, sensitivity, and creativity, along with the indigenous values. However, the past few decades have seen Japanese music educators becoming more concerned with their unbalanced inclination toward Western music and hence, instigated a reformation of their school music curriculum, pedagogy, and cultural identity (Imada, 2000).

# References

Hashimoto, M. (2003). Japan's struggle for the formation of modern elementary school curriculum: Westernization and hiding cultural dualism in the late 19th century. In W. F. Pinar (Ed.), *International handbook of curriculum research*. London: Lawrence Erlbaum Associates.

Imada, T. (2000). Postmodernity and Japan's music education: An external perspective. *Research Studies in Music Education, 15*, 15–23.

Imada, T. (2003). Traditional Japanese views of music. *Journal of the Indian Musicological Society, 34*, 64–74.

Liou, L. (2005). *Shokuminchika no Taiwan ni okeru gakko shoka kyoiku no seiritsu to tenkai* [The development and pervasion of shoka music education in colonized Taiwan]. Tokyo: Yuzankaku.

Nishijima, H. (1994). *Gakko ongaku no kokumin togo kino: Nashonaru aidentiti to shite no "kantori ishiki" no kakuritsu o chushin to shite* [The functions of music education in school in the national integration: Focusing on "country consciousness" as the national identity]. *Tokyo daigaku kyoiku gakubu kiyo, 34*, 173–184.

Ogawa, M. (2000). *Early nineteenth century American influences on the beginning of Japanese public music education: An analysis and comparison of selected music textbooks published in Japan and the United States*. Unpublished doctoral dissertation, Indiana University, Bloomington.

Park, S. (1994). *Kankoku kindai ongaku kyoikushi ni okeru "aikoku shoka kyoiku undo" no igi* [The role of "the Patriotic Songs Educational Movement" in the history of modern musical education in Korea: Against the background of the Japanese policy of music education in Korea]. *Ongaku Kyoikugaku, 24*(2), 37–50.

Yamazumi, M. (1967). *Shoka kyoiku seiritsu katei no kenkyu* [A study on the development of shoka education]. Tokyo: Tokyo daigaku shuppankai.

Yasuda, H. (1993). *Shoka to jujika: Meiji ongaku kotohajime* [Shoka and the crucifix: The beginning of music education in Meiji]. Tokyo: Ongaku no Tomosha.

# INTERNATIONAL COMMENTARY

# 5.4

# Turkey

**H. Seval Köse**
*Suleyman Demirel University, Turkey*

Music was one of the cultural, artistic, and educational fields which were deemed to be significant for social development in the early times of the Turkish Republic in the early twentieth century. Therefore, training music teachers also became one of the priorities to be accomplished in line with the new Republican reforms. These points make the history of Turkish Music Education worth exploring.

The establishment of Musiki Muallim Mektebi (i.e., School of Music Teacher Training; hereinafter referred to as MMM) in 1924 was an indicator of how important music education was for the founders of the Turkish Republic. Since music courses were run only by the musicians trained in the Ottoman palaces until the establishment of MMM, proper training for music teachers became a dire necessity.

MMM which was established to respond to the need for training music teachers is thus still an important source of inspiration for academic discussions about music education. "It has both direct and indirect historical motives for training music teachers in Turkey; and it is closely related to the occurrence, development and spread of the polyphonic music culture in Turkey" (Uçan, 2004, p.11).

MMM was established to train music teachers for secondary schools, high schools, and schools of music. The first founding regulation of MMM was put into force in 1925, and it indirectly envisaged the training of music teachers for primary schools. This regulation also required a four-year training course for the would-be teachers. After a while, the four-year-training period was increased to five years.

The first three years of the training process were devoted to education, while the students were required to have sufficient school experience in the final year. The founding directive (1925) involved the following courses: (1) music courses such as Theory of Music, Harmony, Composition, Counterpoint, History of Music, Vocal; (2) general and cultural courses such as Turkish, Literature, History, Geography, Psychology, German, Math. Violin, piano, flute, and violoncello were the instruments required for instrumental training; and it was compulsory for the trainees to choose one of those instruments.

*L. Bresler (Ed.), International Handbook of Research in Arts Education*, 91–92.
© 2007 *Springer.*

The regulation was also put into force for higher education in 1934, and it was considered legally valid for the Academy of National Music (i.e., Milli Musiki ve Temsil Akademisi). In 1936, the scope of music education was expanded by the establishment of conservatories. These important steps were taken with the help of the foreign music experts such as Paul Hindemith and Eduard Zuckmayer.

MMM was restructured as a "music department" in Gazi Orta Öğretmen Okulu ve Terbiye Enstitüsü (i.e., Gazi School of Music and Institute of Teacher Training) in 1937. Being compulsory for the prospective music teachers who completed the secondary-school training, this department provided a three-year-higher education. The restructuring program also enabled the students to go abroad for education and to work as an assistant after graduation. Meanwhile, Hasanoglan Yuksek Koy Enstitutusu (i.e., Hasanoglan Village Institute) was set up in 1942 in order to train music teachers to work in music institutes; however, that institute was closed down in 1947.

In 1974, the new restructuring program for the music department at Gazi Education Institute envisaged a four-year-training process for the prospective music teachers. The new four-year-undergraduate program was carried out in İstanbul, İzmir, Bursa, and some other cities.

The four-year higher education programs which were first supervised by the Ministry of National Education were later structured as university programs and then restructured as music education departments within the faculties of education. In 1990, for the first time, a university department, that is, School of Music in the Faculty of Education at Gazi University, taught courses such as Theories of Music Education, Vocal Education, and Instrumental Training. The faculty members were expected to develop expertise in specific fields.

However, that program was abolished by the Higher Education Board (hereinafter referred to as YÖK); and it became impossible for the music instructors to maintain expertise only in specific fields. YÖK's new restructuring program attached a scientific status to music education organised as a branch of fine arts.

This program still functions today. There are various points of view with regard to music education and teacher training programs. These different approaches focus on modernizing the process and quality of training the would-be teachers. Their priorities are continuously shaped and reshaped in line with national expectations and needs, as well as international planning and implementation.

# Reference

Uçan, A. (2004). "Türkiye" de Başlangıcından Günümüze Müzik Öğretmeni Yetiştirmeye Genel Bir Bakış' in *1924–2004 Musiki Muallim Mektebi' nden Günümüze Müzik Öğretmeni Yetiştirme Sempozyumu*, Isparta: Süleyman Demirel Üniversitesi Burdur Eğitim Fakültesi.

# INTERNATIONAL COMMENTARY

## 5.5

## Scandinavia

**Eiliv Olsen**

*Bergen University College, Norway*

Historically, Scandinavia did not have an extensive aristocracy compared to many other European countries. Hence, there is not much documentation of music teaching and learning in medieval aristocratic family life in Scandinavia (some can be found in *The Cambridge History of Scandinavia* 2003, pp. 550–555). Much more common was, especially in Norway and Sweden, folk music learned in apprenticeship in rural districts (Stubseid, 1992). But musical life in Scandinavian bourgeoisie families was in many ways similar to the description in Cox's chapter (Öhrström, 1987). In Sweden and Denmark, there were musical institutions in many towns in the 1800s (Ahlbäck, 1998).

In Norway, Sweden, and Denmark, learning music in the Lutheran church historically has been linked to choir boys singing in the great cathedrals (Fæhn, 1994). In rural districts of Norway, where pietism often dominated church life, the hymn melodies were often locally "translated" and learnt in a mentor-apprentice setting, as in other folk music. Today, the Ten Sing movement has become very popular in many congregations.

Music in Scandinavian compulsory schools was from the beginning focused on the singing of hymns by rote. During the nineteenth century, the singing of national songs and hymns became important in the upbringing of children, due to nationalistic trends, especially in Norway where the political struggle to reach autonomy was quite strong (Dahl, 1959; Johnsson, 1973; Jørgensen, 1982; Nielsen, 1998; Varkøy, 1993; Vea and Leren, 1972). Today, music curricula in many Scandinavian compulsory schools may be said to have a "praxial" profile.

The "folkehøjskole" for adolescents, a free school originally founded by the Danish poet and clergyman N.F.S. Grundtvig (1783–1872), as an alternative to the more theoretical "latin school," has become very popular, and many of these schools offer a lot of musical activities. Most Scandinavian municipalities have music schools, important alternatives to music learning in compulsory schools (Gustafsson, 2000; Olsson, 1993; Persson, 2001). In 1997, the Norwegian government decided by law that every municipality shall have its own music or culture school.

*L. Bresler (Ed.), International Handbook of Research in Arts Education, 93–94.*
© 2007 *Springer.*

In Norway, there is a unique tradition of brass or wind bands ("school bands") in compulsory schools. Many children have been introduced to music through playing in such bands which have a central role in the celebration of Norway's National Day.

# References

*Historical references*

*General:*
de Geer, I. (2003). Music. In: Knut Helle (Ed.,) *The Cambridge history of Scandinavia*. Cambridge: Cambridge University Press.

*Denmark:*
Johnsson, B. (1973). *Den danske skolemusiks historie indtil 1793*. København: Gads forlag.

*Norway:*
Dahl, H. (1959). *Norsk lærerutdanning fra 1814 til i dag*. Oslo: Universitetsforlaget.
Fæhn, H. (1994). *Gudstjenestelivet i den norske kirke*. Oslo.
Stubseid, G. (1992). *Frå spelemannslære til akademi*. Bergen: Forlaget Folkekultur.
Vea, K., & Leren, O. (1972). *Musikkpedagogisk grunnbok*. Oslo: Norsk Musikforlag.

*Sweden:*
Ahlbäck, B. (1998). *Musikdirektör Anders Sidner. Musikundervisning och musikliv i skolstaden Härnösand 1840–1870*. Stockholm: KMH Förlaget.
Gustafsson, J. (2000). *Så ska det låta. Studier av det musikpedagogiske fältets framväxt i Sverige 1900–1965*. Uppsala: Acta Universitatis Upsaliensis.
Öhrström, E. (1987). *Borgerlige kvinnors musicerande i 1800-talets Sverige*. Göteborgs Universitet.

*Contemporary References*

*Denmark:*
Nielsen, F.V. (1998). *Almen musikdidaktik* København: Akademisk forlag.

*Norway:*
Jørgensen, H. (1982). *Sang og musikk. Et fags utvikling i grunnskolen fra 1945 til 1980*. Oslo: H. Aschehoug & Co.
Varkøy, Ø. (1993). *Hvorfor musikk? – en musikkpedagogisk idéhistorie*. Oslo: ad Notam, Gyldendal.

*Sweden:*
Olsson, B. (1993). *SÄMUS – en musikutbildning i kulturpolitikens tjänst?* Göteborg: Novum.
Persson, T. (2001). *Den kommunala musikskolans framväxt och turbulenta 90-tal*. Göteborgs Universitet nr. 68.

INTERLUDE

6

# HISTORY LOOKING FORWARD

**Richard Colwell**
*University of Illinois, U.S.A.*

I've always been interested in history; as an undergraduate I took a sufficient number of classes that history slipped in as one of my teaching minors. American history was not chronologically distant, my grandfather was an immigrant, one of the founders of Scotland, S. D. had an acquaintance with the American Indian Chief, Sitting Bull. I can think of few reasons for this interest in academic history; I was an undergraduate pre-med major at the time. In retrospect, however, I realize that my identity was influenced and enlarged by my connection with the history of my country. When I became a music major, I found that the history of music was a core course along with music theory and I applied to Harvard in musicology only to be discouraged by my advisor with employment data in that field. In graduate school, my interest narrowed to the teaching and learning of music and I was introduced to education and music education, neither of which seemed to cherish its history. I felt lost: What was my professional identity to be? Where the history of music is a rich and fascinating field with multiple niches and crannies to explore – styles, genres, individuals, ethnicities, and more, but little attention has been paid by musicologists to pedagogy. Music researchers have documented the private teachers, the home environment, and the chance encounters that influenced seminal figures in music but history reveals no unfolding pattern of "music education."

Teaching and learning have a lengthy existence but music education is a recent discipline (if it is one) and remains vaguely defined. Outstanding teachers of music are seemingly randomly distributed in history with no geographic or philosophical identity. Without a proud history, I find it difficult to have an identity as a music educator. Does one identify with the great trumpet, composition, and conducting teachers or with the local folk musicians? The difference between excellence in musical performance and excellence in music pedagogy further confuses the picture.

As a graduate student, I began the search for identity as a music educator. In medicine, one learns of new procedures and drugs and even about changes in education that have resulted from the evaluation of medical education; that is, that conducted by Abraham

*L. Bresler (Ed.), International Handbook of Research in Arts Education*, 95–102.
© 2007 *Springer.*

Fechner in the early twentieth century. In reading about progress in medicine, one also obtains a sense of the problems that remain to be solved and a sense of pride at the great accomplishments of the field. History of any profession is built upon a record of research *and* experience and I needed to know the status, progress, and challenges of music education. The most promising areas of investigation for a scholarly history of music education seemed to me to be (1) events in K-12, (2) events in teacher education, (3) events in research and evaluation, or (4) events in the K-16 curricula that might have influenced teaching and learning.

The first topic, the history of school music K-12 offers an infertile field in which to build an identity. Books authored by historians of education in the United States seldom mention the existence or absence of music in the curriculum. Music education has been recognized by educators only when an external agency has supported a short-term curricular intervention. Chronologies written exclusively about music education tend to highlight the work of Lowell Mason in Boston around 1837 (whose interest in the public schools was likely related to his publications), and then fast-forward to the founding of the Music Supervisors National Conference at the beginning of the twentieth century, this founding likely being a protest movement at the short shrift being given to music by the National Education Association at its annual meetings. The thin gruel that constitutes a possible identity provides the names of a few music supervisors who made such gains as academic credit for music, funds to support their programs, and additional class time, as well as those conductors who developed truly outstanding secondary school ensembles; for example, the first oboist of the New York Philharmonic, Joseph Robinson, names his high school band director, Captain Harper, in Lenoir, N.C. as the most influential teacher in his life. It remains unclear how, or if, research or the success of individual teachers gradually or suddenly improved the teaching and learning of music in the schools in a century or more of existence. There is historical evidence that in elementary school in the 1930s and 1940s public school students could read music and sing 3 and 4 part music and could recognize the compositions of a select number of the major composers. Numerous ensembles were equal to, if not better than, ensembles in today's schools. The Joliet Grade School Band of the 1950s remains a model of excellence and I can recall being excited and moved by its performance of the third movement of Schakowsky's Sixth Symphony. Recently an effort was made to release recordings of William Revelli's high school band in Hobart, Indiana and, with the first release, his University of Michigan band's recording was confused with that of the Hobart high school ensemble. In addition to these gifted teachers (whose own education follows no pattern, certainly not in music education) some K-12 music programs have been influenced by the work of internationalists, Sinichi Suzuki, Carl, Orff, and Zoltán Kodály. The extent of this influence is difficult to document as one cannot say that America has more and better school orchestras as a result of the ideas of Suzuki or that students sing better because of the influence of Orff or Kodály. Because of dissatisfaction with the scope and quality of K-12 music, various philanthropic foundations (Ford, Rockefeller, and others) have sponsored dazzling interventions that had little or no long-term effect on teaching and learning or music education as a profession. The reasons or causes for any lack of progress in K-12 education may be due to the fast-changing American society and the lack of

importance given to music by professional educators. The history of K-12 (or at least K-8) seems to be one of waging a slow retreat while building a defense of present practices and positions.

Topic number two, the history of teacher education in music, however, should be different from that of music K-12 and offer areas of research and innovative practice, being as it is the responsibility of professionals in the field. This is topic number two, and I shall also touch upon topics three and four here.

An early research grant allowed me to travel to the major libraries in search of documentation of the history of music teacher education. What I found was logical but somewhat unexpected. The history of music education actually centers on the role of the classroom teacher. It was the classroom teacher who was expected to be competent in music education; one certification requirement was passing examinations in music. Early on, each school district administered its own examinations, but the administration and control gradually passed to the state, allowing teachers to be state rather than locally certified. These examinations included no performance of any kind but were quite rigorous with respect to music fundamentals and this emphasis explains why, in turn, teachers taught the students in detail the fundamentals of music. For the specialist, the music teacher, there is less systematic history; until the 1920s, performers from the Sousa band and similar ensembles were welcomed into the schools as certified teachers. The practice of accepting performing experience over formal schooling continued in some states until the 1950s. Neither my high school band nor orchestra director had a degree in music or music education. Looking at thousands of student and teacher examinations spurred my interest in the history of evaluation in field of music (topic 3), as these examinations helped shape the direction and scope of music education.

Surprisingly, music teacher education in the first half of the twentieth century didn't change substantially even though the scope of the discipline had broadened considerably and music specialists were given more responsibility for student learning, K-12. There was limited research in music education as few problems were identified. The bureaucratic machinery involved with certification became the dominant force in music teacher preparation. (Changes in this preparation have almost always required music education students to have experiences similar to those of students in a college of education.) This bland, standardized, approach to teacher education encompassed all music education students, whether their interests were early childhood education or the high school orchestra; hence students didn't know whether to think of themselves as musicians or as music educators. The teaching and learning of music through private lessons remains a common mode of instruction, one seldom associated with music education. More about this situation later. Suffice it to say, however, that with respect to undergraduates, identity issues continue in the twenty first century.

Armed with another research grant I took a deeper look at music teacher education. Inspired teachers, including music teachers, seemed to have been at Teachers College in the 1940s and 1950s. Teachers College was a center of progressivism, emphasizing the ideas and philosophy of John Dewey who was professor emeritus in residence until 1939 (and around until 1952). Teachers College had inspiring professors (such as Harold Rugg, John Childs, William Kilpatrick) whose philosophy happened to align with the ideas of some terrific musicians on the faculty: James Mursell, Howard

Murphy, Gladys Tipton, Raymond Burroughs, Peter Dykema, and Harry Robert Wilson. Mursell, a well-respected psychologist, forcefully decried the overemphasis on the mechanics of music that occluded the important outcomes of music, the ability to appreciate its expressiveness.

The education faculty at Teachers College saw in music education a teaching-learning situation that exemplified Dewey's ideas: the *process* of learning was important and the goals *long term*, extending beyond the secondary school. One conjecture of mine is that *Art as Experience*, one of Dewey's last books, resulted when Dewey recognized that it was in arts education that his ideas were practiced. A second conjecture is that Dewey found music education where in education generally, subject matter scholars found Dewey. For the music researcher, one problem that arose with respect to cognitive psychology is that students who learn with an emphasis on "doing" (performing) are taught that the doing is to become as automatic or instinctual as possible. Automaticity with all of its benefits for enhancing performance is not necessarily mindful doing. One can perform and listen with the mind in neutral. It was difficult for me to probe the relationships that existed at Teachers College at this period, including the role of the Dalton School, but there must have been a feeling of equality between the music and education faculties. All of the fine musicians on the faculty were pleased to be identified as music educators – the merging of psychology, music theory, and performance by this faculty established for the first time an educational program where the graduates welcomed their identity as music educators. One has to assume that it was leaders in *education* at Teachers College who recognized the importance of music (and the arts) and supported this strong and cohesive faculty.

A second fortuitous alignment between education and music occurred at the University of Illinois in the 1960s and 1970s and here I can speak more confidently of a situation where students and faculty could identify with and be respected as a music educator. Alonzo Grace, who had been high commissioner for education in postwar Germany became the dean of the College of Education and began to assemble a faculty of scholars who were comfortable with their subject matter disciplines and yet interested in the process of transmitting knowledge, skill, and more in their disciplines. In this atmosphere, all subjects were of equal importance and each was seen as having a basis for scholarship, for research, and for innovation. A science educator, Will Burnett who had worked in industry and taught at Stanford, was chairman of the secondary education department. He offered unqualified support for the founding of the Council of Research in Music Education as its goal was the upgrading of research scholarship in music education. Somewhat later, he supported the initiation of *Visual Arts Research*, a journal patterned after the *Bulletin*. Inspired by a U.S. Office of Education funded research project, arts education philosopher Ralph Smith obtained support from the College of Education to found the *Journal of Aesthetic Education*. Three journals in arts education research initiated within a short period of time within the College of Education is remarkable.

The support for music education as an important discipline permeated all areas of the College and influenced graduate students in music education as well as the faculty. This breadth was important as all music education graduate students, regardless of interest, could identify with one or more subject matter education researchers. Max Beberman,

a math educator, was developing at this time his version of new math at University High School and he welcomed and supported my ideas about curriculum innovation in the arts and with Ned Levy in theater and Laura Chapman in visual arts, we were encouraged to explore and innovate with University high school students as our subjects. When music educators wondered about the importance of evaluation and testing in the arts, Lee Cronbach, Gene Glass, Bob Linn, Bob Stake, Ernie House, and Tom Hastings offered support and advice. Charles Osgood suggested exploratory studies with his semantic differential and Barak Rosenshine cooperated on research on direct instruction applicable to the teaching of musical skills. Formal curriculum work was supported by Ian Westbury while the National Reading Center under the leadership of Dick Anderson encouraged exploration of the relationship of music reading to new reading strategies. Ken Travers, conducting TIMSS evaluation studies in math education, encouraged us to think about cross-cultural issues. The list is long and included philosophers Harry Broudy, Foster McMurray, Joe Burnett, and B. Othanel Smith and administration specialists Tom Sergiovani, James Raths, Tom McGreal, and Joe Murphy, augmented by Dean J. Myron Atkin. Lillian Katz in early childhood education was a regular performer in a string quartet and, in educational psychology, J. McVicker Hunt assisted Marilyn Pflederer Zimmerman with her research on Piaget. For those interested in giftedness James Gallagher was a willing colleague as was Alan Knox in adult and continuing education. One result of this interest was the sponsorship by the College of Education of a campus-wide conference on the role of aesthetic education.

The idea that music *education* could be important seeped into the School of Music and influenced to varying extents the string education research of Paul Rolland, the interest in Zoltan Kodaly as a music educator by the musicologist Alexander Ringer, and an appraisal of teaching and learning in music by Claude Palisca, all Illinois faculty members.

What was the commonality between Teachers College and Illinois, two places where the music educator had a substantive identity during an almost 30-year period in history? At Illinois, and presumably at Teachers College, the education faculty continued to explore (research and write) in their own subject matter discipline as well as offering suggestions for teaching. No subject had priority on resources. I was unable to document the administrative support for music at Teachers College around the time of WWII but concert pianist Lawrence Cremin, who later became president of Teachers College, assured me it was substantial.

The Illinois College of Education faculty at the time I describe was a congeries of faculty members who were comfortable as focused scholars in their own discipline but with a serious interest in teaching and learning, and willing to be identified as an education faculty member. Their standards were high for themselves and their students; no apologies were necessary for being a science, a math, or a music educator, or being a psychologist or philosopher with a commitment to education. Similarly, John Dewey's affiliation with Teachers College did not lessen his competence or reputation as an American philosopher.

As a student and faculty member at Illinois, I was initially unaware that excellence in music education was predicated upon the importance of scholarship in both a college of education and a school of music. Music education was valued both by a College of

Education and by a School of Music. Without this early experience and an opportunity through funded research to make this historical comparison, it is not likely that the opportunity would have arisen for a *Handbook of Research on Music Teaching and Learning* or that Gordon Cawelti of ASCD would recognize that research in the arts was of equal importance to teachers as that identified by Doug Grouws in math, James Shavelson in social studies and Jim Squire in language arts. (*Handbook of Research on Improving Student Achievement, 3rd edition*, 2004.)

Around 1980, this historically important relationship between education and music changed in the United States and the role of colleges of education in the preparation of music teachers and as supporters of music education decreased. Colleges of education focused on internal issues and elected to minimize their role in subject matter disciplines. Schools of music assumed more responsibility for music education and thus transformed music education's status and identity. Without cooperative ventures, the discipline is open to criticisms as those cited by Hersh and Merrow (2005, pp. 54–55) where "An undergraduate can meet the math requirement at the University of Illinois, for instance, with a course called "Principles and Techniques in Music Education" and the English composition requirement at Nebraska with a course in "instructional Television" …" As Larry Cuban (2004, p. 104) reports, confusion arose between policy talk and policy action in Colleges of Education. No such confusion existed at Illinois when the policy talk of such eminent educators as Max Beberman, Lillian Katz, and Merle Karnes was implemented on a daily basis. Each of them was skeptical of long-term lesson planning. Max Beberman argued that it was not possible to plan more than a day in advance as he needed to plan any innovation based upon student reactions to the previous day's instruction. The focus of these education faculty members was not on what teachers are doing [as Mary Kennedy (2005, p. 54) has insightfully described] but on what teachers *should* be doing. Kennedy's careful study of teachers found that "no teacher indicated a specific intention to ensure that the content they taught was *inherently* (italics in the original) important. Instead, for teachers, content was important because it would be on a test, because it was in curriculum guidelines, or because the teacher at the next grade level would expect students to know it." Intellectual engagement with a subject was only a topic of minor importance to Kennedy's sample of competent teachers (p. 54) – engagement yes, intellectual engagement, probably not. I cite Kennedy and Cuban to indicate a historical change in the focus within Colleges of Education and to indicate issues of identity in music education. There is a limited role in a college of education for a music scholar interested in teaching and learning, for example, there has not been a chapter on music education in any of the four handbooks published by AERA on research on teaching. Within Schools of Music, the emphasis is on performance and there does not seem to be a continuation of interest in education as exemplified by Illinois School of Music faculty such as musicologist Alexander Ringer who took teachers to Hungary to study Kodály, or musicologist Claude Palisca who organized the Yale Seminar on contemporary music in the schools.

The history of music education during the past 25 years is not one of decline: high school music ensembles remain valued and competent musical organizations. High school graduates are technically proficient and equipped to continue the study of

music. It is not that teacher education in music has substantially changed; only that the promising model established by Teachers College and continued at the University of Illinois did not take root elsewhere, and disappeared. Without meaningful acceptance of music by educators, competent music educators will identify themselves as performers and not as the local music teacher in the school.

The history of music education in the public schools and in teacher education does provide an important insight. The discipline of music does not need the discipline of music education – music was taught successfully for centuries and continues to be well-taught by individuals not trained in music education. Education, however, requires that music be part of any thoughtful curriculum. Without arguing for what constitutes a complete education or what enables an individual to have a full life – an argument that has been well-articulated in all societies – it appears that the responsibility for ensuring that music be provided to students lies within the discipline of education with the most obvious responsibility falling to Colleges of Education and their support for music teacher education.

# References

Cuban, L. (2004). *The blackboard and the bottom line: Why schools can't be businesses*. Cambridge: Harvard University Press.

Hersh, R. H., & Merrow, J. (Eds.). (2005). *Declining by degrees*. New York: Palgrave Macmillan.

Kennedy, M. M. (2005). *Inside teaching: How classroom life undermines reform*. Cambridge: Harvard University Press.

# 7

# SOCIAL HISTORY AND DANCE AS EDUCATION

**Ann Dils**

*University of North Carolina at Greensboro, U.S.A.*

In Thomas Hagood's *A History of Dance in Higher Education* (2000) it is emphasized that dance must meet the "charge of the academy" (p. 116): to "push back the boundaries of knowledge, forward the cultural legacy, and contribute to society" (p. 319). Anyone who attends dance education conferences or works in a dance department is familiar with questions that underlie Hagood's remark: Why teach dance in a university or in public education? How does dancing further the greater good? How can dance be considered research or to increase knowledge? In my recent reading of histories of dance education, I was struck by the contribution that contemporary historians make to thinking about dance as education. To a field that is obsessed with drawing up standards and proving worth, historians of dance education, particularly social historians of dance education, lend information about the impact of the moving body in the social sphere, as dancers form and reform schools and dance organizations, shape ideas about the body, dancing, and education, and transform the ways people are seen and understood.

In this chapter, I develop a short summary of dance education in American public schools and colleges and universities, derived entirely from existing literature. I also discuss the current state of historical writing in dance education and project some ideas for future research. (One obvious deficit in the literature will be clear in my summary: that histories of dance education have been limited to the experiences of European immigrants to the United States.) As a conclusion, I return to the perspectives that historians bring to understanding dance as education. The writings I cite and discuss include Nancy Lee Chalfa Ruyter's *Reformers and Visionaries: The Americanization of the Art of Dance* (1979), Ruyter's entry in the *International Encyclopedia of Dance* (1998), Hagood's *A History of Dance in Higher Education* (2000), Janice Ross's *Moving Lessons: Margaret H'Doubler and the Beginning of Dance in American Education* (2000), and Linda J. Tomko's *Dancing Class: Gender, Ethnicity, and Social Divides in American Dance, 1890–1920* (1999). I also include information found on Websites of dance organizations, universities, and databases.

*L. Bresler (Ed.), International Handbook of Research in Arts Education, 103–112.*
© 2007 *Springer.*

## Dance Education in United States Public and University Education

Ruyter (1979, 1998) first discusses social dance education, and then the development of dance as physical education.[1] She points out that social dancing was an important element of upper-class life in the 1700s and, while practiced everywhere in the colonies, was especially important for the families of Southern planters.[2] Strict dancing masters and the precise, patterned dances of the period instilled an appreciation for order and good manners in young people, both necessary to function in society. European dance treatises such as John Playford's *The English Dancing Master* (published in many editions around 1700) and Pierre Rameau's *The Dancing Master* (translated into English by John Essex and published in 1728) were brought to America, although Ruyter notes that the role these texts played in dance education is not clear. Social dancing remained important to upper-class families throughout the 1800s. By the end of the 1900s, social dance teaching was an established profession whose members wrote books, edited magazines, and founded organizations such as the 1879 American Society of Professors of Dancing.[3]

Ruyter next moves to the importation of German and Swedish gymnastics to the United States. German immigrants brought Jahn gymnastics, a form of exercise done to music that combined work with different kinds of apparatus, calisthenics, and games, to the United States in the 1800s. Jahn gymnastics was practiced in *Turnvereine*, gymnastic clubs popular with immigrants, and then practiced more widely in gymnasiums, colleges, and normal schools. Also popular were Ling or Swedish gymnastics and training systems developed by Americans such as Diocletian Lewis. An American Delsarte movement system was the province of upper middle class women, this system focusing on flexibility and poise (see especially Tomko, 1999, pp. 11–20).

Hagood (2000) notes that German immigrants changed American universities in many ways, bringing not only ideas about physical culture but ideals of academic freedom for both professorate and learners, and "an emphasis on the importance of discipline-based specialization, the use of scientific methods in research, and the importance of research and development to a university's mission" (p. 27).

In her chapter "Bodies and Dances," Tomko (1999) discusses the Progressive-era worker, often new to America, employed in some kind of industry, and living in cramped conditions, along with the physical training systems and social dance forms that counterbalanced these stresses. Tomko describes the Progressive Era as one in which men and women were thought to occupy separate spheres and have separate, biologically driven propensities that influenced labor practices and physical training. Ross (2000) furthers this idea: "[a]thletics and intense competition were important for manhood and wartime readiness, while sports for girls were used to develop leadership qualities, sociability, and 'health' – defined differently than for the males" (p. 60).

In her chapter "Folk Dance, Park Fetes, and Period Political Values," Tomko (1999) offers information and analysis on dance for children, something other authors discuss only briefly. Luther Halsey Gulick, Director of Physical Training in the public schools of New York City school system, formed the Public School Athletic League (PSAL) in 1902 as an afterschool program, hoping to augment the scant physical training possible

in the overcrowded, under equipped public schools. The Girls' Branch, headed by Elizabeth Burchenal, was formed in 1905 and came to emphasize folk dance, especially as performed at large public pageants or park fetes. As Tomko describes it, hundreds of girls came together in choreographed folk dances, taught by public school teachers trained by Burchenal. Although girls also participated in games, folk dancing was favored because it fit theories of child development put forward by G. Stanley Hall, who thought that children develop in the same pattern that societies develop. Folk dancing, being a "primitive" activity, matched the developmental stage of young girls. Furthermore it was non-competitive, could be elevating in its artistic patterning, and allowed young girls to appear in public without an immodest focus on an individual girl.

Teaching became a respectable alternative to family life, allowing women like Elizabeth Burchenal and Margaret H'Doubler, a measure of independence. Ross and Tomko both point out that women dancing – teachers dancing in schools, performers and choreographers such Isadora Duncan and Ruth St. Denis, and adult women dancing for pleasure and exercise – were forging new professions for women and new ways for women to appear in public spaces. American women gained the right to vote at the end of this era, in 1920.

The 1910s and 1920s was the heyday of modern educational dancing in colleges and universities. Ross (2000) notes that a number of women were exploring dance forms, especially as part of teacher training, that emphasized "natural" expressiveness or relied on gesture, among them Gertrude Colby, who taught at Teacher's College, Columbia University from the 1910s through the early 1930s, and Bird Larson, who taught at Barnard from 1916 to 1923. These practices were highly influenced by Isadora Duncan, American Delsartianism, Denishawn, and Dalcroze eurythmics.

As Ross explains, Margaret H'Doubler, a physical education teacher at the University of Wisconsin, was sent to New York by her department head, Blanche Trilling, in 1916 to attend Teacher's College and explore dancing as a potential curricular area for the Wisconsin program. H'Doubler, was not a dancer – before going to New York, her favorite activity was basketball – and she thought of dancing as experiential learning rather than preparation for performance. Although H'Doubler did not emphasize her connections to Dewey, Ross examines her writing and teaching alongside Dewey's ideas. In general, their works share a mutual emphasis on experience as the starting point for thinking, for knowledge construction; an interest in moving past dichotomies (mind and body, science and art) that cloud the integrative nature of the learning process and its reliance on discovery in all fields; and aesthetic experience as important to all people, available in the everyday, and a way of bringing into dialogue the individual and her experience of others and her environment.

In 1926 Wisconsin established the first dance major offered at a college or university. Through her teaching and writing, H'Doubler's influence was unprecedented in college dance. Ross notes that H'Doubler's *Dance: A Creative Art Experience* (1940) "sold more than thirty-six thousand copies, a record for any dance education book, in the forty years it dominated the literature of dance education" (Ross, 2000, p.142).

In the 1930s, modern dance became an established concert form. The ideas and techniques of Martha Graham, Doris Humphrey and Charles Weidman, and Hanya Holm,

as taught in summer programs like those at Bennington College and Perry-Mansfield camp, became important to university dance education. College dance departments sponsored concerts by touring modern dancers, professionals sought employment through residencies or as full-time instructors in colleges, and departments sent their graduates, in part, out into the professional world. Hagood (2000) discusses the infusion of professional dance into the university through a remark made by Martha Hill in a 1933 lecture demonstration at the New School for Social Research in New York: "Anything good in the dance ... is likewise good in art and education, since the dance is no longer removed from life." Hagood follows:

> Hill may have made these comments in an effort to help push dance towards an artistic meaning in education; however the practical result of her remarks are contained in her first sentence – what the dance artist did in technique and choreography, the educator began to imitate, and if not imitate, import directly into their programs through hiring. (p. 165)

He goes on to discuss the "schizophrenia" of dance in academia, noting that questions about dance as a discipline and dance as education, as "acknowledging an ever increasing push toward professionalism, yet conflicted about the integrity of dance as a part of liberal learning" (p. 166) continue to occupy dance educators.

Hagood pushes on through the twentieth century, establishing a chronological history for dance in the university by examining books and position statements, studies, and correspondence generated by people involved in professional organizations and conferences. Dance in public schools is not his focus, but it is evident that the availability of dance in schools is a continuing question. In the early 1930s, the American Physical Education Association added a Section on Dancing which was to remain the premier organization in dance education until the late 1950s. At the time the Section was founded, there was equal concern with dance for women in colleges and universities and with dancing in elementary schools. Dorothy LaSalle was charged with creating a special presentation on dancing in elementary schools for an upcoming conference. That presentation survives as *Dancing in the Elementary Schools* (1933). Hagood (2000) notes that "into the late 1950s, the work of the National Section on Dancing was steady and largely concerned with developing criteria for implementing dance programs at all levels of education" (p. 161).

By the late 1940s and early 1950s, dance educators were in search of an academic identity.[4] Dance in higher education was now primarily artistic training – technique and choreography – but labeled physical education and dance faculty pushed to have dance reclassified as a fine or performing art or as its own subject area. Some faculty, such as Alma Hawkins, who became a department head at the University of California at Los Angeles and was the founder and driving force of the Council of Dance Administrators, saw the need for thinking more clearly about the place of dance training in liberal education. In her *Modern Dance in Higher Education* (1954) she underscores principles for the dance experience. Her first goal is that "The goals of modern dance in the college and university program should be in harmony with the purposes of higher education." Later principles emphasize the "development of the individual through experiences that

help the student meet his needs for an adequate body, satisfying expression, and effective human relations" and that dance education should emphasize "process and growth rather than upon dance as the end product" (Hagood, 2000, pp. 166–167).

Other dance educators were concerned about the broader impact of this new conceptualization of dance as an arts discipline. Hagood comments on an article "Creative Dance Experience and Education" written by Marian Van Tuyl in 1951. Van Tuyl complains that college dance can only be considered remedial education until dance is part of K-12 education and the general public becomes more physically developed and astute. Although she notes that university physical education students are not enamored of dancing, "The trend toward transferring dance to the departments of fine arts where it rightfully belongs can serve the small group immediately involved, but under the present setup does little to help in teaching in elementary and secondary schools" (Hagood, 2000, p. 174). Hagood does not explore the history of dance specialists in public schooling nor their relationship to physical education. Some studies suggest that most dance in public schooling is still taught through physical education (see DeBruyn, 1988; Papalardo, 1990 in Overby, 1992).

In the 1960s, dance benefited from an upsurge in artistic and intellectual life inspired by John Kennedy's administration. The National Endowments for the Humanities and for the Arts and the Kennedy Center for the Arts in Washington, DC were all products of 1960s pride in America as a great nation, measurable by the health of its cultural productivity. Within universities, the arts were seen as a way of displaying cultural excellence to their communities. Bachelor of Fine Arts and Master of Fine Arts degrees were instituted in colleges as degrees marking professional preparation. Hagood notes that thirteen dance major programs existed in American colleges in 1950, but by 1963, there were sixty-five.

Dance was the subject of several major conferences in the 1960s including the Conference of the National Council on Arts in Education in September 1964. In the following year, members of the newly formed Dance Division of the American Association for Health, Physical Education and Recreation, a more autonomous version of the old National Section on Dance, met to consider Dance as a Discipline. Hagood quotes Nancy W. Smith, writing in the foreword to the conference document: "Specific aims for the endeavor were to (1) To clarify the status of dance as an area of learning in the academic environment; (2) To support the premise the arts, and therefore dance, are significant to the development of the individual in society; and (3) To prepare the case for dance as a full partner in the academic enterprise" (p. 195).

Propelled by cultural interests in the body including social dance and bodybuilding, students entered academic dance departments in record numbers in the 1970s – dubbed the Dance Boom in American colleges and universities. The American College Dance Festival, a regional meeting of university faculty and students for classes and choreography showings first met in the 1970s. The Council of Dance Administrators (CODA) was formed, and the concern of its members – mostly dance department heads – was standards. Working with Samuel Hope, Executive Director of the Office of Arts Accreditation in Higher Education, an organization was formed to discuss a Joint Commission for Dance and Theater Accreditation. The endeavor became the National Association of Schools of Dance (NASD), an association that accredits dance departments.

Hagood (2000) notes that in the 1980s, private and public universities adopted a "corporate-consumer" character, as they increasingly interfaced with state and national agencies and other aspects of government. Funding for dance was cutback, and some departments saw enrollments decline. Hagood notes the rise of doctoral education and of scholarship in dance in the 1990s, and discusses the importance of multiculturalism and technology to curricular innovation. The National Dance Education Organization (NDEO, founded in 1997) Website provides some additional information about the 1990s, noting that dance educators worked to support Goals 2000: Educate America Act, develop national standards and assessments in the arts, and to require state certification or licensure in dance education.

As conclusion, Hagood sums up the current state of dance departments:

> For dance in higher education, the discipline has come to be about art. The adaptation of the conservatory model was a way out from under physical education, and a way to identify with art. … . We have made performance the focus of dance in higher education, although this need not be so for all programs. We must help the faculty of each program bring to the fore that which makes their cooperative effort substantial. We must also help the field expand its notions of the merit and worth of dance related pedagogy, develop multicultural appreciation, and theoretical inquiry. Excellence in dance education must be referenced not only to professional art standards, but also to individual creativity, to cultural understandings, to theoretical appreciation, and to intellectual and kinesthetic development. (pp. 317–319)

"Ultimately," Hagood says, "and perhaps most importantly, dance in education must attend to the charge of the academy: to push back the boundaries of knowledge, to forward the cultural legacy, and to contribute to society" (p. 319).

## Toward New Histories of Dance Education

Historians have established informational and methodological inroads to an area of research that begs for further development. Very little has been written, for example, about the history of dance in K-12 schooling. Here, Hagood's technique of examining documents related to dance organizations might prove helpful. The Progressive Era has been discussed by Ruyter, Ross, and Tomko, but other eras remain unexplored. Ross's melding of biography and social history is an especially compelling way to elucidate how dance operates in individual lives and as an educational and social phenomenon. By discussing dance in Wisconsin, she also helps us see dance as an American social tradition, not only an artistic practice centered in New York. Other biographies might further this process for other eras and communities.

One possibility is the work of Charles Williams, who directed a physical education program at the Hampton Institute beginning in the 1910s. His contributions to American concert dance and education have been discussed by Susan Manning in *Modern Dance, Negro Dance: Race in Motion* (2004), and by John Perpener in

*African-American Concert Dance: The Harlem Renaissance and Beyond* (2001). Founded in 1868, Hampton is known for its education programs for Native Americans (1878–1923) as well as African Americans (Hampton's Heritage). Williams, according to Perpener, wrote articles and books about physical training and about African-American cultural traditions and staged drills, gymnastics, and dances at Hampton (pp. 81–88). The Hampton Institute Creative Dance Group, established in 1933, toured extensively, including performances at other historically black colleges and at the 92nd Street YMHA in New York City. Manning notes that

> Although [Williams] never explicitly dismissed jazz dancing, he clearly saw creative dance as an important alternative that a Negro college committed to moral uplift should cultivate. Largely divided into singe-sex groups, the Hampton Institute Creative Dance Group presented (masculine) African ritual and (feminine) artistic expression as alternative to the Lindy Hop. The gendered imagery of Hampton's repertory became saturated with respectability and racial uplift. (pp. 41–42)

The existing literature suggests the richness of a book-length exploration of Williams as an educator within the Hampton context, and of the politics of gender and race he negotiated as a college professor and artist.

Other possibilities are contained in O'Neil's *Dance Education in Michigan: Recollections of Three Pioneers: Grace Ryan, Ruth Murray, and Fannie Aronson* (1979). The book begins with brief biographies of three dance educators (and my biographic summaries are largely paraphrased from these, pp. iii–iv), followed by interviews with each woman. Grace Ryan was a professor of physical education at Central Michigan University from 1923 to 1958. The author of *Dance of Our Pioneers*, Ryan was instrumental in making American country dance a standard part of physical education in schools especially through her published compilations of round, square, and contra dances (see Ryan & Benford, 1926; Ryan & Benford, & Emerson, 1939). In her interview, Ryan mentions her connection with Henry Ford, who wrote about country dancing and promoted dancing as a means of self and community development. Ryan visited Ford's home, knew his family, and credited Ford as creating an environment in which her own interests could flourish. O'Neil's second Michigan educator, Ruth Murray, is a still-recognized name in dance education, especially through her book *Dance in Elementary Education: A Program for Boys and Girls* (1953/ 1963/1975). Murray studied at Detroit Normal School, then in New York studios and at Bennington School of the Dance in the 1920s and 1930s and she later founded a modern dance program at Wayne State University. The close ties that existed between Wayne and the public schools brought modern dance into the curriculum in the Detroit Schools. The final educator discussed is Fannie Aronson. Aronson studied in New York and at Bennington and also in Colorado with Hanya Holm and at Perry-Mansfield camp. She was an active performer and taught dance in her own studio, the Detroit public schools, and community centers.

Virginia Tanner might also be the subject of an interesting biography and investigation of dance in Utah. I wrote a short article about her (Dils, 2000–2001), fascinated by her connections to choreographer Doris Humphrey whom Tanner studied with in the 1930s and 1940s (see Tanner papers). Tanner, a member of the Church of Jesus Christ

of the Latter Day Saints, went back to Utah to teach and to found Children's Dance Theater, a dance company that reached national prominence and is still an important Salt Lake City educational and cultural institution, some thirty years after Tanner's death. Because Tanner saw dancing as expressive of community and religious values, her work makes a good case for examining dance as an American tradition with strong regional variants and a socializing purpose.

## Social History and Dance in the University

Arguably, dance faculty already meet Hagood's idea stated at the beginning of this chapter. By choreographing dances, artists push at the boundaries of artistic process and understanding, sharing their discoveries with other art makers and providing edifying experiences for the general public. The technique class is a place of constant experimentation concerning the physical and expressive capabilities of the body.

But limiting the purpose of dance in universities to the training of professional artists comes at a cost. Hagood points out the ongoing struggle of dance educators to justify dance as part of elementary and secondary public education. Emphasis on professional training has also limited scholarly exploration of dance and the development of dance history, as scholars have traditionally focused on writing about the lives and works of great choreographers. In her Introduction, Linda Tomko (1999) notes,

> This point of view is imminently visible in canonical works of twentieth-century modern dance and ballet history alike. It partakes of a "modernist" view of art making articulated in the early decades of this century, and it has had the effect of positioning theatrical dance as "high art" and as a subject for rarefied tastes. It has also had the effect of marginalizing theatrical dance as a subject of academic inquiry, distancing dance from theorizations about how societies operate and change over time. (p. xiv)

Further, dance curriculums have largely been dedicated to dance forms that stem from the western tradition and that are framed as art – ballet and modern dance – and closed to dance forms derived from other traditions that are framed as social or "traditional" forms.

The works of social historians, and by dance writers in a number of fields that currently use strategies from performance studies, gender studies, social and cultural history, ethnography, and education expand and inform the dance field in important ways, suggesting that dance be viewed not only as "art," but as a medium of social exchange. This broader emphasis allows dance educators, artists, and scholars to investigate the meanings of choreographic works, but also the experiences of and exchanges between choreographers, dancers, and dance observers; educators and students; and dancers and their practices, traditions, and institutions. The ideas that the body is socially constructed and inscribed – that we learn and display our genders, sexualities, economic class, and so on – and the idea that motion is a means of reshaping who we are, how we are represented, and the meanings those representations hold for

others is central to the work of contemporary dance scholars. Might these ideas be useful to deliberations about the educational worth of dancing as it is enacted in schools? To contemporary dance scholarship done in other fields, historians add the possibility of looking to the past to see individual lives moving alongside others, and in concert with changes in social practices and beliefs, communities and institutions. Ultimately, the long lens of history helps us think about how dancing contributes to what and how we know and to our constructions of culture and society.

## Notes

1. Ann Barzel offers a separate discussion of ballet education in the *International Encyclopedia of Dance* (1998). At points, her history of ballet education dovetails with Ruyter's explanation of social, folk, and modern forms. Nineteenth century dancing masters also taught ballet, for example, and ballet is an important subject in college and university dance programs and in performing arts high schools (pp. 290–293). The *Encyclopedia* also contains discussions of dance education in many other countries, including New Zealand (Shennan, 1998), Australia (Craig, 1998), Canada (Warner, 1998), and Great Britain (Brinson, 1998).
2. See also Elizabeth Aldrich (1991), *From the Ballroom to Hell: Grace and Folly in Nineteenth-century Dance*, and Lynn Matluck Brooks (1990), *Dancing Masters in Eighteenth-century Philadelphia*.
3. In her *International Encyclopedia of Dance* article, Ruyter (1998) continues to discuss social dance training in the twentieth century, noting that private instruction in studios became the most important means of social dance training, that dance instruction is subject to the popularity of social dancing in general and of specific social dances, and that a division grew between the types of dances learned by youth and older people (p. 294).
4. The author of the history found on the National Dance Education Organization Website also notes that physical education also took a disciplinary turn towards athletics and sports science. Changes that occurred with Title IX (1972) and the Equal Educational Opportunity Act (1974) brought together men's and women's physical education and placed an emphasis on sports.

## References

Aldrich, E. (1991). *From the ballroom to hell: Grace and folly in nineteenth-century.* Evanston, Il: Northwestern University Press.

American Physical Education Association. (1933). *Dancing in the elementary schools.* New York: A. S. Barnes.

Barzel, A. (1998). United States of America: Ballet education. In S. J. Cohen (Ed.), *International encyclopedia of dance* (Vol. 6, pp. 290–293). New York: Oxford University Press.

Brooks, L. M. (1990). Dancing masters in eighteenth-century Philadelphia. *Dance: Current selected research, 2,* 1–21.

Brinson, P. (1998). Great Britain: Dance education. In S. J. Cohen (Ed.), *International encyclopedia of dance* (Vol. 3, pp. 276–281). New York: Oxford University Press.

Craig, V. L. (1998). Australia: Dance research and publication. In S. J. Cohen (Ed.), *International encyclopedia of dance.* (Vol. 1, pp. 218–219). New York: Oxford University Press.

Dils, A. (2000/2001). Dance with us: Virginia Tanner, Mormonism, and Humphrey's Utah legacy. *Dance Research Journal, 32*(2), 7–13, 17–31.

Hagood, T. K. (2000). *A history of dance in American higher education: Dance and the American university.* Lewiston, NY: E. Mellen Press.

Hampton University. Hampton's heritage. Retrieved June 19, 2005, from http://www.hamptonu.edu/about/heritage.htm.

Hawkins, A. M. (1954). *Modern dance in higher education*. New York: Bureau of Publications, Teachers College, Columbia University.

H'Doubler, M. N. (1940). *Dance: A creative art experience*. Madison, WI: University of Wisconsin Press.

Manning, S. (2004). *Modern dance, Negro dance: Race in motion*. Minneapolis, MN: University of Minnesota Press.

Murray, R. L. (1953/1963/1975) *Dance in elementary education: A program for boys and girls*. New York: Harper and Row.

National Dance Education Organization. Who we are: Evolution of the field. Retrieved June 19, 2005 from http://www.ndeo.org/whoweare.asp.

O'Neil, K. (Ed.) (1979). *Dance education in Michigan: Recollections of three pioneers, Grace Ryan, Ruth Murray & Fannie Aronson*. East Lansing, MI: Michigan Dance Association.

Overby, L.Y. (1992). Status of dance in education. *ERIC Digest*. Retrieved June 19, 2005, from http://eric.ed.

Perpener, J. O. (2001). *African-American concert dance: The Harlem Renaissance and beyond*. Urbana, IL: University of Illinois Press.

Ross, J. (2000). *Moving lessons: Margaret H' Doubler and the beginning of dance in American education*. Madison, WI: University of Wisconsin Press.

Ryan, G. L., & Benford, R. T. (1926) *Dances of our pioneers*. New York: A. S. Barnes & Co.

Ryan, G. L., Benford, R.T., & Emerson, B. (1939). *Dances of our pioneers*. New York: A. S. Barnes & Co.

Ruyter, N. L. C. (1979). *Reformers and visionaries: The Americanization of the art of dance*. New York: Dance Horizons.

Ruyter, N. L. C. (1998). United States of America: Social, folk, and modern dance education. In S. J. Cohen (Ed.), *International encyclopedia of dance* (Vol. 6, pp. 293–296). New York: Oxford University Press.

Shennan, J. (1998). New Zealand: Dance education. In S. J. Cohen (Ed.), *International encyclopedia of dance* (Vol. 4, p. 628). New York: Oxford University Press.

Tanner, V. (1915–1979). *Virginia Tanner Papers* (Available from the Jackson Library Special Collections, University of North Carolina at Greensboro, 1000 Spring Garden Street, Greensboro, NC 27402).

Tomko, L. J. (1999). *Dancing class: Gender, ethnicity, and social divides in American dance, 1890–1920*. Bloomington & Indianapolis: Indiana University Press.

Warner, M. J. (1998). Canada: Dance education. In S. J. Cohen (Ed.), *International encyclopedia of dance* (Vol. 2, pp. 46–48). New York: Oxford University Press.

# INTERNATIONAL COMMENTARY

# 7.1

# Korea

**Su-Jeong Wee**
*University of Illinois at Urbana-Champaign, U.S.A.*

Until the early 1900s, there had not been any formal dance education in Korean schools. Between 1910 and 1945, Korea had been ruled by Japan, and in this period military gymnastics started as a national salvation movement to resist Japanese influence. It provided Koreans with a chance to change their ideas about dance from being mere entertainment to becoming one of the best ways to develop the complete personality by integrating the arts and physical health (Society of Dance Education, 2003).

In 1921, a student choir and dance group from Vladivostok visited Korea, and this led to an important opportunity to develop dance education in Korea. There were several reasons for this. First, the public were interested in the traditional dance of Russia as well as of other Western countries. Second, it stimulated the establishment of dance institutes. Third, school dance groups started performing outside the academic realm. Thus, the Vladivostok student music performance in Korea is now considered to be a great contribution to internationalizing and westernizing Korean dance beyond the traditional perspective (Kim, 1998).

With regard to the early 1900s, dance education had been considered to be an adjunct of physical education, and most of the dance activities comprised dances with singing and marching. Also, the philosophy of dance education was strongly influenced by the media and the press.

A Japanese dancer, Baku Ishi, performed in Korea in the early 1920s. His performance influenced the Korean people to consider dance as an art form (Kim, 1998). Until that time dance as physical movement had been emphasized (Song, 1998). However, dance education still belonged to physical education whose goals were to have interest in the body, to cultivate a positive attitude toward adopting a healthy life style, to develop the basic movement abilities, and to live safely. In practice, physical education focused on entertainment and sports, and dance education did not change much (Kim, 1998).

In 1926, the first dance course for school teachers was developed and in the 1930s, the teachers who participated in the dance training played active roles in developing a dance curriculum. The 1930s was considered as a golden age of dance education: many

*L. Bresler (Ed.), International Handbook of Research in Arts Education, 113–116.*

dance institutes opened and various dance courses were provided for teachers. However, in terms of school education, the role of dance education to provide amusement was still highlighted.

From the late 1930s through to 1941, both the China-Japan war and the Pacific war broke out, and, accordingly, all education began to focus on military training. Dance education merely existed to provide amusement and to provide for the military dance.

In 1945, Korea was liberated from Japan and two years later the Society of Chosun[1] Dance Education was established with the purpose of developing authentic dance. This Society played an important role in developing dance education and laid the foundation for future dance departments at universities (Yong, 1994).

In 1955, the first Korean native educational curriculum was established and dance was proclaimed as part of the official curriculum. However, it was still not accepted as an independent subject but was a part of physical education. Moreover, due to physical education teachers who did not appreciate the nature of dance, dance lost its genuine meaning in the field of education.

In 1963, a dance department was first established at Ewha Womans University. At the elementary level, curricular content consisted of gymnastics, play, and health hygiene. At the middle and high school levels, it was more specialized into such activities as body exploration, rhythmic movement, dancing, and dance theories.

In the 1970s, various dance performing societies were developed. However, dance education did not change much because it was still considered as part of physical education. A more fundamental reason for its unstable position was that it failed to convince people that "dance is an art and physical training is not an art" (Kim, 1998). In practice, dance education in middle and high schools did not address students' creativity and artistic sense, but focused on simple movements as did physical education. This type of dance education practice might have helped students' physical health and diverse expressions but it failed to promote emotional and intellectual development (Society of Dance Education, 2003).

In 1981, dance education highlighted rhythmic movements, traditional dances, and creative dances through the newly amended curriculum, and in 1987, movement and artistic aspects were strengthened in particular. The content highlighted the cognitive element, such as learning and then integrating the basic elements of movement in dance, perceiving the relationships between the elements of movement and dance, dancing with forms, and constructing the relationship between people and objects.

In spite of dramatic developments in dance education, Korean dance education has tended to drift according to the socio-cultural trend (Kim, 1998). In addition, the educational aspect of dance education has been neglected. It is to be hoped that in future dance education in Korea will address (1) the potential of creativity, (2) the perception of self and society, (3) an interest in health, and (4) the understanding of indigenous and other cultures (Society of Dance Education, 2003).

# Note

1. Chosun was the old name for Korea from 1392 to 1910.

# References

Kim, W. M. (1998). *History of dance education in Korea*. Seoul: Hanhak.
Society of Dance Education (Ed.). (2003). *What is dance education?* Seoul: Hanhak.
Song, S. N. (1998). *History of Korean dance*. Seoul: Kumkwang.
Yong, M. R. (1994). *Complete dance*. Seoul: Korean Dance Education Society.

# INTERNATIONAL COMMENTARY

## 7.2

# New Zealand

**Ralph Buck**
*University of Auckland, New Zealand*

Ann Dils validates the important role that dance historians play in recording and analyzing dance education practices and events as important components of social history. As an Australian dance educator currently leading a tertiary dance studies program in New Zealand, and having researched dance education in New Zealand primary (elementary) schools, I recognize issues and histories outlined by Dils that are relevant on our side of the globe.

In New Zealand public schools at present, dance education enjoys dual recognition in two curriculum areas through the documents, *The Arts: in the New Zealand Curriculum* (2000) and, *Health and Physical Education in the New Zealand Curriculum* (1999).

Similar to the United States, within New Zealand, dance has been referred to in past and current physical education curricula. For example, the 1933 English Physical Training syllabus was taught in New Zealand up to the mid-1940s (Stothart, 1974). Stothart noted that the dance component of this syllabus was adapted to include folk dance for New Zealand children. Many physical educators trained in England brought Laban's movement education to New Zealand (Smithells, 1974), but most came with Swedish Gymnastics and, more specifically, the Ling system of movement training, where the emphasis was upon posture and physical development (Burrows, 1999).

In 1942 the Thomas Report on the New Zealand secondary school curriculum included physical education as a core component of the school curriculum (Stothart, 1974). In response to this all secondary schools received the English texts *Recreation and Physical Fitness: for youths and men* (Board of Education, 1937) and *Recreation and Physical Fitness: for girls and women* (Board of Education, 1937). The three-page dance chapter in the male's book is limited to descriptions of set dances such as Morris dancing, and where dance "is a fundamental form of exercise" (p. 216). This makes for an interesting comparison with the female version, where dance is covered in depth for forty pages and describes a vast range of dance activity in great detail. For girls and women, "The first aim of dancing is to learn to move with ease and rhythm, to enjoy moving and to gain a sense of power over the body" (p. 155).

*L. Bresler (Ed.), International Handbook of Research in Arts Education, 117–120.*

In the 1950s the influence of Laban's theories were found in syllabuses such as the *Physical Education in the Primary School* (The Department of Education and Science and The Central Office of Information, 1953). In this document, exploration of movement, singing games and national dances provided the focus. However, as male teachers returned to physical education teaching, sport performance and human movement measurement "sciences" overtook physical education. Dance became limited to folk and social dance. Learning steps and skills rather than problem solving and creativity was the focus (Burrows, 1999).

*The Arts in the New Zealand Curriculum* (2000) included dance, drama, music, and visual arts and was mandated for implementation in all New Zealand primary schools from 2003 (Hong, 2001). The key rationale for the arts curriculum at large focuses upon "literacies in the arts" (Ministry of Education, 2000, p. 10); expression and communication; individual and community awareness; and, awareness of the functions the arts fulfil in societies and histories. Dance is stated as offering "a significant way of knowing, with a distinctive body of knowledge" (Ministry of Education, 2000, p. 19), and offers "personal" and "social" benefits through the development of confidence in physical expression. Also, "Dance in the NZ curriculum promotes the dance heritages of the diverse cultures within New Zealand" (Ministry of Education, 2000, p. 19). Further rationales noted that dance is a holistic experience "that links the mind, body and emotions" (Ministry of Education, 2000, p. 19) and note was taken of the importance of developing critical audiences and fostering students' enthusiasm as viewers or creative participants. In summary, the New Zealand dance curriculum is focused upon developing:

- Students' literacy for engagement with dance practically or theoretically.
- Personal holistic knowledge of self.
- Knowledge of cultural and social diversity in New Zealand.

The curriculum has artistic and aesthetic concerns, yet is also orientated to personal development issues and sociopolitical issues specific to New Zealand. It is proposed that the study of dance may fulfill various educative and political functions, whereby the dance practice provides access to knowledge via artistic exploration, personal physical exploration and appreciation of diverse dance forms and functions.

Around the world we find common historical threads, such as, Laban's models, physical education and arts advocacy, and "training" and "education" debates and pedagogies. Tertiary dance education in New Zealand, as within the United States continues to wrestle with dance's schizophrenic identities within "professional" training models and "humanistic" liberal arts education models.

Today, dance education in New Zealand classrooms is informed by, the evolutionary influences of Rudolf Laban's Modern Educational Dance model, Janet Adshead's conception for the Study of Dance, Jacqueline Smith-Autard's Midway model, The Getty Foundation's Discipline Based Arts Education, Howard Gardner's Theory of Multiple Intelligences, somatic education and Tina Hong's theories of dance literacy (Buck, 2003). Add to this melting pot the influence of cultural contexts and artistic practices.

When the histories of dance education are noted and seen in conjunction with how dance education can study who we are, and therefore, reveal how we can alter meanings and constructions of who we are, we start to see the full impact of Hagood's (2000)

statement that, "[dance can] push back the boundaries of knowledge, forward the cultural legacy, and contribute to society" (p. 116, p. 319). As Dils advocated, and I agree, the more histories written from different perspectives, with different methodologies and focus, then the more likely it is that dance education can be valued for its contributions to society.

# References

Board of Education. (1937). *Recreation and physical fitness: For girls and women*. London: His Majesty's Stationery Office.

Board of Education. (1937). *Recreation and physical fitness: For youths and men*. London: His Majesty's Stationery Office.

Buck, R. (2003). *Teachers and dance in the classroom: "So, do I need my tutu?"* Unpublished PhD, University of Otago, Dunedin.

Burrows, L. (1999). Developmental discourses in school physical education. Unpublished PhD, University of Wollongong, Wollongong.

Department of Education and Science and the Central Office of Information. (1953). *Physical education in the primary school: Planning the programme*. London: Her Majesty's Stationery Office.

Hagood, T. (2000). *A history of dance in American higher education: Dance and the American university*. Lewiston, NY: E. Mellen Press.

Hong, T. (2001). Getting cinders to the ball. *Physical Educator: Te Reo Kori Aotearoa, 3*(1), 4–6.

Ministry of Education New Zealand. (1999). *Health and physical education in the New Zealand curriculum*. Wellington: Learning Media.

Ministry of Education New Zealand. (2000). *The arts in the New Zealand curriculum*. Wellington: Learning Media.

Smithells, P. (1974). *Physical education: Principles and philosophies*. Auckland: Heinemann Educational Books.

Stothart, R. (1974). *The development of physical education in New Zealand*. Auckland: Heinemann Educational Books.

8

# THE TEACHING OF ENGLISH LANGUAGE
# ARTS AS POETIC LANGUAGE:
# AN INSTITUTIONALIST VIEW

**Alyson Whyte**
*Auburn University, U.S.A.*

## Introduction

The purpose of this chapter is to review historical, conceptual, and empirical research related to poetic language as English language arts teachers' and their students' mutual work. By *poetic language* I mean text that functions primarily as literature (i.e., as art).[1] While poetic text can be graphic or multimodal, most research on poetic language as teachers' and their students' mutual work has focused on verbal texts: poetry; story; drama; and, more recently, creative nonfiction (e.g., nature essays, personal essays, and literary journalism).

This chapter makes two claims: that for centuries strong pressures have worked against English teachers' and their students' mutual experience of poetic language and that a persistent countercurrent in the institutional and now in the technical environment of schools as organizations (Coburn, 2004) pressures English teachers toward fostering their students' engagement in poetic language. This second norm is set to become a stronger pressure and a stronger attractant toward the teaching of poetic language in English language arts classrooms, depending on what outcome measures researchers select for use in national and international comparison-based studies of student achievement.

## Historical, Conceptual, and Empirical Research on the Teaching of English Language Arts as Poetic Language

Historians of education have described schooling of the general public as persistently requiring students to absorb and then recite information learned by rote. Conceptual, empirical, and prescriptive literature, however, indicate some pressures in twentieth- and twenty-first-century schools' environments promote teachers' and students' experiencing

*L. Bresler (Ed.), International Handbook of Research in Arts Education*, 121–140.
© 2007 *Springer.*

poetic language. In the second, longer portion of this chapter, I review scholarship by Dewey and Rosenblatt and contemporary works by writing teachers such as Georgia Heard, Ralph Fletcher, and Joann Portalupi to describe these messages in schools' and classrooms' environment encouraging teaching to foster teachers' and students' mutual experience of poetic language. First, though, I review the historical literature on pressures in schools' and classrooms' environment that sustain teaching-as-replication.

## *Messages in Schools' and Classrooms' Institutional Environment Sustaining English Language Arts as Replication*

Research on children's drawings (of teachers and of school) and on mass-produced representations of schooling documents that internationally teaching-as-replication is the predominant image of school practice (Barbieri, 2002; Weber & Mitchell, 1995/2000). Contemporary pressures toward teaching-as-replication stem from the nature of the modern nation state.

*Mass literacy instruction and the emergence of the modern nation state.* Mass literacy instruction characterized the new nation states of the United States, France, and Italy beginning in the eighteenth century and the new nation state of Prussia as well as England and its colonies in the second half of the nineteenth century (Kaestle, 1983; Noether, 1951; Pflanze, 1990; Weber, 1976). The United States is the earliest instance of mass education in reading, memorization of texts, and spelling and handwriting aimed to foster a common national identity. The eighteenth-century mass literacy movement in the United States began in rural one-room schoolhouses and urban neighborhood schools where children brought to school whatever texts their families owned. In rural schoolhouses, "after children had learned the alphabet, they began memorizing words of one syllable and practicing vowel exercises like 'ab, eb, ib, ob, ub, ac, ec, ic, oc, uc, ad, ed, id, od, ud'" (Kaestle, 1983, p. 16). Records of urban schools for children of the poor and near-poor and for what Kaestle (1983, p. 55) calls "the middling ranks" suggest literacy instruction there tended, as in rural schools, toward rote memorization and recitation.

The English Lancasterian system for managing urban charity schools allowed early nineteenth-century educational reform societies in U.S. cities to expand the scale of their work. Quaker educators used this system almost universally in African Free Schools, despite complaints by African American parents about its mechanical nature. Lancasterian schools relied on nonsectarian moral instruction, highly specified manuals explaining procedures and lesson plans, and rewards for correct recitation, which moved individuals to the head of the class and then after three successful moves to the head of the class, to the next class. One schoolmaster could supervise as many as 500 children. Two senior student monitors occupied a raised platform, where monitors seated at the end of each row of students delivered reports of the results of recitations conducted in the aisle at the end of each row (Kaestle, 1983).

Lancasterian schools had fallen out of favor in England and other early industrializing countries by 1840, but regimented schooling of students to "toe the line" continued: When

Joseph Rice visited urban classrooms in the eastern United States to study the public high school at the beginning of the twentieth century, he described students expected to stand "perfectly motionless, their bodies erect, their knees and feet together, the tips of their shoes touching the edge of a board in the floor" (Rice, 1893, quoted in Brint, 1998, p. 145). Regimented, routinized approaches to socializing students, which Brint (1998) has described as characteristic of schools in newly industrializing, nation-building societies,[2] can still be found, Brint contends, in many urban, working class schools (Anyon, 1980; Bowles & Gintis, 1976; Cookson & Persell, 1985, all cited in Brint 1998).

*The factorylike high school as the formal organizational context of English teaching.* Two features of twentieth-century English teaching in the United States compatible with teaching-as-replication would be the graded school and the commercially published literature anthology, with its teacher's edition of answers to questions published at the ends of the selections in the student editions (Squire, 2003). Both these developments were foreshadowed in the United States in 1836 by the first publication of the graded McGuffey readers, consisting of fragments and précis literature that was "decidedly moral, though not overtly religious" and patriotic, but "not as narrowly nationalistic as Webster's [speller and reader] had been" (Applebee, 1974, p. 5). English language arts education as a school subject in consolidated systems of elementary and secondary schools would follow.

By 1860, graded schools, with prescribed curriculum for each grade, were common in large U.S. cities. Before the Civil War in the United States (1861–1865), school reformers had accomplished the expansion of normal schools for teacher training and had established education journals, professional supervision of teachers, higher teacher wages, and use of uniform textbooks in many locations in the northern United States. Then following the Civil War, city school superintendents began to envision and establish clocklike school systems (Kaestle, 1983). Inkeles and Smith (1974)

> ... classify as *modern* those personal qualities which are likely to be inculcated by participation in large-scale productive enterprises such as the factory, and perhaps more critical, which may be required of the workers and the staff if the factory is to operate efficiently and effectively. (p. 19)

These authors state that like the factory as an institution, the compliance with routine procedures that fits workers and staff to factory work has no nationality.

By 1879, the graded school, modeled after the factory, with prescribed curriculum for each grade, characterized nearly every school where there were enough pupils to sort into grades. Advocates of the graded school, prominent among them city and state superintendents of schools and school board leaders, Tyack and Cuban (1995) assert, "were impressed with the division of labor and hierarchical supervision common in factories" (p. 89). Tyack and Cuban state that these advocates of sorting students into grades that would receive uniform instruction sought an egalitarian kind of schooling for boys and girls, immigrant and native born. Administrators, typically male, divided the traditional curriculum – including reading, spelling, and writing – into required

sequences tied to end-of-year tests and supervised teachers, typically female, to ensure they followed the prescribed courses of study (Tyack & Cuban, 1995, pp. 89–90).

Through 1890, most of the states in the United States passed compulsory school attendance laws – but these laws were unenforced. By the early twentieth century, however, with the emergence of the first large, urban school bureaucracies, new technologies for enforcing compulsory school attendance laws arose together with decreased opposition to compulsory school attendance (Tyack, 1976). This "quiet but significant revolution ... in the urban centers of the country" (MacDonald, 1999, p. 427) produced the institution of the high school organized into subject-area departments as the capstone of the urban school system, together with centralized teacher-hiring processes, increased years of the formal education of teachers, and elaborated hierarchical supervision (Kaestle, 1983; MacDonald, 1999). The organizational form of the bureaucratized school system institutionalized the role of the teacher and students alike as compliant employees following administrative directives. In 1904, the superintendent of the Denver, Colorado, public schools would proclaim, "The independence of a teacher is limited .... It is comparable to the turning out of work by an industrial establishment" (Gove, 1904, cited in MacDonald, 1999, p. 428).

By 1950, high schools with ten or fewer teachers were unusual. Numerous faculty members were therefore assigned to teach the same school subject, thereby institutionalizing "English" as a core subject and instituting the high school subject-area department. In 1911, the National Council of Teachers of English (NCTE) had formally organized in the United States, largely to contest rigid college entrance requirements (Squire, 2003). Through the end of the twentieth century, NCTE's book lists for high school, junior high, and elementary schools aimed to advance wide reading by young people (Applebee, 1974). Continued emphasis by the College Entrance Examination Board (CEEB) on Scholastic Aptitude Tests, however, in determining college entrance requirements meant that at the same time teachers' resources regarding reading material broadened, a theme-per-week approach to teaching English "ossified" (Squire, 2003, p. 4) into formulaic five-paragraph essay writing, which privileges unity, coherence, and emphasis over quality of ideas and voice.

Between 1907 and 1911, Professor Romiett Stevens found that over the course of New York City high students' school days teachers asked an average of two to three questions per minute. The average number of questions students faced daily was 395. Using stenographic reports, Stevens calculated that teachers were talking 64 percent of class time. Many of the student responses she observed were brief, usually single words or short sentences (Cuban, 1993). In 1932, Dora V. Smith reported finding that in high school classes in New York (Smith, 1933, quoted in Dixon, 2003, p. 19) she saw "methods conditioned by desks nailed to the floor: ... Question and answer procedures with the teacher in command, and recitation around the class of sentences written out at home the night before." More students were conjugating English verbs in six tenses than participating in all other English language arts activities combined (Squire, 2003). These teachers told Smith of "fear under which they [the teachers] labor[ed] because of the requirements (real or imaginary) of the institutions higher up." The result, Smith (quoted in Dixon, 2003, p. 19) reported, was "deadly and uninteresting routine."

*Teaching-as-replication in bureaucratized school systems.* The efforts of early twenti-eth-century urban school reformers to consolidate city schools into a few districts, each with a sovereign school board, catalyzed consolidation of schools and districts that continued well into the 1970s. Between 1940 and 1980, mean school enrollment in the United States increased from 142 to 440, and the mean number of school dis-tricts per state declined eightfold, from 2,437 to 330 (Meyer, Scott, Strang, & Creighton, 1994). During this period, empirical studies document the predominance nationwide of English teaching-as-replication.

Squire and Applebee's observations 1963–1966 of more than 1,600 English lan-guage arts classes at 158 schools, selected because of their reputedly outstanding pro-grams in English, recorded that a large number of classes consisted mainly of lecture and recitation (Squire & Applebee, 1968, cited in Applebee, 1974). Moreover, in the lower tracks of these academically oriented schools much time was spent on work-sheets completed by students working individually at their desks. Oakes' (1985) analy-sis of data collected during 1977 in 25 junior and senior high schools across the United States (in 75 high-track classes, 85 middle-track classes, and 64 low-track classes, about evenly divided between English and math) documented a pattern that Gamoran and Carbonaro's (2002) secondary analysis of the 1990 wave of the National Educational Longitudinal Survey (NELS) data documented yet again. Quoting Oakes, Gamoran and Carbonaro describe how the 1990 NELS data also showed

> ... passive activities – listening to teachers, writing answers to questions, and tak-ing tests – were dominant at all track levels. ... opportunities students had in any group of classes to answer open-ended questions, to work in cooperative learning groups, to direct the classroom activity, or to make decisions about what hap-pened in class were extremely limited. (Oakes, 1985, p. 129; Gamoran & Carbonaro, 2002, p. 6).

Students in the high-track classes in the NELS sample, Gamoran and Carbonaro (2002) found, reported more student-led discussion and more use of oral reports than in lower tracks. But the use of these practices was not common in any track placement. Most research that provides descriptions of classrooms, Cuban (1993) states in his history of school practice in the United States (1890–1990), portrays the teacher as the authority who passes on required knowledge to students, who in turn are expected to take in and digest the knowledge, a process reinforced through the use of short-answer and multi-ple-choice tests (Cuban, 1988, cited in Eisner, 1994). This image of teaching-as-replication is a vestige of life centuries ago, Cuban (1993) states, "when men and women lived guided by a deep reverence for the accumulated wisdom of their elders" (p. 15).

Expanding formalization and scale in U.S. public education (1940–1980), together with expanded monitoring of schooling through measures of student achievement linked to sanctions of schools and school systems, have made state and district organi-zational structures "agents at the disposal of a national culture, serving to bring each subunit into conformity with it," state Meyer, Scott, Strang, and Creighton (1994, p. 204). Mass culture, in the United States and internationally, is replete with icono-graphic images of teaching-as-replication (Weber & Mitchell, 1995/2000).

## English Language Arts as the Experience of Poetic Language

*The intellectual heritage of teaching the experience of poetic language.* Like the deep roots of teaching-as-replication in centuries of trusting the wisdom of elders (Cuban, 1993), the teaching of poetic language has ancient beginnings. In the West, together with the shift from classical Greek epic poems to the novel in literature (Bakhtin, 1981), the Stoic tradition that arose from the teachings of Heraclitus, Socrates, and Plato (Abbs, 2003) foreshadowed autobiography as a form of poetic language. Augustine's 397 C.E. hybrid classical and dramatic work *Confessions* marked the emergence of poetic language rendering the unique experience of a given writer (Abbs, 2003). Rousseau's 1766–1770 *Confessions*, initial use of the term *autobiography* in 1807, many published autobiographies during the nineteenth and twentieth centuries, and Freud's and Jung's work during the twentieth century (Abbs, 2003) all fueled current worldwide emphasis on the individual (Scott & Meyer, 1994). "Education, for instance," Scott and Meyer write, "has become worldwide" (Meyer, Ramirez, & Soysal, 1992, cited in Scott & Meyer, 1994, p. 210), and formal curricula worldwide "tend to emphasize the status of the individual student – very few curricula ... take the older form of celebrating high sacred truths through ritual instruction" (Meyer, Kamens, Benavot, Cha, & Wong, 1992, cited in Scott & Meyer, 1994, p. 210). Thus at the same time that the institutional environment of schools encourages and rewards teaching-as-replication, that environment also pressures schools, and likely classrooms (Coburn, 2004), to attend to students as individuals, not *only* as recipients and replicators of information transmitted by the teacher.

English language arts education during the twentieth and early twenty-first centuries has enacted two conceptually distinctive stances toward the student as negotiating meaning in response to or in the process of making poetic literature. One of these stances is what Eisner (1994) has defined as *Rational Humanism*. More prevalent has been the second stance: that of Progressivist curriculum ideology, which has become during the late twentieth and early twenty-first centuries the converging stances of *Cognitive Pluralism* and *Critical Theory* (Eisner, 1994) currently known, together, as *multiliteracies* or the *new literacies*.

*Rational Humanist English language arts teaching.* Beginning during the late 1930s and 1940s, scholars in university English departments (Brooks and Warren, 1938 and Wellek & Warren, 1949, both cited in Squire, 2003) advised secondary school teachers to strengthen their literature teaching by focusing their attention directly on literary texts. Frye's *The Educated Imagination* (1964, cited in Squire, 2003) was a later foundational publication advocating that teachers emphasize interrelationships of language and metaphor within texts.

In secondary schools in the United States this emphasis on text, known as *The New Criticism*, became institutionalized during the 1960s, about the time when university departments were turning away from this exclusive concern with text. Placement exams awarding college credit for advanced performance had become established among elite colleges and private preparatory schools in the United States by the mid-1950s, and in 1955 the CEEB had begun offering Advanced Placement (AP) examinations in

literature and other subjects. English literature has consistently been one of the most widely selected AP exams. The emphases in the examination are textual analysis and literary criticism on the model of the New Critics (Applebee, 1974; Dixon, 2003; Nelson & Kinneavy, 2003).

During the 1930s to 1950s Hutchins and Adler developed and promoted the Great Books Program, which centered on study of texts considered the best that humans have written and employed a method of studying these texts that Adler, referring to the Greek word for *midwife*, called *mieutic* teaching (1982, cited in Eisner, 1994, p. 63). This approach to the experience of poetic literature sought to engage students in in-depth reasoning about the material they study. The teacher's role is dialectic rather than didactic: to enable students to provide reasons for their opinions and evidence and counterarguments for views being expressed by the students as a group. In the case of poetic literature, this approach seeks for students to grasp the unity of a whole work and its elements by "becoming at home in the world in which [the imaginative writer's] characters 'live, move, and have their being'. ... becom[ing] a member of its population, willing to befriend its characters, and able to participate in its happenings by a sympathetic insight, as you would do in the actions and sufferings of a friend" (Adler 1940/1972, p. 211). Probst's analysis of theories of literary response (1988, cited in Marzano, 2003) emphasizes that – in contrast to Rosenblatt's transactional approach, reflecting neoProgressivist ideology, reviewed in the following section of this chapter – Rational Humanist teaching of poetic literature, while seeking entry by the reader into the world of the text, subordinates the reader to the text.

Great Books Training for teachers and face-to-face and online discussion groups are available today. Eisner (1994) has suggested that a niche in schools where Rational Humanist teaching is likely to flourish is in private schools serving social and economic elites. As noted previously, AP courses, an elite track in U.S. high schools, constitute a niche where Rational Humanist teaching fits the nature of subsequent examinations students may take in pursuit of units of college credit.

*The American Progressivist movement in English language arts teaching through the mid-twentieth century.* The thinker and writer who has most forcefully expressed Progressivist curriculum ideology, Eisner (1994) has stated, is Dewey. Dewey's philosophy and writings, Eisner writes (p. 67), can be understood as two "related but distinguishable streams [of thought], one rooted in a conception of the nature of human experience and intelligence, the other in social reform." Dewey conceived of the human being as a growing organism whose main developmental task is to iteratively come to terms with the environment in which he or she lives. The implication of this concept for school practice is that the teacher's task is to construct *educational situations* (Dewey, 1902, cited in Eisner, 1994), through which the student becomes able to deal with ever more complex and demanding problems. Through this process the student's competence and intelligence grow (Eisner, 1994).

Applebee (1974) has described how Dewey's early (1900, 1902/1990) writings contributed to U.S. English teachers at the turn of the twentieth century countering lists of literature selections stipulated as requirements for college entrance examinations with recommendations of their own. The Committee of Ten appointed by the National

Council of Education of the National Education Association (NEA) in 1892 and the National Conference on Uniform Entrance Requirements in English in 1894 had institutionalized the high school subject of "English" as the study of literature, especially by major English writers, combined with the teaching of essential grammatical skills (Applebee, 1974). Accompanying that formal definition of English as a high school subject leading to college entrance examinations were lists of revered adult texts approved for study in preparation for those exams. These texts, though remote from the lives of most high school students, determined the curriculum of high school English because they were the basis for college entrance examinations. Further, an 1899 report from the NEA's Committee on College Entrance Requirements declared there should be no differentiation of terminal high school from college preparatory English coursework (Applebee, 1974). During the first half of the twentieth century, only incremental change toward a literature curriculum for the new figure of the adolescent reader (Bartholomae, 1990) occurred, however. For example, when the National Joint Committee of English – consisting mainly of secondary school rather than college members, in contrast to the earlier committees – made its final report in 1917, the report proclaimed the independence of the high school and rejected the principle that college preparation was the best preparation for all students' lives after high school graduation. Then in its lists of works to be studied as common, whole-class readings and as individual reading, however, the committee selected most of the same titles as the earlier college entrance examination lists. As a new pressure, or invitation, in the institutional environment of schools and classrooms, this report declared a shift in the goals of English teaching from emphasis on "excellence of style ... to value of content and power to arouse interest" and from formal disciplinary learning to emphasis on instruction that is "social in content and social in method of acquirement" (Applebee, 1974, p. 66). But the report did not alter the materials recommended to attain these new, Progressivist goals.

Moreover, in the messages to English teachers conveyed by this Progressivist document, there was not yet any sense of what Abbs (2004, p. 57, 54) has called the *aesthetic field*: the "living tradition and a repertoire of techniques and exemplars or a language for discussing the intrinsic elements of art." Without thorough, experiential awareness of the living discipline of poetic language as an art, the English teacher cannot wed students' engagement in artistic problems with the resources of the culture that the teacher's and students' repertoires in the art form(s) can provide. Dewey (1938/1973) alluded to this gap between Progressivist philosophy and school practice in that he countered the misconception of Progressive education as abandoning, or marginalizing, subject matter. Presently, English language arts leaders adept at Progressivist practice have articulated a collective understanding of ways of invoking the aesthetic field of poetic texts. Without widespread understanding of this tenet of Progressivist practice, what displaced exclusive emphasis on expository writing in English classrooms in the United States and many other parts of the world through Dewey's influence for most of the twentieth century was some emphasis on self-expression (Nelson & Kinneavy, 2003). That is to say, English language arts practice labeled *Progressive* emphasized self-expression by students more than it inducted young readers and writers into the aesthetic field of poetic language.

The second stream within Dewey's philosophy and American Progressivism conceived of the organization of the school as exemplifying education in the problems of living together for all in the microsociety of the school (i.e., the school as a microcosm of the wider society of the nation) (Applebee, 1974). In English classrooms, this stream of Deweyan Progressivism resulted in greater emphasis on the teaching of drama – as self-expression and also to promote the growth of intelligence and the social goals of cooperation and groupwork – during the years before World War I (Applebee, 1974). Drama as a way of experiencing literature would reemerge in late twentieth-century Cognitive Pluralist research on engaging students as readers (e.g., Wilhelm, 1997). This recent research is reviewed in the section below on Cognitive Pluralism and Critical Theory as stances toward English teaching.

After the height of implementation of practices labeled Progressive, approximately from the late 1920s through the 1940s (Eisner, 1994), Progressivist pedagogy became the target of vigorous public criticism in the United States during the late 1940s and the 1950s. In the context of the onset of the Cold War and the Soviet launching of Sputnik during the 1950s, concerns burgeoned in the United States about Progressivist approaches to teaching English language arts, such as permitting students to choose what they would read and what topics they would write about (Applebee, 1974; Dixon, 2003). The antiProgressivist environment of schools as organizations at the mid-twentieth century resulted in both elementary and secondary schools gravitating toward what Fogarty (1959, cited in Nelson & Kinneavy, 2003) has termed the *current traditional* approach to teaching writing:

> ... focusing instruction on arrangement and style, emphasizing mechanical correctness instead of rhetorical effectiveness, assigning topics for writing, stressing paragraph development, and teaching students about some abstract qualities of writing, such as unity and coherence. (Nelson & Kinneavy 2003, p. 789)

This approach to teaching writing is consistent with teaching-as-replication. Current-traditional writing instruction disregards virtually all aspects of writing that cannot be translated into algorithms that the teacher trains students to employ when they write.

Through the mid-twentieth century, English language arts was only marginally affected by Progressivist ideas, especially at the high school level, where "English," not "language arts" (the preferred term at the elementary school level) generally consisted of routinized teaching of poetic language as art history and of conventions of standard academic syntax, mechanics, and word usage (Applebee, 1974; Dixon, 2003; Squire, 2003). These norms for practice were enforced by "local insistence upon the more formal elements of instruction" (Applebee, 1974, quoted in Dixon, 2003, p. 19) and also by college entrance examinations on set texts through the 1930s (Dixon, 2003).

An important symbolic event during the first half of the twentieth century toward the teaching of English language arts as poetic language in the United States was the publication in 1935 of *An Experience Curriculum in English* by the NCTE Commission on the Curriculum (Applebee, 1974). The report recommended abandoning formal grammar instruction, except as an elective for high school seniors, and a curriculum based on "selected experiences," each unit forming an "organic whole" (Hatfield, 1935, quoted

in Dixon, 2003). Most classrooms at the time were not affected by this Progressive man-
ifesto. In the historical context of the Great Depression, Dixon (2003, p. 19) argues,
"clinging" to the "recognizable results" of success on college entry tests may have
occurred. The English teachers of the time had been educated in linguistic features of
the English language taught in a way modeled on the study of the classical languages.
And local institutional environments contained few Progressivist messages and many
messages to schools legitimizing grammar and didactic literature instruction. Not until
decades later, during the late 1960s, would the countercurrent to English teaching-as-
replication that formed during the 1920s-1940s recur (Dixon, 2003).

*Rosenblatt as the bridge from early Progressivism to neoProgressivist practice.*
Beginning during the early 1960s (Squire, 1964, cited in Squire, 2003), earlier work on
readers' responses to literature by Richards (1929, cited in Squire) and Rosenblatt
(1938/1976) influenced researchers. As Hall states in her chapter in this handbook,
Rosenblatt argues for evocation: the organic, *lived-through experience* of merging
with poetic language possible only when an aesthetic stance toward poetic text,
entailed in immersion in the story world of the poetic text, rather than an efferent,
or information-seeking, stance is taken. Rosenblatt described how teaching-as-
replication undermines the possibility of reader response:

> ... the techniques of the usual English classroom tend to hurry past ... active cre-
> ation and re-creation of the text. The pupil is, instead, rushed into peripheral con-
> cerns. How many times youngsters read poems or stories or plays trying to
> memorize as many random details as possible because such "facts" will be the
> teacher's means for testing – in multiple-answer questions – whether they have
> read the work! Or students will read with only half a mind and spirit, knowing this
> is sufficient to fill in the requirements of a routine book report: summarize the
> plot, identify the principal characters, describe the setting, ... the search for mean-
> ing is reduced too often to paraphrase ... while the analysis of techniques becomes
> a preoccupation with recognizing devices .... (Rosenblatt 1938/1976, p. 285)

The *experience* of poetic text, in contrast, leads the young reader "to learn how to enter
through the printed page into the whole culture surrounding him" (Rosenblatt 1938/
1976, p. 284). To foster that experience of poetic text, the English language arts
teacher "[i]nstead of hurrying the youngster into impersonal and so-called objective
formulations as quickly as possible, ... makes the classroom a place for critical shar-
ing of personal responses" (Rosenblatt 1938/1976, p. 286).

Rosenblatt explained how students' experience of literature can take place through
educational situations by applying Dewey's (1934/1980) philosophy of art as experi-
ence to the subject area of English language arts. She argued that no currently popu-
lar way of using literature – to increase social awareness, convey worthwhile
information, or develop students' awareness of literary form – was likely to lead to an
"intimate personal response" to poetic language (p. 70, cited in Applebee, 1974).
Cultivating such responses was more complex, Rosenblatt argued, than any approach
teachers were accustomed to taking. Rosenblatt contended that it is the response of
the student, not the content of the poetic text, that must be the object of the teacher's

attention and that the teacher must respond to students in a way that invites them to question, refine, or extend their previous responses to texts. What emerges, in this characterization of Rosenblatt's approach that Applebee (1974) has provided, is "the picture of quiet discussion, 'a friendly group, come together to exchange ideas.'" (Rosenblatt 1938, p. 83, quoted in Applebee, 1974, p. 124). Rosenblatt terms the entry into the text and consequent evocation of the text by the reader a *transaction* between the reader and the text.

By the late 1960s, concern with the response of the reader began to surface widely in U.S. schools as a reaction against the formalism of midcentury reforms of English teaching (Squire & Applebee, 1968, cited in Squire, 2003). Carlsen's *Books and the Teen-Age Reader* (1967) was landmark scholarly research on young adults' specific reading interests and on patterns in teenagers' progression in their preferred reading through increasingly literary genres. Carlsen's book went into three editions and was read by parents, teachers, and librarians (Abrahamson, 2004). Publication by Rosenblatt of a second work on reader response in 1987 and major research publications (Beach, 1993; Cooper, 1982; Farrell & Squire, 1990; and Purves & Beach, 1972, all cited in Squire, 2003), Squire states, focused teachers on the response of students as readers in relation to literary texts. Presently, Young Adult (YA) fiction – which features adolescent protagonists, aims at the young adult market, generally stays within a length of 200 pages or less (Small, 1992, cited in Milner & Milner, 1999), and "possesses literary distinction" (Milner & Milner, 1999, p. 197) – is a large category of trade books for purchase by individuals and schools. Kaywell (1993) and Herz (1996) are two YA specialists who have described ways of integrating YA literature into teaching canonical literature as poetic language.

In 1966, bridging a separation between English language arts researchers in the United States and in Britain, 50 British and U.S. scholars gathered at the Anglo-American Dartmouth Conference at Dartmouth, New Hampshire. In Britain, the philosophy of the London group (i.e., leaders from the London Institute of Education, including James Britton) that writing can transform learning was gaining ascendancy over the philosophy of the literary critics known as the Cambridge school (Squire, 2003). Britton and Chorney (1991, cited in Smith & Stock, 2003) describe the Dartmouth conference as having set the stage for a unifying theory of the subject of English language arts, replacing a view of English that focused on products with a view that focused on process and replacing a sense of the learner as a passive receiver (teaching-as-replication) with a recognition of learning as an activity to be pursued.

The teaching of writing in the United States during the late twentieth century was strongly affected by empirical research. In 1961 an NCTE committee reviewing research in written composition found only five studies among hundreds that met most of their criteria for research design (Applebee, 1974). Fifteen years later, in the mid-1970s, university research on writing and network activity among teachers to improve the teaching of writing were proliferating. During the late 1960s and especially during the early 1970s, researchers (e.g., Emig, 1971; Britton, 1975) and practitioners (e.g., Elbow, 1973; Koch, 1973/1990; Macrorie, 1970; Moffett, 1968; Murray 1968/1984/2004) were framing the teaching of writing conceptually as a process, or mode of learning, rather than "merely a modality for reporting learning" (McDonald, Buchanan, and Sterling, 2004, p. 94). During the 1970s and early 1980s, extensive research on writers' cognitive

processes occurred (e.g., Flower & Hayes, 1981; Hayes & Flower, 1980, cited in Sperling and Freedman, 2001; Shaughnessy, 1977; Sommers, 1980). These studies focused on transactional[1] more than on poetic writing, however, and usually focused on writers creating verbal texts in their native language and at the college level (Sperling & Freedman, 2001).

Through state, foundation, and then federal funding, the Bay Area Writing Project, founded in 1973–1974 by James Gray at the University of California, Berkeley, became the National Writing Project (NWP), a vast network (presently in all 50 United States and historically international, together with the British National Writing Project) of teachers who write, who make their practice visible for collegial review, and who attend to students' writing lives across the school subject areas from kindergarten through college (McDonald et al., 2004). Across the NWP's history, the network's members have tended to emphasize poetic writing more than predominantly transactional writing (Greene, 1995). During the NWP's early years, only rarely (e.g., Ponsot & Deen, 1982[3]) did NWP teachers who wrote widely read books on particular methods for teaching writing focus mainly on transactional writing.

During the 1980s United States researchers published studies of students' learning in elementary classrooms (Calkins, 1983, 1986/1994; Graves, 1983) that were organized to nurture not only the kinds of individual thinking cognitive-processes researchers (e.g., Flower, 1979; Sommers, 1980) had documented among expert young adult writers but also high-quality interaction among writers and readers in response to poetic text. Perl and Wilson (1986/1998) studied such classrooms across elementary, middle, and high school in a district where a high proportion of teachers had been inducted into the NWP. In general, though, what was labeled "writing process" teaching (Applebee, 1986, cited in Sperling & Freedman, 2001) in United States secondary school was "mechanical" (Applebee, 1981, p. 101): teachers typically formularized tasks for students and evaluated student writing for compliance with the formulae for producing satisfactory texts.

The conceptual and empirical literature on writing generated during the late 1980s and 1990s (e.g., Brandt, 1992 and Flower, 1989, both cited in Sperling & Freedman, 2001; Flower, 1994) focused on sociocognitive and sociocultural aspects of diverse writers across diverse contexts for writing, inside and outside of school (Nystrand, 2006; Sperling & Freedman, 2001). Literature on the teaching of writing by practitioners, which also remained active during this period, therefore focused more on the particular setting of the English language arts or elementary classroom than did general scholarly literature on writing. At the same time as the middle school reform movement, Atwell (1987, 1998, 2002), Rief (1992, and Rief & Barbieri, 1995), and Calkins (1986/1994) published widely read books on organizing the elementary and middle school English language arts classroom to promote high-quality talk about poetic qualities and features of text (e.g., Kaufman, 2000). During the past decade, widely read books for practitioners (e.g., Fletcher & Portalupi, 1998; Fletcher & Portalupi, 2001; Heard, 1999; Ostrum, Bishop, & Haake, 2001; Portalupi & Fletcher, 1998) have articulated how the English language arts (or writing) teacher and his or her students can learn aspects of the craft of writing in the environment of the elementary, middle school, or university classroom organized like an artist's studio (Kirby & Kuykendall, 1991) rather than like a factory assembly line.

*Cognitive Pluralism and Critical Theory as stances toward English language arts teaching.* Cognitive Pluralist educational ideology emphasizes that the graphic and lively arts, as available symbol systems, can and should be used to teach English language arts. Perhaps the earliest instance of a formal educational organization with a Cognitive Pluralist (Eisner, 1994) orientation to the teaching of English language arts was the Teachers College, Columbia University, Center for English Communication Arts, established during the 1940s and 1950s to apply the philosophy of art of Suzanne Langer (1942, cited in Squire, 2003) and the multimedia theories of Marshall McLuhan (1964, cited in Squire, 2003). This center not only generated research but trained school administrators, teacher educators, and research professors (Squire, 2003).

In contrast to the Anglo-American Dartmouth Seminar, which sought to develop a unifying concept of English language arts as a school subject, in 1987 at the English Coalition Conference at the Wye Plantation in rural Maryland, U.S.A., 60 English language arts scholars convened to "chart [plural] directions for the study of English in the 21st century" (Smith & Stock, 2003, p. 114). The participants at the Wye Conference articulated such goals as making critical literacy possible for all students, enabling students to use language to articulate their own points of view, and encouraging students to respect different points of view (Smith & Stock, 2003).

Arising from research interest in out-of-school as well as in-school literacies (Kist, 2005), the idea of *multiliteracies*, associated with New Literacy scholars such as the New London Group (1996) and Brian Street (1995) (both cited in Kist, 2005), addresses the interest of cognitive pluralist educators in students' access to expression in multiple symbolic systems (e.g., Greene, 1995, cited in Albers, 2006; Myers, 1996 and Suhor, 1992, both cited in Whitin, 2006) and the interest of educators whose ideology reflects Critical Theory in ameliorating ways that schooling reproduces inequalities in the wider society (Eisner, 1994). Wagner (1998) has reviewed the large body of research on drama and English language arts learning, and researchers such as Wilhelm (1997), Enciso (1990, cited in Wilhelm, 1997), and Whitelaw and Wolf (2001) (see also Edmiston & Enciso, 2003) have studied and documented how through nondiscursive means of experiencing poetic text, readers can engage emotionally and intellectually (Guthrie & Alvermann, 1999) with print text – including young readers who identify themselves as not liking to read.

Kist (2005) conducted an empirical study of six settings where English and other subject area teachers in Canada and the United States were pursuing teaching through new literacies.[4] Kist defined classrooms using *new literacies* as classrooms where students work daily using multiple forms of representation; there are explicit discussions of the merits of using certain symbol systems in certain situations with much choice; the teacher models working through problems, providing metadialogue; students, working in certain symbol systems, take part in a mix of individual and collaborative tasks; and students report achieving intellectual and emotional engagement in their work (p. 16). Claggett (1992), Gilmore (1999), and Smagorinsky (2002) have described approaches to English language arts teaching that integrate graphic and verbal representation. Albers (2006), Salvio (1999, cited in Edmiston & Enciso, 2003), and Whitin (2006) have described ways teacher education can emphasize the multimodal.

Sanders-Bustle (2003) has published an edited volume of approaches to teaching, including literacy teaching, through multiple symbolic systems and with a strong focus

on social justice. Ethnographic research by Valde's (2001) and Hynds (1997) illustrates how school practice can reproduce inequalities in the wider society, however, regardless of whether English is approached as the experience of poetic language. Valde's case studies of four students' English as a Second Language placements in U.S. schools document the reproduction of inequalities in the wider society – regardless of one instance of the organization of the writing classroom to foster growth in writing as text with poetic as well as formulaic qualities. Hynds' (1997) ethnographic research on race and gender issues beneath the surface of interactions in an urban middle school classroom conveys the importance in this setting of the teacher becoming a fellow writer with her students, student choice, and multimodal teaching for students' engagement with text as poetic language as well as the problem of attempted neutrality toward social and cultural issues such as race, gender, perceived academic ability, and social class.

## The Current Technical Environment of English Language Arts Teaching

In the technical environment of U.S. schools and school systems, increased testing began during the 1960s and 1970s (Squire, 2003). By the early 1980s, district, state, and national accountability systems for monitoring student achievement on reading skills tests were in place in 48 of the 50 U.S. states (Valencia & Pearson, 1987, cited in Squire, 2003). Student writing samples were assessed in two-thirds of these states (Applebee, Langer, & Mullis, 1986, cited in Squire, 2003).

During the 1990s, Dixon states, Australia, Canada, and the United Kingdom suffered economic setbacks that made them, in effect, "dependent economies, relying on multinational firms to bring in new capital and enterprise" (Dixon, 2003, p. 22). Such business enterprises seek locations where large supplies of potential employees have the profile of credentials indicating skills and demeanor that school certificates document; thus pressures to decrease the cost of public education and pressures to produce large numbers of graduates, especially with math and science skills demonstrated through cross-national comparisons as being higher than that in other countries, are simultaneously present (Carnoy, 2000). Through the 1970s, early institutional theorists argued, schools exemplified *institutional-sector* organization: core operations were uninspected while the credentials of teachers were carefully monitored. During this time the relationship between school administration and classroom practice and the legitimacy of the school both depended on isomorphism in a particular school's external features with the class of organizations known as *schools* (Coburn, 2004; Weick, 1976). During the 1980s through the present, however, as a population of organizations, schools have shifted markedly toward being in the *technical* rather than institutional sector of organizations. Technical-sector organizations can be recognized through demands in the organizations' environment for efficiency: Inspection of the core operations (i.e., quality control) of technical-sector organizations rewards these organizations for efficient production (Coburn, 2004). In the case of schools as a type of organization, the technical environment of the school rewards the efficient production of high, or increasingly high, standardized test scores.

The new emphasis on measuring and comparing school outcomes across countries and within countries has been pursued by international organizations such as the International Association for Evaluation of Educational Achievement (IEA), the Organization for Economic Cooperation and Development (OECD), and the World Bank. These organizations share, in Carnoy's (2000, p. 56) words, "an explicit understanding that 'better' education can be measured and that better education translates directly into higher economic and social productivity." Carnoy claims, however, that there is more political and financial space for nation states to condition the way globalization is brought into public education than is generally recognized. Messages in classrooms' and schools' institutional environments suggesting national interests counter to efficiency through routinization of school practice include France's recently instituted drive for "student autonomy" and "local flexibility," the Netherlands' similar proclamation, and Japan's urging education to pursue "personal and creative self-realization" (Dixon, 2003).

As of the 1990s, Dixon writes (2003), in England and Wales educational outcomes were being measured at ages 7, 11, 13, and 16, the results reported in tabular form for individual schools. In the United States, where each of the states has its own policy for testing English language arts, Hillocks (2002) has studied several different states' policies for the testing of writing. State contexts pressed teachers toward formularizing writing instruction (teaching-as-replication) in some states compared to others where policy pressed teachers toward more authentic teaching of writing, including poetic writing.

What is known as the process-writing movement was validated (Pritchard & Honeycutt, 2006) during the 1990s by the National Assessment of Educational Progress conducted by the U.S. government. Researchers have held various views of what this approach to teaching writing entails, from definitions that include routine production of a first and final draft to definitions that stipulate the embeddedness of craft (strategy and skill) instruction in an environment that cultivates writers' problem-solving. Nevertheless, between the late 1980s and the present, empirical research has accrued that has found process-oriented approaches to writing instruction more productive than current-traditional approaches. Outcome measures have included measures of students' attitudes and dispositions toward writing as well as measures of students' achievement in writing (Pritchard & Honeycutt, 2006). Pritchard and Honeycutt link the origins and expansion of process-oriented methods for teaching writing to the Bay Area Writing Project, now the NWP.

In a review of empirical studies of induction into the NWP, teachers' and their school colleagues' practices, and student achievement, Pritchard & Honeycutt (2006) point out that the NWP "eschews a singular formula for teaching writing" (Friedrich & LeMahieu, 2004, quoted in Pritchard & Honeycutt, 2006, p. 282). The particular classroom practices characteristic of NWP-affiliated teachers have accrued over the three decades of the NWP's history, from ways of teaching prewriting during the early years of the NWP to the use of scoring rubrics and portfolio assessment and ways of incorporating writing across the curriculum during the NWP's later years. Now practices becoming more widespread through the NWP network include electronically mediated ways of writing and ways of teaching writing appropriate for special populations. In the growing body of literature on the NWP's effects, main results in published statistical studies have favored the NWP approach to teaching writing over traditional

approaches (Pritchard & Honeycutt, 2006). Further, in 2004 the NWP launched a multiyear research agenda, through which consortia of researchers studied NWP and comparison teachers' practices and their students' gains in achievement in writing 2003–2004 and 2004–2005. The 2004–2005 consortium adopted scoring procedures sensitive to features of writing as poetic language. That is, participating students' writings were scored holistically and for voice, syntactic fluency, and diction as well as for unity and for compliance with conventions for sentence structure, word usage, and mechanics. These studies permit discussion of how the teaching of writing as replication compares to more aesthetically grounded teaching of writing in the *efficiency* of these contrasting approaches in producing gains in achievement in writing (e.g., National Writing Project, 2006). Provided that government arbiters selecting proficiency tests choose measures that are even somewhat sensitive to the aesthetic qualities of students' experience and writing of poetic language, schools' and classrooms' technical environment is likely to press, and also invite, schools and teachers toward approaching the school subject of English as an art, comprising elements of craft, rather than as an assortment of atomistic, routine tasks (Olshansky, 2006).

## Future Research and Practice

Few studies have attended to how readers and writers of poetic language make the transition from novice to expert in the sociocognitive and sociocultural context of this development. Longitudinal studies of the development of students' poetic reading and writing – attending to the sociocognitive and sociocultural context of this development and incorporating nondiscursive as well as discursive indicators of the experience of poetic language – can improve understanding of how students' poetic imagination and repertoires can develop through school practice.

Given current incentives for researchers to conduct comparison-based studies of instructional procedures and student achievement, how sensitive the achievement measures used by researchers employing these designs are to students' achievement in reading and writing as poetic language (including in multimodal forms), rather than only to achievement in English language arts as replication, will be important. In the United States, where school systems' access to federal funds is tied to the adoption of methods found effective through comparison-based research, the achievement measures employed in these studies will affect teachers' formal authority to educate students as connoisseurs and practitioners of poetic language.

## Notes

1. Britton (1970) distinguished among the cognitive processes and social contexts (Sperling & Freedman, 2001) of three functions of writing: poetic, transactional, and expressive. In contrast to poetic writing, transactional writing serves to accomplish some exchange or negotiation and provides information. Transactional writing includes, for example, essays written to demonstrate having apprehended course content, legal documents, and reports. Expressive writing is writing with formal conventions for global and syntactic form relaxed (e.g., as in a journal or diary) and allows exploration by the writer much as

informal talk would. Research on the teaching of literature has more fully inquired into the teaching of poetic language than has research on the teaching of writing. Research on the teaching of writing has focused mainly on transactional rather than poetic or expressive writing (Sperling & Freedman, 2001).

2. The enacted form of schooling, Brint (1998) suggests, has more to do with the degree to which a nation has become industrialized than with the symbolic features of formal curriculum. Brint describes how the same emphasis on behavioral conformity and moralism found in nineteenth century schools in the United States can be found today in industrializing parts of the world. Brint states that in slow-industrializing countries, in contrast to the United States and England, mass schooling preceded industrialization and socialization of children took a different path, at first, than the industrializing pattern of strict behavioral control and moral instruction (e.g., Pestalozzi's approach in Switzerland and Germany during the early 1800s to activating children's interest in learning).

3. In the instance of Ponsot and Deen's teaching of transactional writing to inexperienced college writers, these NWP teachers emphasized experience of aesthetic aspects of students' and their classmates' transactional writing.

4. Multiple literacies were incorporated into formal curriculum in Canada earlier than in the United States (Willinsky, 2004). In the United States the NCTE Executive Committee approved a position statement by its Multi-Modal Literacies Issue Management Team in 2005 declaring the need for English language arts teachers to become more informed about multimodal literacy (NCTE, 2005).

# References

Abbs, P. (2003). *Against the flow*. London: Falmer.

Abrahamson, R. F. (2004). An educator who changed lives. *Assembly on Literature for Adolescents (ALAN) of National Council of Teachers of English (NCTE) Review, winter*. Retrieved November 16, 2005, from http://www.zinkle.com/p/articles/mi_qa4063/is_200401/ai_n9385116

Adler, M. J., & Van Doren, C. (1940/1972). *How to read a book: The classic guide to intelligent reading* (Rev. ed.). New York: Simon & Schuster.

Albers, P. (2006). Imagining the possibilities in multimodal curriculum design. *English Education, 38*(2), 75–101.

Applebee, A. N. (1974). *Tradition and reform in the teaching of English: A history*. Urbana, IL: National Council of Teachers of English.

Applebee, A. N. (1981). *Writing in the secondary school: English and the content areas*. NCTE Research Report No. 21. Urbana, IL: National Council of Teachers of English.

Atwell, N. (1987). *In the middle: Writing, reading, and learning with adolescents*. Portsmouth, NH: Heinemann.

Atwell, N. (1998). *In the middle: New understandings about writing, reading and learning* (2nd ed.). Portsmouth, NH: Heinemann.

Atwell, N. (2002). *Lessons that change writers*. Portsmouth, NH: Heinemann.

Bakhtin, M. (1981). *The dialogic imagination*. Austin, TX: University of Texas.

Barbieri, M. (2002). *"Change my life forever": Giving voice to English-language learners*. Portsmouth, NH: Heinemann.

Bartholomae, D. (1990). Producing adult readers: 1930–50. In A. A. Lunsford, H. Moglen, & J. Slevin (Eds.), *The right to literacy* (pp. 13–28). New York: The Modern Language Association of America.

Brint, S. (1998). *Schools and societies*. Thousand Oaks, CA: Pine Forge.

Britton, J. N. (1975). *The development of writing abilities*. London: Macmillan.

Calkins, L. M. (1983). *Lessons from a child: On the teaching and learning of writing*. Portsmouth, NH: Heinemann.

Calkins, L. M. (1986/1994). *The art of teaching writing* (new ed.). Portsmouth, NH: Heinemann.

Carlsen, R. (1967). *Books and the teen-age reader*. New York: Harper & Row.

Carnoy, M. (2000). Globalization and educational reform. In N. P. Stromquist & K. Monkman (Eds.), *Globalization and education: Integration and contestation across cultures* (pp. 43–61). Lanham, MD: Rowman & Littlefield.

Claggett, F. (1992). *Drawing your own conclusions: Graphic strategies for reading, writing, and thinking.* Portsmouth, NH: Heinemann.

Coburn, C. E. (2004). Beyond decoupling: Rethinking the relationship between the institutional environment and the classroom. *Sociology of Education, 77*(3), 211–244.

Cuban, L. (1993). *How teachers taught: Constancy and change in American classrooms, 1890–1990* (2nd ed.). New York: Teachers College.

Dewey, J. (1900, 1902/1990). *The school and society* and *The child and the curriculum.* Chicago, IL: University of Chicago.

Dewey, J. (1934/1980). *Art as experience.* New York: Perigee.

Dewey, J. (1938/1973). *Experience and education.* New York: Collier.

Dixon, J. (2003). Historical considerations: An international perspective. In J. Flood, D. Lapp, J. R. Squire, & J. M. Jensen (Eds.), *Handbook of research on teaching the English language arts* (2nd ed.) (pp. 18–23). Mahwah, NJ: Erlbaum.

Edmiston, B., & Enciso, P. E. (2003). Reflections and refractions of meaning: Dialogic approaches to reading with classroom drama. In J. Flood, D. Lapp, J. R. Squire, & J. M. Jensen (Eds.), *Handbook of research on teaching the English language arts* (2nd ed.) (pp. 868–880). Mahwah, NJ: Erlbaum.

Eisner, E. W. (1994). *The educational imagination: On the design and evaluation of school programs* (3rd ed.). New York: Macmillan.

Elbow, P. (1973). *Writing without teachers.* London and New York: Oxford.

Emig, J. A. (1971). *The composing processes of twelfth graders.* Urbana, IL: National Council of Teachers of English.

Fletcher, R., & Portalupi, J. (1998). *Craft lessons.* Portland, ME: Stenhouse.

Fletcher, R., & Portalupi, J. (2001). *Writing workshop.* Portsmouth, NH: Heinemann.

Flower, L. (1979). Writer-based prose: A cognitive basis for problems in writing. *College English, 41*(1), 19–37.

Flower, L. (1994). *The construction of negotiated meaning: A social cognitive theory of writing.* Carbondale, IL: Southern Illinois.

Flower, L., & Hayes, J. R. (1981). A cognitive process theory of writing. *College Composition and Communication, 32*(4), 365–387.

Gamoran, A., & Carbonaro, W. J. (2002). High school English: A national portrait. *The High School Journal, 86*(2), 1–13.

Gilmore, B. (1999). *Drawing the line: Creative writing through the visual and performing arts.* Portland, ME: Calendar Islands.

Graves, D. H. (1983). *Writing: Teachers and children.* Portsmouth, NH: Heinemann.

Greene, M. (1995). *Releasing the imagination: Essays on education, the arts, and social change.* San Francisco, CA: Jossey-Bass.

Guthrie, J. T., & Alvermann, D. E. (Eds.). (1999). *Engaged reading: Processes, practices, and policy implications.* New York: Teachers College.

Heard, G. (1999). *Awakening the heart: Exploring poetry in elementary and middle school.* Portsmouth, NH: Heinemann.

Herz, S. K. (with Gallo, D. R.) (1996). *From Hinton to Hamlet: Building bridges between young adult literature and the classics.* Westport, CT: Greenwood.

Hillocks, G. Jr. (2002). *The testing trap: How state writing assessments control learning.* New York: Teachers College.

Hynds, S. (1997). *On the brink: Negotiating literature and life with adolescents.* New York: Teachers College.

Inkeles, A., & Smith, D. (1974). *Becoming modern.* Cambridge, MA: Harvard.

Kaestle, C. F. (1983). *Pillars of the republic: Common schools and American society, 1790–1860.* New York: Hill & Wang.

Kaufman, D. (2000). *Conferences and conversations: Listening to the literate classroom.* Portsmouth, NH: Heinemann.

Kaywell, J. F. (Ed.). (1993). *Adolescent literature as a complement to the classics.* Norwood, MA: Christopher-Gordon.

Kirby, D., & Kuykendall, C. (1991). *Mind matters: Teaching for thinking.* Portsmouth, NH: Heinemann.

Kist, W. (2005). *New literacies in action: Teaching and learning in multiple media*. New York: Teachers College.

Koch, K. (1973/1990). *Rose, where did you get that red? Teaching great poetry to children*. New York: Vintage.

MacDonald, V. M. (1999). The paradox of bureaucratization: New views on Progressive era teachers and the development of a women's profession. *History of Education Quarterly, 39*(4), 427–453.

Macrorie, K. (1970). *Telling writing*. New York: Hayden.

Marzano, R. J. (2003). Language, the language arts, and thinking. In J. Flood, D. Lapp, J. R. Squire, & J. M. Jensen (Eds.), *Handbook of research on teaching the English language arts* (2nd ed.) (pp. 687–716). Mahwah, NJ: Erlbaum.

McDonald, J. P., Buchanan, J., & Sterling, R. (2004). The National Writing Project: Scaling up and scaling down. In T. K. Glennan, S. J. Bodilly, J. R. Galegher, & K. A. Kerr (Eds.), *Expanding the reach of education reforms: Perspectives from leaders in the scale-up of educational interventions* (pp. 81–106). Santa Monica, CA: RAND.

Meyer, J. W., Scott, W. R., Strang, D., & Creighton, A. L. (1994). Bureaucratization without centralization: Changes in the organizational system of U.S. public education, 1940–1980. In W. R. Scott & J. W. Meyer (and Associates) (Eds.) (1994). *Institutional environments and organizations: Structural complexity and individualism* (pp. 179–205). Thousand Oaks, CA: Sage.

Milner, J. O., & Milner, L. F. M. (1999). *Bridging English* (2nd ed.). Upper Saddle River, NJ: Merrill.

Moffett, J. (1968). *Teaching the universe of discourse*. Boston, MA: Houghton Mifflin.

Murray, D. M. (1968/1984/2004). *A writer teaches writing* (Rev. 2nd ed.). Boston, MA: Heinle.

*NCTE guideline: Multi-modal literacies*. (2005). Retrieved January 21, 2006, from http://www.ncte.org/pring.asp?id=123213&node=618

National Writing Project. (2006). Local Site Research Initiative Report Cohort II 2004–2005. Retrieved August 6, 2006, from http://www.writingproject.org/cs/nwpp/download/nwp_file/5683/LSRICohort/SummaryReport.pdf?w-r+pcfile_d

Nelson, N., & Kinneavy, J. L. (2003). Rhetoric. In J. Flood, D. Lapp, J. R. Squire, & J. M. Jensen (Ed.), *Handbook of research on teaching the English language arts* (2nd ed.) (pp. 786–798). Mahwah, NJ: Erlbaum.

Noether, E. P. (1951). *Seeds of Italian nationalism, 1700–1815*. New York: Columbia.

Nystrand, M. (2006). The social and historical context for writing research. In C. A. Macarthur, S. Graham, & J. Fitzgerald (Eds.). *Handbook of writing research* (pp. 11–27). New York: Guilford.

Oakes, J. (1985). *Keeping track: How schools structure inequality*. New Haven, CT: Yale.

Olshansky, B. (2006). Picturing Writing and Image-making: Effectiveness. Retrieved August 8, 2006, from http://www.picturingwriting.org/effectiveness.html

Ostrum, H., Bishop, W., & Haake, K. (2001). *Metro: Journeys in writing creatively*. New York: Longman.

Perl, S., & Wilson, N. (1986/1998). *Through teachers' eyes: Portraits of writing teachers at work*. Portland, ME: Calendar Islands.

Pflanze, O. (1990). *Bismarck and the development of Germany*. Princeton, NH: Princeton.

Ponsot, M., & Deen, R. (1982). *Beat not the poor desk. Writing: What to teach, how to teach it and why*. Portsmouth, NH: Boynton/Cook.

Portalupi, J., & Fletcher, R. (2001). *Nonfiction craft lessons*. Portland, ME: Stenhouse.

Pritchard, R. J., & Honeycutt, R. L. (2006). The process approach to writing instruction: Examining its effectiveness. In C. A. Macarthur, S. Graham, & J. Fitzgerald (Eds.), *Handbook of writing research* (pp. 275–290). New York: Guilford.

Rief, L. (1992). *Seeking diversity: Language arts with adolescents*. Portsmouth, NH: Heinemann.

Rief, L., & Barbieri, M. (1995). *All that matters: What is it we value in school and beyond?* Portsmouth, NH: Heinemann.

Rosenblatt, L. M. (1938/1976). *Literature as exploration* (3rd ed.). New York: Noble & Noble.

Sanders-Bustle, L. (Ed.) (2003). *Image, inquiry, and transformative practice: Engaging learners in creative and critical inquiry through visual representation*. New York: Lang.

Scott, W. R., & Meyer, J. W. and Associates (1994). *Institutional environments and organizations: Structural complexity and individualism*. Thousand Oaks, CA: Sage.

Shaughnessy, M. P. (1977). *Errors and expectations: A guide for the teacher of Basic Writing*. New York: Oxford.

Smagorinsky, P. (2002). *Teaching English through principled practice*. Upper Saddle River, NJ: Merrill.

Smith, K., & Stock, P. L. (2003). Trends and issues in research in the teaching of the English language arts. In J. Flood, D. Lapp, J. R. Squire, & J. M. Jensen (Eds.), *Handbook of research on teaching the English language arts* (2nd ed.) (pp. 114–130). Mahwah, NJ: Erlbaum.

Sommers, N. (1980). Revision strategies of student writers and experienced writers. *College Composition and Communication, 31*(4), 378–388.

Sperling, M., & Freedman, S. W. (2001). Research on writing. In V. Richardson (Ed.), *Handbook of research on teaching* (4th ed.) (pp. 370–389). Washington, DC: American Educational Research Association.

Squire, J. R. (2003). The history of the profession. In J. Flood, D. Lapp, J. R. Squire, & J. M. Jensen (Eds), *Handbook of research on teaching the English language arts* (2nd ed.) (pp. 3–17). Mahwah, NJ: Erlbaum.

Tyack, D., & Cuban, L. (1995). *Tinkering toward utopia: A century of public school reform*. Cambridge, MA: Harvard.

Tyack, D. B. (1976). Ways of seeing: An essay on the history of compulsory schooling. *Harvard Educational Review, 46*(3), 355–389.

Valde's, G. (2001). *Learning and not learning English: Latino students in American schools*. New York: Teachers College.

Wagner, B. J. (1998). *Educational drama and language arts: What research shows*. Portsmouth, NH: Heinemann.

Weber, E. (1976). *Peasants into Frenchmen: The modernization of rural France, 1870–1914*. Stanford, CA: Stanford.

Weber, S., & Mitchell, C. (1995/2000). *"That's funny, you don't look like a teacher." Interrogating images and identity in popular culture*. Philadelphia, PA: Falmer.

Weick, K. (1976). Educational organizations as loosely coupled systems. *Administrative Science Quarterly, 21*, 1–19.

Whitelaw, J., & Wolf, S. A. (2001). Learning to "see beyond": Sixth-grade students' artistic perceptions of *The Giver. The New Advocate: For Those Involved with Young People and their Literature, 14*(1), 56–67.

Whitin, P. (2006). Forging pedagogical paths to multiple ways of knowing. *English Education, 38*(2), 123–145.

Wilhelm, J. D. (1997). *"You Gotta BE the Book." Teaching engaged and reflective reading with adolescents*. New York: Teachers College.

Willinsky, J. (2004). A history not yet past: Where then is here? In B. R. C. Barrell, R. F. Hammett, J. S. Mayher, & G. M. Pradl (Eds.), *Teaching English today* (pp. 24–35). New York: Teachers College.

# Section 2

# CURRICULUM

**Section Editor: Susan W. Stinson**

# PRELUDE

# 9

# MAKING SENSE OF CURRICULUM
# RESEARCH IN ARTS EDUCATION

**Susan W. Stinson**
*University of North Carolina at Greensboro, U.S.A.*

When I was a child in an elementary school with no art education, map-making was an opportunity to explore different media. While sculpting mountains out of a salt/flour/water mixture, carving rivers, and drawing symbols for cities, I also imagined myself traveling to the lands I was representing. For my teachers, of course, the purpose of making and reading maps was to learn geography and social studies. National and world maps were common décor in our classrooms; different states in the United States and different countries were indicated by distinct colors, with clear black lines showing the boundaries between them. Puzzles and other games, as well as our own map-making, helped us recognize the shapes and other features of these political units so that we could eventually label them on tests. In those days, fixed and clear boundaries seemed a given in many parts of our lives.

Today, of course, maps are constantly changing and other boundaries seem a matter for constant negotiation as we try to determine who and what will be included and excluded. Similarly, determining boundaries has been a challenge for all authors of the *Handbook*, including those in this section. The boundary issues have been reflected in many of the questions that circulated through the cyber-process of this project: "What counts as *research*?" "What educational research is *not* about curriculum?" "How can one adequately contextualize this research without describing its *history*, which is a separate section of the Handbook?" "How far back should I go?" "How can I cover this topic completely within the word limit – what gets left out?"

Readers will undoubtedly notice that these questions have been answered differently within each chapter in this section. The task implicitly set for authors was both academic and aesthetic: to review scholarly literature within a specific area of inquiry, and then to make a meaningful whole out of what they found. The structures selected by the authors create forms in which they have explored the content of curriculum research in their discipline or area of inquiry. Successive drafts not only made minor adjustments to boundaries (fueled by the reviewing process, which often included suggestions of additional sources), but also refined the cohesiveness and clarity of each

*L. Bresler (Ed.), International Handbook of Research in Arts Education, 143–146.*
© 2007 *Springer.*

chapter. In the process, every author in this section had to cope with the question, What *is* curriculum research in arts education?

The history of curriculum, even if it were restricted to only the United States,[1] is far too complex to do justice to here. I can present an overview only with the realization that such a picture is a construction, not simply a factual account. The most traditional understanding of curriculum, likely held by the majority of individuals other than curriculum scholars, is simply the course content. When I began taking education courses in the late 1960s, I recall learning about two strands of the curriculum, the content (*what* students are taught) and the methodology (*how* they are taught). Once attempting to apply my limited dance education knowledge to practice, I very quickly realized the significance of a third: the students. After taking classes in human development, I naively thought my own education would be complete and I would be prepared to be a good teacher. Indeed, I taught for many years before starting to seek something more. That "something more" is often labeled curriculum *studies*, a field which is broad in scope and interdisciplinary in nature. Although perspectives from the humanities and social sciences have been essential in developing inquiry in this field, arts educators have also made their mark. Elliott Eisner (2005) may be the best known example, although the editor of this *Handbook*, Liora Bresler, represents the next generation of artists/arts educators-turned curriculum scholars.

Researchers in curriculum studies often engage in theory-building, asking major philosophical questions such as "What's worth knowing?", "Who decides?", and "In whose interest?"[2] While these scholars may gather empirical data as well, they normally engage in analysis of that data using postpositivist lenses ranging from phenomenology to critical social theory (see Lather, 1991). Recognition of the significance of aesthetic decisions and embodied experience in conducting research may be among the greatest contributions of the arts to this work (see, e.g. Barone & Eisner, 1997; Bresler, 2005; Cahnmann, 2003; Eisner, 1993, 1997; Stinson, 1995; articles in the journal *Qualitative Inquiry*).

At the same time that researchers in curriculum studies have been grappling with the "big questions," researchers from other curriculum traditions have been trying to get *yes* or *no* answers to different ones, usually related to the effectiveness of particular arts education practices in accomplishing stated goals. Such questions imply a need for different methodological approaches. In the United States the federal government has changed funding requirements to support only "scientifically based research" in education (see Jacob & White, 2002). Such research is avidly sought by arts advocates to support claims about the value of arts education in improving student-learning in other areas of the curriculum (see Deasey, 2002).

The research included in the various chapters of this section is reflective of the range of work in the different arts education areas as well as the aesthetic choices of the authors. Several authors, from John Dewey (1934) to William Pinar (2004), refer specifically to curriculum scholars from outside arts education. Donald Blumenfeld-Jones looks at literature in dance curriculum through the lens created by his current work as a scholar in curriculum studies, as well as his first career as a professional dancer; the chapter he wrote with Sheaun-Yann Liang, organized around different research aims, reflects this dual perspective. Examining visual arts education, authors

Rita Irwin and Graeme Chalmers structure their chapter around two interpretations of curriculum, which they call *curriculum as plan* (experiencing the visual) and *curriculum as lived* (visualizing experience). Janet Barrett also makes the connection between music education and curriculum studies when she notes that the foundations of music education include philosophy, psychology, and historical studies, with additional perspectives from sociology, ethnomusicology, and qualitative research. Frede Nielsen, writing about *Didaktik* and *Bildung*, describes what might be considered a European version of curriculum studies.

A number of the authors create a developmental/historical model, identifying themes and changes over time in what has been considered important in their area of arts education. The chapters by Irwin and Chalmers, Barrett, and Nielsen take this approach. John O'Toole and Jo O'Mara do so as well, revealing how major themes in drama curriculum have developed over time. Lynn Butler-Kisber, Yi Li, Jean Clandinin, and Pamela Markus examine historical trends in the development of narrative, as well as the emerging role of narrative in visual arts, music, and drama curriculum research.

Looking historically at trends in both arts education curriculum and in research raises questions about the relationship between research and practice, questions which are not directly addressed by most authors. To what extent does practice in arts education drive research and to what extent does research inform practice?

Eve Harwood, in her chapter on arts curriculum research across all the arts within higher education, writes that changes in practice are ahead of research on the effects of such practices. Within a boundary of the past 25 years, the questions she uses as an organizational framework include two classic ones for curriculum research: Who is being taught and what do they experience? What is the content of instruction and who decides? As an editor, I found the third question raised in the chapter especially fascinating: What do *studio* [italics added] teaching and learning look like? Since these questions were derived from a review of the research itself, I could not help but wonder to what degree this reflects the widespread belief that creating and performing are the only *real* work in the arts, and thus the only kinds of teaching/learning worth studying.

Joan Russell and Michalinos Zembylas review research related to arts integration between 2000 and 2005. Rather than describing changes over time, this piece reveals new structures for arts curricula, ones with fewer boundaries between the arts. The authors present arguments for and against arts integration, discussing both benefits and challenges revealed in the studies.

A number of international authors offer responses to the chapters. Although not all of them were able to locate published research in a particular area of arts education curriculum, they provide helpful context for understanding issues in different parts of the world. Many of these authors identify tensions between teaching Western high art and teaching local culture. This brings us back to the questions identified earlier: What's worth knowing, who decides, and in whose interest are the decisions being made?

Also within this section are two "interludes," by Decker Walker and Tom Barone. Their very personal reflections raise issues about arts education curriculum from a different vantage point. These pieces remind us that artistic practice, teaching, and research are all ways of making sense of the world and finding our way through it.

I recall first learning as an adolescent about an important difference between two-dimensional maps and three-dimensional globes: In the flat maps on our classroom walls, the United States appeared larger in relation to other countries than it did on the globe. Indeed, what we know best often seems like the most important. To extend a limited vision, both travel and the arts are valuable, helping us to see different worlds and to see a familiar one differently. As editor of this section, I hope that discovering how these authors have made sense of the world of arts education curriculum research will have a similar effect upon readers.

## Notes

1. See Kliebard, (2004) and Reese, (2005), for thoughtful history and analysis.
2. See the chapter by Blumenfeld-Jones and Liang (Chapter 16) in this section for further elaboration.

## References

Barone, T. E., & Eisner, E. (1997). Arts-based educational research. In R. M. Jaegar (Ed.), *Complementary methods for research in education* (pp. 73–116). Washington, DC: AERA.

Bresler, L. (2005). What musicianship can teach educational research. *Music Education Research, 7*(2), 169–183.

Cahnmann, M. (2003). The craft, practice, and possibility of poetry in educational research. *Educational Researcher, 32*(3), 29–36.

Deasey, R. (Ed.). (2002). *Critical links: Learning in the arts and student academic and social development.* Washington, DC: Arts Education Partnership.

Dewey, J. (1934). *Art as experience.* New York: Minton, Balch & Company.

Eisner, E. W. (1993). Forms of understanding and the future of educational research. *Educational Researcher, 22*(7), 5–11.

Eisner, E. (1997). The promise and perils of alternative forms of data representation. *Educational Researcher, 26*(6), 4–10.

Eisner, E. (2005). *Reimagining schools: The selected works of Elliot W. Eisner.* New York: Routledge.

Jacob, E., & White, C. S. (Eds.) (2002). Theme issue on scientific research and education. *Educational Researcher, 31*(8).

Kliebard, H. M. (2004). *The struggle for the American curriculum, 1893–1958* (3rd ed.). New York: RoutledgeFalmer.

Lather, P. A. (1991). *Getting smart: Feminist research and pedagogy with/in the postmodern.* New York: Routledge.

Pinar, W. F. (2004). *What is curriculum theory?* Mahwah, NJ: Lawrence Erlbaum.

Reese, W. J. (2005). *America's public schools: From the common school to "No Child Left Behind."* Baltimore, MD: Johns Hopkin's University Press.

Stinson, S. W. (1995). Body of knowledge. *Educational Theory, 45*(1), 43–54.

# 10

# CURRENTS OF CHANGE IN THE
# MUSIC CURRICULUM

**Janet R. Barrett**
*Northwestern University, U.S.A.*

Calls for change in curricular practice are ubiquitous in education. The generative tension between traditional views of teaching and learning and innovative proposals for refining, extending, or discarding those traditions feeds the wellspring of curricular discourse. Curriculum studies in music education benefit from probing dialectical tensions between preservation and innovation (Jorgensen, 2003). The triumvirate of foundational disciplines in music education – philosophy, psychology, and historical studies – provide insights into traditional practices of learning and teaching music and also point the way toward avenues of change. For example, principles from utilitarian, aesthetic, and praxial views have stimulated a lively examination of classroom practices in music and their ultimate aims (Elliott, 1995, 2005; Mark, 1982; McCarthy & Goble, 2005; Reimer, 2003). The cognitive, developmental, and social perspectives of music psychology have fueled interest in deeper levels of musical thinking within music classrooms (Hargreaves, Marshall, & North, 2003). Historical scholarship in music education has described the roots and branches of influence that inform our practices while giving us a platform from which to interrogate our culturally and politically embedded routines and conventions (McCarthy, 2003). These core foundations have in turn been informed and revitalized through the cross-fertilization of perspectives from sociology (DeNora, 2003; Shepherd & Vulliamy, 1994), ethnomusicology (Campbell, 2004; Stock, 2003), and policy studies (Barresi, 2000; Chapman, 2004; Spruce, 2002). Qualitative research – particularly ethnography, case studies, narrative research, and phenomenology – also deepens our understanding of the meaningful and situated nature of the musical experience (Bresler, 1995, 1996; Flinders & Richardson, 2002).

As many voices animate this curriculum discourse, the curriculum field becomes more complex, crowded, and contested. Confidence in the prescriptive, scientific, rational, linear, and falsely tidy paradigm of curriculum planning that has been promulgated and widely accepted in education for decades has eroded and given way to a panoramic (some might say vertiginous) array of claims, criticisms, projects, and

147

*L. Bresler (Ed.), International Handbook of Research in Arts Education, 147–162.*
© 2007 *Springer.*

opportunities. The commonly held notion that research drives practice is worn and misguided and is a view amplified by Westbury who suggests that "traditional educational theory and research must be regarded as a failed project, at least when seen from the viewpoint of improving schooling in a sustained and sustaining way" (2002, p. 156). Complementary, synergistic views of theory and practice are needed. Wing (1992) suggests that that the curriculum is best understood as the point of mediation between an idea of education and practice, a perspective consistent with Pinar, Reynolds, Slattery, and Taubman who maintain that "in the contemporary field, theory and practice are often regarded as embedded in each other" (2004, p. 56).

Indeed, Pinar and his colleagues move curriculum study beyond traditional purposes of knowledge generation by giving such inquiry a situated, contextual, and purposeful nature: "the point of contemporary curriculum research is to stimulate self-reflection, self-understanding, and social change" (p. 56). Curriculum research in this vein problematizes practice, foregrounds beliefs that are normally obscured, and calls normative conceptions of teaching and learning into question. The reconceptualization of the curriculum, situated in the postmodern milieu, challenges music educators to recast beliefs and practices, rather than merely improving and refining traditional programs, materials, and organizational patterns of the field (Doll, 1993; Greene, 1995; Hargreaves, 1994; Slattery, 1995). This reconceptualization requires what Slattery terms a "kaleidoscopic sensibility" (1995, p. 243), in which insights constantly shift and realign in a "vast, interrelated web of ideas, texts, personalities, architectural structures, stories, and much more" (p. 244). Increasingly, curriculum scholars in music education are drawn to these postmodern perspectives and describe richly variegated landscapes for exploration and understanding (Hanley, 2003; Hanley & Montgomery, 2002, 2005).

## The Purpose of this Chapter and its Organization

Metaphorically speaking, the title of this chapter is used in three senses: *current* as in the contemporary state of the field; *current* in the sense of flow or momentum, citing scholars whose work carries curricular dialogue into new streams of thought; and *current* as in the potential of discourse to energize the work of teachers who mediate the curriculum. The purpose of this chapter is to describe research along various reconceptualized fronts, including those that (1) challenge longstanding views of musicianship and musical understanding; (2) situate the music curriculum as a dynamic social practice; (3) relate developments in the music curriculum to broad arenas of educational policy that enable or inhibit change; and (4) foster views of teachers as primary agents of change in curriculum work. Nearly every research study in music education has something to say about implications for the curriculum. Given the far-ranging scope of scholarly activity, the challenge of this chapter is to navigate a manageable path that will provide a general orientation for further study. For this reason, I have taken my primary frame of reference as the elementary and secondary curriculum in the formal context of schools, although traditional school programs are increasingly influenced by the twin goals of lifelong engagement in music and the amelioration of

barriers between formal and informal music learning. I have chosen a sample of representative voices and studies to illustrate broad, representative themes of change, acknowledging that there are entire categories of literature (on the use of technology, issues related to gender, early childhood music education, for example) that will not be addressed here. I have also begun this examination by relying on my own knowledge of music education in the United States, with related access to research studies, dissertations, and books by authors from Great Britain, Australia, and Canada. The chapter concludes with implications of this curriculum scholarship for the work of teachers, in concordance with Westbury's assertion that "it is teachers with their priorities and ambitions ... not curricula or policies, who animate the work of the schools" (2002, p. 156).

## Currents of Change in Musicianship and Understanding

Reconceptualizing the music curriculum necessitates that teachers and researchers examine and reflect upon taken-for-granted assumptions of musicianship and musical understanding. Meaningful change begins with the acknowledgment that traditional conceptions of the music curriculum have privileged the skillful performance of music, repertoire drawn primarily from the classical Western tradition, and academic study of common elements and structural properties of music. At the heart of curricular reconceptualization is the notion that these traditional emphases have limited what is learned and taught by narrowly defining musical engagement and musical knowledge. Although they are not discrete and often interrelated, four avenues of curricular reform stimulate dialogue and practice, including: (1) more comprehensive views of musical behaviors; (2) a wider array of musical styles; (3) an integrated sense of music as an embodied experience; and (4) greater depths of musical understanding.

Musical performance has long been the central focus of the curriculum. Since the mid-twentieth century, there have been calls for teachers to expand their primary focus on skilled singing and playing by incorporating a greater range of musical behaviors into their plans and practices. Proposals to diversify the music curriculum have promoted improvisation, composition, listening, analysis, valuing music, situating music in historical and cultural contexts, and relating music to other fields of human endeavor. The roots of this diversification were established through the Comprehensive Musicianship initiative and related projects (Burton, 1990; Mark, 1996; Willoughby, 1990), and were founded on the principle that students form a deeply integrated understanding of music through the study of its complementary aspects. Multiple avenues of engagement also allow students opportunities to more fully demonstrate musical intelligence and participate in varied musical roles. Reimer (2004) calls this expansion a means of cultural empowerment, as the curriculum enables students "to be able to share broadly in all the valued endeavors a culture makes available" while also encouraging them "to become contributors to their culture's endeavors," especially through an elective music program that offers a greater variety of instructional choices (p. 2). Varied musical roles include performers, improvisers, composers, listeners, theorists, critics, philosophers, educational theorists, historians, ethnomusicologists, anthropologists, sociologists, social critics, and others. The curricular implications stemming from

this move towards breadth point to a more eclectic general music program, the restructuring of typical ensemble programs to include musical activities complementary to performance, and a wider array of musical electives and opportunities for study. The extent and degree to which these varied forms of musical engagement are prioritized and accommodated within the curriculum fuels much scholarly debate and practical activity.

A second forefront of change in the music curriculum parallels the increasing hybridization of musical styles and the global transmission of music, accompanied by ready access to performers, new works, and musical experimentation through live and mediated modes of transmission. Music educators face considerable challenges, if the curriculum is to remain relevant and reflective of these fertile expressions of culture, identity, and creativity. By varying traditional instrumental and choral ensemble repertoire, encouraging chamber music and alternative ensembles, and through infusing jazz, popular, folk, electronic, and world music into the classroom, students' musical landscapes in school begin to more closely resemble the panoramic landscapes of music outside of school. Seeger (2002) describes the global transformations in economy, communication, and postcolonial shifts of power that shape the musics that students encounter; these shifts also explain why musical borrowing and hybridization are ubiquitous. Teachers also borrow new pedagogies for teaching diverse musics, relying on oral/aural techniques, improvisation, and cultural informants as musical models.

Bowman stresses the need to develop "an experientially grounded, corporeal account of music that situates it at ... the nexus of knowing, doing, and being" (2000, p. 59). In contrast to Cartesian thought that privileges activity of the mind over the body, music educators are called to explore an embodied view of mind that relies upon a fusion of the kinesthetic, emotional, and cognitive aspects of musicianship (Bresler, 2003, 2004). Somatic knowing becomes a source of deep insight into the phenomenological worlds of teachers and students. An example can be found in Dura (2002), who describes an embodied view as "an experience [such as music listening] that can be so profoundly 'moving' [that it] must at the very least leave its trace or effect upon the body and, at most, involve and implicate the body in its essential workings" (Dura, 2002, p. 119). Such integration was also evident in Powell's study of a *taiko* drumming ensemble (2004), in which she portrayed a learning environment in which participants acquire technical mastery, a heightened sense of self and relation to others, and intensified aesthetic experience. The music curriculum that forwards the integration of mind and body attends to the nonrational and profoundly emotional experiences that music affords.

A body of scholarly work has focused on the making of meaning and the cultivation of musical understanding as a central aim of the curriculum, building on cognitive and constructivist perspectives widened through sociocultural lenses (Campbell, 1998; Hanley & Goolsby, 2002; Wiggins, 2001; Zenker, 2002). Musical understanding is variously construed as the mental representations and schemes for organizing the musical knowledge students possess, their abilities to act on knowledge or apply what they know to solve new problems or create new products, the meanings students derive from music, the interactions of knowing and feeling stemming from cognition and emotion, and the meanings derived from the social context and interaction of others

within the learning setting. Curriculum initiatives in music education, when focused on teaching for meaning and understanding, redefine the roles that teachers play in fostering student's thinking, and for planning classroom activities that lead to musical independence (Boardman, 2002).

These four currents of change drive curricular initiatives and reorientations toward more comprehensive, social, cognitively challenging, meaningful, embodied, resonant, and diverse musical experiences, and consequently a more fluid and dynamic view of what musicianship and understanding entail.

## Currents of Change – Music as a Social Practice

It seems nearly paradoxical to draw attention to music as a social practice, since music making is inherently social in nature. Yet, the infusion of perspectives from sociology, anthropology, ethnography, and cultural studies underscores the need for music educators to consider how the context, content, and processes of music are inextricably related, which in turn strengthens understanding of the communal, interactive, and social components of the educational experience in music. Action and interaction are viewed through music as a "socializing medium" (DeNora, 2003, p. 165). Much of the exploration of the social dimensions of music making is in response to the prevalent feeling that school music programs and students' musical engagement outside of school are parallel but independent worlds, an "inside/outside" problem. Situating the music curriculum more firmly in sociocultural perspectives is an attempt to bridge this perceived gap. Dunbar-Hall suggests that music education can be defined as cultural study – "a subject concerned with uncovering the differences and power relationships among groups of people and their cultures" (2005, pp. 33–34), and that this redefinition of music study "brings the music curriculum closer to the realities of everyday life – realities that involve poverty, ownership, and social justice" (p. 34). Small advocates a similarly integrated approach embedded squarely in the music itself: "Social meanings are not to be hived off into something called a 'sociology' of music that is separate from the meaning of the sounds but are fundamental to our understanding of the activity that is called music" (1998, p. 8).

Research dealing with social aspects of music education holds particular promise to inform teachers' curricular visions. Research on expanding repertoires in the music curriculum draws from the vast array of musical practices, styles, hybrids, and fusions of musical influence that depend upon contextual meanings for understanding. Justifications for including new musical styles provide coherent rationales for rethinking traditional repertoires. Students' musical interests and pursuits lead researchers to examine informal engagements with music in order to more fully understand the situated and collaborative nature of musical understanding. Other researchers have begun to study how informal music-learning practices transfer into classroom settings, or perhaps stand distinctly outside of these settings.

Two particular arenas of research activity in expanded repertoires include popular music and world music/global music (an admittedly awkward construction). These arenas actually overlap, since the vastly inclusive term "world music" embraces both

traditional and popular streams, and the pervasive fusion of varied musical practices. Rodriguez (2004) distinguishes popular music by referring to music that is consumed and measured by rankings, delivered through accessible media, and affiliated with particular groups and target audiences. In contrast, the term "world music" has been associated with musics of cultural traditions, multicultural, ethnic, or non-western examples, particularly those "other" cultures that are less familiar to teachers and students within a particular context of study (Palmer, 2002). The very labels used to refer to these musical practices warrant cultural analysis to unravel persistent biases and narrow perspectives.

Popular music is incorporated in the British and Australian curriculum to a greater extent than in North America (Dunbar-Hall & Wemyss, 2000; Green, 2002; Hebert & Campbell, 2000), and its incorporation has resulted in realignment of instructional goals. Resistance within North America to the inclusion of popular music (rock in particular) is addressed by Hebert and Campbell (2000), who counter six common arguments raised against the use of rock music in the curriculum[1]. Rodriguez (2004) contends that the study of popular music in schools necessitates a redefinition of musicality, and that traditional components of the curriculum such as notating, creating, and performing are recast and revitalized when related to popular music in the classroom. Dunbar-Hall and Wemyss (2000) describe how the inclusion of popular music in Australian music syllabuses since the 1970s has prompted resulting changes in teaching methodologies, a closer alignment of music education with broad goals of multiculturalism, and the meaningful integration of music technology into instruction.

Classrooms that embrace the study of music "as a global phenomenon" (Campbell, 2004, p. 13) reflect an increasingly multicultural and world music focus in the curriculum that has become more sophisticated over the last century (Volk, 1998). Globalization of styles is fostered by unprecedented levels of access to examples of the world music in recorded form and by research-based pedagogical literature for music educators.[2] For example, Wade and Campbell have edited a series of cultural case studies that portray the social meanings and diverse cultural practices in fifteen regions of the world, accompanied by curricular materials that can be used by teachers to lead students through attentive, engaged, and enactive listening to recorded performances while studying cultural musical practices in complementary fashion (Campbell, 2004). An emphasis on oral/aural techniques is also advocated by Goetze (2000), who describes a curriculum that engages choral singers in international vocal traditions in ways that are aurally grounded and contextually congruent with the music sung by culture bearers.

Studies of the inclusion of cultural music in curricular materials such as textbooks reveal how these materials inculcate social and political values. Ideological stances embedded in school music textbooks and analyses of their overt and covert meanings have been addressed through Brand's analysis of Chinese texts (2003), Southcott and Lee's two-pronged study of Japanese imperialism in Taiwan's music texts and British imperialism in Australian music texts (2003), and studies such as those by Schmidt (1999) and Yamamoto (2002) that analyze representations of cultural groups and cultural music in music series texts. Oehrle (2002) describes efforts in South Africa, reminiscent of Bartok and Kodaly in Hungary, to collect genres of African music for

inclusion in curriculum materials to counter a long-standing emphasis on Western classical music in the aftermath of apartheid.

Social contexts for student engagement and collaboration have been studied through naturalistic and phenomenological accounts. One such study is Campbell's multifaceted ethnography of children's music making in formal and informal environments, which draws attention to the musical utterances of children as reflections of their own culture and musicianly impulses (1998). Similarly, children's musical play in Namibia was studied by Mans (2002), who conducted field work among cultural groups defined by language use, deriving characteristics of musical play and dance that inform goals for socialization within the African curriculum.

In addition to children's musical worlds, research on the informal social contexts of music making among adolescents and adults holds promise to inform classroom work by forwarding the nature of students' engagement. Music teachers can reconfigure long-standing processes and traditional practices of music inspired by research that probes students' experiences in common instructional configurations (entire classes or ensemble groups) or less prevalent small group settings. The world of the high school music classroom for American students enrolled in band, choir, and orchestra was portrayed by Adderly, Kennedy, & Berz (2003), who suggest that the social climate of the ensembles develops a musical subculture for developing identity and affiliation with others. A cross-cultural case study of high school students was conducted by Thompson (2001), who found that the meaning students ascribe to music and their attachment to it are influenced by the subject-centered or person-centered emphases of the curriculum in England and British Columbia, respectively. Research on students' interactions within small ensembles investigates the confluence of social and musical engagements in less teacher-directed settings. Berg (1997) studied students' processes of musical interpretation in chamber music settings, using Vygotskian frameworks to examine how peers challenge one another to think at more advanced levels, and the nature of their collaborative exchanges about the music. Allsup (2003) conducted an ethnographic study of high school students in two small ensembles, and noted the creative processes, peer influences, and capacities for critique that emerged in a more open-ended context. He related what Freire terms as a dialogic relationship as the foundation for more democratic practices in music education. A greater emphasis on student collaboration and musical negotiation of ideas is fostered in these small ensemble settings.

Green's research on popular musicians raises important pedagogical issues for the inclusion of expanded repertoires and the learning strategies that characterize musical practice in those repertoires. The provocative problems associated with this boundary crossing have been awaiting our attention, as Green observes, "formal music education and informal music learning have for centuries been sitting side by side, with little communication between them" (2002, p. 216). She cites the results of a questionnaire she administered in 1998 in which 61 teachers reported on their teaching strategies for popular music: "Teachers' classroom approaches are closer to the conventional pedagogy associated with Western classical music than the wide variety of music in the curriculum might seem to imply, and are generally very different indeed from the self-teaching and group informal learning practices of popular and other vernacular

musicians" (p. 183). Green's work with adolescent and adult pop and rock musicians addresses informal learning practices, such as participating in "an apprenticeship of close copying or covering existing recordings" (p. 189).

The transposition of insights from studies of children's and adolescents' musical experiences outside of school to school settings implies a redefinition of teachers' roles in the classroom. Jorgensen (2003) describes how teaching is transformed when it takes on more open-ended, improvisational, and dialogical qualities. In Jorgensen's view, these qualities reside in balance to create educational environments that are "both directive and liberative, didactic and dialogical, subject-centered and student-centered" (p. 141).

## Currents of Change – Music in the Context of Schools and Educational Policy

The curriculum theorist Joseph Schwab declared the curriculum field to be moribund in 1969, provoking a shift among curricular scholars from posing technical questions of curriculum development and improvement toward a critical reorientation aimed at understanding the curriculum (Pinar et al., 2004). Among Schwab's contributions was the notion that the curriculum can best be understood through the examination of four commonplaces: teacher, students, subject matter, and milieu (1983). Many curriculum studies and major initiatives in music have focused primarily on the first three commonplaces, seeking primarily to clarify how the content of music is learned and taught. A greater emphasis on the educational milieu, which Schwab described as the investigation of classrooms, schools, and communities, is particularly important for understanding how teaching and learning music are enabled and constrained by the very school settings in which teachers and students work. A growing body of qualitative studies addresses how music is embedded in these contextual realms, and illustrates how music is construed and valued as a subject of study within the school community. Policy research complements these studies by interrogating how music teaching and learning is influenced by the social and political arenas surrounding the classroom.

An especially promising analytical framework partitions the educational milieu into three levels in which music education is concurrently situated: "The *micro* level – teachers' expertise and beliefs, students' background and values – [which] interacts with the *meso*, institutional, level – the structures, resources and goals of the school system – and ... the *macro* level – the traditions of the specific art discipline, the larger culture, and the place of art in it" (Bresler, 2001, pp. 52–53). Bresler used this framework in her study of music specialists in elementary schools, portraying how the beliefs and personal experiences of teachers inform their daily classroom decisions, how school traditions and administrators' expectations for the music program constrain what teachers do, and how religious, economic, and societal priorities form a backdrop against which curricular decisions are made (Bresler, 1998b). The genre of school music emerges as an amalgam of songs and listening examples selected for the teaching of musical skills and concepts, topical themes such as holidays and seasons, and social and moral messages. Through varied portraits of music teachers, the

operational curriculum, that is actually taught on a daily basis, comes into sharp relief. The influences of the institutional setting can be traced in the practices, routines, and values that are enacted and experienced by teachers and students.

Particular curricular initiatives can be investigated similarly across studies, tracing how movements and proposals are grounded in school life. For example, interdisciplinary approaches – holding particular promise for a more capacious presence of music in school communities – have been studied at all three levels. Miller's action research study (2003) exemplifies changes in teachers' beliefs and practices that result from close collaboration between generalists and specialists on behalf of students in a first grade language arts classroom (the microlevel). Various cases of schoolwide interdisciplinary collaborations are described in their institutional contexts (meso) by Burnaford, Aprill, and Weiss (2001) and through the case studies of Bresler (1998a). At the macrolevel, Detels (1999) addresses the epistemological nature of music as a discipline and the "soft boundaries" that place the arts within the broader streams of arts and aesthetics in culture.

Policy research in music education can inform music educators' initiatives to reconceptualize the curriculum within music and across contexts of school and community, and to understand how policy impacts the curriculum at the micro-, meso-, and macrolevels. A panoramic overview of national policies on music and the arts was provided as part of the International Music Education Policy Symposium (Hull, 2004). Surveys of the landscape for music education in seventeen countries[3] reveal broad similarities as well as distinctions. Government influence on the curriculum is seen through gradations of control and oversight over national curricula, standards, guidelines, and assessments, or equivalent policies at state, provincial, or regional levels. Compulsory music education for students is maintained through early to middle adolescence, when elective music is offered for students who wish to pursue specialized studies. In some countries, conservatories or specialized music schools provide a more focused musical education for students who elect, or are recommended, for more concentrated study. Specialists and generalists play differentiated roles in the delivery of the curriculum, particularly at the primary level, with specialists more common at the secondary and tertiary levels. Curricular collaborations with community artists or with cultural institutions are interspersed as a strategy for utilizing the cultural resources of communities. Some policies promote a nationalistic focus to preserve cultural traditions (such as Croatia, Finland, Indonesia, Japan). South Africa's document speaks of curricular reform after apartheid; Indonesia's document addresses how indigenous kinds of music at the center of the curriculum counter the spread of Westernization. Policies potentially shape the kinds of musical engagements students may have (such as in the U.S. National Standards or British National Curriculum attainment targets of performing and composing, listening, and appraising).

Clearly research on the influences of policy and greater awareness of the impacts of policy on teachers' curriculum making are needed. In their 1992 chapter, Barresi and Olson drew upon Mayer and Greenwood's three characteristics of policy: "(1) it involves an intended course of action; (2) it occurs at the highest or more inclusive level of decision making associated with the action to be taken; and (3) it incorporates

an understanding of the implications of the proposed action" (p. 760). Barresi and Olson advocate that in order to influence policy, music educators must first understand which types of policies they desire to influence: "*Imposed* policies require constituents to comply under penalty of sanction, either economic or professional"; *endorsed* policies motivate constituents to comply through "a desire to receive some benefit from the policy-making body"; "*advocated* policy is characterized by completely voluntary compliance ... [in which] constituents must be in philosophical and/or practical agreement with the policy in order to actively support its tenets" (p. 761). Knowledge of policy types is a first step toward informed response to policy; understanding the difference, for example, between imposed, endorsed, and advocated policy bears on teachers' attitudes towards compliance or cooperation with the general intent.

Research on curriculum policy in music education and the influence of educational policies on teachers' curriculum making is pressing in light of the reduction of autonomy such policies imply (Spruce, 2002). A case study describing the development of the National Curriculum in England in response to the Education Reform Act of 1988 is a particularly informative and telling example. Shepherd and Vulliamy (1994) describe an ideological battle over emphases on Western classical music and popular music in England as conservative and progressive forces contested repertoire and pedagogy in the National Curriculum. They trace how curriculum committees, politicians, the national media, noted musicians, and music educators debated curricular issues that at heart, promulgated attempts to "renegotiate central cultural values" (p. 28) and that brought into question essential concepts of "Englishness" against the backdrop of an increasingly multicultural population. Shepherd and Vulliamy suggest that the ideological debates that attend the formation of national policy may operate in a discursive space that has little to do with implementation, noting that the "actual and concrete effects [of the policy] on classroom practice are questionable" (p. 37). Examples of research on policies that establish common frameworks or standards in the music curriculum include critical analyses of the forces that shape policy and practice in Canadian provinces (Dundas, 1997), case studies of the implementation of music curricular frameworks in particular school districts (Dickerson, 2003), and utilization of critical theory to unpack the pedagogical and philosophical assumptions of standards in music (Kassell Benedict, 2004). Chapman (2004) analyzes the effects of national policy through the *No Child Left Behind Act* on the arts in the United States, painting a portrait of growing vulnerability and marginalization of arts programs in the current climate of testing and accountability. Research on the effects of educational policy on the curriculum raises questions about teachers' curricular autonomy, students' access to learning opportunities in music, and institutional efforts to standardize content and delivery of the curriculum.

## Currents of Change – Music Teachers as Agents of Change

At the nexus of these currents of change stands the teacher, who faces what may seem as an alternately bewildering or liberating panorama of choices for guiding students' musical growth and experience in classroom settings. Now more than ever before,

a teacher's work requires a kaleidoscopic sensibility, and keen judgment to maintain one's bearings while responding flexibly to the shifting contingencies of daily practice. Even within the limited scope of the curricular ideas and studies sampled in this chapter, music teachers move out from constrained conceptions of musicianship to provide more comprehensive avenues for students' musical participation. Teachers' working theories of musical understanding influence the kinds of experiences they plan for students, and frame how they gauge the breadth and depth of students' musical knowledge. Construing music education as a field that is deeply rooted in social practice orients a teacher's attitude toward diverse musical repertoire, the importance of peer interaction and collaboration within classroom settings, and respect for deeply held beliefs related to identity, culture, and community. Within the context of school settings and policy environments, teachers may also feel a simultaneous push and pull toward poles of tradition and innovation. In the face of competing demands and visions of the music curriculum, teachers strive to construct coherent and meaningful musical experiences for students.

The intersection of contemporary curriculum research with the lives, aspirations, and initiatives of teachers can be sensed in Pinar's assertion, worth repeating, that "the point of contemporary curriculum research is to stimulate self-reflection, self-understanding, and social change" (Pinar et al., 2004, p. 56). Teaching is upheld as a process of inquiry that is driven by questions about the nature of musical understanding and the meanings students derive from music. Sustainable and meaningful curricular change requires a redefinition of central purposes rather than just tinkering around the edges of practice (Tyack & Cuban, 1995). It also requires disrupting and dislodging routines and traditions that are robust and firmly embedded in music teachers' roles (as Jorgensen observes, "music educators have been a remarkably consistent breed for millennia," 2003, p. 202). In addition, music teachers forge ahead through cycles of curricular contraction and expansion in the general educational milieu. Curricular contraction is a response to conservative views of what schools should teach and what students should learn, reducing teacher autonomy and constraining their initiative (Woodford, 2005). Cycles of curricular expansion engage teachers in new practices and professional development opportunities, which in turn intensify their roles and responsibilities (Hargreaves, 1994).

Teachers' capacities for self-reflection and strong orientations toward social change are congruent with Westbury's claim that "it is teachers with their priorities and ambitions ... who animate the work of the schools" (2002, p. 156). If proposals for change are not aligned with images of teachers as informed, reflective, and purposeful agents, the reform will have little chance of success. Thiessen and Barrett (2002) describe multiple realms of music teachers' work – in the classroom, in the corridors, and in the community – to portray the actions and initiatives of teachers in the current context of school reform. We suggest that pre-service and in-service teacher education programs based on a reform-minded image of music teaching would foster teachers' critical and reflective stances toward change in educational settings. Giroux's metaphor of teachers as transformative intellectuals is similarly grounded in democratic visions of teachers "who combine scholarly reflection and practice in the service of educating students to be thoughtful, active citizens" (1988, p. 122). Teachers

who exemplify democratic stances work with and alongside students to challenge and interrogate injustice and exclusion by problematizing taken-for-granted assumptions; music's reflection of the social contexts in which it is embedded can serve as one locus for this investigation. Recognizing the political dimensions of music and schooling may be difficult for teachers who are not accustomed to regard music teaching as a political act (Jorgensen, 2004), yet it represents an avenue for rich insight regarding the purposes, functions, and uses of music in schools and society.

Curriculum discourse in music education within the reconceptualized field is building momentum and energy as curricular practices and beliefs are examined and informed by a panorama of related disciplines, methodologies, and theoretical perspectives. These currents of change call for synergistic efforts in research and practice, supporting the work of teachers who are deeply motivated by the prospect of transforming students' lives through music.

## Notes

1.  These arguments are that rock music is aesthetically inferior, damaging to youth, and anti-education; teachers are not adequately trained; there is little time for the vernacular; and little attention paid to rock music in the curriculum (Hebert & Campbell, 2000).
2.  Although as Jorgensen reminds us, globalization of music itself can mask distinctive practices with a veneer or "epidermis" of capitalist ideologies (2004, p. 2).
3.  Australia, Croatia, England, Finland, France, Greece, Hungary, Indonesia, Japan, Latvia, New Zealand, Norway, Singapore, Slovenia, South Africa, Sweden, and the United States.

## References

Adderly, C., Kennedy, M., & Berz, W. L. (2003). "A home away from home": The world of the high school music classroom. *Journal of Research in Music Education, 51*(3), 190–205.

Allsup, R. E. (2003). Mutual learning and democratic action in instrumental music education. *Journal of Research in Music Education, 51*(1), 24–37.

Barresi, A. L. (2000). Policy in schools. In G. B. Olson (Ed.), *Looking in on music teaching* (pp. 146–163). New York: McGraw-Hill Primis.

Barresi, A. L., & Olson, G. B. (1992). The nature of policy and music education. In R. Colwell (Ed.), *The handbook of research on music teaching and learning* (pp. 760–772). New York: Schirmer Books.

Berg, M. H. (1997). *Social construction of musical experience in two high school chamber music ensembles.* Unpublished doctoral dissertation, Northwestern University, Evanston, IL.

Boardman, E. (Ed.) (2002). *Dimensions of musical learning and teaching: A different kind of classroom.* Reston, VA: Music Educators National Conference.

Bowman, W. (2000). A somatic, "here and now" semantic: Music, body, and self. *Bulletin of the Council for Research in Music Education, 144*, 45–60.

Brand, M. (2003). Dragons in the music classroom: Political and philosophical subtexts in Chinese school music textbooks. *Bulletin of the Council for Research in Music Education, 158*, 72–80.

Bresler, L. (1995). Ethical issues in qualitative research methodology. *Bulletin of the Council for Research in Music Education, 126*, 29–41.

Bresler, L. (1996). Towards the creation of a new ethical code in qualitative research. *Bulletin of the Council for Research in Music Education, 130*, 17–29.

Bresler, L. (1998a). "Child art," "fine art," and "art for children": The shaping of school practice and implications for change. *Arts Education Policy Review, 100*(1), 3–11.

Bresler, L. (1998b). The genre of school music and its shaping by meso, micro, and macro contexts. *Research Studies in Music Education, 11*, 2–18.

Bresler, L. (2001). Agenda for arts education research: Emerging issues and directions. In M. McCarthy (Ed.), *Enlightened advocacy: Implications of research for arts education policy and practice: The 1999 Charles Fowler colloquium on innovation in arts education* (Vol. 4, pp. 44–71). College Park, MD: University of Maryland.

Bresler, L. (2003). The role of musicianship and music education in the twenty-first century. In S. Leong (Ed.), *Musicianship in the 21st century: Issues, trends and possibilities* (pp. 15–27). Marrickville, NSW: Southwood Press.

Bresler, L. (Ed.). (2004). *Knowing bodies, moving minds: Towards embodied teaching and learning.* Dordrecht, Netherlands: Kluwer Academic Publishers.

Burnaford, G., Aprill, A., & Weiss, C. (Eds.) (2001). *Renaissance in the classroom: Arts integration and meaningful learning.* Mahwah, NJ: Lawrence Erlbaum Associates.

Burton, L. (1990). Comprehensive musicianship: The Hawaii music curriculum project. *The Quarterly Journal of Music Teaching and Learning, 1*(3), 67–76.

Campbell, P. S. (1998). *Songs in their heads: Music and its meaning in children's lives.* New York: Oxford University Press.

Campbell, P. S. (2004). *Teaching music globally: Experiencing music, expressing culture.* New York: Oxford University Press.

Chapman, L. H. (2004). No child left behind in art? *Arts Education Policy Review, 106*(2), 3–17.

DeNora, T. (2003). Music sociology: Getting the music into the action. *British Journal of Music Education, 20*(2), 165–177.

Detels, C. (1999). *Soft boundaries: Re-visioning the arts and aesthetics in American education.* Westport, CT: Bergin & Garvey.

Dickerson, M. S. (2003). *The impact of the state arts curriculum framework on one public school system (Massachusetts).* Unpublished doctoral dissertation, Boston College, Boston, MA.

Doll, W. E. Jr. (1993). *A post-modern perspective on curriculum.* New York: Teachers College Press.

Dunbar-Hall, P. (2005). Colliding perspectives?: Music curriculum as cultural studies. *Music Educators Journal, 91*(4), 33–37.

Dunbar-Hall, P., & Wemyss, K. (2000). The effects of the study of popular music on music education. *International Journal of Music Education, 36*, 23–34.

Dundas, K. D. (1997). *The construction of school curriculum and music education (Newfoundland, Labrador).* Unpublished master's thesis, Memorial University of Newfoundland, St. John's.

Dura, M. T. (2002). Movement and music: The kinesthetic dimension of the music listening experience. In B. Hanley & T. W. Goolsby (Eds.), *Musical understanding: Perspectives in theory and practice* (pp. 119–134). Victoria, BC: Canadian Music Educators Association.

Elliott, D. J. (1995). *Music matters: A new philosophy of music education.* New York: Oxford University Press.

Elliott, D. J. (Ed.). (2005). *Praxial music education: Reflections and dialogues.* New York: Oxford University Press.

Flinders, D. J., & Richardson, C. P. (2002). Contemporary issues in qualitative research and music education. In R. Colwell & C. Richardson (Eds.), *The new handbook of research on music teaching and learning* (pp. 1159–1175). New York: Oxford University Press.

Giroux, H. A. (1988). *Teachers as intellectuals: Toward a critical pedagogy of learning.* New York: Bergin & Garvey.

Goetze, M. (2000). The challenges of performing choral music of the world. In B. Reimer (Ed.), *Performing with understanding: The challenge of the national standards for music education* (pp. 155–169). Reston, VA: Music Educators National Conference.

Green, L. (2002). *How popular musicians learn: A way ahead for music education.* Aldershot, England: Ashgate.

Greene, M. (1995). *Releasing the imagination: Essays on education, the arts, and social change.* San Francisco: Jossey-Bass.

Hanley, B. (2003). Navigating unpredictable possibilities in postmodern music education. *Journal of the Canadian Association for Curriculum Studies, 1*(2), 93–116.

Hanley, B., & Goolsby, T. W. (Eds.). (2002). *Musical understanding: Perspectives in theory and practice.* Victoria, BC: Canadian Music Educators Association.

Hanley, B., & Montgomery, J. (2002). Contemporary curriculum practices and their theoretical bases. In R. Colwell & C. Richardson (Eds.), *New handbook of research on music teaching and learning* (pp. 113–143). New York: Oxford University Press.

Hanley, B., & Montgomery, J. (2005). Challenges to music education: Curriculum reconceptualized. *Music Educators Journal, 91*(4), 17–20.

Hargreaves, A. (1994). *Changing teachers, changing times: Teachers' work and culture in the postmodern age.* New York: Teachers College Press.

Hargreaves, D. J., Marshall, N. A., & North, A. C. (2003). Music education in the twenty-first century: A psychological perspective. *British Journal of Music Education, 20*(2), 147–163.

Hebert, D. G., & Campbell, P. S. (2000). Rock music in American schools: Positions and practices since the 1960s. *International Journal of Music Education, 36*, 14–22.

Hull, B. J. (2004). *Fact sheets on music education in seventeen countries.* Reston, VA: MENC: The National Association for Music Education.

Jorgensen, E. R. (2003). *Transforming music education.* Indianapolis, IN: Indiana University Press.

Jorgensen, E. R. (2004). Pax Americana and the world of music education. *Journal of Aesthetic Education, 38*(3), 1–18.

Kassell Benedict, C. L. (2004). *Chasing legitimacy: The national music standards viewed through a critical theorist framework.* Unpublished doctoral dissertation, Columbia University Teachers College, New York.

Mans, M. (2002). To *pamwe* or to play: The role of play in arts education in Africa. *International Journal of Music Education, 39*, 50–64.

Mark, M. L. (1982). The evolution of music education philosophy from utilitarian to aesthetic. *Journal of Research in Music Education, 30*, 16–21.

Mark, M. L. (1996). *Contemporary music education* (3rd ed.). Belmont, CA: Schirmer Books.

McCarthy, M. (2003). The past in the present: Revitalizing history in music education. *British Journal of Music Education, 20*(2), 121–134.

McCarthy, M., & Goble, J. S. (2005). The praxial philosophy in historical perspective. In D. J. Elliott (Ed.), *Praxial music education: Reflections and dialogues* (pp. 19–51). New York: Oxford University Press.

Miller, B. A. (2003). Integrating elementary general music instruction with a first grade whole language classroom. *Bulletin of the Council for Research in Music Education, 156*, 43–62.

Oehrle, E. (2002). A diverse approach to music in education from a South African perspective. In B. Reimer (Ed.), *World musics and music education: Facing the issues* (pp. 71–90). Reston, VA: MENC: The National Association for Music Education.

Palmer, A. J. (2002). Multicultural music education: Pathways and byways, purpose and serendipity. In B. Reimer (Ed.), *World musics and music education: Facing the issues* (pp. 31–53). Reston, VA: MENC: The National Association for Music Education.

Pinar, W. F., Reynolds, W. M., Slattery, P., & Taubman, P. M. (2004). *Understanding curriculum: An introduction to the study of historical and contemporary curriculum discourses* (Vol. 17). New York: Peter Lang.

Powell, K. (2004). The apprenticeship of embodied knowledge in a taiko drumming ensemble. In L. Bresler (Ed.), *Knowing bodies, moving minds: Towards embodied teaching and learning* (Vol. 3, pp. 183–195). Dordrecht, Netherlands: Kluwer Academic Publishers.

Reimer, B. (2003). *A philosophy of music education: Advancing the vision* (3rd ed.). Upper Saddle River, NJ: Prentice Hall.

Reimer, B. (2004). *Music education for cultural empowerment.* Paper presented at the International Music Education Policy Symposium, Minneapolis, MN.

Rodriguez, C. X. (Ed.). (2004). *Bridging the gap: Popular music and music education.* Reston, VA: MENC: The National Association for Music Education.

Schmidt, C. M. (1999). *Multiculturalism and the representation of culture in the 1995 elementary music series textbooks: A discourse analysis.* Unpublished doctoral dissertation, University of Wisconsin-Madison.

Schwab, J. J. (1983). The practical 4: Something for curriculum professors to do. *Curriculum Inquiry, 13*(3), 239–265.

Seeger, A. (2002). Catching up with the rest of the world: Music education and musical experience. In B. Reimer (Ed.), *World musics and music education: Facing the issues* (pp. 103–116). Reston, VA: MENC: The National Association for Music Education.

Shepherd, J., & Vulliamy, G. (1994). The struggle for culture: A sociological case study of the development of a national music curriculum. *British Journal of Sociology of Education, 15*(1), 27–40.

Slattery, P. (1995). *Curriculum development in the postmodern era*. New York: Garland.

Small, C. (1998). *Musicking: The meanings of performing and listening*. Hanover, NH: Wesleyan University Press.

Southcott, J., & Lee, A. H.-C. (2003). Imperialism in school music: Common experiences in two different cultures. *International Journal of Music Education, 40*, 28–40.

Spruce, G. (2002). Ways of thinking about music: Political dimensions and educational consequences. In G. Spruce (Ed.), *Teaching music in secondary schools: A reader* (pp. 3–24). London: RoutledgeFalmer.

Stock, J. P. (2003). Music education: Perspectives from current ethnomusicology. *British Journal of Music Education, 20*(2), 135–145.

Thiessen, D., & Barrett, J. R. (2002). Reform-minded music teachers: A more comprehensive image of teaching for music teacher education. In R. Colwell & C. Richardson (Eds.), *New handbook of research on music teaching and learning* (pp. 759–785). New York: Oxford University Press.

Thompson, J. K. (2001). *"I feel therefore I am": Selected British and Canadian senior high school students' conceptions of music and music education*. Unpublished doctoral dissertation, University of British Columbia, Vancouver.

Tyack, D., & Cuban, L. (1995). *Tinkering toward utopia: A century of public school reform*. Cambridge, MA: Harvard University Press.

Volk, T. M. (1998). *Music, education, and multiculturalism: Foundations and principles*. New York: Oxford University Press.

Westbury, I. (2002). Theory, research, and the improvement of music education. In R. Colwell & C. Richardson (Eds.), *New handbook of research on music teaching and learning* (pp. 144–161). New York: Oxford University Press.

Wiggins, J. H. (2001). *Teaching for musical understanding*. New York: McGraw-Hill.

Willoughby, D. (1990). Comprehensive musicianship. *The Quarterly Journal of Music Teaching and Learning, 1*(3), 39–44.

Wing, L. B. (1992). Curriculum and its study. In R. Colwell (Ed.), *Handbook of research on music teaching and learning* (pp. 196–217). New York: Schirmer Books.

Woodford, P. G. (2005). *Democracy and music education: Liberalism, ethics, and the politics of practice*. Bloomington, IN: Indiana University Press.

Yamamoto, M. (2002). *Analysis of American curricular materials on Japanese music, K through 8: Rethinking the images of the koto, sakura, and kimono*. Unpublished doctoral dissertation, University of Illinois at Urbana-Champaign.

Zenker, R. (2002). The dynamic and complex nature of musical understanding. In B. Hanley & T. Goolsby (Eds.), *Musical understanding: Perspectives in theory and practice* (pp. 27–50). Victoria, BC: Canadian Music Educators Association.

# INTERNATIONAL COMMENTARY

# 10.1

# Decolonizing Music Curricula in Modern Africa

**Anri Herbst**
*University of Cape Town, South Africa*

The African Renaissance characterizes an attempt to deepen an understanding of Africa and its methods of development, and thus its indigenous knowledge systems. Masoga (2005) sees the absence of "a comprehensive African relevance" in schools and universities in Africa as an insult to African scholars and future leaders (p. 6). Odora-Hoppers warns against the "erosion of people's knowledge" (2002, p. 6).

It is not necessary to rehash Africa's colonial history to understand the qualms of some African intelligentsia (see Odora-Hoppers, 2002 and *Indilinga*). At the 2003 Pan African Society for Musical Arts Education (Pasmae) conference in Kenya, delegates generally lamented the overbearing Western-oriented musical arts curriculum at all levels (Herbst, 2005). Learning to read and write Western staff notation and play a Western instrument is still the prize achievement for many students. Wanting to immerse oneself in another culture is not necessarily negative, but it becomes problematic when this involves scoffing at one's mother culture, or looking down on indigenous knowledge systems.

Issues related to content and ways of teaching that would not only enhance uniquely African sociocultural values, but also empower the present and future generations to function in a global context, were at the core of the discussions at the above-mentioned conference. Miya and Floyu note a strong sense that curricula should include both African and Western content taught in oral folklore-based and written ways (as cited in Herbst, 2005). Hountondij (2002) phrases this sentiment as follows:

> We must accept that we do not have to prove anything to anybody. We must get rid of the obsession of the "Other" in both ways, and make ourselves the privileged, if not the unique reference of our calculations and plans. (p. 25)

Walugembe from Uganda criticized government-based education when he said that "the people who are excelling in any field are not products of our formal education system" (as cited in Herbst, 2005, p. 17). His main concern seems to be that the

*L. Bresler (Ed.), International Handbook of Research in Arts Education, 163–166.*
© 2007 *Springer.*

curricula do not prepare learners to contribute to the sociocultural values of a community and/or to earn a living. Although a contentious generalization, it seems as if the remains of a colonially infused aesthetics-based music appreciation taught in schools on the African continent has failed to do justice to the deep-rooted sociocultural role of the musical arts to "transact" life (Herbst & Nzewi, 2003).

It has yet to be seen whether the MUESSA rubic-based model (Grové, Van Niekerk, & Van der Mescht, 2003) will fulfill its promise to "propose a solution for the very complex problem of re-structuring music education in South Africa" (p. 69) and whether it will successfully meet with Kwami's quest for music education (1998), which takes cognizance of the sociocultural function and significance of music (The entire 1998 issue of the *British Journal of Music Education* was devoted to music education on the African continent. See also Blacking, 1990; Dargie, 1996.).

By taking a pan-African perspective in this short contribution, I know that am not fully acknowledging the fact that curricula, infrastructures, and levels of problems in the different sub-Saharan African countries differ. However, it became clear at the Pasmae 2003 conference that delegates from southern, east, and central Africa felt that (1) their own sociocultural heritages have been jeopardized in favor of foreign influences, (2) one of the ways forward would be to ensure that teachers in Africa are skilled in playing and teaching the indigenous musical instruments of their countries, and (3) the mother-tongue culture of a country or region should be at the core of the curriculum, while also paying attention to global culture.

The last two recommendations may seem obvious to an outsider who does not know that the majority of teachers teaching in government schools on the continent lack rudimentary indigenous African musical arts knowledge. Filling this gap is not an easy task; for one, knowing exactly what indigenous knowledge systems entail requires a critical approach to what has been written about African music (see Agawu, 2003). Teachers should develop critical approaches to sources and interact more closely with archives such as the International Library of African Music (ILAM). The real danger, it seems, lies in limiting the musical arts to modern classrooms without critically reflecting on the values of indigenous knowledge systems.

# References

Agawu, K. (2003). *Representing African music: postcolonial notes, queries, positions*. New York & London: Routledge.

Blacking, J. (1990). Music in children's cognitive and affective development: Problems posed by ethnomusicological research. In F. Roehmann & F. Wilson (Eds.), *The biology of music making: Music and child development t – Proceedings of the 1987 Denver conference* (pp. 68–78). St. Louis, MO: MMB Music.

Dargie, D. (1996). African methods of music education: Some reflections. *African Music, 7*(3), 30–43.

Grové, P., Van Niekerk, C., & Van der Mescht, H. (2003). Researching a new perspective on music education in Southern Africa. *Perspectives in Education, 21*(2), 57–70.

Herbst, A. (2005). Musical arts education in Africa: A philosophical discourse. In A. Herbst (Ed.), *Emerging solutions for musical arts education in Africa* (pp. 11–23). Cape Town: African Minds.

Herbst, A., & Nzewi, M. (2003). Envisioning Africa-sensitive music education: What viable directions? In E. Olsen (Ed.), *Samspel – ISME 2002 (Bergen, Norway, August the 11th–16th, 25th Biennial World Conference and Music Festival, International Society for Music Education: Proceedings*. Bergen: Bergen University College Media Centre.

Hountondji, P. (2002). Knowledge appreciation in a post colonial context. In C. A. Odora- Hoppers (Ed.), *Knowledge and the integration of knowledge systems: Towards a philosophy of articulation* (pp. 23–38). Claremont: New Africa Books.

Indilinga: African Journal of Indigenous Knowledge Systems. www.indilinga.org.za

International Library for African Music (ILAM). www.ilam.ru.ac.za

Kwami, R. (1998). Non-Western musics in education: Problems and possibilities. *British Journal of Music Education, 15*(2), 161–170.

Masoga, M. (2005). Establishing dialogue: Thoughts on music education in Africa. In A. Herbst (Ed.), *Emerging solutions for musical arts education in Africa* (pp. 1–10). Cape Town: African Minds.

Odora-Hoppers, C. A. (2002). Indigenous knowledge and the integration of knowledge systems: Towards a conceptual and methodological framework. In C. A. Odora-Hoppers (Ed.), *Knowledge and the integration of knowledge systems: Towards a philosophy of articulation* (pp. 2–22). Claremont: New Africa Books.

# INTERNATIONAL COMMENTARY

## 10.2

## Music Curricula in the Arab World

**Ibrahim H. Baltagi**
*Baldwin-Wallace College, U.S.A.*

Music Education found its niche within nonformal educational institutions in the Arab world such as private conservatories, and until quite recently, constituted a marginal element in the formal system. In the last decade, there has been a growing interest in expanding the concept of music education, and a corresponding search for ways to provide instruction in music classes. Music objectives and curricula to train children aesthetically and artistically were required, paying due attention to psychological and emotional aspects, and preparing the children to participate in cultural, social, and economic life.

According to Fakhouri (2002), music objectives and curricula had common ground in the Arab countries that witness music education. These ambitious objectives and curricula were difficult to accomplish, considering that little or no time was allocated for the music classes, only one period a week if it exists. Fakhouri adds that, according to reports received from Jordan, UAE, Tunisia, Algeria, Syria, Iraq, Qatar, Kuwait, Saudi Arabia, Lebanon, Libya, Egypt, and Morocco, formal music education in these countries is a reproduction of the music curricula in the Western world and lacks authenticity.

Lebanon, the gate to Middle East is culturally, geographically, and economically part of the Arab world (Jarrar, 1991). Recent statistics collected in Lebanon by the Educational Center for Research and Development (Zein Eddine, 2005) show only 513 music specialists teaching in public schools in this country with a population of 4,000,000, and they are not evenly distributed throughout the districts. It is clear that the position of music as a subject has little importance to the school administration and has moved to a low priority. Educational ideology in Lebanon is becoming very traditional and unable to adapt with the changes and evolution in music education.

The efforts of those in charge of music education in the Arab world demonstrate an awareness of recent innovations worldwide. However, the slow pace of renovation, the paucity of resources, and the poor situation of teaching in general all make it difficult to keep abreast of the latest developments in arts education. The analysis above shows

*L. Bresler (Ed.), International Handbook of Research in Arts Education, 167–168.*
© 2007 *Springer.*

that improvements are to be made in three directions: curriculum development and the enhancement of teaching methods, teacher training, and the production of materials for students and teaching aids.

# References

Fakhouri, K. (2002). *The teaching of music in the Arab world.* Amman: The National Conservatory of Music.

Jarrar, S. (1991). Lebanon. In P. Altbach (Ed.), *International higher education: An encyclopedia* (pp. 1055–1063). London: Gerland Publishing.

Zein Eddine, H. (2005). [Arts in education: A study of reality, usefulness, and expectations]. [*The Education Journal*], *24*, 39–46.

# INTERNATIONAL COMMENTARY

## 10.3

# Current Developments in Music Curriculum in China, Hong Kong, and Taiwan

**Chi Cheung Leung**
*Hong Kong Institute of Education, Hong Kong S.A.R.*

At the turn of the twenty-first century, the school music curricula in China, Hong Kong, and Taiwan have undergone immense changes, usually adopting Western trends into local contexts. Decentralization of curriculum design and new emphases on content have increased the need for better professional development for music teachers.

In China, the new music curriculum standard (MCS) seeks to motivate student interest in learning, encourage investigation and creativity, and establish integrated assessment criteria (Deng, 2003). It aims to avoid overemphasis on subject matter, lack of integrative and comprehensive design, overreliance on textbook knowledge, and separation from social context (Wu & Jin, 2002). The design of the MCS allows teachers to have autonomy in making educational decisions, such as choosing the teaching repertoire (Xie, 2003), leading to the need for enhancement of teacher-education (Tao, 2004; Wan, 2004; Wen & Wen, 2003; Yang, 2004). Popular songs were included in one of the newly published textbooks in China, although most of the songs were designed to arouse love of the country. Many scholars (Fan, 2001; Zhao, 2000; Zhou, 2000) also urge the promotion of teaching Chinese music. Among many issues in China is its vast territory which has extreme differences in resource allocation among regions, especially between urban and rural areas. With the continued exposure of China to Western ideas and thoughts in music education, it is expected that there will be further adjustments in curriculum development in the future.

Since the return of Hong Kong's sovereignty back to China in 1997, the new government has initiated a series of educational changes. Among these was the curriculum reform which led to the launching of the new music curriculum guide (MCG). At the same time, the government called for new music textbooks to be submitted for publication. In the previous music syllabi, an academic approach to teaching and Western music dominated the implemented curriculum (Everitt, 1998; Leung, 2004; Yu-Wu & Ng, 2000), although creativity and Chinese music were mentioned. The new MCG included emphases in creativity, Chinese music, popular music, and the study of music in relation to its context, areas in which teachers need further professional development.

*L. Bresler (Ed.), International Handbook of Research in Arts Education, 169–172.*
© 2007 *Springer.*

However, it should be noted that world music was not an explicit area in the MCG because Hong Kong needs more time to rebuild its own culture, that is, Chinese culture, in the curriculum. Moreover, though integrative arts were initially promoted, they were put backstage after intense discussions.

In Taiwan, with the lifting of the Martial Law in 1987, education policy was more liberalized and opened to wider cultural diversity. Since then, local arts and culture have been incorporated into the school curriculum (Chen & Chang, 2005) and continued to develop. Music textbooks have included an increasing number of local folk songs and songs written by Taiwan composers (Lai, 2005). A new music curriculum was introduced in 2001. With its enforcement, folk song teaching became important in the Arts and Humanities domain (Chang, 2005), which includes drama and other existing music and visual art subjects. The objective of the cultivation of nationalism through education was removed from the new music curriculum, though emphasis on the promotion of ethnic culture still prevails (Ho & Law, 2003: Law & Ho, 2003; Zhuang, 1995). Furthermore, the new curriculum provides guidelines but not detailed contents for teachers. It is a school-based curriculum which requires teachers to be engaged in curriculum planning. A thematic approach was adopted, whereby music content is required to be taught in relation to themes rather than concepts and fundamentals (Lai, 2003). With these changes, there have been calls for the provision of further professional development for teachers.

From the above discussion, it is not hard to identify the similarities and differences in the directions and emphases of changes with regard to the music curricula of China, Hong Kong, and Taiwan. Although not new from the Western perspective, these changes represent challenges for music teachers of the three Chinese communities. Issues of implementation will be inevitable and adjustments will be needed to confront continuing external changes and internal demands.

# References

Chang, H. (2005). The current implementation of native folk song teaching for Taiwan elementary school. In S. Morrison (Ed.), *The 5th Asia-Pacific Symposium on Music Education Research* [CD-Rom]. San Diego, CA: University of Washington.

Chen, H.-F., & Chang, C.-J. (2005). Multicultural music education in Taiwan: A case study of teaching Hakka songs. In S. Morrison (Ed.), *The 5th Asia-Pacific Symposium on Music Education Research* [CD-Rom]. San Diego, CA: University of Washington.

Deng, Y. (2003). Yinyue kecheng gaige de jidian zuofa [A few strategies in music curriculum reform]. *Dalian jiaoyu xueyuan xuebao* [Journal of Dalian College of Education], *19*(4), 51.

Everitt, A. (1998). *Arts policy, its implementation and sustainable arts funding: A report for the Hong Kong arts development council*. Hong Kong: Hong Kong Arts Development Council.

Fan, Z. (2001). *Mianxiang ershiyi shiji de Zhongguo yinyue jiaoyu* [Music education of China in the 21st century]. Paper presented at the Chinese Music Research: New Perspective on the 21st Century International Conference, The Chinese University of Hong Kong.

Ho, W. C., & Law, W. W. (2003). Music education in Taiwan: The dynamics and dilemmas of globalization, localization and sinophilia. *Curriculum Journal, 13*(3), 339–360.

Lai, M. (2005). Analysis of required songs from the music textbooks used in elementary and junior high schools in Taiwan (1968–2000). In S. Morrison (Ed.), *The 5th Asia-Pacific Symposium on Music Education Research* [CD-Rom]. San Diego, CA: University of Washington.

Lai, M. L. (2003). Music curriculum reform in Taiwan: Integrated arts. In L. C. R. Yip, C. C. Leung, & W. T. Lau (Eds.), *Curriculum innovation in music* (pp. 171–175). Hong Kong: The Hong Kong Institute of Education.

Law, W. W., & Ho, W. C. (2003). Music education in Taiwan: The pursuit for "local" and "national" identity. *Journal of the Indian Musicological Society*, *34*, 83–96.

Leung, C. C. (2004). Curriculum and culture: A model for content selections and teaching approaches in music. *British Journal of Music Education, 21*(1), 25–39.

Tao, C. (2004). Xin kecheng xia de yinyue jiaoshi jiaoyu gaige [The Reform of music teachers' education with the new curriculum]. *Nanjing Xiaozhuang xueyuan xue bao* [Journal of Nanjing Xiaozhuang College], *20*(2), 74–78.

Wan, A. (2004). Woguo xuexiao yinyue jiaoyu gaige yu fazhan duice yanjiu [Research on reform of school music education, its development and policies]. *Zhongyang yinyue xueyuan xuebao* [Journal of the Central Conservatory of Music], *97*(4), 3–12.

Wen, G., & Wen, Y. (2003). Yinyue kecheng biaozhung yu gaoshi yinyue kecheng gaige de sikao [Thought on the curriculum standard of music and music curriculum reformation in normal school]. *Jiangxi Jiaoyu Xuebao* [Journal of Jianxi Institute of Education], *24*(6), 113–115.

Wu, B., & Jin, Y. (2002). Yinyue kecheng gaige de yiyi ji qi Beijing-yiwu jiaoyu yinyue kecheng biaozhun jiedou zhiyi [The Background and rationale of the reform in music curriculum: The standard illustration of music curriculum in voluntary music education]. *Zhongguo yinyue jiaoyu* [China Music Education], Apr 2002, 16–24.

Xie, J. (2003). Reform on music and art courses in China's (Mainland) schools. In L. C. R. Yip, C. C. Leung, & W. T. Lau (Eds.), *Curriculum innovation in music* (pp. 28–35). Hong Kong: The Hong Kong Institute of Education.

Yang, H. (2004). Yinyue kecheng biaozhun yu jichu yinyue jiaoyu gaige [The Music curriculum standard and music curriculum reform], *Yangzhou jiaoyu xueyuan xuebao* [Journal of Yangzhou college of education], *22*(1), 83–86.

Yu-Wu, R. Y. W., & Ng, D. C. H. (2000). The underlying educational notions of the two earliest official primary music syllabi. In Y. C. Cheng, K. W. Chow, & K. T. Tsui (Eds.), *School curriculum change and development in Hong Kong* (pp. 483–503). Hong Kong: The Hong Kong Institute of Education.

Zhao, S. (2000). "Zhagen banxue" shijian de wenhuaxue yu jiaoyuxue yiyi [The significance of the implementation of "foundation schooling" in cultural and educational studies]. *Zhongguo yinyue* [Chinese Music], *96*(1), 33–34.

Zhou, K. (2000). Zhongguo minzu yinyue jiaoyu de zhuti jianshe yu zhenghe yishi [The major construction and holistic thinking of traditional Chinese music education]. *Zhongguo yinyue* [Chinese Music], *96*(1), 40–43.

Zhuang, S. Z. (1995). Miandui xin kecheng biaozhun, yinyue jiaoshi ying ruhe shishi jiaoxue [The implementation of teaching music according to the new curriculum standard]. *Nan Tau Wen Jiao* [Humanities Teaching in Nan Tau], *8*, 116–118.

# INTERNATIONAL COMMENTARY

## 10.4

## Tradition and Change in the Spanish Music Curriculum

**Gabriel Rusinek**
*Universidad Complutense de Madrid, Spain*

Although music in Spain has an ancient tradition that starts in the Middle Ages, it was incorporated fully into the school curriculum in 1990. Previously, music education had been offered in a few private schools, and since 1975 a course on music history was included in the secondary curriculum. After 1990, music started to be a compulsory academic subject, taught in every Spanish school by elementary and secondary specialists in dedicated classrooms equipped with Orff instruments. Besides the "general music" delivered in those classrooms, outside the schools there are currently many children and adults engaged in musical activities: performing in folk and pop ensembles, bands and choirs; receiving instrumental tuition as amateurs in community or private schools of music; receiving professional training in conservatories; or studying musicology or music education in universities. Music education seems to be stronger every day, but the whole idea of "curriculum" in Spain is based on the idea of the "didactics of music," understood as traditional ways of teaching or those based on methodologies such as Orff, Dalcroze, or Kodály. Within the profession, there is little or no debate that includes research conducted in real school settings and academic discussions in conferences and journals informed by the findings of that research. Only the compulsory national curriculum, and the adaptations in each autonomous region due to cultural or linguistic particularities, are considered to be "the curriculum" and therefore, as with any governmental policy, only changeable through new laws after a lot of lobby activity when one of the two parties that alternate in the government announces a new educational reform.

Research on music teaching and learning is still very scarce because postgraduate studies in music are so new: Conservatory graduates were first accepted for doctorates in 1994 and there are still few programs in Musicology or Music Education. (e.g., the first PhD MusEd program in Madrid is starting in 2005–06.) Because music is not a priority for the educational authorities or for public fund providers (private resources for research are rare because they are not tax deductible), it is not strange that most research has been individual, unfunded, short-length doctoral research. Although there

*L. Bresler (Ed.), International Handbook of Research in Arts Education*, 173–174.
© 2007 *Springer.*

are many good practices in Spanish music education, teachers are not fond of, or do not have time for, sharing and disseminating their knowledge. Very few conferences at national level, which could be an opportunity for curricular debate and for building a research agenda, are organized. The situation of the Spanish Society for Music Education (originally, ISME-Spain) is an example of the local lack of an associative interest: It has, after twenty seven years of existence, hard work and great achievements like the hosting of the 26th ISME World Conference in Tenerife in 2004, only around 250 members; in contrast, in the USA, with six times more population, the national association (MENC) has around 114,000 members. Moreover, the aims of many regional organizations' meetings are generally limited to a momentary advocacy activity when a new reform threatens the survival of the subject within the national curriculum.

Many music education books, mainly textbooks and some song books or collections of games and teaching activities, are published every year; textbook publishing is a huge business in Spain because instead of selling one book to a teacher, publishers sell two or three hundred to his or her pupils. There are also magazines aimed at practitioners, and two printed music education journals: *Música y Educación* (published in Madrid since 1989) and *Eufonía. Didáctica de la Música* (published in Barcelona since 1995). Besides advocacy essays, teaching recipes, and some research reports, the articles in these journals document curricular tensions such as these:

- the inclusion of pop songs and ethnic music vs. the traditional focus on Western art music;
- the inclusion of Spanish or regional folk songs in primary vs. a generic music education repertoire;
- the use of active music making in secondary – including dancing, singing, and playing – to respond to the problems of postmodern adolescence, vs. the tradition of teaching music history;
- the inclusion of music creativity and collaborative learning through student-centered activities such as composing or improvising, vs. the teacher-centered strategies taken from the teaching traditions of the other school subjects;
- the problems in the preparation of primary music teachers because of a legal prohibition against adding a music entrance exam to the national exam for university admission;
- the problems in the preparation of secondary music teachers, who, although having a very high instrumental performance level after graduating from conservatories, only receive extremely short teacher-training.

Finally, the lack of English-language knowledge by most school music teachers, conservatory teachers, and university lecturers – perhaps similar to the ethnocentric lack of knowledge of foreign languages by American, Australian, or British teachers – makes the profession remain out of the currents of change in the rest of the world. Hopefully, the situation will change in some years thanks to the beginning and probable extension of postgraduate studies in music education, at a master's degree level due to the convergence of the programs of study in the European Union, and to the increasing interest in research.

# INTERNATIONAL COMMENTARY

## 10.5

## A Scandinavian Perspective on Music Curriculum Research

**Magne Espeland**
*Stord/Haugesund University College, Norway*

Current trends in Scandinavian music education and research over the past 40 years or so largely mirror those described by Barrett. In Norway, for example, the establishment of music as compulsory subject in public education in 1960 has developed from a focus on singing and listening to Western nineteenth-century art music to an activity-based and multi-style practice centered around performing, listening, and composing. The research being undertaken, for the most part in the form of dissertations, reflects this development to some degree.

There is, however, a major difference between curriculum practices in the USA and the corresponding ones in the Scandinavian countries: Scandinavia belongs to a group of countries with a long tradition of compulsory national curriculum documents, revised every 10 years or so, as the starting point and framework for curricular practices in schools. Alongside the influence of international music education, these curricular documents have influenced curricular practice and research in major ways until recently, for example in terms of introducing and researching "composing" as a new discipline in education. Parts of the research undertaken since the 1960s have been occupied with music and creativity in some way or another, for example Sundin (1963, 1998), Bjørkvold (1980, 1989), Folkestad (1996), and Espeland (2003).

A noticeable erosion of confidence in what Barrett calls the "prescriptive, scientific, rational, linear, and falsely tidy paradigm of curriculum planning" also affects national curricula in Scandinavia, especially in Norway where a comprehensive national curriculum from 1997 still sets the framework for classroom work. However, these kinds of documents not only serve as a framework for curricular practice, but also as policy processes resulting in a written statement reflecting the condition, expectations, and strategies of the respective music education community. As such they tend to influence textbook authors, authorities, teacher education, and schools in a major way. This could explain why curricular documents as well as textbooks have been focused on Scandinavian research and scientific analysis since the 1970s onwards, for example

*L. Bresler (Ed.), International Handbook of Research in Arts Education, 175–178.*
© 2007 *Springer.*

Espeland (1974), Jørgensen (1982), Nielsen (1998), Varkøy (2001), and Johansen (2003).

However, even if Scandinavian countries still use their tradition of national music curricula, there is little doubt of its erosion. This is perhaps not so much due to conscious reorientations in the music teacher community, but rather a consequence of lowered priorities and status from school authorities because of the focus on so-called basic skills such as reading and writing. In a recent Swedish evaluation of music in public schools (Sandberg, Heiling, & Modin, 2005), findings suggest that there are great differences in teachers' frameworks and work conditions as well as in pupils' musical knowledge in different schools, groups, and classes. Teachers' use of the national curriculum, local plans, and other documents seems to be decreasing and curricular practice is increasingly built on teachers' own competence and interest. This development suggests that music education is in the process of becoming more local than national and global and that differences between programs and teachers are growing. Krüger (2000) found that teachers' webs of discourse could be characterized by expressions like "certainty" and "stability" as well as "dynamism" producing change. In any case the fact that Sandberg, Heiling, and Modin's research – and other research and statistics as well – finds that teacher competence has been lowered in the last 10 years, is alarming. The dominant reason given by teachers and principals is that there is not enough time to carry through standards and curricula in low priority areas.

The use of *technology* is a current trend in Scandinavian music education, reflecting a global phenomenon (in terms of its use in important industrialized countries on all continents). There can be no doubt that this particular area seems to be in the process of influencing current changes in music education inside as well as outside schools all over the world to a degree that seems to be unprecedented in music education history. The connections between music education and technology have been researched to some degree in Scandinavia, for example Folkestad (1996), Dyndahl (2003), and Arnesen (2005). Findings suggest that music technology not only influence music education, but also the phenomenon we call music. Only the future can tell to what extent technology may change curricular practices in music classrooms as well as the nature of music and music as a school subject, in Scandinavia as well as in the rest of the industrialized world.

# References

Arnesen, I. G. (2005). *Musikkskaping med PC. Menneske og teknologi i partnarskap,-kven skaper kva?* [*Creating music with computers. Man and technology in partnership?*]. Unpublished masters thesis, Stord/Haugesund University College, Stord, Norway.

Bjørkvold, J. (1980). *Den spontane barnesangen – vårt musikalske morsmål.* [*The spontaneous singing of children – our musical language*]. Unpublished doctoral dissertation, University of Oslo, Norway.

Bjørkvold, J. (1989). *Det musiske menneske* [*The Muse Within*]. Oslo: Freidig forlag.

Dyndahl, P. (2003). *Musikk/Teknologi/Didaktikk. Om digitalisert musikkundervisning, dens diskursivitet og (selv)ironi.* Oslo: Acta Humaniora nr. 152, Unipub. (313 s.).

Espeland, M. (1974) *Lærebøker i musikk for barneskolen: En analyse.* [*Resource books for music in primary education: An analysis*]. Unpublished main study dissertation, University of Trondheim, Trondheim, Norway.

Espeland, M. (2003). The African drum: The compositional process as discourse and interaction in a school context. In M. Hickey (Ed.), *Why and how to teach music composition: A new horizon for music education* (pp. 162–192). Reston, VA: MENC, National Association for Music Education.

Folkestad, G. (1996). *Computer based creative music-making: Young people's music in the digital age.* Göteborg Studies in Educational Sciences 104, Gøteborg, Universitatis Gothoburgensis.

Johansen, G. G. (2003). *Musikkfag, lærer og læreplan – en intervjuundersøkelse av lærerers fagoppfatning i musikk og en ny læreplans påvirkning av på denne* [*Music, teacher and curriculum – an interview based study on teachers' perceptions of music and a new curriculum's influence thereof*]. NMH Publikasjoner 2003:3, Oslo, Norway.

Jørgensen, H. (1982). *Sang og musikk. Et fags utvikling i grunnskolen fra 1945 til 1980* [*Singing and music: The development of a subject in primary education 1945 till before 1980*]. Oslo: Aschehoug.

Krüger, T. (2000). *Teacher practice, pedagogical discourses and the construction of knowledge: Two case studies of teachers at work*, Bergen University College Press- Report N. 1/2000, Bergen Norway.

Nielsen, F. V. (1998). *Almen musikdidaktik* [*General music didactology*]. København: Akademisk forlag.

Sandberg, R., Heiling G., & Modin C. (2005). Nationella utvärderingen av grundskolan 2003. Musik, ämnesrapport till rapport 253 [*A national evaluation of Primary Education 2003. Music, Report 253*]. Stockholm: Royal Academy of Music, Sweden.

Sundin, B. (1963). *Barns musikalska skapande.* [*Children's musical creativity*]. Stockholm: Lieber, Sweden

Sundin, B. (1998). Musical creativity in the first six years, a research project in retrospect. In G. McPherson, B. Sundin, & G. Folkestad (Eds.), *Children composing* (pp. 35–56). Malmö Academy of Music, Lund, Sweden.

Varkøy, Ø. (2001). *Musikk for alt (og alle)-om musikksyn i norsk grunnskole.* [*Music for everything (and everybody)*]. Unpublished doctoral dissertation. University of Oslo, Oslo, Norway.

# 11

# EXPERIENCING THE VISUAL AND VISUALIZING EXPERIENCES

**Rita L. Irwin and F. Graeme Chalmers**
*University of British Columbia, Canada*

This chapter juxtaposes two interpretations of curriculum that have prevailed and shifted in nature over the past few decades. The first is *curriculum-as-plan* which is often understood to mean the curriculum-as-text. The second is *curriculum-as-lived* which is often referred to as *currere*, the Latin root word for curriculum. Currere, meaning "to run the course," emphasizes the doing, being, making, creating, and living qualities of learning experiences, even though most people understand curriculum as extensive planning in order to specify content within scope and sequence identifications (see Aoki's work in Pinar & Irwin, 2005). In art education these differences may be understood in another way. Curriculum-as-plan is often concerned with a subject-based approach and attends to *experiencing the visual*. Curriculum-as-lived is often concerned with a student- or society-based perspective, and attends to *visualizing experiences*.

Despite widespread efforts to shift the field of art education to one or other interpretation, both have continued to exist in practice with the juxtapositions being used to refine, resist, partially embrace, or refuse the other. Recently, curriculum scholar William F. Pinar defined curriculum as a complicated conversation (2004). In this chapter, we illustrate art education curriculum and its research base as a complicated conversation by moving back and forth between themes embedded in *experiencing the visual* and *visualizing experiences*. As with any conversation, several points of view co-exist though one may be more persuasive than another. By embracing the metaphor of a complicated conversation, we also invite the reader to examine his or her tolerance for competing views. Henry Giroux, Anthony N. Penna, and William F. Pinar (1981) suggest that many curricularists denounce competing views by recommending a synthesis of ideas rather than demonstrating a variety of conceptions. We invite the reader to consider the future of art education (and its related research) as a complicated conversation by emphasizing the "and" between *experiencing the visual* "and" *visualizing experiences*. Both interpretations of art education curricula involve a visual component and an experiential component, though one interpretation understands curriculum

*L. Bresler (Ed.), International Handbook of Research in Arts Education*, 179–194.
© 2007 *Springer.*

(and art) primarily as a noun (plan), while the other understands curriculum (and art) primarily as a verb (lived). Recognizing that all orientations may share both conceptions to some extent, we highlight three perspectives within curriculum-as-plan: *perceiving the visual, structuring the visual,* and *designing the visual.* Within curriculum-as-lived, we highlight four different perspectives: *visualizing expression, visualizing engagement, visualizing culture,* and *visualizing inquiry.* Moreover, we attempt to provide a review of curriculum-related art education research and inquiry in Canada and the United States while providing a commentary on related practices in Australia, Britain, and New Zealand. Herein begins the complicated conversation between *visualizing experiences* and *experiencing the visual* with our conversation moving back and forth between the two interpretations of curriculum.

## Visualizing Experiences as Visualizing Expression

*Creativity*

For much of the first half of the twentieth century a creativity or self-expression paradigm dominated the art education field. It has been suggested that the hundreds of research efforts related to creative thinking in the 1950s and 1960s (e.g., Torrance, 1963) both encouraged the cultivation of creativity in the education system and helped to foster individualism rather than collectivism in schools. The work of John Dabron (1958) in Australia, Herbert Read (1943) in Britain, Dudley Gaitskell (see Gaitskell Hurwitz, & Day, 1982) in Canada, Gordon Tovey in New Zealand (see Henderson, 1997), and Viktor Lowenfeld (1947) in the United States, were pivotal to this movement. They believed children had innate creative abilities that would be hindered by intellectualizing their art making. With the possible exception of Tovey's acknowledgement of Maori art, children were not taught how to make connections between their art and their heritage, nor were they taught to consider questions of aesthetics. Instead an emphasis was placed on the creative and mental growth (see Lowenfeld, 1947) of children by using art as a tool to develop social skills and personal self-expression. The creativity and self-expression paradigm emphasized the notion of curriculum-as-lived by encouraging children to be creative. This orientation was a student-centered curriculum that attended to *visualizing expression* and was heavily influenced by psychologists studying child development in art as well as studying philosopher John Dewey (1934), who wrote about art as experience.

   More recently, the creativity paradigm is exemplified in the work of Mihaly Csikszentmihalyi (1996), who advocates that creativity is developed through in-depth knowledge in a domain along with opportunities to stand outside and explore alternatives. Given these conditions, creativity flourishes within "flow" experiences when the creator is lost in an experience that allows for deep inquiry, wonder, and enjoyment. His theory is echoed by Anna Kindler (2004), and others, who believe creativity is neither biologically nor socially determined and is instead realized through a confluence of relationships among individuals, our society, and culture. Within art education, notions of creativity can be seen in the work of scholars such as Peter London (1989), whose interest in the spiritual in art and art education promotes visualizing expression not only

for the self-expression of individuals, but also for communities as they work together to explore ideas of mutual interest. Even though the creativity and self-expression paradigm dominated art education for most of the twentieth century, other paradigms caused major ideological shifts in curriculum in the latter half of that century.

## Experiencing the Visual as Perceiving the Visual

*Aesthetic Education*

One major shift away from visualizing expression within the creativity and self-expression paradigm came with a movement usually referred to as Aesthetic Education, an orientation concerned with *perceiving the visual*. Whereas the creativity paradigm could be conceived as fitting within a curriculum-as-lived understanding, the aesthetic education paradigm was a subject-centered orientation exemplified through curriculum-as-plan. Proponents of this paradigm, such as Manuel Barkan (1962) and Ralph Smith (1966) sought to further artistic and aesthetic sensibilities within human experience through the transmission of cultural heritage and a critical engagement with visual images and artifacts. In the 1970s, Edmund Feldman (1970) wrote a textbook that would become pivotal to defining the theoretical and practical implications of aesthetic education. However, the most influential reform effort in art education was undertaken by the Central Midwestern Regional Educational Laboratory (CEMREL) in the United States under the leadership of Stanley Madeja with Sheila Onuska (1977). Working with colleagues, they wrote an aesthetic education curriculum that was supported by many resource materials for teachers. During this time period, other art educators proposed renditions of the aesthetic education movement. For instance, Vincent Lanier (1982) called for aesthetic literacy to replace art education. Harry Broudy (1972/1994) advocated an aesthetic education program that cultivated an imaginative perception and aesthetic literacy with enlightened cherishing being the result. Elliot Eisner (1985) wrote about perceiving aesthetic qualities in educational practices, and particularly within curriculum, assessment and research. In more recent times, Maxine Greene (2001) has advocated an aesthetic education that develops aesthetic literacy and allows individuals an opportunity to perceive the qualities, values, and meanings within works of art that in turn may open up a greater appreciation for daily life and the natural world while engaging their imaginative and creative capacities. From another perspective, Ralph Smith (1989) advocates a humanities perspective that involves art history, art criticism, and aesthetic ideas with a view toward appreciating the insightful energy within an aesthetic experience. And yet a broader view of aesthetic education looks toward environmental and natural aesthetics. Arnold Berleant and Allen Carlson (1998) as well as Stanley Godlovitch (1999) in Britain look to nature as a genre in art and open up discussions for defining aesthetic contact with nature and how moral values towards nature might provoke ethical discussions and considerations. The common element across all of these renditions of an aesthetic education paradigm is the emphasis on *perceiving the visual*. Planned activities with a focus on perceiving images, artifacts, and the natural world help focus subject-based curricula across specific objectives, learning events, and assessment tools.

# Visualizing Experiences as Visualizing Engagement

## Arts Integration

Visual art as part of a holistic scholarly education in the Far East has been important since the time of Confucius (see Tu, 1985). In the West, integrating the arts into other school subjects has become an area of great interest in recent years. Whereas the aesthetic education movement emphasized *perceiving the visual* within arts disciplines, attention has gradually moved to broad themes that reach across disciplines. In doing so, a counter balance has taken shape that can be characterized as *visualizing engagement*. The notion of *visualizing engagement* is premised on several features. First, recent research has shown that engagement in the arts positively affects a range of cognitive as well as personal and social competencies (see Fiske, n.d.). Second, this engagement in the arts encompasses a range of specialists working with young people. Major research reports were commissioned in each of Canada and the United States. In Canada, Rena Upitis and Kathryn Smithrim (2003) along with a team of researchers from across Canada (e.g., Grauer, Irwin, de Cosson, & Wilson, 2001) studied an artist-in-residence program called *Learning through the Arts*™ (LTTA) funded by the Royal Conservatory of Music (the project encompasses all the arts). After three years of a national study, LTTA found a direct correlation between achievement in mathematical computation and the arts. Their findings were similar to the results found in the *Champions of Change* studies in the United States (see Fiske, n.d.), a collection that represented several groups of researchers working within or across the arts, in separate projects. Relevant to the visual arts, in particular, was a study conducted by Judith Burton, Robert Horowitz and Hal Abeles (1999). Overall, after reviewing all the studies within the *Champions of Change* group, consensus was found for a number of features:

The arts reach students who are not otherwise being reached … .
The arts reach students in ways that they are not otherwise being reached … .
The arts connect students to themselves and/each other … .
The arts transform the environment for learning … .
The arts provide learning opportunities for the adults in the lives of young people … .
The arts provide new challenges for those students already considered successful … .

The arts connect learning experiences to the world of real work. (Fiske, n.d., ix–xii) Within many of the studies, a project-based approach to learning was used and best exemplified when students had direct involvement with the arts and artists, teachers were given professional development opportunities, learners were offered support in their engagement in artistic processes, students were encouraged to be self-directed learners who embraced complexity, and community members or organizations became engaged in promoting the arts within education. Thus, *visualizing engagement* is not only about students being actively involved in their own engagement with the arts, it is about artists, teachers, and community members visualizing their engagement in the learning process. This is well represented in the *LTTA* project mentioned above but also in the *Chicago Arts Partnership in Education* project (Burnaford, Aprill, & Weiss, 2001) in which artists-in-the-schools programs became very involved in helping teachers and students integrate the arts across the curriculum. It is also apparent in the work of

Liora Bresler, Lizanne DeStefano, Rhonda Feldman, and Smita Garg (2000), who studied the impact of an artists-in-residence program in a variety of schools. They found that artists inspired "(i) the uses of imagination and the focus on the visual world to develop imagination; and (ii) the interrelationship of cognition and affect, and the different ways to cultivate their interdependency" (p. 27).

Whereas the above studies emphasized research into artists-in-the-schools programs, other research has studied how classroom teachers integrate the arts throughout the curriculum. For instance Bresler (1995) found four styles of integration among teachers (1) subservient integration where the arts are used to enhance other subjects; (2) co-equal integration where the aesthetic dimensions of the arts complement other subjects; (3) affective integration where emotional awareness is tantamount; and (4) social integration where the social functions of education are highlighted. Don Krug and Nurit Cohen-Evron (2000) describe a continuum of four art education and curriculum integration perspectives revealed through the *Transforming Education through the Arts Challenge* (TETAC): (1) using the arts as resources for other disciplines; (2) enlarging organizing centers through the arts; (3) interpreting subjects, ideas, or themes through the arts; and (4) understanding life-centered issues. All of these studies point to the continuing interest in arts integration across the curriculum for young children.

## Experiencing the Visual as Structuring the Visual

*Discipline-Based Art Education*

Intimately tied to the aesthetic education paradigm is discipline-based art education or DBAE (see Dobbs, 1998; Eisner, 1987; Greer, 1984). In this paradigm, *structuring the visual* becomes the emphasis. The work of art, representing the discipline of art, becomes the focus for all art learning activities. Students are taught how to view and talk about works of art as they analyze subject matter within philosophical, historical, and cultural contexts (see MacGregor, 1997). Students are also encouraged to create their own works of art; however, the difference between the creativity and DBAE/aesthetic education paradigms rests with the positioning of art production. In the former, art is an expression of self within a student-oriented curriculum. In the latter, art is derived from studying the structures inherent in visual images or objects within a subject-based curriculum. In Britain a somewhat similar approach linking studio practice and critical and contextual studies has been termed "critical studies" (see Hickman, 2005; Thistlewood, 1991). Though DBAE and aesthetic education involves both curriculum-as-plan and curriculum-as-lived, using text (documents, curriculum materials) to experience the visual is a primary mode of orientation.

## Visualizing Experiences as Visualizing Inquiry

*Art and Education as Practice-Based Inquiry*

Renditions of the DBAE/aesthetic education and creativity paradigms have persisted across Australia, Britain, Canada, New Zealand, and the United States. However

differences exist. For instance, according to Douglas Boughton (1989), while Australian art education experimented with aesthetic education, design education, and integrated arts education, the dominant model has been a " 'disciplined' form of studio" (p. 201) which is skill-based and product-oriented. Moreover, some Australian, British, and Canadian art educators are beginning to explore another paradigm that, thematically speaking, could be named "inquiry" (see White, 2004) because it emphasizes *visualizing inquiry*. While educators writing within the creativity paradigm speak of inquiry during the making of art, there are art educators, such as Graeme Sullivan (2005) and Rita Irwin (see Irwin & de Cosson, 2004), who believe artists both pose and solve problems while making and perceiving art. Sullivan advocates inquiry in the visual arts through the premise that art practice is research. Similarly, Irwin and her Canadian colleagues (e.g., Pearse, 2004; Springgay, Irwin, & Wilson Kind, 2005) write about the need for art educators and students to think of inquiry through the lenses of an artist/researcher/teacher engaged in ongoing reflective and reflexive practice-based inquiry. For example, Stephanie Springgay (2004) worked as an "a/r/tographer" with high school students who in turn became active inquirers as a/r/tographers themselves. In doing so, she was able to show the intercorporeality of inquiry as the embodiment of the arts and education in coming to know something. Closely related to these ideas is the work of Rudolf Arnheim (1969), who grapples with what it means to think visually, and the work of Howard Gardner (1989), whose Multiple Intelligence Theory formed the basis for the ARTS PROPEL research project and the subsequent inquiry-based curriculum efforts at Harvard Project Zero. Using reflection as a fundamental tool for learning, ARTS PROPEL emphasized an approach to process portfolios that allowed students to be deeply engaged in specific project-based units of interest. For each of the mentioned inquiry-based approaches, curriculum is a process rather than a single text, or said another way, the process of currere *is* the product.

## Experiencing the Visual as Designing the Visual

*Art and Design Education*

John Steers is a British art educator and the General Secretary of the *National Society for Education through Art and Design*. The descriptor for the society is indicative of a long history of art and design education in Britain (other countries have design education but it is more prominent in Britain). In this instance design embraces two notions: design theory known as the elements, principles, and rules of design, as well as applied design known for its decorative objects, commercial art, and interior design. Essentially, in both instances, *designing the visual* is a way of structuring the visual qualities of an object in order to ensure a sense of beauty. Having said this, John Steers is critical of the 1992 and 2000 National Curriculum for art and design because of its orthodoxy of approach. The National Curriculum in Britain stems from a modernist approach derived from two influential ideas:

> The first stems from a tradition of working from direct observation and an emphasis on process … and perpetuated in secondary schools by the examination process.

The second important influence comes from domain-based curriculum models that emerged first in the United States in the late 1960s and which later informed the development of assessment criteria for the General Certificate of Secondary Education (GCSE) examinations in the mid-1980s. (Steers, 2004, p. 26)

As a result, art and design education has evolved into a type of school art approach wherein young people often create formulaic images and concepts. Furthermore, the prescribed assessment practices have increased teachers' reliance on particular kinds of projects that are regarded as safe. The result is an art and design education that lacks "any relationship to contemporary art and design activity beyond the school art room" (p. 27). Ironically, there are shifts occurring. The *National Advisory Committee on Creative and Cultural Education* (NACCCE) (1999) published a report that recommended the need for creativity across all subject areas in the curriculum. To realize this creative imperative, teachers would need to reclaim a professionalization that instills confidence in their abilities to be innovative while being comfortable with risky ideas. This is similar to Paul Tweddle's (1992) notion of a third way for British schools: that is, a blending of polarities. It is here that we have come full circle, returning to the notion of *visualizing expression* through attention paid to creativity.

## Visualizing Experiences as Visualizing Culture

*Visualizing culture*, one of the most dominant threads in contemporary art education, is a way of understanding a variety of sociocultural interests being portrayed across art education. Most notably, cultural pluralism, social activism, visual culture, technological influences, and gender studies each describe an area within the notion of *visualizing culture* that speaks to an active involvement with a particular set of transformative sociocultural ideas. Each seeks to change cultural experiences by visualizing culture in alternative ways or, reflexively, by recognizing the pervasiveness of the visual turn within society and the inevitability of visualizing cultural studies. We turn to each of these areas now in more depth.

### Cultural Pluralism

In carefully documented reviews of research, New Zealander Jill Smith (2000, 2003) notes that the development of multicultural art education theory and practice parallels the evolution of general multicultural education, and, we would suggest, the U.S. Civil Rights Movement in the 1960s and 1970s. Stross-Haynes (1993) and others cite June King McFee (1961) as art education's initial catalyst for much of today's interest in art education and cultural diversity.

Doug Boughton and Rachel Mason (1999) collected essays from an international range of authors that show differences in interpreting and implementing multicultural art education in various parts of the world. Sneja Gunew and Fazal Rizvi (1995) published their edited text *Culture, Difference and the Arts* in Australia. This book is a compilation of work by 15 different authors whose sometimes competing discourses

remind us that multiculturalism *is* politically controversial and that debates surrounding cultural diversity and the arts are firmly located within this contested terrain. Gunew's own chapter, "Arts for a Multicultural Australia: Redefining the Culture," foreshadows contemporary work on the arts, transculturalism, and diasporic experience. Art educators have been very slow to address hybridity, although newer approaches to visual culture education have acknowledged the concept. Gunew emphasizes the tension between "where you're from" and "where you're at." She views multiculturalism, as it then existed in Australia, as too benign. She could be talking about the "soft" multiculturalism that we see in many schools in the "developed" world. Rizvi's own chapter, "The Arts, Education and the Politics of Education," argues that "The school is a site for containing the effects of marginalization and oppression by promoting a fiction of tolerance between social groups in order to produce a society in which a certain truce exists between ethnic groupings and classes" (p. 64). For example, working in Vancouver, Ghanaian art educator Samuel Adu-Poku (2002) found that this was a fairly typical Grade 7 student response: "Multicultural education involves the celebration of Black History Month, Chinese New Year, Halloween, First Nations' Potlatch, and Multicultural Potluck Nights at the school" (p. 186). An astute African-Canadian parent added, "Multicultural education does not mean anything other than a human relations exercise. Cultural inequalities are not addressed in the curriculum" (p. 165). Brian Allison (1995) in Britain, and Themima Kader (2005) in the United States, found similar situations commonly labeled as the "food, fun, and festivals" approach in their respective countries.

To replace this "festivals" approach, Sonia Nieto (1999), who is not an art educator, has identified six criteria characterizing what has become known as *critical (or insurgent) multiculturalism*, an approach that we believe increasingly needs to guide art education's approach to cultural pluralism:

- Critical multicultural education affirms a student's culture without trivializing the concept of culture.
- Critical multicultural education challenges hegemonic knowledge.
- Critical multicultural education complicates pedagogy.
- Critical multicultural education problematizes a simplistic focus on self-esteem.
- Critical multicultural education encourages "dangerous discourses."
- Critical multicultural education admits that multicultural education in schools cannot do it all.

Among the few art educators who address such issues are Susan Cahan and Zoya Kocur (1996), whose book focuses on utilizing vocal contemporary artists from shifting and diverse American subcultures whose work speaks about oppression, identity, and social change. Graeme Chalmers (1996, 2002), Dipti Desai (2000), Elizabeth Garber (2004), and Patricia Stuhr (1994, 2003) are also among those who have embraced more "critical" notions of multicultural art education. In some respects "multiculturalism" has become a tired term that is no longer sufficiently comprehensive. It is being replaced by "inclusive education," which, in addition to culture and ethnicity, considers students with disabilities, different learning styles, and varying socioeconomic backgrounds.

*Social Activism*

Multiculturalism has evolved and, as noted above, social justice issues (human rights issues, antiracist pedagogy, programs that address systemic discrimination, equity, inclusion, etc.) are increasingly being considered with art education. So too is the fact that the "preservation" of culture is highly subjective due to the "fluid" nature of cultures, and consequently multicultural education efforts must recognize the realities of hybridity (see Chalmers, 2002).

In North America, education as social reconstruction can be traced back to George Counts (1932) who, in his book *Dare the Schools Build a New Social Order?*, argued that schools cannot be morally neutral, and that educators need to collaborate with other groups to effect social change. If art education is to be meaningful, we must not shy away from controversial themes. Although somewhat hesitant, the literature in art education is increasingly addressing such issues (e.g., Albers, 1999; Darts, 2004; Heath, 2001; Jeffers & Parth, 1996; Marcow-Speiser & Powell, 2004; Milbrandt, 2001).

More than 30 years ago, American educator Vincent Lanier (1969) proclaimed that "[A]lmost all that we presently do in teaching art in ... schools is useless" (p. 314). He believed that students needed to examine "the gut issues of [their] day" – war, sex, race, drugs and poverty, and argued,

> what we need ... are new conceptions of modes of artistic behavior, new ideas of what might constitute the curricula of the art class. These new curricula must be meaningful and relevant to pupils ... These new ideas must engage the "guts and hopes" of the youngsters and through these excitements provoke intellectual effort and growth. These new ideas must give the art class a share in the process of exploring social relationships and developing alternative models of human behavior in a quickly changing and, at this point in time quickly worsening social environment. (p. 314)

Canadian David Darts (2004) examines the influence of popular and visual culture as informal educative forces, particularly in relation to citizenship, political agency, creative expression, and constructions of identity, and along with educators such as Henry Giroux (1996) (who has recently immigrated to Canada from the United States), supports pedagogical practices that help young people "understand their personal stake in struggling for a future in which social justice and political integrity become the defining principles of their lives" (p. 21). These researchers and essayists claim that art teachers have a major role in helping their students dare to build a new social order. Because the arts can be used in this way, art education has also promoted other, sometimes hidden, agendas. For example, examination systems, in particular, have sought to "colonize" outposts of empire and to "regulate" the indigenous "other" (see Abraham, 2003; Carline, 1968; Chalmers, 1999; Hickman, 1991).

*Visual Culture*

As Kerry Freedman and Patricia Stuhr (2004) illustrate in their comprehensive review, a number of international art educators have argued for broad democratic definitions of the visual arts, to include other forms of material culture that have not been traditionally

associated with the "fine" arts. Although still subject to some debate, this has generally come to be known as "visual culture." Freedman (2003) sees visual culture education paying particular attention to "the objects, meanings, purposes, and functions of the visual arts students make and see every day" (p. 2).

New Zealander Ted Bracey and Australian Paul Duncum (2001) edited a collection of position statements and responses by a small but international (Australian, Canadian, New Zealand, and the United States) group of art educators who take different and sometimes conflicting stances. In general the essays and responses focus on the concept of visual culture, the purposes and functions of visual material culture, and the conditions surrounding the production and comprehension of such visual material. This debate has been continued in a variety of contexts and in a variety of places.

Kevin Tavin (2004) suggests that in the United States, and we would suggest in other parts of the world as well, disputes over the role of popular visual culture in art education has centered around such aspects as low culture vs. high culture, populism vs. elitism, mediocrity vs. excellence, and understanding social context vs. aesthetic experience. Tavin cites Duncum and other art educators who suggest that "When art educators admonish popular culture and critique the shift towards visual culture they usually base their arguments on theories of aesthetics, autonomy, originality, creativity, and cultural sophistication" (p. 102). In this same article Tavin goes on to identify and discuss an international array of scholars who, over the last 200 years, have viewed popular visual culture as "an embodiment of aesthetic and artistic suffering" (p. 101). Kerry Freedman's (2003) book provides a comprehensive introduction to visual culture education for art educators. For those who wish to explore some of the foundational work by scholars outside art education we suggest international texts by Malcolm Barnard (2001), John Fiske (1989), Ian Heywood and Barry Sandywell (1999), Chris Jenks (1995), and Irit Rogoff (2000).

*Technological Influences*

Art educators such as Paul Duncum (2000) concern themselves with ways to address the Americanization of global culture and issue a challenge to use new technologies to continue to create a sense of self and community. As Duncum states, "If art education has a future in the world of image saturation, it must engage with the images that are now characteristically world-wide. Unless it adopts a defensive stand, it has the opportunity also to contribute in an ongoing constitutive role to the globalisation of culture" (p. 178). Kevin Tavin and Jerome Hausman (2004) also claim that:

> Technologies have radically transformed areas of communication and transportation and have influenced profoundly our thinking and action. In particular, new technologies, driven by a global consumer market, make it possible for large numbers of people in virtually all areas of the world to experience "the same complex repertoires of print, celluloid, electronic screens, and billboards" (Duncum, 2001, p.1). In more and more areas of the world, people are constructing knowledge through pervasive forms of visual culture. (p. 48)

A recent thematic issue of *Studies in Art Education*, guest edited by Don Krug (2004) is based on the premise that, in terms of educational technologies, we have

reached the crossroads, and the papers in this issue attempt to "analyse critically our own positions, practices, and policies concerning the effective use of technology in learning" (p. 3). Krug and his contributing authors attempt to answer aspects of this question: "How has, does, and will technological literacy, technological fluency, and technology integration effectively support and enhance learning in and through the visual arts" (p. 3). The answers to these questions indicate just how much the field has moved since Vincent Lanier's (1966) "Uses of Newer Media" project and the publication of the U.S. National Art Education Association's first edited anthology on art education and technology (Gregory, 1997).

*Gender Studies*

In an edited anthology, Georgia Collins and Renee Sandell (1996), consider the increasing number of diverse populations being taught and the types of delivery systems and settings in which they are taught. Authors describe models and means of improving the understanding of gender and achieving equity in and through art education. In a more recent anthology, and in a Canadian/United States partnership, editors Kit Grauer, Rita L. Irwin, and Enid Zimmerman (2003), include the written and/or illustrated work of 33 art educators. The three sections, on remembering, revisioning, and reconsidering issues, contain themes such as historical and contemporary accounts of women artists and art educators, teaching in non-formal contexts, mentoring, healing, friendships, intercultural women's concerns, empowerment, spirituality, and retirement. Within art education there is a strong tradition of feminist scholarship dealing with gender identity (e.g., Keifer-Boyd, 2003; Wagner-Ott, 2002). Less has been written about boys doing art, although a notable exception is the work of Australian Wesley Imms (2003), whose writing challenges and questions what he sees as dominant feminist theoretical frameworks.

   Sexuality too is a theme that is increasingly receiving attention in art education. Serious scholarly work has been accomplished, among others by, Canadian Kenn Gardner Honeychurch (1995) to extend the dialogue of diversity, and Brazilian Belidson Dias (e.g., Dias & Sinkinson, 2005). Honeychurch's work identifies explanations for lack of attention to sexual subjectivity and articulates the values for art education of recognizing sexual plurality. In his recent work Dias is fascinated with the implications for art education of the work of Spanish film maker Pedro Almodovar. American art educators Ed Check (2004) and Laurel Lampela (2005) have been at the forefront of those who support queer students and teachers. They also show all art educators ways to integrate the art of lesbian and gay artists into art teaching and learning. Although visualizing culture pervades much of the discourse within current North American art education, a shift is beginning to be noticed in Britain, and perhaps in North America and elsewhere, toward more emphasis on creativity in the arts.

# And to Complicate the Conversation Further

We began this chapter by juxtaposing two notions of curriculum: curriculum-as-plan (or experiencing the visual) and curriculum-as-lived (or visualizing experience).

Through the metaphor of curriculum as a complicated conversation, we moved back and forth between the two conceptions while considering the practices and policies of art education in Australia, Britain, Canada, New Zealand, and the United States. We should point out another way of complicating the conversation that we are unable to cover here: some scholars argue that "social advantage results in educational advantage … and the education system and the arts thus collude in reproducing social divisions" (Wolff, 1990, p. 204). Unfortunately this points to historical inequities based on class, race, gender, sexuality, and ethnicity (see Bourdieu, 1977). This said, curricularists engaged in complicated conversations should consider a variety of perspectives within each conception. By reflectively and reflexively residing in the space in between different perspectives, art education curriculum scholars and researchers can embrace many complicated conversations.

# References

Abraham, R. (2003). The localization of "O" level art examinations in Zimbabwe. *Studies in Art Education, 45*(1), 73–87.

Adu-Poku, S. (2002). *African-centered multicultural art education: An alternative curriculum and pedagogy.* Unpublished doctoral dissertation, University of British Columbia, Vancouver, BC.

Albers, P. M. (1999). Art education and the possibility of social change. *Art Education, 52*(4), 6–11.

Allison, B. (1995). The arts in a multicultural society with particular reference to the situation in Great Britain. In H. Kauppinen & R. Diket (Eds.), *Trends in art education from diverse cultures.* (pp. 145–153). Reston, VA: National Art Education Association.

Arnheim, R. (1969). *Visual thinking.* Berkeley, CA: University Press.

Barkan, M. (1962). Transition in art education: Changing conceptions of curriculum and theory. *Art Education, 15*(7), 12–18.

Barnard M. (2001). *Approaches to understanding visual culture.* New York: Palgrave.

Berleant, A., & Carlson, A. (Eds.). (1998). Introduction: Environmental aesthetics [Special issue]. *Journal of Aesthetics and Art Criticism, 56*(2), 97–100.

Boughton, D. (1989). The changing face of Australian art education: New horizons or sub-colonial politics. *Studies in Art Education, 30*(4), 197–211.

Boughton, D., & Mason, R. (Eds.). (1999). *Beyond multicultural art education: International perspectives.* New York: Waxman.

Bourdieu, P. (1977). Cultural reproduction and social reproduction. In J. Karabel & A. H. Halsey (Eds.), *Power and ideology in education* (pp. 487–510). Oxford: University Press.

Bracey, T., & Duncum, P. (Eds.). (2001). *On knowing: Art and visual culture.* Christchurch, New Zealand: Canterbury University Press.

Bresler, L. (1995). The subservient, co-equal, affective and social integration styles of the arts. *Arts Education Policy Review, 96*(5), 31–37.

Bresler, L., DeStefano, L., Feldman, R., & Garg, S. (2000). Artists-in-Residence in public schools: Issues in curriculum, integration, impact. *Visual Arts Research, 26*(1), 13–29.

Broudy, H. S. (1972/1994). *Enlightened cherishing: An essay in aesthetic education.* Urbana, IL: University Press.

Burnaford, G., Aprill, A., & Weiss, C. with Chicago Arts Partnerships in Education. (Eds.). (2001). *Renaissance in the classroom: Arts integration and meaningful learning.* Mahwah, NJ: Lawrence Erlbaum.

Burton, J., Horowitz, R., & Abeles, H. (1999). Learning through the arts: Curriculum implications. In E. B. Fiske (Ed.). *Champions of change: The Impact of the arts on learning* (pp. 35–46). The Arts Education Partnership: Washington, DC. Retrieved May 8, 2005, from http://artsedge.kennedy-center.org/champions/

Cahan, S., & Kocur, Z. (1966). *Contemporary art and multicultural education*. New York: The New Museum of Contemporary Art and Routledge Press.

Carline, R. (1968). *Draw they must*. London: Edward Arnold.

Chalmers, F. G. (1996). *Celebrating pluralism: Art, education, and cultural diversity*. Los Angeles: The Getty Education Institute for the Arts.

Chalmers, F. G. (1999). Cultural colonization and art education: Eurocentric and racist roots of art education. In P. Duncum & R. Mason (Eds.), *Beyond multicultural education: International perspectives* (pp.173–184). New York: Waxmann.

Chalmers, F. G. (2002). Celebrating pluralism six years later: Visual transcultures, education and critical multiculturalism. *Studies in Art Education, 43*(4), 293–306.

Check, E. (2004). Queers and art education in the war zone. *Studies in Art Education, 45*(2), 178–182.

Collins, G., & Sandell, R. (1996). *Gender issues in art education*. Reston, VA: National Art Education Association.

Counts, G. (1932). *Dare the schools build a new social order?* New York: Day.

Csikszentmihalyi, M. (1996). *Creativity: Flow and the psychology of discovery and invention*. New York: Harper.

Dabron, J. (1958). Art education and the child. In B. Smith (Ed.), *Education through art in Australia* (pp. 24–31). Melbourne: University Press.

Darts, D. (2004). Visual culture jam: Art, pedagogy, and creative resistance. *Studies in Art Education, 45*(4), 313–327.

Desai, D. (2000). Imagining difference: The politics of representation in multicultural art education. *Studies in Art Education, 41*(2), 114–129.

Dewey, J. (1934). *Art as experience*. New York: Capricorn Books.

Dias, B., & Sinkinson, S. (2005). Film spectatorship between queer theory and feminism: Transcultural readings. *International Journal of Education and the Arts, 1*(2), 143–152.

Dobbs, S. (1998). *Learning in and through art: A guide to discipline based art education*. Los Angeles, CA: Getty Education Institute for the Arts.

Duncum, P. (2000). How can art education contribute to the globalisation of culture? *International Journal of Art and Design Education, 19*(2), 170–180.

Duncum, P. (2001). Theoretical foundations for an art education of global culture and principles for classroom practice. *International Journal of Education and the Arts, 2*(3), 1–15.

Eisner, E. W. (1985). *The educational imagination*. New York: Macmillan.

Eisner, E. W. (1987). *The role of discipline based art education in America's schools*. Los Angeles, CA: Getty Center for Education in the Arts.

Feldman, E. B. (1970). *Becoming human through art: Aesthetic experience in the schools*. Englewood Cliffs, NJ: Prentice Hall.

Fiske, E. B. (Ed.). (n.d.). *Champions of change: The impact of the arts on learning*. The Arts Education Partnership: Washington, DC. Retrieved May 8, 2005, at http://artsedge.kennedy-center.org/champions/

Fiske, J. (1989). *Understanding popular culture*. Boston, MA: Unwin Hyman.

Freedman, K. (2003). *Teaching visual culture. Curriculum, aesthetics and the social life of art*. New York and Reston VA: Teachers College Press and the National Art Education Association

Freedman, K., & Stuhr, P. (2004). Curriculum change for the 21st century: Visual culture in art education. In E. W. Eisner & M. D. Day (Eds.), *Handbook of research and policy in art education* (pp. 815–828). Mahwah, NJ: Lawrence Erlbaum and Associates.

Gaitskell, C. D., Hurwitz, A., & Day, M. (1982). *Children and their art: Methods for elementary school*. New York: Harcourt, Brace & World.

Garber, E. (2004). Social justice and art education. *Visual Arts Research, 30*(2), 4–22.

Gardner, H. (1989). Zero-Based arts education: An introduction to ARTS PROPEL. *Studies in Art Education, 30*(2), 71–83.

Giroux, H. (1996). What comes between kids and their Calvins: Youthful bodies, pedagogy, and commercialized pleasures. *The New Art Examiner, 23* (February), 6–21.

Giroux, H. A., Penna, A. N., & Pinar, W. F. (1981). *Curriculum and instruction: Alternatives in education*. Berkeley, CA: McCutcheon.

Godlovitch, S. (1999). Introduction: Natural aesthetics [Symposium]. *Journal of Aesthetic Education, 33*(3), 1–4.

Grauer, K., Irwin, R. L., de Cosson, A., & Wilson, S. (2001). Images for understanding: Snapshots of learning through the Arts™. *International Journal of Education and the Arts, 2*(9). Retrieved May 8, 2005, at: http://ijea.asu.edu/v2n9/

Grauer, K., Irwin R. L., & Zimmerman, E. (Eds.). (2003). *Women art educators V: Conversations across time.* Reston, VA: National Art Education Association.

Gregory, D. C. (Ed.). (1997). *New technologies in art education: Implications for theory, research, and practice.* Reston, VA: National Art Education Association.

Greene. M. (2001). *Variations on a blue guitar.* New York: Teachers College Press.

Greer, D. (1984). Discipline-based art education: Approaching art as a subject of study. *Studies in Art Education, 25*(4), 212–218.

Gunew, S., & Rizvi, F. (Eds.). (1995). *Culture, difference and the arts.* Sydney: Allen & Unwin.

Heath, S. B. (2001). Three's not a crowd: Plans, roles, and focus in the arts. *Educational Researcher, 30*(7), 10–17.

Henderson, C. (1997). *A blaze of colour: Gordon Tovey, artist, educator.* Christchurch, NZ: Hazard.

Heywood, I., & Sandywell, B. (1999). *Interpreting visual culture: Explorations in the hermeneutics of the visual.* New York: Routledge.

Hickman, R. D. (1991). Art education in a newly industrialized country. *Journal of Art and Design Education, 10*(2), 179–187.

Hickman, R. D. (Ed.). (2005). *Critical studies in art and design education.* Bristol, UK: Intellect.

Honeychurch, K. G. (1995). Extending the dialogues of diversity: Sexual subjectivities and education in the visual arts. *Studies in Art Education, 36*(4), 210–217.

Imms, W. (2003). Masculinity: A new gender agenda for art education. *Canadian Review of Art Education, 30*(2), 41–59.

Irwin, R. L., & de Cosson, A. (Eds.). (2004). *A/r/tography: Rendering self through arts-based living inquiry.* Vancouver, BC: Pacific Educational Press.

Jeffers, C., & Parth, P. (1996). Relating contemporary art and school art: A problem-position. *Studies in Art Education, 38*(1), 21–33.

Jenks, C. (Ed.). (1995). *Visual culture.* London: Routledge.

Kader, T. (2005). DBAE and multicultural art education in the United States of America. *International Journal of Education through Art, 1*(1), 65–84.

Keifer-Boyd, K. (2003). A pedagogy to expose and critique gendered cultural stereotypes embedded in art interpretation. *Studies in Art Education, 44*(4), 315–334.

Kindler, A. M. (2004). Researching impossible? Models of artistic development reconsidered. In E. W. Eisner & M. D. Day (Eds.), *Handbook of research and policy in art education* (pp. 233–252). Mahwah, NJ: Lawrence Erlbaum Associates and the National Art Education Association.

Krug, D. H. (2004). Leadership and research: Reimagining electronic technologies for supporting learning through the visual arts. *Studies in Art Education, 46*(1), 3–5.

Krug, D. H., & Cohen-Evron, N. (2000). Curriculum integration positions and practices in art education. *Studies in Art Education, 41*(3), 258–275.

Lampela, L. (2005). Writing effective lesson plans while utilizing the work of lesbian and gay artists. *Art Education, 58*(2), 33–39.

Lanier, V. (1966). New media and the teaching of art. *Art Education, 19*(4), 4–8.

Lanier, V. (1969). The teaching of art as social revolution. *Phi Delta Kappan, 50*(6), 314–319.

Lanier, V. (1982). *The arts we see.* New York: Teachers College Press.

London, P. (1989). *No more second hand art: Awakening the artist within.* Boston, MA: Shambhala Publications.

Lowenfeld, V. (1947). *Creative and mental growth.* New York: Macmillan.

MacGregor, R. N. (1997). Editorial: The evolution of discipline-based art education. *Visual Arts Research, 23*(2), 1–3.

Madeja, S., & Onuska, S. (1977). *Through the arts to the aesthetic: The CEMREL aesthetic education program.* St. Louis, MO: CEMREL.

Marcow-Speiser, V., & Powell, M. C. (Eds.). (2004). *The arts, education and social change.* New York: Peter Lang.

McFee, J. K. (1961). *Preparation for art.* Belmont, CA: Wadsworth.

Milbrandt, M. (2001). Addressing contemporary social issues in art education: A survey of public school art educators in Georgia. *Studies in Art Education, 43*(2), 141–152.

National Advisory Committee on Creative and Cultural Education. (1999). *All our futures: Creativity, culture and education*. London: Department for Education and Employment.

Nieto, S. (1999). *Affirming diversity: The socio-political context of multicultural education*. White Plains, NY: Longman.

Pearse, H. (2004). Praxis in perspective. In R. L. Irwin & A. de Cosson (Eds.), *A/r/tography: Rendering self through arts-based living inquiry* (pp. 184–197). Vancouver, BC: Pacific Educational Press.

Pinar, W. F. (2004). *What is curriculum theory?* Mahweh, NJ: Lawrence Erlbaum.

Pinar, W. F., & Irwin, R. L. (2005). *Curriculum in a new key: The collected works of Ted T. Aoki*. Mahwah, NJ: Lawrence Erlbaum.

Read, H. (1943). *Education through art*. London: Faber & Faber.

Rogoff, I. (2000). *Terra infirma: Geography's visual culture*. New York: Routledge.

Smith, J. (2000). The multicultural art education debate: Internationally and in New Zealand. *Australian Art Education, 23*(1), 19–25.

Smith, J. (2003). *Literature review project: Beyond biculturalism: Multicultural art education for the plural societies of Aotearoa New Zealand*. (Unpublished paper).

Smith, R. A. (1966). *Aesthetics and criticism in art education*. Chicago: Rand McNally.

Smith, R. A. (1989). *The sense of art: A study in aesthetic education*. New York: Routledge.

Springgay, S. (2004). *Inside the visible: Youth understandings of body knowledge through touch*. Unpublished doctoral dissertation, The University of British Columbia.

Springgay, S., Irwin, R. L., & Wilson Kind, S. (2005). A/r/tography as living inquiry through art and text. *Qualitative Inquiry, 11*(6), 897–912.

Sullivan, G. (2005). *Art practice as research: Inquiry in the visual arts*. Thousand Oaks, CA: Sage.

Steers, J. (2004). Orthodoxy, creativity and opportunity. *International Journal of Arts Education, 2*(1), 24–38.

Stross-Haynes, J. (1993). Historical perspectives and antecedent theory of multicultural art education: 1954–1980. *Visual Arts Research, 19*(2), 24–33.

Stuhr, P. (1994). Multicultural art education and social reconstruction. *Studies in Art Education, 35*(3), 171–178.

Stuhr, P. (2003). A tale of why social and cultural content is often excluded from art education – and why it should not be. *Studies in Art Education, 44*(4), 301–314.

Tavin, K. (2004). Hauntological shifts: Fear and loathing of popular visual culture. *Studies in Art Education, 46*(2), 101–117.

Tavin, K., & Hausman, J. (2004). Art education and visual culture in the age of globalization. *Art Education, 57*(5), 47–52.

Thistlewood, D. (Ed.). (1991). *Critical studies in art and design education*. London: Heinemann.

Torrance, E. P. (1963). *Creativity*. Washington, DC: National Education Association.

Tu, W. (1985). *Confucian thought: Selfhood as creative transformation*. New York: SUNY Press.

Tweddle, P. (1992). Arts education: The search for a third way for schools. *Journal of Art and Design Education, 11*(1), 45–59.

Upitis, R., & Smithrim, K. (2003). *Learning Through the Arts™ National Assessment 1999–2002. Final report to the royal conservatory of music*. Kingston, ON: Queen's University, Faculty of Education.

Wagner-Ott, A. (2002). Analysis of gender identity through doll and action figure politics in art education. *Studies in Art Education, 43*(3), 246–263.

White, J. H. (2004). 20th-century art education: A historical perspective. In E. W. Eisner & M. D. Day (Eds.), *Handbook of research and policy in art education* (pp. 55–84). Mahwah, NJ: Lawrence Erlbaum.

Wolff, J. (1990). Questioning the curriculum: Arts, education and ideology. *Studies in Art Education, 31*(4), 198–206.

# INTERNATIONAL COMMENTARY

## 11.1

# A Middle Eastern Perspective on Visual Arts Curriculum

**Mohamad S. Shaban**
*UAE University, U.A.E.*

Middle Eastern countries such as Egypt, Sudan, Jordan, Saudi Arabia, Lebanon, Syria, Kuwait, Iraq, Bahrain, UAE, Oman, Yemen, Palestine, Iran, Turkey, Libya, Morocco, Tunisia, and Algeria share a common religious (Islamic), political, and cultural history which includes some period of occupation by western countries. Before this occupation Islamic Art was the most important source of artistic vision and visual expression. In contemporary times, it is rather difficult to find a major difference between what is happening in art education in the west and what takes place in the Middle East, although Bassiouny (1984) does identify some differences. Bassiouny, an American university graduate who is one of the leading art educators in the Middle East, has published a number of books and articles in art education and founded many of the art education departments in the area; he concludes that

> Differences result from various factors which shape indirectly, the taste and style of art education in the Middle East and which makes [*sic*] it look different from western art education. Within taste and style there is [*sic*] the tempo, attitudes, habits, and reaction to visual reality which the easterner has acquired through a long history of living in a certain environment. (p. 147)

Carswell (1992) states that more specific guidance is appropriate when the child becomes capable of rational analysis. It is essential to facilitate awareness of the child's own heritage. This can be accomplished through exposure, helping the child to perceive his or her place in time and as part of a cultural continuum, and to analyze his or her relationships to the past. In the Islamic world, this means an appreciation of Islamic art and architecture.

Amru (2002) claims that the developmental theory of children's drawings marginalized the role of the art teacher, leading the child to rely upon memory or lack of it for the visual experience. This has influenced instructional methods in different stages of schooling in the Arab world. Sadiq (1990) argues that the aesthetic value of an image

*L. Bresler (Ed.), International Handbook of Research in Arts Education, 195–196.*
© 2007 *Springer.*

is a reflection of the cultural and social roots which appears in one specific place and time. Therefore, he suggests that an art curriculum that is culturally and socially specific does not fully intersect with the traditional art curriculum. However, a socially and culturally specific art curriculum makes better connections between learners and the content of the curriculum. The main goal of this approach to art education is to understand human nature, including oneself, in a social environment through art making and experimenting, as well as talking about art, and connecting that with human values.

# References

Amru, K. (2002). The developmental theory of children's drawings in light of contemporary research in art education. *Abhath al-yarmouk: Humanities and Social Sciences Series, 18*(3), 1245–1273.

Bassiouny, M. (1984). *Art education west to middle east*. Cairo: Dar Al-Maaref.

Carswell, J. (1992). Art education in the Islamic world. In W. Ali (Ed.), *The problems of art education in the Islamic world* (pp. 57–60). Amman: Ministry of Culture.

Sadiq, M. (1990). The socially specified art curriculum and its reflection on the curriculum of art education. *Abhath al-yarmouk: Humanities and Social Sciences Series, 6*(1), 81–100.

INTERLUDE

12

# ON LEARNING TO DRAW AND PAINT AS AN ADULT

**Decker Walker**
*Stanford University, U.S.A.*

## How I Came to Study Drawing and Painting at Age 60

A few years ago as a full professor, within sight of the normal retirement age, I found myself needing to know more about visual design. I was teaching courses on the design of interactive media for teaching and learning. These courses were an outgrowth of my career-long interest in curriculum design and a decade-long fascination with the learning potential of computers and information technology. In these courses I asked students to create prototypes, mockups, and working models of teaching and learning materials meant for delivery through a video screen as works of interactive media. When the students showed me their designs I felt prepared to comment constructively on learning-related questions and also on their use of words for directions and instruction, but when it came to the visual aspect of their design, I felt at sea. I usually had opinions about the quality of the visual design and sometimes I told students my opinion, labeling it as "just my opinion" and emphasizing that I would not factor that opinion into my grade. Sometimes I would be confident that the way a screen looked either helped or hindered the design's overall effectiveness and appeal, but even then I was often unable to support my conviction with a clear argument.

This situation made me uneasy. I felt that I should be able to comment on the visual aspects of a design with as much confidence as I could comment on the words and the learning principles. And so I decided to devote some sabbatical time to developing my visual literacy. My goal was to become as able to judge the quality of visual design as I was to judge writing or the application of heuristics and principles of learning and teaching.

The obvious way for me to develop this ability was to take courses in a department of art or visual design in one of the many nearby community colleges. I asked the most visually adept people I knew how they developed their skills. Without exception they said that they had taken courses in drawing, painting, and visual design. But when I looked at the lowest level courses offered in the art departments in my area, courses

*L. Bresler (Ed.), International Handbook of Research in Arts Education, 197–202.*
© 2007 *Springer.*

like "Beginning Drawing" and "Painting I," the course descriptions made it clear that they were intended for artists or people striving to become artists. One such description read: "Have you found your paintings to be lacking in form and realism? This course will give you the foundation in drawing you need to move to the next level." Everything about these courses suggested that they were designed for people who wanted to become artists, whereas I had no such ambition. I wanted to develop my understanding and skill in visual representation and visual design but for the purpose of designing utilitarian objects. What I thought I needed was a course like "Art for Klutzes" or "Drawing for the Humanities." After all, English departments offer courses in writing for non-majors and business schools offer accounting courses for the non-financial manager, so why shouldn't the art department offer serious, hands-on, skill-developing courses for non-artists? I didn't find any such courses, so I did the best I could and signed up for several introductory drawing courses in various local institutions.

## My Experiences in Art Classes

My first thoughts on the first day of my first drawing class at the Pacific Art League of Palo Alto, a nonprofit organization by and for visual artists, were full of anxiety. What would these courses be like? Would I be able to learn what I wanted from such courses? Would they teach anything as simple and straightforward as how to draw a recognizable shape, or would they instead focus on other concerns important in the art world such as creativity, style, fantasy, and imagination? Would they be too difficult for me? Would I be embarrassed about my drawing? Would I find it hard to keep up with the artists in the class and to meet their standards of quality? I decided in advance that I was not competing with anybody, that I didn't care if my drawings were laughably primitive, just so long as I could see them getting better. I was prepared to quietly ignore whatever didn't serve my purpose and concentrate on whatever did.

As it happened, I needn't have worried. The teacher put some fruit and jars on a table, set up her paper and drawing board, and slowly and methodically made a basic drawing, explaining each step. Then she helped us set up our paper and charcoal and we drew something from the scene before us – not necessarily the whole setup, just whatever interested us. The teacher roamed the room offering practical help on matters such as how to hold the charcoal, how to make different kinds of marks and asking questions such as "Compare the shadow of this apple to the dark side of that jar. Which is darker? Now look at your drawing. Which is darker there?" One person asked for help in giving something the right proportions, so she showed us how to measure the relative height and width of an object using a pencil at arm's length. She told us to check angles and compare the angles on our paper with the angles we saw on the table. We did several drawings that first class. Then at the end, we each hung a drawing on the wall and we walked around and looked at them and talked about them. We saw that no two were alike. We saw things in others' drawings that we admired and things in our own that we liked. Some drawings were clearly more "advanced" than others – more

fluent, more accurate, more interesting to look at, less clumsy – but that didn't seem to matter much, certainly not to me. I was excited that I was able to do as well as I had done and even more excited that I had already learned about several things that, with practice, would make my drawings better.

For 10 weeks, two times a week, we continued in this way. We drew different things – plants, paper bags, onions, our faces in a mirror. We focused on different challenges in drawing – measuring, controlling tones of light and dark, positive and negative shapes, composition. We tried various drawing strategies – contour drawing, drawing of planes, mass drawing, drawing with scribbles. The teacher demonstrated. We drew. We looked and talked. I learned a tremendous amount. My drawing got noticeably better (in my eyes). It was everything I could have hoped for. My other courses followed a similar pattern. I've been studying drawing and painting now totally for about 5 years, and I've rarely been disappointed in an art class.

I wondered then and often since what it is about such art classes that has made them such marvelous learning environments for me. I should say that I've taken a great many post-secondary courses in many fields of study, dozens in physics and mathematics, at least a dozen in history, literature, philosophy, and education, but my only formal study of the arts was in musical performance – I played the tuba in the band and orchestra in my freshman year. I've learned a great deal from some of these courses, very little from others, and a modest amount from most. I've had some outstanding teachers, some weak ones, and many ordinary ones. In none of these fields have I felt such a string of learning successes as I have experienced in my study of drawing and painting over the past five years.

Why? Are art teachers better than teachers of other subjects? Was I just lucky in finding excellent courses and teachers or did I do a particularly good job of selecting the right courses? Do I have heretofore unrecognized special interests or talents in the arts? Am I a better student now than I was earlier in my career? Any answer would be pure speculation, but there are some respects in which these art courses differed from most other courses I have taken and I believe that the answer lies in those differences.

## What's Different About Art Courses?

Here are some of the ways that my experiences in these art courses seem to me to be very different from other courses I have taken in other disciplines.

- We started making drawings the first day and kept on making them every day.
  We didn't spend weeks doing exercises to prepare ourselves to draw; we didn't talk about how to draw first; and we didn't read about, examine and discuss others' drawings. In doing these drawings we were in a real sense doing art, engaging in the same kind of open-ended confrontation of ourselves with the subject that the greatest artists do. Our work may have been student level work, but the challenges we tackled were serious enough to engage the greatest artists. We were limited only by our skills and imagination, not by the problems set for us by our teachers. From Day 1 this was real, open-ended art, not just preparatory exercises.
- The teachers were doing art, too.

In demonstrations teachers confronted the same complex subjects we confronted and created their own original drawings right before our eyes. This showed us what could be done and gave us a concrete, immediate image and model of an experienced artist drawing.

- Our work did not depend on abstract symbol systems.

  Words, written and oral, played an important but secondary and purely instrumental role. Words helped, but seeing, doing, and making were what we mainly did together.

- Each student made all the major decisions about his or her own work.

  We each decided what to draw from the tableaux before us, how large to make things, where on the paper to put them, how dark or light, how detailed, how realistic. As a result, the work was personal, bearing the stamp of each person's individuality. Each mark is my mark and I must consider how I want it to look and feel and take responsibility for how it looks. These choices require me to look inside myself, to express my preferences and inclinations through my marks. And then when I make the mark, it reveals something of my inner self and something of my body and way of being in the world. It's revelatory of something unique to me in a way that my solution to a math exercise or my answer to a multiple choice question cannot be.

- All work was public, observed and discussed by everyone.

  We didn't do our work in privacy at our desks or at home and hand it in and get it back later with a grade. We put it on the wall for everyone in the room to see.

- Both teacher and students judged the quality of the work done, but there were no right answers.

  Standards teachers and students applied were complex, not simply right or wrong. People might say of some work or part of work that it is interesting, vibrant, mysterious, dynamic, subtle, bold, and so on and on. They might comment that shadows are placed incorrectly, that this form was well turned, and those proportions accurate. Standards are multiple and both tacit and explicit. It may seem strange, but we seldom discussed beauty and I can't recall a single case of the use of any form of the word "creative." We were all trying to make our drawings look better, but the word "beauty" didn't seem to be of much help. We were all struggling to create a two dimensional representation of a three dimensional, full color reality using a burnt stick, but it didn't seem to help to speak of this activity as "creative." Most of our talk was direct and concrete. Where it was metaphorical, the metaphors were attempts to convey perceivable qualities.

- The art teachers I've been fortunate enough to study with have brought to their classes more of themselves as human beings than teachers in other fields. They dress as they normally dress when they draw or paint, not in a suit and tie. They talk in a normal voice, not like an orator. They seem to respond spontaneously. For instance, I've never seen a teacher of another subject be obviously startled and say something like "Oh, look at that color! Have you ever seen anything so stunning?" They talk freely about their life outside the classroom – their children, friends, lovers, fellow artists, freely exposing their likes and dislikes, though not imposing them on anyone else. Students see their moments of doubt as well as their moments of triumph. You don't feel any barriers between their role as teacher, their role as artist, and their lives as persons. They seem to be genuine and direct. Perhaps it's unavoidable. You can't make a drawing without seeing and feeling and expressing who you are. Nor can you respond fully to the qualities of others' work if you wall off parts of yourself.

Is there a way to summarize these distinctive features? I haven't found an adequate summary description. "Authentic tasks" carries part of the load. "Learning by doing," another part. Cognitive apprenticeship, perhaps, or problem-based learning. But these leave out much that's crucial: Discipline, practice, fault finding, setting personal learning agendas, responding to each students' uniqueness, measured development of manual and perceptual skills over weeks, months, and years. For me, the key quality of these art courses is their directness. The learning I experienced benefited enormously from the full and direct contact with the art of drawing that these courses provided for me – no windup, no sugar coating, no pulled punches, no training wheels, no ramping up. This is drawing. And so is this. This is what it involves. This is how it feels. Here's what you just drew. Here's what other people drew. If you want your drawings to look "better" in some way, here's how you can do that. Drawing's not easy for anybody. Nobody has ever mastered it completely. All us artists are in this together doing the best we can.

What would school be like if students participated in some form of real mathematics all along? Impossible? Only if you take a very narrow view of what is mathematics. After all, the art we produced in our beginning classes was not suitable for exhibition in a museum. It was art as we were able to make it then. We could do mathematics in the same way, the teacher setting a complex problem of a mathematical sort, all the students doing their best within a given time frame to solve the problem, the teacher sometimes working along, sometimes helping students, and then showing and discussing their results. I wish now that I had, as a young person, learned mathematics, science, literature, history, philosophy, and education with the same directness. In fact, now that I think back on it, the best parts of my experiences in learning those subjects had the same quality of direct contact with people engaging in a profound human activity.

# 13

# PROTEUS, THE GIANT AT THE DOOR: DRAMA AND THEATER IN THE CURRICULUM

**John O'Toole*** and **Jo O'Mara**[†]

\* *The University of Melbourne, Australia;*
[†] *Deakin University, Australia*

Drama and formal curriculum have always had a relationship of mutual suspicion in Western society. Curriculum is often conceptualized with status and permanence: "*The* Curriculum." Contemporary curriculum theorists such as Robert Stake (1998) ruefully understand this: "Actually, education occurs in complex and differentiated ways in each child's mind ... Goal statements are simplifications ... Procedurally, Education is [still] organized at the level of courses and classrooms, then lessons and assessments" (p. 5).

Drama, by contrast, exists in the moment – simultaneously concrete, protean and entirely evanescent: "a fistful of water ... a land on which one can solidly place one's feet and then fly," as Eugenio Barba reminds us (1995, pp. 110, 118). In Western society, rather than wrestle with this conundrum, most curricula have excluded drama and its manifestations in performance that here we will call theater. Within school and college classrooms especially, drama is usually marginal or absent.

For many traditional societies, dramatic play and performance have always been part of an ongoing artistic curriculum [see Chapter 4, "A History of Drama Education," in this Handbook]. In Western education, this protean art has edged in and out of the curriculum in so many different forms that educational administrators have rarely known what to do with it. Drama flourishes: as extra-curricular activity in school musicals and promotional events; in drama clubs, speech training, self-expression, emotional development and confidence building; in the early childhood play corner; as part of syllabi in English classes; in vocational training and army exercises; as "theater for development" (TfD) with disadvantaged populations worldwide; as a pedagogy with implications across the school curriculum; re-discovered in cyberspace through role-play structures and interactive games (Carroll, 2004, p. 72).

*L. Bresler (Ed.), International Handbook of Research in Arts Education, 203–218.*
© 2007 *Springer.*

## Paradigms of Purpose

How on earth do we – most of us with little or no exposure to drama in our own education – encompass all those conflicting manifestations coherently in the over-crowded school timetable, label them, and teach them?

If we define curriculum in terms of its purposes for the consumer, drama has poten-tially *three* distinct, imposing *paradigms of purpose* that tie in loosely with some or other of the manifestations above:

- cognitive/procedural – gaining knowledge and skills in drama
- expressive/developmental – growing through drama
- social/pedagogical – learning through drama.

These paradigms have diverse manifestations in curricula worldwide, and each com-prises more than one separate movement or tradition. In the last decade, a *fourth* and unifying paradigm has emerged, a consequence of drama bonding firmly with the other creative arts in a foundation common to all.

- functional – learning what people do in drama.

Educational administrations are becoming increasingly interested in the Arts, as the rhetoric of corporations re-appropriates words like "creativity," "communication," and "teamwork." The traditional mechanistic, fragmented, and individualistic curriculum of Western schooling serves society less and less well, and evidence emerges of the benefits of arts education to all aspects of schooling, including literacy and numeracy. This was prophesied in the 1930s by John Dewey (1934/1972), identified in the 1960s by Alec Clegg (1972), and definitively demonstrated in this millennium by The Arts Education Partnerships (Deasy, 2002). This fourth paradigm offers drama a place and parity with the other arts in the twenty-first-century curriculum.

## Philosophies

A range of philosophies, value systems, and ways of defining teaching and learning underpin drama practice and research, some of them conflicting. The strongest tradition historically is humanistic progressivism, promoted by Dewey and his many followers (e.g., Dewey, 1938/1963) and manifested to the present day in holistic, experiential and discovery-based approaches. However, more deterministic and behaviorist approaches to drama education drove the sociodrama movement (Jones, 1980; Moreno, 1953). In the 1950s and 1960s, the romantic ideas of Rousseau provided the impetus for "child drama" and "creative dramatics." That was challenged in the 1970s onward by a new generation, inspired by Brecht (1964) and intent on using drama to interrogate received ideas and replace established social orders. This was in itself challenged by the critical relativists of post-modernity, and bitter battles erupted. Most contemporary drama prac-titioners and theorists espouse constructivist ideas and pursue their research through forms driven by dialogue rather than dogma. The most influential developments in drama curriculum have emerged from praxis: theory and practice developing together

in response to social and educational contexts. The scholarship has overwhelmingly been provided by practitioners, some of whom, like Slade (1954), Ward (1947), and Bolton (1979), certainly treated formal research methods with respect. There is now an increase in the amount of formal research being undertaken in the field.

# The Cognitive/Procedural Paradigm – Learning About Drama

Learning *about* the art form of drama may be divided into two complementary but very different movements, each with its own purposes and curricular positioning:

1. Drama as literature/theater science/performance studies.
2. Theater arts skills and training.

## *Drama as Literature*

This is drama's longest continuous establishment in schools, colleges and universities. Drama is still taught within some literature courses, in the English-speaking world mainly through English and Liberal Studies classes. The basic principle of this has been that students should be given access to and *perhaps* experience of this classic art form as part of their cultural heritage, thus regarding knowledge of the canon of dramatic literature as an essential pre-requisite for a fully educated adult: "all this, together with an understanding of drama's place in a wider culture, amounts to a contextualizing of experience which is an essential and embracing aspect of the dramatic curriculum" (Hornbrook, 1991, p. 112).

Young people are taught to *appreciate* drama primarily as consumers, both to generate audiences for adult theater and for its supposed civilizing influence: "Children are led towards the appreciation of drama … and the works of the great dramatists, and thus towards the true and full humanity that such an experience brings" (Burton, 1955, p. 21). This cultural heritage model has been contested within English teaching (Thomson, 2005, p. 19) and newer models of English teaching have emerged in parallel with changes experienced in drama. Ironically, drama as literature is usually taught sitting down, reading theater as literary text or watching films and occasionally, stage performances. In the early twentieth century, Caldwell Cook (1917) bravely challenged this sedentary study by moving the desks and encouraging his students to bring Shakespeare to life as actors. Since then, enterprising teachers have done their best with inflexible classrooms and schoolhalls to ensure that their students somehow experience drama as performance. In many schools the regular school play or dramatic competition has provided a co-curricular complement and an opportunity for the talented to strut their stuff, which raises the question of where dramatic artists get their training.

## *Theater Training*

For many young children, the urge to perform in public is very strong and countless professional actors ascribe their start to self-organized epics in drawing room, street or

classroom corner. Many schools provide co-curricular drama clubs and school per-
formances. The first professional acting schools, such as England's Central School of
Speech and Drama, were founded in the early twentieth century. In recent years, as a
career in dramatic art has become more respectable, some local education authorities
have created performing arts high schools or senior courses. Interestingly, research in
Australian and English drama schools indicates that many reject the notion of "educa-
tion" in favor of "training" for stage and screen (Prior, 2004, p. 265). The tertiary acad-
emies have themselves spawned an industry of private drama schools for adults and
children.

## The Expressive/Developmental Paradigm – Growing Through Drama

From the nineteenth century, educational scholars have recognized that dramatic play
is an important part of human development, inspired by Rousseau's freewheeling
philosophies of childhood in *Emile* (1762/1956). Among the most influential was Karl
Groos, whose studies into imitative play led to his startling conundrum that higher ani-
mals and humans "cannot be said to play because they are young and frolicsome, but
rather they have a period of youth in order to play" (1896/1976, p. 66). This was part
of the driving force for the "New Education" movement centered on the child, and on
"activity learning": "the New Education treats the human being not so much as a
learner but as a doer and a creator" (Quick, as cited in Bolton, 1984, p. 8). Hand in
hand with this came the awareness that drama might play its part in children's growth
and self-development through formal schooling. As early as 1898, an English Board of
Education Report

> speaks approvingly of the beneficial effect of practical drama on "vitalizing lan-
> guage and quickening the perceptive and expressive faculties of boyhood," an
> encouragement that is repeated with greater emphasis in the Board's *Handbook for
> Teachers in Elementary Schools* (1929) and even more so in the report of an adult
> education committee on *Drama in Adult Education* (1934). (Allen, 1979, p. 10)

This quotation by a 1970s Schools Inspector for Drama indicates the growing approval
throughout the century for drama in formal schooling, and not just for young children.
By the mid-1950s, books such as Bishop E.J. Burton's *Drama in Schools* (1955) were
claiming a distinct place in the curriculum, with an eclectic rationale that privileged
"imaginative play," especially for young children.

### Creative Dramatics

At that time two influential movements became the cornerstones of this creative/
expressive curriculum. In the United States this was mainly known as "creative dra-
matics" or "playmaking"; pioneer Winifred Ward uses these terms interchangeably
in her seminal book *Playmaking with Children* (1947), a developed version of the

theories and practices she used in the public schools of Evanston Illinois, first described in *Creative Dramatics* (1930). In the United Kingdom the impetus was Peter Slade's *Child Drama* (1954). The books are very different, but they may be usefully compared, as both set their national curricular tone for the next 20 years. Both are written by confident and skilled practitioners, their practice informed by a clearly stated theory of child-centered and developmental education. They both unequivocally articulate ideals of the expressive and creative power of drama. Both take as their starting point children's natural dramatic play, not dramatic text but improvisation, acting out stories and various forms of role-play.

Ward, writing that "the arts add immeasurably to the richness and enjoyment of living" (1947, p. 5), was deeply influenced by philosopher Hughes Mearns and his books on creativity (e.g., Mearns, 1929). She lays out her creative and expressive curricular objectives quite clearly:

1. To provide for a controlled emotional outlet.
2. To provide each child with an avenue of self-expression in one of the arts.
3. To encourage and guide the child's creative imagination.
4. To give young people opportunities to grow in social understanding and co-operation.
5. To give children experience in thinking on their feet and expressing ideas fearlessly (Ward, 1947, pp. 3–9).

Her developmental plan addresses the formal education systems – the book's sub-title is "from kindergarten through junior high school" – and the final chapter discusses the teacher's role in playmaking. It is full of vivid anecdotes and practical advice that can be (and constantly has been) lifted straight into the classroom.

From its inception, there has been a strong research base to the creative dramatics movement. In 1961, an effort was made to bring together the research and scholarship in the new field in *Children's Theater and Creative Dramatics* (Siks & Dunnington, 1961). Jack Morrison writes in the foreword:

> Scholarship, experiment (*true* experiment), and new techniques revealing hitherto unavailable aspects of human beings and their relationships to themselves as well as their world must be used to give us and our children deeper insights and new opportunities to grow in ways that will match an open-ended universe … By examining the field of children's theatre systematically and with demands for reportage and careful scholarship [this book] seeks not only to bring the field into focus but also to give a more meaningful artistic experience for children. (1961, pp. vii–viii)

The chapters are all based on formal research or practitioner experience and cover a wide ranging use of creative dramatics at the time including values education, exceptional children, religious education, correctional institutions, community programs, and recreational programs, written by distinguished authors such as Barbara McIntyre and Nellie McCaslin. This strong, broad research base has provided solid ground for later developments.

## Child Drama and Creative Drama

Like Ward, Slade (1954) worked developmentally, but with little regard for the formal educational systems into which his disciples would spend the next decades trying to fit his principles. The book is free-wheeling, opinionated and passionate, wholeheartedly centered on his revolutionary discovery: that Child Drama (he loved emphatic capitals) has a life of its own, and exists as an art form in its own right, with intrinsic purposes, control of form and outcomes that are self-contained artworks. Slade's book is brilliant, if uncontrolled, practical educational research, crammed with detailed examination and analysis of children's play and classroom drama, with dialogue, photographs, and diagrams laying out for the reader the mechanics of the creative processes he observed. Slade acknowledges that the dramatic forms, skills, and conventions change and grow as the Child develops, but not that they "improve"; the product of each age-range is sufficient unto itself:

> The period [age 5–7] is one of increasing skill, of great enchantment, and the extra sensitivity that is developed brings the Child to the threshold of the most wonderful years of dramatic fulfillment. We find exquisite moments in their new Drama creations from now on, in which deep soul experiences and ice-cold logic walk hand in hand. (1954, p. 51)

Curriculum planners do not know what to do with this kind of artistic outpouring either from children or their theorists, and one might question whether it is even "learning." However, Slade's collaborator Brian Way (1967) systematized Slade's principles into a way of working that could be managed in a conventional classroom and timetable. Improvisation was still the basis, but mainly as structured dramatic exercises, many of which came from formal theater and rehearsal techniques. The emphasis was still clearly on the individual child's personal development. In the 1970s and 1980s, Way's book was often the only drama book found in schools, particularly in countries distantly influenced by Slade, such as Australia and Canada. Its descendant is the cheerful exercise-based theatricality of Keith Johnstone's *Theatersports* (1999), which belongs within this creative/expressive paradigm.

In the United States, a similar confluence with theater happened. The Children's Theater Movement had been developing from the early twentieth century and it was not until the 1950s that a distinction was made between children's theater and creative dramatics. McCaslin (1961) wrote, "This clarification, for which Winifred Ward must be given credit, seems important since it has led to the distinction between product and process" (p. 26). Many teachers combined the acting exercises of Viola Spolin (1983) with Ward's ideas, the influence of which can be seen in the next generation of drama educators such as Siks (1983) and McCaslin (1996). Perhaps because of Ward's more system-friendly structures, these pioneers have generated a more natural and peaceful evolution into the next paradigm of drama curriculum than happened in the United Kingdom.

In the late 1960s and 1970s, a quantum leap forward from Slade's principles would largely sweep his writing and influence into the archives, and bury them both behind

the new paradigm and also in an acrimonious battle between the drama of process and the art of theater, to which Slade himself contributed (Allen, 1979). However, recent research into dramatic play (e.g., Dunn, 2003; Lindqvist, 1995) has reinforced Slade's discovery that children's play contains artistry. Moreover, after 20 years as an almost taboo word in education, the word "creativity" has made a spectacular comeback in the lexicon of curriculum, driven by corporate awareness of the need to address the twenty-first century with creative thinking (Florida, 2004; NACCCE, 1999).

## Related Movements Speech/Speech and Drama

A parallel movement has been the Speech movement, based on developing self-confidence through the ability to express oneself articulately and appropriately. This found its way into some state schooling in the United States but in other English-speaking countries mainly dwelt on the co-curricular edge. In United Kingdom and Australia it was usually known as "Speech and Drama" and tended to have strong class connotations of a single "correct" language and deportment. However, Clive Sansom, a British Speech and Drama teacher, became Director of Education in Tasmania and left a strong tradition of language through drama in the primary classroom in Australia (Parsons, Schaffner, Little, & Felton, 1984).

Speech and Drama gained strong purchase in the 1960s to 1980s in tertiary colleges, particularly in teacher training, aiming to give pre-service teachers self-confidence with language, creativity with ideas and show them how to develop these skills in their students. The great majority of the college speech and drama departments created at this time have morphed into professionalized and specialized drama units. Ironically, as this has happened, the amount of speech, communication, and confidence training for trainee teachers has dwindled, often to none.

## Psychodrama

The Psychodrama movement was founded by Jacob Moreno, combining psychoanalysis and theater directing, firstly as therapy, then as learning. He came to psychodrama via treating neurotic actors in Vienna (Nolte, 2000, p. 210). This has subsequently been appropriated by clinicians, for the treatment of mental illness. It is based on role-play, usually on a one-to-one basis with a therapist, where episodes of traumatic memory or dangerous fantasy are dramatized and re-played in various ways, to try and remove hurt or minimize risk. On the whole, educators have shied away from this kind of drama therapy, though Bishop Burton (1955) urges that "drama, then, like every great art, has a cleansing and therapeutic effect ... the teacher ... has within his charge those who might develop in such directions and he has in drama a means of bringing them to normality and health" (p. 20). Only since the late 1980s have the psychodramatists and educators started edging towards each other, particularly through the research of Robert Landy (1994) and Sue Jennings (1987), but there is growing research on how drama might affect change in the lives of its participants (Brice Heath & Roach, 1999; O'Toole, Burton, & Plunkett, 2004).

The expressive/creative purposes may no longer be the dominant paradigm in curriculum development, but they are far from forgotten, and they are in fact quite a preoccupation of contemporary research in drama, with a particular focus of research on the power of drama to promote self-expressiveness and creativity in people with special needs (e.g., O'Connor, 2003; Raphael, 2004), and in gender identity (e.g., Gallagher, 2000; Sallis, 2004).

## The Social/Pedagogical Paradigm – Learning Through Drama

### Drama-in-Education

The idea that in schools work and play are not opposite but complementary (*The Hadow Report* 1931 in Allen, 1979, p. 19) can be taken further: some play theorists propose that the curriculum itself might be encompassed in drama structures, where children might scaffold their learning through the "dual affect" of role-play and reality (Vygotsky, 1933/1976, p. 548). From the late 1960s a clear pedagogy of drama emerged, revolutionary and yet not new, based on using improvised drama for the creation and enactment of realistic models of human behavior. Originally known as "drama-in-education" or "educational drama," it is often now referred to as "process drama." B-J. Wagner describes its goal as "to create an experience through which students may come to understand human interactions, empathize with other people, and internalize other points of view" (1998, p. 5). It provided the tools for using drama as a teaching method across the whole curriculum, to produce deep understanding and higher-order thinking, learning that was holistic and experiential, not just cognitive – in Gavin Bolton's words, "change in a participant's understanding of the world" (1984, p. 148).

The groundwork for this movement can be traced to Harriet Finlay-Johnson in an English village school, who created the first known integrated dramatic curriculum: "Everything to be taught (History, Geography, Scripture, Nature Study, Poetry, Shakespeare, and Arithmetic) was adapted to dramatic action" (Bolton, 1984, p. 11). She anticipated Slade and encouraged children to structure their own drama; she used plays as well as improvisation. The indefatigable Bishop Burton had probably read Finlay-Johnson's *The Dramatic Method of Teaching* (1911), since he notes drama's "application as a method of teaching in various subjects – Scripture, English, the visual arts, geography, history and physical education" (1955, p. 21); apparently arithmetic did not make his list. Winifred Ward warns that "drama is an art, not a tool for making learning easy" (1957, p. 154), but then goes on to describe her own action research projects in history, natural science, art and creative writing, stressing drama's potential to help integrate learning in the primary school.

The drama-in-education movement was kick-started by pioneer British educator Dorothy Heathcote. Working from her profound understanding of how children play and her own highly developed theatrical skills, she attracted many followers, often gifted teachers and researchers themselves, who theorized Heathcote's work and enabled it to be developed into curriculum. For example, Wagner wrote the first sustained

analysis of Heathcote's work in her best-selling book *Dorothy Heathcote: Drama as a Learning Medium* (1976); Gavin Bolton (1979) as well as Heathcote and Bolton (1995) gave Heathcote's work its theoretical basis; Cecily O'Neill (1995) and John O'Toole (1992) identified the art form within and added structural diversity; David Booth (1994) crafted dramatic narrative for depth of understanding; David Davis (Roper & Davis, 1993) and Jonothan Neelands (1996) toughened up its political and social credibility; and Norah Morgan and Juliana Saxton (1989, 1994) analyzed and identified the components for generalist teachers, as well as the most basic skill that drama both demands and provides, that is, effective questioning. These and a host of other practitioner-theorists (see Bowell & Heap, 2001; Bunyan & Rainer, 1995; Manley & O'Neill, 1998; Miller & Saxton, 2004) have developed Heathcote's instinctual tour-de-force into manageable pedagogy.

Heathcote and the drama-in-education movement took a quantum leap forward in curriculum. Process drama's characteristics include that the drama is always improvised, creating the learning context on the spot in the classroom, with the learners all involved as participants in making the drama and as characters within it – unfolding as it goes along, rarely complete, and never entirely pre-ordained. Therefore the drama is episodic, the improvised scenes frequently stopping for re-planning or shifting the dramatic action. What Heathcote called "living-through role-play" (1984, p. 48) is still usually the central dramatic technique used; a range of other improvisational and theatrical techniques, usually known as conventions, are employed to shift the point of view or the dramatic distance. There is no external audience: The participants are engaged in the moment, which exists for their own experiential learning, not for communicating to others. Accordingly, reflection is usually built-in within the action, or through discussion. The drama thus always incorporates the students' ideas and suggestions, sometimes changing its original objectives and goals, if a productive idea is suggested. This of course also means that it builds, in the best tradition of constructivist learning, on what the students already know and can contribute. The purpose of the drama is never just to enact, but to problematize, to make the children ask questions and interrogate the learning context. The teacher takes part actively, not only structuring the dramatic action as playwright and director, but through the key technique of teacher-in-role, as an actor/character in the unfolding drama.

The curricular implications are potentially far-reaching and have been well researched in studies of drama curriculum and teaching (see Dunnagen, 1990; Flynn, 1995; O'Mara, 2000; Scheurer, 1995; Taylor, 1998; Warner, 1995). Not only can drama be used to teach standard subjects in a first-hand, experiential way, but the students themselves can have a say in negotiating the dramatic action and the themes explored, and the social or personal use that will be made of the "change of understanding" that is the outcome. This gives real meaning to Garth Boomer's phrase "negotiating the curriculum" (1982). As Courtney (1980) writes, "In the classroom ... the teacher is working with living immediacy. Curriculum results from this encounter" (p. 67). Particularly in the United Kingdom, teachers carried this philosophy into a direct concern with social issues: Change of understanding came to be synonymous with "changing society."

However, this fact is barely acknowledged by mainstream educational theorists, who just don't know about process drama; for instance, drama figures nowhere in Australia's influential Productive Pedagogies (O'Toole, 2003, p. 40). Moreover, the characteristics of process drama noted above demand a range of skills from teachers that are outside, and run counter to, their experience and training. Few teachers have themselves encountered drama in their own schooling, fewer still sufficient to give them the artistic understanding to select and shape dramatic narrative, focus, and conventions. Even more significantly, teachers usually operate more as they themselves were taught: as purveyors of content rather than as facilitators of learning, in large institutions driven by hierarchical structures of power and status, and by imperatives of discipline and control. Stake alludes to this phenomenon in the first quotation in this chapter, and it can be seen in schools anywhere. Teaching through dramatic process entails suspending teachers' status, relinquishing some of their sovereignty over knowledge, even putting themselves in the hands of the students-in-role (Warren, 1993). This is daunting to many teachers; cosmetic in-servicing in the new pedagogy has been shown not to work for most, though there are now readily available drama education resources in most school systems in English-speaking Western countries and on the Web, such as the excellent new Queensland and New Zealand Arts Syllabuses (Queensland Studies Authority, 2002; New Zealand Ministry of Education, 2002). Most primary generalists and secondary history, science, and English teachers have neither the time nor the motivation for that, even if the financial and skills resources were available.

## Associated Forms Socio-drama/Role-play Training

Meanwhile, two movements using drama as pedagogy, with quite separate origins from drama-in-education, have become established in the curriculum of adult education. The first of these, "socio-drama" – more often referred to nowadays as "role-play training" or "simulation" – largely derives from Moreno, the founder of Psychodrama. This mutated form has distanced itself from its dramatic origins: "A casual visitor looking at creative drama sessions could well mistake them for a role-play simulation in progress" (van Ments, 1983, p. 158). Its purpose is to use role-play to teach and assess procedural knowledge in adult training contexts. It can entail small-scale role-plays, sometimes scripted or semi-scripted, to an audience given the task of assessing the role-players for the correctness of their procedures. Alternatively, it can be in the form of large-group simulation exercises, from fictional office dilemmas exploring ethics in decision-making (Chalmers, 1993) to whole battalions of troops and warships on strategic exercises, which in the end, are all just make-believe, subject to the conditions that make for good or bad drama.

Simulation and role-play (rarely called drama in this context either) are being enthusiastically embraced by Internet educators, who are beginning to use the technology to create conditions of interactivity very akin to the process drama classroom (see Ip and Linser, 2005; Vincent, 2005).

*Theater for Development*

The second of these movements, theater for development, is a way of consciousness-raising in developing countries, mainly among poor, traditional communities. Theatre for Development seems a naturally attractive way of communicating with remote people with high illiteracy rates and little access to television, radio, and computers, to propagate modern sanitation and health, environmental management, avoidance of HIV-AIDS, or the basics of democratic elections. Many governments and organizations like UNICEF have generously funded it, for nearly thirty years (for a good introduction, see Mumma, Mwangi, & Odhiambo, 1998). This was originally in the form of small groups of players touring the communities, sometimes on foot or bicycle, with western-style plays-with-a-message, sometimes engaging the audiences in discussion (e.g., Pattanaik, 2000). Where communities might be resistant, as for instance to modern sanitation practices that contravene traditional mores, subtler techniques have been used, such as touring the schools and engaging the children, assisting them to create theater themselves to convince their parents (Dalrymple, 1996) or using the community elders as actors to "listen to your mothers" (Nyangore, 2000). Another model has been to work with communities where there already is a Western theater tradition, such as a school theater festival (e.g., Mangeni, 2000). However, local resistance to being given gratuitous advice by outsiders, especially in alien artistic forms, can be severe and even hostile, and to prevent the experience becoming counterproductive, Theater for Development is changing. Now more frequently facilitators are sent to communities, to work with them to discover *their* concerns, and *with* them create theater on these issues based on their own local traditional performance forms (e.g., Prentki, 2003).

The other side of this community pedagogy is that, if theater can be used by governments and NGOs to question traditional life and practices, it can equally be used by those opposed to governments, to challenge the assumptions of the powerful and sow questions and subversion among their subjects. In Western societies, protest demonstrations – themselves a form of theater – frequently incorporate some form of theatrical performance to catch attention. In the developing world, the revolutionary demand for universal empowerment through literacy via Paolo Freire's *Pedagogy of the Oppressed* (1970) has found expression in *Theatre of the Oppressed*, articulated by the Brazilian educator/theater artist Augusto Boal and his followers (Boal, 1979; Schutzman & Cohen-Cruz, 1994). They have harnessed common theater exercises, games, and techniques of audience participation into a system of interactive theater that is found now all over the world, particularly the form Boal dubbed "forum theatre."

# The Unifying Paradigm – Learning What People Do in Drama

In the late 1980s, a new paradigm for drama and other arts education began to emerge in schools, most clearly in Australasia. Where all three of the above paradigms existed in varying, and uneasy, proportions, it presented itself as a practical problem: the ratio of

theory to practice within the formal syllabus assessment. What did this mean? So much in theater and drama, as in all arts, embodies both: Is a director's log-book or a scriptwriting exercise theory or practice? Might drama work be more usefully classified for teaching and assessment? At this time Australia was organizing its curriculum into Key Learning Areas (KLAs), and drama was lining up with the other creative and performing arts. This involved a conscious decision to move drama away from the protective hegemony of English. Drama was both looking for commonality and jockeying for territory with the longer established music and visual arts.

Arts education philosophers gave us all a way of providing the systems with a comprehensible structure for managing learning and assessment in all the arts, one that is better than *theory versus practice*. In simple terms, this consisted of the philosophers asking what people do when they engage in the arts (Lett, 1978). This then gave drama a way of unifying the three competing paradigms, in a new set of three dimensions: *making* (in drama: playwright, improviser, director, designer), *presenting* (in drama: actor, technical crew), and *responding* (in drama: audience, dramaturge, critic). All the arts can fit fairly comfortably within these three functions, though presenting may be less significant for visual artists. With some variation of nomenclature, these three dimensions have become widely accepted as the organizing principles of Arts Education and the Arts Key Learning Area, throughout Australasia, and also in the United Kingdom: *making/forming/creating*; *performing/presenting/communicating*; *responding/reflecting/appraising*.

## Conclusion

This model continues to make slow progress towards curricular establishment in Western educational systems. Painfully slow as, for all the new curriculum rhetoric, education systems' traditional double suspicion of drama (as on one hand trivial "play" not "work," and on the other, potential subversion or disruption) prevents most of them (New Zealand honorably excepted) from properly funding syllabus implementation programs to counter teachers' ignorance, fear, lack of training, and lack of skills in drama.

Walking alongside these curriculum developments, there is a growing body of research examining the learning that occurs in drama, focusing on current curriculum concerns. It is not surprising then that much of this centers on literacy skills and multiliteracies in the United States (Crumpler & Schneider, 2002; Wagner, 1998; Wilhelm, 2002), in Australia (Hertzberg & Ewing, 1998; Martello, 2002; O'Mara, 2004), in Canada (Laidlaw, 2005; Miller & Saxton, 2004), and in the United Kingdom (Ackroyd, 2000; Baldwin & Fleming, 2003). Other foci of contemporary drama curriculum research include drama and the new technologies (Carroll, 1996, 2002, 2004) drama and intercultural education (Donelan, 2002; O'Farrell, 1996) and drama in the development of ethics and morals (Wagner, 1999; Wilhelm & Edmiston, 1998; Winston, 1997, 2000). As Saldaña and Wright (1996) remind us,

> The generally skeptical social climate of today, and those with power to distribute funds and mandate programs, demand justification and accountability. Research

has the potential in this field not only to reveal new insights and to improve our practice, but to serve as an agent for advocacy – to show decision makers that drama and theatre for youth "works." (p. 129)

Drama, the playful giant, is knocking at the door, but despite its protean wiles, it is barely over the threshold yet.

# References

Ackroyd, J. (2000). *Literacy alive: Drama projects for literacy learning*. London: Hodder Murray.

Allen, J. (1979). *Drama in schools*. London: Heinemann.

Baldwin, P., & Fleming, K. (2003). *Teaching literacy through drama*. London: Routledge Falmer.

Barba, E. (1995). *The paper canoe*. London: Routledge.

Boal, A. (1979). *Theatre of the oppressed*. London: Pluto.

Bolton, G. (1979). *Towards a theory of drama in education*. London: Longmans.

Bolton, G. (1984). *Drama as education*. London: Longmans.

Boomer, G. (1982). *Negotiating the curriculum*. Sydney: Ashton Scholastic.

Booth, D. (1994). *Story drama: Reading, writing, and role-playing across the curriculum*. Markham, Ontario: Pembroke.

Bowell, P., & Heap, B. (2001). *Planning process drama*. London: David Fulton.

Brecht, B. (1964). *Brecht on theatre*. (J. Willett, Trans.). New York: Hill & Wang.

Brice Heath, S., & Roach, A. (1999). Imaginative actuality: Learning in the arts during the nonschool hours. In E. Fiske (Ed.), *Champions of Change* (pp. 20–34). Washington, DC: Arts Education Partnership.

Bunyan, P., & Rainer, J. (1995). *The patchwork quilt: A cross-phase educational drama project*. Sheffield: NATE.

Burton, E. J. (1955). *Drama in schools: Approaches, methods and activities*. London: Herbert Jenkins.

Carroll, J. (1996). Drama and technology: Realism and emotional literacy. *NJ (Drama Australia Journal), 20*(2), 7–18.

Carroll, J. (2002). Digital drama: A snapshot of evolving forms. *Melbourne Studies in Education, 43*(2), 130–141.

Carroll, J. (2004). Digital pre-text: Process drama and everyday technology. In C. Hatton & M. Anderson (Eds.), *The state of our art* (pp. 66–76). Sydney: Currency Press.

Chalmers, F. (1993). *Best person for the job*. [Video]. Brisbane: Dept. of Education.

Clegg, A. (1972). *The changing primary school: Its problems and priorities*. London: Chatto & Windus.

Cook, C. (1917). *The play way*. London: Heinemann.

Courtney, R. (1980). *The dramatic curriculum*. New York: Drama Books.

Crumpler, T., & Schneider, J. (2002). Writing with their whole being: A cross study analysis of children's writing from five classrooms using process drama. *Research in Drama Education, 7*(1), 61–79.

Dalrymple, L. (1996). The Dramaide project. In J. O'Toole & K. Donelan (Eds.), *Drama, culture & empowerment* (pp. 33–35). Brisbane: IDEA Publications.

Deasy, R. J. (2002). *Critical links: Learning in the arts and students' academic and social development*. Washington, DC: Arts Education Partnership.

Dewey, J. (1934/1972). *Art as experience*. New York: Capricorn.

Dewey, J. (1938/1963). *Education and experience*. New York: Collier.

Donelan, K. (2002). Engaging with the other: Drama and intercultural education. *Melbourne Studies in Education, 43*(2), 26–38.

Dunn, J. (2003). Dramatic play and the intuitive use of the elements of drama. In S. Wright (Ed.), *The arts, young children and learning* (pp. 211–229). Boston, MA: Pearsons.

Dunnagen, K. (1990). *Seventh grade students' awareness in writing produced within and without the dramatic mode*. Unpublished doctoral dissertation, The Ohio State University, Columbus.

Finlay-Johnson, H. (1911). *The dramatic method of teaching*. London: Ginn.

Florida, R. (2004). *The rise of the creative class*. New York: Better Books.

Flynn, R. M. (1995). *Developing and using curriculum-based creative drama in fifth-grade reading/language arts instruction: A drama. Dissertation Abstracts International, 57*(3), 996 (UMI No. 9622061).

Freire, P. (1970). *Pedagogy of the oppressed*. New York: Seabury.

Gallagher, K. (2000). *Drama education in the lives of girls*. Toronto: University of Toronto Press.

Groos, C. (1896/1976). The play of animals: Play and instinct. In J. Bruner, A. Jolly, & K. Silva (Eds.), *Play: Its role in development and evolution* (pp. 65–67). London: Penguin.

Heathcote, D. (1984). Improvisation. In L. Johnson & C. O'Neill (Eds.), *Dorothy Heathcote: Collected writings on education and drama* (pp. 44–48). London: Hutchinson.

Heathcote, D., & Bolton, G. (1995). *Drama for learning: Dorothy Heathcote's mantle of the expert approach to education*. Portsmouth, NH: Heinemann.

Hertzberg, M., & Ewing, R. (1998). Developing our imagination: Enactment and critical literacy. *PEN, 116*, 1–4.

Hornbrook, D. (1991). *Education as dramatic art*. Oxford: Blackwell.

Ip, A., & Linser, R. (2005). *Fablusi: The online role-play simulation platform*. Retrieved December 31, 2005 from http://www.fablusi.com/

Jennings, S. (1987). *Dramatherapy: Theory and practice for teachers and clinicians*. London: Routledge.

Johnstone, K. (1999). *Impro for storytellers: Theatresports and the art of making things happen*. London: Faber.

Jones, K. (1980). *Simulation: A handbook for teachers*. London: Kogan Page.

Laidlaw, L. (2005). *Reinventing curriculum: A complex perspective on literacy and writing*. Mahwah, NJ: Erlbaum.

Landy, R. (1994). *Drama therapy: Concepts, theories and practices*. Springfield, IL: Thomas.

Lett, W. (1978). The arts and the expressive curriculum. *NADIE Journal, 3*(1), 6–9.

Lindqvist, G. (1995). *The aesthetics of play: A didactic study of play and culture in preschools*. [Monograph]. Uppsala: Uppsala Studies in Education, No. 62; Stockholm: Almqvist & Wiksell International.

Mangeni, P. (2000). One earth one family. In J. O'Toole & M. Lepp (Eds.), *Drama for life* (pp. 103–188). Brisbane: Playlab Press.

Manley, A., & O'Neill, C. (Eds.). (1998). *Dreamseekers*. Portsmouth, NH: Heinemann.

Martello, J. (2002). Four literacy practices roled into one: Drama and early childhood literacies. *Melbourne Studies in Education, 43*(2), 53–63.

McCaslin, N. (1961). History of children's theatre in the United States. In G. Siks & H. Dunnington (Eds.), Children's theatre and creative dramatics. Seattle: University of Washington Press.

McCaslin, N. (1996). *Creative drama in the classroom and beyond*. New York: Longmans.

Mearns, H. (1929). *Creative power*. New York: Doubleday.

Miller, C., & Saxton, J. (2004). *Into the story: Language in action through drama*. Portsmouth, NH: Heinemann.

Moreno, J. (1953). *Who shall survive: Foundations of sociometry, group psychotherapy & sociodrama*. New York: Beacon House.

Morgan, N., & Saxton, J. (1989). *Teaching drama: A mind of many wonders*. London: Heinemann.

Morgan, N., & Saxton, J. (1994). *Asking better questions*. Markham, Ontario, Canada: Pembroke Publishers.

Morrison, J. (1961). Foreword. In G. B. Siks & H. B. Dunnington (Eds.), *Children's theatre and creative dramatics* (pp. i–x). Seattle: University of Washington Press.

Mumma, O., Mwangi, E., & Odhiambo, C. (1998). *Orientations of drama, theatre and culture*. Nairobi: KDEA.

NACCCE – National Advisory Committee on Creative and Cultural Education (1999). *All our futures: Creativity, culture and education*. London: NACCCE.

Neelands, J. (1996). Agendas of change, renewal and difference. In J. O'Toole & K. Donelan (Eds.), *Drama, culture and empowerment* (pp. 20–32). Brisbane: IDEA Publications.

New Zealand Ministry of Education (2002). *The Arts in the New Zealand Curriculum*. Retrieved December 2, 2004 from http://www.minedu.govt.nz/web/downloadable/dl3519_v1/thearts.pdf

Nolte, J. (2000). Re-experiencing life. In J. O'Toole & M. Lepp (Eds.), *Drama for life* (pp. 209–221). Brisbane: Playlab Press.

Nyangore, V. (2000). Listen to your mothers. In J. O'Toole & M. Lepp (Eds.), *Drama for life* (pp. 77–84). Brisbane: Playlab Press.

O'Connor, P. (2003). *Reflection and refraction: The dimpled mirror of process drama.* Unpublished doctoral thesis, Griffith University, Brisbane, Australia.

O'Farrell, L. (1996). Creating our cultural identity. In J. O'Toole & K. Donelan (Eds.), *Drama, culture and empowerment* (pp. 125–130). Brisbane: IDEA Publications.

O'Mara, J. (2000). *Unravelling the mystery: A study of reflection-in-action in process drama teaching.* Unpublished doctoral thesis, Griffith University, Brisbane, Australia.

O'Mara, J. (2004). At Sunny Bay: Building students' repertoire of literacy practices through process drama. In A. Healy & E. Honan (Eds.), *Text next: New resources for literacy learning* (pp. 119–136). Newtown, NSW: PETA.

O'Neill, C. (1995). *Drama worlds.* Portsmouth, NH: Heinemann.

O'Toole, J. (1992). *The process of drama.* London: Routledge.

O'Toole, J. (2003). Drama, the productive pedagogy. *Melbourne Studies in Education, 43*(2), 39–42.

O'Toole, J., Burton, B., & Plunkett, A. (2004). *Cooling conflict: A new approach to managing conflict and bullying in schools.* Sydney: Pearsons.

Parsons, B., Schaffner, M., Little, G., & Felton, H. (1984). *Drama, language and learning – NADIE Paper No 1.* Hobart, Tasmania: National Association for Drama in Education.

Pattanaik, S. (2000). Messengers on bicycles. In J. O'Toole & M. Lepp (Eds.), *Drama for life* (pp. 85–92). Brisbane: Playlab Press.

Prentki, T. (2003). Save the children – Save the world. *Research in Drama Education, 8*(1), 39–54.

Prior, R. W. (2004). *Characterising actor trainers' understanding of their practice in Australian and English drama schools.* Unpublished doctoral thesis, Griffith University, Brisbane, Australia.

Queensland Studies Authority (2002). *Years 1–10 Syllabus: The Arts.* Retrieved December 2, 2004 from http://www.qsa.qld.edu.au/yrs1to10/kla/arts/index.html

Raphael, J. (2004). Equal to life: Empowerment through drama and research in a drama group for people with disabilities. *NJ (Drama Australia Journal), 28*(1), 73–86.

Roper, W., & Davis, D. (1993). Taking the right eye out completely. *Drama Broadsheet. NATD, UK, 10*(3), 36–49.

Rousseau, J.-J. (1762/1956). *Emile.* London: Heinemann.

Saldaña, J., & Wright, L. (1996). An overview of experimental research principles for studies in theatre for youth. In P. Taylor (Ed.), *Researching drama and arts education: Paradigms and possibilities* (pp. 115–131). London: Falmer.

Sallis, R. (2004). Con and Charlie do the splits: Multiple masculinities and drama pedagogy. *NJ (Drama Australia Journal), 28*(1), 105–115.

Scheurer, P. (1995). *"A thousand Joans": A teacher case study. Drama in education, a process of discovery.* *Dissertation Abstracts International, 57*(07), 2869 (UMI No. 963942).

Schutzman, M., & Cohen-Cruz, J. (1994). *Playing Boal: Theatre, therapy, activism.* London: Routledge.

Siks, G., & Dunnington, H. (Eds.). (1961). *Children's theatre and creative dramatics.* Seattle, WA: University of Washington Press.

Siks, G. B. (1983). *Drama with children.* New York: Harper & Row.

Slade, P. (1954). *Child drama.* London: Cassell.

Spolin, V. (1983). *Improvisation for the theatre.* Evanston: Northwestern University Press.

Stake, R. E. (1998). Some comments on assessment in U.S. education. *Educational Policy Analysis Archives, 6*(14). Retrieved October 15, 2005 from http://epaa.asu.edu/epaa/v6n14.html

Taylor, P. (1998). *Redcoats and patriots: Reflective practice in drama and social studies.* Portsmouth, NH: Heinemann.

Thomson, J. (2005). Post-Dartmouth developments in English teaching in Australia. In W. Sawyer & E. Gold (Eds.), *Reviewing English in the 21st century* (pp.10–22). Melbourne: Phoenix.

van Ments, M. (1983). *The effective use of role-play.* London: Kogan Page.

Vincent, A. (2005). *Simulation homepage.* Macquarie University Centre for Middle East and North African Studies. Retrieved December 31, 2005 from http://www.mq.edu.au/mec/sim/index.html

Vygotsky, L. (1933/1976). Play and its role in the mental development of the child. In J. Bruner, A. Jolly, & K. Silva (Eds.), *Play: Its role in development and evolution.* (pp. 537–554). London: Penguin.

Wagner, B.-J. (1976). *Dorothy Heathcote: Drama as a learning medium*. Washington, DC: National Education Association.

Wagner, B.-J. (Ed.). (1998). *Educational drama and language arts: What research shows*. Portsmouth, NH: Heinemann.

Wagner, B.-J. (Ed.). (1999). *Building moral communities through educational drama*. Stanford, CT: Ablex.

Ward, W. (1930) *Creative dramatics, for the upper grades and junior high school*. New York: Appleton.

Ward, W. (1947). *Playmaking with children: From kindergarten to high school*. New York: Appleton-Century Crofts.

Warner, C. (1995). *Exploring the process of engagement: An examination of the nature of the engagement in drama when used as a methodology to augment literature in a middle school language arts classroom. Dissertation Abstracts International, 56*(06), 2047 (UMI No. 9534088).

Warren, K. (1993). Empowering children through drama. In W. Schiller (Ed.), *Issues in expressive arts: Curriculum for early childhood* (pp. 69–79). London: Gordon and Breach.

Way, B. (1967). *Development through drama*. London: Longmans.

Wilhelm, J. D. (2002). *Action strategies for deepening comprehension: Using drama strategies to assist improved reading performance*. New York: Scholastic.

Wilhelm, J., & Edmiston, B. (1998). *Imagining to learn: Inquiry, ethics and integration through drama*. Portsmouth, NH: Heinemann.

Winston, J. (1997). *Drama, narrative and moral education*. London: Falmer.

Winston, J. (2000). *Drama, literacy and moral education 5–11*. London: David Fulton.

# 14

# NARRATIVE AS ARTFUL CURRICULUM MAKING

## Lynn Butler-Kisber[*], Yi Li[†], D. Jean Clandinin[†], and Pamela Markus[*]

[*]McGill University, Canada;
[†]University of Alberta, Canada

In this chapter we conceptualize narrative in the curriculum making of arts education as we inquire into our own narratives of experience, review relevant literature on narrative broadly understood and on narrative in the visual arts, music and drama education, and claim spaces for narrative in arts education.[1] We define narrative as a genre of literature, a way to think about writing, and a way to think about experience. Narrative, in this third view, is a helpful way to conceptualize the experiences of teachers and children within the mandated, planned, and experienced curriculum. Yi Li, as an English language teacher and researcher, Jean, as a curriculum theorist and narrative inquirer, and Lynn as a language arts educator and arts-informed researcher, each brought diverse perspectives to this chapter. All are involved in narrative work but not in arts education.[2]

## Beginning the Inquiry

In spite of the current recognition of the need for a cultural context approach to arts education that includes building on oral cultures and children's/learners' personal stories (UNESCO, 2003), discussions about the arts curriculum still focus to a large degree on the visual and performance arts and do not include what might be called "the art of literacy" even though narrative is acknowledged as how we make meaning and understand experience (Bruner, 1986).

## Situating Ourselves within the Legacies of Broudy and Dewey

Choi and Bresler (2000–2001) show how Dewey and Broudy's interests in aesthetic education profoundly influenced arts education and curriculum from quite different positions (p. 22).

*L. Bresler (Ed.), International Handbook of Research in Arts Education, 219–234.*
© 2007 *Springer.*

Broudy, a modernist, believed that aesthetic experience is derived from exposure to exemplary works of art. He argued for an art curriculum consisting of the study and mastery of a "canon of exemplars" and believed the teacher was the transmitter of this knowledge, and the learners were the recipients (Choi & Bresler, 2000–2001, p. 28).

Dewey's (1934, 1938) work was grounded in pragmatism, or the theory of experience. He believed that art is connected to everyday life and is a way meaning can be explored and reconceptualized. An aesthetic experience is derived from the process involved in this kind of activity and the pleasure and new understandings it produces. The meaning making occurs from a fusion of past and current experiences. Hence the form/medium can mediate the kind of understanding that occurs. Dewey's work reflected a postmodern view (Choi & Bresler, 2000–2001) that positioned the learner as central in the learning process, and the teacher as a facilitator in a relationship with the learner, and as the one who provides scaffolding (Wood, Bruner, & Ross, 1976) that transforms understanding.

Conceptually Broudy's ideas helped shape the discipline-based ideas of arts education while Dewey's shaped a more experiential view. The notions of narrative as genre of literature, as writing form and as experience could be seen as fitting within both views of arts education. However, these ideas do not help us understand why narrative is not usually seen as part of arts education, nor does it help us to bring together the diverse conceptions of narrative. So we turned methodologically toward inquiring into our own experiences.

## Beginning Narratively

### Inquiring into Yi Li's Experiences

My schooling experiences in Shanghai, China in the 1970s and 1980s were full of great writers of past ages that every child in China studied. Across the country at each grade level each student had the same textbook. Our responsibility as students was to listen to lectures about how we should understand those classic texts, take notes in class, do our homework, and get good grades in tests. Our topics for writing were always assigned and usually unrelated to our personal experiences. Looking back, I wonder why we were not telling and writing our own stories and studying each other's stories. In Grade 7, I began to record my stories of experience in my diary. Narrative as writing was a personal undertaking, something that occurred outside of school. Later as an English major, I read assigned exemplars of British and American literature, but they were so boring that I read and responded in my diary to other narratives outside the mandated curriculum. In this way, narrative as genre and narrative as writing shaped my narratives of experience.

As a beginning university English teacher in 1989, I wanted my students to engage with the English language in a meaningful way. But I had to use the prescribed textbooks because my students were tested. The discrepancy between my belief of what language teaching should be and the teaching situation I found myself in finally led me to graduate school, where I began to read and think about my practices in more theoretical ways. I was particularly drawn to narrative ways of thinking about and understanding experiences, and my definition of narrative as a genre of literature and as a form of writing also broadened in the process.

## Inquiring into Jean's Experiences

As I think about my early years of schooling in rural Alberta, I recollect my Grade 3 school year during which I learned a subject called Enterprize. I loved it because it was the study of my community and me. We engaged in mini research projects, gathering data on our community, interviewing community members, making maps and writing accounts of what we found. My child's eye view and voice and those of my classmates were valued and made the starting point for each lesson and unit. I now see the way my teacher co-composed the Enterprize curriculum was experiential and valued learners' voices. Enterprize only happened that one year. The rest of my schooling followed the more traditional pattern.

I had a lived moment of what I imagine Dewey described. Narrative was not a genre of reading material, but a way to write and think about curriculum. When I began to teach, each afternoon I read chapter books the children helped select, set up mini-inquiry projects on child-selected topics, worked with them to create data and co-created with them, what I now see as arts-based forms of representation of their interpretations. We wrote our stories on language experience charts and in writing booklets, and we shared our writing. When I began to read curriculum theories and to attend in more theoretical ways to my practices, I was drawn back to Dewey's ideas of experience and education, to Bruner's (1987) ideas of narrative knowledge and to Johnson's (1989) ideas of embodied knowledge. However, these experiences, as child learner, as teacher, as doctoral student, were not connected to arts education.

## Inquiring into Lynn's Experience

As I think about my early school days, my memories are not about active, inquiry-oriented experiences, but rather are sprinkled with pictures of the "sharp corners" of schools that Eisner (1991) speaks about, a metaphor for transmission learning. The highlights are schoolyard and sport experiences, and the after hours spent with friends and filled with books, storytelling, performances, "science fairs," and other kinds of creative play. Dewey was alive and well in neighborhood yards, but far away from rows of desks, silent class-rooms, and strident teachers. Later when I was introduced to Paley's kindergarten (1990) humming with helicopters, double-headed dragons, and supermoms, my memory was of me sitting distraught on a small chair in the corner of my kindergarten, punished after dropping a robin's egg that I had so gingerly and excitedly carried to school.

As a teacher, I translated distant neighborhood memories into classroom projects that enticed children to stay long after the final bell, and to write stories and plays, create poetry and films, and read. Long after the relevant resources were packed away, the children retained the original excitement for the work, and the knowledge acquired in the "doing."

I carried my mostly intuitive, Deweyan learnings with me to the University. I experimented with ways of involving adult learners in language learning through inquiry, exhibitions, and performances, hoping to inspire prospective teachers to explore inquiry in their own classrooms. As I mapped theory onto my experiences and learning, I came to realize that narrative is at the heart of literacy.

# Searching for Threads of the Legacy of Broudy and Dewey

As we inquired into our stories of experiences, we realized that Dewey's legacy lived at the edges of Lynn and Jean's experiences while Broudy's seemed nonexistent. Lost in the technical, Lynn reveals that narrative as genre, writing and performance only occurred outside of school. For Jean, narrative as writing and as a form of inquiry only happened in her storied moments of Grade 3.

In Yi Li's experiences Broudy's legacy seems more evident. The idea that a curriculum of arts education was a canon of exemplars that merited study seemed congruent with the canon of narrative exemplars that Yi Li was required to read in school. For her, too, Dewey's legacy lived outside of school as she chose narratives to read, and chose to write narratives of her experiences in her diary.

In each of our stories, we see how narrative was conceptualized in three distinctively different ways: narrative as genre, narrative as writing stories and narrative as experience. In Yi Li's recollected stories, we see narrative as the reading of great literature in order to learn Chinese and English languages and to study great ideas. We also see narrative as writing stories, although the stories written in school had little personal relevance. Through writing diaries outside the curriculum, she learned to live in imagined places and times and to reflect on her life. Jean's experience with Enterprize provides a sense that narrative was more about children writing their own stories than about reading narratives in basal readers. In Lynn's story, we see narrative as the basal readers' children read to learn language. Later, when Lynn taught, we see narrative as the stories children told and wrote about what they were learning through classroom projects. We also see narrative as creating meaningful learning experiences for students where they took active roles through inquiry, exhibitions, and performances. Curriculum became a co-composition.

Situated within the Deweyan philosophy, we believe that arts education is art as experience. We see narrative not only as genre, but also as the stories we tell and write, as a way of looking more holistically at the experiences we compose. However, while we see narrative in our school experiences, there was no explicit connection to arts education. As we try to claim spaces for narrative in arts education, we draw on complex understandings of narrative to re-imagine arts education.

# Three Views of Narrative

## *Narrative as Genre*

Narrative is a piece of writing that tells a story. It has a beginning, middle, and end. Narrative is the most common genre in literature; it has been used traditionally in literacy education in the school curriculum to teach students how to read and write. Before the 1970s, students in secondary schools were assigned to read the "canon of narrative exemplars" in order to be exposed to the "great works" of the past. Reading at that time meant "understanding the author's intended meaning and appreciating the

artistic nature of the works" (Hammett & Barrell, 2000, p. xvi). Teachers would inter-
pret what students were reading, drawing on curriculum guides and the interpretive
works by great critics (Hammett & Barrell, 2000). Meaning was thought to reside in
the author and the text, "out there" to be discovered and measured objectively (Straw,
1990). Students were taught reading comprehension skills in order to help them
decode the messages in the texts they were reading. Those skills were taught sequen-
tially with an emphasis on the acquisition of grammar and phonics. To ensure the stu-
dents learned the skills, they were tested. Narrative as genre was seen as the subject
matter to be taught and mastered.

With Rosenblatt's groundbreaking work (Rosenblatt, 1938), English teaching grad-
ually shifted "from exposing students to the meaning of great works to developing the
students' own experiences with, and responses to, literature" (Willinsky, 2000, p. 6).
Since the 1970s reading has been seen as a social, linguistic, and cognitive process
where the reader constructs the meaning of the text (Binkley, Phillips, & Norris, 1994;
Rosenblatt, 1985). Rosenblatt's view of narrative as genre started to bring the means
and the end together. Narrative was not only the means to the end, but also the moment
by moment, ongoing co-construction of meaning for each reader. Consequently, stu-
dents were provided with opportunities to use reading and writing to learn. Teachers
helped them develop questions to find ways to get their own answers. Teachers pro-
vided time for students to work together and learn from each other. They encouraged
multiple interpretations and celebrated diversity because they wanted their students
"to understand the relationships and insights that can be gained by looking at the world
through the lens of different cultures" (Pearson & Stephens, 1994, p. 37). This shifted
the focus of the language arts "to make reading and writing more personally meaning-
ful and to make the processes of the formation of literacy more powerful," which John
Willinsky (1990) called the "new literacy".

The New Literacy's work on narrative as genre started to bring more students' lives
into the curriculum. It is much closer to the notion of curriculum that we argue for later
in this chapter. However, in this literature, narrative as genre is situated in the language
arts or literary arts but not in arts education.

*Narrative as Writing*

In 1935, the National Council of Teachers of English espoused an "experience cur-
riculum in English." Recognizing Dewey's work, it created a direction that
English/language arts teaching and learning would follow in decades to come. The
1960s were filled with examples of change. Sylvia Ashton-Warner (1963) was using
"organic teaching" with young Maori students by using their experiences to build a
vocabulary to "write autobiographically" and learn from each other. Chomsky (1965)
revealed the universal and natural propensity children have for developing language.
Sociolinguists (Cazden, 1988), influenced by the work of Halliday (1973), Vygotsky
(1978), and Bruner (1986), demonstrated how pre-school children actively construct
meaning and develop language in social contexts, suggesting a more experiential
approach to language learning that builds on early development. Simultaneously,
Moffett (1968) suggested that because "English" is a communication system and not a

body of content, it should be taught in an interdisciplinary and integrated way. This shift to a more experiential and integrated language arts (listening, speaking, reading, and writing, and later viewing and representing) curriculum resonates with Dewey's notions rather than the disciplinary and mastery-oriented study suggested by Broudy. It valued the capabilities and differences among learners and built on their experiences and contexts. Although retrospectively criticized for lacking a critical edge needed to challenge issues of power and inequity (Peritz, 1994), it was fertile ground for changing the writing curriculum.

In 1966, scholars from England and the United States met at the Dartmouth Conference to help shift the study of English away from analyzing great works of literature to a focus on the uses of language. The result was a change from an emphasis on product to one of process. In North America it became known as the "writing process" approach (Elbow, 1973; Emig, 1971, 1977; Murray, 1968) and in England and Australia as the "language across the curriculum" approach (Britton, 1975; Dixon, 1968; Martin, 1975). This approach embraced the experiences of diverse learners and focused on how to develop their expressive abilities. As well, there was a growing understanding that storying is a fundamental way humans come to understand, structure and express their conceptions about the world (Bruner, 1986). Narratives became central to how the writing curriculum was enacted (Britton, 1975).

In the last two decades additional shifts occurred. Educators recognized the importance of the social interactions in learning to write, the need to scaffold the process with timely interventions (Calkins, 1983; Atwell, 1988) and the need to embrace a reflective (The New London Group, 1996) and a sociohistorical sense of experiences to become critics of what we, and others, write (Heath, 1983). The development of powerful and political communication writing abilities and other literacies (Willinsky, 1990) was seen as capable of addressing inequities and promoting change (hooks, 1994). Process writing remains challenged, however, by the time accorded to essay writing and the amount of curriculum fragmentation. Process writing also failed to address two important issues. The first is the artificial demarcation that remains, the separation between instructional means and curricular ends, instead of what could be a more seamless, but not necessarily smooth, negotiation of meaning making or "artful curriculum-making" between teacher and students, and students and students. The second is the relatively sparse attention given to multiple intelligences and the way individuals learn and communicate best (Butler-Kisber, 1997; Gardner, 1983, 1999). The "new literacies" of the last decade have begun to address these, but writing remains the most emphasized way of communicating, even though there are other ways of representing and understanding the world (Eisner, 1991). However, in these latter views the focus is still on the language arts and rarely directed to arts education.

## Narrative as Experience

The conceptions of situation and of interaction are inseparable from each other. An experience is always what it is because of a transaction taking place between an individual and what, at the time, constitutes his environment ... The two principles of continuity and interaction are not separate from each other. They intercept

and unite ... Different situations succeed one another. But because of the principle of continuity something is carried over from the earlier ones to the later ones. (Dewey, 1938, p. 43)

Dewey's words opened the possibility that experience could be conceived of narratively, that is, as narrative construction.

Theorists in education (Connelly & Clandinin, 1985), philosophy (Carr, 1986), psychology (Bruner, 1986), theology (Crites, 1971), and anthropology (Cruikshank, 1990; Bateson, 1994) turned to understanding experience narratively. Thinking narratively about experience is a view of life as a story we live. These storied lives, these storied experiences, have multiple plotlines, shaped by personal plotlines which are shaped by social, cultural, linguistic, and institutional narratives (Clandinin & Connelly, 2000).

Elbaz (2005) further developed a narrative view of experience. For her, "textuality can be seen as an important feature of experience rather than something set against it" (p. 37). Elbaz drew on Widdershoven (1993), who wrote that experience is "not just there to be uncovered. It is shaped and structured in a process of articulation. A story about life presents us life as it is lived; and as such life is the foundation of the story" (p. 6). Elbaz argued for a more theoretically complex notion of experience as narrative construction, taking into consideration Stone-Mediatore's (2003) essential feature of experience – tension, multiplicity and conflict – and Denzin's notion of "experience as multi-sensual and draws on multiple perspectives" (Elbaz, 2005, p. 38).

Thinking of experience as narrative construction led to conceptualizations such as narrative modes of thought (Bruner, 1987), narrative approaches to teaching (Lyons and LaBoskey, 2002), narrative research methodologies (Connelly & Clandinin, 1990; Polkinghorne, 1988) and narrative therapies (White & Epston, 1990). These narrative views of experience also began to shape views of curriculum (Connelly & Clandinin, 1988). In what follows we turn directly to the visual arts, music education, and drama education curricula to explore how narrative is taken up in arts education.

## The Emerging Role of Narrative in the Visual Arts Curriculum

Early twentieth-century art education was relegated to the teaching of drawing (Efland, 2004), followed by the shift to teaching art using elements of design (Dow, 1913). This mirrored the universal laws of science, and gave art a better chance of surviving in schools. Art curriculum changed again in the 1920s to an emphasis on creative self-expression due to Freud's notions about the negative repercussions of repression, and to an increasing demand for democratic ideals in public schooling. A shift to the use of art in daily life followed in the 1930s in response to the Great Depression. The turn to Discipline-Based Art Education (DBAE) in the United States (Hetland & Winner, 2004) in the 1960s was an attempt to align art with the other curricular disciplines and emulate the sciences, thereby making it more structured and rigorous (Efland, 2004, pp. 694–696). It integrated art making, art history, art criticism, and aesthetics to make art more than just studio art. DBAE

permeated classrooms across North America until the 1990s. It reflected the work of Broudy because of the emphasis on formalism and the study of the great art and artists. DBAE emphasized aesthetics as a way of knowing through the senses (Madeja & Onuska, 1977, p. 3), a type of aesthetic literacy (Smith, 2004). But art continued to remain a very separate part of the overall curriculum. Even now many art teachers continue to focus on studio practice via demonstrations and lectures rather than using more narrative and constructivist ways of teaching and learning (Burton, 2004, p. 561).

In the 1990s new discussions in visual arts education developed. Feminist and postmodern researchers highlighted the need to examine personal and everyday realities to bring diverse and marginalized voices to the center of education. They argued convincingly that there are multiple realities and ways of knowing and doing. Gardner's work on multiple intelligences (1983, 1999) helped support these ideas. Through the Arts PROPEL program he was able to initiate the use of rich learning environments and projects in schools to explore different forms of artistic knowing and understanding (Burton, 2004, p. 567). Eisner's work (1991, 2002) helped to show that artistic creation is found not only in the arts, and experience with different kinds of form and representation can mediate understanding in interesting and diverse ways. His work has opened up valuable dialogue between art and non-art educators, as well as artists and educational researchers (Butler-Kisber, 2002). Efland (2000) has argued that meaning is built on narrative and elaborated through metaphor, and that metaphoric creation, thinking, and reflection are all well suited to the arts. These examples of work and thought, coupled with the recent technological advances and the increasing emphasis on visual culture in daily life, have created a centrality for the visual arts curriculum that it has never enjoyed before. It has pushed some theorists to advocate that the formalist arts curriculum be abandoned, and in addition to the other forms of visual art, "art education should actively embrace the critical study of popular culture" (Barrett, 2004, p. 746) to bridge the gap existing between the art world and everyday life. This social re-constructionist (Siegesmund, 1998) or issues-based approach (Gaudelius & Speirs, 2000) is positioned to situate narrative at the heart of visual arts education because it is so central to the worlds of students and social transformation. Hafeli (2002) has shown this in her qualitative study of how adolescents addressed "cultural and aesthetic themes that borrow, build on and ultimately reinvent conventional narratives and art forms" (p. 28), and as a result, created new understandings for both the teacher and students. Atkinson and Dash (2005) have explored promising instances of different forms of innovative teaching and learning in studio, museum, gallery, community, and teacher education where the practical and the critical are in a dialectical relationship and the students, their ideas and experiences, are at the center of a negotiated pedagogy. These kinds of qualitative studies are extremely useful because they are accessible, contextualized, and show and persuade rather than just tell; however, they are rare (Burton, 2004). We believe if these hopeful trends in visual arts education are to develop and grow, more work of this kind is needed to counteract the standards-based movement that continues to gather momentum in North America and beyond.

# The Emerging Role of Narrative in Music Education

Stake, Bresler and Mabry (1991) frame the content of elementary school arts education when they write

> In American elementary schools, teaching of the arts is largely teaching of custom. In teaching art and music and occasionally, drama or dance, we teach the customs of the culture, honoring the stories of childhood … Children are coached in decorating and performing, joining in the traditions of holiday and celebration. The teacher of the arts is a preparer of shows. (p. 301)

Music education remains "isolated from much in the arts world," although "it [music education] is the closest the arts share in general education. It enjoys a greater place in general education than the other arts" (p. 337). There is no mention of narrative in their summary.

Thirteen years later, McCarthy (2004) turns to narrative when she suggests a new mode of inquiry in the content area of music, an area "still awaiting full curricular status in school culture" (p. 35). There is need for "a critique of philosophic underpinnings and research traditions of music education as a basis for advocating change" (p. 35). Adopting four vantage points on the field of music education, "advocacy for music in education, research traditions, philosophy of music, and the culture of music in education" (p. 35), she argues for "fresh lenses to look at music in classrooms, and a language that is focused on describing encounters with the arts" (p. 35) as well as alternative research paradigms; a philosophy of music grounded in "the meaning of music in the lives of individuals and communities, locally and globally" (p. 35); and a re-conceptualized presence of music in the school. From each of these vantage points she comes to narrative as a way forward. Drawing on Barone (2002) she asks, "how the narrative of music is performed in the classroom, and how that narrative intersects with narratives in other areas of the curriculum?" (p. 36)

Referring to authors outside of music education such as Bateson (1994), Olson (1997), Bruner (1986), and Barone (2000, 2001), McCarthy engages in reimagining the landscape of music education. Elliott (1995) and Small (1998) show that "participation in music is the performance of one's life story" (McCarthy, 2004, p. 38). In her re-conceptualization, we "recognize the kinds of stories that are constructed in music classrooms and … provide a language that is true to describing the narratives of music" (p. 38). McCarthy notes a "central disjunction of music education, that is, the sharp separation in theory and practice between the narratives of music and the narratives of pedagogy, between the art of music and the science of pedagogy" (p. 41). The way to reshape the separation is narrative and attending to "the inter-textual nature of story … how stories of music and stories of pedagogy can be told together, bringing them into one locus of understanding" (p. 41).

This is a recent call with little time to do the work of shifting classroom practice and the research paradigm in music education to more narrative undertakings.

# The Emerging Role of Narrative in Drama Education

"Drama tells stories. In its creation, there is a process of storying; engaging in drama, we engage in an exploration and inquiry into people's storied lives" (Linds, 1999, p. 276). In schools, drama is seen both as art form and curriculum subject. As an art form, it offers teachers another medium to help students engage in the reading of narrative texts (Hertzberg, 2001). After reading an excerpt from the novel *Onion Tears* (Kidd, 1989, p. 9), Hertzberg's research participants, ten and eleven year-old Australian students working in groups of four, were asked to make a still image to communicate their interpretation of an excerpt. This process of enactment enabled the students to see things from different perspectives, to experience someone else's reality and to develop empathy for the motivations and/or reasons for their character's actions. Drama is also used as a planning activity for narrative writing. Moore and Caldwell (1990) compared the effects of drama and discussion as planning activities for narrative writing in the second and third grades. Their findings indicated that the writing quality of the group that used drama activities was significantly higher than those in the discussion group.

In secondary schools, drama is also a curriculum subject. However, "prescribed secondary drama curricula often direct teachers to give students experience in 'making' and 'performing' within the art form" (Hatton, 2003, p. 140). The students' views, voices and experiences are seldom positioned centrally in drama classrooms. Recently, drama educators have attended to the lived experiences of their students. For example, Hatton (2003) explored adolescent girls doing drama based on their personal narratives. Conrad (2005) did a popular theater project with high school drama students in rural Alberta drawing on "stories they told about issues they identified as relevant to their lives" (p. 30).

In teacher education programs, several professors have already started to encourage drama education students to do personal storytelling through the use and development of student written case narratives (McCammon, Miller, & Norris, 1998; Norris, McCammon, & Miller, 2000; O'Farrell, 2000). However, narrative as experience in drama education still has a long way to go.

# Narrative in the Curriculum of Arts Education/Narrative Curricula in Arts Education

Our two-part title suggests a helpful distinction in understanding narrative, curriculum and arts education. The first part suggests narrative as subject matter in arts education. Narrative as genre of literature, or narrative as writing process, could become a topic in a curriculum of arts education. These topics could be taught from a discipline-based view of arts education or an experientially based view of arts education.

The second part suggests attention to experience as narrative construction. Conle (2003), drawing on Connelly and Clandinin (1988), Carter (1993), and Barone (1992) wrote,

> The use of story has been recommended for primary and intermediate education, in the field of art education, as well as for moral and environmental education …

there has been no comprehensive delineation of its various components, no differentiation in the educational functions of these components, and no extensive proposals on how one might see the connection between narrative and curricular learning outside the traditional use of narrative in literary education. (p. 3)

Conle (2003) noted, "The crux of the matter has to do with definitions of narrative and with functions of narrative that are different in different curricular situations" (p. 6). In her view, "Narrative curricula highlight the importance of the moment – the experience of the moment and what happens in encounters with people and things, moment by moment ... the experience of the moment eventually becomes what we understand by experience when we speak of gaining experience or being experienced" (p. 13). Both title parts, narrative in the curriculum of arts education, "the traditional use of narrative in literary education" (Conle, 2003, p. 3) and narrative curricula in arts education offer possibilities for bringing narrative to arts education. We suggest a third possibility, that is, that narrative in all its complexity is an artful curriculum making, that creates spaces for arts education. Choi and Bresler (2000–2001) state that "[in] the operational curriculum, educational values of art can be interpreted in multiple ways, for example, as stimuli to thinking, as aesthetic image, as generating narratives and personal constructions, as historical heritages ... " (p. 34) They see possibility for integrating Dewey's and Broudy's positions in the lived curriculum of schools. It is in the lived curriculum of arts education that we see a place for narrative in artful curriculum making.

## Narrative as Artful Curriculum Making

Conceptualizing narrative as central to artful curriculum making requires a view of curriculum making (Clandinin & Connelly, 1992) with a central place for the teacher:

> Teachers and students live out a curriculum; teachers do not transmit, implement, or teach a curriculum and objectives; nor are they and their students carried forward in their work and studies by a curriculum of textbooks and content, instructional methodologies, and intentions. An account of teachers' and students' lives over time is the curriculum ... (p. 365)

Clandinin and Connelly show how curriculum and instruction became separated through a distinction between means and ends with instruction as means to curricular end. They note an " ... implicit linking of the idea of curriculum to subject matter instead of classroom practice embedded in the means-end distinction that has characterized, and often plagued, the field since" (p. 365).

These points highlight that narrative as instruction of a genre of literature, or narrative as instruction around storytelling or story writing, continue to distinguish instructional means from curricular ends. Seen as subject matter, both views of narrative reinforce the means-end distinction. Seeing curriculum as an account of teachers' and students' life narratives over time offers a possibility for narrative in artful curriculum making.

Calling on Dewey (1938), Jackson (1968), Schwab (1983), and Eisner (1991), Clandinin and Connelly develop "a view in which the teacher is seen as an integral part of the curricular process and in which teacher, learners, subject matter, and milieu are in dynamic interaction" (p. 392). Curriculum making becomes, in this view, the ongoing negotiation of storied lives, the lives of teachers and students.

Greene (1993), believing that "encounters with the arts can awaken us to alternative possibilities of existing, of being human, of relating to others, of being other, [argues] for their centrality in curriculum" (p. 214). While Greene's encounters with the arts include encounters with narrative as genre of literature and narrative as storytelling and story writing, her view of curriculum also calls forward narrative as the composing and living out of artful curriculum making, which requires a curriculum transformation (p. 215). A view of curriculum as an account of teachers' and students' lives over time opens the possibility of artful curriculum making that allows for such imaginative transformations, and, thus, creates new possibilities for arts education as infusing the curriculum experienced by students and teachers.

## Notes

1. We wrote our chapter using a more narrative form of representation for two reasons. One, a substantive reason, was to illuminate the problematic separation of narrative from arts education in schools by inquiring into our own school narratives of experience that spanned 40 years and two countries. The second reason was to take up the challenge of Ellis and Bochner (2003) in their chapter in the Second Handbook of Qualitative Research Methods to expand the genre of handbook chapters to include more narrative forms.
2. As we delved into this work, we invited a visual artist/art educator to respond to our writing and suggest avenues of exploration. Pamela Markus, an arts instructor at McGill as well as a Ph.D. candidate there, is a student of Lynn's. She joined us as this respondent.

## References

Ashton-Warner, S. (1963). *Teacher*. New York: Simon & Shuster.
Atkinson, D., & Dash, P. (2005). *Social and critical practices in art education*. Stoke on Trent, England: Trentham Books.
Atwell, N. (1988). *In the middle: New understanding about writing, reading and learning* (2nd ed.). Portsmouth, NH: Heinemann.
Barone, T. (1992). A narrative of enhanced professionalism: Educational researchers and popular storybooks about school people. *Educational Researcher, 21*(8), 15–24.
Barone, T. (2000). Ways of being at risk: The case of Billy Charles Barnett. In T. Barone (Ed.), *Aesthetics, politics, and educational inquiry: Essays and examples* (pp. 181–189). New York: Peter Lang.
Barone, T. (2001). *Touching eternity: The enduring outcomes of teaching*. New York: Teachers College Press.
Barone, T. (2002). From genre blurring to audience blending: Reflections on the field emanating from an ethnodrama. *Anthropology & Education Quarterly, 33*(2), 255–267.
Barrett, T. (2004). Investigating art criticism in education: An autobiographical narrative. In E. W. Eisner & M. D. Day (Eds.), *Handbook of research and policy in art education* (pp. 725–750). Mahwah, NJ: Lawrence Erlbaum
Bateson, M. C. (1994). *Peripheral visions: Learning along the way*. New York: Harper Collins.

Binkley, M. R., Phillips, L. M., & Norris, S. P. (1994). Creating a measure of reading instruction. In M. Binkley, K. Rust, & M. Winglee (Eds.), *Methodological issues in comparative educational studies: The case of the IEA reading literacy study* (pp. 193–219). Washington, DC: U.S. National Center for Education Statistics.

Britton, J. (1975). *The development of writing abilities*. London: MacMillan.

Bruner, J. (1986). *Actual minds, possible worlds*. Cambridge, MA: Harvard University Press.

Bruner, J. (1987). Life as narrative. *Social Research, 54*(1), 11–33.

Burton, J. M. (2004). The practice of teaching in K-12 schools: Devices and desires. In E. W. Eisner & M. D. Day (Eds.), *Handbook of research and policy in art education* (pp. 553–578). Mahwah, NJ: Lawrence Erlbaum.

Butler-Kisber, L. (1997). The practical: Classroom literacy through stories, questions, and action. In V. Froese (Ed.), *Language arts across the curriculum* (pp. 183–213). Toronto: Harcourt Brace.

Butler-Kisber, L. (2002). Artful portrayals in qualitative inquiry: The road to found poetry and beyond. *The Alberta Journal of Educational Research, XLVII*(3), 229–239.

Butler-Kisber, L., Dillon, D., & Mitchell, C. (1997). Recent trends in literacy education. In V. Froese (Ed.), *Language arts across the curriculum* (pp. 160–182). Toronto: Harcourt Brace.

Calkins, L. M. (1983). *Lessons from a child*. Portsmouth, NH: Heinemann.

Carr, D. (1986). *Time, narrative and history*. Bloomington, IN: Indiana University Press.

Carter, K. (1993). The place of story in the study of teaching and teacher education. *Educational Researcher, 22*(1), 5–12, 18.

Cazden, C. B. (1988). *Classroom discourse: The language of teaching and learning*. Portsmouth, NH: Heinemann.

Choi, J., & Bresler, L. (2000–2001). Theoretical and practical legacies of Broudy and Dewey: Competing frameworks for aesthetic education. *Arts and Learning Research Journal, 17*(1), 22–36.

Chomsky, N. (1965). *Aspects of the theory of syntax*. Cambridge, MA: MIT Press.

Clandinin, D. J., & Connelly, F. M. (1992). The teacher as curriculum maker. In P. W. Jackson (Ed.), *Handbook of Research on Curriculum: A Project of the American Educational Research Association* (pp. 363–401). New York: MacMillan.

Clandinin, D. J., & Connelly, F. M. (2000) *Narrative inquiry: Experience and story in qualitative research*. San Francisco, CA: Jossey Bass.

Conle, C. (2003). An anatomy of narrative curricula. *Educational Researcher, 32*(3), 3–15.

Connelly, F. M., & Clandinin, D. J. (1985). Personal practical knowledge and the modes of knowing: Relevance for teaching and learning. In E. Eisner (Ed.), *Learning and teaching the ways of knowing. Eighty-four Yearbook of the National Society for the Study of Education, Part II* (pp. 174–198). Chicago: University of Chicago Press.

Connelly, F. M., & Clandinin, D. J. (1988). *Teachers as curriculum planners: Narratives of experience*. New York: Teachers College Press.

Connelly, F. M., & Clandinin, D. J. (1990). Stories of experience and narrative inquiry. *Educational Researcher, 19*(5), 2–14.

Conrad, D. (2005). Rethinking "at-risk" in drama education: Beyond prescribed roles. *Research in Drama Education, 10*(1), 27–41.

Crites, S. (1971). The narrative quality of experience. *Journal of the American Academy of Religion, 39*(3), 291–311.

Cruikshank, J. (1990). *Life lived like a story*. Vancouver, BC: University of British Columbia Press.

Dewey, J. (1934). *Art as experience*. New York: G. P. Putnam.

Dewey, J. (1938). *Experience and education*. New York: MacMillan.

Dixon, J. (1968). *Growth through English*. London: Oxford University.

Dow, A. W. (1913). *Composition*. New York: Doubleday Doran.

Efland, A. D. (2000). *Art and cognition: Integrating the visual arts in the curriculum*. New York: Teachers' College Press.

Efland, A. D. (2004). Emerging visions of art education. In E. W. Eisner & M. D. Day (Eds.), *Handbook of research and policy in art education* (pp. 691–700). Mahwah, NJ: Lawrence Erlbaum.

Eisner, E. W. (1991). *The enlightened eye: Qualitative inquiry and the enhancement of education*. New York: MacMillan.

Eisner, E. W. (2002). *The arts and the creation of mind*. New Haven: Yale University Press.

Elbaz, F. (2005). *Teachers' voices: Storytelling and possibility*. Greenwich, CT: Information Age Publishing.

Elbow, P. (1973). *Writing without teachers*. New York: Oxford.

Elliott, D. J. (1995). *Music matters: A new philosophy of music education*. New York: Oxford University Press.

Ellis, C., & Bochner, A. (2003). Autoethnography, personal narrative, reflexivity. Researcher as subject. In N. K. Denzin & Y. S. Lincoln (Eds.), *Collecting and interpreting qualitative materials* (2nd ed.) (pp. 199–258). Thousand Oaks, CA: Sage.

Emig, J. (1971). The composing process of 12th graders. *National Council of Teachers of English Research Report No. 13*. Urbana, IL: NCTE.

Emig, J. (1977). Writing as a mode of learning. *College Composition & Communication, 28*, 122–128.

Gardner, H. (1983). *Frames of mind: The theory of multiple intelligence*. New York: Basic Books.

Gardner, H. (1999). *Intelligence reframed: Multiple intelligences for the 21st Century*. New York: Basic Books.

Gaudelius, Y., & Speirs, P. (2000). Introduction. In Y. Gaudelius & P. Speirs (Eds.), *Contemporary issues in art education* (pp. 1–22). New York: Prentice Hall.

Goodman, N. (1976). *The languages of art*. Indianapolis, IN: Hackett.

Greene, M. (1993). Diversity and inclusion: Toward a curriculum for human beings. *Teachers College Record, 95*(2), 211–221.

Hafeli, M. (2002). A cross-site analysis of strategies used by three middle school art teachers to foster student learning. *Studies in Art Education: A Journal of Issues and Research, 46*(3), 242–254.

Halliday, M. A. K. (1973). *Explorations in the functions of language*. London: Edward Arnold.

Hammett, R. F., & Barrell, B. R. C. (2000). Introduction: It might seem simple. In B. R. C. Barrell & R. F. Hammett (Eds.), *Advocating change: Contemporary issues in subject English* (pp. xiii–xix). Toronto: Irwin.

Hatton, C. (2003). Backyards and borderlands: Some reflections on researching the travels of adolescent girls doing drama. *Research in Drama Education, 8*(2), 139–156.

Heath, S. B. (1983). *Ways with words: Language, life and work in communities and classrooms*. New York: Cambridge University.

Hertzberg, M. (2001). *Using drama to enhance the reading of narrative texts*. Full text retrieved from http://www.cdesign.com.au/aate/aate_papers/105_hertzberg.htm.

Hetland, L., & Winner, E. (2004). Cognitive transfer from arts education to nonarts outcomes: Research evidence and policy implications. In E.W. Eisner & M. D. Day (Eds.), *Handbook of research and policy in art education* (pp. 135–162). Mahwah, NJ: Lawrence Erlbaum.

hooks, b. (1994). *Teaching to transgress: Education as the practice of freedom*. New York: Routledge.

Jackson, P. W. (1968). *Life in classrooms*. New York: Holt, Rinehart and Winston.

Johnson, M. (1989). Embodied knowledge. *Curriculum Inquiry, 19*(4), 361–377.

Kidd, D. (1989). *Onion Tears*. North Ryde, Australia: Angus & Robertson.

Linds, W. (1999). The metaxic journey of the drama facilitator/inquirer. In C. Miller & J. Saxton (Eds.), *Drama and theatre in education: International conversations* (pp. 271–279). Victoria, BC: The American Educational Research Association, Arts and Learning Special Interest Group, and the International Drama in Education Research Institute.

Lyons, N., & LaBoskey, V. (Eds.). (2002). *Narrative inquiry in practice: Advancing the knowledge of teaching*. New York: Teachers College Press.

Madeja, S., & Onuska, S. (1997). *Through the arts to the aesthetic: The CEMREL aesthetic education program*. St. Louis, MO: CEMREL.

Martin, N. (Ed.). (1975). *Writing across the curriculum pamphlets*. Upper Montclair, NJ: Boynton.

McCammon, L. A., Miller, C., & Norris, J. (1998). *Using personal narrative and storytelling to promote reflection and the development of teacher voice in drama teacher education*. Paper presented at the 50th Annual Meeting of the American Association of Colleges for Teacher Education, New Orleans, LA.

McCarthy, M. (2004). Using story to capture the scholarship of practice: Framing and grounding our stories. *Mountain Lake Reader: Conversations on the study and practice of music teaching, Spring, 2004*, 34–42.

Moffett, J. (1968). *A student-centered language arts curriculum, grades K-13*. Boston, MA: Houghton Mifflin.

Moore, B. H., & Caldwell, H. (1990). The art of planning: Drama as rehearsal for writing in the primary grades. *Youth Theatre Journal, 4*(3), 13–20.

Murray, D. (1968). *A writer teaches writing*. Boston, MA: Houghton Mifflin.

Norris, J., McCammon, L. A., & Miller, C. S. (2000). *Learning to teach drama: A case narrative approach.* Portsmouth, NH: Heinemann.

O'Farrell, L. (2000). Enhancing drama teacher education with student-written teaching cases. *Stage of the Art, 11*(2), 15–17.

Olson, M. (1997). Collaboration: An epistemological shift. In H. Christiansen et al. (Eds.), *Recreating relationships: Collaboration and educational reform* (pp. 13–25). Albany, NY: State University of New York Press.

Paley, V. (1990). *The boy who would be a helicopter: The uses of storytelling in the classroom*. Cambridge: Harvard University Press.

Pearson, P. D., & Stephens, D. (1994). Learning about literacy: A 30-year journey. In R. B. Ruddell, M. R. Ruddell, & H. Singer (Eds.), *Theoretical models and processes of reading* (4th ed.) (pp. 22–42). Newark, DE: International Reading Association.

Peritz, J. (1994). When learning is not enough: Writing across the curriculum and the Return to rhetoric. *JAC: online*. Retrieved June 14, 2005 from www.cas.usf.edu/JAC/142/.

Polkinghorne, D. (1988). *Narrative knowing and the human sciences*. Albany, NY: State University of New York Press.

Rosenblatt, L. M. (1938). *Literature as exploration*. For the Commission on Human Relations. New York: Appleton-Century.

Rosenblatt, L. M. (1985). The literary transaction: Evocation and response. *Theory into Practice, XXI*(4), 268–277.

Schwab, J. J. (1983). The practical 4: Something for curriculum professors to do. *Curriculum Inquiry, 13*(3), 239–265.

Siegesmund, R. (1998). Why do we teach art today? *Studies in Art Education: A Journal of Issues and Research, 39*(3), 197–213.

Small, C. (1998). *Musicking: The meanings of performing and listening*. Hanover, NH: University Press of New England.

Smith, R. A. (2004). Aesthetic education: Questions and issues. In E. W. Eisner & M. D. Day (Eds.), *Handbook of research and policy in art education* (pp. 163–186). Mahwah, NJ: Lawrence Erlbaum.

Stake, R. E., Bresler, L., & Mabry, L. (1991). *Custom and cherishing: The arts in elementary school.* Urbana-Champaign, IL: National Arts Education Research Center.

Stone-Mediatore, S. (2003). *Reading across borders: Storytelling and knowledges of resistance*. New York: Palgrave MacMillan.

Straw, S. B. (1990). The actualization of reading and writing: Public policy and conceptualizations of literacy. In S. P. Norris & L. M. Phillips (Eds.), *Foundations of literacy policy in Canada* (pp. 165–181). Calgary, AB: Detselig Enterprises.

The New London Group (1996). A pedagogy of multiliteracies: Designing social futures. *Harvard Educational Review, 66*(1), 60–92.

UNESCO (2003). *Links to Education and Art*. Retrieved June 11, 2004, from http://portal.unesco.org/culture/.

Vygotsky, L. (1978). *Mind in society*. Cambridge, MA: Harvard University.

White, M., & Epston, D. (1990). *Narrative means to therapeutic ends*. New York: W. W. Norton & Company.

Widdershoven, G. A. M. (1993). The story of life: Hermeneutic perspectives on the relationships between narrative and life history. In R. Josselson & A. Lieblich (Eds.), *The narrative study of lives* (pp. 1–20). London: Sage.

Willinsky, J. (1990). *The New Literacy: Redefining reading and writing in the schools*. New York: Routledge.

Willinsky, J. (2000). A history not yet past: Where then is here? In B. R. C. Barrell & R. F. Hammett (Eds.), *Advocating change: Contemporary issues in subject English* (pp. 2–13). Toronto, ON: Irwin.

Wood, D., Bruner, J. S., & Ross, G. (1976). The role of tutoring in problem-solving. *Journal of Child Psychiatry, 17*, 89–100.

# INTERNATIONAL COMMENTARY

## 14.1

## The Literature Curriculum in Israel: Dilemmas and Narratives

**Bracha Alpert**
*Beit Berl College, Israel*

Three main approaches appear to be present in the Israeli literature curriculum: literature studies as a tool for conveying the national and cultural heritage, literature studies for developing interpretive skills, and emphasis on students' needs and interests with an experiential tendency (Feingold, 1999; Orbach, 2002; Poyas, 1999). These approaches reflect educational conceptions and ideologies such as described by Butler-Kisber, Li, Clandinin, and Markus in their paper, and by many curriculum theorists and educational researchers (e.g., Eisner, 1992; Pinar, Reynolds, Slattery, & Taubman, 2002). I have experienced different expressions of these approaches not only as a student growing up in Israel, but also as a researcher examining the teaching of literature in classrooms (Alpert, 1987, 1991).

During the early days of the state there was a tendency to promote hegemonic national goals that were reflected in literary works representing the national ethos and ideology. During the 1970s and the 1980s the structure of knowledge has become a central approach reflected in the curriculum of secondary schools (Hofman, Alpert, & Schnell, in press; Orbach, 2002). The purpose of studying literature, according to this approach, includes acquaintance with high quality literary works and literary genres and forms, as well as development of skills for appreciation of literature. New literature curricula were developed in the 1990s for all levels of education; they advocate an experiential approach that puts emphasis on students' enjoyment and interest, on understanding themselves and others (Language education, 2003; The Literature curriculum for the junior-high school, 1992), and on self directed learning of literary works (Literature for the General High-School, 2000). In the junior-high school curriculum, for example, the major goal is to create a "deeply felt experience," to be achieved by extensive reading for pleasure from various genres and styles. This curriculum also presents the possibility of "light" reading of literary works of suspense, humor, science- fiction, and similar forms, possibly more suitable for young readers. Canonical "great works" should be taught by means of interdisciplinary connections to the arts, including painting, music, film, and others. This curriculum also emphasizes

*L. Bresler (Ed.), International Handbook of Research in Arts Education, 235–238.*
© 2007 *Springer.*

development of social and cultural values through literature (Hofman, Alpert, & Schnell, in press; Orbach, 2002).

According to Poyas (1999), both enhancing cultural heritage and developing literary interpretive skills should be promoted. Orbach (2002) claims that using principles taken from the structure of the discipline, as reflected in various curriculum materials that were developed in recent years in Israel (student workbooks, teacher guides, etc.), is not contradictory to the aim that youngsters will enjoy both aesthetic and cultural experiences through the study of literature.

How should the teaching of literature reflect the discourse of a society that comprises diverse cultural and national groups, presenting a multiplicity of agendas, ideals and values? This is the second dilemma that the teaching of literature in Israel is facing. The Israeli Jewish population is composed of people whose origins are in Europe and the United States, and people whose origins are in Islamic countries. The Jewish population has absorbed immigrants in the past decade from the former USSR and from Ethiopia. About a fifth of Israel's citizens are Arabs. The Israeli educational system is also divided among secular and religious sectors. How should the various cultural narratives be represented in the curriculum?

The literature curriculum was originally oriented towards Western literature and Hebrew literature (both Jewish and Israeli). Over the years, several new literary texts have been introduced into literature studies in order to represent various cultural groups, such as writers and poets of Islamic origins. This reflected a certain degree of social change and awareness of the needs of social groups to achieve some kind of expression of their specific culture. While a few Arab poets and writers are included in the literary works taught in schools, attempts to include in the curriculum for the Jewish sector contemporary Palestinian literary figures, those who present a strong political ideology, met with fierce resistance (Hofman, Alpert, & Schnell, in press).

Finally, it is interesting to point out that, based on examining various sources for the teaching of literature in Israel, there is a wide selection of referrals to representations of literary works in theater, in painting, and in film. A large variety of articles, academic (Elkad-Lehman, 2004) as well as popular didactic (e.g., the bulletin for teachers of literature), offer teachers creative ideas of how to best approach the world of literature through teaching and learning.

# References

Alpert, B. (1987). Active, silent and controlled discussions: Explaining variations in classroom conversation. *Teaching and Teacher Education, 3*(1), 29–40.

Alpert, B. (1991). Students' resistance in the classroom. *Anthropology and Education Quarterly, 22*(4), 350–366.

Eisner, E.W. (1992). Curriculum ideologies. In P. W. Jackson (Ed.), *Handbook of research on curriculum* (pp. 202–326). New York: Macmillan.

Elkad-Lehman, I. (2004). To be a woman, to be an artist: Intertext and children's literature. *Dapim* 37, 145–181. (Hebrew)

Feingold, B. (1999). The teaching of literature – is it going toward "extinction"? *Dapim* 29, 152–159. (Hebrew)

Hofman, A., Alpert, B., & Schnell, I. (in press). Education and social change: The case of Israel's state curriculum. *Curriculum Inquiry*.

Language Education, Hebrew – language, Literature and Culture for the State and State-Religious Elementary School (2003). *Jerusalem*. The Ministry of Education. (Hebrew)

Literature for the General High-School (2000). *Jerusalem*. The Ministry of Education. (Hebrew)

Orbach, L. (2002). The structure of knowledge of literature and its Curriculum for Junior High School. In A. Hofman & I. Schnell (Eds.), *Values and goals in Israeli school curricula* (pp. 265–300). Even Yehuda: Reches. (Hebrew)

Pinar, W. F., Reynolds, W. M., Slattery, P., & Taubman, P. M. (2002). *Understanding curriculum*. New York: Peter Lang. (Hebrew)

Poyas, Y. (1999). Teaching literature: Choosing between cultural heritage and multi-cultural discourse. *Dapim*, 29, 28–43. (Hebrew)

The Literature Curriculum for the Junior-High School (1992). *Jerusalem*. The Ministry of Education.(Hebrew)

# INTERLUDE

## 15

# IMAGINING MS. EDDY ALIVE; OR, THE RETURN OF THE ARTS TEACHER AND HER PERSONALIZED CURRICULUM

**Tom Barone**
*Arizona State University, U.S.A.*

In medieval times, an interlude often meant a light-hearted moment between the main acts of a serious play. But I find myself using this brief space to reflect on weighty matters, on large, enduring issues surrounding the role of the teacher in the co-creation of the arts curriculum, and the place of the school arts curriculum in the lives of students. The issues arise out of memories of contrasting incidents involving two of my own elementary school teachers, neither an arts specialist.

In the beginning there was Light and she was named Ms. Eddy. Ms. Eddy was my only teacher for second and third grades. On one fine day, she and I finally declared as finished a story that had been long in the co-construction. The month was surely October, the story was about Halloween, its protagonist a tragically opaque ghost. With my teacher's patient assistance, I had arrived at a final version over the course of several drafts. And now I was being privileged mightily, selected to travel down the hall and read the story aloud in the other third grade classrooms. The pride and exhilaration that I felt upon the return to my homeroom, like the smile of Ms. Eddy, survives within me decades later, even as I complete my reconstruction of the very paragraph you have just read.

My sixth grade teacher never wore a halo. The events one day in Ms. Rose's classroom at McDonogh #39 Elementary School might serve to represent the sense of malaise and drudgery that I still associate with that entire school year. On one New Orleans afternoon, near two o'clock on a Friday in the winter of 1956, Ms. Rose distributed to each student a chalk pencil and drawing paper. She then tacked to the border above the blackboard an outlined drawing of a penguin and announced the challenge: a kind of "draw me" contest in which those few students (how many I cannot recall) who most precisely replicated the drawing would receive an A for the exercise. Ms. Rose, withdrawing to her desk to mark some arithmetic papers, called this activity "making art." But even then (I do believe), I had other names for it.

The notion of the teacher as a bridge between the private home of the child and the public domain of the curriculum has, we know, a long and venerable history, dating back, in Western culture, at least to the pedagogues of ancient Greece. Much later it

*L. Bresler (Ed.), International Handbook of Research in Arts Education*, 239–244.

would be John Dewey who would most powerfully articulate the indispensable role of the teacher as a chaperone of the rendezvous between student and curriculum.

In *Experience and Education*, Dewey (1938/1963) wrote of *educational experiences* that provide students with a degree of mastery over their environment and that prepare them for later experiences of a even deeper and more expansive quality. In *Art as Experience*, Dewey (1934/1958) describes an *aesthetic experience* as an event that emerges out of, but distinguishes itself from, the inchoate and formless general stream of experience. It is an experience that is, as Dewey put it, "rounded out ... because it possesses internal integration and fulfillment reached through reached through ordered and organized movement" (1934/1958, p. 39). Years later, I would recognize the experience of writing with Ms. Eddy as both educational and, because it was so fulfilling, so life-affirming, as deeply aesthetic.

But the flip side of education was, for Dewey, miseducation. Miseducational experiences are disempowering: they "have the effect of arresting and distorting the growth of further experience" (1938/1963, p. 25). And the opposite of aesthetic was anaesthetic. The penguin replication resembled the kind of deleterious experience that may (especially if, as in Ms. Rose's class, oft recurring) cause a student to "associate the learning process [here, within the visual arts] with ennui and boredom" (1938/1963, p. 25). It was hardly the sort of event that was life-affirming; it was, instead, deadening.

Yes, after a long stretch of "further experience," I still find fulfillment in the process of storytelling. But when it comes to drawing and painting, I feel disinterested, disempowered, miseducated. And so I find myself wondering about the degree of responsibility of these two teachers for this state of affairs. What roles, if any, did their curricula and teaching play in my long-term relationships (or lack thereof) with these art forms? How much did Ms. Eddy engender in me a love for stories? Would I have somehow found my way into the field of literary-style narrative research without her? Did Ms. Rose sow the seeds of my enduring disinclination toward engaging in, and lack of talent for, activities related to the visual arts? Or did both of my teachers merely reinforce larger, less visible influences operating from outside their classrooms?

Dewey deplored any "tendency to exclude the teacher from a positive and leading share in the direction of the activities of the community of which he [sic] is a member" (1934/1958, p. 58). This leadership included a process of familiarization with the personal capacities and needs of the child and an arrangement of the social and physical environment that would tempt the student outward toward significant, purposeful, educational encounters through which those needs would be met.

But another, strikingly different, metaphor of the teacher also serves to maintain her significance in the implementation of the curriculum, even as it withholds from her a professional status. Within the scheme of scientific management, transported a century ago into education by Franklin Bobbitt (1918), the teacher is a functionary responsible for the smooth operation of an educational assembly line. The teacher, asserted Bobbitt, is not meant to be a "philosopher" with the intellectual wherewithal to imagine appropriate curriculum content, but a "mechanic" assigned the narrow task of efficiently imparting a curriculum pre-formulated by supervisors.

Indeed, two parallel but conflicting images of the arts teacher in America are rooted deeply in the history of arts education. In the nineteenth century the arts curriculum

and instruction became deeply associated with industry. This was during an era of robust industrial expansion and development, a time in which the Cole System of art instruction was imported from Great Britain, primarily for the purpose of training students manually in copying master designs. Soon the art curriculum consisted almost entirely of deathly alienating exercises of meticulous reproduction.

It was a few decades later that the Progressive Education movement, with, of course, Dewey's central involvement, finally provided a rationale of the fine arts (including creative writing) as an activity central to the educational process. Dewey and other progressives would provide a justification for, and suggest teaching methods appropriate to, the doing of art in school as a lively process of personal expression, as an activity tied more directly to the purposes of the student.

What I recall as the tedious drawing activities of Ms. Rose were perhaps not as off-putting as those endured by victims of the more elaborately scripted Coles-style training of the eye and hand. Art seemed insufficiently important to Ms. Rose even to provide a few basic tips on drawing. Nevertheless, we, her students, were paradoxically united in our cluelessness as, in competitive isolation, we strove mightily to replicate a common prototype. And as for Ms. Eddy, while I appreciate her obvious (to me, if not to her) debt to Dewey, I nowadays question the significance of the aesthetic content of some of the stories I wrote for/with her. Still, the educational opportunities afforded by these two teachers seem to exemplify these two competing curricular/pedagogical/ educational traditions.

What else, I wonder, influenced their teaching and our learning of the arts back in that earlier era? What factors internal to the school served to frame their lessons – the organization of the school, the available resources, the expectations of administrators and the students themselves, and so on? Not to the mention forces emanating from outside the walls of McDonogh #39 – external curriculum mandates, parents, facets of the popular culture. I refer to what Schubert (2004) calls the *outside curriculum*, the forces operating within the larger, external culture that nevertheless manage to find their way *inside* the schoolhouse to influence the events occurring therein.

Of course, to continue with all of these qualifications on the agency of my former teachers is to arrive at a thoroughly postmodern state of affairs. One in which individual spirits have evaporated, vanished – or, more accurately, been banished. One in which, indeed, my own teachers, at least metaphorically speaking, never existed! This is a narrative in which the central symbol of modernity, the subject, the formerly free agent with a capacity to influence specific events, has, in the words of a popular song of the seventies, "caught the last train for the coast." Especially for post-modernists of the *skeptical* sort (Rosenau, 1992), the two individuals whom I called Ms. Rose and Ms. Eddy, wafts of their distinctive perfumes still lingering within my olfactory memory, have been re-described as merely "contingent effects of language or political activity in a particular historical context" (Ashley, 1988, p. 94). (If they really are gone, I am glad, at least, that they will never know what rubbed them out.)

What this would mean, of course, is that Ms. Eddy and Ms. Rose did not matter. They never had their own curriculum, were never responsible for those classroom experiences, life-giving or otherwise. And so they cannot any longer be my (nor your teachers your) heroine or villain. The heroic arts teacher has enjoyed a long run in modern popular culture (especially, for whatever reason, the music teacher, as protagonists in films

such as *Mr. Holland's Opus, Music of the Heart,* and even *The School of Rock*), defying and defeating various forces of domination that would serve to miseducate their students. The pop culture villains, to the contrary, have included school people who too easily accepted a debilitating socio-cultural matrix and too readily chose a cultural script written by others. Like Ms. Rose?

Among skeptical postmodernists the acceptance of the possibilities of personal pedagogical and curricular heroism opens one to charges of romanticizing the teacher, of wistfulness and nostalgia, and even, in evidencing an infatuation with individual virtue and achievement, of masculinism. And a significant part of me recognizes the dangers that accompany a singular focus on the personal agency and professional qualities of the individual arts teacher. If one arts teacher acting alone – the damning question goes – can prevail against overwhelming odds, why can't they all? The heroic achievements of those rare teachers can be construed as evidence against a need for the redress of a host of debilitating, anaesthetic cultural conditions.

I cannot deny that teachers of art are, by and large, like all earthlings, children of their culture. Their degrees of personal and pedagogical freedom are, admittedly, narrowed within that culture, with any impulse against foreign ("teacher-proof") curricular scripts rendered enormously difficult to act upon. We know that arts teachers (specialists or not), occupying marginalized positions in the school community, are much less likely than their colleagues to be held "accountable" for efficiently delivering a standardized, test-driven curriculum. But this hardly means that they are guaranteed the luxury of full professional autonomy.

Still, because I am (romantically?) determined to keep people such as Ms. Eddy, and even Ms. Rose, (metaphorically speaking) alive, I find myself aligned with those *affirmative* postmodernists (Rosenau, 1992) who seek at least the *half-return* of the subject (Giddens, 1984).

This half-return is premised on the realization that, while these teachers may have acted within structural limitations, it was that very structure which made their subjective agency meaningful. Pure structure, like pure form, is, indeed, static and meaningless. A teacher's way out of that miasma is through awareness of the facets of that structure, careful attention to the nature of the viscous contingencies that constitute the social and physical environment. Through that attentiveness *and* through the kind of imagination that propels students out of the mire of the present into the possibilities of the future.

For Carl Bereiter (1995), a teacher-hero is that rare someone who is able to, through imagination and hope, sustain a purpose or value despite those structural limitations, despite adversity and lack of social support:

> Heroic transfer undoubtedly does exist. There are people who credit some teachers with having instilled in them a disposition or aspiration that stayed with them and intellectually influenced their behavior throughout life. But this is [a] chancy ... business; it probably depends on just the right input in just the right emotional context, at just the crucial moment in a person's development. (1995, pp. 30–31)

I have to believe it was thus with Ms. Eddy. She had to have observed my proclivities toward literature, imagined the possibilities of who I could become, and found a way through the thickets of meaninglessness that surrounded us both. She nurtured those possibilities, I think, with *tact* (van Manen, 1991), knowing exactly how and what to teach at exactly the right time. Such curricular and pedagogical tactfulness can awaken a student out of slumber, foster a degree of self-awareness, and encourage personal growth. And as for Ms. Rose, perhaps we can substitute the term *non-hero* for villain. She may have been, for many reasons, simply unable to recognize and break through the static structure – the hidden curriculum – that enveloped us. The Ms. Roses of the world need not our disdain, but our help.

So have I at least half-succeeded at least in saving Ms. Eddy? I confess that, on gloomy days, I still resonate with the bleakest of postmodernist outlooks on personal agency and the possibilities of an effective, locally negotiated arts curriculum. In especially dark moments, I am susceptible to Althusser's (1977) notion of an overwhelming, all-encompassing ideology that negates the possibility of free will. In Althusserian determinism, we are all figments of our own imaginations, our inner lives constituted in part by the illusion that we are indeed free agents.

But on a clear day I understand the nihilistic implications of that perspective – and a favorite quote from F. Scott Fitzgerald returns to me:

> The test of a first-rate intelligence is the ability to hold opposing ideas in the mind at the same them and still maintain the ability to function. One should, for example, be able to see that things are hopeless and yet be determined to make them otherwise.

And then I feel smart, and hopeful, and, because I am still able to function, quite sane.

Nowadays, more than ever, an ideological state apparatus and an anesthetic larger culture that deliver up a received arts curriculum, may make any rousing of the nascent sensibilities of students seem unattainable for arts teachers. But many find hopelessness unacceptable. So some choose to work outside of their classrooms with like-minded others toward an elevated awareness within the general population of the importance of the artistic imagination. Others are still, like Ms. Eddy, doing their best to make a difference in deep collaboration with their students, through personalized arts curricula that foster genuinely educational and aesthetic experiences. Promethean efforts at all levels of influence, inside the school and in the culture-at-large, seem in order.

Those who insist on making things otherwise are, I believe, affirmative postmodern heroes, under few illusions about the nature of the challenge, but searching for just the right time and manner to slice through the miasma. For them, reports of their death may or may not be exaggerated, but are, paradoxically, irrelevant. Imagining themselves alive, as I have imagined my former teacher of composition, they move relentlessly toward the aesthetic, in turn offering the heightened vitality they find in the arts to their students. Determined, wise, tactful, sane, they are indeed the twenty-first century analogues of Ms. Eddy.

This Interlude is dedicated to her and to them.

# References

Althusser, L. (1977). *Lenin and philosophy*. (B. Brewster, Trans.). London: New Left Books.

Ashley, R. (1988). Geopolitics, supplementary criticism: A reply to Professors Roy and Walker. *Alternatives, 13*(1), 88–102.

Bereiter, C. (1995). A dispositional view of transfer. In A. McKeough, J. Lupart, & A. Mariani (Eds.), *Teaching for transfer: Fostering generalization in learning* (pp. 21–34). Mahway, NJ: Erlbaum.

Bobbitt, F. (1918). *The curriculum*. Boston, MA: Houghton Mifflin.

Dewey, J. (1934/1958). *Art as experience*. New York: Capricorn.

Dewey, J. (1938/1963). *Experience and education*. New York: Collier.

Giddens, A. (1984). *The constitution of society: Outline of the theory of structuration*. Berkeley, CA: University of California Press.

Rosenau, P. (1992). *Post-modernism and the social sciences*. Princeton, NJ: Princeton University Press.

Schubert, W. (2004). Perspectives. *Journal of Curriculum and Pedagogy, 1*(1), 33.

van Manen, M. (1991). *The tact of teaching: The meaning of pedagogical thoughtfulness*. Albany, NY: State University of New York Press.

# 16

# DANCE CURRICULUM RESEARCH

**Donald Blumenfeld-Jones and Sheaun-Yann Liang**
*Arizona State University, U.S.A.*

In this chapter we will review dance curriculum research dealing with P-12 education over the past 20 years (1985–2005). In so doing, we have two ends in mind. First, we give a review of what has been done in the field. Second, we will provide some perspective, from time to time, as to what we think is needed in the field, in what ways the field is strong and in what ways the field has proven to be not sufficiently robust.

There are three ideas which will structure the material of this chapter (1) The slender volume of explicitly designated dance curriculum research, (2) what constitutes curriculum research in general and how this helps identify dance education research that might be pertinent to curriculum research, and (3) what counts as research in the first place. It is important to set out these ideas as parameters for evaluating what we have chosen to include and how we have commented upon the work.

Research explicitly named "dance curriculum research" as such is rare. Locating dance curriculum research requires asking of each possible candidate, "Does this research have implications for curriculum deliberation, curriculum designing, curriculum enactment, curriculum evaluation and/or curriculum experience?" These areas (deliberation, designing, and so forth) constitute the details of curriculum research. In order to determine whether or not specific dance education research qualifies as "curriculum" research, we must determine how it might fit into one of these areas. For example, research that might inquire into teachers' philosophical thinking about teaching dance can be construed to be attending to curriculum enactment since all teaching proceeds, either tacitly or consciously, from a philosophical base and teachers make choices on this basis. This kind of research might also be useful for thinking about curriculum designing, because philosophical positions also tacitly or consciously guide the decisions people make in designing curriculum. Studying change and/or stability in teacher and/or student attitudes about dance connects well with how a curriculum is being enacted and/or what might be needed in future iterations of this curriculum. Thus, these kinds of studies can be construed as examining curriculum enactment and curriculum evaluation. It is this kind of thinking that structured our review of the literature.

*L. Bresler (Ed.), International Handbook of Research in Arts Education, 245–260.*
© 2007 *Springer.*

Curriculum is more complex than conventional understandings of it. We discuss, below, this more complex version of curriculum. In terms of what counts as research, we take "research" to reference both empirical work (gathering data through particular methods and analyzing and discussing it) and philosophical and conceptual work (the researcher presents a question, conceptualizes it in various ways, revealing new dimensions of the question at hand). In general, in an effort to be as open and ecumenical as possible, many kinds of studies and many modes of research are included in this chapter. In reviewing well over 115 articles, book chapters, books, dissertations, and Websites, we selected approximately 60 items which we felt had to do with dance curriculum research.[1]

## Curriculum Definitions and Dance Curriculum Research

We begin with defining curriculum. We provide two synergistic definitions which, when taken together, provide a template with which to examine the literature.

Curriculum studies scholars widely agree that there are two animating curriculum questions: "What shall we teach?" and "Who shall decide?" "What shall we teach?" guides us toward examining not only content but also curriculum goals, plans for enacting the curriculum, and evaluations of the curriculum's success at achieving its goals. These concerns translate into suggesting new curriculum efforts, examining how curricula function in real settings, and considering how a curriculum might be changed. These three foci involve curriculum evaluation since in each case we must evaluate what exists in order to determine what to do next, what to change, and what new curriculum efforts we might develop. "Who shall decide" reminds us that curricula are made by people. The pertinent questions include who was involved in planning and evaluation, who was not involved, what processes (social, intellectual, emotional, and so forth) were used in the planning, and what contexts affected the curriculum that resulted from a curriculum planning process. These two overarching questions led us to seek research that examined curriculum plans, the practice of curriculum evaluation, and/or the processes of curriculum deliberation in making plans.

Curriculum is also more than goals, content, and plans. John Goodlad (as cited in Blumenfeld-Jones, Barone, Appleton, & Arias, 1995) wrote that at any moment in an educational setting three curricula exist simultaneously: the explicit or formal curriculum found in curriculum documents (district guidelines, standards documents, mission statements, and the like), the operationalized curriculum as the teacher puts the explicit or formal curriculum into action in order to teach, and the experienced curriculum as the learners in the classroom experience the operational curriculum being forwarded by the teacher. Beyond these three curricula many curriculum scholars, beginning with Philip Jackson (as cited in Blumenfeld-Jones et al., 1995), examined the hidden curriculum. This curriculum alerts us to the fact that schools teach more than academics and skills. They also teach how to live in the world. For Jackson this meant learning how to live with "praise, power, and patience" (1983, p. 35). Praise means acknowledging only certain people as being legitimate sources of praise; power means accepting that adults have power the learner doesn't have; patience means learning to

wait. These are not part of the explicit curriculum and are not discussed, thus "hidden." Since Jackson's work, the "hidden curriculum" notion has been used to describe all of the ideologies that are taught through school: work before play, social class counts, conflict is bad, certain knowledge is more valuable than other knowledge, and more. A fifth curriculum, the null curriculum developed by Eliot Eisner (as cited in Blumenfeld-Jones et al., 1995), reveals that some topics, dispositions, and ways of thinking and being are left entirely out of the curriculum. Thus, if a girl notices that there are no women composers on the walls of her music room, then she learns that women don't compose music, possibly ruling her out of aspiring to musical composition. She has just pointed out the null curriculum. Dance curriculum research can focus upon describing the effects of a particular dance curriculum upon learning and upon people by studying how teachers enact the curriculum, how students take up the offered curriculum, and how and where the hidden and null curriculum affect learning and experience of dance.

The rest of this chapter is devoted to laying out the literature within seven domains: research into explicit or formal curriculum, operationalized curriculum, experienced curriculum, hidden curriculum, null curriculum, the process of creating or redesigning curriculum, and research that evaluates an existing curriculum. It becomes apparent that these categories are not exclusive. While we have made decisions about where particular studies belong, we recognize that different authors might have made different decisions.[2]

## *Explicit or Formal Curriculum Research*

There are several kinds of texts involved in performing explicit curriculum research. State school boards, district school boards, national accrediting bodies and, at least in the case of dance, certain books or journal articles or book chapters propose particular curriculum ideas for use in teaching dance. For the most part such proposals address the question "What shall we teach?" State and district school boards and national accrediting bodies usually stipulate the content and, on occasion (often found in the preamble or introduction to the curriculum), provide justifications for why this particular approach is presented. In books, book chapters, and journal articles, a particular dance curriculum will be promoted, occasionally with material arguing for the curriculum being proposed. There may also be "theoretical" texts that discuss what might be included in the "good" dance curriculum by presenting various ideas about dance curriculum and arguing for one approach. Each of these documents provides the data for analyzing the relationships across goals, content, and plans as well as, perhaps, ideological underpinnings of the proposed curriculum and connecting the curriculum to its social context, and/or the history of dance curriculum up to that moment. In this chapter section we have also included conceptual and/or philosophical curriculum research that proposes a question about dance curriculum to be answered through conceptual/philosophical work. We have divided this work into two parts. In the first part, we describe "research"[3] presented as preliminary to actually designing the explicit curriculum, labeling it as "descriptive" work, meaning work that describes the state of affairs in dance curriculum in an effort to lay out what curriculum designers should

consider in creating concrete curricula. In the second part we describe what we term "critical" research, which examines curriculum from the point of view of the hidden and null curriculum and connects curriculum to social and ideological context and historical concerns. In some cases, we have found that a particular piece might have been placed in a number of curriculum areas (described above) and our choice for placement might be considered arbitrary. We have made choices, recognizing work might be categorized in a number of ways. In future we hope that researchers will more clearly pursue one domain as central to the work, rather than allude to multiple possibilities in the one research work. In so doing, the work can be more focused and, we believe, more thorough.

In the explicit curriculum domain we see a slender trend developing over the years, moving from advocacy to more research-based understandings of what might be needed in a dance curriculum. In the advocacy approach, three articles appeared in a 1988 issue of *Journal of Physical Education, Recreation and Dance (JOPERD)*. John McLaughlin (1988) "describe[d] how dance curricula has changed from 'a stepchild of the arts curriculum' to "stand[ing] together with music, visual arts, creative writing, and theater, when reformers discuss the term 'arts education' " (p. 59). Some research base is apparent as he noted other events of his time, although even this work was primarily advocacy in character. In that same journal issue, both Beverly Allen (1988) and Elsa Posey (1988) defended linking dance teaching with the Discipline-Based Arts Education movement of the time. In conceptually based research, Kimberly Staley's dissertation (1993) dealt with establishing a multicultural framework for dance curricula. Her work is similar to that of Alma Hawkins (1954) in that both women investigated what Staley terms "literature on the historical cycles of reform that have occurred in secondary education" (p. vi). In Staley's case, she "selected theories about multicultural art education and aesthetic principles inherent in dance and visual art are considered" (p. vi) in order to establish the soundness of her approach; this is very similar to Hawkins, who used educational psychology of her time to establish the soundness of her thinking. All of this work, we would argue, is non-empirical in character. That is, neither present-day curriculum (of the time) nor curriculum practice is examined or referenced.

In what might be termed more empirical work, one researcher did groundwork research for establishing necessary considerations in making a curriculum. This study, by Sylvie Fortin (1994), is fundamentally descriptive.[4] She studied the verbal responses of different groups of high school students to viewing choreography, finding that those with experience in dance were more open to choreographic ideas than those with no experience and noting that gender, which might have been thought to be in play, had no significant effect on the responses. She concluded that her study could help those who desired to advocate integrating dance appreciation into the curriculum. Her findings are not particularly surprising (more education means more knowledge, meaning, usually, more openness to new experiences) and may appear intuitive to those of us who teach dance. We found that empirical study of explicit curriculum was not a well-developed research area and hope for more in the future.

Critical work deals with examining the formal curriculum for underlying meanings not apparent in the curriculum. It also works to put into the curriculum elements of the

hidden and null curriculum. In this vein, Joellen Meglin (1994) edited a special section of *JOPERD* in which she and her authors wrote on the place of gender and multicultural perspectives in the dance curriculum, discussing an Australian gender-fair program (Bond), the pedagogy of teaching dance history (Daly), women and dance performance (Arkin), men and dance (Crawford), using West African dance to combat gender issues (Kerr-Berry), and gender issues in dance curriculum (Ferdun). These works perform what we term simple description in that the authors began with a point of view and then organized materials around that point of view. This sort of research must be distinguished from what is termed "phenomenological" research in which the researcher attempts to describe deep structures of consciousness that give rise to experience.

Other works are critical because they link curriculum with larger social, political, and economic issues. In the spirit of a more explicitly critical approach, Blumenfeld-Jones wrote ideology critiques of formal curriculum (1993, 1995, 1998), a critical historical-hermeneutic study of three dance curricula (2004), and an examination of choosing a particular dance curriculum connected to the community in specific ways (2006). Sue Stinson's work, while critical, will be discussed in the section devoted to the experienced curriculum. Sherry Shapiro produced an edited volume addressing critical issues in dance pedagogy and dance research (1998) and a volume of her own essays (2001), both of which take a distinctly critical social theory and postmodernist approach to dance curriculum issues and lie, primarily, within the philosophical practice of curriculum inquiry.

## Operationalized and Experienced Curricula

In the operationalized and experienced curricula research, the curriculum researcher's prime concern is with what the teacher does with the curriculum being used. That is, the teacher will inevitably make changes to mandated formal curricula in deciding what to actually teach out of that mandate and how to teach it. The students, on the other side, experience the curriculum being offered and their various experiences produce new curricula based on their individuality and how they receive the offered curriculum. The experienced curriculum, unlike either the explicit or operationalized curriculum, is "accidental" in character since the teacher cannot make certain experiences occur, nor can the students plan what experiences they will have. The experienced curriculum is that curriculum which is immediately undergone by the learners.

In inquiring into these two curricula, the researcher would observe dance classrooms or classrooms where dance was part of the curriculum and would, hopefully, interview teachers, students, parents, administrators, and other interested parties. In the studies discussed in this section there was some phenomenological work (seeking to understand the students' experiences in the dance class or the teacher's experience of enacting the curriculum, and the underlying structures of consciousness that bring about this experience) and there was "naturalistic" inquiry in which the empirical material in the classroom is simply described ("this is what I saw"). In some cases the naturalistic work used Glaser's and Strauss's grounded theory (1967) or engaged in case studies, lending more strength to the work. And, as with research into explicit curriculum, some researchers took a critical stance as referenced above.

## Operationalized Curriculum

Strong and consistent research in this area has only recently appeared. Before 2001 we found only two pieces deemed to fit in this domain. The first, by Linda Yoder (1992), examined the use of cooperative learning structures for enhancing student skill development in composition and performance. As with much dance curriculum research, Yoder attempted to do many things: identify student attitudes, determine the effects of cooperative learning strategies, and identify possible teaching strategies. This work was done with an eye to "integrat[ing] critical, historical, cultural, social and aesthetic inquiry into student dance-making" (p. 1). The author used multiple data sources: pre- and post-surveys, written journals, pre- and post-video recordings of individual dance compositions, and interviews, all leading to eight individual case studies. She found that cooperative learning approaches were useful and that survey work was of little help in determining how well cooperative learning worked. On the other hand, in studying attitude, the surveys enhanced understanding. She also found that videos and interviews were the most helpful data collection methods. Kathleen Vail (1997) did an informal study of the New Orleans Center for Creative Activity, a long-standing arts school with an impressive pedigree of graduates, in which she laid out some of the history of the school and included interviews with teachers and the principal. As with other studies, she also included brief discussions of student experience; we have placed her piece in this section because its focus was more on the teaching and organization of the school.

Beginning in 2001, we found a stronger set of studies emerging, more explicitly focused on the teacher. Madeleine Lord (2001) performed an "interpretive" study using participant-observer method to describe two practices of improvisation occurring in a secondary school. She examined the teachers' strategies in relation to the curricular objectives. These objectives were inductively derived from the teachers' practices and interviews rather than from dance curriculum documents. The study doesn't really show us the connection (or lack of connection) between what the teachers know about dance (their personal curricula) and what they are supposed to be operationalizing, since the author simply describes how they teach. Laura Shue and Christina Beck (2001) did an ethnography in a nonprofit dance school, attempting to understand "whether or not instructors within this culture perform behaviors that support their espoused critical feminist pedagogical philosophy" (p. 125). They found that "embedded within some of the instructors' performances are communicative actions that constrain greatly the development of a truly critical feminist pedagogy" (p. 125). Eeva Anttila (2004) studied three dancers/teachers and how they took up a project of dancing out of memories of learning to dance and what it meant for Anttila's project of dance as liberation. Edward Warburton (2004) used a psychological inventory to examine teachers' beliefs about critical thinking. He coupled this with their perceptions of their students as either high- or low-advantage students, concluding that good teaching was offered to good students (in terms of how the school perceived them, probably connecting with being high-advantage), but not necessarily to low-advantage students. Ralph Buck (2003) did an interpretive study of teachers' perspectives on dance in New Zealand primary schools, focusing on the meanings the teachers

attached to their teaching practices and their relationship to dance for themselves (including concern with what would block them from using dance in their classrooms). Bond and Richard (2005) performed action research with a dance teacher to examine how a teacher's practice can evolve through self-examination.

## Experienced Curriculum

Several researchers focused on creative activity and play as people encountered their own dancing. In Denmark, Charlotte Svendler Nielsen (2003) examined video-recordings and interviews with children, seeking "aesthetic moments" children have in making dance. Gunilla Lundquist (2001) wrote on the relationship between dance and play. Her focus was on the experience of children within two approaches to dance education: the Laban approach vs. the Dahlgren approach. She studied how they were taught under these two theories, both of which might support the integration of children's play with dance but were not used to good effect. Eeva Anttila (2003) participated in an art project in an elementary school in Eastern Helsinki, Finland, bringing together classroom teachers and artists; she studied her own teaching practice and the children's experiences through an ethnographic lens. Emmely Muehlhauser (1998) studied how students' owning their learning purposefully engaged them in seeking learning opportunities, constructing meaning, and acting in ways that transcend task completion. She studied both herself in the choreographic process and in teaching dance to children within a choreographic project. As with most of these studies, the work was strongly personal.

Other researchers were concerned with how children and young people related to dance. Liesbeth Wildschut (2003)

> studied the processes of involvement of children watching a dance performance … [focusing] on … the connections between the spectators' variables "dance experience" and "age," the performance characteristics of an abstract and a narrative dance performance, the intensity of identification and kinaesthetic involvement and the ability to provide an interpretation of a performance. (p. 247)

In a parallel fashion, Ana Macara and Pipsa Nieminen (2003) had children from Portugal and Finland make drawings of people dancing and then interviewed them. The study was to look at how "the representation of dance is determined by social and cultural environment" (p. 220). Nelson Neal and Sylvie Fortin (1986) used a survey with French-Canadian elementary aged children in Canada, to study attitude differences in the psychological domains of affect, behavior, and cognition and whether or not a change in only one domain stimulated a change in other domains. Additionally, Neal examined whether native speaking (French) vs. nonnative speaking teachers (English) made a difference. He concluded that psychological domains don't interact and that the attitudes of the subjects shifted based on direct participation and whether or not the teacher spoke the native language of the subjects. Sue Stinson, Jan Van Dyke, and Donald Blumenfeld-Jones (1990) did a phenomenological study of seven

adolescent girls making the transition in their dance lives as studio dancers, considering whether or not dance was a life they could live in the future. This study attempted to illuminate the underlying patterns of thought within each individual and across the group, seeking to describe the "culture" of the dance studio and dance world and how ideas about place in that world were communicated. Such a study exemplifies the phenomenological tradition because the underlying structures of consciousness are developed and the students' ideas and feelings are contextualized within a larger cultural framework. Stinson followed with a study of adolescent experience among high school (1993a, 1993b, 1993c) and middle school (1997) dance students and, with Karen Bond, a large international study of young people's experience in dance (Bond & Stinson, 2000–2001).

In two further studies, Bond engaged in examining the experienced curriculum. In a 1994 study, she looked at children with multiple physical and psychological disabilities using an experimental design and coding both the treatment group and the control group behaviors. She discovered that there was statistically significant change in the treatment group, concluding that those children used dance as an effective way in expression, communication, and learning. In a second study, Bond (2001) examined how using teacher and child responses to dance curriculum integrated with daily curriculum (what Bond terms "emergent curriculum" design) can increase engagement on the part of learners.

### Hidden and Null Curricula

Two other curricula are in force in the classroom: the hidden curriculum and the null curriculum. Both have been well documented by curriculum theorists. These curricula lie "outside" the formal, operationalized, and experienced curricula, but they exercise enormous power within educational settings. For instance, the notion that a dancer becomes freed through self-discipline in the rigors of dancing is not part of dance *per se*, but is a cultural message about what it means to dance. The message that only certain types of bodies can be properly disciplined to be successful in dance is part of the hidden curriculum which has nothing to do with the ability to dance well but is more aligned with predominating professional realities. Dancing as a "pure" act is supplemented by sociological considerations. These curriculum messages are part of the hidden curriculum because they are not discussed in the explicit, formal curriculum, yet they are as much learned as the formal material. The null curriculum, in parallel fashion, points toward the exclusion of certain values and certain kinds of people, making them invisible. There are messages here as well, but they are messages about invisibility rather than how or who to be. A dance curriculum researcher would perform the same kinds of field work as with the operationalized and experienced curricula but might bring to the study outside ideas pertaining to issues of power, justice, and the state. These studies, as with the operationalized and experienced curricula, would be, more than likely, phenomenological, naturalistic, or case studies but with a critical viewpoint added to them.

Several pieces appeared to address the hidden or the null curriculum. Karen Hubbard and Pamela Sofras (1998) addressed how to include African and African-American

culture in the historically Eurocentric dance curriculum. Blumenfeld-Jones, in performing ideology critique (1993, 1995, 1998), discussed how the hidden curriculum is embedded in how we speak and write about dance. Sue Stinson (2005a) has a piece directly confronting the hidden curriculum of gender in dance teaching. As can be seen, this is a very underdeveloped area of investigation.

## Curriculum Deliberation

Studying curriculum deliberation involves studying the processes an individual or group uses to design a curriculum. Three studies were found which partially fulfilled this domain. J. Huang (1998), in China, interviewed 11 dance specialists and sent questionnaires to administrators, teachers, and dance students of the Beijing Dance Academy. The study focused on educational objectives, characteristics of learners, assessment of learning outcomes, curriculum design, and instructional resources. The researcher concluded that there was a need for an advanced-level dance education program. This information, coupled with models from the United States, was used to design an overall mission statement and a basic curriculum design. The design process was research based although the actual process itself was not studied. Jeff Meiners (2001) reported on the various steps taken in writing a curriculum, again only providing a simple description of the process and not investigating who was involved or the context of the design process. For a study of curriculum deliberation to be most useful, we would want to see an examination of how extra-deliberative forces affect decision making. Such forces are, for instance, an environment of high-stakes testing, community demands upon the curriculum designers, cultural influences and value orientations of the designers, and so forth.

Two studies provided a bit more of such context regarding the curriculum design process. Isabel Marques (1995) studied the inclusion of dance in the São Paulo City Brazil school curriculum during the period 1991 to 1992, paying special attention to the relationship between university faculty and school faculty. Her explicit intent was to establish a different kind of relationship between theory and practice, with the teachers (practice) exerting more influence over the outcomes than the university people (theory). Jennifer van Papendorp (2003) examined a new South African curriculum, describing the context in which the curriculum was developed and how the development process took into account multiple needs, both global and local, and focused especially upon cultural diversity. Since this study examines contexts outside of the dance curriculum itself, it could also be considered to be a "critical" piece, in that deeper political issues are broached. Given the slenderness of studies in this curriculum domain and given that a curriculum is profoundly affected by how it is designed and who is involved, studying the process individuals and/or groups use to design curriculum is very important.

Sue Stinson has a very large number of studies dealing with curriculum designing. Most of these studies are conceptual in character but are research in the vein of philosophical work, which sets out a problem and then explores the dimension of the problem through various thought experiments and conceptual analyses. These studies range from aesthetic experience in children, through Piagetian perspectives to the

processes of curriculum design (1982, 1985a, 1985b, 1986a, 1986b, 1991, 1998, 2001, 2004, 2005b).

## Curriculum Evaluation

By far the largest number of studies focused on versions of curriculum evaluation, although many of the studies were not presented as such. Since, however, they were measuring the outcomes of the curriculum, we may take it that they are forms of curriculum evaluation. Here the appropriate article, book chapter, and so forth, is one in which a specific curriculum enactment is examined, analysis is provided about what is found, and our understanding of that curriculum is expanded. The dance curriculum may be evaluated naturalistically, as developed by Robert Stake (2003), may be studied via other program evaluation approaches, or may be studied quantitatively. It is more likely that a dance curriculum will be evaluated within the larger context of a fine arts curriculum, and curriculum evaluations may be designed to assess the impact dance experiences have on academic performances.

A number of studies focused on psychological issues, both attitude and self-esteem. Leigh McSwain (1994) used a survey instrument to investigate attitudes toward dance among Sydney high school students. She sought to understand the "nature and extent of [boys' rejection of dance] as well as 'mapping out' the perceptions and attitudes of adolescents in general, towards dance" (p. 253). Sue Graham (1994) did a quantitative survey evaluation of the effect of movement and dance on self-esteem, investigating the claim from the New Zealand 1987 Physical Education Syllabus that "improved self-esteem [is] a potential, personal and social development outcome" (p. 162). Her study proceeded from an eight-week Social Partner Dancing Program. She noted that the instrument she used may not have been robust, thus weakening the outcome. Robyne Garrett (1994) studied the influence of dance on adolescent self-esteem through a quasi-experimental design, concluding that the group that received the treatment curriculum had greater improvement in self-esteem than the group that didn't receive the treatment. A multiple measurement approach, incorporating both quantitative and qualitative observations, was used to assess the impact of dance education. The bulk of the paper

> examines the pedagogy of dance in education … focus[ing] on approaches to dance teaching which may take advantage of its positive influences on self-esteem … [proposing] possible strategies and teaching methods to be framed which illuminate the potential of dance as a tool for learning and personal growth. (p. 134)

Melinda Blomquist (1998) used a self-concept instrument to measure self-discovery through dance, in the context of a teaching strategy she termed "reciprocal teaching." She analyzed how the teaching process was administered to each of the study group classes, and used narrative description to document how the students progressed, as well as what actually took place in class each day. She found that the change in self-concept was not statistically significant. She noted that reciprocal teaching did have some positive effect on self-discovery, but she did not derive this inference statistically.

Some studies focused on contextual "critical" issues in dance curriculum design and implementation. Lina Chow (2002) surveyed

> teachers in 10 primary and 11 secondary schools who were participating in a seed project titled the "Comprehensive Dance Project" initiated by the Curriculum Development Institute of the Education Department of Hong Kong. "Results obtained from the survey provided a preliminary report on teachers" views towards the existing and the proposed dance curriculum. The need for the new dance curriculum was also examined. (p. 1)

Sita Popat (2002) examined a web-based communications curriculum (TRIAD), studying 40 young dancers aged 9 to 18 from Britain, Portugal, and America, and how they used the Internet to share choreographic ideas. Although this study looked at student practices in the curriculum (perhaps making it an experienced curriculum study), it did not attend to the experience of those students. Rather, the author assessed the way the curriculum functioned. We have placed it in the category of curriculum evaluation because it was dedicated to instructing us as to better ways of teaching choreography.

There were four studies that focused on dance as a means to other than dance ends. Two studies focused on children with special education needs. Martha Cherry Mentzer and Boni B. Boswell (1995) used "anecdotal records, observational checklists, questionnaires/interviews with staff and the children, and children's original poetry" to examine "the efficacy of a movement poetry program on enhancing selected creativity variables of children with behavioral disorders. Two participants, aged 7 and 10, took part in … 16 50-minute sessions … over 10 weeks" (p. 183). They found support for their belief that dance could help these children. Ann Ross and Stephen Butterfield (1989) gave a 36-week curriculum of Dance Movement Education (D/ME) to supplement their test group's regular physical education curriculum. Using a pretest/post-test design, they found that D/ME "contributed to the children's improved motor skill performance," but they cautioned that these children were also undergoing "the effects of their growth and maturation" (p. 54). They used no control group, deeming it "unethical" to deny anyone this opportunity. Thus it is not possible to tell whether the intervention was the cause of the change found. Wendy Funk (1995) studied the effects of creative dance on movement creativity in general, in other words, studying transfer. This study compared results of pre- and post-test scores of an experimental group who received the dance treatment and a control group who received no treatment; the author had a coding scheme for determining the amount of creativity a child showed. She found significant changes in three areas in the experimental group and one area in the control group. However, when all seven dance factors were combined and evaluated together, neither the experimental nor control group had a significant change. Because there was increase in both groups, the changes in the results could not accurately be attributed to the treatment, thus disconfirming the hypothesis. However, the author went on to assert that the project demonstrated one way dance could be used to develop movement creativity in children in the public school setting. This assertion is confusing since it contradicts her findings (that creativity was not enhanced as she had envisioned). Louie Suthers and Veronikah Larkin (1996) also studied creativity,

although in their case it was dance embedded in early childhood arts games. They contended that the games worked well in the classroom and teachers, initially skeptical and reluctant to use the games, eventually came to accept the games as useful something they could actually use the games to develop good self-concept in their learners.

In terms of overall curriculum evaluation, only one citation was found. The Indiana Arts Commission (Art literacy in Indiana, 1990) sponsored an assessment of the status of the arts in public education in the state. They focused their attention on what students should learn through encounters with art practice and what districts need to do in order to make the arts more available. The need for more research in curriculum assessment is an important issue for the field. While there may be many dance programs throughout the Unites States and internationally, there is no sense of how well they are doing what they claim to do.

## Conclusion

In the conclusion of this chapter we have two major points to make, one pertaining to the contents of the chapter and the other, a challenge to the reader. In terms of the contents, we hope the reader will understand that we may have missed some work. And, we only very briefly summarized the work and hope the reader will seek out the full articles, chapters, and books, as well as other works by these authors.

In terms of a challenge to the reader, as we look over the work reviewed we find a preponderance of work is not particularly robust, including what we would consider an over-reliance on surveys, questionnaires, and psychological inventories. We would argue that dance learning is too complex to be understood through these means. We have also shown that there are some significant gaps in the literature. We hope that our identification of them will encourage researchers to embark upon new work and begin to fill in some of these gaps in dance curriculum research.

## Notes

1. A note on sources is appropriate. Sheau-Yann Liang, the first author's graduate assistant, did an extensive search of databases that might yield documents. She primarily covered journals, dissertations, books, monographs, and conference proceedings. The authors added Websites to the possibilities through using a search engine with the terms "dance curriculum research" and "dance curriculum." Additionally, the authors sought book chapters and books that might be pertinent but did not appear in search of databases. The authors read through the 2004 report from the National Dance Education Organization (Bonbright & Faber, 2004) and have taken its sources into account. However, they do recognize that the search, while extensive, could not possibly be exhaustive. They hope, therefore, that readers will be willing to share updates of materials not included, using the guidelines described in this chapter vis-á-vis objects of inquiry and modes of inquiry.
2. We considered including teacher education in this chapter for, although this curriculum occurs in higher education settings, it directly affects curriculum in P-12. However, due to space limitations we simply point the reader toward the work of Sue Stinson and Jill Green, in particular. We recognize that there may be more people doing such research but our literature review didn't reveal it.
3. "Research" is put in quotes to indicate that some of this work only marginally fits our definition of research because it is advocacy oriented.

4. By descriptive we mean that researchers do not interpret what is found for meanings beyond practical actions to be taken. They do not seek deeper meanings that might be occurring for the participants in their studies. See examples of meaning-oriented studies in both the Operationalized and Experienced Curriculum sections of this chapter.

# References

Allen, B. (1988). Teaching training and discipline-based dance education. *Journal of Physical Education, Recreation and Dance, 59*(9), 65–69.

Anttila, E. (2003). *A dream journey to the unknown: Searching for dialogue in dance education.* Helsinki: Theatre Academy (ACTA SCENICA 14).

Anttila, E. (2004). Dance learning as practice of freedom in the same difference? In L. Rouhiainen, E. Anttila, S. Hämäläinen, & T. Löytönen (Eds.), *Ethical and political perspectives on dance* (pp. 19–64). Helsinki, Finland: Theatre Academy.

Arkin, L. C. (1994). Dancing the body: Women and dance performance in *Journal of Physical Education, Recreation and Dance, 65*(2), 37–38, 43.

Art literacy in Indiana: An imperative for change. (1990). Indianapolis: Indiana Historical Bureau. National Endowment for the Arts, Washington, DC. & Indiana Arts Commission, Indianapolis. 1990 (ERIC Document Reproduction Service No. ED334115).

Blomquist, M. E. (1998). *The effect of the reciprocal approach in teaching on the process of self-discovery for beginning modern dance students at the secondary level.* Unpublished master's thesis, Brigham Young University, Provo, Utah.

Blumenfeld-Jones, D. S. (1993). Democracy education and human rights: A critical analysis in *Education in Asia, XII*(2), 31–35.

Blumenfeld-Jones, D. S. (1995). Curriculum, control and creativity: An examination of curricular language and educational values. *Journal of Curriculum Theorizing, 11*(1), 73–96.

Blumenfeld-Jones, D. S. (1998). What are the arts for?: Maxine Greene, the studio and performing arts, and education. In W. Pinar (Ed.), *The Passionate mind of Maxine Greene "I am ... not yet"* (pp. 160–173). London: Falmer Press.

Blumenfeld-Jones, D. S. (2004). Dance curriculum then and now: A critical hermeneutic analysis. In W. Reynolds & J. Webber (Eds.), *Expanding curriculum theory: Dis/positions and lines of flight* (pp. 125–153). Mahwah, NJ: Lawrence Erlbaum.

Blumenfeld-Jones, D. (2006). Aesthetic consciousness and dance curriculum: Liberation possibilities for inner city schools. In K. Rose & J. Kinchloe (Eds.), *Encyclopedia of Urban Education* (pp. 508–518). Westport, CT: Greenwood.

Blumenfeld-Jones, D. S., Barone, T. E., Appleton, N., & Arias, M. B. (1995). Curriculum and the public schools. In R. Stout (Ed.), *Making the grade: Arizona's K-12 education* (pp. 43–62). Phoenix: Arizona Town Hall.

Bonbright, J. M., & Faber, R. (Eds.). (2004). *Research priorities for dance education: A report to the nation.* Bethesda, MD: National Dance Education Organization.

Bond, K. (1994). How "wild things" tamed gender distinctions. *Journal of Physical Education, Recreation and Dance, 65*(2), 28–33.

Bond, K. E. (2001). "I'm not an eagle, I'm a chicken!" Young children's perceptions of creative dance. *Early Childhood Connections, 7*(4), 41–51.

Bond, K. E., & Richard, B. (2005). "Ladies and gentlemen: What do you see? What do you feel?" A story of connected curriculum in a third grade dance education setting. In L. Overby & B. Lepczyk (Eds.), *Dance: Current selected research, Vol. 5* (pp. 85–133). New York: AMS Press.

Bond, K., & Stinson, S. W. (2000/2001). "I feel like I'm going to take off!": Young people's experiences of the superordinary in dance. *Dance Research Journal, 32*(2), 52–87.

Buck, R. (2003). *Teachers and dance in the classroom: So, do I need my tutu?* Unpublished doctoral dissertation, University of Otago, Dunedin, New Zealand.

Chow, L. P. Y. (2002, July). *Is it the right time for a new dance curriculum in Hong Kong?* Paper presented at the 23rd ACHPER biennial conference on interactive health and physical education, Launceston, Tasmania, Australia. Retrieved January 30, 2005 from http://www.ausport.gov.au/fulltext/2002/achper/Chow.pdf

Crawford, J. R. (1994). Encouraging male participation in dance. *Journal of Physical Education, Recreation and Dance, 65*(2), 40–43.

Daly, A. (1994). Gender issues in dance history pedagogy. *Journal of Physical Education, Recreation and Dance, 65*(2), 34–35, 39.

Ferdun, E. (1994). Facing gender issues across the curriculum. *Journal of Physical Education, Recreation and Dance, 65*(2), 46–48.

Fortin, S. (1994). A description of high school students' verbal responses to a contemporary dance work. In W. Schiller & D. Spurgeon (Eds.), *Kindle the fire: Proceedings of the 1994 conference of dance and the child: International* (pp. 107–118). Sydney: Macquarie University.

Funk, W. W. (1995). *The effects of creative dance on movement creativity in third grade children.* Unpublished master's thesis, Brigham Young University, Provo, Utah.

Garrett, R. (1994). The influence of dance on adolescent self-esteem. In W. Schiller, & D. Spurgeon (Eds.), *Kindle the fire: Proceedings of the 1994 conference of dance and the child: International* (pp. 134–141). Sydney: Macquarie University.

Glaser, B., & Strauss, A. (1967). *Discovery of grounded theory: Strategies for qualitative research.* Chicago, IL: Aldine.

Graham, S. F. (1994). A quantitative evaluation of the effect of movement and dance on self-esteem. In W. Schiller & D. Spurgeon (Eds.), *Kindle the Fire: Proceedings of the 1994 conference of dance and the child: International* (pp. 162–165). Sydney: Macquarie University.

Hawkins, A. (1954). *Modern dance in higher education.* New York: Teachers College Press.

Huang, J. (1998). *Developing a graduate dance curriculum model for the Beijing dance academy in China.* Unpublished master's thesis, Brigham Young University, Provo, Utah.

Hubbard, K. W., & Sofras, P. A. (1998). Strategies for including African and African-American culture in a historically Euro-centric dance curriculum. *Journal of Physical Education, Recreation and Dance, 69*(2), 77–82.

Jackson, P. (1983). The daily grind in (Henry Giroux and David Purpel, Eds.) *The hidden curriculum and moral education* (pp. 28–60). Berkeley, CA: McCutchan Publishing Corporation.

Kerr-Berry, J. A. (1994). Using the power of West African dance to combat gender issues. *Journal of Physical Education, Recreation and Dance, 65*(2), 44–45, 48.

Lord, M. (2001). Fostering the growth of beginners' improvisational skills: A study of dance teaching practices in the high school setting. *Research in Dance Education, 2*(1), 19–40.

Lundquist, G. (2001). The relationship between play and dance. *Research in Dance Education, 2*(1), 41–52.

Macara, A., & Nieminen, P. (2003). Children's representations of dancers and dancing. In *Diálogos Possíveis: Special edition with the proceedings of the 9th dance and the child international conference* (pp. 95–101). Salvadore, Bahia, Brazil: Faculdade Social da Bahia.

Marques, I. A. (1995). A partnership toward art in education: Approaching a relationship between theory and practice. *Impulse: The International Journal of Dance Science, Medicine & Education, 3*(2), 86–101.

McLaughlin, J. (1988). A stepchild comes of age. *Journal of Physical Education, Recreation and Dance, 59*(9), 58–60.

McSwain, L. (1994). An investigation of attitudes towards dance among Sydney high school students. In W. Schiller & D. Spurgeon (Eds.), *Kindle the fire: Proceedings of the 1994 conference of dance and the child: International* (pp. 253–260). Sydney: Macquarie University.

Meglin, J. A. (Ed.). (1994). Dance dynamics: Gender issues in dance education. *Journal of Physical Education, Recreation and Dance, 65*(2), 25–48.

Meiners, J. (2001). A dance syllabus writer's perspective: The new south Wales K-6 dance syllabus. *Research in Dance Education, 2*(1), 79–88.

Mentzer, M. C., & Boswell, B. B. (1995). Effects of a movement poetry program on creativity of children with behavioral disorders. *Impulse: The International Journal of Dance Science, Medicine & Education, 3*(3), 183–199.

Muehlhauser, E. K. (1998). *Exploring ownership of learning in children's choreographic projects.* Unpublished master's thesis, University of Oregon, Eugene, Oregon.

Neal, N. D., & Fortin, S. (1986). Domain discrimination in dance attitude research (ERIC Document Reproduction Service No. ED309146).

Nielsen, C. S. (2003). Dance as a form language in Danish schools. In *Diálogos Possíveis: Special edition with the proceedings of the 9th dance and the child international conference* (pp. 131–135). Salvadore, Bahia, Brazil: Faculdade Social da Bahia.

Popat, S. (2002). The TRIAD project: Using internet communications to challenge students' understandings of choreography. *Research in Dance Education, 3*(1), 21–34.

Posey, E. (1988). Discipline-based arts education: Developing a dance curriculum. *Journal of Physical Education, Recreation and Dance, 59*(9), 61–64.

Ross, A., & Butterfield, S. A. (1989). The effects of a dance movement education curriculum on selected psychomotor skills of children in grades K-8. *Research in Rural Education, 6*(1), 51–56.

Shapiro, S. B. (1998). *Dance power and difference: Critical and feminist perspectives on dance education.* Champaign, IL: Human Kinetics.

Shapiro, S. B. (2001). *Pedagogy and the politics of the body.* New York: Garland.

Shue, L. L., & Beck, C. S. (2001). Stepping out of bounds: Performing feminist pedagogy within a dance education. *Communication Education, 50*(2), 125–143.

Stake, R. E. (2003). *Standards-based and responsive evaluation.* Thousand Oaks, CA: Sage.

Staley, K. T. (1993). *Educating through dance: A multicultural theoretical framework.* Unpublished doctoral dissertation, Texas Woman's University, Denton.

Stinson, S. W. (1982). Aesthetic experience in children's dance. *Journal of Physical Education, Recreation and Dance, 53*(4), 72–74.

Stinson, S. W. (1985a). Curriculum and the morality of aesthetics. *Journal of Curriculum Theorizing, 6*(3), 66–83.

Stinson, S. W. (1985b). Piaget for dance educators: A theoretical study. *Dance Research Journal, 17*(1), 9–16.

Stinson, S. W. (1986a). Children's dance: A larger context. *Drama/Dance, 5*(2), 6–18.

Stinson, S. W. (1986b). Planning the dance curriculum: A process of dialogue. *Drama/Dance, 5*(2), 36–46, 51–53.

Stinson, S. W. (1991). Dance as curriculum, curriculum as dance. In G. Willis & W.H. Schubert (Eds.), *Reflections from the heart of curriculum inquiry: Understanding curriculum and teaching through the arts* (pp. 190–196). New York: State University of New York Press.

Stinson, S. W. (1993a). Meaning and value: Reflecting on what students say about school. *Journal of Curriculum & Supervision, 8*(3), 216–238.

Stinson, S. W. (1993b). A place called dance in school: Reflecting on what the students say. *Impulse: The International Journal of Dance Science, Medicine, & Education, 1*(2), 90–114.

Stinson, S. W. (1993c). Voices from schools: The significance of relationship to public school dance students. *Journal of Physical Education, Recreation & Dance, 64*(5), 52–56.

Stinson, S. W. (1997). A question of fun: Adolescent engagement in dance education. *Dance Research Journal, 29*(2), 49–69.

Stinson, S. W. (2001). Choreographing a life: Reflections on curriculum design, consciousness, and possibility. *Journal of Dance Education, 1*(1), 26–33.

Stinson, S. W. (2004). Teaching ethical thinking to prospective dance educators. In L. Rouhiainen, E. Anttila, S. Hämalainen, & T. Löytönen (Eds.), *The same difference? Ethical and political perspectives on dance* (pp. 235–279). Helsinki, Finland: Theatre Academy.

Stinson, S. W. (2005a). The hidden curriculum of gender in dance education. *Journal of Dance Education, 5*(2), 51–57.

Stinson, S. W. (2005b). Why are we doing this? *Journal of Dance Education, 5*(3), 82–89.

Stinson, S. W., Van Dyke, J., & Blumenfeld-Jones, D. (1990). Voices of adolescent girls in dance. *Dance Research Journal, 22*(2), 13–22.

Suthers, L., & Larkin, V. (1996). *Early childhood arts games.* Newcastle, Australia: Macquarie University (Eric Document Reproduction Service No. ED403 056).

Vail, K. (1997). Practice makes perfect. *American School Board Journal, 184*(6), 28–31.

van Papendorp, J. (2003). *Dance, culture and the curriculum*. In *Diálogos Possíveis: Special edition with the proceedings of the 9th dance and the child international conference* (pp. 195–201). Salvadore, Bahia, Brazil: Faculdade Social da Bahia.

Warburton, E. C. (2004). Knowing what it takes: The effect of perceived learner advantage on dance teachers' use of critical-thinking activities. *Research in Dance Education, 5*(1), 69–82.

Wildschut, L. (2003). How children experience watching dance. *Special proceedings of the 9th dance and the child international conference*. In *Diálogos Possíveis: Special edition with the proceedings of the 9th dance and the child international conference* (pp. 247–259). Salvadore, Bahia, Brazil: Faculdade Social da Bahia.

Yoder, L. (1992). *Enhancing individual skills in dance composition and performance using cooperative learning structures*. New York: The National Arts Education Research Center at New York University. (Eric Document Reproduction Service No. ED 366 597).

# INTERNATIONAL COMMENTARY

# 16.1

## Research on Dance Curriculum in Australia and New Zealand

**Ralph Buck**

*University of Auckland, New Zealand*

Research examining historical foundations of dance curriculum in Australia and New Zealand (Buck, 2003; Osmotherly, 1991) has noted the significance of work outside the time frame of this chapter, especially conceptualization of dance curriculum by United Kingdom dance educator Janet Adshead (1981).

In New Zealand, Tina Hong completed her doctoral thesis on *Developing Dance Literacy in the Postmodern: An Approach to Curriculum* in 2002. This curriculum research informed the development of the document *The Arts in the New Zealand Curriculum* (2000) and most specifically the dance component within this document. It is heartening to know that as this *Handbook* goes to press there are other scholars in New Zealand completing research in curriculum evaluation and history.

Within the Asia Pacific region, dance education is changing and growing rapidly. In Hong Kong, Sue Street (2001) acknowledged the pedagogical and curriculum shifts and visions, while research by Tak-on (2003) outlined survey data reflecting curriculum deliberation and evaluation. Similarly, in Singapore Carino (2001) provided insightful formal curriculum research into the design of a dance education elective program in the school curriculum.

## References

Adshead, J. (1981). *The study of dance*. London: Dance Books.
Buck, R. (2003). *Teachers and dance in the classroom: "So, do I need my tutu?"* Unpublished Ph.D., University of Otago, Dunedin.
Carino, C. (2001). Creating a dance elective program: A proposal for Singapore. In S. Burridge (Ed.), *World dance alliance 2001 Singapore: Asia pacific dance Bridge* (pp. 85–99). Singapore: World Dance Alliance.
Hong, T. (2002). *Developing dance literacy in the postmodern: An approach to curriculum*. Unpublished Ph.D., Griffith University, Brisbane.
Ministry of Education New Zealand. (2000). *The Arts in the New Zealand curriculum*. Wellington: Learning Media.

*L. Bresler (Ed.), International Handbook of Research in Arts Education, 261–262.*
© 2007 *Springer.*

Osmotherly, R. (1991). *Dance education in Australian schools*. Brisbane: Australian Association for Dance Education.

Street, S. (2001). New developments in dance education in Hong Kong. In S. Burridge (Ed.), *World dance alliance: Asia pacific dance bridge Singapore 2001* (pp. 65–71). Singapore: World Dance Alliance.

Tak-on, S. (2003). *School dance education research and development project: Report of the questionnaire survey and summary of the interviews*. Hong Kong: The Hong Kong Dance Alliance.

# INTERNATIONAL COMMENTARY

## 16.2

## Dance Curriculum Research in Africa

**Minette Mans**
*Windhoek, Namibia*

In Africa, the notion that African dance is exotic but does not belong in formalized curricula has severely limited research in dance curriculum. Dance education in schools is rare, exceptions being a few specialized art schools in South Africa, Ghana, and Nigeria. Existing dance curricula usually promote a specific way of teaching, and advanced students learn the practice with good choreographers. Tertiary education in dance can be found at several universities across the continent, but to date these curricula generally remain firmly rooted in Western dance principles, with African dance classes attached as extras. A notable exception was Mudra Afrique (1977–1986) in Dakar, where Germaine Acogny developed an African dance curriculum into which she also blended certain Western techniques. A quick glance at recent South African attempts to Africanize existing dance curricula in schools, shows that while they espouse multiculturalism in theory (learning "cultural dances" as though they are and always will be frozen in time), there are no clear indications what a teacher or learner should do, except to consult with "experts in the community."

Research continues to conceptually explore and refine the philosophies that underpin African dance (Asante, 1996), or to record the countless ethnochoreological studies that explore characteristics of dance in different regions. In early development stages yet, several dancer-scholars are attempting to formalize a Pan-African dance system that would not be overly influenced by culture, ethnicity, or region, but which addresses commonalities of dance within the broader African continental context. Tiérou (1992), Dagan (1997), Mans (1997), Bakare and Mans (2003), and others, have all tried to extract movement components and stances from the broader scheme of African traditions, and to reduce them to common basics. In Namibia, this led to a national dance curriculum for schools that would incorporate these movements. It appears that no research in African dance curricula has been done on the effects of a particular dance curriculum on students or teachers. Evaluations of the outcomes of dance curricula take place at school level in certain countries, but this has yet to be

*L. Bresler (Ed.), International Handbook of Research in Arts Education*, 263–264.

collated and analyzed. The field of dance curriculum research requires urgent attention if dance is to play out its educational role as fundamental embodiment of Africanness.

# References

Asante, K. W. (Ed.). (1996). *African dance: An artistic, historical and philosophical inquiry*. Trenton, NJ: Africa World Press.

Bakare, O. R., & Mans, M. E. (2003). Dance philosophies and vocabularies. In A. Herbst, M. Nzewi, & K. Agawu (Eds.), *Musical arts in Africa: Theory, practice and education* (pp. 215–235). Pretoria: Unisa Press.

Dagan, E. (Ed.). (1997). *The spirit's dance in Africa: Evolution, transformation and continuity in sub-Sahara*. Montreal: Galerie Amrad African Art Publications.

Mans, M. E. (1997). Namibian music and dance as *ngoma* in arts curricula. Unpublished doctoral dissertation, University of Natal, Durban.

Tiérou, A. (1992). *Dooplé: The eternal law of African dance*. Choreography and Dance Studies Vol. 2. Chur, Switzerland: Harwood.

# 17

# MUSIC (AND ARTS) EDUCATION FROM THE POINT OF VIEW OF *DIDAKTIK* AND *BILDUNG*

**Frede V. Nielsen**

*Danish University of Education, Denmark*

This chapter deals with the theoretical basis of music education from the perspective of *Didaktik* and *Bildung*. Parallels will be drawn to education in other arts subjects. The concepts of *Didaktik* and *Bildung* are closely connected with a continental European pedagogic tradition and have special significance in the German language area and in Scandinavia. Because no terms in English readily correspond to *Didaktik* and *Bildung*, the German terms will be used in order to retain the intended conceptual content. For the adjective form of Didaktik, "Didactic" is suggested.

The chapter will focus on Didaktik in the tradition of Bildung.[1] The text emphasizes the situation and development in Germany and Scandinavia after approximately 1950, when Didaktik grew as a specific area of theory and research. In the case of subject-matter Didaktik, this took place especially after 1970.

## The Concept and the Object of Study of Didaktik

*Concept and Tradition*

The word "Didaktik" derives from the Greek *didáskein* (to teach, to be taught). A corresponding expression in Latin is *didactica*, which is found in more recent times in the famous work *Didactica magna* by J. A. Comenius (1592–1670) (Comenius, 1985). Didaktik as an object of study within pedagogy and as a theoretical and scientific discipline is closely related to the tradition of German humanities (*Geisteswissenschaft*) over the last 200 years (Hermann, 1983; Thiersch, 1983). In the second half of the twentieth century, key figures affiliated with Didaktik in general (*allgemeine Didaktik*) include Erich Weniger (1894–1961), Herwig Blankertz (1927–1983), Paul Heimann (1901–1976), Wolfgang Schulz (1929–1993), Gunter Otto (1927–1999), Hilbert L. Meyer (born 1941), and not least, Wolfgang Klafki (born 1927).

*L. Bresler (Ed.), International Handbook of Research in Arts Education, 265–286.*

The German and Scandinavian concept of Didaktik refers to a particular pedagogic tradition, even though, like the Anglo-American concept of curriculum, it deals with teaching/learning and its written basis (*"Lehrplan"* and "curriculum" respectively).[2] Research in the Didaktik tradition is distinctive in that it is analytically reflective, philosophically interpretive and critical. This can be explained by the fact that Didaktik, in terms of both theory and practice, is intertwined in a vision of human *Bildung* and related thinking about the rationale of upbringing and education. In the Didaktik tradition, the teacher is expected to be able to take part in discussions about educational aim and content and to contribute to developing them. This affects teacher training at colleges and universities of education, which therefore become the home of Didaktik as scholarly activity.

The curriculum tradition has affected the European Didaktik tradition in two waves. In the 1970s and 1980s, a "curriculum revision" manifested itself in Germany, but on the whole it seems to have taken place within the framework of Bildung theory.[3] In the past decade the part of curriculum thinking that focuses on teaching and learning as goal and standard oriented has been influential in countries that are otherwise characterized by the Didaktik tradition.

*Demarcation*

There are diverging conceptions and theories of how Didaktik is to be delimited in relation to other subsections of pedagogy. Roughly speaking, there exist (a) a specific conception of Didaktik, which is first and foremost concerned with the question of the content, aim, and rationale of teaching and learning, together with the criteria for the selection of content, and (b) a broad conception, according to which practically all problems regarding teaching and learning are viewed as Didactic, including questions of teaching methods, forms of organization, and the choice of media (Heimann, Otto, & Schulz, 1965; Schulz, 1970).

The "correct" demarcation of the field of Didaktik can only be determined on the basis of a given theoretical position.[4] This does not mean that one can arbitrarily choose the extent to which questions of the method and organization of teaching and learning, the choice of media, and so forth, are important or not. The problem is whether they are regarded as questions of another category than questions about the content and rationale of teaching/learning, and are in principle subordinate to them (Adl-Amini, 1981, 1986). From the perspective of Bildung, this would be the case (a relationship also referred to as *Primat der Didaktik*, primacy of Didaktik). On the other hand, it has been claimed that there is an interplay between the goal, content and method dimensions of teaching/learning as equally important (Jank & Meyer, 2002), or that it is a case of an "inter-dependency" (Adl-Amini, 1986; Blankertz, 1975). The treatment of this problem is complicated, however, in part by the presupposed Bildung theoretical perspective, and in part by problems related to the determination of the very concept of teaching/learning content as a theoretical category.

Nonetheless at present it is possible to summarize one main problem of Didaktik based on the concept of Bildung in the following question: What is (most) essential to learn and therefore to teach and why? Künzli puts it this way: "We may identify the

more or less explicit predominance of the content aspect over the other aspects of instruction as the fundamental characteristic of German Didaktik" (2000, p. 43).

Didaktik denotes *both* (1) the theory and science *and* (2) the planning and decision-making of teaching and learning. "Didaktik" thus refers to both *theoretically oriented* and the *practically directed* concerns. A widespread understanding of the object of study of Didaktik can therefore, conditioned by the specific Didaktik concept, be summarized in the following definition: Didaktik deals with the theory and science as well as the planning and decision-making of the content, aim and rationale of teaching/learning. In the case of the broad Didaktik concept, methodological and organizational issues, choice of media and so forth are also comprised. Jank and Meyer opt for an even broader definition: "Didaktik is the theory and practice of learning and teaching" (2002, p. 14).[5]

It may seem inappropriate to let "Didaktik" refer to both a theoretically oriented and a practically directed perspective on teaching and learning. Attempts have been made to make a systematic distinction between the two perspectives by distinguishing between (a) *Didaktologie* (didactology) that is a descriptive, analytical, theoretical and science-oriented perspective, and (b) *Didaktik* (didactics) that is a normative, prescriptive, practical and action-oriented perspective (Nielsen, 2005).

## Subject-Matter Didaktik ("Fachdidaktik")

Where there is teaching, something is taught. There will always be educational content. It is the task of subject-matter Didaktik to deal with teaching/learning content or the potential content of a subject area (e.g., the arts), a subject (e.g., music) or parts of a subject (e.g., singing, playing, composition, or music of a given period) in a more concrete form than is possible within general Didaktik. Since subjects have different characteristics and traditions (e.g., arts subjects vs. science subjects or music vs. visual art), and these differences color Didactic thinking about and in the subject, it may be more correct to speak of subject-matter Didaktiks in the plural.

W. Klafki has emphasized subject-matter Didaktik as a "field of relations" between the subject and pedagogy:

> The individual sciences do not in themselves develop adequate selection criteria, even though of course Didactic decisions cannot be made irrespective of the sciences they refer to. As independent scientific disciplines, the Didaktik of individual subjects must be developed in the boundary between, or rather: in *the field of relations* [italics added] between pedagogical sciences and basic sciences. (Klafki, 1985, pp. 36–37)[6]

The subject-oriented Didactic analysis and reflection as the precondition of selecting and justifying educational content, planning of the teaching/learning process and explication of its conditions take place (a) on various levels and (b) in several dimensions related to the significance of the content for the student.

(a) On a general level, it may be asked, what subjects, topics and activities should be compulsory in ordinary schools and on what grounds? Should arts subjects have

this status and why? On the next level, which arts subjects and to what extent? Should it be music and/or visual arts and/or drama and bodily movement? This raises the question of the relationship between these subjects and between the individual subject as a school subject and the branch of art on which it is based. This means that fundamental aesthetic problems related to views on art, on music, and so forth, become an aspect of the subject-matter Didactic reflection (Nielsen, 2005). On yet another level it may be asked, what music, what forms of musical activity, and why?

(b) Didactic analysis has been emphasized as the essence of the teacher's planning and preparation of teaching by raising a number of key issues:[7] the significance of the content for the student seen in his/her present-day perspective and in his/her future perspective, the structure and essence of the content area as such, the exemplary value of the concrete teaching/learning content, and the accessibility of the content for the student. The combination of these issues grows out of an overarching double perspective, namely, a perspective based on the content itself (the importance of it) and on the student (the importance for him/her) as well as the interrelation between these two perspectives. Moreover, the teacher's confrontation with these questions when planning presupposes that he or she engages in theory-based reflection and consideration. The interplay between the three main elements of the "triangle of Didaktik" – the content, the student and the teacher – becomes decisive (Künzli, 2000).

## Subject-Matter Didaktik Positions

Several types of high-level criteria for the selection of teaching/learning content in arts subjects can be identified:[8]

(1) In the position of *basic subject Didaktik*, the point of departure is the subject itself (e.g., music) and its structure, extending from an *ars* to a *scientia* dimension (music as art, craft and science). Characteristic forms of activity in arts subjects correspond to this continuum.[9]

(2) In the *ethno-Didaktik* position, the point of departure is pupils' everyday experience and criteria arising out of current local culture. It represents a micro-cultural position in post-modern style.[10]

(3) In *critical challenge Didaktik*, the point of departure is the great social problems, such as environmental issues, global North-South relations, conditions of democracy, or for that matter terrorism. The position has a macro-cultural, problem-oriented, and inter-disciplinary bias. A theory of social criticism is an anchoring point.[11]

(4) In *existence Didaktik*, the point of departure is the fundamental existential conditions and the question and view of what it means to be a human being. The endeavor is towards a unifying conception of general education through a determination of what is generally human and the common core of humanity. The concept of "life world" and expressions of life in symbolic forms (inclusive of the arts) are crucial to the position. Philosophical anthropology and phenomenology may be theoretical bases.[12]

# Bildung and Bildung Theories

*The Concept of Bildung*

The concept of Bildung originated in the second half of the eighteenth century and grew in importance for pedagogic thinking in the beginning of the nineteenth century. It is associated with the current of thought called neo-humanism (Lenzen, 1989). In the concept of the cultured person (*der Gebildete*) the neo-humanists[13] formulated an ideal image of man in clear contrast to philanthropy and its utilitarian rationale of upbringing and education. Neo-humanists' thinking on the topic of education was not aimed at vocational utility, but at "general Bildung," which was best achieved, according to neo-humanistic thinking, at a certain distance from daily practical circumstances.

Key terms are "individuality," "completeness," "universality," and *"Mündigkeit."* The idea is that human beings do not have personal individuality when they are born. This is gradually acquired in a process of Bildung that leads to personal freedom. Bildung must be complete in the sense that all of a person's powers (*"Kräfte"*), not just single skills, should be cultivated. The attainment of personal individuality means that the powers are developed as an integrated whole. The content of Bildung is based on this aim. It should be universal in the sense that it represents the spiritual structures and values that are necessary for the individual's complete development. It is thus "general" in the double sense that it has the status and character of something that is both of a general sort and of significance to everyone. The neo-humanists believed that they could find something along these lines realized (i.e., objectified) in antique culture.

Bildung is supposed to lead to creation of personal *Mündigkeit.* Mündigkeit is a concept related to personality and citizenship rooted in the philosophy of the Enlightenment, which can be said to epitomize the pedagogic Bildung thinking of the last 200 years. In a famous formulation Immanuel Kant links enlightenment and *Mündigkeit* in this way:

> Enlightenment is man's release from his self-incurred tutelage. Tutelage is man's inability to make use of his understanding without direction from another. Self-incurred is this tutelage when its cause lies not in lack of reason but in lack of resolution and courage to use it without direction from another. (Kant, 1980, p. 85)

The intertwining of Bildung and Didaktik appears from a basic pedagogic question formulated by Wolfgang Klafki in accordance with Humboldt, Schleiermacher and others: What content and subject matter must young people come to grips with in order to live a self-competent and reason-directed life in humanity, in mutual recognition and justice, in freedom, in happiness and self-fulfilment? (Klafki 1986, 2000b).

This both implies a relation between the two concepts and suggests something about the nature of Bildung. The goal is man's self-determination and autonomy based on reason, a life in freedom and mutual respect between fellow human beings. Through a process of Bildung, a human being becomes him- or herself in cooperation with others (*Selbsterfüllung*). Bildung is not a foregone conclusion or something given by others,

but must be acquired in a personal Bildung process (*Selbstbildung*) within historical, social, and cultural frameworks. Bildung is the main aim, and educational content (subjects, topics) is the means to achieve this aim. Seen in this light, the arts-oriented subjects are means to achieve Bildung. The content of Bildung is a historically conditioned phenomenon. Artistic forms of expression also change, as does the understanding of their nature and function. Therefore, the arts subjects must continuously be justified, legitimized and be brought up to date as means of achieving Bildung.

## Bildung Theories and Didaktik Consequences

A Bildung theory is a theoretically based idea and comprehensive view of the main aims of upbringing and general education as well as its main means, building on a notion of human nature and society. Seen from the perspective of Didaktik, a Bildung theory provides a point of departure and a direction for the selection, justification and legitimization of educational content and the ways of dealing with it, even though the content cannot be derived directly from the idea of Bildung.

A distinction can be made between main positions of Bildung.[14] In *material Bildung theories* the teaching/learning matter, including the subject-related forms of activity, is central and in itself a criterion for the selection of educational content. In the subject of music, this means education *to* music rather than *through* music. Based on an *"objectivistic"* notion of material Bildung, the goal is to attain as comprehensive an amount of subject-related knowledge as possible, without any more specific criteria for importance (ready knowledge, encyclopedic knowledge). In *"classic"* material Bildung thinking, the idea is, on the contrary, that cultural objects that have achieved the status of classics within our culture first and foremost have Bildung value (*Bildungsgehalt*). The idea behind this notion is that such objects (not least objects of art) embody and objectify the essential spiritual structures and values of culture. Therefore, one becomes cultivated (*gebildet*) through one's encounter with the works. Current thinking in terms of canons rests on this sort of classic Bildung thinking, even though the underlying theory about the objects' embodiment of subjective (spiritual) structures is seldom revealed. Because of this, the public and political canon discussion may tend to move in the direction of an objectivistic Bildung position (knowledge of as many works and as much data as possible). This seems to be a state that can be characterized using Adorno's concept of "half-Bildung" (*Halbbildung*, Adorno, 1962).

In *formative Bildung theories*, the person going through and becoming formed by the process of Bildung ("formation") is in focus. The educational content is the means to realize this formation. In the case of *"methodological"* Bildung, the idea is to acquire methodological knowledge and insight with the aim of being able to apply it in other contexts as well. To use a pedagogic slogan, it is about "learning to learn." The *"functional"* Bildung theory is based on an anthropology and a notion of human beings as encompassing a number of general "powers" (*"Kräfte"*) of a cognitive, bodily and moral nature (e.g., powers of logical thinking or creativity), which are developed through the Bildung process. This view of Bildung is probably the one closest to the neo-humanists' original Bildung thinking. In the arts subjects, not least in music education, a philosophy in accordance with functional Bildung (in its extreme form

approaching a therapeutic aim) has played a prominent role as a legitimization strategy as far back as in Ancient Greek thinking (Plato, Aristotle) and has been a powerful thesis ever since (Nolte, 1986; Kraemer, 2004). There has been considerable interest in investigating whether there is empirical evidence to support an effect on upbringing through the arts (especially music) that goes beyond subject-related learning. This interest has been expressed in psychological theory ("transfer") and has been conducted in experimental research[15] as well as in naturalistic teaching/learning research.[16] An overall impression is that formative effects of arts education, and transfer from one cognitive dimension to another, are scientifically documented to a lower degree than generally believed and often asserted.

According to the theory of *categorial Bildung*, Bildung is ultimately not a question of either material or formative Bildung, but both. An integration of the two perspectives has been developed by Wolfgang Klafki in his categorial Bildung theory (1963). In a well-known formulation he expresses this double-sided perspective: "Bildung is categorial Bildung in the double sense that a reality has been opened 'categorially' to the human being, and that in this way – thanks to the self-gained 'categorial' knowledge and experience – he/she has been opened to this reality" (p. 44).

Three concepts have been central in the formulation of the categorial Bildung theory. The "elementary" (*das Elementare*) concerns the object side and the material dimension in the categorial double relation. Something "elementary" signifies important characteristics and aspects of, for example, objects of art and music, structural and stylistic traits and historical conditions of such phenomena. The student's encounter with elementary aspects of an object area may result in "fundamental" experiences. The "fundamental" (*das Fundamentale*) thus signifies something essentially meaningful seen in relation to the subject side (the student) in an interplay between the object and the subject. The Bildung process thereby acquires the character of a hermeneutic spiral of understanding, where the horizons of the object and the subject meet and intervene. The fundamental experience of something elementary arises through dealing with phenomena and problems that are "exemplary." The "exemplary" (*das Exemplarische*) refers to typical examples that facilitate further understanding of the object area. A good example has an "eye-opening" pedagogic function.

There are special Didactic problems with the concept of the elementary. Related to the subject of music, it can be differentiated into four categories (element, simplicity, originality, and essence), which have all had an impact on the determination of content and the conceptualization of general music education. On this basis a phenomenology-oriented theory of art objects' "multi-spectral universe of meaning" and their "correspondence" with human consciousness has been developed.[17]

*Critically oriented Bildung* builds on the view that the said Bildung theories may have a one-sided culture-preserving effect. According to this view, their perspective is to lead into culture and not to change it. A critical-emancipatory Bildung idea has drawn inspiration from a socially and ideologically-critical theory that had considerable influence on educational philosophy and general education in Western democracies starting in the late 1960s. A "Bildung-socialization" with critical potential was contrasted with an "adaptation-socialization," which, it was claimed, built on the tutelage of man (Hellesnes, 1976). There are important common traits between this line of

thinking about Bildung on the one hand and the previously discussed critical challenge Didaktik and the critical-constructive Didaktik developed by Klafki on the other. This Didactic position can be seen as a socially critical further development of his categorial Bildung theory. However, the internal connection between these elements in Wolfgang Klafki's pedagogic thinking does not yet appear to be analytically clarified. Nonetheless, special perspectives may emerge in relation to arts subjects seen in a critical Bildung context, because the art object potentially embodies the articulation, objectification and experience of a utopia and vision that cannot yet be expressed verbally, but which, by aesthetic experience, can bring us in touch with our own and others' inner potential (Marcuse, 1978). A perspective of aesthetic *Mündigkeit*, aesthetic Bildung, and aesthetic rationality seems to be outlined.

The Bildung positions discussed here constitute a point of departure and a basis for Didactic reflection and deciding. They are seldom directly put into practice in institutionalized general education (e.g., in the individual school subjects) but as trends they are also applicable here. Therefore there are connections between the views of Bildung described here and the previously described basic positions of (subject-matter) Didaktik; for example, between critically oriented Bildung and critical challenge Didaktik. However in concrete form, this will also have to build upon categorial Bildung concepts, which in turn will act as links to basic-subject-related dimensions. The connection between Didaktik and Bildung thinking is therefore constitutive for the concept of Didaktik itself and the Didaktik tradition as a whole, yet the connection is not simple, but rather extremely complex, many-sided and often indirect. The relation is in itself a challenge for Didactic reflection in its own continuous clarification process.

## The Concept of Content in Relation to Arts Subjects

### The Double-Sided Concept of Content

The concept of content, understood as the content of teaching and learning, is central to Didactic thinking. However, as a theoretical category, the concept seems only partially clarified.[18] In relation to arts subjects, a distinction must be made between two dimensions of content. The teaching/learning can be related to the following:

- phenomena, objects and their characteristics, for example music, paintings, drama, dances of given periods, in given genres and styles, with given characteristics of form and structure, and with given functions, purposes and effects, and
- subject-related forms of activity (ways of dealing with the media and phenomena in question), for example playing, singing, drawing, dancing, forming, producing, reciting, describing, analyzing, interpreting, reflecting.

In curricula of arts subjects and in course schedules for education programs, content of both types can normally be found, but it can be seen that the content description is heavily weighted on the activity side, for example, in connection with the teaching of young children.[19]

Both the object and the activity categories may have the characteristics of and function as teaching/learning content. As Didactic categories, both of them are functionally

determined. If the purpose of a course is that the student gains insight into currents in music after 1950, it may be of lesser importance (not meaning that it is without importance) in terms of content whether this insight is gained by singing, playing, analyzing or composing pieces of music in styles characteristic of the period. The form of activity here has the function of method. The situation is reversed if the goal is to learn to sing, to play an instrument, to analyze or to compose. The form of activity then assumes the status of content. A result of this functionally determined distinction between teaching/learning content and method is that much planning and preparation of teaching could be focussed more clearly by being confronted with the question of to what extent a possible element should have the status of content or the status of method.

## Subject-Related Forms of Activity

A subject-related form of activity should be understood as a way the student can engage in (be "actively" involved with) the medium and the object area in question. In relation to art subjects a distinction can be made between five forms of activity that are potentially content-oriented:[20]

| | |
|---|---|
| Production | create, compose, improvise, paint, shape, produce, write |
| Reproduction | recreate, carry out, perform, recite |
| Perception | receive sense impressions and process them so they give musical, artistic, dramatic, poetic meaning |
| Interpretation | analyze and interpret music, art, drama, dance, poetry, and so forth, and as a rule express understanding and interpretation in another medium than the medium analyzed (most often verbal) |
| Reflection | put into perspective, consider, investigate music, pictures, drama, dance, poetry etc. in historical, sociological, psychological and other contexts |

A few comments:

(1) The category "reproduction" is connected in particular to forms of art whose medium is temporal (e.g., music), and where the object produced is contained in a form of notation (e.g., a score) as a basis for the subsequent realization of the object (the sounding work of music). Production and reproduction are in this case two different but equally important processes, even though they can also meld together (e.g., in improvisation). There is a corresponding situation for poetry reproduced in spoken language (recitation), and for works of drama (re-production of plays, musicals), including some types of bodily movement (e.g., ballet).

(2) Each of the five forms of activity comprises several sub-functions. They are also mutually connected. For example, all good reproduction of music and drama is also creative and interpretive, and almost unthinkable without simultaneous perceptual activity. Taken on its own, the interpretation category is meant as analytical interpretation in accordance with hermeneutic tradition (most often verbal,

but other trans-medial interpretations are also possible). Finally, there is no hard-and-fast boundary between verbal analytic interpretation and reflective activity.

(3) The five areas of activity viewed as a whole encompass both the *ars* and *scientia* dimensions in arts subjects as well as the connections between them. They can thus utilize the entire basis of the basic subject (the art, the craft and the science aspects).

(4) Seen in a broader perspective, the five forms of activity are not attached to artistic phenomena alone. From a general Bildung point of view the activities may function as approaches to all aspects of our world and life that we can sense, experience, interpret, understand, imitate, recreate, think about and consider in a critically reflective way. In this sense the forms of activity constitute a system of *general Bildung categories*, which can contribute to establishing connection and equality between artistic activity and the activities of other subjects and to justify arts subjects as means to achieve general Bildung.

## Positions, Conceptions and Development Trends of Didaktik in General Music Education

Over the last 50 years several specific positions, conceptions and development trends of Didaktik have found expression in general music education (music as school subject). This is also true of other arts subjects, but will be exemplified here on the basis of music. Especially after 1970, new conceptions can be observed.

### Conceptions and Positions

A music Didaktik "conception" should be understood as a reasonably coherent and justified combination of emphases with regard to the musical content, the forms of activity, the use of media and the working methods. As a rule, conceptions have a normative basis, which in the course of a long tradition of practice has a tendency to become implicit, whereas in connection with newly developed conceptions, it will often assume a more explicit form. Often a music Didaktik conception is argued for polemically in opposition to other conceptions, but different conceptions can also be combined in practical music teaching and learning, which may result in the blurring of the contours of the individual points of departure. This means that a music Didaktik conception in some cases may be noticeable without appearing unadulterated. In other cases, it is expressed in a relatively pure form as a "method concept."

A music Didaktik "position" should be understood as something more general. It can bring together several conceptions and sub-trends and contribute to the understanding of their common purpose, justification and theoretical basis.

Despite these efforts toward defining the two concepts it is not an easy task to achieve a coherent and detailed understanding and overview, because different criteria for systematizing meld together. This becomes apparent through a critical reading of

research and presentations of overviews, for example, Schmidt (1986), Gruhn (1993), Helmholz (1995), Hanken and Johansen (1998), Nielsen (1998), Helms, Schneider, & Welder (2005), Jank (2005). Combining historical and systematic criteria it seems possible to isolate the following categories:

(1) "Music as a singing subject" denotes a traditional version of the general school subject (from the beginning of the nineteenth century), whose designation in most European countries was only changed from "singing" to "music" after 1950. It is possible to distinguish between three sub-positions, which may be structured into partially independent conceptions, but may also be combined. (a) The songs that are sung constitute the main content due to their value as cultural objects and their function in introducing pupils to culture and community. (b) The songs are a means to learn about and be introduced to musical structure in a general sense. To a large extent this seems to be the case in the transition of the Kodály conception from Hungarian national culture to functioning as a method concept in Western countries' music education. (c) The singing (or vocal) activity itself is the main content for physiological (voice development), psychological (expression of oneself) and socio-psychological (together with others) reasons.[21]

(2) "Music as a '*musisch*' subject" is an aspect of German reform pedagogy and is based on the Ancient Greek concept of "*musiké*" (the integration of music, poetry, and bodily movement). It may therefore draw other forms of art into music teaching and learning. It is based on formative Bildung thinking, including a notion of the formative effect of music on human "creative powers." A philosophical point of departure is an anthropological notion of the originally human, which today, according to the position, can be found mainly in the child and in ethnic communities. A critical relation to modern Western civilization may be the result. Pedagogic slogans include "from the child" ("*vom Kinde aus*"), "the creating child" ("*das schaffende Kind*"), and the aim of "preserving the child in us." The *musisch* position played a major role in general music education in Germany and Scandinavia throughout most of the twentieth century and even gave impetus to the creation of schools with distinct *musisch* profiles. Many characteristics of the position can, for example, be found in the Carl Orff conception, at least in its original form in Germany and Austria.[22]

(3) "Music as a matter-of-music subject" arose as a position specifically focused on "music" as opposed to "*musisch*" (cf. Adorno, 1956) and was expressed comprehensively in influential books by Michael Alt (1973) and Heinz Antholz (1976). The position is characterized by being based on material and categorial Bildung and comprising both *scientia*- and *ars*-oriented activities, but in more radical forms it may become of a one-sided *scientia*-nature and even become marked by science propaedeutics (cf. Eggebrecht, 1972; Günther & Kaiser, 1982; Richter, 1980). In all cases some form of *scientia*-based content and activity is included, and the analysis of music is a main category of content. A specific conception in this context is the so-called "Didactic interpretation" (Helms, Schneider, & Weber, 2005) developed theoretically and practically by K. H. Ehrenforth (1971) and Christoph Richter (1976) on the basis of hermeneutic theory.

(4) "Music as a social subject" generally has an important basis in critical social science theory and specifically in music sociology as a sub-discipline of musicology. It is therefore primarily *scientia*-oriented, but based on a political and social engagement it also develops in the direction of an *ars*-orientation. The position thus becomes divided, according to Nielsen (1998), into an ideology-critical relation to market-governed popular music and an ethno-Didactic acceptance of this same music. This apparent paradox does not yet seem to have been thoroughly researched. A concrete conception that articulates several aspects of the position can be found in the textbook system *Musik aktuell* (Breckoff et al., 1974), which includes an alternative songbook (*Liedermagazin*, 1976) and a variety of supplementary teaching materials on jazz, film music, music from ethnic cultures and other topics (cf. Nielsen, 1998, pp. 227–230).

(5) Music as "integrative music education" or as part of "poly-aesthetic education" represents a markedly interdisciplinary, cross-aesthetic position, which includes several branches of art, mainly in their avant-garde forms of expression. As a concrete conception it is described as multi-dimensional and integrative from several points of view, seeing that the content of the conception is of a multi-medial, interdisciplinary, tradition-integrative, intercultural and socio-communicative nature (Roscher, 1976, 1983–1984). Seen in relation to the main positions of subject-matter Didaktik, the concept combines a critical challenge Didactic and an existence Didactic foundation. It is concerned with the education and Bildung of human beings as sensing, perceiving, interpreting, reflecting and creating creatures in a modern world that, according to the underlying philosophy, tends to corrupt basic conditions for human development, self-expression and self-worth.

(6) "Music as a sound subject" can in general be seen as an attempt to create a radical new-orientation of the subject of music. A point of departure is the notion that music is the school's sound subject *par excellence*. The potential content of the subject is therefore made up of everything that can be heard (Abel-Struth, 1985). Here, too, responsibility to our auditory sensuousness and sensibility, based on the Greek concept of *aisthesis*, is crucial (Hentig, 1969, 1985). Musical phenomena make up only part of our total sound world. Still, there is a tendency towards modern (avant-garde) music (and in some contexts, rock music), with its experimental approach to sound and timbre, and alternative structural principles such as "open form," aleatoric procedures and improvisation, becoming a cornerstone in terms of content. An impression of the position in this respect can be gained by studying the series of publications *Rote Reihe* from Universal Edition in Vienna, with parallel publications in English. In the English-speaking world, publications by Paynter and Aston (1970) and R. Murray Schafer (1969) are examples of the same position. This suggests its international reach. A specific conception based on a program for auditory perceptual education (*auditive Wahrnehmungserziehung*) is the ambitious research, development, and textbook project *Sequenzen* (Frisius, Fuchs, Günther, Gundlach, & Küntzel, 1972–1976) which, perhaps due to its very high level of ambition, was never concluded. Nevertheless, it deserves respect as a thoroughly reflected manifestation of music Didaktik (cf. Nielsen, 1998, pp. 259–270).

In addition to these positions, it should be mentioned that music as a general school subject also can be said to manifest itself as a subject with a content of instrument playing, bodily movement, and most recently, information and music technology. Especially, the instrumental content dimension (*Klassenmusizieren*) tends now to be of considerable importance (cf. Jank, 2005).

## Development Trends

Two main development trends in music Didaktik, which seem to be in contrast to one another, can be derived from the above discussion: (1) the expansion of content, as the most obvious trait, and (2) concentration on something very basic.

(1) The expansion of content has taken place along several tracks:

   (a) An object track: from singing/songs to music to more different music to sound. This track is represented by the positions of music as "singing subject," as "matter-of-music" and as "sound subject."

   (b) A perspective track: from singing/music/sound to such phenomena in an interdisciplinary, inter-artistic and social perspective as well. This track is represented by music as "*musisch*," as "integrative music education," and as a "social subject."

   (c) An activity track: from one main form of activity to a range of activities. The music subject's content-related activity profile has developed from singing as the dominant activity to include playing instruments, improvisation and composition, listening with musical analysis, as well as interpretation of and reflection on music in historical, social, and other perspectives.

(2) Music as a *musisch* subject represents on the one hand, an expansion of content characterized by cross-disciplinarity, but on the other hand, still comprises a vision of something original and basic. A search for "origins" seems to be a trend in the twentieth century, which in both educational and artistic contexts has manifested itself in efforts to synthesize something original in the culture and in ourselves (the child). Think, for example, of the Cobra movement in painting. The stylistic similarity between a child's drawing, a painting of Asger Jorn, and a mask from New Guinea can be striking. In the area of music education we may mention both the Carl Orff conception, drawing inspiration from early European polyphony, and "rhythmic" music education, building on jazz and its ethnic roots. However different these examples of tendencies are in the choice of musical material and style, they meet in a mutual vision of the creative, the original, the spontaneous, the free, the anti-conforming, and playing human being.

Correspondingly it may be said in reference to the sound conception, that on the one hand it represents an enormous expansion of content. On the other hand, it is also an expression of a preoccupation with the basic foundation of all music: sound and its compoundedness, the timbre. It may be seen as a fascination for sounds as raw material, which can be sensed, perceived, studied, analyzed, experimented with, composed

and functionalized in innumerable ways. It is thought-provoking that a corresponding trend can be observed in the visual arts in a very basic preoccupation with elements such as color, shape, surface, space, and material.

The trends towards expansion and concentration do not, therefore, necessarily stand in contrast to one another. One may imply the other. Seen as a whole, it is characteristic that all of the positions and conceptions discussed here can be found in actual music education, but possibly mutually intertwined. This demonstrates that we are living in a multi-positional and polyvalent time seen from the perspective of music Didaktik.

## Final Comment on the Didaktik of Arts Subjects as a Field of Theory and Research

As has been shown, subject-matter Didaktik (the Didaktik of arts subjects) as an area of theory and research based on Bildung theory is in a multifaceted field of tension. This is true first of all in the field of relation between subject and pedagogy. As an independent science, the Didaktik of a subject must grasp and delve into both on an equal footing in order to define and develop its own domain. If it leans too heavily toward the subject, the result may be a narrow focus lacking a pedagogic perspective, and subject-matter Didaktik will approach the science of the basic subject. If, on the contrary, it is based too heavily on general pedagogy and Didaktik, the result may be pedagogic thinking that lacks content, and from which the specific subject's Didaktik and Bildung perspective disappear.

Didaktik is also a field of tension between theory and practice. This applies in a double sense, in relation to both the pedagogic aspect and the subject-related aspect. In relation to pedagogy, the Didaktik of a subject is a science both *on* and *for* pedagogic practice. In order to maintain this double-sidedness without confusing one side with the other, it may be appropriate to distinguish between "didactology" focused on theory and science and "didactics" oriented toward practice as dimensions in the field of Didaktik. In terms of subject-related relations, the Didaktik of an arts subject must be based on a multidimensional foundation that covers the practical, artistic, and craft aspects of the subject as well as its theoretical and scientific aspects, in other words, its *ars* and its *scientia* dimensions. Subject-matter Didaktik (the Didaktik of arts subjects) is thus a subject-related pedagogic theory and research field of an interdisciplinary, integrative and double-functional nature.

## Notes

1. This means that some Didaktik positions are not considered, for example Didaktik based on systemic and constructivistic thinking, or models rooted in information theory and cybernetics. Nevertheless, it is the author's opinion that, in continental European pedagogy, the connection of Didaktik with Bildung theoretical traditions is of a more fundamental character than sometimes presumed by reformist Didactic approaches. See Peterssen (2001) and Jank and Meyer (2002).

2. Compare Gundem and Hopmann (1998); Westbury (1998); Westbury, Hopmann, and Riquarts (2000).
3. See the influential book by Robinsohn (1967), *Bildungsreform als Revision des Curriculum* and the *Handbuch der Curriculumforschung* (Hameyer, Frey, & Haft, 1983), which took status of the situation. In the field of music, see Ettl (1969) as an early example of a Robinsohn-inspired music education research strategy; see also Abel-Struth (1985), Gieseler (1978, 1986), Gruhn (1993), and Helms, Schneider, and Weber (2005).
4. Compare Peterssen, "Didaktik is not just Didaktik!" (2001, chap. 1).
5. Compare the very wide definition of Didaktik in Dolch (1965).
6. Concerning the relationship between general Didaktik and subject-matter Didaktik, see also Peterssen (2001). Concerning the "field of relations" as "co-ordinate" or of an "integrative" nature, see Nielsen (1998, 2005).
7. Klafki (1962, 1963, 1980, 2000a); compare Adl-Amini (1986), Hopmann (2000).
8. Compare Nielsen (1998).
9. The concept of basic subject was originally identical with the scientific subject in the science-oriented curriculum that became an international trend after 1960. See Bruner (1960, 1966), Phenix (1962, 1964), Robinsohn (1967), Wilhelm (1969). With regard to music education, see Eggebrecht (1972, 1980), Richter (1980), Günther and Kaiser (1982), Gruhn (1993).
10. On a general level, compare Ziehe and Stubenrauch (1982) and Giddens (1991). Concerning the inclusion of "popular" culture alongside or instead of "fine culture," see Schütz (1995) with bibliography. Concerning the student-oriented aspects (*Schülerorientierung*), see Günther, Ott, and Ritzel (1982, 1983). The position has certain critical perspectives in common with the third position.
11. Compare Schnack (1993, 1995). In Klafki's "critical-constructive" Didaktik (Klafki, 1985, 1995a, 1995b, 1996, 1998a, 1998b), the position is translated into a number of "key issues, typical of the epoch, regarding our cultural, social, political and individual existence" (1995b, p. 12). Concerning aesthetic education and "aesthetic rationality" from this point of view, see Seel (1985), Otto (1991, 1998, 2000), Kaiser (1995), Rolle and Vogt (1995). See also Hentig (1969, 1985, 1996). An example of a journal of research in music education with a critical profile is the electronic *ZfKM*.
12. Key figures in philosophical anthropology are Max Scheler, Helmuth Plesner, Otto Bollnow, Arnold Gehlen, K.E. Løgstrup. Concerning symbolic forms, see Cassirer (1944). Concerning the position as articulated in music education, see Schneider (1987, 1994), Ehrenforth (1981, 1986, 1987), Richter (1975, 1976, 1993a, 1993b). A thorough analysis of the "life world" as related to music education, and "musical-aesthetic experience" as a core concept, has been conducted by Vogt (2001).
13. A key figure was W. von Humboldt (1767–1835); see Lüth (2000).
14. Compare Klafki (1963) and later works by Klafki. With regard to the subject of music seen in light of Bildung theory, see *Musik und Bildung 1984(4)*, *Musik und Bildung 1999(6)*, Helms, Schneider, and Weber (1994), Abel-Struth (1985), Kaiser (1998), Nielsen (1998), Kraemer (2004), and Jank (2005).
15. See overview in *The Journal of Aesthetic Education, 34*(3–4) (2000).
16. For example, Bastian (2000, 2001); see discussion in Gembris, Kraemer, and Maas (2001).
17. See Nielsen (1998, 2006).
18. Compare Meyer (1986), Kaiser and Nolte (1989), Jank and Meyer (2002), Kraemer (2004).
19. See Nolte (1975, 1982) for extensive collections of curricula for the subject of music in German schools, with commentary.
20. Compare Alt (1969, 1973; here the term "functional field," *Funktionsfeld*, is used); Küntzel (1975); Nolte (1982); Venus (1984); Gundlach (1984); Kaiser and Nolte (1989), Nielsen (1998, 2000); Kraemer (2004).
21. For an historical account of music as a singing subject see Abel-Struth (1985), and Kraemer (2004) for various aims and criteria for the selection of songs. For an argumentation for singing rooted in anthropology and existence-Didaktik, see Klusen (1989).
22. For a short introduction see Helms, Schneider, and Weber (2005). For a general discussion, see Abel-Struth (1985, index *musisch* ...), and for historical presentations, see Gruhn (1993) and Ehrenforth (2005). A special aspect of the position is its ideological exploitation during the 1933–45 period in Germany (Günther 1967, 1986), which may cause a dissociation from the very concept of *musisch* in Germany (Jank 2005).

# References

Abel-Struth, S. (1985). *Grundriss der Musikpädagogik* [The fundamentals of music pedagogy]. Mainz: Schott.

Adl-Amini, B. (Ed.). (1981). *Didaktik und Methodik* [Didaktik and methodology]. Weinheim/Basel: Beltz.

Adl-Amini, B. (1986). Ebenen didaktischer Theoriebildung [Areas of Didactic theory formation]. *Enzyclopädie Erziehungswissenschaft, 3*, 27–48.

Adorno, T. W. (1956). *Dissonanzen. Musik in der verwaltenen Welt* [Dissonances. Music in the administered world]. Göttingen: Vanderhoeck & Ruprecht.

Adorno, T. W. (1962). Theorie der Halbbildung [The theory of half-Bildung]. In M. Horkheimer & Th.W. Adorno (Eds.), *Sociologica II. Reden und Vorträge* (pp. 168–192). Frankfurt a.m.: Europäische Verlagsanstalt.

Alt, M. (1969). Die Funktionsfelder des Musikunterrichts und ihre Integration [The functional fields of music education and their integration]. *Musik und Bildung, 1*, 109–111.

Alt, M. (1973). *Didaktik der Musik* [The Didaktik of music] (3rd ed.). Düsseldorf: Schwann.

Antholz, H. (1976). *Unterricht in Musik. Ein historischer und systematischer Aufriss seiner Didaktik* [Education in music. An historical and systematic outline of its Didaktik] (3rd ed.). Düsseldorf: Schwann.

Bastian, H. G. (2000). *Musik(erziehung) und ihre Wirkung. Eine Langzeitstudie an Berliner Grundschulen* [Music (education) and its impact. A long-term study at primary schools in Berlin]. Mainz: Schott.

Bastian, H. G. (2001). *Kinder optimal fördern – mit Musik* [Supporting children optimally – through music]. Mainz: Atlantis Musikbuch-Verlag.

Blankertz, H. (1975). *Theorien und Modelle der Didaktik* [Theories and models of Didaktik] (9th ed.). München: Juventa.

Breckoff, W., Kleinen, G., Krützfeldt, W., Nicklis, W. S., Rössner, L., Rogge, W. et al. (1974). *Musik aktuell. Informationen, Dokumente, Aufgaben. Ein Musikbuch für die Sekundar- und Studienstufe* [Current music. Information, documents, exercises. A music book for the secondary and upper secondary level] (5th ed.). Kassel: Bärenreiter.

Bruner, J. S. (1960). *The process of education*. Cambridge, MA: Harvard University Press.

Bruner, J. S. (1966). *Toward a theory of instruction*. Cambridge, MA: Belknap Press of Harvard University Press.

Cassirer, E. (1944). *An essay on man; an introduction to a philosophy of human culture*. New Haven, CT: Yale University Press.

Comenius, J. A. (1985). *Grosse Didaktik* [Great didactics]. Stuttgart: Klett-Cotta. (Orig. publ. in Latin 1657 under the title *Didactica magna*).

Dolch, J. (1965). *Grundbegriffe der pädagogischen Fachsprache* [Basic concepts of the language of pedagogy] (7th ed.). München: Ehrenwirth.

Eggebrecht, H. H. (1972). Wissenschaftsorientierte Schulmusik [Science-oriented school music]. *Musik und Bildung, 4*, 29–31.

Eggebrecht, H. H. (1980). Über die Befreiung der Musik von der Wissenschaft [On the liberation of music from science]. *Musik und Bildung, 12*, 96–101.

Ehrenforth, K. H. (1971). *Verstehen und Auslegen. Die hermeneutischen Grundlagen einer Lehre von der didaktischen Interpretation der Musik* [Understanding and interpretation. The hermeneutic basis of the Didactic interpretation of music]. Frankfurt a.M.: Diesterweg.

Ehrenforth, K. H. (1981). *Humanität, Musik, Erziehung* [Humanity, music, education]. Mainz: Schott.

Ehrenforth, K. H. (1986). Zur Neugewichtung der historischen und anthropologischen Perspektiven der Musikerziehung [On the new weighting of the historical and anthropological perspectives of music education]. In H. Schmidt (Ed.), *Geschichte der Musikpädagogik. Handbuch der Musikpädagogik, Band 1* [The history of music education. Handbook of music pedagogy, Vol. 1] (pp. 267–296). Kassel: Bärenreiter.

Ehrenforth, K. H. (1987). Braucht der Mensch Musik(Erziehung)? Anthropologie als Apologie [Does the human being need music (education)? Anthropology as apology]. In R. Schneider (Ed.), *Anthropologie der Musik und der Musikerziehung* [The anthropology of music and music education] (= Musik im Diskurs, Vol. 4) (pp. 55–72). Regensburg: Bosse.

Ehrenforth, K. H. (2005). *Geschichte der musikalischen Bildung. Eine Kultur-, Sozial- und Ideengeschichte in 40 Stationen* [The history of music education. A history of culture, sociology and ideas in 40 stages]. Mainz: Schott.

*Enzyklopädie Erziehungswissenschaft.* Handbuch und Lexikon der Erziehung in 11 Bänden und einem Registerband [Encyclopedia of pedagogy. Handbook and encyclopedia of education in 11 volumes and an index volume]. (vols. 1–12), (1983–1986). Lenzen, D. (Ed.). Stuttgart: Klett-Cotta.

Ettl, H. (1969). Lehrplanforschung für das Unterrichtsfach Musik. Grundlegende Systematik und Entwurf zu einem Forschungsprojekt [Curriculum research for the educational subject of music. Basic systematics and draft of a research project]. *Forschung in der Musikerziehung. Beiheft der Zeischrift Musik und Bildung, 1969*(2), 51–59.

Frisius, R., Fuchs, P., Günther, U., Gundlach, W., & Küntzel, G. (Eds.). (1972–1976). *Sequenzen. Musik Sekundarstufe 1. Beiträge und Modelle zum Musik-Curriculum.* 1. Folge 1972. 2. Folge 1976 [Sequences. Music in secondary school. Contributions and models for the music curriculum. 1st part 1972. 2nd part 1976]. Stuttgart: Ernst Klett.

Gembris, H., Kraemer, R.-D., & Maas, G. (Eds.). (2001). *Macht Musik wirklich klüger? Musikalisches Lernen und Tranfereffekte* [Does music really make you smarter? Musical learning and transfer effects]. (= Musikpädagogische Forschungsberichte. Vol. 8). Augsburg: Wissner.

Giddens, A. (1991). *Modernity and self-identity: Self and society in the late modern age.* Cambridge, MA: Polity.

Gieseler, W. (1978). Curriculum [Curriculum]. In W. Gieseler (Ed.), *Kritische Stichwörter zum Musikunterricht* [Critical keywords for music education] (pp. 59–65). München: Wilh. Fink Verlag.

Gieseler, W. (1986). Curriculum-Revision und Musikunterricht [Curriculum revision and music education]. In H. Schmidt, (Ed.), *Geschichte der Musikpädagogik. Handbuch der Musikpädagogik, Band 1* [The history of music education. Handbook of music pedagogy, Vol. 1] (pp. 215–266). Kassel: Bärenreiter.

Gruhn, W. (1993). *Geschichte der Musikerziehung* [The history of music education]. Hofheim: Wolke Verlag.

Gundem, B. B., & Hopmann, S. (Eds.). (1998). *Didaktik and/or curriculum: An international dialogue.* New York: Peter Lang.

Gundlach, W. (1984). Lernfelder des Musikunterrichts. Versuch einer Strukturierung des Gegenstandsbereichs Musik in der Grundschule und deren Veränderungen in den letzten zehn Jahren [Fields of learning in music education. An attempt at structuring the object areas of music in primary school and their changes over the last ten years]. In F. Ritzel & W. Stroh (Eds.), *Musikpädagogische Konzeptionen und Schulalltag. Versuch einer kritischen Bilanz der 70er Jahre* [Music educational conceptions and everyday schooling. An attempt at taking critical stock of the seventies] (pp. 105–114). Wilhelmshaven: Heinrichshofen.

Günther, U. (1967). *Die Schulmusikerziehung von der Kestenberg-Reform bis zum Ende des Dritten Reiches* [School music education from the Kestenberg reform until the end of the Third Reich]. Neuwied/Berlin: Luchterhand.

Günther, U. (1986). Musikerziehung im Dritten Reich [Music education in the Third Reich]. In H. Schmidt (Ed.), *Geschichte der Musikpädagogik. Handbuch der Musikpädagogik, Band 1* [The history of music education. Handbook of music pedagogy, Vol. 1] (pp. 85–173). Kassel: Bärenreiter.

Günther, U., & Kaiser. H. J. (1982). Wissenschaftspropädeutischer oder wissenschaftsorientierter Musikunterricht? [Science propaedeutic or science oriented music education?] *Musik und Bildung, 14,* 84–89.

Günther, U., Ott, T., & Ritzel, F. (1982). *Musikunterricht 1–6* [Music education 1–6]. Weinheim/Basel: Beltz.

Günther, U., Ott, T., & Ritzel, F. (1983). *Musikunterricht 5–11* [Music education 5–11]. Weinheim/Basel: Beltz.

Hameyer, U., Frey, K., & Haft, H. (Eds.). (1983). *Handbuch der Curriculumforschung. Erste Ausgabe. Übersichten zur Forschung 1970–81* [Handbook of curriculum research. First edition. Overview of research 1970–81]. Weinheim/Basel: Beltz.

Hanken, I. M., & Johansen, G. G. (1998). *Musikkundervisningens didaktikk* [The Didaktik of music education]. Oslo: Cappelen Akademisk Forlag.

Heimann, P., Otto, G., & Schulz, W. (1965). *Unterricht. Analyse und Planung* [Teaching. Analysis and planning]. Hannover: Schroedel.

Hellesnes, J. (1976). *Socialisering og teknokrati* [Socialization and technocracy]. København: Gyldendal.

Helmholz, B. (1995). Musikdidaktische Konzeptionen nach 1945 [Music Didactic conceptions after 1945]. In S. Helms, R. Schneider, & R. Weber (Eds.), *Kompendium der Musikpädagogik* [Compendium of music pedagogy] (pp. 42–63). Kassel: Gustav Bosse Verlag.

Helms, S., Schneider, R., & Weber, R. (Eds.). (1994). *Neues Lexikon der Musikpädagogik, I–II, Personenteil, Sachteil (NLxMP)* [New encyclopedia of music pedagogy, I–II]. Kassel: Gustav Bosse Verlag.

Helms, S., Schneider, R., & Weber, R. (Eds.). (1995). *Kompendium der Musikpädagogik* [Compendium of music pedagogy]. Kassel: Gustav Bosse Verlag.

Helms, S., Schneider, R., & Weber, R. (Eds.). (2005). *Lexikon der Musikpädagogik (LxMP)* [Encyclopedia of music pedagogy]. Kassel: Gustav Bosse Verlag.

Hentig, H. von (1969). *Spielraum und Ernstfall. Gesammelse Aufsätze zu einer Pädagogik der Selbstbestimmung* [Scope and gravity. Collected writings on a pedagogy of self-determination]. Stuttgart: Klett Verlag. (Rev. ed. 1981: Frankfurt: Ullstein).

Hentig, H. von (1985). *Ergötzen, Belehren, Befreien. Schriften zur ästetischen Erziehung* [Amusing, instructing, freeing. Writings on aesthetic education]. München/Wien: Carl Hanser Verlag.

Hentig, H. von (1996). *Bildung* [Bildung]. München/Wien: Carl Hanser Verlag.

Hermann, U. (1983). Erziehung und Bildung in der Tradition Geisteswissenschaftlicher Pädagogik [Education and Bildung in the tradition of a humanities-oriented pedagogy]. In D. Lenzen (Ed.), *Enzyklopädie Erziehungswissenschaft. Handbuch und Lexikon der Erziehung in 11 Bänden und einem Registerband* [Encyclopedia of pedagogy. Handbook and encyclopedia of education in 11 volumes and an index volume] (Vol. 1, pp. 25–41). Stuttgart: Klett-Cotta.

Hopmann, S. (2000). Klafki's model of didactik analysis and lesson planning in teacher education. In I. Westbury, S. Hopmann, & K. Riquarts (Eds.), *Teaching as a reflective practice: The German Didaktik tradition* (pp. 197–206). Mahwah, New Jersey: Lawrence Erlbaum.

Jank, W. (Ed.). (2005). *Musik-Didaktik. Praxishandbuch für die Sekundarstufe I und II* [Music Didaktik. Handbook of praxis for the elementary and upper secondary level]. Berlin: Cornelsen Scriptor.

Jank, W., & Meyer, H. (2002). *Didaktische Modelle* [Models of Didaktik] (5th ed.). Berlin: Cornelsen Scriptor.

Kaiser, H. J. (1995). Musikerziehung/Musikpädagogik [Music education/Music pedagogy]. In S. Helms, R. Schneider, & R. Weber (Eds.), *Kompendium der Musikpädagogik* [Compendium of music pedagogy] (pp. 9–41). Kassel: Gustav Bosse Verlag.

Kaiser, H. J. (1998). Zur Bedeutung von Musik und Musikalischer Bildung [On the significance of music and musical Bildung]. In H. J. Kaiser (Ed.), *Ästhetische Theorie und musikpädagogische Theoriebildung* [Aesthetic theory and music pedagogical theory formation] (= Musikpägogik: Forschung und Lehre. Beiheft 8) (pp. 98–114). Mainz: Schott.

Kaiser, H. J., & Nolte, E. (1989). *Musikdidaktik*. [The Didaktik of music]. Mainz: Schott.

Kant, I. (1980). *Foundations of the metaphysics of morals and What is enlightenment?* (L. W. Beck, Trans.). Indianapolis: Bobbs-Merrill.

Klafki, W. (1962). Didaktische Analyse als Kern der Unterrichtsvorbereitung [Didactic analysis as the core of preparation of teaching]. In H. Roth & A. Blumenthal (Eds.), *Didaktische Analyse. Auswahl – Grundlegende Aufsätze aus der Zeitschrift Die Deutsche Schule* [Didactic analysis. Selection – Basic writings from the journal Die Deutsche Schule] (pp. 5–32). Hannover: Schroedel.

Klafki, W. (1963). *Studien zur Bildungstheorie und Didaktik* [Studies on Bildung theory and Didaktik]. Weinheim/Basel: Beltz.

Klafki, W. (1980). Zur Unterrichtsplanung im Sinne kritisch-konstruktiver Didaktik [On the planning of teaching in the sense of critical-constructive Didaktik]. In B. Adl-Amini & R. Küntzli (Eds.), *Didaktische Modelle und Unterrichtsplanung* [Didactic models and planning of teaching] (pp. 11–48). München: Juventa Verlag.

Klafki, W. (1985). *Neue Studien zur Bildungstheorie und Didaktik. Beiträge zur kritisch-konstruktiven Didaktik* [New studies on Bildung theory and Didaktik. Contributions to critical-constructive Didaktik]. Weinheim/Basel: Beltz.

Klafki, W. (1986). Die Bedeutung der klassischen Bildungstheorien für ein zeitgemässes Konzept allgemeiner Bildung [The significance of classical theories of Bildung for a contemporary concept of Allgemeinbildung]. *Zeitschrift für Pädagogik, 32*(4), 455–476.

Klafki, W. (1995a). On the problem of teaching and learning contents from the standpoint of critical-constructive Didaktik. In S. Hopmann & K. Riquarts (Eds.), *Didaktik and/or Curriculum* (pp. 185–200). Kiel: Institut für die Pädagogik der Naturwissenschaften an der Universität Kiel.

Klafki, W. (1995b). "Schlüsselprobleme" als thematische Dimension eines zukunftsorientierten Konzepts von "Allgemeinbildung" ["Key problems" as the thematic dimension of a future-oriented concept of "Allgemeinbildung"]. In W. Münzinger & W. Klafki (Eds.), *Schlüsselprobleme im Unterricht* [Key problems in education]. (= *Die Deutsche Schule, 3. Beiheft*) (pp. 9–14).

Klafki, W. (1996). *Neue Studien zur Bildungstheorie und Didaktik* [New studies on Bildung theory and Didaktik] (5th ed.). Weinheim/Basel: Beltz.

Klafki, W. (1998a). Characteristics of critical-constructive didaktik. In B. B. Gundem & S. Hopmann (Eds.), *Didaktik and/or Curriculum: An international dialogue* (pp. 307–330). New York: Peter Lang.

Klafki, W. (1998b). "Schlüsselprobleme" in der Diskussion – Kritik einer Kritik ["Key problems" in the discussion – critique of a critique]. *Neue Sammlung, 38*(1), 103–124.

Klafki, W. (2000a). Didaktik analysis as the core of preparation of instruction. In I. Westbury, S. Hopmann, & K. Riquarts (Eds.), *Teaching as a reflective practice: The German Didaktik tradition.* (pp. 139–159). Mahwah, New Jersey: Lawrence Erlbaum.

Klafki, W. (2000b). The significance of classical theories of Bildung for a contemporary concept of Allgemeinbildung. In I. Westbury, S. Hopmann, & K. Riquarts (Eds.), *Teaching as a reflective practice: The German Didaktik tradition* (pp. 85–107). Mahwah, New Jersey: Lawrence Erlbaum.

Klusen, E. (1989). *Singen. Materialien zu einer Theorie* [Singing. Material for a theory]. Regensburg: Bosse.

Kraemer, R.-D. (2004). *Musikpädagogik – eine Einführung in das Studium* [Music pedagogy – an introduction to the study]. Augsburg: Wissner-Verlag.

Küntzel, G. (1975). Zur Klassifikation von Lerninhalten im Musikunterricht [On the classification of contents of learning in music education]. In H. Antholz & W. Gundlach (Eds.), *Musikpädagogik heute. Perspektiven, Probleme, Positionen. Zum Gedenken an Michael Alt 1905–1973* [Music pedagogy today. Perspectives, problems, positions. In memory of Michael Alt 1905–1973] (pp. 174–186). Düsseldorf: Schwann.

Künzli, R. (2000). German Didaktik: Models of re-presentation, of intercourse, and of experience. In I. Westbury, S. Hopmann, & K. Riquarts (Eds.), *Teaching as a reflective practice: The German Didaktik tradition.* (pp. 41–54). Mahwah, New Jersey: Lawrence Erlbaum.

Lenzen, D. (Ed.). (1989). *Pädagogische Grundbegriffe I–II* [Basic concepts in pedagogy I–II]. (Vol 1–2). Reinbek bei Hamburg: Rowohlt Taschenbuch Verlag.

Lüth, C. (2000). On Wilhelm von Humboldt's theory of Bildung. In I. Westbury, S. Hopmann, & K. Riquarts (Eds.), *Teaching as a reflective practice: The German Didaktik tradition* (pp. 63–84). Mahwah, New Jersey: Lawrence Erlbaum.

Marcuse, H. (1978). *The aesthetic dimension: Toward a critique of Marxist aesthetics.* Boston, MA: Beaver.

Meyer, H. (1986). Unterrichtsinhalt [Content of education]. In Lenzen, D. (Ed.), *Enzyklopädie Erziehungswissenschaft. Handbuch und Lexikon der Erziehung in 11 Bänden und einem Registerband* [Encyclopedia of pedagogy. Handbook and encyclopedia of education in 11 volumes and an index volume] (Vol. 3, pp. 632–640). Stuttgart: Klett-Cotta.

Nielsen, F. V. (1998). *Almen musikdidaktik* [The general Didaktik of music] (2nd ed.). Copenhagen: Akademisk Forlag.

Nielsen, F. V. (2000). Faglighed og dannelse i de musisk-æstetiske fag [Professionalism and Bildung in the aesthetic subjects]. In H. J. Kristensen & K. Schnack (Eds.), *Faglighed og undervisning* [Professionalism and education] (pp. 67–85). Copenhagen: Gyldendal.

Nielsen, F. V. (2005). Didactology as a field of theory and research in music education. *Philosophy of Music Education Review, 13*(1), 5–19.

Nielsen, F. V. (2006). On the relation between music and man: Is there a common basis, or is it altogether individually and socially constructed? In B. Stålhammar (Ed.), *Music and human beings: Music and identity* (pp. 163–182). Örebro, Sweden: Örebro Universitet.

Nolte, E. (1975). *Lehrpläne und Richtlinien für den schulischen Musikunterricht in Deutschland vom Beginn des 19. Jahrhunderts bis in die Gegenwart. Eine Dokumentation* [Lehrpläne and guidelines for school music education in Germany from the beginning of the 19th century until the present time. A documentation]. Mainz: Schott.

Nolte, E. (1982). *Die neuen Curricula, Lehrpläne und Richtlinien für den Musikunterricht an den allgemeinbildenden Schulen in der Bundesrepublik Deutschland und West-Berlin. Einführung und Dokumentation. Teil 1: Primarstufe* [The new curricula, Lehrpläne and guidelines for music education at public shools in the Federal Republic of Germany and West Berlin. Introduction and documentation. Part 1: Primary level]. Mainz: Schott.

Nolte, E. (Ed.). (1986). *Historische Ursprünge der These vom erzieherischen Auftrag des Musikunterrichts* [Historical origins of the thesis of the formative aim of music education] (= Musikpädagogik: Forschung und Lehre. Beiheft 1). Mainz: Schott.

Otto, G. (1991). Ästhetische Rationalität [Aesthetic rationality]. In W. Zacharias (Ed.), *Schöne Aussichten? Ästetische Bildung in einer technisch-medialen Welt* [Beautiful prospects? Aesthetic Bildung in a technical-medial world] (pp. 145–162). Essen: Klartext.

Otto, G. (1998). *Lehren und Lernen zwischen Didaktik und Ästhetik. Bd. 1: Ästhetische Erfahrung und Lernen* [Teaching and learning between Didaktik and aesthetics. Vol. 1: Aesthetic experience and learning]. Seelze: Kallmeyer.

Otto, G. (2000). Ästetische Erziehung. Ekstase und/oder Unterricht. Voraussetzungen ästetischer Bildungsprozesse: Wieviel Ästhetik hält die Schule aus? [Aesthetic education. Ecstasy and/or teaching and learning. Preconditions of aesthetic Bildung processes: How much aestheticism can schools take?]. In W. Jank & H. Jung (Eds.), *Musik und Kunst. Erfahrung, Deutung, Darstellung. Ein Gespräch zwischen den Wissenschaften* [Music and art. Experience, interpretation, performance. A conversation between the sciences] (pp. 133–150). Mannheim: Palatium.

Paynter, J., & Aston, P. (1970). *Sound and silence. Classroom projects in creative music.* Cambridge, MA: Cambridge University Press.

Peterssen, W. H. (2001). *Lehrbuch allgemeine Didaktik* [Textbook on general Didaktik] (6th ed.). München: Oldenbourg.

Phenix, P. H. (1962). The disciplines as curriculum content. In H. A. Passow (Ed.), *Curriculum crossroads* (pp. 57–71). New York: Teachers College Press.

Phenix, P. H. (1964). *Realms of meaning: A philosophy of the curriculum for general education.* New York: McGraw-Hill.

Richter, C. (1975). *Musik als Spiel. Orientierung des Musikunterrichts an einem fachübergreifenden Begriff. Ein didaktisches Modell* [Music as play. The orientation of music education from an interdisciplinary concept. A Didactic model]. Wolfenbüttel: Möseler.

Richter, Chr. (1976). *Theorie und Praxis der didaktischen Interpretation von Musik* [Theory and praxis of the Didactic interpretation of music]. Frankfurt a.M.: Diesterweg.

Richter, C. (1980). Wissenschaftspropädeutik im Musikunterricht [Science propaedeutics in music education]. *Musik und Bildung, 12*, 15–18.

Richter, C. (1993a). Anregungen zum Nachdenken über das eigene Tun. Anthropologische Grundlagen der Instrumental- und Vokalpädagogik [Suggestions for reflexion on one's own doing. The anthropological foundations of instrumental and vocal education]. In C. Richter (Ed.), *Instrumental- und Vokalpädagogik 1: Grundlagen. Handbuch der Musikpädagogik, Band 2* [Instrumental and vocal education 1: Foundations. Handbook of music pedagogy, Vol. 2] (pp. 65–116). Kassel: Bärenreiter.

Richter, C. (Ed.). (1993b). *Instrumental- und Vokalpädagogik 1: Grundlagen. Handbuch der Musikpädagogik, Band 2.* [Instrumental and vocal education 1: Foundations. Handbook of music pedagogy, Vol. 2]. Kassel: Bärenreiter.

Robinsohn, S. B. (1967). *Bildungsreform als Revision des Curriculum* [Bildung reform as the revision of curriculum]. Neuwied/Berlin: Luchterhand.

Rolle, C., & Vogt, J. (1995). Ist ästhetische Bildung möglich? [Is aesthetic Bildung possible?]. *Musik und Unterricht, 34*, 56–59.

Roscher, W. (Ed.). (1976). *Polyästhetische Erziehung. Klänge, Texte, Bilder, Szenen. Theorien und Modelle zur pädagogischen Praxis* [Polyaesthetic education. Sounds, texts, pictures, scenes. Theories and models for educational praxis]. Köln: DuMont Schauburg.

Roscher, W. (Ed.). (1983–1984). *Integrative Musikpädagogik. Neue Beiträge zur polyästhetischen Erziehung, I–II* [Integrative music education. New contributions to polyaesthetic education]. Wilhelmshaven: Heinrichshofen.

Schafer, R. M. (1969). *The new soundscape: A handbook for the modern music teacher*. London: Universal Edition.

Schmidt, H.-C. (Ed.). (1986). *Geschichte der Musikpädagogik. Handbuch der Musikpädagogik, Band 1* [The history of music education. Handbook of music pedagogy, Vol. 1]. Kassel: Bärenreiter.

Schnack, K. (1993). Sammenlignende fagdidaktik [Comparative subject-matter Didaktik]. In K. Schnack (Ed.), *Fagdidaktik og almendidaktik* [Subject-matter and general Didaktik] (pp. 5–17). Copenhagen: Danmarks Lærerhøjskole [The Royal Danish School of Educational Studies].

Schnack, K. (1995). The didactics of challenge. In S. Hopmann & K. Riquarts (Eds.), *Didaktik and/or Curriculum* (pp. 407–416). Kiel: Institut für die Pädagogik der Naturwissenschaften an der Universität Kiel.

Schneider, R. (Ed.). (1987). *Anthropologie der Musik und der Musikerziehung* [The anthropology of music and music education]. (= Musik im Diskurs, Vol. 4). Regensburg: Bosse.

Schneider, R. (1994). Anthropologie der Musik [The anthropology of music]. In *Helms, Schneider, & Weber. Sachteil* (pp. 14–15).

Schulz, W. (1970). Aufgaben der Didaktik. Eine Darstellung aus lehrtheoretischer Sicht [The objects of Didaktik. A presentation from a teaching theorical perspective]. In D. C. Kochan (Ed.), *Allgemeine Didaktik. Fachdidaktik. Fachwissenschaft* [General Didaktik. Subject-matter Didaktik. Science] (pp. 403–440). Darmstadt: Wissenschaftliche Buchgesellschaft.

Schütz, V. (1995). Didaktik der Pop/Rockmusik. Begründungsaspekte [The Didaktik of pop/rock music. Aspects of rationale]. In S. Helms, R. Schneider, & R. Weber (Eds.), *Kompendium der Musikpädagogik* [Compendium of music pedagogy] (pp. 262–280). Kassel: Gustav Bosse Verlag.

Seel, M. (1985). *Die Kunst der Entzweiung. Zum Begriff der ästhetischen Rationalität* [The art of ambiguity. On the concept of aesthetic rationality]. Frankfurt a.M.: Suhrkamp.

Thiersch, H. (1983). Geisteswissenschaftliche Pädagogik [Humanities-oriented pedagogy]. In D. Lenzen (Ed.), *Enzyklopädie Erziehungswissenschaft* (Vol. 1, pp. 81–100). Stuttgart: Klett-Cotta.

Venus, D. (1984). *Unterweisung im Musikhören* [Teaching in music listening] (2nd ed.). Ratingen: Henn.

Vogt, J. (2001). *Der schwankende Boden der Lebenswelt. Phänomenologische Musikpädagogik zwischen Handlungstheorie und Ästhetik* [The rolling grounds of the life world. Phenemological music education between action theory and aesthetics]. Würzburg: Königshausen & Neumann.

Westbury, I. (1998). Didaktik and Curriculum Studies. In B. B. Gundem & S. Hopmann (Eds.), *Didaktik and/or Curriculum: An international dialogue* (pp. 47–48). New York: Peter Lang.

Westbury, I., Hopmann. S., & Riquarts, K. (Eds.). (2000). *Teaching as a reflective practice: The German Didaktik tradition*. Mahwah, New Jersey: Lawrence Erlbaum.

Wilhelm, T. (1969). *Theorie der Schule. Hauptschule und Gymnasium im Zeitalter der Wissenschaften* [The theory of school. Primary and secondary school in the era of science] (2nd ed.). Stuttgart: Metzlersche Verlagsanstalt.

Ziehe, T., & Stubenrauch, H. (1982). *Plädoyer für ungewöhnliches Lernen. Ideen zur Jugendsituation* [A plea for unusual learning. Ideas on the situation of youth]. Reinbek bei Hamburg: Rowohlt Taschenbuch Verlag.

ZfKM = *Zeitschrift für kritische Musikpädagogik*. http://home.arcor.de/zf/zfkm/home.html

18

# ARTS INTEGRATION IN THE CURRICULUM: A REVIEW OF RESEARCH AND IMPLICATIONS FOR TEACHING AND LEARNING

**Joan Russell\* and Michalinos Zembylas[†]**

*\*McGill University, Canada;*
*[†]University of Cyprus, Cyprus/Michigan State University, U.S.A.*

> Given a pile of jigsaw puzzle pieces and told to put them together, no doubt we would ask to see the picture they make. It is the picture, after all, that gives meaning to the puzzle and assures us that the pieces fit together, that none are missing and that there are no extras. Without the picture, we probably wouldn't want to bother with the puzzle. ... To students, the typical curriculum presents an endless array of facts and skills that are unconnected, fragmented, and disjointed. That they might be connected or lead to some whole picture is a matter that must be taken on faith by young people. (Beane, 1991, p. 9)

The idea of the *integrated curriculum* recurs from time to time, in tandem with other social progressive movements (Beane, 1997), and the notion that curriculum *should* be integrated has regained much popularity among educators in recent years (Parsons, 2004). Proponents of the integrated curriculum argue that an integrated approach promotes holistic education – unity rather than separation and fragmentation (Wineberg & Grossman, 2000) – and cognitive gain (e.g., Efland, 2002; Mansilla, 2005). In addition, as Parsons (2004) argues, recent societal changes, changes in the contemporary art world, the faster pace of life, and the enormous growth of technology and visual communication require more information – and its critique – from many different sources. From these perspectives, an integrated curriculum seems to make sense.

The concept of integration is by no means new. In Western writings, references to integration can be traced back as far as Plato, and later to Rousseau and Dewey. More recently, the concept has appeared in constructivist approaches in teaching and learning (Chrysostomou, 2004). In the last two decades, there has been a renewed interest in implementing integration, and numerous debates, are taking place with respect to the *value* and *effectiveness* of integrated curricula (Parsons, 2004; Wineberg & Grossman, 2000). National curriculum reform efforts (e.g., in science, mathematics,

*L. Bresler (Ed.), International Handbook of Research in Arts Education, 287–302.*
© 2007 *Springer.*

language arts) in the United States, Canada, Europe, and Australia are currently stress-ing the need to make cross-curricular connections.[1]

But what happens with *arts integration*? Are arts integrated in the curriculum with the same enthusiasm and commitment as other subjects? What does research tell us about the value and effectiveness of arts-integrated programs? What are the indicators of "value" and "effectiveness" for arts-integrated programs and how are these terms defined? How is success measured? How *should* success be measured? At the heart of these questions lie philosophical issues: the nature and value of arts in education. That is, does arts integration *require* that arts be defined as *disciplines* – an idea that empha-sizes the *intrinsic* values of art in education – or simply as *"handmaidens"* – an idea that focuses on the *instrumental* values of arts in education? (Bresler, 1995; Brewer, 2002; Parsons, 2004; Winner & Hetland, 2000). Although it is beyond the scope of this chapter to engage in a detailed account of the discourse around these tensions, we wonder whether using the terms "disciplines" and "handmaidens" is too limiting. Horowitz and Webb-Dempsey (2002) describe the relationship of arts and other learn-ing as *"parallel, symbiotic, interactive or multi-layered"* (p. 100, italics added). We believe these kinds of relationships of arts and other learning are particularly impor-tant in defining arts integration in school curricula. Therefore, if we stop thinking in dualisms and move beyond the *either* (disciplines)/*or* (handmaidens) dichotomy, we may begin to examine arts integration on a totally different level of thinking – that is, as multilayered and symbiotic with other learning.

This chapter is divided into three parts. First, we present some attributions of the meaning and value of arts integration, and some of the arguments surrounding arts integration. Then, we critically review selected large-scale programs and small-scale arts-integration initiatives and we consider some pedagogical, methodological, and political issues of arts integration. We conclude that a closer examination of the role of arts integration in the curriculum and its attendant research is needed, and more sophisticated and reliable ways of documenting student growth must be developed.

# The Meaning(s) and Value of *Arts Integration*

It has been argued that the boundaries among disciplines and subject areas are artifi-cial and limit students' access to broader meanings in life (Beane, 1997; Doll, 1993). Disciplinary curricula are associated with current practices that place a high value on efficiency, behavioral objectives, and high-stakes achievement tests (Parsons, 2004). Whereas rigid boundaries inhibit students' proper preparation for participation in a democratic society (Dewey, 1916; Parsons, 2004), "soft" (Detels, 1999) or "porous" (Bresler, 2003) boundaries invite cross-fertilization, and lead to new ideas and per-spectives (Russell, 2006). Beane and Brodhagen (1996) suggest that curriculum inte-gration has the potential to offer the challenging curriculum, the higher standards, and the world-class education that is often talked about, but rarely experienced.

At the most basic level, it is hard to define *integration*, because integration "can mean different things in terms of contents, resources, structures, and pedagogies to different people" (Bresler, 1995, p. 31). This ambiguity is evident in the sheer number

of terms used in the literature on integration; many of these terms are used synony-
mously and this adds to the confusion. Other terms one encounters include cross-dis-
ciplinary, interdisciplinary, infused, thematic, trans-disciplinary, multidisciplinary,
holistic, and blended (see Bresler, 1995).

Similarly, various terms are used in the context of integrating arts in the curriculum.
Terms such as arts integration, arts-infused curriculum, arts-centered curriculum, and
arts-across-the-curriculum, are used to describe the concept of the arts as an integral
part of the whole curriculum, while other terms identify specific programs (e.g.,
Learning Through The Arts™, and Artists-in-Residence).

A more precise definition of *arts integration* is "the use of two or more disciplines
in ways that are mutually reinforcing, often demonstrating an underlying unity" (The
Consortium of National Arts Education Organizations, 1994, p. 13). In other words,
arts integration involves the combination to some degree, or the connections between
two or more of the traditional disciplines or subjects. For instance, Joan uses antislav-
ery songs to do two things: to open up discussion about slavery as a moral issue, and
to talk about how the songs might be performed in order that their underlying "affect"
(sorrow, resistance, defiance) might be conveyed most effectively. Michalinos inte-
grates poetry and fish printing with science to highlight the power of poetry and art to
stimulate observation, imagination, and emotion. These two examples from our own
experiences indicate how arts integration differs from arts as the study of a disscipline.
For this chapter we find "arts integration" a useful conceptual term to refer to activi-
ties that strive to infuse the arts across school disciplines.

## Arguments For and Against Arts Integration

The historical roots of arts integration in western education can be traced to the ideals
of progressive education at the beginning of the twentieth century (Beane, 1997;
Bresler, 1995; Dewey, 1934; Parsons, 2004). Dewey's (1934) emphasis on aesthetic
experience and the importance of holistic learning encouraged arts educators to begin
exploring interrelations with other subject areas (Bresler, 2003). Efland (1990) pointed
out that in the 1960s there was a move to conceive arts from a discipline-centered per-
spective, but arts integration gained attention in the 1970s, a period during which the
arts and artistic ways of knowing and experiencing acquired a more legitimate status.
As a result, new pedagogies focused on the value of students' explorations and experi-
ences and a fusion between arts and other subject matter areas was promoted. The
1980s and 1990s witnessed a revival of the discussions about integrative work in edu-
cation (see Eisner, 1985). During this time, Gardner's (1983) multiple intelligences
theory provided research-based evidence for the claim that human intelligence is
multi-faceted, multi-modal and brought the voice of developmental psychology to the
discourse on arts integration.

Arguments for and against arts integration abound. On the one hand, it is argued that
the integration of arts in the curriculum offers students and teachers learning experi-
ences that are intellectually and emotionally stimulating (Barrett, McCoy, & Veblen,
1997; Burton, Horowitz, & Abeles, 1999; Chrysostomou, 2004; Deasey, 2002;
Goldberg, 2001; Mansilla, 2005; Patteson, 2002; Veblen & Elliott, 2000). It is also

maintained that arts integration can help students learn to think more holistically, and thus contributes to the development of connected ways of knowing (Mason, 1996). In light of findings and theories from cognitive science that describe learning as situated, socially-constructed, and culturally mediated processes of making meaning (Efland, 2002; Freedman, 2003), it is argued that integrated learning promotes learning and creativity (Marshall, 2005). These arguments validate arts integration because integration is essentially about making connections among things. Finally, it is suggested that arts-integrated curricula promote socially relevant democratic education, because the issues involved transcend disciplinary boundaries and engage students in self-reflection and active inquiry (Parsons, 2004).

On the other hand, there are serious concerns about the benefits and effectiveness of an arts-integrated curriculum, and the lack of strong empirical research to support the belief that arts-integrated curricula are actually effective in terms of student achievement. In their evaluation of the impact of arts in education, Hetland and Winner (2000) concluded that while arts-integrated approaches to teaching academic subjects sometimes led to improvement in an academic subject, the improvement was not significant when compared with a traditional approach to teaching the same subject. Hetland and Winner pointed out the danger in expecting that arts integration will cause academic improvement: if improvement does not result, integration will be blamed. Winner (2003) also questioned sweeping claims made on behalf of arts integration proponents. Finally, other concerns about the benefits and effectiveness of an arts-integrated curriculum include teachers' complaints that integration adds to their already overloaded curriculum, and their apprehensions about meeting curriculum requirements (e.g., Horowitz, 2004). Artists' concerns include fears that integrating the arts across the curriculum undermines the disciplinary understanding and experience of an art, and could lead to the disappearance of arts specialists in schools (e.g., Veblen & Elliott, 2000).

A dichotomous view – arts for arts sake *vs.* arts integration – assumes that schools must choose one approach or the other. As some scholars argue, integrated curricula may be related to political and business interests and administrative policies rather than student learning (Beane, 1997; Brewer, 2002; Efland, 1990; Gee, 2003, 2004). According to these views, the instrumental drive of an integrated approach is said to diminish the academic integrity of arts as distinct disciplines. For example, in his review of literature on arts-integrated curricula, Brewer (2002) concluded that integrated approaches "have had a major and not altogether positive impact on our schools and on educational policy" (p. 31). In our view, this conclusion needs to be considered with caution, because Brewer does not offer evidence to justify his claim. It is interesting to note that although advocates for arts integration abound, empirical studies of the effectiveness and impact of integration have not received much critical attention (Bresler, 2003). Indeed, there are difficulties associated with collecting data that capture and show repeatedly what learning looks like and what kinds of learning are taking place, because learning in an arts-integrated environment looks qualitatively different from the ways in which learning looks in other models of curriculum (e.g., Berghoff, 2005; Borgmann, 2005). Thus, research on arts integration should examine the impact of arts-integrated programs across many factors and not focus solely on test results in distinct subject matter areas.

# Review of Research

*Selection of Studies for Review*

We conducted a search for studies that explore the implementation and evaluation of arts-integration efforts and the implications of these efforts for teaching and learning. The inclusion criteria that were used for this review were as follows: English language, empirical studies published or presented in conferences between 2000 and 2005, focusing on integration of arts with other subject matter. The relevant literature was located by electronic searches of the Educational Resources Information Center (ERIC), telephone conversations with researchers, request for information about current research from the arts and learning listserve, online journals (e.g., *Arts Education Policy Review*, *International Journal of Education and the Arts*), and keyword searches via internet search engines for research and programs in arts integration. We point out that this is not a comprehensive research review, but rather a review of selected examples of two types: large-scale arts-integrated programs and small-scale arts initiatives and their evaluations. We conducted the analysis for this review by critically reading the selected reports. To facilitate this analysis, we used the following guiding questions:

- Who conducted the research?
- What was the research focus and what methods were used?
- What were the findings?
- Were the obstacles and disadvantages of arts integration clearly mentioned?
- What do these studies contribute to the discourse on arts integration?

*Overview and Evaluation of three Large-Scale Arts-Integrated Programs*

In this section we present a brief description and critical analysis of three large-scale programs, selected to illustrate a variety of approaches and structures: the North Carolina *A + Schools Program*, *Learning Through the Arts* (LTTA™), and *Chicago Arts Partnerships in Education* (CAPE). Then, we present briefly the reported findings of the evaluations for these programs.

*The North Carolina A1 Schools Program.*[2]    The North Carolina A+ Schools Program is a comprehensive, statewide, PreK-12, whole school reform initiative that implements the *North Carolina Standard Course of Study* through interdisciplinary thematic units, combined with arts integration. The program espouses hands-on, experiential learning. Every child is to have drama, dance, music, and visual arts at least once a week. Ongoing professional development includes school-based workshops, demonstration teaching, and residential summer A+ Institutes. A+ schools work to develop partnerships with parents, cultural resources in the area, local colleges and universities, and the media.

In their evaluation of the NC A+ Schools Program, Wilson, Corbett, and Noblit (2001) reported that state scores within A+ Program Schools matched scores in other (nonA+ schools) North Carolina Schools. In their report they also emphasized that different kinds of assessment are needed to capture creative and higher order skills supported by the program. For example, they described heightened engagement and

enthusiasm in arts-integrated environments, mentioning that students and teachers alike reported a growth in enjoyment for school and learning. On the other hand, Groves, Gerstl-Pepin, Patterson, Cozart, and McKinney (2001) reported that the A+ Program Schools faced serious challenges such as inadequate funding, time constraints, personnel turnover, and state demands for high-stakes testing and accountability.

*Learning Through The Arts™ (LTTA).*[3]   Learning Through The Arts (LTTA) is a Canadian initiative of the Royal Conservatory of Music, Toronto, self-described as "a comprehensive public school improvement program." LTTA provides instructional materials, ongoing program coordination, program evaluation, and trained artist-teachers who collaborate with generalist teachers in the design of lessons. LTTA teachers teach math, science, geography, and language curriculum through LTTA-approved units of study that incorporate performing and visual arts into the learning process.

Independent researchers (Upitis, Smithrim, Patteson, & Meban, 2001; Upitis & Smithrim, 2003) studied the impact of the LTTA program in partner schools across Canada. The sample included 6,675 students from Grades 1 through 6, from LTTA schools and two types of control schools. Evaluation focused on students' attitudes, habits and achievements, teachers' beliefs and practices, administrators hiring and budget practices, parents' attitudes towards the arts and artists' beliefs and practices. On most measures of mathematics and language, no significant differences were found between the Grade 6 students in the LTTA schools and students in the two types of control schools. The researchers concluded that involvement in the arts for the students in the LTTA schools did not come at the expense of achievement in mathematics and language. The study also reported noticeable improvements in test scores in other basic subjects. Students, teachers, parents, artists, and administrators mentioned the emotional, physical, cognitive, and social benefits of learning in and through the arts. Ninety percent of parents, regardless of school type, believed that the arts motivated their children to learn. Participating artists reported that they observed a wide variety of benefits to students engaged in the arts, including the development of arts skills, exploration of curriculum topics through the arts, and the laying of a foundation for a lifelong love of the arts.

*Chicago Arts Partnerships in Education (CAPE).*[4]   The CAPE, formed in the early 1990s as a school improvement initiative, aimed to forge a clear connection between arts learning and the rest of the curriculum. The program entails long-term partnerships among Chicago public schools, professional arts organizations, and community organizations, and receives support from private, community, state and business collaborations, and foundations. A feature of the program is ongoing participation of classroom teachers and arts teachers in planning the role of the arts and visiting artists in CAPE schools.

Waldorf (2002) explored the work of professional artists involved in classroom partnerships with teachers in the CAPE, while DeMoss and Morris (2002) examined students' cognitive processes when engaging in arts-integrated instruction. The evaluation methods used included surveys, observations and interviews, focus groups, and student writing. DeMoss and Morris (2002) reported six desirable characteristics

of arts-integrated programs: (1) Clear activities, expectations, and outcomes; (2) student work habits; (3) equal participation, connected instruction; (4) content integrity; (5) applied arts concepts; and (6) democratic inclusion. Their analysis of student interviews revealed that arts-integrated environments affected student learning by broadening learning communities, enhancing students' motivation to learn, enriching students' written analytic interpretations, developing affective connections in their writing, and helping the students engage subject content. According to Horowitz (2004), the research on CAPE suggests that arts-integrated teaching has the potential to develop many typically unmeasured facets of student development; however, it is not clear how the cognitive processes gained through arts-integrated experiences fit within a larger picture of student academic and personal development.

## *Overview and Evaluation of Selected Small-Scale Studies*

It is apparent that arts integration occurs beyond the scope of the large-scale partnership programs that have gained a great deal of national and international attention. Imaginative teachers have always integrated arts with other subject areas; their voices are quiet, and their efforts are not always documented or evaluated.[5] Our (Michalinos' and Joan's) pre-service student teachers return from their field experiences from time to time, singing the praises of a cooperating teacher who draws on artistic ways of knowing to engage students more fully either to promote achievement in the standard curriculum or to promote socialization goals. We sometimes find their stories in the extensive literature that advocates for arts integration, or describes what teachers and students are actually doing, or presents units of instruction for teachers to implement or build on (see, e.g., Perkins, 1989). There is a wealth of material in this vein.

We classified the small-scale research roughly into two categories: studies that focused on K-12 *students'* learning and studies that focused on pre-service or *practicing teachers'* learning. Studies that examined broader learning outcomes (socialization, for instance, change of attitude, etc.) rather than specific subject areas are included. We identified 15 studies that met these criteria. All the studies in this section were longitudinal and used qualitative methods.

*Student learning.* Eight of the 15 studies we identified focused on student learning. Berghoff's (2005) work-in-progress, focused on the impact of engagement with visual arts and dance on students' concepts of identity – their own and others' – as individuals in community with others. The arts and their influence on literacy development were the focus of four studies: Coufal and Coufal's (2002), Cowan's (2001), Crumpler (2002), and Trainin, Andrzejczak, and Poldberg's (2005). Hanley (2002), studied the use of drama to promote multicultural education with high school students. Maher (2004) investigated the uses of visual arts, music, and quilting in a unit in social science, while McDermott, Rothenberg, and Hollinde (2005) studied the impact of visual arts engagement on student learning in literacy, science, and social science. Mello (2001) examined the impact of storytelling on fourth grade students' social relationships and development of moral concepts.

*Teacher learning, teacher change.* Teacher change is a prominent theme in the large-scale studies reviewed by Horowitz (2004). It is also prominent in the seven small-scale studies we identified. Borgmann (2005) used in-depth, individual narratives to investigate what pre-service teachers' learning looks like. Borgmann, Berghoff, and Parr's (2001) five-year study of pre-service classroom teachers examined how personal voice, metaphor, aesthetic modes of knowing, and the practice of revision of arts products contribute to strengthening teachers' positive disposition towards the arts. Mello (2004) investigated the impact of arts-based pedagogy on pre-service student learning. Patteson, Upitis, and Smithrim (2002) studied transformation among teachers who engaged in their own art-making through a professional development program. They speculated that teachers who were convinced of the importance of the arts to human life would then introduce and sustain the presence of the arts in their classrooms, whether mandated by curricula or not. Oreck (2002, 2004) focused on teachers' skills and confidence in using the arts in their classrooms, while Parr (2005) proposed a research-based, cyclical curriculum model that she argued would "dramatically change how pre-service and practicing teachers understand and value the arts" (p. 19). Wilson (2002) studied the impact of 125 hours of instruction in arts integration on teachers' beliefs about change, and the importance of the arts in the elementary classroom. One interesting finding in Wilson (2002) is pertinent to teachers' sense of agency. Worth noting, we think, is the finding that several teachers reported being more concerned with making the total program more meaningful for students and less concerned with the breadth of the Education department's expectations.

## Critical Commentary

Evaluations and studies of arts-integration initiatives use a variety of measurement and descriptive approaches, and there are many examples of qualitative data informing quantitative measures (see also Horowitz, 2004). Such studies, drawing out the challenges and successes of large-scale and small-scale arts-integrated programs, can make a valuable contribution to the study of arts-integration outcomes. Most of the small studies and large-scale evaluations we have cited here used qualitative methodologies; these reported positive learning outcomes. These outcomes include claims that engagement with subject matter through the arts helps students and teachers approach school tasks with increased intensity, commitment, and capacity for critical thinking. Yet, policymakers in many school districts increasingly focus on high-stakes standardized tests as measures of success in learning. It is, therefore, important, according to Horowitz (2004) to acknowledge that arts-integrated programs "are inherently complex and multi-dimensional, and don't easily lend themselves to experimental designs and purely outcome-based evaluations" (p. 7).

There are certainly numerous aspects involved besides student achievement when trying to capture the diversity of experience and the effects of programs and initiatives. The assessment of student learning is particularly problematic because, as some researchers (Horowitz, 2004; Mansilla, 2005) point out, it is difficult to obtain data that serve as evidence of learning – other than what is measurable. Some researchers (e.g., Berghoff, 2005; Mansilla, 2005), however, raise methodological and conceptual

concerns related to assessment of learning in qualitative studies of arts-integration programs and projects. Arguing that the purpose of subject integration is to achieve cognitive advancement, Mansilla (2005) proposes guidelines for assessing cognitive gain built on a "performance view of understanding" – a view that privileges the capacity to *use* knowledge over that of simply having or *accumulating* it. From this perspective, individuals are judged to have understood a concept when they are able to apply it, or think with it accurately and flexibly in novel situations.

In addition, Berghoff (2005) contends that growth in students' ability to think abductively – what we do when we create new or more complex mental models for ourselves – depends upon students' engagement with a variety of rich experiences. Berghoff argues therefore, abductive thinking occurs when students engage with arts-infused curriculum. For this reason, discipline-specific knowledge is an important asset in promoting learners' ability to think abductively. Aligned with these views on abductive thinking is a methodological issue. Berghoff (2005) and Borgmann (2005) explain that it is difficult both to obtain data that capture learning and to show learning in art-infused curriculum, because the learning looks qualitatively different from learning in other models of curriculum. Moreover, student-produced artifacts or their behaviors are not necessarily dependable indicators of students' thinking and therefore analysis of such data is not necessarily reliable. We agree that any evaluation of arts-integrated programs will be *misguided*, if it is primarily focused on measuring *success* in terms of improvement on high-stakes tests.

There are, however, two troublesome issues in determining the impact of these programs and studies on a policy and political level. One such issue has to do with who does the evaluation, and what the evaluation seeks to evaluate. An issue not raised in the literature, which we think is important, pertains to the distance that is achievable by researchers conducting studies of their own practices in arts integration. Therefore we think, with Gee (2003, 2004), that it is important to ask: Who is conducting the research, for which/whose purposes, and what methodological issues need to be addressed to ensure transparency? Programs that aim to enrich school curricula through the arts are aware of the importance of satisfying various groups and especially the demand that students' academic achievement will not be adversely affected. Thus, given the importance of evaluating program outcomes, or effectiveness, we note that two types of approaches are used to evaluate different types of outcomes of the arts-integration programs that we examined in this chapter: analyses of test scores and qualitative studies. The statistical analyses respond to concerns about students' abilities to do well on tests in the core curriculum, while qualitative inquiries aim to elicit deeper understandings of how the arts experiences affect students' and teachers' behaviors, attitudes, and learning strategies, parents' and administrators' outlooks, and so on. The studies reported here often used mixed methods to ascertain outcomes that are measurable (test scores) and outcomes that do not lend themselves easily to measurement (e.g., enthusiasm, intrinsic motivation, affective connections, analytic thinking skills, etc.). These studies reflect a chasm between the expectations of standardized testing with the assessment of qualitative outcomes.

Second, we agree with Horowitz (2004) that there is still a critical need to find better outcome measures, particularly in the area of student growth. The evaluation reports and

studies we discussed here do not capture the full extent of learning within arts integrated environments. However, the goal of this effort should not be to justify arts integration by showing that students' achievement is enhanced through arts-integrated programs. We also agree with DeMoss and Morris (2002) that evaluators and researchers should seek to develop a variety of ways to represent the multiple *kinds* of student growth in arts-integrated programs. Further research should focus on how students' arts-integrated learning provides both cognitively and affectively *different* experiences.

## Discussion and Implications

As the vigorous debates between those supporting arts as disciplines and those arguing for arts integration continue, our review has sought to move beyond these dichotomous discussions in order to explore the outcomes and implications of learning and teaching in integrated learning environments. Our hope is to show that, as researchers and practitioners in arts education, we need to engage in more in-depth research on the role of arts integration in education so that recommendations and decisions regarding arts integration are based less on belief and more on evidence. The studies and programs we reviewed here suggest that there are benefits and challenges associated with the implementation and evaluation of arts-integrated programs. In the next section, we discuss some of those benefits and challenges of arts integration in schools, drawing particular attention to the pedagogical, methodological, and political implications.

### Benefits

Studies abound that seek to quell anxieties about the abilities of students who have experienced arts-integrated curricula to achieve test success in core school subjects. Quantitative studies show repeatedly that students' grades do not suffer, and may even improve. Qualitative studies and anecdotal evidence, on the other hand, suggest strongly that a more important, possibly more long-lasting benefit to students is a positive change in attitude towards school itself. Such change lends itself well to description, less so to measurement. On the other hand, description seems to work less well than measurement for advocacy purposes, where a table can show results at a glance, and results are presented as unbiased, distanced, scientific, reliable, and truthful. It is clear that each type of assessment speaks to different audiences in different ways; each has a role to play in advocacy, in curriculum planning, and program design.

### Challenges

In spite of the many advantages of arts integration in the studies and programs we reviewed, there are still some important objections and obstacles. In the programs reviewed here, we identified and discussed some of the challenges that arose in our literature review earlier in this chapter. These challenges include the concerns that arts integration undermines the concepts from individual subject matter areas, issues of

teacher self-efficacy, the structure of the school day in traditional educational systems, and issues associated with teacher education in implementing integrated approaches.

At the center of concerns with the adoption of arts-integrated curricula remains the issue of the integrity of individual subject matter areas. The concern is that teaching all the arts together along with other subject areas undermines deep understanding of the concepts in each subject area. The pedagogical side of this argument is that demands for cognitive operations involved in each subject area are fundamentally different and discrete. The political side of this argument is that blending all the arts together undermines the place of each particular art in the school curriculum and sends the message that it is acceptable to do so. In any case, it is clear that a key requirement for successful arts integration is the close collaboration of the teacher-artist partnership. Yet, without arriving at some common vision about objectives or how to attain them, it is unlikely that constructive work can occur. Bumgarner's (1994) conclusion that "to expect professional artists to inculcate teachers and school administration with a conception of arts education so vastly different from prevailing practice is illogical and unrealistic" (p. 11) is a conclusion shared by Meban (2002) a Canadian artist-teacher.

Another important issue in arts integration relates to teacher self-efficacy and preparation to teach using integrated approaches. Self-efficacy refers to the belief in one's own capability to execute a task (Bandura, 1997). Given that most teachers at the secondary level are educated in a particular discipline and that teachers at the elementary level usually have more confidence in certain subjects, it is understandable that teachers feel uncomfortable when asked to teach in an integrated manner, unless they have had opportunities to develop deeper knowledge in the subjects they are trying to integrate. The programs and studies we examined suggest that when appropriate training and sustained support is provided then the issue of self-efficacy can be successfully tackled (e.g., Borgmann, Berghoff, & Parr, 2001; McCammon & Betts, 2001; Oreck, 2002, 2004; Patteson, 2002, 2004; Patteson et al., 2002).

Concerns about the allocation of time to accomplish goals may also be related to the structure of the school day (Groves et al., 2001). This is particularly an issue in jurisdictions where a national curriculum is adopted by all schools, and where the structure does not allow enough time or flexibility to integrate. Unless teachers team-teach, they may lack opportunities to collaborate with other teachers. Moreover, if there is lack of belief in the value of integrated curricula then any effort in that direction may be resisted. Any changes in culture and practice must be supported by structural changes, particularly in the use of time (Groves et al., 2001).

The programs and studies we have reviewed here suggest that meaningful experiences for teachers and students occur where there is sufficient training in how to use integrated approaches in pre-service or in-service education programs, and where appropriate structures of support are in place. Fostering this kind of teaching presents the more difficult task of deciding the mode of integration one wants to make, how to implement it and how to go about evaluating students' (and teachers') learning. Not surprisingly, no approach is free of problems. Releasing teachers' creative energy through professional development programs and other types of support seems to empower teachers to create the "space" that they need to blossom. Ultimately, the success of arts-integration programs depends upon the commitment of classroom teachers.

# Conclusion

The most intriguing challenge in integration is to find ways of collaborating across disciplines and professional ideologies. Successful cases of integration are character-ized by "transformative practice zones" that "provide spaces to share and listen to oth-ers' ideas, visions and commitments, and to build relationship in collaboration across disciplines and institutions" (Bresler, 2003, p. 24). Integrated curricula have the poten-tial to create transformative zones, thereby encouraging open-endedness, spaces for exploration, connection, discovery, and collaboration by bringing together various areas of knowledge, experiences, and beliefs.

Integration initiatives seem to be in tension with the current conservative "back-to-basics" vision of what education is for, and how it should be carried out. There seems to be a public perception that the arts are being stripped from the curriculum, yet the body of literature that we examined seems to suggest otherwise. The growing body of research as well as practical suggestions for program organization, teacher education, and classroom applications form a base of knowledge from which to engage in discus-sions about arts integration that are grounded in actual experience rather than in per-ception. Researchers and teacher educators also have a role to play in helping others to learn to distinguish between evidence and perception, between fact and belief.

We conclude our review of the issues surrounding arts integration across the cur-riculum with this quote from philosopher David Best (1995), which we think is a fit-ting way to end:

the value and intelligibility of integrated work will always depend ultimately on particular cases. Whether and when it is educationally enlightening to work with other subjects, whether arts or non-arts, will depend, as all education ought to depend, primarily upon the informed professional judgment of teachers who are expert in their particular fields. It will depend upon our having confidence in well-educated teachers. They are in the best position to make sound decisions about the value of working collectively with other disciplines. (p. 38)

# Notes

1. We note also a growing body of literature from African and aboriginal communities in North America and Australia that advocates a return to a precolonial era holistic approaches to teaching and learning. In this chapter we focus on literature pertaining to mainstream, Western-style educational practices.
2. Updated information on this program retrieved on October 7, 2005 from http://aplus-schools.uncg.edu.
3. Information about this program retrieved from http://www.ltta.ca. For a detailed description of the pro-gram, see Elster (2001) at http://IJEA.asu.edu/v2n7
4. Further information on this program is available at http://www.capeweb. org. The rationale, organization, and implementation of this program are presented in Burnaford, Aprill, and Weiss (2001). The text offers a theoretical framework for arts-integration practice.
5. One has only to do an Internet Search to discover the integrative work that teaching professionals are doing in their classrooms in attempting to make their teaching and their students' learning more mean-ingful. These individuals, often working in collaboration with colleagues, tend to operate outside the research community and the large institutional programs.

# References

Bandura, A. (1997). *Self-efficacy: The exercise of control*. New York: Freeman.

Barrett, J. R., McCoy, C. W., & Veblen, K. K. (1997). *Sound ways of knowing: Music in the interdisciplinary curriculum*. New York: Schirmer/Wadsworth.

Beane, J. (1997). *Curriculum integration: Designing the core of democratic education*. New York: Teachers College Press.

Beane, J., & Brodhagen, B. (1996). *Doing curriculum integration*. Madison, WI: University of Wisconsin.

Beane, J. A. (1991). The middle school: The natural home of integrated curriculum. *Educational Leadership, 49*(2), 9–13.

Berghoff, B. (2005). *Views of learning through the arts in elementary classrooms*. Paper presented at the annual meeting of the American Educational Research Association, Montréal, Canada.

Best, D. (1995). Collective, integrated arts: The expedient generic myth. *Arts Education Policy Review, 97*(1), 32–39. Retrieved online September 23, 2005 via McGill University Library.

Borgmann, C. B. (2005). *Views of learning through the arts in teacher education*. Paper presented at the annual meeting of the American Educational Research Association, Montréal, Canada.

Borgmann, C. B., Berghoff, B., & Parr, N. C. (2001). Dispositional change in pre-service classroom teachers through the aesthetic experience and parallel processes of inquiry in arts integration. *Arts & Learning Research Journal, 17*(1), 61–77.

Bresler, L. (1995). The subservient, co-equal, affective and social integration styles and their implications for the arts. *Arts Education Policy Review, 96*(5), 31–37.

Bresler, L. (2003). Out of the trenches: The joys (and risks) of cross-disciplinary collaborations. *Council of Research in Music Education, 152*, 17–39.

Brewer, T. M. (2002). Integrated curriculum. What benefit? *Arts Education Policy Review, 10*(4), 31–37.

Bumgarner, C. M. (1994) Artists in the classrooms: The impact and consequences of the National Endowment for the Arts' artist residency program on K-12 arts education. *Arts Education Policy review, 95*(3), 14–30.

Burnaford, G., Aprill, A., & Weiss, C. (Eds.). (2001). *Renaissance in the classroom: Arts integration and meaningful learning*. Mahwah, New Jersey: Lawrence Erlbaum Associates.

Burton, J., Horowitz, R., & Abeles, H. (1999). *Learning in and through the arts: Curriculum implications*. Washington, DC: Champions of Change Report, The Arts Education Partnership, and the President's Committee on the Arts and Humanities.

Chrysostomou, S. (2004). Interdisciplinary approaches in the new curriculum in Greece: A focus on music education. *Arts Education Policy Review, 10*(5), 23–29.

Consortium of National Arts Education Organizations. (1994). *National standards for arts education*. Reston, VA: Music Educators National Conference.

Coufal, K. L., & Coufal, D.C. (2002). Colorful wishes: The fusing of drawing, narratives, and social studies. *Communication Disorders Quarterly, 23*(2), 109–121.

Cowan, K. W. (2001). The arts and emergent literacy. *Primary Voices, 9*(4), 11–18.

Crumpler, T. (2002). Scenes of learning: Using drama to investigate literacy learning. *Arts & Learning Research Journal, 18*(1), 55–74.

Deasey, R. (Ed.) (2002). *Critical links: Learning in the arts and student academic and social development*. Washington, DC: Arts Education Partnership.

DeMoss, K., & Morris, T. (2002). How arts integration supports student learning. Students shed light on the connections. Retrieved online September 12, 2005 from http://www.capeweb.org/demoss.pdf

Detels, C. (1999). *Soft boundaries: Re-visioning the arts and aesthetics in American education*. Westport, CT: Bergin & Garvey.

Dewey, J. (1916). *Democracy and education*. New York: Free Press.

Dewey, J. (1934). *Art as experience*. New York: Putnam.

Doll, W. (1993). *A post-modern perspective on curriculum*. New York: Teachers College Press.

Efland, A. (1990). *A history of art education: Intellectual and social currents in teaching the visual arts*. New York: Teachers College Press.

Efland, A. (2002). *Art and cognition, integrating the visual arts in the curriculum*. New York: Teachers College Press.

Eisner, E. W. (1985). *Learning and teaching the ways of knowing*: Eighty-fourth Yearbook of the National Society for the Study of Education, Part II. Chicago: University of Chicago Press.

Freedman, K. (2003). *Teaching visual culture: Curriculum, aesthetics and the social life of art*. New York: Teachers College Press.

Gardner, H. (1983). *Frames of mind: The theory of multiple intelligences*. New York: Basic,

Gee, C. B. (2003). Uncritical pronouncements build critical links for federal arts bureaucracy. *Arts Education Policy Review, 104*(3), 17–20.

Gee. C. B. (2004). Spirit, mind and body: Arts education the Redeemer. In E. Eisner & M. Day (Eds.), *Handbook of research and policy in art education* (pp. 115–134). Mahwah, NJ: Lawrence Erlbaum Associates, Publishers.

Goldberg, M. (2001). *Arts and learning: An integrated approach to teaching and learning in multicultural and multilingual settings* (2nd ed.). New York: Longman/Addison Wesley.

Groves, P., Gerstl-Pepin, C. I., Patterson, J., Cozart, S. C., & McKinney, M. (2001). *Educational resilience in the A+ Schools Program: Building capacity through networking and professional development*. Winston-Salem, NC: Thomas S. Kenan Institute for the Arts.

Hanley, M. S. (2002). Bird in the air: Critical multicultural education through drama. *Arts & Learning Research Journal, 18*(1), 75–98.

Hetland, L., & Winner, E. (2000). The arts in education: Evaluating the evidence for a causal link. *The Journal of Aesthetic Education, 34*(3/4), 3–10.

Horowitz, R. (2004). *Summary of large-scale arts partnership evaluations*. Washington, DC: Arts Education Partnership.

Horowitz, R., & Webb-Dempsey, J. (2002). Promising signs of positive effects: Lessons from the multi-arts studies. In R. Deasey (Ed.), *Critical links: Learning in the arts and student academic and social development* (pp. 98–101). Washington, DC: Arts Education Partnership.

Maher, R. (2004). "Workin' on the railroad:" African American labor history. *Social Education, 68*(5), 4–10.

Mansilla, V. B. (2005). Assessing student work at disciplinary crossroads. *Change, 37*(1), 14–22.

Marshall, J. (2005). Connecting art, learning, and creativity: A case for curriculum integration. *Studies in Art Education, 46*(3), 227–241.

Mason, T. C. (1996). Integrated curricula: Potential and problems. *Journal of Teacher Education, 47*(4), 263–270.

McCammon, L., & Betts, D. J. (2001). Breaking teachers out of their little cells. *Youth Theatre Journal, 15*(1), 81–94.

McDermott, P., Rothenberg, J., & Hollinde, P. (2005). "Let me draw!" How the arts foster knowledge and critical thinking in an urban school. *Arts & Learning Research Journal, 21*(1), 119–138.

Meban, M. (2002). The postmodern artist in the school: Implications for arts partnership programs. *International Journal of Education and the Arts, 3*(1). Retrieved online September 12, 2005 from http://ijea.asu.edu/v3/n1

Mello, R. (2001). The power of storytelling: How oral narrative influences children's relationships in classrooms. *International Journal of Education and the Arts, 2*(1). Retrieved online September 12, 2005 from http://ijea.asu.edu/v2n1

Mello, R. (2004). When pedagogy meets practice: Combining arts integration and teacher education in the college. *Arts & Learning Research Journal, 20*(1), 135–164.

Oreck, B. (2002). *The arts in teaching: An investigation of factors influencing teachers' use of the arts in the classroom*. Paper presented at the annual meeting of the American Educational Research Association, Seattle, WA.

Oreck, B. (2004). The artistic and professional development of teachers: A study of teachers' attitudes toward and use of the arts in teaching. *Journal of Teacher Education, 55*(1), 55–69.

Parr, N. C. (2005). *Semiotic cycles of learning and the challenges of visual data*. Paper presented at the annual meeting of the American Educational Research Association, Montréal, Canada.

Parsons, M. (2004). Art and integrated curriculum. In E. Eisner & M. Day (Eds.), *Handbook of research and policy in art education* (pp. 775–794). Mahwah, NJ: Lawrence Erlbaum Associates.

Patteson, A. (2002). Amazing grace and powerful medicine: A case study of an elementary teacher and the arts. *Canadian Journal of Education, 27*(2&3), 269–289.

Patteson, A. (2004). *Present moments, present lives: teacher transformation through art-making.* Unpublished doctoral dissertation. Queen's University, Kingston, Canada.

Patteson, A., Upitis, R., & Smithrim, K. (2002). Teachers as artists: Transcending the winds of curricular change. In B. White & G. Bogardi (Eds.), *Professional development: Where are the gaps? Where are the opportunities? Educators' and artists views on arts education in Canada* (pp. 83–100). Montréal, Canada: The National Symposium on Arts Education.

Perkins, D. (1989). Selecting fertile themes for integrated learning. In H. Jacobs (Ed.), *Interdisciplinary curriculum: Design and implementation* (pp. 67–76). Alexandria, VA: ASCD.

Russell, J. (2006). Preservation and development in the transformative zone: Fusing disparate styles and traditions in a pedagogy workshop with Cuban musicians. *British Journal of Music Education, 23*(2), 1–12.

Trainin, G., Andrzejczak, N., & Poldberg, M. (2005). Visual arts and writing: A mutually beneficial relationship. *Arts & Learning Research Journal, 21*(1), 139–156.

Upitis, R., & Smithrim, K. (2003). *Learning Through The Arts&trade;: National assessment 1999–2002 Final Report to the Royal Conservatory of Music.* Toronto: The Royal Conservatory of Music.

Upitis, R., Smithrim, K., Patteson, A., & Meban, M. (2001). The effects of an enriched elementary arts education program on teacher development, artist practices, and student achievement: Baseline student achievement and teacher data from six Canadian sites. *International Journal of Education & the Arts, 2*(8). Retrieved online September 12, 2005 http://ijea.asu.edu

Veblen, K., & Elliott, D. J. (2000). *Integration: For or against? General Music Today, 14*(1), 4–12.

Waldorf, L. A. (2002). *The professional artist as public school educator: A research report of the Chicago Arts Partnerships inn Education, 2000–2001.* UCLA Graduate School of Education & Information Studies.

Wilson, B., Corbett, D., & Noblit, G. (2001). *Executive summary: The arts and education reform: Lessons from a 4-year evaluation of the A+ Schools Program 1995–1999.* North Carolina School of the Arts, NC: Thomas S. Kenan Institute for the Arts.

Wilson, M. (2002). Integrated arts: A partnership model for teacher education. Symposium paper. In B. White & G. Bogardi (Eds.), *Professional development: Where are the gaps? Where are the opportunities? Educators' and artists' views on arts education* (pp. 119–126). National Symposium on Arts Education.

Wineberg, S., & Grossman, P. (Eds.). (2000). *Interdisciplinary curriculum: Challenges to implementation.* New York: Teachers College Press.

Winner, E. (2003). Beyond the evidence given: A critical commentary on Critical Links. *Arts Education Policy Review, 104*(3), 1–13.

Winner, E., & Hetland, L. (2000). The arts and academic achievement: What the evidence shows. Executive Summary. *The Journal of Aesthetic Education, 3*(4), 1–10.

# INTERNATIONAL COMMENTARY

# 18.1

## Integrated Arts Education in South Africa

**Anri Herbst**

*University of Cape Town, South Africa*

I am surrounded by singing, dancing and acting bees, and crickets in a picturesque urbanized rural area in South Africa. These "insects" also write poems and paint colorful pictures: They are the learners of a Grade 3 (age 9) class in which numeracy, literacy, and life skills are taught through the "musical arts" (see Mans, 1999; Nzewi, 2001). The teacher, a generalist classroom teacher in a government school, is trying to fulfill the ideals of the Revised National Curriculum Statement, labeled "Curriculum 2005," which was formulated after the 1994 democratic elections in South Africa. This Curriculum promises to be student-centered, outcomes-based, and skills-oriented with the focus on intra- and interdisciplinary integration (National Department of Education, 2002).

The above snapshot highlights the tension between oral and written knowledge systems in postcolonial democratic South Africa (see Herbst, De Wet, & Rijsdijk, 2005; Primos, 2001). In the indigenous sub-Saharan African curriculum-of-life approach, the musical arts not only amplify daily life experiences, but also act as an important mediator and transactor of life (Dlamini, 2004; Nzewi, 2003). It is no wonder that stories and games (with and without music) act as important carriers of sociocultural knowledge (e.g., Agawu, 1995; Dzansi, 2002; Mans, Dzansi-McPalm, & Agak, 2003; Ng'andu & Herbst, 2004).

While the indigenous classroom presents a natural integration of the arts into daily events, accelerated learning in government schools attempts to simulate the indigenous "classroom" by presenting subjects glued together, often superficially, and approached in an intradisciplinary and interdisciplinary way (see National Research Foundation/NRF, 2005). In a survey by the Human Sciences Research Council (HSRC) in 2005, 90% of rural primary school educators indicated that games form an important part of their teaching strategies. The quality of the teaching and the success rate of using these strategies were unfortunately not assessed.

Despite the grand ideals outlined in "Curriculum 2005," reality shows that implementation of the Arts and Culture learning area falls short in the majority of South

<div align="center">303</div>

*L. Bresler (Ed.), International Handbook of Research in Arts Education, 303–306.*
© 2007 *Springer.*

African government schools (Herbst et al., 2005; Klopper, 2004). Musical arts education suffers because of inadequate generalist teacher training, unrealistic expectations from generalist teachers, poverty, AIDS-related health issues, and discrepancies between rural and urbanized general education (Human Sciences Research Council, 2005). It is therefore not surprising that I could not locate any formal South Africa research equivalent to that discussed in the preceding chapter. Completed research projects reflect the need for inter- and multicultural teaching, in-service training, models, and learning programs for integration. Current studies focus on the values of indigenous knowledge systems for modern Africa and a sociocultural musical arts identity amidst a strong global market-driven music industry (see NRF, 2005).

Although it may seem as if scholarly research on the success of integration and outcomes-based education has been put on the back burner, it could well be that the singing and dancing insects mentioned in the first paragraph hold the promise that South Africa will indeed succeed in merging indigenous and global knowledge systems in a unique way. This can occur only when we have fully grasped the impact of our colonial past on indigenous knowledge system and developed a workable vision for the future (see Potgieter, 2005), and when Arts and Culture as a learning area is indeed taught in all schools in South Africa.

# References

Agawu, K. (1995). *African rhythm: A northern Ewe perspective*. Cambridge, MA: Cambridge University Press.

Dlamini, S. (2004). The role of the *umrhubhe* bow as transmitter of cultural knowledge among the amaXhosa: An interview with Latozi "Madosini" Mpahleni. *Journal of the Musical Arts in Africa, 1,* 138–160.

Dzansi, M. (2002). Some manifestations of Ghanaian indigenous culture in children's singing games. *International Journal of Education and the Arts*, *3*(7). Retrieved November 18, 2005, from http://ijea.asu.edu

Herbst, A., De Wet, J., & Rijsdijk, S. (2005). A survey of music education in the primary schools of South Africa's Cape Peninsula. *Journal of Research in Music Education, 53*(3), 260–283.

Human Sciences Research Council with the Education Policy Consortium for the Nelson Mandela Foundation/HSRC. (2005). *Emerging voices: A report on education in South African rural communities*. Cape Town: HSRC Press. Retrieved November 18, 2005, from www.hsrcpress.ac.za

Klopper, C. (2004). *Variables impacting on the delivery of music in the learning area arts and culture in South Africa*. Unpublished doctoral thesis, University of Pretoria, South Africa.

Mans, M. (1999). *Namibian music and dance as Ngoma in arts education*. Unpublished doctoral thesis, University of Natal, Durban, South Africa.

Mans, M., Dzansi-McPalm, M., & Agak, H. (2003). Play in musical arts pedagogy. In A. Herbst, M. Nzewi, & A. Agawu (Eds.), *Musical arts in Africa: Theory, practice and education* (pp. 195–214). Pretoria: University of South Africa Press.

National Department of Education, South Africa. (2002). *Revised national curriculum statement*, Arts and culture. Retrieved September 16, 2005, from http://curriculum.wcape.school.za/ncs/index/lareas/view/6/#9

National Research Foundation of South Africa (NRF). (2005). Nexus database of completed and current research projects undertaken in South Africa. Retrieved September 16, 2005, from www.nrf.ac.za

Ng'andu, J., & Herbst, A. (2004). *Lukwesa ne Ciwa* [The story of Lukwesa and Iciwa]: Musical storytelling of the Bemba of Zambia. *British Journal of Research in Music Education, 21*(1), 41–61.

Nzewi, M. (2001). Music education in Africa: Mediating the imposition of Western music education with the imperatives of the indigenous African practice. In C. Van Niekerk (Ed.), *PASMEC 2001: Selected conference proceedings from the conference held in Lusaka, Zambia, 21–25 August* 2001 (pp. 18–55). Pretoria: Pasmae.

Nzewi, M. (2003). Strategies for music education in Africa. In A. Herbst, M. Nzewi, & A. Agawu (Eds.), *Musical arts in Africa: Theory, practice and education* (pp. 13–37). Pretoria: University of South Africa Press.

Potgieter, H. (Ed.). (2005). *Musical arts education in transformation: Indigenous and global perspectives in South Africa*. Cape Town: African Minds.

Primos, K. (2001). Africa. In D. Hargreaves & A. North, A. (Eds.), *Musical development and learning: The international perspective* (pp. 1–13). London: Continuum.

# INTERNATIONAL COMMENTARY

## 18.2

# Arts Integration in Greece

**Smaragda Chrysostomou**
*National and Kapodistrian University of Athens, Greece*

Issues involved in holistic approaches to education, integrated curricula, and interdisciplinary approaches to teaching and learning have dominated Greek and Cypriot educational literature during recent decades. Since 2001, Greece has embarked on the application of a new integrated approach in which horizontal and vertical connections are aimed across the curriculum at all levels of education. Nevertheless, a number of educators in the country (Grollios, 2003; Noutsos, 2003; Therianos, 2003) have questioned this new curriculum in view of the limited application of similar programs in Europe. They have also criticized the possibility for realization of the philosophical and theoretical aims, as well as the lack of research and evaluation of a pilot application of the program.

On the other hand, the creators of the new integrated curriculum, based on a preliminary evaluation of the pilot application, report positive outcomes and acceptance by teachers, students, and parents (Alahiotis, 2004). Also, a growing number of educational researchers (Aggelidis & Mavroidis, 2004; Matsaggouras, 2003; Spiropoulou, 2004) have attempted interdisciplinary and integrated approaches in their classrooms around the country and are exploring different outcomes and questions relating to their appropriateness and effectiveness, as well as change in students' attitudes towards learning.

The only large-scale application of arts integration in Greece is the "Melina project" (Melina Project, n.d.), piloted in 93 primary schools in Greece and 2 schools in Cyprus in 1995–2001. Its main aim, the enhancement of the cultural dimension of education and the empowerment of everyday school life through the arts (music, dance-movement, plastic arts, drama, and audio-visual arts), is achieved through development of artistic expression, interpersonal communication skills, and cultural conscience. The success of the program is evident from the evaluation and assessment that was completed during and after the project, as well as the important legacy that it created for the schools where it was applied. Since 2001, the project has entered its next phase, defined as generalization, and is being piloted in one prefecture in Crete (Chania).

*L. Bresler (Ed.), International Handbook of Research in Arts Education*, 307–308.
© 2007 *Springer.*

# References

Aggelidis, P., & Mavroidis, G. (Eds.). (2004). *Educational innovations for the school of the future* (Vol. A). Athens: Typothito.

Alahiotis, S. (2004). Towards a contemporary educational system: Integration and flexible zone change education and upgrade educational quality. In P. Aggelidis & G. Mavroidis, G. (Eds.), *Educational innovations for the school of the future* (Vol. A). Athens: Typothito.

Grollios, G. (2003). Foundation, aims and integration in the new curriculum for education. *Ekpaideutiki Koinotita, 67*, 30–37.

Matsaggouras, I. (2003). *Integration in school knowledge*. Athens: Gregory.

Melina Project Education & Culture. (n.d.). Retrieved September 14, 2005 from www.prmelina.g

Noutsos, M. (2003). Unified curriculum: The ideology of confusion. *Ekpaideutiki Koinotita, 67*, 24–29.

Spiropoulou, D. (2004). The flexible zone as educational innovation: A case study of three secondary schools. *Epitheorisi Ekpaideutikon Thematon, 9*, 157–171.

Therianos, K. (2003). Integration in education: Can DEPPS and Flexible Zone change schools if we do not change examinations and assessment? *Ekpaideutiki Koinotita, 67*, 18–23.

# INTERNATIONAL COMMENTARY

## 18.3

# Arts Integration in Japan

**Koji Matsunobu**
*University of Illinois at Urbana-Champaign, U.S.A.*

The Japanese Ministry of Education secures a minimum time and budget allotment for arts instruction in schools. Given this situation, almost no research on extrinsic values of arts learning exists in Japan.

The status of the arts being equivalent and comparable to that of academic subjects in schools allows for the implementation of different types of arts integration. One example is *sogotekina gakushu no jikan* ("an integrated course"), one of the new curriculum areas sanctioned by the Ministry of Education and introduced in 1998, requiring two hours of instruction per week. This program will be in place until the next curriculum review results in changes in 2010.

The main objective of *sogotekina gakushu no jikan* is to encourage students to engage in self-learning and to develop skills necessary for problem-finding/solving in real-life situations. Four major areas were proposed by the government as examples for ideal integrated projects: (1) international understanding, (2) welfare, (3) information, and (4) the environment. During implementation, arts educators discussed how their roles might support and enhance this new area of the curriculum. Examples of arts inclusion were teaching multicultural arts in a series of international education, giving musical performances in nursing homes as part of welfare education, studying/sharing/exhibiting art works through the Internet, and promoting and engaging in soundscape activities. There are numerous anecdotes and self-report accounts of successful practices of arts integration by school teachers, such as ones in a special 1999 issue of a music educator's journal, *Kyoiku Ongaku* (Limited information in English about this project may be found at http://www.mext.go.jp/english/news/2000/10/001001.htm.). It is a common understanding among scholars and teachers that this program will disappear when the curriculum policy is renewed next time, for the same reason that arts education in many other countries has been cut: concern over standardized test scores. However, there is almost no research in Japan that proves the relationship between students' engagements in integrated programs and their academic achievement.

*L. Bresler (Ed.), International Handbook of Research in Arts Education*, 309–310.
© 2007 *Springer.*

In his study on arts integration in Japan and the United States, Matsunobu (2005) contemplated possible factors regarding arts integration in schools within both cultures. In Japan there tends to be a cohesive view with regard to the aims of schooling and those of arts education, advocating for the holistic development of students, so-called *joso-kyoiku*, loosely translated as the cultivation of aesthetic and moral sentiments. Indeed, another word that can be substituted for *Joso* is *kokoro* (heart), the center of one's entire being, and thus the inseparable combination of mental, physical, emotional, aesthetic, and spiritual capacities (Sato, 2004). This belief system, it seems, brings about the equal positioning of the arts and other subjects in school, as both are considered to serve the development of *kokoro*. Thus, the emphasis on academic subjects is not to denigrate the arts; rather the arts are seen as "pivotal vehicles" for improved academic studies (p. 4). Viewed from this point, the issue of arts integration reveals the necessity of integrating different perspectives and aims of school subjects that often contradict with each other. Matsunobu (2005) also questions whether the real issue is to incorporate the arts into the school curriculum or to promulgate aesthetic values as part of an indispensable component of a well-rounded school education.

# References

*Kyoiku Ongaku*. (1999). *Kyoiku Ongaku Shogakuban: Ongakuka ga kakawaru sogoteki na gakushu jissen jirei 32* [Elementary music education: 32 Cases of integrated programs involving music]. Tokyo: Ongaku no Tomosha.

Matsunobu, K. (2005). *Ongakuka ni okeru togokyoiku no tenkai ni kansuru kenkyu* [A study on music in the integrated curriculum]. Unpublished doctoral dissertation, Tokyo Gakugei University, Tokyo.

Sato, N. E. (2004). *Inside Japanese classrooms: The heart of education*. New York: RoutledgeFalmer.

# INTERNATIONAL COMMENTARY

## 18.4

## Flashes on Research and Practice in Integrated Music Education in German-speaking Europe

**Markus Cslovjecsek**
*University of Applied Sciences Aarau, Switzerland*

In the starting phase of a Swiss project called "Schulen mit erweitertem Musikunterricht EMU" (Schools with Enhanced Music Education), primary school teachers taught 5 hours of music a week with their classes. Despite the correspondingly reduced hours in the main subjects, the curriculum remained unchanged for all subjects. The first finding (after 4 years) indicated that the competences in the main subjects did not decrease (Weber, Spychiger, & Patry, 1993). In a second phase, it became obvious that musical activities have extramusical contents and that extramusical activities have musical contents (Spychiger, 1995, 2001). From the intense collaboration with the teachers involved, a practical teacher-manual was constructed (Cslovjecsek & Spychiger, 1998), textbooks on "Maths by Music" (Cslovjecsek, 2001/2004) have been developed, and "Train-the-trainer" programs in early language learning with music (Kramer, 2002) have been installed. Integrating musical activity in other subjects is still an innovative approach. A field study about math and music in Switzerland shows that even teachers with high interest in both subjects are not involving aspects of music education in their math lessons (Cslovjecsek, 2003).

Through observations and interviews with experts, Donata Elschenbroich (2001) explored the knowledge of the seven-year-olds (Weltwissen der Siebenjährigen), developing not a canon of competencies but a list of learning experiences in music that should be integrated into the curriculum. Elschenbroich notes that young children are experts in developing verbal language out of sounds, in developing meaning out of gestures, and in creating learning games. Children do not distinguish between art-as-discipline and art-as-handmaiden. The author finds that children construct an enormous amount of active knowledge through exploration of sound and motion, concluding that many important steps in children's ways of exploring the world are anchored in how they deal with sound and motion, the sign systems of musical and kinesthetic intelligence.

Another area of research relevant to arts integration has to do with auditory capacities and school success. Tewes, Steffen, and Warnke (2003) empirically demonstrate

*L. Bresler (Ed.), International Handbook of Research in Arts Education, 311–312.*
© 2007 *Springer.*

that it is possible to train auditory capabilities through electronic games. In their research on learning problems at the earliest stages of school, Breuer and Weuffen (2000) state that mostly insufficient linguistic perceptions and/or weak basic auditory and linguistic skills are involved. The children concerned show deficiencies regarding phonematic, kinesthetic, melodic, rhythmic, and optical differentiation. Ptok (2000) notes that such "basic processing abilities" are the foundation for linguistic competences and thus fundamental for a successful start at school. Since early learning difficulties often have a negative long-term effect, early arts education may be seen as critical. Sound colors, accents and melodies, and movement play major roles in language learning and understanding of young children, and can facilitate learning games.

Despite this importance, boundaries between language and the arts are often questioned. Helmut Holoubek (1998) reconstructed the relationship of music in language education, offering a unique basis for interdisciplinary discourse as well as for the planning and implementation of integrated curriculum on the secondary school level.

# References

Breuer, H., & Weuffen, M. (2000). *Lernschwierigkeiten am Schulanfang – Schuleingangsdiagnostik zur Früherkennung und Frühförderung* [*Learning difficulties when starting school – diagnostics for early diagnosis and encouragement*]. Weinheim, Germany: Beltz.

Cslovjecsek M., & Spychiger M. (1998). *Mus ik oder Mus ik nicht? – Musik als Unterrichtsprinzip* [*To sound or not to sound – Music as an educational principle*]. Hölstein [Switzerland]: Verlag SWCH.

Cslovjecsek, M. (Ed.). (2001/2004). *Mathe macht Musik: Impulse zum musikalischen Unterricht mit dem Zahlenbuch* [*Music by maths: Impulses for music education with the Math-Textbook*]. (vols. 1–3). Zug [Switzerland]: Klett und Balmer.

Cslovjecsek, M. (2003). Klang und Bewegung als Zugang zur Welt der Zahlen – ein lohnender Zugang zu einem musikbetonten Unterricht? [Sound and movement as the gateway to the world of numbers – a rewarding approach to education emphasizing music?]. *Musikerziehung: Zeitschrift der Musikerzieher Österreich* [Music education: *Magazine of the Austrian Music Teachers*] 57, 15–18. öbv&hpt. Vienna, Austria.

Elschenbroich, D. (2001). *Weltwissen der Siebenjährigen: Wie Kinder die Welt entdecken* [*World knowledge of the seven-year olds: How children can discover the world*]. München [Germany]: Kunstmann.

Holoubek, H. (1998). *Musik im Deutschunterricht. (Re-)Konstruierte Beziehungen, oder: Thema con Variazioni.* [*Music within the language class. (Re)-constructed relationships or tema con variazioni*]. Frankfurt on the Main: Peter Lang.

Kramer, A. (2002). Musikalische Wege zur Fremdsprache in der Grundschule [A musical approach towards foreign language education in elementary school]. Teaching and learning. *Lehren und Lernen, Zeitschrift des Landesinstitutes für Erziehung und Unterricht* [*Journal of the Federal Institute of Education*], 9(28), 19–25. Germany.

Ptok, M. (2000). Auditive Verarbeitungs – und Wahrnehmungsstörungen und Legasthenie [Auditive processing and percepting disorders and dyslexia]. *Hessisches Ärzteblatt [Medical Journal of Hesse]*, 2, 52–54. Germany.

Spychiger, M. (1995). *Mehr Musikunterricht an den öffentlichen Schulen?* [*Should public schools offer more music education?*]. Hamburg: Kovac.

Spychiger, M. (2001). Understanding musical activity and musical learning as sign processes: Toward a semiotic approach to music education. *Journal of Aesthetic Education, 35*(1), 53–67.

Tewes, U., Steffen, S., & Warnke, F. (2003, January). Automatisierungsstörungen als Ursache von Lernproblemen [Automatization disorders as the origin of learning difficulties]. *Forum Logopädie [Forum for logopedics], 1*(17), 2–8.

Weber, E., Patry J. L., & Spychiger, M. (1993). *Musik macht Schule* [*Music makes the school*]. Essen [Germany]: Die blaue Eule.

19

# ARTISTS IN THE ACADEMY: CURRICULUM AND INSTRUCTION

**Eve Harwood**

*University of Illinois at Urbana-Champaign, U.S.A.*

In the contemporary world of professional artists, a dance production may include spoken text and visual images; visual artists may present their ideas through performance art; architectural and acoustic space may be essential elements of a musical composition. In this world, conceptual boundaries between the arts have little meaning. But disciplinary structure is slow to change, at least in the North American academy, and research on college curriculum and instruction reflects the work of doctoral students and scholars in separate departments of theater, dance, music, art, and design.[1] This chapter summarizes evidence-based accounts of teaching and learning in higher education, from roughly 1980 to the present, in four individual disciplines,[2] visual art, music, theater and dance. Peer reviewed journals, dissertations, and single volume essays or histories in English have been the principal sources.

The attempt is to identify trends, commonalities, and points of difference among these arts through consideration of three questions: Who is being taught and what do they tell us about the experience? What is the content of instruction and who decides? What do studio teaching and learning look like? The first two questions reflect primary ways of conceiving the purpose of education. In simplest terms they have been labeled by theorists as student-centered and discipline-centered approaches to curriculum. The third question often, but not exclusively, addresses teacher-centered approaches to curriculum in the central component of any arts program, namely the studio. For most arts students, studio instruction is at the heart of the curriculum. This setting relies on a model of teaching that is largely problem-based, as opposed to the information transmission model typically associated with lecture/discussion courses. I highlight studio teaching because research on exemplary practitioners and on assessment of student performance in such settings is a significant contribution the arts disciplines make to the general literature on undergraduate education.

To narrow the scope of the chapter, I have excluded research on arts courses for non-majors within a liberal arts education. Because sequential and incremental learning in the arts is structured through curriculum reserved for students who major in them

*L. Bresler (Ed.), International Handbook of Research in Arts Education*, 313–330.

(Harris, 1997), this chapter is limited to studies concerned with curriculum and instruction for students majoring in performing and visual arts. The large body of research literature on teacher preparation in the arts disciplines is also excluded; I refer the reader instead to existing literature on teacher education.[3]

Readers interested in the history of each discipline as it grew within American higher education will find comprehensive accounts in dance (Hagood, 2000), art (Ritchie, 1966; Singerman, 1999), theater (Berkeley, 2004; Ney, 1989), and music (Hays, 1999). These narratives present the development of the respective arts from European conservatory models (music and visual art), from physical education departments (dance), or from departments of English literature and speech (theater) to their present status within the academy. Some commonalities in these historical accounts bear mention here, as they provide context for the research reported in the main body of the chapter. First, each discipline carved out its place in higher education through the contributions of remarkable individuals and the establishment of model programs at significant institutions. Second, a signal event in establishing undergraduate curriculum content and standards within each discipline was the formation of an accrediting body: National Association of Schools of Music in 1924; National Association of Schools of Art and Design in 1944; National Association of Schools of Dance in 1981; and National Association of Schools of Theatre in 1989.[4] Third, all describe a version of boom time in the 1970s and reduction in growth from the 1980s to the present. Significantly, contemporary debate about the place of the arts in higher education reflects questions raised during their first uneasy acceptance into the academy.

I turn now to consideration of the first question: Who are the learners and what do they tell us about their experience of higher education?

## Undergraduate Students in the Fine Arts

Students[5] who seek an arts education at the modern university must meet the institution's academic standards and often an individual artistic review by audition or portfolio as well. While many of their counterparts at age 18 are uncertain about what they want to study, most entering fine arts students are already heavily invested in their disciplines. Some even choose a university in order to study with a specific faculty member, a criterion more commonly associated with graduate school in other disciplines. In some senses, the freshman fine arts student is seeking through university to extend a tradition that goes back centuries in the arts, where students lived with their teachers or worked as apprentices in an artist's studio to gain their advanced education.

Enrolment patterns in the United States indicate that the arts are far from marginal in terms of attracting students to higher education. In 2001 to 2002 there were 66,773 Bachelor's degrees awarded in the visual and performing arts from Title IV degree-granting institutions.[6] As the table below indicates, this is comparable to the percentage of degrees awarded in psychology and biology.

Institutions of Postsecondary Education in the United States (IPEDS) 2001–2002

| Field of study | Bachelor's degrees | Percentage of total |
| --- | --- | --- |
| Biological sciences | 60,256 | 4.7 |
| Business administration | 276,047 | 21.4 |
| Education | 106,383 | 8.2 |
| Psychology | 76,671 | 5.9 |
| Visual and performing arts | 66,773 | 5.2 |

Given demanding entrance criteria and the uncertainty of developing a career after graduation, one may well wonder why so many students choose the arts. Evidence suggests that their primary reason is love of their art, even when they are realistic about the likelihood of a professional career. Survey results show that postsecondary students "have chosen this career path not out of a sense of financial remuneration or job security, but for the love of the disciplines they are studying" (Luftig, Donovan, & Farnbaugh, 2003, p. 10)

## Student – Focused Research

What do we know about the lived experience of these students in our university curricula? Two circumstances account for the paucity of answers to this question: the lack of theoretical framework for artistic development, and an untheorized teaching tradition that is largely mimetic from expert teacher to student novice. There is no established or even tentative theory of artistic development in the college years comparable with the multiple models for intellectual, ethical, and psychological development. In a longitudinal study of 21 visual art students from first year to graduation, Bekkala (2001) concluded that "while research pointed to general changes in cognition and experiences of self which impact the works young people create in art college, when they engage in creative activities, development also occurs in a manner which lies beyond the linear framework offered by theorists such as Erikson and Perry" (p. 256).

The mimetic teaching tradition associated with studio teaching has resulted in a marked absence of student voice and in some cases a lack of concern for students' aspirations. Comments from researchers make the point.

[Theater] Our review of the (scanty) literature dealing with the impact of acting revealed that a voice conspicuously underrepresented was that of the university student actor. In our study, we decided to allow this voice to be heard. (Burgoyne, Poulin, & Reardon, 1999, p. 157)

[Music] Historically, the predominant relationship between teacher and student in instrumental instruction has been described as a master-apprentice relationship, where the master usually is looked at as a role model and a source of identification for the students and where the dominating mode of student learning is imitation. (Jorgensen, 2000, p. 68)

[Dance] … the feedback that is frequently emphasized in technique class usually comes from an outside source, such as the teacher or the mirror. It is separate

from the experience of dancing, is given whether or not it is solicited and, as teachers, we expect our students to apply our feedback whether or not it correlates with their personal agendas. (Bracey, 2004, p. 20)

What knowledge we have of students' experience in the arts curriculum emerges from a combination of quantitative measures and direct student testimony reported in qualitative studies. One topic where both kinds of data are available is student response to evaluation of their work. How students understand such assessments, known variously as juries, critiques, or reviews, is of particular concern in the arts because the work submitted is often highly personal, involving body, mind, and spirit.

One means of understanding how students experience criticism comes from self-report surveys and standard personality tests. These have been used to identify personality types of students and teachers (Donovan, 1994; Gelbard, 1993), to identify students as ego or task oriented (Nieminen, Varstala, & Manninen, 2001), and to identify preferred feedback strategies (Salapa, 2000). Investigations of performance anxiety in music (Atlas, Taggart, & Goodell, 2004; Rack, 1996), and student attributions of success in art courses (Roach, 1993) suggest that students with low anxiety and less sensitivity to criticism experience more pleasure in their artistic performances.

Such survey and correlation data provide one picture of arts students, as tending to be feeling/intuitive types (Salapa; Donovan; Gelbard) with regard for authority, needing acceptance, and respect to perform well (Rack; Roach; Atlas et al.). Qualitative studies investigate the meaning such general characteristics have in the context of individual student lives.[7] Bracey (2004) used a qualitative design to understand the experience of five dancers taking advanced technique courses. Her informants reported feeling tension between emphasis on mechanics in technique class and emphasis on overall expression required in performances. Another tension was the relationship between their education in dance as art and dance as academic discipline. Third was the importance of community, the presence of other dancers as influencing each dancer's learning. Risner (2000) studied the process of learning a particular piece of choreography. Many of his student dancers echoed sentiments expressed by Bracey's informants, including the important role played by the presence of other dancers as they learned the piece. They also articulated that body memory, in particular, was a means of "knowing" the dance. In theater, Burgoyne et al. (1999) developed a theory regarding the blurring of boundaries between actor and character. A psychologist and an acting instructor interviewed 15 actors, including 7 undergraduate students, using grounded theory in their analysis. They found that in some cases the psychological effects of portraying characters had emotionally distressing consequences for the actor. Ability to control the blurring of boundaries influenced whether acting experience led to growth or to emotional distress. They recommended that "an ethical first step would be to incorporate discussion of boundary issues into the curriculum for acting and directing students" (p. 171).

Several issues are embedded in these studies of fine arts students: the need to balance essential corrective feedback with developing independent artists, the presence of other students as essential for certain kinds of learning, and the relative lack of student voice in the research literature.[8]

# Curriculum Content: Who decides?

The curriculum required of students in the arts at North American postsecondary insti-
tutions is a mosaic, each piece representing the various stakeholders who have a hand
in shaping undergraduate education. These include the various accrediting bodies for
higher education, university- specific graduation requirements, accrediting bodies in
the arts and disciplinary experts in individual university departments. The result is a
curriculum with few elective hours. In such an environment, curricular space becomes
highly contested and the arts may have to assert their legitimacy in the academy. Many
faculty will recognize the position described here for dance: "My conclusions illumi-
nate the frequent mis-perceptions of the performing arts, and particularly dance, as
merely narrow recreational or entertainment activities and show how these initial con-
ceptions of dance had to be addressed and refuted when dance first entered the uni-
versity" (Ross, 1998, p. v).

## *Historical Studies*

Research on the content appropriate to undergraduate arts programs exists in many
forms, including historical, philosophical, and empirical studies. Historical research
outlines the philosophical debates over content that emerged as each discipline entered
the academy. The next section highlights selected issues in the history of each art, cho-
sen because they have continued resonance.

Singerman's *Art Subjects: Making Artists in the American University* (1999) offers
a history of the Master of Fine Arts degree but many issues apply equally to under-
graduate programs in visual art. He addresses "not only the various images of the artist
on campus but also the arguments those images advance for the place and position of
art as a study in the university: its likeness to university scholarship and theoretical
research. On campus, art cannot be a calling or a vocation" (p. 5). The case that art
itself is a form of research is very much a contemporary idea, but Singerman suggests
that its antecedents are to be found in arguments advanced for art in the academy from
the beginning.

In music, Hays (1999) explores the nexus between the music academy and the larger
society through a cultural history of music schools' development in North America. He
traces music in education from its European roots in the Paris Conservatoire, to music
conservatories in the new world, to social and political changes from the 1940s
through the 1980s, and their influence (or lack of it) on curriculum in music in
American higher education. His conclusions point to major changes in thinking now
facing traditional schools of music: "The fundamental challenge of the music academy
of the future is how to deal with a second paradigm of music defined by produced
sound (vs. acoustic sound), popular music idioms, and the recording-as-art-work
model of the virtual performance" (p. 233).

Readers interested in a complete history of dance from the medieval university
to postmodern aesthetics will find a comprehensive account in Hagood's *A History
of Dance in American Higher Education: Dance and the American University*
(2000). One issue he examines is gender in dance programs, a concern also raised

by Ross (1998), who characterizes the introduction of dance into the academy during the 1920s as representing a feminization of physical culture. In a related study (2000), Ross examines the initial controversy regarding whether dance should properly be seen as belonging to physical education, as represented by Margaret H'Doubler, or to the profession of dance as art, represented by figures such as Ruth St. Denis and Martha Graham. The difference between these two positions is evident decades later. Casten's survey of dance program coordinators (1983) found significant curricular differences between those allied with departments of physical education and those housed in fine arts, with arts programs overwhelmingly stressing performance.

In theater, Ney's *Functions of Academic Theatre Programs* (1989) and Berkeley's (2004) article "Changing view of knowledge and the struggle for the undergraduate curriculum 1900–1980" describe the evolution of theater curricula. Ney conceptualizes theater as having four phases in its development on campuses: play productions, curricular offerings for credit, creation of academic departments of theater, and growth of a professional training model for curriculum (p. 65). One of Berkeley's conclusions is that "the values that gave rise to the inclusion of theater curricula at the turn of the twentieth century have little in common with the values of those who now govern the university and set its priorities" (p. 24).

Such a conclusion applies beyond theater to all the arts, whose advocates must demonstrate how their curricula support the values embraced by the twenty-first century university. These values on North American campuses include achieving scholarly and professional preeminence in individual disciplines,[9] providing "multicultural" and global education, infusing technology through the curriculum, and engaging communities outside the university. The next section summarizes selected studies as indicative of the arts' response to such imperatives. The coverage of research here is in no way comprehensive; rather the titles listed are representative of many more in each category.

## Empirical Studies: Discipline-Specific Content

Many studies have proposed curricular reform, typically through the addition of particular subject matter.[10] This approach is particularly evident in dissertation topics. A more or less random sampling in music, the most prolific of the arts in this area, includes the following:

- appropriate inclusion of songs from the American musical theater repertoire in the undergraduate vocal studio (Bell, 1996);
- incorporating team teaching as an approach to vocal instruction (Forderhase, 1991);
- adding arts administration training to the music performance curriculum (Westin, 1996);
- the inclusion of jazz studies (Hennessey, 1995; Murphy, 1990; Rabideau, 1998);
- providing vocational skills and counseling within the violin performance curriculum (Reimer, 2003);
- specialization within percussion studio curricula in North America and Puerto Rico (Nave, 2001).

Dissertations in the other arts are less numerous than in music, but there are similar examples:

- teaching fiber art as an art (Craig, 1984);
- constructivist learning in a first-year art foundations course (Wright-Evans, 2001);
- including mime in the training of stage actors (Davis, 1991);
- training in film and video for stage actors (Ivins, 1993);
- the role of a student dance company in an academic setting (Nelson, 1980).

Discipline-specific research apart from dissertations includes reports of practitioner experience or case studies with individuals. Examples here are Fortin's work on the empowering effect of somatic training for dancers (1998; Fortin, Long, & Lord, 2002); Butterworth's (2004) proposal for a new paradigm in teaching choreography; Steven's (2000) review of choreographic pedagogy in the United Kingdom including the history of professional choreographers; a report of an ensemble theater program designed as an alternative to the "increasingly rigid specialization in the theatre arts" (Leff, 1990) and an account of how aesthetic fundamentals in college art became subordinated, including a discussion of the schism between arts and design curricula (Lavender, 2003).

## Curricular Trends in the Twenty-First Century

Arts curricula have been affected by the so-called culture wars being waged in higher education since the 1960s. Feminist and postmodern critiques are challenging what was the core content in many arts, the European high art tradition. Such critiques are evident in journal articles for theater (Dolan, 1997; Nascimento, 2001; Schmor, 2004), dance (Shapiro, 1999), art (Freedman & Stuhr, 2004), and music (Parenti, 1996). The growth of departments of ethnomusicology, the rise of cultural studies centers, and a proliferation of global studies courses on the American campus are clear indications that the whole community has moved beyond a Eurocentric curriculum. A selection of such research in the arts includes strategies for including African-American dance and culture (Hubbard & Sofras, 1998), documenting changes over several decades in multicultural music education (Volk, 2004), and developing historically Black colleges as critical pedagogy sites for theater (Medford, 2004). In music, consideration of what repertoire belongs in the curriculum has been particularly problematic. According to Hays, canonicity itself is an organizing principle for the music academy (1999, p. 227). Thus when jazz studies or world musics are proposed, their repertoire is presented as having its own canon, jazz standards, or identifiable regional musics worthy of study.

Advances in technology have transformed the way artists work, and consequently the way they teach. Recent dissertations on technology-assisted instruction in the arts show the variety in applications to arts teaching: spectrographic analysis in the college voice studio (Callaway, 2001), use of a CAI program to teach music theory (Sterling, 2002), and the possibilities for distance education in art foundation courses (Cassidy, 2002). However, the real impact of technology on arts instruction stems from the ways that technology continues to transform how choreographers, composers, and visual

artists work. Practice is changing continually, well ahead of research on the effects such innovations may have on student learning.

Another trend with widespread implications for research is the mandate for universities to connect with the wider community. This is an arena where the arts are actively engaged in projects of many kinds, but systematic investigations of their effectiveness at present are lacking. For a review of research in music education and partnerships across the arts, see "Music Education Connections" (Myers, 2002). A British volume, *Making Music Work: Professional Integration Project* (Barnes, 1999), describes several kinds of partnerships being undertaken there. In American contexts sample connections include primary and secondary education (Beck & Appel, 2003), local artists (Walker, 2001), and community arts organizations (Alexander, 1997; Cohen-Cruz, 2001).

# Instruction: Studio Teaching

Close personal relationships between student and teacher naturally develop and are an expected part of studio teaching.[11] These are learning-by-doing experiences, where teachers act as coaches and mentors. By definition, the instruction is problem-based, as students work to master specific repertoire or techniques and display continued advancement in their execution and artistry, as defined within the discipline and in the judgment of their teachers. What Ted Sizer (1996) called for as part of the essential schools movement, the public exhibition as demonstration of significant learning within a discipline, has been standard operating procedure in the arts for centuries. The presentation of plays, music and dance concerts, and art exhibitions serves as the public demonstration of competence for undergraduate arts majors.

Perhaps no area of instruction in the arts in higher education has received more attention from researchers than evaluation of studio work. In visual arts, the "crit" serves as a public forum for assessment of individual students' art. The practice of talking about a painting, both commenting as the students are working and when the work is completed, has a long history in art practice: "Reading a finished painting back to its maker so that the student artist's project might be refined and extended is the teaching of painting by 'crit' " (Singerman, 1999, p. 143). In dance, theater, and music, end-of-semester juries or reviews serve a similar function, although verbal criticism may be given privately.

## Assessing Studio Work

In the studio, critiques serve several purposes. Some teachers use them to deliver summative judgments about the quality of student work. Others attach an educative value to the process and invite active participation by the students. Several writers have drawn attention to the negative effects assessment of student work in studio may have, in part, because individual competencies and personal experiences are publicly revealed (Anthony, 1991; Bekkala, 2001; James, 1996).

Barrett (1988, 2000, 2004) has studied art criticism at many levels, including critique in higher education. Most studio teachers he interviewed saw evaluation as the

primary purpose of critique. Many expressed interest in having students talk about their work, although none reported a systematic approach to the critique process. Studio teachers implicitly used intention as a major criterion for judgment; that is, they compared the student's stated intention with its realization. Expert art critics, trained in aesthetics, did not share the studio artists' assumption that intentionality by itself is an adequate criterion for judgment. Barrett concludes that "these studio professors are not doing criticism as it is recommended in art education literature" (1988, p. 26). A later study (Barrett, 2000) compares the way students perceive the critique process with the way their faculty see it. His suggestion is that literature on mentoring could greatly enhance the effectiveness of the critique for students and teachers.

Kent (2001) conducted a case study of Lucio Pozzi's studio critique method in a graduate summer course at NYU. This critique format included an introduction, close examination of an artwork, clarification questions and dialogue based on the act of looking, and a reiteration of salient points. Kent suggests that the content of Pozzi's critique reflected his values, and therefore his method could be adapted but not copied by others.

In dance, Lavender (1994, 1996) piloted a method for conducting critiques of students' choreography with his own college class. Many studio teachers find it difficult to move students past comments such as "I like it" to engage the work critically. Lavender's solution was a system based on Ecker's five-step program, ORDER (observation, reflection, discussion, evaluation, revision). Student choreographers reported that they learned both from articulating criticism and from receiving analytical and aesthetic comments from their peers. Research on evaluation of choreography is reviewed by Hamalainen (2002), who proposes specific roles for both teachers and students. She also points to evidence that independent expert evaluators differ significantly from each other. An inference is that critiquing choreography has more value as an educative process for students than as a reliable assessment tool.

A similar finding is reported in several music studies involving peer assessment of composition and performance (Daniel, 2004; Hunter & Russ, 1996; Searby & Ewers, 1997). Such innovations represent an alternative to the pass/fail of the senior recital experience. As did dancers and art students, the music students grew in their critical abilities through the process of evaluating their peers. Daniel raises an important question for future study: to what extent do students' performances improve as a result of engaging in peer assessment?

### In the Studio: How Does Teaching and Learning Occur?

What actually transpires in the instructional setting of the studio remains difficult to quantify.[12] Some research indicates that the focus is not particularly on student development. Bekkala notes, "As the study has shown, many current practices of the studio serve to focus upon the concept of art rather than the concept of the learner" (2001, p. 258). Several researchers have focused their attention on studio teachers. Inkster (1997) used interviews to compare methods and pedagogy of 12 outstanding trumpet teachers, including their approach to lesson structure, embouchure, transposition, and practice. In visual arts, James (1996) used case study to investigate the construction of meaning

in a sculpture studio. She identified an instructional structure composed of assigned readings, instructor talk, slides of sculptures, studio time, and critique. In the studio phase students interacted with materials, with the instructors, and with each other. In the critique phase, students commented on each other's work, as did the instructor. Students' sculpture became the vehicle for learning creative process, aesthetics, and critical process (p. 156).

Persson's case study (1996) of a brilliant piano performer-turned-teacher describes the learning experience for nine of the teacher's students. The teacher in this case had no formal training in education and therefore relied on what Persson described as "common sense." Ultimately he concluded that the performer-teacher was not able to provide effective instruction for all students. Kennell (1989) observed instrumental music teachers and proposed a teacher attribution theory of scaffolding. That is, teachers' preferred intervention is based on their attribution of why the student's performance failed or succeeded. This theory was different from scaffolding theory as presented in general education literature, suggesting that music studio instruction has unique features.

Another source of evidence regarding teaching and learning in the studio setting comes from student accounts of their understanding. Kostka (2002) found that music students' expectations about the quality and quantity of individual practice between music lessons differ from those of their studio teachers. Goffi (1996) asked students to rate their studio voice instructors. Two main factors emerged as contributing to students' learning, the teacher's cognitive (technical and instructional knowledge) and interpersonal skills. Based on a comprehensive literature review and interviews with his own students, Jorgensen (2000) concluded that although teachers might be too dominant in lessons, "the opposite is the case for practicing behaviours [*sic*]. Here, paradoxically, the absence of a teacher's influence, advice and discourse may limit the student's development of independence and responsibility" (p. 73).

## Reflections

Why does the research literature look as it does? I offer three general observations. First, as college teachers, we are doing more than we are documenting. Through authoring textbooks, redesigning syllabi, programs of study, and the daily work of faculty with students, we are creating the lived curriculum for undergraduates. We share our knowledge through conference presentations, keynote speeches, and creative performances. The research article as defined for this chapter[13] is only one way of disseminating knowledge in an arts community.

Second, as a profession, we have given less scholarly attention to the study of our teaching than we have to our creative endeavors. This commentary from theater applies across the arts:

It is one of the great ironies of theatre scholarship that what most of us do [teaching], few of us study. Why we should have neglected our own intellectual home as an area of research is puzzling-and also unexplored. Our scholarly neglect does

not arise from indifference ... Most of us signal in other ways our sense of the importance of our teaching: We think about it, talk about it, and strive to improve it. What we don't do much is study it. Why? (Gillespie, 2004, p. ix)

I propose a couple of answers to this question. The working reality for most arts faculty is that their first loyalties are to their creative lives as artists, then to their development as teachers and to scholarship on their art. Research on teaching comes a distant fourth. As well, the arts disciplines have a relatively young history in academe, and there are a limited number of research- intensive institutions where the scholarship of teaching and learning might reasonably be expected. I return later to possible remedies for this set of circumstances.

A third general observation is that there is considerable variation in research on specific topics according to discipline. Coverage is partly a result of numbers of faculty and university departments. In North America, the number of accredited institutions tells the tale: music – 610; dance – 60; theater – 135; art – 248.[14] Art and music generally have a longer history in the academy; thus there is a larger body of research from music and art than from theater and dance. Coverage also results from scholars' choice in where to focus their attention: on students; on knowledge and skills to be learned; on pedagogical method; on teachers, and so on. In general, the student voice and student responses to the curriculum offered in higher education, is still largely under-studied in the arts.[15]

## Missions and Traditions

There appears to be no consensus about the purpose of the arts across or even within disciplines. I suggest that curricular values represent a continuum, with conservation/preservation of tradition at one end, and innovation/deconstruction of tradition at the other. Schools of music are generally at the conservative end while visual art is at the other; dance and theater fall somewhere between depending on individual department philosophies. Performing a canon of masterworks and analyzing and writing music based on eighteenth-century models remain hallmarks of most music curricula.[16] The bulk of researchers' suggestions for reforming music content typically represent additions to the canon of Western music literature. As Hays puts it,

> While there are a few curricular innovations on the horizon, most seem to center on assimilating new technologies rather than attempting to revise the core curriculum by injecting jazz or world music idioms, let alone a popular music component. Changing technology is far easier than changing ideology. (1999, p. 227)

In contrast, the problem for the art curriculum is not what belongs in the canon, but rather of defining art itself.[17] According to Singerman, "the problem of definition is at the heart of the artist's education because it is the formative and defining problem of recent art. Artists are made by troubling over it, by taking it seriously" (1999, p. 3). Ritchie, writing in 1966, identified this approaching change in the art curriculum,

> as painting and sculpture depend less and less on stabilized traditional techniques, and the term "art" becomes correspondingly less restrictive as an evaluative term,

the function of education for the "pure" arts, in a traditional sense, becomes increasingly less capable of precise definition. (p. 83)

In this environment, "What is it that artists do?" becomes a defining question, and the role of visiting artists as models for professional behavior becomes singularly important for art curricula. Without an 'old masters' set of criteria for evaluating excellence, students must rely heavily on critique from their individual instructors. This is perhaps why the subject of the critique has drawn considerable attention from art researchers and relatively little from their counterparts in music.

Some commonalities are evident regarding the current status of higher education arts programs today, struggling for survival in an increasingly chilly fiscal environment. All four disciplines as they evolved on campuses had to overcome the perception that they are decorative and therefore expendable, enriching but not essential. The efforts being made to justify their continuing existence in higher education in the twenty-first century take at least three forms. First is the development of community partnerships. Along with many other disciplines, the arts are undertaking teaching, production, and research projects with partners outside of academe. These include initiatives such as theater in prisons programs, museum-based art projects, music in community centers, and so on.

Second is increasing specialization within the arts. One means of claiming legitimacy for a discipline is that it offers unique and essential knowledge, not available elsewhere in the university. Since overlap and duplication are likely to be cut, disciplines are scrambling to protect their intellectual individuality. The proliferation of journals, special topic conferences, and scholarly special interest research groups attest to this phenomenon in the arts as elsewhere in higher education.

A third justification for arts curricula proposes a new kind of knowledge claim. Since cognition and research are the legitimate and overt values of the academy, artists are articulating how what they do aligns with those values. The claim is twofold: that the arts constitute an essential way of knowing the world, evidenced by new courses in visual literacy on the one hand, and reference to theories such as embodied cognition on the other, and a related claim that creative work in the arts is itself a form of scholarly research (Alexander, 2002; Pakes, 2003; Sullivan, 2004, 2005).

## Future Directions

Earlier I listed some practical answers to Gillespie's question: Why don't we study our own practice as teachers? But a better question for the twenty-first century is: What conditions are necessary for faculty to conduct research on their students' learning? To engage a community of scholars in this kind of inquiry, changes are needed in institutional reward systems, in disciplinary thinking, and in the enculturation of the next generation of scholar-artist-teachers into the academy. Fortunately, there are signs that academic culture is evolving in this direction. In North America, the growth of campus centers for enhancing college teaching is an indication that excellent teaching is recognized in the university reward structure. The work of the Carnegie Foundation has helped give legitimacy to research on college teaching and to increase venues for

publication of results.[18] A landmark for the arts is the award in the United Kingdom of a £4.5 million grant from the Higher Education Funding Council to conduct research specifically on teaching and learning in theater, dance, and music technology.[19] The International Society for Scholarship of Teaching and Learning is working through various disciplinary associations to incorporate a college teaching track into conferences and journals.[20] An example is the Mid America Theater Conference which includes a pedagogy symposium as one of its major elements. Here is an excerpt from their call for papers:

> We have come a long way from a time when pedagogy was a separate discipline focused primarily on the teaching of theatre in K-12, or in children's theatre companies or youth theatre programs, to the present day where we see pedagogical theory integrated into the fiber of every course syllabus as well as such non-traditional uses as departmental planning.[21]

I conclude with the assertion that scholarship in teaching and learning is needed to give substance to such a vision, where pedagogical theory is integrated into all aspects of curriculum and instruction. As long as teaching remains a private affair within studio and classroom walls, we will not advance our knowledge as a profession. We know that the development of individual artists benefits greatly from their study of the achievements of predecessors and contemporaries. We need to develop in the professoriate a similar tradition of individual innovation and communal sharing, wedding systematic research with artistic sensibility. Both are essential if we are to gain a deep understanding of how students learn in the arts.

## Notes

1. While there are some notable cross-disciplinary journals such as *International Journal of Arts Education* and *Arts Education Policy Review*, most of the research is domain-specific in its scope and intended audience.
2. In higher education the "arts" may also include film studies, creative writing, architecture, and environmental design. The definition here as performing and visual arts, excluding cinema studies from theater, mirrors usage in other chapters of this handbook.
3. North American publications include separate handbooks of research in music education (Colwell & Richardson, 2002) and art education (Eisner & Day, 2004).
4. See accrediting body information at http://www.arts-accredit.org/intro.jsp.
5. The term "students" in this section refers to primarily to undergraduate majors. Where noted, graduate students were also included in a study.
6. Extracted from IPEDS 2001–2002. U.S. Dept. of Education. accessed online March, 2005. This was the most recent report available at the time of writing.
7. In music, see Roberts (1993) and Pitts (2004) on the development of students' self-identity in music schools.
8. An exception is the considerable research on students in teacher preparation programs in the arts, where student reflection is often prominent.
9. A Google search for preeminence/university/strategic plans calls up over 300,000 sites.
10. There are no parallel studies of what should be removed to make room for the new content. The "disposal problem in education," inability to throw anything away, is ubiquitous.

11. Imagine the luxury of a physics teacher giving an undergraduate one hour of individual attention and careful critique every week for 4 years! Yet this is the norm for music students.

12. A complete review of systematic research on studio instruction in music (Kennell, 2002) identifies four components of the system: novice learner, musical artifacts (etudes, repertoire, teacher-made material on the spot) teacher expertise, and lesson interactions. Only the last of these deals with the nature of instruction as such.

13. Evidence-based, peer reviewed, and published reports of systematic inquiry.

14. Numbers accessed online at www.arts-accredit.org October 2005.

15. As noted earlier, art and music education have a significant body of research on students in the college years.

16. An exception is Berklee School of Music in Boston, dedicated to study of contemporary music including popular idioms.

17. For a passionate rejection of this trend, see "A Portrait of the Artist as a Young Mess" (Fendlich, 2005).

18. See the Carnegie Foundation for the advancement of teaching and learning. http://www.carnegiefoundation.org/ourwork/prof-grad.htm and the National Teaching and Learning Forum http://www.ntlf.com/.

19. See DeMontfort University http://www.dmu.ac.uk/faculties/humanities/news/humanities/cetl/ .

20. http://www.bsu.edu/web/cfa/ATHE/ represents an example under construction. Conference papers on theater pedagogy are archived here.

21. http://www.wiu.edu/matc/

# References

Alexander, B. (2002). Intimate engagement: student performances as scholarly endeavor. *Theatre Topics, 12*(1), 85–98.

Alexander, C. (1997). *Relationships between community music programs and their affiliated collegiate music schools*. Unpublished doctoral dissertation, Peabody College for Teachers of Vanderbilt University.

Anthony, K. (1991). *Design juries on trial: the renaissance of the design studio*. New York: Van Nostrand Reinhold.

Atlas, G., Taggart, T., & Goodell, D. (2004). The effects of sensitivity to criticism on motivation and performance in music students. *British Journal of Music Education, 21*(1), 81–87.

Barnes, J., Project Director. (1999). *Making music work: professional integration project; fostering professional skills among those studying music in higher education*. London, UK: Royal College of Music.

Barrett, T. (1988). A comparison of the goals of studio professors conducting critiques and art education goals for teaching criticism. *Studies in art education, 30*(Fall), 22–27.

Barrett, T. (2000). Studio critiques of student art: As they are, as they could be with mentoring. *Theory into Practice, 39*(1), 28–35.

Barrett, T. (2004). Investigating art criticism in education: An autobiographical narrative. In E. Eisner & M. Day (Eds.), *Handbook of research and policy in art education* (pp. 725–749). Mahweh, NJ: National Art Education Association: Lawrence Erlbaum Associates.

Beck, J., & Appel, M. (2003). Shaping the future of postsecondary dance education through service learning: An introductory examination of the ArtsBridge model. *Research in dance education, 4*(2), 103–125.

Bekkala, E. (2001). *The development of artists at Rhode Island School of Design*. Unpublished doctoral dissertation, Columbia University Teachers College.

Bell, E. (1996). American musical theater songs in the undergraduate vocal studio: A survey of current practice, guidelines for repertoire selection, and pedagogical analyses of selected songs. *Dissertation Abstracts International, A57/06 p. 2406.*

Berkeley, A. (2004). Changing views of knowledge and the struggle for undergraduate theatre curriculum, 1900–1980. In A. Fliotsos & G. Medford (Eds.), *Teaching theatre today: Pedagogical views of theatre in higher education* (pp. 7–30). New York: Palgrave Macmillan.

Bracey, L. (2004). Voicing connections: An interpretive study of university dancers' experiences. *Research in Dance Education, 5*(1), 7–24.

Burgoyne, S., Poulin, K., & Reardon, A. (1999). The impact of acting on student actors: boundary blurring, growth, and emotional distress. *Theatre Topics, 9*(2), 157–179.

Butterworth, J. (2004). Teaching choreography in higher education: A process continuum mode. *Research in Dance Education, 5*(1), 45–67.

Callaway, P. (2001). The use of computer-generated spectrographic analysis of female voices in the college voice studio. *Dissertation Abstracts International, A63/01, p.19.*

Cassidy, G. N. (2002). Distance education applicability to foundation studio art courses. *Dissertation Abstracts International, A63/01, p.10.*

Casten, C. S. (1983). The differences between dance programs allied with physical education departments and fine arts departments in American colleges and universities. *Dissertation Abstracts International, A45/05, p. 1307.*

Cohen-Cruz, J. (2001). When the gown goes to town: The reciprocal rewards of fieldwork for artists. *Theatre Topics, 11*(1), 55–62.

Colwell, R., & Richardson, C. (Eds.). (2002). *The new handbook of research on music teaching and learning: A project of the Music Educators National Conference.* Oxford: Oxford University Press.

Craig, C. (1984). Teaching fiber art. *Dissertation Abstracts International, A46/01, p. 53.*

Daniel, R. (2004). Peer assessment in musical performance: The development, trial and evaluation of a methodology for the Australian tertiary environment. *British Journal of Music Education, 21*(1), 89–110.

Davis, D. (1991). Mime as an actor training technique: A professional problem. *Dissertation Abstracts International, A52/06, p. 1945.*

Dolan, J. (1997). Advocacy and activism: identity, curriculum and theatre studies in the twenty-first century. *Theatre Topics, 7*(1), 1–10.

Donovan, A. (1994). The interaction of personality traits in applied music teaching. *Dissertation Abstracts International, A55/06, p. 1499.*

Eisner, E., & Day, M. (Eds.). (2004). *Handbook of research and policy in art education.* Mahwah, NJ: National Art Education Association: Lawrence Erlbaum Associates.

Fendlich, L. (2005, June 3). A portrait of the artist as a young mess. *The Chronicle Review,* p. B6.

Forderhase, J. (1991). Attitudes toward team teaching as an approach to vocal instruction. *Dissertation Abstracts International, A52/11, p. 3853.*

Fortin, S. (1998). Somatics: A tool for empowering modern dance teachers. In S. B. Shapiro (Ed.), *Dance, power and difference: Critical and feminist perspectives on dance education.* Champaign, IL: Human Kinetics.

Fortin, S., Long, W., & Lord, M. (2002). Three voices: researching how somatic education informs contemporary dance technique classes. *Research in dance education, 3*(2), 155–179.

Freedman, K., & Stuhr, P. (2004). Curriculum change for the 21st Century: Visual culture in art education. In E. Eisner & M. Day (Eds.), *Handbook of research and policy in art education* (pp. 815–828). Mahweh, NJ: National Art Education Association: Lawrence Erlbaum Associates.

Gelbard, E. (1993). Dance graduate students: Their personality preferences and related instructional preferences. *Dissertation Abstracts International, A54/10, p. 3620.*

Gillespie, P. (2004). Preface. In A. Fliotsos & G. Medford (Eds.), *Teaching theatre today: Pedagogical view of theatre in higher education.* New York: Palgrave Macmillan.

Goffi, J. (1996). Applied voice instruction: Constructing a measure for evaluating teacher effectiveness. *Dissertation Abstracts International, A57/12. p. 5093.*

Hagood, T. (2000). *A history of dance in American higher education.* Lewiston, NY: Edwin Mellen Press.

Hamalainen, S. (2002). Evaluation in choreographic pedagogy. *Research in Dance Education, 3*(1), 35–45.

Harris, E. (1997). The arts. In J. Gaff & J. Ratcliff (Eds.), *Handbook of the undergraduate curriculum: A comprehensive guide to purposes, structures, practices and change* (pp. 320–340). San Francisco, CA: Jossey Bass.

Hays, T. (1999). *The music department in higher education: History, connections and conflicts, 1865–1998.* Unpublished doctoral dissertation, Loyola University of Chicago.

Hennessey, P. (1995). Jazz education in the four-year institution: A comparative study of selected jazz curricula. *Dissertation Abstracts International, A33/06, p. 1625.*

Hubbard, K., & Sofras, P. (1998). Strategies for including African and African-American culture in an historically Euro-Centric dance curriculum. *The Journal of Physical Education, Recreation and Dance, 69*(2), 77–82.

Hunter, D., & Russ, M. (1996). Peer assessment in performance studies. *British Journal of Music Education, 13*, 67–78.

Inkster, M. (1997). *A review of twelve outstanding university trumpet studios: A comparison of methodology, pedagogy and structure.* Unpublished doctoral dissertation, Florida State University.

Ivins, J. (1993). *The training of stage actors in film/video acting techniques: An interdisciplinary approach.* Unpublished doctoral dissertation, Texas Tech University.

James, P. (1996). The construction of learning and teaching in a sculpture studio class. *Studies in art education, 37*(3), 145–159.

Jorgensen, H. (2000). Student learning in higher instrumental education: Who is responsible? *British Journal of Music Education, 17*(1), 67–77.

Kennell, R. (1989). *Three teacher scaffolding strategies in college instrumental applied music instruction.* Unpublished doctoral dissertation, University of Wisconsin-Madison.

Kennell, R. (2002). Systematic research in studio instruction in music. In R. Colwell & C. Richardson (Eds.), *The new handbook of research on music teaching and learning: A project of the the Music Educators National Conference* (pp. 243–256). Oxford: Oxford University Press.

Kent, L. A. (2001). *The case of Lucio Pozzi: An artist/teacher's studio critique method.* Unpublished doctoral dissertation, Columbia University Teachers College.

Kostka, M. (2002). Practice expectations and attitudes: A survey of college-level music teachers and students. *JRME, 50*(2), 145–154.

Lavender, L. (1994). *Critical evaluation in the choreography class.* Unpublished doctoral dissertation, New York University.

Lavender, L. (1996). *Dancers talking dance: Critical evaluation in the choreography class.* Champaign, IL: Human Kinetics.

Lavender, R. (2003). The subordination of aesthetic fundamentals in college art instruction. *The Journal of Aesthetic Education, 37*(3), 41–57.

Leff, T. (1990). Texts and actors: Ensemble theatre in academe. *New England Theatre Journal, 1*, 101–108.

Luftig, R., Donovan, M., & Farnbaugh, C. (2003). So what are you doing after college? An investigation of individuals studying the arts at the post-secondary level, their job aspirations and levels of realism. *Studies in art education, 45*(1), 5–19.

Medford, G. (2004). Deconstructing the dominant: Educational theatre in historically Black colleges and universities as critical pedagogy sites. In A. Fliotsos & G. Medford (Eds.), *Teaching theatre today: pedagogical views of theatre in higher education* (pp. 175–194). New York: Palgrave Macmillan.

Murphy, D. (1990). The development of objectives for a model studio pedagogy component in the undergraduate jazz and contemporary music program. *Dissertation Abstracts International, A51/10, p. 3355.*

Myers, D. (2002). Music education connections. In R. Colwell & C. Richardson (Eds.), *The new handbook of research on music teaching and learning: A project of the Music Educators National Conference.* Oxford: Oxford University Press.

Nascimento, C. (2001). Burning the (monologue) book: disobeying the rules of gender bias in beginning acting classes. *Theatre Topics, 11*(2), 145–158.

Nave, P. (2001). *A survey of percussion studio curricula in the state universities of the United States and Puerto Rico.* Unpublished doctoral dissertation, The Ohio State University.

Nelson, S. (1980). The dance factory: A collegiate dance company as an artistic enterprise. *Dissertation Abstracts International, A41/06, p.2334.*

Ney, S. (1989). *Functions of academic theatre programs: An historical and critical study.* Unpublished PhD, University of Illinois at Urbana Champaign, Champaign, IL.

Nieminen, P., Varstala, V., & Manninen, M. (2001). Goal orientation and perceived purposes of dance among Finnish dance students: A pilot study. *Research in dance education, 2*(2), 175–193.

Pakes, A. (2003). Original embodied knowledge: The epistemology of the new in dance practice as research. *Research in dance education, 4*(2), 127–149.

Parenti, S. (1996). Composing the music school: proposals for a feminist composition curriculum. *Perspectives of New Music, 34*(1), 66–73.

Persson, R. (1996). Brilliant performers as teachers: A case study of commonsense teaching in a conservatoire setting. *International Journal of Music Education, 28*, 25–36.

Pitts, S. (2004). Starting a music degree at university. In J. Davidson (Ed.), *The music practitioner: Research for the music performer, teacher and listener* (pp. 215–224). Burlington, VT: Ashgate.

Rabideau, M. (1998). *The incorporation of jazz pedagogy in the traditional trombone studio.* Unpublished doctoral dissertation, University of Illinois at Urbana Champaign, Champaign, IL.

Rack, J. E. (1996). Performance anxiety in student musicians: A correlational study. *Dissertation Abstracts International, A57/01, p. 146.*

Reimer, D. (2003). *Violin performance training at collegiate schools of music and its relevance to the performance professions: A critique and recommendation.* Unpublished doctoral dissertation, The Ohio State University.

Risner, D. (2000). Making dance, making sense: Epistemology and choreography. *Research in dance education, 1*(2), 155–172.

Ritchie, A. (1966). *The visual arts in higher education.* New York: College Art Association of America.

Roach, D. (1993). *Attributions of success or failure in art courses.* Unpublished doctoral dissertation, University of Maryland College Park.

Roberts, B. (1993). *I, musician. Towards a model of identity construction and maintenance by music education students as musicians.* St. John's, Newfoundland: Memorial University.

Ross, J. (1998). *The feminization of physical culture: The introduction of dance into the American university curriculum.* Unpublished doctoral dissertation, Stanford University.

Ross, J. (2000). *Moving lessons: Margaret H'Doubler and the beginning of dance in American education.* Madison, WI: University of Wisconsin Press.

Salapa, S. (2000). *The relationship between student personality types and traits and instructor corrective feedback in dance education.* Unpublished doctoral dissertation, University of Central Florida.

Schmor, J. (2004). Devising new theatre for college programs. *Theatre Topics, 14*(1), 259–273.

Searby, M., & Ewers, T. (1997). An evaluation of the use of peer assessment in higher education: a case study in the school of music, Kingston University. *Assessment and Evaluation in Higher Education, 22*(4), 371–383.

Shapiro, S. B. (Ed.). (1999). *Dance, power and difference: Critical and feminist perspectives on dance education.* Champaign, IL: Human Kinetics.

Singerman, H. (1999). *Art Subjects: Making artists in the American university.* Berkeley, CA: University of California Press.

Sizer, T. (1996). *Horace's Hope: What works for the American High School.* Boston, MA: Houghton Mifflin.

Sterling, J. (2002). *Reinventing music theory pedagogy: the develpment and use of a CAI program to guide students in the analysis of musical form.* Unpublished doctoral dissertation, University of Maryland, College Park.

Stevens, S. (2000). Choreographic pedagogy in higher education: Learning from practitioners. *Research in dance education, 1*(1), 87–91.

Sullivan, G. (2004). Studio art as research practice. In E. Eisner & M. Day (Eds.), *Handbook of research and policy in art education* (pp. 795–814). Mahweh NJ: National Art Education Association: Lawrence Erlbaum Associates.

Sullivan, G. (2005). *Art practice as research: inquiry in the visual arts.* Thousand Oaks, CA: Sage Publishing.

Volk, T. (2004). *Music, Education, and Multiculturalism: Foundations and Principles.* Oxford: Oxford University Press.

Walker, H. (2001). Interviewing local artists: A curriculum resource in art teaching. *Studies in art education, 42*(no. 3), 249–265.

Westin, M. (1996). *Should the teaching of arts administration principles be a part of a music performance undergraduate student's curriculum?* Unpublished Master of Performing Arts, The American University.

Wright-Evans, K. (2001). R2D2 goes to work: The design and development of a first-year art foundations course. *Dissertation Abstracts International, A62/02, p. 427.*

# INTERNATIONAL COMMENTARY

## 19.1

## Japanese Perspectives on Artists in Higher Education

**Koji Matsunobu**
*University of Illinois at Urbana-Champaign, U.S.A.*

An extensive literature search for studies on the arts in higher education indicates that there is no substantial body of research in Japan. For example, major journals of studies in high education, such as *Journal of the Liberal and General Education Society of Japan, Japanese Journal of Higher Education Research*, and *Bulletin of Institute for Higher Education*, have not carried any articles dealing with art instruction or artists in higher education. The lack of research on art programs in higher education is brought about in part by the separation between faculty at academic institutions of higher education (referred to below as universities) and those at independent fine arts institutions that are not part of the university system (referred to below as colleges of fine arts). In most cases, these two kinds of faculty cannot coexist within the same institution.

Most Japanese universities do not have colleges of fine arts or provide performance-based programs for the study of the arts. They offer only academic courses in such areas as aesthetics, film, media, general music, ethnomusicology, soundscape, architecture, art history, and criticism as part of liberal arts education. These courses are not intended for individuals whose career aspirations lie in the performing arts. The fact that most universities, whether public or private, do not house a college of fine arts indicates that the arts have been considered secondary to academic subjects. Given this situation, students who wish to study the arts need to enroll in colleges of fine arts for their professional training.

This situation, however, does not mean that opportunities for studying the arts are not available at universities. Due to the intense competition to enter public colleges of fine arts (and the high cost for private ones), students tend to enroll as education majors and then join music or art programs offered by colleges of education within their universities, not at colleges of fine arts outside their universities. All regional public universities have colleges of education that embrace music and art divisions whereby students can have extensive experiences in performing and studying the arts. As a result of this system, many students who indeed want to pursue performance

*L. Bresler (Ed.), International Handbook of Research in Arts Education, 331–332.*
© 2007 *Springer.*

degrees may end up joining a college of education with the sole intention of becoming artists rather than school teachers. Yet documents on teaching and learning of the arts in colleges of education are scarce, typically self-reports made by the instructors of the programs, which appear in non-refereed university journals. As Eve Harwood pointed out in the preceding chapter, however, professors in arts education are doing more than they are documenting. An example is their recent interest in the instruction of Japanese arts as well as multicultural arts at their pre-service teacher education programs, an apparent result of increasing numbers of conference workshops being organized in Japan.

# INTERNATIONAL COMMENTARY

## 19.2

## Higher Education Arts Curricula in Africa

**Minette Mans**
*Windhoek, Namibia*

In contrast to research on school curricula, research on arts education curricula at institutions of higher education has low priority in Africa. This does not mean that no research has been conducted, but a general survey of music and dance research literature produces surprisingly little. Journals and conference proceedings contain many reports on curriculum structures and content (explaining "how we do it"). Similarly, education journals publish reports on curriculum research in terms of relevance, methodologies, and philosophies. An Internet search produced The Multi-Site Teacher Education Research Project (MUSTER), which provided information on the development of teacher education policies and the changing patterns of teacher education in South Africa. Avenstrup (1997) takes a development perspective in terms of practice-based teacher education. None of these focus on arts curricula.

Most of the attention of research dissertations and reports is focused on curriculum content, postcolonial and postapartheid approaches, and gender studies. Strange as it may seem, many parts of Africa have only recently begun loosening ties with the Western structures and conceptualizations that have informed curricula. Arts institutions are increasingly adopting philosophies, frameworks, and content more suited to African societies and their environments. Research into the curricula, their implementation, teaching strategies, and outcomes is still pending. Modern literary music education is found at most *tertiary* African music institutions, and composition in African and other styles receives strong emphasis. African music curricula in Nigeria (and elsewhere) tend to "emphasize, primarily, contextual features" and unfortunately, it is a common situation that there are

> very few competent staff to teach meaningfully the theoretical content of African music, that is, composing rationalizations of textual structures and performance practice; also the crucial philosophical foundations from which creativity derives, in addition to how music structures transact non-music objectives. (Nzewi, 1998, p. 485)

*L. Bresler (Ed.), International Handbook of Research in Arts Education*, 333–334.
© 2007 *Springer.*

From personal experience and discussions with tertiary educators across Africa, it appears that a common cause lies in arts teacher education. Most universities offer music education in at least two cultural spheres, African and Western, or African and jazz/popular performance. Whereas specialists in Western music with university qualifications are easily appointed, masters of African music, lacking university qualifications, are seldom appointed to teach, despite evidence of the longstanding tradition of an "oral university" which educates and assesses musicians and dancers in societal and performance contexts (see Saether, 2003).

# References

Avenstrup, R. (1997). *Shaping Africa's future through innovative curricula*. Windhoek: Gamsberg MacMillan.

Multi-Site Teacher Education Research Project. Retrieved November 18, 2005, from http://www.sussex. ac.uk/usie/muster

Nzewi, M. (1998). Strategies for music education in Africa: Towards a meaningful progression from tradition to modern. In C. Van Niekerk (Ed.), *Ubuntu: Music education for a humane society* (pp. 456–486). Conference proceedings of the 23rd World Conference of the International Society for Music Education, Pretoria. Pretoria: UNISA Press.

Saether, E. (2003). *The Oral University. Attitudes to music teaching and learning in the Gambia*. Studies in Music and Music Education no. 6. Lund: Malmö Academy of Music, Lund University.

# SECTION 3

## Assessment and Evaluation

**Section Editors: Regina Murphy and Magne Espeland**

# PRELUDE

# 20

# MAKING CONNECTIONS IN ASSESSMENT AND EVALUATION IN ARTS EDUCATION

**Regina Murphy*** **and Magne Espeland**[†]
* *Dublin City University, Ireland;*
[†] *Stord/Haugesund University College, Norway*

In many general education settings, assessment debates are often dominated by performance in literacy and numeracy (often referred to as "the basics" or "core subjects"), relative to peer groups, grades, regions, or to perceived standards nationally and internationally. At the same time, debates concerning the nature and purpose of assessment in the arts – leaving aside questions of performance standards – rarely even begin. As soon as the cacophony on "basics" diminishes, and once the latest report exposing national or international comparisons becomes yesterday's news, the arts begin again by revisiting advocacy matters, searching for a rationale, questioning their *raison d'être*, protesting their underrepresentation and politely requesting a place at the table. Yet, recent calls for evidence-based research in the arts (e.g., Arts Education Partnership, 2004; Deasy, 2002) have brought the areas of assessment and evaluation in arts education into sharp relief as questions begin to emerge on how arts practice is evaluated, what assessment information is being sought, and where the consequences of the findings might lead.

For many teachers and artist-educators, these questions have always been uppermost in their work as assessment and evaluation are integral in the refinement and reflection of arts practices – be it in the blending of color, the shaping of phrase, the tightening of tension, or the weaving of narrative. However, what is different in the current debate is what happens when the discussion takes place under the gaze of other educators and scrutiny by the public at large. Despite the experience of practice and accepted implicit value of assessing the arts in educational contexts, the task of making assessment practices explicit and articulating their role and function has posed dilemmas across art forms. Inevitably, this raises questions on the nature of assessment and evaluation itself, and very quickly, dilemmas begin to emerge. In this prelude, we identify what we see as some of the main dilemmas posed in assessing and evaluating the arts in educational contexts and we identify them as issues that permeate the chapters that follow.

*L. Bresler (Ed.), International Handbook of Research in Arts Education, 337–340.*

## Connecting the Two Inherent Concepts of Value

First it is important to consider the two concepts: assessment and evaluation. In arts education practice they are often used interchangeably. In terms of etymology they both have "value" as a central point: evaluation in terms of meaning "to find the value or amount of" and assessment in terms of meaning "to assist in the office of judge" (Webster's New World College Dictionary, 1996). It can be argued that evaluation is associated with final results and that this is the activity of finding the value of the performance being observed at a special point of time. It can also be argued that assessment is associated with "sitting beside" (from the Latin, *assidere*) – to assist in a process that goes on over time. However, it is impossible to assist without making a judgment or finding a value, and in education "finding the value of" can be applied to processes as well as final results. In fact, in progressive education as conceived by Dewey (1934/1980), one would insist that processes as well as final results should be considered.

This close examination of the etymology illustrates the need in the English-speaking world (and perhaps in other languages) to apply the concepts interchangeably as well. Assessing and evaluating mean to "assist" as well as to "value" something. It is possible however, to distinguish between the areas where assessment and evaluation are applied, for example, for individuals or groups on the one hand, and systems on the other hand. Individuals or groups are agents operating through processes and final results in a system. Systems are programs or organizations wherein individuals and/or groups operate in processes to achieve final results. The meaning of the two concepts rely therefore on how they are used. When dealing with individuals and groups, teachers and artist-educators seem to use the terms assessment as well as evaluation, whereas for those dealing with systems, the term evaluation tends to be used exclusively.

## Connecting the "Stage Show" with "Behind the Scenes"

One of the characteristics of education is that it is concerned with the process of those being educated or developed as well as the final result of whatever goes on. This is the case when arts educators work with student assessment and evaluation as well as program evaluation, and can easily be observed in any kind of feedback given by assessors or evaluators. This is different from performance in some other fields close to arts education, such as a professional concerts or theater performance. While critics may comment on the final result as they see it on stage, they seldom comment on the process behind the scene. Neither do they expect their comments to change the performance itself or the process behind it, even if this occurs on occasion.

In education, however, the assessment of artistic practice poses a number of dilemmas for the educators in the field. They are not only assessors or evaluators but agents of change as well – be it change in the individual (student level), or in a system (a program or organization). These professionals try to ensure that final performances of any kind, as well as processes of any kind, have the quality that is expected or demanded

from the stakeholders in the system within which they operate. In many cases they have to rely on their own judgment as professionals in the field – or as is typically expected of teachers in many jurisdictions – on attainment target formulations that state something about the processes or final results that should be achieved. Often, arts educators operate without explicit criteria while in other cases they create their own criteria or they rely on a common ethos or standard accepted in the specific field, basing their judgment on what they see, and on what they know about how the artwork came to be.

## Connecting NonVerbal Activity with Assessment

Once they have established criteria, the next dilemma for arts educators is how to capture non-verbal activity – mime, music, visual image, movement, and all its subtleties – through verbal expression. Despite the advances in authentic assessment and performance assessment, the unique ways of knowing are subsumed into descriptors which cannot always capture the spiritual, ephemeral or visceral qualities of an artwork that is listened to, observed or sensed in a single moment. Even for art forms with language components (poetry, literature, writing, drama, and multimodal texts), the use of language-based descriptors can fall short of illuminating the heart of the process and the meaning it communicates.

## Connecting what is assessed with learning in the art form

Another dilemma arises from the setting in which arts assessment takes place – that is, within education and alongside other curricular areas. Although there may be a renewed focus on the arts in education, it is not always in the manner desired. Increasingly, it appears that the arts cannot exist without serving another purpose; here it is a case of transfer, to other areas of learning, and having to prove that they measure up to something else. All too often, and unsurprisingly, this amounts to exploring the relationship between the arts and literacy and language development, as evidenced in Deasy's (2002) compendium. Arts may be in focus, but it appears that in many studies the dependent variable continues to be reading achievement. Keeping assessment in the arts relative to just that, appears be an increasingly difficult task.

Such dilemmas, though challenging, provide opportunities for rich exploration of ideas, and this interweaving of old dilemmas with new insights is evident in the chapters presented in this section. Collectively, the various authors have gleaned their knowledge from across continents and disciplines, class levels and educational settings, while individually they add their unique voices, based on years of research and experience in their respective fields.

Among the issues that are addressed in this section are Oreck's analysis of evaluation and assessment practices across a wide range of programs, settings and jurisdictions and his exemplification of best practices in the area of dance education. Murphy focuses

on findings in the evaluation of programs and music curricula at the national level and calls for an increased focus on what happens in the interaction between the music teacher and students in the classroom setting. Hall, Rix, and Eyres look at English as an expressive discipline and broaden the concept of literacy to include multimodal texts. The attendant assessment opportunities are also addressed. Schonmann on the other hand examines the dilemmas posed by the use of the language of assessment and evaluation in the discourse of accountability and in the attempts to measure the process of drama. Finally, in reviewing research in visual arts, Haanstra and Schönau identify the possibilities and challenges for teachers in various settings in discussing and using criteria to assess studio work.

The authors add color and depth to both concepts – assessment and evaluation – through foregrounding one over the other as they present instances of both in practices that take place in schools and educational settings. Combined with international comments from local research undertaken and published in Sweden (Lindström), Spain (Aróstegui), Taiwan (Liu on dance; Lin on music) and Turkey (Kose) this section offers a global perspective on assessment and evaluation in the arts. Finally, the interludes provided by Higgins and Eisner add breadth and depth to the section by reminding us of the intimate relationship between assessment and evaluation on the one hand, and the nature of perception, the methods we use, and the very teaching and learning cycle on the other.

# References

Arts Education Partnership (2004). *The arts and education: New opportunities for research*. Washington, DC: Author.

Deasy, R. (Ed.). (2002). *Critical links: Learning in the arts and student academic and social development*. Washington, DC: Arts Education Partnership.

Dewey, J. (1934/1980). *Art as experience*. New York: Perigee Books.

*Webster's New World College Dictionary* (3rd edn.) (1996). New York: Macmillan.

# 21

# TO SEE AND TO SHARE: EVALUATING THE DANCE EXPERIENCE IN EDUCATION

**Barry Oreck**

*University of Connecticut, U.S.A.*

Dance plays many roles in education. Its social, emotional, physical, and cognitive effects vary dramatically depending on the individuals involved, the kind of dance, its duration, intensity, and goals, along with the culture and nature of the community, school or studio in which it takes place. As Thomas Hagood (2001) writes, dance is "an extremely complex experience to attempt to measure for its educational merit and worth" (p. 27). Some of that complexity arises from its physical, nonverbal nature and its personal connections to body-image, sexuality, gender, religion, and spirituality (Hanna, 1992; Ross, 2000a). Dance as a field of study (rather than a social activity) is a relative newcomer in education (Bonbright, 2000; Ross, 2000b) and straddles the fields of physical education and the arts, further complicating the task of evaluating it based on common purposes or standards of performance.

In this chapter I will address some issues facing evaluators and educators as they seek to evaluate both the dance experience of individuals and the overall effects and effectiveness of dance education programs. These two types of evaluation – of individual student learning and development, and of programs – are, of course, highly interrelated. Student evaluation or assessment (terms often used interchangeably, as I will do here) involves dance learning as well as a range of attitudinal, behavioral, and cognitive outcomes. Program evaluation may include measures of student learning and development along with other criteria concerning program delivery, curriculum, instruction, cost effectiveness, and institutional impact.

The interrelationship of participants to programs is part of a hermeneutic circle (Guba & Lincoln, 1989) in which the interpretation of the whole helps uncover the meaning of the parts and vice versa. In dance the circle also involves the relationship of the inner world of the dancer to the outer world of the observer, and of dance as an art form to dance as a field of study. Uncovering and understanding these relationships is a key part of the challenge for those seeking to evaluate dance education in the widely varied settings in which it takes place.

*L. Bresler (Ed.), International Handbook of Research in Arts Education, 341–356.*
© 2007 *Springer.*

In recent years, arts educators and evaluators have adopted a number of assessment approaches that include the perspectives of students, teachers, administrators and other participants in ongoing processes of reflection and evaluation (Callahan 1999; Fineberg, 2004a; McNamara, 1999). These "best practices" (Zemelman, Daniels & Hyde, 1998), also implemented across the wider education field, include:

- defining and adapting content and achievement standards;
- clearly articulating expectations for students;
- involving students in self-reflection and self-assessment;
- collecting multiple types of data from multiple sources; and
- using technology to document, reflect on, and share learning processes and outcomes.

When applied to formative and summative evaluation of both students and programs, these practices have the potential both to deepen understanding and to communicate more effectively the complex phenomena of learning and expression in dance.

Unfortunately, while best practices and general principles are well articulated in the evaluation literature and in guidelines for dance evaluation (British Columbia Ministry of Education, 1998; New Zealand Ministry of Education, 2003; Saskatchewan Education, 1991, to name but a few), completed evaluation studies in dance education are rarely published, providing little opportunity to share, compare, or study actual results and methodologies. As the National Dance Education Organization (U.S.) research compendium *Research Priorities for Dance Education* (Bonbright & Faber, 2004) puts it, "Most of the literature in assessment of program effectiveness focused on evaluating specific programs and not the processes and tools used in program assessment. More research about assessment in dance education would help clarify the types of assessment tools that are most effective for evaluating the dance experience" (p. 76).

In this brief review I will highlight some current and promising evaluation practices in dance from around the world. Most published material and the curricula, standards, assessments, and evaluation guidelines available through the Internet are from Britain, Canada, Australia, New Zealand, and the United States. My contact with dance educators in South America, Asia, Scandinavia, and Europe suggests that some of the same educational trends and evaluation practices exist in other countries but that little or nothing has been published or disseminated to date.

I will look first at some ways in which students are evaluated in dance classes, then at the evaluation of dance programs. Finally, I will address some of the special challenges and difficult realities dance educators and evaluators face as they strive to improve their programs and communicate the results of their work.

# Evaluating Students

## Direct Dance Outcomes

Where students take dance regularly over a period of years, the criteria for evaluating success and quality are usually specific, ongoing, and formative, primarily directed toward helping students and teachers monitor progress and improve learning. Private

schools and dance studios, magnet schools for the arts, and professional and pre-professional training institutions tend to use means of evaluation directly tied to their own goals, focused on students' performance in dance class, and based on criteria set by the instructors or institution (Berkeley Carroll School, 2004; Booker T. Washington High School, 2004; Dalton School, 2004; New World School of the Arts, 2005; Posey, 2002). Ironically, places with limited instructional time and scarce resources often face the most stringent requirements for formal, summative evaluation focused on broad outcomes such as changes in attitudes toward dance, transferable learning processes, and the integration of dance with other areas of the curriculum (Horowitz, 2004; Remer, 1996).

Reflecting the growing emphasis on authentic, performance-based assessment processes in general education (Wiggins, 1998), many dance programs employ multiple forms of assessment to evaluate student work and progress. These processes include direct observation of students in class, audition or stage settings; self-reflection and self-assessment using interview, discussion and portfolios; peer response and assessment; and written testing of knowledge (Alter, 2002; Schmid, 2003). Those assessments may address a mix of technical or physical skills, knowledge and vocabulary of one or more styles of dance, and behaviors that include focus, effort, task commitment, and collaboration. Creativity and self-expression may be assessed in programs that involve improvisation or choreography, while presentation and performing skills are emphasized in performance-oriented programs.

Two program foci, often referred to as theatrical (or concert) dance and educational dance, are distinguished by an emphasis on specific performance and/or choreographic skills or on a broader set of educational goals. Jacqueline Smith-Autard (1994) suggests a "midway model," that seeks to balance the continuum of instructional approaches in dance education. This continuum spans process and product orientation; creating dances and learning existing dances; developing physical skills in and gaining knowledge about dance. The attempt to find a balance is expressed in many existing dance educational standards and informs curriculum, assessment, and evaluation in schools around the world (Australian Dance Council, 1997; Consortium of National Arts Education Associations, 1994; Saskatchewan Education, 1994).

Professional and pre-professional training programs often use a criterion-referenced checklist of characteristics based on the specific technique studied and may include physical characteristics such as body type (Byrnes & Parke, 1982). Competitive dance, a growing outlet for dance students (Giffen, Almendarez, & Garofoli, 2004) uses highly structured and detailed evaluation criteria. While the idea of competition is anathema to some dance educators, others value its potential to motivate students, reward mastery, and reinforce self-discipline.

Booker T. Washington High School (2005) in Dallas, Texas, a magnet school for the arts, assesses students in modern dance on 21 items, including physical characteristics. These range from the specific (e.g., "balance on relevé, off-centered turns, high chest release") to the more general (e.g., "kinesthetic and spatial awareness, dynamic qualities"). The categories also include knowledge (e.g., "knowledge of anatomical and muscular functions"), and characteristics that some consider natural or innate (e.g., "musicality"). The dance assessment is combined with a one-on-one interview and

self-reflection process called "Glow and Grow" aimed at heightening students' awareness of their learning process and other personal outcomes they have experienced through dance (Cabatu-Weiss, personal communication, 2005). The trend toward self-reflection and self-assessment is also finding its way into some professional and pre-professional ballet schools, historically known for highly specific, externalized evaluation criteria (Leach, 1997). The Pacific Northwest Ballet conducts twice yearly interviews with all students in its children's and young adult programs in which students set goals and gauge their own progress toward advancement to the next level (D. Bolstad. personal communication, November 15, 2005). Such self-reflective processes are used to reinforce instruction and integrate nonverbal and verbal learning.

A broader set of criteria is used at the Dalton School in New York City (2004) where students are informed that dance teachers look for how they apply corrections, how well they work with peers and how they approach creative and technical risks and challenges. These general criteria are part of the ongoing assessment and report card. Additionally, Dalton and other private school programs (Berkeley Carroll School, 2004; Boston Arts Academy, 2002) set a high priority on how students collaborate and observe and respond to each other's work.

Student assessment processes in higher education vary widely according to the goals and philosophy of the program, its standing as a degree or non-degree granting program, and the nature of the curriculum (National Association of Schools of Dance, 2003). Methods include performance-based assessment in class and concert settings and juries, tests, research papers, and portfolios. Lacking commonly applied standards or expectations it is difficult to make comparisons or judgments of instructional adequacy of programs based on student data (Kerr-Berry, 2005).

Schools that teach dance notation (various systems devised to record and analyze movements using pictorial symbols) employ evaluation criteria related to the student's ability to identify movement elements and qualities and to use the written notational tools themselves (Hutchinson Guest, 1984; Laban, 1956). Research into the use of notation and motif writing in instruction and assessment suggests a variety of evaluative applications including: student mastery and awareness of the elements of movement, their ability to learn new material, and the use of the notational tools themselves (Gingrasso, 2005; Warburton, 2000).

Dance educators, along with other arts educators (Kendall & Marzano, 1997), have widely embraced the standards movement as a means of both improving instruction and strengthening the case for the arts as core academic subjects (Purcell, 1996). The adoption of dance standards around the world offers both opportunities and challenges for evaluation (Australian Dance Council, 1997; National Curriculum Council, England, 1992; among many others). These guidelines, most often applied in public schools and institutions that are accountable to external audiences, articulate what students should learn in dance and the appropriate expectations for developmental levels of achievement. Given the small number of dance specialists in U.S. schools, and the limited instructional time for dance in all but a few specialized schools however (National Center for Education Statistics, 1998; Office for Standards in Education, 2002), the comprehensive vision of dance education expressed in the standards is, for many, but a distant ideal (Gingrasso, 1991). Schools must decide whether to concentrate

on a few selected strands or attempt to cover more material in the same amount of time. As a result the standards have yet to fulfill their promise as evaluative tools (Libman, 2004; Ross, 1994a).

Dance educators throughout the world have also made an immense effort to create frameworks, guidelines, activities, rubrics and instruments for student assessment and overall program evaluation in dance. Many excellent tools are readily available on the Internet from England (The Standards Site, 2005; Office for Standards in Education, 2002), New Zealand (New Zealand Ministry of Education, 2003), Canada (British Columbia Ministry of Education, 1998; Saskatchewan Education, 1991, among others), and many states and cities in the United States (New York City Department of Education, 2005; Perpich Center for Arts Education, 2005, among others). Printed material, CD ROMS, assessment rubrics and sample activities are also available through many clearinghouse Websites such as the one maintained by the Council of Chief States School Officers in the United States (Council of Chief States School Officers, 2005).

Whether evaluating student progress through standards-based criteria or other measures, the use of multiple sources of data, including teacher, self, and peer response, in both nonverbal and verbal symbol systems has become widespread. I will briefly look at some tools employed in both intensive, ongoing dance programs and in short-term or intermittent instructional settings.

Portfolios, used to collect and assess evidence of student dance learning and development over time, can capture stages of the choreographic process, student reflections on their own learning and art-making processes, sources of inspiration for dances, research into dances and dancers, drawings, and formal and informal teacher- and self-evaluations (Alter, 2002; McGreevy-Nichols, 2003; Sprague, 2003). A variety of criteria can be used to judge portfolios related to the purposes for which they are used. Guidelines for developing and scoring dance portfolios are available on the Internet from a number of sources (British Columbia Ministry of Education, 1998; Center for Educator Development in the Fine Arts, 2005; among others).

Video and computer technology can be powerful learning and evaluation tools for students, teachers, and evaluators. Using videotape, students can collect and analyze movement, add personal commentary, and examine and reflect on stages in the dance-making process (Parish, 2001). They can share their work and collaborate with others directly or through the Internet (Popat, 2002). Videotape can be difficult, costly, and time-consuming to use as an assessment tool, however, and successful procedures and strategies for its use could be more widely investigated and shared (National Assessment Governing Board, 1994 [U.S.]; Ross, 1994b). One carefully designed video assessment developed by ArtsConnection (Video Description Process) (Batton, 2005) was adapted from the Descriptive Review process (Himley & Carini, 2000), in which observers take a descriptive, rather than a judgmental or interpretive stance to ground observations in concrete phenomena. Such in-depth viewing, usually focused on just a few students, can uncover subtle responses and actions easily missed in casual viewing.

Another approach to collaborative inquiry into arts teaching and learning is through the use of structured response protocols. Examples such as Liz Lerman's Critical

Response Protocol (Lerman & Borstel, 2003), the ORDER approach (Lavender, 1996), and the Tuning Protocol (Allen, 1995) have been used in dance as part of improvisation and choreography class, peer and self-assessment, and a host of other group evaluative processes.

Some formal and informal evaluation is directed toward the assessment of student talent. Talent and potential is evaluated for many purposes: admission to magnet schools or dance programs, selection for performing ensembles, placement in special classes, and to determine award or scholarship recipients. Most talent assessments assume prior dance instruction and are based on an audition or observed class format (e.g., Boston Arts Academy, 2005; Elam & Doughty, 1988; New World School of the Arts, 2005). The Dance Talent Assessment Process, (D/TAP) (ArtsConnection, 1993; Oreck, Owen, & Baum, 2004) is a multi-session, performance-based assessment process designed to evaluate the potential of students without prior formal instruction, using criteria organized into three categories – above average ability (skills), creativity, and task commitment – using 10 behavioral criteria that transcend a specific dance style or technique. Warburton's Multidimensional Assessment Instrument in Dance (MAiD) (2002) assesses content-related understanding in dance, an aspect not addressed by D/TAP. Using video-taped movement phrases it evaluates students' ability to "recognize, produce, and express the meaning of actions, efforts, and use of space and movement" (pp. 117–118). The ease of scoring and clear assessment and analysis methodology of both MAiD and D/TAP suggest instructional applications for these processes beyond talent assessment.

## *Evaluating Indirect or Instrumental Effects of Dance*

Many programs articulate broad educational and personal outcomes as primary goals of dance education. England's National Dance Curriculum, for example, asks evaluators to consider how dance "contributes to pupils' spiritual, moral, social, and cultural development, and how effectively it helps to prepare students for adult life in a culturally and ethnically diverse society" (Office for Standards in Education [Ofsted], 2002, p. 7). Other aspects of affective development such as self-image and esteem, identity, attitudes toward life, behavior toward others, and general creativity, also stated as goals of some dance programs, require long-term interventions and data collection (Oreck, Baum, & McCartney, 2001; Ross, 1994b).

A dance program whose central objectives concern personal development must use different evaluation criteria than those focused primarily on dance skills. Middle school students at Ailey Camp, in addition to dance classes, participate in a daily Personal Development Class, a forum in which students can freely discuss issues that concern them (Fineberg, 2004b). These sessions are designed to provide a network of peer and adult support to "discover their personal power to determine their own conduct" (p. 9). Not surprisingly (due to low numbers of students and short intervention) results of pre-post questionnaires on self-concept issues were not statistically significant, but direct observations and student responses in surveys and interviews provided evidence that the class, combined with the dance experiences, supported development of affective attitudes and behaviors, a central goal of the camp. Can the evaluator say

that the dance experience alone had an effect? No – as in most programs, the results are due to a combination of factors; dance may play a part or act as a catalyst. The key point for evaluation is that the outcomes directly relate to the defined goals of the program and that multiple means are used to investigate the results.

A great deal of attention has also been directed toward using dance instruction to help students read, write, decode, develop creative thinking skills, and apply learning strategies to other academic subject areas (Bradley, 2002). Such academic transfer effects require highly focused research relying on specific measures such as performance on tests, observation data, and other external criteria. The seven dance studies included in the Critical Links (Deasy, 2002) research compendium look specifically at instrumental outcomes and reveal the enormous difficulties involved in implementing experimental or quasi-experimental research designs in dance. Simplifying the dance experience and narrowing the specified outcomes in order to increase reliability and validity can undermine the creative and expressive qualities of dance that distinguish it from other types of movement. Karen Bradley's (2002) commentary points out that most of the studies cited in Critical Links do not adequately define or describe the nature of the dance activity or approach studied or how the dancing itself is assessed (if at all) in relation to the intended outcomes (p. 17). In a field with such diverse pedagogy, tradition, stylistic breadth, and individual adaptation, it is incumbent upon each researcher or evaluator to identify what they mean by "dance" and how that aspect of dance is being assessed. Further, as Winner and Hetland (2000) point out in *Reviewing Education and the Arts Project* (REAP), evaluating programs based on their indirect transfer effects is risky and can undermine the value of the arts for their own sake.

The study of both affective outcomes and academic transfer effects require highly structured research designs based on clearly articulated, conceptually-grounded theory. In what ways, and for which students, can we expect that the effects of a specific dance experience (or range of experiences) will show up? Given the relatively small amount of dance research literature in this area, theory-building and testing must rely to a great extent on other fields of educational and psychological research. While the inclusion of empirical research is often seen as the "gold standard" of educational evaluation, few dance programs have the time or resources to conduct such research. Evaluators must therefore concern themselves with more immediate outcomes and available data.

## Evaluating Dance Programs

While the purpose of student evaluation can, in many cases, be simply stated as improving learning and teaching, the purposes of program evaluation are widely diverse. Program evaluations tend to look at complex sets of relationships – of teaching to learning; curriculum to the needs of the students; curriculum to defined content standards; assessment measures to the outcomes sought – among others (Center for Educator Development in the Fine Arts, 2005). Institutional evaluations may also address the quality and qualifications of the faculty, adequacy of facilities and equipment, diversity and sequence of course offerings, and percentages of students reaching

achievement standards (National Association of Schools of Dance, 2003; Ofsted, 2002). Increasingly, evaluations investigate the contributions of dance programs to school change and school reform, school climate, integration of dance with other areas of the school curriculum, interdisciplinary teaching, impact of dance on the attitudes and practices of classroom teachers, and the partnership between schools and cultural institutions (Horowitz, 2004; Orlafi, 2004).

Understanding the context for a program is a particular challenge in dance education. Evidence of quality and judgments of success are deeply interwoven with the program's relationship to the school or institution in which it resides. Economic and practical realities also help determine how program evaluation is conducted and disseminated. The academic department housing a dance program affects the purposes and audiences for evaluation; the expectations and quality indicators for physical education may be substantially different than those for a program in the theater or music department. Finally, a range of very basic issues defines a program's conditions and, thus, its evaluation criteria: whether classes are held during or after school, if there is coordination between dance and other academic curricula and faculty, if dance is an elective, if faculty is full or part-time, among other variables. Describing and clarifying the setting – its origins, rationale, and context – is essential to understanding the program's outcomes.

*Use of Research in Program Evaluation*

Empirical research can play a significant role in program evaluation. Existing research can provide theoretical grounding and context for an intervention. Evaluators can also explore the phenomena under study through their own research. The studies collected for the National Dance Education Organization research compendium (Bonbright & Faber, 2004), highlight the potential and limitations in the existing research literature. Of the 2,300 documents analyzed, less than a third of the research focused on K-12 education (with grades 9–12 predominant). A large percentage of early dance experiences – taking place in private studios (14.7%), community and family settings (8%), afterschool (1.8%) and outreach (0.9%) programs – were scarcely studied. Not surprisingly, given the preponderance of graduate theses cited, the most common subjects of dance research are higher education programs.

*Partnership programs*

Many of the most comprehensive program evaluations have resulted from partnerships among schools, arts-in-education organizations, cultural institutions, and universities (Harland et al., 2000; Remer, 2004; Woolf, 1999). Funded by one or more private and public sources and lacking permanent institutional sponsorship, partnership programs typically face a high standard of accountability and employ a wide range of evaluation techniques (Fineberg, 2004a), using multi-method evaluation designs and both qualitative and quantitative data to explore questions related to student learning and school improvement. Often these one- to five-year programs have ambitious goals involving enhancement of academic curricula, professional development for classroom teachers

and subject area specialists, and improved academic performance on the part of students (Remer, 1996).

Dance has been well-represented among many of the most extensive partnership programs, although rarely as the sole art form. Evaluation designs investigating such partnerships may look at the collaborative process itself and the relationship among its partners, participants and service components, as well as outcomes for students, classroom teachers, teaching artists, parents, and other constituents (Baker, Bevan, & Admon, 2001).

## Dance in Higher Education

Given the wide range of types of programs in the 759 institutions of higher education offering dance majors or minors in the United States alone, there is little apparent commonality in evaluation methods (Ross, 1994b). In one of the few cross-site studies (two schools) published, Prioleau (2001) identified five keys to successful dance programs in higher education: leadership (from school administration and department heads), clear strategic goals, high levels of collaboration among faculty, collaboration with other departments and the community, and morale of faculty.

Most dance departments undergo regular review under the general criteria of their college and accrediting institutions (Prioleau, 2001). In the United States approximately 50 colleges and universities (along with 12 professional dance schools) have voluntarily become accredited through the National Association of Schools of Dance (NASD) (2003) since 1980. NASD evaluation involves an examination by dance educators of the program's mission, goals and objectives, operational conditions, resource allocation, program offerings, curricular quality and diversity, and opportunities for sequential study. While limited time and resources and the ongoing struggle to maintain existing programs may discourage some from seeking NASD accreditation, it remains one of the few external sources of credentials and credibility in the field.

## Teacher Preparation

Preparation to teach dance has received little research and evaluation attention. Teacher education is conducted in many settings including higher education, professional studios and company-affiliated schools, community dance schools, arts-in-education organizations, and through associations and foundations. While no comprehensive listing exists, Dance Teacher magazine currently lists 63 teacher education programs in the United States ranging from degree granting programs (1) to company-affiliated ongoing or periodic training programs (27). Though schools of higher education conduct periodic internal and external evaluations of teacher education programs, these evaluations are not made public. Forty-two documents (dating back to 1926) were collected in the NDEO research compendium concerning teacher preparation. Although many university dance programs offer some instruction few have a primary focus on teaching as a career (National Center for Education Statistics, 1995).

# Issues and Implications for Evaluation in Dance Education

Among the many issues under the vast topic of evaluation in dance education two seem particularly relevant across the diverse settings in which dance is taught. The first issue concerns the scarcity of dance instruction in education. The second concerns the special challenges of identifying and measuring dance learning and related outcomes.

## *Living on the Margins: Scarcity, Objectivity and the Need for Advocacy*

With consistent, sequential dance instruction offered in just 3–8% of U.S. public schools (depending on the statistics cited) (U.S. Department of Education, 1995) and similarly low participation rates reported for other countries (Harland et al., 2000, among others) dance educators may understandably feel marginalized and threatened with extinction. How does the long-term self-image as "stepchild of the arts" in schools (Ross, 1994b) affect dance educators' approaches to evaluation?

The struggle for survival can make evaluation primarily a tool for advocacy and fundraising. Dance education advocates, according to Sue Stinson (2005), "have found our discipline to be easily malleable to fit whatever goals and values seem in style" (p. 82). The advocacy stance hinders the kind of self-examination and analysis that can generate new ideas and solutions to problems, including the scarcity of dance education. Common symptoms of noncritical, promotional approaches to evaluation include: inadequately supported claims of long-term results (e.g., changes in self-esteem, attitudes toward school, and institutional changes) based on short-term interventions; large conclusions (e.g., changes in teacher practices, test score improvement, effects on school climate) based on data from small samples or with low response rates; lack of follow-up, member checks, or deeper investigation of negative cases and confusing or contradictory responses. The impetus to overstate claims is, in many cases, a direct response to unrealistic demands of funders, not an attempt to exaggerate or manipulate evaluation results.

Lack of adequate funding also threatens the reliability and objectivity of evaluation. Many programs cannot afford to hire outside evaluators or designate a person to play the role exclusively. As a result, an evaluator may participate in many aspects of program design, professional development, and instruction, and that can certainly affect their objectivity. Further, lack of funding can make standard research procedures such as surveying nonrespondents, field-testing and piloting new surveys and instruments, and conducting blind reviews with outside experts, impractical.

The evaluation literature itself reflects the dearth of dance in education. In researching this chapter, I found many useful guidelines for evaluation but few completed reports or studies. Many are shelved at the institution for which they were conducted, referred to in bullet points on a Website or brochure. Some are planned but never conducted for lack of funding or lack of dance instruction. In the United States, the National Assessment of Educational Progress (NAEP) (National Center for Education Statistics, 1998) in dance was abandoned because an adequate sample could not be located. Unfortunately, only a small sample of the NAEP assessment process, tasks,

and scoring rubrics is available to the public (Council of Chief States School Officers, 1997). Well-designed evaluation studies from England also lack sufficient numbers to glean reliable results. The dance results reported in Harland et al.'s (2000) study *Arts Education in Secondary Schools: Effects and Effectiveness* include just seven students in some analyses as opposed to 30–150 in music and art.

These realities suggest a number of questions, including: How do evaluators make sense of small samples and how can we improve evaluation practices in programs with few participants? How might evaluators deal with the lack of consistent instruction and shifting priorities for dance within some institutions? To what extent can methodologies, surveys, interview protocols or research designs be shared among programs or does each program need to design its own to be relevant and responsive to unique conditions? What can we learn and share from struggles and problems encountered as well as success stories about evaluation? Until completed evaluation reports are more widely conducted and shared, a large gulf will remain between "best" and actual practices in dance evaluation.

## Emergent Goals and Set Objectives

A tension always exists in evaluation between pre-ordinate and emergent goals (Stake, 1975). Do evaluators gauge success by comparing a program's progress toward its stated goals or by investigating the value of whatever outcomes emerge, what Stake calls a responsive approach? This tension is particularly great in dance, I would argue, where much of the learning is nonverbal, and the interplay of social, emotional, physical and cognitive responses is so complex. In this regard, the adoption of educational standards for dance and the definition of explicit goals and objectives for students, while highly useful in articulating the benefits and importance of dance learning, can narrow the evaluative focus and obscure the intrinsic merit of the experience.

The problem of relying on predetermined criteria for evaluation is also seen in the artistic process. Larry Lavender (1996) observes that the use of external or teacher-defined criteria for judging dances in the choreography classroom can limit the development of students' own reflective, interpretive, and critical capacities, reducing "critical evaluation to a rote process that pretends to be a logical classification" (p. 26). I would argue that a comparable danger exists for all evaluation in the arts; relying too strongly on a checklist of characteristics meant to define excellence may undermine personal response, critical analysis, and unexpected discoveries.

As the need for accountability throughout education grows, dance educators are further pressured to prove the benefits of dance experiences for learning in other domains. This can shift the focus in assessment to easily measured verbal outcomes, while de-emphasizing harder to measure physical responses and embodied knowledge (Bresler, 2004; Green, 2002). Further, the current intense focus in U.S. schools on verbal literacy may lead dance educators to try to justify their programs based on their direct connections to reading and writing processes as opposed to the more subtle, indirect links and deeper understandings of language and meaning. Assessments in dance must take care not to confuse verbal ability with dance learning. An overly verbal, analytic approach can devitalize the dance experience just as a solely physical or technical one may miss the valuable learning potential of including verbal integration and reflection. Researchers

and evaluators have an important role to play in finding ways to capture the creative interplay of intelligence, emotion, somatic experience, and verbal and nonverbal symbol systems at work in dance.

# Conclusion

The field of dance education is at a crucial juncture with regard to its evaluation practices. A broad body of literature exists to guide evaluation. Curriculum frameworks and content standards, authentic assessment processes, and established models of mixed-methods research from dance, the other arts, and general education, provide methodologies and theoretical foundations to help us understand and communicate the complexity of the experience of learning and teaching in dance. What is needed, I believe, is the opportunity to apply those tools on a larger scale and for a longer time, with the insight and courage to deeply and honestly evaluate the data and share the results.

# References

Allen, D. (1995). *The tuning protocol: A process for reflection*. Providence RI: Coalition of Essential Schools.

Alter, J. B. (2002). Self-appraisal and pedagogical practice: Performance-based assessment approaches. *Dance Research Journal, 34*(2), 79–92.

ArtsConnection (1993). *Talent beyond words* (Report to the Jacob Javits gifted and talented students education program, United States Department of Education, #R206A30046). New York: Author.

Australian Dance Council. (1997). *Australian guidelines for dance teachers*. Retrieved May 1, 2005 from http://www.ausdance.org.au/outside/interest/guidelines/index.html.

Baker, T., Bevin, B., & Admon, N. (2001). *Final evaluation report on the Center for Arts Education's New York City partnerships for arts and education program*. New York: Education Development Center/ Center for Children and Technology.

Batton, B. W. (2005). A case study: shall we dance? Establishing an inquiry-based partnership. In B. Rich (Ed.), *Partnering arts education: A working model from ArtsConnection* (pp. 27–31). New York: Dana Foundation.

Berkeley Carroll School. (2004). *Sequential dance curriculum and evaluation criteria, grades 5–12*. Unpublished document. Author.

Bonbright, J. M. (2000). Dance: The discipline. *Arts Education Policy Review, 100*(2), 31–32.

Bonbright, J. M., & Faber R. (Eds.). (2004). *Research priorities for dance education: A report to the nation*. Bethesda, MD: National Dance Education Organization.

Booker, T. Washington High School (2005). *Student report card*. Unpublished assessment form. Author.

Boston Arts Academy (2002). *Student evaluation form*. Unpublished assessment form.

Bradley, K. K. (2002). Informing and reforming dance education research. In R. Deasy (Ed.), *Critical links: Learning in the arts and student and academic achievement social development* (pp. 16–18). Washington, DC: Arts Education Partnership.

Bresler, L. (Ed.). (2004). *Knowing bodies, moving minds: Toward embodied teaching and learning*. Dordrecht, Netherlands: Kluwer Academic Publisher.

British Columbia Ministry of Education. (1998). *Appendix D: Assessment and evaluation*. Retrieved November 11, 2005 from http/www.bced.gov.bc.ca/irp/dan11_12/apdint.htm.

Byrnes, P., & Parke, B. (1982). *Creative products scale: Detroit public schools*. Paper presented at the Annual International Convention of the Council for Exceptional Children, Baltimore, MD.

Callahan, S. (1999, Spring). The art of evaluation: Transforming the research process into a creative journey. *Dance/USA Journal*. Retrieved March 24, 2005 from www.forthearts.org.

Center for Educator Development in the Fine Arts. (2005). *Sample portfolio design for dancers*. Retrieved November 11, 2005 from http://finearts.esc20.net/dance/dance_assessment/dance_as_example.html.

Consortium of National Arts Education Organizations. (1994). *National standards for arts education*. Reston, VA: Music Educators National Conference.

Council of Chief States School Officers. (1997). *Arts education assessment consortium year-end report & collection of refined exercises* [CD ROM]. Washington, DC: Author.

Council of Chief States School Officers. (2005). *SCASS projects*. Retrieved August 2, 2005 from www.ccsso.org/projects/SCASS/Projects.

Dalton School (2004). *High school dance department procedures and dance report*. Unpublished evaluation document. Author.

Deasy, R. (Ed.). (2002). *Critical links: Learning in the arts and student and academic achievement social development*. Washington, DC: Arts Education Partnership.

Elam, A., & Doughty, R. (1988). *Guidelines for the identification of artistically gifted and talented students* (Rev. ed.). Columbia, SC: South Carolina State Department of Education.

Fineberg. C. (2004a). *Creating islands of excellence: Arts education as a partner in school reform*. Portsmouth, NH: Heinemann.

Fineberg. C. (2004b). *AileyCamp Berkeley/Oakland*. Unpublished Evaluation Report. Author.

Giffen, M., Almendarez, L., & Garofoli, W. (2004, October). Dance teacher competition guide 2005. *Dance Teacher*, 116–181.

Gingrasso, S. H. (1991). North Carolina: State of the arts. *Design for Arts in Education, 93*(1), 9–20.

Gingrasso, S. H. (2005). *Promoting deep learning in dance technique: A case for using the Language of Dance*. Unpublished report.

Green, J. (2002). Somatic knowledge: The body as content and methodology in dance education. *Journal of Dance Education, 2*(4), 114–118.

Guba, E. G., & Lincoln, Y. S. (1989). *Fourth generation evaluation*. Newbury Park: Sage.

Hagood, T. K. (2001). Dance to read or dance to dance? *Arts Education Policy Review 102*(5), 21–26.

Hanna, J. L. (1992). Tradition, challenge and the backlash: Gender education through dance. In L. Senelick (Ed.), *Gender and performance* (pp. 223–238). Hanover, NH: University Press of New England.

Harland, J., Kinder, K., Lord, P., Stott, A., Schagen, I., & Haynes, J. (2000). *Arts education in secondary schools: Effects and effectiveness*. Slough: National Foundation for Educational Research.

Himley, M., & Carini, P. F. (Eds.). (2000) *From another angle: Children's strengths and school standards*. The Prospect Center's Descriptive Review of the Child/the Practitioner Inquiry Series. New York: Teachers College Press.

Horowitz, R. (2004). *Summary of large-scale arts partnership evaluations*. Washington, DC: Arts Education Partnership.

Hutchinson Guest, A. (1984). *Dance notation: The process of recording movement on paper*. New York: Dance Horizons.

Kendall, J. S., & Marzano, R. J. (1997). *Content knowledge: A compendium of standards and benchmarks for K-12 education*. Aurora, CO: McRel.

Kerr-Berry, J. (2005). The application of national dance standards in higher education dance programs. *Journal of Dance Education, 5*(3), 80–81.

Laban, R. (1956). *Principles of dance and movement notation*. London: MacDonald & Evans.

Lavender, L. (1996). *Dancers talking dance: Critical evaluation in the choreography class*. Champaign, IL: Human Kinetics.

Leach, B. (Ed.). (1997). *The dancer's destiny: Facing the limits, realities and solutions regarding the dancer in transition*. Laussane: International Organization for the Transition of Professional Dancers.

Lerman, L., & Borstel, J. (2003). *Critical response process: A method for getting useful feedback on anything you make, from dance to dessert*. Washington, DC: Liz Lerman Dance Exchange.

Libman, K. (2004). Some thoughts on arts advocacy: Separating the hype from reality. *Arts Education Policy Review, 105*(3), 31–33.

McGreevy-Nichols, S. (2003). Documenting the process. *Dance Teacher*, June, 79–81.

McNamara, C. (1999). *Basic guide to outcomes-based evaluation for nonprofit organizations with very limited resources*. Downloaded September 1, 2005 from ww.managementhelp.org/evaluatn/outcomes.htm.

National Assessment Governing Board (1994). *Arts education assessment and exercise specifications*. Retrieved December 20, 2004 from www.nagb.org/pubs/artsed.pdf.

National Association of Schools of Dance (2003). *The NASD accreditation process*. Retrieved May 1, 2005 from http://nasd.arts-accredit.org/site/docs/PIM%202003-NASD/PIM-Part1-NASD2003.pdf.

National Center for Education Statistics (1995). *Degrees and other formal awards conferred" surveys, and integrated postsecondary education data system (IPEDS)*. Washington DC: U.S. Department of Education.

National Center for Education Statistics (1998). *The NAEP 1997 arts report card*. Washington, DC: U.S. Department of Education.

National Curriculum Council (1992). *Physical education: Non-statutory guidance*. London: NCC.

New York City Department of Education (2005). *Blueprint for teaching and learning in the arts: Dance grades pre K-12*. New York: Author.

New World School of the Arts (2005). *Student examination form*. Unpublished evaluation document. Author.

New Zealand Ministry of Education (2003). Retrieved May 1, 2005 from ww.nzqa.govt.nz/ncea/assessment/exemplar/index.html.

Office for Standards in Education (2002). *Inspecting dance 11–16 with guidance on self-evaluation*. Retrieved on May 2, 2005 from www.ofsted.gov.uk.

Oreck, B. A., Owen, S. V., & Baum, S. M. (2004). Validity, reliability and equity issues in an observational talent assessment process in the performing arts. *Journal for the Education of the Gifted, 27*(2), 32–39.

Oreck, B. A., Baum, S. M., & McCartney, H. (2001). *Artistic talent development for urban youth: The promise and the challenge*. Storrs: CT, National Research Center for the Gifted and Talented.

Orlafi, A. (2004). *Artists working in partnership with schools: Quality indicators and advice for planning, commissioning and delivery*. Arts Council of England. Retrieved March 12, 2005 from http://www.artscouncil.org.uk/documents/publications/phpIi3JsA.pdf.

Parish, M. (2001). Integrating technology into teaching and learning of dance. *Journal of Dance Education, 1*(1), 20–25.

Perpich Center for Arts Education (2005). *Research, assessment and curriculum*. Retrieved September 1, 2005 from www.pcae.k12.mn.us/rac/pubs/facs/dance.pdf.

Popat, S. (2002). The triad project: Using internet communications to challenge students' understandings of choreography. *Research in Dance Education, 3*(1), 21–34.

Posey, E. (2002). Dance education in dance schools in the private sector: Meeting the demands of the market place. *Journal of Dance Education, 2*(2), 43–49.

Prioleau, D. (2001). Leadership of the arts in higher education. *Journal of Dance Education, 1*(2), 55–62.

Purcell, T. (1996). National standards: A view from the arts education associations. *Arts Education Policy Review, 97*(5), 8–9.

Remer, J. (1996). *Beyond enrichment: Building effective arts partnerships with schools and your community*. New York: ACA Books.

Remer, J. (2004). *Portraying student learning in dance and music: The final year of the PS 6/ArtsConnection Annenberg arts partnership. A report in progress*. Unpublished Evaluation Report. New York: New York City Partnerships for Arts and Education.

Ross, J. (1994a). National standards for arts education: The emperor's new clothes. *Arts Education Policy Review, 96*(2), 26–32.

Ross, J. (1994b). The right moves: Challenges of dance assessment. *Arts Education Policy Review, 96*(1), 11–17.

Ross, J. (2000a). Arts education in the information age: A new place for somatic wisdom. *Arts Education Policy Review, 101*(6), 27–32.

Ross, J. (2000b). *Moving lessons: Margaret H'Doubler and the beginning of dance in American Education*. Madison, WI: University of Wisconsin Press.

Saskatchewan Education (1991). *Student evaluation: A teacher handbook*. Retrieved April 1, 2005 from http://www.sasked.gov.sk.ca/docs//policy/studeval/index.html.

Saskatchewan Education (1994). *Arts education: A curriculum guide for the secondary level*. Regina, SK: Saskatchewan Education.

Schmid, D. W. (2003). Authentic assessment in the arts: Empowering students and teachers. *Journal of Dance Education, 3*(2), 65–73.

Smith-Autard, J. M. (1994). *The art of dance in education*. London: A.&C. Black.

Sprague, M. (2003). Documenting student learning: Making the invisible visible. *Journal of Dance Education, 3*(3), 107–108.

Stake, R. E. (1975). *Evaluating the arts in education: A responsive approach*. Columbus, OH: Merrill.

The Standards Site (2005). *The power of arts assessment in teaching and learning handbook*. Retrieved May 15, 2005 from http://www.standards.dfes.gov.uk.

Stinson, S. W. (2005). Why are we doing this? *Journal of Dance Education, 5*(3), 82–89.

United States Department of Education (1995). *Arts education in public elementary and secondary schools*. Washington, D.C. National Center for Education Statistics. (Office of Educational Research and Improvement No. NCES 95–082.)

Warburton, E. (2000). The dance on paper: the effect of notation-use on learning and development in dance. *Research in Dance Education, 1*(2), 193–213.

Warburton, E. C. (2002). From talent identification to multidimensional assessment: Toward new models of evaluation in dance education. *Research in Dance Education, 3*(2), 103–121.

Wiggins, G. (1998). *Educative assessment: Designing assessments to inform and improve student perform-ance*. San Francisco, CA: Jossey-Bass.

Winner, E., & Hetland, L. (2000). The arts and academic improvement: What the evidence shows. *The Journal of Aesthetic Education, 34*(3/4).

Woolf, F. (1999). *Partnerships for learning: A guide to evaluating arts education projects*. London: Regional Arts Boards and the Arts Council of England.

Zemelman, S., Daniels, H., & Hyde, A. (1998). *Best practice: New standards for teaching and learning in America's schools*. Portsmouth, NH: Heinemann.

# INTERNATIONAL COMMENTARY

## 21.1

# A Taiwanese Perspective on Assessment and Evaluation in Dance

**Shu-Ying Liu**
*National Hsinchu University of Education, Republic of China (Taiwan)*

Taiwanese parents have high academic expectations. Languages and mathematics, both of which are regularly and easily assessed through examinations, dominate the school curriculum. In contrast, dance has long been sidelined in general education, and is seen by many to be only a physical activity or entertainment, and not a discipline or school subject in its own right. Dance education has also been much neglected by scholars and teachers.

In 2001, the Taiwanese Ministry of Education introduced a new national curriculum in elementary and junior high schools (Chinese Taipei Ministry of Education, 2001). For the first time, a new subject of "Performing Arts" was included in the Arts and Humanities domain, allowing the possibility of developing dance in schools. Although well intentioned, in practice the reforms have done little to change the position since:

(i) There remain very few specialist dance teachers qualified to teach in public schools;

(ii) The theory and practice of dance education is insufficiently developed;

(iii) Dance at all levels of education is generally performance-based and does not seek to develop young children's creativity or appreciation of dance;

(iv) There is an absence of curriculum guidelines translating government policy into practice;

(v) There is no system in place to assess and evaluate dance teaching and learning outcomes.

Although a few elementary and high schools have specialist dance departments providing prevocational training, most public school and kindergarten dance is taught by physical education or generalist teachers. Partly in response to parental demand and partly for commercial reasons, private kindergartens often provide extracurricula dance activities more associated with theater-dance. Although these are taught by specialist dance teachers, they are not usually qualified to teach full-time in schools or kindergartens.

357

*L. Bresler (Ed.), International Handbook of Research in Arts Education*, 357–360.
© 2007 *Springer.*

In almost all cases, tuition is product-oriented with children learning by rote, the nondance specialist teachers especially imitating what they find on dance videos rather than asking the children to create or do themselves. Tuition usually leads towards performance, often allied to special celebratory events such as graduation ceremonies, rather than being integrated into a curriculum. The primary concerns with regard to assessment and evaluation are the critical reaction of the audience and whether the students perform the set choreography well. The child's learning and development of other skills appears very much a secondary concern.

In response to these issues, my own collaborative action research focused on investigating and developing strategies for kindergarten teacher training in Taiwan to develop young children's abilities to make, perform and appreciate dance (Liu, 2004). Specifically, it explored ways in which drawing and painting could stimulate dance and help young children reflect upon it. Appropriate teaching and learning strategies were developed and tested using Davies' Movement Framework (2003) as a basis. The research also aimed to contribute to Matthews' (2003) theory of "figurative representation" and "action representation" by providing a better understanding of how young children connect their learning in drawing and painting with action in dance.

Effective evaluation and assessment was critical. The research team consisted of 20 generalist kindergarten teachers, an art specialist and myself – the triangulation reducing bias and allowing diverse viewpoints to be heard. The participant teachers engaged in "reflective dialogues" (Moyles, Hargreaves, Merry, Paterson, & Esarte-Sarries, 2003) in their evaluation of the children's learning and their own practice. Portfolio assessment was used, with all lessons fully documented, and audio and video recorded. The effectiveness of the stimuli and strategies used, and the young children's dance and art learning outcomes were reviewed and compared in weekly team evaluation meetings.

Although the research teaching strategies are now being evaluated to establish the extent to which they were effective for dance teaching and learning, this process was important. Besides providing a means of assessing and evaluating the students' learning outcomes lesson by lesson, it contributed to the teachers' professional development and their knowledge of dance teaching and learning and allowed consideration of further curriculum development.

A similar assessment and evaluation process is used by Taiwan's Cloud Gate Dance School[1]. Although classes are not audio or video recorded, teachers have to provide feedback after each one, and regular team meetings are held. Curriculum and lesson goals are given to parents and students, who are also asked to provide regular feedback, which is fed into discussions. The whole experience is used to plan teacher and future curriculum development (Wen, 2005).

As in both the above cases, evaluation and assessment should be seen as a two-pronged tool. It should be used for considering both the students' and teachers' actions, learning and outcomes. The evaluation and assessment must however take place against specified criteria and it is therefore essential to have curriculum guidelines in place, something sadly lacking in most Taiwanese dance education at this time.

# Note

1. The Cloud Gate Dance School offers dance classes for the community at 18 locations throughout Taiwan. It does not participate in any performances preferring to emphasise the development of the student through its three curricula. The School has a close relationship with, but is not part of, Cloud Gate Dance Theater, Taiwan's leading dance company.

# References

Chinese Taipei Ministry of Education (2001). *Education reform initiatives: Nine-year integrated curricula to be enforced in 2001.*

Davies, M. (2003). *Movement and dance in early childhood* (2nd ed.). London: Paul Chapman Publishing.

Liu, S. Y. (2004). *Developing generalist teachers' understanding of dance teaching in early childhood education in Taiwan.* Paper presented at the National Dance Education Organization Conference, Merging Worlds: Dance, Education, Society and Politics, Michigan State University, October 2004.

Matthews, J. (2003). *Drawing and painting: Children and visual representation* (2nd ed.). London: Paul Chapman Publishing.

Moyles, J. R., Hargreaves, L., Merry, R., Paterson, F., & Esarte-Sarries, V. (2003). *Interactive teaching in the primary school: Digging deeper into meanings.* Philadelphia, PA: Open University.

Wen, H.-W. (2005). Executive Director of the Cloud Gate Dance School, unpublished interview with David Mead, December 5, 2005.

22

# HARMONIZING ASSESSMENT AND MUSIC IN THE CLASSROOM

**Regina Murphy**
*Dublin City University, Ireland*

## Introduction

In the field of music education, assessment is fuelled by ardent passion on the one hand and blithe disregard on the other. While typical assessment practices such as grading, marking, ranking and selecting are integral to the world of the performing musicians, in the world of the classroom, especially among generalist teachers at the lower grades, the very opposite tends to occur in the case of music. Since young children are usually encouraged to play and have fun with music, primary teachers are provided with the freedom to consider assessment as unimportant and to treat assessment criteria in a liberal way (Olsson, 2001). In addition, music tends to have a low priority in the eyes of many educational administrators and music education is rarely criticized for its lack of effectiveness (Colwell, 2002). Halfway between these two extreme views are various positions of exemplary practice, experimentation, initiative, trial and error, enlightenment, uncertainty, lack of confidence, contention and pockets of resistance. Yet, current theories on learning, on assessment in education and in music have much to offer to support a vibrant middle ground and a meaningful approach to assessing music. In this chapter, then, I first consider some of the ongoing challenges in assessing music and from there examine the ordinary, and sometimes unique, assessment initiatives and practices in several countries and states. Next, I look at one of the most recent trends emerging in educational assessment. This provides an important backdrop as well as a contemporary theoretical underpinning for the most appropriate assessment strategies in music which are discussed in the final section of the chapter. The educational contexts implied throughout the chapter largely encompass the years of compulsory schooling, although examples from preschool and higher education are included where studies have proved particularly illustrative.

*L. Bresler (Ed.), International Handbook of Research in Arts Education, 361–380.*
© 2007 *Springer.*

*Definition and Purpose of Assessment*

The term assessment is used as a general one to incorporate a wide range of *methods* for evaluating pupil performance and attainment, including formal testing and examinations, practical and oral assessment, and classroom-based assessment undertaken by teachers (Gipps, 1999, p. 356). Assessment is also considered as the *process* of gathering, recording, interpreting, using and communicating information about all aspects of a learner's development (social, emotional, physical, cognitive) to aid decision making (Airasian, 1997; O'Leary, 2004; Stiggins, 1997).

The notion of assessment for selection has been the most pervasive role of assessment (Glaser & Silver, 1994). A second purpose is curriculum control at the national level as a common response to global demands where governments link economic growth to educational performance and use assessment to help determine curriculum to impose high "standards" of performance and to encourage competition among schools (Gipps, 1999, p. 363). More recently, assessment as an approach to reform has become the preferred means of promoting higher standards of teaching, more powerful learning and more credible forms of public accountability (Hargreaves, Earl, & Schmidt, 2002).

During the years of compulsory schooling, the purpose of assessment in music education is predominantly to improve student learning. While the typical purposes of assessment prevail – such as to determine student abilities to achieve objectives, outcomes and standards, to improve planning, instruction and motivation (Hepworth-Osiowy, 2004) – the focus on accountability is also high, especially in program evaluation in the United States, and in the need to prove that the subject is valid and important enough to keep on the curriculum (Brophy, 2000).

# Challenges in Assessing Music

The difficulties in assessing music have been noted by several commentators, researchers and music educators. Despite the growth in alternative approaches to assessment (e.g., Darling-Hammond, Ancess, & Falk, 1995; Torrance, 1995) and performance assessment (Eisner, 1999), the legacy of assessment for selection persists. Given that assessment in music was traditionally associated with the Bentley and Seashore tests which were largely designed to eliminate those who would be *unsuitable* to study music, it is hardly surprising that a negative emotional response to assessment in music is not unusual (Ruddock & Leong, 2005; Sloboda, Davidson, & Howe, 2000; Welch & Adams, 2003). For example, the awarding of a grade or numerical equivalent to the performance of a musical work can be traumatic and frustrating for the performer, as well as having inherent challenges for the assessor (Daniel, 2004). To assess in the arts might be regarded therefore as "sheer madness" (Colwell, 2004). On the other hand, according to test-developer James Popham, avoiding assessment and remaining assessment illiterate is deemed "professional suicide." He adds that the absence of assessment in arts education – or in any other education enterprise – creates an intellectual vacuum that impedes the improvement of pedagogical practice (Popham, 2004, p. 83).

Aside from attitudinal difficulties in assessing music, other challenges arise in the assessment of the domain itself, in the curriculum, in cultural contexts and in the question of personnel: who teaches music – and who should teach music?

## Assessing the Domain of Music

As an approach to assessing music, Brophy (2000) first presents the cognitive perspective and defines music as a complex, ill-structured content domain. He argues that there is no one prototype or analogy sufficient to cover all of the possibilities for potential musical performances or experiences. This implies that in order to assess music, one must obtain a multiplicity of perspectives on musical problem solving through multiple musical experiences. Adding constructivists views and the notion of situated cognition (Brown, Collins, & Duguid, 1989; Lave & Wenger, 1991), he emphasizes that learning must occur as part of an authentically situated cognitive experience and new musical knowledge is constructed from previous knowledge gained from case-by-case, or lesson-by-lesson experiences. In a similar vein, Elliott (1995) declares that since "musicianship is a multifaceted, progressive, and situated form of knowledge, music educators require a multidimensional, progressive and situated approach to assessment and evaluation" (p. 282). Brophy (2000) therefore suggests that assessment can only take place when it is embedded in an authentically musical context.

## Assessing the Curriculum in the Classroom

In the operational curriculum, the tension between the cognitive, higher-order and aesthetic aspects of music vs. the dispensable role of music as entertainment in school settings has been described by Bresler (1994) as music's "double bind" and begs the question: what should be assessed? Such dilemmas permeate the domain which vacillates between philosophical and organizational desires to value the innate musicality in all children (Ruddock & Leong, 2005; Sloboda, Davidson, & Howe, 2000; Welch & Adams, 2003) while cultivating assessment for selection. Added to this is the fact that participation in music lessons outside of school tends to have a high bearing on assessment outcomes within school, as findings from different settings indicate (Persky, Sandene, & Askew, 1998; Skolverket, 2004). Children taking music lessons outside of the main curriculum are invariably oriented towards the ritual of performance, which as Stephens (2003) observes, has enjoyed a long tradition of graded assessment in choral work and instrumental playing, with specific technical, interpretative and repertoire requirements – leading to showcase events and competitions. While competitions associated with controversial adjudicators' decisions are legendary[1] they remain an integral part of the culture of performance. Conversely, in composing, structure and progression is less obvious, less widely studied and external benchmarks are less commonly understood (Stephens, 2003), and therefore, in the messy, unfinished classroom work in progress, assessment continues to be problematic.

## Assessing in a Cultural Context

As Woodward (2002) reminds, all musical experience is culture specific. In any classroom, the range of differences among children is vast and includes, for example, differences by gender, by teacher expectations, access to resources; differences in tonality, melodic lines, textures and harmony, use of voice and instruments, rhythm, idiom, and form; differences in social occasion and purpose for the music; differences among children in multicultural communities, and differences in monocultural communities from different backgrounds. The cultural aspect of music can be detected even among very young children. Woodward (2002) reports that by assessing perceptual sensitivity, it has been demonstrated that very young children imitate the musical language of the mother, making musical that is culturally specific and typified by distinctive modal scales and rhythmic characteristics.[2] Culture and context are therefore regarded as a "gargantuan issue" (Woodward, 2002, p. 117) and the context in which assessment takes places is critical and complex. In the development of composition, culture impacts in a similar way. Studies suggest that what governs the ways in which music is created is the past musical experiences of the participants, drawing from features of their contemporary musical cultures, and using these either on instruments or with computer-based technology (Folkestad, 1996; Seddon, 2002; Seddon & O' Neill, 2001).

## Assessment by Specialists or Generalists

The assessment debate on who teaches music – specialists or generalists – has been raised by a number of authors. In the United Kingdom, a study of teacher identities found that both specialist and nonspecialist teachers could promote children's musical development by making time and opportunities for musical activities (Hargreaves, Welch, Purves, & Marshall, 2003). However, Byo (2000) found marked differences in her study of classroom teachers' and music specialists' perceived ability to implement the national standards for music education in the United States. She concluded that the music specialist is the primary provider of music instruction. The most striking result of her study was the generalists' near complete rejection of the music standards based on limitations of time, resources, training, ability, perceived responsibility, and interest. Their responses also indicated a reliance on the music specialist for effective teaching of most of the standards while the generalists declared that they could not effectively teach the content required by the national standards for music by themselves.

But by virtue of the fact that specialist teachers teach several classes, the greatest challenges in assessing students can be of time management and valid tools, where too little contact time with large numbers of students mitigates against any meaningful assessment (Chuang, 2004; Hepworth-Osiowy, 2004); learning goals may be quite diverse, ranging from the acquisition of skills for musical performance to the acquisition of knowledge about the structure and style of music (Chuang, 2004). Finding ways of developing an appreciation for the value that music adds to human life – an aim espoused by many in national curriculum statements – and then assessing such an aim, may be too tall an order.

Ross (1995) has been a persistent critic of the "classical" ethos of classroom music and its teachers. Drummond (2001) concurs with this view. He describes music teachers nurtured in "what many would term an elitist educational background that was 'classical' rather than inspired by other styles" and where their "knowledge and skills were inspired by instrumental tuition, extracurricular performance, and more specialized studies" (p. 23). Hence there is a disjunction of musical values, knowledge and experiences in the classroom (Small, 1999; Spruce, 2001) where children's tastes reflect their exposure more than ever to a wide range of music (Welch & Adams, 2003).

But the argument concerning who assesses, specialist or generalist, may be redundant if the findings of Sharp and LeMétais (2000)[3] are to be considered. In their study of the arts encompassing 19 countries, specialist teachers in the arts were found to be a rarity at the primary level, with some exceptions (Spain, the Netherlands, the Republic of Korea, and Queensland in Australia). The authors note the concern in many countries to improve primary teachers' confidence in arts teaching and the need for secondary teachers to develop new skills to replenish their own creativity.

*Summary*

Given the inherent difficulties in assessing music from several perspectives, it would appear that, as Waldorf (2005) emphasizes, to seek "indisputable instruments that monitor student learning in a way that can be generalized across programs" (p. 86) may be premature and that more meaningful assessment can be extracted from enhancing the educational value of work in schools. It is in the classroom that the most vital teaching, learning and assessment takes place and arguably the best use of assessment expertise should be towards this end. As Paynter (2002) asserts:

> When we begin to consider why music might have a place in the school curriculum we must believe that a teacher's commitment is to all the pupils, not only to those with conventional talent. Music may have a role in school life socially but, if it is to be a valuable *curriculum* subject, what is done in the classroom must reach out to every pupil; that is to say, it must exploit natural human musicality. (p. 219)

We turn then to the field of national monitoring to gather insights on how the music curriculum is assessed in various countries.

# International Practices in Assessing Music

Insights on national assessment practices in music are seldom featured in music education journals although information can be gleaned from other sources such as ministry Websites, national reports and international reviews.[4] The unique nature of a country's approach, as well as common issues across many jurisdictions, come into sharp relief through such illustration. As Spruce (2001) observes: "the manner in which musical achievement is defined and assessed inevitably articulates a set of

philosophical and political principles about the nature and purpose of learning, the subject being assessed and the relationship between school and society" (p. 118). How music is assessed is frequently reported together with other arts subjects rather than as a separate domain (Taggart, Whitby, & Sharp, 2004) – a factor which, it itself, may reflect its perceived role and value in society.

Building on previous research in the arts (Sharp & Le Métais, 2000) the more recent international review of curriculum frameworks in the arts conducted by Taggart et al. (2004)[5] sought answers to the following questions on assessment from 21 educational systems: (1) Which approaches are used to monitor and assess progress and attainment in the arts?; (2) What support is provided to help teachers assess pupils' progression and attainment in the arts?

The authors concluded that all countries/states use teacher assessment for arts subjects. Assessment is approached in three main ways: the first requires teachers to make a professional judgment in relation to curriculum content, that is, in relation to a student's ability to perform, as well as to respond, in the arts. The second approach involves the teacher in marking pupils' performance against a standard required for a given age-group/grade. Most countries/states use the first two approaches to assessment. A third approach involves the teacher in ascribing a level of progress to each pupil using a graduated scale, regardless of age or grade. Teachers are commonly expected to assess progress in the arts through observation and assessment of portfolios or samples of work. Most countries/states provide guidance for teachers in planning, monitoring and assessing the arts. Although this guidance provides suggestions for activities and resources, exemplification material is not commonly provided (Taggart et al., 2004, pp. iii–iv). However, in England, detailed exemplification material is available online and the Qualifications, Curriculum and Assessment Authority for Wales (ACCAC) also produces exemplification materials in the form of a video and explanatory notes. In Australia, the states of both Queensland and Victoria (see Table 1) provide detailed exemplification materials in the form of annotated work samples for every area of music at every level, together with professional development

**Table 1.** Example of annotated work samples in music at Level 4 (11- to 12-year-old pupils) provided by the Victorian Curriculum and Assessment Authority (VCAA), Australia (2003) (cited in Taggart et al., 2004)

|  | Towards the level | At the level | Beyond the level |
|---|---|---|---|
| Understanding of designated features of music works | Identifies key features of the works | Identifies and discusses musical features of a range of works | Develops aural perceptiveness and describes distinctive features of the works |
| Use of appropriate terminology | Describes key features of works using appropriate terminology | Describes use of specific elements using appropriate terminology | Discusses, compares and contrasts music using appropriate terminology |
| Ability to make a personal response to music works | Explains responses to music | Describes the effectiveness of the music | Evaluates the technical and expressive qualities of the music |

resources for in-service. They were designed to assist teachers to make reliable judgments of student achievement.

## *National Monitoring*

National Monitoring provides information on student achievement for a nation or state as a whole. Taggart et al. (2004) concluded that national or state-wide monitoring featured only very occasionally and cited the National Assessment of Educational Progress (NAEP) in the United States as the most prominent. The following section looks at practices in the United States, Europe and New Zealand.

*United States.*    In the United States, the original purpose of National Assessment of Educational Progress (NAEP) was to measure and report on the status of student achievement and on change over time. To date, there have been three national assessments in the arts: 1971–1972, 1978 and 1997. Since its inception, recognition of the quality and integrity of the National Assessment has led to a multitude of demands and expectations beyond reporting on achievement. Yet, information gleaned from the 1997 NAEP assessment of music yields information which may have implications at school and classroom level. For example, it is reported that female students outperformed male students in music; White students outperformed Black and Hispanic students with one notable exception in music-creating for which there was no significant difference between the White and Black students; and higher levels of parental education were associated with higher levels of student performance in music. Persky, Sandene and Askew (1998) point out that that student involvement in music activities is positively related to student achievement in music. The assessment also found a positive relationship between students responding to music and students "doing" music-creating and performing. While they emphasize that these are not causal relationships, nevertheless they highlight their relevance for practice in music education. However, given that the next NAEP in the Arts is scheduled for 2008 (National Assessment Governing Board, 2005), 11 years after the previous assessment, the potential for monitoring trends as they impact on practice is somewhat diminished.

*England.*    In England, monitoring takes place through subject evaluation reports carried out by the Office for Standards in Education (Ofsted) and Her Majesty's Inspectorate (HMI). The 2003 report on music at secondary level, for example, identifies the assessment strategies that are appropriate to learning and achievement in music, the best ways of collecting assessment information and organizational approaches that are most effective. Though evaluating progress in a broad sense, the report provides insight on good practice in the classroom.

At primary level, the Ofsted report of 2003 identifies "key and emerging issues that schools should address, as appropriate, if they are to bring about subject improvement"

(np). The report points to strengths, for example, noting that where assessment is effective, there is a secure focus on what is to be learned, how it will be observed, how many pupils can realistically be observed in each session and how the evidence of progress and achievement can be logged an stored. It identifies "unmusical" practice as well, where students are required to demonstrate musical knowledge and understanding verbally, rather than through live or recorded music-making.

*Republic of Ireland.*    In the Republic of Ireland, the inspectorate of the Department of Education and Science monitor student achievement through frequent inspection of schools. A recent publication provided a synthesis of inspectors' school reports on a subject basis and identified in the broadest terms, what may be regarded as features of good practice as well as some concerns (Department of Education and Science, Ireland, 2002). The generality of the report means that teachers seeking to improve their practice will find few pointers. However, the report may serve as a baseline for future studies and reports.

*New Zealand.*    Another example of national monitoring is found in the National Education Monitoring Project (NEMP) in New Zealand. Here the purpose is to focus on the educational achievements and attitudes of New Zealand children in year 4 (aged 9–10) and year 8 (aged 13–14), providing a "snapshot" of their knowledge, skills, motivation in music and a way to identify which aspects are improving, staying constant or declining. The authors of the Music Assessment Results 2004 state that the information "allows successes to be celebrated and priorities for curriculum change and teacher development to be debated more effectively, with the goal of helping to improve the education which children receive" (Flockton & Crooks, 2005, p. 5). The scheduling of assessment in music at 4-year intervals: 1996, 2000, and 2004, allows for a tighter focus on overall standards and trends than in the NAEP model. Most of the assessment tasks are made available to schools apart from the "trend" tasks which are used for comparison to past and future assessments. On the whole, the assessment process appears to be held in high regard by the profession: some teachers are trained in administering and marking the tasks while others display a good deal of interest in the tasks and like to use them to compare the performance of their own students to national results on some aspects of the curriculum. The current results show a slight overall improvement for year 4 students, with a greater reduction in low performance than an increase in really high performance. At year 8, there is no meaningful change in performance since 2000.

   In addition, surveys sought information from students about their involvement in and enjoyment of the music curriculum. Both age levels are generally very positive about doing music in school. However, the survey reveals a large gap between how much students say they enjoy *doing* musical activities (singing, playing instruments, listening to music, dancing/moving to music, making up music) and how much they actually *did* these things at school. Listening to music was reported as the dominant activity while opportunities to make up (compose) music appeared to be infrequent.

*Sweden.* A national evaluation of curriculum undertaken in 2003 illustrates musical activity in Sweden (Skolverket, 2004) with both similarities and contrasts to the New Zealand one. This study targeted teachers and pupils in year 9 (aged 14–15) and sought information in relation to attainment targets, pupils' knowledge of music, teacher competence, the pupils' perceptions of their own knowledge and their views on school music vs. music in their leisure time. A comparison between a 1992 evaluation was also carried out. A major finding is the degree of variation in terms of what kind of musical knowledge is developed in different schools, groups and classes. Similarly, great differences are also found in teachers' frameworks: some draw from the national curriculum documents – either the old one (1994) or the new one (2000), others use local plans. A substantial proportion of teachers create their own curriculum by building on their own competence and interests. The evaluation shows a wide array of activities taking place in classrooms. Music listening appears to be the dominant aspect of the 2000 curriculum whereas creative music is scarce and attainment targets are considered unclear. A major conclusion of the study is that when it comes to music, as researched for year 9, authorities do not provide for frameworks and conditions that enable equal opportunities and provision for all.

The survey of pupils' attitudes towards music revealed that the majority of pupils rated the subject as less useful compared to the earlier study. They also perceived it as non-modern and restricted in focus, with differences between the kind of music enjoyed by students outside of school and that which is taught in lessons. This is illustrated by the comment from one child: "the music I like doesn't come into lessons." In terms of assessment and grading, a large proportion of pupils indicated that they had not been informed about the goals of teaching, did not receive sufficient feedback, and as their teachers did not speak to them about how they were progressing in music, they did not know how to attain different grades. Furthermore, it was found that schools tended to disregard the national goals for music and instead focus on goals which are less demanding.

### Summarizing the Role of National Assessments

In a cogent analysis of the relationship between large-scale and classroom assessments, Asp (1998) suggests that large-scale assessments can be made more accessible to the classroom teacher by including performance-based items, and involving teachers in scoring the items – a practice which is noted in the New Zealand NEMP. Second, large-scale assessment can be embedded in the instructional program in the classroom in a meaningful way and by providing specific feedback to students and teachers about how well the intended aspect of learning was achieved. Although Flockton and Crooks (2005) state that this is neither the intention of NEMP, nor is it practical, nevertheless their report provides valid and meaningful information on the performance of subgroups (e.g., Maori, Pasifika, or low socioeconomic background) which creates an impetus for schools to respond to and act on the results. Third, Asp suggests that multiple measures through a variety of assessments can serve as anchors for classroom efforts and provide a context for a comprehensive view of student achievement.

Finally, Asp underlines that individual student achievement is best assessed by classroom teachers, with large-scale assessment serving as an anchor for their judgment. This calls for professional development of teachers so that they may become better assessors and time should be provided for them to share and discuss student work (p. 43).

# Learning from Educational Assessment

*Formative Assessment and Assessment for Learning*

One of the most influential pieces of research evidence to emerge in recent years on effective assessment is the study on formative assessment by Black and Wiliam (1998) with evidence continuing to accumulate of the positive benefits (Black, 2003; Black, Harrison, Lee, Marshall, & Wiliam, 2004). Black and Wiliam reported that improved formative assessment helps low achievers more than other students and therefore reduces the range of achievement while raising achievement overall. Their research reveals that achievement gains are maximized in contexts where the accuracy of classroom assessments is increased, where students are provided with frequent informative feedback (rather than infrequent judgmental feedback), and where students are deeply involved in the classroom assessment, record keeping, and communication processes. Self assessment by students is a critical component and the elements of feedback are clear. Black and Wiliam conclude their study as follows:

> Thus self-assessment by pupils, far from being a luxury, is in fact *an essential component of formative assessment*. When anyone is trying to learn, feedback about the effort has three elements: redefinition of the *desired goal*, evidence about *present position*, and some understanding of a *way to close the gap between the two*. All three must be understood to some degree by anyone before he or she can take action to improve learning (emphasis in original). (p. 141)

To reinforce the messages specifically for policymakers, implicit in the Black and Wiliam review, the Assessment Reform Group (1999) coined the term "Assessment *for* Learning". The principles underpinning their work has generated interest among curriculum and assessment providers in several countries/regions, such as Australia, Hong Kong, England, Scotland, Wales, and Ireland. A key principle in the assessment for learning approach is the use of assessment in the classroom as a tool to improve students' learning.[6]

The nature of feedback is critical to formative assessment and in assessment *for* learning. Roos and Hamilton (2005) revisit the work of scholars Ramaprasad (1983) and Sadler (1989). They note the role of information in altering the achievement gap, and that if information on the gap is merely stored without being utilized to alter the gap, it is not feedback. The learner is at the heart of the assessment process, and that if given specific feedback tailored to the nature of the assessment task, the learner will progressively appreciate what constitutes high quality work and the strategies needed for high achievement.

# From Educational Assessment to Assessment in Music

The assessment *for* learning debate raises many issues which are pertinent to assessment in music. Although many tools, strategies, approaches and techniques are not new to the field, in light of current research, it is worth focusing attention on some of these as part of evolving approaches and future developments.

## *Assessment Tools and Strategies*

Several researchers in music education (e.g., Brophy, 2000; Chuang, 2004; Spruce, 2001) recommend the collection of a wide range of data on classroom activities. In terms of formative assessment, such data enable teachers to thoughtfully reflect on student learning and effectively plan successive learning experiences (Chuang, 2004). Use of multimedia approaches such as videotaping, audiotaping and photographing are among the methods recommended. This form of documentation can be rich in context, respect diversity, encourage different ways of showcasing different strengths and enable the development of skills in self assessment.

The benefits of portfolios for goal setting, instructional planning, instructional strategies, classroom management, interaction with students and as assessment tools have been widely documented and many of the issues raised by Hall, Rix, and Eyres (in this volume) are also relevant to music. The assessment dimensions (*production, perception, reflection*, and *approach to work*) identified by the Project Zero (Davidson, Scripp, & Winner, 1992) still provide a noteworthy framework for assessment in music. Colwell (2002) provides a detailed review of portfolio models and the related issues of validity and reliability in using portfolios as an assessment tool. In a more recent study on the experiences of elementary music teachers in developing and using class portfolios in general music classes in Taiwan, Chuang (2004) reports the benefits of portfolios as promoting reflective teaching, effective teaching and student centeredness. However, Chuang also noted the sources of frustration for the teachers as the time-consuming nature of portfolio work, the demands of technology and the challenge of overcoming their low level of confidence which impeded the work.

Another feature of assessment *for* learning is the emphasis on the centrality of the student in the assessment process and Daniel's (2004) study of peer assessment is worth examining in this regard. Despite the potential for resistance towards its implementation in higher education, together with the extra demands of time, peer assessment has been found to have considerable benefits for students (Daniel, 2004). Such benefits include the development of a range of skills relating to assessment: critical thinking; evaluation and independent learning skills; increased confidence in and knowledge of assessment procedures. In addition, Daniel found that students had a greater sense of participation in and control of the learning process and offered a greater variety of feedback. Blom and Poole (2004) further report that the involvement of students in peer assessment enabled them to reconcile their expectations with reality which resulted in a demystifying of assessment. The students understood they were being offered another way of learning about the performance process of others and, at the same time, through self-reflection, their own performing.

While both peer marking and peer feedback or criticism offer different but complementary benefits to students (Falchikov, 1995), ultimately Blom and Poole (2004) found the sharing of comments to be of most use, and have continued to explore peer assessment of performance without the awarding of marks and grades. Their approach concurs with Daniel's (2004) view that assessment should not be something done *to* students, but *with* students (p. 91).

## Using Assessment Criteria

Stanley, Brooker, and Gilbert (2002) report that while subjectivity is an important aspect of performance assessment, accuracy of assessments can be improved considerably by adopting procedures that increase the level of objectivity. Citing McPherson and Thompson's (1998) study they emphasize that biases can occur in assessment due to reliance on subjective opinion, and the sometimes low reliability among assessors as the reasons for the increasing use of standardized criteria. Stanley et al. (2002) argue that the use of evaluative criteria and rating scales provide a useful focus during the assessment process and help to articulate desirable performance characteristics in feedback to students. However, the authors also recognize that criteria can impose limitations on examiners that undermine the assessment process, emphasize a narrow view of music performance characteristics and even interfere with holistic judgment. Similarly, in general education settings, Tierney and Simons (2004) identify several issues in relation to the use of criteria in rubric design which concern the validity of results obtained and the reliability of interpretations. The authors caution that rubrics that are used for classroom assessment in particular must present clear and consistent performance criteria across their scale levels if they are to be instructionally useful.

In the area of composition, an alternative to specific rating scales and rubrics is supported by Hickey (1995) where she explored Amabile's (1983) consensual assessment technique (CAT) and found it to be a useful mechanism for rating the creativity of musical compositions. In a related study, Webster and Hickey (1995) claimed that open-ended rating scales of the CAT type were at least as reliable, if not more reliable, than more closed, criterion-defined scales. Hickey (2000) also noted that those closest to the students, that is, teachers, were the most expert at judging creativity, a finding she bases on the higher inter-rater reliability of teachers, as compared to composers and students. Although Hickey recognizes that teachers are not likely to use the CAT method as a form of assessment in the classroom, she underlines the fact that the premise upon which it is based can enable teachers to appreciate that an unusual composition can also signify a good composition. More recently, Hickey and Lipscomb (2006) explored the concept of difference in the study of "cantometrics" based on the work of ethnomusicologist, Alan Lomax (1962, 1976). This is a method for observing and objectively analyzing the musical traits of a composition. Hickey and Lipscomb used cantometrics as an evaluative tool to determine the extent to which the musical compositions of 9 to 10 year olds diverged from a given template when encouraged to do so. High inter-rater reliability was again found among judgments. Hickey and Lipscomb emphasize that the goal of the research was *not* to evaluate student composition in terms of quality; rather, they sought to identify

specific differences between student compositions as a means of considering how students approach such compositional tasks. Nevertheless, they urge teachers to be sensitive to odd compositions that are created by children and to resist the urge to dismiss them immediately as incorrect.

### Going With the Flow

Adopting an assessment view that the whole is more than the sum of its parts, the study of "flow" or "optimal experience" offers a unique assessment lens in music education. This is the view shared by a growing body of researchers in music who base their work on the theories of Csikszentmihalyi (1988, 1992). Sheridan and Byrne (2002), for example, claim that the prevalence of templates in teaching composition in Scottish schools is linked to a complex examination system where the needs of assessment stifle the very creative process which the curriculum seeks to foster. According to Csikszentmihalyi (1988, p. 30), the study of flow, or optimal experience, requires a balance between the challenges perceived in a given situation and the skills a person brings to it. The concept of flow is also found in approaches to assessment which can be described as effortless involvement with everyday life and may occur when a person is engaged in absorbing activities which are both challenging and enjoyable. Custodero (2005) has observed flow in young children's music making in various settings. Finally, Byrne, MacDonald, and Carlton (2003) found a significant correlation between optimal experience or flow levels of students and the quality of their group compositions as measured by creativity ratings.

### Feedback – the Essence of Assessment for Learning in Music

A final note of resonance between educational assessment and music assessment is found in the role and nature of feedback. As stated earlier in the chapter, feedback which enables the student to "close the gap" between where he/she is at to where he/she needs to go is vital in the teaching, learning and assessment loop. In music education, the use of feedback is typically associated with the composing process, and it features in research in this area, both directly (Reese, 2003; Webster, 2003; Younker, 2003) as well as indirectly (e.g., Espeland, 2005; Paynter, 2002). Pitts (2005) has examined feedback on music students' written work and although the setting is in higher education, arguably there are salutary lessons for students and teachers for the years of compulsory schooling. In addition, given the dearth of literature on feedback in music with younger students, it is worthwhile drawing attention to this recent study.

Reese (2003) examines the body of research on how children, novice learners, and professional composers think and work through the compositional process in relation to the nature of feedback and responding to student compositions. He recommends that the teacher's response must first be to the whole work and its overall expressive character before appraising the details of melody, rhythm, harmony etc. Second, the teacher must be able to carefully judge the students' readiness to receive criticism, moderating responses as necessary. Reese draws attention to the dialogic nature of the relationship between student and teacher and its balance of give-and-take, stating that

neither a primarily directive, didactic approach nor a heavily facilitative, heuristic approach is sufficient on its own. Finally, he reminds that responses should be strongly related to the purpose of the composition within the larger music education of the student.

For feedback to be truly meaningful in composing, Younker (2003) suggests that as a prerequisite, the model of teacher-student relationship must shift from one of master and apprentice to one of listener and responder. In the latter, both teacher and student are engaged in a dialogue of problem-framing and problem-solving. The teacher recognizes, understands and values students' roles in an interactive relationship and offers insight only as required, and through using feedback, knows when to encourage autonomy and independence, and when to monitor and supervise work more systematically. Echoing Sadler's (1989) view of the embedded nature of feedback, Younker describes the process of feedback as "a multidimensional one in which teacher and students offer feedback to each other and reflect on and respond to the given feedback" adding that "assessment, then, is an ongoing process that occurs during and after the completion of the project" (pp. 235–236). The use of judicious questioning is an important feature of assessment *for* learning and Younker recommends both the use of Bloom's taxonomy (1956) in formulating challenging questions as well as the Socratic method of questioning. A similar approach is proposed by Paynter (2002) who describes the setting thus:

> For the teacher, the essential quality is an ability to comment purposefully and encouragingly on pieces which pupils produce … either in small groups or individually. The teacher's observations must follow on immediately from the presentation of the music, drawing in all other members of the class in addition to the composers themselves to recall what happened in the piece: the relationship of material to Idea, and the extent to which the Idea was fulfilled – that is to say, "fully filled out". Much of this will be achieved through appropriate questioning, with occasional reference, preferably by demonstration, to compositions by other composers who have explored similar ideas. (Paynter, 2002, p. 224)

Younker concludes that feedback is not about single right answers but real musical growth, suggesting that "closure is not always necessary, nor is it always possible" (p. 240).

Finally, a small-scale study of feedback on music students' written work conducted by Pitts (2005) reveals several interesting findings. First, she asks students what they *need* from feedback. In the first instance, students say that they are irritated by hastily written comments which they interpret as a lack of care and interest in their work. This tends to lessen their trust in the tutor's professional judgment and if the comments are carelessly negative, lessens the students' self-confidence. Quantitative findings indicate that students like comments to be brief, fair and helpful. A second question in the study required the students to supply a piece of feedback that had a particular effect on them, either positive or negative. Pitts notes the students' sensitivity to language and remarks that the range of interpretation to which comments are open has worrying implications. Third, students may know what they *want* from feedback, but appear

unable to communicate this to their tutors. Their main request is for more verbal, face-to-face feedback to be given at meetings with tutors, and greater consistency and quality in written feedback. Pitts also establishes from her music teaching colleagues their aims in giving feedback which she finds to be similar to those of the students, that is to provide formative feedback that will improve future work; to provide encouragement for things that were done well; and to highlight areas where more work could have taken place or more insight used. While the links between tasks, criteria and feedback may be obvious to staff, Pitts argues, if they are not consistently made, students will not see the links for themselves. In addition, good intentions in providing feedback on an individual staff level can be "subverted by the context in which they occur" (p. 227).

## Conclusion

With the increasing demand for accountability as described at the beginning of this chapter there is a danger that assessment and feedback may join the ever-increasing list of administrative tasks to be undertaken by teachers. But as Pitts reveals, feedback is not just "for the file" but an important teaching task and in echo of Sadler (1989) and other proponents of assessment *for* learning, where feedback is hidden from students, even unwittingly, it serves very little purpose.

A recurring motive in this chapter has been the locus of assessment – the classroom – and its agents: the teacher and students. For despite the desires of politicians and policy makers, the real high-stakes assessment for music occurs not in a blaze of accountability spotlights, but in the everyday decision making and dialogue between the teacher and the student. Given the current interest of the educational assessment community in formative assessment, it is opportune for music education to consider this topic with renewed vigor. However, enabling teachers to become more assessment literate is key. As numerous researchers and music educators remind, negative labels can adhere for a lifetime and inhibit student progress. On the other hand, assessment that keeps the learner at its heart, nurtured through the art of carefully considered feedback, has the power to transcend many of the vagaries of curriculum and culture, resources and circumstances, and bring harmony to the cycle of music teaching, learning and assessment.

## Notes

1. The *Helsingin Sanomat*, Finland's leading national newspaper, reported that at the third International Sibelius Conductors' Competition held in Helsinki in September 2005, the international jury of the competition made a unanimous decision to award no first, second or third prizes. To an astonished audience, the chairman of the jury declared that the level of the competition was a disappointment, and the jury felt that not one of the contestants met the criteria for a winner of the competition. Instead, the jury decided to award smaller prizes in quite new categories: an "incentive prize," and a prize "for participation in the final."

2. For a review of studies in the assessment of young children's natural musical understanding in spontaneous music making, see Woodward (2002).

3. The report draws on information from 19 educational systems (Australia, Canada, England, France, Germany, Hong Kong, Hungary, Italy, Northern Ireland, Republic of Ireland, Japan, Republic of Korea, the Netherlands, New Zealand, Singapore, Spain, Sweden, Switzerland, and the United States) to provide

a comparative analysis of the arts, creativity and cultural education. It is based on information from the International Review of Curriculum and Assessment Frameworks (INCA) Archive (which provides detailed descriptions of different educational systems), together with discussions at a seminar, held in July 2000.

4. Exceptions to this are studies and commentaries on the U.S. National Assessment of Educational Progress [NAEP] in Music, 1997.

5. The evidence base comprised 21 questionnaire replies and relevant online information. The authors point out that it would be unwise to generalize the results of this study to other countries and states. It is also important to point out that the document represents statements of intent, rather than a description of actual classroom practice. The 21 countries/states that contributed to the study were: Australia (Queensland and Victoria); Canada (Alberta, Ontario, and Saskatchewan); England; France; Germany; Hungary; Italy; Japan; the Netherlands; the Republic of Ireland; the Republic of South Africa; Singapore; Spain; Sweden; Switzerland; United States of America (Kentucky and Massachusetts); and Wales.

6. For detailed information on the aims, principles and methodologies inherent in Assessment *for* Learning, see, for example, the National Council for Curriculum and Assessment 2006: www.ncca.ie.

# References

Airasian, P. W. (1997). *Classroom assessment* (3rd ed.). New York: McGraw-Hill.

Airasian, P. W., & Walsh, M. (1997). Constructivist cautions. *Phi Delta Kappan, 78*(6), 444–449.

Amabile, T. M. (1983). *The social psychology of creativity*. New York: Springer-Verlag.

Asp, E. (1998). The relationship between large-scale and classroom assessment: Compatibility or conflict. In R. Brandt (Ed.), *Assessing student learning: New rules, new realities* (pp. 17–46). Arlington, VA: Educational Research Service.

Assessment Reform Group. (1999). *Assessment for learning: Beyond the black box*. Cambridge, UK: University of Cambridge School of Education.

Black, P., & Wiliam, D. (1998). *Inside the black box: Raising standards through classroom assessment*. London: King's College University.

Black, P., Harrison, C., Lee, C., Marshall, B., & Wiliam, D. (2004). Working inside the black box: Assessment for learning in the classroom. *Phi Delta Kappan, 86*(1), 9–21.

Blom, D., & Poole, K. (2004). Peer assessment of tertiary music performance: Opportunities for understanding performance assessment and performing through experience and self-reflection. *British Journal of Music Education, 21*(1), 111–125.

Bloom, B. (1956). *Taxonomy of educational objectives: The classification of educational goals*. New York: Longmans.

Bresler, L. (1994). Music in a double bind: Instruction by Non-Specialists in Elementary Schools. *Arts Education Policy Review, 95*(3), 30–36.

Brophy, T. (2000) *Assessing the developing child musician*. Chicago, ILL GIA.

Brown, J. S., Collins, A., & Duguid, P. (1989). Situated cognition and the culture of learning. *Educational Researcher, 18*(1), 32–43.

Byo, S. (2000). Classroom teachers' and music specialists' perceived ability to implement the national standards for music education. *Arts Education Policy Review, 101*(5), 30–35.

Byrne, C., MacDonald, R., & Carlton, L. (2003). Assessing creativity in musical compositions: Flow as an assessment tool. *British Journal of Music Education, 20*(3), 277–290.

Chuang, M. J. (2004). *The experiences of teachers developing and using class portfolios in general music classes in Taiwan, Republic of China*. Doctoral thesis at The Pennsylvania State University. http://wwwlib. umi.com/dissertations/preview_all/3140000

Colwell, R. (2002). Assessment's potential in music education. In R. Colwell & C. Richardson (Eds.), *The new handbook on research on music teaching and learning* (pp. 1128–1158). Reston, VA: MENC.

Colwell, R. (2004). Evaluation in the arts is sheer madness. *Artspraxis No. 1*. Online journal. Retrieved 25/11/2004 http://education.nyu.edu/music/artspraxis/articles/colwell_content.html

Csikszentmihalyi, M. (1988). The flow experience of human psychology. In M. Csikszentmihalyi & I. Csikszentmihalyi (Eds.), *Optimal experience: Psychological studies of flow in consciousness* (pp. 15–35). Cambridge, MA: Cambridge University Press.

Csikszentmihalyi, M. (1992). *Flow: The psychology of happiness*. London: Random House Ltd.

Custodero, L. (2005). Observable indicators of flow experience: A developmental perspective on musical engagement in young children from infancy to school age. *Music Education Research, 7*(2), 185–209.

Daniel, R. (2004) Peer assessment in musical performance: The development, trial and evaluation of a methodology for the Australian tertiary environment. *British Journal of Music Education, 21*(1), 89–110.

Darling-Hammond, L., Ancess, J., & Falk, B. (1995). *Authentic assessment in action*. New York: Teacher's College Press.

Davidson, L., Scripp, L., & Winner, E. (Eds.). (1992). *Arts PROPEL: A handbook for music*. Cambridge, MA: Project Zero, Harvard Graduate School of Education.

Department of Education and Science Inspectorate, Ireland. (2002). *Fifty school reports: What inspectors say*. Dublin, Ireland: Author.

Drummond, B. (2001). The classroom music teacher – inspirations, aspirations and realities. The evidence from Northern Ireland. *British Journal of Music Education, 18*(1), 5–25.

Eisner, E. (1999). The uses and limits of performance assessment. *Phi Delta Kappan, 80*(9), 658–660.

Elliott, D. (1995) *Music matters: A new philosophy of music education*. Oxford: Oxford University Press.

England (2005). National Curriculum in Action, 2005. Accessed September 2005, http://www. ncaction.org.uk/

Espeland, M. (2005). *Compositional process as discourse and interaction*. Unpublished doctoral dissertation. Danmarks Pædagogiske Universitet [The Danish University of Education].

Falchikov, N. (1995). Peer feedback marking: Developing peer assessment. *Innovations in Education and Training International, 32*(2), 175–187.

Flockton, L., & Crooks, T. (2005). *National education monitoring report 32: Music assessment results 2004*. Dunedin, New Zealand: Educational Assessment Research Unit, University of Otago.

Folkestad, G. (1996). *Computer based creative music making: Young people's music in the digital age*. ACTA Universitatis Gothoburgensis.

Gipps, C. (1999). Socio-cultural aspects of assessment. *Review of Research in Education, 24*, 355–392.

Glaser, R., & Silver, E. (1994). Assessment, testing, and instruction: Retrospect and prospect. In L. Darling-Hammond (Ed.), *Review of Research in Education*, (Vol. 20, pp. 393–421). Washington, DC: American Educational Research Association.

Hargreaves, A., Earl, L., & Schmidt, M. (2002). Perspectives on alternative assessment reform. *American Educational Research Journal, 39*(1), 69–95.

Hargreaves, D., Welch, G. F., Purves, R., & Marshall, N. (2003). *Teacher Identities in Music Education (TIME). Final Report*. Roehampton University, London: Centre for International Research in Music Education.

Helsingin Sanomat [Finland's leading national newspaper]. Accessed September 2005, http://www.helsinginsanomat.fi/english/article/No+winner+in+disappointing+Sibelius+Conductors+Competition%0D%0A/1101980971420

Hepworth-Osiowy, K. (2004). *Assessment in elementary music education: Perspectives and practices of teachers in Winnipeg public schools*. Masters Thesis, University of Manitoba, http://wwwlib.umi.com/dissertations/preview_page/MQ91239/4#top

Hickey, M. (1995). *Qualitative and quantitative relationships between children's musical thinking processes and products*. Unpublished Doctoral Dissertation, Northwestern University, Evanston, IL, 1995.

Hickey, M. (2000). The use of consensual assessment in the evaluation of children's music compositions. In C. Woods, G. Luck, R. Brochard, F. A. Seddon & J. A. Sloboda (Eds.), *Proceedings from the Sixth International Conference on Music Perception and Cognition* [CD-ROM], Keele, UK, August.

Hickey, M., & Lipscomb, S. (2006). How different is good? In I. Deliege & G. Wiggins (Eds.), *Musical creativity: multidisciplinary research in theory and practice*. Psychology Press: Taylor & Francis Group).

Lave, J., & Wenger, E. (1991) *Situated learning. Legitimate peripheral participation*. Cambridge, MA: University of Cambridge Press.

Lomax, A. (1962). Song structure and social structure. *Ethnology, 1*, 425–451.

Lomax, A. (1976). *Cantometrics: A method in musical anthropology*. University of California Extension Media Center, Berkeley, CA.

McPherson, G. E., & Thompson, W. (1998). Assessing music performance: Issues and influences. *Research Studies in Music Education, 10*, 12–24.

National Assessment Governing Board. (2005). NAEP schedule approved for 2008 Accessed August 15, 2005, http://www.nagb.org/naep/NAEP_schedule_approved_05_05.doc

Office for Standards in Education [Ofsted]. 2004. Ofsted Subject Reports 2002/03. Music in Primary Schools. Her Majesty's Inspectors [HMI] UK.

O'Leary, M. (2004). *Towards a balanced assessment system for Irish schools.* Keynote address to the Department of Education and Science Inspectorate, 2004.

Olsson, B. (2001). Scandinavia. In D. J. Hargreaves & A. C. North (Eds.), *Musical development and learning: The international perspective* (pp. 175–186). London and New York: Continuum.

Paynter, J. (2002). Music in the school curriculum: Why bother? *British Journal of Music Education, 19*(3), 215–226.

Persky, H. R., Sandene, B. A., & Askew, J. M. (1998). *The NAEP 1997 Arts report card: Eighth-grade findings from the national assessment of educational progress* (NCES 1999–486). U.S. Department of Education. Washington, DC: U.S. Government Printing Office.

Pitts, S. E. (2005). "Testing, testing ..." How do students use written feedback? *Active Learning in Higher Education, 6*(3), 218–229.

Popham, W. J. (2004). All about accountability: Why assessment illiteracy is professional suicide. *Educational Leadership, 62*(1), 82–83.

Ramaprasad, A. (1983). On the definition of feedback. *Behavioral Science, 28*, 4–13.

Reese, S. (2003). Responding to student compositions. In M. Hickey (Ed.), *Why and how to teach music composition: A new horizon for music education* (pp. 211–232). Reston, VA: MENC: The National Association for Music Education.

Roos, B., & Hamilton, D. (2005). Formative assessment: A cybernetic viewpoint. *Assessment in Education, 12*(1), 7–20.

Ross, M. (1995). What's wrong with school music? *British Journal of Music Education, 15*, 255–62.

Ruddock, E., & Leong, S. (2005). "I am unmusical!": The verdict of self-judgement. *International Journal of Music Education, 23*(1), 9–22.

Sadler, D. R. (1989). Formative assessment and the design of instructional systems. *Instructional Science, 18*, 119–144.

Seddon, F. A. (2002). An interpretation of composition strategies adopted by adolescents with and without prior experience of Formal Instrumental Music Tuition [FIMT] engaging with Computer-Based Composition. In M. Espeland (Ed.), *Focus areas report, Samspel – International Society for Music Education* [ISME]. Bergen, Norway: ISME.

Seddon, F. A., & O'Neill, S. (2001). An evaluation study of computer-based compositions by children with and without prior experience of Formal Instrumental Music Tuition. *Psychology of Music, 29*(1), 4–19.

Sharp, C., & Le Métais, J. (2000). *The arts, creativity and cultural education: An international perspective.* London: Qualifications and Curriculum Authority.

Sheridan, M., & Byrne, C. (2002). Ebb and flow in assessment in music. *British Journal of Music Education, 19*(2), 135–143.

Skolverket: Swedish National Agency for Education (2004). *National evaluation of the compulsory school in 2003.* Stockholm, Sweden: Author.

Sloboda, J. A., Davidson, J. W., & Howe, M. J. A. (2000). Is everyone musical? In P. Murphy (Ed.), *Learners, learning and assessment* (pp. 46–57). London: RoutledgeFalmer.

Small, C. (1999). Musicking: the means of performing and listening: A lecture. *Music Education Research, 1*(1), 1–25.

Spruce, G. (2001). Music assessment and the hegemony of musical heritage. In C. Philpott & C. Plummeridge (Eds.), *Issues in music teaching* (pp. 118–130). London: RoutledgeFalmer.

Stanley, M., Brooker, R., & Gilbert, R. (2002). Examiner perceptions of using criteria in music performance assessment. *Research Studies in Music Education, 18*, 46–56.

Stephens, J. (2003). Imagination in education: Strategies and models in the teaching and assessing of composition. In M. Hickey (Ed.), *Why and how to teach music composition: A new horizon for music education* (pp. 113–138). Reston, VA: MENC: The National Association for Music Education.

Stiggins, R. (1997). *Student-centered classroom assessment* (2nd ed.). Upper Saddle River, NJ: Prentice-Hall.

Taggart, G., Whitby, K., & Sharp, C. (2004). *Curriculum and progression in the arts: An international study.* National Foundation for Educational Research [NFER]/Qualifications and Curriculum Authority [QCA]. Accessed August 22, 2005, http://www.inca.org.uk/pdf/INCA_arts_curriculum_progression.pdf

Tierney, R., & Simon, M. (2004). What's still wrong with rubrics: Focusing on the consistency of performance criteria across scale levels. *Practical Assessment, Research & Evaluation, 9*(2), Retrieved June 6, 2005 from http://PAREonline.net/getvn.asp?v=9&n=2.

Torrance, H. (Ed.). (1995). *Evaluating authentic assessment.* Buckinghamshire, England: Open University Press.

Waldorf, L. A. (2005). Assessment training for teaching artists. *Arts & Learning Research Journal, 21*(1), 63–89.

Webster, P. R. (2003). Asking music students to reflect on their creative work: Encouraging the revision process. *Music Education Research, 5*(3), 243–249.

Webster, P., & Hickey, M. (1995). Rating scales and their use in assessing children's compositions. *The Quarterly Journal of Music Teaching and Learning, VI*(4), 28–44.

Welch, G. F., & Adams, P. (2003). *How is music learning celebrated and developed?* Southwell, Notts, UK: British Educational Research Association.

Woodward, S. (2002). Assessing young children's musical understanding. *Music Education International, 1*, 112–121.

Younker, B. A. (2003). The nature of feedback in a community of composing. In M. Hickey (Ed.), *Why and how to teach music composition: A new horizon for music education* (pp. 233–242). Reston, VA: MENC: The National Association for Music Education.

# INTERNATIONAL COMMENTARY

## 22.1

## Evaluation and Assessment in Music Education in Spain

**José Luis Aróstegui**
*University of Grenada, Spain*

The political setting in curriculum and evaluation can be clearly perceived in the educational system in Spain. The current law governing education was passed in 1990 when the socialist party was in power. At that time, a contextual approach to student assessment was proposed. When the government changed, the conservatives prepared a new law in 2000. This time assessment criteria were based on propositional contents, with less consideration given to the more experiential and aesthetic sides of music. However, the schedule to implement this new law was immediately put on hold as soon as the socialists returned to power in 2004. At present, the Parliament is discussing a new education law and drafts made public so far suggest a more comprehensive view of curriculum and evaluation.

Practitioners' and researchers' practices in assessment have been reported in a number of studies. In kindergarten, for instance, Mosso (1999) suggests a student assessment model based on developmental features and needs, and also based on the role of music in the official curriculum. Espona (2003) reports an empirical study to evaluate students' recorder playing in Secondary Education according to psychomotor functions. Also at this level, Gómez-Pardo (2003) supports an instructional model which encompasses assessment as part of the teaching-learning process. She builds her proposal on Howard Gardner's idea that certain elements should be a high priority as they provide clear evidence of effective learning.

The wider concept of evaluation has also been considered at the national level but the main focus has been on the compulsory curriculum as a whole, with little attention given to evaluating arts education. Perelló (2003) investigates the musical studies at conservatories in the Spanish region of Valencia. The author discusses students' scores achieved and aspects connected to the relationship between workloads for students at conservatories and their corresponding general education level. On the basis of the results of a questionnaire survey, the author reflects on the problems and challenges of music teaching at conservatories.

*L. Bresler (Ed.), International Handbook of Research in Arts Education*, 381–382.

A more systematic approach to evaluation is found in music teacher education. The European Network for Quality Assurance and the Spanish Ministry of Education have been promoting the evaluation of every university degree since 1995. Prieto (2002) summarizes the evaluation process of the music teacher education degree at the University of Alicante in the Valencia region. A similar evaluation study by Aróstegui (2004) at the University of Granada in the South East of Spain is an illustration of the new standards in evaluation at higher education, discussing critical issues in contemporary institutional evaluation, such as the promotion of participation, and the concept of quality focused on efficiency.

Philosophical arguments about evaluation in music education are also found. Prieto (2001) reflects on conditions of evaluation in education, suggesting directions for evaluating music education. Finally, Aróstegui (2003) discusses the epistemological nature of musical knowledge as a determinant of what we actually measure in music education.

# References

Aróstegui, J. L. (2003). On the nature of knowledge: What we want and what we get with measurement in music education. *International Journal of Music Education, 40*, 100–115.

Aróstegui, J. L. (2004). Uncovering contradictions in evaluation: The case of the music education programme at the University of Granada. *The Quality of Higher Education, 1*, 138–157.

Espona, I. (2003). *Avaluació dels aprenentatges en flauta de bec* [Assessment of student learning in recorder playing]. Barcelona: Generalitat de Catalunya. Departament d'Ensenyament.

Gómez-Pardo, M. E. (2003). Evaluar el desarrollo musical en Secundaria [Assessing musical development in Secondary Education]. *Música y Educación, XVI* (1), n. 53, 35–43.

Mosso, M. M. (1999). *El aprendizaje musical infantil y su evaluación en el nivel inicial* [Children's musical learning and its assessment in kindergarten]. Salamanca: Universidad deSalamanca.

Perelló, V. (2003). *Los estudios musicales en la nueva ordenación del sistema educativo: su aplicación en la comunidad valenciana* [Musical studies in the new educational system and its implementation in the Valencia region]. Unpublished doctoral thesis. *Autónoma* University of Madrid.

Prieto, R. (2001). La evaluación de las actividades musicales [The evaluation of musical activities]. *Contextos Educativos, 4*, 329–340.

Prieto, R. (2002). Investigación evaluativa del currículum de maestro especialista en música para primaria [Evaluative research of the primary music teacher education degree]. *Revista de Enseñanza Universitaria, 20*, 137–148.

# INTERNATIONAL COMMENTARY

# 22.2

# Music Assessment in Taiwan: Educational Practices and Empirical Studies

**Sheau-Yuh Lin**
*Taipei Municipal University of Education, Republic of China (Taiwan)*

Music assessment in formal education has always been the responsibility of music teachers in Taiwan. For many years, music teachers had assessed students in music theory, singing, and recorder playing through paper-pencil tests and performance assessments. However, the implementation of Grade 1–9 Curriculum of the Arts and Humanities learning area made students' work sheets replace paper-pencil tests while performance assessment has remained the same (Lai, 2005).

The Ministry of Education (MOE) has mainly played the role of providing national standards or guidelines for implementation. The 1993 Music Curriculum Standards for primary schools (MOE) and the 1994 Standards for middle schools (MOE), for instance, specified the assessment percentages of cognitive, psychomotor and affective domains of music learning respectively. The concept of assessment is expanded in the Grade 1–9 Curriculum Guidelines of the Arts and Humanities learning area (MOE, 2003). In this document it is recommended that assessment includes – besides students' learning outcomes – the evaluation of the quality of instruction and curriculum design. In addition, approaches to assessment have been broadened to embrace multiple ways including peer review, self-assessment, interviews, rating scales, checklists, etc.

Researchers' practices in music assessment are mainly geared towards three directions: classroom-based assessment, formal testing and examination, and alternative approaches to assessment. Classroom-based assessments use mostly self-developed instruments and are to be widely found in research studies, despite their differences in emphasis on either qualitative or quantitative data, on either conventional paper-pencil tests or alternative assessment approaches, or on either the cognitive, affective or psychomotor aspect.

Music researchers have utilized formal testing and examinations to develop measures for aptitude and achievement. Chen (2002) designed a computer-based online music aptitude test for primary students; Chang (2001) tested fifth-grade students for creative thinking music ability. Achievement tests were developed for comprehensive cognitive learning outcomes testing (Chang, 2002; Ho, 2004), and for specific music

*L. Bresler (Ed.), International Handbook of Research in Arts Education, 383–386.*
© 2007 *Springer.*

element identification or recognition including melodic-aural ability (Li, 2003), rhythm perception (Cheng, 2003), two-part music identification (Huang, 2004), and mode melody recognition (Shiu, 2004). Several issues implied from these studies are noteworthy. These efforts were undertaken mostly for masters theses in music education related departments as well as in departments of educational testing or psychology orientations. For music researchers, the challenge of using assessment concepts and statistical analysis is evident. Factors such as cultural background, home environment, music learning experience, gender, age level, or participation in musically talented programs were examined in some studies. The complexity of music achievements thus cannot be ignored. World renowned measures including Gordon's *Musical Aptitude Profile* (Cheng, 2003) and Webster's *Measure of Creative Thinking in Music* (Chang, 2001) were translated or transformed for test formulation. Gordon's *Intermediate Measures of Music Audiation* was utilized for examining correlation (Chang, 2002). The need and lack of standardized music assessment measures seems to be an undeniable phenomenon.

In contrast to formal testing and examinations, research practices in alternative approaches to music assessment were conducted mostly, at least up to this time, through efforts of university professors. Through case study, Chuang (2005) described a music teacher's experience of using a teaching portfolio to enhance her own reflection and teaching. The participant teacher reported that the use of the teaching portfolio enhanced her reflective thinking and improved her teaching effectiveness. Hsieh (2001, 2002) organized a team of music teachers to be engaged in a research project for developing fourth-grade music learning assessment measures. Exemplification materials were designed for a wide variety of music behavior including singing, recorder-performing, music appreciation, improvisation and composition, and music reading. The contextual consideration and the language of feedback in music assessment were particularly addressed. Lai (2005) studied assessment approaches used by junior high school music teachers to investigate how these teachers assessed in response to the implementation of the Grade 1–9 curriculum. Recommendations of this study included the need to improve the structure of worksheets, to improve performance assessment and to establish music class portfolios. Finally, Lin (2005) developed assessment tools for the implementation of the Arts PROPEL curriculum model in music composition instruction (Lin, 2005). Results of this study indicate the advantages of using alternative assessment approaches to music composition.

# References

Chang, C.-P. (2001). *Er tong yin yue chuang zao si kao ce yan bian zhi yan jiu* [The development of the Measure of Creative Thinking in Music for elementary school children]. Unpublished master's thesis, National Taichung Teachers College, Taichung, Taiwan.

Chang, H.-W. (2002). *Guo xiao si nian ji yin yue ping liang bian zhi* [*A primary music test for fourth grader*]. Unpublished master's thesis, National Pingtung Teachers College, Pingtung, Taiwan.

Chen, Y.-T. (2002). *Guo xiao xue tong yin yue xing xiang ce yan bian zhi yan jiu* [Development of music aptitude tests for primary school students]. Unpublished master's thesis, National Taichung Teachers College, Taichung, Taiwan.

Cheng, S.-Y. (2003). *Guo xiao si dao liu nian ji jie zou ting yin neng li ji xiang guan yin shu zhi yan jiu* [A study of the relationship between the rhythm perception of fourth to sixth grades Taiwanese children and their home environment and music experience]. Unpublished master's thesis, National Taipei Teachers College, Taipei, Taiwan.

Chuang, M.-J. (2005). Yun yong jiao xue dang an jia qiang hua yin yue jiao shi xing shi zhi ge an yan jiu [The use of a teaching portfolio in enhancing a music teacher's reflective thinking: A case study]. *Research in Arts Education, 9*, 71–94.

Ho, Y.-C. (2004). *Guo zhong yin yue yue li cheng jiu ce yan zhi fa zhan* [The development of a music achievement test for junior high school students]. Unpublished master's thesis, National Taiwan University of Science and Technology, Taipei, Taiwan.

Hsieh, Y.-M. (2001). *Guo xiao si nian ji yin yue xue xi dang an ping liang gong ju zhi fa zhan yan jiu* [Investigation of the development of fourth-grade music learning portfolio assessment measures I]. (NSC 89-2411-H-024-008)

Hsieh, Y.-M. (2002). *Guo xiao si nian ji yin yue xue xi dang an ping liang gong ju zhi fa zhan yan jiu* [Investigation of the development of fourth-grade music learning portfolio assessment measures II]. (NSC 90-2411-H-024-002)

Huang, I.-C. (2004). *Guo xiao wu nian ji xue sheng ting bian er sheng bu qu diao neng li zhi yan jiu* [Two-part music identification abilities of fifth grade students]. Unpublished master's thesis, National Taipei Teachers College, Taipei, Taiwan.

Lai, M.-L. (2005). Assessment approaches used by Taiwanese music teachers in junior high schools. In C. H. Chen & K. C. Liang (Eds.), *Proceedings of 2005 International Symposium on Empirical Aesthetics: Culture, Arts and Education* (pp. 151–158). Taipei: National Taiwan Normal University.

Li, C.-Y. (2003). *Guo xiao si nian ji er tong qu diao ting yin neng li zhi diao cha yan jiu* [The survey study on melodic-aural ability of fourth-grade children in the elementary school]. Unpublished master's thesis, National Taipei Teachers College, Taipei, Taiwan.

Lin, S.-Y. (2005). *Yin yue chuang zao li zhi shi zheng: Yi Mai Xiang Yi Shu ke cheng fang an yun yong yu guo xiao yin yue chuang zuo jiao xue* [An empirical study of music creativity: The implementation of arts PROPEL program in elementary school music composition instruction]. (NSC 93-2411-H-133-002).

Ministry of Education (1993). *Guo min xiao xue ke cheng biao zhun* [Elementary school curriculum standards]. Taipei: Author.

Ministry of Education (1994). *Guo min zhong xue ke cheng biao zhun* [Junior high school curriculum standards]. Taipei: Author.

Ministry of Education (2003). *Guo min zhong xiao xue jiu nian yi guan ke cheng gang yao yi shu yu ren wen xue xi ling yu* [Grade 1–9 curriculum guidelines arts and humanities learning area]. Taipei: Author.

Shiu, J.-L. (2004). *Zhong bu di qu guo min xiao xue xue sheng diao shi xuan luu bian ren zhi yan jiu* [An investigation of mode melody recognition of elementary students in central Taiwan]. Unpublished master's thesis, National Taipei Teachers College, Taipei, Taiwan.

# INTERNATIONAL COMMENTARY

## 22.3

# Program Assessment in Turkish Music Education

**H. Seval Köse**
*Suleyman Demirel University, Turkey*

Music education studies date back to very old times in Turkey. However, it is only recently that the training activities have been planned and the related programs have been subject to assessment. The first program assessment activities include the theses completed by Süer (1980), Uçan (1982), Özdemir (1983), and Bilen (1983).

Ertürk divides the program assessment activities into six main categories (i) assessment via program planning; (ii) assessment via environment; (iii) assessment via success; (iv) assessment via learning process; (v) assessment via product; and (vi) assessment via accessibility (Ertürk, 1993, pp. 114–115).

The major characteristics of the general and specific training fields are seen as significant criteria in order to specify the most sufficient and reliable program assessment activities which aim at successful program planning. The studies conducted in Turkey usually include stating the problem, determining the subjects, and analyzing and interpreting the data obtained through research techniques and data collection instruments.

The first program assessment for music education was accomplished in Bolu and İstanbul Experimental Primary Schools. The postgraduate studies on program assessment for music education began in the 1970s. These studies provided considerable knowledge and experience with respect to program assessment, and the first assessment reports were delivered in 1980. Ankara University and Hacettepe University led pioneering activities by providing the field with postgraduate studies on training programs and education as well as program planning for education.

The School of Music at Gazi Institute of Education has run postgraduate courses on program assessment since 1974. Furthermore, in 1979, the same school added this course to the draft program prepared for master and PhD studies. In 1983, a restructuring plan which was carried out for academic training, education, research, practice and publications required the transfer of music education to the university curriculum. "Program Planning in Music Education" was established – for the first time – as a valid course in Master of Music Education at Gazi University (Gazi University, Faculty of Science, 1983–1984).

*L. Bresler (Ed.), International Handbook of Research in Arts Education, 387–388.*
© 2007 *Springer.*

# References

Bilen, I. (1983). *The course "methods for music teaching" given in music teacher education institutions, and evaluation of this course in the scope of program development*. Unpublished Master thesis, Ankara University Faculty of Education Sciences, Ankara (in Turkish).

Ertürk, S. (1993). *Program development in education* (7th ed.). Ankara: Meteksan A. S. (in Turkish).

Gazi Institute of Education, music department (1979). Graduate and undergraduate education programs in music education (in Turkish).

Özdemir, S. (1983). *Comparison of a course based on singing with a course enhanced with instrument based on singing*. Gazi University Faculty of Education Department of Music Education, Ankara (in Turkish).

Süer, R. (1972). *Teaching in music teacher education institutions*. Uunpublished doctorate thesis. Ankara University Faculty of Education, Ankara (in Turkish).

Uçan, A. (1982). 1st year program assessment of Gazi School of Education Music department. Hacettepe Üniversitesi Doktora Tezi, Ankara (in Turkish).

# INTERLUDE

## 23

# REFLECTIONS ON A LINE FROM DEWEY

**Chris Higgins**
*University of Illinois at Urbana-Champaign, U.S.A.*

## The Madness in Our Methods

In the overheated debates over which method is best for evaluating educational programs we tend to ignore a more basic question: what is a method and what is it good for? A humble response, though I think an accurate one, is that methods are simply tried and true procedures for eliminating common errors associated with a given form of inquiry. This leaves us with an even more basic question: if methods only help us avoid error and misunderstanding, what is it that leads us toward truth and understanding?[1] For example, it is not hard to imagine a pair of quantitative studies, both with very small $p$ values, but only one with genuine significance; or two ethnographies, both based on countless hours in the field, but only one revealing something we hadn't already noticed with casual observation; or two theoretical essays, both containing the same number of references to the latest name worth dropping, but only one mining the text deeply enough to extract a living idea that can enlarge our understanding. What is it that enables some researchers to find that place Robert Stake (1997) calls "sweet water"? What gives some studies the power described by Jackson (1990), following Cronbach and Suppes, "to affect the prevailing view"?

If Tom Barone and Elliot Eisner (1997, p. 93) are right, the answer lies not in methodological acumen but in a quality in the scholar herself:

> If a scholar's initial perceptions lack insight, technical skills and even refined sensibilities are likely to lead to little more than superficial productions, though at times glittering ones. [Insightful research] … is fed by what is called perceptivity: seeing what most people miss. We need to find out the extent to which perceptivity can be developed.

In a moment, I want to turn to this specific notion of perceptivity, but first we should simply take note of what a fundamental challenge this general approach represents to

*L. Bresler (Ed.), International Handbook of Research in Arts Education, 389–394.*
© 2007 *Springer.*

the standard view of the education of researchers. It suggests that learning to become an evaluator and researcher amounts to a process of self-cultivation. This contrasts sharply with what we might call the black box model of research: method plus theoretical approach plus data equals study. Research and evaluation students are all too eager to acquire such glittering tools as multivariate regression, triangulation of data, and post-structuralist critique, and we are not wrong to want to share them. But this talk of acquiring the tools to do the job seems to me to be seriously misleading.[2] After all, posing an interesting question or defining the problem is the most difficult part of the job, and this requires not tools but an educated mind. Ironically, we professors of education are more confident about training students in methods than about educating future researchers to be cogent, imaginative, and perspicacious. What might education in research look like, I wonder, if we were to take as our goal not the well-equipped technician but what William Arrowsmith (1971) calls "ripeness of self" (p. 12) or "active mind at the top of its bent, flexible intelligence, [and] a positive appetite for complexity and sympathy" (p. 14)?

In this interlude, I join Barone and Eisner's call to explore the nature of perceptiveness and consider how we can cultivate this ability to notice what most people miss. To do so, I spend some time thinking through a single line from John Dewey's (1934, p. 52) *Art as Experience*: "Recognition is perception arrested before it has the chance to develop freely." My purpose is twofold. First, I want to help make the case that good research, evaluative or otherwise, begins and ends with imaginative perception, with what Dewey (p. 52) calls "seeing what is there."[3] Those of us interested in aesthetic approaches to research will immediately recognize this idea.[4] The challenge for us – and this brings me to my second purpose – is to *perceive* it. Too often we are hurried into thin descriptions of the need for thick description, rushed into unimaginative defenses of the imagination. Thus, I will attempt not only to gloss Dewey's argument but also to embody and extend it through a series examples drawn from the arts. In effect, the goal is to prolong our own perception of perceptiveness, to realize Dewey's idea in a medium.

## Seeing As and Seeing More

Dewey's *Art as Experience* is packed with understated insights, the kind of ideas that make a modest first impression only to stay with you and change everything. A perfect example is his contrast between "bare recognition" and "full perception." What does he mean when he defines recognition as arrested perception? In a nutshell, he is saying that categories are shortcuts. We scan a room, recognizing table and chairs, fruit bowl and coffee cups. As soon as we have safely located each object in a known group of objects, it ceases to occupy our attention. As Dewey (p. 53) puts it, "bare recognition is satisfied when a proper tag or label is attached." In moments of recognition, our seeing stops short and we lose our chance to experience the uniqueness and complexity, the "thingi-ness" and "thereness" of the object. In seeing as, we fail to see more. To bring out the stakes of this idea Dewey (p. 52) offers the example of recognizing a person:

> In recognition, there is the beginning of an act of perception. But this beginning is not allowed to serve the development of perception of the thing recognized. It

is arrested at the point where it will serve some *other* purpose, as we recognize a man on the street in order to greet or to avoid him, not so as to see him for the sake of seeing what is there.

Dewey offers us a picture of ourselves that is as true as it is unflattering. We rush through each present moment with blinkers on, grabbing things by their most familiar and convenient handles. Everything we encounter becomes something to be used, something already known.

At this point a skeptical voice interrupts:

A life without purpose and recognition would be impossible. Maybe you aesthetes have time to stand around staring at people on the street, but I'm trying to get somewhere. Without recognition, you wouldn't even be able to find your way to the museum!

Let us concede some points to the skeptic who represents, after all, the voice of practicality in each of us. A life of pure perception would be intolerable for any duration. As the skeptic points out, categories are crucial for navigating the world. Furthermore, without recognition, which helps us ease certain phenomena into the background, it is not clear that we would be able to foreground and carefully perceive any object. If we allowed all phenomena equal claim to our attention, we would confront only chaos.

Having said this, we must insist that the skeptic's worry is somewhat academic compared with the problem diagnosed by Dewey. We are much more likely to stop short of perception than we are to get lost in it. According to Maxine Greene – the thinker who has done the most to reveal the existential import of Dewey's aesthetics – the human condition is characterized by numbness and somnolence.[5] We stumble through life like sleepwalkers, struggling to achieve moments of "wide-awakeness." Our categories (by which we recognize single objects) and habits (by which we organize whole sequences of recognition into repertoires of automatic action) insulate us all too fully from the thorny, the surprising, the complex. In other words, recognition is not simply a problem for the aesthete who wants to luxuriate in some "enrichment experience." Recognition threatens experience itself. "Experience, insofar as it is experience," Dewey (p. 19) writes, "is heightened vitality." For Socrates, famously, the unexamined life is not worth living; for Dewey, it is the unexperienced life which is not worth living, the unperceived world which is not worth inhabiting. "Even a dog," Dewey (p. 53) writes, "that barks and wags his tail joyously on seeing his master return is more fully alive in his reception of his friend than is a human being who is content with mere recognition."

## Artistic Strategies for Cultivating Perception

Let us now heed the advice of the skeptic and find our way to the museum. While it is central to Dewey's (p. 5) project to knock art off its "remote pedestal" and reroot aesthetics in everyday life, he too recognized the special power of art to provoke perception. "Art," he writes (104), "throws off the covers that hide the expressiveness of experienced

things." Art invites us to see more and different works of art issue this invitation in different ways. By looking at some examples from painting we can identify two major strategies at work, each with its own variations.

The first strategy involves prolonging perception through exploration of a medium. Recall our earlier example of recognizing the objects in an ordinary room. Now consider what happens when we encounter a table and chairs in a Van Gogh, or a fruit bowl in Cezanne, or (my most recent discovery) a coffee cup in Fantin Latour. We still recognize each object. And yet, such artworks somehow simultaneously remind us that there is more to see, more to seeing than seeing as. It is as if spending some time with such a painting helps restore the balance between the brain and the eyes. This effect cannot be generated simply by the obvious simulacral quality of the works. The pictures of the man and woman on public bathroom doors also call attention to their own construct-edness, but we hope that they do not cause us to linger in perception. How do paintings coax us toward perception?

The answer is less obvious than it sounds: it is because painters realize their objects in paint. Paint has its own properties, such as thickness, slickness, creaminess, and crustiness. It has its own history, defined by the sequence of notable attempts to explore these properties and to frame and reframe visual problems. Paint is its own world, and it is in this world that Van Gogh builds his chairs, that Cezanne grows his apples, that Fantin-Latour molds his coffee cup. When we behold their paintings, the objects do yield to our seeing as, but not completely or easily. The paint pushes back against us, just as it did to the artists. We see a table, but we also see color, shape, line, brightness, reflectiveness, overlap, and next-to-ness. Paradoxically, this difficulty in grasping the objects leads to a fuller, less alienated connection with them in the end. After spending time with these paintings, we remember what it is like to sit around a small table; we feel what it is to have one's weight supported by a chair; we sense the way an apple fills out its orb; and, we behold how the hollow of a coffee cup lies ready to receive its coffee.

It is important to note that the contrast here is between schematic visual recognition and full visual experience, not between words and some essentially nonlinguistic reality. In fact, we can just as easily locate the tension between recognition and perception within the life of language. It is the special province of poetry to help us perceive words themselves and the experiences they embody instead of simply decoding them. Just as the painted apple gave us back aspects of the real apple, so the poetic word reconnects us with the way words actually bear meaning. In the medium of words, meanings have tone, rhythm, weight, voice, texture, memory – since words are haunted by past uses – and neighbors – since words are interconnected by vast networks of criss-crossing connotations.

Now let us turn to the second strategy. Rather than aiming to prolong perception, some works of art aim to interrupt the recognition. Instead of inviting us to see more about apples, for example, the second strategy pushes us to see more about seeing as. Consider, for example, René Magritte's playful labeling. A picture of a clock is labeled "The Wind", a pipe is declared not to be one, and in my favorite example a picture of a sponge is labeled "the sponge". Magritte's true subject would seem to be neither clocks, pipes, nor sponges but our own drive toward recognition.

Marcel Duchamp goes one step further. By placing ordinary objects such as a toilet and a snow shovel in the museum setting, he asks us to consider what it means to see something *as art*. Art institutions may be designed to help us suspend the practical attitude and take up a perceptive stance, but as we have all experienced, museums and galleries present their own obstacles to aesthetic experience. Instead of fully perceiving the work, we may stop short as we recognize a "masterpiece," "a Duchamp," "a found object," "an example of the early period," and so on.

My favorite example of the second strategy may be Andy Warhol's "Do It Yourself" series. In one of these pieces, Warhol replicates a kitschy sailboat scene from a paint-by-numbers set, filling in some of the many colored fields. What Warhol seems to be doing is inviting us to finish the picture, offering us in the process a hilarious glimpse at our own tendency to schematize and romanticize, to set up cardboard versions of things in front of the things themselves.

## Coda

What do painters and poets, sailboats and snow shovels, have to do with educational evaluation? The seeming disjunction between the two stems from our received ideas about art and research. Research is objective; art is subjective. Research discovers; imagination invents. And yet as we have just seen, even in these brief examples, the arts themselves constitute forms of inquiry into the world. Artists teach us how to see more, how to notice what most people miss. And like the best artists, the best researchers use their imagination to move past the cardboard versions of things. The question for educational evaluation is not which method to choose or how to employ it, but how to notice the aspects of schools hidden by our stereotypes of schools, the qualities of teachers and learners obscured by our cynicism or sentimentalism, the dimensions of classrooms that are hiding in plain view. The challenge for all of us is to become researchers who are able to laugh with Warhol at our tendency to paint by numbers; who are able, like Stevens, to reconnect our concepts with felt experience; who are able to give educational phenomena the same loving attention as Cezanne gives his apples.

## Acknowledgements

Thanks to: the Oaxaca Montessori Congress for providing the occasion for this paper in its original form; Olga Hubard for her support of this project and her own example in leading young people to see more; Audra DiPadova and the Office of Student Life at Teachers College for the invitation to present a version of this paper; the Spencer Foundation which funded the Ways of Knowing project at Teachers College, providing valuable opportunities to discuss doctoral education and the aesthetics of research; Audrey Bryan, Rachel Ciporen, and Laura DeSisto for their collaboration around issues of personhood and perspective in research and their enthusiasm for my "Bildung spiel"; René Arcilla, Ben Blair, Darryl DeMarzio, and Eli Moore for providing feedback on

drafts of this paper; Jennifer Burns for art historical advice, editorial help, and moral support; Liora Bresler whose interest in and support of my work could not have come at a more valuable time; and, the sombrero-wearing Maxine Greene in whose classes I first discovered how the "dreary science" of aesthetics might come alive.

## Notes

1. For what remains the definitive exploration of this question, see Gadamer (1993, [1960]).
2. In one of the great ironies of publishing, the stirring conclusion of Phillip Jackson's (1990, p. 9). AERA presidential address republished in *Educational Researcher* – in which Jackson tries to move the debate beyond issues of method to include questions of personal vision and voice – shares the page with a large advertisement for the "Methodologist's Toolchest."
3. In another work, in progress, I defend the link between imagination and a complex realism. Imagination, I argue, should not be understood as escape from the real to an as-if world, but precisely as that which increases our contact with the real. Here reality is seen not as a world of brute facts, but one of infinite aspects. Greater imagination in the major modes of relating self and world – thinking, feeling, and perceiving – allows wider access to the world in its complexity.
4. The major figure here is Elliot Eisner. See, for example, Eisner (1997). Cf. Philip Jackson (1990, pp. 7–8); Maxine Greene (1990; pp. 191, 199) and, David Tyack (1997). On Dewey's recognition/perception distinction in particular, see, for example Eisner (2002, p. 5) and Jackson (1998, p. 57).
5. This theme runs throughout her work; see, for example, Maxine Greene (1978).

## References

Arrowsmith, W. (1971). Teaching and the liberal arts: Notes toward an old frontier. In D. Bigelow (Ed.), *The liberal arts and teacher education: A confrontation* (pp. 5–15). Lincoln: University of Nebraska Press.

Barone, T., & Eisner, E. (1997). Arts based educational research. In R. M. Jaeger (Ed.), *Complementary methods for research in education* (2nd ed.). (pp. 73–94). Washington, DC: American Educational Research Association.

Dewey, J. (1934). *Art as experience*. New York: Perigree/Putnam.

Eisner, E. (1997). *The enlightened eye: Qualitative inquiry and the enhancement of educational practice* (2nd ed.). New York: Merrill Publishing Company.

Eisner, E. (2002). *The arts and the creation of the mind*. New Haven: Yale University Press.

Gadamer, H. G. (1993 [1960]). *Truth and method* (J. Weinsheimer & D. G. Marshall, Trans.) (2nd rev. ed.). New York: Continuum.

Greene, M. (1978). Wide-awakeness and the moral life. In M. Greene (Ed.), *Landscapes of learning* (pp. 42–52). New York: Teachers College Press.

Greene, M. (1990). A philosopher looks at qualitative research. In R. M. Jaeger (Ed.), *Complementary methods for research in education* (2nd ed.) (pp. 189–206). Washington, DC: American Educational Research Association.

Jackson, P. W. (1990). The functions of educational research. *Educational Researcher*, *19*(7), 3–9.

Jackson, P. W. (1998). *John Dewey and the lessons of art*. New Haven: Yale University Press.

Stake, R. E. (1997). Case study methods in educational research: Seeking sweet water. In R. M. Jaeger (Ed.), *Complementary methods for research in education* (2nd ed.) (pp. 401–414). Washington, DC: American Educational Research Association.

Tyack, D. B. (1997). Ways of seeing: An essay on the history of compulsory schooling. In R. M. Jaeger (Ed.), *Complementary methods for research in education* (2nd ed.) (pp. 35–69). Washington, DC: American Educational Research Association.

# 24

# ASSESSING ENGLISH WITHIN THE ARTS

**Kathy Hall, Jonathan Rix, and Ian Eyres**
*Open University, U.K.*

## Introduction

Taking English as a curriculum area (a) within the arts and (b) as multimodal, this chapter explores the literature on assessing achievement in English language arts in the primary and secondary phases of education. Our overarching aim is to synthesize relevant research literature in a way that will offer insights about culturally responsive assessment. A key question for us is: what are the issues in offering a valid account of achievement in English in the classroom? By locating English within the arts (Abbs, 1982) and by recognizing its multimodality (Cope & Kalantzis, 2000), key themes are identified which the chapter explores with reference to contemporary research on assessment, learning and purposes of English teaching.

The chapter is in two main parts. The first part describes English as a curriculum subject that fits within the arts. It links this theoretical work with a sociocultural perspective that defines English broadly, taking account of the contemporary period when "multimodality is salient" (Street, 2004, p. 327). In reviewing some of the studies of classroom assessment in English in the context of this broad definition of the subject, the second part of the chapter identifies significant, interrelated, but unresolved issues. One of these is the tension between the international trend towards specifying *the* standards and success criteria against which student work must be judged and the need for less determinacy in aesthetic pursuits. Another is the role of project and group assessments. The chapter identifies several lines of enquiry for further research.

## English Within the Arts and as Multimodal

Given the nature of this international volume, it is important at the outset to justify our location of English within the arts and to do this with reference to contemporary learning theory. While others have in the past made the case for English as an aesthetic discipline,

*L. Bresler (Ed.), International Handbook of Research in Arts Education, 395–408.*
© 2007 *Springer.*

they have not drawn explicitly or intentionally on sociocultural learning perspectives in so doing, nor have they embraced multimodal texts, assuming print texts only. Since our review of assessment approaches within the English classroom is informed by a sociocultural view of learning, it behoves us at the outset to align what constitutes English with this same perspective.

A quarter of a century ago Peter Abbs (1982, p. 24) put forward the notion of English as an expressive discipline and he assumed that there is an innate need in each personality "to shape, to articulate, to make and symbolize in the quest for existential understanding and fulfilment." He and others at the time (e.g., Harrison, 1983; Holbrook, 1979) viewed English as a discipline of existential meanings and a means of existential expression for being and for potentiality for being. Reacting against what they saw in England as (a) an exclusive emphasis on self-expression in the progressive school; on (b) an exclusive emphasis on historical study of texts in the Cambridge school; and on (c) the narrow conception of English/language of the sociolinguistic school, they emphasized the development of the creative, imaginative and experiential capacities of the student. In America, theorists like Maxine Greene (see Greene, 1994, 1995, 1997; Pinar, 1998) and Louise Rosenblatt (1991, 1994, 1995) argued along similar lines, although with some differences in emphasis. They all highlighted the expressive dimension of English and its capacity to foster what they saw as the neglected emotional and imaginative energies of students, attending especially to literature and poetry. For instance Greene invited English teachers to align themselves with their students' existential quests to understand and construct a meaningful life. The study of imaginative literature and the creation of expressive objects alongside others, "also in quest" (Greene, 1994, p. 218) was seen as assisting students in constructing a life full of meaning. Literary theorists, especially reader response theorists (Benton, 1983; Langer, 1995; Rosenblatt, 1994) gave as much authority to the reader as to either the text or the author. Louise Rosenblatt (1991) for instance argued that the opportunity for evocation, for the lived-through experience that narrative fiction and poetry offer is possible only when a predominantly aesthetic (as opposed to efferent) stance is taken. Such a stance allows learners to "savor the images, the sounds, the smells, the actions, the associations, and the feelings that the words point to" (Rosenblatt, 1991, p. 447). These writers shared the notion that the intellectual or cognitive dimension was overvalued in education to the detriment of the affective and aesthetic. Reader response theorists argued that without the opportunity for an aesthetic experience, learners are less likely to use literature to contemplate themselves and others. Their influence on practice was considerable especially in the United States and the United Kingdom (Galda & Liang, 2005; McMahon, Raphael, Goatley, & Pardo, 1997; Pearson & Hamm, 2005) indicated by such practices as dramatizing, illustrating, creative writing, and writing in dialogue journals (e.g., Roser & Martinez, 1995).

The propositions of the above theorists about art and the art-making process are in tune with a sociocultural take on learning in general and on English language arts learning in particular, although they did not make such connections in their writings. While Abbs, for instance, contends that the symbolic form (e.g., the poem, novel, sculpture, dance) makes objective to a public world what was previously the individual's subjective impulse, he also suggests that the process of making and evaluating

happens in a social and cultural context of existing, shared practices and traditions. He writes: "The art grows out of the culture as well as out of the deep impulses of self ..." (p. 46). In addition, he suggests (Abbs, 1982, p. 38) that:

> the activity of making and responding to what is made do not take place in a vacuum. The art-maker lives in a culture, within a heritage ... he cannot escape the meanings which surround him ... Even if he is reacting against, he is learning from his culture. He needs these meanings in order to make his meaning. His audience too live in the same culture, within a comparable net of shared assumptions, associations, expectations. It is through this common cultural background that the new work of art in the foreground of consciousness can develop in the artist and be recognized, at least to some degree, by the audience gathered to respond to it.

A similar point is expressed by more recent literacy theorists in relation to "multiliteracies", although these theorists, unsurprisingly, are much more explicitly indebted to sociocultural learning perspectives. Using the notion of "Design" (Cope & Kalantzis, 2000, p. 7) it is suggested that humans are "both inheritors of patterns and conventions of meaning while at the same time active designers of meaning." This idea also recognizes that different available patterns ("Available Designs") of meaning are located in different cultural contexts. The notion of "Design" itself (New London Group, 1996) stems from two sources: the need to extend the scope of literacy to account for the cultural and linguistic diversity in globalized societies and the need for literacy pedagogy to take account of the diversity of text forms or modes of meaning. The latter would span linguistic, visual, audio, gestural, spatial modes and the interconnections among these modes referred to as multimodal. The idea of Design emphasizes the relationships between received modes of meaning ("Available Designs"), the transformation of these modes of meaning in their intertextual use ("Designing") and their new "Redesigned" status. Reviews of the field of English language arts (Flood, Heath, & Lapp, 1997; Flood, Lapp, Squire, & Jensen, 2003) conclude that society now requires students to engage in the meaning-making process using increasingly sophisticated and layered combinations of symbolic forms that use video, audio, and print representations. Alphabetic or print literacy is just one of the many competencies of representation needed for success as individuals routinely move between these various literacy modes – listening, speaking, reading, writing, viewing and producing symbolic forms to share meanings. In this regard, the elevation of one form of literacy (specifically print literacy) over others suggests "an irrational loyalty to reading and writing" (Flood et al., 1997, p. xvi).

While this particular (print-oriented) definition of literacy is increasingly giving way to more expanded conceptualisations in policy and school practices (e.g., see QCA, 2004), researchers from across the English-speaking world, lament the misalignment of and/or slow take-up by national and school policies and practices of developments in literacy theory and literacy practices outside school (see Hall, 2004; Kenner & Kress, 2003; Lankshear & Knobel, 2003; Luke & Luke, 2001). The reality is that national policies on English curricula and assessments tend to prioritize traditional,

print literacy and tend to marginalize or neglect the broader, richer definition of the subject endorsed by the research community. Any overview of the field of English language arts learning cannot avoid engagement with what has become known as the new literacy studies, given the burgeoning of the literature (Barton, Hamilton, & Ivanic, 2000; Flood et al., 1997, 2003; Kress, 2003). While more detailed attention to the philosophies underlying multiliteracies and multimodal approaches is outside the scope of this chapter, we will return to some of the assessment implications soon.

The various descriptions and accounts of the processes of designing, making and creating, in all the above sources, connect well with a sociocultural stance on learning. This connection can be illustrated with reference to Jerome Bruner's cultural psychology. Bruner makes the important point that while nothing is culture-free, neither are individuals merely reflections of their culture (Bruner, 1996, pp. 13–14). He suggests that the interactions between the individual and the culture give rise to human thought having a "communal cast" on the one hand and on the other hand to human thought having an "unpredictable richness". This gives rise to subjectivity or one's personal take on a situation which in turn gives rise to the need to negotiate, share and communicate meanings to others in our community. The human gift of coming to know the minds of others, he termed intersubjectivity, and language, he argues, is the primary symbol system that allows us to shape and share meaning. That learning is inherently social is inescapable in Brunerian learning theory. This notion of learning is reinforced and developed by other theorists of socially situated cognition (e.g., Lave, 1996; Lave & Wenger, 1991). The salient feature of learning for these theorists is that learning involves a change, not just in one's practice, but in one's identity. Lave (1996, p. 157), for instance, suggests that "crafting identities in practice becomes the fundamental project" and that more important than particular tools and techniques, are "ways of becoming a participant, ways of participating, and ways in which participants and practices change." English as a curricular area within the arts and as multimodal offers new ways of participating and crafting identities.

How does assessment align with the expanded, multimodal conceptualisation of English, as a subject within the arts? What are the issues involved in offering accounts of English language arts learning? In the next part of this chapter we review some of the major assessment trends and their implications for the development of English language arts.

## Assessing English Language Arts

Few aspects of education have received more attention than assessment in recent times and our understanding of assessments designed to support learning and offer more fine-grained information about learners across the curriculum has developed apace over the past two decades (e.g., Black, Harrison, Lee, Marshall, & Wiliam, 2003; Black & Wiliam, 1998). In line with sociocultural learning theory, "authentic" ways of assessing English language arts have been developed ranging from portfolio assessment (e.g., Brady, 2001; Underwood, 1999; Valencia, 1998) to small group tasks and projects (e.g., Calfee & Miller, 2005; Flockton & Crooks, 1996) and from nonprint

narrative comprehension assessment (Paris & Paris, 2003) to assessments of multimodal literacies (e.g., Newfield, Andrew, Stein, & Maungedzo, 2003). These newer, performance assessments recognize that learners construct their own meanings and that evidence of learning needs to be sought from a variety of sources and contexts (Hall, 2003a; Hall & Burke, 2003). Process as well as product is assessed (e.g., Fehring, 2003; Wyatt-Smith & Castleton, 2005) and attention has to be paid to social and cultural contexts (e.g., Ivinson & Murphy, 2003).

The complexity of the field of assessment together with the complexity of literacy itself is further complicated when considered alongside the various and potentially conflicting purposes of assessment. There is a vast literature alone on the tension between external assessments for accountability purposes and classroom assessments for formative purposes (Harlen & Deakin Crick, 2002; Hoffman, Paris, Salas, Patterson, & Assaf, 2003; Wiliam, 2002) and the tension between assessment for accountability purposes and other policy imperatives, for example inclusion, is also beginning to be documented (Hall, Collins, Benjamin, Sheehy, & Nind, 2004). While recognizing those complexities, our task at this point is to seek out those studies that offer insights on and challenges to assessment within the English language arts classroom. Electronic and manual searches of the research on classroom assessment of literacy going back to the mid-1990s, especially classroom assessments in line with our expanded conceptualisation of English as outlined in the first part of this chapter, reveal a relative dearth of empirical studies. International research journals typically associated with assessment (e.g., *Assessment in Education*) and literacy (e.g., *Reading Research Quarterly*) while, incorporating such studies, tend to have more nonempirical than empirical research papers on the theme of assessing English language arts. A considerable array of studies that could variously be described as illustrations of good practice, reviews of the field, viewpoints, prescriptive commentaries, policy analyses, or theoretical and vision accounts (e.g., Au, 2001; Au & Raphael, 2000; Coles & Jenkins, 1998; Cumming & Wyatt-Smith, 2001; Farr & Jongsma, 1997; Frey & Hiebert, 2005; Gee, 2003; Harrison & Salinger, 1996; Johnston & Costello, 2005; Johnson & Kress, 2003; Kalantzis, Cope, & Harvey, 2003; Marshall, 2004; Murphy, 2003; Salinger, 2002; Shepard, 2000; Wyatt-Smith & Cumming, 2003) were consulted. Useful though these are in terms of disseminating good practice, debating the complexities, identifying key issues, and clarifying concepts, we suggest that there is an urgent need for more empirical studies that shed light on the practice of assessment at classroom level in English language arts classrooms.

However, descriptive and analytic accounts of new, performance-oriented classroom assessment of English were found in several sources and from several countries. An analysis of the contexts of these accounts show that they span the age ranges of primary and secondary schooling, they represent several countries where English is taught as a first language, they offer insights that are highly relevant to English as a discipline within the arts, and they, to varying degrees, acknowledge the complexity of English on the one hand and of assessment on the other. There are studies set in England (e.g., Black et al., 2003; Jewitt, 2003) Australia (e.g., Brady, 2001; Fehring, 2003; Wilson, 2003; Wyatt-Smith & Castleton, 2005) South Africa (Newfield et al., 2003), Bangladesh (Johnson, 2003), the USA (e.g., Paris & Paris, 2003; Paris & Stahl, 2005; Valencia,

1998; Valencia & Au, 1997; Valencia & Place, 1994; Worthy et al., 1998), Russia (Ushakova, 2001), and New Zealand (Flockton & Crooks, 1996, 2001, 2003).

The following three interrelated subheadings allow us to explore some of the main issues arising from that body of literature for the assessment of English language arts: standards, learning outcomes and predetermined success criteria, collaborative assessments, and direct evidence and ecological validity.

### *Standards, Learning Outcomes and Predetermined Success Criteria*

Despite the diversity of learners now in mainstream classrooms there is a push internationally to specify *the* standards against which students are judged. This means that evidence needs to be collected to show that learners have achieved prespecified learning outcomes. Evidence available from the above studies suggests this is highly problematic in some important areas (e.g., Fehring, 2003; Jewitt, 2003; Newfield et al., 2003). Jewitt's study clearly showed how multimodality changes what is to be learned (in that case about character and narrative) in the move from page to screen, and from "novel", to "film", and "comic". What was available to be learned by students in that study got "reshaped" in the move from "high literacy aesthetic" to "popular textual genre". The study showed how the resources of page and screen afforded students and their teacher different possibilities for engaging with specific characters in the novel in question (*Of Mice and Men*) and for the construction of character as entity. The screen facilitated quite different interactional practices and opportunities for assessment that question more traditional methods. This exploratory study challenges the assumption that curriculum designers and assessors can anticipate and predetermine all the relevant worthwhile learning outcomes.

Newfield et al.'s study powerfully demonstrates how criteria are not necessarily external, explicit and predetermined, but are ambiguous and at least partially revealed "as you go along". In their study, a secondary teacher (also a coauthor of the paper) used a multimodal pedagogic approach to encourage his class of 54 South African students to write and respond to poetry. The approaches adopted involved producing a range of artistic artifacts about their own lives to share with an unknown class of students in China. They drew or embroidered maps of South Africa onto small pieces of cloth; they wrote poems about themselves in English; they created "praise poems" (a widely used genre in Southern Africa used for naming and praising people) in their own languages; they produced three-dimensional objects to represent their cultural groups; they took photos; they stitched together their individual cloth maps, named the cloth; and finally they attached the photos and the contemporary poems to a larger cloth. The project took two months to complete and, while it was not set up originally for assessment purposes, the students who made the cloth wished it to be assessed, hence it would seem, the origin of their action research study. The study grapples with the following kinds of questions: What is being assessed? Is it the cloth, as artifact? Is it the learners, the makers of the cloth? Is it the process of making? Are those processes separable? The meaning that the learner is seeking to make and convey would appear to be key atleast for the class teacher, who suggested that the explanations offered by learners for the decisions they made and for responding semiotically in a particular

way should be crucial in assessment. The cloth is described as "a complex product of a dynamic process of designing and codesigning across genres, modes and disciplinary borders such as literature, geography, cultural studies, craft practices and visual communication" (Newfield et al., 2003, p. 71). As a product it defies the conventional criteria of an assessment task in English and differs radically from the usual means in which students demonstrate their understanding of poetry in English classrooms. As the authors report: the work differs greatly from the "customary paraphrase, textual glosses, comprehension tests, analytical paragraphs or essays (and even poems written on a page)" (Newfield et al., 2003, p. 71).

However, the action research team deliberate in considerable detail about the process of assessment. They refer to: the evidence in relation to curriculum content, in this case poetry, evidence of learning about genre, the poetic devices and its value and use in the contemporary world; evidence in relation to the *how* of representation in a range of modes; evidence in relation to interdisciplinary learning; the presence of "student voice" as well as the ability to represent themselves; evidence of the extent of engagement with issues of identity on personal, social and cultural levels. Their study demonstrates how multimodal assessment needs to assess holistically, to move beyond assessing each mode autonomously and how assessment needs to recognize the interrelational aspect of such an endeavor. We have described this paper in some detail here since it raises an assessment dilemma (namely the issue of assessing learners against prespecified criteria) that we suggest is likely to be more problematic within the arts than in other curricular areas. In our view, it highlights an area that is ripe for research.

While literary and arts theorists (Abbs, 1982; Eisner, 1985, 1999) and assessment experts (Sadler, 1989) have advocated that learners be supported in understanding the standards against which their work is judged, there has also been a recognition on their part (if not as often on the part of the policy makers and curriculum designers) that what constitutes "good work" is an intuitive act, not reducible to the application of predetermined criteria. In aesthetic areas, such as English language arts, and especially in the context of multimodal work, the application of (decontextualized) predetermined learning outcomes and success criteria would appear to be a simplistic, crude and mostly inappropriate way of offering a defensible portrayal of what might be learned. To quote Eisner (2004) "In the arts judgments are made in the absence of rule. Of course there are styles of work that do serve as models ... but what constitutes the right qualitative relationships for any particular work is idiosyncratic to the particular work". He goes on to suggest that the "the arts teach students to act and to judge in the absence of rule, to rely on feel, to pay attention to nuance, to act and appraise the consequences of one's choices and to revise and then to make other choices". In sum, more attention needs to be devoted to "what is distinctive than to what is standard".

In order to better understand how the learning accompanying such work might be judged, we need in-depth, qualitative accounts of learners and teachers co-constructing success criteria and evaluating their achievements in the context of ongoing aesthetic projects that involve multiple outcomes and meanings and that have an open-ended quality. We do not know currently what would constitute "improving" in multimodal representation for instance? How might that be different to "getting better" in other language modes such as writing? Could the same criteria be applied? How might fiction

and nonfiction differ in multimodal work? In addition, ways of recording and reporting such assessment evidence for different audiences, including for learners themselves, also need research attention.

### Collaborative Assessments and Ecological Validity

One of the many criticisms leveled against most high stakes assessments and traditional assessment techniques such as standardized testing is that they require students to complete tasks individually in a set time, even though in real life people tend to work collaboratively to solve problems that are not usually timed (Wiliam, 2002) and in the real world knowledge is distributed, possessed by groups and organizations rather than individuals (Gee, 2000). However, some assessment researchers within the language arts are grappling with such dilemmas, not least Newfield and her colleagues in South Africa. Other researchers have sought to incorporate group activity into assessments (Johnson, 2003) and this has not just been confined to assessments designed primarily to support learning directly. Assessments designed primarily for system accountability (Calfee & Miller, 2005; Flockton & Crooks, 1996, 2001, 2003) have also incorporated such elements. In the light of the impact of high stakes assessments on classroom practice ("teaching to the test") and given that a good assessment is one that one would wish teachers to teach to, it is noteworthy that in New Zealand and the United States, there are some examples of assessments based on student collaboration.

In New Zealand the National Educational Monitoring Project (NEMP) includes an element involving students working in groups – as a class library committee – to select books from a set of books. The task involves students, at an individual level, justifying their choices to the group and then negotiating and justifying their final selection as a group. As Flockton and Crooks (1996) explain, the group work which has a time limit, is video recorded for later analysis of the reading and literate interactions. Students are assessed in relation to their demonstrated skills in judging the quality of the books, taking and justifying a position, and making an argument, active listening and negotiating and agreeing on a group stance. However, it is also noteworthy that NZ national assessments are designed to hold the *system* to account, not individual schools and teachers, and it occurs only every four years, not annually (Gilmore, 2002) all of which mitigate their high stakes nature.

Yet, it must be added that even high stakes assessments aimed at school and teacher accountability have at least tried to accommodate collaborative approaches in language arts assessments. We mention one here because such assessments are likely to become more significant in the future in the light of the ongoing critique of standardized testing (Allington, 2002; Harlen & Deakin Crick, 2002; Johnston & Costello, 2005). The one in question exemplifies performance-based assessments in the language arts and treats English as an aesthetic discipline as indicated by its emphasis on response to literature and on stance. Moreover, high stakes assessments tend to have influence on informal, classroom assessments insofar as the latter so frequently mimic the former. Abandoned due to difficulties regarding reliability, the California Learning Assessment System (CLAS) was consciously located in sociocultural principles and sought to assess what teachers ought to be teaching. Response to literature and stance

were important elements in it and the assessment questions encouraged a reflective and critical engagement on the part of students (Calfee & Miller, 2005; Pearson & Hamm, 2005). Students were required to read and respond to a passage of literature; they had to discuss their responses in a group in preparation for a writing composition based on that text. The assessment included introductory scaffolding of the topic and a sharing of the products of students' discussions among the group; the provision of graphic organizers for both comprehension and composition; and, crucially, explicit discussion of performance criteria (Calfee & Miller, 2005; CLAS, 1994; Pearson & Hamm, 2005). Questions such as the following featured (CLAS, 1994, pp. 6–9): If you were explaining what this essay is about to a person who had not read it, what would you say? What do you think is important or significant about it? What questions do you have about it? This is your chance to write any other observations, questions, appreciations, and criticisms of the story. The written assignments were rated in relation to awareness of audience, purpose, and voice and all assessments incorporated a social aspect in terms of sharing finished products. In the current National Assessment of Educational Progress (NAEP) in the United States ideas deriving from literature response theory (Rosenblatt, 1995) and stance (Langer, 1995) remain key drivers although performance assessments generally, and an emphasis on collaboration and group work in particular, have been in retreat in recent years (Pearson & Hamm, 2005).

A rich notion of literacy incorporating multimodality is by its nature more collaborative than individualistic, involving people co-participating on activities and co-constructing meanings (Johnson, 2003). However, we need studies that illuminate how students make meaning with artifacts and in cooperation with each other. While Johnson (and others) offers frameworks for assessing multimodality, drawing on one-off pilot studies, such frameworks have yet to be empirically applied and evaluated.

## Direct Evidence and Ecological Validity

One of the most important messages underlying classroom assessments in the English language arts is that assessment is not a simple or innocent business. Assessing learning is always bound up with the attitudes, beliefs and prejudices on the part of those carrying out the assessments and those who designed the assessment instruments and procedures. Equally, those being assessed bring their expectations, histories and values with them, thus influencing their responses. All participants in the assessment enterprise construct their own meanings on the basis of their respective expectations and values. This line of thinking has led to our recognition that the interpretation of assessment information is contestable, summed up well by the title of a critical review of the field of reading assessment, *Fragile Evidence* (Murphy, Shannon, Johnston, & Hansen, 1998). It has also led researchers and practitioners to develop procedures that seek direct evidence of achievement from a range of meaningful literacy circumstances, evidence that could be considered to have high ecological validity. Compelling research evidence of the impact of formative assessment, including self and peer assessment, on student learning has given impetus to assessment procedures that can capture the variability and patterns in student achievement across time and contexts. Two examples of such procedures are portfolio assessment (Brady, 2001; Underwood, 1999; Ushakova, 2001; Valencia, 1998;

Valencia & Au, 1997; Valencia, Hiebert, & Afflerback, 1994; Wilson, 2003) and the assessments underlying the primary language record (PLR) (Barrs, Ellis, Hester, & Thomas, 1990; Falk, 1998; Worthy et al., 1998). We consider just the first of these here.

The concept of the portfolio as a means of recording and assessing achievement in English language arts derived from the field of fine arts where portfolios are used to illustrate the depth and breadth of an artist's work. Published reports of the use of portfolios tend to distinguish between the portfolio itself and portfolio assessment – the latter referring to the procedure used to plan, collect, and analyze the multiple sources of data maintained in the portfolio (e.g., Moya & O'Malley, 1994; Valencia, 1998; Wilson, 2003). Portfolios can take different forms in the English language arts from a simple individual folder of work including lists of books read and discussed, written responses to literature or other experiences, nonfiction writing, drawings or paintings in response to a variety of experiences, final pieces and drafts of work in progress. They may also include anecdotal records and observations made by teachers (and others) made of pupils during readers' workshops and lessons. Valencia (1998) advocates including a variety of items in the portfolio so that it offers a comprehensive portrayal of the pupil's growth in literacy. Valencia and Place (1994) describe different kinds of portfolios – the "showcase portfolio", for example, may be used to display the pupil's best or favorite pieces of work; "documentation portfolios" capture the pupil's growth over the year while "process portfolios" capture the steps taken by a pupil to complete a given project and these usually contain pupil reflections of their own learning. The "feedback portfolio" (Ushakova, 2001) is designed to support learners' self assessments and to promote their construction and understanding of success criteria. Portfolios can be used as public documents (Hall & Harding, 2002) providing concrete examples of the pupil's accomplishments and areas for further development that can be shared with parents and other teachers and also to demonstrate the way a school interprets nationally-set standards. Students themselves can review their progress over time, take pride in their achievements and make plans for future learning.

In an in-depth empirical study of the implementation of portfolio assessment Valencia and Au (1997) present persuasive evidence of its potential to raise standards and positively influence teaching and learning. They highlight what they call the "essential components and the internal and external conditions" which their research suggests constitute a successful portfolio assessment system. Key among these were portfolio evidence and teacher professional development. As teachers closely examined students from their own and other teachers' classrooms, they fine-tuned their observational and interpretive skills based on multiple forms of evidence. Their study shows that the use of portfolios compels teachers to rely on evidence for their decisions and so grounds assessment in concrete data, that are open to all interested parties to share. It supported teachers and students in the development of evaluation criteria and encouraged students' understanding of the criteria against which their work was evaluated.

## Concluding Comments

Ultimately, of course, the potential of any assessment approaches depends on the political, organizational and professional settings in which they are applied as much as they do

on the procedures themselves (Bird, 1990; Valencia & Au, 1997). This takes us back to the impact of high stakes assessments on creative, classroom-based approaches that are likely to reflect better the complexity of the domain of English language arts and the learning process. The tendency for high stakes testing to subvert, low stakes classroom-based, formative assessment continues to exercise scholars (Harlen & Deakin Crick, 2002) especially in the United States (e.g., Johnston & Costello, 2005). However, in our view, it is likely that, despite the current trend towards measurement, system and local accountability, and the insatiable desire for comparative assessment information, classroom assessment approaches that prioritize learning will continue to be refined and promoted by the professional and research communities. Research reviews of effective English teachers and their teaching at both primary and secondary level (Hall, 2003b; Hall & Harding, 2003) indicate that outstanding literacy teachers are distinguished by their ability to notice details of their students' literate behaviors. They are adept at understanding their students' meanings and interpretations of literacy events. Since raising standards depends far more on this kind of professional competence, investment in teachers' professional development as classroom assessors is likely to pay more dividends than investment in high stakes testing. But that is to ignore the political imperatives surrounding assessment and that is quite another story.

# References

Abbs, P. (1982). *English within the arts*. London: Hodder and Stoughton.

Allington, R. L. (Ed.). (2002). *Big brother and the national reading curriculum: How ideology trumped evidence*. Portsmouth, NH: Heinemann.

Au, K. H. (2001). Culturally-responsive instruction as a dimension of new literacies *Reading Online, 5*(1), Available: http://www.readingonline.org/newliteracies/lit_index.asp?HREF=/newliteracies/zu/index .html

Au, K. H., & Raphael, T. E. (2000). Equity and literacy in the next millennium. *Reading Research Quarterly, 35*(1), 170–188.

Barrs, M., Ellis, S., Hester, H., & Thomas, A. (1990). *The primary language record*. London: Centre for Language in Primary Education.

Barton, D., Hamilton, M., & Ivanic, R. (Eds.). (2000). *Situated literacies: Reading and writing in context*. London: Routledge.

Benton, M. (1983). Secondary worlds. *Journal of Research and Development in Education, 16*, 68–75.

Bird, T. (1990). The schoolteacher's portfolio: An essay on possibilities. In J. Millman & L. Darling-Hammond (Eds.), *The new handbook on teacher evaluation* (pp. 241–256). Newbury Park, CA: Sage.

Black, P., & Wiliam, D. (1998). Assessment and classroom learning. *Assessment in Education, 5*(1), 7–84.

Black, P., Harrison, C., Lee, C., Marshall, B., & Wiliam, D. (2003). *Assessment for learning: Putting it into practice*. Buckingham: Open University Press.

Brady, L. (2001). Portfolios for assessment and reporting in New South Wales primary schools. *Journal of Educational Enquiry, 2*(2), 25–43.

Bruner, J. (1996). *The culture of education*. Cambridge MA: Harvard University Press.

Calfee, R., & Miller, R. G. (2005). Comprehending through composing: Reflections on reading assessment strategies. In S. G. Paris & S. A. Stahl (Eds.), *Children's reading comprehension and assessment* (pp. 215–233). Center for Improvement of Early Reading Achievement (CIERA) and LEA.

California Learning Assessment System (1994). Elementary performance assessments: Integrated English language arts illustrative material. Sacramento: California Department of Education.

Coles, M., & Jenkins, R. (Eds.). (1998). *Assessing reading, vol. 2: Changing practice in classrooms*. London: Routledge.

Cope, B., & Kalantzis, M. (Eds.). (2000). *Multiliteracies: Literacy learning and the design of social futures*. London: Routledge.

Cumming, J. J., & Wyatt-Smith, C. M. (Eds.). (2001). Examining the literacy-curriculum connection. *Linguistics in Education, 11*(4), 295–312.

Eisner, E. (1985). *The art of educational evaluation. A personal view*. London: Falmer.

Eisner, E. (1999). The uses and limits of performance assessment. *Kappan Online* available at http://www.pdkintl.org/kappan/keis9905.htm accessed May 30, 2005.

Eisner, E. (2004). What can education learn from the arts about the practice of education? *International Journal of Education and the Arts, 5*(4), retrieved April 14, 2005 from http://ijea.asu.edu/v5n4/.

Falk, B. (1998). Using direct evidence to assess student progress: How the Primary Language Record supports teaching and learning. In C. Harrison & T. Salinger (Eds.), *Assessing reading: Theory and practice* (pp. 152–165). London: Routledge.

Farr, R., & Jongsma, E. (1997). Accountability through assessment and instruction. In J. Flood, S. B. Heath, & D. Lapp (Eds.), *Research on teaching literacy through the communicative and visual arts* (pp. 592–606). NJ: LEA.

Fehring, H. (Ed.). (2003). *Literacy assessment: A collection of articles from the Australian Literacy Educators' Association*. Newark, DE: International Reading Association.

Flockton, L. C., & Crooks, T. J. (1996) *National Education Monitoring Project [NEMP]: Reading and speaking*. Dunedin, New Zealand: Educational Assessment Research Unit.

Flockton, L. C., & Crooks, T. J. (2001). *Reading and speaking assessment results 2000: National monitoring report 19*. Dunedin, New Zealand: Educational Assessment Research Unit. [Accessed November 2005 http://nemp.otago.ac.nz/read_speak/2000/silent_reading/]

Flockton, L. C., & Crooks, T. J. (2003). *Listening and viewing assessment results 2002: National education monitoring report 25*. Dunedin: Educational Assessment Research Unit. [Accessed November 2005 http://nemp.otago.ac.nz/listen_view/2002/index.htm]

Flood, J., Heath, S. B., & Lapp, D. (Eds.). (1997). *Research on teaching literacy through the communicative and visual arts*. Mahwah, NJ: Lawrence Erlbaum Associates.

Flood, J., Lapp, D., Squire, J. R., & Jensen, J. M. (Eds.). (2003). *Handbook of research on teaching the English language arts*. Mahwah, NJ: Lawrence Erlbaum Associates.

Frey, N., & Hiebert, E. H. (2005). Teacher-based assessment of literacy learning. In J. Flood, D. Lapp, J.R. Squire, & J. M. Jensen (Eds.), *Handbook of research on teaching the English language arts* (2nd ed.). (pp. 608–618). Mahwah, NJ: LEA.

Galda, L., & Liang, L. A. (2005). Literature as experience or looking for facts: Stance in the classroom. *Reading Research Quarterly, 38*(2), 268–275.

Gee, J. P. (2000). New people in new worlds: Networks, the new capitalism and schools. In B. Cope & M. Kalantzis (Eds.), *Multiliteracies: Literacy learning and the design of social futures* (pp. 43–68). London: Routledge.

Gee, J. P. (2003). Opportunity to learn: A language-based perspective on assessment. *Assessment in Education, 10*(1), 27–46.

Gilmore, A. (2002). Large-scale assessment and teachers' assessment capacity: learning opportunities for teachers in the National Education Monitoring Project in New Zealand. *Assessment in Education, 9*, 343–361.

Greene, M. (1994). Postmodernism and the crisis of representation. *English Education, 26*(4), 206–219.

Greene, M. (1995). *Releasing the imagination: Essays on education, the arts, and social change*. San Francisco: Jossey-Bass.

Greene, M. (1997). Curriculum and consciousness. In D. J. Flinders & S. J. Thornton (Eds.), *The curriculum studies reader* (pp. 137–149). New York: Routledge.

Hall, K. (2003a). *Listening to Stephen read: Multiple perspectives on literacy*. Buckingham: Open University Press.

Hall, K. (2003b). Effective literacy teaching in the early years of school: A review of evidence. In N. Hall, J. Larson, & M. Marsh (Eds.), *Handbook of early childhood literacy* (pp. 315–326). London: Sage.

Hall, K. (2004). *Literacy and schooling: Towards renewal in primary education policy*. Aldershot: Ashgate.

Hall, K., & Burke, W. (2003). *Making formative assessment work: Effective practice in the primary classroom*. Buckingham: Open University Press.

Hall, K., Collins, J., Benjamin, S., Sheehy, K., & Nind, M. (2004). SATurated models of pupildom: Assessment and inclusion/exclusion. *British Educational Research Journal, 30*(6), 801–817.

Hall, K., & Harding, A. (2002). Level descriptions and teacher assessment: Towards a community of assessment practice. *Educational Research, 40*(1), 1–16.

Hall, K., & Harding, A. (2003). A systematic review of effective literacy teaching in the 4–14 age range of mainstream schooling. In *Research evidence in education library*. London: EPPI-Centre, Social Science Research Unit, Institute of Education.

Harlen, W., & Deakin Crick, R. (2002). A systematic review of the impact of summative assessment and tests on students' motivation for learning. In *Research evidence in education library*. London: EPPI-Centre, Social Science Research Unit, Institute of Education.

Harrison, B. (1983). *Learning through writing*. London: NFER.

Harrison, C., & Salinger, T. (Eds.). (1996). *Assessing reading 1, theory and practice: International perspectives on reading assessment*. London: Routledge.

Hoffman, J. V., Paris, S. G., Salas, R., Patterson, E., & Assaf, L. (2003). High-stakes assessment in the language arts: The piper plays, the players dance but who pays the price? In J. Flood, D. Lapp, J. R. Squire, & J. M. Jensen (Eds.), *Handbook of research on teaching the English language arts* (2nd ed.). (pp. 619–639). Mahwah, NJ: LEA.

Holbrook, D. (1979). *English for meaning*. Windsor: National Foundation for Educational Research.

Ivinson, G., & Murphy, P. (2003). Boys don't write romance: The construction of knowledge and social gender identities in English classrooms. *Pedagogy, Culture and Society, 11*(1), 89–112.

Jewitt, C. (2003). Rethinking Assessment: multimodality, literacy and computer-mediated learning. *Assessment in Education, 10*(1), 83–102.

Johnson, D. (2003). Activity theory, mediated action and literacy: Assessing how children make meaning in multiple modes. *Assessment in Education, 10*(1), 104–129.

Johnson, D., & Kress, G. (2003). Globalisation, literacy and society: Redesigning pedagogy and assessment. *Assessment in Education, 10*(1), 5–14.

Johnston, P., & Costello, P. (2005). Principles for literacy assessment. *Reading Research Quarterly, 40*(2), 256–267.

Kalantzis, M., Cope, B., & Harvey, A. (2003). Assessing multiliteracies and the new basics. *Assessment in Education, 10*(1), 16–26.

Kenner, C., & Kress, G. (2003). The multisemiotic resources of biliterate children *Journal of Early Childhood Literacy, 3*(2), 179–202.

Kress, G. (2003). *Literacy in the new media age*. London: Routledge.

Langer, J. A. (1995). *Envisioning literature: Literary understanding and literature instruction*. New York: Teachers' College Press.

Lankshear, C., & Knobel, M. (2003). *New literacies: Changing knowledge and classroom learning*. Buckingham: Open University Press.

Lave, J. (1996). Teaching, as learning, in practice. *Mind, culture and activity, 3*, 149–164.

Lave, J., & Wenger, E. (1991). *Situated learning: Legitimate peripheral participation*. Cambridge MA: Cambridge University Press.

Luke, A., & Luke, C. (2001). Adolescence lost/childhood regained: On early intervention and the emergence of the techno-subject. *Journal of Early Childhood Literacy, 1*(1), 91–120.

Marshall, B. (2004). *English assessed*. London: National Association for the Teaching of English (NATE).

McMahon, S. I., Raphael, T. E., Goatley, V. J., & Pardo, L. S. (1997). *The book club connection: Literacy learning and classroom talk*. New York: Teachers' College Press.

Moya, S. S., & O'Malley, M. (1994). A portfolio assessment model for ESL. *The Journal of Educational Issues of Language Minority Students, 13*, 13–36.

Murphy, S. (2003). Finding literacy: A review of research on literacy assessment. In N. Hall, J. Larson, & M. Marsh (Eds.), *Handbook of early childhood literacy* (pp. 369–378). London: Sage.

Murphy, S., Shannon, P., Johnston, P., & Hansen, J. (1998). *Fragile evidence: a critique of reading assessment*. Mahwah, NJ: LEA.

New London Group. (1996). A pedagogy of multiliteracies: Designing social futures *Harvard. Educational Review, 66*, 60–92.

Newfield, D., Andrew, D., Stein, P., & Maungedzo, R. (2003). "No number can describe how good it was": assessment issues in the multimodal classroom. *Assessment in Education, 10*(1), 61–81.

Paris, A., & Paris, S. (2003). Assessing narrative comprehension in young children *Reading Research Quarterly, 38*(1), 36–76.

Paris, S., & Stahl, S. (Eds.). (2005). *Children's reading: Comprehension and assessment*. Mahwah, NJ: Lawrence Erlbaum Associates.

Pearson, D. P., & Hamm, D. N. (2005). The assessment of reading comprehension: A review of practices – past, present and future. In S. G. Paris & S. A. Stahl (Eds.), *Children's reading: Comprehension and assessment* (pp. 13–70). Mahwah, NJ: Center for the Improvement of Early Reading Achievement (CIERA), LEA,

Pinar, W. F. (Ed.). (1998). *The passionate mind of Maxine Greene*. London: Falmer.

Qualifications and Curriculum Authority. (2004). *More than words: Multimodal texts in the classroom* London: QCA.

Rosenblatt, L. (1991). Literature SOS! *Language Arts, 68*, 444–448.

Rosenblatt, L. (1994). *The reader, the text, the poem: The transactional theory of the literary work*. Revised paperback edition Carbondale, IL: Southern Illinois University Press.

Rosenblatt, L. (1995). *Literature as exploration* (5th ed.). New York: Modern Language Association.

Roser, N. L., & Martinez, M. G. (Eds.). (1995). *Book talk and beyond: Children and teachers respond to literature*. Newark, DE: International Reading Association.

Sadler, D. R. (1989). Formative assessment and the design of instructional systems. *Instructional Science, 18*, 119–144.

Salinger, T. (2002). Assessing the literacy of young children: The case for multiple forms of evidence. In S. B. Newman & D. K. Dickinson (Eds.), *Handbook of early literacy research* (pp. 390–418). New York: Guilford Press.

Shepard, L. A. (2000). The role of assessment in a learning culture presidential address. *Annual Meeting of the American Educational Research Association*. New Orleans, April.

Street, B. (2004). Futures of the ethnography of literacy? *Language and Education, 18*(4), 326–330.

Underwood, T. (1999). *The portfolio project: A study of assessment, instruction and middle school reform*. Urbana, IL: Council of Teachers of English.

Ushakova, S. (2001). Making literacy learning and teaching creative: Feedback portfolios. In G. Shiel & U. Ní Dhálaigh (Eds.), *Other ways of seeing: Diversity in language and literacy (Vol. 1*, pp. 51–61). Dublin: Reading Association of Ireland.

Valencia, S. W. (1998). *Literacy portfolios in action*. Texas: Harcourt Brace.

Valencia, S. W., & Place, N. A. (1994). Literacy portfolios for teaching, learning and accountability: The Bellevue Literacy Assessment Project. In S. W. Valencia, H. H. Hiebert, & P. P. Affleback (Eds.), *Authentic reading assessment: Practices and possibilities* (pp. 134–156). Newark, DE: International Reading Association.

Valencia, S. W., & Au, K. H. (1997). Portfolios across educational contexts: Issues of evaluation, teacher development, and system validity. *Educational Assessment, 4*(1), 1–35.

Valencia, S. W., Hiebert, E. H., & Afflerback, P. P. (Eds.). (1994). *Authentic reading assessment: Practices and possibilities*. Newark, DE: International Reading Association.

Wiliam, D. (2002). What is wrong with our educational assessment and what can be done about it? *Education Review, 15*(1), 57–62.

Wilson, J. (2003). Portfolios: Valuing the whole of children's learning. In H. Fehring (Ed.), *Literacy assessment: A collection of articles from the Australian Literacy Educators' Association* (pp. 84–89). International Reading Association Newark, DE.

Worthy, J., Hoffman, J. V., Roser, N. L., Rutherford, W., McKool, S., & Strecker, S. (1998). Teachers changing the system: Alternative assessment of first graders' literacy. In M. Coles & R. Jenkins (Eds.), *Assessing reading: Changing practice in classrooms* (pp. 40–53). London: Routledge.

Wyatt-Smith, C. M., & Cumming, J. J. (2003). Curriculum literacies: Expanding domains of assessment. *Assessment in Education, 10*(1), 47–59.

Wyatt-Smith, C., & Castleton, G. (2005). Examining how teachers judge student writing: An Australian case study. *Journal of Curriculum Studies, 37*(2), 131–154.

25

# WRESTLING WITH ASSESSMENT IN DRAMA EDUCATION

**Shifra Schonmann**
*University of Haifa, Israel*

## Prologue

"Who dare deny that revised modes of assessment, increased rigor, and altered authority structures will guarantee success for us all?" So argues Maxine Greene in her essay on *Imagination, Community, and the School*. She claims that: "Given such a preoccupation, it follows that certain children are conceived of as human resources rather than persons. Much of the time, they are spoken of as if they were raw materials to be shaped to market demand." (Greene, 1995, p. 32). My continuing search for an appropriate approach to assessment in the broad sense in education, and in the focused sense in the context of drama education, goes along with Greene's line of thought. Thus, I will aim this chapter towards describing and discussing different approaches to assessment in drama education, focusing on the process in which the students are regarded as persons in pursuit of possibilities for themselves and for the schools they live in.

The various arguments for including the arts in school curricula, and the need to allocate them sufficient time and suitable locations, such as for any other subject-matter taught in schools, are based on the understanding that the arts must operate as an integral and significant element in the lives of all children in schools and serve not just as a decoration for ceremonial events and after-school activities. The status of the dramatic arts as a subject stems from its place within the formal curriculum where the emphasis in many countries seems to be on assessing and reporting achievement for accountability purposes. It seems to be a cause of many heated debates which attempt to find appropriate ways to assess students' achievements.

The aim of the chapter then is to discuss some of the multifaceted issues involved in evaluating dramatic arts in education and thus to justify the focus on assessing an individual's achievements. The chapter consists of three sections as follows (i) the language of assessment and drama education; (ii) the drama curriculum and its practical concerns; and (iii) the examination of two approaches to assessment: their nature and uses. Concluding comments bring the chapter to a close.

409

*L. Bresler (Ed.), International Handbook of Research in Arts Education*, 409–422.
© 2007 *Springer.*

# The Language of Assessment and Drama Education

The thread of my argument in this section centers around evaluation, assessment and standards, giving the reader a glimpse of past confusions and drawing attention to writers such as O'Neill and Lambert who remind us of the experiential component of any assessment process.

> The way in which teachers perceive and understand their students as learners, and the way in which students perceive and understand their learning, occurs through particular discourses which inform and regulate teaching and learning. Such discourses operate through specific enunciative strategies, such as assessment, which construct pedagogic meaning. (Atkinson, 2002, p. 102)

This claim by Dennis Atkinson in his book, *Art Education: Identity and Practice*, can lead to an attempt to identify particular criteria of drama practice in the classroom, which also include assessment. One could consider such criteria as norms of the student's ability to participate in a meaningful way in the classroom drama. Along with Atkinson we should ask ourselves: What are the norms of practice knowledge that should be established? What are the codes of recognition through which student's work is made visible?

In the classroom and beyond students can produce, perform, create or expose physical or verbal images that cannot be interpreted, or given any meaning on the basis of norms and standards decided in advance. O'Neill and Lambert (1988) suggest that the progress in drama which a pupil is likely to make over a period of time will not only have to do with an increased technical competence in using the drama medium but also in evaluating how the pupils increase their understanding in the complexity being created in the drama – the feeling, ideas, events, and relationship which are being explored and represented. They suggest that "an increased skill in working with drama and theater forms is to be expected, as is the ability to use the elements of theater in order to negotiate and develop meaning" (p. 146). Other art forms, writes O'Neill, "offer us new worlds, worlds in which we can feel but not act, worlds for contemplation. In process drama, we go beyond that. We create the world and live, however briefly, by its laws" (O'Neill, 1995, p. 152).

The intuitive base of dramatic activity serves as a possible source for debate on philosophy of drama. Schonmann (1997) suggests that teachers rely on their sensitivity to assess their students' achievement. The persistent influence of intuition on drama teachers' thinking has been challenged, but no substantial alternative has been offered to replace it in the assessment of dramatic work (p. 13). Drama teachers recognize the limitations of assessment models that overestimate the outcome over the process; however, they also recognize the limitation of assessment models that overestimate the creative process and that do not do justice to the students' artistic achievements. Narrative accounts of their practice indicate that teachers have to rely on what they called their "gut feeling" or "intuition" in addition to their experience. The result of this open nature of assessment and its subjective core is that it serves only the speakers themselves, and it cannot be passed easily to other teachers for their use or to develop further

discussions. Lyn McGregor, who wrestled with the notion of standards in drama in the 1980s, reports that a few pupils told her that they did not like drama because they were "not good at it". She claims that "unlike a number of teachers, the pupils recognized that there are forms of achievements in drama and that for various reasons some pupils are better than others" (McGregor, 1983, p. 125). She struggled to answer the question: What are the standards that should be achieved in drama work? She came up with the idea that the criteria are governed by prevailing trends and existing knowledge about and attitudes toward children and learning. Being able to appreciate other people's drama means for her, the ability to understand the meaning behind the drama and whether the student's activity has been adequately done. McGregor's understanding stems from a notion that the act of evaluating is part and parcel of everyday life and as Blomberg (1991) puts it concisely: "There is nothing mysterious about it" (p. 32).

The general discourse we meet in the field of education includes topics such as evaluation, assessment, measurement of student achievement, accountability, standards, criteria, indicators, feedback, tests, and examinations. These terms and others embody meaning; they set the discourse and give substance to the practices they serve. Eisner (2002) claims that "*assessment* generally refers to the appraisal of individual student performance, often but not necessarily on tests. *Evaluation* generally refers to the appraisal of the program – its content, the activities it uses to engage students, and the ways it develops thinking skills" (Eisner, 2002, p. 178). In a previous work, Eisner (1993) develops eight criteria for creating what he calls "authentic assessment". Three of these seem to be particularly relevant to drama education (i) assessment tasks need not be limited to solo performance; (ii) assessment tasks should have curricular relevance, but not to be limited to the curriculum as taught; (iii) assessment tasks should permit the student to select a form of representation he or she chooses to display what has been learned (pp. 226–231).

It is also interesting to highlight Colwell who argues that: "Evaluation is usually associated with reporting the success and/or failure of a process or a product" (Colwell, 2004, p. 1), whereas Jackson stresses the more general meaning by which evaluation is "a judgment about the worth or value of something achieved through a systematic organization of the criteria and the means by which the evidence is collected" (Jackson, 2002, p. 6).

Elliot Eisner's distinction between *assessment* and *evaluation* is still widely used in drama education. In fact it is reminiscent of Ken Robinson's 1990s description of the two concepts in drama education in terms of their purpose. He writes: "In broad terms the purpose of assessment is to provide information about student's abilities and attainments in education: the purpose of evaluation is to provide information about the quality of educational opportunities they receive" (Robinson, 1993, p. 252). Assessing individual achievements is based on a collection of chosen criteria to be used in deciding whether the performance of a student is proper or not. Moreover, the questions to be asked are many and profound such as: How can we decide whether the results are valuable? How do we decide what are the needs to be met through the assessment? Who decides what information can be gathered to demonstrate the level of performance? What are the major sources of relevant information?

Listening to teachers we may discover that they mean different things when they say that they assess their students' achievements in drama education (McKone, 1997;

Simpson, 1999). Terms such as assessment, evaluation, estimation, appraisal, account-ability, engagement, summative assessment and formative assessment take place in their discussions (Cockett, 1998; Warner, 1997). The problem, however, in all of this is not only with the ways in which one uses one term or another, but with the ideological commitments that it presents. Sally Brown writes:

> In the field of assessment, a great deal of talk over the last decade has been about change, and substantial attempts have been made to introduce new practices. Different practices usually reflect different ideological commitments, and one of the most salient features of the movement has been the recognition that assess-ment, as a part of education, must be about promoting learning and opportunities, rather than sorting people into social roles for society. (Brown, 1990, p. 5)

Brown's approach served as a basis for a project to assess achievements in the arts, by Ross, Radnor, Mitchell, & Bierton, aiming to give the pupils a voice, a place, in the assessment of their aesthetic activities and, at the same time, to allow the teacher's judg-ment to take full account of the pupils' subjective worlds. Ross et al. report: "We, for our part, have made subjectivity central in our account of assessment in the arts. Our chosen vehicle is pupil-teacher talk: assessment in and through conversation" (Ross et al., 1993, p. xi). They derived their inspiration from the Latin source of the word "assess" which is composed from "ad + sedere", meaning "to sit down together." They proposed that teachers and pupils should sit down together in regular shared acts of assessment through talk. The terms: common sense assessment; authentic assessment; self-assessment and peer assessment are all approaches to assessments that often feature in the arts.

An interesting interpretation of the word "standard" comes from examining the root of the word. Miller and Saxton (2004) remind us that standard comes from the old French, *estende*, meaning "to extend". Thus standards "implies something that is always on the move, always stretching" (p. 38). Even if I like to think of this root with its potential of changing the meaning of *standards* it does not change the reality of using this term in the language of assessment and evaluation as units of measure. The issue of standards in arts preoccupied great education philosophers, such as Dewey, who struggled with the idea in his book *Art as Experience* (1934/1980). He described the difference between criteria and standards, asserting that standards are measures of definite things. Eisner elaborates on this by saying that: "In assessing works of art, standards are inappropriate; criteria are needed. Standards fix expectations; criteria are guidelines that enable one to search more efficiently for qualities that might matter in any individual work" (Eisner, 1995, p. 763). The language the teacher uses must be understood by the students. Since the terms mentioned above are still often used inter-changeably there is a practical need for each teacher in his/her classroom context to clarify his/her own use to help students understand the requirements.

## The Drama Curriculum and its Practical Concerns

The field's historical record or curriculum (see John O'Toole's chapter in the curriculum section) clearly shows that until the 1980s issues of systematic assessment of students'

achievements in schools did not preoccupy the leading figures in drama education. It is an avenue they largely avoided. Rather, they chose to concentrate on class practices and on engaging students with the emerging field. Since then, there have been some rapid developments. Drama education proved to have the weaknesses and the strengths of a relatively new and evolving discipline in school, but it also had the promise that no other art could offer – celebrating life through the medium of verbal and dramatic expression. Theater, as a form of communication, conveys human experiences without leaving the *here* and *now*. In this context wrestling with assessment is an integral part of building an understanding of what the field consists of (Fleming, 1994; Gallagher & Booth, 2003; Hornbrook, 1989, 1991; Neelands, 2004a; O'Neill, 1983; O'Toole, 1992; Schonmann, 2000; Somers, 1995; Taylor, 2000).

In their book *Drama Structures*, Cecily O'Neill and Alan Lambert suggest that it is the quality of the experience that is important in drama and theater assessment and evaluation. They argue that:

> Among the problems which may arise in attempting to assess the quality of the drama experience will be the group nature of the work and the fact that one has to be guided by externals in judging what may be largely an inner experience. But of necessity, teachers must constantly try to assess their own work and that of their pupils. Without the feedback provided by effective assessment it will be difficult for either teachers or pupils to make progress. (O'Neill & Lambert, 1988, p. 145)

What I find most interesting in their stand is the conscious demand for an ongoing assessment which involves the teacher, the student and an outside eye. Placing the focus on assessing the drama experience is a valuable point of view. It examines what the teacher contributes to the situation, what is appropriate to that class and how the pupils were able to show their understanding, and their level of commitment to the work and their interest in the theme. Their attempt to achieve a balance between some predetermined strategies and unpredictable elements of response is a call for a "flexible lesson formula" (p. 137). Thus we learn that in the 1980s questions of evaluation and assessment became the core of lesson planning and implementation, a trend that only accelerated in the 1990s. Evaluation became somewhat of a buzzword and drama in education projects grew more concerned with finding ways to help developing coherent assessment procedures (Allen, Allen, & Dalrymple, 1999, pp. 21–22).

In his book, *New Perspectives on Classroom Drama*, Gavin Bolton dedicates the last chapter to assessment although he confessed that he had eschewed writing about methods of assessment in drama until that chapter because: "I simply haven't felt that I have anything to add to common practice among drama teachers" (Bolton, 1992, p. 128). It seems that at the time he wrote the book, he did not want "to give people the impression that neglected aspects are not worthy of attention" (p. 128), and he entered the heated debate of the 1990s with a strong criticism for those who tried to publish work on assessment (using the term broadly to include evaluation and attainment targets) but, generally speaking, he claims (p. 129), that their writing suffers from one or more of four critical weaknesses:

(a) They do not draw on classroom practice as they write, but rather on some philo-sophical or aesthetic theories to do with making judgments *about* classroom practice.

(b) They are too keen to find theories that embrace *all* the arts.

(c) Instead of discussing the assessment of drama with reference to what they know most about, that is, their own practice, they purport to speak for a wide range of educational experiences in drama.

(d) Some drama specialist writing about assessment still sees drama practice almost entirely in terms of acting skills, and believes that, ultimately, "success" is about playing "big parts" in school productions.

Even though he declared: "anyone having the stamina to comb through my previous books of articles would search in vain for the subject to be given any more than a passing reference" (Bolton, 1992, p. 129) his earlier Selected Writings on drama in education (edited by Davis & Lawrence, 1986), includes a whole chapter, and not just a passing reference, from 1981 under the topic: "Assessment of Practical Drama" (pp. 217–222) which formed the basis for his framework for assessment in the 1990s. My point is that assessment is such a fundamental activity rooted in the practitioner's work that some-times, even leading figures in the field such as Gavin Bolton "speaks prose" without being aware that the assessment topic stands at the core of understanding the nature of the field and the ways we hope to develop its horizons. Bolton aims at finding a frame-work for assessment and suggests that the phrase "Drama for meaning-making" might be useful in the context of combining "a concept that may imply openness to concep-tual learning or a change of understanding without being an explicit requirement. It would also imply a search for dramatic form" (Bolton, 1992, p. 141). This broad sense of "drama for meaning-making" can serve as a guideline for teachers to operate their assessment. However, the big problem for the teacher of how to activate this process is still not solved.

The issue of disciplinary knowledge in education, in general, is currently under debate (Zeus, 2004). As an educational drama program is more often than not what a teacher decides, flexibility is the main principle of its praxis. It can be argued that measuring, testing and assessing the student's achievement is bound basically to the teacher's own standards and his/her ability to evaluate. It is of interest to note in this context that, even though evaluating educational programs and assessing student's achievements are part and parcel of everyday life in schools, teachers do not know much about assessment (Weeden, Winger, & Broadfoot, 2002, p. 41), and we do not yet have any data in the arts that indicate the strength and weaknesses of any of the methods taught (Colwell, 2004, p. 5). If we accept these views, what further steps can now be taken?

Intentions and decisions about the contents (*what* to teach) and the methodologies (*how* to teach) characterize disciplinary knowledge. If this is the case, then it can be argued that drama education does not come forward as a discipline in the traditional sense because there is no consensus among educators as to the contents, that is, what we actually teach in this field. Neither are there any common claims to any definite method-ology. Drama education, then, does not seem to fulfill the two conventional criteria (*what and how*) necessary to define a discipline in education. Thus the difficulties of assessing

students' achievements or evaluating educational programs rise to a level that even explicit or implicit discussions that took place in the field (such as: Best, 1996; Blomberg, 1991; Courtney, 1990; Fleming, 1994; Heathcote, 1988; Hornbrook, 1989; McGregor, 1983; O'Neill & Lambert, 1988; Redington, 1983; Ross et al., 1993; Salazar, 1996; Somers, 1995; Vernon, 1983; Verriour, 1994; Wheetley, 1996) remain unconcluded, leaving us with no clear tools for appreciating the value of the drama curriculum. Efforts that have been made "to formulate evaluative schemes for educational drama strikingly reveal the field's contradictions and paradoxes" (Hornbrook, 1989, pp. 23–24).

The place of drama in the curriculum is currently facing Neelands' (2004a) call to celebrate the marginality of drama in schools as a barricade against "domestication" and "governmentality." His fundamental question about the role of drama in education "Does drama's space in the boundaries of the curriculum, its marginalized status, give it the opportunity to be the site for going "beyond" the "curriculum" in counter-cultural and pedagogic terms? (p. 54) is thought provoking. Perhaps even more stimulating, in this context, is his assertion that drama is valued for different reasons in different schools. In his book *Beginning Drama 11–14* (2004b) he introduces three different kinds of drama curriculum (*Drama as personal, social and moral education; Drama as English; Drama as a subject in its own right*). Each has different aims and consequently different objectives by which it is assessed. For example, he explains, in schools where drama is perceived as personal and social education, drama curriculum emphasizes development and assessment of skills and objectives associated with personal, social, and moral education. In schools where drama is taught as part of English studies, assessment relates either to the national standards for arts and theater for Shakespeare and speaking, listening or to written work in response to drama. In schools where drama is taught as a subject in its own right by specialist teachers, there is strong emphasis on the development and assessment of individual dramatic skills, the history of theater, and the production and presentation of plays by pupils. Such discussion about the content and parameters of a curriculum for drama is possible, Neelands claims, because no agreed legislative framework exists for drama in the United Kingdom, as is the case in many other countries.

*Drama and theater education* is an inherently integrative discipline. Along with Fleming (1997), it can be argued that the dichotomies between "theater" and "drama"; "drama for understanding" and "drama as art"; "experience" and "performance", "process" and "product" are false polarities (p. 2). Wearing interdisciplinary glasses could justify the attempts to develop multiple approaches to assessment and the usefulness of many possibilities to construct quality education in the field. Among them, one impressive effort has been made by the American National Assessment of Educational Progress (NAEP). In 1998, NAEP conducted an assessment of students' achievements in the arts which included theater. The sample for the theater assessment was about 2,000 students, in both public and private schools; this was enough, they claim, to obtain statistically valid results. The theater assessment framework covered both content and processes. NAEP used two types of assessment tasks in the field test: paper-and-pencil tasks that assessed students' abilities to respond to theater, and performance tasks that assessed the creating and performing aspects. Assessment tasks were prepared by the Educational Testing Service, under the guidance of a committee

of theater education experts. It is beyond the scope of this chapter to "evaluate" the NAEP (1998) project but one should mention that its main positive result was that through the effort to assess, there was a need to discuss and receive agreement as to *why, what,* and *how* we teach in drama education. Furthermore, a wave of debate started to roll in other countries such as Canada, Australia, and England, the leading countries in the field.

The field benefits from such discussions, which should be encouraged as long as it struggles to ascertain an agreed definition. In fact, in recent years attempts are being made to find ways to define approaches to the assessment of students' achievements and the evaluation of dramatic arts in the curriculum (such as: Clark & Goode, 1999; Kempe & Ashwell, 2002; Levy, 2001; Miller & Saxton, 2004; Neelands, 2004b; Pearce, 2003).

In their book *Progression in Secondary Drama* (2002), Andy Kempe and Marigold Ashwell devote an entire section to planning and assessing progression in drama. Monitoring, assessing and recording are suggested strategies to developing knowledge skills and understanding in drama.

Whereas Kempe and Ashwell are very clear about the need to monitor and assess, Alan Hancock has different ideas. He suggests the metaphor of chaos as a way of understanding the drama process and reports on his practical work with a nonspecialist drama group in which: "through a chaotic, non-linear process which develops our narrative in quite unpredictable ways, we arrived at a turbulent flow of devised drama which was open to multiple readings, in which could be discerned a powerful emergent theatrical structure" (Hancock, 1995, p. 22). The nature of the work in drama contains: "ambiguity, complexity, the unexpected and unpredictable, the wildly intuitive, the dangerously contradictory ... in short, chaos" (p. 20). His line of thought merits further probing in future discussions.

## Examining Two Approaches to Assessment: Their Nature and Uses

We should constantly bear in mind that school drama differs in significant ways from dramatic arts as they are found in non-school locations. As Liora Bresler pointed out: "School art is a blend of educational and artistic expectations, where the agenda of schools and their expectations seems to be dominant" (Bresler, 2002, p. 182).

Clear premises for assessment can help the teacher in creating such an understanding. Thus in the continuing search for constructing appropriate assessment in drama education I have tried to define four premises whenever an attempt is made to assess a student's achievements:

1. "One size" does not fit everyone. The metaphor implies that different learning styles call for different types of assessment. (*difference*)
2. Information should be gathered on the basis of using several elements from many sources. (*plurality*)
3. The many variables should serve as a check on one another and provide support for a more reliable assessment. (*reliability*)

4. There is a need to define ethical principles to guide the assessment procedures. (*ethics-values*)

These premises offer us, in principle, an opportunity to develop flexible approaches to assessment. They are based on accepted ideas widespread in the literature of the field, some of which were discussed above. On the basis of the four premises and Bolton's baseline *drama for meaning-making* (Bolton, 1998, 2003), numerous approaches to assessment can be developed. They should be considered in the light of Greene's warning discussed at the beginning of the chapter. My understanding is that different kinds of assessment suit different occasions and purposes. To illustrate this thinking I shall examine two approaches to assessment. They are not novel in the sense that we have previously encountered several of their components in praxis or in literature of drama education (as the reader will recognize even from the literature mentioned in this chapter). However, they are novel in the sense of cumulative ideas, innovatively merging old and new approaches that may come to serve future developments in the field.

*The directive approach: pointing out which dramatic action leads to an artistic and aesthetic "right" or "wrong".*   This approach aims to assess a student's artistry in creating a particular dramatic event. The understanding here is that there should be a product at the end of the process and that there is an individual responsibility to contribute to the collective enterprise. According to this approach, individual achievements are evaluated through predetermined criteria. These criteria are defined and established in relation to the particular goals set for the success of a performance event. The criterion here about collaboration would be that of Jonathan Levy's: "Willingness and ability to work with others and to take the lead when appropriate" (Levy, 2001, p. 57). Defining goals and choosing the means to achieving them is a linear way of thinking. It is deeply rooted in the educational thinking and has been accepted by the mainstream since Tyler (1950) offered his model for curriculum planning in the early 1950s.

In the context of this mainstream I offer the directive approach which accepts the basic idea of defining goals and finding suitable means for achieving them. However, instead of detailed criteria to monitor the progress of the student (Kempe & Ashwell, 2002) this approach proposes phases to control the process, not the student. The understanding is that the teacher should give his/her students feedback on the principles they have chosen to work on while on the detailed work within the principle, the students should be completely free to establish their own search for meaning. The spirit of this approach concurs with Jonathan Levy's justifications for criticism of work done in the theater: "to illuminate that work and to provide a point of departure for further discussion" (Levy, 2001, p. 52). In this approach the concern is to break up the monopoly rights exercised through assessment by the teacher upon the pupil's personal creative work (Ross et al., 1993). The students are required to take an active role as well as risks and responsibilities for their work. This form of interactive assessment *in* and *through* dialogue is conducive to the development of a learner-centered pedagogy of assessment. The way the teacher chooses to assess should be derived from his/her understanding that students are people, not human resources, and from the teacher's willingness to share the amount of control and influence that he/she may want to have

over the students' creative process. It recognizes that in an "innovative partnership, students should join with their teachers, share their knowledge, and in doing so gain a sense of increased power" (Taylor, 2000, p. 119).

*The dialectical approach: organizing and prioritizing values that are particular in the nature of the theater over others via a set of dialectical questions that create a profile of the student's achievement.*    This approach aims to create a profile of the student's journey to becoming an artist in the making and understanding of drama.

The dialectical approach is designed around branches of questions: How can one know or discover whether the students have undergone a change? Did the students improve enough? The deliberation goes through a series of dialectic questions at the end of which a student's profile is achieved. It is basically a motivational way of assessing student's achievements. The main concern in this approach is the improvement, helping the student to work better next time. It is based on a constructivist pedagogy which is inherently connected to the theater pedagogy demands (Miller & Saxton, 2004). Questioning as a tool for teaching and assessment is a known strategy (Hubbard & Miller, 1993).

Drawing on the work of Belenky, Clinchy, Goldberger, and Tarule (1986) *Women's Ways of Knowing*, who developed a number of coding categories to capture the ways in which women construe their experience of themselves as developing beings (pp. 237–238), it is possible to suggest a framework of guiding dialectical principles for all levels in education. Appropriating them to use as drama educational dialectics, the following are suggested:

1. What are the aims that the student has to achieve?
   Process oriented (means) vs. Goal oriented (ends)
2. How is the act of becoming a "theatrical knower" viewed?
   Discovery (constructed knowledge) vs. Didacticism (received knowledge)
3. Which methods has the student valued?
   Rational (logical, analytical, objective) vs. Intuitive (gut feeling, subjective)
4. Which arrangement for learning does the student prefer?
   Collaborative; cooperative vs. Solitary, competitive.
5. What is the student's range of interest in learning?
   Breadth (generalist, dilettantism) vs. Concentration (specialist, narrowness)
6. What are the relationships between self and the content of drama that the student is learning?
   Personal vs. impersonal (i.e., the manner in which a student goes about his/her work, the relationships with basic qualities in theater such as concentration and preparation, listening and speaking, and willingness to take risks).

The above six adjusted dimensions could be further elaborated by each teacher according to his/her own understanding. This approach would strive to create a profile of achievement for each student. The profile would be based on the broadest range of information that the teacher could collect. The teacher should look for the persistence of coherence in the profile as well as seeing if there are any perceptions about the artistic and the aesthetic values concerning theater, or if it is merely a chance accumulation of various notions about theater.

The two discussed ways of assessment are not mutually exclusive. They suggest that during the course as well as at the end, the teacher and the students will be able to value achievements in relation to the experience that students undergo. Such achievements will reflect the result of their unique endeavors.

## Concluding Comments

Assessment approaches are a manifestation of a wider conceptualization about life in schools in general, and about how dramatic arts should be developed in the schools in particular. Any assessment approach derives its path from a comprehensive ideology of the role these arts should play in school settings.

Unlike some mature fields of study, the relatively young field of drama education remains open in its constant search for identity and in searching for best options to enhance its status. In the absence of agreement over drama curriculum, the door remains open to: an intensified search for what can be learnt from the short history of the field; developing and refining the language of assessment in drama; deepening understanding of the nature of the field and consequently, developing various approaches to assessment in drama education.

## Author's Note

I wish to thank Gavin Bolton, Lili Orland, Regina Murphy and Magne Espeland for their invaluable comments.

## References

Allen, G., Allen, I., & Dalrymple, L. (1999). Ideology, practice and evaluation: Developing the effectiveness of theater in education. *Research in Drama Education, 4*, 1, 21–36.

Atkinson, D. (2002). *Art in education: Identity and practice*. Dordrecht, Netherlands: Kluwer Academic Publishers.

Belenky, M. F., Clinchy, B. M., Goldberger, N. R., & Tarule, J. M. (1986). *Women's ways of knowing*. New York: Basic Books.

Best, D. (1996). Research in drama and the arts in education: The objective necessity-proving it. In J. Somers (Ed.), *Drama and theater in education: Contemporary research* (pp. 4–23). Canada: Captus Press.

Blomberg, D. G. (1991). The teacher as evaluator. *Curriculum Perspectives, 11*(4), 32–41.

Bolton, G. (1992). *New perspectives on classroom drama*. Hempstead, UK: Simon & Schuster Education.

Bolton, G. (1998). *Acting in classroom drama: A critical analysis*. Birmingham: Trentham Books.

Bolton, G. (2003). *Dorothy Heathcote's story*. Stoke on Trent, UK: Trentham Books.

Bresler, L. (2002). School art as hybrid genre: Institutional contexts for art curriculum. In L. Bresler & C. M. Thompson (Eds.), *The arts in children's lives: Context, culture, and curriculum* (pp. 169–183). Netherlands: Kluwer Academic Publishers.

Brown, S. (1990). Assessment: A changing practice. In T. Horton (Ed.), *Assessment debates* (pp. 5–11). London: Hodder and Stoughton.

Clark, J., & Goode, T. (Eds.). (1999). *Assessing Drama*. London: National Drama Publications.

Cockett, S. (1998). Formative assessment in drama. *Research in Drama Education, 3*(2), 248–250.

Colwell, R. (2004). Evaluation in the arts is sheer madness. *Arts Praxis, 1*, 1–12.

Courtney, R. (1990). *Drama and intelligence cognitive theory*. Montreal: McGill-Queen's University Press.

Davis, D., & Lawrence, C. (1986). *Gavin Bolton: Selected writings*. London: Longman.

Dewey, J. (1934/1980). *Art as experience*. New York: Perigee Books.

Eisner, E. W. (1993). Reshaping assessment in education: Some criteria in search of practice. *Journal of Curriculum Studies, 25*(3), 219–233.

Eisner, E. W. (1995). Standards for American schools: Help or hindrance? *Phi Delta Kappan, 76*(10), 758–764.

Eisner, E. W. (2002). *The arts and the creation of mind*. New Haven, CT: Yale University Press.

Fleming, M. (1994). *Starting drama teaching*. London: David Fulton Publishers.

Fleming, M. (1997). *The Art of drama teaching*. London: David Fulton Publishers.

Gallagher, K., & Booth, D. (Eds.). (2003). *How theater educates: Convergences and counterpoints*. Toronto: University of Toronto Press.

Greene, M. (1995). *Releasing the imagination: Essays on education, the arts, and social change*. San Francisco: Jossey-Bass.

Hancock, A. (1995). Chaos in drama: The metaphors of chaos theory as a way of understanding drama process. *N.A.D.I.E. Journal, 19*(1), 15–26.

Heathcote, D. (1988). The nature of educational drama. In L. Johnson & C. O'Neill (Eds.), *Dorothy heathcote collected writings on education and drama* (pp. 41-42). London: Hutchinson.

Hornbrook, D. (1989). *Education and dramatic art*. Oxford: Basil Blackwell.

Hornbrook, D. (1991). *Education in drama*. London: Falmer Press.

Hubbard, R. S., & Miller P. B. (1993). *The art of classroom inquiry: A handbook for teacher-researchers*. Portsmouth, NH: Heinemann.

Jackson, T. (2002). Between evaluation and research: Theater as an educational tool in museum theater. *Stage of the Art, 15*(1), 1–6.

Kempe, A., & Ashwell, M. (2002). *Progression in secondary drama*. Oxford, UK: Heinemann.

Levy, J. (2001). The vexing question of assessment. In J. Levy (Ed.), *Practical education for the unimaginable: Essays on theater and the liberal arts* (pp. 52–59). Virginia: New Plays.

McGregor, L. (1983). Standards in drama: Some issues. In C. Day & J. L. Norman (Eds.), *Issues in educational drama* (pp. 123–133). London: Falmer Press.

McKone, F. (1997). Engagement and assessment in drama. *Research in Drama Education, 2*(2), 215–216.

Miller, C., & Saxton, J. (2004). Standards: The illusion of comfort. *Arts Praxis, 1*, 38–42.

NAEP (1998). NAEP and theater: Framework, field test, and assessment. *National Center for Education Statistics*. 3, 3. U.S. Department of Education. Office of Educational Research and Improvement.

Neelands, J. (2004a). Miracles are happening: Beyond the rhetoric of transformation in the Western traditions of drama education. *Research in Drama Education, 9*(1), 47–56.

Neelands, J. (2004b). *Beginning drama 11–14*. London: David Fulton.

O'Neill, C. (1983). Context or essence: The place of drama in the curriculum. In C. Day & J. L. Norman (Eds.), *Issues in educational drama* (pp. 25–32). New York: Falmer Press.

O'Neill, C. (1995). *Drama worlds: A framework for process drama*. Portsmouth, NH: Heinemann.

O'Neill, C., & Lambert, A. (1988). *Drama structures*. London: Hutchinson.

O'Toole, J. (1992) *The process of drama*. London: Routledge.

Pearce, G. (2003). "Ehrr ... what's up doc?": Using cartoons tests to evaluate educational drama programmes. *Research in Drama Education, 8*(2), 157–169.

Redington, C. (1983). *Can theater teach?* Oxford: Pergamon Press.

Robinson, K. (1993). Evaluating TIE. In T. Jackson (Ed.), *Learning through theater: New perspectives on theater in education* (pp. 251–265). London: Routledge.

Ross, M., Radnor, H., Mitchell, S., & Bierton, C. (1993). *Assessing achievement in the arts*. Buckingham: Open University Press.

Salazar, L. G. (1996). Act IV: Theater teacher assessment and evaluation. *Arts Education Policy Review, 98*(1), 27–31.

Schonmann, S. (1997). How to recognize dramatic talent when you see it: And then what? *Journal of Aesthetic Education, 31*(4), 7–21.

Schonmann, S. (2000). Theater and drama education: Themes and questions, In B. Moon, S. Brown, & M. Ben-Peretz (Eds.), *Routledge international companion to education* (pp. 944–955). London: Routledge.

Simpson, L. J. (1999). An engaging assessment in early years drama. *Research in Drama Education, 4* (2), 258–264.

Somers, J. (1995). *Drama in the curriculum*. London: Cassell Educational.

Taylor, P. (2000). *The drama classroom: Action, reflection, transformation*. London; Routledge Falmer.

Tyler, R. W. (1950). *Basic principles of curriculum and instruction*. Chicago, IL: University of Chicago Press.

Vernon, M. (1983). A plea for self-evaluation. In C. Day & J. L. Norman (Eds.), *Issues in educational drama* (pp. 135–148). New York: Falmer Press.

Verriour, P. (1994). *In role: Teaching and learning dramatically*. Ontario: Pippin.

Warner, C. (1997). The edging in of engagement: Exploring the nature of engagement in drama. *Research in Drama Education, 2*(1), 21–42.

Weeden, P., Winger, J., & Broadfoot, P. (2002). *Assessment: What's in it for schools?* London: Routledge-Falmer.

Wheetley, K. A. (1996). A discipline-based theater education handbook. In *The Getty Education Institute for the Arts* (The Southeast Center for Education in the Arts.), National Advisory Board Meeting, October 25, 1996. The University of Tennessee at Chattanooga.

Zeus, L. (2004). Theme issue: Disciplinary knowledge and quality education. *Educational Researcher, 33*(5), 3–5.

# INTERLUDE

## 26

# ASSESSMENT AND EVALUATION
# IN EDUCATION AND THE ARTS

**Elliot Eisner**
*Stanford University, U.S.A.*

My aim in this chapter is to explore the meanings and complexities of assessment and evaluation in the arts and education. I have no intention of providing anything like an exhaustive or comprehensive analysis of major issues and complexities, rather, I intend to identify what some of those complexities might be. I start with some basic ideas about assessment. One place to begin is to point out that there is no hard and fast distinction between assessment and evaluation, but there is a tendency to think about assessment as pertaining to judgments about individuals and evaluation as pertaining to appraisals of programs.

The first point that I wish to make is that assessment is both pervasive and inherent in teaching. We have a tendency in conceptualizing practice to make distinctions between curriculum and teaching, and between teaching and learning. Yet, it surely is the case that teaching and curriculum cannot be separated, nor can assessment be separated from evaluation or learning from teaching. Whenever a teacher is engaged making judgments about the appropriateness of content he or she elects to employ, whenever judgments are made about the character and quality of a student's response, whenever a teacher judges the value of what is transpiring in class time, evaluation is taking place. Certainly one cannot be adequately engaged in teaching without also being engaged in an evaluative process. Thus, assessment, as I said, is both pervasive and inherent in teaching.

The second point is that assessment does not require the use of measurement. I cannot count the number of times I have heard discussions of evaluation slip into the assumption that measurement must be the way in which one determines the consequences of what one has taught. It is almost as though measurement and evaluation are thought to be the same. This is hardly the case. One can measure without evaluating, and one can evaluate without measuring. This is not an argument about measuring, it simply is a recognition that evaluation requires making judgments about the *value* of what one is paying attention to. Measurement has to do with the quantitative description of a set of conditions. Most of our evaluation practices both in school and in daily life outside of

*L. Bresler (Ed.), International Handbook of Research in Arts Education*, 423–426.

school have little or nothing to do with measurement. The assumption that it does should be parked where it belongs.

A third problematic belief regarding assessment and evaluation pertains to the often tacit assumption that assessment and evaluation require the use of tests. It should be remembered that tests are basically devices through which one can secure information that could have been secured in other more naturalistic ways. Tests are short hand devices that create artificial conditions that often have little ecological validity for assessing thinking or behavior. The key question regarding the usefulness of tests pertains to the test's predictive or concurrent validity. If test scores are proxies for what people do outside of the test situation, such relationships should be demonstrated before huge amounts of educational significance is assigned to the scores that tests yield. This is seldom done, and for good reason. That reason has to do with the complexity and costliness of making such appraisals.

It should also be remembered that at their best, assessment and evaluation processes are educational tools; they can be used to inform policy and contribute to improved educational practice. This can be done if feedback pertaining to policy issues and teaching practices are, in fact, guided by what assessment and evaluation provide. For example, if it is found that children are reluctant to do what they know how to do, say, to read, a new and more effective approach to reading must be created. In this case evaluation feeds curriculum and teaching. It is not particularly useful to know how to do something and then have no inclination to do it.

It is also well to remember that students learn both more and less than teachers intend. Students learn more than teachers intend because students make connections that no teacher is able to predict. The meaningfulness of learning increases when connections between past and present are drawn. And since the past belongs to the student's history, the teacher is not likely to be able to anticipate beforehand what those connections are likely to be. At the same time, students learn less than teachers intend because they seldom achieve the levels that are held out for them as educational goals. Thus, the paradox: students learn more and less than what teachers intend for them to learn.

Another kind of maxim for evaluators pertains to the idea that good assessors and evaluators recognize that it is important to address outcomes as well as the achievement of intended standards and objectives. Collateral damage and collateral benefits are often very important side effects of policy and practice in schools. An important distinction should be drawn between outcomes and objectives. Objectives are the targets at which one aims. Outcomes are what one secures as a result of action. The latter is often far broader, both positively and negatively, than the former. Good evaluation practices assess the ancillary consequences of practice, "just as" drug companies do and as the military does when it makes an assessment of the battle that one has just fought. Some targets, though achieved, may not be worth the cost of achieving them. Just as this is true in the armed service, it is also true in educational practice.

Finally, sensitive assessment may require not only the use of measurement or letter grades as a form of reporting, but the uses of narrative as well. Each form of representation – number, image, text – possesses its own strengths and limitations with respect to what it can convey. To try to represent phenomena as complex as

student learning with a letter or a number alone may create an inadvertent bias in description. Narratives may tell a fuller story and certainly complemented with quantitative information can broaden our understanding of the consequences of our practices. Good evaluation is typically "multilingual".

The need for what I have called a "multilingual" approach to educational evaluation and assessment is motivated by our propensity to seek simple indicators of academic accomplishment. Objectively scored, multiple choice, high-stakes tests are sources of such simplicity. The idea that education has only one outcome per item is a fundamental mistake. As long as individuals make distinctive sense out of what they study, there will need to be an approach to evaluation that makes it possible for those idiosyncratic meanings to be expressed and taken into account. Otherwise, what one has is a factory model of educational performance in which the end in view is known, the process of achieving it is known (or supposedly so), and the task in evaluation is to determine the extent to which there is an isomorphic relationship between aspiration and consequence. That model might work well on an assembly line. It is not an appropriate model for education, at least for an educational program in which one is interested in cultivating students' productive idiosyncrasies.

Conceptualizing productive idiosyncrasy as an educational goal has much to do with what the arts promote. Such an aspiration frequently flies in the face of the aims of typical assessment programs. Typical assessment programs formulate goals or objectives and try to determine the extent to which the achievement of known objectives are, in fact, attained. With productive idiosyncrasy, commonality of outcome among a population of students is not an aspiration. What is an aspiration in this model is the desire to enable students to do something that is distinctive. Even more than that, its aim is to enable students to do something that is not only distinctive, but is inventive. Put another way, surprise rather than predictability is the aim. This, of course, creates certain problems, or at least challenges, for assessors. As I said, in conventional approaches to assessment and evaluation, known goals (or standards) are specified and, as I have already indicated, the gap between those goals and student performance is measured. The last thing one wants among students is surprise. In the arts, however, surprise is an important feature of artistic work. With surprise, one secures outcomes that one had not anticipated and, hopefully, such achievements are on the positive rather than on the negative side of the ledger. In this sense, those who pursue the arts are typically seeking to work at the edge of incompetence and try to push, as they say, the envelope. As a result, assessors need to make judgments. Such judgments are, of course, fallible as are all judgments. But in the arts a central role is played by invention and imagination. The last thing an excellent teacher of art wants are drawings of 30 yellow ducks sitting in the middle of each paper. What one wants is productive diversity or, as I have called it, productive idiosyncrasy.

The implications of such an aspiration are that assessors must not only state preferences but render judgments. The difference between a preference and a judgment is significant. Preferences are incorrigible. A person can never be wrong in expressing a preference: You like chocolate ice cream, I like vanilla. That's all there is to it. A judgment, however, requires justifications regarding conclusions regarding quality; the person doing the judging must give reasons for claiming that this work is better or worse,

or stronger or weaker, or whatever the adjective might be than the other one or the group as a whole. To give reasons is time consuming and labor intensive, yet I do not see how to get around providing reasons since they are needed to justify one's choices. To say this is a fine piece of work is a judgment, not a preference, and it needs to be a judgment that is grounded in reasons.

Thus the challenge to those who wish to do assessment and evaluation in the arts is to be able to see the qualities that constitute virtue in an art form and to have the articulateness to provide reasons for choices made by the assessor pertaining to quality of work that has been created. This is no small task, but it is a devilishly important one. It is so important and so educationally virtuous that in many ways the orientation to evaluation and assessment I have just described, I believe, ought to serve as a model for what really sophisticated assessment addresses: the use of refined sensibility to notice what is subtle but significant, and the ability to provide reasons for one's appraisal of their worth. That is not a bad model for thinking about how assessment might be made more educationally significant than the check-off forms that now play such a strong role in our typical assessment and evaluation practices.

The task for those who wish to do educational assessment and evaluation is to conceptualize the phenomena with sufficient sensitivity that it does not neglect what is significant yet subtle, and then as a result of such conceptualization, to determine how those conceptualizations play out in practice. It is of little value to have concepts that cannot be acted upon, at least in one way or another. The aim of the enterprise, to paraphrase Karl Marx, is not simply to understand the world, but to improve it.

# 27

# EVALUATION RESEARCH IN VISUAL ARTS EDUCATION

**Folkert Haanstra*** and **Diederik W. Schönau†**

*Amsterdam School of the Arts, The Netherlands;*
† *Dutch National Institute for Educational Measurement-CITO, The Netherlands*

## A Problematic Relationship

When writing about art education and evaluation or assessment it is not unusual to start with mentioning their uneasy (Eisner, 1996), extremely contentious (Allison, 1986) or even overtly hostile (Soep, 2004) relationship. This problematic relationship has a long history. In the child-centered movement that dominated art education in many Western countries in the 1950s and 1960s, art production had a central place and creative self-expression was the main goal. Sequential written curricula and formal assessments of students' progress were rejected. In his influential textbook "Creative and Mental Growth" Lowenfeld states that art "should be the one area in secondary school that youngsters can turn to without the concern for being evaluated ..." (Lowenfeld & Brittain, 1982, p. 413).

Since the mid-1960s Lowenfeld's ideas have been challenged. A cognitive approach in art education rejected the division between the cognitive domain (applying to most school subjects) and the affective domain (applying to the arts). All our mental activities can be considered cognitive and that implies a different view on the art abilities of children and on the goals and curriculum of art education. Despite divergent developments in different countries generally, art education has moved towards more pedagogical formalism derived from discipline-oriented curriculum initiatives (Efland, 1990). In these initiatives art is viewed as a subject with content that can be taught on the basis of sequentially organized goals and curricula. As a result of this assessment of students' results has become more accepted.

Discussions on assessment and evaluation not only are strongly related to the changes in goals and curriculum content but also to the general educational policies of states and nations. In the 1970s the effectiveness of schools was questioned and opposition to the continued rise of educational costs grew. This caused a demand for accountability and a shift from input to evaluation and measuring output in curricular affairs. In many countries national curricula and national standards for subjects,

*L. Bresler (Ed.), International Handbook of Research in Arts Education, 427–442.*
© 2007 *Springer.*

including the art subjects, were developed and as a consequence standardized tests, nationwide final examinations or national assessments in the arts were introduced.

Besides governmental policy, also in art advocacy policy there was a growing need for evaluation studies that could prove the claims that art education is an important instrument to help building the art audiences for tomorrow and the claims that art education has wider academic, social and motivational repercussions. Evaluation and assessment in education have various functions (such as selection, feedback, diagnosis, licensing, achievement of program goals and accountability) and can focus on different subject matter (students' learning, teaching, educational programs and materials, etc.) (e.g., Eisner, 1996). Different functions and subject matter require different evaluation methods. Moreover evaluation and assessment take place in different contexts and at different scale levels (individual, class, school, national, etc.).

In this chapter, we restrict ourselves to research into some functions and aspects of assessment and evaluation. First we consider student assessment of studio art, second we review examples of program evaluation and lastly we treat the evaluation of transfer of art learning.

# Research on Assessment of Studio Work

Making art works (studio work) is central in art education at all school levels. Whatever the goals pursued by either the teacher or the student, it is vital that the results in one way or another be judged and discussed in order to know if the goals have been met, or what learning has taken place. In daily school practice, teachers give feedback to students while they are at work, or they come to general observations and suggestions when the student's work is completed. In most cases this leads to new assignments, and thus the cycle starts again. Assessment in the arts faces problems that are common for most subjects, but they are more pregnant and problematic. Students develop their skills in making studio work, and the results are assessed as part of their learning tasks. Because of this, there is as much variation in assessment tools as there is in instruction. Beattie (1997) presents some 59 assessment strategies that in most cases can also be used as varieties of formal assessment in instruction. But when it comes to systematic research on the best way to assess, the literature is much more limited. In this section some examples will be discussed.

## Portfolio Assessment: An Example from Sweden

A common instrument in studio work assessment is the portfolio. A portfolio can be defined as a purposeful collection of student work that exhibits the student's efforts, progress, and final products. Portfolios can have a formative function in assessment and focus on the learning process and encourage student reflection and self-directed learning. They can also have a summative function and represent a collection of students' best works and documents, recording growth and development toward mastering identified outcomes. Portfolios can be assessed holistically or analytically, that is using explicitly formulated criteria.

In several studies on portfolio assessment Lindström has investigated how studio work can be assessed analytically when concentrating on creative skills (Lindström, 2002). He formulated seven performance criteria: three product criteria (visibility of intention, color, form and composition, and craftsmanship) and four process criteria (investigative work, inventiveness, ability to use models, and the capacity for self-assessment). In a series of investigations in Sweden between 1997 and 1999, studio work by about 500 students, aged 5 to 19 years was assessed on these criteria. The work was made during 10 to 30 lessons, and the portfolio also included logbooks and a videotaped interview with each student. For each criterion four rubrics were formulated that reflected four levels of accomplishment on an ascending scale, from novice level to expert level. For each criterion the different levels were described and an explanation given of its meaning within the framework of creativity studies. To give an example, the second level of the criterion "ability to use models" was described as follows: "The student shows some interest in other people's pictures that she or the teacher has found, but she is content to copy them". For the construction of rubrics, varying from novice to expert level, Lindström (2005) has also used the method of repertory grids, as originating from Kelly (1955). In this method, individuals' mental categorizations of perceived phenomena in the world are systematically investigated. Lindström adapted the method to study how teachers and professional craftspeople discern experts in craft and design from novices.

Judges of visual arts portfolios were asked to not only indicate the rubric which "best fit", but also indicate whether a performance was slightly below, on par or slightly above the average as described. A twelve-grade scale was developed, making it possible to compare students from different school-levels. All portfolios were assessed by the student's own teacher and a teacher at the same grade from another school. When judges differed by only one or two points on the 12-point scale, they were considered to be in agreement. In almost 3,100 comparisons thus made, teachers reached 78% agreement. It was concluded, that it is possible to assess portfolios on creative skills in a satisfactory way, using not only the work itself, but also the information given by the student in a logbook and a short videotaped interview. Statistical analysis showed that all process criteria very much related to one another, while the product criteria also strongly related to one another. Students from age 8 to 15 improve over the years on only two product criteria: "craftsmanship", and "elements and principles" (color, form, and composition). The process criteria (investigative work, inventiveness, ability to use models and capacity for self-assessment show no or minimal growth, which might be explained by an instructional focus in school on products rather than on studio thinking habits.

## Final Examinations: An Example from The Netherlands and Hungary

Another type of assessment studies is research on the reliability of judgment by experts. In the Netherlands the assessment of studio work was studied as part of the introduction of final examinations in the three visual arts disciplines (drawing, handicraft and textile arts) in secondary education at preuniversity level. Here the examination program was designed to challenge and assess students on qualities thought relevant

for studies at university level. From this starting point criteria were developed that underscore aspects like process, independence, communication and research.

It was then necessary to investigate if these criteria could be judged in such a way that this type of exam could be given the status of a national exam. To improve objectivity in assessment, several procedures were compared (Schönau, 1996). The first way was to compare the final marks given independently by art teachers to a collection of works. The judges used a ten-point-scale (with decimals), which is the traditional way of grading in Dutch education. In this research the scores of the student's own teacher and of a teacher from another school were compared. The correlation coefficients floated around 0.68. As the judges have to confer on their marks given, and as in almost 80% of the cases judges disagree by one point or less on a ten-point scale, in practice the final results are in most cases based on agreed judgments and not on an average score.

Next analytic judgment was investigated. Due to the newness of the exercise it was difficult to find common ground on both the exact formulation and the weight given to each criterion used. In the end seven criteria were agreed upon. A fundamental problem was: how does one determine the "true score" of a collection? This was done by asking five art teachers to judge the work independently according to their best experience and insights, and to average their final scores. To know whether analytic judgment generates a better approach of the true score, global judgments, based on first impression, were also made. The results showed, that analytic judgment did not predict the true score better than global judgment.

A third way to improve agreement between judges is to give assignments that are more structured according to predetermined criteria. The research showed that analytic judgments of collections made on a structured assignment do not necessarily result in greater agreement between judges, than traditional assessment on nonstructured tasks.

The Dutch preuniversity exam became a model for reform in Hungarian secondary education. A follow-up study took place in Hungary from 1994 to 1996 (Kárpáti, Zempleni, Verhelst, Veldhuijzen, & Schönau, 1998). It showed that teachers who were trained to judge the work in the experimental situation were more rigorous that the students' own teachers. According to the teachers themselves this could be explained by their growing awareness of the importance of different aspects, in contrast to their earlier interest in what they considered the most important characteristic of the work. This proves the importance of training of judges. It became clear that there are great differences between judges in their strictness and stability, and that these factors are also dependent on the kind of assignment given. Judging work horizontally – all collections are judged first on one criterion, then on the next, etc. – also improved the reliability.

*Arts Performance Testing in the Classroom: Research in the United States*

More recently a large-scale research on students' studio work assessment has been done by Dorn, Madeja, and Sabol (2004). Some 8,000 artworks, made by nearly 1,000 students K-12 from 70 teachers in three different states of the United States were assessed. The main purpose of this research was to show that assessing studio work at school level can be done in a fairly objective way, although the teachers all work independently with no mutual contacts. The criteria were inspired by a topology of

practice as formulated by Howard (1977). It was shown that in judging studio work on these criteria a certain level of reliability can be reached. The criteria used reflect the concern of the researchers: that studio work in the arts has an artistic and visual merit in itself. In this study, special attention was given to the promising use of digital photography and the Internet as tools to collect, communicate and judge examples of studio work in electronic portfolio.

*School Independent Assessment: The Advanced Placement and the International Baccalaureat*

Systematic research on the assessment of studio work was done for the Advance Placement program (AP) in the United States and in the International Baccalaureate (IB). In both programs judges are trained by using visual examples of work reflecting specified levels of competency.

The AP is preparing for entrance to academies, which makes this a more selective and "artistic" program. Because of the selective character the assessment originally used three-point scales on a limited set of general criteria. Over time the scales have been refined into six-point scales. As the results have to be predictive of future success, the requirements of the academies have influenced the character and formulation of the criteria used. The AP has been made more objective by introducing a yearly intensive group training of judges which has resulted in a greater reliability among judges' scores (Myford & Sims-Gunzenhauser, 2004).

The IB is a final examination program used by schools worldwide. More recently emphasis is laid upon the working process and the students' intellectual pathways, but also on the freedom to connect oneself to specific art traditions all over the world. Boughton (2004) underscores this choice by the development of postmodern views on art and art education, leaving much more space in the individual choices and the use of non-Western and nontraditional expression of visual culture. The use of predefined criteria with fixed weights, has therefore made way for a combination of a holistic appraisal by the judge and a more detailed negotiated assessment between student and his art teacher. The international character of the IB also introduced the use of uncommented visual benchmarks on the IB Website. This makes it possible to both inform students but also to calibrate judges all over the world.

# Research on the Quality of Art Instruction at a National Level

## National Assessment of Educational Progress (NAEP)

Individual student assessment is normally related to specified instructional goals, either by the teacher, the researcher or a national examination body. When we wish to know more about the results outside this context, it becomes more difficult to make informed comparisons. This is particularly the case in national assessment projects, where the "level" of proficiency of students at a specified age is measured nationwide.

The best known examples are the three NAEP studies that have been conducted in the United States in 1975, 1978, and 1997 (Myford & Sims-Gunzenhauser, 2004; Persky, 2004). The research designs and the content investigated very much reflect the theories and practices of the moment when these assessments took place. Actually this makes it almost impossible to compare the results at all. In 1997 students were given a combination of questions on an art work presented to them, and a two-dimensional creating task in which students had to elaborate on the art work investigated. Next to this a three-dimensional assignment was given. The assessment was done by trained judges outside the school where the work was made. Several approaches of scoring were used, varying form analytic to holistic. It turned out that a more holistic approach is more in line with what a student is also doing in practice.

## Dutch National Assessment

In the Netherlands there is an ongoing research project into the quality of education, known by its acronym PPON. This research concentrates on the last year of primary and special education, when pupils are aged 11 to 12 years. A problem in assessing the visual arts (Hermans, Schoot, Sluijter, & Verhelst, 2001) was to find studio work that was an honest reflection of work made in schools. Instead of collecting a great array of studio work produced by students according to whatever assignment the teachers had given, this research used work that was made based on three centrally given drawing assignments. These assignments reflected the three domains that are traditionally discerned in Dutch art education (and in many art curricula throughout the world): making work based on fantasy, memories or ideas, work based on direct observation and work made according to design-based specification and with a practical purpose. All three assignments were made by some 1,000 pupils from around 100 schools, representative of all school types in primary education.

A series of 30 criteria was formulated by a group of art teachers from second level education who teach children in the first grade of secondary school, aged 12 to 13. The criteria formulated were intended to represent the most common and relevant comments normally given when judging work of students, like "This drawing shows a good command of materials and technique", or: "This drawing shows a coherent representation of space." To make the assessment more objective and reliable, a series of scaled visual examples was constructed for each assignment. From each of the three series of about 1000 drawings made, 24 examples were selected at random. To these four more drawings were added for each assignment, chosen by experts, and representing the extremes of the continuum: "very poor" and "excellent". The example drawings were scored on the criteria by 20 judges and through statistical analysis it was possible to construct an interval scale for each assignment. The actual judgment of the 3000 collections was done by 12 art teachers/judges by putting each work on the "best fitting" position on the visual scale.

The outcomes showed that on all three assignments the majority of the work was below the centre of the scale. The skewed distribution of results is difficult to explain, as it is not known how evenly the quality of instructional level is distributed on

a national level, nor how much time a student has devoted to drawing during the eight preceding years in school.

The differences between the US NAEP and the Dutch PPON reflect some of the fundamental problems of nationwide comparisons over time. First there is the issue of changing visions on the purpose and character of visual art education. Second there is a difference between convergent vs. divergent assignments. Third there is the validity of the assessment criteria used. How much do these criteria reflect what is actually and purposefully taught? And finally how stable are these assessments over time, also taking into consideration the social and cultural changes that take place in modern societies? A study by Bevers (2005) illustrates the culture-based content of art examinations. He compared secondary school exams in music and art history/art criticism in the period 1990 to 2004 in four countries: France, Germany, England, and The Netherlands. His question is whether a national canon of the cultural past is still present in these examinations or whether this canon is being replaced by a contemporary global culture. In France and Germany, and to a lesser degree England, their national canon from the past still dominates the exams. In The Netherlands a larger part of the examinations is devoted to art from different countries. Moreover the Dutch exams pay much more attention to contemporary art and popular art. Bevers concludes that a small country is inclined to follow the cultural centers of the world, and to emphasize and to join what is new instead of nourishing its own cultural past.

# Program Evaluation

The goal of most program evaluations is to influence decision making or policy formulation through the provision of empiricism-driven feedback. In the quantitative, objectives-based evaluation research the purpose is to measure the effects of a program against the goals it sets out to accomplish. On the other hand there are more qualitative and participant oriented evaluation strategies. These include various naturalistic forms of evaluation, using rich descriptions and emphasizing the value of subjective human interpretation of the observations made. A major exemplar is Eisner's Connoisseurship Model (1979), based on principles borrowed from art criticism, claiming that the evaluator's background must include the ability to appreciate (perceive and criticize) at an expert's level. So-called "responsive models" (e.g., Guba & Lincoln, 1989; Stake, 1975) focus on the claims, concerns, and issues of a variety of potential stakeholders. These evaluation approaches draw attention to detail of activities of the program in their special contexts, responding to the issues and values of the people close at hand.

## *Large Scale Program Evaluation*

These different strategies can be demonstrated in the evaluation studies of art programs as well. An example is the large scale evaluation of six Regional Institute Grant (RIG) programs that implemented the Discipline Based Art Education curriculum reform by the Getty Institute (Wilson, 1997). In this study the evaluators employed a responsive approach. Responses to the evaluative reports were discussed at length with

Getty Educational Institute officers, program directors, faculty members, museum educators, and participants. The evaluative reports look much like Eisner's educational criticism: "the RIG programs are texts to be interpreted and evaluated. Members of the evaluation team see events and documents as signs that point to conceptions of art and education. Questions that are asked include, What is going on here? What does it mean? Does it have merit? Does it reflect a disciplined approach to the study and creation of art? ..." (Wilson, 1997, p. 33). The evaluation study was carried out by a team of evaluators spanning 7 years. In addition to particular findings on the six institutes, the final report includes general conclusions on the contribution of art to the vitalization of education and on the conditions that make educational reform efforts effective.

Another example of a large scale program evaluation is the 3-year study by Harland, Kinder, Lord, Stott, Schagen, and Haynes (2000). This evaluation study set out to investigate the range of outcomes attributable to art education in British secondary schools and examine the key factors and processes that may bring about these effects, including the portrayal of effective practices. The evaluators took a more external position than in the Getty evaluation and quantitative data played a bigger role. The research does not seek to make judgments about the relative desirability of different effects or outcomes of arts education. Instead, "it attempts to examine effective practice without attributing value judgments to the merits of the observed outcomes" (p. 17). The evaluation study collected data through case studies of five secondary schools. These included annual interviews with school managers and arts teachers, and video observations of arts lessons. Other data include questionnaires to year 11 pupils, secondary analyses of data on pupils from 152 schools of year 11 pupils taking GCSEs. Pupils' perceptions of effects were elicited through direct and focused questioning about outcomes. Different types of outcomes were identified. They include effects on pupils as well as effects on schools, communities and the arts. The effects on pupils include artform knowledge and skills, intrinsic and immediate effects (forms of enjoyment and therapy), knowledge in the social and cultural domains, creativity and thinking skills, communication and expressive skills, personal and social development.

Nagel, Ganzeboom, Haanstra, and Oud (1997) studied the long term effects of the examination programs in visual arts and music in The Netherlands. The effects of the programs on the cultural participation in later life were studied in a quantitative manner (see next section on transfer). Long term effects were also studied in a qualitative manner by the written reports of former students on their learning experiences. In these so called learner reports students write their own "learning effect sentences" of the type "I have learned that ..." and "I have learned how to ..." and also statements about the self in the form of: "I have learned that I ..." It is important that learning should not be used in a strict sense, but that students are encouraged to use sentences like: "I have discovered that I ..."; "I have experienced that I ..." etc. The learner report is worthwhile for explorative and heuristic aims and especially provides insight on outcomes concerning personal development and what Harland et al. (2000) call "forms of enjoyment and therapy".

*Evaluation of Curriculum Units*

Large scale and longitudinal program evaluation studies are scarce. There are however a large number of short-term evaluation studies investigating the effectiveness of particular

curriculum units on artistic production (e.g., Brewer, 1991, 2002; Dowell, 1990) and on understanding art (e.g., Short, 1998). Part of these evaluations involve quasi-experimental studies comparing outcomes of different teaching strategies or different curriculum contents. Haanstra (1994) collected 39 studies that evaluated the effects of art education programs on aesthetic perception, which he described as the informed perception of art: the awareness of aesthetic characteristics of art objects. This awareness of the aesthetic characteristics can be demonstrated by instruments such as preference and judgment tests as well as different kinds of verbal reports. Verbal reports often contain descriptions, interpretations, and evaluations of art works. Measures involve the classification of verbal responses to specific prior categorizations. The results of the studies indicated that the combination of studio art and the study of art works, rather than a purely theoretical approach, proved to be the most effective form of instruction with respect to aesthetic perception.

The studies were published between 1960 and 1990. The instructional methods, as well as the educational content of the collected studies, reflect some of the main concerns in art education of that period. Studio lessons focused on formal elements and principles of design and, to a lesser degree, on representational and expressive features. The primary objects of art criticism instruction were Western paintings, as well as emphasis on the analysis of the "internal" features (mimetic, formal, expressive) characteristics of art works. In part of the recent art curricula the focus has shifted to the complexity of relations between the art work and its historical, social, and philosophical context. Consequently, evaluation studies on art understanding try to investigate students' interpretative abilities in relation to current aesthetic and art historical theories. These studies search for new categories and new criteria for analyzing verbal responses to art. Examples are an evaluation of viewing and writing about an art work presented to students with other works of art in different contexts (Koroscik, Short, Stavropoulus, & Fortin, 1992), and a study on the effectiveness of a curriculum built around the concept of the "artworld" (Erickson, 2002).

According to Duncum (2001), Freedman (2003) and others the new domain of art education is visual culture. Visual culture refers to the totality of human designed images and artifacts. Visual culture curricula try to promote critical inquiry and interdisciplinary exploration of visual culture through postmodern interpretive approaches. Visual culture has led to new art programs and to many debates pro and contra, but until now no systematic evaluation research on the visual culture programs nor studies comparing more traditional art programs with visual culture have been carried out.

# Evaluation of Transfer of Art Learning

Transfer of learning, which is the application of learning to both similar and new situations, contexts and domains is what we aim for in education (Haskell, 2001). An issue for cultural policy is the transfer of art learning to situations outside school in later life. Arts education is thought to be one of the important instruments to promote cultural participation in later life. Another kind of transfer concerns the application of art learning in non- art related domains. How have these transfer effects been evaluated and have these studies led to definite answers?

## Long Term Effects on Cultural Consumption

It seems plausible that people become more actively involved in visual arts and become more active museum visitors as a consequence of art education. However according to some sociological theories (e.g., Bourdieu & Passeron, 1979) school-based instruction has little or no independent positive effect on adult participation in the "high status" arts such as museum attendance, the latter being primary the result of the cultural recourses of the family and of the socialization experiences provided through those recourses. At most, school could compensate partially for the initial disadvantage of those who did not receive in their family environment any encouragement of cultural practice. This means that evaluation studies on this topic have to take into account the family socialization in the arts.

In the United States two evaluation studies (Bergonzi & Smith, 1996; Kracman, 1996) compare the effectiveness of school-based lessons and arts lessons received in the community (outside school). The studies are based on data from the 1992 Survey of Public Participation in the Arts (SPPA92). Data are representative of the population of the United States with respect to age, race and gender. Participation in the arts activities included in the survey can be considered as either consumptive (attendance and media-accessed arts participation) or productive (performance, creating) in nature. The survey also included questions on the number and type of arts classes taken. To answer their research questions, Bergonzi and Smith (1996) created several art education indexes. An important conclusion is that except for performance arts for almost every type of arts education the more one received of both school- and community-based arts education, the more one participated in the arts as an adult, either through consumption or creation (drawing, painting, writing, composing). Arts education had a stronger impact than did overall educational attainment, even after taking personal background and socioeconomic status into account.

Kracman (1996) studied the effect of art instruction on art consumption, not on art production. She concludes that school-based instruction in the arts does have a significant, independent positive effect on probabilities of adult museum attendance, even though subjects who were provided with childhood lessons in the arts outside of school are slightly more likely to be adult museum attendees. By "independent" effect Kracman means that effects of race, gender, educational attainment of the subject as well as parents educational level have been taken into account. Not surprisingly these variables are also related to cultural participation as well as to taking art lessons.

The SPPA92 data on which both studies are based, have some restrictions. First of all the data on arts education are so-called retrospective data. Respondents have to report on their art education in their youth and there is the danger of selective memory. Perhaps those who have a positive attitude towards the arts remember their art classes better than those who have (and never had) much interest in the arts. Second there is no information on the content or the quality of the arts lessons. And third in many cases the art lessons are not obligatory. In fact Kracman demonstrates that the probability of taking childhood lessons, in or outside school, is strongly affected by race, gender and family background, as indicated by parents' education. As stated before, it is important to take into account the family background of the students. Both studies

try to do this, but in the SPPA data the parental socialization in the arts is imperfectly captured by the educational level of the parents. One would expect that the cultural participation of the parents themselves is a more adequate indication in this respect.

Nagel, Ganzeboom, Haanstra, and Oud (1997) studied the effects of art education in secondary school on the cultural participation of Dutch students 10 to 20 years after leaving school. They conclude that cultural participation in childhood and parental socialization are more important determinants of later cultural participation than art education in school. The same conclusion holds for a study that evaluated the first years of implementation of a new arts subject and studied its effects on cultural partic- ipation (Ganzeboom, Haanstra, Nagel, & Damen, 2003). Attendance of cultural activ- ities (exhibitions, films, concerts, theater performances, etc.) is the core of this new subject, which students take when they are about 16 years old. One of the goals of the subject is to stimulate the cultural interest and the cultural activities of the Dutch youth. In a period of five years the researchers collected longitudinal data from about 1,900 students at 72 secondary schools throughout the Netherlands. Students answered questions about their consumption of traditional arts (represented by museum, theater, cabaret, ballet, and classical concerts), popular arts (attendance of cinema, popcon- certs and dj-/vj-events), and also about their attitude towards art and their opinion on several aspects of the new subject. Parents of the students were questioned about cul- tural participation and teachers were interviewed about their experiences with the new subject. The final data of the study show that while taking the new subject students do indeed participate more in high culture as well as in popular culture than other sec- ondary school students. However, no effects on cultural consumption are shown after 2 years or more. Of the control variables the cultural consumption of the parents turns out to be most important: students whose parents actively participate in cultural activ- ities, do participate more in culture.

The four evaluation studies into effects of art education on cultural participation in later life differ in the kind of data collected, the research methods used and in the con- clusions drawn. The American studies are more optimistic about the effectiveness of school-based art instruction, but this is partly due to methodological limitations. These studies tend to overestimate the effect of art education because they do not sufficiently control cultural socialization in the parental family.

## *Transfer from Art Education to Non-art Outcomes*

Within the arts education research there is a rich tradition of evaluation of cognitive transfer from arts learning to non-arts learning such as general academic attainment, spatial ability, or creative thinking. But also non-art outcomes as perceptual motor skills, self-concept, self-esteem, and social adjustment have been studied. Some well- known examples are a study on the impact of high-arts-involvement on academic suc- cess (Catterall, Chapleau, & Iwanaga, 1999) and a study comparing high-arts involvement and low-arts-involvement on such variables as creativity, self concept and personal traits (Burton, Horowitz, & Abeles, 2000). Besides these studies that are gen- erally psychological in nature, there are studies examining more sociologically based variables such as improvement of social cohesion or employment opportunities

through the arts (e.g., Newman, Curtis, & Stephens, 2003). These evaluation studies play an important role in art education advocacy campaigns. However single studies have limited generalizability and often a body of effect studies on a particular topic show contradictory findings. Informal narrative reviews of study outcomes cannot cope with this problem, but meta-analysis has been put forward as a more systematic and more sophisticated way of research synthesis. Meta-analysis is not a single method but rather a group of methods for integrating research findings in a quantitative manner (Cooper & Hedges, 1994).

Haanstra (1994) conducted a meta-analysis of visual arts education effects on visual spatial ability. A literature search produced 30 relevant experimental studies published between 1960 and 1990. No generalizable education effect on visual-spatial ability was found. Training effects on visual-spatial abilities were only demonstrated among children of 4 to 6 years old. The successful art programs involved explicit visual-perceptual training through structured exercises (sorting, matching, copying, etc.).

The best known example of meta-analysis of transfer studies in arts education is REAP: Reviewing Education and the Arts Project (Winner & Hetland, 2000). The project involved ten meta-analytic reviews of the effects on non-arts cognition from instruction in various art forms. Only three meta-analyses demonstrate generalizable, causal relationships: classroom drama and verbal achievement, music listening and spatial reasoning and music learning and spatial reasoning. There was no support for the claim that the visual arts enhance reading. Nor was there support for the claims that arts-rich education (including the visual arts) leads to higher verbal and mathematical achievement or to critical and creative thinking outside the arts.

Critical links, a compendium of studies of academic and social effects of learning in the arts (Deasy, 2002) also shows that compared to drama and music there are few convincing transfer studies in the visual arts. In the epilogue of Critical links, Catterall (2002) suggests that we should follow Bransford and Schwartz (1999) proposal and instead of looking for immediate tests of application, transfer studies should aim at longer-term impacts on thinking skills and problem-solving dispositions. Catterall further states that studying only one-way effects is too limited and that transfer often implies reciprocal processes involving interactions among domains and disciplines. These kinds of interactions are studied in research concerning the effects of curricula integrating art and other subjects (e.g., DeMoss, 2005; Trainin, Andrzejczak, & Poldberg, 2005).

Various authors (Eisner, 2002; Perkins, 2001; Winner & Hetland, 2000) stress that in future theory-driven and more rigorous research is needed. Many transfer studies use nonrandomly selected groups, short treatments of unknown quality and use inadequate measures to operationalize effects. Eisner (2002, p. 220) describes the kind of conventional experimental study it would take to get the evidence that would provide credible support for claims about transfer. It is also recommended that we need to shift our focus to more reasonable "bridges" between specific art and specific subject matters. Instead of expecting improvement of more basic level skills measured by standardized paper-and-pencil tests of spelling, spatial ability, etc. it is more plausible to expect improvement of more arts-appropriate higher order cognition (reflection, critical thinking, ability to tolerate ambiguity). A possible example in

this respect is the evaluation of an art-viewing program by Housen (2001). This program, called visual thinking strategy (VTS), was designed to develop aesthetic understanding: the range of thoughts and feelings that occur when looking at art. In a controlled experiment which lasted five years Housen implemented the VTS curriculum and observed experimental and control students. The two principal instruments used were the Aesthetic Development interview and the Material Object interview, which was specially developed to assess transfer. In this nondirective interview the subject is asked to comment on an object. These interviews are transcribed and coded according to certain predetermined categories. Results of the study indicate that it is possible to develop critical thinking skills through VTS and that such skills transfer to other subjects. Tishman, MacCillivary, and Palmer (1999) come to similar conclusions in their evaluation of the VTS program in the Museum of Modern Art [MoMa].

It can be expected that evaluation studies of transfer of art learning will become more sophisticated over time. However, as far as policy implications are concerned, it is our opinion that instrumental reasons such as transfer to extra-artistic outcomes should never be the core justification for arts education; rather, learning in and through the arts is highly valuable in its own right.

## Conclusion

Both pedagogical and political arguments in favor of student assessment and program evaluation in art education have been put forward and in the last decades a wide range of methodologies has been developed. They concern authentic assessment of studio art through portfolios as well as nationwide standardized examinations and national assessments. More is known about relevant judgment criteria used and how to improve the reliability of judgments. Evaluation research has also shed light on the impact of art education programs on students, schools and communities as well as the possibilities and limits of transfer from art education to non-art outcomes.

However the debate on assessment and evaluation in art has never ended. Many questions concerning the validity of assessments have not been solved and the interpretation of outcomes between different moments in time and between different countries is problematic. For many art teachers the artistic process remains associated with emotions, unpredictability, and individual quality whereas assessment and evaluation stand for rationality, predictability and quantification. And despite adaptations, national standards and standardized examination are criticized because of their restrictive impact on art instruction. Moreover, the modernist Western art is challenged by postmodernism, non Western art movements and the use of new technologies (especially in popular art). These developments in art unsettle the conceptions on which many student assessments are based. Partly because of their continuing problematic relationship, alternative ways of evaluation will be developed that try to do justice to learning in the art domain. This makes evaluation in art education an interesting and sometimes innovative field in evaluation methodology.

# References

Allison, B. (1986). Some aspects of assessment in art and design education. In M. Ross (Ed.), *Assessment in arts education: A necessary discipline or a loss of happiness?* (pp. 113–129). Oxford: Pergamon Press.

Beattie, D. K. (1997). *Assessment in art education.* Worcester: Davies Publications.

Bergonzi, L., & Smith, J. (1996). *Effects of arts education on the participation in the arts.* Research Division Report 36. Santa Anna CA: National Endowment for the Arts, Seven Locks Press.

Bevers, T. (2005). Cultural education and the canon: A comparative analysis of the content of secondary school exams for music and art in England, France, Germany, and the Netherlands, 1990–2004. *Poetics, 33*(5–6), 388–416.

Boughton, D. (2004). Assessing art learning in changing contexts: High-stakes accountability, international standards and changing conceptions of artistic Development. In E. W. Eisner & M. D. Day (Eds.), *Handbook of research and policy in art education* (pp. 585–605). New Jersey, London: Lawrence Erlbaum Publishers.

Bourdieu, P., & Passeron, J.-C. (1979). *Reproduction in education, society and culture.* London: Sage.

Bransford, J. D., & Schwartz, D. L. (1999). Rethinking transfer: A simple proposal with multiple solutions. *Review of Research in Education, 20,* 61–100.

Brewer, T. M. (1991). An examination of two approaches to ceramics instruction in elementary education. *Studies in Art Education, 32*(4), 196–206.

Brewer, T. M. (2002). An examination of intrinsic and instrumental instruction in art education. *Studies in Art Education, 43*(4), 354–372.

Burton, J. M., Horowitz, R., & Abeles, H. (2000). Learning in and through the arts: The question of transfer. *Studies is Art Education, 41*(3), 228–257.

Catterall, J. (2002). The arts and the transfer of learning. In R. Deasy (Ed.), *Critical links: Learning in the arts and student academic and social development* (pp. 151–157). Washington, DC: Arts Education Partnership.

Catterall, J. S., Chapleau, R., & Iwanaga, J. (1999). Involvement in the arts and human development: General involvement and intensive involvement in music and theatre arts. In E. Fiske (Ed.), *Champions of change: The impact of the arts on learning* (pp. 1–18). The Arts Education Partnership and The President's Committee on the Arts and the Humanities.

Cooper, H., & Hedges, L.V. (Eds.). (1994). *The handbook of research synthesis.* New York: Russell Sage.

Deasy, R. (Ed.). (2002). *Critical links: Learning in the arts and student academic and social development.* Washington, DC: Arts Education Partnership.

DeMoss, K. (2005). How arts integration supports student learning: Evidence from students in Chicago's CAPE partnership schools. *Arts and Learning Research Journal, 21,* 91–117.

Dorn, Ch., Madeja, S., & Sabol, F. R. (2004). *Assessing expressive learning: A practical guide for teacher-directed authentic assessment in K-12 visual arts education.* Mahwah, NJ: Lawrence Erlbaum Associates.

Dowell, M. L. (1990). Effects of visual referents upon representational drawing of the human figure. *Studies in Art Education, 31*(2), 78–85.

Duncum, P. (2001). Visual culture: Developments, definitions, and directions for art education. *Studies in Art Education, 42*(2), 101–112.

Efland, A. (1990). *A history of art education: Intellectual and social currents in teaching the visual arts.* New York: Teachers College Press.

Eisner, E. W. (1979). *The educational imagination: On the design and evaluation of school programs.* New York: Macmillan publishing Co.

Eisner, E. W. (1996). Overview of evaluation and assessment: conceptions in search of practice. In D. Boughton, E. W. Eisner, & J. Ligtvoet (Eds.), *Evaluating and assessing the visual arts in education: International perspectives* (pp. 1–16). New York: Teachers College Press.

Eisner, E. W. (2002). *The arts and the creation of mind.* New Haven: Yale University Press.

Erickson, M. (2002). Teaching about artworlds: A collaborative research project. In M. Ericson & B. Young (Eds.), *Multicultural artworlds: Enduring, evolving and overlapping traditions* (pp. 33–39). Reston, VA: National Art Education Association.

Freedman, K. (2003). *Teaching visual culture: Curriculum, aesthetics, and the social life of art.* New York and London: Teachers College Press and Reston, VA: National Art Education Association.

Ganzeboom, H., Haanstra, F., Damen, M., & Nagel, I. (2003). *Momentopnames CKV1 – Eindrapportage CKV1-Volgproject.* Cultuur+Educatie 8. Utrecht: Cultuurnetwerk Nederland.

Guba, E. G., & Lincoln, Y. S. (1989). *Fourth generation evaluation.* Newbury Park: Sage.

Haanstra, F. (1994). *Effects of art education on visual-spatial ability and aesthetic perception: Two meta-analyses.* Amsterdam: Thesis Publishers.

Harland, J., Kinder, K., Lord, P., Stott, A., Schagen, I., & Haynes, J. (2000). *Arts education in secondary schools: Effects and effectiveness.* York, UK: National Foundation for educational Research.

Haskell, R. E. (2001). *Transfer of learning: Cognition, instruction, and reasoning.* San Diego, CA: Academic Press.

Hermans, P., van der Schoot, F., Sluijter, C., & Verhelst, N. (2001). *Balans van de peiling beeldende vorming aan het einde van de basisschool 2. Uitkomsten van de tweede peiling in 1996* [National assessment of visual arts education: Outcomes of the second assessment in 1996]. Arnhem: Citogroep.

Housen, A. (2001). Aesthetic thought, critical thinking and transfer. *Arts and Learning Research Journal, 18*(1), 99–131.

Howard, V. (1977). Artistic practice and skills. In D. Perkins & B. Leondar (Eds.), *The arts and cognition* (pp. 208–240). Baltimore: Johns Hopkins University.

Kárpáti, A., Zempleni, A., Verhelst, N. D., Veldhuijzen, N. A., & Schönau. D. W. (1998). Expert agreement in judging art projects – A myth or reality? *Studies in Educational Evaluation, 24*(4), 385–404.

Kelly, G. A. (1955). *The Psychology of Personal Constructs.* New York: Norton.

Koroscik, J. S., Short, G., Stravropoulus, C., & Fortin, S. (1992). Frameworks for understanding arts: The function of comparative art contexts and verbal cues. *Studies in Art Education, 33*(3), 154–164.

Kracman, K. (1996). The effect of school-based art instruction on attendance at museums and the performing arts. *Poetics, 24*, 203–218.

Lindström, L. (2002). Criteria for assessing students' creative skills in the visual arts: A teacher's manual. In *Conference report of a must or a-muse, arts and culture in education: policy and practice in Europe, Rotterdam, The Netherlands, September 26–29, 2001* (pp. 175–189). Utrecht: Cultuurnetwerk.

Lindström, L. (2005). Novice or expert? Conceptions of competence in metalwork. In L. Lindström (Ed.), *Technology Education in New Perspectives* (pp. 61–83). Stockholm: Stockholm Institute of Education Press (HLS Förlag).

Lowenfeld, V., & Brittain, W. L. (1982). *Creative and mental growth* (7th ed.). New York: Macmillan.

Myford, C. M., & Sims-Gunzenhauser, A. (2004). The evolution of large-scale assessment of program in the visual arts. In E. W. Eisner & M. D. Day (Eds.), *Handbook of research and policy in art education* (pp. 637–666). New Jersey, London: Lawrence Erlbaum Publishers.

Nagel, I., Ganzeboom, H., Haanstra, F., & Oud, W. (1997). *Effecten van kunsteducatie in het voortgezet onderwijs* [Effects of art education in secondary education]. SCO Rapport 452. Amsterdam: SCO-Kohnstamm Instituut.

Newman, T., Curtis, K., & Stephens, J. (2003). Do community-based arts projects result in social gains? A review of the literature. *Community Development Journal, 38*(4), 310–322.

Perkins, D. (2001). Embracing Babel: The prospects of instrumental uses of the arts in education. In E. Winner & L. Hetland (Eds.), *Beyond the soundbite: arts education and academic outcomes* (pp. 117–124). Los Angeles, CA: J. Paul Getty Trust.

Persky, H. (2004). The NAEP arts assessment: pushing the boundaries of large-scale performance assessment. In E. W. Eisner & M. D. Day (Eds.), *Handbook of research and policy in art education* (pp. 607–635). New Jersey, London: Lawrence Erlbaum Publishers.

Schönau, D. W. (1996). Nationwide assessment of studio work in the visual arts: actual practice and research in the Netherlands. In D. Boughton, E. W. Eisner, & J. Ligtvoet (Eds.), *Evaluating and assessing the visual arts in education* (pp. 156–175). New York: Teachers College.

Short, G. (1998). The highschool studio curriculum and art understanding: An examination. *Studies in Art Education, 39*(3), 154–169.

Stake, R. E. (1975). *Evaluating the arts in education.* Columbus, Ohio: Charles Merill Publishing Co.

Soep, E. (2004). Assessment and visual arts education. In E. W. Eisner & M. D. Day (Eds), *Handbook of research and policy in art education* (pp. 579–583). New Jersey, London: Lawrence Erlbaum Publishers.

Tishman, S., MacCillivary, D., & Palmer, P. (1999). *Investigating the educational impact and potential of the Museum of Modern's Art visual thinking curriculum: Final report.* Unpublished manuscript. Harvard Project Zero.

Trainin, G., Andrzejczak, N., & Poldberg, M. (2005). Visual arts and writing: A mutually beneficial relationship. *Arts and Learning Research Journal 21*, 139–155.

Wilson, B. (1997). *The quiet evolution: Changing the face of arts education.* Los Angeles, CA: The Getty Center for Education in the Arts.

Winner, E., & Hetland, L. (Eds.). (2000). The arts and academic achievement: What the evidence shows. *Journal of Aesthetic Education, 34* (3/4).

# INTERNATIONAL COMMENTARY

# 27.1

## Assessment and Professional Development

**Lars Lindström**
*Stockholm Institute of Education, Sweden*

As a result of the potential importance of the final exams for the life career of students, the work is often judged not only by the student's teacher but by a colleague from another school as well. "This procedure," says Diederik Schönau, one of the architects of the Central Practical Examination (CPE) in the Netherlands, "in combination with the obligation to visit other schools and to discuss the quality of studio work with unacquainted colleagues, has made the experimental examination of studio work in the Netherlands a success" (Schönau, 1996, p. 164). Teresa Eça (2005) reports on similar findings from an experiment in Portugal, using portfolios for art external assessment at the end of secondary education (age 17+). The new assessment procedures developed "communities of assessors". These enabled increased consistency of examination results and positive professional development opportunities.

The successful use of the community of art teachers as an arbiter of quality, may have major implications for how we look upon standard setting and staff development in general (Boughton, 1997). In countries such as the United Kingdom, the Netherlands, Australia, and New Zealand, community moderated procedures of judging studio art have been established at the upper secondary level. However, similar procedures can be used at lower levels in school, too. Defining and interpreting criteria for quality, examining samples of work and setting standards are, after all, procedures used not only in the wider "art world" but in any genuine profession.

However, describing criteria for quality is no easy task. Donald Schön (1987) noted that "not only in artistic judgment but in all our ordinary judgments of the qualities of things, we recognize and describe deviations from a norm very much more clearly than we can describe the norm itself" (pp. 23–24). One implication of this observation is that in order to define criteria and achievement levels, teachers should be given the opportunity to compare a set of portfolios of varying quality.

In a study by Lindström (2005), a comparative approach, called Repertory Grids, was applied to articulate implicit criteria used by teacher educators and professional craftspeople to assess craft-and-design portfolios, consisting of final products,

*L. Bresler (Ed.), International Handbook of Research in Arts Education*, 443–444.
© 2007 *Springer.*

sketches, and interviews about the working procedure. The criteria used by these assessors were categorized in five themes. Three of these distinguish the expert from the novice by properties of the working process (idea and design; realization; evaluation); the other two were articulated in the assessment of the final product (craft; form). Two additional themes (function, utility) appeared in the interviews, but merely descriptively and not as a means of discerning expert ability from that of a novice.

Large similarities were found in the way that teacher educators and the artisan assessed craft portfolios (Lindström, 2005). However, the craftsperson tended to be more product-oriented, while the teacher educators were more process-oriented. This discrepancy is important to keep in mind when discussing the relationship between formal education and the world of work. Ambitions to make education more "authentic" or "real", if carried too far, can reduce the freedom and tolerance for failures that are required in order to foster lifelong learning. With too much autonomy, on the other hand, learning will become disconnected from the everyday contexts in which people live and work. In defining criteria of quality, a decision has to be taken on the relevance of social contexts and cultures of learning that education should prepare for.

Portfolio assessment as a vehicle in professional development can be applied in a more or less formalized way, from the strictly regulated collegial systems used in national exams to an informal "portfolio culture" developed at an individual school. The latter may imply that teachers, within or across subject areas, take turns in bringing a few student portfolios (representing, for example, diverse achievement levels or kinds of assignments) to staff meetings, in order to discuss their qualities and get feedback on how they should be assessed.

For the less experienced trainees, participation in such discussions will help them to decode what is often called the "tacit knowledge" of the profession, or "knowledge by familiarity". But the more experienced teacher will profit as well, since teachers typically conduct most assessment of students' work alone in the art room. These unchallenged and apparently "subjective" judgments are sometimes questioned by those outside the field. A greater openness about criteria and how these are applied will not only sharpen the eye of the individual teacher but also raise the status of the profession in its relation to the outside world (students, parents, school administration, etc.).

# References

Boughton, D. (1997). Reconsidering issues of assessment and achievement standards in art education. *Studies in Art Education, 38*(4), 199–213.

Eça, T. (2005). Using portfolios for external assessment: An experiment in Portugal. *International Journal of Art & Design Education, 24*(2), 209–218.

Lindström, L. (2005). Novice or expert? Conceptions of competence in metalwork. In *Technology Education in New Perspectives* (pp. 61–83). Stockholm: Stockholm Institute of Education Press (HLS Förlag) (SLOC 14).

Schön, D. A. (1987). *Educating the reflective practitioner: Toward a new design for teaching and learning in the professions.* San Francisco, CA: Jossey-Bass.

Schönau, D. W. (1996). Nationwide assessment of studio work in the visual arts: Actual practice and research in the Netherlands. In: D. Boughton, E. W. Eisner, & J. Ligtvoet (Eds.), *Evaluating and assessing the visual arts in education: International perspectives* (pp. 156–175). New York: Teachers College Press.

# SECTION 4

## Composition

**Section Editor: Sarah J. McCarthey**

PRELUDE

28

# THE COMPOSITION SECTION COMPOSING AS METAPHOR AND PROCESS

**Sarah J. McCarthey**
*University of Illinois at Urbana-Champaign, U.S.A.*

In *Notebooks of the Mind*, Vera John-Steiner (1985) reports on her interviews with over 100 artists, scientists, philosophers, and historians to explore the multiplicity of modalities in the arts and sciences. In representing ways of thinking, composing processes, and sources of ideas for artists, she identifies particular modes of thinking as well as processes that appear to cut across modalities. For example, when describing visual thinking, vital to the visual arts she suggests that, "It is the representation of knowledge in the form of structures in motion; it is the study of relationships of these forms and structures; it is the flow of images as pictures, diagrams, explanatory models, orchestrated paintings of immense ideas, and simple gestures; it is work with schemes and structures of the mind" (p. 109). For writers, words are the tools as they draw on "carefully observed details … for their intricate task of weaving together resonant language with the themes of their intellectual and emotional concerns … the early sources of the writer's craft can be linked to their playful explorations in childhood, to their feverish, all-encompassing reading, to their immersion in their work of a favorite master" (p. 127). Describing the process of playwrights, she suggests that they "search for different devices to ensure the authenticity of their theatrical language: the reading aloud of what they write, the use of acting experience by playwrights to help them imagine the different possibilities of the stage, and a commitment to a constant search for vivid words and gestures" (p. 134). For musicians, there is often the process of "generating first-phrase ideas that get shifted, rearranged, extended, or abandoned" (p. 153), while for choreographers, the "communication of meaning through movement requires an ability to weave together physical, emotional, and intellectual aspects of one's understanding" (p. 165). While making distinctions among the artistic modes as well as indicating differences among artists within a particular modality, John-Steiner also notes some similarities. For example, she reports that many artists have spoken of the impact of family members on their artistic development, that artists often experienced some type of apprenticeship, and that they possess "invisible tools" such as intensity, memories, and discipline that allow them to synthesize "ideas,

447

*L. Bresler (Ed.), International Handbook of Research in Arts Education*, 447–452.

images, disarrayed facts and fragments of experiences, which have previously been apprehended by them as separated in time and space, into an integrated work" (p. 77). It is this process of synthesis – bringing together words, images, musical notes, dialogue, and movements – suggested by John-Steiner that provides a springboard for the chapters included in this section.

How does composition manifest itself in different modalities? How do visual artists/writers/choreographers/playwrights/musicians compose? What is the source of their ideas? To what extent is composing personal? To what extent is it social? Is composition the process or the product? How do we teach students to compose music, texts, visual arts, dances, and plays? These questions are raised, explored, discussed, interpreted, and raised again as the authors present research about composition in music, writing, the visual arts, drama, and dance.

*Themes*

Each of the authors writes about composition that is specific to her or his field, reflecting insights about the nature of the process. Yet, three themes are reflected across the chapters: use of metaphor, composing as a dialogue between the individual and the social, and composing as a process. In their interludes, both Keith Swanwick and Michael Parsons use metaphor as a means to help the reader understand composing processes. Swanwick describes the power of metaphor in music on three levels: expressive shapes, emphasizing new relationships, and fusing with previous experiences. Focusing on metaphor in the visual arts, Parsons' interlude helps us to understand how metaphors allow us not only to create new forms, but also to critique existing ones. Several chapter authors also use metaphor as a means to help readers see new forms and relationships. For example, Hagood refers to movement as metaphor when discussing choreography, McKean considers spatial metaphor in relation to drama, and McCarthey employs metaphor to distinguish four different ways of conceptualizing the writing process. Metaphor, through its power to contextualize new ideas in familiar images, words, or sounds, enables artists to develop new ways of seeing, hearing, feeling, knowing, and representing the world to their audiences.

While metaphor serves as an overarching idea in the composing process in the arts, two other themes link the chapters. One central theme is the movement away from considering composing as an individual enterprise to a view that emphasizes the social and collaborative aspects of composing. McCarthey's chapter on composing in the writing process traces the emergence of theories from more individualistic orientations (composing as discovery and individual cognitive process) to theories that embrace more social and political views. Much of the recent research on composing in the writing process has been conducted from a social-political perspective highlighting the importance of the classroom as a social context and the influence of teachers and peers in the writing process. In her chapter on the visual arts, Anna Kindler argues for the importance of looking beyond the cognitive factors to considering composing in the visual arts as a semiotic activity that occurs within specific social and cultural conditions. Drawing from Csikszentmihalyi (1988), Kindler describes a systems approach that includes an interplay of the individual, the domain, and the field of experts. She

creates a three-dimensional image that illustrates the dynamic and relational aspects of the visual arts within the systems approach. Thomas Hagood and Luke Kahlich emphasize the cultural background of the choreographers in their chapter. They present research that suggests that choreographers bring their personal and social backgrounds into the pieces they are composing. Barbara McKean's chapter focuses on the social and interactive nature of drama. Performance is defined as a relationship among the text/performance, the artist, and the audience. The social nature of drama is most evident through the emphasis on devising or group playwriting – the emphasis is less on the individual playwright and much more on what the group does collectively. McKean argues that collaboration and the consideration of individual students' cultural, social, and academic backgrounds create a greater range of possibilities than a work created by a single individual. The benefits of collaboration are also evident in Jackie Wiggins chapter on composing in music. Particularly with young children, music making is a communal enterprise embedded in students' life experiences. As students mature, peer interactions and peer approval play a major role in the composing process. Wiggins finds evidence in the research that group work makes it easier to explore different musical options and that peer interactions can shape the products.

Another theme that runs through the chapters on composition is the emphasis on composing as a process. For example, Kindler cites artists who understand composing in the visual arts as a process of learning to see and perceive nuances. McKean describes composition in drama as a "recursive process … . The writing and the enactment of the writing lead to further revisions and discussion." Hagood and Kahlich find evidence that dance is a process of finding meaning in life, connecting and integrating knowledge that is transformed into dance. The chapters on writing and music highlight the steps in the composing processes. Wiggins' chapter describes the stages of composition that include exploring/experimenting, setting ideas into context, and rehearsing to produce the musical piece. Her stages are parallel to McCarthey's description of the writing process that draws from the Hayes and Flower (1980) model of generating, translating, and revising as recursive aspects of the composing process. Both the writing and music models emphasize the environments that support the ideas and compositional tasks.

## *The Chapters*

Wiggins' review of the literature on composing in music addresses such questions as: Must a musical composition be written down? What counts as compositional process? At what point is a student composing as opposed to improvising? Are young children who invent songs during play composing? What do students do in the context of a formalized lesson as opposed to when they produce original music on their own? Are there commonalities across settings? She includes a detailed model that describes the features of the composing process including exploration/experimentation, setting ideas into context, and rehearsing, all within a larger social context. While recognizing that social contexts shape musical compositions, Wiggins also highlights the role of personal agency in the composing process.

McCarthey's chapter presents four metaphors to characterize the composing process in writing. Beginning with the composing as discovery and exploration metaphor, she

demonstrates how researchers and practitioners drew from a variety of sources to understand the processes of young children learning to compose texts. The cognitive perspective shaped much of the research in the 1980s that considered the problem-solving nature of composing as it defined the processes of writing such as prewriting, drafting, and revising. The social perspective, articulated by the composing as conversation metaphor, led the way for research on writing conferences, collaboration, the role of community and context, and issues of identity and positioning. Finally, the metaphor of composing as a social and political tool expresses how writing can create opportunities for students to reflect about their social circumstances in terms of race, social class, gender, and ethnicity.

In her chapter on drama, McKean reviews literature on writing and devising plays with an eye toward uncovering some of the conceptual foundations for considering composition and the methods for teaching. She argues that teaching the composition process relies on investigating and interrogating assumptions about theater and performance, on thinking and working theatrically, and using techniques of improvisation, both physically and on paper, as a primary technique for rendering dramatic texts. She suggests that once material is actively generated, the writer or group use elements of structure and genre to shape the performance script into forms for publication and/or production. Throughout the process, young writers/devisors develop a critical eye for discovering key criteria for success as well as documenting individual contributions and learning.

The chapter written by Hagood and Kahlich explores research-based literature about the process of choreography. They review studies that examine concepts underpinning creativity, the creation of dances, or pedagogies for teaching choreography. They organized their chapter to focus on the following (a) the *creative process* posing such questions as: What informs creative vision in dance? How does the artist organize and effect an approach to movement invention and following invention, organize movement into choreography? (b) *creative dance* that describes studies conducted in a variety of countries, highlighting the cultural elements of dance; and (c) *choreographic pedagogy* that focuses on the teaching of students to create dances.

Kindler's chapter addresses the topic of composition in art as understood in dynamic terms: as a verb rather than a noun; as a creative act rather than its outcome. It focuses on the examination of cognitive processes, cultural and social conditions, and other contextual determinants of artistic development. It presents an overview of theories that explain how young children, adolescents, and adults develop their visual vocabulary of expression and how they grow (or decline) in their ability and interest to "compose" in art. Her chapter situates these theories in the context of the changing world of art and suggests a systems approach to understanding artistic development that allows us to address the often-neglected distinction between "composing visual imagery" and "composing in visual arts." This chapter also provides suggestions for new ways to study developmental phenomena from a systems perspective.

By presenting research in the areas of music, writing, the visual arts, drama, and choreography, the chapters extend our notions of composition. No longer will we think of composing as the product of a lone individual at a particular point in time, but rather appreciate the complex, lengthy, and social nature of the process. No doubt the chapters

and interludes will inspire us to build on "notebooks of the mind" to create even more metaphors to envision the composing process.

# Reference

John-Steiner, V. (1985). *Notebooks of the mind: Explorations of thinking*. New York: Harper & Row.

29

# COMPOSITIONAL PROCESS IN MUSIC

**Jackie Wiggins**
*Oakland University, U.S.A.*

Researchers have considered a broad range of activities in a variety of contexts toward understanding processes of composing music. While particulars of contexts and settings give rise to variation in pathways (Burnard & Younker, 2004) taken by composers, there are sufficient commonalities to inform lesson design, learning environments, and ways of scaffolding student creation of original music.

Earlier studies attempted to generalize about process from product analysis. More recent work looks at process itself, through observation, interview, and protocol analysis of verbal reports. Researchers have designed experiments, collected data in naturalistic settings, and engaged in work that lies along a continuum in-between experiments and naturalistic data. Most recent studies recognize contextual and sociocultural embeddedness. There are studies of individual and collaborative composing, songwriting by schoolchildren and rock musicians, composing for acoustic instruments and through computer environments. Some analyze students' first "public" composition efforts while others look at work of those with more experience. In some, music notation was integral; in others, students invented notation systems, but in many cases, notation did not enter into the process.

Must a musical composition be written down? What counts as compositional process? At what point is a student composing or improvising? Does it matter? Do students differentiate between composing and improvising? Are young children inventing songs during play composing? Is work in formal and informal settings the same? Are there commonalities across settings regardless of context? Let us consider how researchers define composing and then attempt to map their understanding of the process.

## Definitions of Composing

How do researchers define *what* composing is and *when* composing begins? In some studies, participants have time to become familiar with tools (instrument, software) *before* composing; in others, this is considered part of the compositional process. Some

453

*L. Bresler (Ed.), International Handbook of Research in Arts Education*, 453–470.
© 2007 *Springer*.

differentiate between composing and improvising; others do not. Most consider compos-
ing a process of thinking in sound but some ask participants to compose through manip-
ulating notation in ways that do not necessarily require or allow for thinking in sound.

### Composing vs. Improvising

Creation of original music is generally described as composing and/or improvising.
Sloboda (1985) regards these processes as fundamentally different in that "the composer
rejects possible solutions until he [*sic*] finds one which seems to be the best for his pur-
poses" while "the improviser must accept the first solution that comes to hand" (p. 149).
Kratus (1994) defines a composition as a product with "fixed, replicable sequences of
pitches and durations" and improvisation as "the fluid thoughts and actions of the com-
poser in generating the product" (p. 116). For Webster (1992), composing includes
opportunity for revision during the process while in improvising, "the product or process
is not reconsidered for change" (p. 270). Wiggins (1992) defined composing as "pre-
planned performance of original musical ideas" and improvising as "spontaneous per-
formance of original musical ideas within the context of a real time performance" (p. 14).

Others see improvising and composing as integrated, considering improvisation part
of compositional process. Analyzing children's products, Swanwick and Tillman (1986)
did not differentiate, considering "the briefest utterances" and "more worked out and sus-
tained invention" to be composing (p. 311). Davies (1986, 1992) described "invented"
songs of children as compositions with improvisational ideas spontaneously generated
within them. For Faulkner (2001), composing is both process and product, includ-
ing ... improvising, arranging, and spontaneous singing (p. 5). For Green (2001) and
Barrett (2003), composing encompasses a range of musically creative activities, includ-
ing improvising, performing, and listening.

Burnard (1999a, 1999b) shared young composers' conceptions of composing and
improvising in their own experience, linking the processes to bodily intention. In impro-
vising, her participants "indicated a willingness to accept uncertainty and participate in
ways for which 'having no time to think' was played out as a kind of prereflective playful
impulse" (Burnard, 2000, p. 232), whereas "(c)omposing seemed to be an activity, which
was relived 'over and over' " with pieces becoming time-tested works within which cer-
tain ideas recurred, "a piece I play" (p. 234). This involved a kind of reflective process in
which ideas were found, focused, fixed, and finalised [*sic*] circuitously (p. 237).

### Composing: Notating or Thinking in Sound?

Various authors have considered composing to be thinking – creative thinking (Webster,
1992, 2003) and musical thinking (Barrett, 1996, 1998; Gamble, 1984; Paynter, 1997;
Wiggins, 2001, 2002, 2003). Most musicians agree that engaging in any musical process
involves hearing or conceiving of music in one's mind (e.g., Gordon, 1984; Swanwick,
1988). The process of inventing and organizing musical material is intrinsically linked
to conceptualizing music in one's mind or thinking in sound, as described by Aaron
Copland (1952): "You cannot produce a beautiful sonority or any combination of
sonorities without first hearing the imagined sound in the inner ear" (p. 22).

Must a musical composition be notated? Lerdahl (1988) posits that composing must be based on a listening grammar and not on artificial grammars that are disconnected from listening grammar (p. 235). Discussing playing "by ear," Liliestam (1996) sees notation as setting a framework, presenting a composer with both possibilities (a tool for remembering music or learning music systems) and limitations (confining options to sounds that can be expressed in symbols) and contends that notation is not appropriate for all music. One of McGillen's (2004) participants offered, "You can write down the notes, but you can't write down the spirit of the songs" (p. 290). Students are often capable of conceiving of and creating music that is more complex than they are able to notate. Wiggins (2001) describes students performing music rife with contemporary rhythms, syncopations, and other complexities who, remembering they were expected to notate their work, immediately switched to creating music simple enough for them to record on paper. Upitis (1990) also found that notating can limit work, describing students' notated compositions as simpler and less interesting than their improvisations. Hamilton (1999) describes students' efforts to solve a notation-based problem. One of her key informants reluctantly performed a rather unmusical work created in response to the assignment, but then improvised much more interesting music with considerable development and variation. To Hamilton, the improvisations of all six participants in this study seemed much more interesting than their notated compositions.

In a few instances, researchers have equated notating with composing, or at least, assumed study participants capable of composing through notation, which assumes they are able to conceive of music through notation without hearing it. Only individuals schooled in these processes can operate in this arena; for Davidson and Welsh (1988), more experienced musicians worked from inner hearing, while less experienced needed a piano. Green (1990) described a student who created a piece through notation that she was unable to perform as "alienated" from her own work.

Allsup (2002) engaged musically experienced high-school band students in collaborative composing and found that those who chose to notate seemed reluctant to revise; their piece evolved less than one created by peers working without notation. Upitis (1990) reports notation informing children's awareness of structural features of their music. Observing work with graphics-based composition software, Stauffer (2001, 2003) saw students use visual representation to organize sound and the visual, noting interaction between the processes. For Auh and Walker (1999), graphic representation enabled a wider variety of strategies and more expressive work.

Barrett (1997), who invited students to invent ways of notating their music after its creation, found that the musical experience held the meaning; the notation was only a record of that experience. When Upitis' (1990) students first felt a need to notate their music, their representations tended to be minimal, "only enough to remember the piece, not enough to share it with others" (p. 64).

## Mapping Compositional Process

In spite of differences in ways of defining composing and the influences of variation in study design and setting, in general, enough similarities emerge from descriptions

of process to suggest commonalities that may apply across contexts. Most informative are descriptions that emerged from observations of process in action, particularly from data collected in naturalistic settings where participants were able to make most of the decisions. Freed-Garrod (1999) described a series of interrelated procedures: *exploring*, which occurred first but also reappeared when a composition was "not working" or when a new idea or sound source was added; recursive *selecting*, practicing, editing, and polishing; volunteer *performance/sharing*, when groups shared work or sought feedback; and ongoing *evaluation/assessment* by teacher and students (p. 54). Christiansen (1993) observed *exploration* of sounds, *sharing* of ideas, *organization* of sounds into a structure, and *polishing* the product, which included revision. Berkley (2001) proposed a circular map indicating motion between *generating* (playing with ideas, exploring, inventing, improvising), *realizing* (practicing, playing, establishing a fixed version, recording, transcribing, notating), and *editing* (manipulating, modifying, adjusting, evaluating, self-criticism, appraisal, aural judgment). Emmons (1998) identified three nonlinear, nonsequential stages: *formation*, *preservation*, and *revision* of musical ideas. Both Tsisserev (1997) and Savage (2004, Savage & Challis, 2002) developed recursive models from professional compositional experience and then asked students to use the models as guides.

All descriptions emerging from the literature characterize compositional process as circular or recursive with considerable interaction among elements. Further, the fundamental process emerging from analysis of these studies seems to hold true for both individual and collaborative work.

### *Generating Musical Ideas*

There seems to be agreement that the first step in composing involves some process of generating or inventing musical ideas. From where and how do these ideas come? Sloboda (1985) shares responses from the writings of Beethoven ("they come unbidden"), Richard Strauss ("a melodic phrase occurs to me suddenly"), Mozart ("whence my ideas come I know not; nor can I force them"), and Roger Sessions ("may come in a flash, or as sometimes happens it may grow and develop gradually"). Eric Clapton does not really compose a song, but rather plays around on the guitar until it formulates itself (Turner, 1976, p. 44, cited in Lilliestam, 1996, p. 200). For Keith Richards, "songs just write themselves once you've got the initial thread" (Flanagan, 1990, p. 206, cited in Lilliestam, 1996, p. 208). From the literature, it is clear that across time, place, style, and genre, people of all ages seem to be capable of generating musical ideas, spontaneously and with intent.

*Children's spontaneous music making.* Researchers have used ethnographic and ethnomusicological techniques to study the nature of young children's creation of original music in naturalistic settings. Moorhead and Pond (1941/1978), analyzing children's spontaneous music making in an unstructured play setting, described these instances as intentional, compelling expressions, connected to and reflective of children's life experiences. Analyzing young children's creation of original music on classroom instruments (Moorhead & Pond, 1942/1978), they noted their strong ability to maintain their own rhythm "against all competition and interference" and described the music making as a communal enterprise (p. 44).

From this and other early work (Dowling, 1984; Moog, 1960s/1976; Sundin, 1960s/ 1998; Werner, 1917/1948), it is evident that generating musical material is something all people do. Both Davies (1986, 1992) and Young (1995, 2002, 2003) provide clear evidence of nursery children's ability to generate original musical material with intent and meaning. In elementary age children, Marsh (1995, 2001) found this ability extended to "constant variation and striving for novelty" in children's performance of the playground games (2001, p. 93). Campbell (1998) found similar characteristics in a variety of informal settings, including that children's spontaneous music making seemed like an almost unconscious effort at times, that it was often linked to physical movement, and always intrinsically linked to and embedded in their life experiences, knowledge, and emotions. Bjørkvold (1989) describes children's early spontaneous singing as fluid and amorphous noting that with life experience, their music begins to include more musical norms of the culture, but still with the sole intent of personal expression and sometimes communication.

*Exploration/Experimentation.* Many researchers characterize the beginning of stages of composing as a period of *exploration*, a term applied to a variety of complex actions and processes. For the term to be meaningful, we need to understand these variations in definition and the contexts within which the process has been observed. The key question is whether students explore to *find* musical ideas or whether what researchers describe as exploration is a process of *enacting* musical ideas.

First, researchers who engage participants in environments or with equipment that are new to them usually note that initial work time is spent exploring the medium. The subject of Stauffer's (2001) case study spent time getting to know how the computer and software worked before she began composing. This process, which Stauffer labeled exploration, included her first composition, which was significantly different from her subsequent works, suggesting that it was more of an experiment with the medium than a composition. Savage (2004) noted an increase in the amount of exper-imentation and "doodling" when students had access to sound processors for the first time. Christiansen's (1993) first-time composers, engaged in what she called explo-ration at the beginning of each session – a time that "seemed chaotic but involved get-ting to know the instruments; finding out what does what, lots of enthusiastic playing around, and personal identification with certain instruments" (p. 8). From students' own descriptions of what they are doing in these initial stages (Kaschub, 1999; Wiggins, 2003), it is clear that what may appear chaotic is actually musical thinking in action where students are "trying out" or "finding" their ideas on instruments, judging their merit, and then either adopting or discarding them.

Second, researchers who have looked at children's processes in naturalistic settings (e.g., Burnard, 1999a; Glover, 2000; Kondo, 2004; Marsh, 1995, 2001) also recognize that it is not uncommon for young composers to *experiment* with ways of extending and/or varying music they already know how to sing or play. Some of Stauffer's (2003) partici-pants working at computers listened to pieces they had previously composed in search of ideas for new works. Clearly one source of ideas is music a composer already knows as a performer or composer. Since many note that student compositions reflect their musical enculturation (e.g., Barrett, 1996; Bunting, 1988; Campbell, 1998; Marsh, 1995, 2001; Sloboda, 1985), we can assume that students' ideas are also derived from music they know

through listening. Some characterize this experimentation with music that students already know as *exploration*; perhaps *experimentation* is a better descriptor.

Kratus (1994) defined *exploration* as music that sounds unlike music played earlier – in contrast to *development*, where the music sounds similar to, yet different from, music played earlier and *repetition*, where music sounds the same as music played earlier. Both Kratus (1989, 1994) and Seddon and O'Neill (2003) found that students with more prior musical experience seemed to spend less time with what they each identified as exploring while students with less experience spent more time exploring. Hewitt (2002) concurred, finding more experienced musicians better able to generate initial material enabling more time for developing and refining while less experienced musicians tended to rely on what he called *experimentation* ("playing about" and "mucking about") to invent ideas.

Researchers who have collected data in naturalistic settings (e.g., Barrett, 1998; Burnard, 1999a; Cohen, 1980; Kaschub, 1999; Wiggins 1992, 2003) tend to describe *exploration* as an intentional act rooted in musical thinking. Aaron Copland (1952) describes his own process of initiation of ideas: "The way music sounds, or the sonorous image, as I call it, is nothing more than an auditory concept that floats in the mind of the executant or composer; a prethinking of the exact nature of the tones to be produced" (p. 21).

Student composers describe their own processes quite similarly. Kaschub's (1999) students described their own process as "thinking up ideas in their heads" (p. 189). Students that Wiggins (2003) interviewed described knowing the music in their heads before trying to find it on instruments or having an idea and then trying it again and again until you get it.[1] Faulkner's (2001) students talked about ideas just appearing before their eyes and then needing to "try them and see if they come out well" (p. 24). A participant in Allsup's (2002) study described his process, "I think of melodies and what not in my head. Then I like to play them on piano to see if they sound good" (p. 111). Allsup describes another participant repeatedly singing what she heard in her head and then finding the pitches on a piano, and a third as composing in his head before going to an instrument. As she brainstormed Latin rhythms for her conga, one student in Wiggins' (1992) study, consistently chanted rhythms before playing them, rejecting all until she found the one that sounded right for the piece in progress. Seeing the text he was to set, one of Kennedy's (2004) participants reported that he immediately started writing the song in his head. A composer recording think-alouds reported, "The composition process goes on in my head all the time, over a long period of time. When I sit down at the piano, I'm sort of filling in details of forms and styles that have already come to mind and have already developed" (Whitaker, 1996, p. 5).

From analysis of the extant literature, it is also clear that composers generate musical ideas in relation to and in the context of (a) the nature and capabilities of the sound source, (b) the intended musical role of the section under construction (is it an introduction? transitional passage? accompaniment?), and (c) text, if present. It seems evident that composing begins with the generation of musical thought (informed by sound, role, and possibly text) that is then enacted (realized, performed) in some way (see Figure 1).

Figure 1

*Setting Musical Ideas into Context*

As initial musical ideas are generated they are immediately contextualized, which includes repetition, development, revision, and refinement, as informed by the composer's holistic conception of the work in progress.

*Repetition, development, revision, and refinement.* Most researchers who observe process in action identify periods in which invented ideas are repeated, developed, revised, and refined. *Repetition* seems to be an important part of the compositional process for students who are thinking in sound but unable to represent and hold their ideas on paper. Christiansen (1993) noted that repeating and rehearsing helped students know what the composition was. Faulkner (2003) saw that his students kept the music "in hearing" (by repeating) as an integral part of the process of thematic *development*. Tsisserev (1997) connects *repetition* and *development* in his own process, repeating ideas to determine their possibilities and to decide whether or not to pursue them, with development an outgrowth of this process.

Researchers who study the work of composers over time are more likely to observe *revision* and *refinement*. Studies of students' first attempts are less likely to identify refinement. Stauffer's (2005) study of individual composers over a period of several years enabled her to understand and describe *revision* process as one that (a) changes with experience and age, (b) becomes more complex over time, and (c) is marked by listening.

*Interplay between musical ideas and holistic conception of the work.* When researchers look at compositional process in action, they find considerable evidence that, as they work, individuals hold some kind of holistic conception or vision of the final product. If music is composed for a particular event, ensemble, occasion, instrument, etc., this will color preconception and establish some of the context. Beyond this, it is evident in composers' descriptions of their initial conceptions and in what researchers have observed in initial stages of the work that composers generally work from a preconceived image of where they are headed and accept or reject ideas based on how they fit that image. Alternatively, the image may shift to embrace the emergence of an interesting idea. The interaction between germ and image of the whole is constant throughout the process.

Holistic conception is evident in the ways composers talk about their process and in their actions. In an interview, composer Libby Larson indicated that color and form were the most important elements she considered when structuring a new piece (Robbins, 1995). Composer Wing Fai Law tries "to develop a visual image as the first step" (Leung, 2002, p. 211; Leung & McPherson, 2002, p. 72). Wiggins (1994) noted that young composers' initial comments seemed to concern broader issues, like style, form, textural organization, or affective qualities. One of Bamberger's (1991) key findings was that the actions and decisions of her subjects reflected the "interaction between detail and larger design" with the most significant learning occurring "in the dynamic interplay between local and global focus" where "local detail shed light on global possibilities" and "global structures revealed new details" (p. 307). She notes the similarity to Schoenberg's (1967) perspective that a composer does not "add bit by bit" as a child building with blocks but "conceives an entire composition as a spontaneous vision" (pp. 1–2). In Folkestad, Hargreaves, and Lindström's (1998) analysis of variation in process of students' composing through computers, despite variation in pathway, in general the work started with "the whole composition being conceived to completion" (p. 89).

Analysis of students' statements about their processes led Kaschub (1999) to conclude that "both individuals and collaborators relied heavily upon their preconceived ideas of what a composition should be to determine when their compositions were complete and to plan conventional endings" (p. 153). The most successful students in Berkley's (2001) study constantly tested their ideas against their original hypotheses, appeared to identify a common thread as they worked, and kept sight of the overriding goal. Christiansen's (1993) students frequently referred to wanting the music to make sense or sound right. She noted that students "recognized the need to make the sounds match a preconceived musical framework" (p. 9) and that "each student seemed to have a preset view of what the composition was and any deviation from this caused them to stop and explain it to the others so they too would understand (and fix it!)" (p. 11). Describing high school students' processes, Allsup (2002) labeled their first step conceptual, including discussions of form, genre, orchestration, mood, and tonality. "Underlying their discussion are 'big picture' questions such as: What purpose will our music serve? How do we say what we want to say? How will our choices adequately represent us?" (p. 157). He notes "a collective understanding that appropriate musical ideas will develop from a predetermined structure" (p. 157).

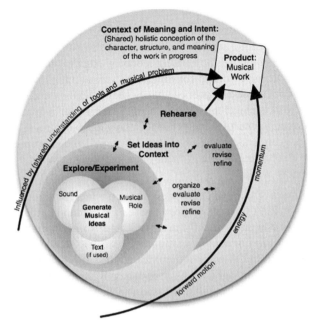

Figure 2

Even in young students, there is evidence of holistic conception of the work in progress, for example, Moorhead and Pond's (1942/1978) description of children demanding the elimination of unwanted timbres, unanimity of volume, or beginning or ending together.

There is consistent evidence that as musical ideas are generated and enacted, they are considered within the frame of the individual's or group's initial conception of the work as a whole. This (sometimes instantaneous) reflection on the potential contextualization of ideas is what provides a basis for their acceptance or rejection, whether by the individual or group. It also sparks development of ideas within the frame of the context, sometimes by the initiator, but often by collaborators (if present). The composer's conception of the initial ideas is also influenced by a preconceived vision of what the whole might be, including potential mood, affective qualities, and style. Further, all researchers who have observed the process over time note that once the product begins to take shape, it is performed or rehearsed repeatedly, spawning continual revision and refinement until the composer decides the work is finished. Figure 2[2] is an attempt to represent the embedding of the generation of musical ideas within a vision of how they will operate in the context of the whole – and also the later stages of contextualization, development, revision, and refinement. The small arrows represent the recursive nature of and interactive relationships among all aspects of the process. Figure 2 also represents the influence of the nature of the sound source, the musical problem (if present), and the energy and momentum that drives toward the goal of producing a product.

## Social Context and Personal Agency

Composing, like all human experience, occurs in a sociocultural context within which capacity for personal agency impacts the nature of the work. Sociocultural influences are active whether a composer is working alone or engaged in collaborative work. These include knowledge of music constructed in formal and informal settings, perceived expectations of adults and peers who may hear the music, and social issues arising among peers working together. Personal agency refers to an individual's feelings of self-determination in a particular context, that is, how much control an individual feels over his or her own circumstances and ability to act. When composing takes place in school or research settings, the role of agency can be highly influential in the nature of students' or subjects' work.

*Sociocultural context.* Folkestad (1996) describes composing as situated practice. For Csikszentmihalyi (1999), "Creativity presupposes a community of people who share ways of thinking and acting" (p. 316) and for Rogoff (1990), "Individual creativity occurs in the context of a community of thinkers" (p. 198). These communities can be contemporary or historical. A composer working alone is influenced by musical and social enculturation, and engaged in an act of personal expression of ideas that others may share. Stauffer's (2003) longitudinal study of young composers working alone revealed that, over time, their products and processes reflected their musical identity (unique quality of their sound) and voice (expression, meaning).

As noted by those who study the collaborative composing of popular musicians (e.g., Green, 2001; Lilliestam, 1996), the notion of composing as an independent act is genre, style, and culture specific. Composition on acoustic instruments in school settings is almost always collaborative, rooted either in teacher design or in the ways students choose to work. Students working at computer workstations may opt to work with peers, when given the opportunity. At the very least, they invite peers' suggestions and opinions of their work in progress (Ruthmann, 2005). Young people who compose in informal settings are likely to compose with peers, the preferred way of working of most garage bands, which are more and more prevalent in the lives of youth (Jaffurs, 2004).

The nature of collaborate problem solving [studied extensively by social constructivists like Rogoff (1990, Rogoff & Lave, 1984) and Wertsch (1985, 1991, 1998)] and collaborative creating [studied by social psychologists, such as John-Steiner (2000) and Sawyer (2003)] may alter the complexion of compositional process by incorporating features that are not present in individual work. One advantage, however, to studying collaborative work is that by nature it requires a public sharing of ideas "in the moment," which makes them more accessible to the researcher without having to rely on participant's artificial think-alouds, recall, or reflections. Espeland (2003) emphasizes the dynamic relationship between the musical and social aspects of compositional process recognizing that even when children compose individually, they rely on and interact with their context, cultural tools, and other people. Miell and MacDonald (2000) note important interrelationships between social factors and musical process and product, and Gromko (2003) suggests that group compositional process reveals children's social styles noting that participants' social skills matured alongside their musical skills.

Researchers who have studied collaborative composing in naturalistic settings (Campbell, 1995; Davis, 2005; DeLorenzo, 1989; Faulkner, 2001, 2003; Kaschub, 1999; Marsh, 1995, 2001; Wiggins, 1999/2000, 2003) note the importance of shared understanding or *intersubjectivity* (Rogoff, 1990) in the process. Collaborators seem to share an unspoken understanding of the overall quality of the work in progress even at the earliest stages of conception, evident in their ability to cooperatively decide which ideas should be used in the work and which should be discarded or altered.

In collaborative work of elementary students, Wiggins (1992, 1994), found that while the initiation of musical material was most often an individual act, initiators tended to seek immediate peer approval. As work continued, all ideas seemed to be judged against the group's vision of the whole – or at least, against each individual's interpretation of the group's vision of the whole. This interpretational issue sometimes led to disagreement within the group, which was usually followed by periods of explaining and demonstrating of ideas of various individuals until some kind of consensus was reached, allowing the group to once again move forward and have a reference point for making decisions. Allsup (2002) describes joint ownership of material in the work of high school students: "Musical material is not only shared and 'pulled apart,' but the group seems to exist as a single body. Work is independent, but connected; distracted, but apprised. Ideas can be traced to individual moments of inspiration, but often material is validated by someone other than the inventor" (pp. 338–339). He was struck by the plural nature of the process in which every idea was negotiable, any member could make a request, judicial comments were rarely withheld, and decisions were finalized by consensus. He described the process as messy and rarely linear.

Kaschub (1999) found that group work made it easier for students to experiment with multiple sounds, requiring them to consider how they would sound together. Working alone, students reported spending time planning while they reported starting right in without planning when working with peers. Kaschub suggests that collaborators rely on ideas and experiences of peers, making it easier to get started, and that the perception of peer support may provide them with "courage to dive into the task" (p. 151).

Faulkner's (2001, 2003) study of sociocultural aspects of collaborative composing supports much of what is described above, especially the role of intersubjectivity, but emphasizes students' perceptions of the social aspects of their work. When asked to select favorite works and explain why, the majority of reasons did not concern the musical product, but rather the social context within which it had been created, chosen because of the "corporateness of their making" (2001, p. 19). He describes this quality as essential for empowering and developing individual learning and creativity.

*Personal agency.* Social contexts can nurture or impede individuals' creative work. Amabile (1996) suggests that adults can nurture children's creativity by encouraging autonomy, avoiding excessive control of their activities, and respecting their individuality. Csikszentmihalyi's (1996) *flow* is the optimal experience in which we feel that things are going well in an almost automatic, effortless, highly focused state of consciousness, a feeling which Byrne, MacDonald, and Carlton (2003) correlated with successful compositional work. Accomplished composers indicated the importance of tranquility, security, and relaxation in their ability to produce music (Bennett, 1976).

The lack of a safe-feeling environment can negatively impact findings when partici-
pants are placed in an experimental setting that might leave them feeling uncertain or
uncomfortable.

Claire (1993/1994) observing students composing in different classrooms, found
that peer interactions that facilitated creative work were fostered by mutual rather than
hierarchical work processes. Perceptions of process as mutual or hierarchical were
rooted in who had responsibility for decision making. Where Dogani (2004) found
instances of good practice in classrooms, it was the result of "supportive and engaging
teacher roles which allowed time for independent learning through experimentation
and children's reflection during the creative process, enabling children to approach
musical creation in a personal and meaningful way" (p. 269). In settings with less
effective practice, problems had roots in teachers' fears of losing control and/or their
lack of belief in children's capabilities. DeLorenzo (1989) found their students' work
reflective of their perception of its relevance. Stauffer (2003) observes, "(I)ndividuals
create what is meaningful to them on their own terms" (p. 95). Folkestad (2005) notes
the importance of framing composing contexts in teaching situations so that students
perceive the process as "a free choice, as a way of expressing oneself and to commu-
nicate in music" (p. 285).

When data were collected in contexts in which participants were able to experience
personal agency, researchers tended to comment about composers' feelings of personal
satisfaction and ownership. In particular, researchers who studied adolescents and
young adults composing music in formal (school) settings (e.g., Burnard, 1995;

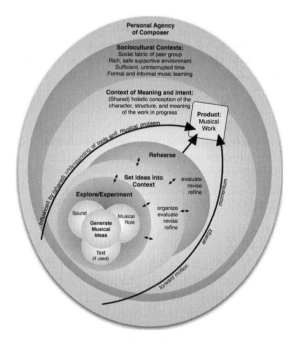

Figure 3

Faulkner, 2001, 2003; Savage, 2004; Berkley, 2004), informal settings (e.g., Campbell, 1995; Davis, 2005), and informal emerging from formal settings (e.g., Allsup, 2002; McGillen, 2004; Upitis, 1990) talk about the authorship, ownership, agency, power sharing, valuing, and positive interdependence that the experiences seem to generate.

Regarding the meaningfulness of the experience, Burnard and Younker (2004) found meaning rooted in relevance to students' lives. When Nilsson and Folkestad's (2005) participants had trouble creating meaning in an assigned task, they "turned the task itself into the meaningful context" (p. 35). Faulkner's (2001) students found meaning in their products but more in the processes and social contexts. In developing their own voice and identity, Stauffer's (2003) composers, over time, developed their own recognizable signatures and styles. From her study of young children's processes and products in the context of classroom learning, Barrett (2003) describes composing as a form of dialogical meaning-making through which children construct knowledge of themselves and their culture by interacting within their material and social worlds. The most salient findings of Davis (2005) study of the compositional processes of a garage band lay at the intersection of their musical growth, musical enculturation, and musical meaning with meaning rooted in their ability to invest part of themselves in the music. "Ownership, agency, relevance, and personal expression fuse at the core of the value they place on this musical and social experience" (p. 26).

Figure 3 shows compositional process embedded in its sociocultural contexts, emphasizing the necessity of personal agency in enabling participation in the process.

# Implications

The work analyzed here has implications for designing compositional experiences in both learning and research settings. First, since all people are capable of inventing musical ideas, it would seem that all music learners should, at some time in their education, have opportunities to explore this capability as part of their learning. This also suggests the importance of studying compositional process as it occurs in a variety of settings with a diversity of participants.

Second, if the process of inventing and organizing musical material is intrinsically linked to conceptualizing music or thinking in sound, compositional experiences for learning should be designed to allow for and foster musical thinking. Restricting pitches or rhythms that a composer can use, for example, could inhibit the invention of musical ideas. This is even more important when we consider that composers tend to invent melodic material holistically, conceiving rhythm and pitch simultaneously. Composition assignments should be designed with understanding of the ways that people compose so as to not inadvertently impede the process.[3]

Third, music educators and researchers need to understand and value the musical knowledge that students bring into the classroom – knowledge constructed from a lifetime of musical experience both in and out of school. Creating original music provides opportunity for nonverbal expression of musical understanding, with all of its complexity. Restrictive situations may inhibit students' ability to use and share what they know.

Fourth, the dynamic qualities of collaborative composing experience should not be overlooked, including its capacity to nurture and validate the musical thinking of individuals within the group.

Finally, learners engaged in composing need to work in an environment that fosters ownership and agency.

When designing opportunities for composing, researchers and teachers need to recognize, honor, and validate (a) the holistic nature of compositional process, (b) the intentional and cognitive nature of the conception and generation of musical ideas, and (c) the need for personal agency within the sociocultural and musical contexts. Environments for composing that are most in keeping with composers' ways of being will have the greatest potential to enable success.

## Notes

1. Describing language arts process, Hayes and Flower (1980) also identify generation of ideas as coming before exploration. Martin (2002) used this model to analyze musical process.
2. These conceptual maps are based on one that emerged from my own work (Wiggins, 2003), enriched and reframed by what emerged from this review. There are many similarities between this map and one recently offered by Fauntley (2005).
3. Also articulated by Folkestad, 2005, p. 285.

## References

Allsup, R. E. (2002). *Crossing over: Mutual learning and democratic action in instrumental music education*. Unpublished doctoral dissertation, Teachers College, Colombia University, NY.

Amabile, T. M. (1996). *Creativity in context*. Boulder, CO: Westview Press, HarperCollins.

Auh, M. S., & Walker, R. (1999). Compositional strategies and musical creativity when composing with staff notations versus. graphic notations among Korean students. *CRME Bulletin, 141*, 2–9.

Bamberger, J. (1991). *The mind behind the musical ear*. Cambridge, MA: Harvard University Press.

Barrett, M. (1996). Children's aesthetic decision-making. *International Journal of Music Education, 28*, 37–62.

Barrett, M. (1997). Invented notations. *Research Studies in Music Education 8*, 1–13.

Barrett, M. (1998). Researching children's compositional processes and products. In B. Sundin, G. E. McPherson, & G. Folkestad (Eds.), *Children composing* (pp. 10–34). Malmö Academy of Music, Lund University, Malmö, Sweden.

Barrett, M. (2003). Freedoms and constraints. In M. Hickey (Ed.), *Why and how to teach music composition?* (pp. 3–27). Reston, VA: MENC.

Bennett, S. (1976). The process of musical creation. *Journal of Research in Music Education, 24*(1), 3–13.

Berkley, R. (2001). Why is teaching composing so challenging? *British Journal of Music Education, 18*(2), 119–138.

Berkley, R. (2004). Teaching composing as creative problem solving. *British Journal of Music Education, 21*(3), 239–263.

Bjørkvold, J. (1989). *The muse within*, (W. H. Halverson, Trans.). NY: Harper Collins.

Bunting, R. (1988). Composing music. *British Journal of Music Education, 5*(3), 269–310.

Burnard, P. (1995). Task design and experience in composition. *Research Studies in Music Education, 5*, 32–46.

Burnard, P. (1999a). "Into different worlds." Unpublished doctoral dissertation, University of Reading, UK.

Burnard, P. (1999b). Bodily intention in children's improvisation and composition. *Psychology of Music, 27*, 159–174.

Burnard, P. (2000). Examining experiential differences between improvisation and composition in children's music-making. *British Journal of Music Education, 17*(3), 227–245.

Burnard, P., & Younker, B. A. (2004). Problem-solving and creativity. *International Journal of Music Education, 22*(1), 59–76.

Byrne, C., MacDonald, R., & Carlton, L. (2003). Assessing creativity in musical compositions. *British Journal of Music Education, 20*(3), 277–290.

Campbell, P. S. (1995). Of garage bands and song-getting. *Research Studies in Music Education, 4*, 12–20.

Campbell, P. S. (1998). *Songs in their heads.* Oxford: Oxford University Press.

Christiansen, C. B. (February 1993). Music composition, invented notation, and reflection in a fourth grade music classroom. Paper presented at the Symposium on Research in General Music, University of Arizona, Tucson.

Claire, L. (1993/94). The social psychology of creativity. *CRME Bulletin, 119*, 21–28.

Cohen, V. W. (1980). *The emergence of musical gestures in kindergarten children.* Unpublished doctoral dissertation, University of Illinois at Urbana-Champaign.

Copland, A. (1952). *Music and imagination.* Cambridge, MA: Harvard University Press.

Csikszentmihalyi, M. (1996). *Creativity.* New York: Harper Collins.

Csikszentmihalyi, M. (1999). Implications of systems perspective, In R. J. Sternberg (Ed.), *Handbook of Creativity*, Cambridge: Cambridge University Press.

Davidson, L., & Welsh, P. (1988). From collections to structure. In J. A. Sloboda (Ed.), *Generative processes in music* (pp. 260–285). Oxford: Clarendon.

Davies, C. (1986). Say it till a song comes. *British Journal of Music Education, 3*(3), 279–293.

Davies, C. (1992). Listen to my song. *British Journal of Music Education, 9*(1), 19–48.

Davis, S. G. (2005). That thing you do: Compositional processes of a rock band. *International Journal of Education in the Arts 6(16). Retrieved [December 8, 2005] from http://ijea.asu.edu/v6n16/.*

DeLorenzo, L. C. (1989). A field study of sixth-grade students' creative music problem-solving processes. *Journal of Research in Music Education, 37*(3), 188–200.

Dogani, K. (2004). Teachers' understanding of composing in the primary classroom. *Music Education Research, 6*(3), 263–279.

Dowling, W. J. (1984). Development of musical schemata in children's spontaneous singing. In W. R. Crozier & A. J. Chapman (Eds.), *Cognitive processes in the perception of art* (pp. 145–163). Amsterdam: Elsevier.

Emmons, S. E. (1998). *Analysis of musical creativity in middle school students through composition using computer-assisted instruction.* Unpublished doctoral dissertation, University of Rochester, Eastman School of Music.

Espeland, M. (2003). The African drum: The compositional process as discourse and interaction in a school context. In M. Hickey (Ed.), *Why and how to teach music composition* (pp. 167–192). Reston, VA: MENC.

Faulkner, R. (2001). *Socializing music education.* Unpublished doctoral dissertation, University of Sheffield, UK.

Faulkner, R. (2003). Group composing. *Music Education Research, 5*(2), 101–124.

Fauntley, M. (2005). Group composing process of lower secondary school students. *Music Education Research, 7*(1), 39–57.

Folkestad, G. (1996). *Computer based creative music making.* Unpublished doctoral dissertation, Acta Universitatis Gothoburgensis, Götegerg, Sweden.

Folkestad, G., Hargreaves, D. J., & Lindström, B. (1998). Compositional strategies in computer-based music-making. *British Journal of Music Education, 15*(1), 83–97.

Folkestad, G. (2005). Here, there and everywhere: Music education research in a globalised *[sic]* world. *Music Education Research, 7*(3), 279–287.

Freed-Garrod, J. (1999). Assessment in the arts. *CRME Bulletin, 139*, 50–63.

Gamble, T. (1984). Imagination and understanding in the music curriculum. *British Journal of Music Education, 1*(1), 7–25.

Glover, J. (2000). *Children composing 4–14.* London: Routledge Falmer.

Gordon, E. E. (1984). *Learning sequences in music.* Chicago: G.I.A.

Green, L. (1990). The assessment of composition. *British Journal of Music Education, 7*(3), 191–196.

Green, L. (2001). *How popular musicians learn*. Aldershot, UK: Ashgate.

Gromko, J. E. (2003). Children composing. In M. Hickey (Ed.), *Why and how to teach music composition?* (pp. 69–90). Reston, VA: MENC.

Hamilton, H. J. (1999). Music learning through composition, improvisation, and peer interaction in the context of three sixth grade music classes. Unpublished doctoral dissertation, University of Minnesota.

Hayes, J. R., & Flower, L. S. (1980). Identifying the organization of writing processes. In L. W. Gregg & E. R. Steinberg (Eds.), *Cognitive processes in writing* (pp. 3–30). Hillsdale, NJ: Lawrence Erlbaum.

Hewitt, A. (2002). A comparative analysis of process and product with specialist and generalist preservice teachers involved in a group composition activity. *Music Education Research, 4*(1), 25–36.

Jaffurs, S. E. (2004). The impact of informal music learning practices in the classroom, or how I learned how to teach from a garage band, *International Journal of Music Education, 22*, 189–200.

John-Steiner, V. (2000). *Creative Collaboration*. NY: Oxford University Press.

Kaschub, M. (1999). *Sixth grade students' descriptions of their individual and collaborative music composition processes and products initiated from prompted and unprompted task structures*. Unpublished doctoral dissertation, Northwestern University, Evanston, IL.

Kennedy, M. A. (2004). Opening the doors to creativity. *Research Studies in Music Education, 23*, 32–41.

Kondo, S. (2004). *Children's musical thinking during collaborative composing*. Unpublished master's thesis, Oakland University, Rochester, Michigan.

Kratus, J. K. (1989). A time analysis of the compositional processes used by children ages 7 to 11. *Journal of Research in Music Education, 37(*1), 5–20.

Kratus, J. (1994). Relationships among children's music audiation and their compositional processes and products. *Journal of Research in Music Education, 42*(2), 115–130.

Lerdahl, F. (1988). Cognitive constraints on compositional systems. In J. A. Sloboda (Ed.), *Generative processes in music* (pp. 231–259). Oxford: Clarendon.

Leung, B. W. (2002). *Creative music making in Hong Kong secondary schools*. Unpublished doctoral dissertation, University of New South Wales, Sydney, Australia.

Leung, B. W., & McPherson, G. E. (2002). Perception about creativity in Hong Kong school music programs. *Music Education International, 40*(1), 67–77.

Lilliestam, L. (1996). On playing by ear. *Popular Music, 15*(2), 195–215.

Marsh, K. (1995). Children's singing games. *Research Studies in Music Education, 4*, 2–11.

Marsh, K. (2001). It's not all black or white. In J. C. Bishop & M. Curtis (Eds.), *Play today in the primary school playground* (pp. 80–97). Buckingham: Open University Press.

Martin, J. (2002). Categorising the compositional thinking of tertiary-level students. *Research Studies in Music Education, 18*, 2–11.

McGillen, W. (2004). In conversation with Sarah and Matt. *British Journal of Music Education, 21*(3), 279–293.

Miell, D., & MacDonald, R. (2000). Children's creative collaborations. *Social Development, 9*(3), 348–369.

Moog, H. (1976). *The musical experience of the pre-school child*. (C. Clarke, Trans.). London: Schott.

Moorhead, G. E., & Pond, D. (1978). *Music of young children*. Santa Barbara, CA: Pillsbury Foundation for Advancement of Music Education. (Originally published 1941, 1942, 1944, & 1951.)

Nilsson, B., & Folkestad, G. (2005). Children's practice of computer-based composition. *Music Education Research, 7*(1), 21–37.

Paynter, J. (1997). The form of finality. *British Journal of Music Education, 14*(1), 5–21.

Robbins, J. (1995). The mysteries of creation. *The Orff Echo, 27*(4), 13–15.

Rogoff, B. (1990). *Apprenticeship in thinking*. New York: Oxford University Press.

Rogoff, B., & Lave, J. (Eds.). (1984). *Everyday cognition*. Cambridge, MA: Harvard University Press.

Ruthmann, A. (November 2005). Inside the composers' workshop. Paper presented at New Directions in Music Education, Michigan State University.

Savage, J. (2004). *Re-imagining music education for the 21st century*. Unpublished doctoral dissertation, University of East Anglia, Norwich, UK.

Savage, J., & Challis, M. (2002). A digital arts curriculum? *Music Education Research, 4*(1), 7–24.

Sawyer, R. K. (2003). *Group creativity*. NJ: Lawrence Erlbaum.

Schoenberg, A. (1967). *Fundamentals of musical composition*. New York: St. Martins Press.

Seddon, F. A., & O'Neill, S. A. (2003). Creative thinking processes in adolescent computer-based composition: An analysis of strategies adopted and the influence of instrumental music training. *Music Education Research, 5*(2), 125–137.

Sessions, R. (1939). The composer and his message. In E. T. Cone (Ed.) (1979), *Roger Sessions on music.* Princeton, NJ: Princeton University Press.

Sloboda, J. A. (1985). *The musical mind.* Oxford, UK: Clarendon.

Stauffer, S. L. (2001). Composing with computers. *CRME Bulletin 150,* 1–20.

Stauffer, S. L. (2003). Identity and voice in young composers. In M. Hickey (Ed.), *Why and how to teach music composition?* (pp. 91–111). Reston, VA: MENC.

Stauffer, S. L. (November 2005). Notes on an Emerging Pedagogy of Composition. Paper presented at the Conference of Music Learning and Teaching, Center for Applied Research in Musical Understanding, Oakland University, Michigan.

Sundin, B. (1998). Musical creativity in the first six years. In B. Sundin, G. E. McPherson, & G. Folkestad (Eds.), *Children composing* (pp. 35–56). Malmö Academy of Music, Lund University, Malmö, Sweden.

Swanwick, K. (1988). *Music, mind, and education.* London: Routledge.

Swanwick, K., & Tillman, J. B. (1986). The sequence of musical development. *British Journal of Music Education, 3*(3), 305–339.

Tsisserev, A. (1997). *An ethnography of secondary students' composition in music.* Unpublished doctoral dissertation, University of British Colombia, Canada.

Upitis, R. (1990). *This too is music.* Portsmouth, NH: Heineman.

Webster, P. (1992). Research on creative thinking in music. In R. Colwell (Ed.), *Handbook of research on music teaching and learning* (pp. 266–280). New York: Schirmer.

Webster, P. (2003). What do you mean "make my music different?" In M. Hickey (Ed.), *How and why to teach music composition* (pp. 141–166). Reston, VA: MENC.

Werner, H. (1948). *The comparative psychology of mental development.* New York: International Universities Press.

Wertsch, J. V. (Ed.). (1985). *Culture, communication and cognition.* New York: Cambridge University Press.

Wertsch, J. V. (1991). *Voices of the mind.* Cambridge, MA: Harvard University Press.

Wertsch, J. V. (1998). *Mind as action.* New York: Oxford University Press.

Whitaker, N. L. (1996). A theoretical model of the musical problem solving and decision making of performers, arrangers, conductors, and composers. *CRME Bulletin, 128,* 1–14.

Wiggins, J. H. (2001). *Teaching for musical understanding.* New York: McGraw-Hill.

Wiggins, J. H. (2002). Creative process as meaningful musical thinking. In T. Sullivan & L. Willingham (Eds.), *Creativity and music education* (pp. 78–88). Alberta: CMEA.

Wiggins, J. H. (2003). "A frame for understanding children's compositional processes," In M. Hickey (Ed.), *How and why to teach music composition* (pp. 141–166). Reston, VA: MENC.

Wiggins, J. H. (1992). *The nature of children's musical learning in the context of a music classroom.* Unpublished doctoral dissertation, University of Illinois at Urbana-Champaign.

Wiggins, J. H. (1994). Children's strategies for solving compositional problems with peers. *Journal of Research in Music Education, 42*(3), 232–252.

Wiggins, J. H. (1999/2000). The nature of shared musical understanding and its role in empowering independent musical thinking. *CRME Bulletin, 143,* 65–90.

Young, S. (1995). Listening to the music of early childhood. *British Journal of Music Education, 12,* 51–58.

Young, S. (2002). Young children's spontaneously vocalizations in free play. *CRME Bulletin, 152,* 43–53.

Young, S. (2003). Time–space structuring in spontaneous play on educational percussion instruments among three- and four-year-olds. *British Journal of Music Education, 20*(1), 45–59.

# INTERNATIONAL COMMENTARY

## 29.1

# Composition in Taiwan: Empirical Studies and Educational Practices

**Sheau-Yuh Lin**

*Taipei Municipal University of Education, Republic of China (Taiwan)*

In this article, composition is defined as the creation of original music through composing, improvising, and arranging. Empirical studies in Taiwan that are related to composition as part of formal school education began in the early 1990s. They were conducted mostly through master level theses by mainly in-service music teachers, or through research publications of college/university professors of either composition or music education backgrounds. Among about 170 music education-related master theses completed up to this time, eight completely or partially dealt with composition. Six focused on melody composition (Chen, 1995; Chen, 1996; Chen, 2002; Lu, 2001; Tzen, 2004; Yang, 1992), one involved sound associations (Huang, Yu-Sheng, 2003) and one emphasized improvisation (Huang, Yu-Ping, 2003). Research techniques consisted of mostly the experimental method, with observation, action research and case study methods also utilized. Variables included computer-assisted instruction, creative thinking strategies instruction and the effectiveness of visual icons for composition.

For the studies conducted by professors, creative thinking strategies instruction (Chen, 1995), self-developed computer software (Sun, 1996), Web Project-Based Learning (WPBL) (Hong & Hsieh, 2001, 2002, 2003), and the Arts PROPEL curriculum model (Lin, 2005) were implemented and empirically examined. Except for Chen's study, the other three were all funded by the National Science Council – the highest government agency in Taiwan responsible for promoting the development of science and technology. For example, the WPBL study lasted for 3 years. The project aimed at offering internet communication, showcasing examples of student collaborative work and rating students' on-line discussions or assignments completed. Arranging and composition tasks were involved as part of the assignments. Results suggested that WPBL promoted deeper and broader understanding of content and longer-term recall of content than conventional approaches.

There are at least two phenomena that are contributions of Taiwanese researchers to composition practices that have promising research potential; namely, the implementation of various versions of national music curriculum standards and guidelines as

471

*L. Bresler (Ed.), International Handbook of Research in Arts Education, 471–474.*
© 2007 *Springer.*

well as the practices of music methods. First, The Ministry of Education set up national standards and guidelines in Taiwan. Composition was included in the Music Curriculum Standards since 1962 for the elementary curriculum and since 1968 for the junior-high curriculum. Educational policies changed from time to time resulting in different versions of music curriculum standards and textbook systems. For example, the compulsory education system was extended from 6 to 9 years in 1968 and the textbook system was then switched to uniform series compiled by the National Institute for Compilation and Translation. However, educational policy was liberalized in 1987 after the lifting of Martial Law, and music textbooks were published by various companies. In addition, Taiwan has undergone educational reform since the past decade and implemented Grade 1–9 Curriculum Guidelines of the Arts and Humanities learning area to deliver integrated arts disciplines of music, visual arts, and drama in 2001. In spite of all the changes, composition has obtained an ever-increasingly secure position in Taiwan's national curriculum standards and guidelines, as well as in music textbooks and in educational arenas. In a content analysis study of creativity between America and Taiwan Elementary Music Textbook Series, results indicated that Taiwan's texts involve higher music composition page occurrence percentages than American texts do (Lin, Chi, & Chien,  2005). The influence of national music curriculum standards and guidelines on educational practices of composition instruction cannot be ignored. However, the class time for music has been cut down in Grade 1–9 Curriculum, and studies need to examine how the reduction of class time for music influences composition instruction.

Among the music curriculum standards and guidelines mentioned above, the nature of composition tasks and instructional modes presented is in many ways, even though gradually, consistent with what literature recommends. Game-like approaches were suggested; both processes as well as products were emphasized; products of composition were broadened to include outputs such as body movements; improvisation as well as composition were implemented; perception was reinforced before the production of sound and before the production of notation; the concept of individuality was considered; materials used involved not only western music but also local music idioms such as pentatonic music scales; composition was strongly recommended to integrate other music behaviors such as performing and appreciating as well as students' everyday experiences; and both individual and group compositions were encouraged. Even though the implementation of these standards and guidelines are not satisfactory in terms of tasks and instructional modes, the music curriculum standards and guidelines are an important feature of Taiwan's educational arenas.

The other phenomenon that promotes composition practices has to do with the popularity of famous music method systems in Taiwan. *Chinese Orff-Schulwerk Association, the Dalcroze Society of Taiwan, and the YAMAHA Corporation in Taiwan*, to list some, are all active organizations that offer music classes to children and that offer teacher training programs to adults. Composition occupies a central place in all these systems. Students learn to improvise and compose using a variety of mediums such as body gestures, pianos, electronic keyboards, and Orff instruments. The teacher training programs help promote the idea that composition is an integral part of music curriculum for all participants.

Composition is slowly but surely becoming one integral part of formal and informal music education practices in Taiwan. Striving to meet the challenge of knowledge-based economies, Taiwan the Republic of China (R.O.C.) has regarded the enhancement of creativity as an increasingly important national goal. To meet this goal, the government initiated the 2003 White Paper on Creative Education to establish a Republic of Creativity (ROC). However, to bridge the gap among composition as standards and guidelines, as textbook materials, as classroom practices, and as a focus for empirical study, additional efforts need to be made. For example, assessment problems need to be addressed; more studies involving scaffolding of composition need to be conducted; more preservice composition pedagogy courses should be offered; and more time for music teaching should be allotted since composition takes time.

# References

Chen, Y.-J. (1996). *Chuang zao shi kao ce lue jiao xue dui guo xiao xue tong qu diao chuang zuo xue xi xiao guo zhi yan jiu* [Effects of the creative thinking strategies instruction on melodic composing learning of elementary students]. Unpublished master's thesis, National Taichung Teachers College, Taichung, Taiwan.

Chen, Y.-M. (1995). *Guo min xiao xue yin yue ke chuang zao jiao xue yan jiu* [Study of elementary school music creative thinking instruction]. Taipei: Huang Long.

Chen, Y.-M. (2002). *Ying yong dian nao fu zhu guo xiao yin yue jiao xue zhi tan tao* [A study of the computer-assisted music instruction in elementary school]. Unpublished master's thesis, National HsinChu Teachers College, Hsinchu, Taiwan.

Hong, B.-X., & Hsieh, Y.-M. (2001). *Guo xiao wang lu zhuan ti xue xi huan jing yu duo yuan dong tai ping liang mo shi fa zhan zhi yan jiu* [Investigation of the development of elementary school Web-based learning environment and multiple dynamic assessment models]. (NSC 89-2520-S-024-005)

Hong, B.-X., & Hsieh, Y.-M. (2002). *Guo xiao wang lu zhuan ti xue xi huan jing yu duo yuan dong tai ping liang mo shi fa zhan zhi yan jiu* [Investigation of the development of elementary school Web-based learning environment and multiple dynamic assessment models]. (NSC 90-2511-S-024-005)

Hong, B.-X., & Hsieh, Y.-M. (2003). *Guo xiao wang lu zhuan ti xue xi huan jing yu duo yuan dong tai ping liang mo shi fa zhan zhi yan jiu* [Investigation of the development of elementary school Web-based learning environment and multiple dynamic assessment models]. (NSC 91-2520-S-024-017)

Huang, Y.-P. (2003). *Guo zhong yin yue ke cheng ji xing jiao xue zhi xing dong yan jiu* [Action research on improvisational teaching of music curriculum at junior high school]. Unpublished master's thesis, National Taiwan Normal University, Taipei, Taiwan.

Huang, Y.-S. (2003). *Dian nao ke ji zai yin yue chuang zuo shang zhi yin yong* [The applications of computer technology on musical composition]. Unpublished master's thesis, National Taipei Teachers College.

Lin, S.-Y. (2005). *Yin yue chuang zao li zhi shi zheng: Yi Mai Xiang Yi Shu ke cheng fang an yun yong yu guo xiao yin yue chuang zuo jiao xue* [An empirical study of music creativity: The implementation of arts PROPEL program in elementary school music composition instruction]. (NSC 93-2411-H-133-002-)

Lin, S.-Y., Chi, Y.-C., & Chien, C.Y. (2005, July). *A comparative study of creativity between American and Taiwan elementary music textbook series*. The 5th Asian-Pacific Symposium on Music Education Research Seattle, WA.

Lu, I.-C. (2001). *Shi jue chuang yi shi kao yin yong yu guo xiao yin yue jiao xue zhi yan jiu* [A study of the effects of the visually creative thinking on music teaching in elementary school]. Unpublished master's thesis, National Taiwan Normal University, Taipei, Taiwan.

Sun, D.-Z. (1996). *You er yin yue chuang zuo jiao xue zhi dian nao xue xi huan jing zhi fa zhan yu yan jiu* [Development and study of computer learning environment for young children's music creating instruction]. (NSC 84-2511-S-134-004-CL)

Tzen, P.-I. (2004). *Yin yong zhi xun ke ji rong ru yin yue ke jiao xue she ji zhi shi zheng yan jiu* [The experimental study of integrating information technology on music instruction]. Unpublished master's thesis, National Taiwan Normal University, Taipei, Taiwan.

Yang, Y.-H. (1992). *Yun yong dian nao fu zhu zhi qu diao chuang zao jiao xue yan jiu* [A study of musical composition teaching through computer-assisted instruction]. Unpublished master's thesis, National Taiwan Normal University, Taipei, Taiwan.

# INTERNATIONAL COMMENTARY

## 29.2

# Teaching Music Composition in Hong Kong

**Bo Wah Leung**
*Hong Kong Institute of Education, Hong Kong S.A.R.*

Music teachers in Hong Kong rarely apply creative music-making activities in class. Surveyed by Leung (2000), only 5 and 9% of teaching time, in terms of mean, were allocated to creative activities in junior and senior secondary classrooms. Factors contributing to this situation included the teachers' personal competence and experience in composing, teachers' relevant training in teaching composing, teachers' perception towards the support of schools, the external support from the official curriculum, and students' attitudes towards music composition.

As teacher education has been identified as a significant factor affecting the quality of teaching composition in schools, Leung (2004a) further investigated how teacher education programs should equip music teachers to undertake creative activities. A general lack of discipline-based knowledge in composing was the main reason that led to a rather negative attitude of in-service teachers. They always asked for more existing teaching packages rather than learning theories or practices to increase creativity. This study implies that theory and practice should be closely related when preparing teachers to understand why and how creative projects should be delivered. The discipline-based knowledge in music should therefore be more emphasized and well-integrated with pedagogical skills in teacher education programs.

Strategies of designing and implanting creative projects are another important factor. Leung (2004b) further explored the teaching strategies by observing 13 in-service teachers teaching creative activities in class within 2 years. Based on the observation and interviews with teachers, he proposed four strategies for designing and six for implementation. In designing creative projects, teachers should (1) address students' musical tastes for better motivation, (2) integrate performing and listening activities into creative projects for more musical input, (3) spread the creative task over a number of lessons, and (4) provide assessment criteria for students' planning. In implementation, teachers should (1) negotiate the task with students to maximize the ownership of the project by students, (2) develop students' musical conceptualization by providing relevant musical knowledge, (3) provide sufficient time for composing,

*L. Bresler (Ed.), International Handbook of Research in Arts Education, 475–476.*
© 2007 *Springer.*

(4) act as musical models by demonstrating how to compose, (5) provide on-going feedback to students in order to maintain students on task, and (6) develop two-way communication with students during the creative process.

A recent study (Leung, 2005) on student composing focused on motivation changes. A total of 810 students from four secondary schools were invited to respond to a set of pre- and postactivity questionnaires before and after they were involved in a composing project. Results from a series of repeated measure ANOVA suggest that gender and the identity of the student as an instrumentalist significantly affected the motivational changes. The noninstrumentalists significantly elevated their levels of motivation measures, while instrumentalist's motivation remained the same. While male students had a significantly lower level of self-efficacy than females before composing, they were more significantly confident and motivated in composing than females. Implications include that teachers should consider individual differences among students when designing and implementing creative projects.

# References

Leung, B. W. (2000). Factors affecting Hong Kong secondary music teachers' application of creative music-making activities in teaching. *Asia-Pacific Journal of Teacher Education and Development, 3*(1), 245–263.

Leung, B. W. (2004a). Equipping in-service music teachers to undertake creative music-making activities in Hong Kong secondary schools: Implications for teacher education. In P. M. Shand (Ed.), *Music education entering the 21st century* (pp. 117–121). Nedlands: International Society for Music Education.

Leung, B. W. (2004b). A framework for undertaking creative music-making activities in Hong Kong secondary schools. *Research Studies in Music Education, 23*, 59–75.

Leung, B. W. (2005). An investigation on motivation changes of secondary students on composing activities in Hong Kong. *Proceedings to the 5th Asia-Pacific Symposium on Music Education Research* (CD ROM). Seattle: University of Washington.

# 30

# FOUR METAPHORS OF THE COMPOSING PROCESS

**Sarah J. McCarthey**
*University of Illinois at Urbana-Champaign, U.S.A.*

Current research and pedagogy on writing derive from theories about how writers compose texts. Bizzell (1986) defines composing as "all of the processes out of which a piece of written work emerges" (p. 49). In this chapter, I present four metaphors that capture the different ways in which theorists, researchers, and practitioners have explained the process of composing text. I identify major principles, discuss writing pedagogies and practices, and review studies that relate to each of the following metaphors: composing as discovery, composing as a cognitive process, composing as conversation, and composing as a social and political tool.[1]

The literature on writing and the composing process is extensive; thus, I have selected only four of many metaphors that might be used to describe the composition of written text. I have also drawn upon the work of other researchers and theorists who have conceptualized research in writing using models including LeFevre's (1987) paradigms for writing, Applebee's (2000) models of writing development, and Ward's (1994) analysis of various dialogic pedagogies and their theoretical roots. In an attempt to balance selection and comprehensiveness, I have not covered several important topics such as writing to learn, writing across the curriculum, the use of technology in the composing process, and second language writing. Additionally, the metaphors I present below are intended to map the general terrain of writing to enhance the reader's understanding, not to draw boxes around particular theories or constructs. In reality, theories of composition overlap, intertwine and inform one another, while researchers often draw on more than one construct when designing studies. The metaphors do provide a means to frame assumptions about the composing process, to consider research questions that are shaped by those assumptions, and identify pedagogies that are connected to the metaphors.

## Emergent: Composing as Exploration and Discovery

The metaphor of composing as exploration and discovery has its roots in a diverse set of sources: (a) phenomenological philosophy, (b) Bruner's (1962) studies of cognition

477

*L. Bresler (Ed.), International Handbook of Research in Arts Education*, 477–492.
© 2007 *Springer.*

and creativity, (c) Chomsky's (1965) view of language acquisition, and (d) the Paris Review interviews (Plimpton, 1963). Phenomenology suggests that there is no objective reality; rather, reality is organized and experienced by the individual through language (Husserl, 1962). Bruner's early work focused on the ways in which children's learning developed through manipulation, representation, and symbolism of the external world, while Chomsky theorized that children acquired language through a series of successive grammars. At the same time, the *Paris Review* (Plimpton, 1963) published works by twentieth-century poets, novelists, and essayists and interviewed them about their writing processes as well as their work; many of these writers focused on the creative, and often challenging process of exploration and discovery. Together these sources gave rise to a focus on the individual writer struggling to find her voice and perfect her craft.

Composing as exploration and discovery made its way into classrooms through three major sources: (a) research from the United States and Britain on writing; (b) pedagogy developed by Murray (1982) and Elbow (1981) for college classrooms, and Graves (1983) and Calkins (1983) for elementary classrooms; and (c) the emergent literacy perspective that focused on the developmental nature of written language (Clay, 1975). In the late 1970s and early 1980s, educators began to investigate the role of writing in the school curriculum. Two major studies focusing on writing instruction, one conducted in Britain (Britton, Burgess, Martin, McLeod, & Rosen, 1975), and the other conducted in the United States (Applebee, 1981), found that writing assignments tended to be limited in scope and purpose; typical assignments were fill-in-the blank exercises or first- and-final draft reports written for the teacher. In secondary schools, students had some opportunities to do more extended writing, but only within English classes. Based on the study of British secondary schools, Britton and his colleagues developed a model suggesting that learning to write is a process of learning to use language in different ways. At the core of the model is expressive language that is informal, everyday language used among people who share a common context such as caregiver and child. As language users develop, they seek to communicate with more distant audiences; their language becomes more formalized and they are capable of using new genres for purposes of informing, persuading, or entertaining. Britton and his colleagues laid out a developmental continuum that suggested younger students engage in more expressive writing while older students move towards more transactional and literary writing (Applebee, 2000).

Educators began to adopt some of Britton's ideas, particularly for college students, developing pedagogies that would help students to produce more lively texts for multiple purposes and audiences other than the teacher. Macrorie (1985) recommended that free writing could help students generate ideas, while Murray (1982) suggested that students must take the lead in discussing their work as instructors ask open-ended questions raising students' awareness of the text and the composing process. Elbow (1981) argued for the formation of writing groups in which readers pointed to effective features of the text, summarized the author's ideas, described what they experienced as they read the text, and showed their understanding by finding their own metaphors for the text. The role of the instructor in this model is that of an experienced coach or craftsperson with whom a student can consult. This pedagogical model found its way

into the elementary school through the work of Donald Graves (1983) and Lucy Calkins (1983, 1986) who worked with Murray.

Calkins (1983) followed one child through her third and fourth-grade years, documenting her progress as a writer. The child gained confidence as she developed understandings of writing and new composing strategies. Major instructional components that assisted the child's development of writing strategies included peer conferences, teachers talking about writing, and the use of model texts. From her research, Calkins (1986) developed an approach to writing that included student choice of topics, writing for real audiences, developing revision strategies, and sharing work with peers. Conventions such as capitalization and punctuation were taught through mini-lessons and the context of students' own writing; the teacher's role was to organize the workshop into a predictable structure and provide modeling and support for individual writers. Teaching strategies for writing workshops were refined (Graves, 1994); teacher authored books about conducting workshops increased, and teachers across the United States began to implement aspects of the workshop (Dahl & Farnan, 1998).

Despite some of the current focus on state testing (Strickland et al., 2001), some teachers have continued to implement workshops focusing on particular genres and increasing collaborative elements. For example, Roser and Bomer (2005) describe an effective writing workshop consisting of a demonstration of a particular convention or genre, writing opportunities that students see as authentic, the use of appropriate models such as books and other students' writing, and the teacher's guidance. The team also identify quandaries such as conferring with students, helping students revise their work, and assessing students' progress – all challenges to teachers' learning to implement workshops.

Because writing workshop focuses on helping children express their ideas in a print-rich environment by using invented spelling, it fit well with a perspective on language and literacy development, emergent literacy, that derived from the work of the New Zealand educator, Marie Clay (1975). By focusing on the patterns underlying different forms of writing, Clay found that children used invented spelling as they developed more conventional spelling. Writing begins early as preschoolers and toddlers become increasingly purposeful in representing concepts in their environment. Through immersion in print-rich environments and interacting with knowledgeable language users, children learn the forms and functions of print and learn to link meaning and form (Schickedanz, 2000). Sulzby (1982, 1985) investigated kindergarten students to find that children used different forms of writing for different tasks such as words, sentences, or stories. She found that children tended to use less mature forms of writing (e.g., scribble) when attempting a more difficult task, writing a story. In further studies Sulzby and her colleagues (1989) found developmental patterns as students engaged in drawing, making letter-like units, using random letters, using invented spelling in syllables and then for larger words, and then writing conventional words. Teale and Martinez (1989) followed kindergartners who participated in a writing program from an emergent literacy perspective; they found that connecting writing to authentic purposes, to children's literature, and connecting student writers with each other were key aspects in fostering students' writing development. More recent work by Casbergue and Plauché (2005) found that a kindergartener developed through

different stages as she gained control of mechanical aspects of writing; at times, she appeared to regress as she alternated focusing on form and meaning. They documented the benefits of encouraging children to read their own writing to an audience, raising the expectations gradually for students to make more accurate sound-symbol connections, and providing spelling instruction that is organic, that is, proceeding from the child's abilities.

Studies focused on older students also supported the premise that children develop writing skills as they mature. For example, Bissex (1980) used an emergent perspective as she followed her own child's development from ages five through ten, and found that he used a variety of forms including signs, notes, stories, and lists for communicative purposes. Her son developed a range of writing strategies from invented spelling to more conventional spellings through his literate environment and interactions with his parents. Langer (1986) explored children's knowledge of genre at ages 8, 11, and 14 to find that children clearly differentiated between storytelling and exposition. She also found that students developed more complex prose structures and more elaboration in their writing with age and experience. Newkirk (1987) documented children's development from lists to paragraphs and found that young children use a variety of genres, challenging Britton's emphasis on the expressive nature of writing. Chapman's more recent study (1995) suggested that students' use of genre emerged developmentally.

Research conducted from the perspective of composing as discovery has focused on the development of individual writers as they come to understand and express themselves. Writing is conceptualized as an individual process to discover the nature of what to say and identify appropriate language for expression (Ward, 1994). The emergent perspective highlights the developmental nature of children's writing as they interact with print.

Much of the research methodology used within the composing as discovery model tends to highlight the individual; thus, case studies of children (Bissex, 1980; Calkins, 1983) were often conducted. However, studies with groups of children at different developmental levels using a variety of methods (e.g., Sulzby, 1982; Langer, 1986) have also revealed important findings that have influenced researchers' views of children's development as writers and informed classroom instruction.

## Cognitive: Composing as a Cognitive Process

In 1980 Hayes and Flower (1980) proposed a model of writing that derived from cognitive psychology (Simon & Hayes, 1976) and challenged previous assumptions about how writers composed text. In their model, the authors proposed three major components: (a) the task environment, "all those factors influencing the writing task that lie outside of the writer's skin" (Hayes, 2000, p. 8); (b) cognitive processes involved in writing such as planning, translating, and revision; and (c) long-term memory including knowledge of topic, genre, and audience. Although the authors have revised their model to emphasize the role of working memory, visual representations, motivation, and revision, the newer model continues to focus on composing as a problem-solving activity consisting of related sub-processes (Hayes, 2000).

Emig's (1971) seminal study on the writing processes of twelfth graders contributed to the development of the metaphor of composing as a process. She found that the conventional wisdom about how to teach writing (grammar, outlining, five-paragraph essay format) actually inhibited students' writing development, and recommended that writing should be conceptualized as a tool for reasoning and learning rather than a means to demonstrate knowledge already acquired. While Emig was also influenced by the discovery metaphor, her work initiated cognitive studies that (a) identified recursive aspects of composing such as planning, organizing, drafting, and revising; (b) focused on the differences between novices and expert writers; and (c) suggested that processes vary according to the task, context, and students' backgrounds (Newell, 1996).

Researchers have investigated factors involved in the writing process to understand the role of memory, problem solving, text production, and motivation (Hayes, 2000). For example, better writers are able to coordinate multiple subprocesses more easily than poor writers (Ransdell, Levey, & Kellogg, 2002). Problem-solving, decision making, and inferencing have all been found to be important factors influencing writers' representations of texts (Hayes, 2000). Writers draw from their understanding of tasks and knowledge of their audience to compose texts, which involves producing parts rather than whole sentences (Kaufer, Hayes, & Flower, 1986). However, several studies have shown that students often have difficulties identifying problems in their own texts and avoid making large-scale revisions (Flower, Hayes, Schriver, Stratman, & Carey, 1986). Research on college students has found that beliefs about their own abilities as writers can have important motivational and affective consequences (Palmquist & Young, 1992; Pennebaker & Beall, 1986). Bereiter and Scardamalia (1987) delineated two different writing processes: (a) *knowledge telling* enables students to write about what they know about a topic, often appropriate for the narrow demands of school-type tasks, and (b) *knowledge transforming* that goes beyond telling in order to develop new ideas and transform writers' understandings. In their research on fifth-grade, tenth-grade, and adult writers, the researchers found that novice and expert writers differed in their experiences, capabilities, and composing behaviors. Elementary writers tend to do little planning or goal setting, instead using the "what-next" strategy of writing from one sentence to the next.

Several intervention programs focused on helping students to become more motivated, and strategic writers have their roots in the cognitive model. Direct teaching of metadiscourse (i.e. markers that make text organization more explicit and develop a relationship between the reader and writer) in a college course has shown that students in the experimental group produced better essays with fewer errors than a control group; additionally, they increased their awareness of audience and the rhetorical functions of composition (Cheng & Steffensen, 1996). Other research has found that explicit instruction in text structures has improved students' performance in writing compare-contrast essays (Hammann & Stevens, 2003). Hidi and her colleagues (2002) found that providing instruction on argumentative writing and using extensive collaborative writing activities with junior high school students was effective in improving self-efficacy and interest in writing. Two instructional programs, Cognitive Strategy Instruction in Writing (CSIW) (Raphael & Englert, 1990) and Concept Oriented

Reading Instruction (CORI) (Guthrie et al., 1996), were designed to help elementary students improve their texts and increase awareness of their composing processes. Research investigating the effects of such instruction has demonstrated positive effects on students' ability to synthesize information from multiple sources; identify various text structures; and use strategies to collect information, organize information and write reports (Raphael & Hiebert, 1996). Guthrie et al. (1996) found that the increased use of strategies was highly correlated with students' motivation.

Research from the cognitive model has also focused on the role of genre and the use of models for developing students' writing. At the college level, Charney and Carlson (1995) found in their experimental study that prose models influenced the content and organization of students' research papers. Novice writers using prose models produced responses that were more introspective and evaluative than novices who did not use models (Stolarek, 1994). In his study of middle school minority students, Yeh (1998) found that students in an experimental group benefited from using heuristics for writing persuasive essays; they used principles rather than rote procedures to transfer their knowledge to a range of topics. In a study of professional writers and students in grades six, eight, and ten, Crammond (1998) found the complexity of arguments increased with age and knowledge about audiences. Donovan's (2001) study of students' texts in grades K-5 indicated that even the youngest students were able to differentiate between stories and informational texts and produce the requested genre by second grade. She suggests that teachers should provide opportunities for informational writing as well as narrative in the first days of school.

Research from the composing-as-a-cognitive-process model has produced important information about the subprocesses writers use as they compose text. The model has yielded research about the role of motivation as well as the effects of task and instruction on learning to write. Many of the studies derived from the cognitive model have employed experimental and quasi-experimental designs to understand the effects of planning and revising on texts as well as examining the influence of motivation and instruction on learning to compose. Think-aloud protocols, analysis of students' texts, and structured observations of teachers and students have served as major data sources.

## Social: Composing as Conversation

Composing as conversation derives from Bruffee's (1984) work entitled "Collaborative Learning and 'The Conversation of Mankind'" in which he suggested that thought is internalized conversation and writing is "internalized conversation re-externalized." Bruffee drew from philosophers who theorized that knowledge is the product of negotiation and consensus among members of a discourse community (Kuhn, 1970; Rorty, 1980), and from Vygotsky (1978, 1986), who viewed writing as a psychological tool that mediated thought. LeFevre (1987) used the idea of invention to articulate the foundations of social constructivism for writing: (a) the writer is influenced by the social context; (b) writing norms and genres build on knowledge from the past; (c) writing may be enhanced by an imagined dialogue with another; (d) writers involve others as editors, collaborators, and devil's advocates; and (e) social context

influences how texts are received, evaluated, and used. Writing, then, is viewed as a social activity in which texts are part of an ongoing chain of discourse (Bakhtin, 1986).

The impact of the composing as conversation metaphor can be found in both research and instruction in the following areas: (a) writing conferences, (b) collaboration, (c) the role of community and context, and (d) issues of identity and positioning. Through writing conferences and collaborative writing, students are literally participating in conversations. At a more abstract level, the individual is engaged in a conversation with the community and the specific context through writing. In a social constructivist view identity is shaped through the voices we have encountered in the past (Bakhtin, 1986).

Bruffee (1973) recommended that instructors take advantage of the social nature of writing by providing classroom contexts that support students' engagement in dialogue about their own writing. Gere (1987) suggested that collaborative peer groups could provide support for writing and development of ideas. While the idea of peer groups was adopted for college and high school students, other educators such as Calkins (1986) and Graves (1994) sought to introduce peer conferences to elementary students at the same time as they focused on teachers' responses to students.

Descriptions of ideal teacher-student conferences focus on the role of the teacher as one who invites the student to set the agenda and gives the student critical feedback, while the student takes an active role by responding, asking questions, and describing her own work (Anderson, 2000; Graves, 1983). Instructors differ in their approaches from prescriptive to collegial in their writing conferences (Patthey-Chavez & Ferris, 1997). Newkirk (1995) found that tensions and miscommunication might occur in conferences, resulting in misevaluations of students' performance and lost teaching opportunities. Teachers tend to be less directive and elicit student opinions more frequently with stronger writers than weaker writers; students' diverse backgrounds affect teacher-student interactions and help structure the event (Patthey-Chavez & Ferris, 1997). In a study that consisted of both national surveys of writing teachers and an ethnographic study of two teachers, Freedman (1987a) found that successful response to writing was guided by a strong philosophy of teaching writing, that successful teachers guided students but did not take over their students' writing, and that the teachers established successful classroom activities that allowed students to communicate their ideas without providing prepackaged curricula. Research focusing on conferences in ninth grade classrooms suggests that more collaborative conferences consist of teachers and students actively negotiating topic and structure, whereas less collaborative conferences consist of students accepting teachers' contributions (Sperling, 1990). Additionally, conferences function differently at various points in the writing process (e.g., prewriting, drafting, and revision), and students obtain different benefits depending on the circumstances (Sperling, 1998). In elementary classrooms, research has shown that teachers tend to dominate conferences and turn them into traditional lessons (Michaels, 1987). McCarthey (1994) found that what elementary students internalized from writing conferences was related to the quality of their interactions and relationships with the teacher.

Studies focused on changes in students' writing have found that college students do make revisions based on conferences and comments on papers (Patthey-Chavez &

Ferris, 1997), and their revisions are shaped by personal, interpersonal, and institutional histories (Prior, 1995). High school students tend to focus their revisions on surface and stylistic features depending on the classroom context and focus of instruction (Yagelski, 1995). At the elementary level, researchers have found that students' text revisions reflected conversations during conferences, and that the conferences had differential effects on students with different levels of experience as writers (Fitzgerald & Stamm, 1992).

Researchers investigating classroom interactions during writing time noted that not all "writing process" classrooms were alike; contexts shape classroom activities and student learning (Lipson, Mosenthal, Daniels, & Woodside-Jiron, 2001). Context includes factors such as the history of classroom events, teachers' own histories, and institutional, disciplinary, and social contexts (Prior, 1998). Contexts also include factors such as students' knowledge of books or the writing topic, perceptions of what teachers expect, and the particular task; these "dynamic streams of overlapping and integrated discourses, spaces, sociocultural practices, and power relations" all influence children's writing (Kamberelis & de la Luna, 2004, p. 243).

Freedman's (1992) research in ninth-grade classrooms indicated that teachers' implementations of response groups varied in the purposes, nature of interactions, and types of talk within the groups. Sperling and Woodlief (1997) compared the writing environments of two tenth-grade classrooms, one in a white middle-class school and the other in an urban multi-ethnic school, and found that the teachers and students created quite different kinds of communities as expressed through teachers' goals and assignments and the students' values for writing. Gutierrez (1992) found that the quality of instruction and the specific classroom context affected elementary students' learning to write. Chapman (1995) found that first-graders' writing increased in complexity and richness as the children responded to each other, to readings, and to the teacher's suggestions. Other researchers have found that the nature of the writing opportunities, the quality of the student-teacher interaction during writing time, and the ways in which peers respond to one another influence students' understanding of the tasks and their willingness to engage in the composing process (Lensmire, 1993; McCarthey, García, Lòpez-Velásquez, Lin, & Guo. 2004; Reyes, 1992).

Practices such as collaborative writing also derive from social constructivist theories. For example, Daiute (1989) found that young children enjoyed writing together and enhanced their skills when they were encouraged to play and invent on the computer. Schultz (1997) identified a multitude of types of collaboration including sharing texts, writing about the same topic, and writing a single text in a fifth/sixth-grade classroom that encouraged students to work together. A study in Brazil with 8 to 13-year-olds found that texts written in pairs were of better quality than those written individually; working collaboratively aided students in becoming more aware of decisions and enhanced sharing of information during text production (Ferraz & Santos, 2001).

Research from the point of view of composing as conversation has also found that social and cultural contexts affect students' attitudes towards writing, their positioning of themselves in relation to the tasks, and the ways in which they construct their identities as writers. Smidt's (2002) study of Norwegian high school students and their teacher found that students took different stances depending on their perceptions of

themselves and others, their attitudes towards writing, and shifting perspectives of what counts in each setting. Abbott's (2000) study focused on avid elementary student writers found that the participants' motivation to write was strongly influenced by social context and the teacher's willingness to allow students to pursue their own interests. Through interviews with 60 Argentinean preschool and elementary students, researchers found that their responses were differentiated by age, purposes, and context for writing (Scheuer, de la Cruz, Huarte, Caino, & Pozo, 2001).

Fecho and Green (2002) studied a high school student who used writing to construct different facets of his identity in different contexts. McGinley and Kamberelis (1996) found that students used writing for a variety of personal and social functions including exploring new roles and social identities. McCarthey (2002) found that elementary students constructed their identities as writers in accordance with the school curriculum as well as the teacher's, their parents, and their peers' views of them as literacy learners. A yearlong study of a primary grade classroom revealed that students engage in a variety of subject positions that they assigned to themselves and each other during writing workshop; they interwove social and emotional as well as intellectual dimensions of themselves as they struggled to become writers (Bomer & Laman, 2004).

Research using the composing as conversation metaphor has focused on writing conferences, classroom context, collaboration, and identity. Most of the research has used methodology aimed at investigating issues of context using ethnographic and qualitative case study methods. Researchers have collected data through intensive interviews, observations, and the collection of writing samples to show the ways in which writing is situated in particular contexts, and how those contexts influence students' performance, attitudes, and identities.

## Critical: Composing as a Social and Political Tool

The Brazilian educator, Paolo Freire, (1970) based his pedagogy on the notion that it was essential to subvert traditional "banking models" of education with dialogic, liberatory ones. He theorized that humans are able to reflect on their lives and take action to transform their worlds, yet many people cannot develop their full potential because of their social positions. Those who are oppressed and illiterate are unable to think critically about their positions. Therefore, liberatory educators help the oppressed transform their situations by creating more democratic relations within the classroom and bringing students into critical dialogue with one another.

Ira Shor (1999) was one of the first to apply Freirean frames to college-level composition classes. His strategy was to help students identify features of everyday life that become the focus of critical dialogue. Students wrote about their experiences, read their work aloud, and engaged in dialogues about the themes that arose from their essays. Like the critical pedagogues, feminist writing theorists such as Code (1991) have also focused on the issue of oppression in society. Code suggested that women might be disempowered in mixed-gender peer writing groups because they lack confidence in their own knowledge bases and are not viewed as credible by others. Jarratt (1991) recommended that teachers should acknowledge differences among students

such as gender, race, and social class; dialogue, although it may be filled with conflict, is the means for students to acknowledge and value differences. Those advocating critical pedagogy suggest that writing classes can provide the opportunities for students to engage in critical analyses of texts; reflect upon their own experiences as members of racial, cultural, linguistic, and gender groups; and compose texts that effect changes within a community.

Research in college composition classes has found that some instructors have engaged students successfully in critical literacy practices (see Brodkey, 1987; Villanueva, 1991). Although critical literacy practices are not widespread in K-12 schools, some educators have attempted to implement pedagogy consistent with the metaphor of composing as a social and political tool. Fairbanks (1998) has demonstrated the potential for secondary students to become connected to their social and political contexts through writing. The "Write for Your Life" (Swenson, 2003) project engaged students in generating themes of concerns in their own lives, writing texts, turning their problems into questions, and developing service projects to address real-world problems. DeStigter (1998) involved Latino and Anglo at-risk high school students in a reading and writing project that drew upon family histories to form a democratic community. Henry's (1998) study of African-Caribbean adolescents found that allowing girls space to talk and write about their lives resulted in students' beliefs that they were learning and becoming more empowered. A group of Australian elementary teachers have engaged students in social critique of texts (Comber, 2001; Luke, O'Brien, & Comber, 2001). Burns (2004) reported that first-grade American students were able to develop a language of critique of presidential candidates' platforms and wrote letters to the president to express their concerns. Bomer and Bomer (2001) have involved elementary students in activities to identify problems within their communities, conduct research projects together, and write to specific audiences to raise awareness of community issues.

While several writing programs have been organized to engage students in using writing to become more reflective about their social circumstances, other research studies have used a social/political lens to engage in critique of classrooms in terms of race, social class, gender, and ethnicity. For example, Ashley (2001) examined the relations between social class, basic writing, and academic writing to find that working class undergraduates were able to express agency and trick teachers into helping them produce acceptable texts. The narratives of 27 Puerto Rican and Mexican students written while they were in eighth grade and then again as juniors in high school revealed that Latino students were highly critical of both their educational experiences and their own academic decisions (Quiroz, 2001). In their work establishing a democratic-oriented, first-second-grade classroom with a multicultural language arts curriculum, Solsken and her colleagues (2000) found that a Latina student interwove her home, school, and peer languages in her writing to serve a variety of social and personal agendas. However, they also found that her texts were more sophisticated and appropriate than the teacher or researchers had initially recognized. Their analysis suggests that barriers deeply rooted in schools and society prevented them from valuing her texts, yet the authors suggested that the tensions they uncovered could inform the construction of new pedagogical spaces.

While some researchers have argued that the theories of Bakhtin (1981, 1986) coincide with a social constructivist point of view, others have suggested that his focus on *ideologiya* fits within the critical pedagogy framework because "it does not exclude the development of a political idea system as part of ideological development" (Freedman & Ball, 2004, p. 5). Because Bakhtin's work focuses on "language as mediator of historical, cultural, and social experience" (Dressman, 2004), and highlights the struggle among diverse voices as they interact, his work has influenced writing research. For example, focusing on college students, Ivanic and Camp (2001) found that second language learners positioned themselves to sound like members of specific social groups. Knoeller (2004) used a Bakhtinian framework to show how high school students created complex narratives (oral and textual) in which they reconciled multiple, competing perspectives on race relations and other social topics. Dyson (2003) documented the ways in which students from a first-grade classroom represented their official (classroom) and unofficial (out of school) worlds in their writing through a Bakhtinian frame. By drawing extensively on popular culture such as sports, cartoons, raps, and other features of the media and through their interactions with a small circle of friends, students developed complex texts that rearticulated their literate identities. McCarthey (1994) examined the ways in which elementary writers struggled to assimilate and resist the authoritative voice of the teacher to create an "internally persuasive discourse" (Bakhtin, 1981, p. 341) in their own texts. Lensmire (2000) used a Bakhtinian lens to provide a critique of writing workshop in the elementary school, specifically noting that the conception of voice was limited to that of a "unitary, unfettered, individual self" (p. 63). He provided an alternative conception of voice, "voice as project" (p. 75) that emphasizes the struggle in which a student engages to do something new with existing resources.

What these studies have in common with critical pedagogy is the focus on critique, conflict, and change. Researchers have provided critiques of current classrooms, writing programs, and the society that reflects and reproduces inequitable relationships. They have focused on the tensions that arise from individuals as members of different racial, socio-economic, and linguistic groups, and the differences in power relations resulting from an inequitable society. Researchers have examined the conflicts between teacher's expectations and students' own goals in writing, as well as clashes between students' unofficial and official worlds. Yet, these researchers suggest that the seeds of change exist within these critiques. Therefore, researchers who view composing through a socio-political lens see the potential for writing to serve as a tool for revealing tensions and inequities and for reducing those inequities within the larger society.

Studies that reflect the metaphor of composing as a social and political tool frequently use ethnographic data and case studies that involve long-term engagement in settings (Dyson, 1993, 1997, 2003). Often these studies are conducted by teachers investigating their own classrooms (Bomer & Bomer, 2001; Comber, 2001) or by researchers working with teachers (e.g., Fairbanks, 1998; Henry, 1998; Solsken et al., 2000). Sources of data include observations of students in and out of school, interviews with participants, and the collection of writing samples and other documents.

# Conclusion

The four metaphors of composing serve to organize the theories, research, and pedagogy that have emerged in the last 30 years about writing. Each model has theoretical strengths and weaknesses in its conceptions of the writer, the processes of composing text, and the instruction that best supports students' learning to write. No single metaphor of the composing process can capture the complexity of the process nor inform us about the best methods of instruction to enhance the abilities, motivations, and products of writers. However, together, the metaphors provide different lenses for viewing the processes, the writer, the context, and the text. By continuing to conduct research about the composition of written text, we can create new metaphors as well as generate new understandings of the complex processes of composing.

# Note

1.  Strictly speaking, I use similes rather than metaphors because my comparisons employ the term "as".

# References

Abbott, J. A. (2000). "Blinking out" and "Having the touch": Two fifth grade boys talk about flow experiences in writing. *Written Communication, 17*, 53–92.

Anderson, C. (2000). *How's it going? A practical guide to conferring with student writers*. Portsmouth, NH: Heinemann.

Applebee, A. (1981). *Writing in the secondary school: English and the content areas* (Research Monograph 21). Urbana, IL: National Council of Teachers of English.

Applebee, A. (2000). Alternative models of writing development. In R. Indrisano & J. R. Squire (Eds.), *Perspectives on writing: Research, theory, and practice* (pp. 90–110). Newark, DE: International Reading Association.

Ashley, H. (2001). Playing the game: Proficient working–class student writers second voices. *Research in the Teaching of English, 35*, 493–524.

Bakhtin, M. M. (1981). *The dialogic imagination*. Austin, TX: University of Texas Press.

Bakhtin, M. M. (1986). *Speech genres and other late essays*. Austin, TX: University of Texas Press.

Bereiter, C., & Scardamalia, M. (1987). *The psychology of written composition*. Mahwah, NJ: Erlbaum.

Bissex, G. L. (1980). *Gyns at wrk: A child learns to read and write*. Cambridge, MA: Harvard University Press.

Bizzell, P. (1986). The writer's knowledge: Theory, research, and implications for practice. In A. R. Petrosky & D. Bartholomae (Eds.), *The teaching of writing: Yearbook of the National Society for the Study of Education*. Chicago, IL: University of Chicago Press.

Bomer, R., & Bomer, K. (2001). *For a better world: Reading and writing for social action*. Portsmouth, NH: Heinemann.

Bomer, R., & Laman, T. (2004). Positioning in a primary grade workshop: Joint action in the discursive production of writing subjects. *Research in the Teaching of English, 38*, 420–466.

Britton, J., Burgess, T., Martin, N., McLeod, A., & Rosen, H. (1975). *The development of writing abilities*. London: McMillan Education, Ltd.

Brodkey, L. (1987). Modernism and the scene(s) of writing. *College English, 49*, 369–418.

Bruffee, K. A. (1973). Collaborative learning: some practical models. *College English, 34*(5), 634–643.

Bruffee, K. A. (1984). Collaborative learning and the "Conversation of Mankind." *College English, 46*, 635–652.

Bruner, J. (1962). *On knowing: Essays from the left hand*. Cambridge, MA: Harvard University Press.

Burns, T. J. (2004). Making politics primary: Exploring critical curriculum with young children. *Language Arts, 82*(1), 56–67.

Calkins, L. M. (1983). *Lessons from a child*. Portsmouth, NH: Heinemann.

Calkins, L. M. (1986). *The art of teaching writing*. Portsmouth, NH: Heinemann.

Casbergue, R. M., & Plauché, M. B. (2005). Emergent writing: Classroom practices that support young writers' development. In R. Indrisano & J. R. Paratore (Eds.), *Learning to write: Writing to learn* (pp. 8–25). Newark, DE: International Reading Association.

Chapman, M. L. (1995). The sociocognitive construction of written genres in first grade. *Research in the Teaching of English, 29*, 164–192.

Charney, D. H., & Carlson, R. A. (1995). Learning to write in a genre: What student writers take from model texts. *Research in the Teaching of English, 29*(1), 88–125.

Cheng, X., & Steffensen, M. S. (1996). Metadiscourse: A technique for improving student writing. *Research in the Teaching of English, 30*(2), 149–181.

Chomsky, N. (1965). *Aspects of the theory of syntax*. Cambridge, MA: MIT Press.

Clay, M. M. (1975). *What did I write?* Auckland, NZ: Heinemann Educational Books.

Code, L. (1991). *What can she know? Feminist theory and the construction of knowledge*. Ithaca, New York: Cornell University Press.

Comber, B. (2001). Classroom explorations in critical literacy. In H. Fehring & P. Green (Eds.), *Critical literacy* (pp. 90–102). Newark, DE: International Reading Association.

Crammond, J. G. (1998). The uses and complexity of argument structures in expert and student persuasive writing. *Written Communication, 15*, 230–268.

Dahl, K., & Farnan, N. (1998). *Children's writing: Perspectives from research*. Newark, DE: International Reading Association.

Daiute, C. (1989). Play as thought: Thinking strategies of young writers. *Harvard Educational Review, 59*(1), 1–23.

DeStigter, T. (1998). The "Tesoros" Literacy project: An experiment in democratic communities. *Research in the Teaching of English, 32*(1), 10–42.

Donovan, C. A. (2001). Children's written development and control of written story and informational genres: Insights from one elementary school. *Research in the Teaching of English, 35*(3), 394–447.

Dressman, M. (2004). Dewey and Bakhtin in dialogue: From Rosenblatt to a pedagogy of literature as social, aesthetic practice. In S. W. Freedman & A. F. Ball (Eds.), *Bakhtinian perspectives on language, literacy, and learning* (pp. 34–52). Cambridge, UK: Cambridge University Press.

Dyson, A. (1993). *The social worlds of children learning to write in an urban classroom*. New York: Teachers College Press.

Dyson, A. (1997). Rewriting for, and by, the children: the social and ideological fate of a media miss in an urban classroom. *Written Communication, 14*(3), 275–312.

Dyson, A. (2003). *Brothers and sisters learn to write*. New York: Teachers College Press

Elbow, P. (1981). *Writing with power*. Oxford, UK: Oxford University Press.

Emig, J. (1971). *The composing process of twelfth graders* (Research Monograph 13). Urbana, IL: National Council of Teachers of English.

Fairbanks, C. (1998). Nourishing conversations: Urban adolescents, literacy, and democratic society. *Journal of Literacy Research, 30*(2), 187–203.

Fecho, B., & Green, A. (2002). Madaz publications: Polyphonic identity and existential literacy transactions. *Harvard Educational Review, 72*, 93–115.

Ferraz, T., & Santos, P. (2001). *Produçao de textos narratives em pares: reflexes sobre o processo de inter-açao*. [The production of narrative texts in pairs: Reflections on the interaction process.] *Educaçao e Pesquisa, São Paulo, 27*(1), 27–45.

Fitzgerald, J., & Stamm, C. (1992). Variations in writing conference influence on revision: Two case studies. *Journal of Reading Behavior, 24*, 21–50.

Flower, L., Hayes, J. R., Schriver, K., Stratman, J., & Carey, L. (1986). Detecting, diagnosis, and the strategies of revision. *College Composition and Communication, 37*, 16–55.

Freedman, S. W. (1987a). *Peer response groups in two ninth grade classrooms* (Tech. Report No, 12). Berkeley, CA: University of California, Center for the Study of Writing.

Freedman, S. W. (1987b). *Response to student writing.* (NCTE Research Report No. 23) Urbana, IL: National Council of Teachers of English.

Freedman, S. W. (1992). Outside-in and inside-out: Peer response groups in two ninth grade classrooms. *Research in the Teaching of English, 26*(1). 71–107.

Freedman, S. W., & Ball, A. F. (2004). Ideological becoming: Bakhtinian concepts to guide the study of language, literacy, and learning. In S. W. Freedman & A. F. Ball (Eds.), *Bakhtinian perspectives on language, literacy, and learning* (pp. 3–33). Cambridge, UK: Cambridge University Press.

Freire, P. (1970). *Pedagogy of the oppressed.* New York: Seabury.

Gere, A. (1987). *Writing groups: History, theory, and implications.* Carbondale, IL: Southern Illinois Press.

Graves, D. (1983). *Writing: Teachers and children at work.* Exeter, NH: Heinemann.

Graves, D. (1994). *A fresh look at writing.* Portsmouth, NH: Heinemann.

Guthrie, J. T., Van Meter, P., McCann, A. D., Wigfield, A., Bennett, L., Poundstone, C. C. et al. (1996). Growth of literacy engagement: Changes in motivations and strategies during concept-oriented reading instruction. *Reading Research Quarterly, 31*, 306–332.

Gutierrez, K. (1992). A comparison of instructional contexts in writing: Process classrooms with Latino children. *Education and Urban Society, 24*, 244–252.

Hammann, L. A., & Stevens, R. J. (2003). Instructional approaches to improving students' writing of compare-contrast essays: An experimental study. *Journal of Literacy Research, 35*(2), 731–756.

Hayes, J. (2000). A new framework for understanding cognition and affect in writing. In R. Indrisano & J. R. Squire (Eds.), *Perspectives on writing: Research, theory, and practice* (pp. 6–44). Newark, DE: International Reading Association.

Hayes, J., & Flower, L. (1980). Identifying the organization of writing processes. In L. Gregg & E. R. Steinberg (Eds.), *Cognitive processes in writing* (pp. 3–30). Hillsdale, NJ: Erlbaum.

Henry, A. (1998). Speaking up and speaking out: Examining voice in a reading/writing program with adolescent African Caribbean girls. *Journal of Literacy Research, 30*(2), 233–252.

Hidi, S., Berndorf, D., & Ainley, M. (2002). Children's argument writing, interest, and self-efficacy: An intervention study. *Learning & Instruction, 12*, 429–446.

Husserl, E. (1962). *Ideas: General introduction to phenomenology* (W. R. B. Gibson, Trans.). New York: Collier.

Ivanic, R., & Camp, D. (2001). I am how I sound: Voice as self–representation in L2 writing. *Journal of Second Language Writing, 10*, 3–33.

Jarratt, S. C. (1991). Feminism and composition: The case for conflict. In P. Harkin & J. Schlib (Eds.), *Contending with words: Composition and rhetoric in a postmodern age* (pp. 105–123). New York: MLA.

Kamberelis, G., & de la Luna, L. (2004). Children's writing: How textual forms, contextual forces, and textual politics co-emerge. In C. Bazerman & P. Prior (Eds.), *What writing does and how it does it* (pp. 239–277). Mahwah, NJ: Erlbaum.

Kaufer, D. S., Hayes, J. R., & Flower, L. S. (1986). Composing written sentences. *Research in the Teaching of English, 20*, 121–140.

Knoeller, C. P. (2004). Narratives of rethinking: the inner dialogue of classroom discourse and student writing. In S. W. Freedman & A. F. Ball (Eds.), *Bakhtinian perspectives on language, literacy, and learning* (pp. 148–171). Cambridge, UK: Cambridge University Press.

Kuhn, T. S. (1970). *The structure of scientific revolutions.* Chicago, IL: University of Chicago Press.

Langer, J. (1986). *Children reading and writing: Structures and strategies.* Norwood, NJ: Ablex.

LeFevre, K. (1987). *Invention as a social act.* Carbondale, IL: Southern Illinois University Press.

Lensmire, T. (1993). Following the child, socioanalysis, and threats to the community: Teacher response to children's texts. *Curriculum Inquiry, 23*(3), 265–299.

Lensmire, T. (2000). *Powerful writing, responsible teaching.* New York: Teachers College Press.

Lipson, M., Mosenthal, J., Daniels, P., & Woodside–Jiron, H. (2001). Process writing in the classrooms of eleven fifth–grade teachers with different orientations to teaching and learning. *Elementary School Journal, 101*(2), 209–232.

Luke, A., O'Brien, J., & Comber, B. (2001). Making community texts objects of study. In H. Fehring & P. Green (Eds.), *Critical literacy* (pp. 112–123). Newark, DE: International Reading Association.

Macrorie, K. (1985). *Telling writing.* Portsmouth, NH: Boynton.

McCarthey, S. J. (1994). Authors, text, and talk: The internalization of dialogue from social interaction during writing. *Reading Research Quarterly, 29*(3), 201–231.

McCarthey, S. J. (2002). *Students' identities and literacy learning*. Newark, DE: International Reading Association and National Reading Conference.

McCarthey, S. J., García, G. E., López-Velásquez, A., Lin, S., & Guo, Y. (2004). Writing opportunities for English Language Learners. *Research in the Teaching of English, 38*, 351–394.

McGinley, W., & Kamberelis, G. (1996). *Maniac Magee* and *Ragtime Tumpie*: Children negotiating self and world through reading and writing. *Research in the Teaching of English, 30*, 75–113.

Michaels, S. (1987). Text and context: A new approach to the study of classroom writing. *Discourse Processes, 10*, 321–346.

Murray, D. M. (1982). *Learning by teaching*. Portsmouth, NH: Boynton Cook.

Newell, G. E. (1996). Reader-based and teacher-centered instructional tasks: Writing and learning about a short story in middle-track classrooms. *Journal of Literacy Research, 28*(1), 147–172.

Newkirk, T. (1987). The non-narrative writing of young children. *Research in the Teaching of English, 21*(2), 121–144.

Newkirk, T. (1995). The writing conferences as performance. *Research in the Teaching of English, 29*, 193–219.

Palmquist, M., & Young, R. (1992). The notion of giftedness and student expectations about writing. *Written Communication, 9*(1), 137–168.

Patthey-Chavez, G. G., & Ferris, D. R. (1997). Writing conferences and the weaving of multi-voiced texts in college composition. *Research in the Teaching of English, 31*, 51–90.

Pennebaker, J. W., & Beall, S. K. (1986). Confronting a traumatic event: toward an understanding of inhibition and disease. *Journal of Abnormal Psychology, 95* (3), 272–281.

Plimpton, G. (Ed.). (1963). *Writers at work: The Paris review interviews*. (Second series). New York: Viking Press.

Prior, P. (1995). Tracing authoritative and internally persuasive discourses: A case study of response, revision, and disciplinary enculturation. *Research in the Teaching of English, 29*(3), 288–325.

Prior, P. (1998). Contextualizing teachers' responses to writing in the college classroom. In N. Nelson & R. C. Calfee (Eds.), *The reading-writing connection: Ninety-seventh Yearbook of the National Society for the Study of Education* (pp.153–177). Chicago, IL: University of Chicago Press.

Quiroz, P. A. (2001). The silencing of Latino student "voice": Puerto Rican and Mexican narratives in eighth grade and high school. *Anthropology and Education Quarterly, 32*(3), 326–349.

Ransdell, S., Levey, C. M., & Kellogg, R. (2002). The structure of writing processes as revealed by secondary task demands. *L1 Educational Studies in Language and Literature, 2*, 141–163.

Raphael, T. E., Englert, C. S. (1990). Reading and writing: Partners in constructing meaning. *The Reading Teacher, 43*, 388–400.

Raphael, T. E., & Hiebert, E. H. (1996). *Creating an integrated approach to literacy instruction*. Fort Worth, TX: Harcourt Brace College Publishers.

Reyes, M. (1992). Challenging venerable assumptions: Literacy instruction for linguistically different students. *Harvard Educational Review, 62*, 427–446.

Rorty, R. (1980). *Philosophy and the mirror of nature*. Princeton, NJ: Princeton University Press.

Roser, N. L., & Bomer, K. (2005). Writing in primary classrooms: A teacher's story. In R. Indrisano & J. R. Paratore (Eds.), *Learning to write, writing to learn: Theory and research in practice*. Newark, DE: International Reading Association.

Scheuer, N., de la Cruz, M., Huarte, M., Caíno, G., & Pozo, J. I. (2001). Escribir en casa, aprender e escribir: La perspectiva de los niños. [Writing at home, learning to write: The children's perspective]. *Cultura y Educación, 13*, 331–458.

Schickedanz, J. (2000). Emergent writing: A discussion of the sources of our knowledge. In R. Indrisano & J. Squire (Eds.), *Perspectives on writing: Research, theory, and practice* (pp. 66–89). Newark, De: International Reading Association.

Schultz, K. (1997). "Do you want to be in my story?": Collaborative writing in an urban elementary classroom. *Journal of Literacy Research, 29* (2), 253–287.

Shor, I. (1987). *Critical teaching and everyday life*. Chicago, IL: Chicago University Press.

Shor, I. (1999). What is Critical Literacy? *Journal for Pedagogy, Pluralism & Practice, 4*(1), 1–26.

Simon, H. A., & Hayes, J. R. (1976). The understanding process: Problem isomorphs. *Cognitive Psychology, 8*, 165–190.

Smidt, J. (2002). Double histories in multivocal classrooms; Notes towards an ecological account of writing. *Written Communication, 19*(3), 414–443.

Solsken, J., Willett, J., & Wilson–Keenan, J. (2000). Cultivating hybrid texts in multicultural classrooms: Promise and challenge. *Research in the Teaching of English, 35*(2), 179–212.

Sperling, M. (1990). I want to talk with each of you: Collaboration and the teacher-student writing conference. *Research in the Teaching of English, 24*(3), 279–321.

Sperling, M. (1998). Teachers as readers of students' writing. *The reading-writing connection: Ninety-seventh Yearbook of the National Society for the Study of Education* (pp. 131–152). Chicago, IL: University of Chicago Press.

Sperling, M., & Woodlief, L. (1997). Two classrooms, two writing communities: Urban and suburban tenth-graders learning to write. *Research in the Teaching of English, 31*, 205–240.

Stolarek, E. A. (1994). Prose modeling and metacognition: The effect of modeling on developing a metacognitive stance toward writing. *Research in the Teaching of English, 28*(2), 154–171.

Strickland, D., Bodina, A., Buchan, K., Jones, K. M., Nelson, A., & Rosen, M. (2001). Teaching writing in a time of reform. *The Elementary School Journal, 101*(4), 385–398.

Sulzby, E. (1982). Oral and written mode adaptations in stories by kindergarten children. *Journal of Reading Behavior, 14*, 51–59.

Sulzby, E. (1985). Kindergartners as writers and readers. In M. Farr (Ed.), *Advances in writing research, vol. 1. Children's early writing development* (pp. 127–199) Norwood, NJ: Ablex.

Sulzby, E., Barnhart, J., & Hieshima, J. A. (1989). Forms of writing and rereading from writing. In J. M. Mason (Ed.), *Reading and writing connections* (pp. 31–63). Boston, MA: Allyn & Bacon.

Swenson, J. (2003). Transformative teacher networks, on-line professional development, and the write for your life project. *English Education, 35*(4), 262–321.

Teale, W., & Martinez, M. (1989). Connecting writing: Fostering emergent literacy in kindergarten children. In J. M. Mason (Ed.), *Reading and writing connections* (pp. 177–198). Boston, MA: Allyn & Bacon.

Villanueva, V. (1991). Considerations for American Freirestas. In R. Bullock & J. Trimbur (Eds.), *The politics of writing instruction: Postsecondary* (pp. 247–262). Portsmouth, NH: Boynton.

Vygotsky, L. (1978). *Mind in society*. Cambridge, MA: Harvard University Press.

Vygotsky, L. (1986). *Thought and language*. Cambridge, MA: Harvard University press.

Ward, I. (1994). *Literacy, ideology, and dialogue: Towards a dialogic pedagogy*. Albany, New York: State University of New York Press.

Yagelski, R. P. (1995). The role of classroom context in the revision strategies of student writers. *Research in the Teaching of English, 29*, 216–238.

Yeh, S. S. (1998). Empowering education: Teaching argumentative writing to cultural minority middle-school students. *Research in the Teaching of English, 33*(1), 49–83.

# INTERNATIONAL COMMENTARY

## 30.1

## Writing Production as Metaphoric Activism: Notes on the Interplay of Creative Writing in the Classroom

**Francois Tochon**

*University of Wisconsin-Madison, U.S.A.*

I have fond memories of creative writing experiences as a junior high teacher in Geneva, Switzerland.

> The billboard company had allotted a huge downtown space for the posting of a poem for peace for two months. This poetic action had been recognized by the Guinness book of records for Europe as the largest poem in the world. The initiative did not pass unnoticed by students, who fell into step with it. They created poems to musical backgrounds, some of which were recorded in studio; and they painted poem posters, several of which were put up in town. A poem by a student was posted in the Old City and attracted the attention of a journalist who dedicated a whole page to the subject in a local weekly. A year later, Geneva poet Huguette Junod launched another initiative deriving from this whole experience. As well, since that time, giant poems on billboards have turned up from time to time. (Tochon, 2000)

In action poetry, action produces an image. This abstract action erects a set of values into an active symbol. Values cannot be separated from situations and action, and yet they present the sign as a means of transcending the semantic connections usually promoted by urban life. Such metaphoric activism has been noticed lately in many large cities like Montreal where whole building facades present huge poems. In Paris, France, the metro employees post poems of international authors in each subway wagon and launched a competition to post the poems of "metro bards" (RATP, 2005). Poetry-in-the-Métro received over 7,000 entries, a better response than the Elle contest that launched Lancôme's "Poème" perfume. Cafés-Poésie multiply in France as well as Urban-Poem demonstrations (Printemps des Poètes, 2006). That much for the poem freed from the book. Here is an excerpt from E-Tigre's "Si c'est ça l'Amérique"

*L. Bresler (Ed.), International Handbook of Research in Arts Education, 493–496.*
© 2007 *Springer.*

(Etienne Gressin, 2005[1]):

| | |
|---|---|
| *If this is America* | *Si c'est ça l'Amérique* |
| The American Dream is so nice | C'est beau le rêve américain |
| Especially when you're dead | Surtout quand t'es mort |
| Because there is no dream | Car il n'y a point de rêve |
| When one can't leave | Quand on ne peut pas partir |
| Proof be the Storm | Preuve révélée par Ouragan |
| There is a Third World in America | C'est le Tiers Monde en Amérique |

Back into the classroom, differentiated approaches and focusing on the needs of the learner have gained widespread acceptance. Allowing learners to plan part of their own learning has been highly acclaimed. Creative writing in the classroom meets such needs. The opening up of planning models and the subsequent risk of deviation are often the focus of the debate surrounding these models. Yet without some freedom within the curriculum, classroom management becomes tedious and the learner becomes bored and/or disruptive. An open plan that fosters thinking skills includes creativity, critical thinking and, unavoidably, a measure of unpredictability. The best teaching plans are in all likelihood those that empower the learners by granting them responsibility for part of the planning, and are flexible enough to accommodate the unforeseen. One factor that is often overlooked is the difficulty of keeping track of the learner's reactions and level of awareness. It seems easier to teach within a closed system than to leave open the possibility of going off on a tangent or straying from the foreseen plan. The most competent teachers seem to know how to adapt themselves and motivate their students without losing sight of their basic intentions. They can negotiate in such a way as to fulfill the learners' subjective needs as well as the curriculum objective needs.

One highly problematic issue arises when the education action is "initialized", since even in this early phase, the student has some input into the plan of action. The teachers must be able to listen without passing judgment. This counseling function is extremely delicate where group activities are concerned. It is vulnerable to the risk of upsetting the precarious balance among subjective needs, objective needs, and the creative project. The subjective needs relate to the student's Self, the objective needs relate to the school curriculum. Creative actions must find a match between both projects. No model can convey every aspect of the teacher's role or responsibility. Even within those educative projects of smaller scope wherein success depends upon fewer conditions, there are pitfalls that can jeopardize success. The creative action's initialization hinges upon the teacher's ability to build analogies – to relate the students' expressed wishes to curricular goals. In this way a metaphor is constructed, establishing a congruity (Greimas, 1983) between the two poles – objective and subjective needs. The metaphor becomes active and concrete only in a writing production whose phases are planned by students themselves, with or without the teacher's help. The teachers cannot impose their metaphor upon the students. The most difficult aspect of this task lies in developing guidelines that are acceptable to the students and faithful to their intentions.

Concepts are very often understood and assimilated by the metaphoric route. A new concept is initially perceived as a metaphor, that is, its first representation within the

learner's mind is an approximation based on prior knowledge. By going through various approximations, or compare/contrast loops, the learner concretizes her or his knowledge. The teacher's role is to guide the learner through this process, without forcing it. A teacher will spontaneously relate a new concept to the learner's life experiences to help her/him grasp its meaning. In an educative production, the students themselves execute this strategy, starting from a reflexion on their intentions. They assimilate the organizers of meaning within an action. The creative links they build help them attain increasingly abstract metaphoric levels to the point where they understand the action and its meaning, and the meaning they wish to create using their own potential.

Creative workshops are expressive actions in search of internal consistency. Their ongoing appraisal develops indexical relations with the socially useful aspects of this evolutionary activism. Creativity situates education in the autonomous possibility of constructive emergence from the relation with others (Tochon, 2002). Its artistic and discursive expressions are partially explicable and duly made explicit through momentary consensual anticipations; but in their originality, they elude the representational exhaustiveness upon which customary school evaluation rests. Writing workshops allow the construction of meaning on the basis of a collective choice. They enrich the learning experience by multiplying the interconnections and favor real learning over the straightforward transmission of contents.

# Note

1. The translation is mine.

# References

Greimas, A. J. (1983). *Structural Semantics*. Lincoln, NE: University of Nebraska Press.

Gressin, E. (2005). *Ma plume se promène*. Paris: Publibooks. http://spaces.msn.com/members/poesiamondus/

Printemps des Poètes (2006). Ma ville pour un poème. http://www.printempsdespoetes.com/la_manifestation/index.php?http://www.printempsdespoetes.com/la_manifestation/nos_partenaires.html Retrieved Nov. 7, 2005.

RATP (2005). Règlement concours de poésie. http://www.ratp.fr/corpo/evenements/poesie/reglement.html Retrieved on Nov. 7, 2005.

Tochon, F. V. (2000). Action poetry as an empowering art: A manifesto for didaction in arts education. *International Journal of Education and the Arts, 1*(2), http://ijea.asu.edu/v1n2/

Tochon, F. V. (2002). *Tropics of Teaching: Productivity, Warfare, and Priesthood*. Toronto, ON: University of Toronto Press.

# INTERLUDE

# 31

# METAPHOR AND THE MISSION OF THE ARTS

**Keith Swanwick**
*The Institute of Education, University of London, U.K.*

The literature on metaphor spans literary, philosophical, psychological, and scientific perspectives. Within the scope and size of this chapter it is neither possible nor necessary to review this work. Instead I intend to explore the central concept of metaphor taken in its generic sense: *metaphor*, not *a metaphor*. To be briefly technical: the word *metaphor* is from the ancient Greek: *meta* indicating time, place or direction; while *phéro*, means to carry. *Metaphorá* suggests conveyance from one "place" to another and the very term "metaphor" is obviously metaphorical. We do not literally mean that we carry things from one place to somewhere else, but that shifting an image or concept to a new context is something *like* moving a physical object. *Likeness* is fundamental to metaphor. To some extent the transplanted element becomes like, or is assimilated into, it's new environment. But it also "makes waves" in its new location, as it impinges on a good deal of resident *unlikeness*. I want to argue that the creation, contemplation, and enjoyment of this friction between *like* and *unlike* lies at the heart of artistic production and response.

Scruton (1997) tells us that metaphor is the process of "bringing dissimilar things together, in creating a relation where previously there was none" (p. 80). Metaphor in this generic sense corresponds with what Koestler calls "bisociation." For Koestler (1964), bisociation occurs when different conceptual domains intersect bringing about novel consequences. He shows this process at work in humor, science, and the arts and sees it as the essential creative act. Though not exclusive to the arts, metaphorical processes are fundamental to them. In the arts metaphor is deliberately and explicitly sought and celebrated, generating impact and creating meaning. This is a unique element of artistic endeavor that distinguishes it from scientific work, which has what Dewey might call a difference in emphasis. Creativity of course occurs in both domains.

The metaphoric play of likeness and unlikeness is most easily illustrated in poetry.

*L. Bresler (Ed.), International Handbook of Research in Arts Education*, 497–502.

*On seeing weather-beaten trees*
Is it as plainly, in our living shown
By slant and twist, which way the wind has blown?
(Adelaide Crapsey 1878–1914)

An obvious *likeness* is suggested here. There *may* be (and it is raised as a question), a similarity between wind-blown trees and the way human lives are lived. In this metaphor the poet creatively stirs up a number of potential thoughts and images. Among these might be the sad reduction of human living to the relative passivity of trees. We remember though that metaphorical likeness is always partial. Our lives are obviously in so many other ways not like those of trees, and this unlikeness generates an ironic friction.

Such dissonance is characteristic of artistic metaphor. We take delight in generating and reflecting upon ambiguity, lifting small pieces of likeness out of their original context and dropping them into unlikely settings. For instance, in a cartoon film, Tom is chasing Jerry. He runs smack into a wall. His eyes rotate *like* fruit machines, his teeth crack *like* ice and fall out of his mouth, *like* melting icicles on a roof. Such is metaphoric playfulness: it is not serious but it is art. Similarly, the old music-hall joke, "what's a Grecian Urn?" is supposed to elicit the stock response of "five Euros an hour." This is a simultaneous allusion to different domains of meaning by way of an ambiguous apostrophe, an uncertainty over the linguistic correctness of the word "Grecian" and an aural pun between "urn" and "earn." It is worth noting that Koestler sees rhymes as half puns, where similar speech sounds chafe against the unlikeness of different meanings.

All humor depends on such clashes of different worlds of meaning, sometimes sudden, as is the case with a punch line, sometimes with different sets of possibilities running alongside over a period of time, as in a farce where there may be a sustained misunderstanding known to the audience but not to the characters. The metaphorical impulse towards new ways of seeing is found in all forms of discourse. In science it is sometimes called the "eureka" experience. The arts share this fundamental creative process. Along with the sciences they help us to think the previously unthinkable. The old convergent/ divergent distinction is relevant here, as are investigations into analogical reasoning (Vosniadou & Ortony, 1989). However, the arts differ in emphasis, in that they deliberately extend and luxuriate in the sheer playfulness of metaphor. The focus of the arts is on metaphorical impact rather than verifiable scientific knowledge.

Visual artists invite us to look at things in particular ways, to see things "as" to explore new relationships; perhaps seeing the human form in geometrical terms, elongated or opened up to nature by large holes. One evening, after other guests had departed, Salvador Dali is said to have remained at the dinner table, watching runny cheese oozing over the side of a plate. His famous picture, *The Persistence of Memory*, brings the relaxation of such a moment and the soft texture of this cheese into a new relationship with the unrelenting imperative of time and the metallic hardness of watches.

Dance, drama, and expressive movement also invite us to "see as" – to explore the tensions of crossing borders, of suggestive new likenesses. I once saw a Japanese

woman dancing with a man disguised as an animal. She later told me that she too was supposed to be an animal. At the same event I saw a Javanese Court dance in which a man pretended to be a woman who was herself pretending to be a man. This took place at a conference on Asian dance and music in Singapore. As far as I know, no one was arrested.

# Music as Metaphor

Music is the most difficult art to think of in terms of metaphor and I shall, at this point, try to address this difficulty along the lines of an earlier analysis in *Teaching Music Musically* (Swanwick, 1999). There I argue that in music metaphorical processes function on three cumulative levels. These are: when we hear "tones" as if they were "tunes," as expressive shapes; when we hear these expressive shapes assume new relationships with other shapes as if they had "a life of their own;" when these relationships, these symbolic forms, appear to fuse with our previous experience, when, to use a phrase of Susanne Langer's (1942), music "informs the life of feeling" (p. 243).

## *"Tones" are Heard as "Tunes"*

Tones become tunes through a psychological process whereby we group single sounds into lines and phrases, hearing them as gestures. In the same way we tend to see alternating lights around the illuminated borders of billboards or shop window displays as continuous lines rather than as separate lamps. I am of course using the word tunes very broadly to mean any kind of musical gesture, expressive unit, or phrase, including atonal and non-tonal shapes that form much mid-twentieth century Western music, Indian tabla playing and African drumming patterns. Even a single tone can be heard as a phrase, such as the single note "A" played on the trumpet at the start of Wagner's *Rienzi* overture. This is perceived quite differently from the very same "A" that would previously have been used for orchestral tuning.

Hearing sounds "as music" requires that we experience an illusion of movement, a sense of weight, space, time, and flow. Normally we do this very easily, except when music is very unusual for us or when, in educational settings, we are required to listen in a pre-metaphorical mode; as when naming the notes of a melody, notating a rhythm pattern, or identifying chords in a conventional aural training session. Of course we cannot climb through this kind of technical analysis toward any sense of line or motion. Even when a wider view of aural discrimination is taken, (Pratt, 1990), no amount of analytical skill with intervals, durations, and timbres gets us to experience sounds as expressive shapes. Indeed, a focus on labeling sound materials may divert us from hearing sounds as line and motion.

Converting tones to tunes depends to some extent on performance decisions, involving choice of speed, weight of sound, accentuation, balance between the various components and other elements of articulation. It also involves a particular interpretative stance. As Donald Ferguson (1960) says, musical metaphor consists in a "transfer of the behavior-patterns of tone into the behavior-patterns of the human body" and

motion and tension is the basis of musical expression (p. 185). This process has been noted by other writers, including Scruton (1997) who also believes that music involves "metaphors of space, movement, and animation" (p. 96). For him music is an experience that has "sound as its object, and also something that is not and cannot be sound-the life and movement that is music" (p. 96). In other words, music is *like* sound but is also *unlike* or more than sound. Musical encounter involves attending to the phenomena of sounds, while simultaneously being aware of the illusion of expressive gesture. Elements of one domain of experience are transplanted into another, rather like recognizing in the theater or cinema that a person may be a well-known actor but is, at the same time, a character in a story.

## *Expressive Shapes are Located in New Relationships*

The second level of the metaphorical process depends upon internal relationships that are constantly changing and evolving. On this, the second metaphorical level, what we perceive as expressive shapes appear to undergo change by juxtaposition, realignment, and transformation. Carrying with them their affective charge, musical gestures are brought into new relationships with elements of internal playfulness and musical speculation. For example, John Chernoff (1979) notes that Ghanaian musicians "expect dialogue, they anticipate movement, and most significantly they stay very much open to influence. ... there is always an in-between, always a place to add another beat" (p. 158).

The same fundamental metaphorical processes are at work in all music. Sounds are heard as expressive gestures; these gestures are transformed into new relationships. In this dynamic and open way music appears almost to have a life of its own. The creation of new relationships lies at the heart of what is called musical form, an organic process involving the relocation of musical ideas in new contexts, essentially metaphorical. The tensions between the likeness of repetition and the unlikeness of contrast and transformation are obvious enough not to require further elaboration here.

## *Music Informs the "Life of Feeling"*

The third metaphorical layer goes beyond hearing sound materials as expressive shapes juxtaposed into new forms. This third transmutation gives rise to the strong sense of significance so often noted by those who value music. These responses have attracted a variety of names-some of them problematic, including "peak experience" and "aesthetic emotion." Csikszentmihalyi calls it "flow," and believes that through such optimal experiences we develop "sensitivity to the being of other persons, to the excellence of form, to the style of distant historical periods, to the essence of unfamiliar civilizations. In so doing, it changes and expands the being of the viewer' (Csikszentmihalyi & Robinson, 1990, p. 183). Flow is thought to occur across different activities and cultures (Elliott, 1995, p. 116). Flow is characterized by a strong sense of internal integration, by high levels of attention and concentration and – at times – complete loss of self-awareness. Similarly, aesthetic experience is seen as "intrinsic, disinterested, distanced – involved, outgoing, responsive – absorbed by and

immersed in" (Reimer, 1989, p. 103). Definitions of 'flow' are attempts to describe and evaluate those experiences that seem to lift us out of the ruts of life and that have been variously called transcendental, spiritual, uplifting, "epiphanies," yes, and "aesthetic." I would not quibble over what we want to call such experiences, but would rather acknowledge their existence and try to understand how they occur.

Flow occurs in response to music when three levels of the metaphorical process are activated. Tones become gestures, gestures are integrated into a new form, and the new form corresponds with our personal and cultural history. Creative and insightful tensions are set up by likeness and inevitable unlikeness at every level. The ability to hear sounds connected as expressive shapes is a stimulating ambiguity. Beyond this, music is most powerful when expressive gestures are perceived to undergo variation and transformation, when the likeness of repetition is challenged by the unlikeness of change or contrast. Then we ourselves may to some extent be transformed. Two domains intersect; we are able to empathize with the expressive charge of music, while at the same time responding to that which is new and insightful. Whether we want to call this aesthetic experience or flow, these peak experiences give music a special place in virtually every culture.

We remember Roger Scruton's definition of metaphor, "bringing dissimilar things together, in creating a relation where previously there was none" (p. 80). Patterns, or schemata, of "old" experiences are activated, though not as separate entities. They are fused into new relationships. We may then make an imaginative leap from many old and disparate experiences into a single, coherent, new experience. It is this potentially revelatory nature of music that accounts for the high sense of value frequently accorded to it, along with other artistic forms. As William Empson (1947) put it:

> ... whenever a receiver of poetry is seriously moved by an apparently simple line, what are moving in him are the traces of his past experience and of the structure of his past judgments (p. xvii).

Poetry makes an appeal "to the background of human experience which is all the more present when it cannot be named" (Empson, 1947, p. xv). This is certainly so for music, where the virtual images of weight, time, space, and flow may resonate within us; unnamed, nonrepresentational, yet powerfully expressive.

What differentiates music, literature, and the other arts from the sciences is the strength of connection with personal and cultural histories. In science this personal element runs along, so to speak, in the background, rather than as the prime object of attention. In the arts the play of this web of feeling becomes a central focus. Nothing more is required or expected. This is the mission of the arts, to extend metaphoric playfulness and in so doing to keep the human spirit open and alive.

# References

Chernoff, J. M. (1979). *African rhythm and African sensibility*. Chicago and London: University of Chicago.
Csikszentmihalyi, M., & Robinson, R. E. (1990). *The art of seeing*. Malibu, CA: Getty.

Elliott, D. J. (1995). *Music matters: A new philosophy of music education*. New York and Oxford: Oxford University Press.

Empson, W. (1947). *Seven types of ambiguity*. London: Chatto and Windus.

Ferguson, D. N. (1960). *Music as metaphor: The elements of expression*. Westport, CO: Greenwood Press.

Koestler, A. (1964). *The act of creation*. New York: Macmillan.

Langer, S. K. (1942). *Philosophy in a new key*. New York and Cambridge, MA: Mentor Books and Harvard University Press.

Pratt, G. (1990). *Aural awareness: principles and practice*. Milton Keynes: Open University Press.

Reimer, B. (1989). *A philosophy of music education*. Englewood Cliffs, NJ: Prentice Hall.

Scruton, R. (1997). *The aesthetics of music*. Oxford: Clarendon Press.

Swanwick, K. (1999). *Teaching music musically*. London and New York: Routledge.

Vosniadou, S., & Ortony, A. (Eds.). (1989). *Similarity and analogical reasoning*. Cambridge, MA: Cambridge University Press.

32

# COMPOSITION IN THEATER: WRITING AND DEVISING PERFORMANCE

**Barbara McKean**

*University of Arizona, U.S.A.*

The act of composing is one of forming, arranging, and ultimately creating a whole, fashioned from its many parts. Composition is at the heart of theater education. Any act of theater is an act of composition, whether it is young children creating imagined worlds for dramatic play, adolescents finding their voices and expressing their ideas through performance or high school students engaged in creating theatrical productions. The communal nature of theater complicates the attempt to define composition as accomplished by any single individual. While the image of a solitary playwright toiling away to create his or her masterpiece might be a common stereotype, upon closer inspection, it is clear that playwrights do not work alone. Rather, composing in the theater requires collaboration of many artists before any realization of a piece can be accomplished. Individuals might compose a text for performance; however, the work doesn't become theater until it is interpreted and then shared in real time, person to person, with the audience. Unlike similar medium such as film or television, the event of performance, occurring in present time inside a living space, is the essence of theater.

In theater education, the curriculum and methods for teaching composition include teaching playwriting where single individuals compose the work and then share their work with others and teaching students to develop plays collaboratively, where participants work together and often take on roles of writer, director, actor, designer, and so on, to create theatrical performance. To distinguish from playwriting, collaborative composition is often referred to as devising. Devising is a term used to refer to work that "has grown out of a group's combined imagination, skill and effort" (Kempe, 2000, p. 64). Approaches to teaching composition are employed differently depending on the degree of collaboration of individuals during the composition process, the goals and purposes of the teacher, and the needs and purposes of the group.

In schools in the United States, language arts standards include play reading and writing as one of the core areas for instruction. The National Standards for English Language Arts include plays as one of the broad range of texts teachers should include

*L. Bresler (Ed.), International Handbook of Research in Arts Education*, 503–516.

in their curricula (IRA/NCTE, 1996). The standards encourage teachers to ask students to interpret and analyze the ways ideas are communicated through a variety of texts and create their own texts using language "to communicate effectively with a variety of audiences and for different purposes" (p. 5). Further, the standards emphasize the social processes of literacy where language is perceived, used and understood as a shared system agreed upon by members of a group. Given the expressive nature of playwriting and devising, it would seem that language arts teachers could well meet these standards through the development of a strong playwriting/devising curricula. However, most of the literature on playwriting and devising lives in the drama/theater education world. While language arts teaching texts explore the link between the drama/theater and language arts (see for example Tuttle, 1995; Piazza, 1999; Wagner, 1998), this chapter relies on what is found in the drama/theater literature.

A key component of both national and state standards for student learning in theater in the United States is the knowledge and application of the processes of creating theater. The National Standards refer to playwriting consistently across grade levels as "script writing" either by planning, creating, and recording improvisations in the upper grades or writing scripted scenes "based on personal experience and heritage, imagination, literature, and history" (MENC, 1994). Similarly, in the United Kingdom, *Drama in the Schools*, published by The Arts Council in 1990, proposed a framework for drama education "resting on pupil's abilities to make, perform and respond to drama" (Kempe, 2000, p. 66).

Research on the effects of drama/theater techniques on the development of oral language and writing has shown consistently positive results. *Critical Links*, a compendium of empirical research, clearly demonstrates connections between learning in the arts and student academic and social development (Deasey, 2002). Drama promotes oral language development and written story understanding (Catterall, 2002). Winner and Hetland's (2001) review of research also confirmed this outcome. However, there is little empirical research on student academic achievement in drama/theater with older students and even less empirical research on the effects of teaching play writing or devising on student academic achievement. Existing studies on either the writing or devising processes are qualitative in nature and usually focus on the social development of adolescents and the ways in which playwriting and devising contribute to a healthy interrogation of issues and topics of concern to the group (see, for example, Gonzalez, 2002) rather than the development of understandings regarding composition or writing.

The literature on teaching playwriting and devising is primarily practical, offering instructions for how to write or devise plays (see, for example, Bray, 1994; Grebanier, 1961; Korty, 2002; O'Farrell, 1993). In this chapter I attempt to highlight those aspects of composition that align themselves with writing and devising performance, recognizing that such work is only part of the whole. I limit the discussion to include literature that focuses on the conceptual dimensions of dramatic structure as presented in the educational literature on teaching playwriting and then turn to methods for teaching techniques and processes to engage students in creating/writing plays either individually or in groups. I conclude the chapter with a look at two recent developments in composition in theater education: the use of technology and ethnodrama/ ethnotheater.

# Conceptual Dimensions

It is impossible to begin any discussion of playwriting without giving a nod to Aristotle's *Poetics* (1954) and the six elements he described as essential to a well-made play: plot, character, thought, melody, diction, and spectacle. These core elements, particularly plot, character, and thought are seen in most introductory textbooks on theater and remain the focus of much of the literature on teaching playwriting. When discussing plot, the general agreement is that plot refers to the total arrangement of action of a play. Not to be confused with the story line or structure of the play, plot describes the overall arrangement of the actions of the character(s) from start to finish. Story most often implies a linear structure, where one event follows the next in logical and often, chronological fashion. However, stories need not be told through linear structures. An episodic structure reveals critical moments or actions within a story that are deliberately arranged to not follow a logical or chronological path from beginning to end. In much of the literature on playwriting, the concept of plot is used to illustrate the variety of structures available to the playwright to tell a story and the conscious decisions on the part of the writer to fit the choice of structure to the story or theme of the overall performance (Farrell, 2001).

Characters are "the material of plot, and plot is the form of all the characterizations, what the words and deeds amount to as a whole" (Smiley, 1971, p. 79). Put another way, plot is "characters in action" (Chapman, 1991, p. 23). Plays consist primarily of human action or personifications of nonhumans in action. All drama is primarily concerned with the relationship of human character to human action. Playwrights are concerned both with what the characters say and what they do. Chapman points out, "The playwright must show the character acting in a situation that clarifies not only *what* the character is doing but *why*" (p. 30). How characters speak and behave informs language choices (what Aristotle termed diction and to a lesser degree, melody) and physical expression through action. All characters are a "combination of someone's self-perception and other people's perceptions" (p. 3). Thus, exploration of character involves close observation and reflection on one's own lived experiences as well as of those around us. Dramatic tension occurs when characters face conflict; however, drama is not "the conflict itself, but the changes (on the character) arising from the conflict" (p. 5). Characters that speak and behave in believable and fully realized ways are critical to the success of any composition of the overall performance/script.

The underlying thoughts of the characters reveal both the spoken and the unspoken (often referred to as subtext) words and actions, and reflect the overall ideas and thoughts of the playwright. When students are asked to compose monologues for created characters, for example, they engage the concept of thought, evoking both the inner or unspoken thoughts and those the character actually says (see, for example, Brownstein, 1991; Neelands, 1984). Complicating the concept further are those thoughts of the receivers of the play, the audience. "All the recognitions, realizations, and imaginings stimulated *by* the play are included in this category of thought" (Smiley, 1971, p. 107). Audiences want to know what the play is about; what meaning they are to take from the play. Often, this is expressed as the theme of the play, rather than the individual thoughts of the characters. Theme, as Smiley points out, "means so

many different things to so many people that it has come to mean practically nothing" (p. 112). And yet, when working with young playwrights, theme can suggest a subject or topic of a drama that in turn can spark inspiration for the development of characters' thoughts that lead to action within or in response to the topic/theme. This exploration deepens understanding and breathes drama into what could become a relatively static and boring topic. Exploration of theme is a common starting place for group devising where characters and situations are created through group improvisations.

While Aristotle's core elements continue to inform our understandings of dramatic structure and composition in the theater, Michael Wright (1997) points out, given the changes in theater over the last few centuries and most particularly in the twentieth century, "there is little reason to believe that theater will retreat to the well-made play or to some Aristotelian framework" (p. xiv). Recent literature on playwriting and devising, like theories of modern theater in general, invites us to see performance as an interactive practice that is constructed through negotiation of relationships among the text/performance, the artist and the audience. From this vantage point, composition becomes a dynamic and ever-changing process, responding to both the personal and the collective experiences of the writer(s). Playwriting and devising become acts of investigation of the set of assumptions that inform decisions about style, conventions, structure, and relationships of the given work. Recent literature moves beyond Aristotle and includes investigations of other ways of composing, such as the Brechtian episodic structures or Augusto Boal's (1985) structures of Image Theatre, Forum Theatre, and Invisible Theatre.

In the theater today, investigations of structural choices for composition draw on the diverse forms of expression that are part of the overall society. As Suzan Zeder expresses in her new book on playwriting, *Spaces of Creation* (2005), "the influences of visual arts, installations, and interdisciplinary artists, such as Anna Halprin, Meredith Monk, and Deborah Hay, have brought multiple languages of dance and movement and the visual forms of photography, video, and film into the performance arena" (p. 5). Her book plays with conceptions and dimensions of space as a way to investigate the choices available to composers of theater. Zeder maintains that with the abundance of choices available to composers of theater, "it is hard to find a vocabulary with which to discuss the process of creation of so many diverse forms" (p. 5). In her work with playwrights, she has "found it useful to enter into this conversation through an exploration of the kinds of spaces they might inhabit in mind and body as they create their theatrical worlds and see them come to life in performance" (p. 6).

Contemporary literature on teaching playwriting and devising suggests that composition in theater needs to embrace multiple avenues for introducing writers to the variety of modes and ways of working in theater. Reading and responding to a variety of plays and performances (and most everyone agrees that to compose theater one should read and see theater) is a critical component to be sure. And writers need multiple avenues to manipulate, to play with, to experiment and explore their ideas in order to apply their understandings to the act of composition. Writing and/or devising for performance is hard work and knowing how to introduce and scaffold instruction for students through active engagement and manipulation is the focus of much of what is written on composition in drama/theater education.

# Methods for Teaching

Approaches to teaching composition in theater depend on the conceptual perspectives of the teacher. Most of the practical literature on teaching composition relies on the familiar elements of character and plot. Others, like Michael Wright and Suzan Zeder, choose different entry points for organizing the work. In some instances, the authors presenting ideas for teaching composition focus on students working as individual playwrights, each one creating his/her own script. In others, the focus is devising performance, based on the collective composition of a group.

Michael Wright (1997) believes the challenge for teaching composition rests in the ability to teach students to think and work theatrically. Characters, plots, themes, and thoughts are components of the theater to be accessed and utilized by writers in service to the larger enterprise of crafting stories and people for the stage. He encourages writers to become familiar with all aspects of theatrical production: "The more you know about the work of those interpretative artists, the better" (p. 9). Wright begins with an exploration of the spaces in which theater occurs rather than the traditional elements of dramatic structure: "The stage is a place that contains possibilities, not realities: it is a place for imagining" (p. 2). The consideration of theatrical space finds echoes in the work of contemporary theater creator/directors such as Peter Brook. "A man walks across this empty space whilst someone else is watching him, and this is all that is needed for an act of theater to be engaged" (Brook, 1968, p. 9). Even empty, the stage holds the promise of worlds imagined and actions undertaken. The theatrical world is a "world selected, delimited and organized" (Smiley, 1971 p. 190), by the playwright, the director, designers, and actors and also by the audience. Audiences participate by sustaining its agreement to believe (or suspend disbelief) and enter into imagining the world as it is presented during performance. The degree to which audiences willingly participate and are actively engaged in the world represented in space is one of the measures of a successfully composed play.

Wright's conception of thinking theatrically goes hand in hand with his ideas for working theatrically. Methodologies that suggest writers "develop plots from outlines or work up characters from lists of traits" (p. 13) do not encourage the kind of composing Wright has in mind. In his book, he presents what he calls "etudes" or exercises. "Etudes help build techniques necessary for a greater range of expression and provide a way of experimenting with new applications of your expression" (p. 22). His compilations of etudes are grouped by "functions such as technique, plot, structure and character" (p. 21).

Suzan Zeder's alternative approach to the process of playwriting also focuses on space by presenting a series of "spatial metaphors" or discussions of "space from a variety of perspectives (physical, philosophical, psychological, etc)" (2005, p. 11). Like Wright, she perceives the need for writers to embody their ideas throughout the process of composition. Zeder, writing with Jim Hancock, organizes her text as essays leading from "internal notions of space (child and psychological space) to more external concepts (geographical and architectural space)" (p. xvii). Each essay encourages the reader/writer to apply the spatial concepts to his or her practice of crafting a play. Exercises derived from different movement disciplines and related to the specific spatial concepts accompany the essays.

Others believe the jumping off place comes from the students. Whether undertaken as a group or individually, teaching young playwrights begins "with the students and their potential for creating imaginary characters and worlds, and for developing action and passion in the context of these created environments" (Kohl, 1988, p. 11). Chapman (1991) advises first asking if students have "already written plays, acted in them, or even seen them" (p. 6). From there, he moves to a discussion with students about what they believe is necessary for a good play. Most often, he finds, the students' answers reveal their implicit understandings of interesting theater. Good plays have "… lots of action. A play must grab the audience's attention. Plays must be real (believable). Plays are visual not just words" (p. 7). By starting with the students, the literature reinforces the idea that students need to become aware of their own experiences with theater first. From there, teachers can encourage discussion and conversation about traditional Western structures of plays as well as non-Western and experimental forms to expand the range of possibilities. "Put simply, if students are not introduced to different dramatic forms, they can only draw on those which are already familiar to them. This is not an argument for inducting students into a 'better' culture, but about expanding the cultural field, about giving them more variety" (Nicholson, 1998, p. 79).

As students begin to compose, the methods for teaching emphasize the necessity of action performed by characters in specific spaces for an audience. Through action, students begin to understand the unique qualities of writing for performance. Plays are conceptualized as "essentially physical texts" (Margetts, 2000, p. 35). The challenge for composing in theater is presenting living characters in action. "This means that certain axioms of the theater hold true, such as 'suggest rather than spell out' and 'show, don't tell' " (Wright, 1997, p. 4). As students realize that a play or performance (unlike other forms of writing) exists in the action, the unique craft of the playwright is discovered. Unlike writers of novels or poetry, the material of the playwright is alive. Students develop awareness that their work is interpretive and dynamic. Plays in production are what Wright calls a "witnessed present. H(h)umans watching humans" in the right here and now. This awareness becomes part of what Wright describes as thinking theatrically, grounding one's work in the "awareness of the existence of the other" (p. 7). As many a playwright has discovered, characters are "larger than life and frustratingly human" (p. 9).

Grounding the work in physical actions of the characters also prompts students to explore the characters' backgrounds, their motivations and inner thoughts in search of the drama. Asking "why?" questions leads students to explore the complications that arise from a variety of causes and effects, motives, and purposes. Exploring possible complications encourages exploration of points of view. Chapman (1991) encourages students to find the point of view carefully for it determines "the emotional tone of the work" and may lead to choices in terms of structure and genre. This work emphasizes the "value of (the playwrights') craft. Situations are created and shaped in order to serve the playwright's purpose"(p. 13).

In devising or group playwriting, culture and the situated view of the participants is also critical. In devising, the starting place is grounded in the ideas and issues of the group itself. "These are pieces of theater that come from questions you ask about

topics your group cares about" (Rohd, 1998, p. 3). The role of the teacher is to encourage students to discover what they, collectively, have enough passion and excitement about that it will sustain them throughout the composition process. Sometimes, the teacher may have a specific topic or theme based on teaching and learning objectives in the curriculum. If the topic has resonance with the group, "the enthusiasm and creativity generated by putting on a show can add a dynamic sense of purpose to a group and can foster productive discussions about important issues" (Weigler, 2001, p. 31). And again, the generation of topics and ideas can spark curiosity about the cultural and social contexts that inform the choices of the group (see Johnston, 1998).

Beyond ideas and topics, in devising, it is also important to take inventory of the cultural, social, and academic skills and knowledge that individual members of the group bring to the work (Weigler, 2001). This step is critical because "in the collaborative process of devising drama, the work is divided between the participants depending on their individual interests, knowledge and skills" (Kempe, 2000, p. 64). And like all scripts, the final "script" is physical and will require more than words to create a dynamic and interesting performance. Also in devising plays, participants take on many roles. "Students are likely to act as performers, directors and designers of their work" as well as writers (Nicholson, 1998, p. 85). Defining roles students play during the collaborative devising process is critical to the success of the enterprise. In many professional theaters, a playwright will collaborate with director and/or actors and the play script will be the playwright's record and interpretation of the work done by the group (Nicholson, 1998). In the classroom, the teacher or a visiting teaching artist may take on this role of the playwright recording the work and checking interpretations and choices with the members of the group. In other instances, groups write the script collectively. Usually, at some point in the process, the task of actual recording (either with pen or with camera) is accomplished by one or two members of the group. Whether individually or group written, devising theater opens up student conceptions of the role of the playwright. "It takes account of both the spontaneity of improvisation and rehearsal and the specific knowledge and crafts of the playwright" (Nicholson, 1998, p. 76).

Whether writing individual plays or devising plays as a group, exercises in improvisation inform much of the composition process. In this instance, improvisation is what can be termed "applied improvisation" in contrast to "real time" or "pure" improvisation (Smith & Dean, 1997). Pure improvisation refers to those instances where actors perform scenes spontaneously within open-ended structures. While this is composition in that actors are composing the content and form of the performance, pure improvisation falls outside of the providence of playwriting or devising because the performance itself is not known until the moment it happens during the real time on the stage with the audience. Applied improvisation is a technique for the classroom, studio and/or rehearsal hall for the purpose of exploring character, situations, settings, and issues.

When working with young playwrights, improvisation exercises lead to active development of character and situation and experimentation with a variety of approaches to solving problems. Improvisations can serve to inspire the creative impulse or as a tool for imagining, revising, and expanding ideas in action. Improvisational exercises also allow playwrights to see their texts "as something

which is not finished" until it is interpreted by the actors (Margetts, 2000, p. 38). Wright (1997) joins playwrights and actors together in his writing workshops to help focus comments on "craft questions" coming from the artists "who might be responsible for trying to make something truthful in production"(p. 15). He structures improvisations around what he terms "negotiations." Negotiations are "the matter, issues or problems between two people who each want a different result" (p. 16). By exploring these negotiations between characters, the playwright uncovers the conflicts, which are the essence of dramatic writing and become the situations "the characters talk though" in order to discover the behaviors or actions that show rather than tell (p. 16). Through improvisation, the playwright enlists the aid of actors toward the "conscious development of imaginative and experience choices for characters" and suggest a "greater range of expression" than might be achieved working alone (Wright, 1997).

Gerald Chapman (1991) advocates having students approach improvisation exercises as writers as opposed to actors in order to maintain focus on the task at hand. The goal is to explore characters and situations in order to move actively toward the goal of writing. He sets forth rules for working with improvisations: keep it simple (who, where, what); keep it short; and everything is valid as long as it is real to the situation (pp. 40–41). He emphasizes improvisation as a way for writers to find the need for characters to "fight to stay on stage" thereby engaging both character and audience in the resolution (pp. 86–87). This process of actively earning the resolution keeps plays from becoming passive and denying the very form, that of conflict and drama, that theater evokes. Still, Chapman's goal is to move young playwrights from talk and improvisation to paper and pen. He offers exercises that are improvisations in writing to help make the transition less of an individual struggling alone to create a masterpiece and more a part of the overall process of composition in theater.

The process of group devising plays for performance relies even more heavily on applied improvisation. "Trusting in the students' ability to generate something from nothing, and perhaps more importantly, encouraging the group to trust in this ability, is pivotal to the devising process" (Kempe, 2000, p. 68). The basic ingredients of the theater–characters, space, and action–serve as the starting points for devising. Kempe starts with close examination of character, basing improvisations on real life or photographs and paintings to develop narratives in dialogue or monologue forms. From there, students begin to explore action and genre. Weigler (2001) uses an "unpacking" list to gather evocative images, words, gestures, and sounds buried in the topics and/or issues the group has chosen to explore. From there, students explore similes, exaggerations, and musical versions to build dialogues, choreography, lyrics, and eventually scenes that are woven together for the final performance piece.

Michael Rohd (1998) divides exercises into three main activities – warm ups, bridge activities, and activating material (p. 2). After using warm ups to build group trust and community, and spark imaginations, the bridge activities link the warm-ups with the activating material to "theatricalize the space" (p. 49). The bridge activities call on image work and improvisations and "is the part most often left out" either because of time constraints or difficulty in planning (p. 50). He believes bridge activities allow, "the energy generated in the warm-ups to gently become creative and quietly begins to address subjects of interest and concern to the participants" (p. 50). Activating exercises

employ improvisation to allow for deeper scene development and group commitment to the material. Rohd creates structured improvisations around locations/activities, relationships, circumstances, and intentions. In every exercise, he asks participants to make specific and strong choices in character and situation. When devising performance, Rohd draws a distinction between activating scenes and message scenes. In message scenes, resolutions are quickly gained and remove the dramatic action of the scene. In activating scenes, resolutions are earned through dialogue and emotional involvement of the characters and everyone, audience and actors, are involved in struggling with the possibilities for action. "This then allows you to investigate the reality, the wisdom, and the potential of (those) choices within real life circumstances, and actively analyze strategies and possibilities with everyone in the room" (p. 103).

Other playwriting and devising techniques include adapting existing texts – poems, stories, scenes from plays, lyrics, songs, and so on – what Kohl (1988) refers to as "favorite conversations" to revise and improve the improvised work (p. 76). Doyle (2003) bases his discussion of devised pieces of theater on adaptations of well-known stories and historical journals. Whether the adaptations comprise the whole piece or as complementary scenes to original improvised work, calling on other works can serve to expand students' search for diversity of genre and style. "A conceptual understanding of what the craft of playwriting means entails a recognition that playwrights adapt, bowdlerize, borrow and steal dramatic genres for particular ends" (Nicholson, 1998, p. 83).

Most of the literature organizes discussions on finding the shape or form for composition around a linear structure of beginning, middle, and end. "The audience usually needs to know certain things first, second, and third for some kind of coherency" (Wright, 1997, p. 145). Usually, in the beginning, playwrights establish characters and situations and introduce the elements that upset the basic situation, the complications that lead to the dramatic actions and tensions that result in perhaps not a single climax, but to a final moment when the tension decreases, decisions are made and there is an end to complications or change (Chapman, 1991). However, "what's at stake is not how we understand the plot, but how we understand the plot's ramifications" (Wright, p. 145). Nontraditional structures that play with the progression or temporal organizations of the story lines of the characters and complications can reinforce how the individual or group wants the story to be seen. "Structure, then, sets up the perceptions about the given story; it shows us how to see the story and asks us to consider more carefully how we think about that story" (Wright, p. 146). This refers back to the vision of the individual or group and the cultural and social contexts surrounding the decisions that are made.

In devising, groups use the material generated through the improvisations, along with found texts as a way to begin to figure out structure. Documenting improvisations, either through written scenes, photographs, or videotapes or some other form is a critical step. "… Endowing students with strategies to record the different stages of the devising process can help students acquire the particularly difficult skill of editing and shaping their work and then reflecting upon the journey" (Kempe, 2000, p. 72). Once the group has amassed a collection of pieces, students begin to consider how to put it together to create the desired overall production. "There are no hard and fast

rules ... Ultimately, the show's topic is the unifying element; all the pieces relate to it in one way or another" (Weigler, 2001, p. 76). Sometimes a narrative structure that follows the basic beginning, middle, and end of the well-made play fits the material. When adapting well-known stories for the stage, this is often the case. The use of storyboards and/or a comic book or graphic novel type of organization is helpful for finding narrative structure (Kempe, 2000).

Playing with the story structure may also lead to an adaptation that includes a disruption of the source structure (see Kohl, 1988). Other times the material itself may be more episodic in nature and the group may create what is sometimes referred to as a "dramatic collage" (Kempe, 2000, p. 67). Weigler (2001) suggests that a place, a prop, or a single image or metaphor might emerge as the unifier for the overall piece. Recurring visual or musical motifs can also help to provide a sense of unity when working within episodic or collage type structures. Such projects expose students to a wide variety of expression and genres. Students learn that "by juxtaposing different forms with the elements of the content, now, often ironic, dramatic narratives" emerge (p. 68).

Throughout the process, whether accomplished individually or as a group, students learn that composition is a recursive process. The writing and the enactment of the writing lead to further revisions and discussion. Ultimately, the work is composed with either publication of written script or performance in front of an audience in mind. Identifying the intended audience may occur early in the process, as in the case of issue-based pieces or theater-in-education plays, where the social and/or educational intentions are deliberately part of the overall process. However, at other times, "when teaching students how to devise theater, the identification of an appropriate audience for the work may justifiably come towards the end of the process rather than being the bedrock of the whole thing" (Kempe, 2002, p. 71). What is important is to treat "your students' plays seriously as drama" and to make sure that all work is shared with an audience. While publication is an option for young playwrights to obtain public response for their work, "the final test of ownership" is performance, since "that is what plays are meant for" (Chapman, p. 102). Young Playwright's Festivals and other venues offer individual students opportunities for submitting scripts for production. The Dramatist Sourcebook (2002), published each year by the Theatre Communications Group, offers playwrights tips and a list of theater accepting new plays. Most drama/theater programs in schools, that include playwriting or devising, will feature either studio or fully mounted production opportunities.

Developing a critical eye for one's own work takes practice and responsive guidance from the teachers as well as students. Teachers can engage students in individual conference sessions and students can participate in peer assessments either in partners or small groups, using some form of a critical response process, either structured by the teacher or the group. Kerrigan (2001) distinguishes between evaluation and criticism. "Evaluation talks about processes, methods, tools abilities, what is learned, and what is valuable – all in terms of agreed upon goals." A critique focuses on the "subjective, complex criteria that comprise a work of art. A critique doesn't deal with process, it deals with performance" (p. 138). Clearly, in education, it is important for teachers and students to engage in both. Using the vocabulary of core elements and the engagement

of the audience with the work can lead to informed critiques that offer constructive feedback and response. Focusing on the processes and the goals for learning aids in the assessment and evaluation of student contribution to one's own and the group's learning. In devised work, it is sometimes difficult to assess the individual's contribution to the process unless teachers are clear about the goals for assessment at the beginning of the project. "Requiring individual students to employ a range of devises for recording, visually, aurally and through notation, what is being created, allows the teacher to monitor and report on elements of each individual's contribution to and understanding" of such things as information and value of background research, the different forms of expression and how those forms are generated; the structure and sequence possibilities; evaluation of their own and others' contributions; and the audience response (Kempe, 2000, p. 74). It is also important to note that for most, composing for the theater should be fun. "Theatre itself is a game: it has rules, true, but within those parameters the essence is fun" (Wright, 1997, p. 24).

An interesting development in playwriting for the twenty-first century is the use of technology. Margetts (2000) uses electronic scripts where students can drop in digital photographs of performance alongside the text frames. "In this way, we were able to view the text being read as a working document, one which was essentially unfinished and appearing in the context of us" (pp. 40–41). The electronic scripts helped students discover "how written texts come to signify performance" (p. 46). The scripts also became documentation of students' learning that could be used later in revisions and assessment of student work. The electronic scripts "helped to store some of the imaginative depth produced by the process so that it could be tapped when we were writing in the computer room" (p. 49). Manhattan Theater Club's (MTC) education program started a playwriting program called TheaterLink in 1996. The internet strategy links schools with each other and the theater company. In phase one, all the classes study an MTC play and use their web-based discussion to become familiar with the technology. In phase two, each class writes a short play based on a theme or issue presented in the MTC play. In phase three, in a round-robin set up, classes exchange plays and produce a videotaped production that is then shared with all the project participants. Teachers report positive results in teaching and learning and many schools have stayed on from year to year (Shookhoff, 2004).

While playwrights and groups devising theater regularly include background study and research as a necessary component of the composition process, a final interesting development in composition is the emergence of a more deliberately research-based form of composition, referred to as ethnodrama/ethnotheater. Ethnotheater "employs the traditional craft and artistic techniques of theater production to mount for an audience a live performance event of research participants' experience and/or the researcher's interpretation of data" (Saldaña, 2005, p. 1). An ethnodrama refers to the written script. Saldaña asserts that "all playwrights are ethodramatists" since their task is always one of "representing social life on stage" (p. 4). Ethnotheater brings into the fold a new category of playwrights, namely contemporary artists and theater companies as well as social science researchers employing qualitative, ethnographic strategies to present their work in dramatic form. Much of the same processes of the composition process outlined in the chapter apply to the creation of ethnotheater. What

is added is the rigor and methodology of the research process and the tension that arises "between an ethnodramatist's ethical obligation to re-create an authentic representation of reality (thus enhancing fidelity), and the license for artistic interpretation of that reality (thus enhancing the aesthetic possibilities ...)" (Saldaña, 2005, p. 32). While the ethical considerations for the researcher complicate questions of authenticity for the artist, such concerns are viable. The pioneering work in ethnodrama/theater that is occurring in professional theater and in academia holds great potential for deepening the conversation regarding values and representations of "reality" in the classroom and for urging young playwrights to "reflect on and critique the artistic quality of any venture in an honest and nurturing manner" (Saldaña, 2005, p. 32).

## Conclusion

This chapter reviewed literature on writing and devising plays with an eye toward uncovering some of the conceptual foundations for considering composition and the methods for teaching. Starting with one's own or the group's interests, visions, and concerns, teaching the composition process relies on investigating and interrogating assumptions about theater and performance, on thinking and working theatrically, and using techniques of improvisation, both physically and on paper, as a primary technique for rendering dramatic texts. Once material is actively generated, the writer or groups uses elements of structure and genre to shape the performance script into form for publication and/or production. Throughout the process, young writers/devisors develop a critical eye for discovering key criteria for success as well as documenting individual contributions and learning.

While the literature embodies key qualitative examples of students' creating theatrical compositions, there remains a need for continued empirical investigations that focus on the academic achievements of students, with regard to state and national standards both in theater and in language arts. Such studies will increase the visibility and perhaps the proliferation of deliberate teaching of theatrical composition in the theater classroom.

## References

Aristotle. (1954). *Poetics*. (I. Bywater, Trans.). New York: Random House.

Boal, A. (1985). *Theatre of the oppressed*. New York: Theatre Communications Group.

Bray, E. (1994). *Playbuilding: A guide for group creation of plays with young people*. Portsmouth, NH: Heinemann.

Brook, P. (1968). *The empty space*. New York: Atheneum.

Brownstein, O. L. (1991). *Strategies of drama*. New York: Greenwood.

Catterall, J. S. (2002). Research on drama and theater in education. In R. Deasey (Ed.), *Critical Links: Learning in the arts and student academic and social development* (pp. 59–62). Washington, DC: Arts Education Partnership.

Chapman, G. (1991). *Teaching young playwrights*. Portsmouth, NH: Heinemann.

Deasey, R. (2002). *Critical Links: Learning in the arts and student academic and social development*. Washington, DC: Arts Education Partnership.

Doyle, R. (2003). *Staging youth theater: A practical guide*. Wiltshire: Crowood Press.

Farrell, G. (2001). *The power of the playwright's vision*. Portsmouth, NH: Heinemann.

Gonzalez, J. B. (2002). From page to stage to teenager: Problematizing "transformation" in theater for and with adolescents. *Stage of the Art, 14*(3), 17–20.

Grebanier, B. (1961). *Playwriting: How to write for the theater*. New York: Barnes and Noble, 1979.

IRA/NATE: International Reading Association and the National Council of Teachers of English. (1996). *Standards for the English language arts*. USA: Author.

Johnston, C. (1998). *House of games: Making theater from everyday life*. NY: Routledge.

Kempe, A. (2000) "So whose idea was that, then?": Devising drama. In H. Nicholsen (Ed.), *Teaching drama 11–18* (pp. 64–76). New York: Continuum.

Kerrigan, S. (2001). *The performer's guide to the collaborative process*. Portsmouth, NH: Heinemann.

Kohl, H. R. (1988). *Making theater: Developing plays for young people*. New York: Teachers and Writers Collaborative.

Korty, C. (2002). Getting into the act: Interviews with six playwrights of participation theater. *Stage of the Art, 19*(1), 17–23.

Margetts, D. (2000). Reading and writing plays in an electronic classroom. In H. Nicholsen, (Ed.), *Teaching drama 11–18* (pp. 37–50). New York: Continuum.

MENC: Music Educators National Conference. (1994). *National standards for arts education*. Reston, VA: Author.

Neelands, J. (1984). *Making sense of drama*. London: Heinemann Books.

Nicholson, H. (1998). Writing plays: Taking note of genre. In D. Hornbrook (Ed.), *On the subject of drama* (pp. 73–91). New York: Routledge.

O'Farrell, L. (1993). Challenging our assumptions: Playwrights and the drama curriculum. *Canadian Journal of Education, 18*(2), 106–116.

Piazza, C. L. (1999). *Multiple forms of literacy: Teaching literacy and the arts*. Upper Saddle River, NJ: Prentice-Hall, Inc.

Rohd, M. (1998). *Theatre for community, conflict and dialogue*. Portsmouth, NH: Heinemann.

Saldaña, J. (2005). *Ethnodrama: An anthology of reality theater*. Walnut Creek, CA: AltaMira Press.

Shookhoff, D. (2004). TheatreLink: Wired to make plays together at a distance. *Teaching Artist Journal, 2*(1), 25–30.

Smiley, S. (1971). *Playwriting: The structure of action*. Englewood Cliffs, NJ: Prentice-Hall, Inc.

Smith, H. & Dean, R. (1997). *Improvisation, Hypermedia and the Arts since 1945*. Australia: Harwood Academic Publishers.

Theatre Communications Group. (2002). *Dramatists sourcebook (2002–2003 edition)*. New York: Theatre Communications Group.

Tuttle, J. (1995). The dramatic climax and "the right way to write a play." In D. Starkey (Ed.), *Creative writing as a teaching tool* (pp. 48–52). South Carolina Council of Teachers of English: Carolina English Teacher Special Issue 1995–1996.

Wagner, B. J. (1998). *Educational drama and language arts: What research shows*. Portsmouth, NH: Heinemann.

Weigler, W. (2001). *Strategies for playbuilding: Helping groups translate issues into theater*. Portsmouth, NH: Heinemann.

Winner, E. & Hetland, L. (2001). The Arts and Academic Achievement: What the Evidence Shows. *Arts Education Policy Reveiw, 102*(5), 3–7.

Wright, M. (1997). *Playwriting in process: Thinking and working theatrically*. Portsmouth, NH: Heinemann.

Zeder, S. with J. Hancock (2005). *Spaces of creation*. Portsmouth, NH: Heinemann.

# 33

# RESEARCH IN CHOREOGRAPHY

**Thomas K. Hagood\* and Luke C. Kahlich†**
*\*Florida International University, U.S.A.;*
*†Temple University, U.S.A.*

## Introduction

As a topic of scholarly inquiry, research in choreography is a fairly new idea in dance education. In the western tradition the act of making dances has its history in step patterns, and in prescribed movements of the body, such as in ballroom dancing or ballet. It was only in the early twentieth century that the notion of making dances based on one's personal aesthetic or perspective became a real option. Isadora Duncan inspired many young artists to find their own approach to "making and doing" in movement, establishing a tradition that influenced both the emerging professional modern dancers, and the dance educators who studied with them.

When dance became an academic discipline, courses in dance composition were included in the earliest curricula. H'Doubler's (1926) curriculum for the first dance major at the University of Wisconsin included a senior level course, PE 165 "Dance Composition" (Hagood, 2000, p. 336). H'Doubler investigated the inherent characteristics of making dances and proposed a set of "guiding principles for art" for the choreographer to consider, among these "unity," "variety," "repetition," and "transition" (H'Doubler, 1940). As a result of the influence of the Bennington Summer School of the Dance (1934–1942), dance educators and students were exposed to Louis Horst's composition courses in "Pre-Classic" and "Modern" forms. Teachers rushed back to their high schools and colleges to try out what they had learned about choreography from Horst, or from Martha Graham, Doris Humphrey, and Hanya Holm. Since then modernist and post-modernist approaches to dance composition have dominated secondary and university instruction in choreography.

With the growth of graduate programs in dance in the 1960s came an interest in studying choreography, as students and faculty sought avenues of productivity for meeting degree requirements or for promotion and tenure. Dance composition became the focus of studies looking at "best practices" in choreography, analysis of approaches for teaching composition, the creative process involved in making dances, and even the

*L. Bresler (Ed.), International Handbook of Research in Arts Education, 517–528.*
© 2007 *Springer.*

psychology of self and creative choice in choreography. As a relatively new discipline in academia, the question arises regarding how scholarly inquiry would develop out of initial, autobiographical "how to" writings on choreography and focus more on in depth and generalizable analyses concerning the many aspects of creating dance works.

This chapter explores research-based literature on and about the process and act of choreography. Our text is limited to the review of fully developed, research-based documents that address questions or examine concepts underpinning creativity, the creation of dances, or pedagogies for teaching choreography. We looked for studies that suggest new paradigms for doing, thinking about or teaching choreography to students in the K-16 environment. We do not include review of studies, articles, or texts whose primary purpose is to reveal a personal approach and further explain existing methods used in creating or teaching choreography.

With the exception of a few articles published in professional journals, the majority of citations discussed below are in the form of dissertations and theses. Most sources were found in the National Dance Education Organization's Research in Dance Education database (*RDEdb*). This new resource proved invaluable for locating and reviewing the essential characteristics of inquiry on choreography. Other sources included the Paley Library at Temple University, Philadelphia, Pennsylvania and the United State's Library of Congress.

We have organized citations earliest to most contemporary, and as each study is related to one or more of the following rubrics:

- Inquiry focused on choreography as a result of a creative process: *Creative Process*.
- Inquiry that deals with choreography as a product of creative dance: *Creative Dance*.
- Research focused on the processes of generating choreography: *Choreographic Process* and,
- Research on teaching choreography: *Choreographic Pedagogy*.

## Creative Process

We start with inquiry into the processes of creative work in movement. What informs creative vision in dance? How does the artist organize and effect an approach to movement invention and following invention, organize movement into choreography? Such questions are complex, many layered and not easily answered with the kinds of results we often expect of inquiry: "Answers" and rules of behavior applicable to all cases, or studies that, when replicated, lead to like or the same conclusions. The struggle for clarification in creativity and its myriad processes presents real and significant challenges to those who would seek answers to the question: What processes of creative action underpin the making of dances?

The earliest study considered here is Turner's (1963) article for the *Research Quarterly*. Here, Turner asks: How well does modern dance "as a creative and expressive art form," communicate? She lists a broad and rather ambitious set of objectives seeking to analyze how dance communicates through movement, to establish the value of jury ratings as an evaluative tool for expression in modern dance composition, to test

agreement of a trained jury in identifying emotional and physical qualities of expression presented in abstract form, to weigh the relative merits of choreographic structures, and to identify essential elements of movement themes in dance composition. To analyze and comment on these objectives Turner collected, analyzed and evaluated 19 dance studies, choreographed by 18 freshman and sophomore college age students who had successfully completed a 30-hour course in "dance fundamentals." The course emphasized problem solving that resulted in the creation of individual dance studies. Studies were filmed and then reviewed by five qualified judges who evaluated each composition's ability to communicate emotional and physical qualities; the type and structure of the composition; and each study's choreographic and artistic effectiveness.

Hanstein's (1989) dissertation is a philosophical work that identifies, describes and structures the scope of artistic processes involved in making dances and teaching choreography. Hanstein presents questions regarding the inherent characteristics of the product created as a result of choreographic work, relationships between the product and the process, the character of the dance medium with which the artist interacts, and the role of the audience in the choreographer's process. While Hanstein's work is based on previous theory, its importance is in her analysis of gaps and failures evidenced in existing models for teaching choreography. The study outlines a process-based model for teaching choreography. The teaching of choreography should be predicated on defining meaning in life's experience and transferring this meaning to the dance-making process, connecting and integrating knowledge from diverse areas, fostering the choreographer's ability to change and evolve her work, alter experience and reform knowledge to further the pursuit of personally relevant artistic methods.

Crawford identifies, describes, and compares principles of organization used by the choreographer, composer, and painter. His inquiry presents the organizing principles of unity, variety, contrast, balance and other related concepts/dimensions used in dance, art, and music. Based on his analysis of unity, variety, contrast and balance, Crawford proposes additional concepts that are interrelated between art forms including, coherence, dynamism, repetition, rhythm, emergence and recedence, and development. Dance serves as the nucleus and educational focus within the study and the teaching progression suggested for future curriculum development begins with dance, relates dance and music, and culminates with dance, music, and painting.

Munjee's M.A. thesis (1993) combines research into theories of creative process, with personal reflections by choreographers and dance educators on their own choreographic process. Munjee reviews citations on the creative process, arts education, choreography, and methods of teaching. Her focus is on the creative process involved in choreography rather than the resulting product. The author features Wallas' "Stage Theory" (1926) of creativity and incorporates her personal experiences as a choreographer and educator.

Munjee's work discusses the paucity of research on the creative process in dance and dance choreography. Her curricular model seeks to resolve a schism between exercises in creative arts and theoretical inquiry into the creative process. Munjee concludes that there are three basic approaches choreographers take in beginning their creative work, those who start with a seed idea, those who start with an exploration of materials, and those who work with some combination of both approaches.

Minton's (2003) article investigates parallels between Alma Hawkins' approach to the creative process and contemporary learning theory. Here, Hawkins' insights into the cognitive processes of choreography are compared and contrasted with other contemporary theories on learning and creative activity. Minton discusses Hawkins' theory of sensation and response to stimulus to explain the creative process in choreography: Sensation from outside the self initiates dance-making (sensation translated into a kinesthetic or body response), as a result of sensation and by exaggerating response to the initial stimulus, the choreographer creates visible movements. Minton compares Hawkins' theories to the writings of Robert and Michelle Root-Berstein and Renata and Geoffrey Caine. Although different words are used, the authors share similar ideas in terms of sensory experience, use of imagery, active involvement, and abstraction.

## Creative Dance

The topic of creative dance appears repeatedly in the literature, defined in a variety of ways and often linked to creative thinking and process in experiencing and teaching dance. Extensive searches in the *RDEdb* and databases at Paley Library, Temple University and the Library of Congress yielded a number of citations, but most of these were "how to" guides for teaching creative dance that provide little or no analysis of how creativity in movement studies can be employed in understanding creativity role in practicing or teaching choreography in the educational environment.

As an example of the focus of research in the area of creative dance, we include Ayob's (1986) dissertation, in which she asks three questions: What purpose concepts of creative dance will an observer witness in the operation of creative dance classes? What purpose concepts of creative dance do teachers perceive to be most meaningful for the students? and; What purpose concepts of creative dance were consistent with those used by teachers in creative dance classes? Ayob's study presents an ethnography based on analysis of data collected through document review, content analysis, nonparticipant observation, and interviews. The author found that psychomotor responses to observed movement purposes were more favorable than affective components. Cognitive purposes were only moderately addressed in the study. All observed purposes for moving as identified through critique of literature were consistent with those used by teachers, with some more frequently observed than others. These creative dance programs were typically designed with specific emphasis on emotional health, skill development, and understandings of movement meanings, creativity, and cooperation. While assessment through observation and use of "purposeful" movement can be employed in the choreographic process and teaching, this study does not make it clear how the mover's purpose as identified by observation and interview is manifested in the creation of a dance work.

Nilges' (2004) article follows 18 fifth-graders during a creative dance experience that focuses on force, time, space, and flow. Data were collected with videotape, journal entry, homework assignments, and semistructured interviews. Analytical induction through a four-step process sought to reduce meaning to its essence. These

meanings were found across five dimensions and instructors were encouraged to consider reflexively their philosophical orientation, instructional techniques, and the contributions of dance as a source of meaning. Although Nilges' study used a small number of students and is indeterminate in time period, the research design clearly poses questions and arrives at analysis that could be helpful to creating dance. Both the methodology and technique may provide the teacher with specific tools with which to approach the making of dances as well as considering personal approaches to meaning within the process.

## Choreographic Process

When looking at literature addressing choreographic processes, there is more research available in this category than is evidenced in inquiry on the creative process, and many of these studies include clear attempts at working from a rigorous research design. In Turner's (1963) article the author includes such terms as "identify," "analyze," and "weigh," leading to her description of the work as "an evaluative study." She notes that "five qualified judges" evaluated the data, but does not clarify what these qualifications were, nor does she discuss how consideration of jury qualifications fit into the research paradigm of the study. Even with such limitations, Turner's study does represent an early attempt at developing a useful methodology for collecting, arranging, and evaluating data within the creative environment. Use of terms such as "the composition's ability to communicate emotional and physical qualities," "type and structure of composition," and "choreographic and artistic effectiveness" are helpful in addressing how we might approach teaching choreography within assessment frameworks.

Goodrick's (1986) dissertation looks at the choreographic process and attempts to analyze how dance movements evolve out of "innate movement patterns." Goodrick's approach analyzes how students arrive at movements chosen from a personal vocabulary, and how they then define these as "dance." While this study presents an interesting and valuable question, the use of demonstrated patterns and subsequent analysis based only on perception of style does not address the actual process of the student in the creation of choreographic works. Although the use of 60 participants is significant for this study, the use of and comparison of first grade, sixth grade and adult learners may present problems in defining and comparing disparate developmental issues. These data, however, might be useful in terms of creating pedagogy within a larger context of choreographic process.

Press (1990) investigates the application of Heinz Kohut's psychoanalytic theories of self and creativity to the choreographic process used in modern dance. This work provides a clear research question regarding application of Kohut's theories to the choreographic process, and suggests a number of intriguing curricular implications. While the design and purpose of this study are philosophical, with careful attention to educational application, the teacher could easily glean theoretical structures on which to build in the classroom, both in terms of practice and assessment.

Risner's (1990) M.F.A. thesis engages focus groups and individual interviews to study the dancer's experience in rehearsal. Out of his analysis five themes based on

personal experience emerged: relationships between choreographer and dancer, between dancers, processes of new beginnings, personal definitions of what dance "is," and positive experiences in rehearsal. Risner's data reveal personal and social dynamics within the creation process of choreography, and suggest a useful application in designing and assessing the pedagogical process of leading students in choreography.

In a study on guiding choreography, Ianitelli (1994) looks at the "process-oriented, person-centered approach" from the realm of psychology. Parallels to Press' work are evident in terms of Ianitelli's theoretical base, as are connections to Risner's work in terms of her use of experientially based data. Ianitelli's engages a number of important research elements such as six creative process activities, as well as "preconditions" for creativity (described as motivation and attitude). In describing and analyzing the choreographic process however, much of the study depends on the author's "8-step teaching process" that is not clearly defined in terms of origin or praxis. The value of this study lies in Ianitelli's attempt to provide multiple paradigms and look at them both in a comparative and process mode. The emphasis on the process of creating choreography within this larger design can be a useful tool for creating and evaluating the learner's experiences.

Alonso-Snyder's (1995) dissertation brings cultural issues into focus regarding the choreographic process. The author looks at three contemporary female choreographers of Asian descent and attempts to define and analyze the evolution of their artistic expression within American modern dance. The cultural backgrounds of the choreographers are studied in reference to both cultural and personal needs and how their life experiences affect and reveal meaning in their work. This work provides and illustrates an important methodology for analyzing and understanding the unique experiences of diverse groups of students who work within the choreographic process. Alonso-Snyder's study also yields information for both material and structure within choreography that can be used by the teacher. Since this is designed as a case study research, the teacher would need to clearly define and apply both general and specific aspects of the choreographers studied, as well as realize that it is culturally specific to an Asian perspective.

Cho's (2004) analysis of choreographic practice in South Korea also contributes to the important issue of cultural expression within the study and creation of choreographic process and practice. Through careful analysis of contemporary choreography the author examines how indigenous dance culture in South Korea has addressed the confluence of eastern and western practice. The conclusion that there is substantial intercultural play within the emerging choreographic process can inform the educator seeking to broaden the student's perspective regarding cultural information and practice when creating dances.

Stock's (2000) article explores issues of possible engagement in research; it is based on a specific example of an intercultural choreography between Australian and Vietnamese artists working in Hanoi. The author notes the following items regarding her research design: a creative pursuit involving experiment, trial and error, and exploration; investigation of ideas and concepts to advance understanding and knowledge; public/practical outcomes; and, new ways of thinking about things, "conceptual advances." Stock speaks of reflective practice regarding artistic practice as research,

which consciously explores and analyses connections between perception and action, experience and cognition. While acknowledging that other research practices may also address these issues, Stock notes that "artistic practice as research also involves the presence of researcher/artist and researched/artists in a mutual collaboration and thus its nature is not only relational but emergent, interactive and embodied." In this study, the author frames the research question as artistic exploration of idea or concept through a theoretical framework of interculturalism and overlapping paradigms such as post colonialism, nationalism, and "orientalism." The interpretive paradigm was a contextualization of practice and theory, and the methodology was creative process, creating meanings and points of view as outcomes of performance and documentation, as seen through a blend of action research and ethnographic research methods.

Stock states specific objectives pertaining to the broad context of a Vietnamese setting and intercultural performance practice including the examination of evolving Vietnamese dance traditions to identify contextual and procedural issues arising from a particular intercultural performance practice; to devise and implement a model for intercultural performance practice, to implement a case study in the form of a new artistic project; and, to extend the theory of intercultural performance from the experiential perspective of professional artists from both cultures.

Like Alonso-Snyder and Cho, Stock looks at the choreographic process through concepts dealing with cultural universals/cultural differences, representation of self and "other;" appropriation and "orientalism," and ownership and control. Stock notes that since no single existing methodology encompassed an artistic practice component in research, she created a hybrid methodology consisting of aspects of action research and ethnography in conjunction with the artistic practice. Outcomes noted were analysis that provided a key to understanding the "process of cultural translation via Vietnamisation" as a significant outcome of the study, in addition to conclusions that context was paramount in how deeply social, historical, and political factors were embedded into the actions, thoughts and practice of the collaborating artists both consciously and subliminally, and that artistic practice contributed direct insights into intercultural performance theory in relation to a number of variables.

Stock's study represents important elements for analysis of the choreographic process, both in general reference to research methodology and regarding the growing field of intercultural artistic creation and performance. Her insights and conclusions are valuable information for the student, teacher or researcher who seeks to analyze, understand or inquire into the creation of dances, particularly in specific cultural terms.

In the 2003 study by Stevens et al.; the process of inception, development, and refinement during the creation of a new dance work is described and explored. The inquiry is based on annotated video of a professional choreographer and dancers as they create and sequence new movement material. Weekly journal entries made by one of the dancers, within a 24-week time period, are included. The authors analyze the choreographic process using the "Geneplore" model of creative cognition as an organizing framework and point out generative and exploratory processes, including problem finding and problem solving, metaphorical thinking, nonlinear composition, and multi-modal imagery. An analytical tool adapted from music analysis is applied to

explore relationships between recurring themes and visual, visceral, spatial, and tactile images. Ideas for experimental work relating to choreographic cognition are discussed.

This study is particularly interesting and useful regarding the role of cognition in the choreographic process. Both its methodology and its outcomes provide data that can be applied to the study of the process as well as a pedagogical approach in leading students through personal exploration, creation, and analysis of their choreographic work. The methodology and technique employed demonstrate an important example of a cross-disciplinary approach to dance research and ways in which to adapt and apply them for specific purposes within the discipline.

## Choreographic Pedagogy

Our final category for inquiry in choreography focuses on research in teaching composition. Here, we look at the teaching of students to create dances, employing the other categories cited herein as filtered through the educational lens.

Appleton's (1968) thesis analyzes the effectiveness of two methods of teaching choreography: "Part" and "Cumulative." The "part" method involves a process of separating the development of skills from teaching and learning composition. The "cumulative" method involves accumulating skills as they are learned. Appleton's test group consisted of 23 high school, junior, and senior dance students who were assigned participation in part or cumulative groups. Subjects were given a pretest and posttest involving creation of a short dance sequence at each stage. A panel of judges evaluated pre- and posttest knowledge measures and participant choreographies. Other techniques for gathering data included self evaluations generated by the students, and a daily log kept by the group instructor (one instructor for both groups).

Appleton found that participants who experienced cumulative instruction had a consistently greater, but statistically insignificant, understanding of concepts and skills used in making dances. She also found that the cumulative method of instruction led to more confusion with beginners. Juried review of post-test composition studies and associated knowledge tests showed those who received instruction via the cumulative method had a better understanding of choreographic concepts and their use in generating compositions. On the other hand, data from student evaluations and the teacher's log indicated those that received the cumulative method experienced more confusion and frustration in their work. Appleton concludes that the part method may be better suited to meet the needs of beginning students in the high school setting.

Hanstein's (1986) dissertation cited above may also be considered in the category of research in choreographic pedagogy. Because Hanstein posits a curricular model for teaching choreography that identifies, describes and structures the artistic processes involved in making dances, this work may be useful to teachers of composition seeking a better understanding of how they might ground choreographic experiment in process skills.

We also briefly revisit Munjee's process based model for teaching choreography that seeks to resolve what she feels is a significant schism between exercises in creative

arts and theoretical inquiry into the creative process. Munjee's identification of those who start with a seed idea, those who start with an exploration of materials, and those who work with some combination of both, may be informative for teachers seeking clarification regarding the kinds of individual differences students display in approaching the creation of original works in choreography.

As an interesting side bar, we include reference to Willis' (1986) M.A. thesis. Willis taught 17 high school students Laban's concepts in 10 working lessons. While the study lacks any sophisticated methodology or design for addressing and answering a question, it does point to the potential efficacy of using Laban's notation concepts and lexicon in choreographic pedagogy.

Ianitelli's (1994) work clearly has a corresponding application to choreographic peda-gogy. Although elements of the research design are not clearly articulated (she discusses six creative process activities [generating, interpreting, exploring, selection, evaluation and the forming of movement], two preconditions of creativity [motivation and attitude], and five guiding principles important to the choreographic process [intrinsic motivation, process simultaneity, project specificity and pluralism, dialogue interaction and artistic autonomy]), the study does provide practical recommendations following her eight week workshop with five college students. Ianitelli advises the teacher of choreography to: define content information; operate with an empathic, experience-near mode of teach-ing; create an environment of constructive honesty, honor freedom of expression and a sense of peer-support; closely accompany each student's learning process and respond to perceived needs; be perceptive and sensitive to student's progress status; and encourage and facilitate the student's perception of their own creative flow.

Technology and choreographic pedagogy are addressed in Popat's (2002) article in which the author devised a choreographic development project for student's aged 9 to 18 in Britain, Portugal, and the United States. Two leaders led student groups in each country. A two-month preparation period allowed students and supervisors to become familiar with project technologies. Over the four-month project, each group developed its own original choreography, shared and learned each other's choreography, and actively engaged with peer groups in augmenting, adding on to, and/or developing choreographic work, using the Internet as their means of communication. Each group created its own five-minute dance, taught this to the other two groups, and learned the work of their peer groups, ending the project with three variations on a 15-minute work. Popat discusses successes and problems with her research design. Younger stu-dents had more difficulties in conceiving and shaping choreographic passages, the open and student directed nature of the choreographic assignment led to some uncer-tainty and confusion, lack of a similar level of experience in technique and in choreo-graphic invention and structuring led to self consciousness in both directions of group work – forwarding choreography to students in the other test groups, and accepting choreographic product and direction from afar. Nonetheless, Popat's TRIAD Project presents an innovative methodology for instructors interested in distance learning, developing cooperative choreography with multiple groups, and working with students representing a variety of experiences and cultural backgrounds.

Finally, we include Carney's (2003) article in which the author's goal is to create an approach to teaching that will help students develop an aesthetic sense in high school

composition and dance composition. Drawing on historical content, Carney's approach engages writing tools developed by the National Urban Alliance to help students analyze the historical framework of choreography, better understand its aesthetic properties, and appreciate the choreographer's intent. The specifics of Carney's methodology for analysis of choreographic works is unclear, but does include exposing the student to a technique class, a choreography class (where students were introduced to basic compositional principles, forms, and ideas), an analytic language (Laban), and dance history (focusing on the choreographers she is investigating). Focusing on her twelfth grade high school students, Carney sought a means to clarify student opinions on choreography because she noticed many had negative reactions to contemporary western choreographers.

## Conclusions

When collecting materials for this chapter, several aspects of the citations reviewed became evident. While some of the authors attempted to follow specific numbers of participants through defined periods of time to provide a quantifiable aspect to the research design, they are few and their designs entail limitations such as small numbers, lack of control groups, limited time-frames and lack of specific information on or comparative aspects of assessment tools or processes. While these limitations are understandable – restrictions in dance related inquiry are impacted by funding, scheduling, availability of subjects or trained researchers, etc. – they do represent shortcomings in the research field of dance education. Shortcomings in the rigor of research designs makes it difficult for other researchers to fully understand the methodologies or techniques of the study or to attempt replication for further research. And, without replicate studies, much inquiry in dance education remains autobiographical and, while perhaps interesting and useful, does not present longitudinal and verifiable data, either for practitioners in the field or for those outside the discipline. In addition, due to the aesthetic aspects of the work and the role of personal interpretation, the field tends to depend almost exclusively on qualitative or philosophical research designs and tools. This is not to disparage these important studies, but to point out that any academic discipline needs a broad range of research perspectives in order to fully articulate the content, processes, applications, and value of the discipline within the educational environment, and make findings accessible to a wide audience.

Since this review is limited in scope, it is important to note that our analysis represents only a beginning analysis of this research. The items chosen for analysis are only representative of a much wider range. Selection of these studies was limited due to availability, time and publishing restrictions and self-imposed parameters and issues that were used to organize the information. There is clearly ample room for future analysis of additional literature in choreographic inquiry and in analysis of alternative frameworks for analyzing the processes and products of choreographic efforts. As an emerging area of research, inquiry in dance education represents both challenges and opportunities to

our field. We must promote research to match our successful efforts in generating artistic repertory.

One important lesson from this brief review is to ask questions regarding what future research might be helpful that can be informed both by the studies cited here and the other numerous publications that seek to further the discussion about the process of creating dances as well as how that process resides in and contributes to dance, arts and general education.

# References

Alonso-Snyder, M. C. (1995). Contemporary female choreographers of Asian descent: Three case studies of an evolving cultural expression in American modern dance. Unpublished Ed.D. dissertation: Teacher's College-Columbia University.

Appleton, E. A. (1968). A Study of experimentation in two different methods of teaching modern dance composition. Unpublished M.A. thesis: University of Minnesota. E-path: MnCAT-Dance (kw) and Minnesota (kw) in Thesis/Dissertation.

Ayob, S. (1986). An examination of purpose concepts in creative dance for children. Unpublished Ph.D. dissertation: University of Wisconsin-Madison.

Carney, R. D. (2003). Teaching high school dance composition: Drawing on our history to develop an aesthetic understanding. *Journal of Dance Education, 3*(3), 96–102.

Cho, K. C. (2004). A theory and practice of choreography towards overcoming Eurocentrism: The case of South Korean dance. Unpublished dissertation. University of Surrey.

Goodrick, T. S. (1986). Sensitivity to choreographic styles in dance as related to age, experience and cognitive differences. Unpublished Ph.D. dissertation: Ohio State University. E-path: Dance (OSU thesis); subject: choreography; or dance.

Hagood, T. K. (2000). *A history of dance in American higher education: Dance and the American university*. Lewiston, New York: The Edwin Mellen Press.

Hanstein, P. (1986). On the nature of art making in dance: An artistic process skills model for the teaching of choreography. Unpublished Ph.D. dissertation: Ohio State University. E-path: Choreography – Study and Teaching (subject search); Dance (OSU thesis).

H'Doubler. M. N. (1940). *Dance: A creative art experience*. New York, Appleton-Century Crofts, Inc.

Ianitelli, L. M. (1994). Guiding choreography: A process-oriented, person-centered approach with contributions from psychoanalytic, cognitive and humanistic psychology. Unpublished Ed.D. dissertation: Temple University. E-path: Diamond catalog/danc* and theses.

Minton, S. (2003). Parallels between Alma Hawkins' approach to the creative process and contemporary learning theory. *Journal of Dance Education, 3*(2), 74–78.

Munjee, T. (1993). Explorations in the creative process: A new model for choreography pedagogy. Unpublished M.A. thesis. Teacher's College, Columbia University.

Nilges, L. M. (2004). Ice can look like glass: A phenomenological investigation of movement meaning in one fifth grade class during a creative dance unit. *Research Quarterly for Exercise and Sport, 75*(3), 298.

Popat, S. (2002). The TRIAD project: Using Internet communication to challenge students' understandings of choreography. *Research in Dance Education, 3*(1), 21–34.

Press, C. (1990). Heinz Kohut's psychoanalytic theories of the self and creativity: Implication for the choreographic process in modern dance. Unpublished Ed.D. dissertation: Teacher's College-Columbia University.

Risner, D. S. (1990). Dancers in the rehearsal process: An interpretive inquiry. Unpublished M.F.A. thesis: University of North Carolina-Greensboro. E-path: AS36_N65_PE 90–10.

Stevens, C., Malloch, S., McKechnie, S., & Steven, N. (2003). Choreographic cognition: The time-course and phenomenology of creating a dance. *Pragmatics & Cognition, 11*, 299–329.

Stock, C. (2000). The reflective practitioner: Choreography as research in an intercultural context. In H. Onuki (Ed.), *World Dance 2000 – A Celebration of the Millennium: Choreography Today* (pp. 209–225). World Dance Alliance, Japan Chapter.

Turner, M. J. (1963). A study of the modern dance in relation to communication, choreographic structure and elements of composition. *Research Quarterly for Exercise and Sport, 32*(2), 219–227.

Willis, L. L. (1986). Choreography and Labanotation curriculum for secondary schools. Unpublished M.A. thesis: Mills College, Oakland, CA.

# INTERNATIONAL COMMENTARY

# 33.1

# Research in Dance Composition in Portugal

**Ana Macara**

*Universidade Técnica de Lisboa, Portugal*

In what concerns theatrical dance, the Portuguese were mostly the spectators of the dance that came from abroad, during the first half of the twentieth century. Basically only one national dance company had some expression, and dance teaching was addressed by some few ballet teachers in private studios. In the eighties the repercussions of the democratic revolution of 1974, which changed all social relations in Portugal, also influenced the dance field, and more and more people, especially youngsters were attracted to dance concerts. New contemporary techniques and aesthetic ideas were developed, imported first from the United States and then from Europe. New independent groups started to appear. All this evolution was accompanied by the creation of dance schools at different levels of education and with different philosophical and technical assignations, which we propose to present and discuss.

Only since the late eighties, Dance has been included in the University, so academic research is still quite recent, but increasing. In the university, thesis and dissertations have been developed in the area of dance composition, either in the analysis of works (Barros, 2004; Roubaud 1991, 2001), in the analysis of the composition process (Figueira, 1998), or in the reception by the audience (Abrantes, 1998). The authors have presented a few publications in this area, such as the paper presented by Macara and Figueira (2001), a study that had the aim of understanding how contemporary choreographers perceive their performers and what they consider as important in terms of technique, body and personality characteristics. The authors (Macara 1999a, 1999b, 1999c, 2003) have also addressed different relations between dance and visual arts, and a good number of research studies in these areas are under way.

Lepecki (1998) has presented important research about contemporary choreography, thus characterizing Portuguese contemporary dance: "Increasing sensorial intensification characterizes the Portuguese corporeal predicament for the past two decades" […]. It is the task of the director, the choreographer, the performance artist, the composer, to delineate the contours, probe the limits, explore the potentials and invent new possibilities of embodiment, of sensorial awareness: new grounds for

*L. Bresler (Ed.), International Handbook of Research in Arts Education, 529–532.*
© 2007 *Springer.*

presence as well as new vehicles for a deep auscultation of the present. Also, Gil (2001), an essential philosopher, has dedicated several studies to the theme of the body, and one of his last books is a philosophical approach to the meanings of the body and the dance.

The work of dance critique has also been important in developing this area of study, including some compilations of the most significant work of Portuguese choreographers (Assis, 1995; Fazenda, 1997; Ribeiro, 1994, 1997). Finally, there are some articles (Guimarães, 1986; Pereira, 1995; Tércio, 1991; Macara, 1993, 1998, 2000) about dance in Portugal that may be important to understand our present situation.

# References

Abrantes, M. (1998). *Dança Teatral Contemporânea: Estudo de relaç&otilde;es entre o público e a obra* [Contemporary Dance Theatre: Study of the relations between the audience and the work]. Unpublished Master Thesis. Universidade Técnica de Lisboa, Faculdade de Motricidade Humana.

Assis, M. (1995). *Movimentos* [Movements]. Lisbon: Danças na Cidade.

Barros, M. M. O. (2004). *Corpo e sentido: Uma proposta sorbe a materialidade da Dança* [Body and sense: A proposal abouit the materiality of Dance]. Unpublished Doctoral dissertation. Universidade Técnica de Lisboa. Faculdade de Motricidade Humana.

Fazenda, M. J., (Ed). (1997). *Movimentos presentes*. [Present movements]. Lisbon: Cotovia/Danças na Cidade.

Figueira, M. S. R. (1998). *Papel da improvisação nos processos de criação coreográfica* [The role of improvisation in the choreografic process]. Unpublished Master Thesis. Universidade Técnica de Lisboa, Faculdade de Motricidade Humana.

Gil, J. (2001). *Movimento total: O corpo e a dança* [Total movement: The Body and the Dance]. Lisbon: Relógio d'água.

Guimarães, A. P. (1986). "Couple" and other dances. In *Portugal*, (pp. 130–131). Monfort Publishing.

Lepecki, A., Ed. (1998). *Theaterschrift extra, Intensification: Contemporary Portuguese Performance*. Lisbon: Danças na Cidade.

Macara, A. (1993). The functions of art and the importance of teaching dance composition. In A. Raftis (Ed.), *Teaching Dance. Proceedings of the 7th International Conference on Dance Research*, (Vol. 2, pp. 59–68). Atenas, Grécia: International Organization of Folk Art.

Macara, A. (1998). Interaction between choreographer and dancer: New possibilities. In *Proceedings, Arts on the Edge Conference*. Perth, Australia: Western Australian Academy of Performing Arts.

Macara, A. (1999a). Visual Arts as stimulus for choreography: An interdependent process. In Jo Butterworth & Sita Popat (Eds.), *The Art and Science of Nurturing Dancemakers: Papers from The Greenhouse Effect Conference* (pp. 167–172). Leeds, UK: University College, Bretton Hall and Yorkshire Dance.

Macara, A. (1999b). Video technology: Common ground for Visual Arts and Choreography. In A. W. Smith (Ed.), *Proceedings International Dance and Technology IDAT 99* (pp. 47–48). Lethbridge, Aberta, Canada Fullhouse Publishing.

Macara, A. (1999c). *Arts plastiques comme stimuli pour la creation chorégraphique* [Visual arts as stimuli for dance creation]. In R. Vanfraechem & M. Frydman (Eds.), *Journée d'étude: Approche Psychologique et Pedagogique de la Danse* (pp. 35–43). Bruxelas: ULB/Groupe de contact FNRS Psychologie du Sport/Danse Université.

Macara, A. (2000). Dance in Portugal. In *Proceedings of International Scientific Practical Conference: Education and Contemporary Dance*. http://www.russianballet.spb.ru/eng/exercise/e00.html.

Macara, A., (2003). *The partnership of dance and visual arts revealed in costumes for stage. Proceedings, Hawaii International Conference on Arts and Humanities*. Honolulu, Hawaii.

Macara, A., & Figueira, A. (2001). What is the ideal dancer? The performer in Portuguese contemporary dance theater. In R. Duerden (Ed.), *Proceedings of the first Momentum Conference. Dance Theatre: An*

*International Investigation* (pp. 39–45). Alsager, Reino Unido: The Manchester Metropolitan University.

Pereira, A. (1995). What moves in the Portuguese dance? In J. Butterworth (Ed.), *Dance '95 Move into the Future. Proceedings of the Dance Conference* (pp. 62–63). Wakefiel: Centre for Dance Studies, University College of Bretton Hall.

Ribeiro, A. P. (1994). *Dança Temporariamente Contemporânea* [Temporarily contemporary dance]. Lisbon: Passagens.

Ribeiro, A. P. (1997). *Corpo a corpo: Possibilidades e limites da crítica* [Body to body: Possibilities and limitations of criticism]. Lisbon, Portugal: Edições Cosmos.

Roubaud, L. (1991). *Estudo psicológico do simbolismo na dança teatral: Análise dos bailados portugueses Verde-Gaio* [Psychological study about symbolism in theater dance: Analysis of Portuguese Ballet VerdeGaio]. Unpublished Master thesis, Universidade Nova de Lisboa.

Roubaud, L. (2001). *Corpo e imaginário: Representacões do corpo na danca independente em Portugal* [Body and imaginary: Representations of the body in Portuguese independent dance]. Unpublished Doctoral dissertation. Universidade Técnica de Lisboa. Faculdade de Motricidade Humana.

Tércio, D. (1991). Portugal. In M. Pasi (Ed.), *A dança e o bailado: Guia histórico das origens a Béjart* [Dance and Ballet: historical guide from the origins to Béjart]. Lisbon: Caminho.

\

# INTERLUDE

## 34

# ART AND METAPHOR, BODY AND MIND

**Michael Parsons**

*Ohio State University, U.S.A.*

Metaphor has long been associated with the arts and with creativity. Keith Swanwick, in his excellent interlude in this handbook, discusses these associations and refers to various sources that justify them. This has the incidental virtue of saving me from having to make similar initial references for my own rumination on metaphor and the arts. In some ways, this interlude can be regarded as a companion piece to Swanwick's, though it lacks its elegance and systematicity.

I will speculate on what metaphors look like in the visual arts, as Swanwick does with music. One difference is worth noting. I have been interested for some time in the claim that the arts require one to think (as well as to feel). I think it is an important claim for many reasons and yet it has proved difficult to explain or justify. I am beginning to believe that the idea of metaphor may help us do that by serving as the link between thought and bodily experience – body and mind – in the arts. So I will focus on the connection of metaphor with both ends of this chain – with both bodily experience and with thinking as it occurs in the arts.

## Metaphor as Embodiment

In the introduction to her *Knowing Bodies, Moving Minds*, Liora Bresler (2004) (citing Csordas, 1999) says that the distinction between body and embodiment is that the latter is "a methodological field," a paradigm for thinking, and that to use it is to "address familiar topics – healing, emotion, gender, power – from a different standpoint" (p. x). I will begin by discussing the "familiar topic" of metaphor – currently a hot one – from the standpoint of embodiment.

The recent work of Lakoff and Johnson (1980, 1999) is a good place to begin. Their most basic argument is that metaphors arise from bodily experience, a claim that is new and highly suggestive for the arts. They develop this claim in detail and with great sophistication but unfortunately they say little about the arts. In addition, their concern

<center>533</center>

*L. Bresler (Ed.), International Handbook of Research in Arts Education*, 533–542.
© 2007 *Springer.*

is mostly with the metaphors that occur in our thinking in ordinary life and in intellectual disciplines, metaphors that are established and commonplace and, because they are usually not noticed, control our thinking. Lakoff and Johnson are most concerned with the influence of commonplace metaphors and have less interest in the creative ones more often found in the arts.

Lakoff and Johnson argue that metaphors have their origins in our basic sensorimotor and perceptual patterns, which are determined primarily by the neurological structures of the human body. These patterns (sometimes they call them "domains") are mapped onto our subjective experience, enabling us to think about that experience in ways that make it far more elaborate and intelligible than it would otherwise be. Examples are the metaphors *love is warmth* and *love is closeness*. These originate, Lakoff and Johnson argue, in the experience of a baby being held closely by mother and they allow us to think about love in certain ways; to think of characters as being warm or cold, an affair as being red hot or cooling off, or to warn others not to play with fire.

Another example is the metaphor *knowing is grasping*, which originates in the experience of grasping a toy or a teddy bear. A baby first comes to know the world through grasping it with the mouth and the hands. This allows us later to speak of understanding as grasping an argument, of failing to hold a thought in mind, and so on.

In these examples, being held by mother and grasping a toy are bodily experiences that create sensorimotor patterns ("domains") and loving and knowing are subjective experiences. "Subjective experiences" include both our emotions and our thoughts and that means that metaphors make an enormous contribution to our understanding of ourselves and of the world. It suggests that metaphors are at least one kind of connection between body and mind, and perhaps, more radically, that thought is "embodied."

## Art and Cognition

The arts have traditionally been associated with both bodily and subjective experience. On the one hand, art making and responding is often thought of as guided by bodily experience: Musicians feel the music in their body, dancers and other performers dance with their whole body (actors with their voice as well), and for painters the brush becomes an extension of the arm and hand. As Collingwood (1938) said, all the arts are a specialization of the body. And on the other hand, the arts have traditionally been connected, perhaps even more strongly, with subjective experience, with the expression of feeling. Since at least the nineteenth century, the arts have been considered as essentially about the human heart and its purpose as the articulation of subjective experience.

Unfortunately, the expression of feelings has not traditionally been considered to be a matter of thought or knowledge; art has been considered an expressive but not a cognitive business. Expressions of feelings were not thought to have truth value, having to do much more with sensitivity than with thought. In the simplest terms, they were more like exclamations (*Ouch!*) than like propositions (*Doctor, my knee hurts*). But most of us in arts education today would probably agree that the arts do require

thinking. We would probably agree that this thinking is of a kind that is as demanding and rewarding as is thinking in the sciences and other school subjects. Eisner (2002) recently articulated what may have become a central belief in arts education today, when he said that "many of the most complex and subtle forms of thinking take place when students have an opportunity to work meaningfully" in the arts (p. xii). I think this belief has important consequences for both the conduct of arts education (curriculum, instruction, assessment) and for advocacy (how to articulate and justify the role of the arts in education). It has been increasingly taken as a truism in our field since the "cognitive revolution" of the late 1950s and yet there is little agreement about how to describe the kinds of thinking involved, nor, consequently, on how to teach and advocate for them.

Generalizing broadly, one could say that, in the fifty-year history of attempts to describe the thinking characteristic of the arts, two major approaches have emerged. One, which descends from Arnheim (1954), tends to ascribe a distinct way of thinking to each art medium. The idea is that each art medium offers its own "terms" in which to think. So, for example, painters think in the terms of line, shape and color. A number of versions of this approach can be found. One is Goodman's (1976) notion that each medium provides a distinct language to think in (with consequent slogans about "literacy" in the arts). Another is Gardner's (1999) notion of a number of distinct intelligences. All versions of this approach tend to separate thinking into a number of "kinds" that, though equally valued, do not much affect each other. I think this tendency is in contrast with the view from embodiment, for the body is where all sensory and motor systems, no matter how specialized, communicate and are integrated. In the view from embodiment, normal (i.e., nonpathological) thinking results in one understanding, however complex, in the same way that the body normally responds to situations with one action, however complex. I take this as a general truth about both thinking and action.

The second major approach (which I have begun to find equally unsatisfactory) has been to identify aesthetic experience as the distinctive contribution of the arts to mind. Aesthetic experience has been understood as the direct grasp of the aesthetic (or "expressive") qualities of objects, a result of an activity that is cognitive, though not discursive. This approach is the more important one currently. Its most notable exponents in arts education are probably Elliott Eisner (1988), Ralph Smith (1986), and Bennett Reimer (1989). I find the same difficulty with this second approach. It also divides thinking into different and separate kinds, though it uses a different principle to distinguish the kinds. In addition, I think there is a continuing lack of clarity about the "aesthetic" principle. How far is it affected by the context of the work's origins or of the present particular viewer? This lack of clarity is a symptom of the artificiality of the division of thinking into kinds. Further, these approaches fail to account for the character of much contemporary art, with its heavy dependence on context, social and political content, and experimentation with new or mixed media.

Rather than debating these approaches, I am interested here in building on the suggestion recently made by Arthur Efland (2002) that the idea of metaphor may offer a better way to conceptualize thinking in the arts.

## *Metaphor as More than Linguistic and as General*

There are two common views about metaphor that we should first discard. The first is that metaphor is primarily a linguistic affair. If Lakoff and Johnson are right that the origins of metaphor lie in our early bodily experience, it is not plausible that metaphor occurs only in language. After all, we think pre-linguistically and in many ways, including visually. Piaget, for one example, is famous for investigating pre-linguistic thinking in children; for example, he studied how babies learn to coordinate hand and eye to grasp an object (the same grasp that later becomes a metaphor for grasping a thought). The basic idea is that if metaphors occur in the visual arts, they will be nonlinguistic and may be found in many different forms and media. Since Lakoff and Johnson's examples are almost all linguistic, we need to develop examples in other media. Swanwick does this in music and I will suggest some in the visual arts.

The second assumption that we need to discard is that metaphor is only an ornament of style. Pope (1742) expressed this assumption when he said:

> True wit is nature to advantage dressed,
> What oft was thought but ne'er so well expressed.

The assumption is that the metaphorical use of words is superficial to thought; what is fundamental is the literal use. "Literal" means that there is a standardized connection between symbols and their meanings that allows them to be understood in the same way by everyone familiar with those connections. Literal language provides the body of thought, while metaphor clothes it, to make the body more attractive.

From this point of view, metaphor is only one of a number of possible ornaments of thought. Some others are simile, personification, and metonymy. If style is ornamental clothing in general, then metaphor, simile, personification, and metonymy are different kinds of clothing: hats, scarves, coats, and shoes. The choice to use any of these is a superficial one; it does not seriously affect the underlying thought.

The alternative view, of which Lakoff and Johnson are recent representatives, reverses this relation between the literal and metaphorical. It holds that metaphor affects, or even governs, the thought it articulates. It is a primary conduit through which thought travels, allowing thought to go further, to be more elaborated and flexible, than it otherwise could be. Thought, one might say, is like electricity. Metaphors form a network of wires, enabling thought to run further and in many directions, limited only by the complexity of the network. Metaphors underlie most ordinary thought as wires run throughout our cities and, like them, are vital for living and often not noticed.

From this point of view, *metaphor* is the general name for a pattern of thought that may appear in a number of forms, as simile, personification, metonymy, and so on. These latter are merely variations on the underlying pattern of thought that, according to Lakoff and Johnson, has its origin in a pattern of sensorimotor experience, as with *love is warmth*.

# Metaphor in the Visual Arts

What does metaphor look like in the visual arts? It seems that there are several levels. At the simplest level, there are cases where the artist takes a well-known linguistic metaphor and translates it visually. For example, sculptors have often put the likeness of the powerful on a pedestal or in other ways forced us to look up to them. Or they have personified an abstraction, as with the Statue of Liberty. Or again, Chagall portrays two lovers floating in air, one of them turning head-over-heels to kiss the other (this example comes from Efland, 2002). These are cases where the structure of the metaphor has already found linguistic expression and it is not much affected by their visual expression.

At a slightly deeper level, because it is dependent on the visual character of the medium, is Bierstadt's well-known painting *Among the Sierra Nevada Mountains.*

Among the Sierra Nevada Mountains, Reproduced by permission of the Smithsonian American Art Museum

The majesty of this painting, produced by the towering size of the mountains, the tranquility of the scenery, and the patterns of light and color in the clouds, and the suggestion of the sun, unseen, may be said to be a metaphor for the glory of God. Usually we would discuss this work as expression of glory of God, not as a metaphor for it. But the thought has the structure of metaphor, which Lakoff and Johnson analyze abstractly as mapping the qualities of something in one domain onto another domain. We could say the Bierstadt that maps qualities of Nature onto its Maker, which would be a straight metaphor. Perhaps we should say it maps the qualities of a part onto the whole. This would mean it is a case of metonymy (my dictionary, the Random House unabridged, says that *metonymy* is "the use of the name of one object or concept for that of another to which it is related or of which it is a part"). A simpler

explanation would be to say that it has the structure of a simile: It says that the majesty of the Sierra's is like that of God's. All of these amount to mapping the qualities of the painting onto the idea of God, something that does not need to be put into words in order to be appreciated. The variations in my explanation of its structure (*metaphor, metonymy* or *simile*) result only from the attempt to compare it with linguistic figures.

Another example with the same basic structure comes from James Clifford, who speaks of collections, especially in art and ethnographic museums, that "create the illusion of adequate representation" by making objects on display "stand for abstract wholes – a 'Bambara mask,' for example, becoming an ethnographic metonym for Bambara culture" (Clifford, 1988, p. 218).

It seems likely that this metonymic structure, taken as a figure of thought and not just of speech – the part for the whole, or one thing for another to which it is related – plays an especially important role in the visual arts. Its opposite would be to take an image as just a representation of the object (or of the visual field) that it pictures, as we usually do with snapshots and as young children often do with artworks. That would be a literal reading. In these two examples, the literal reading would be to see the Bierstadt as just picturing a scene from the Sierra Nevada and the Bambara mask as a particular mask with no contextual relevance. A metaphorical reading is to see what is presented as related to something else, something usually larger or more abstract.

A third example, also a case of metonymy, is the automobile advertisement in which a pretty woman is pictured with an automobile (I add this example only to make it clear that popular visual culture, and not just the artworld, often has a metaphorical structure). The structure is again that of metonymy: Some of the qualities of the woman are mapped onto the automobile. Lacan (1981) might explain it as the metonymy of desire – the substitution of one desired object for another. It is clearly grounded in the metaphorical thought that, in some unspecified way, the car is like a pretty woman. The literal reading, of course, would be that a woman is leaning on an automobile.

## Art and Creativity

So far I have not discussed the creative use of metaphor or the association of the arts with creativity. After all, we find metaphors in all disciplines and fields of endeavor – think of the family of man, evolutionary trees, the foundations of chemistry, the course of history, moral rectitude, the kindergarten. Metaphor also structures our thought about most ordinary affairs of life. In fact, one view of what we call literal language is that it consists of metaphors with which we have become so familiar that we no longer notice them at all. Although this is not quite Lakoff and Johnson's view, they spend time digging up and examining the bodies of metaphors that lie buried deep in our collective unconscious. "*Love is warmth*" is an example. Usually we are unaware of these as metaphors and for that reason they not only enable but also control our thought. One of Lakoff and Johnson's motives is to promote greater awareness of these established metaphors (especially in politics: See Lakoff, 2002), thereby giving us greater freedom of choice.

So, one might ask, what is so special about metaphor in the arts? How can it explain the difference between thinking in the arts and thinking in other areas of life?

One difference is that the arts don't just use metaphors, they invent them. Much of the creativity of art, from this point of view, lies in the creation of new metaphors, which amounts to the creation of new possibilities of thought. This is close to the view of Rorty (1989), who argues that artists are more important for social change in the long run than scientists or politicians because their new metaphors allow us to think in new ways. When these ways are beneficial ("help us to do what we want to do"), they constitute progress. For the same reason and much earlier, Shelley (1815) called poets "the unacknowledged legislators of the world," because it was only through their new ways of speaking that people could be freed of "the mind-forged manacles of man," that is, the old habits of thought that control our behavior. Hence creativity in the arts has often been associated with freedom of thought and social change.

Of course, no work of art is creative in all respects. It is always a mixture of tradition and novelty and, as I have already mentioned, the underlying metaphorical structure of some of the most powerful works is quite traditional – my example was the Statue of Liberty. Consider the case of Seurat's *Sunday Afternoon on the Island of the Grande Jatte*.

The figures presented in the *Grande Jatte* are stiff and highly controlled. The most prominent are walking in the park after church on Sunday afternoon, parading their social virtue and upright morality. One might note here – Linda Nochlin (1989) has argued this – that their morality requires a strict control of nature and it is visible in both the stiffness of their gestures and the neatness of the park. This is a metaphor at the same level as that of the *Sierra Nevada*. Their erect postures, joyless expressions, the clipped trees in the background, the monkey on a leash, are part of a metaphor for their morality. At the same time, however, these figures have been seen as quite traditional, as modeled on classical figures, especially from Roman traditions, and they may not be so creative after all. If so, the metaphor is more routine, one that has been used many times in the history of art. It says something like *the citizens of Paris are very like ancient Greeks.*

But there is also metaphor here at work at a deeper level, the level of style. One aspect of Seurat's creativity was to paint with very controlled dots of varied colors, in a style that has subsequently been called *pointillism*, rather than with the personal and expressive brushstrokes of the Impressionist movement of the time. Many critics have commented on this new style as influenced by a scientific theory of light at the time, as an effort to paint light in a scientific manner. One might claim that this has the structure of a metaphor, again a kind of metonymy. It maps the color and light presented by the painting onto color and light in general; it says, in effect, *light is like what you see here; vision works like this.* In the same way, one might say that the style that Seurat was refusing, the Impressionist style of personal and expressive brushstrokes, also had a metaphorical structure. It mapped the qualities of the brushstrokes onto the personal qualities of the artist, saying, in effect: *my emotional life is like what you see in these brushstrokes.*

There is a somewhat more subtle account of this notion of metaphor in the arts. It is that the arts always invite a metaphorical interpretation at some level, whether or not the artist intended it. We don't read artworks as merely literal, as we do family snapshots. Rather we always want to go beyond the literal and look for meanings, which I am suggesting are possible only through the use of metaphors. The arts are about meanings at several levels and for this they need metaphor. Moreover, they have developed elaborate ways of debating interpretations of the meanings of works, which are ways of examining and critiquing metaphors both old and new. These ways have been institutionalized in the various critical traditions, psychoanalytic, political, art-historical, feminist, and so on; and it is notorious that there is rarely agreement about particular interpretations, nor any limit to what can be proposed. We can think of art criticism as the collective critique of metaphors through the detailed discussion of particular works. This is a way of saying that creativity in the arts lies not only in the creation of new metaphors but also in reading them in new ways.

Moreover, artists often exploit this fact and create works that invite interpretation but remain ambivalent. At the simplest level, they may portray people with enigmatic expressions – think of Grant Woods' *American Gothic*. Is it a satirical comment on rural mid-western life, or not? Or they create ambiguous situations – for example, Hopper's *Nighthawks*. What does it say about American urban life? A great deal of contemporary performance and installation art goes much further. One of my favorites is the work of Sandy Skoglund; for example, *Revenge of the Goldfish*.

Revenge of the Goldfish, Reproduced by permission of the artist: Sandy Skoglund

Its fascination lies in just this combination of the suggestion of meaning – an invitation to interpretation – and resistance to it. The invitation lies in the careful design, the oddity of the content, the obviousness of the staging, the title. At the same time, any particular interpretation can be endlessly debated. The work, we may say, suggests numerous metaphors without making it easy to decide which is most appropriate. This, incidentally, makes Skoglund's work excellent educational material.

The answer, then, to the question why art is special with respect to metaphors is that in other areas of life we use metaphors to think with as convenient schema and usually without examining them. When so used, they facilitate thought but they also control it. Our thought becomes the working out of the consequences of whatever metaphor we happen to be using. This is a basic concern of Lakoff and Johnson. Art, on the other hand, is essentially in the business of examining metaphors, through both the creation of new ones – which then in turn throw light on old ones – and the traditions of art criticism. When metaphors are so examined, some degree of critical leverage on them is created and a larger space for intellectual freedom is opened up. And art is usually allowed to operate in this way freely, socially and politically, because it remains a domain where practical consequences are not expected (although some art is banned often enough to make the point).

This possibility of critical purchase on the concepts we use to understand both bodily experiences and subjective experiences is what art contributes to mind.

# References

Arnheim, R. (1954). *Art and visual thinking*. Berkeley, CA: University of California Press.

Bresler, L. (Ed.). (2004). *Knowing bodies, moving minds: Towards embodied teaching and learning*. Dordrecht, The Netherlands: Kluwer.

Clifford, J. (1988). *The predicament of culture*. Cambridge, MA: Harvard University Press.

Collingwood, R. G. (1938). *The principles of art*. Oxford: The Clarendon Press.

Csordas, T. (1999). Embodiment and cultural phenomenology. In G.Weiss & H. Haber (Eds.), *Perspectives on embodiment: The intersections of nature and culture*. New York: Routledge.

Efland, A. (2002). *Art and cognition: Integrating the visual arts in the curriculum*. New York: Teachers College Press.

Eisner, E. (1988). *The role of discipline-based art education in America's schools*, Los Angeles, CA: Getty Center for Education in the Arts.

Eisner, E. (2002). *The arts and the creation of mind*. New Haven, CT: Yale University Press.

Gardner, H. (1999). *Intelligence reframed: Multiple intelligences for the 21st century*. New York: Basic Books.

Goodman, N. (1976). *The Languages of Art*. Indianapolis, IN: Hackett Publishing Co.

Lacan, J. (1981). *The four fundamental concepts of psycho-analysis*. (Jacques-Alain Miller, Ed., Alan Sheridan, Trans). New York: W.W. Norton.

Lakoff, G. (2002). *Moral politics: How liberals and conservatives think*. Chicago, IL: University of Chicago Press.

Lakoff, G., & Johnson, M. (1980). *Metaphors we live by*. Chicago, IL: University of Chicago Press.

Lakoff, G., & Johnson, M. (1999). *Philosophy in the flesh: The embodied mind and its challenge to Western thought*. New York: Basic Books.

Nochlin, L. (1989). *The politics of vision: Essays on nineteenth-century art and society*. New York: Harper & Row.

Pope, A. (1742). *An essay on man*. Frank Brady, (Ed.). Indianapolis, IN: Bobbs-Merrill (1965).

Reimer, B. (1989). *A philosophy of music education*. Englewood Cliffs, NJ: Prentice Hall.

Rorty, R. (1989). The contingency of language. In *Contingency, irony, and solidarity*. Cambridge, MA: Cambridge University Press.

Shelley, P. (1815). *A defence of poetry and A letter to Lord Ellenborough*. London: Porcupine Press. (1948).

Smith, R. (1986). *Excellence in art education: Ideas and initiatives*. Reston, VA: National Art Education Association.

35

# COMPOSING IN VISUAL ARTS

**Anna M. Kindler**
*University of British Columbia, Canada*

In visual arts, the term "composition" carries at least two meanings. When we stand in front of a painting, we tend to think about composition as an arrangement of its visual structure: lines, shapes, colors, and textures organized by the artist to guide our sensory experience, engage our imagination and, hopefully, provide us with a powerful aesthetic experience. From this perspective, composition is a characteristic of a work of art; a testimonial to the ingenuity and skill of the artist; and an object of contemplation of the spectator. It is the interface between the ideas and intentions of an artist and the experience of the viewer. Composition, construed in this way, is a subject of research for every artist each time he or she engages in a creative process. It has long been a focus of theories concerned with articulation of elements and principles of art and design. It has also been a subject of empirical studies aiming to understand patterns in visual scanning of artifacts as well as explorations of quality of aesthetic experience.

When we enter an artist's studio and see him or her engaged in a creative act we are presented with another meaning of "composition." Here, the focus is on the process, on the ways in which ideas find a tangible visual form; where a moment of concentration translates into an image; and where engagement with a medium allows new meaning to emerge. In this chapter, I address the topic of "composition" as understood in these dynamic terms: as a verb rather than a noun; as a creative act rather than its outcome. I focus on the examination of cognitive processes, cultural and social conditions and other contextual determinants of what in the educational literature has traditionally been termed as "artistic development."

I present in this chapter an overview of theories that explain how people: young children, adolescents and adults develop their visual vocabulary of expression and how they grow (or decline) in their ability and interest to "compose" in art. While doing so, I attempt to situate these theories in the context of the changing world of art and suggest ways in which the long neglected distinction between "composing visual imagery" and "composing in visual arts" may be articulated and further researched. I try to account for the fact that not only the medium and the repertoire of tools of

L. Bresler (Ed.), *International Handbook of Research in Arts Education*, 543–558.

composition have significantly expanded but also that the very aims and purposes of composing in art have evolved and shifted focus as the world moved into the twenty-first century and has increasingly become more global.

While my chapter draws heavily on psychologically oriented, empirical research as well as art education literature generated primarily within the Western contexts, I make some references to cross-cultural inquiry conducted in other parts of the world. I also chart some possible new approaches and methods of researching developmental phenomena related to "composing" in visual arts from a vantage point of a contemporary culture of the world of art, which too often has remained outside of the focus of our scholarly discourse in art education.

## How Do We Develop The Ability to Compose in Visual Arts?

*Scholarly interest in children's drawings.*    How we develop in the ability to compose in the visual arts is an intriguing question and one that has been asked for some time. That we are still struggling with the "right answer" is not a result of the lack of diligence or persistence in investigations, nor the small caliber of researchers who have attempted to shed light on this fascinating area of human endeavor. To the contrary, research concerned with artistic development and its cognitive, cultural, and social determinants has a long standing history, with scholars such as Jean Piaget and Rudolf Arnheim contributing to the debate. The difficulty lies, however, in the challenge of connecting the act of producing visual imagery and the achievement of recognized artistry. In other words, more than a century of inquiry has enabled us to gain significant insights into the ways in which humans grow in their capacity to use pictorial medium for a wide range of expressive purposes. Children's drawings have been studied as sources of insights into the workings of human mind and have been seen and interpreted as both indicators as well as the outcomes of cognitive capacity of those who have produced them (e.g., Piaget, 1929; Piaget & Inhelder, 1956). Yet, despite numerous attempts to track down *artistic* progress (e.g., Fein, 1993; Golomb, 1995; Pariser, 1987, 1991, 1997) – as opposed to the progress in the ability to create visual simile which match desired criteria of iconic resemblance or desired standards of visual attractiveness – the jury is still out on how the ability to compose in *Art* – as opposed to composing in drawing – develops over time.

Certainly, much has been learned from studies of artistically gifted youngsters (e.g., Golomb, 1992) and from explorations of juvenile work of accomplished artists: Henri de Toulouse-Lautrec, Edvard Munch, Paul Klee, or Pablo Picasso (e.g., Carroll, 1994; Murray, 1991; Paine, 1987; Pariser, 1995), with one of the outcomes being a suggested set of common characteristics of graphic productions of artistically gifted children (Pariser, 1997). Yet, attributes such as high volume of early pictorial work, early "specialization" or focus on specific themes, or developmental progress from simple to complex forms and increasing sophistication in the use of a chosen technique are neither the necessary nor sufficient predictors of artistic success that could warrant broad generalizations. I emphasize here the distinction between possible patterns in the development of pictorial imagery and composing in *A*rt, because I believe

that we tend to fall into the trap of neglecting this difference. We do so when we allow our emotive responses to enchanting children's drawings (or our cultural mind-frames developed as a result of us sharing a particular moment in history with artists who have venerated "children's art" by seeking in it sources for their own inspiration) to acclaim all pictorial production as art without acknowledging the fact that *A*rt has been, and continues to be, a domain with some boundaries. Arguably, these boundaries have been stretched in recent years more than ever before, to the point of possibly creating an illusion of their disappearance. Yet, even with the unprecedented expansion of the domain and its increasingly ill-defined character, not every "nice" drawing constitutes a work of art – not any more than a random "60 pounds of well-salted raw flank steak" (Rice, 1999, p. 1) – as much as the world of *A*rt has embraced Jana Sterbak's *Flesh Dress*. What we tend to forget is that understanding how children develop in their drawing competencies gives us, at best, only a tiny glimpse on what it takes to compose in the visual arts.

*Modernism and Emergence of "Child Art"*   If we were to search for those most responsible for the present confusion in understanding and defining artistic development, the likely culprits would be the modernists. Artists of that era, breaking away from the constraints of tradition, extended the use of the word "art" to pictorial production of children by seeking inspiration and by incorporating structural and formal ideas embedded in juvenile productions in their own artistic work. Although "the creative vitality of childhood had been discovered in the course of the eighteenth and nineteenth centuries, (…) it was the early modern search for an alternative to the imitation of nature that first gave the license to the serious use of children's drawings" (Franciscono, 1998, p. 96). Seduced by the undeniable freshness, innocence and naivety of young children's drawings, modernist artists validated a vocabulary of forms, compositional arrangements, and uses of pictorial devices that are commonly at the disposal of the untrained and immature. In doing so, artists like Paul Klee, Jean Dubuffet or Joan Miro both "democratized" art and forever exposed it to suspicion by blurring, for the ordinary audience, the important distinction between *a possibility* of almost anything to become art and such assumed certitude. To be clear, as much as for an untrained eye a child-like drawing by Dubuffet may look like any other juvenile drawing, in reality, very few ordinary drawings of similar visual appearance have made it to the world's history of art. For, as Franciscono (1998) noted in reference to work of Paul Klee, "whatever power children's drawings might have" it is, "after all, severely limited; only in a trained and developed art could originality be fully displayed" (p. 100). In the twenty first century North America, we live in an era of a satisfying deception, where one and all can call themselves artists without attracting societal criticism – and yet, also without the gratification of approval that can only come from recognition by the field of relevant experts.

The modernist legacy has had a significant influence on research in "artistic development." A notable example is the U-curve theory which suggests that young children and professional artists share much in common in terms of artistic quality of their  drawings their drawings potential (Davis, 1991, 1997a, 1997b; Gardner & Winner, 1982). Davis, who provided empirical evidence supporting the U-curve

developmental model concluded that "children possess an early gift in artistic pro-
duction that bears similarities to the artistry of professional artists and seems to be
lost to most of them by the middle childhood" (1997a, p. 54). Yet, when her original
study was replicated and extended by Pariser and van den Berg (1997) with the
involvement of Chinese-Canadian judges, the universality of the U-shaped develop-
mental pattern was brought into the question. Further studies in Taiwan and Brazil
(e.g., Kindler, 2001; Kindler, Liu, Pariser, & van den Berg, 2003; Kindler, Pariser,
van den Berg, & Liu, 2002; Kindler, Pariser, van den Berg, Liu, & Dias, 2002) have
also failed to replicate prevalence of the U-shaped developmental trend and con-
firmed a strong cultural (and likely modernist) influence embedded in the U-curve
model. These studies reinforced doubts expressed by Duncum in his attempt to
"break down" the U-curve (Duncum, 1986) by demonstrating how the conception of
artistic development – if tied to aesthetic judgment – is inseparably linked to the aes-
thetic frameworks and traditions within which such judgments are exercised. Any
model built on such a premise can achieve only a "local" validity restricted to the
temporal and cultural contexts of its origin. This conclusion is consistent with David
Feldman's "nonuniversal theory" of cognitive development (Feldman, 1980) which
will be addressed later in this chapter.

## art and Art

The disconnection between the domain of *A*rt and the casual use of the term "art" has
been evident in the body of research concerned with "artistic development." A very
good example is provided by the work of Margaret Hagen who argued that "there is no
development in art" (1985), pointing to the lack of evidence of existence of any devel-
opmental patterns based on her extensive research of projection systems (in particular,
the use of primary geometry and light in drawing). Her consideration of development
in art was not only limited by a rather narrow focus of investigations, but was also
clearly embedded in limitations inherent in her operational definition of art. Hagen
described art as "two-dimensional creations of skilled people, whether painted, drawn,
etched, engraved or photographed, or even programmed" adding that such creations
would always be a result of "skilled labor, the end product of developed technique."
She further indicated that considerations of "intention, function or aesthetic appeal"
had no relevance to this definition and acknowledged that she purposefully excluded
"sculpture, crafts and artifacts" such as "startling beautiful patterns of nature" (p. 3).
Needless to say, such definition of art falls significantly short of what art critics, his-
torians, educators, gallery curators, collectors, and – very importantly – artists them-
selves would ever accept as a fair description of their field of expertise and
accomplishment. Consequently, we are faced with a situation where scholarly accounts
of the development within the domain do not hold validity, nor even significant rele-
vance, to the very domain that they purport to describe.

It is important to note that this observation does not diminish the significance of
Hagen's research on the use of projection systems in pictorial imagery – although her
conclusions are not universally shared (e.g., Willats, 1997). It is rather to alert us to the
problems that arise when scientific research embraces terms with meanings more con-
sistent with the colloquial use, rather than adhering to the definitions and meanings

validated by the domain to which they apply. This problem is particularly significant in a cross-cultural perspective, because some cultures more than others have allowed the word "art" to migrate into everyday language in separation from the "Art world" and, consequently, where direct translation is bound to contribute to a conceptual confusion. In North America where Hagen's work originated, the noun "art" can readily refer to most manifestations of human pictorial engagement – from early scribbles of a child quickly executed on a torn piece of paper and displayed with the help of a magnet on a refrigerator door to a painting, sculpture, or installation that resulted from years of study, reflection and refinement of conceptual and technical skills and is publicly shared at a national gallery. However, in many European and Asian contexts these distinctions would not be as easily blurred nor disregarded. This issue has increasingly become clear to me in the course of over ten years of research collaboration with Bernard Darras, Professor at the Université Paris 1, Pantheon-Sorbonne in Paris, who had long insisted on more precision in this regard (Darras, 1993–2001, 1996), as well as through numerous conversations with fellow art educators and artists in Taiwan, Hong Kong, and mainland China. I am raising this point now to acknowledge the limitations of the possible interpretation of research and theories which I discuss in the next section.

*Theories of "Artistic Development"*[1]   This section offers a very quick glimpse at developmental theories that constitute the core of the literature on "artistic development," that is, graphic development. In essence, the notion of development in ability to compose using languages of visual expression has been explored through the prism of two types of theories which take either a "stage" or a "repertoire" approach. The stage theories posit that "artistic development" proceeds in a step like fashion resulting in increasingly sophisticated pictorial outcomes over time. According to Luquet (1927), such progression occurs from "fortuitous realism," "failed realism," "intellectual realism" to "visual realism." In Viktor Lowenfeld's model (1947), "artistic development" is described as a progression from early scribbling, through preschematic and schematic stages, eventually leading to the stage of "dawning realism." Descriptors of the developmental milestones in both of these influential theories make it clear that visual realism has been regarded as a hallmark of development and a benchmark against which the progress ought to be assessed. More recent explorations of development in drawing have also considered visual realism as the endpoint (e.g., Chen, 1985; Cox, 1992; Freeman, 1980, 1995; Milbrath, 1998; Porath, 1997; Reith, 1990; Willats, 1997) – even if the scholars contributing to this developmental debate represented different perspectives on the actual causes or sources that would account for changes in the appearance of pictorial images. Piaget and Inhelder (1956), for example, argued that differences in children's drawings can be explained in terms of their cognitive deficit, while Freeman (1980, 1995) attributed the cause of "immature drawings" of young children not to their lack of knowledge about the world but rather to their inability to translate it within a pictorial medium.

Relying on visual realism as a benchmark for assessment of "artistic growth" has now long been contested, with Rudolf Arnheim (1966, 1974) first challenging this claim and contending that both children and artists alike do not strive in their pictorial attempts to "copy" reality but rather work on creating pictorial equivalences within a selected

creative medium. In order to function well as pictorial substitutes, these pictorial solutions need to embody some structural or dynamic equivalence to the objects or scenes being represented – not iconic visual resemblance. Arnheim's theory has created a fertile ground for development of "repertoire" theories, which posit existence of multiple possible "endpoints" of "artistic growth" (e.g., Darras & Kindler, 1993; Golomb, 2002; Kindler, 1999; Kindler & Darras, 1994, 1997, 1997a, 1998; Wolf, 1994; Wolf & Perry, 1988). These theories indicate that, from early on in their lives, young children have at their disposal more than one "genre" of drawing and that they resort to different repertoires of pictorial strategies depending on their intentions and purposes. What we see on paper then is not a reflection of a "default" solution constrained by a child's developmental stage, but rather it represents a selection of a drawing strategy that the child finds most appropriate for his or her pictorial purpose. The set of these pictorial strategies is closely related to cultural influences (e.g., Wilson, & Wilson, 1977, 1985) and eventually expanded or limited as a result of social and cultural validations (e.g., Kindler, 1994, 1995, 1999, 2001; Kindler & Darras, 1998). It is important to note that while these "repertoire" theories have become an integral part of "artistic development" literature, they have been formulated in the context of researchers' interest in "drawing systems" (e.g., Wolf and Perry, 1988) or in development in pictorial representation in much broader terms than those restricted to "art" (e.g., Darras, 2002; Darras & Kindler, 1993; Kindler & Darras, 1994, 1997; Kindler, 1999, 2004).

The "repertoire" theories mentioned above reflect conceptions of development that depart from the traditional Piagetian model that has guided the discourse in the field for decades. Rather, they constitute an extension of David Feldman's "nonuniversal" theory which contrasted with Piaget's understanding of cognitive development (Feldman, 1980). The "nonuniversal" theory contests the assumption that children move through a set of universal stages in a biologically predetermined sequence in order to acquire universal cognitive abilities. It posits that, as a function of culture and environment, children around the world do not develop the same cognitive abilities in the same way. Feldman's theory acknowledges that there are some fundamental universal developmental achievements, but also notes the importance and significance of "developmental regions" that are significantly affected by specific cultural or societal influences. Thus the next region on the Feldman's continuum is the pancultural region: referring to spontaneous developmental gains, such as language, that involve all who live in any society. The cultural region embraces accomplishments which are expected to be achieved because of their specific cultural importance in specific contexts – increasingly differentiating the possible developmental paths. Disciplined, idiosyncratic and unique regions not only highlight developmental "options" but also indicate the increased importance and necessity of a conscious effort to pursue knowledge and master the skills. The unique achievements region, for example, requires the ability to reorganize knowledge in ways in which it has not been considered before, commanding its thorough grasp.

Although Feldman's "nonuniversal" theory was not developed to specifically address development in *Art*, it provides an important context for its consideration. It supports ways of thinking about such development free from the obligation to search for a universal solution. The disciplined region in particular situates the concept of

development within a particular discipline of expertise pointing to the significance of the discipline itself in guiding and defining the developmental achievement. Most importantly, it highlights the possibility of framing the concept of development in *A*rt in relational terms and to consider it from a perspective of a system: where biology, society and culture – with the disciplines and institutions that the latter two allowed to emerge – interact in guiding the developmental paths.

*How Do These Theories Inform Discourse about Composing in Visual Arts?*   Despite the apparent separation between the theories describing "artistic development" and the world of *A*rt itself, the theories described above contribute important insights into understanding of at least some aspects of composing in visual arts. First of all, if we agree that artistic ability in visual arts resides within the realm of human pictorial representation, we can conclude that composing in *A*rt involves at least some variation of use of a "visual language" that, as Arnheim suggested, is guided by an internal logic of the pictorial medium – whatever it may be. In other words, composing in visual arts involves thinking within a medium and selecting a pictorial repertoire that matches the artist's intent. The current prevalence of visual culture and the advent of new technology-enabled media of representation have created new possibilities and challenges, further expanding the possible systems of imagery that artists may employ in their work. As Darras (2002) proposes in his ecosystemic approach, these choices involve selection, integration, and mixing of systems of imagery that span a full spectrum of possibilities between the visual/mimetic and schematic/pictographic orientation.

Studies of social and cultural determinants of "artistic development" and resulting theories bring to the forefront the connection between an individual's pictorial semiotic activity and the context within which it occurs. In particular, they emphasize the impact of social and cultural conditions on acquisition, learning and mastery of pictorial systems and point to the significance of these factors in determining artistic merit.

However, what these theories, independently and as a body of collective knowledge, fail to account for is the dynamics of the world of *A*rt and its "power" to ultimately define what is *A*rt. They provide a reasonable explanation of possibilities and choices and identify at least some range of potential trajectories of growth in visual semiotic activity but they fall short of indicating the necessary conditions for the trek along these trajectories in order to reach *A*rt at the destination. As ill-defined and as changing as the category of *A*rt is, it is also well defined by the boundaries guarded by its "custodians," which becomes clear as soon as we distinguish between the casual use of the term "art" and one that functions within the *A*rt world.

I realize that I am walking here on thin ice and that my insistence on this distinction, if misunderstood, could be perceived as being in conflict with the significant interest in art education circles in visual culture as the "new" focus of art education (e.g., Boughton et al., 2002; Duncum, 2001; Freedman, 2003; Freedman & Stuhr, 2004, Tavin, 2000, 2003; Wilson, 2003) – thus putting me at the risk of fitting Tavin's (2005) description of "an antagonistic specter that haunt" the visual culture agenda (p. 6). It is therefore necessary for me to clarify that my interest in *A*rt as a distinct category does not contradict my profound interest in providing students with the opportunities to study "an inclusive register of images and objects" (Tavin, 2005, p. 7). I have long

agreed with June McFee, who, as early as 1966, alerted the art education community to the need to pay attention to the visual environments that frame students' daily experiences and advocated that "we need careful content analysis of the values being projected through mass media" (McFee, 1966, p. 139). In my own work, I have actively argued the value of study of visual culture in education (Kindler, 2003) – and still am committed to this notion. I am suggesting, however, that the "shift" towards visual culture in art education runs a risk of constraining, rather than broadening, this comprehensive register of explorations if we fail to recognize that it contains categories of images and objects which in many ways seem alike – but which indeed function very differently within our societies – and thus would benefit from distinct conceptual frameworks for their consideration, appraisal, and nurturing.

Freedman (2003) defines "visual culture" as "all that is humanely formed and sensed through vision and visualization and shapes the way we live our lives" (p. 1) – which, naturally, includes much of *Art*. Boughton (2004) makes this connection between art and visual culture very explicit in his assertion that "new approaches to art education assume students already posses sophisticated knowledge of visual arts defined more broadly as visual culture" and attributes students' capacity to understand visual arts to their experiences with "computer games, feature-length films, and television commercials" (p. 590). I concur with Boughton that these experiences contribute to students' "visual education" and expand their sociocultural understandings of the ways in which images communicate and impact on our lives, and perhaps even affect a social change. However, I find it useful to acknowledge that the world of *A*rt has not ceased to exist, nor has become less significant, because of this new reality. Although it has now embraced imagery not included within its boundaries in the era before "the end of art" (Danto, 1997), the world of *A*rt still is very exclusive and carefully guarded by its "custodians." I believe that our students have an interest and right in understanding how this world operates and how it guides and controls the future of *A*rt. It is still possible, to define *A*rt, as a *distinct* concept and a *distinct* category, which deserves to be acknowledged as such and not be confused with other manifestations of human pictorial engagement – as an area of study in public education and as an area of focused research – and that development in this unique domain requires alternative models to describe it. In other words, despite many points where the two may intersect, I see "composing in visual culture" as not synonymous with "composing in *Art*."

I feel particularly compelled to assert this in the context of questions raised by Freedman (2003) regarding art education curriculum. I see a potential danger of discounting *Art* if the answers to "What art is worth teaching?" and "What about art is most important to learn?" were to be solely guided by the criterion of it exerting a "powerful social influence." I agree with Freedman that we "can conceptualize quality not as great (inherent) value, but as powerful (social) influence" (Freedman, 2003, p. 54). However, I would be concerned if this were to be interpreted as the guiding principle for art education curriculum decisions. I see Freedman's assertion as an excellent criterion for discerning and selecting from the "visual culture" content the elements worthy to include in the curriculum, but I do not regard it as the appropriate lone standard for assessment of "curricular worthiness" of instances of *Art*. This is another reason why I believe that it is important to maintain a conceptual distinction between

"visual culture" and *Art* and to study *Art* within the understanding of its unique rela-
tionship to the society, which the proposed systems approach attempts to illuminate.

## Systems Approach to Understanding Composing in Visual Arts

*Why a systems approach?* My search for alternative models to explain how we grow
in the abilities to compose in *Art* had reached a turning point when I came across the
work of Csikszentmihalyi (1988, 1990, 1999), Gruber (1988), Simonton (1990) and
Feldman (1999) concerned with understanding creativity. These scholars posited that
creativity cannot be explained in an exclusive reference to psychological processes and
insisted that variables that reside outside of an individual need to be taken into account
in determining his or her creativity. They suggested that a systems approach, which
effectively focuses on an interplay between the individual, the domain within which his
or her creativity is manifested and the field of experts who are the "custodians" of this
domain, accounts for the distinction between creative and noncreative behavior. I was
intrigued by this model as it opened a possibility of extending it to the discourse about
development in visual arts and bridging the gap between the accounts of "artistic devel-
opment" emerging from psychologically-oriented research and the realities of the world
of *Art*. Consequently, I embarked on the task of extending Csikszenmihalyi's concept to
provide an alternative account of development in *Art* (Kindler, 2003, 2004, 2004a). This
account, unlike my earlier work, makes a clear distinction between pictorial
representation in general, and *Art*, in particular.

*Visualizing artistic development from a systems perspective.* Csikszentmihalyi's
model can be represented graphically as a triangle with three anchors: the individual,
the field, and the domain. In case of artistic development, there is a need to introduce an
additional plane to account for the impact of time, thus creating a three-dimensional
image. The "base" triangle is complemented by lines pointing upwards, each containing
an infinite number of points signifying possible changes over time in relation to the
aging and maturation of the individual, changes in positions, views and preferences of
the field, and the resulting changes to the domain itself.

To illustrate how this model works, Figure 1 presents three hypothetical visual rep-
resentations of artistic development under three sets of assumptions.

The first drawing in this Figure represents artistic development under the assump-
tion that neither the field nor the domain has changed over the course of an individual's
life. This is a hypothetical model consistent with traditional perspectives on "artistic
development," where the focus had been restricted to the child and to his/her develop-
mental unfolding. The second drawing implies some change in the position of the field
but without an apparent impact on the domain, alongside the developmental progres-
sion at the level of the individual. It accounts for circumstances where a change within
the domain is being "championed" but not yet achieved or sufficiently integrated to
transform the domain. The third drawing attempts to visualize the concept under con-
ditions where all three: the individual, the field, and the domain have undergone some

Figure 1

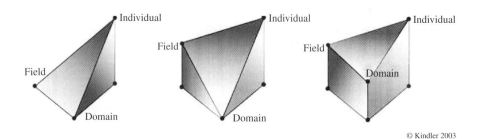

© Kindler 2003

Artistic Development from a Systems Perspective

change over time, and are likely the most accurate representation of the concept as it evolves. Specific appearance of these rudimentary representations in Figure 1 is of no significance – they are only illustrative of random possibilities. Their importance is in signaling that artistic development, from a systems perspective, is a concept in flux, always in the state of "becoming" and reshaping itself and that it is dependent on and fully relational with respect to at least three significant variables. In the third drawing, for example, the anchoring points on the lines extended from the base in actuality constantly fluctuate, as the individual, the field, and the domain change over time and the dynamics and interplay among these variables never remains constant (an animation would be required to adequately represent this phenomenon). This model suggests that a final, conclusive answer to the question "how humans develop in their ability to compose in the visual arts" will never be found, or rather, that the answers will change as the symbol system within a culture that defines the domain of *A*rt and the field of social organization within this domain charged with defining, maintaining and moderating its transformations, continue to evolve.

If we are to situate this developmental discourse firmly within the world of *A*rt, we need to balance the emphasis of our inquiry. Traditional interest and focus on young children and their pictorial imagery needs to be complemented by insights contributed by mature, accomplished artists. The systems approach to artistic development, because of its dynamic, relational nature, allows a multitude of models which, collectively but in separation, rather than collectively in a pooled fashion, allow us to seek understanding of the mystery of artistic becoming. These individual modules of our understanding are located across communities and cultures and they require reaching to these sources for insight.

*Some Possible Approaches to Study Artistic Development*    As I have indicated earlier, exploring *A*rtistic development from a systems perspective will call for new approaches and methods because of the enlarged scope and expanded nature of the required investigation. This new conceptual framework establishes the need to study not only the individual, but also the changes that occur within the field and the domain itself, and eventually find ways to tie these findings together.

I would like to stress that I still see a need to explore *A*rtistic development through the prism of interests and methods traditionally situated within the fields of psychology and cognitive sciences. I am particularly excited about the possibilities created by the advent of new technologies that provide new ways of access to the workings of the human brain. The work of those who have studied "visual brain" and "visual intelligence" (e.g., Hoffman, 1998; Zeki, 1999) demonstrated how the use of fMRI, for example, makes it possible to explore aspects of cognitive functioning that in the past could only be explained through the inferences made based on the analysis of "evidence" in the form of generated visual images. I believe that the new approaches that incorporate advances in medical technology have a potential to bring valuable insights into our understanding of what factors – at the level of an individual – are key to "composing" in visual arts. With further advances in the instrumentation and decreasing costs of its use over time, a number of studies with significant informative potential could be generated. These may include, among many others, inquiry focusing on the brain functions engaged in routine drawing tasks performed by art novices compared to similar drawing tasks performed by accomplished artists who use drawing as an expressive medium in their work; investigations that would allow researchers to gather brain function data related to engagement in tasks that specifically call for creative thinking on a developmental continuum; as well as studies designed to capture aesthetic sensitivity of artists and non-artists in response to visual stimuli.

Needless to say, the specific questions to be answered through such investigations would need to be guided by what we know to be the salient attributes that define the domain of *A*rt itself, as it evolves over time. In this context, it would be essential to abandon the almost exclusive focus on drawing and reach out to other media and forms of artistic expression that exemplify the spectrum of what *Art* is today. Cognitive processes that are engaged in creative work in photography, installation, or creation of digital animation could well become the subject of future investigations.

An obvious implication of the recommendation to tie the inquiry into *A*rtistic development at the level of an individual and the "current status" of the domain would be to apply a collaborative research model where those with expertise in cognitive science would partner with those with an intimate knowledge and understanding of the domain. It also suggests that access to research infrastructure currently reserved almost exclusively for medical research and diagnosis would need to be afforded to researchers with other interests. Needless to say, there are currently many hurdles to such collaboration and sharing of research facilities, as research founding councils, at least in North America, still seem ill equipped to support these forms of interdisciplinary research. However, with the growing acknowledgement of the value of cross-disciplinary collaboration within the universities and its contribution to the advancement of human knowledge, there is hope that opportunities for such engagement will increase over time.

Future investigations into the individual dimension of *Artistic* growth from the systems perspective should also extend the existing studies focused on examination of pictorial evidence. Of particular interest would be studies extending beyond drawing and those that would pay attention to the purposes, intentions, and "destinations" of the produced images. In other words, studies into the distinction between imagery that has entered the domain of Art and that that has remained outside of its boundaries can provide fascinating

insights into the development of the concept over time. Studies of juvenile works of artists as well as work of those who in their childhood seemed destined, by the application of the criteria relevant within their historical and cultural contexts, for artistic success but have never realized this potential, may further contribute to this debate.

Finally, the "field" itself needs to be considered as a significant source of insight. Those who have achieved artistic success – artists themselves, as well as those who effectively serve as the "custodians" of the domain – art critics, curators, historians, theoreticians, collectors, or even brokers – can help articulate the interaction of the individual attributes and characteristics with the changing "requirements" of the domain. Although they may be hard pressed to project into the future, they can help shape the understanding of *Artistic* development as applied to the past and to the present day.

One of my recent studies, conducted in collaboration with Victor Lai Ming Hoi and Ma Kwai Shun in Hong Kong and mainland China allowed me to consider contemporary Chinese artists as sources for concept development (Kindler, Lai, & Ma, 2002; Kindler, 2005). Our informants included artists pursuing traditional Chinese painting, as well as painting that combines Western and traditional influences, experimental art/installation, digital media, sculpture/ceramics, and those recognized for their artistry in cartoon/caricature. A common characteristic was that all of these artists enjoyed international recognition and have been "accepted" by the world of *A*rt, as evidenced by refereed exhibitions records, awards, and so on. We invited these artists to participate in semistructured, open-ended interviews designed to access their understanding of how people develop in visual arts and what accounts for human growth in the ability to compose in this domain. In most cases, we were invited to the artists' studios which allowed the artists to refer to examples of their work – originals or reproductions in catalogues, and sometimes even to demonstrate how they engage in their practice. As a result, we were able to apply a cognitive case study approach (Gruber & Davis, 1988) to inform our understanding of *A*rtistic development through the perspective of some of those intimately connected with the domain, those who belong to its field, and those who have a potential to actively shape not only its present but its future.

Naturally, these artists' reflections on the development of their own artistry and identification of attributes and characteristics that define artistic capacity and potential for success do not lend themselves to a generalization – not in the sense of generalization to the entire population of artists – those who practice their art today, and certainly not those artists-to-be in the future. However, they are open to analytic generalization (Yin, 1994) and, from a systems perspective, contribute valuable knowledge that helps define the "shape" of the concept of artistic development reflective of at least some aspects of its understanding at the onset of the twenty-first century.

## Concluding Remarks

In this chapter I make a claim that *A*rtistic development, the human ability to compose in visual arts, needs to be understood from a systems perspective. This perspective

takes under consideration not only cognitive, developmental readiness and attributes and characteristics contained within an individual, but also accounts for the context within which these capacities grow and unfold, in particular the context of the world of Art and the domain of Art itself. This approach recognizes that all the "variables" key to this concept remain in a constant flux: individuals, as they develop over time as a result of physical maturation, social interactions and cultural influences, including exposure to formal education; field of relevant experts, as they formulate judgments of merit that lead to inclusion or exclusion of specific works or entire Art forms over time; and Art as a domain, welcoming under its umbrella and enshrining in its heritage, manifestations of human creativity in thought and visual expression of an ever-expanding nature and scope. The systems approach prevents us from defining artistic development as a concept once and for all and it calls for different approaches to inquiry that would allow us to understand it over time. I suggested such possible approaches and claimed that they will necessitate a close interdisciplinary collaboration, bringing together cognitive sciences and those working within the domain of Art. I indicated the need to actively reach into the field of Art for insights that can illuminate salient dimensions along which artistic growth can be explored.

As much as we often strive for comfort of a "final answer," this ephemeral nature of the concept of Artistic development also holds great appeal. While it makes the task of an art teacher significantly more problematic, it also connects human pictorial activity to the domain of Art in ways that accurately reflect the ill-defined nature of Art as a cognitive category and challenges us to never leave Art behind as we consider the future of art education.

## Note

1.  I use quotation marks while referring to "artistic development" to reflect the point made in the previous section.

## References

Arnheim, R. (1966). *Towards a psychology of art. Berkeley*, CA: University of California Press.

Arnheim, R. (1974). *Art and visual perception*. Berkeley, CA: University of California Press.

Artist. (n.d.). Retrieved June 26, 2005, from http://www.lilycomix.com/

Boughton, D. (2004). Assessing art learning in changing contexts: High stakes accountability, international standards and changing conceptions of artistic development. In E. Eisner & M. Day (Eds.), *Handbook of Research and Policy in Art Education*. Reston, VA: NAEA.

Boughton, D., Freedman, K., Hausman, J., Hicks, L., Madeja, S., Metcalfe, S. et al. (2002). *Art education and visual culture*. NAEA Advisory. Reston, VA: National Art Education Association.

Carroll, K. (1994). Artistic beginnings: The work of young Edvard Munch. *Studies in Art Education, 36*(1), 7–17.

Chen, M. J. (1985). Young children's representational drawings of solid objects: A comparison of drawing and copying. In N. Freeman & M. V. Cox (Eds.), *Visual order: The nature of development of pictorial representation*. Cambridge, England: Cambridge University Press.

Cox, M. (1992). *Children's drawings*. London: Penguin Books.

Csikszentmihalyi, M. (1988). Society, culture and person: A systems view of creativity. In R. Sternberg (Ed.), *The nature of creativity* (pp. 325–339). Cambridge, MA: Cambridge University Press.

Csikszentmihalyi, M. (1990). The domain of creativity. In M. A. Runco & R. S. Albert (Eds.), *Theories of creativity* (pp. 190–212). Newbury Park, CA: Sage.

Csikszentmihalyi, M. (1999). Implications of a systems perspective for the study of creativity. In R. Sternberg (Ed.), *Handbook of creativity* (pp. 313–335). Cambridge, MA: Cambridge University Press.

Danto, A. C. (1997). *After the end of art. Contemporary art and the pale of history*. Princeton, NJ: Princeton University Press.

Darras, B. (1993–2001). Private communication.

Darras, B. (1996). *Au commencement etait l'image: Du dessin de l'enFangt a la communication de l'adulte.* Paris: ESF.

Darras, B. (2002). Les formes du savoir et l'education aux images. *Recherches en communication, 18*, 1–14.

Darras, B., & Kindler, A. M. (1993). Emergence de L'Imagerie: Entre L'Essence at L'Accident. *Mediascope, 6*, 82–95.

Davis, J. (1991). Artistry lost: U-shaped development in graphic symbolization. Doctoral dissertation. Harvard Graduate School of Education.

Davis, J. (1997a). The "U" and the wheel of "C:" Development and devaluation of graphic symbolization and the cognitive approach at Harvard Project Zero. In A. M. Kindler (Ed.), *Child development in art* (pp. 46- 58). Reston, VA: National Art Education Association.

Davis, J. (1997b). Drawing demise: U-shaped development in graphic symbolization. *Studies in Art Education, 38*(3), 132–157.

Duncum, P. (1986). Breaking down the U-curve of artistic development. *Visual Arts Research, 12*(1), 43–54.

Duncum, P. (2001). Visual culture: Developments, definitions and directions for art education. *Studies in Art Education, 42*(4), 101–112.

Fein, S. (1993). *First drawings*. Pleasant Hill, CA: Exelord.

Feldman, D. H. (1980). Beyond universals in cognitive development. Norwood, N. J.: Ablex.

Feldman, D. H. (1999). The development of creativity. In R. Sternberg (Ed.), *Handbook of creativity* (pp. 169–188). Cambridge, MA: Cambridge University Press.

Franciscono, M. (1998). Paul Klee and children's art. In J. Fineberg (Ed.), *Discovering child art. Essays on childhood, primitivism and modernism*. Princeton, NJ: Princeton University Press.

Freedman, K. (2003). *Teaching visual culture: Curriculum, aesthetics and the social life of art*. New York, NY and Reston, VA: Teachers College Press and National Art Education Association.

Freeman, K., & Stuhr, P. (2004). Curriculum changes for the 21st century: Visual culture in art education. In E. Eisner & D. Day (Eds.), *Handbook of research and policy in art education* (pp. 815–828). Reston, VA: National Art Education Association.

Freeman, N. H. (1980). *Strategies of representation in young children: Analysis of spatial skills and drawing processes*. London, UK: Academic Press.

Freeman, N. H. (1995). The emergence of a framework theory of pictorial reasoning. In C. Lange-Kutter & G. V. Thomas (Eds.), *Drawing and looking*. Hemel Hempstead, UK: Harvester Wheatsheaf.

Gardner, H., & Winner, E. (1982). First intimations of artistry. In S. Strauss (Ed.), *U-shaped behavioral growth*. New York: Academic Press.

Golomb, C. (1992). *The child's creation of a pictorial world*. Berkeley, CA: University of California Press.

Golomb, C. (1995). *The development of gifted child artists*. Hillsdale, NJ: Erlbaum.

Golomb, C. (2002). *Child art in context: A cultural and comparative perspective*. Washington, DC: American Psychological Association.

Gruber, H. (1988). The evolving systems approach to creative work. *Creativity Research Journal, 1*(1), 27–51.

Gruber, H. E., & Davis, S. (1988). Inching our way up Mount Olympus: the evolving – systems approach to creative thinking. In R. Sternberg (Ed.), *The nature of creativity* (pp. 243–270). Cambridge, MA: Cambridge University Press.

Hagen, M. A. (1985). There is no development in art. In N. H. Freeman & M. V. Cox (Eds.), *Visual order: The nature and development of pictorial representation*. Cambridge, MA: Cambridge University Press.

Hoffman, D. D. (1998). *Visual intelligence*. New York: Norton.

Kindler, A. M. (1994). Artistic learning in early childhood: A study of social interactions. *Canadian Review of Art Education, 21*(2), 91–106.

Kindler, A. M. (1995). Significance of adult interactions in early childhood artistic development. In C. Thompson (Ed.) *The visual arts in early childhood learning* (pp. 10–15). Reston, VA: National Art Education Association.

Kindler, A. M. (1999). "From endpoints to repertoires:" A Challenge to art education. *Studies in Art Education, 40*(4), 330–349.

Kindler, A. M. (2001). From the U-curve to dragons: Culture and understanding of artistic development. *Visual Arts Research, 26*(2), 15–29.

Kindler, A. M. (2003). Responding to the changing landscapes of art and childhood: A Systems approach to artistic development. Invited John Landrum Bryant Lecture. Harvard Graduate School of Education. Harvard University, Cambridge, MA.

Kindler, A. M. (2003a). Visual culture, visual brain and (art) education. *Studies in Art Education, 44*(3), 290–296.

Kindler, A. M. (2004). Researching impossible? Models of artistic development reconsidered. In E. Eisner & M. Day (Eds.), *Handbook of research and policy in art education.* Reston, VA: NAEA.

Kindler, A. M. (2004a, December). Artistic development in the context of a changing world of art: Art education in/through the school and the art community. Keynote address presented at the Asia-Pacific Art Education Conference, Hong Kong, SAR, China.

Kindler, A. M. (2005). Creativity and art education: A discourse informed by perspectives of three Asian artists. *International Journal of Arts Education.*

Kindler, A. M., & Darras, B. (1994). Artistic development in context: Emergence and development of pictorial imagery in early childhood years. *Visual Arts Research, 20*(2), 1–13.

Kindler, A. M., & Darras, B. (1997). Map of artistic development. In A. M. Kindler (Ed.), *Child development in art.* Reston, VA: NAEA.

Kindler, A. M., & Darras, B. (1997a). Development of pictorial representation: A teleology-based model. *Journal of Art and Design Education, 16*(3), 217–222.

Kindler, A. M., & Darras, B. (1998). Culture and development of pictorial repertoires. *Studies in Art Education, 39*(2), 147–167.

Kindler, A. M., Lai, V. M. H., & Ma, K. S. (2002). Artists as sources for concept formation. Research proposal. Hong Kong Institute of Education.

Kindler, A. M., Liu, W. C., Pariser, D., & van den Berg, A. (2003). A cultural perspective on graphic development: Aesthetic assessment of local and foreign drawings in Taiwan. *Research in Arts Education*, May (5), 23–47.

Kindler, A. M., Pariser, D., van den Berg, & Liu, W. C. (2002). Visions of Eden: The differential effects of skill on adults' judgments of children drawings: Two cross-cultural studies. Canadian Review of Art Education, *28*(2), 15–29.

Kindler, A. M., Pariser, D., van den Berg, A., Liu, W.C., & Dias, B. (2002). Aesthetic modernism, the first among equals? A look at aesthetic value systems in cross-cultural, age and visual arts educated and non-visual arts educated judging cohorts. *International Journal of Cultural Policy, 8*(2), 135–152.

Lowenfeld, V. (1943). *Creative and mental growth.* New York: Macmillan.

Luquet, G. H. (1927). *Le dessin enfantin.* Paris: Alcan.

McFee, J. K. (1966) Society, art and education. In Mattil, E. (Ed.), *A seminar in art education for research and curriculum development* (pp. 122–140). University Park, PA: Pennsylvania State University.

Milbrath, C. (1998). *Patterns of artistic development in children.* Cambridge, MA: Cambridge University Press.

Murray, G. (1991). *Toulouse-Lautrec: The formative years, 1878–1891.* New York: Oxford University Press.

Paine, S. (1987). The childhood and adolescent drawings of Henri de Toulouse-Lautrec (1884–1901). Drawings from 6 to 18 Years. *Journal of Art and Design Education, 6*(3), 297–312.

Pariser, D. (1987). The juvenile drawings of Klee, Toulouse-Lautrec and Picasso. *Visual Arts Research, 13*(20), 53–67.

Pariser, D. (1991). Normal and unusual aspects of juvenile artistic development in Klee, Toulouse-Lautrec and Picasso: A review of findings and directions for further research. *Creativity Research Journal, 3*(1), 51–56.

Pariser, D. (1995). Lautrec – Gifted child artist and artistic momentum: Connections between juvenile and mature work. In C. Golomb (Ed.), *The development of artistically gifted children* (pp. 31–70). Hillsdale, NJ: Erlbaum.

Pariser, D. (1997). Graphic development in artistically exceptional children. In A. M. Kindler (Ed.), *Child development in art*. Reston, VA: National Art Education Association.

Pariser, D., & van den Berg, A. (1997). The mind of the beholder: Some provisional doubts about the U-curve aesthetic development thesis. *Studies in Art Education, 38*(3), 158–178.

Piaget, J. (1929). *The child's conception of the world*. New York, NY: Harcourt, Brace & World.

Piaget J., & Inhelder, B. (1956). *The child's conception of space*. London: Routledge & Kegan Paul.

Porath, M. (1997). A developmental model of artistic giftedness in middle childhood. *Journal for the Education of the Gifted, 20*, 201–223.

Reith, E. (1990). Development of representational awareness and competence in drawing production. *Archives de Psychologies, 58*, 369–379.

Rice, R. (1999, October 28–November 14). Discomfort zones. A dress made of meat, and other enticements from Jane Sterbak. *Citipaper.net*. Retrieved from http://citypaper.net/articles/102899/ae.art.shtml

Simonton, D. K. (1990). Political pathology and societal creativity. *Creativity Research Journal, 3*, 85–99.

Tavin, K. M. (2000). Teaching in and through visual culture. *Journal of Multicultural and Cross-cultural Research in Art Education, 18*(1), 37–40.

Tavin, K. M. (2005). Opening re-marks: Critical antecedents of visual culture in art education. *Studies in Art Education, 47*(1), 5–22.

Willats, J. (1997). *Art and representation*. Princeton, NJ: Princeton University Press.

Wilson, B. (2003). Of diagrams and rhizomes: Visual culture, contemporary art, and the impossibility of mapping the content of art education. *Studies in Art Education, 44*(3), 214–229.

Wilson, B., & Wilson, M. (1977). An iconoclastic view of the imagery sources in the drawings of young people. *Art Education, 30*(1), 5–15.

Wilson, B., & Wilson, M. (1985). The artistic tower of Babel: Inextricable links between cultural and graphic development. *Visual Arts Research, 11*(1), 90–104.

Wolf, D. (1994). Development as the growth of repertoires. In M. B. Franklin & B. Kaplan (Eds.), *Development and the arts* (pp. 59–78). Hillsdale, NJ: Laurence Erlbaum.

Wolf, D., & Perry, M. (1988). From endpoints to repertoires: Some new conclusions about drawing development. *Journal of Aesthetic Education, 22*(1), 17–34.

Yin, R. K. (1994). *Case study research. Design and methods*. Thousand Oaks, CA: Sage.

Zeki, S. (1999). *Inner vision: An exploration of art and the brain*. Oxford: Oxford University Press.

# INTERNATIONAL COMMENTARY

# 35.1

# Composition in Context: A Nordic Perspective
# Sweden

**Lars Lindström**
*Stockholm Institute of Education, Sweden*

Until the mid-1960s, children's drawings were one of the most popular themes in Swedish professional writing on art education. Then suddenly, this topic almost disappeared from the agenda, not to return until the 1990s. The focus of curricula, teacher training and research shifted to picture analysis, popular forms of visual communication, and cultural analysis.

In Denmark, "child art" was never abandoned as a topic of study. Instead, established accounts of children's appropriation of a pictorial language were revised. Soon after but independent of the publication of Brent and Marjorie Wilson's "Iconoclastic view of the imagery sources in the drawings of young people" (1977), the Danish art educators Rolf Köhler and Kristian Pedersen (1978) published a book where they criticized Lowenfeld (Lowenfeld & Brittain, 1969) for not taking into consideration the great impact of the visual culture in which children participate. Like the article by the Wilsons, their book created a huge stir among those who cherished a romantic view of the innocent child.

In the Nordic countries, Lowenfeld's grand narrative of the emancipation of the child from artful scribbles, via a growing mastery of visual realism, to the expressive qualities of early Modernism is giving way to a variety of smaller, less comprehensive narratives. The copies sold of *Creative and Mental Growth* in Scandinavia declined from around 1,200 in 1984 to less than 300 in 1995/1996. Today, artistic development is described as the growth of a gradually more differentiated repertoire, with different options coexisting and being available for different purposes rather than replacing each other in a hierarchical order.

Process and sociocultural approaches laid the empirical foundation for the revival of interest in children's "artistic growth" (e.g., Hansson et al., 1991; Andersson 1994; Lindström 1995; Aronsson & Andersson 1996; Aronsson 1997; Pedersen 1997). One manifestation of the current trend is *The Cultural Context* (Lindström, 2000), presenting papers from a symposium held in Vilnius, Lithuania, which was organized by the Network of Nordic Researchers in Visual Arts Education.

*L. Bresler (Ed.), International Handbook of Research in Arts Education, 559–562.*
© 2007 *Springer.*

In this volume, researchers from USA, United Kingdom, France, Denmark, Finland, Sweden, Norway, Latvia, and Lithuania analyze issues such as the hegemony of artistic doctrines in the teaching of visual communication (Darras), paradigm shifts in research on children's drawings (Pedersen), as well as educational implications of a postmodern conception of the visual arts (Illeris). The Finlanders Saarnivaara, Sava and Pohjakallio discuss the subjectivity of the researcher and suggest that child studies will profit from a dialogue with the "child within ourselves."

Aronsson and Junge, Wilson, Lindström, and Cox present a series of cultural comparative studies of children's drawings in various cultures, such as Ethiopia, Japan, Nepal, Mongolia, and Cuba as well as among Australian Aboriginals. Tornau reports on work with Gypsies in Lithuania, Nikiforovs on work with mentally retarded children in Latvia. The Norwegian Hilde Lidén analyzes children's creative art as a social activity. The book ends with a philosophical agenda for the future study of child art, formulated by Brent Wilson.

During the last decade, a few doctoral theses in the Nordic countries have focused on children's appropriation of a pictorial language. In Denmark, Pedersen (1999) made a detailed case study of a boy's pictorial world from age 2 to 16. Flensborg (1994) studied children's representation of space, inspired by Gibson (1979). Anne Maj Nielsen (1994) presented a thesis on gender issues and symbolic layers in children's pictorial activity. More recently, Illeris (2002) looked at art education in Denmark and elsewhere through postmodern glasses. Pohjakallio (2005) examined the Finnish discourse with an emphasis on the late 1960s, when visual observation and pictorial imagery began to be understood as cultural, socially constructed phenomena.

In Norway, Liv Merete Nielsen (2002) investigated children's spatial representations, on the basis of 11,000 drawings from a contest. Bendroth Karlsson (1996) studied visual arts projects in the Swedish preschool and school. Ahlner Malmström (1998) analyzed communicative qualities in children's pictures. Löfstedt (2001) compared pictorial learning in various preschool settings. Löfstedt (2004) also wrote a short introduction to sociocultural approaches in art education. Änggård (2005), finally, studied picture making in the context of preschool children's peer cultures. Paradoxically, she found that "the methods [copying, using templates] that make pictures attractive in the children's eyes make them less valuable in adults' eyes."

# References

Ahlner Malmström, E. (1998). *En analys av sexåringars bildspråk* (An Analysis of the Six Year Child's Pictorial Language). Diss. Lund University.

Andersson, S. (1994). *Social Scaling and Children's Graphic Strategies*. Diss. Linköping University.

Änggård, E. (2005). *Bildskapande – en del av förskolebarns kamratkulturer* (Making Pictures: a Part of Preschool Children's Peer Cultures). Diss. Linköping University

Aronsson, K. (1997). *Barns världar – barns bilder* (Children's Worlds – Children's Pictures). Stockholm: Natur och Kultur.

Aronsson, K., & Andersson, S. (1996). Social Scaling in Children's Drawings of Classroom Life. *British Journal of Developmental Psychology, 14*, 301–314.

Bendroth Karlsson, M. (1996). *Bildprojekt i förskola och skola* (Visual Arts Projects in Preschool and School). Diss. Linköping University.

Flensborg, I. (1994). *Rumopfattelser i børns billeder* (Spatial Perceptions and Representations in Children's Pictures). Diss. The Royal Danish School of Educational Studies.

Gibson, J. J. (1979). *The Ecological Approach to Visual Perception*. Boston: Houghton Mifflin.

Hansson, H., Nordström, G.Z., Pedersen, K., & Stafseng, O. (1991). *Barns bildspråk – Children's Pictorial Language*. Stockholm: Carlssons.

Illeris, H. (2002). Billedet, pædagogikken og magten (Picture, Education and Power). Diss. The Danish University of Education.

Köhler, R., & Pedersen, K. (1978). *Børns billedproduktion i en billedkultur* (Children's Picture Making in a Visual Culture). Bredsten, Denmark: Ulrika.

Lindström, L. (1995). Budskap i barns bilder (Messages in Children's Pictures). *Bild i skolan, 2*, 35–43.

Lindström, L. (Ed.) (2000). *The Cultural Context*. Stockholm Institute of Education Press (SLOC 7).

Lowenfeld, V., & Brittain, W. L. (1969). *Creative and Mental Growth*, 4th ed. New York: Macmillan.

Löfstedt, U. (2001). *Förskolan som lärandekontext för barns bildskapande* (Preschool as a Learning Context for Children's Pictorial Activity). Diss. Gothenburg University.

Löfstedt, U. (2004). *Barns bildskapande* (Children's Pictorial Activity). Jönköping University Press.

Nielsen, A. M. (1994). *Køn og symbollag i børns billeder* (Gender and Symbolic Layers in Children's Pictures). Diss. The Royal Danish School of Educational Studies.

Nielsen, L. M. (2000). *Drawing and Spatial Representations*. Diss. Oslo School of Architecture.

Pedersen, K. (1997). *Teorier og temaer i børnbilledforskning* (Theories and Themes in Research on Children's Pictures). Copenhagen: Dansklærerforeningen.

Pedersen, K. (1999). *Bo's billedbog: en drengs billedmæssige socialization* (Bo's Picture Book: a Boy's Pictorial Socialization). Diss. The Royal Danish School of Educational Studies.

Pohjakallio, P. (2005). *Miksi kuvista? Koulun kuvataideopetuksen muuttuvat perustelut* (Art Education, Why? The Changing Justifications for Art Education in Schools). Diss. University of Art and Design, Helsinki.

Wilson, B., & Wilson, M. (1977). An iconoclastic view of the imagery sources in the drawings of young people. *Art Education, 30*(1), 5–11.

# SECTION 5

## Appreciation

**Section Editor: Margaret S. Barrett**

PRELUDE

36

LOCATING THE HEART OF EXPERIENCE

**Margaret S. Barrett**
*University of Tasmania, Australia*

Early in my teaching career I worked as an itinerant music teacher, traveling between schools, sometimes up to five per week, teaching music and dance to children aged between 5 and 12 years. In what felt at times like an endless *da capo* aria, certain events stand out as signal moments.

> On a hot summer's afternoon, in my first year of teaching, I took a small group of kindergarten children for a listening lesson. They were new to school and the idea of education and were yet to absorb the rules of "appropriate listening behaviour." I had chosen a recording of Swedish composer Arne Mellnas' work for children's choir *Aglepta*, a difficult work for choir and listener, that challenges the conventions of the singing voice and stretches the listener to think about vocal sound in new ways. The text is mostly nonsense words culminating in an ancient Swedish chant from the Troll proverbs.
>
> The children's initial reaction to the work was incredulous, and they rolled on the floor, whooping and babbling in imitation of the sounds the choir produced. I recall feeling a rising sense of panic – this was not the way my colleagues at the Conservatorium had responded to similar works – and debating with myself whether I should stop the recording as it continued for a seemingly endless four and a half minutes. And yet, the children seemed to be listening in all their movement and noise.
>
> At the end of that first experience of the work, the children asked to hear it again, a response I hadn't expected. Before listening again we talked about what we had heard and the composer's description of the work, and experimented with our voices and bodies to hear how we could match the voices in the recording, and capture the swoops and leaps of sound. When we listened a second time, the children did not move or vocalise with the recording as they had before: rather, they listened whilst shuffling their out-stretched legs on the floor, swaying their seated bodies, and fidgeting their hands and fingers in an uneasy accompaniment that

565

*L. Bresler (Ed.), International Handbook of Research in Arts Education, 565–568.*
© 2007 *Springer.*

mirrored the fluctuations of the music. At the end of that second hearing, I asked the children to tell me about their favourite part. Georgie, a five-year old, commented "I liked it when the heart fell out of the music". In the ensuing talk she identified that moment in the penultimate section of the work where, after tension is built through increasing volume, vocal texture, and pitch, the choir falls suddenly silent, before ending with the rhythmic whispering of a chant, and an extended exhaled breath from all singers.

We went on to talk of trolls and spells, and, as *Agelpta* played again, the children drew trolls, and chanted spells to themselves.

Recalling this signal moment has prompted me to question many assumptions and preconceptions that arise around children, music, the arts, and appreciation. In an I-Pod age where music is a constant accompaniment to, enhancement of, or protection from, the experiences of daily life, what is "appropriate listening behaviour?" I wonder if the behaviour of the audience in the concert hall is one of those "conventions that get in the way of fresh insight" (Dewey, 1934, p. 1) when imported into settings such as that of the classroom. What is an appropriate listening experience for young children? As a teacher working with young children should I have started with something more accessible, more conventional? Perhaps Prokofiev's *Peter and the Wolf* where music and story work seamlessly in an educational narrative that introduces the instruments of the orchestra? What is appropriate response? Why does verbal response dominate in our appreciation of the arts? I can't pretend that Georgie's powerful metaphoric reference to the embodied experience of that work was a commonplace in my classrooms. And yet, the responses of the children were immediate, visceral, and for all their unconventionality, demonstrated a capacity for insight into the ways the raw materials of voice and music come together in a work that held meaning for them.

Whilst I have focused in this story on the experience and appreciation of music, similar questions may be asked in other arts forms concerning the ways in which we engage with, and come to an appreciation of, arts experience. As a prelude to a discussion of appreciation in the arts forms of dance, drama, music, poetry, creative writing, and, the visual arts, the retelling of this story[1] raises two key issues that have been recurring themes in the ongoing debate about the nature and experience of arts appreciation: the "attention" or "interest" we bring to our engagement with the arts; and the modes by which arts engagement and response may be experienced and expressed.

Dewey reminds us "the actual work of art is what the product does with and in experience" (1934, p. 1). Reflecting on what *Agelpta* did *with* and *in* experience for Georgie and her classmates, I suggest that despite a lack of formal knowledge of the conventions of the art form, and the language specific to those conventions, these children evidenced an appreciation, a capacity to link their everyday experience with "the refined and intensified forms of experience that are works of art" (Dewey, 1934, p. 2), an openness to learning, if not yet learned, engagement with music.

For Dewey, it is our task to restore continuity between the experience of the everyday, and that of art. He reminds us that to understand the aesthetic, we must "begin with it in the raw" (1934, p. 3) in attentiveness to everyday experience, in order to move beyond a "compartmental conception of art" that locates art "in a region inhabited

by no other creature, and that emphasize(s) beyond all reason the merely contempla-
tive character of the aesthetic" (1934, p. 8). In this way our experience of the everyday
can be brought to our developing understanding of art (as did the children in response
to hearing *Agelpta*) and, in an ongoing dialogue, our understanding of art can inform
our experience of the everyday.

Dewey's emphasis on attentiveness and increasingly refined and complex attune-
ment to the qualities of experience in and through the arts distinguishes between
enjoyment and understanding. In working toward "appreciation" we move beyond a
singular focus on enjoyment (although this is not discounted) to understanding: an
understanding that requires knowledge, that leads to deepened awareness and greater
insight, and links us to other larger conversations in, of, and about the arts and our
experience of them. Importantly, such understanding is always provisional, open to
revision as experience accumulates and understanding deepens. As Dewey reminds us,
experience that educates "prepare(s) a person for later experience of a deeper and more
expansive quality" (1938, p. 28).

One of the recurring themes in the discussion of arts appreciation relates to the
nature of our "attention" or "interest" in the arts experience. In a tradition that stems
from Kant (1952) a number of theorists have referred to a particular kind of attention,
the "disinterested", as the unique feature of arts appreciation. A "disinterested" atten-
tion seeks to exclude any interest extraneous to the qualities of the work itself (for
example, social, economic, personal, or cultural issues) from any judgment or appre-
ciation, focusing exclusively on the work itself. Critics of a "disinterested" stance sug-
gest that such a narrowed focus excludes vital information from the judgment and
appreciation, thereby missing key elements of the experience and the arts work. For
example, writing of appreciation in the visual arts in this section of the handbook,
Terry Barrett seeks to "devalue" the notion of "disinterest" as a determining factor in
arts appreciation and instead locates arts experience firmly in a range of "interests"
that shape our ways of approaching and arriving at an understanding of arts works and
experiences. Taking up the notion of "psychical distance", a variant of a Kantian "dis-
interest" developed by Edmund Bullough (1912), Shifra Schonmann writes of the
importance of developing a sense of distance in and from the theater experience in
order to understand it *as* an art work, and as an experience that is connected to but sep-
arate from everyday life.

Appreciation is not restricted to the "merely contemplative" and the traditional roles
of participation such as those of the audience member, the listener, the viewer: appre-
ciation can arise also through informed engagement with the arts as art-maker, as per-
former, and creator. In discussion of a second recurring theme in arts appreciation,
some emphasize the ways in which perception and appreciation not only occur as
thought on action (that of others and self) but also as thought in action. Ann Dils writes
of appreciation in dance as a form of "learned regard", an ability to "read" the dance
in and on bodies, through an attentiveness that strives toward "dance literacy." She sug-
gests that such literacy is not only acquired and evidenced through audience participa-
tion and writing practice but also, importantly through participation in the dance itself,
a process that may deepen and inform engagement. This notion of arriving at an appre-
ciation, as a form of literacy, through participating in making and creating arts works

is taken up also by Stuart Lishan and Terry Hermsen in their discussion of appreciation in poetry and creative writing.

In considering arts appreciation we need to interrogate the frames we bring to the experience and interaction: frames that when left unexamined, may unconsciously shape our attention, our interests, and our judgments. This is explored in my discussion of the ways in which modernist views of appreciation and the aesthetic have shaped the research endeavor and teaching project in music education.

An education in and for arts appreciation is presented in these chapters as the necessary first steps in a life-long dialogue with the arts: a dialogue that not only explores new territory but also returns to known themes, to question these anew, to make the familiar strange. In conversation with Edward Said, Daniel Baremboim described the conductor Wilhelm Furtwangler's approach to music-making as one in which "He understood that music is not about statements or about being. It's about becoming" (Baremboim & Said, 2003, p. 21). Through an education in and for arts appreciation we strive to equip those with whom we work, and ourselves, with the skills, knowledge, and understandings required in our search for the heart of experience, for our becoming.

## Note

1.   A vignette from this story is presented in Barrett (2001).

## References

Barenboim, D., & Said, E. (2003). *Parallels and paradoxes: Explorations in music and society*. London: Bloomsbury Publishing Plc.

Barrett, M. S. (2001). Going beyond the literal: Probing children's musical thinking as musical critics. *Proceedings of the third Asia-Pacific Symposium on Music Education Research* (pp. 152–158). Nagoya: Aichi University.

Bullough, E. (1912). "Psychical distance" as a factor in art and as an aesthetic principle. *British Journal of Psychology, 5*, 87–98.

Dewey, J. (1934/2005). *Art as experience*. New York: The Berkley Publishing Group.

Dewey, J. (1938). *Experience and education*. New York: MacMillan.

Kant, I. (1952). *The critique of judgement* (J. C. Meredith, Trans.). Oxford: Clarendon Press.

# 37

# MOVING INTO DANCE: DANCE APPRECIATION AS DANCE LITERACY

**Ann Dils**

*University of North Carolina at Greensboro, U.S.A.*

"Dance appreciation" is a term applied to college and university courses that acquaint students with dance. In the United States, dance appreciation is a curricular construct, a parallel drawn with music, theater, and art appreciation courses, but not a field of study with a developed body of teaching and learning research.[1] Drawing on literature created for, or appropriate to the dance appreciation classroom and writings from related areas such as dance studies and dance criticism it is possible, however, to frame a discussion about dance appreciation as a subject – What is it that students learn in these courses? – and as a practice – How is it that people move into a relationship with dance? In this chapter I discuss: dance appreciation readers by Myron Howard Nadel and Constance Gwen Nadel (1970), Judith Chazin-Bennahaum (2004), and Myron Nadel and Marc Raymond Strauss (2003); Jamake Highwater's 1978 *Dance: Rituals of Experience; Dancing*, a video series (Grauer, 1993) and accompanying book (Jonas, 1992); and essays on dance appreciation teaching by Joan Frosch-Schroder (1991), Candace Feck (2000), and Ann Dils (2004). I also discuss perspectives on the process of dance writing by Ann Daly (2002), Ann Cooper Albright (1997), and Larry Lavender (2004) and a conference presentation on community dance by Susan Bendix, Mary Fitzgerald, Jennifer Tsukayama, and Elizabeth Waters Young (2005).

Before I discuss this literature, I want to reassess and revise the terms in play. The word "appreciation" conjures up a learned regard for an aesthetic object, a recognition and perhaps an assessment of quality. In my teaching, and in the course of collaborative projects involving the development of materials for dance learning, I have come to prefer the term "dance literacy".[2] To be literate in dance, individuals build webs of understanding acquired through life experience and education, by reading and writing dancing in multiple ways, and through individual contemplation and dialogue with others. As literacy increases, the person grows to meet the dance, in the sense that skills, knowledge, and sensitivity increase. Concurrently, the dance grows to meet the person, as increasingly astute interpretation benefits our sense of the possibilities of

*L. Bresler (Ed.), International Handbook of Research in Arts Education, 569–580.*
© 2007 *Springer.*

dancing and the field expands to accommodate the perspectives and interests of literate participants.

New Zealand arts educator Tina Hong (2000) discusses a literacy-based dance curriculum, grounding her remarks in the ideas of Bill Cope and Mary Kalantzis (2000), Henry Giroux (1992), and Elliot Eisner (1998).[3] Hong extends Giroux's work on literacy to dance:

> Giroux contends that we ought to view the world as a text. Literacy, given this view of the world, means that we engage not only with what is contained in the library (conventional notions of reading), but also with what is in the art gallery (the making and interpretation of art) and the street (popular culture and student experience). Being literate in the contemporary sense of the word requires therefore that we engage with the full range of readings made possible through the different forms of representation which pervade life and living. Literacy involves the progressive development of our abilities to both interpret and convey meaning through multiple sign and symbol systems, which includes therefore kinesthetic, visual and aural modes of communication. (2000, p. 245)

Literacy in dance involves reading layered, shifting information conveyed through sounds, including music and text; visual elements such as costumes, sets, video, or slides; and, the moving body. Bodily information is often the most illusive.

Slipping through time and over space, the dancer gathers and sheds meanings, as he molds his body (already laden with social and cultural possibilities) through motions and in interactions that are themselves evocative and metaphoric. The literate viewer, even from the safe remove of a theater seat, has a commitment to respond, to be transported by the dancing at the same time she grounds it through her own experience. Here, embodied knowing and memory – emotions, ideas, relationships, sensations, as held in shapes, energies, and rhythms – mix with broader understandings of the world, with the arts, history, contemporary culture, and politics. An appreciative viewer has learned information about dance and acquired a value system; a literate viewer has not only learned information about dance, she has acquired skills and sensitivities that provide multiple modes of engagement with dance – kinesthetic, metaphoric, choreographic, critical, historical – and that allow her to critique her own understandings and values about art.

The literacy I describe is not the only way to come into relationship with dance. Dancing has its own knowledge base, with practices, values, and ways of framing experience that are unique to that experience and intertwined with other practices and ideas. However, literacy means something other than being a good dancer. Whether situated in the viewer, the doer, or in a person with a well-rounded dance experience, the literate person is sensitive to moving bodies and their meanings and willing to think and inquire about them.

## Dance Appreciation as Subject

The subject matter taught in dance appreciation courses is highly contingent on the instructor, the function of the course within the curriculum of the institution, and the

availability of resources. Myron Nadel and Marc Strauss mention that some dance appreciation courses have no actual dancing due to restrictions on studio space and class size (2003, p. xix), while other teachers discuss the availability of videotaped and live performance as important to what is taught. The fact that many of the books prepared for dance appreciation courses are readers rather than textbooks, underscores the disparate uses that will be made of these volumes. Course materials also vary in relationship to changing scholarly conceptions about dance and the nature of dance within academe. Through the literature prepared for dance appreciation teaching, it is possible to trace the moves that dance has made from an aspect of physical education to a professional arts practice during the period from the 1950s through to the 1970s (see Nadel & Nadel, 1970), to a more recent rethinking of dance as an area of study or component of the humanities (see Chazin-Bennahaum, 2004). Indeed some colleges and universities have stopped offering "dance appreciation" courses and added courses such as Black Dance and Pop Culture (Spelman College Academic Programs 2005–2006) and Queer Acts (Oberlin College Bulletin 2005–2006).

Myron Howard Nadel's and Constance Gwen Nadel's text *The Dance Experience: Readings in Dance Appreciation* (1970) is, perhaps, *the* prototype for dance appreciation teaching in the United States.[4] In the preface to the later Nadel/Strauss edition, Myron Nadel provides a sense of the volume's historical importance, pointing out that his first edition was created for:

> the first three-credit, university humanities course in dance. This class became accepted for core academic credit as the equal to any introduction to art, music or theater course – a still proud accomplishment of mine … I am very happy to see that these types of courses, some with studio work, some pure lecture are quite common now. (2003, p. xiv)

In the generous 388 pages of the 1970 edition, a negotiation occurs between dance as part of the humanities, arts, physical education, and/or sciences. The book begins with chapters about aesthetics and phenomenology, then moves forward in sections to discussions of: creativity and choreography; dance forms (including chapters on ballet and modern, and on the distinctions between "folk", "character", or "ethnic" dance); dance notation and analysis systems; dance and its relationship to other art forms; and, dance criticism. The following sections include biographical sketches of or writings by choreographers, explorations of problems in dance, and facets of dance education. The problems section gives a good sense of issues in dance in academia at the time including three articles debating the relationship between dance and physical education and one about men in dance.

While Nadel and Nadel (1970) present dance as the summation of the curricular offerings within college dance departments, Jamake Highwater, in his text *Dance: Rituals of Experience* (1978), conceives of dance as ritual. Mixing discussions of vernacular dance forms by Native and African Americans with American modern dance and ballet, Highwater highlights similarities in terms of experience, structure, and the satisfaction of human need. Highwater's work can seem romantic and simplistic. For example, he states that there are two kinds of ritual: "The first … is an unselfconscious act without deliberate

'aesthetic' concerns, arriving from anonymous tribal influences … [T]he second form of ritual is new: it is the creation of an exceptional individual who transforms his experience into a metaphoric idiom known as 'art' " (p. 14). Such a characterization does not allow for complexity and individuality within traditional societies, or for the reenactment of traditional forms within contemporary society. He did, however, bring together discussions of dance forms that previously seemed disparate, and refigured established paradigms that distinguished dance as divided by purpose (vernacular, religious, or artistic). Highwater presents the possibility of rethinking Western theatrical dancing as a core concern and of constructing courses arranged around a theme or problem (dance as ritual) rather than attempting a broad survey of dance.

Joan Frosch-Schroder (1991) argues that global dance should be central to dance appreciation teaching. She sees this change as both pragmatic and pedagogic. Pragmatically, immigration to the United States of America in the late twentieth century has changed notions of a dominant culture. Pedagogically, building a dance appreciation course around global dance provides a means to create an inclusive classroom in which biases can be examined, difference discussed as a social construct, and pluralistic thinking encouraged. Frosch-Schroder also sees a change to consideration of global dance as an opportunity to "pioneer a more accurate, more relevant conceptualization of dance" (1991, p. 63). Frosch-Schroder lists a growing number of universities with programs in world dance or dance ethnology, helping situate her remarks about dance appreciation teaching within larger changes in the academic positioning of dance programs.

Rhoda Grauer's (1993) Public Broadcasting Service film series, *Dancing*, with its accompanying book by Gerald Jonas (1992), provided materials for the kind of transformation that Frosch-Schroder advocates. In that series, first seen on television and then marketed to colleges and universities, Grauer collects interviews with dance practitioners and scholars and footage of dancing from around the world, and arranges them using two conceptual schemes: function (communication and political, religious, sexual, or artistic expression); and expression of cultural identity that encompasses both traditional identities and the forging of new cultural or social identities. As with any attempt to organize this much material, the selection and placement of each individual instance of dancing tends to obscure the complexity of each form. For example, some editing decisions are curious and, perhaps, misleading: a clip of the nineteenth-century ballet, *Sleeping Beauty*, introduces a section on dance in the court of Louis XIV. But, over twelve years later, the series is still useful and still yields teaching possibilities. For example, in 1993, Grauer's inclusion of Indonesian choreographer Sardono Kusumo in the Individual and Tradition section, along with choreographers working primarily in the United States, seemed anomalous. In contemporary analyses this footage increases in value as more video footage on contemporary Asian dance becomes available.

Judith Chazin-Bennahaum initially created her 2004 edited volume *The Living Dance: An Anthology of Essays on Movement and Culture* for students at the University of New Mexico. This volume presents dance as practiced locally, but connected to diverse world cultures. Chazin-Bennahaum comments that:

> Throughout the book, we witness the way dance responds to conquest, fusion, the advancement of subcultures, the studious attention given to gender roles, to the

fashions of clothing the body while dancing, and to the survival of communities. New Mexico is in many ways a microcosm of the world of dance and so we describe those dance forms that prevail here and also hold currency in the scholarly narratives written about dance. (2004, p. xi)

In the collection, Chazin-Bennahaum divides the chapters into sections entitled Native American Dances of New Mexico (Zuni and Tewa), Mexican and New Mexican Dances (Mexican and New Mexican "folk dances", country-western dancing, Los Matachines), Flamenco Dance, Modern Dance, Ballet, and African American Influences on Dance (social dances and tap). She shifts her vision to include chapters on dance in India, dance on film and video, and finally, a chapter on writing about dance.

Myron Howard Nadel and Marc Raymond Strauss's 2003 edited volume *The Dance Experience: Insights into History, Culture, and Creativity* is divided into two sections: Appreciating the World of Dance (dance forms of various areas of the world including Japan, Greece, and Africa, and of varying types, social, jazz, and ballet) and The Dance Experience. This latter section includes chapters that might be helpful in thinking about dance as it is pursued in colleges and universities or in leading students into writing experiences and includes articles on dance on film, dance and gender, dance and physical education, observing dance, dance notation, costume design and dance, and dance criticism.

Nadel and Strauss write their Introduction as a narrative, following an uncertain new member of a dance concert audience into the theater, and guiding him or her into reflection and meaning-making. The editors emphasize the intensely personal nature of viewing dance and the need for descriptive language and research to explain and ground personal interpretation. They acknowledge that every dance appreciation class cannot include dancing, but hope that the articles they present will provide something of that experience. Strauss's conclusion "Your Dance Experience," again invites readers into further engagement with dance in dance classes, concert halls, and as part of experiencing diverse cultures.

## Dance Appreciation as Practice: Dance Literacy through Writing, Discussing, Dancing

In this section of the chapter, research on teaching methods and their impact on students, discussions of the writing process, and reports of teaching are discussed. In these works, authors suggest that writing, discussion, and dancing are important in moving students into relationship with dance. Writing attunes students to their senses and memories, and improves observation, analysis, and language skills. Recent descriptions of the writing process describe it as deliciously bodily and inescapably integrative in nature. If dancing is written about, discussed, or enacted as a means of social critique, students dialogue about their preconceptions, build new understandings, and bring new skills to their communities.

In a 2000 study Candace Feck discusses her work with general university students and with dance majors studying dance history. She sees dance writing as beginning with a "heightened level of engagement" (2000, p. 168), but situates attention in sensory

experience rather than the mind. Feck begins with an evocative description of the critical process:

> To write clearly about a particular act of performance demands a heightened level of engagement, a conscious attending to one's sensory experience, not unlike the state of being fully awake. Afterward, the necessity of committing the experience to paper compels the writer to an act of "reawakening", a plunging back into the reservoir of sensory information to retrieve stored sensations and memories of the performance. In this way, writing about dance might be conceptualized as a circular conduit, guiding the writer to open and attend to her perceptions at the point of performance; to shape those perceptions into a new form made of words; and in the fermenting stages of reflection, deliberation, and production which comprise the writing experience, to deepen the sensory channels for further rounds of engagement. (2000, p. 168)

She continues to discuss her work with different types of college students, suggesting that university students, dance majors, and nondance majors alike, have wells of sensory experience that can be tapped and nurtured through dance writing. Her teaching techniques include exposing students to live dancing, thus prompting their kinesthetic sympathies, and asking them to pick out the sensory language and information in existing critical writing and in each others' drafts. Feck notes that students most use words that derive from sight – color, light, costumes, body parts, speed, and the like – but that sound and kinesthesia are also important (2000, pp. 172–173).

In a recent article Feck (2005) reports on her work with high school students in language arts classes. She sees dance writing as a useful route to dance literacy for K-12 students, one that would serve state standards for language arts as well. Dance writing includes "the necessity to formulate, organize and concretize thoughts about an essentially non-verbal, elusive experience," and "is often not only a productive exercise in the development of observation skills and memory, but one that constitutes a valuable challenge for the development of higher-order thinking skills and linguistic abilities" (2005, p. 4). Writing about dance involves calling up previous sensory experience and forming relationships between new and old information and experiences (see Feck's discussion of writings found in Gardner and Perkins' *Art, Mind, and Education*, 1989, p. 5) and connects to new models of learning that link the mind and body (see Reimer, 2004).

Other writers have echoed Feck's description of the critical process, especially her sense that dance writing involves opening to the observed experience. Ann Daly, in her Introduction to *Critical Gestures: Writings on Dance and Culture*, states that:

> Ultimately, the critical gesture is the best we can ever hope for: that someone will pay attention. I lean in, the dancer's double and the reader's surrogate, offering myself to be written upon by the dance and, in turn, to write it. I partake in what Merleau-Ponty calls the "flesh of the world." His description of perception is as accurate an account of the critical act as I have found: "[I] *follow with my eyes* the movements and the contours of the things themselves, this magical relation, this

pact between them and me according to which I lend them my body in order that they inscribe upon it and give me their resemblance." (2002, p. vi)

While Daly describes the viewer's body as a conduit for performative experience, Ann Cooper Albright, in her Introduction to *Choreographing Difference*, sees the viewer as a respondent, a witness:

> This traditional gaze doesn't want to get involved, doesn't want to give anything back. In contrast what I call witnessing is much more interactive, a kind of perceiving (with one's whole body) that is committed to a process of mutual dialogue. There are precedents for this responsive watching in Quaker meetings, African-American notions of bearing witness, the responsive dynamics of many evangelistic religions, as well as the aesthetic theory of rasa in Classical Indian Dance. ... This act of witnessing ... raises the stakes of audience engagement, sometimes making the audience member uncomfortable. (1997, p. xxii)

In all of these descriptions, there is a sense of readiness: the viewer can make sense of dance if she only opens herself to the experience.

In my teaching I have found students without experience in concert dance uncertain about moving into union with dancers, unable to see dance movement as related to their personal experience. I often ask students to write about movement that is profound in their own lives, hoping that this will give them practice in describing motion they know well, allowing them to link up motion and emotional response, and activate their somatic memories. Another tactic is to move from student experience of dancing (perhaps, an improvisational experience or a dance class) directly into descriptive writing.

Larry Lavender (2004) recommends a cooler, less involved, initial engagement with dance:

> In the initial encounter with a work you should "forget" in the sense of suspending or putting aside for the moment your knowledge and beliefs about art and artistic assessment. Such temporary "forgetting" gives the work a chance to be seen for what it is – to exist on its own terms, so to speak – before being subjected to tests, comparisons, and interpretive or evaluative analysis. (p. 225)

Lavender continues, describing criticism as having two possibilities: exploration of the work (description, including basic informative statements, formal analysis, characterization), and argumentation (including interpretation and evaluation). He notes that criticism, rather than being arbitrary and judgmental is grounded in an objectivity that is founded in careful consideration of the work, and provides a means to increasing understanding and sharing varied perspectives. While I doubt the possibility of temporary forgetting and much prefer approaching dance writing as an inevitably subjective process, Lavender focuses attention on the choreographer's work rather than on the dancer's performance or the viewer's experience and meaning-making. Especially important is his idea that dances contain observable content that can be described and that grounds discussion of the dance.

In a recent teaching report (Dils, 2004), I describe my experiences using movement observation and description to inspire discussion about how we see and understand others. When I began teaching undergraduates at the University of North Carolina at Greensboro in the mid-1990s, my class plans included discussion of gender and race as social constructs, but I hadn't planned to discuss or investigate sexuality in any detail, other than as a subject for late postmodern choreographers.[5] But it quickly became clear from the giggling and commentary that accompanied some observation exercises, that sexuality is one of the strongest messages students receive from looking at moving bodies. In the interest of creating a classroom community that felt comfortable for everyone, discussions of identity quickly became an opening activity.

In my report, I emphasize dance observation as a way to get at our perceptions and preconceptions and to engage in social critique. One example is a conversation about David Dorfman's *Out of Season*, a community-based work for ex-athletes. In the description and interpretation below, I ask students to first realize the motion, and then what it might mean:

> *Dils*: "Let's think about what we saw: One man is on hands and knees. The other is close by, kneeling to his left side. The kneeling man holds the left arm of his partner and reaches around his partner's back to hold his stomach. In sports, that's a wrestling move, the beginning of a contest of weight and muscle. Why does it change meaning here?"
> *Student*: "Well, they're *dancing*." (2004, p. 12)

Several possibilities exist for furthering this conversation. Once we agreed on a description of the movement, and talked about how this movement might be read differently in different settings, I might return to her "Well, they're dancing" comment – her cultural frame – and ask her what leads her to associate dancing with sexual display or identity. In the past, students have commented that they assume male dancers are gay. Others see the dance space as a feminized space, a place to appreciate beauty and be entertained. When men enter this space they too become feminized, appreciated for their visual appeal rather than their impact and productivity.[6]

I might then get the student to consider other models for the interaction between performer and audience, to realize that an intersubjective relationship is possible where performers lead the audience to new realizations as well as accept the audience's gaze. We might also question the masculine space of sports, asking why we assume that well-muscled, aggressive men are only interested in women as sexual partners. Another possibility for this conversation is to prompt the student to think about the piece itself: Does the tension the viewer experienced between the motion and its setting make sense in the context of the work? It is especially interesting to pair music video, a form in which sex and heterosexuality are isolated and celebrated without any discussion of human complexity, and concert dance. Looking carefully between the two offers the possibility of discussion about adult sexuality, relationship, and its representation, in a way that frames sexuality as part of human experience, rather than as titillating and sensationalized.

Susan Bendix et al. describe their work as "community dance" (2005), but their insights on the impact of bringing together movers of varied experience for choreographic and social exploration is related to activities occurring in dance appreciation classrooms. Fitzgerald and Tsukayama direct Dance Arizona Repertory Theater (DART), a community dance organization housed in the Department of Dance at Arizona State University. Their company learns the works of professional choreographers and collaborates with varied populations, especially youth groups in the Phoenix area, to create community-based performance work. Together with Bendix (Director of Dance at the Herrara School, whose students work with DART), and Young (a researcher studying body image in middle school students participating in DART projects), Fitzgerald and Tsukayama presented a panel on this project at a recent Congress on Research in Dance conference.

Fitzgerald (2005) reports that the DART project has impacted student consideration of dance as practice and social experience:

> Beyond significant transformations in cultural awareness and thought, I … am fascinated by the impact that collaborative community work is having on the art form of dance itself, and the students' perceptions of the art form. Joining the creative forces of the youth (ages 6–14) with the college-aged DART members each year invariably allows for an uninhibited and fresh investigation of ideas. The different cultural and socioeconomic backgrounds of the students, as well as the wide range of movement skills, contribute to a unique environment for choreographic and intellectual exploration. (p. 4)

Further, Fitzgerald reports that:

> Researchers in the community cultural development field define this as a new type of integrative thinking, whereby practitioners seek knowledge from non arts fields in an effort to find new models, languages and resources to enhance their own work (Burnham et al., 1 *sic*). Such fusions and intersections of thought promote different ways of approaching social issues and allow for change in fundamental cultural paradigms. (p. 3)

The "change in fundamental cultural paradigms" that Fitzgerald alludes to might include rethinking "dance appreciation" as primarily concerned with the contemplation of professional dance and unlinking our association of concert dance with the privileges of education and money.

Fitzgerald's codirector, Jennifer Tsukyayama (2005), further investigates the impact that community dance may have on dance appreciation. Tsukayama sees the traditional "one shot" approach to dance appreciation, the lecture demonstration or performance, as less effective than more participatory arts experiences (as cited in Tsukayama, 2005). She goes on to underscore statistics, citing Walker and Sherwood's 2003 *Participation in Arts and Culture: Building Arts Participation, New Findings from the Field*, that support the idea that very few people (only 1% of all people who attend arts events) attend events in traditional venues, experiencing art in churches, schools, and community centers instead of concert halls (as cited in Tsukayama, 2005). This,

together with the underemployment of professional dancers and choreographers, leads Tsukayama to see community dance as a means of revolutionizing dance, its traditional sense of isolation and hierarchy, and its relationship to community.

## Concluding Remarks

In this chapter, I have redefined dance appreciation as dance literacy, and situated literacy as the ability to read and write dancing in multiple ways, skills nurtured by moving, observing, writing, discussing, and making dances. I have been especially concerned with literacy as an ability to understand the dense and shifting messages imparted by moving bodies. Further, dance literacy is important – for students and for the dance professions – as part of an intertwined panoply of literacies that help us know ourselves, negotiate our lives, and understand the world around us. While I too am excited about the impact of community dance on students and on the dance profession, and see these opportunities as vital to dance literacy as taught in colleges and universities, I want to return to another means of gaining dance literacy: through the written word. Is the existing body of literature useful in teaching and learning dance literacy? Surely, students must increase their knowledge about dance, its history and importance to our social endeavors and cultural identities. But is it helpful to give students an overview of dance as enacted worldwide or even as situated in a university? Or is it more useful to deepen student understanding of a particular form, dance event, or choreographic work through multiple approaches to a single topic? And what of the processes of literacy? To inspire their own move into dance, students need readings that model an engaged, dialogical relationship with dancing, that heighten awareness of perceptual skills and deepen understanding of description, interpretation, and critical thinking. Too, it seems important that students think about what they learn by dancing and making dances and of the inextricable union of their thinking, sensing, memory, and experience. Discussions of these ideas are largely absent from literature used for dance appreciation teaching.

## Notes

1. Few writings on dance are labeled as research or writing in "dance appreciation." Type the term into the subject search feature for the New York Public Library, an institution that includes the research Dance Collection, and seventy items appear, none written after 1991. The National Dance Education Organization sponsors a catalog for researchers interested in dance education. This database, a product of a three-year attempt to locate, identify, and catalog "existing research in the field of dance and movement education from 1926 onward" (http://www.ndeo.org/national.asp, accessed 5/31/05), contains only three items with "dance appreciation" in the title. A Google search produced more than 7,000 hits for "dance appreciation," most of them links to syllabi or bulletin listings for college and university courses.

    There is an additional body of literature about dance appreciation, mostly produced by professional arts organizations, that I don't address here. Lincoln Center Institute (http://www.lcinstitute.org/, accessed 5/31/05), which employs the philosophy of Maxine Greene, and The Kennedy Center Arts Edge (http://artsedge.kennedy-center.org/, accessed 5/31/05) have extensive Websites. The Arts Edge Website is very thorough, including K-12 education standards in the arts and teaching materials developed to meet those standards.

2.  In my work at the University of North Carolina, Greensboro, I coteach a two-semester, graduate course with Sue Stinson in which graduate students study the impact of an integrative (combining reading, discussion, writing, and movement in the study of an established dance work) approach to dance teaching. For *Moving History/Dancing Cultures: A Dance History Reader*, I worked with coeditor Ann Cooper Albright to create an introduction in which we describe the learning that might occur in a dance history class. Our writing in this 2001 volume owes much to Albright's idea of "witnessing dance," discussed in her volume *Choreographing Difference*. I have also worked with Albright to create a curriculum design and materials development project called Accelerated Motion: Towards a New Dance Literacy in America. Already underway, this project is a collaboration of seven scholars.

    "Dance literacy" has also been used by Tina Curran in conjunction with her work at the Language of Dance Center (see http://www.ickl.org/conf05_london/sessions/sessions22.html, accessed 11/3/05) and at New York University to describe work with Language of Dance and Laban Movement Analysis (LMA) (see http://education.nyu.edu/music/summer_dance.html, accessed 11/3/05). A practice that integrates bodily practice, observation, analysis, and description of movement within Laban concepts of motion, LMA has had an important influence on and long history within dance and dance education. The integration of Laban principles with cultural or social analysis of dancing is a current interest of dance scholars.

3.  Hong makes a compelling case for conceiving of dance education as literacy noting the usefulness of considering multiple literacies in societies that are linguistically and socially complex, the fit of the term "multiliteracies" with the transformative, pluralistic goals of postmodern education, and the power of aligning a marginalized field such as dance, with a better established field such as literature (pp. 245–247).

4.  Books written or compiled in appreciation of dancing have a long history. The most well-known pre-twentieth-century book is Thoinot Arbeau's 1588 *Orchesographie*, in which he discusses dances, deportment, and the importance of dancing for a well-bred individual and a well-ordered society. Several "how to look at dance" or introductions to modern dance or ballet books were written or compiled previous to the seminal Nadel and Nadel (1970) reader. Arnold Haskell's 1938 *Ballet: A Complete Guide to Appreciation* and John Martin's 1939 *Introduction to the Dance* are examples.

5.  Much of the language I use in this summary is taken directly from my report of 2004. While I emphasize discussion of sexuality and sexual identity here and in the referenced article, it is only a small part of my teaching. The abundant literature on sexuality and performance and sexuality and education points to more thorough explorations of sexuality, accomplished in gender and sexuality courses and other educational settings, and to what might be accomplished in dance. See especially Desmond (2001).

6.  These explanations are common and discussed in Desmond's (2001) *Dancing Desires* and other sources. Ramsay Burt's (2001a) work on male dancers is especially interesting in this regard where he discusses dislike of male dancers in nineteenth-century ballet as a class issue. In other work (2001b), he notes that association of male dance and homosexuality may have arisen with Diaghilev in the early twentieth century.

# References

Albright, A. C. (1997). *Choreographing difference: The body and identity in contemporary dance.* Middletown, CT: Wesleyan University Press.

Arbeau, T. (1925). *Orchesography* (C. W. Beaumont, Trans.). London: C. W. Beaumont. (Original work published in 1588)

Bendix, S., Fitzgerald, M., Tsukayama J., & Young, E. W. (2005). Community dance: An examination of the educational and aesthetic development of collegiate and inner-city youth partnerships. Papers presented at the meeting of the Congress on Research in Dance, Tallahassee, FL (March).

Burt, R. (2001a). Dissolving in pleasure: The threat of the queer male dancing body. In J. Desmond (Ed.), *Dancing desires: Choreographing sexualities on and off the stage* (p. 213). Madison, WI: University of Wisconsin Press.

Burt, R. (2001b). The trouble with the male dancer. … In A. H. Dils & A. C. Albright (Eds.), *Moving history/Dancing cultures: A dance history reader* (pp. 44–55). Middletown, CT: Wesleyan University Press.

Chazin-Bennahaum, J. (Ed.). (2004). *The living dance: An anthology of essays on movement and culture.* Dubuque, IA: Kendall/Hunt Publishing Company.

Cope, B., & Kalantzis, M. (Eds.). (2000). *Multiliteracies: Literacy learning and the design of social futures.* London and New York: Routledge.

Daly, A. (2002). *Critical gestures: Writings on dance and culture.* Middletown, CT: Wesleyan University Press.

Desmond, J. (Ed.). (2001). *Dancing desires: Choreographing sexualities on and off the stage.* Madison, WI: The University of Wisconsin Press.

Dils, A. (2004). Sexuality and sexual identity: Critical possibilities for teaching dance appreciation and dance history. *Journal of Dance Education, 4*(1), 10–16.

Dils, A. H., & Albright, A. C. (Eds.). (2001). *Moving history/Dancing cultures: A dance history reader.* Middletown, CT: Wesleyan University Press.

Eisner, E. (1998). *The kind of schools we need: Personal essays.* Portsmouth, NH: Heinemann.

Feck, M. C. (2000). Writing down the senses: Honing sensory perception through writing about dance. *Proceedings of Dancing in the millennium* (pp. 168–174). An International conference held in Washington, DC July, 2000.

Feck, M. C. (2005). Spreading the word: Building community through writing about dance. Unpublished manuscript, The Ohio State University.

Fitzgerald, M. (2005). Expanding the boundaries of art and life: The impact of a community dance program on college students. Unpublished manuscript, Arizona State University.

Frosch-Schroder, J. (1991). A global view: Dance appreciation for the 21st century. *JOPERD, 62*(3) (March), 61–66.

Gardner, H., & Perkins, D. (1989). *Art, mind and brain: Research from Project Zero.* Champaign, IL: University of Illinois Press.

Giroux, H. (1992). *Border crossings: Cultural workers and the politics of education.* London and New York: Routledge.

Grauer, R. (Executive producer). (1993). *Dancing.* [videorecording]. United States: Thirteen/WNET.

Haskell, A. (1938). *Ballet: A complete guide to appreciation.* Harmondsworth, Middlesex, England: Penguin Books.

Highwater, J. (1978). *Dance: Rituals of experience.* New York: A & W Publishers.

Hong, T. (2000). Developing dance literacy in the postmodern: An approach to curriculum. *Proceedings of dancing in the millennium* (pp. 245–250). An international conference held in Washington, DC July, 2000.

Jonas, G. (1992). *Dancing: The pleasure, power, and art of movement.* New York: H.N. Abrams, in association with Thirteen/WNET,

Lavender, L. (2004). The critical appreciation of dances. In J. Chazin-Bennahaum (Ed.), *The living dance: An anthology of essays on movement and culture* (pp. 224–232). Dubuque, IA: Kendall/Hunt Publishing Company.

Martin, J. (1939). *Introduction to the dance.* New York: W. W. Norton & Company.

Nadel, M. H., & Nadel, C. G. (Eds.). (1970). *The dance experience: Readings in dance appreciation.* New York: Praeger Publishers.

Nadel, M. H., & Strauss, M. R. (Eds.). (2003). *The dance experience: Insights into history, culture, and creativity.* Hightstown, NJ: Princeton Book Company.

National Dance Education Organization (2001). Project summary. Retrieved May 31, 2005 from http://www.ndeo.org/national.asp.

Oberlin College Bulletin 2005–2006. Retrieved May 29, 2005, from http://www.oberlin.edu/catalog/college/theater.html#7.

Reimer, B. (2004). New brain research on emotion and feeling: Dramatic implications for music education. *Arts Education Policy Review, 106*(2), 21–27.

Spelman College Academic Programs 2005–2006. Retrieved May 29, 2005 from http://www.spelman.edu/academics/programs/drama/requirements.shtml.

Tsukayama, J. (2005). *Trends in contemporary modern dance.* Unpublished manuscript, Arizona State University.

# INTERNATIONAL COMMENTARY

# 37.1

## Teaching Dance Appreciation in Finland

**Eeva Anttila**

*Theatre Academy of Finland, Finland*

Dance appreciation is not a clearly defined area of scholarly investigation in Finland. The term "dance appreciation" is not widely used, and does not have an explicit Finnish translation. Instead, "dance analysis" is a term applied to the study of dance works. Generally, most dance programs include coursework in dance analysis, dance history, and dance and society/culture. However, the emphasis is on dancing and in choreographing, that is, in the doing of dance.

Despite the short history of university dance programs, dance research is very vital in Finland. The Theatre Academy has a doctoral program in dance, and several doctoral dissertations on dance have been completed in other universities. The topics range from dance history to dance philosophy and pedagogy.

In a doctoral dissertation investigating dance appreciation from a feminist perspective Inka Välipakka (2003, p. 49) claims that the processes of globalization and issues of multiculturalism have made an impact on dance in the Western scene. She argues that the changes in the field of dance arise in the interfaces where different dance forms and traditions encounter each other, referring to combinations of "ethnic" dances and art dance. This means that previously marginalized dances are shifting toward a more polysemic center. Contemporary or "new" dance performances deal with societal issues such as urbanization and global migration but also with issues of gender, race, disability, or ethnicity. From a semiotic perspective, the author claims that a choreography represents and shares its culture and society through the dancers, and their gendered bodies, as the audience sees dancers as having a gender. Interpretations on gender, however, are never fixed. Reflexive processes involving somatic awareness and engaged presence are important in dance analysis, interpretation, and research. The "somatic turn" that has taken place in the field of dance is certainly affecting all aspects of dance practice, including dance analysis and dance appreciation.

Kai Lehikoinen's (2004, 2005) treatise on masculinity in Western dance offers another interesting viewpoint into dance as gendered practice, devoting some attention to the analysis of choreographies made for boys and male dancers. Lehikoinen, who

581

*L. Bresler (Ed.), International Handbook of Research in Arts Education*, 581–582.
© 2007 *Springer.*

lectures widely on dance analysis in Finland, is developing the teaching of dance appreciation toward a cultural, sociological, and political approach, where the reading of dance happens through a multidisciplinary perspective.

Leena Rouhiainen (2004) illuminates some ways in which gender is discussed and understood in the field of dance in Helsinki, showing that a heterosexual logic and a gender-neutral manner prevail in the discussion. However, her data (based on group interviews with four male choreographers) illustrates instability and contradictions, suggesting ambiguity and multiplicity of gender in the everyday practice of dance art.

Preston-Dunlop's choreological approach to dance analysis and pedagogy has been developed in Finland by Paula Salosaari, who studied and worked with Preston-Dunlop at the Laban Centre. Her dissertation (2001; see also Salosaari, 2002) posits the ballet dancer as an experiencing artist and an agent of change in the evolving dance tradition. Salosaari introduces divergent teaching methods and structural images based on chore-ology as pedagogical and artistic tools, and bases her coursework at the Theatre Academy, Department of Dance and Theatre Pedagogy, on these principles. This way, ballet teaching enhances interpretation and expansion of the traditional vocabulary as well as composition of new dance material having the tradition as a starting point.

Salosaari continues developing this approach as a participant in the research project *Challenging the Notion of Knowledge: Dance, Motion and Embodied Experience as Modes of Reasoning and Constructing Reality*. This project, conducted at the Department of Dance and Theatre Pedagogy of the Theatre Academy (2005–2007), explores the significance that bodily knowledge has in our understanding of reality. The overall aim of the project is to substantiate a paradigm shift towards a holistic notion of knowledge and to affirm the body as integral to the process of knowing (see http://www.teak.fi/challenge/index.htm). The project illuminates dance scholars' and practitioners' growing interest in articulating their experiential understanding of what embodied knowledge means.

# References

Lehikoinen, K. (2005). *Stepping queerly: Discourses in dance education for boys in late 20th century Finland*. Oxford: Peter Lang.

Lehikoinen, K. (2004). Choreographies for boys: Masculinism in Finnish dance education. In I. Björnsdóttir (Ed.), *Dance heritage: Crossing academia and physicality. Proceedings of the 7th NOFOD conference, Reykjavik, Iceland* (pp. 138–145). Reykjavik, Iceland: NOVOD.

Rouhiainen, L. (2004). Troubling gendered views on the choreographic practice of Finnish contemporary dance. In L. Rouhiainen, E. Anttila, S. Hämäläinen, & T. Löytönen (Eds.), *The same difference? Ethical and political perspectives on dance* (pp. 155–190). Theatre Academy, Finland: Acta Scenica 17.

Salosaari, P. (2001). *Multiple embodiment in classical ballet: Educating the dancer as an agent of change in the cultural evolution of ballet*. Doctoral dissertation, Theatre Academy, Finland: Acta Scenica 8.

Salosaari, P. (2002). Multiple embodiment in ballet and the dancer's cultural agency. In V. Preston-Dunlop & A. Sanchez-Colberg (Eds.), *Dance and the performative: A choreological perspective – Laban and beyond* (pp. 219–237). London: Verve.

Välipakka, I. (2003). *Tanssien sanat: Representoiva koreografia, eletty keho ja naistanssi*. (Words of the dances: Representative choreography, the lived body and women's dance). Unpublished doctoral disser-tation, University of Joensuu, Finland. Accessed August 10, 2005, from http://joypub.joensuu.fi/publications/dissertations/valipakka_tanssien/valipakka.pdf

# INTERNATIONAL COMMENTARY

# 37.2

# Researching Dance Appreciation in Australia

**Shirley McKechnie**
*Victorian College of the Arts/University of Melbourne, Australia*

New frameworks for thinking about dance in an Australian context now embrace disciplines not formerly considered in the context of "dance appreciation" (Grove, Stevens, & McKechnie, 2005), including the physical and biological sciences, and the social sciences.

> These sciences must themselves increasingly deal with culture and cognition all at once: questions about pleasure in movement, habit and skill, and kinaesthetic memory, for example, require neuroscientific, physiological, psychological, sociological, and anthropological investigation simultaneously. These then are essentially collaborative enterprises. (Sutton, 2005, p. 50)

Concepts derived from evolutionary theory – chaos, complexity, and dynamical systems theory – now inform the analysis of dance works (McKechnie, 2005) and the creative processes that produce them (McKechnie, 2004). These new trends have been described as:

> the emergence of intriguing and hybrid kinds of writing. Aesthetic theory, cognitive psychology, and dance criticism merge, as authors are appropriately driven more by the heterogeneous nature of their topics than by any fixed disciplinary affiliation. We can spy here the beginnings of a mixed phenomenology and ethnography of dance practice and choreographic cognition, which is deeply informed and empirically inspired by the best current theory in the sciences of the embodied mind. (Sutton, 2005, p. 50)

In Australia, interdisciplinary collaboration is increasingly a feature of dance research, both in the private practice of individual artists and companies, and in postgraduate studies (McKechnie, 2003).[1] Performing arts faculties in some Australian universities have become breeding grounds for the development of knowledge in

*L. Bresler (Ed.), International Handbook of Research in Arts Education, 583–586.*
© 2007 *Springer.*

dance and the other arts. In dance, these tendencies have been greatly enhanced by the imaginative and technical capabilities afforded by film, video, and digital technology (Potter, 2005).

A leading example of a highly successful dance research team is the *Conceiving Connections* project funded by the Australian Research Council (ARC) from 2002 to 2005. Led by Shirley McKechnie at the Victorian College of the Arts in Melbourne, members of the team are dance artists and scholars, musicians, philosophers, and cognitive psychologists (http://www.ausdance.org.au/connections). Industry partners in the research are The Australian Dance Council (Ausdance), The Australian Choreographic Centre (http://www.thechoreographiccentre.org.au/), and the Australia Council for the Arts (http://www.ozco.gov.au/).

An earlier project, *Unspoken Knowledges*, was pioneered by this team and funded by the ARC from 1999 to 2001 to investigate the nature of choreographic thought (http://www.ausdance.org.au/unspoken). Each researcher contributed to the establishment of new paradigms for thinking about the newly termed "choreographic cognition." From these collaborations productive syntheses and emergent hypotheses formed the basis for further investigations (http://www.ausdance.org.au/unspoken/researchers/researchers.html). The relationship of creative practices in dance and music to the wider issues connecting scientific understandings with the function of human groups in societies and cultures has been an ongoing theme (Malloch, 2005). The team also posed new research questions and suggested ways that these may be addressed. Contemporary dance is defined here as a work in which the major medium is movement, deliberately and systematically cultivated for its own sake, with the aim of achieving a work of art. It shares with other art forms the possibility of being viewed either as nonrepresentational/nonsymbolic (typically termed "formalist" in aesthetic theory), or of being representational or symbolic in some sense. Insights into choreographic cognition involve theories of creativity and attempt to explain processes and circumstances that give rise to innovative thought (Stevens et al., 2000). Regardless of the approach that is adopted, time, space, and motion are the media for choreographic cognition. A recent paper concludes with suggestions for experiments to test assumptions regarding "Thought in Action" in composition, performance, and appreciation of contemporary dance (Stevens & McKechnie, 2005). In March 2005, on national radio a dancer/Ph.D. candidate, a cognitive psychologist and a neuroscientist discussed "The Dancing Mind", addressing mirror neurons, memory, thought, and embodiment in the act of dancing. Questions raised include "So where is the mind in dance"? "What's happening in the brains of an audience"? Scientists, dancers, and choreographers are coming together in novel ways to explore the cognitive microcosm that is this long-loved performing art.[2]

## Notes

1. The national Library of Australia, in partnership with Ausdance hosts a portal that includes a database and links to resources relating to dance in Australia (www.australiadancing.org/).
2. Transcript, ABC, March 19, 2005. Natasha Mitchell interviews Shona Erskine, Patrick Haggard, and Kate Stevens, "The Dancing Mind" in *All in the Mind* http://www.abc.net.au/rn/science/mind/stories/s1323547.htm

# References

Grove, R., Stevens, C., & McKechnie, S. (Eds.). (2005). *Thinking in four dimensions: Creativity and cognition in contemporary dance*. Melbourne: Melbourne University Publications.

Malloch, S. (2005). Why Do We Like to Dance and Sing? In R. Grove, C. Stevens, & S. McKechnie (Eds.), *Thinking in four dimensions: Creativity and cognition in contemporary dance* (pp. 14–28). Melbourne: Melbourne University Publications.

McKechnie, S. (2003). Research and writing: Research in creative arts. In J. Whiteoak & A. Scott-Maxwell (Eds.), *Currency companion to music and dance in Australia* (p. 584). Sydney: Currency Press.

McKechnie, S. (2004). Dance: The Dance Ensemble as a Creative System. In R. Wissler, B. Haseman, S. A. Wallace, & M. Keane (Eds.), *Innovation in Australian Arts, Media and Design* (pp. 13–28). Flaxton, Qld: Post Pressed.

McKechnie, S. (2005). Dancing Memes, Minds and Designs. In R. Grove, C. Stevens, & S. McKechnie (Eds.), *Thinking in four dimensions: Creativity and cognition in contemporary dance* (pp. 81–94). Melbourne: Melbourne University Publications.

Potter, M. (2005). In the Air: Extracts from an interview with Chrissie Parrott. In R. Grove, C. Stevens, & S. McKechnie (Eds.), *Thinking in four dimensions: Creativity and cognition in contemporary dance* (pp. 95–106). Melbourne: Melbourne University Publications.

Stevens, C., & McKechnie, S. (2005). Thought in action: Thought made visible in contemporary dance. *Cognitive Processing, 6*(4), 243–252.

Stevens, C., McKechnie, S., Malloch, S., & Petoczl, A. (2000). Choreographic cognition: Composing time and space. In C. Woods, G. Luck, R. Brochard, F. A. Seddon, J. A. Sloboda, & S. O'Neill (Eds.), *Proceedings of the 6th International Conference on Music Perception & Cognition* (published on CD ROM). Keele, UK: Department of Psychology, Keele University.

Sutton, J. (2005). Moving and Thinking Together in Dance. In R. Grove, C. Stevens, & S. McKechnie (Eds.), *Thinking in four dimensions: Creativity and cognition in contemporary dance* (pp. 50–56). Melbourne: Melbourne University Publications.

38

# APPRECIATION: THE WEAKEST LINK IN DRAMA/THEATER EDUCATION[1]

**Shifra Schonmann**
*University of Haifa, Israel*

## Opening: That's Great Art

As we watch a play, we find ourselves commenting, "That's great art", "a wonderful performance," "an important play," "fascinating," or "the play is irrelevant, boring." Spontaneous reactions such as these reflect mostly an intuitive appreciation of a theatrical performance. However, from Bertolt Brecht, we learn that the spectator's appreciation *"that's great art"* can spring from completely different modes of approaching theater:

> The dramatic theatre's spectator says: Yes, I have felt like that too – Just like me – It's only natural – It'll never change – The sufferings of this man appal me, because they are inescapable – *That's great art*; it all seems the most obvious thing in the world – I weep when they weep, I laugh when they laugh. The epic theatre's spectator says: I'd never have thought it – That's not the way – That's extraordinary, hardly believable – It's got to stop – The sufferings of this man appal me, because they are unnecessary – *That's great art*: nothing obvious in it – I laugh when they weep, I weep when they laugh. (Brecht, 1964/1984, p. 71)

Brecht challenged the conventional relationship between stage and audience looking to the political influence of theater and the political commitment of an audience. I mention Brecht in this opening to draw the reader's attention to the idea that the audience is of intrinsic concern for the theater. Theater appreciation is concerned with production and reception, with the performance on stage and the audience reaction.

A discussion about personal preference and taste in theater suggests a relativistic approach, casting doubt on universal judgments. "Personal preference" will be linked in this chapter to the notion of audience response and the idea of reception/perception and participation as indicators of appreciation. We TALK ABOUT the play and expect our interlocutor to understand the language we use. Are our comments comprehensible?

*L. Bresler (Ed.), International Handbook of Research in Arts Education, 587–600.*
© 2007 *Springer.*

Are they shared by the audience? Are they shared by the critics? What do these utterances represent? Do they establish the essential conditions that make for a successful play?

Raising such definitive questions may lead to the expectation that this chapter will culminate in definitive answers. I warn against such expectations: my intent is mostly to raise questions, to examine theoretical ideas and frameworks for appreciating theatrical performance. My use of appreciation is related to judgment and criticism, an approach based on Brockett's work. He maintains that appreciation is one of the purposes of criticism: "Appreciative criticism is usually written by the critic who has already decided that a work is good or bad. His principle motive then is to make others feel the power or the lack of power in the play or production" (Brockett, 1976, p. 12). However, some maintain that it is possible to appreciate a play separately from deciding whether the play is good or bad. The purpose of this stand, described by Brockett as "expository criticism," is "to explain a play or production and the circumstances affecting it" (1976, p. 12). In using this approach there is no need to make judgments of worth. In this chapter my emphasis is on "Appreciative criticism". My intention is to raise the question "how do we educate to appreciate theater"? In a sense all students, as audience members, are critics, and should be educated sufficiently to analyze performance and build their appreciation of the play or the production.

Research in drama/theater education has been largely empirical, whilst philosophical research has been considerably weaker. Consequently, appreciation, which is philosophical in nature has not been well developed and is the weakest link in drama/theater education thinking. The kind of inquiry which philosophy embodies, is, as Bailin argues, "of central importance to the development of sound theories and practices, and moreover, provides the grounding for meaningful research of the empirical kind" (1993, p. 79). While most of the research on appreciation is philosophical some empirical studies have been conducted that seek to answer questions about children's perceptions about theater for young audiences (Burton, 2002; Grady, 1999; Klein, 1995, 1997; Lorenz, 2002; Prendergast, 2004; Saldana, 1995, 1996; Schonmann, 2002). In this chapter, I shall clarify the nature of appreciation in theater and argue for its importance for drama/theater education. Furthermore, I shall examine the characteristic features of an informed critique presented by a learned and experienced observer, as compared with the critique presented in the intuitive appreciation of a child observer.

The origin of the word *intuition* is from the Latin *intuitio*, the act of contemplating. Consequently, *observation* is inherent in *intuition*. An intuitive understanding implies that as I view a *good* play I am able to distinguish it immediately as a good rather than a poor play, although I may not know how to talk about the distinction made, or verbally express my intuitive knowledge. In the context of constructing theatrical knowledge, many questions are raised. What type of knowledge should we bring when we come to appreciate a performance? Is this knowledge founded in the intuitive, the logos, or the pathos? Are the intuitive and the analytic necessarily diametrically opposed? Is a type of expertise needed, such as that of the professional wine taster who relies on years of experience? When judging a theatrical performance, should we exercise the intuitive function of the novice, or the informed, analytic function of the expert? What is the difference between these two perceptions and can they inform each

other? What are the implications of this for the establishment of educational programs that advance students' appreciation of the theater art? With these questions in mind this chapter revolves around five topics:

1. Theater and theatrical experience.
2. What makes a theatrical performance a work of great art?
3. The aesthetic of audience response – indicators of appreciation.
4. Expert vs. novice judgments in theater for young audience.
5. The place of Appreciation in drama/theater education studies and research.

## Theater and Theatrical Experience

Discussion of the theater arts takes us back to early times. Aristotle's *Poetics*, written more than 2,500 years ago in Ancient Greece, is considered still to be the cornerstone of any theoretical or practical argument on theater. Aristotle's main concept of the theater was *mimesis;* that is, on stage we imitate life. But what does it mean to imitate life on stage? For us, to "imitate" means to make a more or less perfect copy of the original model. For Aristotle, as Boal explains, to imitate has nothing to do with copying an exterior model, rather it has to do with a "re-creation." Thus when Aristotle says that art imitates nature, "we have to understand that he actually means, "Art re-creates" the creative principle of created things" (Boal, 1979/1995, p. 1). Therefore, Boal argues, "to imitate" has nothing to do with improvisation or "realism." The concept of *mimesis* is difficult to trace and many erroneous explanations have appeared over the centuries due to poor translations and difficulties of interpretation. Boal's interpretation, where *mimesis* is mostly understood as re-presenting life on stage, not as pure copying or presenting life as closely as possible to the original source, is perhaps most meaningful to contemporary discussions. An actor on the stage stands for someone else or something else. This "else", claims Schechner "may be a character in a drama, a demon, a god, or a pot. On the other hand, a performer in everyday life is not necessarily playing anyone but herself … . The two kinds of performing encounter each other when an actor studies a person in ordinary life in order to prepare a role for the stage. But this *mimesis* is actually not of 'real-life' but of a performance" (2002, p. 186). One of the differences between "art" and "life" is that in art, we do not experience the event itself but its representation (2002, p. 41). It is crucial to clarify this point at the outset since a major difficulty that we face in appreciating theater touches upon the ways we understand the idea of *mimesis* and the kind of theatrical experience we aim to achieve.

Theatrical experience consists of what the actors and the audience have to "celebrate" together. Celebrating our deepest experiences must be extracted from real life situations: a theatrical event should raise its participants to new heights of human existence. A theatrical experience is not necessarily *catharsis* but it is connected to the basic experience that springs from the ongoing dialogue between actors and their audiences, a dialogue that goes back to ancient rituals. Despite the changes and adaptations theater has undergone since the days of ancient Greece, over the course of hundreds of

years it has remained a special kind of spiritual and emotional experience that contains within it the element of *pleasure*.

The only two ingredients necessary for theater are the *actor and his/her audience*. The clear understanding of these minimal essential ingredients for creating theater was given a theoretical dimension and developed by Jerzy Grotowski (1968), whose ideas about "poor" theater influenced the greatest of latter twentieth-century theater creators. "Poor" theater is a concept in which the *actor or the actress* is at the center of the theatrical work. Instead of a wealthy theater that goes to great lengths to rival movies and television, Grotowski wanted a "poor" theater, without props, costumes, decoration, or stage machinery (Gronemeyer, 1996, p. 166).

Boal (1992) sees theater as the human capacity to observe ourselves in action. For him *theater is a form of knowledge;* "It should and can also be a means of transforming society. Theater can help us build our future, rather than just waiting for it" (p. xxxi). Boal believes that theater has the power to transform reality, to provoke deep thought about and challenge people to revolt against appalling conditions in life. His use of the term "theater" and the concept of a social and political mission are completely different from the conventional uses of the concept of theater that bases its understanding on Aristotelian perceptions.

More radical concepts of theater such as Eugenio Barba's (1995) anthropological understanding of theater claim that a theater should be open to the "experiences of other theaters, not in order to mix different ways of making performances, but in order to find basic common principles and to transmit these principles through its own experiences" (p. 9). Opening to diversity does not necessarily mean falling into a confusion of styles but, as Barba sees it, avoiding the risk of sterile isolation. This leads Barba to the conclusion that theaters resemble each other because of their principles, not their performances.

Examination of the concept of *theater* and *theatrical experience* from the perspective of a drama theater educator, provides another viewpoint of what we should be aiming at in developing appreciation of theater in young audiences. Neelands (1991) defines *theater* when structuring drama work for young people as "The direct experience that is shared when people imagine and behave as if they were other than themselves in some other place at another time" (p. 4). This definition seeks to encompass all forms of creative imitative behavior from the spontaneous imaginative play of young children to the more formal experience of the play performed by actors for an audience. This definition assumes that "meanings in theater are created for both spectator and participant through the actor's fictional and symbolic uses of human presence in time and space" (p. 4). Neelands' definition focuses on the "as if" cognitive ability of the young spectator to experience this transformation while watching a play. This ability is the core of theatrical understanding, and serves as the heart of theatrical appreciation.

From Aristotle to Brecht, to Boal, and Barba there are enduring efforts to suggest a reasonable explanation for the pleasure we derive from a theatrical performance and the appreciation that comes with it. The essence of theater lies in this unexplained pleasure, pleasure that performers can give their audiences and, that audiences can give performers. It is not only a pleasure of recognition, it is also a delight which stems from an emotional, intellectual, and aesthetic experience.

# What Makes a Theatrical Performance a Work of Great Art?

Ubersfeld reminds us "theatrical pleasures are rarely passive" (1982, p. 132). The experience of viewing a theater performance is an activity that involves the audience in the interpretation of the "multiplicity of signs, both transparent and opaque" (Bennett, 1990, p. 78). In such activity an audience is expected to understand the language of the theater and to make artistic and aesthetic judgments.

Discussion concerning making artistic and aesthetic judgments deals with one of the most difficult issues in the history of culture, because it seeks to define the essence of a creative entity and our attitude toward it as a cultural product. Every artistic period, movement, and philosophy has attempted to formulate the artistic ideal. Yet, the eternal question "what makes a work of art great?" remains unanswered. The reemergence of several criteria for judgment throughout the history of art and culture serves to substantiate their validity. I refer to the *communicative ability* of a work of art, its ability to *arouse emotions*, to impart a *sense of meaningfulness*, its *complexity*, its *technical aspects*, the *relevance* of the themes of the work of art, and its *sources*. These criteria serve as a focus for thought when establishing principles for appreciating the aesthetic and artistic components of a theatrical performance.

In the history of aesthetic appreciation there has been a preference for *order, symmetry, balance, and harmony*, yet the same history emphasizes that *asymmetry* and *disharmony* may also be viewed positively. Each period adds innovations to the aesthetic regulations, and there is diversity between periods and between cultures. Despite all of these changes, some elements remain constant; for example, we consider whether a work portrays order or lack of order, harmony or disharmony. Certain plays withstand the shifts of time and remain consistently pleasing (e.g., Shakespeare). There are some qualities in the text that pertain to the object itself that render it inherently pleasing. In other words, there is an overall rule, order, or way of observing things that is pleasing to all, regardless of time, place, or culture, and this rule or principle is not determined arbitrarily.

A statement that one particular work of art is better or of greater aesthetic value than another assumes that there are criteria by which to arrive at such a conclusion. The method for determining criteria may stem from a positivistic approach, which seeks to establish absolute universal standards, or from a relativistic approach, according to which standards may be conceived as an individual's value preferences. Although it appears that these are conflicting approaches, I believe that they *complement* each other, as long as the universal standards have withstood the test of time and the individual preferences are not based on an arbitrary "I like it" statement.

In regard to setting standards, Selden "[felt] very strongly that critics in every field of the dynamic arts (music, dance, and drama) ha[d] failed to give proper value to the sensuous foundations" (1941/1967, p. 302). In contrast, Yurka (1959) claimed that it is very easy to set a standard, and she proposed a simple test: "if you can answer me in a few sentences without naming names or describing characters, and if your few sentences make a clear, understandable story, often you've seen a good play" (p. 21). She claims that in all the good examples (*Romeo and Juliet, West Side Story*), the theme

will be remembered long after plot details are forgotten. The difficulty, as I see it, is that this proposal oversimplifies the issues. Surely, a play can be very good, yet the production a catastrophe? Yurka stated "Whatever the plot, the characters must be believable. It takes more than a dark mustache and a sinister leer to make a villain" (1959, p. 24). I wonder if this is also true for young people? Watching children at a play we can see that for them, a dark mustache and a sinister leer can make a villain. How do we teach them the difference between a superficial and a "good" play? I suggest that this is a learned distinction. Yurka relates: "Long ago, I picked up a volume of critical essays, *The Scenic Art*, by Henry James, in which he describes his impressions of the Paris stage in the late eighties. He speaks of a young actress of limited talent ... 'her only asset her charming voice ... all personality, little or no technique ... Will not go far'. The name of this young actress was Mlle Sara Bernhardt" (Yurka, 1959, p. 120). As Sara Bernhardt became one of the greatest actresses in the history of theater, this anecdote demonstrates the very essence of the problem of appreciating art in general and theatrical performances in particular.

I believe it would *not* be an exaggeration to claim that many attempts to define art or the aesthetic experience have failed. Nevertheless, when we speak about and refer to art it seems everyone knows what we mean, just as when we speak of aesthetics a shared meaning is denoted. However, we have no objective criteria by which to gauge art (Eisner, 2002; Greene, 2001). Since no objective and definitive criteria exist, our judgment of a work of art relies not on a set standard but on an appealing type of rationalization that seeks a match between "form," the use of theatrical signs, and "meaning," the significance derived from the signs and comprehended by an audience. This measure has to take into consideration the emotions that a theatrical performance is expected to evoke and the degree of pleasure it produces, the ultimate objective of any performance. Thus when trying to understand what makes a theatrical performance a work of art we learn that answers should acknowledge audience relationships with a performance. In this context examining the aesthetic of audience response is crucial.

## The Aesthetic of Audience Response: Indicators of Appreciation

The concept of aesthetic response is connected with the concept of *distance*. Edward Bullough (1912) was the first to define distancing as the link between our self and its affections (p. 89) that is, our perceptual, emotional state. He used the analogy of people in a fog at sea, who find the fog both terrifying, and, a source of enjoyment. They sense the fear but also abstract the experience. They distance it, and so view it from something other than their usual outlook. Bullough described distancing as a variable affected by the object being viewed and the manner in which it is realized by the subject, and subject to "under-distance" or "over-distance". The subject, for example, can decrease distance to the point where he or she loses appreciation for the object. Aesthetic distance is a balance: "all art requires a distance-limit beyond which, and a distance-limit within which only *aesthetic appreciation* becomes possible" (Bullough, 1912, p. 89).

There have been few attempts to analyze this crucial dimension of theatrical art (Beckerman, 1970; Ben-Chaim, 1984; Bentley, 1964; Styan, 1975) or to develop an understanding of what it means in terms of theater for young people (Klein, 1995; Saldana, 1996; Schonmann, 2002). Ben-Chaim (1984) tries to analyze systematically the concept of distance in theater. She claims: "The spectator's awareness that the theatrical event is a fiction fundamentally determines the viewer's experience" (Ben-Chaim, 1984, p. 73). Drawing on Bullough, the ideal degree of distance is identified as the "least amount of distance without its disappearance" (Ben-Chaim, 1984, p. 49).

In the theater, the aesthetic experience is grounded in aesthetic distance. Aesthetic distance ensures deeper understanding of the aesthetic object, and is located at a mid-point between excessive (too far from the object) and insufficient (too close to the object) distance. It describes the point from which the play is viewed, from which the artistic creation is received, and affects the viewer's judgment. Insufficient aesthetic distance means that the work of art or the play ceases to function as a symbol and is perceived as reality. Excessive aesthetic distance, results in the audience becoming indifferent to the happenings on stage. The term *optimal aesthetic distance* refers to a point located at midrange between these two extremes. It is essentially a psycholog-ical mechanism employed by the viewer of any artistic creation that arouses emotions because of its resemblance to something in the viewer's reality.

The real power of a play is found when it is tested upon an audience. In theater the audience has an active role and some ways of participation become overt ways of appreciation. The choice between the terms *reception* and *perception* is not necessar-ily a choice between two completely different entities, claims Sauter (2000), but is rather a choice between two different traditions. *Perception* is linked to phenomenol-ogy (Sauter, 2000) and is located in Gadamer's thinking and the phenomenological tra-dition. *Reception* refers "to cultural studies and the analysis of social values and mental worlds" (Sauter, 2000, p. 5). The phenomenological tendency and the social tendency suggest we look at different things while examining an audience's reaction to the stage performance, and the ways the interaction on the actor-spectator axis takes place. Sauter suggests connecting *perception* with the immediate communicative aspect of the presentation; in this way it is an integral part of the theatrical event. *Reception* should be employed to describe what takes place after a performance; in this way it describes the consequence, the result of the *perception*, the communication that took place earlier.

The action (actor) reaction (spectator) chain is one way to describe theater as com-municative interaction. Employing a phenomenological approach opens up our exam-ination to other modes of appreciating the act of participating in a theatrical event, for example, through applause. Kershaw asks "In what ways can theater, and particularly its politics, be better understood than through thinking of its applause?" (2001, p. 134), prompting us to consider how we interpret applause. Is applause the theatrical equiva-lent of litmus paper, a reliable indicator of "the cultural toxicity of the event in its whole environment?" or are audience reactions so "fickle and fleeting that generally they are best ignored by theater scholars, or at least relegated to the odd footnote in his-tories of the art?" (Kershaw, 2001, p. 133). Kershaw explains the lack of scholarly interest in applause ironically: "Perhaps theater analysts do not want to acknowledge

applause in the context of serious scholarship because it is perceived to be incidental to performance" (2001, p. 133).

What does the audience appreciate in theater? This is a question that has occupied researchers over the years. When an actor asks the theater manager "How is the house tonight?" he is referring not only to the number of people in the theater that evening but also to the characteristics of the audience: is it homogeneous? heterogeneous? active? energetic? hostile? receptive? elderly? young? The answers to these questions assist the actor to learn about the nature of the spectators at a specific event. For example, playing in a matinee and in a late evening performance are completely different experiences, due to the different audiences attending. In matinee performances, the spectators are often elderly and the way they react to a play is different from more heterogeneous evening audiences. They laugh in different places and can react slowly; they sometimes don't react at all because they don't hear well, do not immediately get the point, or have a differing sensibility and set of values. The way the play is designed takes into account ways to manipulate the audience's response or, to put it less bluntly, how to program the audience's reception. The *presence* of a homogeneous/heterogeneous audience is always a factor in managing the performance and thus channeling the overt appreciation.

## Expert vs. Novice Judgments in Theater for Young Audience

An investigation of the differences between expert (adult) and novice (child) judgments based on different kinds of questionnaire and observations collected during the annual International Children's Theater Festival in Haifa (Schonmann, 2006) reveals that child participants' choice of best play, *The Mermaid's Tail* (fictitious name) was considered by adult participants to be *the worst* play in the festival. The children enjoyed that "the mermaid was so beautiful," "the magician's tricks made me laugh," "it's such a beautiful story – I've heard it before." Responses to the item "What bothered you in the play?" included "almost nothing," "the mermaid jumped around too much," "it started late and I got impatient waiting."

The characteristics of the play chosen as best by the children were

– The play described a situation that the children considered beautiful or emotional.
– The subject of the play was very easily identified.
– There were limited numbers of associations related to the subject of the play; associative enrichment was insignificant.

These attributes coincide with what Thomas Kulka (1992) describes as the defining conditions of kitsch in Art. Whilst Kulka was referring to painting, he conceded that these conditions hold true for all artistic forms.

The lessons learned regarding the enormous gap between children's and adults' judgments were applied the next year at the Theater Festival of 1994, for which a new set of judging rules was devised. Despite thoughtful changes, there was an even greater gap between the findings of experts and novices than there had been the previous year.

This time the adult panel of seven experts selected a play titled *Louisa and the Moon* (fictitious title), which received the award for best play, best director, and best actress. The panel commented: "this play features excellent use of many of the artistic elements of a play: stage setting, plot, characters, and lighting." In contrast, the novice judges ranked this play fifth out of seven, close to last place. The children were bothered by the fact that "at the end, Betty didn't find a solution to her problem", that "the actors kept repeating the same phrase over and over, maybe twenty times, 'the forest is in danger' " (an aspect that the adults approved of and considered stylish).

Another play, *Don't Leave Me Alone* (fictitious title) was highly acclaimed by the critics. A professional whose critiques of children's plays are published regularly in the daily newspaper wrote: "this play was unique. Sometimes one impressive play can justify the entire festival … . This play was performed in two rooms in the theater's underground shelter, thus dealing directly and powerfully with what are some of today's children's most real and deepest fears." All the children ranked this as a poor play and it received the lowest mark possible (33 out of the 70 points possible). They wrote that "the location was lousy," and "I couldn't understand many things." In other words, the children did not like the transgression of familiar conventions, in terms of either the physical space where the play was performed, or the lighting, used in this case to portray images. In contrast, the producer, director, and the actors were willing to go far to develop and extend the symbolic language of the theater, an attempt that was artistically appreciated and encouraged by the adult expert judges.

These findings lead us to examine the significance of the gaps in judgment. How can we understand this trend? What does this tell us about assessing children's theater? Should the criteria for a good children's play follow the observations of the "expert" (the adults) or of the "novice" (the children)? Or something in-between? Sharon Grady (1999) reported that when talking to children about representation in children's theater, "71% of the children in this child audience felt that children's roles should be played by child actors" (p. 89). As one student bluntly suggested: "If you need a kid, cast a kid; if you need an adult, cast an adult" (p. 88). Grady's pilot study points to core differences between children's and adult's aesthetic understanding, a difference which is, as Grady claims: "understandable, given the issue of age (and the beliefs, tastes, and assumptions that go along with it) as it pertains both to the individual subject and to the social grouping" (1999, p. 90).

The issue of expert vs. novice is pertinent to any professional field: the expert possesses knowledge that stems from learning and professional experience, whereas the novice brings a fresh view, based on intuition. The issue of the novice theater viewer is significant and central in children's theater, more so than in any other art. Since the play is intended for this particular audience, we have to wonder whether it matters if the adult doesn't agree with the child's taste, or if children do not enjoy the plays selected by the adults.

Verriour (1994) suggests that the ability to perceive an object as an aesthetic symbol develops at a relatively late stage. In his study, whilst most child participants aged 7 could not identify symbols, at age 9 more did, with most at age 11 able to understand symbols. This finding is reasonably substantiated by theories of cognitive development, whether Piaget's or those of other cognitive psychologists, who would argue that

to understand the symbols of the theater, and to realize that the fictitious world of the theater is not reality, a child must be capable of some degree of abstract thought. S/he has to understand the "rules of the game" that, in the case of theatrical performance are not those of the games usually played in social activities. From research as well as from our own observations we know that when children between the ages of 3 and 7 gather together they play "as if" games in which they always take roles and play "as if" they were somebody or something else. In the absence of research on the infant child as an observer of a theater performance, it would be reasonable to assume that if at the age of 3 a child can actively *play* in a symbolic way, s/he can *observe* "as if" situations on stage and understand and enjoy theatrical situations as both situations contain similar features. Consequently, I suggest that the earliest age children are able to enjoy theater would be 3 years old.

I suggest the key reason for the gap between expert and novice judgments lies in the different aesthetic distances applied by these different viewers. This difference may suggest that there is no need to establish criteria for appreciation. However, I argue that it is necessary to define criteria for judging the quality of plays because it is possible to educate for artistic appreciation. We can develop the child's ability to make informed judgments by constantly providing theater education, much like teaching any medium of art that includes a critical approach to that artistic medium.

## The Place of Appreciation in Drama/Theater Education Studies and Research

What does the discussion above mean for our understanding of the place of appreciation in Drama/Theater Education studies and research? The common assumption that children do not accept a poor production is not necessarily accurate. Children, many times, do not distinguish between a "good" and a "poor" production; their reasons and sources of enjoyment appear to differ from those of adults, and that is why we should be concerned about educating children in this respect. It is true that if children do not like a particular play, we may find them wriggling, talking, making paper airplanes from their programs, and exhibiting other kinds of misbehavior, but their reasons for not liking the play do not necessarily emerge from it being a poor play. The opposite is also true: good behavior is not necessarily because the production is very good. Understanding the essence of the artistic and the aesthetic that are the object of appreciation can help us strengthen the weakest link of appreciation in drama/theater education. Theater for young people is first and foremost a form of art, it is *theater* (Klein, 1988, 1997; Levy, 1998; Lorenz, 2002; McCaslin, 1975; Saldana, 1995, 1996; Schonmann, 2006). However, in developing and strengthening the weakest link we have to be sure that neither the pedagogical nor the psychological dimensions are overlooked.

Levy (1990) struggles with the notion that children attending theater in the age of film are captive audiences. "They do not choose to come," he says, therefore we should ask ourselves "What can live theater offer, and in particular what can theater offer children of the film generation that film in all its variations cannot?" (1990, p. 11). He answers: "Film can, perhaps, stand for dreams and thoughts in some ways no other art

can. But theater – the only art whose precondition is that human beings confront one another – can uniquely stand for life and thus is inexhaustible" (1990, p. 16).

Levy's question is echoed in a number of studies in drama/theater education (Bolton, 1992; Hamilton, 1992; Jackson, 1993; Miller & Saxton, 1999; O'Neill, 1995; O'Toole, 1992; Schonmann, 2000; Taylor, 2000) and is taken up in a recent collection of essays (Gallagaher & Booth, 2003). Gallagher and Booth explore the question by legitimating the voices of actors and actresses, singer-actor-students, playwrights, filmmakers, directors, educators as well as researchers – giving all of them a right to build the knowledge in the field with their authentic tones of personal experiences.

However, the question of how theater educates again exposes the weakest link, appreciation in drama theater education, as it avoids the notion of how we can educate to appreciate theater. In another edited collection (Jackson, 1993), the authors present recent developments in some Theater in Education (TIE) programs, asking similar questions but in the context of TIE: "Is TIE education or theater or both? Does theatre make the education offered superficial, transitory, untrustworthy?" (Jackson, 1993, p. 34). Jackson (1995) later argues that Boal's rationale and methodology for *Forum Theater* work well for Theater in Education (TIE).

In recent work Monica Prendergast explores ways to develop audiences for performance through education. She maintains that performance theorist Herbet Blau's *The Audience* is an important yet neglected theoretical text on theater audience. His thoughts lead her

… to education and the beginning moments of a curriculum theory of audience-in-performance (AIP). This is a curriculum that intends to nurture an audience that is aware of its psycho/social/cultural responsibilities and that consists of perceivers and memory-keepers and questioners in genuine dialogue with performance and performing artists. (2004, p. 89)

Appreciating theater and enjoying theater are active processes that develop the abilities to grasp questions of application, generalization, and symbolism. In the theater the thought is present; the imagination is fixed by the concrete characters. In this sense, in the process of watching a play, the spectator is *not* creating an imaginary world that takes the place of the real world, but is witnessing a reality that is created in front of his eyes, in the here and now on the stage. This reality on stage has its own language, which should be studied from the beginning of the learning process. This language is based on a sign system in which conventions play a central part. The sign system of the theater involves the transmission of meaning through symbols and conventions (Elam, 1980; Kowzan, 1968; O'Toole & Haseman, 1989; Pavis, 1992), and it expresses multiple realities, experiences, and cultures. The notions of theater as a form of language, and as a form of knowledge and of knowing (intuition) are interconnected. The requisites of this kind of language and knowledge provide a basis on which education of appreciation can be developed.

Educational programs should strengthen the weakest link in their projects. In order to advance childrens' appreciation of theater, they need to encounter theatrical experiences that emphasize the symbolic nature of the theatrical performance and its many

components: words, intonation, facial and bodily expressions, gestures, the actor's use of space, make-up, and costumes; and, properties such as lighting and music. This does not mean that the child should be able to decipher all the symbolic components and their uses, but s/he has to be aware of certain symbolic elements that are directed at the audience's perceptive abilities. Thus the question that we have now to make our main concern is not *how theater educates* but *how we educate to appreciate theater?*

# Note

1.  The chapter is partly based on my book *Theater as a Medium for Children and Young People: Images and Observations* (Schonmann, 2006).

# References

Bailin, S. (1993). Theatre, drama education and the role of the aesthetic. *Curriculum Studies, 25*(1), 423–432.

Barba, E. (1995). Theatre anthropology. In E. Barba & N. Savarese (Eds.), *A dictionary of theatre anthropology: The secret art of the performer* (pp. 8–22). New York: Routledge.

Beckerman, B. (1970). *Dynamics of drama: Theory and method of analysis*. New York: Knopf.

Ben-Chaim, D. (1984). *Distance in the theatre: The aesthetics of audience response*. Ann Arbor, MI: UMI Research.

Bennett, S. (1990). *Theatre audiences: A theory of production and reception*. London: Routledge.

Bentley, E. (1964). *The life of the drama*. New York: Atheneum.

Boal, A. (1979/1995). *Theatre of the oppressed*. New York: Theatre Communications Group.

Boal, A. (1992). *Games for actors and non-actors*. London and New York: Routledge.

Bolton, G. (1992). *New perspectives on classroom drama*. London: Simon & Schuster.

Brecht, B. (1964/1984). Theatre for pleasure or theatre for instruction. In J. Willett (Ed.), *Brecht on theatre* (pp. 69–77). New York: Hill & Wang.

Brockett, O. (1976). *The essential theatre*. New York: Holt, Rinehart & Winston.

Bullough, E. (1912). "Psychical distance" as a factor in art and an aesthetic principle. *British Journal of Psychology, 5*(2), 87–118.

Burton, B. (2002). Staging the transitions to maturity: Youth theatre and the rites of passage through adolescence. *Youth Theatre Journal, 16*, 63–70.

Eisner, E. W. (2002). *The arts and the creation of mind*. New Haven, CT: Yale University Press.

Elam, K. (1980). *The semiotic of theatre and drama*. London: Methuen.

Gallagher, K., & Booth, D. (Eds.). (2003). *How theatre educates: Convergences & counterpoints*. Toronto: University of Toronto Press.

Grady, S. (1999). Asking the audience: Talking to children about representation in children's theatre. *Youth Theatre Journal, 13*, 82–92.

Greene, M. (2001). *Variations on a blue guitar*. New York: Teachers College Press.

Gronemeyer, A. (1996). *Theater: An illustrated historical overview*. New York: Barron's Educational Series.

Grotowski, J. (1968). *Towards a poor theatre*. London: Methuen Drama Books.

Hamilton, J. (1992). *Drama and learning: A critical review*. Australia: Deakin University Press.

Jackson, A. (Ed.). (1993). *Learning through theatre*. London: Routledge.

Jackson, A. (1995). Framing the drama: An approach to the aesthetics of educational theatre. In P. Taylor & C. Hoepper (Eds.), *Selected readings in drama & theatre education* (pp. 161–170). Brisbane: NADIE Publications.

Kershaw, B. (2001). Oh for unruly audiences! Or, patterns of participation in twentieth-century theatre. *Modern Drama, 42*(2), 133–154.

Klein, J. (1988). Understanding your audience from television research with children. In J. Klein (Ed.), *Theatre for young audiences* (pp. 87–102). Lawrence, KN: The University of Kansas.

Klein, J. (1995). Performance factors that inhibit empathy and trigger distancing: Crying to laugh. *Youth Theatre Journal, 9*, 53–67.

Klein, J. (1997). Elementary teacher's evaluations of university performances for young audiences. *Youth Theatre Journal, 11*, 1–14.

Kowzan, T. (1968). The sign in the theatre. *Diogenes, 61*, 52–80.

Kulka, J. (1992). Psychosemiotic transformation in the arts. *Semiotica, 89*(1/3), 25–33.

Levy, J. (1990). Theatre for children in an age of film. In J. Levy (Ed.), *A Theatre of the Imagination: reflections on children and the theater* (pp. 10–17). Charlottesville, VA: New Plays.

Levy, J. (1998). *A Theatre of the imagination: Reflections on children and the theatre.* Charlottesville, VA: New Plays.

Lorenz, C. (2002). The rhetoric of theatre for young audiences and its construction of the idea of the child. *Youth Theatre Journal, 16*, 96–111.

McCaslin, N. (1975). *Children and drama.* New York: David McKay.

Miller, C., & Saxton, J. (Eds.). (1999). *Drama and theatre in education: International conversations.* USA: The American Educational Research Association. Arts and Learning. Special Interest Group.

Neelands, J. (1991). *Structuring drama work: A handbook of available forms in theatre and drama.* Cambridge: Cambridge University Press.

O'Neill, C. (1995). *Drama worlds.* Portsmouth, NH: Heinmann.

O'Toole, J. (1992). *The Process of drama: Negotiating art and meaning.* London: Routledge.

O'Toole, J., & Haseman, B. (1989). *Dramawise: An introduction to GCSE drama.* Oxford, UK: Heinemann Educational Books.

Pavis, P. (1992). *Theatre and the crossroads of culture.* London: Routledge.

Prendergast, M. (2004). "Shaped like a question mark": Found poetry from Herbert Blau's "The Audience". *Research in Drama Education, 9*(1), 73–92.

Saldana, J. (1995). Is theatre necessary? Final exit interviews with sixth grade participants from the USA longitudinal study. *Youth Theatre Journal, 8*(3), 14–30.

Saldana, J. (1996). "Significant Differences" in child audience response: Assertions from the USA longitudinal study. *Youth Theatre Journal, 10*(3), 67–83.

Sauter, W. (2000). *The theatrical event: Dynamics of performance and perception.* Iowa City, IA: University of Iowa Press.

Schechner, R. (2002). *Performance studies: An introduction.* London: Routledge.

Schonmann, S. (2000). Theatre and drama education: Themes and questions, In S. Brown, M. Ben-Peretz, & R. Moon (Eds.), *Routledge international companion to education* (pp. 944–955). London: Routledge.

Schonmann, S. (2002). Fictional worlds and the real world in early childhood drama education. In L. Bresler & C. M. Thompson (Eds.), *The arts in children's lives: Culture, context, and curriculum* (pp. 139–151). Dordrecht, The Netherlands: Kluwer Academic Publishers.

Schonmann, S. (2006). *Theatre as a medium for children and young people: Images and observations.* Dordrecht, The Netherlands: Springer.

Selden, S. (1941/1967). *The stage in action.* London: Feffer & Simons.

Styan, J. L. (1975). *Drama, stage and audience.* London: Cambridge University Press.

Taylor, P. (2000). *The drama classroom.* London: Routledge.

Ubersfeld, A. (1982). The pleasure of the spectator (P. Bouillaguet & C. Jose, Trans.). *Modern Drama, 25*(1), 127–139.

Verriour, P. (1994). *In role: Teaching and learning dramatically.* Ontario, Canada: Rippin Publishing.

Yurka, B. (1959). *Dear audience: A guide to the enjoyment of theatre.* Englewood Cliffs, NJ: Prentice Hall.

# INTERNATIONAL COMMENTARY

## 38.1

## Researching Drama Appreciation:
## An Australian Perspective

**John A. Hughes**
*University of Sydney, Australia*

In Australia, drama appreciation has been conceptualized variously as: appreciating, responding, interpreting, and critically analyzing. These various terminologies denote active student engagement with performance (Anderson, 2004; NSW Board of Studies, 2003, 2000, 1999). Drama appreciation research, especially in tertiary settings, also intersects with the discipline of performance studies located in the area of performance semiotics (Maxwell, 2006; McAuley, 2001). The traditional division between a semiology of performance text and a semiology of performance has been superseded by the analysis of multiple texts and an understanding of the concept of the *mise en scene*; that is, the total stage picture, its relationship with the performance space and the performers' contract with the audience (Fitzpatrick, 1989; Grady, 2000; McAuley, 1996, 1999).

In Australia, this notion of a multiplicity of texts aligns with a focus, at all levels of education, on developing multiliteracies, the ability to read and interpret differing texts, be they written, visual, audio, gestural, spatial, or multimodal as is increasingly the case in this digital age (Cope & Kalantzis, 2000). Within the field of drama and theater education research, the cultural landscape has been changed by digitized communication systems and media related forms of performance such as television, film, and multimedia, which in turn, influence what knowledge and expectations people bring to a theater experience and how they "read" it (Carroll, 2005; Haseman, 2002; Hunter, 2000; Mooney, 2005).

International and national research has informed Australian educators in their efforts to link students' experiences with an appreciation of performance texts. Drama educator Dan Urian argues that students' "dormant knowledge" of drama, gleaned from digital and electronic forms, can be activated by teachers to enrich their students' understanding of the theater experience, in what he calls "Guided Spectatorship" (Urian, 1998, p. 135). Australian educators have tapped into young peoples' experiences of "youth culture" as the foundation for the aesthetic upon which their theater literacy can be built (Hunter, 2000; McLean, 1996). In addition to these approaches, the

*L. Bresler (Ed.), International Handbook of Research in Arts Education, 601–604.*
© 2007 *Springer.*

acquisition of a theater-specific metalanguage is also considered pivotal to a meaningful experience of the theater, particularly for youth audiences, who may feel alienated without prior experience or curriculum related preparation (Cahill & Smith, 2002; Grady, 2000; Hughes, 2004).

In recent research commissioned by the Australia Council for the Arts (Costantoura, 2000) and the NSW Ministry for the Arts (Positive Solutions, 2003) the role of education and educators as key facilitators of young people's experiences of the arts, especially theater, is highlighted. Other studies (Hughes, 2004; Hughes & Wilson, 2004) point to the critical role of adult facilitators for the positive and ongoing arts experiences of young people. Unfortunately, research in Australia, and elsewhere, indicates that most high school teachers of drama, especially those involved with English literature curricula, are unfamiliar with the grammar of performance analysis and appreciation unless they have undertaken undergraduate or postgraduate courses in theater/performance studies (Grady, 2000; Hughes, 2002). Australian arts researchers and teacher educators face the challenge of equipping teachers with current theoretical knowledge and understanding of the performing arts in an increasingly limited curriculum allocation in preservice teacher education programs.

Research indicates the complexity of analysing the *mise en scene* as the ephemeral nature of performance poses sometimes seemingly insuperable difficulties for us all (Grady, 2000; Hughes, 2002; McAuley, 1996, 1999). As Eco reminds us:

> Every reception of a work of art is both an interpretation and a performance of it, because in every reception the work takes on a fresh perspective. (Eco, 1979, p. 49)

Yet, great researchers and teachers are often motivated by a belief that human nature can overcome seemingly insuperable difficulties.

# References

Anderson, M. (2004). A recent history of drama education in NSW. In C. Hatton & M. Anderson (Eds.), *The state of our art: NSW perspectives in drama education* (pp. 3–18). Sydney: Currency Press.

Cahill, H., & Smith G. (2002). *A pilot study of arena theatre company's audiences.* Melbourne: Australian Youth Research Centre.

Carroll, J. (2005). YTLKIN2ME? Drama in the age of digital reproduction. *NJ, 29*(1), 15–23.

Cope, B., & Kalantzis, M. (Eds.). (2000). *Multiliteracies: Literacy learning and the design of social futures.* South Yarra: Macmillan.

Costantoura, P. (2000). *Australians and the arts:What do the arts mean to Australians?* Sydney: Australia Council for the Arts.

Eco, U. (1979). *The role of the reader in the semiotics of texts.* Bloomington, IN: Indiana University Press.

Fitzpatrick, T. (Ed.). (1989). *Altro polo: Performance from product to process.* Sydney: Frederick May Foundation for Italian Studies.

Grady, S. (2000). Languages of the stage: A critical framework for analysing and creating performance. In H. Nicolson (Ed.), *Teaching drama* (pp. 11–18). London: Continuum.

Haseman, B. (2002). The 'Creative Industry' of designing a contemporary drama curriculum. *Melbourne Studies in Education, 43*(2), 119–129.

Hughes, J., & Wilson, K. (2004). Playing a part: The impact of youth theater on young people's personal and social development. *Research in Drama Education 9*(1), 57–73.

Hughes, J. (2004). Playscripts and performances. In W. Sawyer & E. Gold, (Eds.), *Reviewing English in the 21st century* (pp. 166–173). Melbourne: Phoenix Education.

Hughes, J. (2002). *Teacher professional development in performance and literary arts education.* Unpublished EdD thesis, University of Western Sydney.

Hunter, M. A. (2000). Contemporary Australian youth-specific performance and the negotiation of change. *NJ, 24*(1), 25–36.

McAuley, G. (1996). Theater practice and critical theory. *Australasian Drama Studies, 28*, 140–145.

McAuley, G. (1999). *Space and performance: Making meaning in the theatre.* Ann Arbor: University of Michigan Press.

McAuley, G. (2001). Performance studies: Definitions, methodologies, future directions. *Australasian Drama Studies, 39* (October), 5–19.

McLean, J. (1996). *An aesthetic framework in drama: Issues and implications.* Brisbane: National Association for Drama in Education.

Maxwell, I. (2006). Parallel evolution: Performance studies at the University of Sydney. *The Drama Review, 50* (Spring), 33–45.

Mooney, M. (2005). Morphing into new spaces: Transcoding drama. *NJ, 29*(1), 25–35.

NSW Board of Studies (2003). Drama: Years 7–10 Syllabus. Sydney: NSW Board of Studies. Retrieved on 27.02.06 from: http://www.boardofstudies.nsw.edu.au/syllabus_sc/pdf_doc/drama_710_syllabus.doc

NSW Board of Studies (2000). Creative Arts K-6 Syllabus. Sydney: NSW, Board of Studies. Retrieved on 27.02.06 from:http://k6.boardofstudies.nsw.edu.au/arts/pdf_doc/K6_creatart_syl.pdf

NSW Board of Studies (1999). Drama: Stage 6 Syllabus. Sydney: NSW Board of Studies. Retrieved on 27.02.06 from: http://www.boardofstudies.nsw.edu.au/syllabus_hsc/pdf_doc/drama_syl.pdf

Positive Solutions (2003). *Review of theatre for young people.* Sydney: Australia Council and NSW Ministry for the Arts.

Urian, D. (1998). On being an audience: A spectator's guide. In D. Hornbrook (Ed.), *On the subject of drama* (pp. 133–150). London: Routledge.

# 39

# MUSIC APPRECIATION: EXPLORING
# SIMILARITY AND DIFFERENCE

**Margaret S. Barrett**

*University of Tasmania, Australia*

Lucia began to sing, and there was a moment's silence. She was stout and ugly; but her voice was still beautiful, and as she sang the theater murmured like a hive of happy bees. All through the coloratura she was accompanied by sighs, and its top note was drowned in a shout of universal joy.

So the opera proceeded. The singers drew inspiration from the audience, and the two great sextets were rendered not unworthily. Miss Abbott fell into the spirit of the thing. She, too, chatted and laughed and applauded and encored, and rejoiced in the existence of beauty. As for Philip, he forgot himself as well as his mission. He was not even an enthusiastic visitor. For he had been in this place always. It was his home.

Harriet, like M. Bovary on a more famous occasion, was trying to follow the plot. Occasionally she nudged her companions, and asked them what had become of Walter Scott. She looked round grimly. The audience sounded drunk, and even Caroline, who never took a drop, was swaying oddly. Violent waves of excitement, all arising from very little, went sweeping round the theater. (E. M. Forster, *Where angels fear to tread*, 1905/1985, pp. 109–110)

In this depiction of a performance of *Lucia di Lammermoor* in a regional Italian opera house, E. M. Forster presents us with the intoxicating possibilities of music appreciation, whilst reminding us, through Harriet's grim observation of her fellow audience-members, that in some circles, such abandonment to the sensuous is frowned upon, not the mark of the serious connoisseur of music. Whilst Miss Abbott rejoices in "the existence of beauty" and Philip "forgets himself," Harriet seems determined to retain a sober, rational, detached "appreciation" of the musical experience. In a later novel, *Howards End* (1910/1976) Forster is more specific about the ways in which we may "appreciate" music, as he describes the varied responses of the Schlegel family to

*L. Bresler (Ed.), International Handbook of Research in Arts Education*, 605–620.
© 2007 *Springer.*

a performance of Beethoven's Fifth Symphony:

> It will be generally admitted that Beethoven's Fifth Symphony is the most sub-
> lime noise that has ever penetrated into the ear of man. All sorts and conditions
> are satisfied by it. Whether you are like Mrs Munt, and tap surreptitiously when
> the tunes come – of course, not so far as to disturb others; or like Helen, who can
> see heroes and shipwrecks in the music's flood; or like Margaret, who can only
> see the music; or like Tibby, who is profoundly versed in counterpoint, and holds
> the full score open on his knee; or like their cousin, Fraulein Mosebach, who
> remembers all the time that Beethoven is "echt Deutsch"; or like Fraulein
> Mosebach's young man, who can remember nothing but Fraulein Mosebach; in
> any case, the passion of your life becomes more vivid, and you are bound to admit
> that such a noise comes cheap at two shillings. (1910/1976, pp. 44–45)

In this latter passage Forster presents us with the ways key modernist "aesthetic theo-
ries" are lived out in the experience of music appreciation. Through the thoughts and
actions of his characters we come into contact with representational, expressive, and
formalist views of the meaning and value of music listening experience.[1] These theo-
ries have been the subject of debate in the fields of arts appreciation, criticism, and
aesthetics since the early writings of Plato and Aristotle. Whilst Forster shows no overt
allegiance to any one of the theories, his assertion that "the passion of your life
becomes more vivid" through the encounter with Beethoven suggests that for him, the
experience of music is of profound importance, holding transformative possibilities
for the individual. This is reinforced in his account of Miss Lucy Honeychurch's ren-
dering of a Beethoven sonata (Opus 111 it is implied) at the Pensione Bertolini one wet
afternoon in nineteenth-century Florence:

> It so happened that Lucy, who found daily life rather chaotic, entered a more solid
> world when she opened the piano. She was then no longer either deferential or
> patronizing; no longer either a rebel or a slave. The kingdom of music is not the
> kingdom of this world; it will accept those whom breeding and intellect and cul-
> ture alike have rejected. The commonplace person begins to play, and shoots into
> the empyrean without effort, whilst we look up, marvelling how he has escaped
> us, and thinking how we could worship him and love him, would he but translate
> his visions into human words, and his experiences into human actions. (E. M.
> Forster, *Room with a view*, 1908/1978, p. 50)

I have quoted so extensively from Forster's work as he writes powerfully of the diverse
ways in which music appreciation has been conceived (from modernist perspectives),
and the difficulties of arriving at a definitive view of the concept. Rather than becom-
ing embroiled in attempts to define what music appreciation is, part of my project in
this chapter is to describe the experience of music appreciation as it has been advo-
cated in various music disciplines, and to contemplate the multilayered meanings in,
of, and about music that arise through examination of these various descriptions.

The literature on music appreciation is both vast and disparate, and has been cate-
gorized in the fields of the philosophy, psychology, and sociology of music, and

related interdisciplinary fields such as ethnomusicology. In other approaches, the appreciation of music has been investigated through analysis of its cognitive, affective and/or somatic affects. To attempt to cover all of this literature is beyond the scope of this chapter. Accordingly, I confine myself to consideration of those areas that hold implications for music education, and our understanding of the ways in which we acquire meaning in and through music encounter.

## Exploring Music Appreciation: Meaning, Value and Participation

As is suggested by E. M. Forster in his depictions of music appreciation, the meanings, values, and modes of participation in music appreciation are contested. The term "Appreciation" is often linked to issues of approval, approbation, admiration, positive reception, enjoyment, pleasure, and by implication, their binary opposites, such as disapproval and depreciation. When used in relation to arts experience, appreciation takes on a cognitive aspect, as it relates to understanding, to the capacity to grasp, to comprehend, to be aware, and to make judgments. When considered in this light, appreciation intersects with the concerns of aesthetics, a field of debate and inquiry that dates from Plato and Aristotle, and was formalized under the term "aesthetics" by Alexander Baumgarten in 1735 (*Meditationes Philosophicae de Nonnullus ad Poema Pertinentitous*). By implication, appreciation is also concerned with criticism, as the "connoisseur" is engaged in making judgments about the relative value and merit of particular works. One approach to understanding music appreciation is to look to the uses to which the term has been put.

## Music Appreciation: Philosophical Accounts

In the field of philosophy, music appreciation has been concerned variously with defining musical "beauty," identifying the distinctive features of music experience from other types of experience, and, making judgments of quality about specific musical works, their performance, and their creators (composers and performers). In this approach, the philosophy of music has worked *from* the mind *to* the senses, reasoning an understanding in an object orientation that focuses on the musical work[2] and our reception of the work. Philosophical accounts of musical experience have attempted to: identify the focus of our attention (The form? The content? The expression? The context?); judge the quality of our "listening" (for it is primarily from the mode of listening that philosophical accounts of music experience have worked); and, make judgments concerning the value of the musical work and its performance. Harriet's companions' surrender to the expressive/emotive features of the performance of *Lucia di Lammermoor* (an expressive response), contrasts with her concern with Scott's original story (a representational response) and the ways in which it was presented (a formalist response). Here Forster implies there is "a" particular way of appreciating music (soberly, and in a "disinterested" manner) and a specific focus for our attention in the musical "object" or "event" (content and form intertwined). In so doing he moves us from a focus on sensory perception and sensual response, to one that is "minded," to cognitive response. It could be speculated that Forster is attempting to

move beyond Kant's relegation of music to a secondary kind of aesthetic engagement. Writing in the *Critique of judgment* (1952/1790), Kant asserted that music's formal properties were primarily located in the realm of the senses rather than the contemplative, thereby removing music from the "first order" of aesthetic experience in the arts. To suggest that music engagement could encompass the contemplative and cognitive, suggests that Forster is attempting to raise the status of music in Kant's relative ranking of the arts.

The attempt to identify a singular way of engaging with and appreciating music experience is evident in the work of the nineteenth-century music critic Eduard Hanslick. In his book *On the musically beautiful* (first published in 1854) Hanslick argues an "absolute formalist" account of music that rests in the central belief that "The content of music is tonally moving forms" (1986, p. 29). For Hanslick, what music should express was "musical ideas", ideas that were "... an end in (themselves) ... in no way primarily a medium or material for the representation of feelings or conceptions" (1986, p. 28). Tibby, who is "profoundly versed in counterpoint," and follows the performance of Beethoven's Fifth in the score, exemplifies Hanslick's formalist listener. Hanslick's account of formalism has been highly influential in philosophical accounts of music and aesthetic theory in general, although few have held so strictly to his "contentless" view of musical meaning.

The enduring nature of the aesthetic theories of representationalism, expressivism, and, formalism, is evidenced in some contemporary accounts of the philosophy of music education. For example, Bennett Reimer's presentations (most recently, 2003) of music education as aesthetic education draw on the work of philosopher Suzanne Langer, and music theorist Leonard B. Meyer, to present an "absolute-expressionist" (Meyer, 1956) view of music appreciation. Langer proposes that art works are "presentational symbols" of emotions, whereby we do not experience the emotions as emotional states; rather we experience the "structure" of emotions. In short, music is a kind of formal analogue of emotional experience (1942/1979). Meyer's early account of music appreciation (1956) focuses on the ways in which the listener attends to musical structures, specifically, the ways in which musical expectations are "aroused," travel through a period of uncertainty, and are resolved in expected and/or unexpected ways. In such processes, uncertainty and instability are of paramount importance. As Meyer puts it: "... the uncertainty and lack of cognitive control created by intervening instability make the return to mentally manageable patterns satisfying. In short, it is the uncertainty-resolution ... process, not similarity of melodic, rhythmic, or tonal pattern, that unifies the succession of emotional states presented in a piece of music" (Meyer, 2001, p. 354). Reimer's use of the work of these two theorists emphasizes music listening as a prime mode of engagement in music appreciation, and suggests that it is through increasingly informed attention to and knowledge of musical structure/s and the feeling possibilities of such experience that music appreciation develops. This view has been challenged by those who espouse a "praxial" view of music engagement (Elliott, 1995, 2005; Regelski, 1998), suggesting that music appreciation, a capacity to "value knowledgeably" (Elliott, 1995, p. 56) occurs in and through all modes of musical engagement, and encompasses knowledge of social and cultural context, and the uses of music in experience.[3]

An exclusive focus on musical structure/s as the location of musical meaning has been challenged by postmodern critiques and accounts of meaning and value in the arts. Bowman suggests that

> Musical meanings are not structurally determined or defined. They arise and are sustained in cultural context, and are enmeshed in webs of interpretants; and thus, there is no definitively musical meaning for any musical event or sign situation. Musical meanings are multiple, fluid, and dynamic – perhaps, we might say, like a ship being perpetually rebuilt while at sea. (1998, p. 201)

If, as Bowman suggests, musical meanings and interpretations of a specific musical work can differ from one setting to another, then the central notions of modernist accounts of music appreciation are challenged, those of "autonomous form," eternal and universal properties, and, a specific mode of attention, the "disinterested." Kant's notion of "disinterestedness," central to Hanslick's view of music engagement, and later taken up by Bullough (1912) in his concept of "psychical distance," implies that music appreciation arises solely through the mode of audience-listening. Importantly the model of music listening from which this view has been developed is that of the nineteenth-century concert hall, so powerfully described by E. M. Forster. When we move beyond this setting to consider the models and modes of music listening in contemporary society, "disinterestedness" no longer holds as the singular form of attention in music appreciation. The exponential growth in the use of personal stereos such as I-Pods, Walkmans, and Discmans, has led to the use and appreciation of music by listening in and through other activities. Further, consideration of the modes of music engagement evidenced in a range of cultural settings reinforces the diversity of ways in which music appreciation is experienced and developed. For example, "… in traditional African societies a child's musical experience and development may well begin with hearing and sensing multiple bodily rhythms as it rides on its mother's back while she dances or with being dandled and bounced in time with the drums, and they continue through multiple socially sanctioned and encouraged musical and dance activities …" (Small, 1998, p. 207).

The admission of diverse views of musical appreciation and consideration of diverse modes of attending is reflected in a move away from "grand narratives" in contemporary philosophical theory in music. As Bowman comments:

> instead of one definitive account of music's nature and value, late twentieth-century thought appears more inclined to offer alternatives … contemporary thought is far more inclined to conceive of philosophy as a perspectival undertaking whose capacity to illuminate is partial, relative to point of view and method, capable of clarifying, yet capable of obfuscating at the same time. Most contemporary music philosophy has become more cautious in its claims, more sensitive to the profound multiplicity and diversity of its subject, and less inclined to assume that music – or anything else for that matter – is unconditionally good. The Western art music canon, once presumed the apotheosis of musical achievement is increasingly seen as one set of musical possibilities rather than the definitive one. (1998, p. 357)

E. M. Forster's set of musical possibilities as presented in his novels, is grounded in the Western art music canon, and draws on modernist aesthetic theories that have arisen in conjunction with that "canon." Contemporary philosophical approaches prompt us to consider both similarities *and* differences: in experience, context, and belief, and the shaping forces of these on our conception of music appreciation. I shall take up these notions later in this chapter.

## Music Appreciation: Psychological Accounts

The empirical investigation of music appreciation has been largely the concern of researchers in the psychology of music. In the subdisciplines of empirical aesthetics (Fechner, 1878/1978) and experimental aesthetics (Berlyne, 1971, 1974), researchers have sought to understand the nature of music perception and cognition in relation to those issues of musical meaning and appreciation raised in philosophical aesthetics. Consequently, the philosophical underpinnings of much research in both empirical and experimental aesthetics have been firmly modernist in conception, and concerned with identifying and measuring (predominantly) listeners' perception and conception of "autonomous musical form", the "universal features" of music (melodic, rhythmic, dynamic features, and their subcomponents), and, the distinctive ways in which listeners engage with and make meaning from music experience (representational, expressive, and/or formal accounts).

Despite this interest in issues that are related to music appreciation, in a recent major overview of research in the psychology of music (Deutsch, 1999), the terms appreciation and aesthetic do not appear in the index. The most nearly related term found is "affect" which is dealt with through discussion of "comparative music perception"; specifically, the perception and cognition of pitch, musical structures, and timbre, and consideration of the "aesthetic ideals" of novice and expert listeners in music listening experience (Carterette & Kendall, 1999, pp. 756–766). In recent consideration of music and emotion as an evaluative psychological concept a focus has been the "determination, or awareness, of music as eliciting liking or disliking; preference; emotion and mood; and aesthetic, transcendent, and spiritual experiences" (Juslin & Sloboda, 2001, p. 4). Tellingly, whilst the terms "aesthetic" and "affect" are indexed in this edited volume of research, the term "appreciation" does not appear. It could be speculated that the apparent dismissal of the term "appreciation" is symptomatic of a perception in the psychology of music that issues of "appreciation" are "soft" in comparison with the more scientifically determined notion of "preference." Alternatively, "appreciation" is a term so variously used and abused, it defies operational definition and subsequent measurement. It could be further speculated that the psychological focus on perception and cognition of music is viewed as a necessary precursor to any exploration of issues of appreciation, with studies of music preference making provision for the "subjective" judgments of music listeners. Clearly the term "appreciation" is a contested one in the psychology of music literature.

Psychological views of music "appreciation" issues have worked *from* the senses *to* the mind, primarily through the auditory sense (although not exclusively as demonstrated in psychogalvanic studies of aesthetic response). Such studies have focused on

auditory and sensory perception in order to identify the nature of this phenomenon and to measure its effects (awareness and intensity) in a sensory-experience orientation. Early work in experimental aesthetics has focused on measuring listener's perception of nonmusical acoustic stimuli such as isolated tones (Berlyne, 1971) or partial elements of musical systems such as tuning (Lynch & Eilers, 1991). Criticisms of this work center on the failure to distinguish between responding to isolated elements of sound rather than music wholes, and have led to a greater emphasis in recent psychological investigations on using partial ("bleeding chunks") or complete musical works as experimental items.

The identification and measurement of music perception and cognition through listening is fraught with difficulties, as the phenomenon is not readily observable. These difficulties are compounded when working with young children as their language skills are often not sufficiently developed to provide a clear indication of their understanding and appreciation. Nevertheless, research has suggested that young children are able to understand and respond to music concepts and terminology more readily than they are able to verbalize these (Costa-Giomi & Descombes, 1996; Hair, 1981, 1987). Consequently, researchers working with children, infants, and those not holding specialized music vocabulary (nonmusicians) have attempted to access and measure listening perception and cognition, preference and response through a range of secondary indicator strategies including:

- Eliciting verbal or written accounts during listening experience (Richardson, 1995).
- Eliciting verbal or written accounts after listening experience (Barrett, 2000/2001; Flowers, 1984; Nelson, 1985; Preston, 1994; Rodriguez, 1998; Rodriguez & Webster, 1997; Swanwick & Franca, 1999).
- Eliciting kinesthetic responses during or after the listening experience (Fung & Gromko, 2001; Gromko & Poorman, 1998).
- Eliciting graphic representations during or after listening experience (Hair, 1993), and verbal, visual, and kinesthetic responses (Kerchner, 2001).
- Observing respondents' actions in following maps during listening experience (Gromko & Russell, 2002).
- Eliciting response through manipulation of a "measurement" device (Byrnes, 1997; Madsen, Brittin, & Capparella-Sheldon, 1993a; Madsen, Byrnes, Capparella-Sheldon, & Brittin, 1993b; Madsen & Geringer, 1990).
- Observing respondents' attention focus, and duration of focus during listening (Sims & Nolker, 2002).
- Head-turn preference procedures (HTPP) (Schellenberg & Trehub, 1999; Trainor, Tsang, & Cheung, 2002; Zentner & Kagan, 1996).

Research in the developmental psychology of music has had a largely psychometric orientation, seeking to identify and measure developmental trajectories and provide accounts of the development of music perception and cognition, preference and response (Trehub, 2003). Studies in musical preference have attempted to identify listeners' preferences for musical styles (LeBlanc, Sims, Siivola, & Obert, 1996), musical genres such as world music (Demorest & Schultz, 2004), and various elements of music such as tempo (LeBlanc, Colman, McCrary, Sherril, & Malin, 1988; Montgomery, 1996), and dynamic nuance (Burnsed, 2001).

In research that has focused on eliciting verbal interpretive response (spoken and/or written) to music listening experience the following developmental trends are suggested:

- young children are more concerned with describing isolated properties of sound than with the affective aspects of music (Rodriguez & Webster, 1997);
- children's most common form of description centers on naming instruments (Flowers, 1998, 2000; Flowers & Wang, 2002);
- musically untrained children's and adults' verbal responses are primarily concerned with "extra-musical" references with some references to timbre, tempo, and dynamics (Flowers, 1990); and
- children move progressively through stages dominated respectively by:
  1. a focus on the materials of music (isolated properties),
  2. a focus on expressive properties, and
  3. a focus on issues of form and structure (Swanwick & Franca, 1999).

The separation of affective properties from issues of cognition that is implied in many of these findings draws on a "dualistic" view of music understanding, a view that places affective issues prior to (and, in a Kantian sense, inferior to) those dealing with structure, and form (formal properties). Importantly, such a hierarchic distinction promulgates the Cartesian separation of the cognitive from the sensory, of the mind from emotion. This view of the nature of human thought and action has been widely disputed and subject to extensive criticism in such fields as philosophy (Lakoff & Johnson, 1999) and cognitive neuroscience (Damasio, 1994, 2000, 2003). Studies of children's verbal response to music listening experience tend to report what children say in a literal sense, that is, the child's utterance is taken at face value with little exploration of the notion of "implied meaning" or an intended distinction between what is said and what is meant. When children's verbal responses to music listening are examined for use of figurative language and metaphor in making and communicating meaning (Barrett, 2001, 2000/2001) the hierarchical distinction between materials (isolated properties of sound, instruments), expression, and structure and form is less clear-cut. Children's (and adults') use of figurative language and metaphor is a means of connecting cognition and emotion, a connection that belies the dualistic separation of these issues.

A concern to find alternative means to access children's communication of musical appreciation to music listening experience has led to the study of children's decision-making as composers (Barrett, 1996, 1998, 2002, 2003a, 2003b). This research further challenges the notion of a developmentally hierarchic distinction between materials, expression, and structure, and form. It could be speculated that research that is theorized from a modernist and dualistic account of musical experience and appreciation inevitably produces results that present a developmental trajectory based in a modernist and dualistic account of musical experience and appreciation.

In summary, much of the research that has explored music appreciation through the lenses of psychology and developmental psychology has focused on identifying and measuring individuals' musical attention, focus, and preference as listeners. Much of this research has been concerned with mapping the capacity to identify and respond to music elements such as pitch, melodic and rhythmic patterning, temporal variation,

and harmonic complexity: that is, the concerns of modernist aesthetics. Other work has examined individuals' use of nonmusical imagery in describing and or attributing expressive or representational meaning to the experience of music listening. Significantly, much of this work has been undertaken with music of the Western canon (classical and popular), and confirms a focus on the concerns of modernist aesthetic theories. These trends are perhaps indicative of the influence of an approach to music education theory and practice, in which music listening has been a prime mode of musical engagement, with a specific focus on informed attention to and knowledge of musical structure/s and the feeling possibilities of such experience (absolute-expressionism). Whilst the psychology of music does not explicitly espouse the tenets of absolute-expressionist aesthetic theory, a critical reading of the work in the field suggests that this underpins much of the research endeavor.

Just as contemporary philosophy beyond the field of music education has questioned the capacity of "grand narratives" such as "modernist aesthetics" to account for the evident "differences" in human thought and understanding when variations of culture and context are taken into account, so has contemporary psychology. In recent work the notion of a cultural psychology of human development (Cole, 1996; Rogoff, 2003) has reemerged. Cultural psychological approaches acknowledge the shaping forces of culture in and on human thought and action. Such work moves beyond the notion of culture and context as "variables" to be manipulated, to acknowledge that culture is deeply implicated in all areas of human development, thought, and action. Whilst there is significant growth in cultural psychological approaches in such areas as mathematics and symbol making and use, the study of music through a cultural psychological lens is less developed, and provides rich possibilities for further study.

## Music Appreciation: Sociological Approaches

Sociological (and psychosociological approaches)[4] to the study of music appreciation have worked *from* the description and analysis of the functions and meanings of music in social and cultural settings, *to* the mind, in a relational/use orientation that acknowledges the interdependent relationships between social, cultural, and psychological factors in music appreciation. Many studies have been less concerned with arriving at a framework (philosophical and/or developmental) that lays out a pancultural approach to aesthetic valuing and music appreciation, than with seeking to understand those particular social and cultural factors that underlie and influence our appreciative choices.[5] Such acknowledgment of music appreciation as a process that is shaped by social and cultural forces, leading to varying presentations of "what" is music appreciation, throws musical "differences" into sharp relief. Whilst the study of the sociology of music education is a relatively recent phenomenon, the antecedents for this work may be found in that of ethnomusicologists as the concerns of sociology intersect with those of anthropology and ethnomusicology. Writing of the research intent and endeavour of the disciplines of anthropology and ethnomusicology, Judith Becker reminds us that whilst both disciplines have adherents to universalist or particularist views, respectively interested in identifying commonalities and understanding difference,

both disciplines are characterized by an "attempt to understand behaviours and belief systems from within ... to understand other musics and other styles of emotional expression from the perspective of their owners" (2001, p. 135).

Sociological and sociopsychological studies of music appreciation have been concerned with the shaping forces *on* and *of* musical taste, musical preference, and, musical engagement and use. In regard to the former, shaping forces "*on*," research has sought variously to understand the ways in which factors such as gender (Green, 1997; McClary, 1991; McRobbie, 1990), age (Behne, 1997; Boal-Palheiros & Hargreaves, 2001; Hargreaves & North, 1999; Zillman & Gan, 1997), and social class (Willis, 1978) contribute to the shaping of music appreciation and musical engagement and use.

Sociological researchers have sought to understand the influence of world musics (Burton, 1997; Volk, 1998) and popular and rock musics (Frith, 1978, 1983, 1996) on shaping musical appreciation, and the influence of music in establishing particular social, cultural, and personal "positions" and identities. McRobbie's (1993) analysis of girls' participation in popular music, specifically rave culture, demonstrates the ways in which this music culture silences girls through an insistence on dance as their form of participation. Studies have suggested that music is used as a "marker" of particular affiliations that influences adolescents' social categorization of self and others (North & Hargreaves, 1999; Tarrant, Hargreaves, & North, 2001). Musical listening and/or participation provide opportunities for individuals to "try on" other presentations of self (Becker, 2001; DeNora, 2000). This suggestion of the transformative possibilities of music experience is evident in E. M. Forster's description of a "transformed" Miss Lucy Honeychurch, one who is admitted to another world when playing Beethoven, and transformed from a "commonplace person" to a more wondrous "other." However, in contemporary applications, the "other" may be less defined by romantic ideals of the transcendent, and more by the particulars of historical, socio-cultural, and geographic location. Increasingly music has been viewed as a mechanism or device used by listeners to achieve or regulate emotional states, as "... a device that actors employ for entraining and structuring feeling trajectories" (DeNora, 2001, p. 173)

The emphasis on the uses and processes of music evident in sociological approaches to music appreciation, has moved us away from a focus on a unidirectional relationship between the mind and the senses observed in much philosophical and psychological endeavor (*from* the mind *to* the senses, or *from* the senses *to* the mind) to one that admits of the influencing factors of sociocultural setting. A shift is evident from the singular analysis of the music "object or event," to examination of the human experience of such objects and events, to the interrogation of the shaping role of music (object and event) in the conduct of daily life. In this process, the appreciating mind has become "situated" and similarities *and* differences acknowledged.

## Music Appreciation: Accounts of Similarity *and* Difference

Dissanayake (2000) proposes a "naturalistic aesthetics" in which she asserts that appreciation of the arts develops from early rhythmic-modal experiences between mother and

infant, from our early experience of mother-infant "intimacy and love." These experiences are shaped by five psychosocial needs, those of mutuality, belonging to, finding and making meaning, competence through handling and making, and, elaborating (2000, p. 8). For Dissanayake, art develops from the "active human capacity and motivation to elaborate and respond to elaborations" (2000, p. 207). She proposes four criteria for "assigning aesthetic quality": accessibility coupled with strikingness; tangible relevance; evocative response; and, satisfying fullness (2000, pp. 209–218). Whilst Dissanayake's initial proposal rests in musicoverbal interchanges between mother and infant, her account of a naturalistic aesthetic is argued largely through reference to the visual arts. Such a reliance on the visual may be the inevitable result of writing about intangible music in tangible images. However, given that the proposal of a "naturalistic aesthetics" is suggested to have universal relevance (a return to a grand narrative?), the theory's capacity to account across all art forms is of importance. Whilst Dissanayake's theory may be criticized for its valorization of traditional societies, and its Western and romanticized view of the mother-infant relationship, the admission of culture in shaping and developing appreciation is of importance. In striving to encompass what is "similar," Dissanayake leads us once more to think about differences.

In parallel moves in recent philosophy, the recognition and valuing of difference has been taken up:

> Different musics serve different needs and answer to different interests. There is growing recognition that the evaluation of music by values foreign to its intent is as unjustified as colonial occupation of territory. Recognition of the integrity of diverse and divergent musics, and of the need to understand them on their own terms, has transformed the way most people engage with music philosophy today. Musics of different cultures clearly do not all conform to the same sets of concerns, cannot be judged by the same standards without distortion. "Other" it is increasingly recognized, must not be taken for "worse," only for "different." (Bowman, 1998, p. 357)

This recognition of "differences" provides opportunities and challenges for music education. Somewhat like Bowman's philosophical voyagers, for whom musical meanings are multiple, fluid and dynamic, music educators are challenged to rebuild perpetually  the craft of music appreciation whilst charting their way through philosophical, psychological, sociological, and increasingly interdisciplinary waters. From a journey that commenced in the modernist ideal of identifying similarities in music experience, founded in notions of "autonomous form," eternal and universal properties, and, the "disinterested" mode of attention, we are challenged to explore the opportunities offered by identifying differences.

In doing so, it is important to remind ourselves that "… modes of listening implicate not only structures of knowledge and beliefs, but intimate notions of personhood and identity. Listening addresses interiors; listening provides access to what is hidden from sight" (Becker, 2001, p. 137). Importantly, all modes of music engagement are drawn on in the processes of music appreciation, those of listening, of improvising and composing, of playing and performing. All of these modes implicate structures of knowledge,

belief, personhood, and identity. In short, to engage in music appreciation provides opportunity to acknowledge the knowledge structures we hold, and the underlying patterns of belief, personhood, and identity that inform and construct our views of music, a process that may assist us in avoiding "ship-wrecks in the music's flood" (Forster, 1910/1976, pp. 44–45).

## Author's Note

This chapter draws in part on arguments presented in Barrett (2006).

## Notes

1. For an account of these theories and their application to music see Kivy (1980, 1984, 1990).
2. For a critique of the "objectification" of music as a "musical work" see Lydia Goehr (1992).
3. For an account of the development of the praxial philosophy of music education see McCarthy and Goble (2005).
4. I include psychosociological studies in this section as an indicator of increasing interdisciplinary work.
5. Inevitably notable exceptions spring to mind, including Adorno's promulgation of a specific way of listening, "structured listening" and his condemnation of popular music (1962/1976).

## References

Adorno, T. (1962/1976). *Introduction to the sociology of music*. New York: Seabury Press.

Barrett, M. S. (1996). Children's aesthetic decision-making: An analysis of children's musical discourse as composers. *International Journal of Music Education, 28*, 37–62.

Barrett, M. S. (1998). Children composing: A view of aesthetic decision-making. In B. Sundin, G. E. McPherson, & G. Folkestad (Eds.), *Children composing* (pp. 57–81). Malmo: Lund University Press.

Barrett, M. S. (2000/2001). Perception, description and reflection: Young children's aesthetic decision-making as critics of their own and adult compositions. *Bulletin of the Council for Research in Music Education, 147*, 22–29.

Barrett, M. S. (2001). Going beyond the literal: Probing children's musical thinking as musical critics. *Proceedings of the third Asia-Pacific Symposium on Music Education Research, Volume 1* (pp. 152–158). Nagoya: Aichi University.

Barrett, M. S. (2002). Towards a "situated" view of the aesthetic in music education. *Journal of Aesthetic Education, 36*(3), 67–77.

Barrett, M. S. (2003a). Freedoms and constraints: Constructing musical worlds through the dialogue of composition. In M. Hickey (Ed.), *Composition in the schools: A new horizon for music education* (pp. 3–27). Reston, VA: MENC.

Barrett, M. S. (2003b). Meme engineers: Children as producers of musical culture. *International Journal of Early Years Education, 11*(3), 195–212.

Barrett, M. S. (2006). Aesthetic response. In G. E. McPherson (Ed.), *The child as musician: A handbook of musical development* (pp. 173–191). Oxford: Oxford University Press.

Becker, J. (2001). Anthropological perspectives on music and emotion. In P. N. Juslin & J. A. Sloboda (Eds.), *Music and emotion* (pp. 135–160). Oxford: Oxford University Press.

Behne, K.-E. (1997). The development of "Musikerleben" in adolescence: How and why young people listen to music. In I. Deliege & J. A. Sloboda (Eds.), *Perception and psychology of music* (pp. 143–159). East Sussex: Psychology of Music Press.

Berlyne, D. E. (1971). *Aesthetics and psychobiology*. New York: Appleton Century Crofts Publishers.

Berlyne, D. E. (1974). *Studies in the new experimental aesthetics: Steps towards an objective psychology of aesthetic appreciation*. Toronto: John Wiley.

Boal-Palheiros, G. M., & Hargreaves, D. J. (2001). Listening to music at home and at school. *British Journal of Music Education, 18*(2), 103–118.

Bowman, W. (1998). *Philosophical perspectives on music*. New York: Oxford University Press.

Bullough, E. (1912). "Psychical distance" as a factor in art and as an aesthetic principle. *British Journal of Psychology, 5*, 87–98.

Burnsed, V. (2001). Differences in preference for subtle dynamic nuance between conductors, middle school music students, and elementary school students. *Journal of Research in Music Education, 49*(1), 49–56.

Burton, B. (1997). The role of multicultural music education in a multicultural society. In R. R. Rideout (Ed.), *On the sociology of music education* (pp. 81–84). Norman: University of Oklahoma School of Music.

Byrnes, S. R. (1997). Different-age and mentally handicapped listeners' response to Western art music selections. *Journal of Research in Music Education, 45*(4), 568–579.

Carterette, E. C., & Kendall, R. A. (1999). Comparative music perception and cognition. In D. Deutsch (ed.), *The psychology of music* (2nd ed.) (pp. 725–792). San Diego, CA: Academic Press.

Cole, M. (1996). *Cultural psychology: The once and future discipline*. Cambridge, MA: the Bellknapp Press of Harvard University Press.

Costa-Giomi, E., & Descombes, V. (1996). Pitch labels with single and multiple meanings: A study with French-speaking children. *Journal of Research in Music Education, 44*(3), 204–214.

Damasio, A. (1994). *Descartes' error: Emotion, reason and the human brain*. New York: Quill (Harper Collins).

Damasio, A. (2000). *The feeling of what happens: Body, emotion and the making of consciousness*. London: Vintage.

Damasio, A. (2003). *Looking for Spinoza: Joy, sorrow, and the feeling brain*. New York: Harcourt.

Demorest, S. M., & Schultz, S. J. M. (2004). Children's preference for authentic vs. arranged versions of world music recordings. *Journal of Research in Music Education, 52*(4), 300–313.

DeNora, T. (2000). *Music in everyday life*. Cambridge: Cambridge University Press.

DeNora, T. (2001). Aesthetic agency and musical practice: New directions in the sociology of music and emotion. In P. N. Juslin & J. A. Sloboda (Eds.), *Music and emotion: Theory and research* (pp. 161–180). Oxford: Oxford University Press.

Deutsch, D. (1999). *The psychology of music* (2nd ed.). San Diego, CA: Academic Press.

Dissanayake, E. (2000). *Art and intimacy: How the arts began*. Seattle, WA: University of Washington Press.

Elliott, D. J. (1995). *Music matters: A new philosophy of music education*. New York: Oxford University Press.

Elliott, D. J. (Ed.). (2005). Praxial Music Education: Reflections and dialogues. New York: Oxford University Press.

Fechner, G. (1878/1978). *Die forschule der aesthetik* [The introduction to aesthetics]. Hildesheim: Geor Holms.

Flowers, P. J. (1984). Attention to elements of music and effect of instruction in vocabulary on written descriptions of music by children and undergraduates. *Psychology of Music, 12*, 17–24.

Flowers, P. J. (1990). Listening: The key to describing music. *Music Educators Journal, 77*, 21–23.

Flowers, P. J. (1998). Music vocabulary of first-grade children: Words listed for instruction and their actual use. *Journal of Research in Music Education, 46*(1), 5–15.

Flowers, P. J. (2000). The match between music excerpts and written descriptions by fifth and sixth graders. *Journal of Research in Music Education, 48*(3), 262–277.

Flowers, P. J., & Wang, C. (2002). Matching verbal description to musical excerpt: the use of language by blind and sighted children. *Journal of Research in Music Education, 50*(3), 202–214.

Forster, E. M. (1905/1985). *Where angels fear to tread*. Middlesex, England: Penguin Books Ltd.

Forster, E. M. (1906/1978). *Room with a view*. Middlesex, England: Penguin Books Ltd.

Forster, E. M. (1910/1976). *Howards End*. Middlesex, England: Penguin Books Ltd.

Frith, S. (1978). *The sociology of rock*. London: Constable.

Frith, S. (1983). *Sound effects: Youth, leisure, and the politics of rock*. London: Constable.

Frith, S. (1996). *Performing rites*. Oxford: Oxford University Press.

Fung, V., & Gromko, J. (2001). Effects of active vs. passive listening on the quality of children's invented notations and preferences for two Korean pieces. *Psychology of Music, 29*(2), 128–138.

Goehr, L. (1992). *The imaginary museum of musical works: An essay in the philosophy of music*. Oxford: Oxford University Press.

Green, L. (1997). *Music, gender, and education*. Cambridge: Cambridge University Press.

Gromko, J., & Poorman, A. S. (1998). Does perceptual-motor performance enhance perception of patterned art music? *Musicae Scientiae: The Journal of the European Society for Cognitive Sciences of Music, 2*(2), 157–170.

Gromko, J., & Russell, C. (2002). Relationships among young children's aural perception, listening condition, and accurate reading of graphic listening maps. *Journal of Research in Music Education, 50*(4), 333–342.

Hair, H. (1981). Verbal identification of musical concepts. *Journal of Research in Music Education, 29*(1), 11–21.

Hair, H. (1987). Descriptive vocabulary and visual choices: Children's responses to conceptual changes in music. *Bulletin of the Council for Research in Music Education, 91*, 59–64.

Hair, H. I. (1993/1994). Children's descriptions and representations of music. *Bulletin of the Council for Research in Music Education, 119*, 41–48.

Hanslick, E. (1986). *On the musically beautiful: A contribution towards the revision of the aesthetic of music* (Trans. G. Payzant from the 8th ed., 1891). Indianapolis, IN: Hackett Publishing Company.

Hargreaves, D. J., & North, A. C. (1999). Developing concepts of musical style. *Musicae Scientiae, 3*, 193–216.

Juslin, P. N., & Sloboda, J. A. (2001). Music and emotion: Introduction. In P. N. Juslin & J. A. Sloboda (Eds.), *Music and emotion* (pp. 3–20). Oxford: Oxford University Press.

Kant, I. (1952). *The critique of judgement* (J. C. Meredith, Trans.). Oxford: Clarendon Press.

Kerchner, J. (2001). Children's Verbal, Visual, and Kinaesthetic Responses: Insight into their Music Listening Experience. *Bulletin for the Council of Research in Music Education, 146*, 31–50.

Kivy, P. (1980). *The corded shell: Reflections on music expression*. Princeton, NJ: Princeton University Press.

Kivy, P. (1984). *Sound and semblance: Reflections on musical representation*. Princeton, NJ: Princeton University Press.

Kivy, P. (1990). *Music alone: Philosophical reflections on the purely musical experience*. Ithaca, NY: Cornell University Press.

Lakoff, G., & Johnson, M. (1999). *Philosophy in the flesh: The embodied mind and its challenge to western thought*. New York: Basic Books.

Langer, S. (1942/1979). *Philosophy in a new key: a study in the symbolism of reason, rite, and art* (3rd ed.). Cambridge, MA: Harvard University Press.

LeBlanc, A., Colman, J., McCrary, J., Sherril, C., & Malin, S. (1988). Tempo preferences of different age music listeners. *Journal of Research in Music Education, 36*(3), 156–168.

LeBlanc, A., Sims, W. L., Siivola, C., & Obert, M. (1996). Music style preferences of different age music listeners. *Journal of Research in Music Education, 44*(1), 49–59.

Lynch, M. P., & Eilers, R. E. (1991). Children's perception of native and non-native music scales. *Music Perception, 9*(1), 121–132.

Madsen, C. K., Brittin, R. V., & Capparella-Sheldon, D. A. (1993a). An empirical investigation of the aesthetic response to music. *Journal of Research in Music Education, 41*(1), 57–69.

Madsen, C. K., Byrnes, S. R., Capparella-Sheldon, D. A., & Brittin, R. V. (1993b). Aesthetic responses to music: Musicians versus non-musicians. *Journal of Music Therapy, 30*(3), 174–191.

Madsen, C. K., & Geringer, J. M. (1990). Differential patterns of music listening: Focus of attention of musicians versus non-musicians. *Bulletin of the Council for Research in Music Education, 105*, 45–47.

McCarthy, M., & Goble, S. (2005). The praxial philosophy in historical perspective. In D. J. Elliott (Ed.), *Praxial music education: Reflections and dialogues* (pp. 19–51). New York: Oxford University Press.

McClary, S. (1991). *Feminine endings: Music, gender and sexuality*. Minneapolis, MN: University of Minnesota Press.

McRobbie, A. (1990). *Feminism and youth culture: From Jackie to just seventeen*. London: MacMillan.

McRobbie, A. (1993). Shut up and dance: youth culture and changing modes of femininity. *Young, 1*(2), 13–31.

Meyer, L. B. (1956). *Emotion and meaning in music*. Chicago, IL: University of Chicago Press.

Meyer, L. B. (2001). Music and emotion: Distinctions and uncertainties. In P. N. Juslin & J. A. Sloboda (Eds.), *Music and emotion: Theory and research* (pp. 341–360). Oxford: Oxford University Press.

Montgomery, A. (1996). Effect of tempo on music preferences of children in elementary and middle school. *Journal of Research in Music Education, 44*(2), 134–146.

Nelson, D. J. (1985). Trends in the aesthetic responses of children to the musical experience. *Journal of Research in Music Education, 33*(3), 193–203.

North, A. C., & Hargreaves, D. J. (1999). Music and adolescent identity. *Music Education Research, 1*(1), 75–92.

Preston, H. (Ed.). (1994). Listening, appraising, and composing: Case studies in music. *British Journal of Music Education, 11*(2), 15–55.

Regelski, T. A. (1998). The Aristotelian bases of praxis for music and music education as praxis. *Philosophy of Music Education Review, 6*, 22–59.

Reimer, B. (2003). *A philosophy of music education: Advancing the vision* (3rd ed.). Upper Saddle River, NJ: Prentice Hall.

Richardson, C. P. (1995). The musical listening processes of the child: An international perspective. In H. Lee & M. Barrett (Eds.), *Honing the craft: Improving the quality of music education* (pp. 212–219). Hobart: Artemis Publishing Consultants.

Rodriguez, C. X. (1998). Children's perception, production and description of musical expression. *Journal of Research in Music Education, 46*(1), 48–61.

Rodriguez, C. X., & Webster, P. R. (1997). Development of children's verbal interpretative responses to music listening. *Bulletin of the Council for Research in Music Education, 134*, 9–30.

Rogoff, B. (2003). *The cultural nature of human development*. New York: Oxford University Press.

Schellenberg, E. G., & Trehub, S. E. (1996). Natural intervals in music: a perspective from infant listeners. *Psychological Science, 7*, 272–277.

Sims, W., & Nolker, D. B. (2002). Individual differences in music listening responses in kindergarten children. *Journal of Research in Music Education, 50*(4), 292–300.

Small, C. (1998). *Musicking: The meanings of performing and listening*. Hanover, NH: Wesleyan University Press.

Swanwick, K., & Franca. C. C. (1999). Composing, performing and audience-listening as indicators of musical understanding. *British Journal of Music Education, 16*(1), 5–19.

Tarrant, M., Hargreaves, D. J., & North, A. C. (2001). Social categorization, self-esteem, and the estimated musical preferences of adolescents. *Journal of Social Psychology, 141*, 565–581.

Trainor, L. F., Tsang, C. D., & Cheung, V. H. W. (2002). Preference for musical consonance in 2-month-old infants. *Music Perception, 20*, 185–192.

Trehub, S. E. (2003). Toward a developmental psychology of music. In *Annuals of the New York Academy of Science*, Nov: *999*: 402–413.

Volk, T. (1998). *Music, education, and multiculturalism: Foundations and principles*. New York: Oxford University Press.

Willis, P. (1978). *Profane culture*. London: Routledge.

Zenter, M. R., & Kagan, J. (1996). Perception of music by infants. *Nature, 383*, 29.

Zilman, D., & Gan, S.-L. (1997). Musical taste in adolescence. In D. J. Hargreaves & A. C. North (Eds.), *The social psychology of music* (pp. 161–187). Oxford: Oxford University Press.

# INTERNATIONAL COMMENTARY

# 39.1

# Soundscapes of Music Appreciation in Japan

**Koji Matsunobu**
*University of Illinois at Urbana-Champaign, U.S.A.*

One of the Japanese contributions to research in music appreciation can be found in the emphasis on the continuity between musical and natural sounds. Scientists suggest that the Japanese language in terms of its facilitation of specific brain function, promotes listening to natural sounds as well as sounds of Japanese instruments, a process that occurs in the left hemisphere of the brain. This phenomenon is believed to stem from the brain's capacity to process and discern a wide range of vowel sounds (Tsunoda, 1978). Indeed, the close union of musical and natural sounds is depicted in Japanese classic literature such as *The Tale of Genji* (Kikkawa, 1984) as well as in the Japanese genre of poetry called *Haiku* (Horikiri, 1998). Haiku poets like Basho (1644–1694) acknowledge that aesthetic encounters arise in natural surroundings, rather than in concert halls, and that nature is a necessary condition to achieve aesthetic being (Otsuru, 2004). Some historical records of Westerners who visited Japan during the nineteenth century illustrate that this aesthetic sensitivity was shared by ordinary people at the time (Naito, 2005). As are indicated in these historical sources, the Japanese tended to be more inclined toward natural sounds such as those coming from insects; it was not uncommon for people to spend time listening to and appreciating the sounds of insects (Kikkawa, 1984; Torigoe, 1997). This form of sensitivity still prevails today. There appears to be a significant growth and interest in "soundscape" activities, followed by scholars' continuing concerns and accumulated studies on them, something of a rare occurrence in places outside of Japan (Torigoe, 1997). The studies in the area of soundscape have noticeably expanded the scope of music appreciation to encompass issues in cultural studies, ecology, ethnomusicology, architecture design, and life history (see articles in Tanimura & Torigoe, 1997).

# References

Horikiri, M. (1998). *Basho no otofukei* [Soundscape of Basho]. Tokyo: Perikansha.
Kikkawa, E. (1984). *Nihon ongaku no biteki kenkyu* [The aesthetics of Japanese music]. Tokyo: Ongaku no Tomosha.

*L. Bresler (Ed.), International Handbook of Research in Arts Education, 621–622.*

Naito, T. (2005). *Meiji no oto: Seiyojin ga kiita kindai nihon* [Sounds of Meiji: Heard by westerns in modern Japan]. Tokyo: Chuo Koron Shinsha.

Otsuru, T. (2004). Kotoba eno michi: Geijutsu no genshogaku e mukete [The road to language: Toward the phenomenology of art]. *Shiso, 968*, 67–85.

Tanimura, A., & Torigoe, K. (Eds.). (1997). Saundosukepu [Soundscape]. *Gendai no Esupuri* [Contemporary Spirit] (Vol. 354). Tokyo: Shibundo.

Torigoe, K. (1997). *Saundosukepu: Sono shiso to jissen* [Soundscape: Its theory and practice]. Tokyo: Kashima Shuppankai.

Tsunoda, T. (1978). *Nihonjin no no: No no hataraki to tozai no bunka* [Japanese brains: The function of brain and the culture of the East and the West]. Tokyo: Taishukan Shoten.

# 40

# LATER "IN THE EARLY WORLD": THE CHANGING ROLE OF POETRY AND CREATIVE WRITING IN THE K-12 CLASSROOM

**Stuart D. Lishan*** and **Terry Hermsen**[†]

\* *Ohio State University, U.S.A.;*
[†] *Otterbein College, U.S.A.*

## Introduction

In this chapter we trace three strands that have contributed to poetry and creative writing's emerging role in the K-12 classroom: (1) the shift from New Critical based pedagogical strategies to reader-response influenced techniques where the transactions and processes of negotiation between text, reader, and writer have resulted in more decentralized, student-centered, and participatory learning environments; (2) a recognition among linguists, philosophers, and cognitive scientists that metaphor and analogy, long the province of poetry, are at the heart of how the mind uses language to create thought; and (3) the interest in the teaching of creative writing, fostered originally by the poetry-in-the-schools movement in the United States in the 1970s, but gradually spreading globally.

## The Teacher, the Critic, and the Poet

Creative writing exercises and assignments are not only excellent pedagogical tools to teach students those process-level skills of reading and writing, but they also can reinforce knowledge-based skills more broadly throughout the curriculum. That is to say, creative writing can assist educators in their goals of helping to enable and empower students to develop, synthesize, and organize thoughts, feelings and understandings about a subject. At the same time such an application can help us to retain, or in many cases recover, a perspective of openness and receptivity so necessary for productive inquiry. Elwyn Richardson, who, in his book, *In the Early World* (1964), documented his work with elementary school age students at Oruaiti school in northern New Zealand, seemed to have an intuitive awareness of how creative writing could function in this way in the classroom. He brought poetry back into the hands of his students and linked it to the whole of their study, demonstrating how creative writing can become a

*L. Bresler (Ed.), International Handbook of Research in Arts Education, 623–638.*
© 2007 *Springer.*

bridge for integrating and uniting a whole arts-based curriculum. Not an advocate of "anything-goes-just-express-yourself," Richardson tried to develop in his students a responsive yet critical eye – for the shape of an argument or a piece of clay pottery, for the line of a lithograph or the turn of a poem. Writing became an art and art became a way of making meaning. As such, by placing poetry and creative writing (in this chapter, the terms will be used interchangeably when the assignments discussed are not necessarily poetry specific) at the center of a web linking all of his students' learning, he anticipated many of the discoveries into the impact of the arts on student learning that have emerged in the succeeding years.

One of Richardson's methods was to make a habit of requesting what he called "ten minutes' thought writing to a set topic" (p. 108), the strategy of free-writing so important to the invention part of the writing process (DeWitt, 2001). "We found it useful to write about unfamiliar things that were still close enough to our experience to warrant some attention" (p. 111), Richardson writes. He describes how one student chose to write about "Feeling a Pine Cone in my Hand" (p. 111), or how others described seagulls or the sounds of engines (pp. 110–111), or the "Warmth of the Kitchen" (p. 108). The same year that Richardson's book appeared, J.R.R. Tolkien published his now famous essay, *On Fairy-Stories*, in which he explains his notion of "Recovery" (1964, p. 46), one of the "prime values," he argues, that fairy-stories offer. We "need recovery" (p. 57), he explains. "We should look at green again and be startled anew [....] Recovery […] is a regaining – regaining of a clear view" (p. 57). Recovery is exactly what seems to have been occurring among the students in Richardson's classroom at Oruaiti School.

Using creative writing as an inherent part of the curriculum did not begin exclusively with Richardson, but he did, at that time, produce one of its most sustainable models. Other progenitors helped lay the ideological foundation for the use of poetry and creative writing in the classroom. Several decades before Richardson, for example, Louise Rosenblatt (1938) suggested a way of responding to literature that involved a "personal sense" (p. 60), "an unself-conscious, spontaneous and honest reaction" (p. 67). In a similar vein, Robert Frost (1966) anticipated the metaphor revolution in the late twentieth century, when he claimed:

> Unless you are at home in the metaphor, unless you have had your proper poetical education in the metaphor, you are not safe anywhere. Because you are not at ease with figurative values: you don't know the metaphor in its strength and its weakness. You don't know how far you may expect to ride it and when it may break down with you. You are not safe in science; you are not safe in history […].
> (p. 39)

Taken together, Rosenblatt and Frost suggest that poetry in particular and creative writing in general can be the medium of expression by which a personal, unself-conscious, spontaneous, honest reader response can be integrated with a "proper … education in the metaphor" (Frost, p. 39). At some level Richardson seems to have understood this. In this chapter, we trace out many changes in the attitudes toward an

application and appreciation of the teaching of poetry and creative writing, but none that go quite as far as Richardson … yet.

## The Cognitive Foundation of Metaphor: Implications for Teaching

The latter parts of the twentieth and the beginning of the twenty-first century have been awash in a new recognition of the centrality of metaphor to the formation of thought. While such a revolution in thinking has perhaps only begun to infiltrate teaching practices, philosophers, linguists, poets, semioticians, and cognitive scientists have come to support Robert Frost's inkling from the 1930s. His definition of thinking as "just putting this and that together … just saying one thing in terms of another" (1966, p. 41) has been picked up by a wide range of investigators, who have laid the groundwork for a deep application of metaphor as a tool to transform the teaching of the literary arts.

Roman Jakobson (1971) is the linguist and semiotician most responsible for this seismic shift in our understanding of metaphor (Hawkes, 1977, p. 141). Two keys within Jakobson's work provide entrance to a more active, creative pedagogy. The first is his splitting of all speech between either the metaphoric or the metonymic (Hawkes, 1977, pp. 77–79), the latter of which could best be understood as the "replacement mode" of language. It serves the "communicative function" of day-to-day talk, allowing us, as Gibbs (1994) puts it, to say such things as "Ozawa GAVE a terrible concert last night" (p. 324). What, he points out, does "gave" stand for but a metonymic means of referencing the whole experience of the music? "Gave" gets us by. It saves us from having to detail every painful off-note, every itch of restlessness in the audience. Similarly, in a large percentage of our communication, we rely on just such metonymic power to "get by," relying on established ways to pass on information that needs to be conveyed. Appropriately, *conveyed* is an instructive word here, as it illustrates Jakobson's principle that metonymic speech is used like a conveyor belt to load information from one place to another.

Where Jakobson's theories become most useful for teachers is his characterization of metaphor as the associative tool of thought, allowing access from the communicative plane to a rich world of links and pairings. Metaphor is where language and thought is taken apart and spliced together. Think of the branching of an elaborate forest or web, where one strand can lead to thousands of others, vs. the image of a conveyor belt, and you have something of the difference Jakobson proposes between the metaphoric function of language and the metonymic. In the metaphoric realm, we can take a word such as "smoke" and link it not just with house fires or cigarettes but also, by extension, with any other term in the language. A student might link "smoke" with the word "swimmer" and imagine a man standing before a field at night,

Looking down at the valley,
With smoke being the best swimmer
              (Laura M., 7th grade, Westerville, Ohio.) (Hermsen, 2005)

Such a construction evokes a whole new reference for the word. The ability of metaphor to create NEW meanings is where the poetic function of speech takes on irreplaceable importance.

Other philosophers and linguists also offer support for transforming the use of metaphor in the classroom (Fauconier & Turner, 2002; Hofstadter, 2001; Johnson, 1987; Lakoff & Turner, 1989). Lakoff and Turner, for instance, claim that when Frost writes "Two roads diverged in a yellow wood . . ." he is tapping into a common cultural stream of a metaphor that says "life is a journey," which we avail of all the time when speaking of decisions and "turning points" in our lives (p. 3). Hofstadter puts the general insight this way: "Every concept we have is essentially nothing but a packaged bundle of analogies [. . . and] all we do when we think is move fluidly from concept to concept – in other words, to leap from one analogy-bundle to another" (p. 500). The use of metaphor, then, creates new "analogy bundles," which can result in new conceptual frameworks for our thinking.

Such theory is beginning to "trickle down" into research and classroom practices. In a study of forty-two 10th grade students, Hermsen (2003) found that when students received training in both recognizing and writing metaphors, their abilities to shape "an engaged view" of the world around them increased, as evidenced by their application of metaphor to the interpretation of paintings and of literature, as well as the way they paid attention to qualities of their hometown environment previously unnoticed. Morena (1993) "examined the relationship between the comprehension of metaphor and critical understanding of texts" and found that "if competence increases, metaphoric comprehension grows [and that, by the same token,] if there is an increase in metaphorical competence, reading comprehension grows" (p. 12). But more remains to be uncovered.

## Responding Readers: Changing Attitudes Among Education Scholars

From Plato onward, teachers and students have sometimes found poetry misleading, intimidating, or irrelevant. As recently as 1992, at a symposium hosted at the University of Durham, Thompson (1996) reported "poetry is a frequently neglected aspect of the language curriculum" (11). Writing in the same volume, Gundel Mattenklott ponders what she calls "a perplexing phenomenon: [that] young people [in Germany], adolescents and students at universities ... tend to reject poetry" (p. 13). Dias and Hayhoe (1988) lay the problem at the feet of the New Critics, whose influence in secondary schools has remained strong well past its demise at the university level (pp. 5–8). "Until recently, the teaching of poetry," they argue, "has been dominated by the conception of the poem as an object that can and must be closely analyzed" (p. 5). Traditionally, "the teacher, the keeper of the poem, 'owns' the poem [and] the children merely rent it" (p. 7). Thus, "the teacher's questions are often not real questions; that is, they are not questions to which the answers are not already known" (p. 7). They consider such teaching a kind of "packaged tour" approach, where the teacher guides the students along a preestablished path – and the readers "[arrive] without having traveled" (p. 7). The joys of discovery are missing.

Dias and Hayhoe call for ways of teaching, "whereby each pupil has the opportunity to confirm and develop his or her experience of the poem" (p. 48), often in collaboration with small groups of other readers. They lay out just such a method in what they call "Responding-Aloud-Protocols," noting student responses from classrooms in England and Quebec (p. 48) where whole-class discussion arises from initial small group discussions that focus on eliciting initial reactions, feelings, or observations, providing multiple accounts of the poem. The authors comment:

> The several accounts of the poem should create the impression that the poem is more than each of the summary accounts [that the groups have created ... .] The questions that are raised by the teacher at [the] concluding stage must be real questions sparked by an interest in the inquiring of the pupils and reinforcing a belief in their own resources as readers. (p. 49)

As a result of such a shift in pedagogy, the authors report "a growing positive attitude toward poetry as well as increasing confidence in [the] ability [of students] to make sense of poetry on their own," as evidenced in students' daily journals (p. 50) and a "noticeable improvement in pupils' abilities to voice what are quite often complex and subtle observations about what they have read" (p. 51).

Such shifts of emphasis, particularly among teachers' approaches to poetry, have been widely reported in the last 15 years. Referring to work published in 1995 Benton was able to describe such reader-response methods as "the new orthodoxy," claiming that while "New Criticism ... invented 'the assumed reader' ... reader-response criticism deals with real and implied readers" (1999, p. 2). He credits "Iser's theory of aesthetic response (1978) and Rosenblatt's transactional theory of the literary work (1978, 1985) [in having] helped change the culture of the classroom to one which operates on the principle that the text cannot be said to have a meaningful existence outside the relationship between itself and its readers" (p. 2). Bleich (1978) makes similar arguments. He describes the process of "negotiation" that occurs when "the object of observation appears changed by the act of observation" as "knowledge is made by people and not found" (pp. 17, 18). What can result from such negotiations and transactions are the sorts of classroom environments that Ken Watson (1988) observed in Australian schools:

1. Children in groups deciding on the questions that they, not the teacher, want to ask about a particular poem;
2. Pupils making their own selections from a wide variety of poetry collections;
3. Groups arguing about the most appropriate poem to be placed at the beginning of a particular novel;
4. Groups preparing readers' theater presentations of poems;
5. Groups arranging a cut-up poem in what seems to be the best sequence;
6. Pupils writing their own poetry. (p. 112)

Wallace-Jones (1991) also confirms this trend, adding that the major effect of reader-response strategies, in terms of the appreciation of poetry, is a new understanding of what it means to interpret and to know. Such reading strategies recognize that

"knowledge [is] built upwards and downwards at the same time" (p. 9) and thus such interactive reading of poetry helps students better negotiate such "building" in general. "While on the one hand, [these methods foster] an increasing ability to generalize; on the other hand, there is movement towards detail and a reading of metaphor that reveals greater specificity and insight" (p. 9). Using different terms, Italian semiotician Umberto Eco (1979) echoes Wallace-Jones in noting a performative, interactional dynamic through the encouragement of reader-response strategies, what Mattenklott calls an active, open field (1996, pp. 12–13). Eco calls for a view of responding to literature and art as "both interpretation and performance" and puts forth the principle that "a work of art gains its aesthetic validity precisely in proportion to the number of different perspectives from which it can be viewed and understood" (p. 49). We "perform" our own readings, of course, in close association with the work itself, but our readings are alive and active precisely in correspondence with the work offering a variety of open places to enter. "A road traffic sign," says Eco, "can only be viewed in one sense" (p. 49), but a poem – or any other piece of art – in many. Similarly, Dutch researcher Willem de Moor (1996) comments that these sorts of "open spots [in literature] appear to be essential for the aesthetic response of the reader" (p. 68).

As a result of bringing reader-response strategies into the classroom, Benton (1999) suggests that teachers are growing in their appreciation of the pedagogical function of poetry. He compares a 1982 survey in the attitudes of English teachers and students toward poetry to a similar one conducted in 1998. While admitting that resistance to reading poetry still remains strong among students (in 1998, for instance, among 8th grade students "only 30% of girls and 22% of boys agreed with the proposition, 'I enjoy reading poetry'"), among teachers there was a far greater sense that "poetry is of the highest value in encouraging students to think analytically, unraveling the complexities of this 'charged' language in terms of its meanings and structures" (p. 225). Benton notes at "least 70% of teachers (as against 49% previously) volunteer such comments as 'it opens students' minds to new uses of language' or 'poetry encourages discussion of language use'" (p. 4). "In 1982 only 31% of teachers agreed with the proposition that 'teaching poetry is at the heart of English teaching': [By] 1998 this figure [had] risen to 51%" (p. 226). "[T]here is a sense that many teachers are actively enjoying teaching poetry, using new material creatively and actively exploring texts alongside their pupils" (p. 225). Such an opening of minds may usher in a new understanding of poetry's place in the classroom.

## Through the Looking Glass of the Classroom: Teachers Becoming Writers, Writers Becoming Teachers, Students Becoming Poets

Along with advancements in more dynamic ways of teaching responses to poetry, Benton (1999), Kane and Rule (2004), and Wilson (2005) note a surge of recognition in the value of students writing poetry. Benton reports that whereas in 1982, 32% of teachers surveyed saw the writing of poetry as "'very important' with 18% regarding it as 'not important' in 1998 … 54% [saw] the writing of poetry as 'very important'

and only 4% as 'not important' " (p. 227). Says one teacher, "They can only under-stand poet[ry] if they've practiced it themselves" (p. 227). But before many teachers can feel comfortable teaching creative writing to their students in a way that is peda-gogically useful, they need to have a first hand understanding themselves of what it is like to work as a "creative writer." This has led to a related trend of teachers becoming writers of poetry themselves, often through National Writing Project and other univer-sity and arts-council-sponsored summer workshops in writing (Hermsen & Fox, 1998). Participants in these workshops often report coming away with a changed atti-tude about poetry in particular and creative writing in general. For example, after spending a week taking on the role of the writer at *The Experience of Writing* work-shop, sponsored for teachers by the Ohio Arts Council, participants reported positive results: "I *experienced* what I ask of my students," and "I learned that you have to be a good writer to be a good teacher of writing" (Hermsen & Fox, 1998, p. xix). Another teacher, Titus "realized the intimate connection between reading and writing" (Hermsen & Fox, 1998, p. 121) and took that experience back to her students. Says Titus, "reading Blake's 'The Tyger' fired their hearts. The line 'what immortal hand or eye could frame thy fearful symmetry' rang continuously inside our room" (p. 122) with the result that "the children were hearing rhythms previously unnoticed and enjoying the sound of words whose meanings they might not yet know. Most of all they were becoming comfortable with mystery in a setting where mystery too often goes unacknowledged – school" (p. 123).

An important influence in the trend toward using creative writing in the classroom has been the many visiting-writer-in-the-schools programs that have sprung up in the United States and beyond. Kenneth Koch did much to inspire this movement with his book *Wishes, Lies, And Dreams, Teaching Children to Write Poetry* (1970), where he wrote about his experiences as a visiting poet in a public elementary school in lower Manhattan. His work provided one of the first extensive models of how to teach cre-ative writing to elementary school-aged children. Many of his assignments and exer-cises employ the use of anaphora, the repetition of the same word or words at the beginning of a line, in order to provide coherence for the reader and an organizing principle for the writer, such as when he asks students to begin each line of a poem with "I Used to be a _____, but now I'm. ..." (pp. 156–174). Many of Koch's exer-cises center upon the creation of wishes (pp. 66–86), lies (192–198), or dreams (pp. 128–137), but they also provide ways for children to build comparisons and metaphors (pp. 107–127, 148–174), assisting them in the Tolkienesque recovery of a clearer view into a subject or experience.

In later work Koch (1973) builds writing assignments inspired by great (canonized) poetry. For example, using William Blake's poem *The Tyger*, Koch constructs an assignment in which students "write a poem in which they ask questions of a mysteri-ous and beautiful creature" (p. 4); or building upon Wallace Stevens' poem, *Thirteen Ways of Looking at a Blackbird*, he suggests that students "write a poem in which [they] talk about the same thing in a number of different ways" (p. 116). Working with Kate Farrell and Koch (1982) also used less canonized, mostly twentieth-century avant-garde poets, from whom they imaginatively created or "riffed" writing assign-ments. Following Koch and Farrell's model, Teachers & Writers Collaborative

(www.twc.org) has produced a number of books that contain writing exercises inspired by the works of a single author, such as Walt Whitman (Padgett, 1991), William Carlos Williams (Lenhart, 1998), and Frederick Douglas (Brown, 1996).

Koch modeled a pedagogy in which educators can use poetry writing to "riff" assignments that accomplish a range of pedagogical goals, an approach taken up by others (Collom, 1985; Collom & Noethe, 2000; Fletcher & Portalupi, 2001; Padgett, 1995; Padgett & Edgar, 1994; Padgett & Zavatsky, 1977; Ray & Laminack, 2001; Rodari, 1996; Sears, 1986, 1990; Willis, 1991, 1993, 2000; Ziegler, 1984). Although more work needs to be done in measuring these results, the ever growing body of work in this area testifies that well developed and carefully articulated creative writing lessons that make use of poetry as an integral part of a teacher's pedagogy can activate a classroom by evoking the kind of attentiveness and openness that one brings to the world when one is fully engaged, both physically and intellectually.

## The Movement from Reading to Listening: Appreciating the Aural Nature of Poetry

We live in an auditory culture as well as a visual one. More and more of our students live in an I-Pod world where, "music is ... at the epicenter of practices of [their] discursive identity formation" (McCarthy, Hudak, Miklaucic, & Saukko, 1999, p. 2). Since music plays an important role in the cultural politics of education, they suggest a classroom in which a "Pedagogy of Musical Affect" (pps. 13, 361) is practiced. Of course, poetry, language made musical, is an auditory (oral/aural) art form, as well. Its affects play out their changes through other portals beyond the eyes – through the mouth and the body as we ingest the poem when reading it out loud, and through the ears as we listen to it. A nod, at least, needs to be made to this aspect of the art.

For the teacher and student interested in exploring some of the possibilities of the "poetry-affected" classroom, in which poetry is both read *and* heard, useful web sites include: The Academy of American Poets (www.poets.org), a site that hosts a number of resources, including an audio archive; The Poetry Archive (http://www.poetryarchive.org/poetryarchive/home.do), a site based in the United Kingdom that collects audio recordings of poets reading their poems and those of their favorite poets; the Favorite Poem Project (http://www.favoritepoem.org/), initiated by Robert Pinsky during his tenure as US Poet Laureate, a site in which "ordinary" people read out loud and discuss one of their favorite poems; Youthkspeaks (http://www.youthspeaks.org), a site dedicated to spoken word poetry; and Read*Write*Think (http://www.readwritethink.org), also accessed through the National Council of Teachers of English (NCTE) web site (http://www.ncte.org), which offers many audio-based language arts lesson plans for K-college classrooms based on IRA-NCTE English Language Arts Standards.

First, however, comes learning *how* to listen. Most of us can hear. Listening can be another matter. Danish researcher Thorkild Borup Jensen (1996) proposes that teachers "help students become active listeners (p. 31). "Every recital," she says, "is a unique way of understanding and interpreting the poem" (p. 33). In the United States,

Joseph Bruchac, a native American of the Abenaki nation, describes a lesson that emphasizes the use of figurative language based, not on seeing, but on listening:

> Have [students] close their eyes and listen deeply, hear everything that is around them – or even within them [... .] This can be done in two stages. The first, the literal, is to have the students simply write down what they hear. The second is to use similes to extend their descriptions: to write what those sounds were like, what those sounds made them think of [... .] Have them write down the sound of a bird song, the sound of a pine tree's breath as the wind shushes through it on a high ridge [... .] Listen [...] Listen. (2000, pp. 30–34)

## Breaking the Line Across the Disciplines: The Broader Pedagogical Uses of Poetry

One of the most valuable aspects of Richardson's work in *In the Early World* is his demonstration of how the use of creative writing can lead to an appreciation and understanding of other disciplines, and vice versa. After one nature study class, for example, where students wrote short creative pieces about wasps, he concludes:

> Unless the interest had been deep, unless the subject had been followed in fullness, and unless there had been a certain amount of the thrill of achievement through making advances on the basis of certain criteria, the impression, and hence the creative expression, is unlikely to be good. Nor will the process be of interest to them. (1964, p. 168)

That is to say, Richardson suggests, it's a two-way process: Using creative writing helps to enable the "deep interest" into a subject, which allows it to be "followed in fullness," to the successful outcomes that all teachers wish for in their lessons. Likewise, such engagement leads to greater creative expression in the writing.

McEwen and Statman (2000) provide a comprehensive follow-up to Richardson's work in nature study. Based on the idea that writing enables the two-way process described above, McEwen and Statman claim that creative writing in the teaching of natural science is a vital activity, since "most students ... see nature as 'Other' " (p. xv). An introductory essay by the poet Gary Snyder suggests a context for the book, an intimate interdependence between the "wild tune" (Frost, 2003, p. 984) that poetry is and nature: "Wildness ... the essential nature of nature [can best be articulated in] language [. . . that] does not impose order on a chaotic universe, but reflects is own wildness back" (p. 1).

Creative writing has also been used successfully in the teaching of history. Kane and Rule (2004), for example, report that "there is a convincing literature base showing that teachers in a variety of content areas [are using] poetry to enrich their curricula" (p. 658) and cite as an example one teacher who wrote, "I have found that poetry is a particularly useful and engaging vehicle for revealing the complexities of a historical

moment" (p. 659). In a similar vein, Brown (1988) shows how students might write oral histories and how teachers might assess such projects, Roorbach (1998) explains how students can create detailed memory maps of their earliest neighborhoods (pp. 18–34) as they work to uncover and collect material toward the writing of memoirs, and Galt (1992) uses creative writing to help students enter the lives and times of "real" historical people and events. "When we study history at arm's length," she writes, "with more emphasis on facts than on individual human responses [. . . t]he past remains distant, not quite real, safe. But when we invite imagination to enter our study of history, we open the door to character, emotion, irony, and the magic of metaphorical language" (p. 165).

Richardson (1964, pp. 49–70) also documents his work in the visual arts over three years. At the end of that time he concluded "I believe that the final success of most of this work came from the forging of a close association of the child's thinking with some actual experience or observation" (p. 49). What his students were discovering was what Foster and Prevallet call, in their anthology of essays of the same title (2002), the "third mind": "Listening to works of art and participating in a conversation with them can produce ... [t]he 'third mind,' ... a state in which something new, or 'other,' emerges from the combination that would not have come about with a solo act" (p. xv). Morice (2002) also uses the visual arts to teach poetry, and vice versa, by taking well-known poems and resetting them within the field of play of illustrated comic strip panels. In other books (1995, 2001), he encourages students to play physically with the materials of language through the use of cut outs and other strategies. Wooldridge (1996) also encourages the use of cut-out words, what she calls "creating a wordpool" (p. 10), not only as a way of collecting or "banking" words to come back to and use, but as an aid in the revision process, since the words and phrases, collected on what she calls "word tickets" (p. 14), are easy to rearrange.

Wooldridge's book, *Poemcrazy*, details her experience as a teacher in the California Poets-in the-Schools Program. She finds that "writing poems can help kids shift the way they see themselves" (1996, pp. 97–98), helping them articulate positive self-identities. Statman (2000) has also demonstrated that the use of creative writing in the classroom can help students engage issues such as identity, as well as an understanding of and engagement with other cultures (see also Marzán, 1996; Thomas, 1998; Tinto, 1989). Each and all of these writers can assist in Tolkienesque recovery, as students and teachers "shift the way they see themselves" and others through the writing of poetry.

## Recommendations for Future Research

While many positive changes have occurred in the teaching of poetry and creative writing over the past 20 years, much needs to be done to fully implement the promises of recent theoretical and pedagogical insights. In the main, research into the teaching of poetry and the literary arts needs to question more deeply its own assumptions, lest complacency with new models become as embedded as in the past. Do the tools of creative writing, for example, help students become better readers of literary texts as well as more astute readers of the world around them? How do we measure progress in these areas?

Some of this work has been done in the other arts (see Burton, Horowitz, & Abeles, 2000), but methods developed for tracking the transfer of skills through the documented accounting of improved student learning is still too hazy in the realm of creative writing.

At the same time, we must be careful not to make poetry one more set of statistics, one more item on the proficiency exam. Research needs to be undertaken into methods of evaluating and assessing students' progress in poetry that honors the true, nebulous nature of the art. In one appropriately named article, *The Conveyor Belt Curriculum? Poetry Teaching in the Secondary School*, Peter Benton (2000) quotes numerous teachers reflecting on how the current concentration on testing interferes with their ability to teach poetry in the ways detailed in this article. "There is so much concentration on [...] SAT preparation, poetry becomes 'exam material,' " comments one (p. 85). "The spontaneity has been lost" and "we rarely have time to read poetry for pleasure," (p. 86) admit two others. "We find ourselves teaching against our will and better judgment" (p. 85) is another statement that might well speak for many. The sustainability of gains in reader-response methods is thrown into question by a statistic from Benton's 1999 study in which "Sixty-five percent of teachers surveyed [agreed] with the proposition that 'I feel constrained by the examinations to spoon-feed my classes rather than letting them develop their own views about poems' " (p. 88).

One way around this dilemma would be to change what we are testing for as well as our testing methods. Wilson (2005) suggests we need to "promote a view of poetry which puts less emphasis on form *per se*, and more on the demands upon thinking which different poetic forms require" (p. 239). Can we find ways, he wonders, to measure students' writing of poetry that look at "a small range of qualities per piece of work, or even one ... the use of line breaks in free verse, for example [or] the quality of revelation/perception [. . . or] the way feelings are described through concrete detail and not bald statement" (p. 240)? Such context-based evaluation might well create a testing atmosphere that is freeing rather than restrictive – and truer to the nature of what poetry writing has to teach.

Another way to make testing more genuine and "true to the art" would be to research methods in making the tools of metaphor more accessible to students. It does little good to give them a catalog of metaphoric techniques if students can't turn them into working tools for their own thinking, reading, and writing processes. A semiotics of the literary arts needs to be more fully articulated and documented in age appropriate ways. If the mind is indeed a "pattern-mad supposing machine," as Diane Ackerman (2004) has put it, if societies are structured around signs, symbols, and embedded meanings, as theorist after theorist has demonstrated (Fauconnier & Turner, 2002; Jakobson, 1971; Lakoff & Turner, 1989), if poetry is the place where language is unpacked and investigated (Benton, 1999), then research in the teaching of poetry should document in more thorough ways how such concepts can be applied in the classroom.

Part and parcel with the above suggestions would be a change in how well teachers are prepared to approach poetry and creative writing. Comments one professor in the College of Education at The Ohio State University:

What do teachers need to know, what do they need to have experienced themselves in order to teach writing creatively? How is this addressed in teacher

education programs, if at all? [. ...] How do teachers get to know what to do and how to do it if their own exposure has been limited or non-existent? I have recently worked with teachers in a Poetry for Middle and High School teachers [class] and found that there is a dismal lack of exposure on their part to poetry throughout their schooling, no experience of it in college, none required, and very little, if any, post-licensure "training." (Dr. Anna Soter, personal communication, August 6, 2005)

Without such background, and research on methods of weaving creative writing into the whole of teacher education, that which a "proper poetical education" enables – a delight in bodily rhythms that in their roots go back to the heartbeats we first heard in the womb; a process of knowing, and of understanding ourselves and of empathizing with others beyond ourselves; and a metaphorical, attentive way of living more completely in this world and in our experiences past and present – cannot be fully enacted, and it certainly will not flower among nearly enough of our students.

In his "Forward" to *In The Early World*, John Melser writes:

In much discussion of teaching there is an assumption that a radical difference of kind exists between work which is variously called "creative," "imaginative," or "expressive" – work which is about children's feelings and sensations – and, on the other hand, work which is distinguished as "factual" and which concerns the "real" or "outside" world [. . . .] It seems evident from the work at Oruaiti that the distinction has little relevance to the work of children [... .] Because the children were not required to make a divorce between the parts of their experience, a divorce hostile to their intuitive grasp or situations, they could bend to their work with an enthusiasm and a degree of concentration which ordinary schooling never touches. (Melser, 1964, pp. v–vi)

Writing over 40 years ago, Melser hit the nail on the head. Poetry helps heal this "divorce" between the "imaginative" and the "factual." It is in all our best interests that this marriage be recovered and prosper. If this can occur, if we can bring the spirit of Elwyn Richardson into the heart of our teaching, then perhaps we won't have to wait another 40-plus years to see the changes suggested in this article brought to fruition.

# References

Ackerman, D. (2004). *Alchemy of mind: The marvel and mystery of the brain*. New York: Scribners.

Benton, P. (1999). Unweaving the rainbow: Poetry teaching in the secondary school I. *Oxford Review of Education, 25*, 521–531.

Benton, P. (2000). The conveyor belt curriculum? Poetry teaching in the secondary school II. *Oxford Review of Education, 26*, 81–95.

Bleich, D. (1978). *Subjective criticism*. Baltimore: Johns Hopkins UP.

Brown, C. S. (1988). *Like it was: A complete guide to writing oral history*. New York: Teachers & Writer's Collaborative.

Brown, W. (Ed.). (1996). *The teachers & writers guide to Frederick Douglas*. New York: Teachers & Writer's Collaborative.

Bruchac, J. (2000). *The land keeps talking to us.* In C. McEwen & M. Statman (Eds.), *The alphabet of the trees: A guide to nature writing* (pp. 30–34). New York: Teachers & Writer's Collaborative.

Burton, J. M., Horowitz, R., & Abeles, H. (2000). Learning in and through the arts: The question of transfer. *Studies in art education, 41,* 228–257.

Collom, J. (1985). *Moving windows: Evaluating the poetry children write.* New York: Teachers & Writer's Collaborative.

Collom, J., & Noethe, S. (2000). *Poetry everywhere: Teaching poetry writing in School and in the Community.* New York: Teachers & Writer's Collaborative.

de Moor, W. (1996). The teaching of poetry in the Netherlands since 1968. In L. Thompson (Ed.), *The Teaching of Poetry: European Perspectives* (pp. 63–77). London: Cassell.

DeWitt, S. L. (2001). *Writing inventions: Identities, technologies, pedagogies.* Albany, NY: State University of New York Press.

Dias, P., & Hayhoe, M. (1988). *Developing response to poetry.* Milton Keynes: Open University Press.

Eco, U. (1979). *The role of the reader: Explorations in the semiotics of texts.* Bloomington, IN: University of Indiana Press.

Fauconnier, G., & Turner, M. (2002). *The way we think: Conceptual blending and the mind's hidden complexities.* New York: Basic Books.

Fletcher, R., & Portalupi, J. (2001). *Writing workshop: The essential guide.* Portsmouth, New Hampshire: Heinemann.

Foster, T., & Prevallet, K. (Eds.). (2002). *Third mind: Creative writing through visual arts.* New York: Teachers & Writer's Collaborative.

Frost, R. (1966). *Education by poetry.* In H. Cox & E. Lathem (Eds.), *The selected prose of Robert Frost* (pp. 33–46). New York: Holt, Rinehart & Winston. (Original work published 1931)

Frost, R. (2003). *The Figure a Poem Makes.* In J. Ramazani, R. Ellmann, & R. O'Clair (Eds.), *The Norton Anthology of Modern and Contemporary Poetry, Vol. 1* (pp. 984–986). New York: Norton. (Original work published in 1939)

Galt, M. F. (1992). *The story in history: Writing your way into the American experience.* New York: Teachers & Writer's Collaborative.

Gibbs, R. (1994). *The poetics of mind: Figurative thought, language, and understanding.* Cambridge: Cambridge University Press.

Hawkes, T. (1977). *Structuralism and semiotics.* Berkeley, CA: University of California Press.

Hermsen, T. (2003). *Languages of engagement: Metaphor, physicality, visuality and play.* (Doctoral dissertation, The Ohio State University, 2003).

Hermsen, T. (2005). *Classroom observation notes, Genoa Middle School,* May 24, 2005. Westerville, Ohio.

Hermsen, T., & Fox, R. (Eds.). (1998). *Teaching writing from a writers' point of view.* Urbana, IL: National Council of Teachers of English.

Hofstadter, D. (2001). *Analogy as the core of cognition.* In D. Gentner, K. Holyoak, & B. Kokinov (Eds.), *The analogical mind: Perspectives from cognitive science* (pp. 299–322). Cambridge, MA: MIT Press.

Jakobson, R. (1971). Language in relation to other communication systems. In *Selected writings, Volume II* (pp. 697–708). The Hague: Mouton.

Jensen, T. (1996). Ways of experiencing poetry and acquiring poetic knowledge in the secondary school. In L. Thompson (Ed.), *The teaching of poetry: European perspectives* (pp. 30–36). London: Cassell.

Johnson, M. (1987). *The body in the mind: The bodily basis of meaning, imagination, and reason.* Chicago, IL: University of Chicago Press.

Kane, S., & Rule, A. (2004). Poetry connections can enhance content area learning. *Journal of Adolescent and Adult Literacy, 47,* 658–669.

Koch, K. (1970). *Wishes, lies, and dreams: Teaching children to write poetry.* New York: Vintage Books.

Koch, K. (1973). *Rose, where did you get that red? Teaching great poetry to Children.* New York: Vintage Books.

Koch, K., & Farrell, K. (1982). *Sleeping on the wing: An anthology of modern poetry with essays on reading and writing.* New York: Vintage Books.

Lakoff G., & Turner, M. (1989). *More than cool reason: A field guide to poetic metaphor.* Chicago, IL: University of Chicago Press.

Lenhart, G. (Ed.). (1998). *The teachers & writers guide to William Carlos Williams*. New York: Teachers & Writer's Collaborative.

Marzán, J. (Ed.) (1996). *Luna, luna: Creative writing ideas from Spanish & Latino literature*. New York: Teachers & Writer's Collaborative.

Mattenklott, G. (1996). Poetry as play: Rules for the imagination. In L. Thompson (Ed.), *The teaching of poetry: European perspectives* (pp. 12–21). London: Cassell.

McCarthy, C., Hudak, G., Miklaucic, S., & Saukko, P. (1999). *Sound identities: Popular music and the cultural politics of education*. New York: Peter Lang.

McEwen, C., & Statman, M. (Eds.). (2000). *The alphabet of the trees: A guide to nature writing*. New York: Teachers & Writer's Collaborative.

Melser, J. (1964). Forward. In E. Richardson (Ed.), *In the early world* (pp. v–ix). New York: Random House.

Morena, E. (1993). *Metaphor and lexical competence: Didactic applications in secondary school*. (Doctoral dissertation: Universitat Autonoma de Barcelona). Dissertation Abstracts International, *56*(1), 12.

Morice, D. (1995). *The adventures of dr. alphabet: 104 unusual ways to write poetry in the classroom & the community*. New York: Teachers & Writer's Collaborative.

Morice, D. (2001). *The dictionary of wordplay*. New York: Teachers & Writer's Collaborative.

Morice, D. (2002). *Poetry comics: An animated anthology*: New York: Teachers & Writer's Collaborative.

Padgett, R. (Ed.). (1991). *The teachers & writers guide to Walt Whitman*. New York: Teachers & Writer's Collaborative.

Padgett, R. (Ed.). (1995). *Old faithful: 18 writers present their favorite writing assignments*. New York: Teachers & Writer's Collaborative.

Padgett, R., & Edgar, C. (Eds.). (1994). *Educating the imagination: Essays and ideas for teachers and writers)*. New York: Teachers & Writer's Collaborative.

Padgett, R., & Zavatsky, B. (1977). *The whole word catalogue 2*. New York: McGraw-Hill.

Ray, K. W., & Laminick, L. L. (2001). *The writing workshop: Working through the hard parts (And they're all hard parts)*. Urbana, IL: The National Council of Teachers of English.

Richardson, E. (1964). *In the early world*. New York: Random House.

Rodari, G. (1996). *The grammar of fantasy: An introduction to the art of inventing stories*. New York: Teachers & Writer's Collaborative.

Roorbach, B. (1998). *Writing life stories: How to make memories into memoirs, ideas into essays, and life into literature*. Cincinnati, OH: Writers Digest Books.

Rosenblatt, L. (1938/1968). *Literature as exploration*. New York: Noble and Noble.

Sears, P. (1986). *Secret writing: Keys to the mysteries of reading and writing*. New York: Teachers & Writer's Collaborative.

Sears, P. (1990). *Gonna bake me a rainbow poem: A student guide to writing poetry*. New York: Scholastic.

Snyder, G. (2000). Language goes two ways. In C. McEwen & M. Statman (Eds.), *The alphabet of the trees: A guide to nature writing* (pp. 1–5). New York: Teachers & Writer's Collaborative.

Statman, M. (2000). *Listener in the snow: The practice and teaching of poetry*. New York: Teachers & Writers Collaborative.

Thomas, L. (Ed.). (1998). *Sing the sun up: Creative writing ideas from African American literature*. New York: Teachers & Writer's Collaborative.

Thompson, L. (1996). *The teaching of poetry: European perspectives*. London: Cassell.

Tinto, P. (1989). *El Libro de la Escritura*. New York: Teachers & Writer's Collaborative.

Tolkien, J. R. R. (1964). *Tree and leaf*. London: Allen & Unwin.

Wallace-Jones, J. (1991). Cognitive response to poetry in 11 to 16 year olds. *Educational Review, 43*, 25–38.

Watson, K. (1988). Teaching poetry in Australia. In P. Dias & M. Hayhoe (Eds.), *Developing response to poetry* (pp. 110–112). Milton Keynes: Open University Press.

Willis, S. (1991). *Blazing pencils: A guide to writing fiction and essays*. New York: Teachers & Writer's Collaborative.

Willis, S. (1993). *Deep revision: A guide for teachers, students, and other writers*. New York: Teachers & Writer's Collaborative.

Willis, S. (2000). *Personal fiction writing: A guide to writing from real life for teachers, students, and writers*. New York: Teachers & Writer's Collaborative.

Wilson, A. (2005). "Signs of progress": Reconceptualizing response to children's poetry writing. *Changing English, 12*, 227–242.

Wooldridge, S. G. (1996). *Poemcrazy: Freeing your life with words*. New York: Three Rivers Press.

Ziegler, A. (1984). *The writing workshop*. New York: Teachers & Writer's Collaborative.

# 41

# TEACHING TOWARD APPRECIATION IN THE VISUAL ARTS

**Terry Barrett**
*Ohio State University, U.S.A.*

## Introduction

The topic of art appreciation is vast: An internet search of *art appreciation* yielded about 3,540,000 results. The complexity of the concept of art appreciation is its overlap with related concepts of aesthetic response, art history, art criticism, art education, aesthetic education, and art museum education. Appreciation is also affected by understandings of concepts of perception, sensibility, interpretation, taste, preference, and evaluation or judgment. Appreciation is meshed with beauty and beauty to aesthetic experience. In aesthetic philosophy as well as in daily living, concepts of beauty and appreciation are applied to nature, works of art, and a wide range of artifacts.

Art appreciation is generally assumed and often explicitly claimed to be *the* desired outcome of art education. This chapter attempts to map philosophical terrains of "art appreciation," exemplify acts of appreciation in the visual arts, briefly explore the history of teaching for art appreciation in the United States, and sample some educational strategies for appreciation. The purpose of the chapter is to expand notions of the concept of art appreciation, to devalue "disinterested" appreciation in favor of engaged appreciation, to broaden the candidates for appreciation, including an appreciation of the "interpreting-self" and the "interpreting-other," and to motivate empirical investigations of appreciation.

## Defining Appreciation

Stein Olsen's (1988) definitional considerations of *appreciation* in the *Encyclopedia of Aesthetics* can be condensed to "the act of apprehending a work of art with enjoyment" (p. 66). Appreciation entails valuing, positive or negative; it is dependent on acquired perception that requires initiation and practice, training one's sensibilities, and learning how to apply apt vocabulary to distinguish aspects of what is being appreciated.

*L. Bresler (Ed.), International Handbook of Research in Arts Education*, 639–654.

Succinctly, appreciation requires knowledge. Olsen's definition is reminiscent of Harry Broudy's (1972) "enlightened cherishing": "a love of objects and actions that by certain norms and standards are worthy of our love. It is a love that knowledge justifies" (p. 6).

## Aesthetic (Disinterested) Appreciation

Concepts of appreciation and aesthetic experience have overlapped since the eighteenth century. One traditionally necessary condition of experiencing something "aesthetically" is to view it with an attitude of "disinterest" as developed by philosophers such as William Shaftesbury, Immanuel Kant, Arthur Schopenhauer, and in the twentieth century by Clive Bell, Edward Bullough, Monroe Beardsley, and Jerome Stolnitz. Shaftesbury typifies disinterested appreciation as enjoying something for its own sake and without wanting to possess it. For Kant, disinterestedness means not caring whether the object of appreciation even exists[1].

Aesthetic attitude theories conceive of aesthetic experience as an "episode of exceptional elevation wholly beyond our ordinary understanding of empirical reality" (Honderich, 1995, p. 8). An aesthetic attitude is independent of anything of utilitarian, economic value, moral judgment, or idiosyncratic personal emotions. One should view the object "for its own sake" as the purpose of art is wholly aesthetic. Proper apprehension may result in an "aesthetic experience," which is, according to Bell, "one of the most valuable things in the world" (in Wolterstorff, 2004, p. 327).

Recently, traditional aesthetic response theory is contested. George Dickie (1997), for example, offers a succinct and dismissively sarcastic summary of the concept of aesthetic experience:

> The traditional picture of the aesthetic experience of a work of art goes like this: the work and the person or subject who is experiencing it are surrounded by an impenetrable, psychological wall "secreted" by the subject that experientially nullifies all relations that the work has to things outside the experience. Aspects of works of art may, and frequently do, refer, but a "proper" subject of aesthetic experience cannot take account of such references. (p. 156)

Developments in art over the last hundred years such as Dadaism, found art, happenings, Pop Art, Fluxus, performance art, technological art, art of social protest, and conceptual art have seriously challenged traditional aesthetics. In his rejection of "aesthetic experience," Dickie (1997) asserts, "aesthetic experience has a sharp edge that severs the referential relation to the world beyond it" (p. 147). To Dickie, Arthur Danto (1994), and Richard Eldridge (2003), traditional aesthetic response theories "tame" art "to an idle plaything of empty pleasure" (Eldridge, 2003, p. 60). Many theorists see the philosophical claim that "art is a thing of pleasure" to be a way of simultaneously "misunderstanding, devaluing, and repressing the real cognitive, political, and spiritual insights (or wit) that art may have to offer" (Eldridge, 2003, p. 60). Eldridge argues that artists "work for the sake of ideas and insight, not absorption in form" and not for "escapist pleasure" (2003, pp. 60–61).

*Appreciating Nature*

Recent philosophers of nature also threaten disinterested appreciation. Historically, Donald Crawford (2001) tells us, theories of beauty in nature have centered on four aspects: the human body, natural organisms and objects, natural phenomena, and scenery. More recently, aesthetic theories of nature do not include the body. Most recently, appreciation of nature is interested rather than disinterested. Crawford offers this list of questions that introduce the breadth of possible considerations of nature with implications for appreciation:

> What is it about nature and natural objects that we find aesthetically interesting or pleasing? Do we respond to beautiful animals, seashells, flowers, and scenery simply because of their color, texture, and design characteristics, or is our response guided by scientific knowledge? What part do our biological and social needs and interests play in the aesthetic appreciation of nature? How is the aesthetics of nature related to the aesthetics of fine art? Do we find nature beautiful because it resembles art, or is art beautiful because it resembles nature? How do aesthetic values form a part of contemporary environmental and ecological concerns? (2001, p. 306)

In considering the complications of nature, Crawford (2001) offers a succinct and useful summary definition of nature and how aspects of it might be distinguished, written by Stephanie Ross:

> (i) areas of unexplored wilderness (the original "given"), (ii) areas that were wilderness, have been entered, but haven't been developed, (iii) areas that have been entered, have been affected by humankind, yet remain noticeably wilder than other areas in specifiable respects, (iv) areas that have been entered, developed, but then returned to a more natural state through careful management. (in Crawford, 2001, p. 323)

Although pure nature is often the topic for dialogue, Crawford points out that little unexplored wilderness remains, and if any exists, it is probably disturbed by human intervention such as global warming. Pure nature is a possibly useful philosophical concept, but not a reality. He further complicates the notion of pure nature by citing hybridization and domestication of animals, and genetic engineering.

Some theorists devalue natural beauty on both philosophical and theological grounds. Hegel, for example, relegated natural beauty to the lowest end of his scale of expressiveness of spirit. In some cultures, religious objections to the notion of natural beauty sometimes emerge with serious consequences: because of the biblical "fall," for example, some see striking land formations, like mountains, as God's punitive response to sin. Accordingly, after expulsion from Eden, humans experienced lands resistant to agriculture and became vulnerable to natural disasters. The biblical book of Isaiah (4:4) joyously anticipates when "every mountain and hill shall be made low; and the crooked shall be made straight, and the rough places plain." Isaiah sets nature and

humans in conflict, and justifies humankind in radically altering nature to suit perceived human needs, even to the detriment of Earth.

Recent aestheticians (e.g., Berleant, 1997; Carlson, 2005; Eaton, 1997) hold that appreciation of nature must be informed by knowledge provided by science and ecology, rather than being merely dependent on emotion, physical involvement, and meditative reflection. We ought be aware of "natural forces deserving of our appreciation and warranting our respect in the form of minimal interference" (Crawford, 2001, p. 309). These qualifications tie ethics to aesthetics and reject the concept of aesthetic disinterest.

## Appreciation and Knowledge

Some fear that overanalyzing something will kill it. Nobel physicist Richard Feynman (1999), however, rebuts an artist friend who maintains that a scientist could only take apart a beautiful thing, like a flower, and not appreciate its beauty. To the contrary, Feynman argues:

> I see much more about the flower than he sees. I can imagine the cells in there, the complicated actions inside which also have beauty. I mean it's not just beauty at this dimension of one centimeter, there is also beauty at a smaller dimension, the inner structure. Also the process, the fact that the colors in the flower evolved in order to attract insects to pollinate it is interesting – it means that insects can see color … a science knowledge only adds to the excitement and mystery and the awe of a flower … I don't understand how it subtracts. (p. 2)

Beliefs in the cognitive import of the arts are very old. Both Plato's and Aristotle's theories of art, for example, are embedded in their metaphysical and epistemological theories. Appreciation, both positive (Aristotle) and negative (Plato), is dependent on interpretation. Plato's critique of art is highly dependent on his ethical theory, particularly the moral consequences of a work on an audience.

## Appreciation and God

Many appreciators of nature, and some of art, include notions of God in their appreciative considerations. Plato's "Form of Beauty" is located in the divine. Kant's aesthetic philosophy derives from his metaphysical beliefs, which include God's purposive system of nature, God's "unfathomably great art" (in Dickie, 1997, p. 21). Bell, the prototypical Formalist of the twentieth century, asserts that the importance of "significant form" is that through its recognition "we become aware of its essential reality, of the God in everything" (in Wolterstorff, p. 327).

## Appreciation, Ethics, and Politics

Socially critical aesthetic theories, including feminism, multiculturalism, Orientalism, colonialism, and queer theory merge aesthetic and ethical concerns, and reject "distancing" oneself in the face of art. These theories consider all art to be subject to moral

concerns and political critiques. To deny the social content of art that is expressly made as political is to miss its point.

Some skeptics of "the aesthetic" (e.g., Bourdieu, 1984) hold that concepts of aesthetic value, taste, and appreciation are the result of upper-class cultural dominance. Sociologists find correlations between elitist tastes and social class membership reinforcing a Marxist position that such taste is "a mere epiphenomenon without objective aesthetic basis, or, more sinister, a strategy for maintaining the sharp distinction between the upper class and others" (Goldman, 2004, p. 95). Indeed, class comes to mind when reading accounts that exemplify aesthetic appreciation by many authors today who cite connoisseurs of fine wine as exemplar appreciators.

## Insider and Outsider Appreciation

One consequence of aesthetic attitude theories is that they tend to encourage the perception of art apart from its origins and purposes and to see it only as form, rather than as having specific and special meaning for its makers and original users. Religious objects from different times and places, for example, are torn from their original contexts and decontextualized in museums. Art critic Thomas McEvilley (1984) negatively reviewed a "blockbuster" exhibition, *"Primitivism" in Twentieth-Century Art: Affinity of the Tribal and the Modern*, which displayed tribal works from around the world along with modern art made by Picasso and others to demonstrate affinity between the modern and "the primitive". McEvilley raised questions about the intent and execution of the show, especially the museum's decision of providing no anthropological information about the tribal objects in the exhibition, reducing them to objects for formalist contemplation. He chastised the museum for failing to show differences between the views of the tribal participant and the outside observer by "art historians, engrossed as they seem to be in the exercise of their particular expertise, the tracings of stylistic relationships and chronologies" (p. 157).

## Appreciating the Interpretive-Self and the Interpreting-Other

Hans-Georg Gadamer, in the Hegelian tradition, asserts that responding to art is a mode of self-understanding.

> Our experience of the aesthetic too is a mode of self-understanding. Self-understanding always occurs through understanding something other than the self, and includes the unity and integrity of the other. Since we meet the artwork in the world and encounter a world in the individual artwork, the work of art is not some alien universe into which we are magically transported for a time. Rather, we learn to understand ourselves in and through it. (1998, p. 92)

Further, Gadamer argues, "the work of art has its true being in the fact that it becomes an experience that changes the person who experiences it" (1998, p. 93).

In recent Pragmatism, Richard Rorty argues that there should be no difference between appreciating a work and using it to better one's life and to rearrange one's

priorities. "Interpreting something, knowing it, penetrating to its essence, and so on are all just various ways of describing some process of putting it to work" (in Barrett, 2003, p. 221).

Concomitant with greater self-knowledge and resulting appreciation of the changing self, one can also come to better know and appreciate others through their interpretations. To read or hear others' interpretations provides the possibility of learning about those interpreters as well as the work: How they think, what they notice, what they value and why, and their views of the world.

# Examples of Appreciation

## *An Appreciation by a Cultural Historian*

A landscape painting serves as an example of the need to intermix ethics, aesthetics, and scientific knowledge to appreciate it as it was painted. Alexis Rockman's *Manifest Destiny* (2004) is an 8 by 24 foot mural that shows Brooklyn, New York, submerged in water in the year 5000 after three millennia of global warming. The depiction is eerily devoid of humans while new bioengineered species thrive, as do deadly viruses and bacteria that float across the flooded surface. Cultural historian Maurice Berger (2004) interpretively appreciates the painting as "haunting" and identifies it as "an amalgam of science and aesthetics" informed by the artist's consultations with "ecologists, paleontologists, biologists, archeologists, and architects to help him create an accurate rendering" (p. 8). Both the artist and the admiring critic are engaged rather than removed, distanced, or detached. Berger's vocabulary in reference to the painting includes terms with ethical connotations: "greed," "selfishness," "shortsightedness," "indifference," "ignorance," and "complacency" (p. 15). In the view of this artist and critic, to appreciate is to know and care about the world outside of the painting itself.

## *An Appreciation by an Artist*

Andy Goldsworthy (2004), the Scottish artist who works directly in and with natural environments, recounts his struggle with a temporary piece he built in the woods – the tip of an abandoned quarried stone that he covered with torn wet red leaves – and his challenge to make the piece work in the dappled light of the forest floor: "I have learned a lot this week and have made progress in understanding a quality of light that I have never previously been able to deal with properly." After 28 years, he realized that "not understanding a woodland floor on a sunny day has represented a serious gap in my perception of nature" (p. 74).

From this example we can infer that artmaking for Goldsworthy is a process of discovery and not a rendering of preconceived knowledge or experience. The artist is making art in order to better understand what he is making art about. Through his artmaking he comes to a better understanding of an aspect of the world and how to render it in visual form. His verbal insights about light exemplify the artist's acute knowledge and appreciation of subtleties in the world, and points to properties to which we might appreciatively attend.

*An Appreciation by an Art Critic*

Art critic Richard Kalina (2002) attends closely to one of Joan Mitchell's nonobjective paintings, *George Went Swimming*. Despite its title, the painting has no recognizable subject matter. The critic describes its composition of two sections, its brushstrokes, and its colors: "… a zone of smeared blue pushes in from the upper right corner, desta-bilizing the composition, giving the brushwork it impinges on a frenetic quality. The painting alternates markedly between warm and cool, evoking heated air and frigid water, the weather's changeability and, by implication, restlessness and uncertainty" (p. 92). Kalina's writing exemplifies an apprehension with enjoyment that is depend-ent on acquired perceptual ability and an apt vocabulary (Olsen, 1998).

*An Appreciation by an Art Collector*

Steve Martin (2004), the American comedic actor, writer, and art collector recalls a drawing he acquired.

> It was done in fine pencil, extreme in detail, a monochromatic rainbow of gray gradients on white paper. The picture had its heart in Surrealism, more akin to the Russian Pavel Tchelitchew than Dali, though the quality of the draftsmanship rivaled Dali at his best. The drawing was done in the early 1940s, before Abstract Expressionism obliterated the art world's need for academic drawing. It had other roots too. There was something old master-ish about it, Bosch-like, reminiscent of a dark etching emerging from the style of a 16th-century obsessive … . (p. 24)

Martin's appreciation demonstrates historical knowledge that he brings to inform his judgment of the drawing as "an exceptional artwork." He notices details and nuances, but while attending to the representational ability of the artist, he is not a "sucker" for skill apart from its use to express meaning.

# Appreciation and Education: A Sampling

*A History of Art Appreciation in Education in the United States of America*

Examining the history of art teaching in the United States, Mary Anne Stankiewicz (2001) found that instruction in aesthetics, art history, and art appreciation are con-flated, and that the general purpose of teaching these areas was to improve morals and manners. The development of good taste and the ability to appreciate art and nature was thought to elevate the spirit and improve the taste of the nation. Those of the mid-dle class are to emulate the tastes and manners of the upper class.

Lecturers in early nineteenth-century colleges taught aesthetics as moral philoso-phy, classical art history in classical language classes, and modern art in modern lan-guage departments. At Harvard University in 1874, Charles Elliot Norton taught art history within the humanities, with three goals: "(1) to explain how the fine arts expressed the moral and intellectual conditions of past cultures; (2) to demonstrate

how the barren American experience starved the creative spirit; and (3) to refine the sensibilities of Harvard men" (Stankiewicz, 2001, p. 110). The Boston Museum of Fine Art was founded in 1870, and its goals mirrored those of the educators. Courses in the history of art became especially popular in women's colleges at this time.

During the last quarter of the nineteenth century, secondary school teachers taught art history and appreciation to refine young people's morals and manners. Before World War One, most high school students were upper-middle-class women, and knowledge of art history was to prepare them to become art patrons and advocates of refined culture. According to Stankiewicz (2001), "aesthetic didacticism – that is, the belief that art can teach right behavior" entered the twentieth century through texts and lectures for secondary students and those studying to be teachers based on "unquestioned assumptions of superiority and progress, a literacy of aspiration to help middle and lower-class students emulate upper-class taste, rather than the liberating literacy of drawing or the critical literacy advocated by some art educators today" (p. 112). Knowledge of facts was expected of the students, but the most important goal was that students appreciate "the good".

With the advent of mechanical reproductions of works of art and their widespread distribution, participants in a "picture study movement" decorated schools and offered direct study of (reproductions of) works of art. From the mid-1890s to the 1920s, teachers and volunteer "picture ladies" used "masterpieces" to develop children's "character and taste" (Stankiewicz, Amburgy, & Bolin, 2004).

Within the picture study movement, Estelle Hurll (1914) offers attitudes and assumptions that prefigure recent practices. In *How to Show Pictures to Children*, Hurll poses the "first rule" of not talking down to children, especially in selecting pictures (p. 5), and choosing pictures that children like because of subject matter and narratives interesting to them. Pictures outside the range of children's interests should not be forced upon them. Although she maintains "pictures are primarily intended for pure aesthetic joy" (p. 5), that children should be taught how pictures are technically and compositionally made, that a picture may be considered "quite apart" from its subject so as to admire its composition (p. 25), she also distinguishes between "subject and art", and asserts "the word art is not a synonym for prettiness or sentimentality" (p. 23). Although influenced by Arthur Wesley Dow (1899), a formulator of "elements of art" and "principles of design", Hurll does not elevate compositional concerns above all else: "The critical analysis of a picture would be a sad process if it were the end and object of our interest" (1914, p. 25).

Hurll advocates use of images in popular magazines, prefiguring later art educators' interests in popular culture and in visual culture studies (e.g., Duncum & Bracey, 2001; Tavin, 2003). She also advocates that children write about art, as do recent art educators (e.g., Barrett, 1994; Stout, 1995; Wilson, 1986). "Picture study" advocates instrumental goals of developing character; visual culturists advocate social justice (e.g., Tavin, 2003). Current art educators have answered questions about learner's cognitive developmental abilities regarding understandings of art with implications for its appreciation (e.g., Efland, 2004; Parsons, 1987; Winner, 1982). The majority of developmental studies, however, have been directed toward the production of art rather than its reception. Norman Freeman (2004), however, provides an overview of "pictorial reasoning" and "aesthetic reasoning" which occasionally bears on issues of interpretation

and thus appreciation. Anna Kindler's (2004) overview of developmental research touches on developments in "artistic thinking" and has implications for interpretation and appreciation, and not just production of artifacts.

### College Art Appreciation Courses

Professors of introductory art history and appreciation courses are increasingly reexamining their practices for educational efficacy (e.g., College Art Association, 2005; Lindner, 2005). *The Cheese Monkeys*, a novel by Chipp Kidd (2001), a professor of design, describes what may be many students' unfortunate experiences in such courses. Following is an excerpt of one young man's exposure to modern art as taught by Professor Mistelle ("Misty").

> During what was to become a pivotal moment for me at State, Misty put one of the silliest paintings I had ever seen up on the screen. It was of five … figures. You could tell that they were supposed to be people because they had eyes. At least three of them were female, sporting pointy boobs the shape of horizontal midget dunce caps. The one farthest to the left apparently started out as a Negro, but the artist changed his mind when he got to the neck and made the rest of her white, pink, apricot, and deep rust.
>
> These she-things looked stunned, as if they'd just been told they all had cervical cancer. And the two on the right were racked with skin problems the likes of which I prayed I'd never know. The whole thing appeared to have been abandoned far from completion, the artist having come to his senses and taken up something less ghastly, like infanticide.
>
> "This," Mistelle announced, "is Picasso's *Les Demoiselles d'Avignon*, 1907."
> (pp. 67–68)

The Professor continued his lecture, all of which merged into what the student characterized as "a continual membrane of ambiguous declaration" (p. 68). The student came to realize "something strange was happening to me. I was starting to feel ashamed … stupid" (p. 68). In the fictional student's experience, who was taking the elective course to appreciate modern art, he came instead to appreciate that he was an "idiot" and that modern paintings were "unknowable."

### Appreciation in Methods Textbooks for Teachers

There are many well-intentioned but vague claims and exhortations in methods textbooks about teaching art, preschool through 12th grade. For example, early in her textbook on teaching art to elementary education students, Joan Koster (2001) writes: "Students need to learn how to appreciate art and to understand how being knowledgeable in art can enrich their lives" (p. 17). She neither explicitly explains what appreciation will entail nor how knowledge of art enriches students' lives.

Some art educators are more explicit when writing about art appreciation. In their textbook for teaching art in elementary schools, Al Hurwitz & Michael Day (1995) define art appreciation:

the word appreciate means "valuing" or having a sense of an object's worth through the familiarity one gains by sustained, guided study. Appreciation also involves the acquisition of knowledge related to the object, the artist, the materials used, the historical and stylistic setting, and the development of a critical sense. (pp. 309–310)

Hurwitz and Day connect appreciating with valuing that requires knowledge. They weaken relations of appreciating and knowing, however, when they write: "Knowledge, however, is not a precondition for deriving pleasure from works of art – if it were, people would not collect African or Asian art or anything else about which they know little but which nevertheless has the power to capture and hold their attention" (p. 311).

The claim that making art increases one's appreciation for art is also commonplace. For example, Koster (2001) states: as if it were self-evident and without need of argumentation or evidence, "In creating their own art, students learn how artists think in the context of reflecting and analyzing their own artistic productions" (p. 434).

Hurwitz & Day (1995) explicitly promote the idea that art teachers should teach toward appreciation of art by teaching artmaking skills, but they do not assume that there is an automatic transference from students making art to students appreciating art: to attain such a goal, teachers must teach for it. In support of consciously teaching toward appreciation, the authors cite Manuel Barkan and Laura Chapman who in 1967 argued for balancing making and reflecting as mutually reinforcing, asserting that neither one is sufficient without the other.

### Aesthetic Education at the Lincoln Center Institute

The Lincoln Center Institute in New York City is an example of a program developed and refined over a 25 year period. It is dedicated to "aesthetic education" that provides students with experiential studies of actual works of art, including dance, music, theater, film, visual arts, and architecture. The Institute's philosophy and practices are predominantly based on philosophical and psychological theories of Maxine Greene (2001), Howard Gardner (1999), and John Dewey (1934). The Institute's repertory from which teachers may choose changes yearly and is broad in range, including works from the Paul Taylor Dance Company, Shakespeare's *Twelfth Night*, and Alfred Hitchcock's *Notorious*. The strength of the Institute is the performing arts; visual art experiences are provided by local art museums.

## Expanding the Boundaries of Appreciation

### Engaged Appreciation

The proper place for considerations within art education of the aesthetic is currently contested. As Parsons (2005) makes clear, some art educators place it centrally (e.g., Eisner, 2002), and some toward the side (e.g., Efland, 2002). The role of the aesthetic is unresolved in visual culture literature (e.g., Efland, 2005; Tavin, 2003).

Most of the examples of appreciating artifacts and nature in this chapter require and entail engaged appreciation, rather than distancing oneself from everything but the

"formal" or "aesthetic" properties of a work of art. Even appreciation of art made under Formalist theory requires knowledge of art history (Danto, 1981). To disengage from the meanings and implications of any work of art, and especially works made to be politically confrontational, is to tame them beyond recognition. A morally and ecologically sound appreciation of nature requires engaged participation. When we study visual culture it is not for the purpose of being washed over with an aesthetic glaze.

## A Broadened Canon

Appreciation has been confined too narrowly to "high" or "fine" art. The canon, nevertheless, has been broadened in the past by art educators such as Estelle Hurll, Vincent Lanier (1982) who advocated film study, June King McFee and Rogena Degge (1977) who attended appreciatively and critically in their methods book to the built environment and different cultural groups, and Laura Chapman (1978) who, in her methods book, included discussions of a gas station, doll houses, and commercial television. Currently, art educators who advocate the study of visual culture in art education include a wide range of artifacts beyond those collected by art museums. Doug Blandy and Kristin Congdon (2005) advocate the study of kitsch, which is usually associated with bad taste, and generally avoided by art teachers.

## Nature and Art Education

Charles Garoian (1998) critically considers the aesthetics of land use in art education as it should be affected by ecological understanding and care. When considering pedagogical strategies for teaching elementary school students about constructing environmental art, Karen Keifer-Boyd (2002) asks children these questions which she adopts from ecofeminists: "Where did the material originate? Are the materials biodegradable? Were any species exploited in the production of the material applied to the art process?" (p. 331).

Peter London's writing on teaching art with and about nature includes engaged concerns: "Nature Matters. The apples and pears in the still life, the model on the stand, the trees and hills are not merely bumps and depressions of hues. They are alive … they are all speaking and have things to tell us that we should attend to" (2004, p. 39).

## Appreciating Individual Artists and Cultural Groups

Lawrence Weschler (1982), in his biography of Robert Irwin, offers a compelling example of all that can be learned and appreciated by seeing through the eyes of an artist, his culture, intentions, successes, frustrations, as well as his individual works of art. The title of Weschler's book, *Seeing Is Forgetting the Name of the Thing One Sees*, is a poetic variant definition of "aesthetic experience," but Weschler is clearly engaged in his appreciation of the artist and his work. The book is reminiscent of ground-breaking empirical work relevant to appreciation by Mihalyi Csikszentmihalyi (1990) on "flow."

Art educators Graeme Chalmers (2004) and Patricia Stuhr (1994), among others, advocate teaching art as a means for social change through cultural knowledge of artifacts and people who produce them. Chalmers (2004), for example, identified cultural goals for teachers of art that include "strategies that correct and redress feelings of cultural superiority," "encourage students to make art that challenges racist beliefs of individuals," and "challenge students' assumptions about people who seem 'different' " (pp. 9–10). Stuhr (1988) and Jacqueline Chanda (1993), among others, explore how indigenous peoples appreciate their artifacts.

Paul Bolin (1995) advocates study of material culture within art education, defining the term to encompass all nonnatural objects. The purpose of such study is "offering interpretations about people who make, use, respond to, and preserve these artifacts" in order to "provide students with a range of ways to consider the artifact itself, and more importantly, its maker" (n. p.).

### Teaching for Empathic Appreciation

Candace Stout (2001) advocates explicitly teaching art so that students care about people and the world. In building a "moral-cognitive curriculum" she is influenced especially by Maxine Greene. Stout developed and taught a course to high school students in which all learning activities were "intended to evoke empathic response to fellow human beings as well as to other creatures with whom we share this earth" (p. 84). She observed changes in her students: they showed desire to learn more about artists, they listened to the ideas of others, showed signs of respect for difference, became more reflective, expressive, and invested with their own experiences. Stout was able to effect caring, however difficult that is to measure, by planning and teaching directly for it.

The following quotation is a specific example of the results of directly teaching for an understanding of another person by examining that person's art. Jean Giacolone, a master's student in art education, responds to a self-portrait by Maria Magdalana Campos-Pons, a Cuban woman of African descent. In the large Polaroid photograph, the artist has "slimed" herself, and has these words hand-written across her chest: "IDENTITY COULD BE A TRAGEDY." After examining the photograph in an art gallery, Giacolone wrote about the picture pretending she was the skin of the subject:

> I have been given too much importance in the world. I wrap this woman, warm her, and cool her. I expand with her every breath. The color I give her is from Mendel's lottery – a toss of the protean dice. She is sometimes so proud of my flawless surface and other times I feel if she had a zipper she would step right out of me, and leave me on the floor. Would she then be freer, less conflicted? I glow for her. Be proud of your heritage. If I am your identity I am only the beginning – the wrapper. When you covered me with goo, were you mocking me or paying homage to the origin of our brown-ness? I want you to come to terms with me. I will not take the fall for this – I am not your tragic flaw. (cited in Barrett, 2005, p. 192)

Giacolone's spontaneous writing in front of an artwork is an example of empathic interpretation and appreciation, both of an artwork and what it expresses, and of a living person who is the subject of the work.

*Art Education, the Interpretive-Self, and Interpretive-Communities*

While taking an art education course on teaching criticism and aesthetics, upon request of the instructor, a student pretended to be some specific thing in a painting and to express insights about the painting from her assumed perspective. Shari chose to be a small tree hanging off the edge of a high cliff in a Chinese landscape painting, and wrote about the landscape as if she were the tree. When she read her paragraph aloud to the class, Shari's voice faltered. "When reading this aloud I almost started to cry. I realized I was writing about myself." Shari is a survivor of a life-threatening form of cancer.

> I wrote my interpretation as the tree clinging to the cliff. When I read it, the tree was not speaking any longer. I was. No one else listening would understand what it had become for me, but it changed and I had to acknowledge the power of this discovery. By tapping into a place I like to keep at bay, the examination of this painting unleashed a truth that is uniquely mine and painful to explore. I was forced to see my fear, and for the first time to admit that I don't fully believe I have left it behind. It exists in places and things I can't escape and perhaps I'm not supposed to. (personal communication, fall 2004)

Through interpretation of a landscape Shari better knows herself, and when she shares her insight others can experience a person being vulnerably human.

# Conclusions

Appreciation is a complex act of cognition that is dependent on relevant knowledge of what is appreciated. Full appreciation involves engagement with what is appreciated, and such engagement involves knowledge of various sorts, including emotion that informs knowledge (Scheffler, 1991). Appreciation ought not be set apart from moral implications of what is being appreciated. Distanced vs. engaged appreciation need not be an either-or choice: both can provide useful lenses toward understanding (Brand, 1998), but distanced appreciation is insufficient. Appreciation results from an act of judgment, and a responsive judgment (positive or negative) is dependent on an interpretation. Any interpretation is "preformed, prejudiced, interested, partial, horizontal, incapable of reaching any straightforwardly neutral or objective account of what is interpreted" (Honderich, 1995, p. 13).

Appreciation within art education is too narrowly focused on fine art and ought to be broadened to include nature as environment, artifacts of more kinds, individuals who make and perform, and cultural influences on the makers' expressive activities. Appreciation might also include knowledge of the appreciating-self and the appreciating-other who publicly expresses her or his observations. Because appreciations are prejudiced, interested, and partial, by examining what and why we value, we can learn about ourselves and others and if, how, and why values differ.

Appreciation ought not be assumed to be a natural and inevitable outcome of art education. If it is important to teachers, teachers ought to design their curricula so that

appreciation is taught for and assessed (Wiggins & McTighe, 2005). Making something does not necessarily result in appreciation, and when an artmaking experience is negative, artmaking may result in acquisition of negative attitudes. When making-experiences are positive for the makers, this does not guarantee their appreciation of other things of that kind, nor transfer of that specific appreciation to all things.

Appreciation is a complex phenomenon deserving of continued research about if, when, and how learners achieve appreciation in their present lives, what and who they appreciate, and if it lasts through their lifetimes. Such investigations ought to include philosophical clarifications of what counts as appreciation, appreciation within visual culture studies, anthropological studies of indigenous appreciators, historical studies of international education and appreciation, concepts of appreciation in disciplines other than art, cognitive studies of appreciating individuals and groups, case studies of schools and programs claiming appreciation as an outcome, issues of appreciation and social change, and longitudinal studies to assess life-long learning that continues to result in appreciations of newly experienced objects, events, and people.

# Note

1.  For overviews of theories of aesthetic experience see anthologies of aesthetic philosophy such as those edited by Carolyn Korsmeyer (1998), Peter Kivy (2004), and David Goldblatt and Lee Brown (2005).

# References

Barrett, T. (1994). *Criticizing art: Understanding the contemporary*. Mountain View, CA: Mayfield.

Barrett, T. (2003). *Interpreting art: Reflecting, wondering, and responding*. New York: McGraw-Hill.

Barrett, T. (2005). *Criticizing photographs: An introduction to understanding images* (4th ed.). New York: McGraw-Hill.

Berleant, A. (1997). *Living in the landscape: Toward an aesthetics of environment*. Lawrence: University Press of Kansas.

Berger, M. (2004). Last exit to Brooklyn. In A Rockman (Ed.), *Manifest destiny* (pp. 4–15). New York: Brooklyn Museum.

Blandy, D., & Congdon, K. (2005). What? Clotheslines and popbeads aren't trashy anymore? Teaching about kitsch. *Studies in Art Education. 46*(3), 197–210.

Bolin, P. (1995). Investigating artifacts: Material culture studies and art education, *NAEA advisory*, Fall, n.p.

Bourdieu, P. (1984). *Distinction: A social critique of the judgment of taste* (R. Nice, Trans.). Cambridge, MA: Harvard University Press. (Original work published 1979).

Brand, P. (1998). Disinterestedness and political art. In C. Korsmeyer (Ed.), *Aesthetics: The big questions* (pp. 155–171). Malden, MA: Blackwell.

Broudy, H. (1972). *Enlightened cherishing*. Champaign-Urbana: University of Illinois.

Carlson, A. (2005). Aesthetic appreciation of the natural environment. In D. Goldblatt & L. Brown (Eds.), *Aesthetics: A reader in philosophy of the arts* (2nd ed.) (pp. 526–533). Upper Saddle River, NJ: Prentice-Hall.

Chalmers, G. (2004). Art education in a world where old boundaries, old truth, and old certainties are no longer valid. *The International Journal of Art Education, 2*(2), 8–15.

Chanda, J. (1993). *African arts and cultures*. Worcester, MA: Davis Publications.

Chapman, L. (1978). *Approaches to art in education*. New York: Harcourt Brace Jovanovich.

College Art Association (2005). Art history survey: A roundtable discussion. *Art Journal, 64*(2), 32–51.

Crawford, D. (2001). The aesthetics of nature and the environment. In P. Kivy (Ed.), *The Blackwell guide to aesthetics* (pp. 306–324). Malden, MA: Blackwell.

Csikszentmihalyi, M. (1990). *Flow: The psychology of optimal experience.* New York: Harper Collins.

Danto, A. (1981). *The transfiguration of the commonplace: A philosophy of art.* Cambridge, MA: Harvard University Press.

Danto, A. (1994). *Embodied meanings: Critical essays and aesthetic meditations.* New York: Farrar, Straus, & Giroux.

Dewey, J. (1934/2005). *Art as experience.* New York: The Berkeley Publishing Group.

Dickie, G. (1997). *Introduction to aesthetics: An analytic approach.* New York: Oxford University Press.

Dow, A. (1899). *Composition: A series of exercises in art structure for the use of students and teachers.* New York: Doubleday, Doran & Co.

Duncum, P., & Bracey, T. (Eds.). (2001). *On knowing: Art and visual culture.* Christchurch, New Zealand: Canterbury University Press.

Eaton, M. (1997). The beauty that requires health. In J. Nassauer (Ed.), *Placing nature: Culture and landscape ecology* (pp. 85–106). Washington, DC: Island Press.

Efland, A. (2002). *Art and cognition: Integrating the visual arts in the curriculum.* New York: Teacher's College Press.

Efland, A. (2004). Art education as imaginative cognition. In E. Eisner & M. Day (Eds.), *Handbook of research and policy in art education* (pp. 751–773). Mahwah, NJ: Lawrence Erlbaum Associates.

Efland, A. (2005). Problems confronting visual culture. *Art Education, 58*(6), 35–40.

Eisner, E. (2002). *The arts and the creative mind.* New Haven, CT: Yale University Press.

Eldridge, R. (2003). *An introduction to the philosophy of art.* Cambridge, UK: Cambridge University Press.

Feynman, R. (1999). *The pleasure of finding things out.* New York: Basic Books.

Freeman, N. (2004). Aesthetic judgment and reasoning. In E. Eisner & M. Day (Eds.), *Handbook of research and policy in art education* (pp. 359–377). Mahwah, NJ: Lawrence Erlbaum Associates.

Gadamer, H.-G. (1998). From *Truth and method.* In C. Korsmeyer (Ed.), *Aesthetics: The big questions* (pp. 92–93). Malden, MA: Blackwell. (Original work published 1989)

Gardner, H. (1999). *Intelligence reframed: Multiple intelligences for the 21st century.* New York: Basic Books.

Garoian, C. (1998). Art education and the aesthetics of land use in the age of ecology. *Studies in art education, 39*(3), 244–261.

Goldblatt, D., & Brown, L. (Eds.). (2005). *Aesthetics: A reader in philosophy of the arts* (2nd ed.). Upper Saddle River, NJ: Prentice-Hall.

Goldman, A. (2004). Evaluating art. In P. Kivy (Ed.), *The Blackwell guide to aesthetics* (pp. 93–108). Malden, MA: Blackwell.

Goldsworthy, A. (2004). *Passage.* New York: Abrams.

Greene, M. (2001). *Variations on a blue guitar: The Lincoln Center Institute lectures on aesthetic education.* New York: Teachers College Press.

Honderich, T. (Ed.). (1995). *The Oxford companion to philosophy.* New York: Oxford University Press.

Hurll, E. (1914). *How to show pictures to children.* Boston, MA: Houghton Mifflin.

Hurwitz, A., & Day, M. (1995). *Children and their art: Methods for the elementary school* (6th ed.). New York: Harcourt Brace.

Kalina, R. (2002). Expressing the abstract. *Art in America,* December, 88–97.

Keifer-Boyd, K. (2002). Open spaces, open minds: Art in partnership with the earth. In Y. Gaudelius & P. Spears (Eds.), *Contemporary issues in art education* (pp. 327–344). Upper Saddle River, NJ: Prentice-Hall.

Kidd, C. (2001). *The cheese monkeys: A novel in two semesters.* New York: Scribners.

Kindler, A. (2004). Research impossible? Models of artistic development reconsidered. In E. Eisner & M. Day (Eds.), *Handbook of research and policy in art education* (pp. 233–252). Mahwah, NJ: Lawrence Erlbaum Associates.

Kivy, P. (Ed.). (2004). *The Blackwell guide to aesthetics.* Malden, MA: Blackwell.

Korsmeyer, C. (Ed.). (1998). *Aesthetics: The big questions.* Malden, MA: Blackwell.

Koster, J. B. (2001). *Bringing art into the elementary classroom.* Belmont, CA: Wadsworth.

Lanier, V. (1982). *The arts we see.* New York: Teachers College.

Lindner, M. (2005). Problem-based learning in the art-history survey course. *Newsletter of the College Art Association, 30*(5), 7–9.

London, P. (2004). Drawing closer to nature: Aligning with the cardinal points. *School Arts Magazine*, December, p. 39.

Martin, S. (2004). The masterpiece in the hallway. *The New York Times*, arts and leisure, November 7, p. 14.

McEvilley, T. (1984). Doctor lawyer Indian chief: "Primitivism" in twentieth-century art at the Museum of Modern Art in 1984, *Artforum*, November 1984, reprinted in B. Beckley (Ed.), *Uncontrollable beauty: Toward a new aesthetic* (pp. 149–166). New York: Allworth Press.

McFee, J., & Degge, R. (1977). *Art, culture, and environment: A catalyst for teaching*. Belmont, CA: Wadsworth Publishing Company.

Olsen, S. H. (1998). Appreciation. *Encyclopedia of aesthetics*. New York: Oxford.

Parsons, M. (1987). *How we understand art: A cognitive developmental account of aesthetic experience*. New York: Cambridge University Press.

Parsons, M. (2005). Review. *Studies in Art Education, 46*(4), 369–377.

Scheffler, I. (1991). *In praise of the cognitive emotions and other essays in the philosophy of education*. New York: Routledge.

Stankiewicz, M. A. (2001). *Roots of art education practice*. Worcester, MA: Davis.

Stankiewicz, M., Amburgy, P. & Bolin, P. (2004). Questioning the past: Contexts, functions, and stakeholders in 19th century art education. In E. Eisner & M. Day (Eds.), *Handbook of research and policy in art education* (pp. 33–53). Mahwah, NJ: Lawrence Erlbaum Associates.

Stout, C. (1995). *Critical thinking and writing in art*. Minneapolis/St. Paul: West Educational Publishing Company.

Stout, C. (2001). The art of empathy: Teaching students to care. In J. Portelli & W. Hare (Eds.), *Philosophy of education: Introductory readings* (3rd ed.) (pp. 84–94). Calgary: Detselig Press.

Stuhr, P. (1988). Analysis of gender roles as viewed through the aesthetic production of contemporary Wisconsin Native American arts. *Arts and Learning Research, 6* (1), 116–128.

Stuhr, P. (1994). Multicultural art education and social reconstruction. *Studies in Art Education, 35*(3), 171–178.

Tavin, K. (2003). Wrestling with angels, searching for ghosts: Toward a critical pedagogy of visual culture. *Studies in Art Education, 44*(3), 197–213.

Weschler, L. (1982). *Seeing is forgetting the name of the thing one sees: A life of contemporary artist Robert Irwin*. Berkeley, CA: University of California Press.

Wiggins, G., & McTighe, J. (2005). *Understanding by design* (2nd ed.). Alexandria, VA: Association for Supervision and Curriculum Design.

Wilson, B. (1986). Art criticism as writing as well as talking. In S. Dobbs (Ed.), *Research readings for discipline-based art education: A journey beyond creating* (pp. 134–146). Reston, VA, NAEA.

Winner, E. (1982). *Invented worlds: The psychology of the arts*. Cambridge, MA: Harvard University Press.

Wolterstorff, N. (2004). Art and the aesthetic: The religious dimension. In P. Kivy (Ed.), *The Blackwell guide to aesthetics* (pp. 325–339). Malden, MA: Blackwell.

# INTERNATIONAL COMMENTARY

# 41.1

## On "Teaching toward Appreciation"

**Folkert Haanstra**
*Amsterdam School of the Arts, The Netherlands*

## Appreciation and Class

The Dutch sociologist Ganzeboom (1982) compared two theories explaining differential participation in "high" art. The first one, Bourdieu's status theory, explains art appreciation as a mechanism of social distinction. The second one, the information processing theory, states that each person possesses a limited capacity for apprehending the "information" proposed by an art work. Whether art is experienced as pleasurable or rewarding depends on how much complexity it affords to a person. It is claimed that the preferred level of complexity increases with artistic training, for this training will add to knowledge to solve successfully the "problem" the art work poses. Ganzeboom has found empirical evidence for both theories (e.g., Nagel & Ganzeboom, 2002). Van der Tas (1998) accuses him of using reductionist and deterministic theories. In his research on art appreciation by museum visitors he stresses the great variety of art preferences within a social class. He states that research into art appreciation should focus on individual experiences of art. It is clear however that despite the weakened boundaries between "serious" and "popular" art and the rise of broad individual art consumption patterns (cultural omnivorousness) there still exists a class based hierarchy in high-culture art preferences (DiMaggio & Mukhtar, 2004).

## Expanded Boundaries of Appreciation

A recurrent issue in West European publications on art education is the problematic relationship between art appreciation and contemporary art. A growing number of art educators oppose the reduction of complex meanings of art to make "appreciation" teachable. Belgian philosopher and art educator Elias (2002) states that aesthetics does not refer to the beauty of the object but to the singularity of the formal composition of the work of art being art. The aesthetic codes of contemporary art no longer are based

*L. Bresler (Ed.), International Handbook of Research in Arts Education, 655–656.*
© 2007 *Springer.*

on uniformity and universality. Everything is allowed (including the traditional codes) and education should help students to decipher these complex aesthetic codes. Art educators look for pluralistic methods to make this possible. Danish author Illeris (2000) defends a polycentric approach in teaching art appreciation, suggesting that in the classroom, teachers and students should choose different perspectives and play different roles ("the expressionist", "the humanist", "the feminist") to see what meanings the various roles are able to generate. She adds that this polycentric approach should not mean complete relativism. The German author Kirchner (1999) deals with the relation between education and contemporary art in both theoretical and practical ways. In a book titled *With Art to Art* Kirchner and Kirschenmann (2004) collected three kinds of lessons involving studio art in confrontation with modern art. The first group of lessons takes art works as means for students' experiments in visualization (without necessarily leading to understanding the works). The second group aims at self-understanding through art and the third group aims at understanding and appreciating the art works.

# References

DiMaggio, P., & Mukhtar, T. (2004). Arts participation as cultural capital in the United States, 1982–2002: Signs of decline? *Poetics, 32*(2), 169–194.

Elias, W. (2002). Interpretation and What about the "Ugly" Art? Paper presented at InSEA 31st World Congress, New York City, August 19–24.

Ganzeboom, H. (1982). Explaining differential participation in high-culture activities – a confrontation of information processing and status seeking theories. In W. Raub (Ed.), *Theoretical models and empirical analyses* (pp. 186–205). Utrecht: E. S. Publications.

Illeris, H. (Ed.). (2000). *Studies in visual arts education.* Copenhagen: The Danish University of Education.

Kirchner, C. (1999). *Kinder und Kunst der Gegenwart* [Children and contemporary art]. Seelze: Kallmeyer.

Kirchner, C., & Kirschenmann, J. (Eds.). (2004). *Mit Kunst zur Kunst: Beispiele aesthetischer Praxis zur handlungsorientierten kunstrezeption* [With art to art: examples of aesthetic practice in art reception]. Donauworth: Auer Verlag.

Nagel, I., & Ganzeboom, G. (2002). Participation in legitimate culture: Family and school effects from adolescence to adulthood. *The Netherlands' Journal of Social Sciences, 38*(2), 102–120.

Van der Tas, J. (1998). *"Je (ne) sais quoi": Oordelen en vooroordelen over kunst* ["Je (ne) sais quoi": Judgement and prejudgement on art]. Assen: Van Gorcum.

# INTERLUDE

# 42

# THE ARCHES OF EXPERIENCE

**Maxine Greene**
*Teachers College, Columbia University, U.S.A.*

My memory is studded with moments of wonder, of efforts to understand art-making and the meanings of what were called works of art. Stories and pictures enchanted me. I remember collecting words like "carnelian," "porcelain," and "roundelay," and puzzling how they could summon up images in my head. I looked at photographs of country places and could not figure out why paintings of the same places (Winslow Homer's, Andrew Wyeth's, "realistic" as they were supposed to be) never looked the same. I read about a girl who connected what Virginia Woolf called "shocks of awareness" with some particular experiences of her own – her grandfather's sudden death; her first look at a blue stained glass window; the sight of a speeding train; reading a Keats poem and coming upon a drawing of his face. Then I read that Virginia Woolf said she thought her shock-receiving capacity made her a writer; and I tried to invent situations that would shock me enough to make me see more and feel more and, perhaps, write more like a real writer.

More than that: I tried to figure out how to shape language in such a way as to cause a jolt, a coming awake, a deep noticing on the part of a reader. There was Gwendolyn Brooks (in her *Maud Martha*) writing about a young woman's longing to go to New York:

> What she wanted to dream and dreamed, was her affair. It pleased her to dwell upon color and soft bready textures and light, on a complex beauty, on gemlike surfaces. What was the matter with that? Besides that, who could surely swear that she would never be able to make her dream come true for herself? Not altogether, then, but – slightly? – in some part? She was eighteen years old, and the world waited. To caress her. (1997, p. 1615)

Why and how did Brooks choose those words and arrange them as she did? How did she manage the change in tone? And why those fragmented sentences at the end? What was it that stirred me so strangely? Was it a recognition of that longing, that hope, that uncertainty? Or was it the images or the color or the tone of voice?

*L. Bresler (Ed.), International Handbook of Research in Arts Education*, 657–662.

These, for me, are the kinds of questions that accompany initial explorations of a medium; and, in my case, language has been my chosen medium, even before I thought in those terms. And it appears that becoming conscious of medium, or the materials out of which a work of art is made, has much to do with one's future engagement. We know how many newcomers to the arts find it hard to distinguish between a cry of despair, let us say, and a deliberately created ode to dejection. They overlook the fact that emotions find expression through and by means of language, or clay, or paint, or movements of the body. Aesthetic experiences take place through reflective encounters with Shelley's poems, Henry Moore's sculpted stone women, a Martha Graham dancer's performance – not through face-to-face meetings; and it is in recognition of this that aesthetic education begins.

Equally important is the acknowledgment of the imagination. Imagination has been described as a "passion for the possible," meaning that it is the capacity to bring into being realities alternative to common sense or taken-for-granted reality. If it is indeed the case that ours is an "image culture," our perceiving consciousness may be so crowded with images (from television, films, video, and cartoons) that it is becoming hard to distinguish what we have seen in actual experience from what we have seen on screens. Italo Calvino has warned of the danger of losing the power of "bringing visions into focus with our eyes shut, of bringing forth forms and colors from the lines of black letters and in fact thinking in terms of images" (1988, p. 92). He had in mind a "pedagogy of the imagination" that each of us would control. It might keep us from stifling our imaginations or "letting it fall into ephemeral forms." That might mean a kind of crystallization of an image like Maud Martha's textures and gemlike surfaces, giving it form, perhaps giving birth to a metaphor, generating a play of imagination.

What of the visual images presented by paintings? In what was called "art appreciation" in my youth, we sat through countless slide shows, jotting down titles and dates and the "explanations" by teachers who never asked us what we saw in what was shown to us. There was a clear separation between subjects and objects – between the presumed innocent and uninformed and the expert who could penetrate the codes and point out what was objectively "given." The idea that there is no such thing as an innocent eye had not yet occurred to the experts. For them a student's history of perceiving, of funding meanings, of living in a culture, had no bearing on appreciation.

When I first ventured into art museums on my own, my first response was to turn the paintings into stories. The stories were about Jesus, Mars in full armor with a naked Venus, girls with tranquil faces being tortured, men on horses seizing helpless women and strewing babies on the ground, café dancers, executions, shipwrecks: I only later realized I did not know how to look at paintings even though I had worked now and then on sketches and watercolors. I did not grasp the importance of perspectives nor of the transformation of what was viewed as if through the eyes of a detached spectator into a painting of an interpreted reality, interpreted through distinctive renderings of pictorial space, changing uses of color, breaks with harmony and equilibrium, the disruption of traditional forms. Traditional Western notions were challenged and expanded by the opening to what some called "primitive" images – Iberian, African, pre-Columbian, Aztec, more, and more.

It was not so much that the pictures and their styles changed; nor that we could no longer expect artists like De Kooning, Rearden, Pollock, Picasso, Hopper to present accurate versions of a stable, objective world "out there." More crucial in a sense than the artists' altered perceptions of the appearances of things was the changed perception required of those who chose to enter into the painters' invented worlds. What to some was a threatening relativism was to others (art students as well as spectators) the opening of whole new spaces of possibility. As in the case of modern works of literature – by Joyce, Woolf, Ellison, Morrison, and others – we were expected to enter into the work of art – imaginatively, emotionally, sensually, even physically.

If we could attend with enough care and reflectiveness to the shapes of pain in the *Guernica* and the light bulb and the desperate mother, if we could participate against the background of our own lived and lacerated lives, new visions, our own visions might crystallize for us. Shocked (perhaps) by the *Guernica*, impelled to new modes of thinking and feeling about violence and war and our relation to them, about the meaning of that bulb and the extended arm, we might be aroused to heightened consciousness, to a refusal of mere passivity and indifference. I cannot but move to *Portrait of the Artist as a Young Man*, as much a break with the traditional as Picasso's work, but often treated from a strictly formalist point of view.

Teachers may offer it as an exquisite symbolic piece, perfect in its own terms, referring mainly to itself. Students, even student writers, may be asked to treat it almost in Jesuit terms, as if created by "an indifferent God paring his nails." Moved to participate in it, however, to lend it their lives (whether Catholic or Jewish or Muslim, whether Irish or French or American), they are bound to construct it as meaningful in a variety of ways. Yes, the form of the text, the "plot" will remain the same; but there are multiple ways of experiencing boarding school life in a city, of venturing into dark places, of confronting authorities bent on imposing a Truth. Engaging in aesthetic education, working for full attentiveness to the aesthetic elements in the book – and to the transmutation of a lived life into art – teaching artists and their students may attempt similar transformations of their own memories into fiction. Reading each other's work, dramatizing it, for example, they may return to Joyce's work, not simply to talk about what happened, but to probe what is revealed through internalizing different, sometimes contradictory points of view.

Most of us are aware that meanings emerge as connections are made and new patterns form in experience. We are aware as well that, as Dewey suggested, mere facts are mean and repellent things until imagination opens the way to intellectual possibility. If it is indeed the case that imagination is most clearly released by encounters with art works, it becomes all the more important to make those encounters reflective and infused with an understanding of what it signifies to create and engage with a created world.

This is the task and responsibility of aesthetic education as some of us pursue it today. Even as we ground it in a specific view of the artistic-aesthetic, we do not in any degree think of it as instrumental, means to the end of mastering other disciplines. Nor, for all my searches through the literature of philosophical aesthetics, do I believe that "art" can be defined in any definite or absolute way. With many others, I believe that most theories of art have something to say about some dimensions of art-making and works of art, even as particular theories of literature, painting, music, drama, and other art forms

illuminate their distinctive provinces of meaning. Even listing the forms of art and thinking how the domain has expanded to include phenomena such as video art, photo flicks, unexpected parodies in literature, interweavings of the comic, the tragic, and even the mythic, suggest the appearance of innovations escaping accustomed definitions.

My long association as "philosopher-in-residence" with the Lincoln Center Institute for the Arts in Education, the opportunities to lecture during summer sessions for more than twenty-five years, the collaboration with teaching artists, the contacts with other kindred institutions across the country: all have acquainted me with the changing landscapes of the arts in American education. At a moment marked by conservatism, unpredictable interferences by government agencies into local schools, and an increasing dependence on "measurement," it seems necessary for those of us who speak in any fashion as spokespersons for the arts in education to make clear the sources of our points of view, as well as our autobiographical beginnings (as I have tried to do). With a doctorate from NYU (New York University) in philosophy of education, I have focused on philosophy of education, history, literature, and aesthetics in 25 years of teaching at Teachers College, Columbia University, which co-sponsored our Institute for a decade or so. My acquaintance with educational research stems largely from what I learned during my presidency of AERA (American Educational Research Association) and my years of participating, listening, and arguing for more serious attention to the arts.

The sources of my views on aesthetic education are to be found in John Dewey's *Art as Experience* (1934), *How we Think* (1933), and *Experience and Nature* (1958); but that is not all. I was drawn to Existential writers – Nietzsche, Dostoievsky, Heidegger, Sartre, Camus, Merleau-Ponty – to Rilke and Kafka, in large part because of their concern for freedom in its ambiguities and anguish, because of the centrality of the arts and aesthetics in their writings, (in Merleau-Ponty's work especially) because of their calling attention to the focal importance of perception in art-making and in the appreciation of the arts. Also, I have been interested in the silences, "the muteness of the spheres" when we pose our most heartfelt questions, the unutterable, and (always) the imagination.

And there is the notion of consciousness, our way of thrusting into the world, of grasping its appearances. Acts of believing, perceiving, thinking, wondering, imagining: all are among the acts of consciousness; all exist in complex relationship. It is the hope of those engaged in aesthetic education to free others – teachers, students, creative artists themselves – to reach towards a reciprocity of perspectives. Diverse perspectives are opened by acts of consciousness. Of all human creations, works of art are most likely to resist fixed boundaries, even as they resist one-dimensionality. There are no fixed boundaries between illusion and reality, between the visible and the invisible: illusion awakens us to aspects of the taken-for-granted we never were aware of before; art, many have said, makes visible what was never visible before. Most significant for me is the capacity of an art form (when attentively perceived, when authentically imagined) to overcome passivity, to awaken us to a world in need of transformation, forever incomplete. Beyond the experiences of consummation and integration, beyond the disruptions and the contradictions, there is always a receding horizon, always some unrealized

possibility. The end-in-view for aesthetic education may be best expressed even now by Tennyson:

Experience is an arch wherethro'
Gleams that untravell'd world, whose margin fades
Forever and forever when I move.
                    *Ulysses* (1962, p. 1464)

There is always, always, more.

# References

Brooks, G. (1997). Maud Martha. In H. S. Gates & N. Y. McKay (Eds.), *The Norton anthology of African American literature* (pp. 1615–1650). New York: Norton & Co.

Calvino, I. (1988). *Six memos for the next millennium*. New York: Vintage Press.

Dewey, J. (1933). *How we think*. Lexington, MA: D. C. Heath.

Dewey, J. (1934). *Art as experience*. New York: Capricorn Books.

Dewey, J. (1958). *Experience and nature*. New York: Dover.

Tennyson, A. (1962). Ulysses. In M. L. Abrams (Ed.), *The Norton Anthology of English literature* (p. 1464) New York: Norton & Co.

# INTERLUDE

## 43

# ON READING MAXINE'S INTERLUDE

**Robert Stake**
*University of Illinois at Urbana-Champaign, U.S.A.*

And how do I, a teacher, help raise that arch of experience? How do I help my students, not so much in the happenstance family of the classroom, but each experience-seeking individual? I cannot know their believings and batterings, their wishings and cherishings – yet I agree, I should furbish our classroom to push them a bit toward the receding horizon, toward the unrealized possibility.

Perhaps too much I say, *read these, do this, feel that.* Don't some of my images become their own? I say, *this is the meat of the course* – but I know that each is on a different diet.

Do we not as artists, as teachers, as researchers, overwork the canon? We truly value our experiencing with those who have taught us. You spoke of Dewey, Picasso, Calvino. Can we do better than devote our curriculum to the stars in that firmament?

We can. The first curriculum is the curriculum of one, the living child, the teenager, the graduate student from distant wherever, the office-bound visitor in the chair before me, who needs my encouragement. The experience will be theirs, of their making, but perhaps in part energized or freighted by my bemusement or lure.

There is too much to teach. We would not deny them any corner of the gallery. Our art educator colleagues have scoured the repertories to find the worthy piece. But these directions may be wrong. Oh, Maxine, I am but reaching for what you said so much better.

But in recalling what you said, awakening with the apprehensions you proscribed, I note you didn't press us to see the compulsion of the art teacher to teach the tried and true. Is knowing the very best the way to construct experience, and appreciation, and the furthering of the arts as each would try? Or does the teacher seek the learner's grasp of school and street, the mall and Web, to find the aesthetics of a coming culture? Every teacher?

Some years ago, you may remember, I was doing fieldwork in California for the National Arts Research Center. I asked Madeleine Grumet what I should watch for if I wanted to observe aesthetics in the classroom. She suggested I focus on activities

*L. Bresler (Ed.), International Handbook of Research in Arts Education, 663–666.*
© 2007 *Springer.*

fundamental to aesthetic knowledge. She wrote me:

> If we work from Susanne Langer's thesis in *Feeling and Form* that aesthetic objects are forms that express the artist's knowledge about feeling, then one might also look for teachers and/or students who move to expressive forms other than discursive logic to express their understanding. The student who imitates, who gestures, who draws, sculpts or sings his understanding is caught in a moment of aesthetic process. Similarly, expression that is contingent on context and presentational persuasion rather than representational accuracy might be deemed aesthetic. Forms of expression that use the body, the classroom, that draw upon movement, touch, sound and color as expressive media are aesthetic. And any sense that teachers and students are working to find some new formulation in language or another code to express their mutual understanding is aesthetic, I think, as well.
>
> There is a collective process that verges on ritual that you might look for when a group of kids, a class, maybe, creates a space for itself marked with objects, a configuration of furniture, displays that mark their collective experience. (Madeleine Grumet, personal communication, Chapel Hill, NC, April 15, 1988)

I looked for examples of such expression by pupils in that California classroom but found none right away. I found something closer when I went on a field trip with a fourth grade class.

Nina Bortolio took her children to Luther Burbank House, less than a mile from school. Not far from the orchard and vineyards cultivated by this great naturalist was an old adobe house built by one of the area's first settlers. The house stood just beyond the citrus trees at the base of the grand hill to the west, too low for a view of the river.

The sun was beaming warm as a group of five nine-year-olds began their task of making adobe bricks. As perhaps had the early settlers, they gathered at a six-foot-wide shallow pit under a weeping Deodor Pine, dumped a barrow load of black dirt in the pit, added a few inches of water, took off their shoes, rolled up their jeans and began tramping 'round and 'round to mix adobe, 'round and 'round in a circle of productivity. Their steps were nicely circumscribed.

Gret Neilsen, a park ranger, took off her shoes and socks and joined the circle. In her presence, the work began in sobriety but, as boys and girls warmed to the task, as the pit became slippery and as the ranger voiced no warning, the mud climbed higher on legs, and arms as well. The task moved from work to play. Slipping became more frequent, as did bumping and brushing. 'Round and 'round they went, and down and up.

Ranger Neilsen withdrew. A blonde girl's hair suddenly had a tassel of mud. Giggling and haphazard swelled. A boy became mud to his chest. A parent said "Enough!" They hand-scooped the slurry into the form and patted it flat, still moved by dual persuasion. Then, with little attention to the destiny of their bricks, they moved off to hose away the muck. Gret Neilsen smiled a shy smile and shook her head. The warm sun assured completion of the gig.

It is likely the day will be remembered. Of course the five had been in mud before but, this time, it was at the intersection of history and authority. They previously had mixed work and play but, this time, it had something of the blessing of the Sierra Club. More than memorable, it was a special experience.

The ritual of their play, the choreography of the day, were not credited as arts learning – but could have been. Yes, it was the clowning of artisans more than the artistry of sculptors. The episode was not yet aesthetic. It fell far short of Harry Broudy's enlightened cherishing because the experience evoked little scrutiny in those childhood eyes. They did not realize intellectually what others might find aesthetic in their circling in the mud. They might cherish without enlightenment.

Insight is not a prerequisite to cherishing. Each of these adobe makers was well experienced in cherishing: getting a celebrity's autograph, playing older person to a new baby brother, gaining the respect of a teacher. Enlightened cherishing – as all three of you taught us – is the expansion of our valuings to a realization of the intricacies, the multiple meanings of the object or episode, and stretching beyond the connections between these meanings and the preciousness of things, not only to oneself but as valued by friends or family or society. The cherishing becomes enlightened when the child ponders the fact that splashing in the mud can be fun, and a bit naughty, for a park ranger too.

Cherishings are a given. It is not necessary for a school system to invent them. Beth comes to school in the morning cuddling three porcelain dolls. Shawn whimpers as the teacher threatens to remove his cap. To that, the music teacher wants to add vocal timing and the classroom teacher wants meaningfully to add allegiance to the flag. School must have its lists of cherishings but the way to draw the child more fully into aesthetics may be enlightenment of the child's own, rather than the teacher's. Are we attending to the elegance of a sticker collection, the embroidery on a bowling shirt, the crayola strokes of a self-portrait? In our better moments we pay attention, yes, fawn. In our better moments, we draw the child toward their own arch of experience.

44

# POSTCARDS FROM "A WORLD MADE POSSIBLE": EXCERPTS FROM VIRTUAL CONVERSATIONS

**Jerome S. Bruner\* (with Liora Bresler†)**
\* *New York University, U.S.A.;*
† *University of Illinois at Urbana-Champaign, U.S.A.*

## A Context

Reflecting on my "dream team" for the Handbook, I was hoping for Jerome Bruner's voice. His ideas have provided a solid and inspiring foundation to all disciplines of arts education. I knew that the chances for his agreeing to participate were slim but did write to invite him. Bruner's prompt response was gracious: "I hate to say no to your project – and to you. But I must. I am so up to the ears not only in teaching and writing, but also in civil rights litigation precipitated by this administration … ." I wrote back to acknowledge that a Handbook on arts education feels, indeed, frivolous in these times. Bruner's response was heartwarming and uplifting: "One of the things that make it worthwhile fighting is the existence of the arts as we know them and the promise that they'll flourish freely in the future – which is what art education is about."

Then followed some extensive email communication (about 80 notes from each as Bruner noted), with Bruner's reflections on specific experiences of arts education. Months later he suggested I use some of these virtual conversations for the Handbook. The three snippets below exemplify the power of the arts and the lessons they teach us about perception and meaning.

### December 4, 2004

Dear Liora,
… "It was in London midway through the war. We were being pounded around by buzz-bombs, and the V2s were just starting. I was there working in an Anglo-American secret intelligence unit developing ridiculous plans, some not so ridiculous, for D-Day, the invasion of France via Normandy. I'd got myself into the job because I'd been turned down for the draft but that wasn't going to stop me from killing Hitler. I'd just arrived.

*L. Bresler (Ed.), International Handbook of Research in Arts Education, 667–670.*
© 2007 *Springer.*

Anyway, Wanda Landowska, the Polish harpsichordist who had fled to London, was giving a series of twice weekly noonday concerts – I recall they were at the National Portrait Gallery. I'd managed to get a ticket to one of them. In those troubled days there was a light always placed at center stage forward. When it was green, all was well. When it went yellow it signaled a bombing alert. When it turned red it indicated "aircraft overhead: under attack." The concert started on time, green light glowing, then ten minutes later it turned yellow, two minutes later it was red. Ten minutes later yellow, 30 seconds later red again – on and on.

She was playing some Bach or maybe Monteverdi, flawlessly, of course, but that's not the point. Her playing didn't change, not even the slightest, as the air raid signal changed from one color to another. And neither did the audience show even the slightest stirring. The only other thing I recall is that the light went red again just as somebody brought her the obligatory flowers at the end of the recital, but the applause went on unchanged.

That, of course, was London wartime standard – as I learned. But I remember coming out of that recital hall with my eyes streaming. Even telling about it makes me a little teary! Somehow, it is what life is deeply about."

Jerry

**January 15, 2005**

Liora,

… "The Prado's a bit special though. I took my two kids a lot when they were growing up, and I used to set a prize for finding some particular picture – somebody "suffering as if they'd die" or some easy one like "Veronica with the cloth she'd used to clean Jesus' face on which an image of his face appeared." Some prize money, you know, like twenty pesetas! Later it got more sophisticated, like "something that suggests a landscape (battle, whatever) but isn't really." Anyway, I still remember my then ten year-old.

Janey running down that big central corridor toward where she knew I was. "Hey Dad, come see what I found, something really scary!" You guessed it: she'd come on that room of black, brooding Goyas. And when we arrived in front of them she said (rather terrified), "What's THAT, daddy?" Never forgot it! Neither has she! So it isn't quite like other museums, quite. And it's true that some of them are so chockablock full of mind-blowing things you can hardly get about …

**January 16, 2005**

Liora,

"What puzzles me about "art education" (or even teaching people how to "visit" a museum) is that it's so hard to describe what happens (when it's successful), that you don't know what to repeat or generalize from it. I remember (I must have been a teen-ager) reading Bernard Berenson's *Italian Painters of the Renaissance* and practically passing out! And then, years later, Ernst Gombrich's *Art and Illusion*. (We met much later and became good friends – it was he that convinced

me that any theory of perception that did not have room for the perception of *objets d'art* was just plain puritan fraud). But then again, it wasn't either of them who "taught" me, really, though in some way they did. I recall going back to the Tate in London (after Gombrich) and looking at that landscape of Constable's. It was a real *coup de foudre*! So what the devil had I learned from reading Gombrich, anyway?

Funny how our chatter sets off memories. When I was a kid, my older brother (actually a half-brother, a child of my mother's first marriage) used to take me to the Met here in New York. I STILL have a vivid memory of a painting of San Sebastien, pierced by arrows and suspended from a T-shaped "cross" – it made me ache and made me angry at the same time. My brother said something like "It got to you, eh?" I've no idea what "getting to you" means, but it is surely a lot more than the content of the picture registering. I've no idea who the painter was – though my later reckoning tells me it might have been Giotto.

I used to compare Giotto and Cimabue (to the detriment of the latter, as in my funny book *On knowing: Essays for the left hand*, thinking there was, somehow, only "one" way a work of art can get to you. Then, when we were in Firenze for our last sabbatical, I drove over to Sienna to spend a few afternoons with Cimabue's work in the Duomo there. Its passion (and technique) is, what shall I call it? more feminine, but when you spend time with Cimabue, you get that same feeling of being "possessed," enchanted, a new inhabitant of a world made possible by the painting."

<div align="right">Jerry</div>

# SECTION 6

## Museums and Cultural Centers

**Section Editor: Elizabeth Vallance**

PRELUDE

45

# MUSEUMS, CULTURAL CENTERS, AND WHAT WE DON'T KNOW

**Elizabeth Vallance**
*Indiana University, U.S.A.*

"Cultural centers" are curiously difficult to define. I have been on committees that included representatives of zoos and university continuing-education programs in the definition. I have been in conversations where the symphony orchestra and its concert hall were considered part of a "zoo and museum district," and other conversations where sports arenas and public parks are included as "cultural centers." So what do we mean by the term, and what are our goals in educating students to participate in these institutions?

The shared characteristics of cultural centers reasonably include these: their collections or programs embody the products of human knowledge; the "curriculum" of resources and content may be clearly structured (as in a concert program) or seemingly quite loose (as in a comprehensive art museum); because visits may be for purposes quite other than learning, including socializing or simply "time out" from everyday chores, learning in these sites may be incidental or even quite accidental, though nonetheless memorable; attendance is voluntary, and as a result, attendance may be solo or with family or friends as well as occasionally with the guidance of a teacher but it is erratic and unpredictable; finally, cultural centers' missions are at least partially educational, with intellectual growth and cultural connection a tacit goal. This section addresses research on learning especially in cultural institutions whose collections or programs embody the arts, and omits sports arenas and parks from the definition of "cultural centers"; zoos, natural history museums, and botanical gardens, reflecting human creativity in their interpretation of collections, are addressed as theater sites in the chapter by Hughes, Jackson and Kidd. We focus in this section on institutions where the visual and performing arts are the central content of the programs available to the public, with the additional perspective of a scholar in library science to comment on the resource that libraries – cultural institutions in their own right – offer to all of these institutions and their professional staffs.

Museums and cultural centers close the circle that, at its best, includes primary and secondary education in the arts. These institutions of "informal learning" are the necessary complements to formal arts education, and indeed are sometimes remedial, providing

*L. Bresler (Ed.), International Handbook of Research in Arts Education*, 673–678.

learning opportunities that some schools may have omitted. In the hands of excellent teachers and museum educators, cultural centers can enrich school learning for the young, but they also represent the ultimate goal of arts education: we want our graduates to become lifelong participants in the arts resources available in their communities, long after they have left our schools. We know we have taught our students well if they make lifelong habits of visiting museums, attending music and dance and theater performances, and continuing to learn in nonschool lessons, museum programs, and libraries.

Yet for all their wealth of resources for lifelong enrichment, museums and cultural centers share one characteristic that is rarely true of any formal schooling: their staffs do not know who their students are. As learning sites that are completely voluntary – even for the teachers who may bring their students as temporarily captive visitors – cultural centers can never fully know who their audiences are. In countries with compulsory schooling, school officials know their students' names and much else about them, and may also be able to identify quite precisely who should be attending but is not. The same is not true of cultural centers, whose knowledge of their audiences can only be rather broad – this may be one of their strengths in fact, since they remain places where learning can be private and unmeasured, free from the control that schools try to have over the learning process. All cultural institutions keep attendance records at least in raw numbers, useful for publicity and for grant applications as well as for general planning, but few museum programs ever require participants to yield demographic information or even names: much use of cultural centers can be done quite anonymously, and rigorous audience surveys are rare. This means that what we know of the learning that happens in museums and cultural institutions is colored by the self-selection of the student population, and we cannot answer the question of why nonparticipants don't attend – itself an issue that also closes the circle that includes formal schooling.

The job of arts educators preparing students to be lifelong arts consumers is problematic, for though cultural centers are in principle available to all, participation in them varies according to education level, socioeconomic status, community demographics, and other variables reflected and addressed in schools but less completely known and harder to control for in museums. Especially in a comprehensive art museum, the choices that visitors make are difficult to control in the way that traditional teachers can control the options available to students contained in a classroom: visitors can wander at will, guided by preferences, tastes, and time constraints the staff can never fully anticipate. Audiences of a theater season or concert hall have a more pre-structured and finite experience, having opted to cede their time for that evening to the directions of the theater director or conductor, but even these audiences come to the experience with backgrounds, knowledge, and expectations that the staff cannot know. Not only do we not know exactly who our "students" are in these institutions, we also don't really know how they respond and what they learn when they get there: those who do come make choices we cannot reliably shape, even if we wanted to.

It may be helpful to compare the audience of cultural centers to shoppers on Main Street: museum visitors, faced in their leisure time with what I call the "public curriculum of orderly images" offered by the works in a museum gallery, act something like shoppers wandering down the main street of a town. Shoppers strolling down Main Street will be attracted to some shopwindows and not to others, will have goals

directing them to some shops and not others, will be compelled to engage actively in some – entering, perhaps buying – and not even notice others. Their noticing of and engagement with shopwindows may be affected by excellence or uniqueness of design, by personal interest in content, by companions' priorities, by weather or by time constraints. Likewise, visitors in an art museum may be attracted to landscape paintings and not portraits, or to ancient pre-Columbian ceramics but not ancient Chinese bronzes, may engage with some images by spending substantial time looking at and talking about them and bypass others altogether. Their choices may be affected by excellence or uniqueness of design, by personal preference for styles, media, or subject-matters, by companions' priorities, timing, or other goals in the museum visit such as a lunch schedule. Concert-goers may select classical and rock but not jazz, or only certain kinds of jazz. And theater-goers will make similar choices based on taste for theatrical styles, subjects, schedules, and so on. Participants in the arts "shop" among their options. Surely the behavior of people in libraries is similarly a matter of selecting among choices in the stacks – looking for a specific title, one might be attracted by other titles, a particularly attractive binding, a familiar name, in a process also roughly analogous to shopping on Main Street. Shoppers' attention is a challenge to attract and to hold. Managers of cultural centers know this, to the extent that they can track their audiences' attendance patterns at all.

On a broader level also, the choices made by arts consumers are very similar to the choices made by shoppers faced with more shops than they can actively consider. In the consumer environment that nonschool learning institutions offer, arts consumers' leisure time is finite, and so they pick and choose. An arts consumer shopping through her choices might take a guitar class at the community center one night, visit an art museum the following evening after work, and attend a community dance performance on Sunday afternoon – but this would be an unusually active consumer. More typically, there may be long intervals between consumers' dabblings in the community's offerings, and they may also shop elsewhere, in other cities on their travels. They may be unaware of small specialty "shops" in their own communities, overlooking small house museums or music classes available at night from the community college or music shop. And they may participate in versions of the same art at home, through recordings and copies of their favorite works of visual art as well as by acquiring inexpensive originals or collections of favorite styles of ceramics or textiles. The home as a privately shaped cultural center would be a logical extension of our inquiries here, and though space does not allow us to explore it, readers should be aware that arts consumers' choices might best be indicated by the arts that these "students" incorporate into their everyday lives – after their formal schooling, and between visits to cultural centers.

Also not covered in the chapters in this section is the considerable research on marketing and demographics that most cultural institutions use regularly both in assessing the likely success of programs under consideration and in measuring the success of exhibitions and programs already offered. Headcount and demographic patterns become a routine measure of an institution's effectiveness in reaching its public, a concern beyond this book's focus on how participants in museums and concert halls learn once they get there. But the available data on who attends, and who does not attend, our

cultural institutions reflect socioeconomic patterns in communities that are themselves reflected as well in schools, in a circular pattern of differences in access to and use of resources. We know, for instance, that art-museum visitors on average have a higher education and income level than the average citizen or visitors to other institutions such as zoos and hands-on science centers. The challenge for all community institutions is always to attract populations traditionally not participating in their programs, to have an audience that more accurately represents the public they ostensibly serve. This challenge is a circular one when the institutions work with the schools in "outreach" programs to develop young audiences early enough to breach the socioeconomic divide and develop museum-going habits early in a broad spectrum of children. Audience development is a fascinating area of work and of research, and I mention it here only to remind readers that what we know of learning in museums and cultural centers is somewhat skewed by the very characteristic that gives these institutions open to all a special value – that attendance is voluntary and is therefore shaped by societal forces the institutions themselves cannot control.

Therefore, in exploring the chapters in this section it is useful to remember that museums and cultural centers, unlike schools, are subject to market forces and to socioeconomic differences among a voluntary audience that needs good reason and encouragement to spend time there. Much of what museums and cultural centers do may not in fact always reflect the scholarly or research priorities of the professionals who run them, since these institutions cannot survive without the occasional crowd-pleasing programs: in the United States, at least, hundreds of ballet companies perform "The Nutcracker" every December, and art museums can always count on enormous crowds for exhibitions of French Impressionist paintings. These crowd-pleasers are exactly that – they please huge crowds and build audiences who are at least occasionally loyal to the institutions beyond those single attractions, and in doing so they help cover costs for less popular or more challenging programs. The hope is that the crowds they attract may become more regular users of these resources, may become lifelong learners in the arts even despite a K-12 education that might have neglected them.

And in this sense, one wonderful thing about museums and cultural centers is that they can enrich their regular audiences with excellent offerings at the same time that they may be – deliberately or inadvertently – offering a kind of accessible, comfortable, and welcoming remedial education to adults and families whose formal education in the arts was limited. When we look at research on learning in these institutions, we are looking at evidence about how well these institutions teach the audiences who choose to come there, and as such we are studying the best results of arts education in the schools that produced these visitors. We hope we are also studying the impact of cultural centers on some, perhaps a growing number of, people who see them as the resources they did not have as children, who are using them for the enrichment and learning that they so readily offer to anyone coming in their doors. Museums, in their role as a kind of Main Street of sensory options, attract visitors to explore some of their wares; we who work with museums and music and theater venues want these shoppers to begin to feel comfortable exploring shops that they might not normally visit, going in to look, perhaps "buying" in the form of participating in what is offered there. Research on learning in cultural centers tells us much about how museums and other

institutions reach both those well prepared to learn about the arts and those who only later in life dare to give the arts a try.

This section addresses research about learning in art museums, learning in music conservatories and in the worldwide "institution" of private music lessons, and learning through drama when theater is brought into the museum setting as a teaching tool. An Interlude about the role of libraries as resources for researchers on these subjects gives a broader picture of the kind of information that we can use in understanding what goes on in cultural centers. Another Interlude on the crucial role of museums and cultural centers in shaping individuals' choices as they gradually create their "strategies of being" gives a wonderful perspective on why all these institutions are so important to all of our cultures. Altogether, the chapters in this section raise and answer some fascinating and important questions about how societies continue to teach about the arts long after students have left the care of arts teachers.

# 46

# THE ROLE OF THEATER IN MUSEUMS AND HISTORIC SITES: VISITORS, AUDIENCES, AND LEARNERS

**Catherine Hughes***, **Anthony Jackson†, and Jenny Kidd†**

*Ohio State University, U.S.A.;
†University of Manchester, U.K.

Theater with a direct educational purpose, within and beyond the formal sectors of education, has a long and varied history throughout the English-speaking world. Some very brief examples illustrate the point. Living newspapers in Depression-era America dealt explicitly and energetically with the political, economic, and social matters of the moment, urging audiences to learn and to participate as active citizens in the issues that affected the country. *One Third of a Nation* tackled the problems of poverty, inadequate housing, and land prices in the big cities; *Power*, the state of energy supply and control, and the case for nationalization; and *Spirochete* the taboo subject of syphilis and current programs for its eradication (Flanagan, 1940; O'Connor & Brown, 1980). In the United Kingdom, the theater-in-education (TIE) movement began in the mid-1960s as part of an attempt by the expanding regional repertory theater network to establish close links with the communities it served (Jackson, 1993; O'Toole, 1976). It was valued by teachers for its ability to engage children in a range of subject areas (such as local history, racism, health education, even mathematics), and in ways that complemented more conventional teaching programs, varying its methods of approach according to the target audience. While the work drew extensively on ideas and techniques developed in school-based drama-in-education (notably the work of Heathcote, Bolton, O'Neill – see for example, Bolton, 1999, 2007 [Chapter 4 in this volume]), it was often most valued precisely for its ability to bring into schools a stimulus from the outside world, offering (at its best) a rich, multilayered and multivocal approach quite different from anything teachers could offer on their own – usefully bridging the formal and nonformal education sectors. Similar developments have occurred in the United States, Australia, Eire, Scandinavia, and elsewhere. Even more ubiquitous, Augusto Boal's "theatre of the oppressed" (Boal, 1979) and its associated set of techniques and models for community action emerged in the late 1970s from work in South America, itself inspired by the pedagogy of Paulo Freire, to further influence the expansion of theater and participatory drama activities geared specifically to work for social change.

679

*L. Bresler (Ed.), International Handbook of Research in Arts Education, 679–696.*
© 2007 *Springer.*

Practices and philosophies in such agenda-driven fields of work inevitably undergo constant revision, adaptation, and metamorphosis as they respond to a rapidly changing society. Living newspapers quickly gave way to other forms of documentary and political theater in the postwar era; and TIE as an identifiable "movement" underwent serious contraction in the 1990s, propelled by a variety of economic factors and government-driven structural changes to the education system, followed by redefinition and reemergence often in different guises. Today, there is no doubting the extraordinary diversity of programs of work with performance and drama activity at their core – now often referred to, if loosely, as "applied theatre" (Nicholson, 2005; Taylor, 2003; Thompson, 2003) – that operate in both formal and informal educational contexts across the world. They are funded from equally varied sources (such as Health Promotion bodies or nongovernmental organizations in the developing world). Outreach and educational programs exist at many professional theaters: in the United Kingdom and the United States, most regional theaters now have dedicated education officers on their staff and all theaters in the United Kingdom in receipt of public subsidy (including dance and opera companies) are required to demonstrate their commitment to education in some shape or form and to the government-sponsored program of social inclusion. Similarly, "community outreach" characterizes the work of many publicly funded specialist companies, such as the Creative Arts Team in New York and those dedicated to the use of theater in prisons as a means of rehabilitation and with young offenders and "youth at risk" – notably Geese, both the original American group and its British offshoot (Baim, Brookes, & Mountford, 2002), and the TIPP (theater in prisons and probation) Centre in Manchester (http://tipp.org.uk). Another cultural arena that has increasingly deployed a variety of "applied theater" and related practices and methodologies, again in an attempt to forge closer links with its communities, is that of museums and heritage sites. The expansion in the number of museums in recent decades and their determination to find ways of engaging young people with their collections and imaginative ways to explain to *all* visitors the significance of what they had come to see, has led to an increase in the role of drama as an interpretive and educational medium – and in particular, the use of actors to tell the stories associated with the collections. It has indeed been argued that today's museums are themselves performative in how they exhibit objects and cultures, and in the architecture of their spaces (Casey, 2005). To introduce drama within these halls might therefore appear a natural extension of their function. It is with the emergence of what has come to be known (if problematically) as "museum theater," in its varied forms and in the context of a rapidly changing museum sector in the United Kingdom, the United States, and other countries, that the rest of this chapter is principally concerned. Specific examples will be taken from practice in the United States and the United Kingdom.

## What Is Museum Theater?

Museum theater may broadly be defined as the use of theater and theatrical techniques as a means of mediating knowledge and understanding in the context of museum education (Jackson & Rees Leahy, 2005, p. 304). In striving to communicate the broad fields of science, history, and art, museum theater employs the narrative structure and emotional engagement of drama to pursue educational goals, both affective and

cognitive. It may take place in museums (in galleries or auditoria), in zoos, aquaria, art galleries, and at historic sites, and is generally presented by professional actors and/or interpreters although it may sometimes draw on volunteers. It can involve the performance of short plays or monologues based on historical events or materials exhibited on-site; it can be an interactive event using performance and role-play, tailored to the curriculum needs of visiting schoolchildren; or it may be designed for family groups and/or the independent visitor (Jackson & Rees Leahy, 2005). Whether learning about the chemistry involved in the production of textiles in Catalonia, or the contributions of slaves in colonial America, or the social impact of the mechanization of weaving at the end of the eighteenth century, visitors to many museums today can do so as they encounter puppetry, storytelling, multimedia, roving gallery characters, or scripted performances. For the most part no admission fee is charged, the performances or encounters are short, take place in a variety of different spaces, and usually acknowledge the presence of the audience and interact with them (Bridal, 2004). Actors, directors, writers, and education officers have frequently turned to participatory TIE, "process drama" and Boalian methods to provide the interactivity – through techniques such as role-play, "forum theater," and "hot-seating" – which have then been adapted to the type of collection, the site, the nature of the audience, and the budget available. Other museums prefer to confine interaction to audience questions and answers with the actor out-of-role after the performance, and, in the belief that a strongly delivered, theatrically conceived monologue played to a gathered audience gives much sharper focus to the subject matter, have therefore embraced more traditional, noninteractive styles of performance (the Royal Armouries Museum in Leeds, in the United Kingdom, is a case in point). Probably the most common style – for cost-effective reasons as much as artistic or educational – is that of the single-character monologue, with or without in-role interaction. (See Jackson et al., 2002.)

Museum theater is, then, an eclectic medium. The terms in use vary too. Live interpretation, living history, historical reenactment, first-person interpretation – each have their particular associations, nuances, and advocates. The short-hand term, in common use since the mid-1990s, however, is "museum theater". Although, as Bridal points out, the breadth of the term, coupled with the variety of sites that utilize it, has led to much debate about its suitability (Bridal, 2004, p. 2), this is the term that will be used through this chapter to refer generically to the diversity of practice under discussion.

The use of performance as an educational tool in museums and at heritage sites has its roots in a number of broad traditions: the *theater-based* practice of participatory theater already referred to and the *museum-based* practice of first- or third-person interpretation. First- and third-person interpretation is less overtly performance-based: it generally involves interpreters (with or without actor-training) in appropriate period costume interacting with visitors to interpret a heritage site or museum collection. The first-person interpreter assumes a specific role or character (e.g., a seventeenth-century pilgrim or nineteenth-century loom worker) and talks to visitors as though from the period; the third-person interpreter remains herself in the present while talking about the past. While the character's biography and historical background will be meticulously researched, there is no script and no fixed pattern for the interaction with

visitors. That interaction will be responsive, conversational, enriched by anecdotal storytelling, but shaped by the need to arouse curiosity, offer insight, and (when appropriate) challenge visitors' preconceptions. Some of the more adventurous first-person work has been pioneered at major heritage sites in the United States such as Colonial Williamsburg and Plimoth Plantation, Massachusetts (see Hughes, 1998; Roth, 1998; Snow, 1993), and developed more recently in the United Kingdom at sites such as the Tudor manor house at Kentwell, Suffolk, and the seventeenth-century Llancaiach Fawr Manor in South Wales.

It is in the United States that theater and "performative interpretation" have been exploited as educational tools in both museums and historic sites most extensively and over a longer period of time (Bridal, 2004; Hughes, 1998). In science museums and centers, the forerunner in the use of theater was the Science Museum of Minnesota (Quinn & Bedworth, 1987), which began utilizing theatrical techniques and storytelling in 1971. In historic sites, Colonial Williamsburg has, as already indicated, led the way since the 1950s and 1960s, with Plimoth Plantation not far behind (Leon & Piatt, 1989). In art museums, sporadic attempts at storytelling and various theatrical endeavors have taken place over the last hundred years (Zucker, 1998), while more recently children's museums have provided participatory performances and often activities in which children become the creators of the drama. But the slow steady increase in the use of theater has taken place primarily in institutions of science and history. A number of factors may have contributed to this, including the increased need for better understanding by the public of science and scientific methods, and the recent application of cultural theory to history and its representation in our cultural institutions, not least in museums. Similarly, research into the effectiveness of such programs has mostly emerged from science and history museums, though there has been some undertaken at art galleries, which will be detailed later in this chapter. Among notable examples of current theater programs in the United States, are the Monterey Bay Aquarium, the Minnesota Historical Society, and the Museum of Science, Boston. In particular, the Minnesota History Center has a seasoned program of live performance within its exhibitions. The Center began using individual characters from Minnesota history who roamed through the galleries and interacted with visitors and subsequently expanded to include more formal presentations of short plays within its repertoire. Through those plays, the Center has been able to address controversial and complex issues such as immigration, race, and socioeconomics, the emotional impact of which upon visitors was articulated in an evaluation report (Lanning, 2000).

## Contexts: Developments in Museum Education Policy and Practice

The museum world has undergone something of a transformation over the past two decades, and perhaps most noticeably in Britain. Changes in government policy since 1997 – prompted in part by the findings of a major Government report (Anderson, 1997) – have prioritized *accessibility, inclusiveness*, and *lifelong learning* for all arts and educational organizations in receipt of public funds (Jackson, 2002). As one

commentator put it, "these days ... museums take accessibility and inclusiveness far more seriously ... [partly] because their funding agreements with the Department of Culture, Media & Sport depend on them doing so ... [partly] because of a cultural shift on the part of both the curators and schools ..." (*The Guardian*, London, 13/11/01) That shift was accelerated in December 2001 when extra state funds were provided to enable all publicly funded museums to abolish entrance charges, leading to a significant increase in attendance figures (Jackson, 2002). National Lottery funding has had an influence too, fostering the extraordinary expansion and modernization of museums of recent years. Education has in the process been pushed to the top of the agenda for many such organizations. As Helen Rees Leahy explains,

> No longer the "poor relation" to the core function of curating, the educational role of the museum is now regarded as essential in justifying public investment in the sector, and as a key tool in developing culturally and demographically diverse audiences. Today, education in UK museums is used both to fulfil institutional objectives of audience development and to realise external public policy objectives of ameliorating social exclusion, promoting lifelong learning and increasing access to culture. (Jackson, Johnson, Rees Leahy, & Walker, 2002, p. 11)

This has not been exclusive to the United Kingdom but reflects wider international trends. Thus, in a similar vein, Hein notes that, while education has long been at the core of museum missions (Hein, 1998), a shift in practice from conservation to a more broad-based mandate for education has occurred in the last few decades, evidenced in progressive reports from the American Association of Museums (1969, 1984, 1992), which have consistently elevated and fine-tuned museums' educational function. The most recent initiative from the UK government-funded Museums, Libraries and Archives Council, "Inspiring Learning for All," introduced in 2004, further underlined the priority given to education: it sought to promote and expand the range and quality of education activity in museums in response to developing theories of learning, such as Gardner's "multiple intelligences" (Gardner, 1983, 1993) and Hein's notion of the "constructivist museum" (Hein, 1998). Consequently, while provision remains uneven, many museum education programs today are characterized by an "emphasis on active participation (including role play), self-direction and discovery, and creative expression" (Rees Leahy in Jackson et al., 2002, p. 11).

It is within this context that there has been new interest in ways of using theater and interactive drama, in order to help address the new priorities. But it is at the same time a particularly contested practice. While advocates are keen to promote the educational benefit of this medium, its use is patchy (Jackson et al., 2002). Some museums embrace it while others still view it as inferior to more traditional forms of interpretation, little more than an audio-visual aid or, worse, as an irritating distraction from the real business of the museum: a crowd puller perhaps but to be tolerated at the periphery rather than embraced as central to the public programming. Those in opposition see representation of events, ideas, or processes by live performers as imperfect, unlike the texts that accompany "accurate" collections and documentation elsewhere in the museum. Jackson and Rees Leahy put this opposition down to "distrust of the fictionalizing effect

of museum theatre" that is based on "a refusal to acknowledge the role of the subjective, the arbitrary and the expedient in the construction and narration of history" throughout the museum (Jackson et al., 2002, p. 4). Indeed, these objections also imply a fundamental distrust of visitors' ability to rationalize and critique what they are seeing. The often-expressed worry is that dramatic reenactment can distort people's understanding of the past since that past can never be fully reproduced. The concern is not about being true to recorded history (which by definition is a severely limited version of the past), it is about how and whether one can be true to "the past" itself. By this same token, of course, those interpretations and representations that are made within more traditional museum settings (such as artifact display) do no less of a disservice to "the past." Objects are displayed out of context, by "fallible and culturally influenced humans" (Hein, 1998), and will regularly undergo some form of reconstruction themselves (cleaning, for example) that renders other aspects of the item's past (that which remains damaged, uncleanable, or simply missing) undesirable, perhaps even unfathomable. It is often only within its original form that an object is seen as maintaining its "truth". Seeing it as possible (and desirable) to "reverse the process of history" in this way is, according to Smith, "a species of contemporary arrogance" (Smith in Vergo, 1993, p. 20).

True accuracy of representation is thus an illusion when dealing with the past. It is dependent on incomplete narratives and judgments of value that have been made over and again since that historical moment that we seek to represent. As a part of this process, the polysemic nature of the artifact is largely ignored. This raises all kinds of questions about the stories inherent in and between objects and collections, and the best ways in which to interpret them to audiences. As Rees Leahy again has put it, "… given that neutral interpretation is neither possible nor, arguably, desirable, whose voices are heard in the museum? Should the museum's narratives exceed the 'stories' told by its collections, in order to fill in gaps in the collections and/or to offer alternative points of view? Should museums promote affective, as well as cognitive, learning in order to develop their publics' understanding of issues as well as facts?" (in Jackson et al., 2002, p. 12). Perhaps the practice of museum theater is one way in which the polysemic nature of artifacts can be explored, through the use of characterization, empathy, and conflict.

## Museums and Learning

Museums are places of memory and learning. Traditionally, museums have not been places that attempted to engage visitors' emotions. More recently, however, there has been growing recognition within the museum community that emotions play a key part in visitors' learning (Franco, 1994; Hooper-Greenhill et al., 2003; LaVoie, 2003; Marsh, 1996). Performance presents museums with a feasible and effective method by which to engage visitors' emotions as well as contributing to their more general learning experience. Below is a general outline of how relevant learning theory has affected museums, followed by some observations on theory and research related specifically to museum theater.

Artifact-based museums, as well as zoos and aquaria with live collections, and historic sites with environmental artifacts, provide unique educational experiences for the public to learn from models and objects. The current terms used in museum literature

to describe learning in a museum are "informal", "self-directed," "free-choice," and "life-long". These terms have their antitheses in school-based formal education, where learning has tended to be, by and large, formal, teacher-directed, and restricted by age. There are of course many honorable exceptions to the rule and various schools have experimented with shaping the delivery of their curricula to the perceived learning styles of their pupils; but secondary schools in particular are by definition large institutions catering for large numbers of pupils and having to conform to given curriculum frameworks (set by the states in the United States, by national government in the United Kingdom and many other European countries). Outwardly, learning in a museum has distinct differences from learning in school. Learning in a museum is not necessarily linear (Leinhardt & Crowley, 2002), in that visitors can move through most museums in the direction and at the pace they choose. They are not following from one textbook chapter to another, nor considering topics as part of a predetermined, carefully ordered curriculum package. Visitors also bring a variety of experiences and prior learning to bear on their visits, so that intergenerational groups can learn together, but at different levels or from different perspectives. These external differences indicate clear distinctions in the process of learning in a museum. It can be argued, however, that the internal mechanisms of cognition and heuristic progression are the same processes that occur in any setting.

What is meant by museum learning? Leinhardt and Crowley (2002) provide a vivid example of museum learning from their ongoing research with the museum learning collaborative. Trainee teachers visited the Birmingham Civil Rights Institute in Birmingham, Alabama, as part of a qualitative, naturalistic study. After viewing objects, especially the burned-out shell of a Greyhound bus that represented one that was used by Freedom Riders and attacked during the civil rights struggle of the 1950s–1960s, these teachers exhibited changes in their cognition, as well as in their sociocultural identity. Mapping of their mental constructs of the civil rights era in interviews prior to their visit, and then again after the visit, as well as conversations recorded during the visit, revealed expanded conceptions of who played a part in the struggle for civil rights (Freedom Riders were both black and white) and what threats existed for those who participated. The researchers also noted changes in self-perception for these trainee teachers. Again, these changes were evident in conversation, as they discussed details and related the situation of the bus to themselves (Leinhardt & Crowley, 2002).

At the heart of the museum's endeavor to educate its visitors is the belief, as expressed in the wording of the *Inspiring Learning for All* initiative, that "effective learning," whether formal or informal, with adults or with children, "leads to change, development and the desire to learn more" (http://www.mla.gov.uk/action/learnacc/00insplearn.asp). There has thus been a growing number of studies of the learning experience of visitors to museums. Indeed, as Hein observes, in *Learning in the Museum*, understanding visitors' learning experiences is a matter of survival for museums: such is the importance of its educational function. But, equally, as Eilean Hooper-Greenhill asserts, in respect of museums in the United Kingdom, "it is only recently that museums and galleries have begun to consider audience responses at all." (Hooper-Greenhill, 1999, p. 138).

Research into learning in museums, along with visitor studies, generally utilizes a Vygotskian, sociocultural lens (Bartels & Hein, 2003) to examine the meaning made by visitors from their experience in museums. This lens, as well as that of the constructivist (Hein, 1998), concentrates on how visitors interact and converse before, during, and after a museum experience, or construct their own learning within the museum environment. Recognizing the postmodern turn, museum staff and researchers acknowledge the authority of the individual's response to a museum's programs and exhibitions. This response is necessarily conditioned by each individual's prior experience and learning, as well as motivation and learning style. Consequently, such factors need to be identified and incorporated in any study of visitor learning through performance.

Alongside (and possibly overlapping with) the supposed formal educational benefits of performance within museums and heritage sites, it is claimed that there are many other benefits to its use, including: increased empathy, identity development, increased curiosity, escapism, camaraderie (especially within reenactments), and various other benefits to social life, not least increased knowledge of and interest in "community" (Bridal, 2004; Hughes, 1998). For the sites themselves, benefits lie in any resultant "commercial" gain, possible increases in tourism, and in the longevity of the site experience within visitors' memories. Richard Schechner describes the activities of American restored villages as being "simulation" whereby "… the purpose is to trade on a national nostalgia in the garb of education" (Schechner, 1985, p. 120). Although rather skeptical in his approach to "living history" ("But only children are fooled – and even they not for long," Schechner, 1985, p. 120), Schechner does highlight the two crucial concepts behind performance work: that it must be deemed to be educative (although by and for whom is a separate discussion), and it must serve the "trade" of the site. Museums and heritage sites, as is shown by frequent visitor studies and the increasing emphasis on social inclusion and access, exist for their "consumers." It is thus the case that performances themselves can be used as promotional tactics for the site as a whole and their purposes will therefore include "education, publicity, marketing, entertainment" (Jackson, 2000, p. 200).

The essential goal of most museums is to capture visitors' attention, hold it for as long as possible, and in doing so, provoke a new or deeper understanding of some aspect of science, history, art, the natural world, or human endeavor. Exhibits have been the primary means of communication to do this, with objects, labels, interactives, and increasingly, environments. A common problem, however, is that visitors do not slow down (Serrell, 1997), so that their attention is not held, and no deeper understanding is gained. This is the challenge of a transient audience – they must first be stopped in their tracks in order to learn. A live human being, an actor dressed in period costume, is often one way of slowing visitors down. A scheduled performance in a theater space provides an opportunity to stay still for a portion of one's visit. The spectacle of actors on a stage within an exhibition might draw the visitor's attention to a previously unseen area. Performances have in this way become another means of communicating with visitors (Bridal, 2004; Hughes, 1998; LaVoie, 2003).

By necessity then, arresting visitors' attention is a basic mandate for museum theater. Evaluation of museum theater initially focused on this aspect – whether or not performances were attracting an audience. The next logical question for research

concerns what happens when attention is gained – does learning happen, and if so, how? And what is it about the performance event that helps to generate that learning?

## Research into Learning through Museum Theater

In an analysis of theater for pedagogic purposes (Barbacci, 2004), two distinct categories became apparent: theater created solely to convey information; and theater that is inspired from the contents of a discipline, but maintains its own "artistic expression". These categories, while more porous than absolute, are helpful in defining museum theater. We would argue that museum theater falls into both categories, and that often it contains elements of both. In the first category would fall museum theater that has evolved from science or historic craft demonstrations, with theatrical elements added to enhance the quality of the presentation. Period costuming of interpreters lent a sense of theatricality to historic sites. This category of museum theater will sometimes attempt to utilize theater elements such as lights, sound, character, and plot (Barbacci, 2004), to contextualize isolated facts and in some cases to create a spectacle. At its core are pedagogic objectives, such as explaining the components of a natural phenomenon or (in an art gallery) the steps of an artistic process. Often, demonstrations in science museums have become more performative when educators have taken on the role of characters, for example "Dr. Biology," or added the use of puppetry. As an example of museum theater that has developed from this approach with its school programs, the Central Park Zoo in New York City has created fanciful characters such as Petunia Penguin, who will transform "your class into a team of Antarctic scientists," and rain forest explorer Jungle Jane and her puppet sidekick, Youcan the Toucan, who take classes on a tropical adventure (Central Park Zoo, 2005). Here characters have been created to present didactic material, but they have also incorporated the transformational element of theater, so that time and space can be reimagined, enabling students to "live through" (Heathcote, 1984) the challenge of survival in a rain forest or of Antarctic scientific explorations.

In the second category, museum theater at the Museum of Science, Boston, moves beyond didacticism to metaphor, so that, for example, in a play by Jon Lipsky about technological progress, the *RMS Titanic* disaster becomes a representation of human hubris, while also conveying factual information, such as the inferiority of the steel at cold temperatures that was used in the hull. In this category, performances examine the social and ethical implications of a discipline, controversy, conflict, and the nature of humanity. Theater such as this maintains its roots as pedagogy, while preserving and employing the full structure and potential power of theater. Learning goals move from acquisition of subject matter to reflection or shifts in perspective or attitude.

Research into museum theater has reflected the movement between these two categories, as well as the shift from attracting an audience to fashioning visitors' meaning-making in response to a performance. Almost all such research has been a mix of the quantitative and the qualitative, and naturalistic in approach, using surveys, interviews, and tracking and observation. Until recently, most have also been evaluative in character rather than "open-ended" research. Evaluations of specific museum events

are vital but are of necessity constrained in their remit and all too often address themselves to a very limited audience (usually the museum directorate, the marketing department, and those involved in the development of the program under review). As a result, the findings – no matter how illuminating, and irrespective of their influence upon future programming – usually remain buried in limited-circulation reports and languish on office shelves. More recently, as academic interest in the field has grown, and as the learning-related benefits of performance have become more clearly articulated, so the kinds of research conducted have begun to widen, findings have seen their way to print and, not least, the claims made for museum theater have begun to be subjected to more rigorous scrutiny and interrogation.

Generally, the findings from these earlier evaluations showed that visitors responded positively to pioneering museum theater programs (Bicknell & Mazda, 1993; Hein, Lagarde & Price, 1986; Klein, 1988; Munley, 1982/1993; Rubenstein & Needham, 1993) and that the performances had the power to attract visitors (Bicknell & Mazda, 1993; Hein et al., 1986), as well as to keep them watching. Of those who saw the National Museum of American History's play, *Buyin' Freedom*, 25% stayed to ask questions of the actors (Munley, 1982/1993). Tracking visitors, Cuomo and Hein (1994) found that visitors stayed in an exhibition on bogs longer when the play was being performed, whether they appeared to be watching it or not. Later in follow-up telephone interviews, 35% mentioned remembering the play most clearly (Cuomo & Hein, 1994). Curiously, it was noted that not all these participants sat and watched the whole performance. So, whether they were aware of the play as they visited the exhibition, or sat and watched the entire performance, the play itself became a part of their memory. Klein (1988) found that visitors were provoked to return to an exhibition following a play, and were observed discussing artifacts in relation to the play. This was echoed in Rubenstein and Needham (1993). Finally, in an evaluation of all its interpretive programming (volunteers with "demonstration carts" and stage shows), the Minnesota History Center found that visitors were significantly more likely to stop at stage shows than at the carts (Litwak & Cutting, 1996).

In a large evaluation of its entire drama program, the Science Museum in London found that 83% of visitors surveyed said they spent more time in an exhibition because of a gallery character performance (Bicknell & Mazda, 1993). The study also acknowledged that some adults felt uncomfortable and embarrassed if confronted "out of the blue" by a character in a gallery or asked to sit too close to a staged performance. On the other hand, unsurprisingly, it noted that children were highly attracted to performances, which in turn had the effect of allowing a socially acceptable means of access for many adults. The Canadian Museum of Civilization underwent an evaluation assessment of its drama program in 1992. With on-site surveys, interviews (with visitors and staff), observations, and file reviews, it attempted to assess both quantitatively and qualitatively the fundamental value of the program (Needham, 1999). Surveys were conducted with visitors who left performances, as well as those who stayed. Ninety-five percent of those surveyed felt that the live interpretation enhanced their visit, with 45% specifying that the performances brought the museum or history to life (Needham, 1999).

Collectively, what is documented in these evaluations is a broadly positive response that translated into more time spent in a particular exhibit area, and by inference it can be posited, more time spent considering the subject of the exhibition. In a 1989 pre/post-test study of a random sample of 339 visitors in the "Treasures of the Tarpits" exhibition at the Museum of Science in Boston, those who saw the play within the exhibition were significantly more likely to understand which animals were found in the tar pits, the climate, and a particular scientist's contribution to understanding the tar pits (Baum & Hughes, 2001). Overall, these studies document that in response to performances visitor behavior changed in beneficial ways for learning purposes. People slowed down, reexamined, and conversed. Many visitors also expressed a self-perception of learning (Baum & Hughes, 2001; Bicknell & Mazda, 1993; Malcolm-Davies, 2004; Needham, 1999). They felt that they had learned. Whether this translates into long-term learning, however, has not been established.

In a triangulated, qualitative study with 745 students in grades 6–12 who saw a play about the social and ethical implications of the Human Genome Project by the Museum of Science, Boston, Black and Goldowsky (1999) went beneath the surface of positive or negative response, investigating to what extent the students might be able to think about and discuss the implications of this scientific endeavor. They were also interested in how conflict between the characters in the play affected the students' experience. This study stands out from prior work in that it is more a research study than evaluation. In an open-ended postperformance survey question, 87% of the students were able to articulate how the Human Genome Project might affect their lives or the lives of others. This was a 59% increase from the preperformance survey. Connecting the science to personal experience was echoed in interviews with students. Reactions to the conflict in the play were mostly positive, with a majority of students finding that it allowed for different perspectives to be heard. It also made it more realistic for some. This study supports the notion that performances are appropriate vehicles for presenting complex, controversial subject matter to students.

Most recently, efforts to broaden the scope of research into museum theater have taken place at the Centre for Applied Theatre Research (CATR) at the University of Manchester in the United Kingdom, which has received funding from the Arts & Humanities Research Council for a three-stage project. Stages I and II have been completed, and Stage III is currently under way (entitled "Performance, Learning and 'Heritage'", the project runs from 2005 to 2008). The report from Stages I and II, *Seeing it for real* (Jackson et al., 2002), attempted to better articulate a comprehensive sense of what effectiveness might mean for museum theater, particularly for school-age children. Despite statistically small samples (the research tracked the experience and responses of eight classes of primary school children in their visits to museums in Manchester and London and in their encounters with a variety of stimuli, including, for 50% of the groups, interaction with a character in the exhibition areas), clear patterns of effectiveness emerged in their findings. Both short- and longer-term recall and understanding were enhanced; the dramatic narrative served as an organizing force; and students were able to relate personally to and empathize with characters in the performances. The implications of these findings, if confirmed by further research, are

of considerable significance. If spectators relate personally to characters in a perform-ance they may experience empathy, a key emotion which, as detailed above, supports better recall. The narrative form of a performance may assist in people thinking about the content of a performance. Could it be that the narrative guides improved encoding (of memory), which leads to better recall and understanding? Some qualifications also emerged. For some children, the empathy with a character led to a certain narrowing of their focus. Everything about the period studied was viewed through the lens of that character, and suggested that the empathic understanding of one character's experience *may* have been achieved at the cost of the child's readiness to see the larger picture. This in turn prompts further questions about the most appropriate ways to integrate performance within the museum experience as a whole.

These questions remain, as CATR moves into the third and final phase of its research, embarking on a project that includes case studies of performance in both museums and historic sites, with both school groups and independent visitors, and employing a wide range of methods for capturing data over both the immediate and longer term in order to gauge impact and recall. In trying to understand the learning that may take place through, or in response to, performance, one topic on which the current research project aims to shed some light is that of the visitor/audience crossover within museum theater. How do visitors become audiences? And what happens when they do?

## From Visitors to Audience

When looking at the terms "audience" and "visitor," some stark differences emerge. The term "visitor" recognizes the possible individual nature of the museum experience (even within a social context), whereas the term audience homogenizes all those spa-tially involved in the activity. "Visiting" or being a "visitor" asserts the physicality of the experience, the movement from A to B, and then back to A again. It is as if one is temporarily inhabiting someone else's space or story; moving *through* as opposed to moving *in*. It is, however, an active status, unlike that of the traditional "passive" audi-ence member (a term that embraces numerous other cultural activities as well). Innately passive audiences, according to Horkheimer and Adorno's assessment of the culture industry in the 1950s, seek only the gratification that comes with the absence of thought and imagination; "Amusement always means putting things out of mind ... at its root is powerlessness" (Horkheimer & Adorno, 1955/2000, p. 116). The cultural industries – so the argument goes – thus serve to stunt people's imagination and cre-ativity as opposed to challenging them, resulting in pure pleasure for the consumer. This is a scenario that has increasingly been called into question for its simplicity, and its sweeping ignorance of active modes for using or responding to cultural artifacts or indeed creating them from scratch. These active modes have sat uncomfortably along-side more traditional notions of capitalist power relations, finding expression, for example, in the rise of the radical press or pirate radio, or in the use of existing cultural artifacts for the material expression of resistance (for further discussion, see John Fiske's study of the tearing of jeans, 1989). These days, it is more readily accepted that

audiences are at least capable of being active rather than passive in their relationships with the culture industries.

Differentiating between "audience" and "visitor" within a museum or heritage site is complicated by the lack of commitment those watching performance are required to make. In most instances, the principal purpose of a site visit is not to see a "perform-ance". There is thus no financial commitment to the piece, no prior expectations, and no obligation to see it through to the end:

> Our audiences typically have not made a choice to come to our museums to see a play, they have made no financial commitment to the experience by paying for a ticket, and they feel free to come and go throughout the performance. (Bridal, 2004, p. 3)

"Consumption" of history through heritage sites and museums thus involves navigat-ing a route through being variously a visitor and an audience member. In some writings on the subject, the terms are used interchangeably, implying that traversing perform-ance in these more complex of sites is an active and often critical process – involving accepting, rejecting, or negotiating the preferred reading (Bagnall, 2003). At these sites we also start to see the blurring of the boundaries between producing and consuming. Particularly for interactive performance pieces, (whether first person, third person, performed by a group or a solo artist) we see the public able to coscript the finished piece: as Bagnall acknowledges, reflecting on her research at Wigan Pier, "… my visi-tors were not passive consumers but skilful and reflexive performers" (p. 95).

Museum theater techniques vary in the level of interactivity they afford. In some instances, exchange with the "audience" is an impossibility, for example in the use of fourth wall theater or conventional play: "If it is advertised as a play then the visitors will understandably expect a conventional theatre experience and might find your alternative scenario difficult to deal with" (Brown, 2004, p. 48). However, it is expected that first- or third-person interpretation will usually involve some level of interaction, and that virtually all "living history"[1] will do so also. First-person interpretation in particular, Roth's "prototypical form", "is more demanding of interpreters than third-person interpretation and is also more demanding of the public" (Roth, 1998, p. 13). The level of interaction however is often dependent on the particular audience, and the degree to which the pre-scripting allows for interjection and improvisation. As Bagnall points out, "Different types of audience affect the performances of the actors" (Bagnall, 2003, p. 94).

Through living history and other performance techniques, it is claimed, various audiences can learn to appreciate what it means to live within a society or culture other than their own, or can grasp ideas and discoveries and their practical and/or social implications. This has not only formal learning benefits, but perhaps informal benefits also. As Tivers observes, it is about having experiences that can nurture individual notions of identity, and ideas of community:

> In the presentation of "living history" people are drawn into an *experience* of heritage which may have meaning for them, whether they are participants or

"audience", and which may contribute to a sense of identity and a better understanding of society, both past and present. (Tivers, 2002, p. 199)

# Conclusion

As we have tried to show, the questions raised by this varied and evolving field of performance activity are many and complex, and have only recently begun to be articulated, let alone addressed, by researchers. Theater as an educational medium in museums may not always be appropriate and – perhaps inevitably, when viewed across the whole spectrum of museums and historic sites – the quality of work may be variable to say the least. For a variety of reasons (cost, the pressure to offer "edutainment", poor planning, poor coordination) it may be the wrong medium at the wrong moment; it may be underrehearsed or undertaken by untrained volunteers; it may mislead; it may prioritize "fun" at the expense of learning; it may appear to provide easy answers and close down rather than trigger curiosity. But, at its best, performance within museum and heritage settings is charged with being capable of a range of tasks that are pivotal to museum education: not least providing cognitive and affective educational benefits to children and adults alike. It is variously described as being "a bridge," "filling gaps," "expanding," "a language," and a medium of "translation." Within its many guises, performance is seen as being capable of bringing something new to people who might not previously have had the necessary tools or the motivation to seek it for themselves. The challenge for researchers is then to interrogate these claims, to find effective, sensitive, and responsive ways of generating data about visitor (audience) response, recall, and meaning-making, and – finally but certainly not least – to contribute to the wider understanding and further *development* of the role of performance in museum learning.

# Note

1.   Living history is defined by the International Museum Theater Alliance as a broad term used to describe "recreated historical environments and/or the people who work there. Interpreters ... may be in character, in costume, or both." (http://www.imtal.org/keyDefs.php – last accessed 17/11/05)

# References

American Association of Museums (1969). *America's Museums: The Belmont Report*. Washington, DC: American Association of Museums.

American Association of Museums (1984). *Museums for a New Century*. Washington, DC: American Association of Museums.

American Association of Museums (1992). *Excellence and Equity: Education and the Public Dimension of Museums*. Washington, DC: American Association of Museums.

Anderson, D. (1997). *A Common Wealth: Museums and learning in the United Kingdom – a report to the Department of National Heritage*. London: Department of National Heritage.

Bagnall, G. (2003). Performance and performativity at heritage sites. *Museum and Society, 1*(2), 87–103.

Baim, C., Brookes, S., & Mountford, A. (2002). *The Geese Theatre Handbook*. Winchester: The Waterside Press.

Barbacci (2004). Science and theatre: A multifaceted relationship between pedagogical purpose and artistic expression. Paper presented at the annual meeting of Public Communication of Science and Technology, Barcelona, Spain. Retrieved June 9, 2005 from www.pcst2004.org.

Bartels, D., & Hein, G. (2003). Learning in settings other than schools. *Educational Researcher, 32*(6), 38–42.

Baum, L., & Hughes, C. (2001). Ten years of evaluating science theater at the museum of science, Boston. *Curator, 44*(4), 355–369.

Bicknell, S., & Mazda, X. (1993).*Enlightening or Embarrassing: An evaluation of drama in the Science Museum*. London: National Museum of Science and Industry.

Black, D., & Goldowsky, A. (1999, March). *Science Theater as an interpretive technique in a science museum*. Paper presented at the meeting of the National Association of Research in Science Teaching, Boston, MA.

Boal, A. (1979), *Theatre of the Oppressed*. London: Pluto Press.

Bolton, G. (1999). *Acting in Classroom Drama A Critical Analysis*. Portsmouth, NH: Heinemann.

Bolton, G. (2007). A history of drama education – A search for substance. In L. Bresler (Ed.), *Handbook of arts education* (pp. 51–68). Kluwer: Dordrecht.

Bridal, T. (2004). *Exploring Museum Theatre*. Walnut Creek, CA: Alta Mira Press.

Brown, P. (2004). Show business. *Museum Practice, Autumn 2004*, 48–50.

Casey, V. (2005). Staged Meaning: Performance in the Modern Museum. *The Drama Review, 49*, 78–95.

Cuomo, S., & Hein, G. (1994). *Mysteries of the Bog 3evaluation report*. Cambridge, MA: Program Evaluation and Research Group, Lesley University.

*Electronic program descriptions by the Central Park Zoo*. Retrieved October 2, 2005 from http://nyzoosandaquarium.com/czeducation.

Fiske, J. (1989). *Understanding Popular culture*. London: Routledge.

Flanagan, H. (1940). *Arena: the story of the Federal Theatre*. New York: Duell, Sloan & Pearce.

Franco, B. (1994). The Communication Conundrum: What is the message? Who is listening? *Journal of American History, 81*(1), 161–162.

Gardner, H. (1983). *Frames of mind: The theory of multiple intelligences*. New York: Basic Books

Gardner, H. (1993). *Multiple intelligences: The theory in practice*. New York: Basic Books

Heathcote, D. (1984). *Dorothy heathcote: Collected writings on education and drama* (Edited by L. Johnson & C. O'Neill). Cheltenham: Stanley Thornes.

Hein, G. (1998). *Learning in the Museum*. London: Routledge.

Hein, G., Lagarde, P., & Price, S. (1986). Mary Rose Exhibit at the Museum of Science. Unpublished evaluation report. Cambridge, MA: Program Evaluation and Research Group, Lesley University.

Hooper-Greenhill, E. (1999). Learning from learning theory in museums. In E. Hooper-Greenhill (Ed.), *The Educational Role of the Museum* (pp. 137–145). London: Routledge.

Hooper-Greenhill, E., Dodd, J., Moussouri, T., Jones, C., Pickford, C., Herman, et al. (2003). *Measuring the Outcomes and Impact of Learning in Museums Archives and Libraries* (pp. 301–324). Leicester, England: University of Leicester, Research Centre for Museums and Galleries.

Horkheimer, M., & Adorno, T. W. (1955/2000). *The Dialectic of Enlightenment*. Stanford and California: Stanford University Press.

Hughes, C. (1998). *Museum Theatre: Communicating with visitors through drama*. Portsmouth, NH: Heinemann.

*Inspiring Learning for All* (2004). Museums, Libraries & Archives Council, London. Website: http://www.mla.gov.uk/action/learnacc/00insplearn.asp (last accessed 21/11/05).

Jackson, A. (Ed.). (1993). *Learning through theatre: New perspectives on theatre in education*. London: Routledge.

Jackson, A. (2000). Inter-acting with the past – the use of participatory theatre at museums and heritage sites. *Research in Drama Education, 5*(2), 199–216.

Jackson, A. (2002). Between Evaluation and Research: making the case for Theatre as an Educational Tool in Museum Theatre. *Stage of the Art*, AATE Winter, 6–9.

Jackson, A., Johnson, P., Rees Leahy, H., & Walker, V. (2002). *Seeing it for real: An investigation into the effectiveness of theatre and theatre techniques in museums*. Manchester, England: Centre for Applied Theatre Research, University of Manchester. (Unpublished report.)

Jackson, A., & Rees Leahy, H. (2005). "Seeing it for real …?" – Authenticity, theatre and learning in museums. *Research in Drama Education, 10*(3), 303–325.

Klein, H. (1988). *Heinrich Hertz, restored to life or: Exhibit theater as an interpretive tool*. Paper presented at the meeting of the German International Council of Museums, Lindau, Germany.

Lanning, J. (2000). *Tales of the Territory: Minnesota 1849–1858, Live Play Summative Evaluation*. St. Paul, MN: Minnesota History Center.

LaVoie, R. (2003). *To Engage and Enlighten: Theatre as an interpretive tool in history museums*. Unpublished master's thesis, Arizona State University, Tempe, Arizona.

Leinhardt, G., & Crowley, K. (2002). Objects of learning, objects of talk: Changing minds in museums. In S. Paris (Ed.), *Multiple Perspectives on Children's Object-Centered Learning (page number)*. Mahwah, NJ: Lawrence Erlbaum Associates.

Leon, W., & Piatt, M. (1989). Living History Museums. In W. Leon & R. Rozenzweig (Eds.), *History Museums in the US: A critical assessment* (pp 64–98). Urbana & Chicago, IL: University of Illinois Press.

Litwak, J. M., & Cutting, A. (1996). *Evaluation of Interpretive Programming*. St. Paul, MN: Minnesota History Center.

Malcolm-Davies, J. (2004). Borrowed robes: The educational value of costumed interpretation at historic sites. *International Journal of Heritage Sites, 10*(2), 277–293.

Marsh, C. (1996). *Visitors as Learners: The role of emotions*. Retrieved October 1, 2005 from http://www.astc.org/resource/education/learning_marsh.htm.

Munley, M. (1993). Buyin' Freedom. In C. Hughes (Ed.), *Perspectives on Museum Theatre* (pp. 69–94). Washington, DC: American Association of Museums.

Needham, H. (1999). Evaluation of theatre. In L. Maloney & C. Hughes (Eds.), *Case Studies in Museum, Zoo and Aquarium Theater* (pp. 87–99). Washington, DC: American Association of Museums.

Nicholson, H. (2005). *Applied drama: The gift of theatre*. Basingstoke: Palgrave Macmillan.

O'Connor, J., & Brown, L. (Eds.). (1980). *Free, adult and uncensored: The Federal Theatre Project*. London: Eyre Methuen.

O'Toole, J. (1976). *Theatre in Education*. London: Hodder & Stoughton.

Quinn, S., & Bedworth, J. (1987). Science theater: An effective interpretive technique in museums. In D. Evered & M. O'Connor (Eds.), *Communicating science to the public* (pp. 161–172). New York: John Wiley and Sons.

Roth, S. (1998). *Past into present: Effective techniques for first-person historical interpretation*. Chapel Hill, NC: University of N.Carolina Press.

Rubenstein, R., & Needham, H. (1993). Evaluation of the live interpretation program at the Canadian Museum of Civilization. In C. Hughes (Ed.), *Perspectives on Museum Theatre* (pp. 105–142). Washington, DC: American Association of Museums.

Schechner, R. (1985). *Between Theatre and Anthropology*. Philadelphia, PA: University of Pennsylvania Press.

Serrell, B. (1997). Paying attention: The duration and allocation of visitors' time in museum exhibitions. *Curator, 40*(2), 108–125.

Snow, S. E. (1993). *Performing the pilgrims: Ethno-historical role-playing at Plimoth Plantation. Jackson: University Press of Mississippi*.

Taylor, P. (2003). *Applied Theatre: Creating Transformative Encounters in the Community*. Portsmouth, NH: Heinemann.

Thompson, J. (2003). *Applied theatre: Bewilderment and beyond*. Bern, Switzerland: Later Lang.

Tivers, J. (2002). Performing heritage: the use of live "actors" in heritage presentations. *Leisure Studies, 21*, 187–200.

Vergo, P. (Ed.). (1993). *The New Museology*. London: Reaktion Books.

Zucker, B. (1998). Anna Curtis Chandler: The Metropolitan's costumed storyteller. *Museum Theatre Journal*, Spring, *1*, 3.

# INTERNATIONAL COMMENTARY

# 46.1

# A Response to "Theater in Museums and Historic Sites: Visitors, Audiences, and Learners" (Hughes, Jackson, and Kidd)

**Wei-Ren Chen**

*Taipei Mandarin Experimental Elementary School, Republic of China (Taiwan)*

In the narrative of the wordless picture book *You Can't Take A Balloon Into the Museum of Fine Arts* (Weitzman & Glasser, 1998), the parallel story lines explore the relationship between the exhibition in the museum and the performance in real life. From the meaningful contrast, readers can make sense of both "inside" and "outside" aesthetic experiences and can integrate the complex dynamic between them. These issues apply interestingly to museum drama education in Taiwan.

If we utilize museum theater as an educational tool, the interaction between museum exhibition and learners can be explored, including the interpreted relation of time and space, the dialectical relation of reality and fiction, and the connection relation of objects and humans (modified from Hsu, 2001). Three continuums reflecting the museum experience provide a framework for assessing the role of museum theater:

1. *The time/space interpretative challenge:*
Who/What will take the communicative role, in museum theater, for stimulating visitors to appreciate their aesthetic experience between the difference times and spaces reflected in the museum exhibition and their own lives?

2. *The reality/fiction dialectic*:
How can museum theater not only attract people to passively receive but also involve them actively to explore similarities and differences across the boundaries of reality and fiction?

3. *The objects/humans connection*:
What kinds of museum theater will help people to interact with museum objects to make their own personal meanings of them?

The problems faced by museums in Taiwan are not only how to activate exhibitions, but also how the process and outcome of activation improve the education function and meaning (Liu, 2004). Helping visitors to find their own vision and interpretation is the responsibility of museums (Syu, 1999). Drama, a fundamentally communicative

*L. Bresler (Ed.), International Handbook of Research in Arts Education, 697–700.*
© 2007 *Springer.*

medium, represents artifacts with time-and-space identities in a way that encourages visitors to integrate their own perceptions and sensitivity to cultivate an inner sense of treasure, in turn promoting growth and actualization (Siks, 1983). Furthermore, museum theater explores improvization and openness: since any object has multiple features, excellent exploration reveals multiple aspects, for example, with the diversity of period pieces (Wu, 1999). Thus, drama can construct situated learning environments for visitors. If professional collaboration and integrated resources derive from different social resources, museum theater will be considered not only an activity, but also a cultural praxis.

As to the second continuum, drama is a duplication of life, one mirror of convention, and a reflection of truth. "Museum as theater" or "museum theater" is now common in Taiwan (Syu, 1999), and inviting visitors to become actively involved in that context is the essential issue. However, it can be challenging when, for example, museums offer multimedia virtual reality. Tseng (2001) investigated theatrical interpretation in museums with the National Museum of Natural Science, examining the educational goals and factors affecting the interpreters' job performance. Using museum theater's combination of reality and fiction to enrich the experience is one way for exhibition designers to create situated environments.

On the third point, Foucault (cited in Syu, 1999) regarded the function of contemporary museums as the interpretation of social and cultural contexts through objects and the promotion of the relationship between objects and humans. So, museum theater becomes storytelling for and about objects, and the story style extends the design of exhibition. Convincing the audience is not easy for museum exhibits (Hung, 2000; Hung & Young, 2000), so in order to deconstruct the passive model to prolong active dialogue, narratives would engage visitors in actively conceptualizing the exhibition's meaning. For example, Wu (2004) proposes applying the aesthetic narrative strategies utilized in film in the design of a museum display. The meaningful comparative analysis allows us to build more possibilities of narrative style into the exhibition design.

The differences reflected by each of the three continuums cited above are analogous to the differences between visiting a museum and following the balloon in order to taste the real world. In fact, we re-conceptualize something "visible" or "invisible" in our minds through the multiple displays that museum theater provides in museums.

# References

Hsu, J. J. (2001). *The Nature of Museum Exhibition – An esthetic viewpoint inspired by Brecht's thinking of theatre*. Unpublished thesis, Tainan National University of The Arts, Tainan, Taiwan.

Hung, C.-Y. (2000). *Research of the applying model by narrative thinking in exhibition design – examples of chinese science hall in national museum of nature science and chinese science hall in national science & technical museum*. Unpublished thesis, Tainan National University of The Arts, Tainan, Taiwan.

Hung, J. J., & Young, Y. F. (2000). *The historical review and future trend of the exhibition design in Taiwan museums*. Retrieved January 2, 2006, from http://www.yuntech.edu.tw/~yangyf/studio/pap352.htm.

Liu, W. C. (2004). Between fiction and reality: An opportunity for museum educational reform. *Museology Quarterly, 18*(1), 19–28.

Siks, G. B. (1983). *Drama with children* (2nd ed.). New York: Harper & Row.

Syu, S. H. (1999). The nature of museums and theatre. Retrieved January 3, 2006 from http://web.tnna. edu.tw/~museum/advice_02_a1.htm.

Tseng, S.-C. (2001). *The application of the theatrical interpretation in Museums-A case of the national museum of natural science*. Unpublished thesis, Tainan National University of The Arts, Tainan, Taiwan.

Weitzman, J. P., & Glasser, R. P. (1998). *You can't take a balloon into the museum of fine arts*. New York: Penguin Putnam.

Wu, D. R. (1999). *Minor league, major dream*. Retrieved January 3, 2006 from http://web.tnnua.edu.tw/~museum/advice_02_a6.htm.

Wu, U. S. (2004). *Comparative analysis of museum and cinema narrative: The case study between "Sino-French War and Taiwan" exhibition presented at the National Taiwan Museum, and "Master and Commander: The far side of the world, directed by Peter Weir*. Unpublished thesis, Tainan National University of The Arts, Tainan, Taiwan.

# 47

# QUESTIONS ASKED IN ART-MUSEUM EDUCATION RESEARCH

**Elizabeth Vallance**
*Indiana University, U.S.A.*

Research on art-museum education appears across a spectrum of publications including museum journals and art education journals, as well as in occasional articles on museum history and sometimes in journals of curriculum studies. In this chapter, I offer a snapshot of the kinds of research questions, and the perspectives they reflect, that are available to arts-education researchers, with the important caveat that the literature specifically on art-museum education research is untidily scattered across several disciplines and does not yet seem to constitute a separate discipline of its own. This chapter explores several perspectives that guide – and might guide – our inquiries as to how art learning occurs with artifacts in museums; it draws from work in the fields that most inform art-museum education, specifically school-based art education and museum education generally, as well as an emerging field that encourages study of visual images that have not yet entered museums.

This chapter synthesizes three major perspectives through which we can both ask research questions and interpret their findings. Two perspectives are long established in educational inquiry: John Dewey's conception of aesthetic experience, and Joseph Schwab's conceptual framework of the "commonplaces" of schooling, both here applied to the museum experience, Added to this standard mix is the newer perspective of contemporary visual culture studies, which can bracket our research on museum learning by helping researchers to understand the similarities and differences between visitors' responses to everyday objects and to objects selected and arranged to facilitate an aesthetic response in a museum setting. We will explore how these three perspectives can intermix to reveal some important and promising research questions about how learning in art museums can best be understood and facilitated. The chapter concludes with a quick snapshot of topics actually covered in current museum education research in a sampling of relevant European, Canadian, and American research reports, assessed against the matrix that emerges from a synthesis of the three perspectives.

*L. Bresler (Ed.), International Handbook of Research in Arts Education, 701–716.*

## Aesthetic Experience and the Museum: John Dewey

One avenue into research on the museum experience is through John Dewey's power-ful concept of "art as experience" (Dewey, 1958), and more broadly through the edu-cational implications of his concept of aesthetic experience. As Philip Jackson articulates in his summary of the aesthetic-experience concepts scattered across Dewey's writings, Dewey himself never really pulled the aesthetic-experience concept directly together with teaching or learning, and certainly not with museum-going specifically (Jackson, 1998). Still, Dewey offers our clearest explication of what it means to encounter an object – a thing, a view, a remembered experience, even abstract knowing – as a separate experience in its own right. His conceptions of the aesthetic experience, especially when integrated with Schwab's commonplaces of schooling, suggest a network of questions about how learning happens in museums. They also suggest a layer of interpretation that can be placed on our reading of what we do know about museum learning.

It is astonishing to realize that in *Art as Experience*, published when Dewey was 75, education itself is never addressed; the word does not appear in the book's index. Dewey's writings on art and experience are so familiar to us that their relevance to edu-cation now seems obvious, but Jackson's synthesis of Dewey's concepts offers a clearer view of aesthetic experience and its role in learning than Dewey himself ever did. For example, Jackson distills from Dewey's many definitions and characterizations of expe-rience a clear conception of the aesthetic encounter, showing us "what life might be like if we sought more often to shape ordinary experience in an artistic manner" (Jackson, 1998), starting with a characterization of the "traits of every normally complete experi-ence that the arts serve to clarify and intensify" (p. 6). Every experience that is encoun-tered and remembered as a distinct whole set apart from the everyday flow of life, and particularly every aesthetic experience, is characterized by completeness, uniqueness, and the calling up of a unifying emotion. This would be true of every clear memory that we hold of any moment, and it would be more intensely true of every moment colored by aesthetic qualities: Jackson recounts his own walk to the mailbox as a sequence of events that hold together at the time and later in memory as a distinct and valued "experience". He reviews the impacts of selecting and rejecting in defining how specifically art-centered experiences are different from other experiences – presumably more actively involved in selecting and rejecting art to look at than in filtering out the chaos of every-day life to find the aesthetic moments within it. The formal conditions of aesthetic form that affect our response to works of art – continuity, cumulation, conservation, tension, and anticipation – are conditions that explain or describe why one situation (a perfect film, perhaps) is wonderful and might haunt us for days after seeing it and another proved to be forgettable (perhaps a character's continuity was uneven, or the film created no tension to be resolved). Jackson's synthesis of Dewey also takes us through the roles of active engagement and noticing, as opposed to almost accidentally noticing, in the impact of aesthetic perception on our lives.

The concept of "aesthetic experience" is fundamental not only to the making and experiencing of works of art, but also to how our expectations of and responses to any human-made artifacts, placed in museums for the purpose of aesthetic engagement,

are shaped. Maxine Greene's work uses Dewey's concept unusually richly, developing the concept of aesthetic experience and pairing it with imagination, the necessary openness to experience, as a necessary component of learning (Greene, 1995). In my work with the art-novice undergraduate college students who will become elementary teachers, I introduce this notion of what I call our framing of aesthetic moments and try to cultivate students' openness to finding them in unexpected places. Arguably, what all artists do first is to actively engage with the visual world or the world of ideas, find a compelling pattern or composition or idea in the visual resources available to them, and translate their response to that encounter into an artistic medium such as paint, poetry, or music, which in turn can then shape the aesthetic experiences of others (Kozloff, 1968). It falls to a sequence of people in the art world to notice and value the resulting artwork, acquire it, place it in a museum for others to see, and help those others interpret it through labels, programs, and other resources. At that point it becomes the job of the museum visitor to see that object – now framed, or under glass – in its own right, removed from the context in which it was created, now worthy of contemplation as an artifact of an artist's vision, style, culture, available media, and other influences. The artist's response to an aesthetic experience perhaps long ago or far away becomes available to us as an organized artifact that can be understood, appreciated, or misinterpreted.

It is the job of museum education to help the visitor connect back to the artifact and make meaning from the "public curriculum of orderly images" presented both by the curator's selection and arrangement of art within the galleries and by the visitor's own selection and sequence of exploration of these objects (Vallance, 1995). In Dewey's terms, then, art-museum educators work with the translated aesthetic experiences of artists in a way that makes them accessible as renewed aesthetic experiences of visitors. Museum visitors differ from K-12 students in many ways, the most demanding of which is that they are always unpredictable: we rarely know in advance the characteristics of our audience, not even age or art background, and must design educational resources that are accessible to everyone from first-time visitor to seasoned scholar. But in every case, we can assume that the work of art on view – or the sequence of artworks on view that every visitor further selects from in any given visit – can be encountered as a rewarding and memorable aesthetic experience for a broad spectrum of visitors including families, school groups, teachers, preschoolers, scholars, and "general public" tourists of unknown background. In Dewey's terms, art-museum education helps visitors to have an aesthetic experience with artifacts already deemed aesthetic by the experts. It is the special challenge of museum education to make the aesthetic experiences reflected in the museum's collection as compelling and as rewarding an experience for novice visitors as the original moments were for the artists.

Much research on museum education, especially art-museum education, explores the effectiveness of this reconnection, explicitly or tacitly. Research on the visitor experience (Falk & Dierking, 1992; Hein, 1998; Paris, 2002), on visitation patterns within galleries (Loomis, 1987), on impact of interpretive resources on pre-post test knowledge of exhibition content (Smith & Carr, 1998), sociocultural interactions (Ellenbogen, 2003; Leinhardt, Crowley, & Knutson, 2002), even research on visitor return rates can be understood as research that attempts to understand the nature of the

aesthetic experience of visitors in their response to artifacts they encounter. Much of this research also addresses the quality of the visit itself (fatigue and comfort factors, for example), but to the extent that inquiry explores how visitors respond to the art itself, it is also an exploration of the degree of Deweyan aesthetic experience, of attending to moments in the museum visit that were coherently framed both literally and experientially.

Thus, one approach to understanding art-museum education research is to ask whether the research helps us to know whether visitors are readily able to create and identify the kind of aesthetic experiences that will compel their attention, make them remember an image or a feeling with an image as vividly as Jackson remembers his trip to the mailbox, and help them reconnect with the aesthetic experience that shaped the form the artwork took when it was made. As we will see later in this chapter, the questions raised by the concept of aesthetic experience become clearer still when considered in the context of the standard commonplaces of the curriculum and the broader definition of aesthetic experience made possible by visual culture studies. We turn now to our second framework, the commonplaces of education.

## The "Commonplaces" of Education: Joseph Schwab's Model of Curriculum Discourse

For nearly half a century, Schwab's conceptual model of the four "commonplaces" of education has served as a guide to American discourse about curriculum change. In a series of articles in *School Review*, but especially in the first one, Schwab developed a language for curriculum discourse that identified the basic components of any educational encounter (Schwab, 1969, 1971, 1973).

The model is deceptively simple. Schwab identified four equal and variable aspects of schooling, which he called "commonplaces" – aspects common to the curriculum unfolding in any school setting. That is, every curricular moment in school includes aspects of all four commonplaces, some more salient at any given moment than others. Every conversation about the school curriculum necessarily refers, tacitly or explicitly, to all four. Each commonplace represents an area of expertise in curriculum planning and teaching, and the design and implementation of the curriculum ideally includes the collective participation of people in each area.

The four commonplaces are (in no particular order): subject-matter, teacher, students, and milieu (or setting). Every lesson in every K-12 classroom can be described with reference to all of them, and can't fully be described without reference to all four: it may be a lesson on the Trojan War, taught by an elementary teacher to 10-year-old students, in a small rural elementary school using only books, or a ceramics lesson taught by a master ceramist in a well-equipped urban secondary school near a major museum. In each case, the commonplaces apply. The reason for discourse about a curriculum may focus on one or more of the commonplaces (revising the textbook, perhaps), and the professionals involved in the discussion may come from disciplines reflecting only one of them (such as art teachers). But it is impossible to discuss a K-12 curricular situation fully without acknowledging the roles of each of the four

commonplaces. In the formal school setting, we know what the formal curriculum is and we know the textbooks that embody it; teachers have academic preparation we require and can describe; we can identify the students quite specifically, by name, age, socioeconomic status, prior test scores, and what we can assume they already know from having come up through our system; and we can describe the setting in which teaching takes place, the school building, the classroom, its resources. Every schooling situation can be described in terms of the commonplaces; they are indeed common to all schooling situations.

But as some have argued, the commonplaces are also applicable to the museum setting, though in different ways (Soren, 1992; Vallance, 2003, 2004). Every museum program pertains to a subject-matter tied to the collection, is taught by a museum educator, docent, or guest lecturer, to "students" who are visitors, in a setting which is usually the museum itself but may include outreach locations. Some museums create teams of professionals across departments to plan and implement exhibitions, so that the content, interpretive programs and tools, and design of the setting are tailored specifically to the audience the museum is targeting with the exhibition (see Williams, 1996), addressing all of Schwab's commonplaces without realizing it. And yet in the museum setting, the commonplaces are stretched and redefined. The subject-matter of any given program or educational materials may refer to works of art on the walls or to broader contexts that help explain the art. The "teachers" may be educators in the usual sense but also include behind-the-scenes professionals who select and arrange the art (the curators), write the labels and wall text (curators and editors), produce the audio-tours or video supplements; the teaching may also be done through the sociocultural interactions of the visitors themselves (see Borun, 2002; Ellenbogen, 2003; Fienberg & Leinhardt, 2002; Leinhardt et al., 2002; Stainton, 2002). The "students" in museums are the least controllable variable in this curricular setting, for it is difficult to know in advance who the visitors are, what their backgrounds are, how long they will stay, what art they will notice, or whether they partake of any of the explicitly educational resources offered to them (Eisner & Dobbs, 1990). Unlike students in school, museum visitors are learners who have nearly full control over their own choices, and planning educational programs for them is an ongoing challenge; many museum visitors are – and museum educators hope they are – lifelong learners, repeat visitors who have created personal curricula of pursuing learning in a variety of informal settings. Finally, the museum setting itself, although as contained and finite as most schools, plays a strong but quite different role in museums than in K-12 schools. The setting is designed to showcase artwork, not to marshal visitors into neat rows or to house them in one place for extended periods of time, and yet by being welcoming, intimidating, comfortable, or overly formal, it becomes a salient part of the learning experience offered by museums. This is true perhaps more of children's museums and hands-on science centers where "milieu" includes spaces designed specifically for visitors, but still true of art museums as well, whose outreach programs may be designed specifically to break down the formality that the galleries impose on novice visitors.

Considering museum education through the lens of the commonplaces, we can identify categories of research questions appropriate to each, although no one variable is independent of the others. Just as it is impossible to talk about students without

considering the environment in which they live all day, it is impossible to talk about the subject-matter of an art museum's collection without also acknowledging the strong impact of installation design in the available space. Schwab's commonplaces are not mutually exclusive. But they do function in identifiably different ways in schools and in museums, and as such offer to museum researchers a useful set of both questions and perspectives on museum learning.

For example, consider again the case of visitor-studies research, which focuses specifically on visitor ("student") interaction with the specific content in the collections as identified and explained in teaching materials available on-site (Falk & Dierking, 1992; Loomis, 1987). In this case, the dominant commonplace is the student, interacting with subject-matter in a designed environment whose design also includes materials developed by the behind-the-scenes "teachers" of the museum, if not also live docents. Alternatively, the recent research on visitor interactions within galleries, both as "conversations" (Leinhardt et al., 2002) and as sociocultural learning more broadly construed (Ellenbogen, 2003), can be interpreted as inquiry into student behavior patterns themselves understood as "teaching" resources. Smith and Carr's (1998) study of what visitors know about the content of an exhibition before and after spending time in the exhibition focuses on visitor and on content, but the variables affecting visitor mastery of content depend heavily on the effectiveness of the teaching resource (often, in this research, the audiotour). Considering these research efforts through the lens of Schwab's commonplaces does not necessarily shift the focus of our inquiry, but it does help us to identify where the relative emphasis of the research question and its findings lies. Let us now move to a newer formulation specifically of learning in the arts, the notion that our students' broader visual culture offers a much wider range of content to explore and understand.

## Visual Culture Studies and Museum Education

The past decade has seen the emergence of a revised approach to teaching in the visual arts, a discipline now known as "visual culture", or visual culture studies. The field of visual culture studies opens the subject-matter of art education to a broader conceptualization of what we should be teaching to students (Duncum, 1999, 2003; Freedman, 2003; Heise, 2004; Tavin & Hausman, 2004). Earlier art education philosophies were centered on child development or the psychology of aesthetic development (Arnheim, 1974; Housen, 1987; Lowenfeld, 1957), or on a strict definition of what constitutes "art", as in the United States in the 1980s and 1990s when proponents of Discipline-Based Art Education (DBAE) argued that art education should be broadened beyond traditional art-making to include the rigorous study of art history, criticism and aesthetics (Dobbs, 1992; Getty Center for Education in the Arts, 1985). Visual culture studies further broadens the field of visual arts education to include the broad range of visual encounters with design and arguably with the accidental arrangements of objects in everyday life (Vallance, 2005). In this conception, "visual culture" education aims to "promote the critique and creation of images, artifacts, cultural sites, and public spheres as products and processes of mediation between people" (Boughton

et al., 2002). The aims of visual culture education are broad and substantive, involving educating students to interpret and critique the social patterns that produce art, fostering a global perspective that respects multi-cultural and cross-cultural connections and borrowings, and making regular connections between bodies of knowledge so that art is not isolated as a separate discipline.

Visual culture studies redefines the subject-matter of art: where DBAE focused on teaching about fine art in museum collections, visual culture allows for a focus on everyday design from students' own life experiences – both as a focus in their own right and, some say, as a springboard to understanding the aesthetics of more traditionally-defined fine art. Thus, in a visual culture curriculum, we can help students explore advertising, movies, commercial packaging, contemporary fashion, CD covers, and other artifacts of contemporary commercial culture. Though these artifacts were respected in earlier decades as worthy of attention in such courses as design, film studies, and fashion, the contemporary impact of this focus is to bring these artifacts into the realm of what we teach in art classes – and perhaps to bring consideration of these artifacts into museum programs, even if the objects are not yet in art-museum collections. Visual culture thus can refer, at its most inclusive, to everything designed and made by humans – fine art, traditional crafts, commercial design, and accidental compositions emerging in the course of the design layering that occurs naturally in the built environment.

The potential impact of visual culture studies on understanding art-museum education is at least two-fold. Art museums have traditionally included functional objects of fine design in their collections, objects that were once part of the everyday life and visual culture of their long-ago and/or far-away consumers – such as furniture, silver, porcelain, quilts, and objects of modern design for everyday living such as typewriters and lamps. In this respect, a visual-culture approach to art-museum education is not new, though it might change the way we talk about these objects from everyday life. Indeed, period rooms, house museums, and historic villages can all be conceived as examples of a celebration of the visual culture of their times, now additionally sanctioned by a visual-culture perspective. As such, one impact of visual-culture studies on art-museum education might well be the permission, even encouragement, to incorporate other kinds of museums – history museums, historic houses – as a context for understanding some of the objects now housed in art museums.

But given all this, a major impact of visual-culture education on museum education could be that it changes how we teach about these objects, allowing a fresh emphasis on these objects as the visual culture of their times, restoring them to their status of ordinariness from their present enshrined status, a shift that might change our relationship to them. Indeed, a visual-culture perspective in a museum program might allow us to look more carefully at the design features of objects included in paintings – at the commercial design evident in background carpeting, wallpaper, still-life implements, newspapers, streetscapes, and other facets of everyday life that might not be the focus of an image but do contribute to its meaning for past and present viewers. Secondly, visual-culture education in a museum context would encourage museum educators to use objects from today's visual culture in their teaching about the collection – encouraging students to work with, for example, contemporary advertisements

and packaging as they also seek to interpret and reinterpret more traditional artworks in the collection.

These two possible impacts of visual-culture studies on museum education have not yet permeated research on museum education in any consistent way, though good museum educators have always been able to help visitors connect to works in the collection by exploring analogous objects from their own lives. But the notion of imposing a visual-culture lens on our understanding of museum education raises some interesting research questions and also offers a perspective to help us understand the research we do on museum learning. In the next section, we explore how visual-culture studies, combined with both Dewey's concept of aesthetic experience and Schwab's commonplaces of the curriculum, raises interesting questions about the learning in art museums.

## A Synthesis of Three Frameworks

None of the three conceptual approaches to art education explored here was developed for the museum context, but all are applicable to it. John Dewey's concept of aesthetic experience underlies an art-education direction that would foster students' own abilities both to have, and to reinterpret in artistic media, aesthetic experiences of their own – inspired either by their own surroundings or by objects already so translated by earlier artists and now visible in museum galleries. Under this perspective of art education, museum education becomes an effort to help visitors connect to the visual and conceptual understandings embodied in works of art and, as a corollary, to develop their own abilities to see aesthetically interesting compositions in the world and in the works on view in the galleries. The possible research questions under this perspective involve the effectiveness of museum interpretation in enabling visitors to understand the aesthetic experiences reflected in and provided by works in the collection: research on the aesthetic experience would focus on art novices' growth in understanding artistic composition and meaning, on visitors' aesthetic preferences and the reasons for them, and on longer-term questions such as whether frequent museum-going influences visitors' sensitivity to artful compositions in other settings.

The concept of aesthetic experience is given context by Schwab's four commonplaces of education. The four commonplaces of subject-matter, teacher, student, and setting can reconfigure and combine in various relevant ways in the museum context, but one of the most interesting applications is to conceive of "aesthetic experience" as a subject-matter for museum education: if museum educators work hardest to guide visitors through the unpredictable and uncontrollable public curriculum of orderly images offered by the museum galleries, they do so in order that the aesthetic experience of orderliness – within individual compositions, or within a sequence of images selected to view – is one that colors and strengthens the visitor's response to the art on view there. Dewey helps us to see that in Schwab's terms, one of our most important curricular subjects is aesthetic experience – the visitor's own, the artist's, and the

general principle that all art is an interpretation of an aesthetic experience undergone by the maker.

The research questions raised by Schwab's commonplaces are broad indeed. The varying roles of the commonplaces in teaching and learning allow us to consider far more than the traditional psychology of learning in understanding how education happens in a museum setting. Schwab's framework encourages us to take seriously visitors' reactions to the imposingness or welcoming qualities of the building and individual galleries, to assess tacit qualities not typically considered "teaching" such as the selection and arrangement of works of art, to study visitor characteristics and demographics in ways not always applicable in the school setting (where we rarely need to worry, for example, about how many postal codes are represented, since we already know this). Most importantly, however, Schwab's framework encourages us to focus on the subject-matter of art education in museums, where the subject may seem defined by the focus of the collection itself (African art, Renaissance, Asian, "contemporary") but is further refined by how the collection is presented – the subject-matter as presented on the walls – and enriched by our efforts to develop and enrich visitors' aesthetic experiences. Questions for museum education research along this line of thought would focus on how the setting, tacit and explicit teaching, and visitor backgrounds converge to enrich the immediate and long-term memory of aesthetic experience for the visitor.

Visual culture studies liberates us to look at more than the finite museum collection in our research on what and how visitors learn about art in museums. Visitor culture studies broadens the subject-matter accessible to museum visitors through redefining what "art" can mean and how visitors' own experiences, tastes, and aesthetic choices can affect their learning in the museum setting. Visual culture studies allows museum educators to broaden the range of artifacts included in their teaching and allows researchers to conduct research and interpret research findings in ways that respect the interaction of everyday life in the learnings available in museums. It opens a rich new arena for research on how and why art museum education programs are effective.

I suggest an initial typology of research topics that would accommodate the perspectives suggested by synthesizing Dewey's concept of aesthetic experience, Schwab's commonplaces of schooling, and visual culture studies. This combined multi-layered lens suggests the following kinds of issues that might be raised in museum education research:

1. *Aesthetic experience*
   a. Aesthetic experience as subject of museum programs (understanding the aesthetic experience reflected in museum artifacts).
   b. Aesthetic experience as a goal of museum programs (the visitor's experience as a response to the museum setting: research on visitor preferences, memories, visitation patterns).
2. *The commonplaces: Museum teaching*
   a. Effectiveness of explicit teaching (by docents, educators, labels and text, audio-tours, video programs, and various program formats).

   b. Effectiveness of tacit teaching (impact of gallery installation and design, visitor interaction and sociocultural learning).

3. *The commonplaces: Subject-matter of museum education*
   a. Effectiveness of programs focusing on the existing collection.
   b. Effectiveness of programs extending the content beyond the collection to connections to everyday life or other cultures/media/times.
4. *The commonplaces: Visitors as students*
   a. Studies of visitor behavior.
   b. Studies of visitor demographics and backgrounds.
5. *The commonplaces: Museum setting* (studies of effectiveness of exhibition design, wayfinding, and other physical design qualities of the museum setting).
6. *Visual culture* (past and contemporary) as content in museum education.

One test of the usefulness of this matrix of research topics is to apply it to the topics of research reflected in a sampling of currently available publications on museum education. To test the matrix, I reviewed the topics addressed in publications from five sources, and in each source I noted the number and focus of the articles, special issues, or books that specifically addressed museum education:

(1) One year (2004) of the full articles in *Museum News*, the bi-monthly publication of the American Association of Museums, focusing on museums generally and the various subjects that concern museum professionals, of which education is but one. This one-year snapshot of museum professionals' interests should suggest the relative importance of education research in the museum field generally, and the sample yielded 21 articles, of which 14 pertained to museum education concerns;

(2) The Spring/Summer 2005 catalog of the *AAM Bookstore*, the AAM's publications catalog, listing 323 titles of interest to museum professionals, of which the largest single category (43, or 13.3%) were in the Education/Intepretation section; this quick list is a regular seasonal view of the relative weight of various topics of interest to museum professionals;

(3) A recent sample of a 12-month sequence (6 issues, July 2004–May 2005) of *Art Education*, the bi-monthly publication of the National Art Education Association, a publication addressed to art teachers interested in teaching ideas ranging from simple craft projects to sophisticated projects inspired by museum objects; 10 of the 34 articles in the year pertained to museum education;

(4) The complete list of issue topics and article titles from the 24 years of back issues of the *Journal of Education in Museums*, published annually in the United Kingdom, each issue by definition focusing on museum education;

(5) A review of the issue topics of the *Journal of Museum Education*, published by the Museum Education Roundtable (Washington, DC), from 1973 through 2004. Published twice or three times a year, this journal yielded 76 issues, each fully devoted to research on museum education.

For each publication, I assessed the focus of each relevant title (article, whole-issue topic, or book) and assigned it a single matrix category according to its chief topic, yielding a relatively "clean" distribution of topics. The resulting preliminary profile of research focus reflected in these sources is instructive for guiding future directions of inquiry in museum education.

As Table 1 suggests, this perusal of the topics addressed by professionals writing about museum education suggests that our concerns are skewed in favor of explo-rations of teaching strategies and program reviews – the "teacher" and "subject-matter" commonplaces in Schwab's framework. This was especially true of the books listed in the AAM's 2005 catalog, where most publications explore the effectiveness of specific teaching formats with a special interest in their effectiveness for conveying the sub-ject-matter content of the collection.

Looking at these very simple data, the different emphases of the different publica-tions are interesting: by far the heaviest emphasis in publications on museum education is on exploring explicit teaching (including professional preparation to teach) and pro-gram formats: nearly one-third (44 of the 134 studies cited) of the studies focus on the overt teaching done in museums, while only one-quarter of that number again focus on the tacit teaching that goes on through visitor interaction and the "silent pedagogy" (Eisner & Dobbs, 1990) of the museum visit (the same number of studies – 11 – looked specifically at the educational impact of the museum setting). One clear example of the focus on teaching the collections is a review of different approaches to object-centered learning in museums (Paris, 2002). This emphasis on research on teach-ing strategies is not surprising, for any museum educator can attest that most of

**Table 1.** Research topics within the matrix of museum education perspectives, five publication sources

|  | Museum News (21 articles) | AAM Bookstore (43 books) | Art Ed. (34) | JME (76 issues) | JEM (24 issues) |
|---|---|---|---|---|---|
| 1. Aesthetic experience |  |  |  |  |  |
| a. As subject | 2 | 3 | 1 | 0 | 0 |
| b. As goal | 4 | 5 | 5 | 8 | 2 |
| 2. Teaching |  |  |  |  |  |
| a. Explicit T'g/Pgm formats | 3 | 12 | 1 | 18 | 10 |
| b. Tacit teaching | 1 | 4 | 0 | 6 | 0 |
| 3. Subject-matter |  |  |  |  |  |
| a. Focus on collection | 0 | 3 | 0 | 4 | 3 |
| b. Focus beyond collection, including multi-culturalism | 0 | 1 | 1 | 3 | 0 |
| 4. Students/visitors |  |  |  |  |  |
| a. Visitor behavior | 0 | 1 | 0 | 2 | 0 |
| b. Visitor demographics/background | 4 | 0 | 0 | 11 | 3 |
| 5. Setting | 0 | 3 | 0 | 5 | 1 |
| 6. Visual culture, as content | 0 | 0 | 2 | 0 | 0 |

his/her time is spent in designing and teaching in structured programs listed in the museum's published schedule; the tacit teaching that affects visitors is extremely hard to identify and measure. Other trends also confirm our expectations based on experience: more of the subject-matter emphasis is on the museums' own collections than is on the connections that can be made by going beyond the collections (and indeed many collections in themselves allow for multi-cultural teaching and do not need external extensions). Also, more work seems to be done exploring audience characteristics (demographics and background knowledge) than visitor behavior itself, a trend that makes sense in a research base because educators typically must accommodate audience characteristics in programs targeted to specific groups.

It is noteworthy that 22 issues of JME, though devoted to museum education concerns, focused on topics outside the matrix: eight were variable/open topics, one even called "Potpourri"; two were devoted to a history of museum education or of museum education research. Most interestingly, six each were devoted to two topics that do not fit in the matrix that had emerged from the Dewey and Schwab frameworks. One is best identified as "museum education and the local community" (e.g., Volume 23:3 in 1998 explored "The Classroom Connection: Museums as Catalysts for School reform," and the Fall 1976 issue was devoted to "Superintendent and Museum Educators Meet"). The other might be called "comparative museum education," in which six journal issues explored museum education in specific countries or regions, a focus too far beyond the museum building to fit within Scwab's definition of "milieu". This international/comparative theme appeared also in the *Journal of Education in Museums*, where two issues were devoted to "education abroad" (comparative museum education), in addition to open/variable topics.

The second highest number of topics addressed in these five sources was the one I call "aesthetic experience as a goal", the visitor's own aesthetic experience – defined in Deweyan terms, thus not always focused on art itself – as an outcome of the museum visit. Fully 24 of the 134 topics/titles reviewed here looked at the impact of the museum visit on visitors' preferences, memories, and skills in interpreting art and artifacts. Even more notably, these 24 studies appeared fairly evenly distributed across all publication sources reviewed here. One-third of them appear as whole-issue topics (and thus in many more individual articles) in the *Journal of Museum Education*, though the apparent dominance of that journal in this topic is mitigated by the fact that the data on that journal go back 24 years. One fine example of the study of "aesthetic experience" that a strong memory of a museum visit provides is a compendium of museum professionals' own strong museum visits, presented in a compelling videotape (Spock, 2000). Finally, it is worth noting that of the 134 sources explored here, visual culture appears as a subject of art-education research in only two articles in a publication regularly read by museum educators, both of them in the same recent issue of *Art Education* and neither of them specifically focused on museums' role in art education except in observing that global visual culture can liberate art education from relying solely on museum images. Significant though visual culture studies seems for museum education, it seems so far to have been argued only in forums for school-based art education (see Heise, 2004; Tavin & Hausman, 2004).

# Discussion and a Proposal

This preliminary survey of research topics in five sources of information for museum and art educators is not a complete picture of the literature on museum education research. Some of the strongest current literature on some of the topics suggested by the matrix, for example Csikszentmihalyi's (1997) pivotal work on the "flow" experience, is very closely tied to what Dewey would call aesthetic experience, but is not included in AAM's 2005 publication catalog. The sample of research topics tallied here is, as argued at the start of this chapter, just one snapshot of one universe of discourse on our subject. Nonetheless, this quick look at what museum educators talk about in their research suggests that a matrix combining John Dewey's notion of aesthetic experience with Schwab's commonplaces of education, enriched by the recent fillip added by visual culture studies, is useful in describing, categorizing, and assessing trends in museum education research. Most museum-education research falls into the categories encompassed by this matrix, though most of it is skewed into Schwab's "teacher" or "teaching" commonplace. It is encouraging that much current research does address the formation of visitors' aesthetic experiences as a goal of programming, and that museum educators use information about visitor backgrounds.

What is surprising, and what I propose the field should correct, are two things – the paucity of attention to visual culture as either a subject or a teaching tool in any museums (including art museums), and the role in museum education of the broader context of the museum – its place in the community, and, from time to time, its useful comparisons to other museums in other countries and regions. The first is a relatively new perspective that may emerge over time as a consistent focus in the research literature. The second is an area that seemed to have been demanded a decade ago by the landmark publication, *Excellence and Equity: Education and the Public Dimension of Museums* (AAM, 1992) and is a regular topic of discussion at meetings of museum professionals. That the wider communities to which museums must respond appear so infrequently in museum-education literature, and that they appear chiefly in a single journal and there with a regional/international perspective, has fascinating implications for future research especially in art-museum education: how can art museums better document their impact on connecting the diverse broader communities reflected in their audiences to the world of art represented within their walls? This may be where visual culture can have its greatest impact.

I suggest, then, that we begin to prioritize research on museums, and especially on art-museum education programs, through a lens that would accommodate both those topics from the matrix that are clearly already dominant in museum educators' inquiry traditions and at least two that do not yet dominate the matrix – visual culture and the community extension of the usual institutional definition of the educational setting. As a start, I suggest here a range of questions not now addressed in contemporary research and that might cause future reviewers to reshape a matrix of relevant research questions. Each question integrates research topics already salient in the literature with new slants from visual culture and comparative education; each might take us in new directions.

(1) If creating rich and memorable experiences, what Dewey calls "aesthetic experience", is a goal of museum education, what are the most important contributions to such rich memories? How are museum experiences and museum memories best shaped – what relative roles do the museum's collections, interpretive materials, explicit and tacit teaching, *and* visitors' visual culture play in the effective focus on artifacts, through what teaching strategies?

(2) Combining a focus on two commonplaces, students and subject-matter, what factors most shape the "public curriculum of orderly images" that visitors create for themselves on any given visit, and how do explicit programs over time and the "tacit teaching" such as sociocultural learning affect the shape of the subject-matter choices visitors make? How do these patterns vary across comparative settings such as national or regional differences?

(3) What memories of prior aesthetic experiences – with fine art, other museums, everyday images from visual culture, or reproductions – do visitors bring to a first encounter with any given art museum's collection, and how do these memories affect their expectations, interactions, and learnings during the visit? How do the content and salience of these memories vary by culture?

(4) Of the qualities by which Dewey defines an aesthetic experience (unity, continuity, tension, etc.), which seem most to characterize the museum visit of a visitor who is satisfied with the visit? Do these characterizations vary between art museums and other kinds of museums? Can a satisfied visitor describe the qualities of the flow of experience that may, in time, remain an enduring visual memory of a single work of art or of any selection among those available?

(5) Do programs where the distinction between a museum's collection of fine art and the visual culture of visitors is minimized result in visitors' enhanced ability to make their own critical judgments about objects of design in the everyday world? Does the integration of visual culture studies with exploration of collection objects enhance visitors' openness to seeing artful qualities outside the walls of the museum?

These are only some of the questions suggested by the inequitable distribution of research topics, identified by their placement on a matrix derived from the synthesis of Dewey's and Schwab's traditional curriculum conceptions with one emerging focus of art education (visual culture). The field of museum education research is broad and diverse, and to some extent even the broad sample represented by the five publication sources covered here gives us only one view of the questions these researchers are asking. But applying the basic matrix to this selected sample does indicate some areas where new research questions can be coalesced from proven topics and new directions. For the moment, I would revise the matrix chiefly by adding the wider-community focus as part of the definition of what we research when we research the museum's "setting" or "milieu". Also, I would retain the visual-culture item despite its current low standing in the distribution: we should invite research in this area for museum education as one way to redefine the museum's conceptual milieu and thus to assess the coming changes in its subject-matter.

I would be interested to know, ten years from now, if a snapshot of contemporary research against the current grid would look the same or different, and if a wholly new grid might not better describe the work that we do. For now, I think this is a start.

# References

American Association of Museums (1992). *Excellence and equity: Education and the public dimension of museums*. Washington: American Association of Museums.

American Association of Museums (2005). *AAM Bookstore Catalogue*, Spring/Summer. Washington, DC: American Association of Museums.

Arnheim, R. (1974). *Art and visual perception: A psychology of the creative eye*. Berkeley, CA: University of California Press.

Borun, M. (2002). Object-based learning and family groups. In S. Paris (Ed.), *Perspectives on object-centered learning in museums* (245–260). Mahwah, NJ and Lonson: Lawrence Erlbaum Associates.

Boughton, D., Freedman, K., Hicks, L., Madeja, S., Metcalf, S., Rayala, M. et al. (2002). Art education and visual culture. Reston, VA: NAEA *Advisory*, Spring.

Csikszentmihalyi, M. (1997). *Creativity: Flow and the psychology of discovery and invention*. New York: Harper Perennial.

Dewey, J. (1958). *Art as experience*. New York: Capricorn Books (Original work published 1934).

Dobbs, S. (1992). *The DBAE handbook: An overview of discipline-based art education*. Santa Monica: The J. Paul Getty Trust.

Duncum, P. (1999). A case for art education of everyday aesthetic experiences. *Studies in Art Education, 42*(2), 101–112.

Duncum, P. (2003). Visual culture in the classroom. *Art Education, 56*(2), 25–32.

Eisner, E., & Dobbs, S. (1990). Silent pedagogy in art museums. *Curator, 33*(3), 217–235.

Ellenbogen, K. (Guest Ed.) (2003). *Journal of Museum Education, 28*(1), special issue on *Sociocultural perspectives on museum learning*.

Getty Center for Education in the Arts (1985). *Beyond Creating: The place for art in America's schools*. Los Angeles, CA: Getty Center for Education in the Arts.

Greene, M. (1995). *Releasing the imagination: Essays on education, the arts, and social change*. San Francisco, CA: Jossey-Bass.

Falk, J. & Dierking, L. (1992). *The museum experience*. Washington: Whalesback Books.

Fienberg, J., & Leinhardt, G. (2002). Looking through the glass: Reflections of identity in conversations at a history museum. In G. Leinhardt, K. Crowley, & K. Knutson (Eds.), *Learning conversations in museums* (pp. 167–211). Mahwah, NJ and London: Lawrence Erlbaum Associates.

Freedman, K. (2003) *Teaching visual culture*. New York: Teachers College Press.

Hein, G. (1998). *Learning in the museum*. New York: Routledge.

Heise, D. (2004). Is visual culture becoming our canon of art? *Art Education 57*(5), 41–46.

Housen, A. (1987). Three methods for understanding museum audiences. *Museum Studies Journal, 2*(4), 41–49.

Jackson, P. (1998). *John Dewey and the lessons of art*. New Haven and London: Yale University Press.

Kozloff, M. (1968). *Renderings: Critical essays on a century of modern art*. New York: Simon and Schuster.

Leinhardt, G., Crowley, K., & Knutson, K. (Eds.). (2002). *Learning conversations in museums*. Mahwah, NJ and London: Lawrence Erlbaum Associates.

Loomis, R.J. (1987). *Museum visitor evaluation: new tool for management*. Nashville: American Association for State and Local History.

Lowenfeld, V. (1957). *Creative and mental growth* (3rd ed.). New York: Macmillan.

Paris, S. (Ed.). (2002). *Perspectives on object-centered learning in museums*. Mahwah, NJ and London: Lawrence Erlbaum Associates.

Schwab, J. (1969). The practical: A language for curriculum. *School Review, 78* (November), 1–23.

Schwab, J. (1971). The practical: Arts of the eclectic. *School Review, 79* (August), 493–542.

Schwab, J. (1973). The practical: Translation into curriculum. *School Review, 81* (August), 501–522.

Smith, J., & Carr, D. (1998). Making meaning in Byzantium: Adult learning in a special exhibition. American Educational Research Association annual meeting, session # 46.48.

Soren, B. (1992). The museum as curricular site. *Journal of Aesthetic Education, 26*(3), 91–101.

Spock, M. (2000). *Philadelphia stories (video and study guide): A collection of pivotal museum memories*. Washington, D.C.: American Association of Museums.

Stainton, C. (2002). Voices and images: Making connections between identity and art. In G. Leinhardt, K. Crowley, & K. Knutson (Eds.), *Learning conversations in museums* (pp. 213–257). Mahwah, NJ and London: Lawrence Erlbaum Associates.

Tavin, K., & Hausman, J. (2004). Art education and visual culture in the age of globalization. *Art Education, 57*(5), 21–23/32–35.

Vallance, E. (1995). The public curriculum of orderly images. *Educational Researcher, 24*(2), 4–13.

Vallance, E. (2003). A curriculum-theory model of the art museum milieu as teacher. *Journal of Museum Education, 28*(1), 8–16.

Vallance, E. (2004). Museum education as curriculum: Four models, leading to a fifth. *Studies in Art Education, 45*(4), 343–358.

Vallance, E. (2005). Teaching the aesthetics of everyday life. *Illinois Art Education Association annual conference*, Galena, IL.

Williams, P. (1996). Comments on the Denver Art Museum's education department. In panel on "The order of things: Education departments' organizational structures". Annual meeting of American Association of Museums, Minneapolis MN.

# INTERNATIONAL COMMENTARY

## 47.1

## Aesthetic Experience and Contemporary Art Forms

**Helene Illeris**
*Danish University of Education, Denmark*

In her chapter, Elizabeth Vallance points to three highly useful concepts for research in art-museum education: aesthetic experience, one curriculum model, and visual culture. In this commentary I will briefly comment on these concepts, mainly through the lenses of my own research which has a narrower focus on the educational potentials of encounters between young people and contemporary art forms.

## Aesthetic Experience

During the last decades there has been a significant shift in the art world from a prevalence of artworks inscribed in modernist aesthetics to an increasingly intense focus on art in social settings. In contemporary art forms such as social intervention, interactive installations and performances, the "viewer" of the modernist work is replaced by a "participant" in a relationship (e.g., cf. Borriaud, 2002). Danish field-based studies (Hjort & Larsen, 2003; Illeris 1999, 2005a, 2005b) document how contemporary art works are likely to provide very strong and immediate aesthetic responses, especially from young people, who, unlike adult audiences, seem to be in their "natural element" when engaging in interactive art forms. Rather than reflecting the aesthetic experiences of the artists, as suggested by Vallance, these studies point to the fact that contemporary art works stimulate the young people to "create themselves" through highly individualized experiences, where immediate emotional responses and strong bodily sensations become central.

## A Curriculum Model

As a curriculum model, Schwab's "commonplaces," as reported by Vallance, seem to provide a very useful basic tool for understanding the setting of museum education.

*L. Bresler (Ed.), International Handbook of Research in Arts Education*, 717–720.

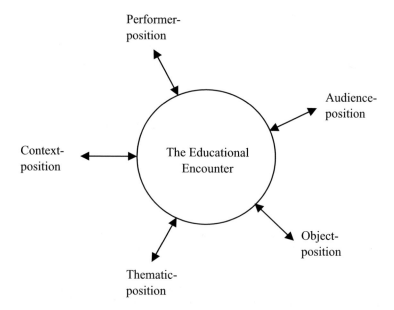

**Figure 1.** Performative positions in the educational encounter in art museums (Illeris, 2003 p. 19)

In a recent article (Illeris, 2003), I have used theory of ritual and performance as the theoretical basis for the construction of a model with similar components (Figure 1). The model defines five "positions" implied in the educational encounter in art museums: the performer position, the audience position, the object position, the theme position, and the environment position. My claim is that in traditional "rituals" of art-museum education, these positions appear to be rather fixed: the teacher performs, the students act as audience, the artwork is the object, the exhibition defines the theme, and the museum building provides the environment. The educational scope of the model therefore provides an inspiring tool for educators seeking to challenge these fixed positions through the active use of performative strategies. What happens if we mix up the positions, for example, by assigning the object position to a student and looking at her as an art work? Or what if we consider the museum building to be the performer? By introducing performance as an educational tool, young people may be able to understand contemporary art not only as a provider of individualized aesthetic experiences, but as a form of strategic action, which can be used as inspiration for the construction of alternative and playful social relationships both inside and outside the art museum.

## Visual Culture

The idea of art-museum education as performance has strong connections to the concept of visual culture. Visual culture is not just about the inclusion of more extended

subject-matter in educational settings, it is also about the inclusion of new and more diversified practices of looking (Illeris, Buhl, & Flensborg, 2004). Furthermore, questions of power, central to visual culture studies, are also crucial to performative art-museum education by raising questions such as: Who has the right to look at whom or what – how, when, and why? How do different educational practices change what and how we see?

In the Nordic countries a considerable number of books, articles, reports, and M.A. theses are dealing with issues of contemporary art in education (cf. Illeris, 2004). The three concepts discussed by Vallance seem to provide fruitful perspectives in relation to this work, for the present and possibly for the future.

# References

Borriaud, N. (2002). *Relational Aesthetics*. Dijon-Quetigny, France: les presses du réel.

Hjort, K., & Larsen, L. (2003). *At skabe sig selv. Evaluering af projekt "Samtidskunst og Unge"* [Creating Oneself. Evaluation of the Project "Contemporary Art and Young People"]. Copenhagen: The Egmont Foundation.

Illeris, H. (1999). Cyclops cameo, exemplary statements of four 14–15-year-old students on their encounter with a contemporary work of art. *Nordisk Museologi, 1/*(1999), 173–181.

Illeris, H. (2003). Performative positioner i kunstpædagogik" [Museum and Gallery Education: Performative Positions]. *Valör, 4/*(2003), 15–28, Uppsala University.

Illeris, H. (2004). *Kunstpædagogisk forskning og formidling i Norden 1995–2004* [Research and Publications Concerning Visual Arts Education in Museums and Galleries in the Nordic Countries 1994–2005], Skärhamn: The Nordic Watercolor Museum (English summary).

Illeris, H. (2005a). Young people and contemporary art. *The International Journal of Art and Design Education, 24*(3), 231–242.

Illeris, H. (2005b). Young people and aesthetic experiences – Learning with contemporary art. Unpublished paper presented at *Childhoods 2005*, Oslo University, 29 June–3 July 2005

Illeris, H., Buhl, M., & Flensborg, I. (2004). Visual culture in education – The Danish research unit. *InSEA news, 3*(9), 10–11.

INTERLUDE

48

# ART INFORMATION, ARTS LEARNERS: THE ROLE OF LIBRARIES

**David Carr**
*University of North Carolina at Chapel Hill, U.S.A.*

Every artwork is in some way a product of an act of knowing. Each one is certain to have historical antecedents, and a history of refinement and connection. And each work of art comes out of a human context that is complex, allusive, and private; it challenges the experiences of those who stand outside it. A mind at work in this way requires tools and perspectives the library provides. Techniques, materials, formative themes, and heroic images flow out of reliable information, an understanding of history, and the interactions of the present and the past. For explainers of art – scholars, teachers, museum educators – knowledge of theories, traditions, and contexts in human expression is essential. We may say of artists and their work, as we can say of all human things, that there is an intellectual record to be retrieved and understood. We keep it in libraries.

It is useful to regard the library as if we had never seen it before; our views are often distorted by our schooling, by images of librarianship, and by the common idea that technology has made traditional reference works obsolete. Libraries continue to hold treasures for learners. This will always be true for those who search for art information, images, and printed visual resources. No one who wants to learn about the arts can afford to miss library collections.

Ironically, the vast tangible resources of art library collections are especially important for invisible things, the values and possibilities they embody. Concentrations of scholarship allow an immersion in examples and discourse, and discovery of abundant information. Collections make comparative, critical thoughts possible. When a collection of information has been developed well, it promises and delivers a treasure to the student, the artist, and the scholar.

Extensive, interwoven narratives abound in libraries. They contain the deep resources of religion, anthropology, psychology, aesthetics, literature, history, and language that inform our knowledge about all the arts. They are places where formative stories can be pieced together, told in multiple voices, and traced to their origins. Libraries create

*L. Bresler (Ed.), International Handbook of Research in Arts Education*, 721–728.
© 2007 *Springer.*

situations where exemplary narratives and the records of individual lives – influences, reflections and processes – can be discovered.

Although libraries may seem inextricably linked to schooling, they are more truly understood as alternative learning spaces, like museums, where lifelong learners are free to design their own cognitive experiences. There is no institution where it is clearer that change follows from questions, that discovery has no end, and that all knowledge is surrounded by contexts. In a responsive library, a perceptive learner will quickly sense that information is infinite, and that good inquiry will always require inspired connections.

The multiple strands inherent in art learning are apparent in the nature and character of any library's provisions. Collections, assistance, and connections are parts of the library's promise. The library experience tends to require the articulation of an idea (e.g., *the meaning of totems*), or a fresh question (*What are the theoretical differences between the beautiful and the ugly?*), or an anticipated outcome (*I want to capture ideas of dreaming in my work.*), or a possible context for use (*I am preparing a course on gender in art.*).

Good questions in the library may not easily close, and can remain open over time; ambiguity and unpredictable outcomes are typical. Extraordinary patience is required when connections are slow to evolve. An inquiry moves slowly, gathers a good deal of data, and prepares the user to move toward increasing independence. Over time, a breakthrough becomes possible. The most useful learning experiences in libraries are gradual, accretionary, and structural.

Wherever art is made in a community or local economy, the library has a place to be, and there are useful educational concepts to explore. I think of the related ideas of apprenticeship and situated learning (Brown, Collins & Duguid, 1989; Lave & Wenger, 1991; Rogoff, 1990; www.exploratorium.edu); of going beyond the information given (Bruner, 1973, 1986); of creativity and interdisciplinarity (John-Steiner, 1985); of critical thinking (Smith, 1990); of transformative adult learning (Mezirow, 1991, 2000); of all the work of Maxine Greene (Greene, 1988, 1995, 2001); and especially I think of the work of John Dewey (Dewey, 1958; Jackson, 1998).

## Intensity and Tenacity

Intensity and tenacity, according to Vera John-Steiner (1985), are hallmarks of a creative mental life, often part of the required tension between an idea and its capture. For learning and problem solving in visual art, the library can occupy the same role that the studio occupies in an artist's practice or that a museum plays for the inquiring visitor making new discoveries: a place for trying out, incubating, and articulating previously disembodied parts of the imagination, an experimental setting where new possibilities can emerge (John-Steiner, 1985). It's a place for intensity and tenacity, reflection and pursuit, a workplace for process.

John-Steiner describes the necessity of creative continuity with others, alternative models of practice and vision. "One of the major challenges facing creative individuals is that of building upon the continuity of human knowledge while achieving novel insights" (John-Steiner, 1985, p. 206). The breakthroughs and extensions that create something new are not wholly self-invented, but derived from the works of predecessors

and the practices of tradition. Such continuities are not simply about transfers of skill or technique, but also about cognition and perception, and the founding of identity. "In linking their efforts with others future scientists and artists learn to join their wonder and commitment with the necessary tools of their craft or discipline" (John-Steiner, 1985, p. 207). The practice of art follows in part from knowledge; knowledge follows in part from information; and information follows from questions.

Experiences of exploration and discovery in libraries involve tentative steps, gradual progressions from one place to another; they involve questions that can open alternative perspectives on possibility. Learners use libraries to move from the known and familiar to the challenging and the fresh. Libraries make it possible for learners to move toward something new, and often to break through the constraints of conventional ideas, in order to express something previously invisible or unspoken.

Artists, art students and those who study and teach them need access to deep and diverse knowledge. Knowledge of all kinds – technical, aesthetic, thematic, religious – must come to such learners in ways that are trustworthy, consistent and generative. What does the artist need to know? What can the library contribute to art experience? What do those who study art and artists need to find in libraries?

Libraries are conducive to sudden, serendipitous discoveries not unlike the breakthroughs of genius at an easel or insights in museums. Yet the information of the library is everything the information of the studio or the museum is not: it is expansive and explicitly cross-listed to connect diversely across multiple disciplines. The structures of libraries (systems, tools, catalogs, indices) encourage complex inquiries that can endure over time; they also encourage collaborations with professional librarians.

Librarians are agents of learning, to assist the user in discovery. A collaborative, improvised sequence of moves in an information setting can be similar to the relationship between a mentor and an apprentice. When it is guided usefully, the process of searching alone can in itself reveal much to the inquirer; it shapes the unknown and maps the territory to be explored. Some think this kind of work, based on intuition and experience, is an art in itself.

To use the library is in some ways to create an experience – a pattern or a journey, in effect a *curriculum*, might be appropriate metaphors – that crosses boundaries, deepens understanding and leads to reflection. Insofar as art depends on exploration and insight, or on combination and synthesis, the library offers vast content and informed assistance to art learners.

## Essential Reference Works for the Art Learner

To walk through a well-developed reference collection developed for artists and scholars of art history is to discover a literature that is expansive and surprising. A collection in the fine arts inevitably leads its users to cultural, social and religious themes, to biographies and personal stories, and to histories of nations and societies without visible limits. Approaching this collection, the inquirer should be prepared to think about multiple paths and angles.

As in humanities disciplines like literature and music, a focus on individual artists and works is appropriate. In general, larger contexts make good beginnings; narrowing

naturally follows. Unlike other aspects of the humanities, however, art literature is almost always shaped by unique objects (not texts or performances), and it is to the unique object itself – painting, mosaic, vessel, photograph, lithograph, or any product of any of the arts – that the literature refers the researcher again and again.

Great information is neither discrete nor finite; start with a biography and suddenly that information leads to an artist's schooling or religion, and subsequently to an influential mentor, patron or religious figure. Much of that pursuit will use paper tools, but significant and critical references will be discovered online and in electronic databases; and information in video formats is more likely to appear in libraries than in most other disciplines.

Art information is robust, unlimited by scope, or form, or medium. At its most compelling, it includes life-contexts, personal histories and civic culture surrounding the artist and the work; tools to explicate religious and mythological allusions, styles and motifs; biographies of both subject and artist; perhaps a catalogue raisonné of the artist's known works; specialized dictionaries with terminology most appropriate to describe the artist's techniques; collections of preliminary sketches and related works of the same period; scholarly interpretation and criticism applied to the work throughout its existence; data about exhibitions, authentications, ownership and sales; museum holdings and locations in other collections; availability of reproductions; details of place, date, medium, and size.

Materials related to art education, the teaching of art history, and degrees in fine arts will also be routinely kept. Materials on archaeology, holy scriptures of all religions, mythologies of all cultures, semiotics, iconics, media studies, gender studies related to art, anthropology, social, and cultural history, changes in the technologies of art production, performance studies, and an array of artisan crafts – all will be here.

## *Questions and Tools*

Looking at art, we might say, is just part of the experience of art; there is a more complex and less visible part of the experience to be discovered through the pursuit of information, and the thinking that accompanies visual discovery. When we examine the thinking, documents, and record of reflection and feeling generated by artworks over time, we can come to understand the discourse below the surface of the object.

In the presence of an object, we might ask: Who made this? How was it made? Do other similar works exist? In what context was this work made? What textures or sounds might the artist have experienced? What music or poetry might have been heard nearby? Did the maker learn from another person? Did the artist teach? Did the artist travel? What do contemporary artists learn from this work? Learning from reference tools follows from such questions.

## *Users*

At the turn of this century we can say that information is never fully out of reach; libraries and librarians strive, as champions for the learner, to assure that paths exist to useful works and ideas, regardless of place, language or form. The Internet often allows users to find things without assistance – and to visit a museum well prepared

without ever having taken Art History 101. The reach of the librarian extends local collections to other resources worldwide. Access to images has expanded incalculably in the last decade, and digitization means that current limits on the visual record are unlikely to last long.

But an oceanic array of knowledge is an oceanic challenge; access to information means nothing unless the user's needs, intentions, and hopes are clear, and paths are apparent. *In my view*, the virtually limitless possibilities of connection can be fulfilled only when a human being is present to help direct and refine the questions asked. Any librarian will direct an inquirer to a starting place, like the extraordinary, beautifully produced encyclopedia *The Dictionary of Art*, in 34 volumes (also available on the World Wide Web as *The Grove Dictionary of Art*). But after that, every inquiry will vary. Here are five hypothetical users, each with a different path to follow. And for every path taken, there are many others nearby.

An *academic user* exploring the social contexts of a work of art needs to explore smaller, specialized encyclopedias, often organized around specific periods. These tools may also cross disciplines, illuminating topics from multiple angles. The best of these are the *Dictionary of the History of Ideas* and the *Encyclopedia of Aesthetics*. There are also multivolume encyclopedias of the Renaissance and the Enlightenment, and the *History of Humanity* in six volumes. The surprisingly diverse *Encyclopedia of Religion* carries articles on art and religion, visual culture, symbols, saints, dance, film, gardens, iconography, and humor, among several hundred others. An incomparable tool, *The International Encyclopedia of the Social and Behavioral Sciences* contains 4,000 articles in nearly 18,000 pages, including entries on "Architectural Psychology," "Censorship and Transgressive Art," "Culture, Production of," "Fine Arts," and "Cultural Policy: Outsider Art." Bibliographic citations abound in all of these tools, extending concepts into additional disciplines.

A *museum educator* wants docents to explore beyond standard art histories. Reference tools in archaeology, anthropology, and the history of religious practices might be appropriate, as would dictionaries of myth, magic, symbol, anthropology, and biblical exegesis. Some tools provide graphic timelines, matching contemporaneous human achievements in science, education, art, literature, politics, exploration, and other endeavors. A user can trace and compare developmental activities among nations and continents over thousands of years. *Timelines of History* is well known, but more recent and elaborate examples are the *Wilson Chronology of Ideas*, the *Chronology of World History*, and *World Eras*. Museum docents will find value in having an array of handbooks and single-volume encyclopedias at hand, tools that can be spread on a library table for cross-references and comparisons, for example, the *Dictionary of Biblical Imagery, Dictionary of Theories*, the *Oxford Dictionary of Byzantium*, or the *Historical Dictionary of the Elizabethan World*.

An *individual learner*, devoted museum user, and an armchair traveler among world cultural settings wants to plan the systematic study of art history, with the possibility of leading a community education class. He wants to learn art history without a teacher, using library materials. The first step he might take is to find a single volume art history text, perhaps a standard text by Gombrich or Janson. Or the learner might seek a series of art history volumes – by publishers such as Thames & Hudson,

Abrams, or Phaidon. Guides to larger museum collections – the Getty Museum, the British Museum, the Metropolitan Museum of Art – can supplement monographs. The learner might then turn for advice to Adelheid Gealt's handbook, *Looking at Art: A Visitor's Guide to Museum Collections* or Marcus Lodwick's *The Museum Companion*, or the Getty Institute Guide to Imagery Series, including *Symbols and Allegories in Art, Nature and its Symbols*, and *Gods and Heroes in Art*.

An *art educator* needs to understand her students and the place of art in their lives. Indexes in education and art could be useful, as may encyclopedias of human development and educational psychology. She might well look for useful concepts and perspectives on learning in the *Encyclopedia of Human Emotions*, the *Encyclopedia of Learning and Memory*, or the *Encyclopedia of Creativity*.

Finally, *an artist* who finds her work to be changing anticipates the need for renewed experiences in figure studies and drawing. Her interests lead to works on technique and anatomy. She needs to see sketches by the masters. Catalogues raisonné will hold everyday studio work by artists of the past. Her inquiries might lead to biographies, letters, interviews with recent artists drawing in a modern sensibility, or to reviews of catalogues and exhibitions, to see what other artists are making right now.

All these suggestions are routine, but the value of the resources should not be underestimated; they contribute to the learner's transition and evolution. A learner may need the conversations, advice and confirmation the librarian and the collection can provide. Of course, when we imagine the needs of an architect, a ceramicist, a sculptor, or a printmaker, the entire array of potentially useful resources will change. And while my examples here all refer to the visual arts, similar cases can be made for the library's role in understanding the social context, traditions, techniques, and ideas behind works of theater, choreography, and music.

## Conclusion

Every scenario in the library, every profile, every user, and every process will differ. The great flexibility of a well-developed library collection, and its ability to adapt to the differences among users, implies that it can offer an infinitely changing partnership with the learner's imagination. The discovery of information in a setting where knowledge takes specific and powerful form, and where help is freely offered, can lead the learner to connect with timeless thinking. This is the library for the art learner: a collection designed for constructing individual questions, sometimes reaching for assistance, and confidently acting on possibility after possibility.

## Note

The possible topics in parentheses are all suggested by extensive essays in the *New Dictionary of the History of Ideas*, a 2004 publication.

## References

Brown, J. S., Collins, A., & Duguid, P. (1989). Situated cognition and the culture of learning. *Educational Researcher, 18*(1), 32–42.

Bruner, J. (1973). *Beyond the information given: Studies in the psychology of knowing*. New York: Norton.

Bruner, J. (1986). *Actual minds, possible worlds*. Cambridge, MA: Harvard University Press.

Dewey, J. (1958). *Art as experience*. New York: Capricorn Books.

Greene, M. (1988). *The dialectic of freedom*. New York: Teachers College Press.

Greene, M. (1995). *Releasing the imagination: Essays on education, the arts, and social change*. San Francisco, CA: Jossey-Bass.

Greene, M. (2001). *Variations on a blue guitar: The Lincoln Center Institute Lectures on Aesthetic Education*. New York: Teachers College Press.

Jackson, P. W. (1998). *John Dewey and the lessons of art*. New Haven, CT: Yale University Press.

John-Steiner, V. (1985). *Notebooks of the mind: Explorations of thinking*. Albuquerque, NM: University of New Mexico Press.

Lave, G., & Wenger, E. (1991). *Situated learning: Legitimate peripheral participation*. New York: Cambridge University Press.

Mezirow, J. (1991). *Transformative dimensions of adult learning*. San Francisco, CA: Jossey-Bass.

Mezirow, J. (2000). *Learning as transformation: Critical perspectives on a theory in progress*. San Francisco, CA: Jossey-Bass.

Rogoff, B. (1990). *Apprenticeship in thinking: Cognitive development in social context*. New York: Oxford University Press.

Smith, F. (1990). *To think*. New York: Teachers College Press.

# 49

# "PRIVATE TEACHING, PRIVATE LEARNING": AN EXPLORATION OF MUSIC INSTRUMENT LEARNING IN THE PRIVATE STUDIO, JUNIOR AND SENIOR CONSERVATORIES

**Jane W. Davidson*** and **Nicole Jordan†**
*University of Sheffield, U.K. / University of Western Australia, Australia;*
† *University of Sheffield, U.K.*

## Overview

This chapter investigates a very specific kind of culture: that of the extensive private music teaching and learning practice carried out throughout much of the Western world and present in slightly different forms in other cultural traditions like Indian classical music. "Private teaching, private learning" is conceptually, at least, part of a rather loosely defined yet powerful "institution", and as such it is an intriguing form of teaching and learning: it is ubiquitous, and it is close to people's everyday living experience, since teacher and learner may exist in a one-on-one context within a domestic setting. This kind of institution interconnects with more formal or typically recognized institutions of the junior and senior academy/conservatory, also present the world over, in different guises. At the senior level, these institutions are often equivalents to universities, and are bastions of excellence in musical performance. They have their own curricula, examination systems and awards, often regulated by national bodies, and many are internationally recognized: the Julliard School of Music, New York; the Royal College of Music, London; the Mozarteum, Saltzburg, for example. At the more junior levels, even in the private home-based scenario, there is also some sort of curriculum. This can be a formal and nationally recognized qualification, such as theory and practical examination boards present in many countries that offer levels of achievement up to university-level entrance. But the curriculum might simply be a negotiated contract between teacher and student – for example, to play so many scales and pieces by a specific deadline, or to participate in a concert at the teacher's home. The place of "private teaching, private learning" as institution presented here is an attempt to bring insight into how and why this form of education is so common and why it should be better understood.

The chapter traces a learning pathway typical for many Western classical music students who progress from home-based to senior conservatory music learning. It investigates the pros and cons of how teaching and learning is approached in these contexts. Research on

*L. Bresler (Ed.), International Handbook of Research in Arts Education, 729–744.*
© 2007 *Springer.*

teacher skills and behaviors is examined as well as the overall learning process, motivation including musician identity, personality and self-esteem and how these elements affect the learning experience within the "private teaching, private learning" institution.

The typical "private teaching, private learning" is found in a one-on-one teacher-student dyad, and it takes place usually in a small room, in the teacher's own house, rented studio, or the student's house. The environment often shifts as the student gets older, with a move away from the home-based lessons to the studio in a junior conservatory (usually a purpose-built building), typically at around secondary/junior-high school age. But this varies from country to country. The senior conservatory is for the full-time student, usually 18 years of age or older, and it is often the place where a diploma or undergraduate degree is studied. These students work full-time on their music studies, receiving group classes on repertoire, musicianship, musicology and theory; but the model of the one-to-one lesson in the enclosed studio persists in work on the principal instrument.

## The Conceptual Institution of Musical Instrument Teaching and Learning

In both Western and Eastern culture the convention of the "private teaching, private learning" goes back for centuries. In its most common form, the learner might be characterized as a youthful apprentice, learning his or her art under the watchful eye of the expert teacher, the older artist of exemplary skill. This teacher is an authority in his or her profession, demonstrating great proficiency and knowledge – a master who aims to pass on knowledge to the apprentice, who in turn aspires to emulate the more accomplished partner in this learning contract (see Hallam, 1998, pp. 234–237).

In previous centuries, the expectation was that the apprentice would work with and for the master, often living in the master's home in order to gain experience and expertise. It was a devotional task, the whole life-style being shaped by the apprenticeship. In Western music, the tradition is linked to the European Guilds of the Middle Ages, which remained strong until the late 1800s, with a few still persisting. These guilds had strong codes of allegiance and behavior including, for example, trumpeters being allowed to teach only one student at a time (usually their own eldest son), and if they broke the rule, then they could lose their position, or could be attacked physically by their peers (there are examples of trumpeters being beaten up so badly that they could not play anymore, because they had lost their teeth).

This one-on-one teacher-student relationship was also surrounded by the secrecy of the craft. This was a code developed to protect and consolidate skill, but it also served to make the working practices seem more magical, and important.

After years of study, the novice would gain enough knowledge and skill to be considered proficient, and be able to strike out alone to make a living as a professional artist. Historically, this tradition can be found in a number of the fine arts and crafts such as painting, sculpture, weaving, instrumental music playing, and music composition. From a young age, a person's vocation was developed; goals and sense of self were shaped during this formative training. But, interestingly, it is only in Western music that the one-on-one lesson and surrounding secrecy has persisted in a clear and definable way. The

live-in tradition which promotes the life-long vocation of the musician still persists in some Eastern cultures, with some branches of Indian classical music, for instance, revealing a close connection between religious and cultural beliefs and concepts such as being born into a certain caste, and therefore having a specific identity and destiny as a musician. With more diverse curricula and less closely bound social and religious belief systems, Western music learning practices have changed. In Sweden, for example, Nielsen and Kvale (2000) have shown that the role of master in the traditional master-apprentice model in music has to some extent been developed by institutions such as the junior and senior music conservatory where it is no longer the knowledge of a single individual, but the combined skills of a number of specialists, which are used to develop each young musician. Whilst this may be true, it is fair to say, however, that the vast majority of instrumental learning still goes on in the one-on-one context. But, nowadays, the teacher and student dyad meet only once or twice a week, focusing on the music to be investigated, for 30 to 60 minutes. These sessions may be intensive, but they are not long when compared with the numbers of hours the older version of the master-apprentice model demanded. Even using a full curriculum with input from others, something of the intensity of the learning experience has changed.

Nowadays, of course, lessons are very costly, and complementing them with expensive instruments, study manuals, and attendance at classical music concerts can restrict the experience to those with the money and motivation to do it. Though the convention of a musical vocation still persists, far fewer young people undertake this challenge today than in earlier centuries. The current cultural expectation seems rather that each young person should experience many different forms of learning in order to make an informed personal choice about which route a learning/career should take. This has led to different foci for the "private teaching, private learning" model: some learners aim for professional achievements, some simply learn for fun or even as social etiquette.

In recent times, socioeconomic status has been shown to be a highly dominant influence on Western classical music learning success (Hargreaves, 1986). Furthermore, Shuter-Dyson and Gabriel (1981) found that it was professional parents (higher socioeconomic groups) who encouraged classical music playing at home, and this in turn positively influenced their children's scores in musical ability tests. So, this "institution" of "private teaching, private learning" is strongly linked to a sub-section of Western society who can pay for it. But state schemes in some countries offer free one-on-one music teaching and learning in parallel with classroom-based general education. When the first author of this chapter was a child in Britain, children were offered one-on-one lessons through state primary and secondary schools, free of charge, as a part of the state education service. However, the social and political tide changed, and today in Britain, with different budgets and educational priorities, state schools may offer students music lessons on the school premises, but the school has a private contract with the instrumental teacher who literally rents the studio space and returns a percentage of the fee back to the school. Statistics and the popular press would have it that more children in Britain are learning musical instruments than ever before, but the reality is that whilst many start, they give up very quickly, once the relative costs are scrutinized. Times have changed, and part of the institution of teaching and learning in the Western world has become

diploma- and high-grade-driven. In this context, it is not surprising that many children give up music when progress is not quick and diplomas cannot be attained immediately. But it is also not surprising that in this same culture, instrumental music teachers place high value on examination boards, to emphasize progress and achievement and the teacher's own merits as a reputable practitioner.

Thus, the socioculture of "private teaching, private learning" both constructs and reflects our attitudes to musical instruments, their values and who learns them. Whilst this institution continues in contemporary Western society, the goals are not the same now as in previous centuries. Although musical participation amongst wealthy amateurs was something of a social frippery (a "divertissement") for eighteenth and nineteenth century educated, domestically-tied young ladies, there was a clear demarcation between those learning for social etiquette and those engaging in the craft of music. Today, the teacher may have to make personal distinctions in approaches towards students – between those apparently interested in fun and social entertainment and those highly motivated individuals likely to invest considerable time and energy in instrumental playing. Teacher and student need to find a means by which both are suitably satisfied, stimulated and appreciative of their interaction. Writing of his own experiences, Leetch (2000) notes that if the teacher can work out why the student is taking lessons, and negotiate what both wish to achieve from the experience, good progress at an appropriate level can be achieved. He proposes that although one-on-one teaching has dominated music learning, there are merits in many different forms of work: small groups, large groups, peer learning. It is also worth noting that not all teachers and students work exclusively in the dyadic context. The following subsections will consider the different forms of "private teaching, private learning".

## One-On-One Teaching and Learning

The one-on-one model clearly has some practical benefits. Learning to play an instrument is a very complex task where knowledge needs to be built gradually, and the attention of an individual teacher can help to secure basic fingering, posture, and an understanding of the symbols and language of music (see Hallam, 1998, p. 116). Moreover, stylistic knowledge, expression and performance behaviors can be absorbed quite naturally in the presence of someone who is more able and engaging in high level skill. But this implies dedication and high levels of investment on the part of the learner. These dyadic relationships also have an inevitable personal investment, and an intense and personal relationship can be inspiring. Davidson, Sloboda, Howe and Moore (1996) found that children who went on to extraordinary achievement in instrumental playing in dyadic teaching were those who dedicated themselves to their teachers as role models.

But such intensity may not be socially appropriate to all teacher-student combinations, and such a relationship may be problematic for the young learner. Indeed in the same study, Davidson, Sloboda, and Howe (1997) showed that students who gave up their music learning often did so because they hated their teachers. It has been argued by Davidson and Burland (2006) that the degree of liking, support and encouragement shown by the teacher to the student is central to the development of a "musician

identity" in the student, and with this established, the learner inevitably has a more highly developed and robust sense of identity as a musician. But if the child is either continually squashed by the teacher's rebukes, or intentionally fails to interact with the learning process according to the rules established by the teacher, he or she will not develop a musician identity, and may indeed construct an anti-musician identity, leading to a dislike of a music teacher and music itself.

But the intense pressure of the dyad is not the only way in which musical instruments have been taught. Group learning has also flourished, especially within the school system, for group lessons help to save money, and recent educational theories actually promote the group experience.

## Group Teaching and Learning

Working with a group to teach musical instrument skills has a long history. We know that at the orphanage of *La Pieta* in Venice in the eighteenth century produced many prodigiously able young violinists, much of the teaching happening in groups. Indeed, violinist and composer Antonio Vivaldi taught many children to play the violin to a very high standard. More recently, a leading figure for Western musical education, Shinichi Suzuki (1969), introduced a method that encourages teachers to work with learners in groups, and emphasizes fun, with family participation for the very youngest learners. The advantages of shared learning seem obvious: students learn from one another, with peer pressure enhancing progress; students learn to spot good and bad practices and to offer and receive constructive criticism (Enoch, 1974); it is certainly less intimidating for the shy or younger student to be part of a group (Evans, 1985); awkward personality clashes between teacher and student are less likely to happen. Group teaching can be potentially more stimulating for teachers as well as students.

But the group approaches can be a mixed blessing, with teachers' conclusions about such work ranging from "you simply cannot correct the individual technical difficulty" to "it is perfect for some children who feel intimidated by the pressure of the one-on-one, and learning alongside friends enables them to copy, peer learning and all manner of other positives" to "progress is slow in group learning" (see Leetch, 2000). As Hallam (1998) and Swanwick (1999) point out, the so called problem of group work may be more to do with the teacher not being able to pitch and pace the lessons to appropriate standards. Two teachers who use both approaches in their studios (Blake, 2003; Leetch, 2000) found that a major advantage of the group scenario was that the learners could almost immediately begin to engage in social music-making and this was a highly motivating and rewarding activity for everyone – teacher and students.

In the United States and Australia, where band training provides a primary channel for students to learn brass and woodwind instruments, the group lesson predominates, and ironically, many of these students find the shift from school to senior music conservatory very difficult, the intimacy and intensity of the one-on-one lessons being so strange to them.

Evidently there is no single or correct way for "private teaching, private learning" to function, but it seems that the teacher-student dyad persists owing to the level of detail that can be attained. The group operates for economic viability, but also because it

encourages collaboration and the fun that ensemble music-making can promote. Returning briefly to our opening scenario and the master-apprentice dyad, it is to be noted that in some forms of this model there were forms of peer learning and group work going on between the apprentices of a master. Perhaps an ideal "private teaching, private learning" approach is to combine dyadic work of the master and apprentice with group work with master-led and peer-led work.

## Institutional Enclosure

The institution of "private teaching, private learning" we have discussed so far has been based in part upon a narrowness of style and tradition owing the enclosed nature of the studio. The tendency has been for teachers to teach as they experienced their own learning (see Hallam, 1998). Whilst there can be positive aspects to this, with good stylistic and technical traditions being carried from one generation to the next, the negatives are evident: for example, if the teacher had been a highly motivated student him/herself, and then has to face students who are not motivated, there may not be strategies and experience to draw upon to deal with the situation.

Olsson (1997) has highlighted a need for those working in "private learning, private learning" to adopt the findings from academic research. His own investigations have demonstrated that teaching techniques found in the studio or conservatory can run contrary to the "proven" research. For example, Masden and Duke (1987) found that despite overwhelming research evidence that positive reinforcement is an effective technique for teachers, there was a tendency in one-on-one lessons for teachers to use disapproval. In addition, teachers tended to spend a lot of time talking to students about their musical progress, without directly addressing the specific aspects of that behavior (Tait, 1992). Again, it is well reported that actions are found to be more effective than verbal instruction in the music lesson (Davidson et al., 1997). Thus, students who find it difficult to make progress might not be aware of what they are doing incorrectly, or more particularly, how to correct their errors.

As Olsson (1993) suggests, it is the isolation of studio teaching institution that works against staff development and a broader educational awareness for the teacher. It seems that the teachers tend to approach teaching with strategies that make them feel safe, whether these are effective or not. Furthermore, whilst many teachers working from home or in a junior academy have teaching qualifications, many do not, so the teach as taught approach and the relative naivete concerning styles of teaching and learning are to be more easily understood.

There is an inherently enclosed mind-set behind the way the institution of "private teaching, private learning" has developed. It is evident from the emergent research literature on styles of musical instrument learning that musical instrument teachers should be trained to face the different challenges that different students offer (see Hallam, 1998; Swanwick, 1999), and to broaden their conceptions of what can be done in the lesson time. The "tradition" has been to work with beginners as young children typically starting between the ages of 6 and 9 years (often depending on factors like when second teeth appear, or when a hand is big enough), working through to accomplished teenagers and adults. However, this chronological approach may no longer be

the single approach required. There is a relatively new sector of Western society which is very interested in music learning: the retired individual who would like to play an instrument as a new challenge. It has been argued that for such a person to "learn", lessons that emphasize the social dynamics as much as the technical and musical aspects can be helpful (see Heiling, 2005; Nielsen, 2004). These older learners are not driven by vocational goals or qualifications, accreditation and certification – the achievement obsession of those moving from compulsory education to the workplace. Their desire is principally for pleasure. They might not require a simply developmental approach. They have areas of great intellectual ability and motivation, but limited motor and technical abilities. So, appropriate structures for their skill acquisition processes need to be considered.

In the last 5 years, increasing numbers of private teachers are enrolling in courses geared towards bringing them into contact with educational theory and offering them workshops to try out new strategies. This is a very positive step, especially when the evidence is clear: that the musical instrument teacher is often the single most influential person to channel a learner through from absolute beginnings in music through to preprofessional training. Given the contemporary Western obsession with achievement benchmarking and recognition, we can only say that it is good news that some professional standards are being brought to this all-too-familiar institution of "private teaching", to ensure good standards and to provide an optimal environment for good learning, whether in a dyad or a group. The special characteristics of the enclosure of the studio will certainly benefit from the teachers being made more aware of one another and by considering the broader frames of reference offered by academic research about different types of learners, learning styles and more research-grounded teaching and learning methods.

## What is Good Musical Instrument Teaching?

Davidson et al. (1997) investigated 257 children receiving studio-based instrumental lessons, and showed that children need to experience different sorts of teacher behaviors at different points in their development. For the initial learning period, and for preadolescent children, a warm and friendly teacher who praised, encouraged and made lessons "fun" – that is, a "motherly figure" – was found to be a primary requirement for progress in early lessons. Later, however, the teacher needed to be able to demonstrate her own musical excellence and authority: teenagers often stated that they did not like the teacher as a person, but respected them as a musician.

Hallam (1998) has shown that time and again, the teacher's enthusiasm more than compensates for skill deficits. Enthusiasm seemingly presents a role model in terms of love of music, the instrument and the repertoire, and this motivates the learner above all else. Being able to make social connection and communication are core attributes of the successful teacher.

In terms of specific strategies to be taught, technical instruction is a bare minimum requirement. Being told or shown how to hold, blow, pluck or beat the instrument with good posture and physical balance, as well as improving dexterity and control is fundamental.

However, also to be taught there is notation to be read and sounds to be understood in terms of their temporal and pitch relations so that the music can be translated from symbol into sound, requiring careful training in oral and aural techniques. Also, although some teachers actually popularize the belief that expressive performance is a natural ability, it has been demonstrated (see Davidson et al., 1997) that there are systematic rules to musical expression and these rules can be both implicitly learned and explicitly taught (see Ebie, 2004). In this context, it seems that at least some teacher behaviors should be connected with helping the student to learn and develop strategies for self-learning. Encouraging listening and modeling (see Davidson, 1989; Rosenthal, 1984) and improvisation are ways these abilities can be nurtured (Lehmann & Davidson, 2002). Hallam lists a number of ways the teacher may encourage the student, including both social and musical means to develop independent and responsible learning and good musical understanding and musical habits (see Hallam, 1998, p. 248).

So far we have established that the institution of "private teaching, private learning" is based upon a long historical tradition, and that educational theory and a general broadening of the teacher's expertise, professionalizing a long-standing tradition, can help to develop students' skills. One area of the private teacher's practice that merits discussion is in the area of how examinations have been and might be used.

## Musical Instrument Examinations and Their Uses

The examinations we are referring to are almost as ubiquitous as the "private teaching, private learning" institution itself. They are found from Newfoundland to Jeddah and though there are national variations (e.g., the Associated Board of the Royal Schools of Music being a UK-based version which is commonly taught in Hong Kong and parts of Africa; the Australian model operates throughout the South Pacific region), there are graded syllabi from rudimentary through to preprofessional training. Most syllabi have set repertory, scales and technical exercises and some tests of musicianship (ear tests, sight-reading). The examination boards themselves promote these syllabuses as benchmarks of attainment and motivators for progress, and many teachers use them accordingly, along with side/other teaching materials. Whilst many teachers are trained to teach and work with these syllabuses, many are not; raising intriguing questions about who is qualified to teach these specific syllabuses, and whether or not a specialist training helps with teaching in general or with these examinations in particular. Though some examination boards do offer training for teachers, and there is the move towards professionalization of private teaching, one scenario still allows teachers to teach to the test, so their students can play the examination pieces but little beside. In this situation, whether the students are actually receiving an apprenticeship in musical instrument skill acquisition is questionable. Using the examination syllabus to structure teaching has been used to justify the studio practice: for example, Davidson (2005) found teachers making such statements as "I sell my services by stating how many of my students achieved Grade 5 by a specific age." The motivation to teach to such a narrow remit is obvious.

Hallam (1998, p. 229) states that "there is currently no consensus regarding the purpose of instrumental teaching (therefore) it is impossible to define an ideal model of teaching," but she does recommend that teachers should primarily see themselves as motivators and stimulators (Hallam, 1998, p. 9). Part of this stimulation surely must be to make the learners all round and "understanding" musicians, so that the capacity to read, audiate and so pick up a score and play for pleasure might be considered to be core Western classical music skills. Moreover, the examination bodies themselves are acutely aware that teachers need to use these examinations appropriately, not simply as frameworks upon which to hang their teaching. So, within the institution of "private teaching, private learning", it seems that a time for broader reflection and engagement is necessary to improve the teaching and learning experience for all. Indeed, Olsson (1997) has indicated a gulf between teachers' preferences within the classical music repertoire and their students' interest. If the teacher is to be a motivator, he or she needs to develop positive relationships with students, including understanding the student's musical interests, and use the examinations appropriately. All syllabuses have a range of repertoire and some even have options for improvisation and self-composed works. But not all teachers use these materials flexibly.

A historical difficulty has been that state education systems have not had musical instrument attainment targets within the school music syllabus, and so the only way to assess achievement for the instrumentalist has been through the external examination board. The private board has been an excellent framework, providing benchmarks of attainment where no general educational criteria exist. Indeed, some of the private boards have become, by default, indicators of a sort of internationally agreed attainment standard, with some universities using the examinations as the entrance benchmark for undergraduate students; since the boards are used in many countries, an international standard operates – in Britain, for example, the Grade 8 of the Associated Board of the Royal School of Music is a commonly recognized university entrance requirement.

The adoption of the private examination boards and their use in general mainstream education (school and universities) as benchmark indicators clearly underscores the power of the "private teaching, private learning" institution: something essentially private – an interpersonal arrangement, usually outside mainstream education – with a private examination system which is then used by the mainstream as a measure of educational attainment. But it seems that if the mainstream has adopted the "private teaching, private learning" institution for the results it achieves, it is useful to look at the positives of this institution alongside the mainstream educational institutions to work towards building the best for teacher and student in musical instrument learning.

## Private Institution vs. State Education

Today, most who go on to become professional musicians have achieved their musical instrument skills through an education outside of their mainstream school work. Their university and senior conservatory music experiences is based almost entirely on work done outside their main mandatory education before 18 years of age. In Sweden, for example, Standberg, Heiling and Modin (2005) found that the students who achieved

best in practical music were girls who were able to draw-upon what they had learned from outside of school, primarily in community music contexts such as bands, and apply both school-based and community-based knowledge.

The separation between formal education and music learning can be shown rather starkly in how a professional opera singer from Portugal (personal communication) constructed his own musical education. He explained in order to become a qualified professional musician, he had two parallel lives: in childhood there was regular school (day time) and junior music conservatory (evenings and weekends); then at university-level, there was the undergraduate degree in philosophy that was studied during the day with state support, and senior conservatory (where he studied voice up to graduate level using private sources of finance, and fitting in these lectures, lessons and other commitments around his main work in philosophy). He commented that this was: "a schizophrenic existence, but common for one wishing to become a professional musician with appropriate qualification."

In the mainstream, from 6 to 18 years of age, young people can participate in school bands and orchestras in their general schools, but they are taught as "extra-curricular" activities in the early morning, at lunchtimes, or after school. As we have established, the music instrument tuition that takes place in school may also have been a "private agreement" between the musical instrument teacher, the learner and the parent. The learner has been required either to miss some mainstream lessons (the first author has memories of missing 20 minutes of story time at elementary school in order to receive her violin lesson) or to have a lesson in one of the school breaks (cramming in a trumpet lesson immediately after bolting down a school lunch!). So, in school, here has been a tradition of fitting musical instrument learning in and around everything else. Of course, it can be argued that the same can be said of many forms of learning: sports and outdoor pursuits, drama, dance, fine arts, and so on. The questions raised by highlighting the different times and places for learning the more practical skills shows that we have developed an educational culture where schools, colleges and universities have become the institutions associated with theory, study and book-based teaching and learning. More practical skills have been either taught in private, like Western classical music, or through the experience of doing it, often overseen by a mentor or guide (e.g., rock climbing, canoeing, etc.) out in the environment in which these activities are done – for example, on a river or a mountain. These are fascinating cultural appropriations of domain, time and priority. The different forms of "institution" coexist, with the mainstream educational establishment often attempting to participate in or reflect some of the skills acquired outside of the main education: the prestigious school orchestra, dance troupe, basketball team, athletics squad and so on. But, it strikes us that the learner needs to have fairly flexible learning styles in order to assure that he or she can negotiate a route though the private learning and the mainstream school education. As we have noted in the previous sections, the intense and private nature of some forms of teaching and learning these practical skills might account for why they have stayed outside mainstream school experience: they simply do not fit the mould. Yet, ironically, what the learners attain in these areas often become key parts of how the mainstream institutions promote their students and themselves: "excellent achievements in music, sport" and so on, are mentioned in the school's promotional literature.

At higher educational levels, in the senior music academy or conservatory, the music instrumentalist is encouraged to study his or her practical area as the core activity. Thus there is at last timetabled space allocated for all forms of activities previously regarded as extracurricular: orchestra, chamber ensemble, one-on-one teaching, repertoire coaching, and so on, in contrast to many university music departments where the practical instrumental skills are still often treated as "extracurricular". They are added value, important, but fitted in and around everything else. Both authors, for example, are currently involved in a student opera production where all rehearsals take place late at night, after more formal schooling.

We now turn our attention to how each "private teaching, private learning" venue (studio, junior conservatory, senior conservatory) reveals how the physical as well as the conceptual "institution" operates.

## Physical Institution

*The Private Studio* is in the teacher's home or in a rented space, such as a block of practice rooms. For a young child, a music lesson in a teacher's home-based studio may be one of the first occasions to be in the house of an adult who is outside the circle of family and family friends. The archetypical "nice" piano teacher seems to be the friendly chocolate-offering kind person – often an older woman with a home full of cats and interesting music-related possessions to fascinate the child. The nasty piano teacher, by contrast, lives in an immaculate, clinical house, and is generally disapproving of the student, rapping knuckles with a ruler if a wrong note is played. Although obviously stereotypes, children may be anxious about their role in these new and potentially bewildering settings. Work by Pace (1999a, 1999b) has shown that having a well-chosen range of teaching-support materials in the studio that is potentially "full" of musical activity is an asset for the environment. Posters with colorful pictures of information to be learned (notation, posture, etc.) are also found to be useful, the children often enquiring about the details of a particular image or wording. There are practical materials, too: a mirror to allow students to see how they are approaching their instrument, a music stand, an easily adjustable piano stood, good lighting, adequate heating/cooling, and so on.

In an increasingly rich technological age, experiments with video and compact-disk recordings have suggested that these kinds of "take away" materials can provide useful information for the student. The technological aids can become key parts of the studio environment, and though costly, can provide immeasurable advantages (Hallam, 1998). If a studio is rented by a teacher, using such equipment might involve the teacher in some fairly elaborate removals. But, as a cost-benefit exercise, the stimulation offered to the learner by these environmental materials is worth considering.

*The junior conservatory* varies from country to country, but typically is a formal building with designated spaces for lessons, theory and musicianship classes and group work like orchestras and chamber ensembles. It is also typically a place an older child might attend – someone over the age of 10 years. In the moderately formal setting of the junior conservatory, many music teachers of a variety of instruments are

assembled in one building. Each teacher has a studio or room in which he or she teaches. The student goes to this building, much like a school, for lessons. As with the lesson in the teacher's home, the student stays for a short time – generally 0.5 to 1 hour per week- and then practices at home.

As in the private studio, the environment of the individual room will be important, though since the junior conservatory rooms are most typically for multi-purpose use, teachers may have less control over how they look. A problem here is that the child is still young, and whilst it would be advantageous to make the building colorful and friendly, the building may operate as a conservatory in evenings and weekends and as a mainstream school during weekdays, and so not have physical ambience ideal for music teaching and learning. The advantage of the conservatory is, of course, that the building allows for group activities, and so is a place for social interaction, and an opportunity to join orchestras and smaller ensembles.

*The senior conservatory* learning environment is formal, and students in this setting may be studying from undergraduate diploma through to post-graduate levels. Here, the building is exclusively for musical use, and will have concert and ensemble rehearsal spaces, individual practice rooms, and studio teaching spaces. The physical advantages of such an environment are obvious, with everything on one site. But the disadvantages can be a sort of insular hot-house where a sense of competition and anxiety levels can soar sky-high (see Persson, 1993).

These institutions have a physical similarity across continents.

## Concluding Comments

From the private studio to the senior conservatoire, complex social environments and social interactions interface with the learner's emergent musician identity. Despite national tendencies and individual differences, it is astonishing that the conceptual institution of "private teaching, private learning" appears across many cultures and historical epochs, largely based on the one-to-one or master-apprentice model. Whilst this has been shown to have strength as a way of securing skills and motivating learning, it has also been shown that group lessons, coaching and peer learning have important roles to play in musical instrument teaching and learning. Moreover, it has been demonstrated that the continued tradition of "private" lessons might be in part the result reactionary rather than progressive approaches, that is teachers may simply stick with the tradition, rather than trying other more novel or even more appropriate approaches. We have considered the privacy of the dyad, closed away in the studio to sometimes be a negative force in the development of optimal teaching strategies, and so we have warmly welcomed and supported initiatives to train teachers working often in these isolated and isolating conditions. We have also spoken about the interesting cultural status of the private examination boards that appear across continents, and that are used by state education authorities like high schools and universities as benchmarks of achievement in music. The positive aspects of this sort of international benchmarking is recognized, but so too is the concern that teachers may simply use the exams as syllabuses for their teaching.

An additional point relating to these examinations needs to be mentioned, however. We need to understand how and why the state sector has not (and cannot) taken on board instrumental tuition. Of course the overall answer is that decisions need to be made about what constitutes a core curriculum, and children, generally speaking, do not receive one-to-one teaching and coaching in any of their recognized core lessons. However, where activities outside of the core curriculum can be supported by external examination boards, and taught in groups, schools do often have them appearing in this category between curricular and extracurricular activities: swimming and swimming achievements; dance and gymnastics and so on. Some music examination boards are achieved in schools where instrumental lessons occur, but these are certainly not attained by everyone, and where examinations are entered into on a regular basis, the work required to support the progress necessary to progress, usually results in the one-to-one studio/home or junior conservatory lesson. We identify a key question relating to this institution of "private teaching and learning" relevant to the younger learner: *What are the best ways to facilitate musical instrument teaching and learning, drawing on the tradition of the "private teaching, private learning" institution, but also exploring how this might interface most effectively with mainstream education?* A part of this question would certainly relate to how teachers are trained and how they structure their teaching and use the culture of the musical grade examination in their practice.

A related area of interest would be to have as full an understanding of how the teacher-student interaction in the lessons prepares for all the very private work that goes on by the learner in his or her practice. We have seen that self-efficacy is required to sustain and make progress in practice, but evidently, teacher strategies appropriate to preparing the student for how to practice are crucially important. An awareness of an assortment of practice strategies may be helpful, indeed, Hallam (1998) has found that no one technique is used by professional performers, but between them, they employ a wide variety of different techniques.

Jorgensen (2002) is one of many who have found a positive relationship between current practice time and instrumental achievement among students. He also found a positive correlation between the number of days Swedish students practiced in a week and their instrumental grade level. Additional support for this result may be found in Davidson et al. (1997) who have determined that the best English conservatoire instrumental students had accumulated 10,000 practice hours by the age of 21 while the less accomplished students had only half that amount of accumulated hours. The high-achieving "specialist" instrumentalists in their study were accomplishing more than four times the amount of practice hours of the "non-specialist" instrumental students. So, strategies to amass practice also seem to be necessary.

Another crucial question to be pursued is simply: *Is the sort of formal teacher-learner dyad we have so far explored the only way to encourage musical instrument skills?*

Consideration of the self-taught musician or informal learner must be made. He or she is a highly skilled musician who has not received any formal one-to-one personal training but whose musical experience emerges from the independent exploration of his or her instrument. In Sweden, 59% of boys learned their instruments (usually a rock or jazz instrument like sax. or guitar) without formal instruction (see Burstrom & Wennhall,

1991). It was discovered that books and helpful peers assisted these individuals to achieve. Davidson et al. (1997, pp. 193–194) discuss and compare two famous self-taught musicians: American jazz trumpeter and singer Louis Armstrong (Collier, 1983) and the autistic monosavant, N.P. (Sloboda, Hermelin, & O'Connor, 1985). Both are examples of self-learning, however, a form of relationship in the mentor-novice vein was still key to their musical development. Armstrong, for example, listened to a great deal of music by inspiring players who he then emulated and, some would say, surpassed. This type of learning would not have had the formal structure of the private lesson, but was instead informal and self-motivated. The self-taught musician likely plays for enjoyment and the satisfaction of improving his or her skill on the instrument (see Collier, 1983). So, it might be that in classical music observational/mentoring partnerships between students and teachers may be helpful, though this still has echoes of the master-apprentice model, simply minus the formalized framework of the studio space and the title "music lesson".

Related to the notion of different approaches and environments for teaching and learning, a third question is raised: *Should the teacher be a social psychologist?*

Olsson (1997) suggests that the music educator should deal with social psychological issues such as attitudes, preferences, motivation, expectations, competency, identity and the influence of institutions centrally in his or her work. Music teacher training has been examined by Roberts (1993), and it was determined that the individuals who teach musical instruments must continuously negotiate between their personal identification with their own role as a "musician" and as a "music teacher" who must exercise many social skills.

The questions raised so far inevitably lead us towards the critical topics for this chapter: *What is the future for private musical instrument lessons?* It seems that the arguments presented so far would have us conclude that "private teaching, private learning" helps empower the student's learning more easily than other approaches to music learning. So, we could say that the future should be positive and encouraged. However, the cultural and political agendas of various state education systems will impact upon how this teaching and learning develops in its various physical environments, and in whether the lessons remain one-to-one or group-focused, and how much responsibility is left with the student and his or her peers.

To encourage the development of a musician, Jorgensen (2002) believes that there is a collective responsibility on the part of the student to do the practicing, the teacher to impart knowledge on a variety of practice strategies, and the conservatoire itself to support and encourage both the students and teachers. Jorgensen cites the eighteenth century philosopher Rousseau who believed that musical experience should be intuitive: that students should create as well as learn music and that music should be enjoyable. Rousseau believed that students should learn by doing or through activity rather than by simply following instructions given by teachers. Playing an instrument in the early days – and indeed through out life – should consist of just that: play. The opportunity to explore and experiment with the instrument is necessary if the novice is to develop a personal interest in and connection with the instrument (see Hargreaves, 1986; Piaget, 1951). Indeed, Davidson et al. (1997, p. 194) state that a free exploration of music is important for skill acquisition and "children who eventually gave up playing did not engage in any informal practice activities". So, we hope that the future of the institution

of "private teaching, private learning" will be one that can encourage the development of creativity and spontaneity – something more present in the informal jazz and pop learning, and less present in the sometimes rather rigid and formal classical training approaches.

The private lesson is very important, and clearly we hope for a bright and stimulating future for this form of teaching and learning, from the student simply aiming for a bit of fun with their music being one extracurricular activity among many, through to the focused student determined to develop professional-level skills. But, we conclude by stating that in the senior conservatory setting in particular, the education and experience received outside the private studio is very important in helping the musician with professional aspirations to develop. Performing, networking, auditioning – they are all necessary parts of being a musician, and the social skills involved in facing these contexts should be taught. A musician also needs business skills, the ability to promote him or herself with self-belief and self-confidence, so entrepreneurial knowledge as well as core technical, social and expressive knowledge relating to music would seem necessary. In other words, the studio context cannot provide a "complete" education for the musician. But, as a form of institution, the private teaching and learning that has gone on in music has evidently persisted largely for good reason. Nowadays, the learner needs to have a broad palette of experiences form a range of learning contexts, so broadening the scope of the institution may be helpful at a later stage for the student aiming towards the music profession. For others who may come to lessons as "third age" (over 60s) learners, or simply for fun, perhaps it is time for teachers to develop appropriate ways of interacting with them to optimize their experience to suit their goals and needs.

"Private teaching, private learning" is a rich and powerful institution and a special one for teaching and learning of instrumental music. We hope that reflection and dialogue between it and state sector education can develop and grow, taking the best of what both "institutions" offer and enabling general enrichment and growth of music education for all, whatever their aims and intentions.

# References

Blake, V. (2003). Primary school woodwind teaching: An investigation into the effect of shared lessons. University of Sheffield, unpublished MA dissertation.

Burstrom, E., & Wennhall, J. (1991). *Ungdomar och musik, I arsbook om ungdom 1991* [Adolescence and music, In: Yearbook of Youth, 1991, State Youth Council, Stockholm]. Statens Ungdomsrad, Stockholm.

Collier, J. L. (1983). *Louis Armstrong: An American genius*. New York: Oxford University Press.

Davidson, J. W. (2005). Before, during and after examinations in England: The interaction of teacher, student and parents. *Asia-Pacific Journal for Arts Education, 3*, 64–81.

Davidson, J. W., & Burland, K. (2006). Musician identity formation. In G. McPherson (Ed.), *Child as Musician* (pp. 475–490). Oxford: Oxford University Press.

Davidson, J. W., Howe, M. J., & Sloboda, J. A. (1997). Environmental factors in the development of musical skill over the life span. In D. Hargreaves & A. North (Eds.), *The social psychology of music* (pp. 188–208). Oxford: Oxford University Press.

Davidson, J. W., Howe, M. J. A., Moore, D. G., & Sloboda, J. A. (1996). The role of parental influences in the development of musical performance. *British Journal of Developmental Psychology, 14*(4), 399–412.

Davidson, L. (1989). Observing a Yang Ch'in in lesson: learning by modelling and metaphor. *Journal of Aesthetic Education, 23*(1), 85–99.

Ebie, B. D. (2004). The effects of verbal, vocally modelled, kinaesthetic, and audio- visual treatment conditions on male and female middle-school vocal music students' abilities to expressively sing melodies. *Psychology of Music, 32*(4), 405–417.

Enoch, Y. (1974). *Group piano teaching.* Oxford: Oxford University Press.

Evans, C. (1985). Attitudes and change in instrumental teaching. *Music Teacher,* May + June, 12–13, 9–11.

Hallam, S. (1998). *Instrumental teaching: A practical guide to better teaching and learning.* Oxford: Heinemann Educational Publishers.

Hargreaves, D. J. (1986). *The developmental psychology of music.* Cambridge: Cambridge University Press, UK.

Heiling, G. (2005). *Spela snyggt och ha kul. Gemenskap, sammanhållning ocg musikalisk utveckling i en amatörorkester* [Play well and have fun. Community, group coherence and musical development in an amateur brass band]. Studies in music and music education no 1. Diss. Malmö: Musikhögskolan, Sweden.

Jorgensen, H. (2002). Instrumental performance expertise and amount of practice among instrumental students in a conservatoire. *Music Education Research, 4*(1), 105–119.

Leetch, D. (2000). An investigation into the role of the orchestra in the musical education of secondary school boys. University of Sheffield, unpublished MA dissertation.

Lehmann, A. C., & Davidson, J. W. (2002). Taking an acquiring skills perspective on music performance. In R. Colwell & C. Richardson (Eds.), *The new handbook of research on music teaching and learning: A project of the music educators national conference* (pp. 542–562). New York: Oxford University Press.

Masden, C., & Duke (1987) . The effect of teacher training on the ability to recognise the need for giving approval for appropriate student behavior. *Bulletin for the Council for Research in Music Education, 91,* 103–109.

Nielsen, B., & Kvale, S. (2000). *Mästarlära* [Master learning]. Lund: Studentlitteratur.

Nielsen, S. G. (2004). Strategies and self-efficacy beliefs in instrumental and vocal individual practice: A study of students in higher music education. *Psychology of Music, 32*(4), 418–431.

Olsson, B. (1993). Music education in the service of a cultural policy? A study of a teacher training programme during the 1970s. Doctoral dissertation, Göteborg: Musikhögskolan.

Olsson, B. (1997). The social psychology of music education. In D. J. Hargreaves & A. C. North (Eds.), *The social psychology of music* (pp. 290–306). Oxford: Oxford University Press.

Pace, R. (1999a). Partners in learning. *Keyboard Journal, 5,* 1–5.

Pace, R. (1999b). *The essentials of keyboard pedagogy* (first, second, and third topic books). New York: Lee Roberts Music Publications Inc.

Persson, R. S. (1993). The subjectivity of musical performance: An exploratory music-psychological real world enquiry into the determinants and education of musical reality. Unpublished doctoral dissertation, School of Human Sciences, Huddersfield University, Huddersfield, UK.

Piaget, J. (1951). *Play, dreams and imitation in childhood.* London: Routledge & Kegan Paul.

Roberts, B. (1993). *I, musician. Towards a model of identity construction and maintenance by music education students as musicians.* Memorial University of Newfoundland.

Rosenthal, R. K. (1984). The Relative Effects of Guided Model, model only, Guide Only, and Practice Only Treatments on the Accuracy of Advanced Instrumentalists' Musical Performance. *Journal of Research in Music Education, 32*(3), 265–273.

Shuter-Dyson, R., & Gabriel, C. (1981). *The psychology of musical ability* (2nd ed.). London: Methuen.

Sloboda, J. A., Hermelin, B., & O'Connor, N. (1985). An exceptional musical memory. *Music Perception, 3,* 155–170.

Standberg, R., Heiling, G., & Modin, C. (2005). *Nationella utvärderingen av grundskolan 2003. Ämnesrapport Musik* [The National Assessment of the Subject of Music in Swedish Compulsory School 2003]. Skolverket Rapport 253, 2005. Stockholm: Skolverket och MPC.

Suzuki, S. (1969). *Nurtured by love.* Athens Ohio: Senzay Publications.

Swanwick, K. (1999). *Teaching music musically.* London and New York: Routledge.

Tait, M. J. (1992). Teaching strategies and styles. In R. Colwell (Ed.), *Handbook of research on music teaching and learning: Music educators national conference* (pp. 525–534). New York: Schirmer Books.

# INTERNATIONAL COMMENTARY

## 49.1

## Comments on "Private Teaching, Private Learning" (Davidson & Jordan)

**Gunnar Heiling**
*Malmö Academy of Music, Sweden*

The authors have addressed a most interesting topic that has also been discussed among music educators at different levels in Scandinavia for at least two decades. It was first a more ideological debate, where the objectives seemed to be different. Either you wanted to guide the student in a sequenced and pre-structured program in order to prevent mistakes and thus make the student an outstanding musician or your aim was to develop the student socially by letting him/her play together with others in a more non-structured way. Exaggerations were made in the debate and the result was that people who favored the former opinion were seen as spokespeople for musical quality or as hopeless and antique and the others were considered progressive, effective and open-minded or as threats to the survival the real music.

In the community music schools in Sweden this debate to some extent still goes on. In a study of instrumental teachers Anderson (2005) asked from where did they get their pedagogical ideas and the answer was: from the first instrumental teacher they met as children. Other role models throughout their educational life had made no impact. One of the reasons might have been that reflections on teaching methods was considered unimportant both during their studies and when they got their positions. Some of them even reported that they never had any teaching methods lessons.

Bouij (1998) and Bladh (2002) in longitudinal projects studied music teacher students (incl. instrumental teachers) at senior conservatory level and found that they preferred their musical identity to the educational during their studies. Their teacher role models during their earlier studies had been musicians and when they entered the senior conservatory/university school of music to become instrumental teachers, their view on how teaching was to be carried out was already set by imitation rather than by reflection. This view was also promoted by some teachers they met at the conservatory, which contributed to the students' restricted picture of how music could be taught, that is, private teaching-private learning. When they graduated from the conservatories, they chose to work as part-time musicians and not become full-time teachers. After

*L. Bresler (Ed.), International Handbook of Research in Arts Education, 745–748.*
© 2007 *Springer.*

about 10 years as part-time professional musicians they returned more permanently to the teaching profession, primarily for economical reasons.

Nielsen and Kvale (2000) point out that the role of the master in the former master-apprentice dyad has been taken over by the institutions where the combined knowledge of its different teachers, whom the students/apprentices meet, will give them a more multi-faceted picture of how instrumental teaching can be carried out. They don't have to become journeymen any more and travel to meet new influences from other masters before they reached their own mastership. They also point at the important part of reflection to bring about change.

At Swedish universities, courses in adult education have been made compulsory for all teachers and reflection on one's own teaching is promoted also at the academies of music where musicians without formal teacher education are the professors for the most talented music students. This has been offered since there are differences in the best ways to teach children and adults. Learning methods typical for children (i.e., imitation) might not be as effective for adult students, who learn better by reasoning. There are plans for international masters courses for academic instrumental teachers within the field of music, where their experiences from private teaching-private learning as a model will be discussed in the context of research findings.

## Musical Instrument Examinations and Their Use

Concerning examinations, we have in Sweden experiences of different systems of peer-review, by bringing in teachers of the same instrument from other community music schools/academies of music into a jury or using teachers representing other instruments simply to get a broader view. At entrance examinations at conservatories vocational representatives have been invited to the juries both at performers' and music teacher education programs to ensure that vocational aspects will be considered.

## Private vs. State Education

In the National Assessment of Music in grade 9 of Swedish Compulsory School, Sandberg, Heiling, and Modin (2005) found that those students who succeeded best in music were girls, and they reported that what they knew they had learned outside school, primarily in the community music school or in bands. The number of school hours was simply not enough to reach the competence needed to get the highest marks. It has to be said that in the syllabus of music, practical skills are focused and the assessment shows that these activities are also predominant in the classroom.

## Social Dynamics of Teaching and Learning

In a study of a Swedish amateur brass band, Heiling (2005) found that social motives were the most important to continue playing in a band that comprised members

between 10 and 70 years of age and at different levels of musical capacity. Especially important to make the musicians stand the hard rehearsing work was that it gave them an opportunity to take part in musical events where the music was packaged in a way to suit the audience, to play together with star soloists and to go on international concert tours. At the same time it also made them better musicians. Primarily they learned to play in the band "by sitting next to Nellie", but in combination with individual lessons and section rehearsals.

# References

Andersson, R. (2005). *Var får instrumentallärarna sina pedagogiska idéer ifrån? Om bakgrunden för instrumentallärares didaktiska ställningstaganden* [From where do the pedagogic ideas of instrumental teachers emanate? About the background for instrumental teachers' didactical standpoints]. Lic.uppsats. Malmö: Musikhögskolan.

Bladh, S. (2002). *Musiklärare – i utbildning och yrke. En longitudinell studie av musiklärare I Sverige* [Music teachers – in training and at work. A longitudinal study of music teachers in Sweden]. Diss. Skrifter från institutionen för musikvetenskap nr 71. Göteborg: Institutionen för musikvetenskap, Göteborgs universitet.

Bouij, C. (1998). *Musik – Mitt liv och kommande levebröd. En studie i musiklärares yrkessocialisation* [Music – My life and future profession. A study in the professional socialization of music teachers]. Diss. Skrifter från institutionen för musikvetenskap nr 56. Göteborg: Institutionen för musikvetenskap, Göteborgs universitet.

Heiling, G. (2005). *Spela snyggt och ha kul. Gemenskap, sammanhållning ocg musikalisk utveckling i en amatörorkester* [Play well and have fun. Community, group coherence and musical development in an amateur brass band]. Studies in music and music education no 1. Diss. Malmö: Musikhögskolan.

Nielsen, B., & Kvale, S. (2000). *Mästarlära* [Master learning]. Lund: Studentlitteratur.

Sandberg, R., Heiling, G., & Modin, C. (2005). *Nationella utvärderingen av grundskolan 2003. Ämnesrapport Musik* [The National Assessment of the Subject of Music in Swedish Compulsory School 2003]. Skolverket Rapport 253, 2005. Stockholm: Skolverket och MPC.

# INTERNATIONAL COMMENTARY

## 49.2

## On the Yamaha Music School in Taiwan (Responding to the Davidson/Jordan Chapter)

**Mei-Ling Lai**
*National Taiwan Normal University, Republic of China (Taiwan)*

Music is a required course in the school curriculum from elementary school to high school in Taiwan. Only recorder, mouth organ, Orff instruments or other classroom percussion instruments are taught in school music class. It is quite popular for parents to send their children to after-school music programs. The study of piano in individual private lessons remains one of the most popular and fashionable extracurricular activities in Taiwan (Chu, 2003; Huang, 2003). Some music schools have introduced group piano instruction with a comprehensive curriculum including listening, singing, playing, reading and notating, and composing. Yamaha Music School is one of the earliest programs introduced to Taiwan; other music programs are Kawai music school, Orff, Kodály, Suzuki, Pace, and so on. Piano instruction is the main course in these schools although instruction for other instruments is offered.

The Yamaha Music School was founded in Japan in 1954, and was established in Taiwan in 1969. Taiwan has become the largest marketplace of Yamaha Music Education System outside of Japan. By 2003, Yamaha Music Schools had 48,000 students enrolled at 175 locations, taught by more than 800 music teachers. During the past three decades, more than 500,000 students have attended Yamaha Music Schools (Chu, 2003; Yamaha Music Foundation of Taiwan, 2004). The Yamaha Music Education System is a sequential learning program for all ages. Courses offered in Taiwan include a Junior Music Course (two-year program for 4 to 5 years old), Junior Extension Course (two-year program) and Advanced Junior Ensemble Course (two-year program) (Chu, 2003). In a typical Yamaha music class, each child sits at one electronic piano while a parent assists. The children often play out loud together (Chang, 2002; Kuo, 1990). In addition, some children take private piano lessons. All method books are provided by the Yamaha Music Foundation in Japan and translated into Chinese. Yamaha teachers are selected through placement examinations which include performance, sight reading, harmonization and improvisation. The prospective teachers receive some training provided by the Foundation. Teachers take examinations to move to teaching higher level classes with higher pay. The teacher training

*L. Bresler (Ed.), International Handbook of Research in Arts Education, 749–752.*
© 2007 *Springer.*

program and method books serve as a quality control of Yamaha Music Schools (Chang, 2002; Kuo, 1990).

The Yamaha Grade Examination System for students was established in 1967 for the purpose of improving musicality and verifying overall ability (Yamaha Music Foundation, 1999). Children in the Yamaha Music School are encouraged to take an examination at each level including piano playing, sight reading, improvising and listening. The comprehensive piano examination program is well received by music teachers and is accepted as the standard for assessing musical abilities (Chang, 2002; Chu, 2003). Participation increases each year (Kuang, 2004).

There is research on piano teaching materials, piano techniques and piano literature, but little related to piano education (Li, 2003). However, most of the research on piano education is related to piano study of college students and programs for musically gifted. Yamaha Music School participants feel positive about the program, but the drop-out rate is rather high. Almost 40% of the students dropped out before completing the Advanced Junior Ensemble Course for various reasons including lack of interest, pressure of academic work and conflict with the preference of the program (Chu, 2003). How can educators deal with the drop-out from Yamaha and other music programs? Comparative studies and analysis of various music programs concerning curriculum, teaching materials, graded examinations have appeared in recent years (Chen, 1997; Chang, 2002; Chu, 2003, Kuang, 2004). The research focus on the musical concepts of piano playing (Ho, 1995) and identifying the meaning of piano playing from the students' perspectives (Li, 2003) is essential to improve piano education in Taiwan.

# References

Chang, I.-L. (2002). *Fang jian er tong yin yue ban zhi xiao fei xing wei tan tao – Yi tai zhong shi wei li* [The investigation of consuming behavior towards children music programs in Taichung City – A case study]. Unpublished master's thesis, Soochow University, Taipei.

Chen, H.-J. (1997). *Xian jie duan tai wan di qu "ao fu yin yue jiao xue" yu "shan ye yin yue jiao xue" shi shi zhuang kuang zhi bi jiao fen xi* [The comparison and analysis between the applied condition of "Orff musical teaching method" and the applied condition of "Yamaha musical teaching method" in Taiwan]. Unpublished master's thesis, Chinese Culture University, Taipei.

Chu, H.-L. (2003). *Tai wan shan ye yin yue jiao yu xi ton jiao cai jiao fa zhi yan jiu* [The study of teaching materials and teaching method of Yamaha music education system in Taiwan]. Unpublished master's thesis, National Taipei Teachers College, Taipei.

Ho, P.-W. (1997). *Tai wan di qu gang jin jiao shi yu xue sheng dui tan gang jin shi ji fa biao jin ji quan shi fa de yin yue gai nian zhi tai du* [Attitude of Taiwan piano teachers and students towards identified musical concepts for fostering expressivity and interpretation in piano playing]. (NSC 85–2413-H-110–002)

Huang, M.-H. (2003). *Guo xiao xue tong ke wai yin yue xue xi zhi you guan yan jiu* [A study on the extracurricular music learning in elementary schools]. Unpublished master's thesis, National Taipei Teachers College, Taipei.

Kuang, M.-L. (2004). *Gang jin zhu jie xue xi zhezhi gang jin kao ji jian ding diao cha yan jiu – yi ying quo huang cha jian ding kao shi, shan ye gang jin jian ding wei li* [The investigation of piano graded examination for piano beginners – "Associated Board of the Royal Schools of Music" and "Yamaha Piano Graded Examination"]. Unpublished master's thesis, National Pingtung Teachers College, Pingtung.

Kuo, H.-L. (1990). *Piano pedagogy in Taiwan: A course design*. Unpublished doctoral project. Northwestern University.

Li, C.-W. (2003). The effect of Taiwanese piano education from the perspectives of college senior piano majors. *Journal of National Kaohsiung Normal University, 14*, 325–350.

Yamaha Music Foundation (1999). *Creating music for tomorrow*. Tokyo: Author.

Yamaha Music Foundation of Taiwan (2004). http//www.yamaha-mf.or.tw

# INTERNATIONAL COMMENTARY

## 49.3

## Commentary on " 'Private Teaching, Private Learning': An Exploration of Music Instrument Learning in the Private Studio, Junior and Senior Conservatories" (Davidson & Johnson)

**Ana Lúcia Louro**
*Federal University of Santa Maria, Brazil*

There are three areas of research from Brazilian literature on music education that seem to complement this chapter. They are Kleber's study on social programs that emphasize music education, my own study about the identities of university instrumental music teachers, and Bozzetto's study on the life of private piano teachers (Louro, 2004). Kleber's work challenges, or at least expands on, the notion that the one-on-one experience in instrumental lessons is restricted "to those with both the money and motivation to do it." In countries such as Brazil there are some social projects where poor children can have instrumental lessons in one-on-one style, such as in the Villa-Lobinhos project studied by Kleber (2004). Another interesting line of thought explored both in this chapter and in Brazilian research is related to instrumental teachers seeing themselves primarily as " 'reputable' practitioners." In my doctoral thesis the practice of defining instrumental teachers by their "music merits" is opened to debate. Some of the instrumental music teachers strongly agreed with that traditional position emphasizing performance skill, but some others pointed to the teaching skills as also very important (Louro, 2004). One last point is related to "the negative aspects of the 'enclosure' of the studio." Bozzetto has studied the private piano teacher in Brazil with an oral history methodology, and part of her analysis deals with the isolation of the studio (Bozzetto, 2004). It is interesting to mention that for some private teachers whom she interviewed, teaching at home is "a wonderful thing, this is a source for satisfaction." Although some of this research points to findings that are in contrast with this chapter's argument, it is important to say that in general the experience of the one-on-one private teaching institution is very similar in Brazil to that described in the chapter.

## References

Bozzetto, A. (2004). *Ensino particular de música: práticas e trajetórias de professores de piano* [Private music teaching: Practices and life histories of piano teachers]. Porto Alegre: Editora da UFRGS/ Editora da Fundarte.

*L. Bresler (Ed.), International Handbook of Research in Arts Education, 753–754.*
© 2007 *Springer.*

Kleber, M. (2004). Terceiro Setor, ONGs e Projetos Sociais em música: aspectos da inserção no campo empírico [Third sector: NGOs, social project, and music: Some aspects of the empirical field]. In: XII ENCONTRO ANUAL DA ASSOCIAÇÀO BRASILEIRA DE EDUCAÇÃO MUSICAL, Rio de Janeiro. *Anais*. 2004, pp. 1–8.

Louro, A. L. (2004). *Ser docente universitário – professor de música: dialogando sobre identidades profissionais com professores de instrumento* [University instructors – instrumental teachers: Dialogues on professional identities]. Porto Alegre: Programa de Pós-Graduação em Música, (Tese de Doutorado).

# INTERLUDE

# 50

# CULTURAL CENTERS AND STRATEGIES OF BEING: CREATIVITY, SANCTUARY, THE PUBLIC SQUARE, AND CONTEXTS FOR EXCHANGE

**Mike Ross**

*University of Illinois at Urbana-Champaign, U.S.A.*

There is little doubt that the role of the cultural center – the museum, the opera house, the theater, the symphony hall, the performing arts center, and so on – has been of considerable value throughout history. It should also be noted that in some cultures – those in which what we refer to as "art" or "culture" in the aesthetic sense is more naturally and seamlessly woven throughout the societal/social experience – the very notion of a "cultural center" might well be considered alien or irrelevant, and certainly unnecessary. But in those societies in which cultural centers are found, it's my view that such institutions have never been of more potentially critical importance – indeed *necessity* – than they are today. I say this because I believe the development of one's own personal strategy of being has never been more critical than it is today, and that cultural centers provide entry to one of the most important aspects of human experience one can employ in the development of such a strategy. I will return to this notion later.

I use the word "necessity" here with clear intent. Our world moment is overfilled with the tragic and ominously threatening. Is it possible that a single day now passes in which virtually every woman, man, and child of a certain age in our society does not have at least a passing thought on terrorism, environmental degradation, nuclear proliferation, extreme intolerance, abject poverty, or any other of a growing handful of deeply troubling issues? In the light of such circumstances, it would seem abundantly self-evident that deeply life-affirming experience should rank high on our priority list in the quest for well-being – of individuals, families, communities, societies, and our collective humanity. But it also appears that we often fail to view and actively seek out such experience as a vital counterpoint to the array of life-denying phenomena of our time.

This is where the notion of "strategies of being" can step in. I borrow this notion from a brilliant art historian and colleague at the University of Illinois, Jonathan Fineberg, who incorporated it into the title of his intriguing survey of contemporary work published as "Art Since 1940: Strategies of Being." Drawing upon his strong interest in psychology, Fineberg developed and used the concept to explore the unique

*L. Bresler (Ed.), International Handbook of Research in Arts Education, 755–758.*
© 2007 *Springer.*

mindsets and impulses that drive the work of extraordinary artists and that distinguish them from one another. My adaptation of his concept is an attempt to help generate broader frames within which individuals living in today's world can more purposefully imagine their lives and the critical experiences that define them.

In a general manner of speaking, one's strategy of being might be thought of as one's philosophy of life. But I prefer strategy of being because it connotes a more active – more intentional – frame of mind. Philosophy can often find itself sitting on the shelf rather than actively influencing the actions of individuals, especially when they find themselves facing extraordinary challenge. I think of one's strategy of being not only as the composite of one's views of religion, politics, socioeconomics, sexual orientation, and so forth, but also as the composite of priority *actions* to which one commits – with clear intent – and that sets one's life pathway. It is a personal metastrategy, if you will.

The absence, intentional or otherwise, of a commitment to seeking out life-affirming experience as part of one's strategy of being is, in my view, at best an unfortunately missed opportunity and, at worst, a fatal flaw, a profound act of surrender. Conversely, I believe that a conscious commitment to seeking out such experience can have a profoundly positive impact on one's sense of well-being. In our society, however, it seems that even when individuals do consider such a commitment they tend to see but a limited set of experience options available to them, such as attending religious services or athletic events. To be sure, these experiences can be powerfully meaningful and uplifting, but it is all too clear that the option of aesthetic experience does not, ironically, readily occur to most people in our society. I say "ironically" because it is no secret that meaningful aesthetic experience can be one of the most deeply transformative of human experiences. That it barely registers on the radar screen of society at large – yet again, especially during a time of extraordinary challenge – should do nothing but motivate cultural workers all the more to imagine new ways of bringing this option into the broader consciousness.

The cultural center holds a special place in this scenario, for it is nothing if not a place of potentially extraordinary experience – different in nature from that of religion, athletics, and other meaningful and useful realms of human experience, to be sure, but also highly potent. In ways the K-16 environment and others cannot, and perhaps should not even if they could, the cultural center can function powerfully and simultaneously as sanctuary, public square, and as a creator of contexts for exchange.

"Contexts for exchange" is also a borrowed notion, one that I gratefully attribute to Nancy Cantor, current president of Syracuse University in New York State and a social psychologist who has given serious thought to the role of the arts in society. The cultural center, by the very nature of its work in presenting and exhibiting the art of the past and of our time, is a creator of contexts for the exchange of ideas, of cultural backgrounds and experience, and of political and social perspectives. As a safe zone for such exchange, it can help negotiate the divides – generational, religious, lifestyle, and others – that tear away at the fabric of togetherness.

To take this notion further, I believe that at its best and most profound the cultural center is a place in which difference – of ideas, backgrounds, perspectives and so on – itself is transcended and, in the most potent of instances, disappears. It is a place for what Edward Said called "the extreme occasion" – the moment in which one experiences

simultaneously the intensely personal and publicly shared. It can be the vehicle to bring about for the first time within an individual a deep, Dewey-esque sense of perception. It can be the place in which, through the experiential process of deep perception, one can dig down far enough to get outside oneself and sense one's connection to our collective humanity.

Again, cultural centers are nothing if not places of potentially extraordinary, deeply meaningful experience. And because, in a certain and important sense, we define ourselves by the experiences we choose to have (we each have our own complex autobiography that has been, in some significant way, written by our choices of experience), the role of the cultural center in our society warrants special attention. Many of the experiences we have, of course, are not of our own choosing. But this fact only increases the importance of the choices we do make.

Much has been observed and commented upon through the centuries – by Dewey and many others – regarding the special case of aesthetic experience, and it is not difficult to imagine that the intriguing wave of emerging breakthrough neuroscientific research on how the mind-body operates with respect to emotion and feeling – coupled with the continuing flow of findings from research on cognition, perception, and intelligence – will only serve to more powerfully reveal the fundamental value of aesthetic experience and underscore its potential to contribute to human well-being. As a provider of such experience, the cultural center is clearly positioned to play a significant – even transformative and liberating – role in one's strategy of being.

As suggested earlier, the experience of art allows us to get outside ourselves to find ourselves and our connection to others. But seasoned seekers of such experience – the most powerful instances of which I refer to as seminal moments – know all too well that such experience doesn't simply just happen, although it can and does at times occur without advance notice. As it has been said that chance favors the prepared mind, it is my view that the possibility of the seminal moment favors the *open* mind. By this I mean a state of mind in which instinct, intuition, and expectation are held in a semisuspended state – vulnerable, perhaps, but also free and receptive to the possibility of heightened experience, to the possibility of being fully "in the moment."

It is no simple task to open one's mind in this manner, and, as I have noted, there are potential vulnerabilities. But there are also big payoffs to be had. For while it is in the nature of such exploration for the seminal moment to be intensely personal, it can also be a moment accompanied by a powerful feeling of connection to others at a very deep level, well beneath the surface of differences – political, cultural, and otherwise – that can obstruct an enriched sense of togetherness. It is this sense, I believe, that underlies Said's notion of the extreme occasion. And it is this sense that provides the cultural center with its capacity to function simultaneously and extraordinarily as sanctuary and public square.

The common ground to which I have been referring and that can be revealed at the deep points of convergence brought about through the shared experience of art leads me to an even more fundamental subject – that of creativity *per se*. It is my view that this common ground is, in fact, the deep underlay of creativity that we share as human beings. To be sure, the domain of art is a unique and particularly visible creative domain, but it is by no means the only one. The domains of science, engineering, technology, the humanities, commerce, education, and others across the spectrum of

human inquiry are full of creativity. While particular domain vocabularies may prefer "innovation" (as in the case of technology) or "entrepreneurship" (as in the case of commerce), creativity is the shared core characteristic – and it is *potent*.

It is also elusive as a subject of research, but there is much insight to be gained from the large and interesting body of literature on creativity that has accumulated in recent years by Howard Gardner, Mihalyi Csikszentmihalyi, Margaret Boden, Dean Simonton, Theresa Amabile, and others. Much of the literature reinforces what those of us in the arts domain may already "know" about creativity through instinct, intuition, and personal or professional experience, but there is also much in the literature that will cause the curious and open arts thinker to reconsider regarding core assumptions. It is clear that a fuller understanding of the nature and needs of creativity, and a commitment to viewing creativity simultaneously from an everyman/everywoman/everychild/everyday perspective as well as from a perspective that vigorously pursues and nurtures extraordinary instances of creative potential can lead to greater achievement and fulfillment of goals, no matter the particular domain.

I point out that art is but one creative domain because I believe it is important for artists and those dedicated to them not to forget that they do not hold exclusive rights on the deeply embedded – indeed, what some argue to be the *defining* – core human characteristic of creativity. But I also believe that as a touchstone realm of human experience the domain of art holds unique potential as an entry point to a powerful pathway of discovery that can lead individuals to an inspiring sense of our collective humanity. It is a special and sometimes mysterious pathway, one that can create discomfort as well as exhilaration, but one well worth the risk of pursuing.

I believe it is the pathway pointed towards when Nietzsche said that "One must have chaos in one's soul to give birth to a dancing star," when Baudelaire attached the element of strangeness to beauty, and when the contemporary British performer Seal recorded the line, "But we're never gonna survive unless we get a little crazy."

And it is the pathway towards which I believe cultural centers – pivotally positioned between the artist and society at large – can lead meaning-seeking individuals. Not all cultural centers are driven by this sort of thinking. But when their doors are opened wide, when they are keenly aware of their role in creating contexts for exchange and of their dual and simultaneous functions as sanctuary and public square, they become vitally important options to be considered in the development of a strategy of being that can lead to a robust, exuberant, and deeply felt affirmation of life.

Yes, even in the midst of a highly challenging world moment.

# 51

# MUSIC BEYOND SCHOOL: LEARNING THROUGH PARTICIPATION

**Stephanie E. Pitts**
*University of Sheffield, U.K.*

## Introduction

Musical learning is an integral part of musical participation. Adults who attend concerts, listen to recorded music, play instruments, or sing in a choir often exhibit the qualities of motivation, determination and self-criticism that are essential to effective learning – even if they would not necessarily characterize their musical experiences as "educative" in the commonly understood sense.

For adults who engage in musical activities, the benefits are potentially manifold: the social effects of belonging to a community of like-minded peers, the growth in self-esteem caused by identifying and attaining a challenging goal, the sheer enjoyment of being closely involved with a particular musical repertoire or, best of all, a combination of all of these forming a fulfilling social-personal-musical experience. There may be disadvantages and costs too: the exhaustion of the final stages of preparation for a staged production, the pressures of trying to fit regular rehearsals into an already busy schedule, or the sense of guilt at devoting time to the pursuit of one's own pleasures amongst the demands of work, family and other commitments.

It is easy to overlook the similarities between these examples of musical participation in adult life, and the more deliberately educational experiences of young people encountering music in the school curriculum and beyond. And yet there is an obvious continuum between the child electing to join the orchestra rather than the football team, and the adult who sets aside time to attend a choir rehearsal or go to a concert. Each, in their own way, is investing in music, and recognizing the contribution that it makes to their well-being, self-esteem and continued development. Both are engaged in a kind of learning, which must be self-directed if it is to be truly sustainable, but which needs also the presence of co-learners, role models and audiences.

This chapter will use evidence from case studies of musical participation to illustrate the potential of informal learning in the lives of participants, and to argue for a greater continuity between "school music" and music in community settings – a broad term

*L. Bresler (Ed.), International Handbook of Research in Arts Education, 759–772.*
© 2007 *Springer.*

which here includes performing societies, concert halls, cultural partnerships and out-reach programs. It will be argued that music in education has a valuable role to play in fostering continued engagement with music beyond school, such that musical participation in its varied forms encompasses the values and characteristics of lifelong learning.

## Understanding Musical Engagement Beyond School

Perhaps more than other curriculum subjects, music has long had to assert its place in compulsory education, and so there is a vast international literature of theoretical justification and empirical evidence pointing to the desirability of studying music for its transferable learning qualities as well as for its specific knowledge and skills (see Hargreaves & North, 2001 for useful summaries). In recent decades, there has been a growing interest in the extent to which musical learning and engagement also occurs beyond institutional contexts, supporting the view that "schools are best seen not as transmitters of culture but as complex cultural exchanges" (Calouste Gulbenkian Foundation, 1982/1989, p. 43). This section reviews the extent and type of musical participation that appears to be typical in modern industrial societies, and considers the implications for music educators of changing patterns of musical engagement in wider society.

### *Music Outside School: National Surveys of Participation*

National surveys of the extent and experience of participating in the arts present a confusing picture, generally concluding that "although involvement in the amateur performing arts is a minority pursuit, for those involved it is undertaken with a considerable degree of commitment" (Policy Studies Institute, 1991, p. 33). Large-scale attitudinal surveys in Australia have been evaluated from an educational perspective by Margaret Barrett and Heather Smigiel (2003) and by Nita Temmerman (2005), who note the need for all age groups to be given greater encouragement to recognize the value of active participation in the arts. Temmerman presents a clear challenge to all those involved in music education, in and out of school: "how to connect the three contexts of the school, home and community to enhance positive attitudes towards music making, to build on existing opportunities to engage in music making, and to bring together the wealth of music activity, resources and expertise" (p. 116). Encouragingly, Barrett and Smigiel found Australian children to be receptive to the arts in daily life, suggesting that "the challenge for the arts community … may rest in creating meaningful links between children's and family's definitions and practices in the arts, and those promoted by the arts community" (p. 16).

In Britain, Anthony Everitt (1997) has documented the wealth of musical learning and participation taking place across the country, calling upon politicians and funding bodies to support "the institutional infrastructure which enables music-making to take place – the clubs, societies and associations – [since this] is a valuable support for the maintenance of a thriving and balanced civil community" (p. 31). François Matarasso's (1997) detailed study of the social impact of participation in the arts points to the increase in self-confidence and social cohesion experienced by those new

to arts partnerships. Acquiring new skills within a supportive social context can have far-reaching implications, as respondents in Matarasso's study reported that "one of the most important outcomes of their involvement in the arts was finding their own voice or, perhaps, the courage to use it" (p. 17). Rachel Gardiner and Andrew Peggie (2003) caution against an overwhelming emphasis on "the social/personal development agenda", fearing the risk of obscuring "an equally vital aspect of getting involved with music – the experience of 'the beyond', of sounds, emotions, and ideas beyond the everyday lives of the participants" (p. 6). Music, Gardiner and Peggie remind us, is "a mind-and soul-expanding tool" (p. 6). In an increasingly individualized society, the cultural centers and partnerships that support community music-making have a vital role to play in sustaining the social and emotional health of those who participate in music – whether actively or in audience.

*Learning through Listening*

For the generation currently leaving compulsory education, the ubiquity of music listening is greater than it has ever been. Some musicologists fear a consequent damage to the ability to engage in concentrated listening (e.g., Johnson, 2002), while others assert that contemporary listeners have retained those skills alongside new strategies for dealing with vast quantities of music; "moving back and forth between hearing music and listening to it [is] a skill that is taken for granted by film scorers, and one that we exercise everyday without thought as we walk down the street or sit in a pub" (Frith, 2003, p. 97).

Tia DeNora's study of *Music in Everyday Life* presents evidence that self-regulated listening is indeed highly sophisticated, acting as a "technology of the self" (DeNora, 2000, p. 61) and contributing to the ways in which individuals structure and understand their life experiences. DeNora uses a combination of interviews and ethnography in her studies of listening in the home, music in aerobics classes, and music policies in clothes shops, aiming to "describe a range of strategies through which music is mobilized as a resource for producing the scenes, routines, assumptions and occasions that constitute 'social life' " (p. xi). Her interviewees reveal high levels of knowledge about the ways in which music affects their moods, enriching their emotional lives by sustaining or helping to lift a particular frame of mind. This sophisticated, self-regulated listening has been shown in other studies to be widespread in contemporary industrialized societies, occurring most often during travel (Bull, 2000) and as an accompaniment to routine activities in the home (Sloboda, O'Neill, & Ivaldi, 2001). Music helps to secure an increased sense of personal autonomy during the time-consuming tasks of housework and commuting, as well as regulating emotional intensity during moments of personal reflection and in social settings. Listeners have not been taught to use music in these ways, but have accumulated skills of selecting and using music through experience, and have developed an instinctive knowledge of how their known musical repertoire will affect their daily circumstances.

Work with younger interviewees has shown that these skills of musical selection and listening operate from a relatively early age, shaping children's soundscapes, friendship groups and personal tastes. Patricia Shehan Campbell's (1998) ethnographic study of

children's musical culture in America illustrates the wealth of musical activity that permeates young people's lives, crossing the artificial boundaries of school, home and community (see also Crafts, Cavicchi, & Keil, 1993). Strikingly, Campbell notes that the influence of the family in children's musical lives is stronger than that of the school: "direct or indirect involvement in music by either parent, by siblings, or by members of their extended families steered these children to many of their musical reckonings" (Campbell, 1998, p. 162). But while the influence of formal education must acknowledge the broader context of informal learning, the responsibilities of music educators are in no way diminished: "the home and school – and the efforts of parents and teachers – can take children from who they musically are to all that they can musically become" (p. 223).

## Learning through Participation

That musical skills are acquired with at least a partial degree of independence is well-established in instrumental learning, whereby pupils are expected to practice between lessons and develop their own strategies for critiquing and correcting their performance (see, e.g., Hallam, 1998; Jørgensen & Lehmann, 1997; McPherson, 2005). Most learners, however, have regular access to a teacher, who largely determines the direction of their learning by acting as an instructor, role model and motivator. In the typical music classroom, similarly, students may work on their own or in small groups on creative tasks, but peer learning is usually a supplement to teacher-led interventions, and the curriculum is decided for, rather than by, the students.

It must be more than coincidence that the research outlining an alternative to this model has focused on non-classical music: most notably Lucy Green's (2002) work with popular musicians, Johan Söderman and Göran Folkestad's (2004) research on the informal creative music-making of hip-hop musicians, and Peter Cope's (2002, 2005) studies of adults learning traditional music. These authors have demonstrated the high levels of intrinsic motivation that come with this kind of independent learning: without the direction of a teacher, self-taught musicians are driven by their engagement with musical activities and the promise of greater involvement and success as their skills develop. Self-sufficient learning in adolescent years appears to lay strong foundations for lifelong musical participation, such that "young musicians who acquire their skills and knowledge more through informal learning practices than through formal education may be more likely to continue playing music, alone or with others, for enjoyment in later life" (Green, 2002, p. 56). Cope's adult learners show that the difference is maybe one of attitude rather than experience: the opportunity to perform and make music with others can provide a strong incentive to acquire skills at any age, and offers a useful model for formal education.

Before music educators in schools start to despair of the declining significance of their role, it is worth considering some instances of attempts within the school setting to foster the independent spirit and high levels of motivation usually associated with informal learning. Christopher McGillen's (2004) participant research with the "Jungle Express" band describes the activities of 21 teenagers in a rural Australian school, who met weekly to collaborate with their peers and teachers in writing and

rehearsing original compositions. McGillen writes of the strong sense of participation and belonging that was felt by members of the band, creating a community that "was based neither totally within the realms of the mainstream school environment nor in peer groups that operated outside the rehearsal environment" (McGillen, 2004, p. 287). He suggests that the success of Jungle Express came from "the sense of role mixing and matching" (p. 292), so that distinctions between learners and teachers were blurred and students were fully participant in the decisions and direction of the group.

Lucy Green (2002) set a similar challenge to teachers in suggesting that the strategies of "purposive listening" and peer learning that she observed amongst pop musicians could find a place in the mainstream classroom. She noted, however, the ways in which conventional educational practices work against such innovative methods: "Many teachers would feel guilty and irresponsible if they found themselves sitting for even ten minutes outside the classroom whilst pupils worked at copying their favourite recordings through peer interaction and without any intervention on teachers' parts!" (Green, 2002, p. 204). At the time of writing, Green is working with teachers in schools and around London to try out the methods of learning reported by popular musicians. Students work in small groups to generate a performance of a pop song of their choice, listening to a CD recording and copying what they hear. They can ask for teacher support, but no unsolicited interventions are made by the staff or researchers – a change in style that teachers acknowledge to have been difficult, but in which the benefits to students are soon evident. Fieldwork recordings show that the aural chaos initially feared by the teachers quickly dissipates, to be replaced by purposeful musical behavior in which the students show sophisticated skills of listening and performing (Green, 2005). Green is careful to emphasize that this research is exploratory and does not seek to replace more traditional teaching methods, but rather to offer a wider repertoire of learning styles and opportunities upon which music teachers can draw in seeking to enthuse their students.

Outside formal educational settings, musical learning flourishes where there is opportunity, high levels of motivation, the immediate prospect of public or peer feedback, and a sense of ownership and participation. The challenge for music educators is to ensure that these qualities can thrive within the confines of a timetabled, assessed curriculum subject, with all the external pressures and measures that implies.

## Case Studies of Musical Engagement Beyond School

It has already been established in this chapter that research into musical behavior in a variety of settings is undergoing a long-overdue rise to prominence, with researchers in musicology and related disciplines challenging the historical privileging of the musical text by taking a more holistic view of musical events and experience (see, for example, Clarke & Cook, 2004; Clayton, Herbert, & Middleton, 2003). This section will present selected evidence from my own large-scale study of musical participation (Pitts, 2005a), focusing on two case studies of singers in amateur performing groups and listeners at a chamber music festival. The aim of this discussion is to identify the essential characteristics of learning through participation, and to consider how these might be relevant in diverse educational settings, including music classrooms.

*Case Study 1: Amateur Singers at a Gilbert and Sullivan Festival*

The study from which this evidence is drawn took place at a music festival held annually in a small town in the North Midlands of England. Every year, amateur performing societies gather to perform the entire canon of Gilbert and Sullivan operettas – a body of late nineteenth century music theater works that attract strong devotees and detractors, particularly in the United Kingdom and America. The festival allowed me to explore the experiences of singers performing accessible but often demanding solo or chorus roles, and the views of audience members, who of the two groups, were the most overtly committed to the genre and its preservation in the face of declining popularity. The focus here will be on the singers and their experience of musical learning and development through their performing activities (for discussion of other aspects of the festival see Pitts, 2004, 2005a).

Singers at the festival rarely referred directly to "learning", but recognized the role of their rehearsing and performing activities in developing their self-assurance, their sense of identity, and their musical skills and confidence. Rehearsals, in particular, were occasions for focused effort and peer critique: as one singer noted, "the toughest place you'll ever perform is in the rehearsal room, where all your folk are sitting around looking at you". Loyalty to their performing group was high amongst all those I interviewed, and it was clear that fitting rehearsals and performances around other family and work commitments demanded real determination. The rewards were also considerable, though, not only in the applause and appreciation of the final performances, but also through the sense of community, belonging and shared endeavor afforded by weekly rehearsals with like-minded enthusiasts. High levels of motivation and a clear sense of shared purpose were a successful recipe for continued participation and satisfaction amongst the group members, outweighing the interim hurdles of learning a difficult musical passage or struggling to fit rehearsals into an already busy schedule.

For several of the performing groups, the emphasis was clearly on participation, with each member seen as serving a distinctive and necessary role. At one extreme, the organizer of a group stated cheerfully that "in this society we have people who can hardly sing at all": all were nonetheless welcome, and it was recognized that membership of the society fulfilled a variety of personal and musical needs at all levels of ability. Other societies took a more serious outlook, focusing on the competitive elements of the festival and pursuing a subtle but deliberate policy of encouraging "weaker" members to find their musical outlet somewhere else. Performing societies implicitly chose to emphasize the musical product – focusing on high standards in the final performance and the consequent appreciation of the audience – or else took greater pleasure in the process of reaching that goal, through all the shared frustrations and triumphs of the rehearsal period.

Both process and product are of course essential to the continued functioning of a performing group, but the difference in emphasis was marked across the groups in my study, and seemed to be problematic only where individual members did not share the wider vision of their peers. There are interesting parallels here with the familiar challenges of mixed ability teaching in music, where it is incumbent on the teacher to ensure that individual students benefit from the musical activities of a disparate group.

Emphasizing particular kinds of skill and attainment has its place in fostering high standards in the music classroom, but so too does the recognition that diverse responses to a task can contribute to a more meaningful group experience. Sometimes the focus in music education discourse can seem to be too strongly on training "musicians", rather than on preparing for the diverse musical futures of all those engaging in instrumental and classroom music tuition.

The singers at the Gilbert and Sullivan festival also had a variety of individual goals: some were seeking to develop and extend their musical proficiency, while others sought opportunities to use and enjoy skills in which they already felt confident. Achieving compatibility between these aims could prove challenging in rehearsal, where levels of concentration might vary. Ruth Finnegan noted similarly in her study of performing groups "the concurrent but conflicting desires of choir members, on the one hand to get on with the rehearsal, on the other hand to exchange news with their neighbours or comment on the bit of music they had just been trying to sing – they'd come partly for a social night out, not *just* for the music" (Finnegan, 1989, p. 242). For most singers, however, a satisfactory balance of "hard work and fun" was readily reached, such that neither musical nor social pleasures were compromised for the group as a whole.

The singers in this case study did not necessarily consider themselves to be musical learners, but were nevertheless gaining skills and confidence as well as enjoyment from their activities. They referred on occasion to the ways in which school music had laid the foundations for their adult musical participation, a theme which was explored further in the second case study, discussed below. Their focus on fun and participation illustrates that musical learning can be accidental, as well as informal; an almost inevitable by-product of being involved in musical activities that are stimulating and rewarding.

### *Case Study 2: Audience Members at a Chamber Music Festival*

It is unrealistic to expect that all those who experience formal music education will become performers in adult life, but it is a near-certainty that all will be lifelong listeners. But even while exposure to and uses of recorded music increase, an apparent decline in attendance at live classical music concerts is causing some consternation amongst academic writers and media commentators. This second case study investigated the attitudes and experiences of audience members at a chamber music festival, held annually in Sheffield, England (see also Pitts, 2005a, 2005b). Through questionnaires, interviews and diaries – each of which helped in articulating the usually private experience of listening – these regular concert-goers showed themselves to be musically active, involved listeners, engaged in their own form of highly rewarding musical education.

Going to a concert is primarily a leisure activity, undertaken for enjoyment and in the hope of experiencing a memorable performance of known or unfamiliar repertoire. Amongst the audience members at the chamber music festival, opinions and tastes were varied but strongly held, with a fair proportion of the audience willing to stretch their musical knowledge within reasonable limits: as one wrote, "I usually look for

concerts with a mixture of my favorite composers and a piece which I know less well or not at all". Many of the audience members had been attending the festival since its inception twenty years ago, and so there was a strong social element to their concert-going – more so perhaps than in a more loosely-connected concert series or a festival based in a larger city. One listener summed up the feelings of many in writing of "the informality, the friendly atmosphere, almost familial, and the excitement at the beginning ... knowing you will have the [audience] utterly stimulated, humming some of the splendid melodies listened to". Being amongst friends – or at least those known to be similarly committed to the festival and its music – was as significant here as for the singers in the amateur performing groups discussed above. Even the potentially solitary activity of listening appears to thrive in a social context, where enthusiasms can be shared and discussed.

Many amongst the festival audience readily acknowledged that their previous years of attendance had formed a substantial part of their musical education, increasing their knowledge of chamber music repertoire and their capacity to listen attentively. Indeed, the concerts were overtly educative in several respects: themed festivals based on the works of a single composer or region were typical, enabling deeper exploration of musical ideas and conventions than would be possible in a more varied program; and introductory talks given by the performers were standard practice, welcomed by audience members as "making the music accessible and therefore much easier to understand and appreciate". Some listeners also undertook individual preparation or follow-up activities to enhance their concert-going, whether by searching the Internet for information on a composer, or by listening before or after the concert to a recording of a programmed work. These kinds of involvement illustrated the high value that concert attendance assumed in their lives, and allowed them to feel fully participant in the musical event, experiencing "the sense of being drawn into something beyond myself" and feeling "part of the whole wonderful experience".

As a coda to this case study, I interviewed some of the audience members about the influences that had shaped their adult musical lives, hoping that there might be insights for music education in the past experiences of these attentive and active listeners. Spanning several decades, the interviewees' educational experiences varied considerably, and were recalled with differing degrees of enthusiasm, often determined by the character of the music teacher and the opportunities available for performing within the school. Significant memories often focused on public performance: learning Schubert songs in German at the age of 10; being one of five soprano boys singing in unison "With verdure clad" from Haydn's *The Creation*; playing the St Matthew Passion in the newly built Coventry Cathedral with the school orchestra; and performing in a school production of Britten's *Noye's Fludde* a year after its 1958 premiere. Not all such opportunities were teacher-directed: several of the respondents now in middle-age recalled forming folk or pop bands with their friends, within a "tacitly supportive context at the school" rather than with adult intervention. Memories of instrumental lessons were not always positive, but those who had experienced them were grateful for the opportunities associated with them: playing in the school orchestra, for example, even where hindsight suggested that "it really wasn't of a high standard at all".

The varied educational experiences of the interviewees shared the common characteristic of being supported and reinforced in the home, whatever their parents' level of musical activity and expertise. Most recalled hearing recorded or live music on a regular basis, and the only interviewee who had not had ready access to a gramophone or radio noted the disadvantages of this, feeling "poverty-stricken" in her knowledge of mainstream repertoire. Several had parents who were performers or avid listeners, and remembered being initially puzzled by their enthusiasms, before gradually coming to share them or form independent musical opinions. All were agreed that while positive attitudes in the home could survive inadequate music teaching in school, the reverse was less likely to be true, so making parental enthusiasm for music central in fostering the next generation of musical participants. This seemed to be a pragmatic approach, rather than a denial of the influence of music education, which was also held to be valuable in making music accessible to all children, and in laying the foundations for lifelong participation.

The influence of their musical background was also noted by those interviewees who had become teachers or parents themselves, and the responsibility for encouraging their children's future musical activity was keenly felt. The ethos of "music for all", sometimes drawn from affectionately remembered school days, was widespread amongst the respondents. They were supportive of the educational outreach programs associated with the chamber music festival, sometimes viewing this in terms of securing a future audience for the festival, but often seeing more far-reaching implications: as one interviewee stated, "for people who are playing chamber music or classical music to have some degree of educational energy and activity is desirable almost to the point of being morally desirable". The strong impetus to share and replicate musical opportunities was striking in the interviewees' comments: the contribution that musical knowledge and awareness had played in their own lives brought with it a sense of obligation to secure such possibilities for the next generation of listeners, performers and enthusiasts. Amongst all the justifications for music in the curriculum, perhaps this one is the most powerful: that musical learning in schools can have an influence far beyond the classroom, bringing with it potential access to a lifetime of musical engagement. It is a daunting task for teachers, tempered by the evidence which shows that school-based learning is one influence among many in children's musical lives – but is no less vital for that.

## Connecting "Cultural Centers" and Classrooms

The amateur singer on stage, the fervent listener attending a concert, and the school student attending a compulsory class music lesson once a week might seem at times to be worlds apart, but there is potential for stronger connection between institutional settings and their wider communities. Such links would be mutually beneficial, tackling both the perceived decline in adult engagement with classical music, particularly (Dempster, 2000; Johnson, 2002), and the apparent disjunction between "school" and "home" music which has long been a cause for concern in music education. This section considers research and practice which has attempted to address these ideas, and

looks at the roles of cultural centers and arts organizations in promoting musical engagement across the community.

## Music Education as Part of the "Art World"

The sociologist Howard Becker has drawn attention to the gap between what he terms "art worlds" – encompassing the whole range of activities associated with art creation, including marketing, reception and criticism – and schools, which by employing educators rather than arts practitioners, risk teaching a version of the arts that is never fully up to date (Becker, 1982, p. 59). Protests that Becker's view is itself now out of date are somewhat dampened by recent evidence suggesting that music teachers are indeed somewhat removed from the broader cultural context of the "music world": a survey by Norton York showed that amongst United Kingdom music educators "engagement with current pop is patchy and in many cases inadequate as is their knowledge of modern jazz" (York, 2001, p. 5). Criticizing teachers for their lack of urban musical knowledge is one possible reaction, but this is to ignore the fact that their task is already unfeasibly complex, demanding diverse and considerable musical expertise as well as the patience and skills needed to communicate this expertise to young people. Perhaps a more reasonable and sympathetic response is to accept that music educators in schools cannot be experts in everything, but are ideally positioned to act as a skilled coordinators for practitioners in the art world, whose distinctive perspectives might add a welcome new dimension to young people's musical learning.

In recent years there has been an expansion in the provision of "outreach" or "partnership" programs by opera companies, orchestras and other musical organizations, working at local or national levels to promote integration between arts providers and the wider community, including schools. For the most part, these initiatives spring from the arts organizations themselves, and are sometimes supported by national networks such as Youth Music in Britain (www.youthmusic.org.uk) and the Arts Education Partnership in America (www.aep-arts.org). An internet search quickly illustrates the wealth of activity taking place; but the reports included on these Websites are understandably biased, since their purpose is promotional as well as evaluative. As yet there is no significant volume of independent, critical research on the aims and effectiveness of this work, a task which, although daunting in scale, would serve a valuable function in ensuring the dissemination of best practice between arts organizations.

One reason for the paucity of research on this topic might be the lack of open discussion about exactly how the effectiveness of such programs can usefully be monitored. As with research on the benefits of extracurricular participation (e.g., Jordan & Nettles, 2000; Mahoney, 2000), the quantitative measuring of effects on school performance, increased attendance at arts events, or lifelong involvement in the arts would be possible, but would seem in some ways to miss the point. Arguably more important than quantifiable effects is the qualitative engagement that outreach work can generate: the cooperative behavior of a previously disaffected pupil, a new depth of enthusiasm for participation, the sense of belonging within a school community. These outcomes are individual, even unreliable, since arts projects are about providing opportunities rather than guaranteeing results – a view which is unfashionable in an

educational climate hemmed in by concerns with value for money and identifiable targets. Just as musical participation in adult life fulfils different needs for different participants, so outreach projects will have varied kinds of impact on those who experience them. Monitoring their effectiveness requires sensitivity and a respect for the immeasurable aspects of arts engagement.

## Existing Research on Musical Outreach and Partnership Projects

Independent studies of outreach and partnership projects fall into two main categories: overview surveys of the aims and effects of projects at a national level, and more closely-focused investigations of individual projects and their impact on participants. It is worth briefly considering some differences in terminology that are notable between United Kingdom and American literature. For the past decade or so, projects based in the United Kingdom have favored the term "outreach" to describe the efforts of orchestras, opera companies and others to extend their performing work into the realm of education. In America, meanwhile, similar projects have been described as "arts partnerships", suggesting a more collaborative relationship between cultural and educational centers. In practice, the approaches seem to be similar, with perhaps a stronger emphasis in American literature on the "extramusical" – confidence, social integration and so on – and in Britain on fostering musical interest and securing future audiences and participants. There are exceptions to these broad differences, and a good deal of overlap in the intentions and practices of programs in both countries and elsewhere. The desirability of involving children in music is widely shared, and whether this is justified with reference to musical or extramusical factors is a decision often politically influenced or shaped by sources of funding.

Some representative examples of musical partnerships will help to set this discussion in context:

*Orchestral partnerships:*   The London Sinfonietta was one of the first orchestras to appoint an education officer, a post taken up by Gillian Moore in 1983. Education projects run by the orchestra often focus on contemporary music, and involve students in local schools in interactions with players and involvement as composers and audience members. Interactive Websites, such as the 'Birtwistle Online' project of 2003[1], mean that resources from the Sinfonietta's education projects are lasting and available beyond the target schools. Many other orchestras in Britain, the United States and elsewhere have similar projects, often directed at children in disadvantaged communities, and with the dual aims of enhancing music education and fostering future audiences for the organizations themselves.

*Musical residencies:*   The power of hearing live instruments has long been recognized in education, and ensemble performances given by string, brass and woodwind teachers are often used in British primary schools to recruit new pupils for instrumental tuition. Such one-off stimulus events certainly serve a purpose, but the rarer examples of musician "residencies" illustrate the potential for greater interaction and development where pupils have regular access to professional players. Peter Perret and Janet Fox (2004) write of a program in Winston-Salem, North Carolina in which a woodwind

quintet worked for several months with the same students in activities designed to develop their listening, concentration and musical knowledge. Similarly, projects associated with Music in the Round, the chamber music festival discussed above, have been running in Sheffield schools and nurseries for several years, enabling a culture of musical involvement to be established in contexts where access was previously limited.

It will be immediately apparent that these examples focus on Britain and America, where even a twenty-year history of such projects has still yielded patchy provision, often concentrated in the major cities and subject to insecure staffing and funding. Conversations with colleagues working in continental Europe[2] reveal that provision in those countries is even less consistent, and often traceable to influences from Britain, such as the visits to Finland of Peter Renshaw, formerly director of the pioneering Performance and Communication Skills course at the Guildhall School of Music and Drama in London (see Renshaw, 2002). The need for greater connections and communication at international levels is evident, if the excellent work that is shaping musical experiences for local communities is to have a wider effect. In particular, the time is ripe for a re-evaluation of the aims and purposes of such work, and its relationship with institutional music education provision.

## Conclusions

This chapter has sought to look beyond the confines of school curricula and assessment pressures in search of a clearer vision of whom and what music education is really *for*. The emerging picture is a confusing one of widespread commitment to music education, and local examples of innovative and inspiring work, hampered by a lack of national and international communication about the potential directions for extracurricular musical education. There is a clearly a need for greater recognition of the roles of arts centers and organizations in promoting music as lifelong learning, and for research associated with current practices that will help to evaluate their successes and implications.

Evidence from adult music-makers of the huge importance of music in daily life has been presented here, from my own work with singers and audience members, and from studies of informal learning in pop and traditional music (Cope, 2002, 2005; Green, 2002). Such work suggests that school music education has much to learn from these "outside" contexts, where high levels of motivation and commitment reveal musical learning processes at their most effective. There are questions to be raised in higher education too, where there is perhaps more obvious scope for exploring and challenging students' views of what it means to be a "musician" in contemporary society (Pitts, 2002), and where the training of future generations of musicians and music educators needs some reframing to keep pace with broader social changes (Rogers, 2002).

This chapter has predominantly focused on industrialized, Western societies, where problematic hierarchies of musical skill and opportunity are most prevalent. It should be remembered, however, that these difficulties are culturally specific: "music is something children do and it is always informed by the social context or culture from

which the child emerges" (Mans, 2002, p. 79). Minette Mans writes of the decline of "community-based education" in Namibia, offering a reminder that even while the processes of formal education are being brought into question in societies where they are long-established, so they are gaining prominence elsewhere. The questions and doubts raised in one kind of educational system have implications for others, and it is vital that knowledge of musical learning is shared internationally, whilst being mindful of the sensitivities of transplanting ideas across cultural contexts.

Music educators and cultural organizations have a great deal to learn from one another: their skills and interests are complementary, and have at their heart a shared commitment to fostering musical engagement in young people and so securing a flourishing musical life in future generations. Their diverse social roles and pressures can seem at times to force a competitive relationship between schools and arts organizations, and greater effort is needed to ensure compatibility and cooperation between them through systematic evaluation of their distinctive roles in musical teaching and learning. Only with this increased understanding of the links between music in schools, informal learning, and the outreach projects that bridge that gap, can music classrooms truly become vibrant places of cultural exchange and musical engagement.

# Notes

1. For further details see http://www.londonsinfonietta.org.uk/birtwistle-online [accessed May 27, 2005].
2. My thanks to Marja Heimonen, Janet Hoskyns and Anna Rita Addessi for their insight on practices in Finland, France and Italy, respectively.

# References

Barrett, M., & Smigiel, H. (2003). Awakening the "Sleeping Giant"?: The arts in the lives of Australian families. *International Journal of Education and the Arts, 4*(4), 1–18.

Becker, H. S. (1982). *Art worlds*. Berkeley, CA: University of California Press.

Bull, M. (2000). *Sounding out the city: Personal stereos and the management of everyday life*. Oxford: Berg.

Calouste Gulbenkian Foundation (1982/89). *The arts in schools: Principles, practice and provision*. London: Calouste Gulbenkian Foundation.

Campbell, P. S. (1998). *Songs in their heads: Music and its meaning in children's lives*. Oxford: Oxford University Press.

Clarke, E., & Cook, N. (Eds.). (2004). *Empirical musicology: Aims, methods, prospects*. Oxford: Oxford University Press.

Clayton, M., Herbert, T., & Middleton, R. (Eds.). (2003). *The cultural study of music: A critical introduction*. London: Routledge.

Cope, P. (2002). Informal learning of musical instruments: The importance of social context. *Music Education Research, 4*(1), 93–104.

Cope. P. (2005). Adult learning in traditional music. *British Journal of Music Education, 22*(2), 125–140.

Crafts, S. D., Cavicchi, D., Keil, C., & the Music in Daily Life Project (1993). *My music*. Hanover: Wesleyan University Press.

Dempster, D. (2000). Wither the audience for classical music? *Harmony: Forum of the Symphony Orchestra Institute, 11*, 43–55.

DeNora, T. (2000). *Music in everyday life*. Cambridge: Cambridge University Press.

Everitt, A. (1997). *Joining in: An investigation into participatory music*. London: Calouste Gulbenkian Foundation.

Finnegan, R. (1989). *The hidden musicians: Music-making in an English town*. Cambridge: Cambridge University Press.

Frith, S. (2003). Music and everyday life. In M. Clayton, T. Herbert, & R. Middleton (Eds.), *The cultural study of music: A critical introduction* (pp. 92–101). London: Routledge.

Gardiner, R., & Peggie, A. (2003). *Opportunities in youth music making*. London: Youth Music. Available at www.youthmusic.org.uk [accessed May 12, 2005].

Green, L. (2002). *How popular musicians learn: A way ahead for music education* Aldershot: Ashgate.

Green, L. (2005). The music curriculum as lived experience: Children's "natural" music learning processes. *Music Educator's Journal, 94*(4), 27–32.

Hallam, S. (1998). *Instrumental teaching: A practical guide to better teaching and learning*. Oxford: Heinemann.

Hargreaves, D. J., & North, A. C. (2001). *Musical development and learning: The international perspective*. London: Continuum.

Johnson, J. (2002). *Who needs classical music? Cultural choice and musical value*. New York: Oxford University Press.

Jordan, W. J., & Nettles, S. M. (2000). How students invest their time outside of school: Effects on school-related outcomes. *Social Psychology of Education, 3*, 217–243.

Jørgensen, H., & Lehmann, A. (Eds.). (1997). *Does practice make perfect? Current theory and research on instrumental music practice*. Oslo: Norges musikkhøgskole.

Mahoney, J. L. (2000). School extracurricular activity participation as a moderator in the development of antisocial patterns. *Child Development, 71*(2), 502–516.

Mans, M. (2002). Playing the music: Comparing children's song and dance in Namibian education. In L. Bresler & C. M. Thompson (Eds.), *The arts in children's lives: Context, culture and curriculum* (pp. 71–86). Dordrecht: Kluwer Academic Publishers.

Matarasso, F. (1997). *Use or ornament?: The social impact of participation in the Arts*. Stroud: Comedia.

McGillen, C. W. (2004). In conversation with Sarah and Matt: Perspectives on creating and performing original music. *British Journal of Music Education, 21*(3), 279–293.

McPherson, G. E. (2005). From child to musician: Skill development during the beginning stages of learning an instrument. *Psychology of Music, 33*(1), 5–35.

Perrett, P., & Fox, J. (2004). *A well-tempered mind: Using music to help children listen and learn*. New York: The Dana Foundation.

Pitts, S. E. (2002). Changing tunes: musical experience and self-perception amongst school and university music students. *Musicae Scientiae, 6*(1), 73–92.

Pitts, S. E. (2004). "Everybody wants to be Pavarotti": The experience of music for performers and audience at a Gilbert & Sullivan Festival. *Journal of the Royal Musical Association, 129*(1), 143–160.

Pitts, S. E. (2005a). *Valuing musical participation*. Aldershot: Ashgate.

Pitts, S. E. (2005b). What makes an audience? Investigating the roles and experiences of listeners at a chamber music festival. *Music and Letters, 86*(2), 257–269.

Policy Studies Institute (1991). The amateur arts and crafts. *Cultural Trends, 12*, 31–52.

Renshaw, P. (2002). Remaking the conservatorium agenda. *Music Council of Australia Network Bulletin, 8*(5), June 2002. Available at www.mca.org.au/mf8renshaw.htm [accessed May 25, 2005].

Rogers, R. (2002). *Creating a land with music: The work, education and training of professional musicians in the 21st century*. London: National Foundation for Youth Music. Available at www.youthmusic.org.uk [accessed November 6, 2002].

Sloboda, J. A., O'Neill S. A., & Ivaldi A. (2001). Functions of music in everyday life: An exploratory study using the Experience Sampling Method. *Musicae Scientiae, 5*(1), 9–32.

Söderman, J., & Folkestad, G. (2004). How hip-hop musicians learn: Strategies in informal creative music making. *Music Education Research, 6*(3), 313–326.

Temmerman, N. (2005). Children's participation in music: Connecting the cultural contexts – an Australian perspective. *British Journal of Music Education, 22*(2), 111–121.

York, N. (2001). *Valuing school music: A report on school music*. London: University of Westminster & Rockschool Ltd.

# INTERNATIONAL COMMENTARY

# 51.1

## Comments on "Music Beyond School: Learning in Informal Contexts" (Pitts)

**Eiliv Olsen**
*Bergen University College, Norway*

The question of musical learning in informal contexts is given some attention in Scandinavian research, especially in Norway and Sweden. Here are some examples:

The Norwegian researcher Even Ruud (1983) suggests that musical learning in schools should be called "intentional," while learning outside school is "functional". He also discusses questions linked to problems of music listening in a world crowded with musical sounds, signs and symbols (Ruud, 2005).

Siw Graabræk Nielsen (2004) has empirically developed a model of students' own practicing strategies.

In an extensive study concerning Norwegian youth and leisure, Lars Grue (1985) found that while many teenagers quit music schools and stop playing at the age of 14 to 16, rock music players have a much higher intrinsic motivation for continuing to play. Claes Ericsson (2001) argues that compulsory school should be a public space where work with rock music becomes as natural as with other genres.

An ongoing project called "Experience and Music Teaching," led by Musikhögskolan, University of Örebro, Sweden, focuses upon some English and Swedish students' experiences with music outside compulsory school. The interviews show the necessity of bridging the gap between different musical worlds (Stålhammar, 2004).

Peer learning is not unusual in Scandinavian schools. In Norway, Magne Espeland (2001) has developed a method of music listening where students are more actively engaged than usual in traditional teaching.

In 2001, the Norwegian government started a national project called "the cultural school bag." The aim is to develop an extensive, regular cooperation between compulsory schools and professional artists in all Norwegian counties. The project has not yet been evaluated. (See St.m. 38, 2002–2003).

Courses in "How to Make an Opera," at first a cooperation between Royal Opera House in London and Stord/Haugesund University College in Norway, have been taken up by several compulsory schools.

*L. Bresler (Ed.), International Handbook of Research in Arts Education, 773–774.*
© 2007 *Springer.*

# References

Ericsson, C. (2001). Skolans musikverksomhet som offentlig rum. En diskussion av Thomas Ziehe's begrepp i ljuset av en empirisk studie [Music education in school as a public room: A discussion of Thomas Ziehe's concepts in the light of an empirical study]. In H. Jørgensen & F. V. Nielsen (Eds.), *Nordisk Musikkpedagogisk forskning, Årbok 5, 2001* (pp. 63–73). Oslo: NMH-publikasjoner.

Espeland, M. (2001). *Lyttemetodikk. Studiebok* [Myriads of music. Learning to listen]. Bergen: Fagbokforlaget.

Grue, L. (1985). *Bedre enn sitt rykte* [Better than their reputation]. Rapport. Oslo: Kultur og Vitenskapsdepartementet.

Nielsen, S. G. (2004). Strategisk læring på instrumentet. In K. Johansen & (initial of the first name) Varkøy (Eds.), *Musikkpedagogiske utfordringer* [Strategic learning on the instrument]. Oslo: Cappelen Akademisk Forlag.

Ruud, E. (1983). *Musikken – vårt nye rusmiddel?* [Music – our new drug?]. Oslo: Norsk Musikforlag.

Ruud, E. (2005). *Lydlandskap. Om bruk og misbruk av musikk* [Soundscapes. On use and misuse of music]. Bergen: Fagbokforlaget.

Stålhammar, B. (2004). Musiken – "deras" liv. Några svenska och engelska ungdomars musikerfarenheter och musiksyn [Music – "their" lives. The experience and view of music of some English and Swedish young people]. In F. V. Nielsen & S. G. Nielsen (Eds.), *Nordisk musikkpedagogisk forskning. Årbok 7 2004* (pp. 93–116). Oslo: NMH-publikasjoner 2004:3. St.m. 38 (2002–2003).

# INTERNATIONAL COMMENTARY

## 51.2

## Comments on "Music Beyond School: Learning through Participation" (Pitts)

**Walenia Marilia Silva**
*Universidade Federal de Minas Gerais, Brazil*

Learning music through participation has been a constant practice in Brazil. In the state of Minas Gerais there is a strong music tradition represented by public conservatories and more than 30 Music Band Societies. The bands are mostly symphonic bands. While the conservatories follow a formal music curriculum, the bands are mainly organized around the inclusive participation of community members. The community members join these societies independent of their age or musical ability. Once they start attending rehearsals, the newcomers learn from the older group members by copying them and through the musical scores. In general, they choose an instrument based on what position is available in the band. The learning of multiple instruments is common. Since 2004, the state government has been promoting music teaching workshops for these band societies. The government hires a group of musicians who have bachelor's degrees in music, for example, conducting or trumpet, and organizes weekend workshops in the towns where the bands are located. It is an attempt to promote the continuity of the musical traditions and to improve musical learning among the local communities. However, little or no formal research has been developed about the music learning in these band societies. Some of the band members, usually the youngest ones, opt for a degree in music and move to the capital of the state to pursue a bachelor degree in music. The music education program is not their main option. Even though band societies are not common in other Brazilian states, there are local music groups maintained by participants from specific ethnic groups, for example, Italian and German immigrants, and communities in small towns hold onto their cultural traditions through music and dance groups. Cultural tourism also influences the development of such local music groups.

Brazilians are known for Samba, Choro, or Bossa Nova music. Samba, for example, has distinctive styles and each one of them may involve a different number of participant musicians. Prass (2004) developed a study about music learning in a Brazilian samba school at the city of Porto Alegre. Her study focuses on the teaching and learning modes in music transmission during the rehearsals that prepare the bateria [1] for

*L. Bresler (Ed.), International Handbook of Research in Arts Education, 775–776.*
© 2007 *Springer.*

the carnival parade. Bateria members learn from each other and from the conductor through practicing the rhythms and its variations by ear. Stein (1998) developed a study about music learning in a cultural center in the neighborhood of Porto Alegre. Her study is an example of the available context for music teaching outside formal institutions.

Since 2000, the Brazilian Association for Music Education (ABEM) has been publishing articles about music teachers' training and educational policies. The main concern has been the curriculum in undergraduate music programs (Cereser, 2004; Lima, 2000; Penna, 2004), music teaching in social projects (Kater, 2004; Souza, 2004), and the multiple contexts of informal music practices and the music education (Del Ben, 2003; Figueiredo, 2004). Nongovernment organizations (NGOs) have been an emerging context for music teaching outside formal institutions in Brazil. Their goal is to enhance citizenship consciousness. Music and arts learning play a strong role in the achievement of this goal. Workshops and public presentations (local, on TV, and overseas), consists of attractive strategies for the NGOs' program development, integration, and continuity in Brazilian society. Brazil is not alone when it comes to the multiple contexts for music teaching and learning practices.

# References

Cereser, C. (2004). A formação inicial de professores de música sob a perspectiva dos licenciandos: o espaço escolar [Music teacher's initial education from the students-teachers' perspective: the school space]. *Revista da ABEM, 11*, Setembro.

Del Ben, L. (2003). Múltiplos espaços, multidimensionalidade, conjunto de saberes: Idéias para pensarmos a formação de professores de música [Multiple spaces, multidimensionality, and basis of knowledge: some ideas to reflect on music teachers' education]. *Revista da ABEM, 8*, Março.

Figueiredo, S. (2004). A preparação musical de professores generalistas no Brasil [The musical preparation of generalist teachers in Brazil]. *Revista da ABEM, 11*, Setembro.

Kater, C. (2004). O que podemos esperar da educação musical em projetos de ação social [What we can expect from music education in social action projects]. *Revista da ABEM, 10*, Março.

Lima, S. A. (2000). A educação profissional de música frente à LDB 9394/96 [Professional education in music according to the LDB 9394/96 law]. *Revista da ABEM, 5*.

Penna, M. (2004). A dupla dimensão da política educacional e a música na escola: I – Analisando a legislação e termos normativos [The double dimension of educational policies and the music in the schools: I – analysing the legal acts and diverse normative terms]. *Revista da ABEM, 10*, Março.

Prass, L. (2004). *Saberes musicais em uma bateria de escola de samba: Uma etnografia entre os Bambas da Orgia* [translation] (with CD). Porto Alegre: UFRGS.

Souza, J. (2004). Educação musical e práticas sociais [Musical education and social practices]. *Revista da ABEM*, n.10, Março.

Stein, M. (1998). Oficinas de Música: Uma Etnografia de Processos de Ensino e Aprendizagem Musical em Bairros Populares de Porto Alegre [Music workshops: a Etnographic approach to teaching procedures and musical learning in low income neighborhood of Porto Alegre]. Dissertação de mestrado, UFRGS. Unpublished.